Paintings from Europe and the Americas in the Philadelphia Museum of Art

This publication was made possible by the
National Endowment for the Arts and a gift from
the Women's Committee of the Philadelphia
Museum of Art

Research was supported by the Andrew W. Mellon
Foundation Endowment Fund for Scholarly
Publications and the CIGNA Foundation Endowment
Fund for Scholarly Publications

Paintings from Europe and the Americas in the Philadelphia Museum of Art

A Concise Catalogue

Philadelphia Museum of Art

Cover: Detail from *The Battle of the "Kearsarge" and the "Alabama,"*
by Édouard Manet (page 143)

Edited by Curtis R. Scott, Owen Hess Dugan, and John Paschetto
Designed by James A. Scott
Printed in Italy by Stamperia Valdonega, Verona

Produced by the Department of Publications and Graphics
Philadelphia Museum of Art
26th Street and the Benjamin Franklin Parkway
P.O. Box 7646
Philadelphia, Pennsylvania 19101

Library of Congress Cataloging-in-Publication Data

Philadelphia Museum of Art.
 Paintings from Europe and the Americas in the Philadelphia
 Museum of Art : a concise catalogue
 p. cm.
 Includes index.
 ISBN 0-87633-093-6 (pbk. : alk. paper). — ISBN 0-8122-7964-6
 (cloth : copublication with University of Pennsylvania Press :
 alk. paper)
 1. Painting—Pennsylvania—Philadelphia—Catalogs.
 2. Philadelphia Museum of Art—Catalogs. I. Title.
 N685.A63 1994
 750'.74'74811—dc20
 94-23570
 CIP

CONTENTS

PREFACE

Almost thirty years have passed since the publication of the first *Check List of Paintings in the Philadelphia Museum of Art*, a slim unillustrated volume representing much hard work and enterprise on the part of Henry G. Gardiner, then assistant curator of paintings at the Museum, who compiled the information on the 1,298 works included therein. The present volume builds upon his labors and expands enormously the usefulness of such an effort by incorporating the large and celebrated John G. Johnson Collection, which has been on permanent deposit at the Museum since 1933. With 3,921 entries, each illustrated with a small photograph, this catalogue thoroughly documents one of the largest collections of paintings in North America. The paintings are grouped into large sections corresponding to curatorial departments within the Museum so that readers consulting this book for its wealth of specific information may also gain a rough sense of the shape and character of the Museum's holdings.

The process of preparing this volume occupied many members of the curatorial and publications staff over the better part of a decade. It incorporates research already published in the Museum's recent catalogues of British paintings, by Richard Dorment, and Northern European paintings, by Peter C. Sutton, and it presages the appearance of Carl Brandon Strehlke's volumes devoted to Italian paintings in the Johnson Collection, which will also contain much new scholarship. The curators in charge of each major section—Joseph Rishel for European Painting before 1900, Darrel Sewell for American Painting before 1900, and Ann Temkin for Twentieth-Century Painting—have encouraged and benefited from the work of more than eighteen colleagues in their departments, whose dedication to accuracy and completeness was essential to this project. George H. Marcus,

head of publications at the Museum, directed the overall production of the book. The mammoth task of preparing the manuscript for the printer was undertaken first by John Paschetto, then Owen Dugan, and finally Curtis Scott, who brought it to completion. Clarisse Carnell, associate registrar for collections, has had the lion's share of reviewing more than 2,653 names and citations of donors of works of art and of purchase funds. Without the initial and valiant work of Martha Small, assisted by Colin Currie, to inventory and measure every painting, this volume could not have begun to take form.

Two generous grants from the National Endowment for the Arts and a handsome contribution from the Women's Committee of the Philadelphia Museum of Art have made this publication possible. No better example can be imagined of a public-private partnership to support the Museum's fundamental mission of making its collections widely accessible. The endowment funds for scholarly publications created by a grant from the Andrew W. Mellon Foundation and funds from the CIGNA Foundation were also invaluable in support of the detailed research necessary to reexamine many attributions. Distributed by the University of Pennsylvania Press and by our own library exchange program to museums and libraries around the world, this book provides students, scholars, and the museum-going public with the most up-to-date information about the entire paintings collection in a single, comprehensive volume.

Since 1965, when the history of the Museum's collections was ably summarized by Mr. Gardiner in the essay reprinted in the following pages, the heady rate of growth that rapidly filled the Museum's vast neoclassical building (nearly empty when it opened in 1928) has slowed somewhat, though gifts of extraordinary importance have continued to enrich the collections. Not surprisingly, individual gifts and purchases since 1965 have wrought among the most significant changes to the Museum's representation of the art of the latter half of the twentieth century. In 1967, the Samuel S. White 3rd and Vera White Collection added important works by Matisse, Rouault, and the School of Paris. In 1974, the Albert M. Greenfield and Elizabeth M. Greenfield Collection brought a wide array of modern paintings, including the first works by Jackson Pollock

and Willem de Kooning to enter the Museum. Also in 1974, Mr. and Mrs. H. Gates Lloyd initiated the gift of their extraordinarily important early masterpiece by Pollock, *Male and Female*, which joins Cézanne's *The Large Bathers* and Duchamp's *The Bride Stripped Bare by Her Bachelors, Even (The Large Glass)* as complex, pivotal works suggesting powerful new directions in twentieth-century art.

The creation of two programs—one national and one enthusiastically local—have helped to emphasize the importance of contemporary acquisitions during the past thirty years. The museum purchase plan program of the National Endowment for the Arts has been a crucial source of matching funds for acquiring works by living American artists, such as Richard Diebenkorn and Philip Pearlstein. The Friends of the Philadelphia Museum of Art, founded in 1964 to raise much-needed purchase funds, gave the Museum its first major painting by Robert Rauschenberg in 1967 and has continued to add strength to strength ever since, contributing works by Sol LeWitt, Frank Stella, Alex Katz, and Ellsworth Kelly, among many others.

Over the past thirty years, Philadelphians have remembered the Museum in their wills with extraordinary generosity. The collections of nineteenth-century painting were substantially strengthened by the 1978 bequest of Charlotte Dorrance Wright, whose love of Impressionism brought important pictures by Monet, Cassatt, Pissarro, and many of their contemporaries. In 1986, a splendid gift from the late Henry P. McIlhenny, former curator, trustee, and chairman of the board, enriched the Museum's nineteenth-century European holdings with his distinguished collection of masterpieces by Ingres, David, Delacroix, Degas, Cézanne, Van Gogh, and Toulouse-Lautrec, as well as a charming group of British Victorian paintings. In 1980, Mr. McIlhenny's longtime friends and fellow benefactors of the Museum, Rodolphe and Willemina Meyer de Schauensee, culminated a lifetime of joint gifts with Mrs. de Schauensee's bequest in 1980 of a splendid late Renoir, a Van Gogh portrait, and the first Tahitian subject by Gauguin to enter the collections.

Over the past fifteen years, a number of spectacular purchases have been made possible by individuals and a foundation with deep roots in Philadelphia. A gift of funds from the bequest of George D. Widener enabled former director Jean Sutherland Boggs to acquire Edgar Degas's late masterpiece *After the Bath*, which she had admired for many years. The generosity of the Mabel Pew Myrin Trust and the gift of an anonymous donor ensured that Charles Willson Peale's five portraits of the family of General John Cadwalader would not leave Philadelphia, where they were painted in the late eighteenth century. Thus was preserved intact for the public a vivid group of personalities revolving about a man who played a notable role in both the arts and the history of the new republic as they were formulated in this city.

Most recently, a munificent gift of purchase funds from the foundation established by Mr. and Mrs. Walter H. Annenberg made possible the Museum's most important Old Master acquisition since Fiske Kimball's brilliant purchases of Poussin's *The Birth of Venus* and Rubens's *Prometheus Bound*. Hendrick Goltzius's exquisitely wrought "pen-painting" *Without Ceres and Bacchus, Venus Would Freeze* will forever alter the character of the Museum's collections, adding an unforgettable image by the master of Northern Mannerism that is, in the true sense of an overused adjective, unique.

On behalf of several generations of curatorial staff at the Philadelphia Museum of Art, whose research and enthusiasm are here reflected, it is a delight and an honor to present this book to the public. It is, in turn, dedicated to the generations of donors of works of art and of acquisition funds whose collective generosity has made the Philadelphia Museum of Art one of the most distinguished institutions of its kind in the world.

Anne d'Harnoncourt
The George D. Widener Director
October 1994

A HISTORY OF THE COLLECTIONS TO 1965

Reprinted from *Check List of Paintings in the Philadelphia Museum of Art* (1965)

In July 1875, a group of Philadelphians met for the purpose of taking steps toward the establishment of a museum of art in Philadelphia. In February 1876, the Pennsylvania Museum and School of Industrial Art, known since 1937 as the Philadelphia Museum of Art, was chartered, and in May of 1877, the new Museum took up residence in Memorial Hall, which had been part of the Centennial Exposition of 1876 and was intended to survive that exhibition as a functioning museum for the enjoyment of the city. The painting collection, at first, was virtually nonexistent.

In 1882, Mrs. Bloomfield Moore, whose husband had been prominent in lumber and paper circles, gave an extensive collection of objects to the Museum, including half a dozen paintings; in 1883, she augmented that gift by about a hundred more paintings. From this moment the new Museum began to consider itself an art gallery and to seek to enlarge its collections. In 1899, Mrs. Moore gave about twenty additional paintings.

However, as the Museum's holdings have become more and more important, the Moore Collection has become less important. Changing tastes and factors of scholarship have brought about the disposition of a sizable portion of the original gift, which contained many copies and inadequate school pieces.

In 1903, Dr. Robert H. Lamborn gave about seventy-five Mexican–Spanish Colonial religious paintings to the young Museum. He was a businessman who, in 1881 and 1883, went to Mexico City, where he bought these works. In subsequent years he studied and researched his finds. His donation remains to this day one of the most original and surprising aspects of the collections. Little is known about the artists, many of whom are unrecorded, or indeed about the history of the paintings prior to Dr. Lamborn's acquisition of them.

In 1893, a benefactress of the city made an indirect but outstanding and lasting contribution to the growth of the new Museum. Mrs. William P. Wilstach, whose husband had made a fortune in saddlery and hardware, bequeathed nearly one hundred fifty paintings to the Commissioners of Fairmount Park, and the Museum Corporation administered the collection on behalf of the Commissioners. She also left a purchase fund, the collection and the purchases from the fund to be known as the W. P. Wilstach Collection. Since the original gift in 1893, many purchases have been made from this fund; the dates of acquisition are indicated in the accession number of each work in the checklist that follows.

In 1895, thirteen works of art were purchased, among them a Ruisdael, a Gainsborough, a Courbet, an Inness, and a Whistler. The next year, twelve more were acquired, including a Vittore Crivelli altarpiece, a Hondecoeter and a Constable. In 1900 and 1901, works by Zurbarán, Murillo, Ribera, Koninck, and Weenix were added to the seventeenth-century Spanish and Dutch collections as well as others by Marieschi, Rosa Bonheur, and Bouguereau.

In 1921, the fund was used to buy from the Alexander J. Cassatt family a remarkably modern group of paintings, considering the local taste of the day—three Monets, two Pissarros, a Degas, a Manet, and a Renoir, as well as a painting by Mary Cassatt, who had been responsible for her brother's purchasing the other works.

Other outstanding bequests to the City and the Commissioners of Fairmount Park came from a father and his son, and the Museum continues to benefit greatly from this generous family in the third generation. William L. Elkins, who was born in West Virginia and was successful in oil, gas, and, later, in the traction business in Philadelphia, and his son, George W. Elkins, bequeathed their noteworthy collections. In 1924 the care of the two collections passed to the new Museum Corporation, which then partially occupied the new museum building being constructed on the site of the former Fairmount Reservoir, at the end of the new parkway.

William L. Elkins exemplified the characteristic taste of his generation in owning primarily, among the nearly one hundred works bequeathed, examples of seventeenth-century Dutch painting, of eighteenth- and nineteenth-century English painting, and of the nineteenth-century French paintings of the Barbizon school and the then-popular Salon art; his bequest also included three Monets, a Homer, and an Inness. His son, George W. Elkins, left thirty-five works presenting a somewhat later taste—eighteenth-century English portraits as well as four Corots and a work each by Alma-Tadema, Boldini, Sargent, Homer, and Whistler. Subsequent purchases have been made from a fund bequeathed by George W. Elkins.

The exceptional collection of English paintings from Hogarth to Constable, formed by John H. McFadden, was received in 1928 and numbered forty-three outstanding works, among them excellent examples by Romney, Raeburn, Gainsborough, Lawrence, and Constable, as well as an outstanding picture by Turner. Mr. McFadden was internationally known, with his brother, as a cotton merchant. His substantial knowledge about English painting, chiefly portraits, was not generally appreciated at the time but can be well comprehended today.

While these valuable assets were being added to the Museum's responsibilities, although they were technically the property of the City and the Commissioners of Fairmount Park, other lesser collections were being given directly to the growing institution, which was fifty years old in 1925. The Walter Lippincott and the Alex Simpson, Jr., Collections added fifty fashionable and popular late nineteenth-century American artists' works to the galleries, which were nearing completion.

The most outstanding single gift of paintings between 1928 and 1950 was, however, the generous one by Mrs. Thomas Eakins and Miss Mary Adeline Williams of thirty-six oils of superb quality by Thomas Eakins, given in 1929, and, in addition, sixteen sketches for these and other works, given in 1930.

The Museum now could boast a fine collection of European paintings and also the works of Thomas Eakins, perhaps the best artist America had yet produced.

As years passed, other good collections were added, the John D. McIlhenny and the Robert Stockton Johnson Mitcheson Collections among them. The John D. McIlhenny Collection was more distinguished for its furniture and rugs, but it included a few fine paintings. The Christian Brinton Collection, given in 1941, was more unusual. Mr. Brinton lived near West Chester and was an art critic who often spoke out for national schools other than our own. His collection comprised over one hundred fifty oils, drawings, and prints done by Russian artists influenced by the Cubist and other stylistic innovations reaching Moscow from Paris before the First World War. Artists of this period of Russian art never fell under the imposition of "Soviet Realism," for the artists themselves all fled Russia, largely for America, where Mr. Brinton patronized them. This collection is as unusual as Dr. Lamborn's Mexican–Spanish Colonial examples, and both are fascinating revelations of how styles can be copied from totally different and foreign contexts—Mexico from Spain, and Moscow copying or being affected by Paris.

Other than by the work of Thomas Eakins, the American paintings in the collection gave only irregular glimpses into our national past and paid virtually no attention to the twentieth century. In 1949, this was partially corrected by the Alfred Stieglitz Bequest, one of several made to the museums of the United States, which numbered thirteen early oils by Hartley and Dove, many watercolors by Marin, and numerous important works by other artists. Stieglitz, as the founder of the famous "291 Gallery" in New York, had introduced modern art to America through his early exhibitions and his efforts on behalf of the Armory Show of 1913. It is most appropriate, therefore, that by his will this Museum received the initial part of its modern American art collection. Although contemporary art had often been exhibited in the Museum, and the collection was on loan here through the war years, the Stieglitz paintings were among the first permanent acquisitions in this area.

However, they were by no means the last, and the next few years were to see three major modern painting collections added to the rapidly growing Museum. In 1950, Lisa Norris Elkins, a daughter-in-law of George W. Elkins, died, and the Museum received works by Renoir, Pissarro, Toulouse-Lautrec, Van Gogh, Picasso, and Matisse, as well as two exceptional paintings by Edward Hicks, the Bucks County artist of a century earlier, whose discovery was causing such excitement at the time.

The collections of Louise and Walter Arensberg and of Albert E. Gallatin were received in 1950 and 1952, respectively, and from that moment onward Philadelphia was almost unrivaled in the world for its proto-Cubist, Cubist, and abstract collections of the 1905–1925 period. To this day, any general study of art in those years has to turn to Philadelphia for source material, and many detailed studies nearly begin and end in the Museum's collections.

Walter Arensberg was born in Pittsburgh and worked as a lawyer in New York, where he came to know and to admire Marcel Duchamp as an artist and as a wise counselor in building the collection. After the Arensbergs moved to Hollywood, they became interested in pre-Columbian sculpture, as well, and added much of that to their famous collection. All in all, they purchased over two hundred paintings and modern sculptures, most noteworthy being thirty-eight works by Duchamp, including all known versions of the *Nude Descending a Staircase*, especially the version which had caused such a furor at the New York Armory Show of 1913; eighteen works by Constantin Brancusi, the Rumanian-Frenchman whose work in essential forms was to become such an integral part of the twentieth-century vision; as well as seven by Georges Braque; five by Juan Gris; seven by Wassily Kandinsky; thirteen by Paul Klee; nine by Joan Miró; fifteen by Pablo Picasso; and four by Henri Rousseau, including the well-known *Merry Jesters*. This was, indeed, a rich accession to the Museum, then celebrating its seventy-fifth year, or its "Diamond Jubilee."

Two years later the Museum was equally, and in a sense doubly, fortunate to receive the A. E. Gallatin Collection, which had been on loan to New York University as the "Museum of Living Art" for many years. Gallatin, an artist himself, knew many of the men whose work he bought, and his sensitively selected collection has, for that reason, an extra fascination. The strongest representations, among some one hundred seventy-five examples, are those of Jean Arp and Georges Braque, with ten examples each; Juan Gris with twelve; Fernand Léger with fifteen, including his supreme early statement, *The City*, of 1919; and twenty-three by Picasso, including the arresting early *Self-Portrait* and *Three Musicians*, one of the two similar closing statements he made to the synthetic Cubist phase of his art.

The collections had now become predominantly twentieth-century and Cubist, whereas the Wilstach, Elkins, and McFadden paintings represented the seventeenth century in Holland, the eighteenth century in England, and the popular Salon and other art of nineteenth-century France as well as England.

The John G. Johnson Collection, which has been housed in the Museum since the early 1930s as a separate unit, gives a firm foundation through its untold wealth of paintings from the early and later Italian Renaissance, through the North European schools of Flanders, Holland, and Germany in the fifteenth, sixteenth, and seventeenth centuries.

As yet, however, the Museum was not as strong as could be desired in the famous French schools of Impressionism and Post-Impressionism. Mr. and Mrs. Carroll S. Tyson, Jr., who gave many years of devoted service to the boards of the Museum, were to remedy that gap in 1963 by their magnificent bequest of twenty-three major paintings, nearly all of which date from approximately forty years: 1869 to 1906, the year of the death of Paul Cézanne, in whose works Mr. Tyson, an artist in his own right, was particularly interested. They bequeathed five works by Cézanne and five by Renoir, including the world-famous *Bathers*, as well as two Manets, two Monets, and a *Sunflowers* by Van Gogh. This tightly focused chronological representation was accompanied by a classical allegory from the circle of Poussin and two early nineteenth-century portraits.

Almost immediately afterwards, in the same year, the Museum was awarded the highly coveted Louis E. Stern Collection of nearly two hundred fifty objects from all schools and national styles of art, including seventy-five paintings of the last one hundred years, of which twenty-five oils, prints, and drawings were by his close personal friend Marc Chagall. Among the many gems of this very individual collection one can cite *Carnival Evening*, by Henri Rousseau, *Madame Cézanne*, by Paul Cézanne, and *The Polish Woman*, by Amedeo Modigliani.

Louis Stern was long a governor of the Museum and a lawyer in Atlantic City and New York. He collected avidly not only modern painting and sculpture but also modern books and prints. In his later years his interests went also to Oriental and African sculpture. The result is a truly unique and personal vision of man's use of art as a creative force throughout the centuries.

As has been stated, the Wilstach and Elkins Collections were accompanied by purchase funds which have extended the collections significantly over the years. The Wilstach Fund had been periodically employed by the Commissioners of Fairmount Park since the original bequest of 1893. From the early 1930s to the present day, the Wilstach and Elkins funds have been employed to purchase truly noteworthy paintings of which the Museum and the public can justly feel proud. In 1932, Poussin's great *Birth of Venus* was obtained from the Hermitage Collection, having been sold by the Russian government. Two exceptional Cézannes were purchased: *Mont Sainte-Victoire* in 1936 and the *Bathers* in 1937. The Degas *Ballet Class* was bought in 1937, and the Charles Willson Peale *Staircase Group* in 1945. In 1950, on the occasion of the "Diamond Jubilee," many purchases were made: the Claude Gellée, the Le Nain, the Rubens *Prometheus*, a Corot, and a Delacroix, thus notably enriching the collections of the Museum. Since that event, the twelfth-century *Crucifixion*, by a follower of the San Francesco Master, was bought in 1953, a Daumier in 1954, the Titian and a Renoir in 1957, a Magnasco and a Cassatt in 1959, and the Kuhn in 1962.

One of the Museum's very few contemporary paintings was bought in 1963 from the John H. McFadden, Jr., Fund. It was *Lumen Naturale*, by Hans Hofmann. Also purchased from that fund have been a Homer and a Prendergast. In addition, other funds of a restricted nature have been employed from time to time to obtain works of art that were within the limits set by the donor.

In addition to major bequests and acquisitions by Museum purchase, the other important factor in the growth of the paintings collection is the gift of a few objects, or even a single object, which the Museum has repeatedly received from many interested Philadelphians. Mr. and Mrs. R. Sturgis Ingersoll have been particularly generous over many years by continuously giving examples from their outstanding private collection, thus greatly enriching the collections of the Museum. Mr. and Mrs. Herbert C. Morris, Dr. and Mrs. MacKinley Helm, and Mr. and Mrs. Henry Clifford have made contributions to the contemporary Mexican paintings collection and have given other works as well. The children of the late John D. McIlhenny— Bernice Wintersteen and Henry P. McIlhenny—have carried on their parents' interest in the Museum, both by their active participation and by generously presenting handsome paintings to fill important gaps in the collection.

Many other persons, too numerous to specify, have frequently donated one or more paintings to indicate their support and to assist the growth of the collections. It is the wealth of smaller donors that collectively creates a museum and gives character to the collections as a whole. Large bequests can change the emphasis of the total presentation, and purchases can fill gaps or vacancies, but smaller, or single, gifts add up to a totality of taste that so often forms the essence of a museum's collection.

Henry G. Gardiner

Assistant Curator of Paintings
January 1965

NOTES TO THE USE OF THE CATALOGUE

This catalogue lists all paintings from Europe and the Americas executed entirely or in part in mediums such as oil, tempera, or acrylic that were in the collections of the Philadelphia Museum of Art and the John G. Johnson Collection as of June 30, 1992. Pastels and works on paper are not included. All miniatures, regardless of medium, are included.

The book is divided into four sections—European Painting before 1900, American Painting before 1900, Twentieth-Century Painting, and Miniatures—and further subdivided into national or regional groupings. Within each subsection, the paintings are arranged alphabetically by artist and chronologically within each artist's listings.

Each artist is listed under the name by which he or she is most commonly known. Given names, if different from the primary listing, appear in parentheses. Alternate names and the names of collaborators are also listed, and all names are cross-referenced in the **Index of Artists**. Unknown artists are listed under national school. Qualifiers are used to indicate the strength of attribution:

The artist's name is used alone when the work is known to be by that artist, or when it is believed, with reasonable certainty, that the work was executed by that artist.

Attributed to is used when the work is believed to have been executed by the named artist but when some doubt exists, either because the present condition of the work precludes certainty, because the named artist's body of work is insufficiently defined to permit a definite attribution, or because the attribution is subject to continuing scholarly debate.

Workshop of or **studio of** is used to indicate that the work is believed to have been executed by a pupil or an assistant under the direction of the named artist. With the earlier paintings, the term *workshop* is used to indicate the social situations then prevalent.

Follower of is used for works dependent upon the work of the named artist but not necessarily executed within the general sphere of the artist's influence.

Imitator of is used for works dependent upon the work of the named artist, sometimes painted at a much later date, and possibly intended to deceive.

Copy after is used for copies after identifiable works of art. Information on the original work or works is included in the entry.

The artist's nationality and dates of activity are listed under the first entry for that artist, regardless of strength of attribution. When the place of birth and places of major activity are different, both locations are given.

Unless otherwise indicated, artists' dates are assumed to be birth and death dates. A solidus is used to indicate *or* in a birth or death date. For example, born 1399/1400 means the artist was born in either 1399 or 1400. Other terms used in dating artists are listed below:

1400–1450 is used if the dates are documented birth and death dates.

documented 1400–1450 is used if the dates are documented dates of activity, but neither is a birth or death date.

first documented 1400, died 1450 is used if the first date is not a birth date, but the death date is known.

first securely documented 1400, died 1450 is used when there are several early possible dates for the artist. Only the first securely documented date is cited.

first recorded 1400, died 1450 is used when the first date comes from a secondary source, not a documented source.

born 1400, died before 1450 is used when the artist's birth date is known, but the death date is known only from a document stating the artist is dead or referring to his or her heirs.

dated works 1400–1410 is used in cases where an artist's only documentation is his work.

Circa (c.) may be used if a date is deduced from another documented source. For example, a tax record stating that an artist is fifty years old in 1450 means that his birth date, depending on the month of his birth, is c. 1400.

Previous attributions are listed below the artists' dates for all works listed in the Museum's 1965 checklist of paintings and the 1941, 1966, and 1972 catalogues of the John G. Johnson Collection when the attributions have changed in any way. The following abbreviations are used for these sources:

JGJ 1941 *John G. Johnson Collection: Catalogue of Paintings.* Philadelphia, 1941.

JI 1966 *John G. Johnson Collection: Catalogue of Italian Paintings.* Philadelphia, 1966.

JFD 1972 *John G. Johnson Collection: Catalogue of Flemish and Dutch Paintings.* Philadelphia, 1972.

PMA 1965 *Check List of Paintings in the Philadelphia Museum of Art.* Philadelphia, 1965.

In order to avoid confusion resulting from variant spellings, the artists' names for previous attributions are listed as they are spelled in the present catalogue. The **Index of Previous Attributions** lists those works for which the change in attribution results in a substantive shift from one artist to another, or where the artist is alphabetized differently.

The titles of paintings are given in English unless a particular significance is intended by the artist's use of a foreign language. Alternate titles are given in parentheses. Names of sitters are given as they were at the time the painting was executed, with supplemental identification provided in brackets. The **Index of Named Sitters** lists portraits and silhouettes for which the subject sat (paintings where a subject is named but did not actually sit are not included). Cross-references for married women and titled persons are also provided.

Additional information is often included about a painting's origin or function, the locations of any known companion paintings, and, in the case of copies, their sources. References to etchings and engravings are identified by entry number in Adam von Bartsch, *Le Peintre graveur*, 21 vols. (Vienna, 1803–21).

Dates of works are assumed to be documented unless preceded by a circa (c.). Inclusive dates are given for works executed over the course of several years. When a work was painted in two or more installments several years apart, or later retouched, the word *and* is used to separate the dates. *By* is used to indicate the date a work was finished, but which may have been started long before. *Before* is used when a painting is referred to in a document, thereby establishing a date before which it must have been completed. For example, if a painting's date is not known, but it is known to have entered a collection in 1892, it may be dated "before 1892."

Signatures and inscriptions in languages using the Latin alphabet are transcribed; those in other alphabets are translated. The transcriptions seek to preserve the spelling and style of the original, including misspellings and grammatical errors, with lacunae and editorial interpolations in brackets. Signatures believed to be spurious or later additions are so identified.

The identification of mediums for most paintings is based upon visual examination. Unusual or mixed media are so designated either by the artist or by scientific analysis. *Panel* indicates a natural wood support. Synthetic fabrications such as cardboard, Masonite, and acrylic are so identified.

Measurements are given both in inches and in centimeters, height preceding width. For irregularly shaped works, dimensions reflect greatest height and greatest width. In some cases, such as multipaneled paintings, overall dimensions are given in addition to the measurements of individual panels.

The names of donors are cited and styled according to their wishes. All donors are listed in the **Index of Donors**.

The last line of each entry is the Museum's accession number, which generally consists of three parts. The first part indicates the year of accession; the second, the place of the painting in the order of gifts within that year; and the third, the

item within that gift. In some cases, the accession number bears a letter prefix indicating that it is part of a named collection (W-Wilstach, E-Elkins, M-McFadden) or was originally given to the City of Philadelphia through the Commissioners of Fairmount Park (F). Paintings from the John G. Johnson Collection are listed by the catalogue or inventory number corresponding to the previous catalogues of that collection. All paintings are listed in the **Index of Accession Numbers**.

ACKNOWLEDGMENTS

This project was completed over the course of a decade with assistance from many people.

In the Department of European Painting before 1900, the John G. Johnson Collection, and the Rodin Museum: Joseph J. Rishel, Senior Curator, Colin Bailey, Brian Clancy, Richard Dorment, Alison Goodyear, Priscilla Grace, Jan Klincewicz, Katherine Luber, Lawrence Nichols, Christopher Riopelle, Carl Strehlke, Peter Sutton, and Jennifer Vanim.

In the Department of American Art: Darrel L. Sewell, the Robert L. McNeil, Jr., Curator of American Art, Andrew Brunk, and Mike Hammer. Kristina Haugland of the Department of Costume and Textiles assisted in the dating of some of the miniatures.

In the Department of Twentieth-Century Art: Ann Temkin, the Muriel and Philip Berman Curator of Twentieth-Century Art, Margaret Kline, John Ravenal, Mark Rosenthal, and Andrew Walker.

In the Department of Conservation: Marigene H. Butler, Head of Conservation, Mark Aaronson, Karen H. Ashworth, Jesse Baker, Paul Cooper, Jonathan Grauer, Stephen Gritt, Teresa Lignelli, Joe Mikuliak, Marie von Möller, Suzanne Penn, Jean F. Rosston, David Skipsey, Michael Stone, and Mark Tucker.

In the Department of the Registrar: Irene Taurins, Registrar, Clarisse Carnell, Colin Currie, and Martha Small.

In the Departments of Rights and Reproductions and Photography: Conna Clark, Manager, Graydon Wood, Senior Photographer, Will Brown, John Costello, Andrew Harkins, Terry Flemming Murphy, Lynn Rosenthal, and Alfred J. Wyatt.

In the Department of Publications and Graphics: George H. Marcus, Head of Publications, Beth Bazar, Owen Dugan, Charles Field, Sandra Klimt, John Paschetto, Alison Rooney, Curtis Scott, James Scott, Catherine Stifel, and Jane Watkins.

Arlene Pagan of the Thomas Eakins House assisted with transcribing the Spanish inscriptions on the Latin American paintings. Katharine Baetjer of the Metropolitan Museum of Art, New York, provided very helpful general advice.

European Painting
before 1900

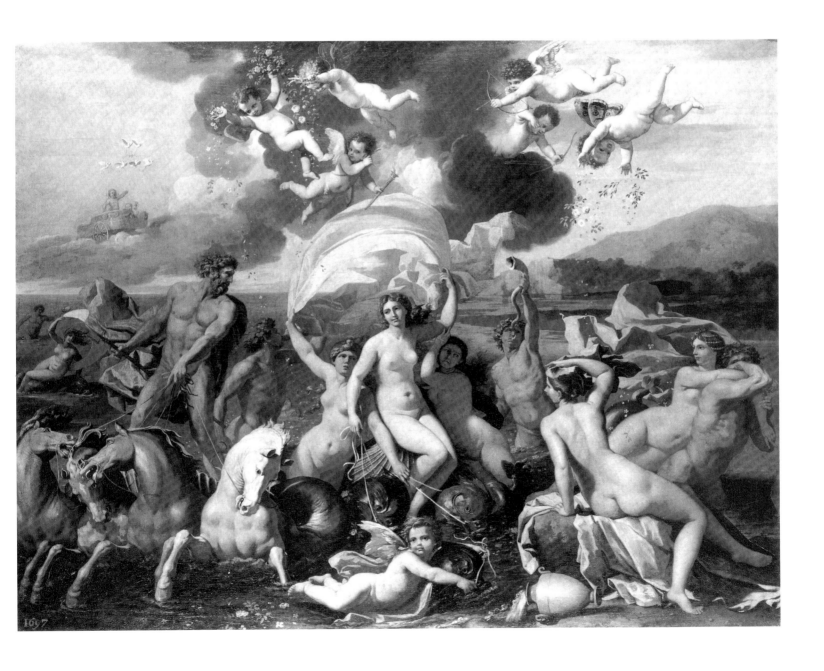

Alma-Tadema, Sir Lawrence
English, born Netherlands,
1836–1912
A Reading from Homer
1885
Upper right: [Greek for
"HOMER"]; center right:
L. ALMA-TADEMA op. CCLXVII
Oil on canvas
36 1/8 × 72 1/4" (91.8 × 183.5 cm)

The George W. Elkins Collection
E1924-4-1

Ansdell, Richard
English, 1818–1885
Mr. and Mrs. John Naylor with a Keeper and a Dead Stag
1847
Oil on canvas
41 × 72" (104.1 × 182.9 cm)

The Henry P. McIlhenny
Collection in memory of
Frances P. McIlhenny
1986-26-271

**Barker, Thomas, also called
Thomas Barker of Bath**
English, 1769–1847
Previously attributed to Thomas
Barker (PMA 1965)
Gypsies on the Heath
c. 1810–15
Oil on canvas
30 × 41 3/8" (76.2 × 105.1 cm)

Gift of John G. Johnson for the
W. P. Wilstach Collection
W1903-1-5

Bartlett, William H.
English, 1858–1932
Stream with a Boat
1884
Lower left: W H Bartlett. 84.
Oil on canvas
12 5/8 × 18 1/2" (32.1 × 47 cm)

John G. Johnson Collection
cat. 889

**Beach, Thomas, also called
Thomas Beach of Bath**
English, 1738–1806
*Portrait of the Honorable Mrs.
Edmund Lambert of Boyton Manor,
Wiltshire*
Companion to *Portrait of Edmund
Lambert*, 1771, unknown location
1771
Oil on canvas
30 × 25" (76.2 × 63.5 cm)

Gift of Mrs. Henry W. Breyer
1974-98-1

Beechey, Sir William
English, 1753–1839
*Portrait of Elizabeth, Lady
Le Despencer*
Cut down on all sides
c. 1795–97
On reverse: Ellsth Lady
Le Despencer / wife of Thomas
22 Baron Le Despencer / about
the year 1795 / by Romney
Oil on canvas
24 3/4 × 19 1/8" (62.9 × 48.6 cm)

Bequest of Helen S. Fennessey in
memory of her stepfather, Horace
Trumbauer
1974-161-1

Beechey, Sir William
Previously attributed to Sir
William Beechey (PMA 1965)
*Portrait of a Young Girl (Little
Mary)*
Fragment
c. 1810–15
Oil on canvas
42 1/2 × 26" (108 × 66 cm)

Gift of Mrs. John S. Williams
1946-88-1

**Beechey, Sir William,
copy after**
*Portrait of Lady Beechey and Her
Child*
After the painting, dated
1800 or 1801, in the Detroit
Institute of Arts (53.387)
19th century
Oil on canvas
29 15/16 × 24 7/16" (76 × 62.1 cm)

Gift of Mrs. S. Emlen Stokes
1973-264-1

Bigg, William Redmore
English, 1755–1828
A Lady and Her Children Relieving a Cottager
1781
Lower right: WR Bigg 178[1?]
Oil on canvas
29 5/8 × 35 5/8" (75.2 × 90.5 cm)

Gift of Mr. and Mrs. Harald Paumgarten
1947-64-1

Bonington, Richard Parkes, follower of
Previously listed as Richard Parkes Bonington (JGJ 1941)
Beach with a Cart and Figures
19th century
Oil on canvas
10 1/4 × 14 1/4" (26 × 36.2 cm)

John G. Johnson Collection
cat. 883

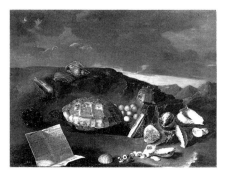

Black
English, 18th century
Still Life with a Tortoise
1743
On letter: April 1743 / Black pinxit
Oil on canvas
29 1/2 × 38" (74.9 × 96.5 cm)

The Henry P. McIlhenny Collection in memory of Frances P. McIlhenny
1986-26-272

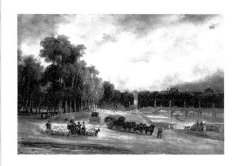

Bonington, Richard Parkes, imitator of
View of the Seine
19th century
Oil on canvas
13 5/8 × 19 1/4" (34.6 × 48.9 cm)

John G. Johnson Collection
cat. 882

Blake, William
English, 1757–1827
The Nativity
1799 or 1800
On reverse: Don't place this picture in the sun or near / the fire, or it will crack off the Copper / W.B.S. [William Bell Scott] 1865.
Tempera on copper
10 3/4 × 15 1/16" (27.3 × 38.3 cm)

Gift of Mrs. William Thomas Tonner
1964-110-1

Brown, Frederick
English, 1851–1941
Girl with a Pitcher
1883
Lower right: FRED BROWN / 1883
Oil on canvas
24 1/4 × 15 3/8" (61.6 × 39.1 cm)

John G. Johnson Collection
cat. 907

Bonington, Richard Parkes, follower of
English, 1802–1828
Previously listed as Richard Parkes Bonington (PMA 1965)
Coast Scene
c. 1828–40
Oil on canvas
24 × 33" (61 × 83.8 cm)

The John Howard McFadden Collection
M1928-1-1

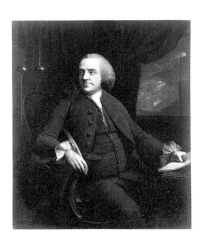

Chamberlin, Mason
English, died 1787
Portrait of Benjamin Franklin
1762
Lower left: M. Chamberlin. pinxt. 1762.
Oil on canvas
50 3/8 × 40 3/4" (128 × 103.5 cm)

Gift of Mr. and Mrs. Wharton Sinkler
1956-88-1

Chinnery, George, attributed to
English, 1748–1847
Portrait of Nathan Dunn
c. 1830
Oil on canvas
23 3/8 × 18" (59.4 × 45.7 cm)

Gift of Mrs. Joseph H. Gaskill
1970-89-1

Constable, John
Portrait of Master Crosby
1808
Lower right: J. Constable. P.
1808.
Oil on canvas
30 1/4 × 25 1/4" (76.8 × 64.1 cm)

John G. Johnson Collection
cat. 873

Collinson, James
English, c. 1825–1881
For Sale
c. 1855–60
Center left, on bottle: Eau / de /
Cologne; center right, on box:
BRICKS; lower right, on sign: ST
BRIDE'S CHURCH / THE ANNUAL /
BAZAAR / FOR THE SALE OF /
USEFUL AND FANCY ARTICLES /
PATRONESS / [RIG]HT HONOUR-
ABLE LADY DORCAS / COMMITTEE
Oil on canvas
23 × 18" (58.4 × 45.7 cm)

The Henry P. McIlhenny
Collection in memory of
Frances P. McIlhenny
1986-26-273

Constable, John
Hilly Landscape
c. 1808
On reverse: J. Constable / about
1808
Oil on panel
6 3/8 × 9 7/16" (16.2 × 24 cm)

John G. Johnson Collection
cat. 859

Collinson, James
To Let
c. 1855–60
Center left, on sign: [reverse of
"FURNISH / APARTM"]
Oil on canvas
23 × 18" (58.4 × 45.7 cm)

The Henry P. McIlhenny
Collection in memory of
Frances P. McIlhenny
1986-26-274

Constable, John
The Stour
1810
Upper right: 27. Sept. 1810.
Oil on canvas
9 3/8 × 9 1/4" (23.8 × 23.5 cm)

John G. Johnson Collection
cat. 857

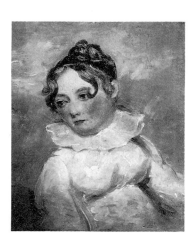

Constable, John
English, 1776–1837
Previously attributed to John
Constable (JGJ 1941)
Portrait of a Girl
c. 1806–10
Oil on paper on panel
9 1/2 × 7 7/8" (24.1 × 20 cm)

John G. Johnson Collection
cat. 872

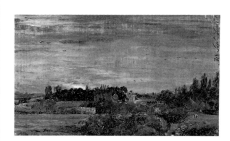

Constable, John
*View toward the Rectory,
East Bergholt*
1810
Upper right: 30 Sept. / 1810
Bergholt Common
Oil on paper on panel
6 1/8 × 9 3/4" (15.6 × 24.8 cm)

John G. Johnson Collection
cat. 856

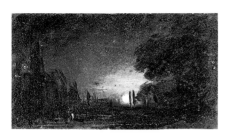

Constable, John
Rising Moon
c. 1810
Oil on paper on panel
4 1/4 × 7 3/8" (10.8 × 18.7 cm)

John G. Johnson Collection
cat. 868

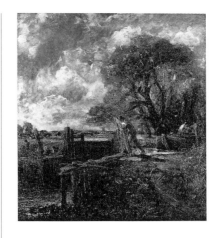

Constable, John
Sketch for "A Boat Passing a Lock"
For the painting in the Thyssen-
Bornemisza Collection, Madrid
1822–24
Oil on canvas
55 1/2 × 48" (141 × 121.9 cm)

The John Howard McFadden
Collection
M1928-1-2

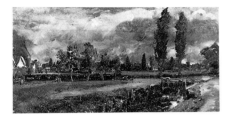

Constable, John
Landscape with a River
c. 1810–12
Oil on canvas
6 1/4 × 11 1/4" (15.9 × 28.6 cm)

John G. Johnson Collection
cat. 863

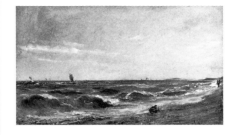

Constable, John
Coast Scene, Brighton
c. 1824–28
Oil on cardboard
10 × 16 5/8" (25.4 × 42.2 cm)

The Henry P. McIlhenny
Collection in memory of
Frances P. McIlhenny
1986-26-4

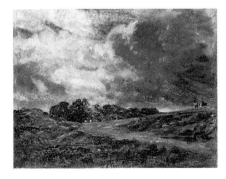

Constable, John
Hampstead Heath
1821
Oil on paper on canvas
10 × 12 1/4" (25.4 × 31.1 cm)

John G. Johnson Collection
cat. 864

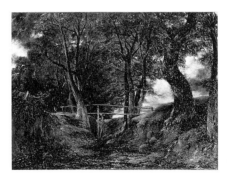

Constable, John
Dell at Helmingham Park
1825 or 1826, retouched 1833
Oil on canvas
28 × 36" (71.1 × 91.4 cm)

John G. Johnson Collection
cat. 871

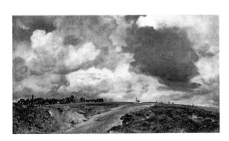

Constable, John
Road to the Spaniards, Hampstead
1822
On reverse: [Hamp]stead.
Monday 2[?] July 1822 looking
NE 3 PM previous to a thunder
squall wind N West.
Oil on canvas
12 1/8 × 20 1/8" (30.8 × 51.1 cm)

John G. Johnson Collection
cat. 858

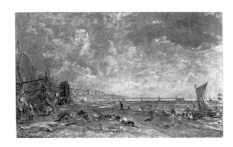

Constable, John
*Sketch for "The Marine Parade and
Chain Pier, Brighton"*
For the painting in the Tate
Gallery, London (N 05957)
c. 1826–27
Oil on canvas
23 3/4 × 38 7/8" (60.3 × 98.7 cm)

Purchased with the W. P.
Wilstach Fund
W1896-1-5

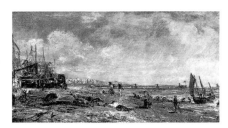

**Constable, John,
attributed to**
Previously listed as John
Constable (JGJ 1941)
Chain Pier, Brighton
After 1826
Oil on paper on canvas
13 1/16 × 24 1/8" (33.2 × 61.3 cm)

John G. Johnson Collection
cat. 869

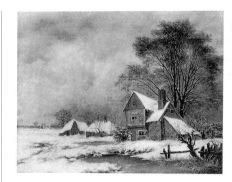

**Constable, John,
follower of?**
Previously listed as John
Constable (JGJ 1941)
Gandish Cottage, Suffolk
Before 1878
On reverse: purchased of Mrs.
Newman Webb the Niece / of the
Artist at the Cottage 27 February
1878 / where the picture had
always hung
Oil on canvas
14 1/16 × 17 9/16" (35.7 × 44.6 cm)

John G. Johnson Collection
cat. 851

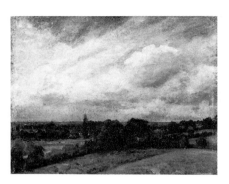

**Constable, John,
attributed to**
Landscape [possibly the Stour
valley]
19th century
Oil on paper on panel
7 7/8 × 10" (20 × 25.4 cm)

John G. Johnson Collection
cat. 853

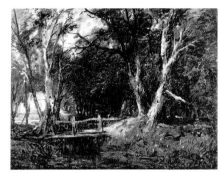

**Constable, John,
imitator of**
Previously listed as John
Constable (PMA 1965)
Dell at Helmingham Park
After 1828
Oil on canvas
30 1/2 × 38 1/2" (77.5 × 97.8 cm)

The John Howard McFadden
Collection
M1928-1-4

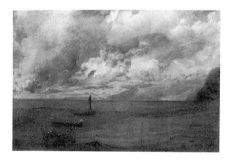

**Constable, John,
attributed to**
Previously listed as John
Constable (JGJ 1941)
Weymouth Bay
19th century
Oil on canvas
21 3/8 × 30 1/8" (54.3 × 76.5 cm)

John G. Johnson Collection
cat. 865

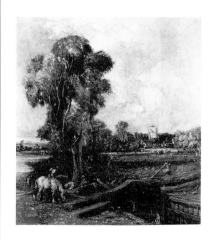

**Constable, John,
imitator of**
Previously listed as English,
unknown artist, 19th century
(PMA 1965)
Landscape with a Lock
19th century
Oil on canvas
35 1/4 × 30 5/8" (89.5 × 77.8 cm)

The George W. Elkins Collection
E1924-4-4

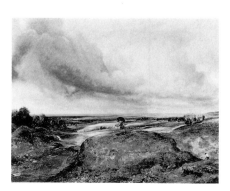

Constable, John, studio of
Previously listed as John
Constable (PMA 1965)
*Branch Hill Pond, Hampstead
Heath*
After 1825
Oil on canvas
23 × 29 1/2" (58.4 × 74.9 cm)

The John Howard McFadden
Collection
M1928-1-3

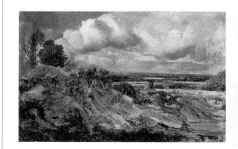

**Constable, John,
imitator of**
Landscape with Brushwood
19th century
Oil on paper on panel
12 13/16 × 20" (32.5 × 50.8 cm)

John G. Johnson Collection
cat. 855

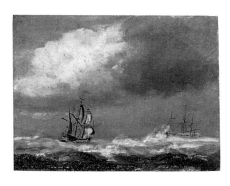

Constable, John, imitator of
Marine
19th century
Oil on panel
5 ³/₄ × 7 ⁷/₁₆" (14.6 × 18.9 cm)

John G. Johnson Collection
cat. 861

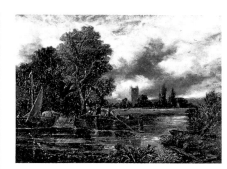

Constable, John, copy after
Previously listed as John
Constable (JGJ 1941)
The Stour
After the painting in the
Huntington Library, San Marino,
California
19th century
Oil on panel
12 ³/₈ × 16 ⁷/₁₆" (31.4 × 41.8 cm)

John G. Johnson Collection
cat. 866

Constable, John, imitator of
Mill
19th century
Oil on canvas
24 ¹/₂ × 21" (62.2 × 53.3 cm)

John G. Johnson Collection
inv. 2814

Constable, Lionel Bicknell
English, 1828–1887
Previously listed as John
Constable (JGJ 1941)
Cottage on the Stour
c. 1850
Oil on paper on canvas
10 × 16 ⁵/₁₆" (25.4 × 41.4 cm)

John G. Johnson Collection
cat. 852

Constable, John, imitator of
Previously listed as John
Constable (JGJ 1941)
Near Bergholt Common
19th century
Oil on canvas
8 ¹/₄ × 11" (21 × 27.9 cm)

John G. Johnson Collection
cat. 860

Constable, Lionel Bicknell
Previously listed as John
Constable (JGJ 1941)
Bridge on the Mole
c. 1850–55
Oil on paper on panel
10 ³/₈ × 12 ³/₈" (26.4 × 31.4 cm)

John G. Johnson Collection
cat. 854

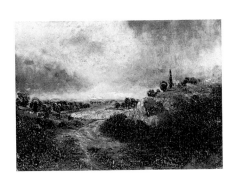

Constable, John, copy after
Previously listed as John
Constable (JGJ 1941)
*Branch Hill Pond, Hampstead
Heath*
After a mezzotint by David Lucas
(English, 1802–1881), after a
composition by Constable
19th century
Oil on canvas
11 ⁷/₈ × 16 ¹/₁₆" (30.2 × 40.8 cm)

John G. Johnson Collection
cat. 862

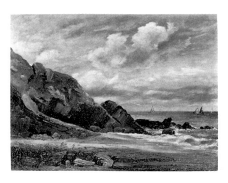

Constable, Lionel Bicknell, attributed to
Beach near Yarmouth
c. 1850
Oil on canvas
14 ¹/₄ × 18 ¹/₂" (36.2 × 47 cm)

John G. Johnson Collection
cat. 867

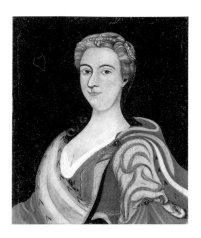

Cooper, J., attributed to
English, born c. 1695,
still active 1754
*Portrait of a Lady with a Beaded
Headdress*
c. 1718
Oil on canvas
22 ³/₈ × 18 ¹/₈" (56.8 × 46 cm)

The Edgar William and Bernice
Chrysler Garbisch Collection
1969-276-1

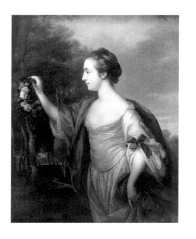

Cotes, Francis
English, 1726–1770
*Portrait of Frances Burdette as
Emma the Nut-Brown Maid*
1761
Oil on canvas
43 ¹/₂ × 33 ¹/₂" (110.5 × 85.1 cm)

Gift of Muriel and Philip Berman
1989-70-5

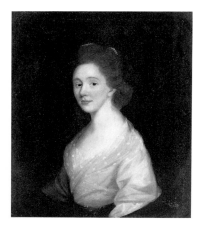

Cotes, Francis, imitator of
Portrait of a Lady
19th century?
Oil on canvas
30 ³/₈ × 25 ¹/₄" (77.2 × 64.1 cm)

Gift of Mrs. Henry W. Breyer
1974-98-2

**Cotman, John Sell,
imitator of**
English, 1782–1842
Previously listed as an English
artist, c. 1820 (JGJ 1941)
Old House with Pillars
19th century
Oil on panel
12 × 10" (30.5 × 25.4 cm)

John G. Johnson Collection
cat. 878

Cox, David
English, 1783–1859
Going to the Hayfield
1849
Lower right: David Cox / 1849
Oil on canvas
28 × 36" (71.1 × 91.4 cm)

The John Howard McFadden
Collection
M1928-1-5

Crome, John
English, 1768–1821
*Blacksmith's Shop near Hingham,
Norfolk*
c. 1808
Oil on canvas
60 ⁵/₈ × 48" (154 × 121.9 cm)

The John Howard McFadden
Collection
M1928-1-6

Crome, John
*Saint Martin's River near Fuller's
Hole, Norwich*
c. 1813–14
On label on reverse: November
12, 1885: I hearby certify that I
have known this picture a view
on St. Martin's River / near
Fullers hole for thirty years & the
late Lord Stafford always told me
it was by Crome. There were
many others of his in the Hall.
C. E. Britcher / The Carver [?]
Oil on panel
20 ¹/₈ × 15 ¹/₄" (51.1 × 38.7 cm)

The William L. Elkins Collection
E1924-3-27

Crome, John, follower of
Previously listed as John Crome
(PMA 1965)
Old Mill on the Yare
c. 1806
Oil on canvas
25 × 30 ¹/₈" (63.5 × 76.5 cm)

The George W. Elkins Collection
E1924-4-9

Crome, John, copy after
Previously listed as John Crome
(PMA 1965)
Woody Landscape at Colney
After Crome's soft-ground
etching *At Colney*, c. 1812
c. 1850–75?
Oil on canvas
22 ¹/₂ × 17" (57.2 × 43.2 cm)

The John Howard McFadden
Collection
M1928-1-7

Crome, John, copy after
Previously listed as John Crome
(JGJ 1941)
The Way through the Wood
After the painting in the
Birmingham Museums and Art
Gallery, England (P.10'50)
19th century
Oil on canvas
23 ¹/₂ × 17 ¹/₂" (59.7 × 44.5 cm)

John G. Johnson Collection
cat. 876

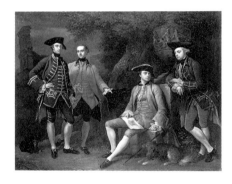

Dance, Nathaniel
English, 1735–1811
*Conversation Piece (Portrait of James
Grant of Grant, John Mytton, the
Honorable Thomas Robinson, and
Thomas Wynne)*
Three other versions, for the
various sitters, are in the collection
of the Earl of Seafield, Cullen,
Banffshire; the Yale Center for
British Art (B1976.7.19); and the
collection of Lady Lucas
1760 or 1761
Oil on canvas
37 ⁷/₈ × 48 ¹/₂" (96.2 × 123.2 cm)

Gift of John Howard McFadden, Jr.
1946-36-1

**Dawson, Henry,
attributed to**
English, 1811–1878
Previously listed as Henry
Dawson (JGJ 1941)
Landscape
19th century
Oil on canvas
20 ³/₈ × 29 ³/₄" (51.8 × 75.6 cm)

John G. Johnson Collection
cat. 885

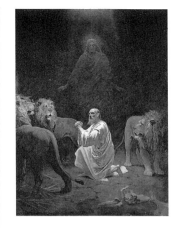

Dowling, Robert
English, born Australia,
1827–1886
Daniel in the Lion's Den
1882
On reverse: DANIEL IN THE DEN
OF LIONS BY DOWLING / 27
COLEHERNE ROAD / WEST
B[ROMPTON] / 1882
Oil on canvas
72 × 50 ¹/₂" (182.9 × 128.3 cm)

Gift of the Richard and Susan
Levy Art Foundation
1968-181-1

Egley, William Maw
English, 1826–1916
Just as the Twig Is Bent
Companion to the following
painting
1861
Lower left: W. Maw Egley.
1861.; lower left, on papers: SEE
THE / CONQUERING / HERO /
COMES
Oil on canvas
24 ¹/₄ × 18 ¹/₄" (61.6 × 46.4 cm)

Purchased with the Katharine
Levin Farrell Fund
1970-3-1

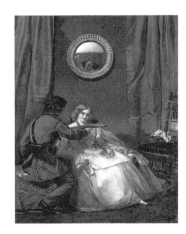

Egley, William Maw
The Tree's Inclined
Companion to the preceding
painting
1861
Lower right: W. Maw Egley.
1861.
Oil on canvas
24 ¹/₄ × 18 ¹/₄" (61.6 × 46.4 cm)

Purchased with the Katharine
Levin Farrell Fund
1970-3-2

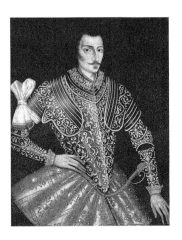

English, unknown artist
Portrait of a Man in Armor
16th century
Oil on panel
13 ⁷/₈ × 10 ³/₄" (35.2 × 27.3 cm)

Bequest of Carl Otto
Kretzschmar von Kienbusch
1977-167-1044

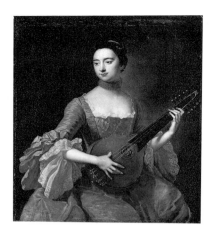

English or Irish, unknown artist
Portrait of a Woman with a Cittern
c. 1725–50
Oil on canvas
41 1/2 × 36 1/8" (105.4 × 91.8 cm)

Gift of Rodman A. Heeren
1971-262-1

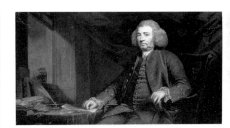

English, unknown artist
Previously attributed to Sir
Joshua Reynolds (JGJ 1941)
Portrait of a Gentleman
18th century
Oil on canvas
36 5/16 × 63 3/8" (92.2 × 161 cm)

John G. Johnson Collection
cat. 826

English, unknown artist
Previously listed as Sir Joshua
Reynolds (JGJ 1941)
Portrait of Sir William Yonge
c. 1750–75
Oil on canvas
30 × 25 1/16" (76.2 × 63.7 cm)

John G. Johnson Collection
cat. 829

English, unknown artist
Previously listed as Sir Joshua
Reynolds (JGJ 1941)
Portrait of a Gentleman
18th century
Oil on canvas
30 5/16 × 25 3/8" (77 × 64.5 cm)

John G. Johnson Collection
cat. 828

English, unknown artist
Previously listed as Sir Henry
Raeburn (JGJ 1941)
Boy with a Mask
c. 1775–1800?
Oil on canvas
30 1/16 × 25" (76.4 × 63.5 cm)

John G. Johnson Collection
cat. 840

English, unknown artist
Previously listed as George
Romney (JGJ 1941)
Portrait of a Gentleman
18th century
Oil on canvas
24 1/16 × 20 1/16" (61.1 × 51 cm)

John G. Johnson Collection
cat. 838

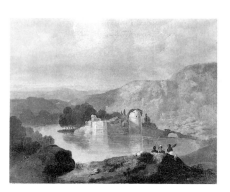

English, unknown artist
Previously listed as Richard
Wilson (JGJ 1941)
Castle by the Sea
18th century
Oil on canvas
18 1/4 × 22 1/2" (46.4 × 57.2 cm)

John G. Johnson Collection
cat. 824

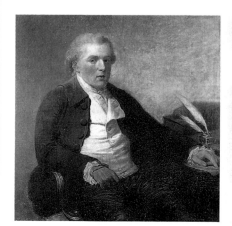

English, unknown artist
Previously listed as John
Hoppner (JGJ 1941)
Portrait of a Gentleman
18th century
Oil on canvas
37 3/8 × 36 1/2" (94.9 × 92.7 cm)

John G. Johnson Collection
cat. 842

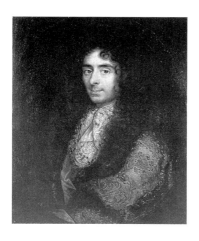

English?, unknown artist
Portrait of a Gentleman
Originally oval
18th century
Oil on canvas
28 1/2 × 23 3/16" (72.4 × 58.9 cm)

John G. Johnson Collection
inv. 2832

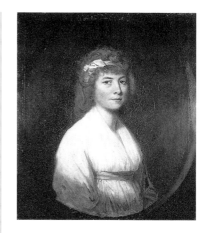

English, unknown artist
Previously listed as John
Hoppner (JGJ 1941)
Portrait of a Woman
18th century
Oil on canvas
30 1/4 × 25 1/16" (76.8 × 63.7 cm)

John G. Johnson Collection
cat. 843

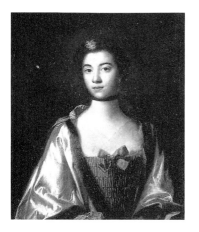

English, unknown artist
Previously listed as Sir Joshua
Reynolds (JGJ 1941)
Portrait of a Lady
18th century
Oil on canvas
29 3/4 × 24 5/8" (75.6 × 62.6 cm)

John G. Johnson Collection
cat. 830

English, unknown artist
*Trompe l'Oeil with a Print of
Alexander Pope*
18th century
On print: Mr. Alexander Pope.
AEts. 28. / G. Kneller Pinx.
1716. J. Smith fec. et ex. 1717.;
on letter: To / Mr. Francis Loobell
/ All neigh / Cornwall
Oil on canvas
29 15/16 × 25 1/16" (76 × 63.7 cm)

John G. Johnson Collection
cat. 825

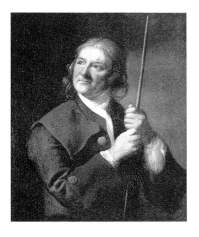

English, unknown artist
Previously listed as Thomas
Gainsborough (JGJ 1941)
Portrait of a Man
18th century
Oil on canvas
30 × 25 1/8" (76.2 × 63.8 cm)

John G. Johnson Collection
cat. 832

**English or American,
unknown artist**
Head of a Girl
c. 1800–25
Oil on academy board
16 × 15 3/4" (40.6 × 40 cm)

John G. Johnson Collection
inv. 2849

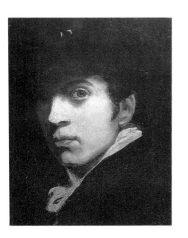

English, unknown artist
Portrait of a Man
18th century
Oil on panel
16 13/16 × 12 11/16" (42.7 × 32.2 cm)

John G. Johnson Collection
cat. 836

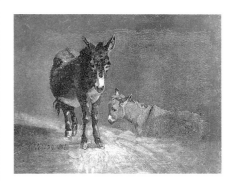

English, unknown artist
Two Donkeys
1816?
Lower left: feb. 29, 1816
Oil on panel
7 1/2 × 9 7/8" (19.1 × 25.1 cm)

John G. Johnson Collection
inv. 155

English, active Norwich, unknown artist
Previously listed as John Crome (PMA 1965)
Ringland Hill
c. 1820–30
Oil on canvas
32 1/2 × 39 3/4" (82.6 × 101 cm)

The William L. Elkins Collection
E1924-3-43

English, unknown artist
Landscape
19th century
Oil on canvas
25 × 30" (63.5 × 76.2 cm)

Bequest of T. Edward Hanley
1970-76-1

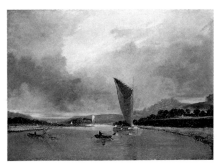

English, active Norwich, unknown artist
Previously attributed to John Crome (PMA 1965)
Hay Barges on the Yare
c. 1825–50
Oil on canvas
30 1/8 × 40" (76.5 × 101.6 cm)

Purchased with the W. P. Wilstach Fund
W1906-1-4

English?, unknown artist
Previously listed as Joseph Mallord William Turner (JGJ 1941)
Landscape
19th century
Oil on panel
12 3/16 × 16 3/8" (31 × 41.6 cm)

John G. Johnson Collection
cat. 850

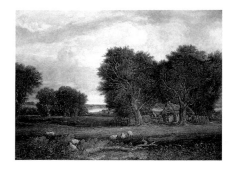

English, unknown artist
Previously listed as John Crome (PMA 1965)
Landscape
c. 1825–50
Oil on canvas
29 3/4 × 39 1/4" (75.6 × 99.7 cm)

Gift of Mrs. Robert M. Hogue
1943-50-1

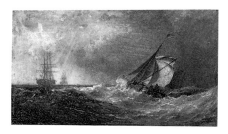

English, unknown artist
Marine
19th century
Lower left (spurious): Cox; on reverse: Off Flushing / Holland
Oil on cardboard
5 5/8 × 9 5/8" (14.3 × 24.5 cm)

Gift of Joseph K. Eddleman and Mrs. William M. Dunlap in memory of Dr. J. S. Ladd Thomas
1974-160-1

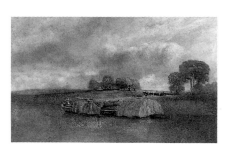

English, unknown artist
Previously listed as John Sell Cotman (PMA 1965)
Barge on a River
19th century
Oil on canvas
8 7/8 × 14" (22.5 × 35.6 cm)

The William L. Elkins Collection
E1924-3-42

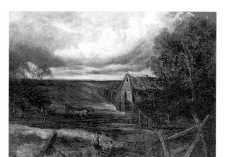

English, unknown artist
Overshot Mill
19th century
Oil on canvas
39 3/4 × 51 1/2" (101 × 130.8 cm)

The William L. Elkins Collection
E1924-3-1

English, unknown artist
Portrait of an Old Man
19th century?
Oil on canvas
30 × 24 ⅞" (76.2 × 63.2 cm)

John G. Johnson Collection
cat. 839

English, unknown artist
Previously listed as an English
artist, c. 1790 (JGJ 1941)
Portrait of a Lady
In an 18th-century style
19th or 20th century
Oil on canvas
30 ³⁄₁₆ × 24 ¹¹⁄₁₆" (76.7 × 62.7 cm)

John G. Johnson Collection
cat. 841

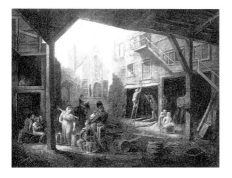

English, unknown artist
Previously listed as Joseph
Mallord William Turner (JGJ
1941)
Winchester Cross
19th century
Oil on canvas
40 ⅛ × 50 ¼" (101.9 × 127.6 cm)

John G. Johnson Collection
cat. 849

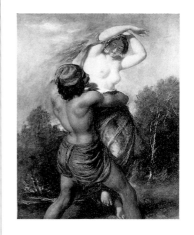

Etty, William
English, 1787–1849
The Corsair
c. 1846
Oil on canvas on fiberboard
27 ¾ × 21" (70.5 × 53.3 cm)

John G. Johnson Collection
cat. 884

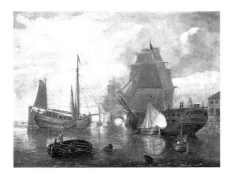

English, unknown artist
Previously attributed to John Sell
Cotman (JGJ 1941)
View of the Yare
19th century
Oil on canvas
28 × 36 ⅛" (71.1 × 91.8 cm)

John G. Johnson Collection
cat. 877

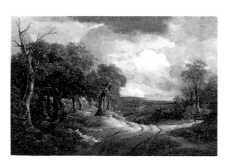

Gainsborough, Thomas
English, 1727–1788
Rest by the Way
1747
Lower left: Gainsbro:1747
Oil on canvas
40 ⅛ × 58" (101.9 × 147.3 cm)

Purchased with the W. P.
Wilstach Fund
W1895-1-4

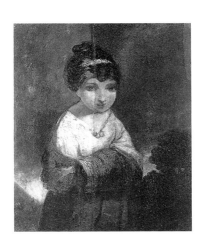

English, unknown artist
Young Girl
19th century?
Oil on panel
22 ½ × 18 ½" (57.2 × 47 cm)

John G. Johnson Collection
inv. 2828

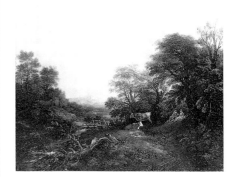

Gainsborough, Thomas
*Landscape with Rustic Lovers, Two
Cows, and a Man on a Distant
Bridge*
c. 1755–59
Oil on canvas
25 ¼ × 30" (64.1 × 76.2 cm)

Gift of Mrs. Wharton Sinkler
1964-103-1

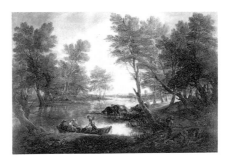

Gainsborough, Thomas
View near King's Bromley, on Trent, Staffordshire
1768–70
Oil on canvas
47 × 66 1/8" (119.4 × 168 cm)

The William L. Elkins Collection
E1924-3-6

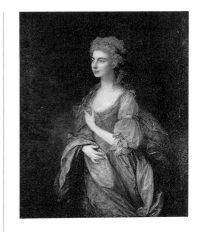

Gainsborough, Thomas
Portrait of Lady Rodney [née Anne Harley]
c. 1781
Oil on canvas
50 1/4 × 39 7/8" (127.6 × 101.3 cm)

The John Howard McFadden Collection
M1928-1-8

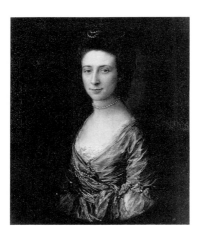

Gainsborough, Thomas
Portrait of Mrs. Clement Tudway
Companion to *Portrait of Clement Tudway*, North Carolina Museum of Art, Raleigh (G.60.11.1)
1773
Oil on canvas
30 1/8 × 25 1/8" (76.5 × 63.8 cm)

The George W. Elkins Collection
E1924-4-12

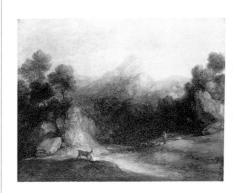

Gainsborough, Thomas
Pastoral Landscape (Rocky Mountain Valley with a Shepherd, Sheep, and Goats)
c. 1783
Oil on canvas
40 3/8 × 50 3/8" (102.6 × 128 cm)

The John Howard McFadden Collection
M1928-1-9

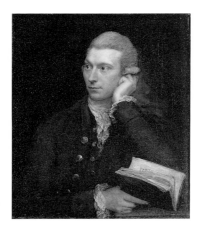

Gainsborough, Thomas
Portrait of John Palmer
c. 1775
Oil on canvas
30 × 25 1/8" (76.2 × 63.8 cm)

The William L. Elkins Collection
E1924-3-28

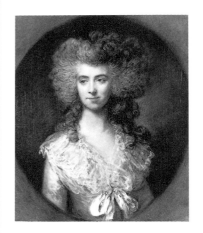

Gainsborough, Thomas
Portrait of a Lady in a Blue Dress
c. 1783–85
Oil on canvas
30 1/4 × 25" (76.9 × 63.5 cm)

Bequest of George D. Widener
1972-50-1

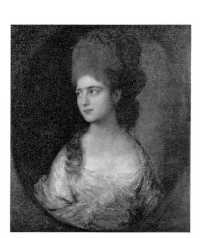

Gainsborough, Thomas
Portrait of Miss Elizabeth Linley [later Mrs. Richard Brinsley Sheridan]
c. 1775
Oil on canvas
30 × 25" (76.2 × 63.5 cm)

The George W. Elkins Collection
E1924-4-13

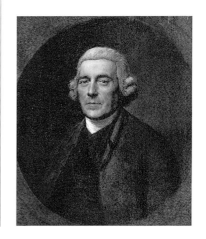

Gainsborough, Thomas, attributed to
Previously listed as Thomas Gainsborough (JGJ 1941)
Portrait of George Coyte
18th century
Oil on canvas
30 1/8 × 25 1/8" (76.5 × 63.8 cm)

John G. Johnson Collection
cat. 833

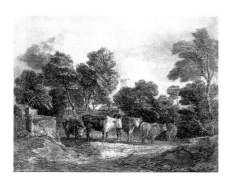

Gainsborough, Thomas, imitator of
Pastoral Landscape
18th or 19th century
Charcoal, watercolor, and oil on paper on canvas
17 × 21 3/4" (43.2 × 55.3 cm)

John G. Johnson Collection
cat. 835

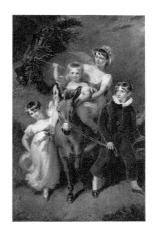

Harlow, George Henry
English, 1787–1819
Portrait of the Leader Children
1813–14
Oil on canvas
94 1/2 × 58 1/4" (240 × 148 cm)

The John Howard McFadden Collection
M1928-1-11

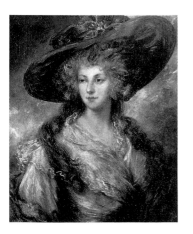

Gainsborough, Thomas, imitator of
Previously listed as Gainsborough Dupont (PMA 1965)
Portrait of a Lady [possibly Lady Cavendish]
19th century
Oil on canvas
30 × 25 1/8" (76.2 × 63.8 cm)

The Walter Lippincott Collection
1923-59-13

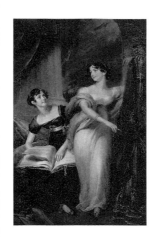

Harlow, George Henry
Portrait of the Misses Leader
1813–14
Oil on canvas
94 1/4 × 58" (239.4 × 147.3 cm)

The John Howard McFadden Collection
M1928-1-10

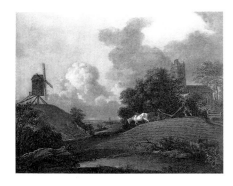

Gainsborough, Thomas, copy after
Previously listed as Thomas Gainsborough (JGJ 1941)
Landscape with a Windmill
After the painting in the collection of Dr. J. B. Labia, Jersey
18th century
Oil on canvas
23 15/16 × 30 1/8" (60.8 × 76.5 cm)

John G. Johnson Collection
cat. 834

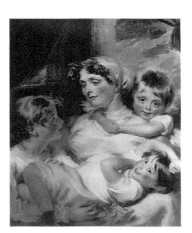

Harlow, George Henry
Portrait of a Mother and Her Children [possibly Mrs. Weddell]
c. 1816
Oil on canvas
36 × 28 1/4" (91.4 × 71.8 cm)

The John Howard McFadden Collection
M1928-1-12

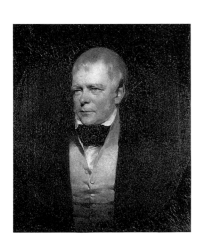

Gordon, Sir John Watson
Scottish, 1778–1864
Portrait of Sir Walter Scott
c. 1831–35
Oil on canvas
30 × 25" (76.2 × 63.5 cm)

The John Howard McFadden Collection
M1928-1-42

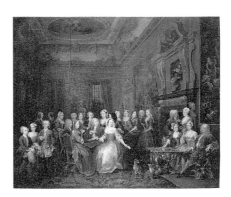

Hogarth, William
English, 1697–1764
Assembly at Wanstead House
1728–31
Oil on canvas
25 1/2 × 30" (64.8 × 76.2 cm)

The John Howard McFadden Collection
M1928-1-13

BRITISH

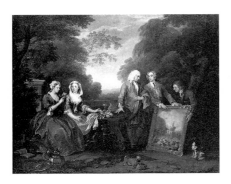

Hogarth, William
Conversation Piece (Portrait of Sir Andrew Fountaine with Other Men and Women)
c. 1730–35
Oil on canvas
18 3/4 × 23" (47.6 × 58.4 cm)

The John Howard McFadden Collection
M1928-1-14

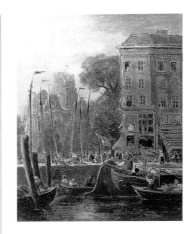

Holland, James, attributed to
Previously listed as James Holland (JGJ 1941)
View of Delft
19th century
Oil on fiberboard
14 1/4 × 11 1/16" (36.2 × 28.1 cm)

John G. Johnson Collection
cat. 887

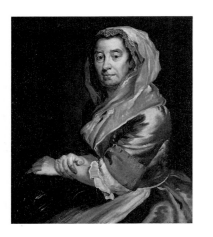

Hogarth, William, imitator of
Previously listed as William Hogarth (JGJ 1941)
Portrait of a Woman
18th century
Oil on canvas
29 15/16 × 25 3/16" (76 × 64 cm)

John G. Johnson Collection
cat. 823

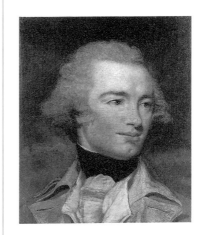

Hoppner, John, attributed to
English, 1758–1810
Portrait of an Officer
c. 1795–1800
Oil on canvas
15 3/4 × 13" (40 × 33 cm)

Bequest of Helen S. Fennessy in memory of her stepfather, Horace Trumbauer
1974-161-2

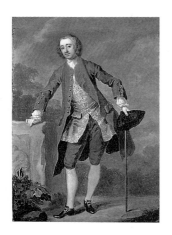

Hogarth, William, copy after
Portrait of Gustavus Hamilton, 2nd Viscount Boyne
After the painting in the collection of Viscount Boyne, Burwarton House, Salop
c. 1740
Oil on canvas
21 × 14 5/8" (53.3 × 37.2 cm)

The John D. McIlhenny Collection
1943-40-49

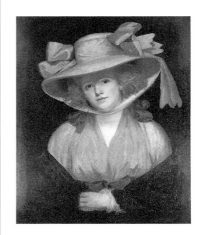

Hoppner, John, imitator of
Previously attributed to John Hoppner (PMA 1965)
Portrait of Mrs. Hoppner
In the style of c. 1783; probably a copy of an unrecorded picture or an adaptation after the print of Hoppner's *Sophia Western*
c. 1850–1900?
Oil on canvas
30 1/4 × 24 7/8" (76.8 × 63.2 cm)

The John Howard McFadden Collection
M1928-1-15

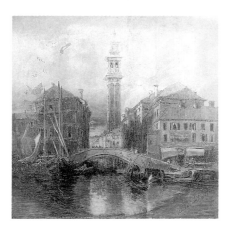

Holland, James
English, 1800–1870
Canal of Venice
1848
Lower left: The Tower of St. George the Greek / Venice; lower right: James Holland, 1848
Oil and ink on fiberboard
20 1/8 × 20 1/8" (51.1 × 51.1 cm)

John G. Johnson Collection
cat. 886

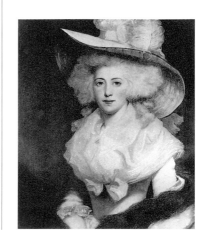

Hoppner, John, copy after
Previously listed as John Hoppner (PMA 1965)
Portrait of Susanna Gyll
After a lost composition of c. 1779
19th century
On reverse: Susanna Daughter of William Gyll of Wysadsbury. Married 4 Feb. 1779 Thomas Cheadle Sanders Esq[ui]re / Died 7 Sept. 1833 aged 77
Oil on canvas
30 1/8 × 25 1/8" (76.5 × 63.8 cm)

The George W. Elkins Collection
E1924-4-16

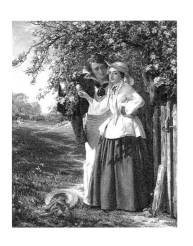

Horsley, John Calcott
English, 1817–1903
Lovers under a Blossom Tree
By 1859
Oil on canvas
35 1/2 × 27 1/4" (90.2 × 69.2 cm)

The Henry P. McIlhenny
Collection in memory of
Frances P. McIlhenny
1986-26-278

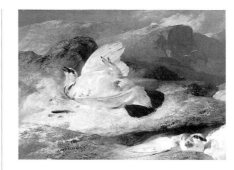

Landseer, Sir Edwin
Ptarmigan in a Landscape
By 1833
Oil on panel
19 1/2 × 25 3/4" (49.5 × 65.4 cm)

The Henry P. McIlhenny
Collection in memory of
Frances P. McIlhenny
1986-26-280

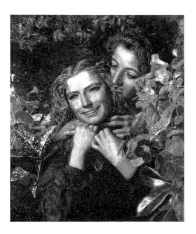

Houghton, Arthur Boyd
English, 1836–1875
The Surprise
c. 1860
Oil on canvas
9 1/4 × 7 1/2" (23.5 × 19.1 cm)

The Henry P. McIlhenny
Collection in memory of
Frances P. McIlhenny
1986-26-279

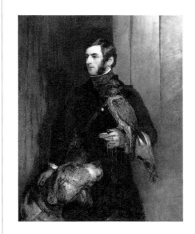

Landseer, Sir Edwin
The Falconer [possibly a portrait
of William Russell]
1830s
Oil on canvas
54 1/2 × 43 1/2" (138.4 × 110.5 cm)

The Henry P. McIlhenny
Collection in memory of
Frances P. McIlhenny
1986-26-24

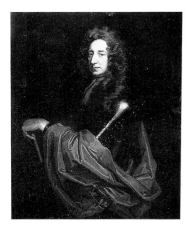

Kneller, Sir Godfrey
English, born Germany,
1646–1723
Portrait of a Soldier
c. 1690–95
Oil on canvas
49 1/2 × 39 1/2" (125.7 × 100.3 cm)

The William L. Elkins Collection
E1924-3-97

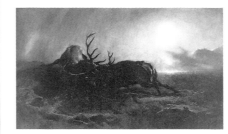

Landseer, Sir Edwin
*Night (Two Stags Battling by
Moonlight)*
Pendant to *Morning*
By 1853
Oil on canvas
56 × 103" (142.2 × 261.6 cm)

The Henry P. McIlhenny
Collection in memory of
Frances P. McIlhenny
1986-26-282

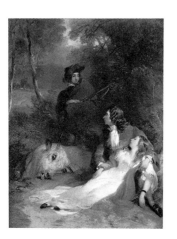

Landseer, Sir Edwin
English, 1802–1873
The Bride of Lammermoor
By 1830
Oil on panel
12 3/4 × 9 3/4" (32.4 × 24.8 cm)

The Henry P. McIlhenny
Collection in memory of
Frances P. McIlhenny
1986-26-281

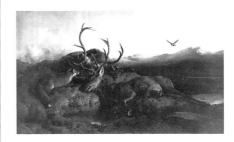

Landseer, Sir Edwin
*Morning (Two Dead Stags
and a Fox)*
Pendant to *Night*
By 1853
Oil on canvas
56 × 103" (142.2 × 261.6 cm)

The Henry P. McIlhenny
Collection in memory of
Frances P. McIlhenny
1986-26-283

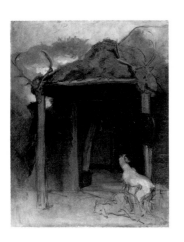

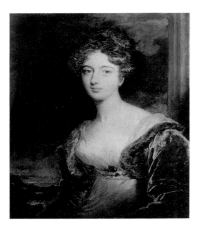

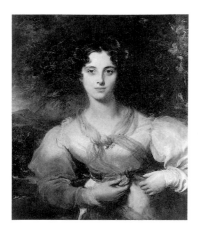

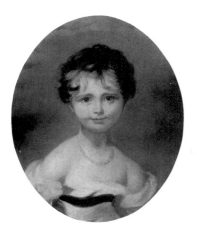

Landseer, Sir Edwin
Duchess of Bedford's Hut, Glenfeshie
Mid-19th century
Oil on panel
23 1/2 × 17 1/2" (59.7 × 44.5 cm)

The Henry P. McIlhenny
Collection in memory of
Frances P. McIlhenny
1986-26-284

Lawrence, Sir Thomas
English, 1769–1830
*Portrait of Mrs. James Fraser of
Castle Fraser*
c. 1817
Oil on canvas
30 1/8 × 25" (76.5 × 63.5 cm)

The George W. Elkins Collection
E1924-4-17

Lawrence, Sir Thomas
Portrait of Harriott West [later
Mrs. William Woodgate]
c. 1824–25
Oil on canvas
30 1/4 × 25 1/8" (76.8 × 63.8 cm)

The John Howard McFadden
Collection
M1928-1-16

**Lawrence, Sir Thomas,
copy after**
Portrait of Lady Emily Cowper
[later Lady Ashley, Countess of
Shaftesbury]
After the painting, dated 1814,
in the collection of the Earl of
Shaftesbury
19th century
Oil on canvas
21 1/8 × 16 7/8" (53.7 × 42.9 cm)

Bequest of Lisa Norris Elkins
1950-92-8

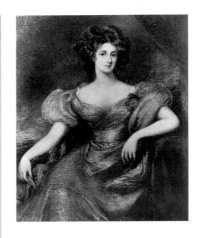

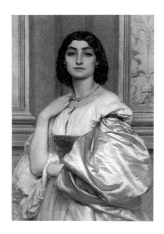

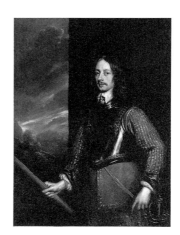

**Lawrence, Sir Thomas,
copy after**
Previously listed as Sir Thomas
Lawrence (PMA 1965)
Portrait of Lady Harriet Clive
[later Baroness Windsor]
After the painting, dated c. 1823,
in the collection of the Earl of
Plymouth, Oakley Park, England
19th century
Oil on canvas
49 1/2 × 40 1/2" (125.7 × 102.9 cm)

The Walter Lippincott Collection
1923-59-17

Lear, Edward
English, 1812–1888
Mahabalipooram
1881
Oil on canvas
9 × 18" (22.9 × 45.7 cm)

The Henry P. McIlhenny
Collection in memory of
Frances P. McIlhenny
1986-26-285

Leighton, Sir Frederic
English, 1830–1896
*Portrait of a Roman Lady (La
Nanna)*
1859
Oil on canvas
31 1/2 × 20 1/2" (80 × 52.1 cm)

Purchased with the Henry
Clifford Memorial Fund
1976-34-1

**Lely, Sir Peter
(Pieter van der Faes)**
English, active Netherlands,
1618–1680
*Portrait of James Butler, 12th Earl
and 1st Duke of Ormonde*
1647
Oil on canvas
47 7/8 × 36 1/2" (121.6 × 92.7 cm)

Bequest of Arthur H. Lea
F1938-1-3

Linnell, John
English, 1792–1882
The Storm (The Refuge)
1853
Lower right: J. Linnell, 1853
Oil on canvas
35 1/2 × 57 1/2" (90.2 × 146.1 cm)

The John Howard McFadden
Collection
M1928-1-17

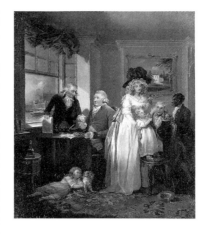

Morland, George
English, 1763–1804
Fruits of Early Industry and Economy
Pendant to Morland's *Effects of Youthful Extravagance and Idleness*, 1789, location unknown
1789
Oil on canvas
30 1/4 × 25 1/8" (76.8 × 63.8 cm)

The John Howard McFadden
Collection
M1928-1-19

Marlow, William
English, 1740–1813
View of Rome from the Tiber
c. 1775
Lower left: W. Marlow
Oil on canvas
40 × 50 1/8" (101.6 × 127.3 cm)

Gift of Jay Cooke
1955-2-4

Morland, George
Coast Scene with Smugglers
1790
Lower right: G. Morland Pinx'
1790
Oil on canvas on panel
38 1/4 × 50 1/2" (97.2 × 128.3 cm)

Gift of Mrs. Edward Browning
1947-99-1

Marshall, Benjamin
English, 1768–1835
Favorite Chestnut Hunter of Lady Frances Stephens [née Lady Frances Pierrepont]
1799
Lower right: B. Marshall pt.
1799; on label on reverse: The favourite hunter of Lady Frances Stephens, / daughter of the first Lord Manvers, / painted for the family by Ben Marshall 1799
Oil on canvas
24 5/8 × 29 1/2" (62.6 × 74.9 cm)

Centennial gift of Mr. and Mrs.
Charles H. Norris
1977-44-1

Morland, George
Farmyard
1790 or 1791
Center right: G Morland
Oil on canvas
28 × 36" (71.1 × 91.4 cm)

Gift of Mrs. Gordon A. Hardwick
and Mrs. W. Newbold Ely in
memory of Mr. and Mrs.
Roland L. Taylor
1944-9-1

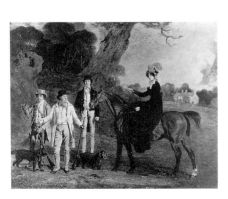

Marshall, Benjamin
Portrait of the Weston Family
1818
Lower right: B. Marshall / 1818
Oil on canvas
39 7/8 × 50 1/4" (101.3 × 127.6 cm)

Gift of Diana Kendall, Alexandra
Dewey, Linda Jones, and Sheila
Neville in memory of their
grandfather, George D. Widener
1978-40-1

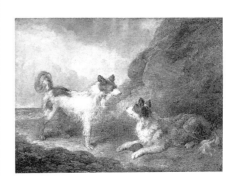

Morland, George
Two Terriers
c. 1790–91
Oil on canvas
18 × 23 7/8" (45.7 × 60.6 cm)

John G. Johnson Collection
cat. 846

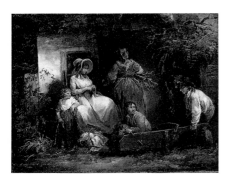

Morland, George
The Happy Cottagers (The Cottage Door)
A larger version is in the Bass Museum of Art, Miami Beach
c. 1790–92
Oil on canvas
14 1/2 × 18 1/2" (36.8 × 47 cm)

The John Howard McFadden Collection
M1928-1-20

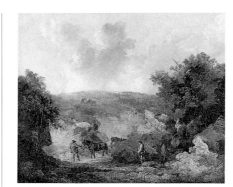

Morland, George, attributed to
Previously listed as George Morland (JGJ 1941)
The Lane
Early 19th century
Oil on canvas
10 1/4 × 12 3/16" (26 × 31 cm)

John G. Johnson Collection
cat. 845

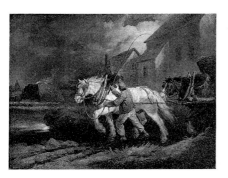

Morland, George
The Carter
1791
Center right: G. Morland / pinx
Oil on canvas
16 1/16 × 20 9/16" (40.8 × 52.2 cm)

John G. Johnson Collection
cat. 844

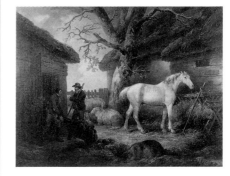

Morland, George, imitator of
Previously listed as George Morland (PMA 1965)
Interior of a Farm
Early 19th century
Lower left (spurious): G. Morland Pinx.
Oil on canvas
28 × 36 1/4" (71.1 × 92.1 cm)

The William L. Elkins Collection
E1924-3-33

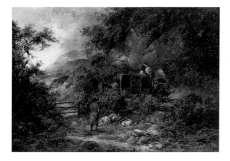

Morland, George
The Stagecoach
1791
Lower left: G. Morland Pinx. / October 3[?]. 1791
Oil on canvas
34 1/2 × 46 1/2" (87.6 × 118.1 cm)

The John Howard McFadden Collection
M1928-1-18

Morland, George, copy after
Previously listed as George Morland (PMA 1965)
Gathering Wood
After a lost painting dated 1791
After 1791
Lower right (spurious): G. Morland 1795
Oil on canvas
15 1/4 × 12 1/2" (38.7 × 31.8 cm)

The William L. Elkins Collection
E1924-3-44

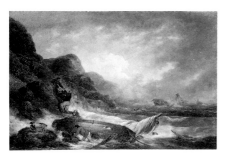

Morland, George
Shipwreck
1793
Center bottom: G. Morland
Oil on canvas
38 1/8 × 57" (96.8 × 144.8 cm)

The William L. Elkins Collection
E1924-3-98

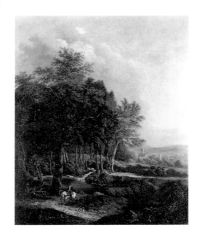

Nasmyth, Peter
Scottish, 1787–1831
View of Lambeth
Early 19th century
Lower left: P. N.
Oil on canvas
28 9/16 × 23 1/8" (72.6 × 58.7 cm)

John G. Johnson Collection
cat. 880

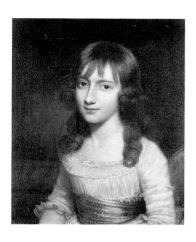

Opie, John
English, 1761–1807
Previously attributed to John
Opie (PMA 1965)
Portrait of Anne Westcott [later
Mrs. Frederick Waller]
By 1799
Oil on canvas
21 1/8 × 17 1/8" (53.7 × 43.5 cm)

Gift of John S. Williams
1947-100-2

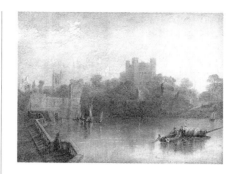

**Pyne, James Baker,
attributed to**
English, 1800–1870
Previously listed as James Baker
Pyne (JGJ 1941)
Rochester
19th century
Oil on canvas
9 × 12 1/4" (22.9 × 31.1 cm)

John G. Johnson Collection
cat. 881

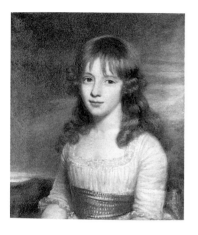

Opie, John
Previously attributed to John
Opie (PMA 1965)
Portrait of Mary Westcott [later
Mrs. Benjamin Waller]
By 1799
Oil on canvas
21 1/8 × 17 5/8" (53.7 × 44.8 cm)

Gift of John S. Williams
1947-100-1

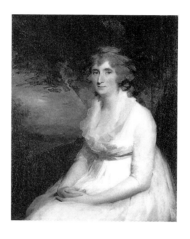

Raeburn, Sir Henry
Scottish, 1756–1823
Portrait of a Woman [possibly Mrs.
William Stewart of Summer
Bank]
c. 1790
Oil on canvas
35 7/8 × 27 1/8" (91.1 × 68.9 cm)

Bequest of George D. Widener
1972-50-3

Parsons, Alfred
English, 1847–1920
River and Towpath
1883
Lower right: ALFRED PARSONS.
1883.
Oil on canvas
24 3/8 × 60 3/8" (61.9 × 153.4 cm)

John G. Johnson Collection
cat. 1054

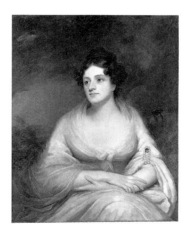

Raeburn, Sir Henry
Previously attributed to Sir
Henry Raeburn (PMA 1965)
Portrait of Lady Belhaven
Another version is in the New York
Public Library
c. 1790
On reverse: Raeburn [?] C. J.
Raeburn / L. W. Raeburn /
Painted by my Grandfather, Sir
Henry Raeburn
Oil on canvas
36 1/8 × 27 7/8" (91.8 × 70.8 cm)

The John Howard McFadden
Collection
M1928-1-21

Paterson, James
Scottish, 1854–1932
Landscape
1890
Lower right: James Paterson. /
Monsoire. 1890.
Oil on canvas
18 1/16 × 30 1/16" (45.9 × 76.4 cm)

John G. Johnson Collection
cat. 1058

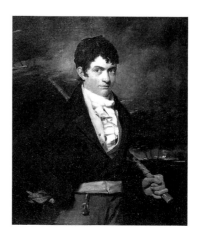

Raeburn, Sir Henry
Portrait of Charles Christie, Esq.
c. 1800
Oil on canvas
30 1/2 × 25 1/2" (77.5 × 64.8 cm)

The John Howard McFadden
Collection
M1928-1-25

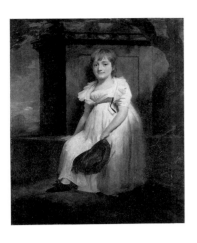

Raeburn, Sir Henry
Portrait of Master John Campbell of Saddell
c. 1800
Oil on canvas
49 1/4 × 39 3/8" (125.1 × 100 cm)

The John Howard McFadden Collection
M1928-1-24

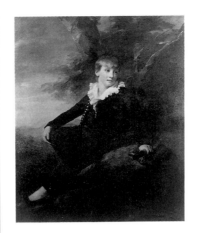

Raeburn, Sir Henry
Portrait of Master Thomas Bissland
c. 1809
Oil on canvas
56 1/2 × 44 3/8" (143.5 × 112.7 cm)

The John Howard McFadden Collection
M1928-1-23

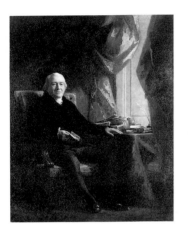

Raeburn, Sir Henry
Portrait of William MacDonald of Saint Martin's
An earlier version, documented in 1803, is in the collection of the Royal Highland and Agricultural Society of Scotland, Edinburgh
c. 1803
Oil on canvas
78 × 60" (198.1 × 152.4 cm)

Purchased with the W. P. Wilstach Fund
W1895-1-9

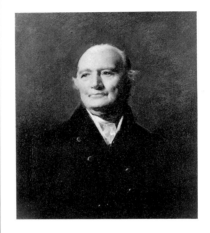

Raeburn, Sir Henry
Portrait of Alexander Shaw
c. 1810–15
Oil on canvas
30 × 25 1/8" (76.2 × 63.8 cm)

The John Howard McFadden Collection
M1928-1-27

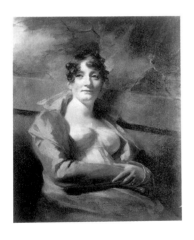

Raeburn, Sir Henry
Portrait of Lady Elibank
c. 1805
Oil on canvas
36 × 28" (91.4 × 71.1 cm)

The John Howard McFadden Collection
M1928-1-22

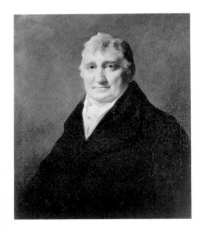

Raeburn, Sir Henry
Portrait of Walter Kennedy Lawrie of Woodhall, Laurieston
c. 1815
Oil on canvas
30 × 25" (76.2 × 63.5 cm)

The John Howard McFadden Collection
M1928-1-26

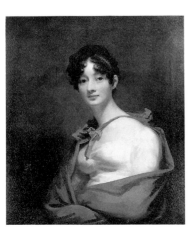

Raeburn, Sir Henry
Portrait of Ellen Cochrane
c. 1808
Oil on canvas
30 1/8 × 25 1/8" (76.5 × 63.8 cm)

Gift of Mr. and Mrs. John Howard McFadden, Jr.
1952-97-1

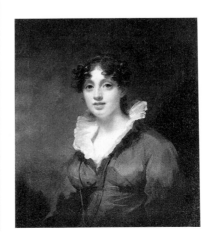

Raeburn, Sir Henry
Portrait of Jane Anne Catharine Fraser of Reelig
1816
On reverse, covered by relining: Jane Anne Catharine Fraser of Reelick Aet: 19 / Raeburn pinx. 1816
Oil on canvas
30 1/8 × 25 3/4" (76.5 × 65.4 cm)

Gift of Mr. and Mrs. Wharton Sinkler
1963-171-1

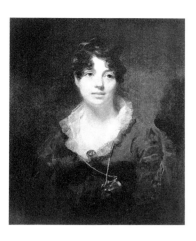

Raeburn, Sir Henry
Portrait of Mrs. John McCall of Ibroxhill
c. 1820
Oil on canvas
30 × 25" (76.2 × 63.5 cm)

The George W. Elkins Collection
E1924-4-23

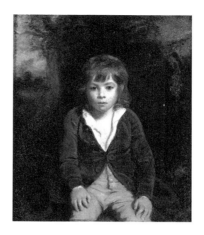

Reynolds, Sir Joshua
Portrait of Master Bunbury
1780 or 1781
Oil on canvas
30 1/8 × 25 1/8" (76.5 × 63.8 cm)

The John Howard McFadden Collection
M1928-1-29

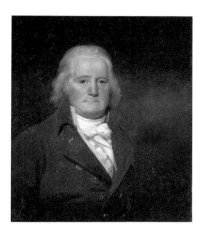

Raeburn, Sir Henry, follower of
Previously attributed to Sir Henry Raeburn (PMA 1965)
Portrait of a Gentleman
19th century
Oil on canvas
29 3/4 × 25 1/4" (75.6 × 64.1 cm)

The John Howard McFadden Collection
M1928-1-28

Reynolds, Sir Joshua, attributed to
Previously listed as Sir Joshua Reynolds (JGJ 1941)
Infant Hercules Strangling the Serpents
Possibly after the large version in the Hermitage, St. Petersburg (inv. no. 6745)
18th century
Oil on paper on canvas
23 7/8 × 23 3/4" (60.6 × 60.3 cm)

John G. Johnson Collection
cat. 831

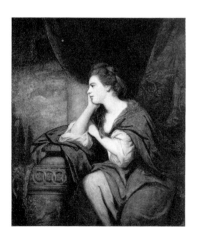

Reynolds, Sir Joshua
English, 1723–1792
Portrait of Lady Mary O'Brien
[later 3rd Countess of Orkney]
c. 1772
Oil on canvas
50 × 40 1/8" (127 × 101.9 cm)

Gift of Mr. and Mrs. William H. Donner
1948-95-1

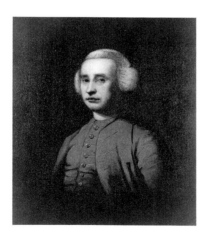

Reynolds, Sir Joshua, follower of
Previously attributed to Sir Joshua Reynolds (PMA 1965)
Portrait of the Right Honorable Edmund Burke
c. 1756–60
Oil on canvas
30 1/8 × 25" (76.5 × 63.5 cm)

The John Howard McFadden Collection
M1928-1-30

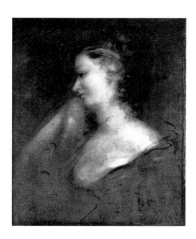

Reynolds, Sir Joshua
Portrait of a Lady
c. 1780
Oil on canvas
24 1/2 × 20" (62.2 × 50.8 cm)

The John D. McIlhenny Collection
1943-40-40

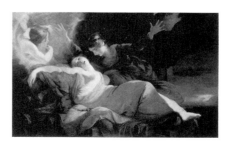

Reynolds, Sir Joshua, copy after
The Death of Dido
After the painting, dated 1781, in the collection of Her Majesty Queen Elizabeth II (1029)
c. 1781
Oil on canvas
58 1/4 × 94 5/8" (148 × 240.3 cm)

The William L. Elkins Collection
E1924-3-18

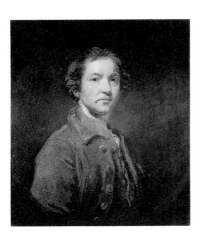

Reynolds, Sir Joshua, copy after
Portrait of Sir Joshua Reynolds
After the self-portrait in the Tate Gallery, London (N 889)
c. 1820
Oil on canvas
30 3/16 × 25 1/4" (76.7 × 64.1 cm)

John G. Johnson Collection
cat. 827

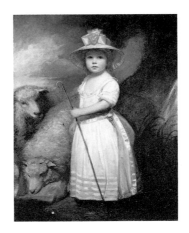

Romney, George
English, 1734–1802
Shepherd Girl (Little Bo-Peep)
c. 1778
Oil on canvas
46 1/2 × 35 1/2" (118.1 × 90.2 cm)

The John Howard McFadden Collection
M1928-1-38

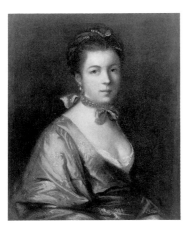

Reynolds, Sir Joshua, copy after
Previously attributed to Sir Joshua Reynolds (PMA 1965)
Portrait of Lady Monnoux [née Elizabeth Riddell]
After the painting sold at Christie's, March 28, 1952 (lot 53)
After c. 1860
Oil on canvas
29 7/8 × 24 7/8" (75.9 × 63.2 cm)

The George W. Elkins Collection
E1924-4-24

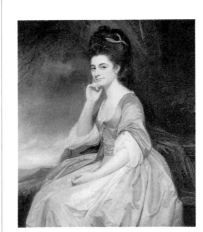

Romney, George
Portrait of Lady Grantham
1780–81
Lower right: Mary Jemima 2nd / Daughter Marchioness Grey / and Wife of Thomas Lord Grantham
Oil on canvas
46 1/2 × 39" (118.1 × 99.1 cm)

The John Howard McFadden Collection
M1928-1-36

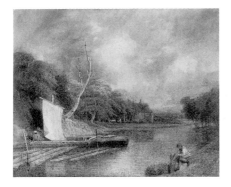

Reynolds, Samuel William, attributed to
English, 1773–1835
Fisherman
19th century
Oil on canvas
20 1/16 × 23 7/8" (51 × 60.6 cm)

John G. Johnson Collection
cat. 847

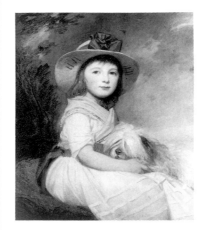

Romney, George
Portrait of Marianne Holbech
1781–82
On label on reverse: 1781–82, / Sometime in 1782 Romney painted the portrait of Mary Anne Holbech / (afterwards Lady Mordaunt) / — who was born 1777. See entry in her father's account — "1782 / Oct: 21 Romney for Mary Anne's picture £ 21.8.6. / It was paid for, being sent home / 10 Oct. / CWH"
Oil on canvas
30 × 25" (76.2 × 63.5 cm)

The George W. Elkins Collection
E1924-4-25

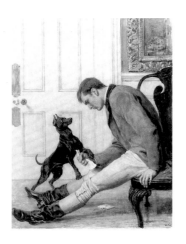

Riviere, Briton
English, 1840–1920
Jilted
1887
Lower right: [Signed with monogram and dated 1887]
Oil on canvas
30 1/2 × 23" (77.5 × 58.4 cm)

Gift of Muriel and Philip Berman
1989-70-6

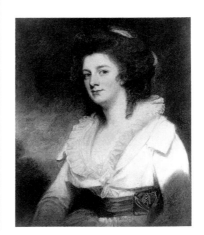

Romney, George
Portrait of the Honorable Mrs. Beresford
c. 1785
Oil on canvas
30 1/8 × 24 3/4" (76.5 × 62.9 cm)

The George W. Elkins Collection
E1924-4-26

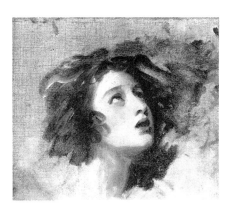

Romney, George
Portrait of Emma Hart as Miranda
[later Lady Hamilton]
1785 or 1786
Oil on canvas
14 1/8 × 15 1/2" (35.9 × 39.4 cm)

The John Howard McFadden
Collection
M1928-1-34

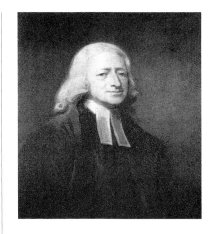

Romney, George
Portrait of John Wesley
1788–89
Oil on canvas
30 × 25" (76.2 × 63.5 cm)

The John Howard McFadden
Collection
M1928-1-37

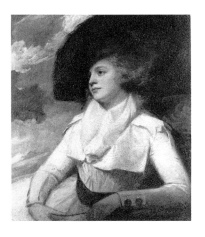

Romney, George
Portrait of a Lady
c. 1786
Oil on canvas
30 1/8 × 25 1/4" (76.5 × 64.1 cm)

Bequest of George D. Widener
1972-50-2

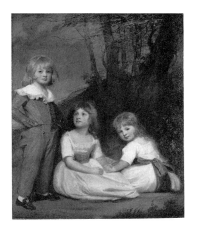

Romney, George
Portrait of Mr. Adye's Children
(The Willett Children)
1789–90
Oil on canvas
60 × 48" (152.4 × 121.9 cm)

The George W. Elkins Collection
E1924-4-27

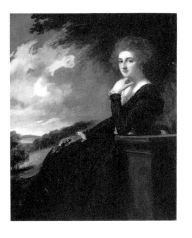

Romney, George
Portrait of Mrs. Champion de
Crespigny [née Dorothy Scott]
1786–90
Oil on canvas
51 1/8 × 40" (129.9 × 101.6 cm)

The John Howard McFadden
Collection
M1928-1-32

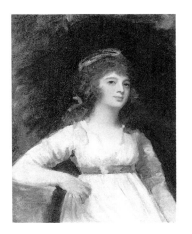

Romney, George
Portrait of Mrs. Finch
1790
Oil on canvas
35 7/8 × 27 3/4" (91.1 × 70.5 cm)

The John Howard McFadden
Collection
M1928-1-33

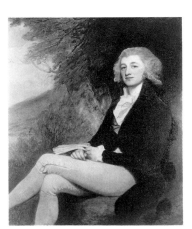

Romney, George
Portrait of Sir John Reade
1788
Oil on canvas
50 × 39 7/8" (127 × 101.3 cm)

The William L. Elkins Collection
E1924-3-19

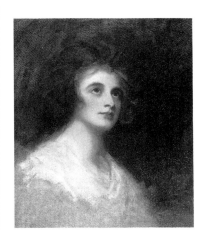

Romney, George
Portrait of Mrs. Tickell
1791 or 1792
Oil on canvas
24 × 20 1/8" (61 × 51.1 cm)

The John Howard McFadden
Collection
M1928-1-35

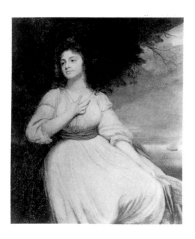

Romney, George
Portrait of Mrs. Crouch
The original version, dated 1787,
is in the Iveagh Bequest,
Kenwood, London (34)
c. 1793
Lower right, on musical score:
[Hus]h Ev'ry Breeze let /
[nothi]ng [or:] [su]ng by Mrs.
Crouch / composed by Hook /
Andantino Hush ev'ry breeze let
nothing
Oil on canvas
50 1/4 × 39 1/2" (127.6 × 100.3 cm)

The John Howard McFadden
Collection
M1928-1-31

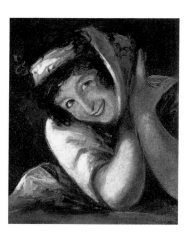

**Romney, George,
copy after**
Previously listed as George
Romney (JGJ 1941)
*Portrait of Lady Hamilton as a
Bacchante*
After the painting in the Tate
Gallery, London (N 00312),
known through numerous
engravings
19th century
Oil on canvas
22 3/16 × 18" (56.4 × 45.7 cm)

John G. Johnson Collection
cat. 837

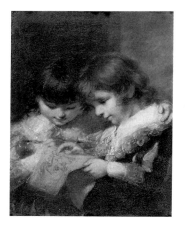

Russell, William
English, 1784–1870
Previously listed as John Russell
(PMA 1965)
*Young Artists (Portrait of William
and Thomas Russell)*
After a lost pastel by John Russell
(English, 1745–1806)
After 1793
Oil on canvas
24 × 18" (61 × 45.7 cm)

Gift of John S. Williams
1947-100-3

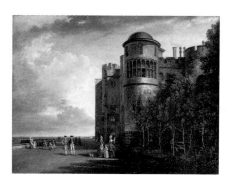

Sandby, Paul
English, 1730–1809
*The North Terrace at Windsor
Castle, Looking East*
c. 1775–80
Oil on canvas
39 3/4 × 50" (101 × 127 cm)

Gift of John Howard McFadden, Jr.
1951-125-18

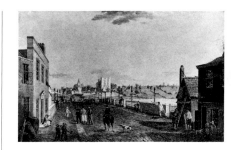

Scott, Samuel, follower of
English, c. 1702–1772
Previously listed as Samuel Scott
(PMA 1965)
Old Rochester Bridge
c. 1732–40
Oil on canvas
22 5/8 × 34 5/8" (57.5 × 88 cm)

Purchased with the W. P.
Wilstach Fund
W1906-1-5

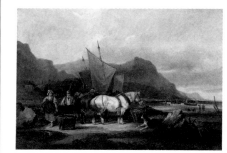

Scott, William Bell
Scottish, 1811–1890
*The Gloaming (Manse Garden,
Berwickshire)*
1863
Lower left: WB Scott 1863
Oil on canvas
16 × 24" (40.6 × 61 cm)

Purchased with the John Howard
McFadden, Jr., Fund
1971-164-1

Shayer, William, Sr.
English, 1781–1879
Previously listed as George
Morland (PMA 1965)
Fishing Scene
c. 1850?
Lower left (spurious): G.
Morland Pinx / 1797
Oil on canvas
26 × 36 1/8" (66 × 91.8 cm)

The Walter Lippincott Collection
1923-59-11

Stark, James
English, 1794–1859
Landscape with Cattle
c. 1820–30
Oil on panel
16 1/2 × 21 7/8" (41.9 × 55.6 cm)

The John Howard McFadden
Collection
M1928-1-39

Stark, James
Millstream, Norfolk
c. 1830–40
Oil on panel
19 3/4 × 29 7/8" (50.2 × 75.9 cm)

The William L. Elkins Collection
E1924-3-46

Swan, John MacAllan
English, 1847–1910
Wild Boars
1879
Lower left: J. M. SWAN. 1879
Oil on panel
4 7/8 × 8 3/8" (12.4 × 21.3 cm)

John G. Johnson Collection
cat. 1086

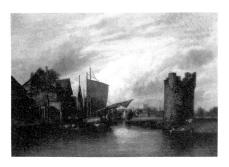

Stark, James, copy after
Previously listed as James Stark
(PMA 1965)
The Devil's Tower
After 1831
Lower left: J. Stark
Oil on canvas
19 1/4 × 26 1/4" (48.9 × 66.7 cm)

The William L. Elkins Collection
E1924-3-45

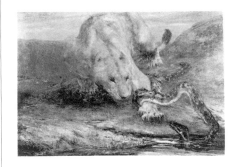

Swan, John MacAllan
A Lioness and a Snake
Before 1889
Lower left: JOHN. M. SWAN
Oil on canvas
24 1/2 × 34 1/2" (62.2 × 87.6 cm)

John G. Johnson Collection
cat. 1089

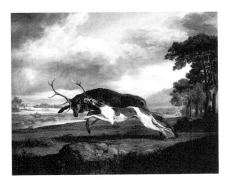

Stubbs, George
English, 1724–1806
Hound Coursing a Stag
c. 1762
Lower right: Geo. Stubbs / pinx
Oil on canvas
39 3/8 × 49 1/2" (100 × 125.7 cm)

Purchased with the W. P.
Wilstach Fund, the John D.
McIlhenny Fund, and gifts (by
exchange) of Samuel S. White
3rd and Vera White, Mrs. R.
Barclay Scull, and Edna M. Welsh
W1984-57-1

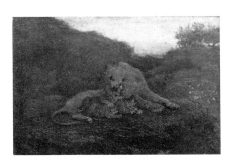

Swan, John MacAllan
A Lioness and Cubs
c. 1890
Lower left: J. M. Swan
Oil on canvas
17 1/8 × 24 1/2" (43.5 × 62.2 cm)

The William L. Elkins Collection
E1924-3-65

Stubbs, George
Laborers Loading a Brick Cart
1767
Lower right: Geo: Stubbs / 1767
Oil on canvas
24 × 42" (61 × 106.7 cm)

The John Howard McFadden
Collection
M1928-1-40

Swan, John MacAllan
Jaguars and a Crocodile
1891
Lower left: JOHN. M. SWAN. 1891.
Oil on canvas
18 × 35 3/8" (45.7 × 89.9 cm)

John G. Johnson Collection
cat. 1088

Swan, John MacAllan
Tigers
Before 1893
Lower left: J. M. SWAN
Oil on canvas
16 3/4 × 27 15/16" (42.6 × 71 cm)

John G. Johnson Collection
cat. 1087

Vincent, George
English, 1796–1831
Cottage on the Roadside
1831
Lower right: GV 1831
Oil on panel
8 3/4 × 13" (22.2 × 33 cm)

John G. Johnson Collection
cat. 879

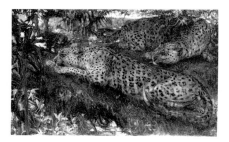

Swan, John MacAllan
In Ambush
1894
Lower left: John M. Swan / 1894
Oil on canvas
32 1/4 × 52 1/8" (81.9 × 132.4 cm)

The William L. Elkins Collection
E1924-3-81

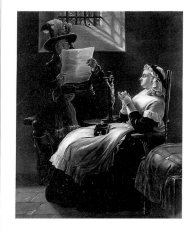

**Ward, Edward Matthew,
copy after**
English, 1816–1879
*Marie Antoinette Listening to the
Act of Accusation, the Day before Her
Trial*
19th century
Lower left: J. M. Baudy
Oil on canvas
36 7/8 × 29 5/8" (93.7 × 75.2 cm)

Bequest of Katherine E. Sheafer
1971-272-1

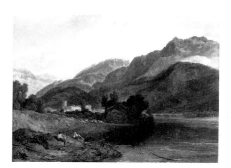

**Turner, Joseph Mallord
William**
English, 1775–1851
Bonneville, Savoy
c. 1812
Oil on canvas
36 9/16 × 48 3/4" (92.9 × 123.8 cm)

John G. Johnson Collection
cat. 848

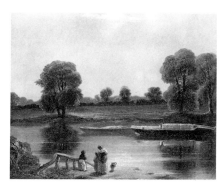

Watts, Frederick William
English, 1800–1862
Landscape with a River and Boats
1840
Lower left: F. Watts Pintx 1840
Oil on canvas
25 3/8 × 30 3/8" (64.5 × 77.2 cm)

The William L. Elkins Collection
E1924-3-41

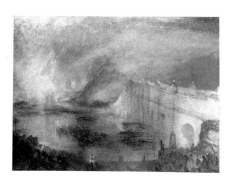

**Turner, Joseph Mallord
William**
*The Burning of the Houses of Lords
and Commons, October 16, 1834*
1834 or 1835
Oil on canvas
36 1/4 × 48 1/2" (92.1 × 123.2 cm)

The John Howard McFadden
Collection
M1928-1-41

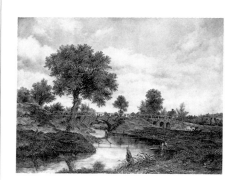

Watts, William
English, 1752–1851
Suffolk Landscape
Early 19th century
Oil on canvas
34 1/2 × 45 5/8" (87.6 × 115.9 cm)

John G. Johnson Collection
cat. 874

Watts, William, attributed to
Previously listed as William Watts (JGJ 1941)
Lock
19th century
Oil on canvas
24 1/16 × 32" (61.1 × 81.3 cm)

John G. Johnson Collection
cat. 875

West, Benjamin
Elijah Raising the Widow's Son
1774, retouched 1819
Center right: Benjamin West
1774 / Retouched 1819
Oil on canvas
64 5/8 × 82 5/8" (164.1 × 209.9 cm)

The Bloomfield Moore Collection
1899-1106

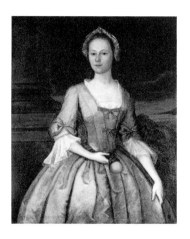

West, Benjamin
English, born America,
1738–1820
Portrait of Miss Mary Keen
By 1767
Oil on canvas
41 × 32" (104.1 × 81.3 cm)

Gift of Caleb W. Hornor
1956-39-2

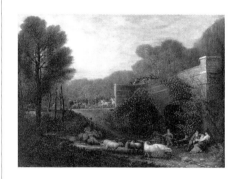

West, Benjamin
Landscape with a Coaching Party
1791, retouched 1801
Right center: B. West 1791 /
retouched 1801
Oil on canvas
28 × 36" (71.1 × 91.4 cm)

Gift of Mrs. Craig W. Muckle
1991-182-1

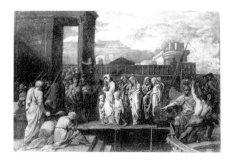

West, Benjamin
Sketch for "Agrippina Landing at Brundisium with the Ashes of Germanicus"
For the following painting
c. 1767
Lower left: B. West / 1766.
Oil on paper on canvas on panel
13 3/8 × 18 7/8" (34 × 47.9 cm)

Gift of the Robert L. McNeil, Jr.,
Trusts
1965-49-1

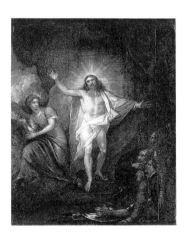

West, Benjamin
The Resurrection
c. 1808
Oil on slate
15 3/4 × 12 1/16" (40 × 30.6 cm)

Gift of Mr. and Mrs. D. Clifford
Ruth
1967-195-1

West, Benjamin
Agrippina Landing at Brundisium with the Ashes of Germanicus
1770
Center bottom: B. West PINXIT. /
1770.
Oil on canvas
65 × 94" (165.1 × 238.8 cm)

Purchased with the George W.
Elkins Fund
E1972-1-1

West, Benjamin
Benjamin Franklin Drawing Electricity from the Sky
c. 1816
Oil on slate
13 3/8 × 10 1/16" (34 × 25.6 cm)

Gift of Mr. and Mrs. Wharton
Sinkler
1958-132-1

West, Benjamin, copy after
Previously listed as Benjamin
West (PMA 1965)
Death on the Pale Horse
After the painting in the
Pennsylvania Academy of the
Fine Arts, Philadelphia
Before 1829
Oil on canvas
21 × 36" (53.3 × 91.4 cm)

Gift of Theodora Kimball
Hubbard in memory of Edwin
Fiske Kimball
1928-112-1

West, Benjamin, copy after
Previously listed as Benjamin
West (PMA 1965)
Death on the Pale Horse
After the painting in the
Pennsylvania Academy of the
Fine Arts, Philadelphia
19th century
Oil on paper on panel
11 1/4 × 22 1/2" (28.6 × 57.2 cm)

Purchased with the John D.
McIlhenny Fund
1938-11-1

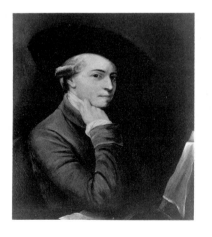

West, Benjamin, copy after
Portrait of Benjamin West
After the self-portrait in the
National Gallery of Art,
Washington, D.C. (592)
19th century
Oil on canvas
30 × 24 7/8" (76.2 × 63.2 cm)

Gift of Miss Lena Cadwalader
Evans
1935-28-1

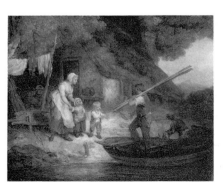

Wheatley, Francis
English, 1747–1801
The Fisherman's Return
c. 1790
Lower right: F. Wheatley Pinxt
1790
Oil on canvas
18 × 22 1/8" (45.7 × 56.2 cm)

The William L. Elkins Collection
E1924-3-85

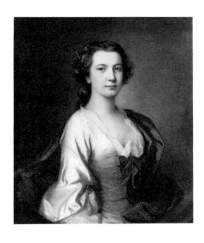

**Wilson, Benjamin,
attributed to**
English, 1721–1788
Portrait of a Lady
c. 1745–50
Oil on canvas
29 7/8 × 25" (75.9 × 63.5 cm)

Gift of Sol M. Flock
1966-121-1

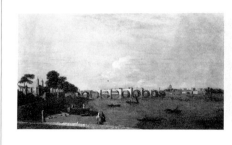

Wilson, Richard
Welsh, 1713–1782
*The Thames, Westminster Bridge
under Construction*
1745
Lower left: R. Wilson / 1745
Oil on canvas
32 1/8 × 54" (81.6 × 137.2 cm)

The John Howard McFadden
Collection
M1928-1-43

Wilson, Richard
Previously listed as an
18th-century copy after Richard
Wilson (PMA 1965)
*Tivoli: Temple of the Sibyl and the
Campagna I*
c. 1760–65
Center bottom: RW
Oil on canvas
25 × 33 1/8" (63.5 × 84.1 cm)

The William L. Elkins Collection
E1924-3-47

Wilson, Richard
Previously listed as an
18th-century copy after Richard
Wilson (PMA 1965)
Lake Avernus I
c. 1765
Oil on canvas
27 3/4 × 35 1/4" (70.5 × 89.5 cm)

The William L. Elkins Collection
E1924-3-39

Wilson, Richard, follower of
Landscape with a Horse
Late 18th century
Lower right: Maninus
Oil on canvas
21 ½ × 25 ½" (54.6 × 64.8 cm)

Bequest of Arthur H. Lea
F1938-1-13

Adriaenssen, Alexander
Flemish, active Antwerp,
1587–1661
Still Life with Fish and Oysters
1649
Lower left: Alex Adriaenssen
Fecit Ao 1649
Oil on panel
17 ¼ × 27 ¾" (43.8 × 70.5 cm)

John G. Johnson Collection
cat. 646

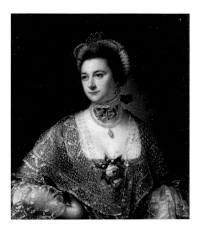

**Wright, Joseph, also called
Joseph Wright of Derby**
English, 1734–1797
Portrait of Mrs. Andrew Lindington
c. 1761–63
Oil on canvas
30 × 24 ⅛" (76.2 × 61.3 cm)

Gift of Mr. and Mrs. Henry W.
Breyer, Jr.
1968-73-1

**Adriaenssen, Alexander,
attributed to**
Still Life with Fish and Shellfish
17th century
Center bottom: II
Oil on canvas
13 ⅞ × 19" (35.2 × 48.3 cm)

John G. Johnson Collection
cat. 647

**Aken, Joseph van,
also called Joseph Haecken,
attributed to**
Flemish, active London,
1709–1749
Previously attributed to William
Hogarth (JGJ 1941)
Conversation Piece (Winter)
Before 1750
Oil on panel
25 ⅛ × 30 3/16" (63.8 × 76.7 cm)

John G. Johnson Collection
cat. 822

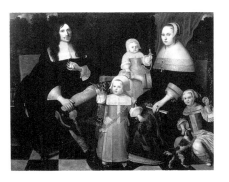

Aldewerelt, Hermanus van
Dutch, active Amsterdam,
1628/29–1669
Family Portrait Group
1664
Center top: H.V. Alde
[cryptogram] f 1664
Oil on canvas
61 × 77 ½" (154.9 × 196.8 cm)

Gift of Mrs. Al Paul Lefton
1972-264-1

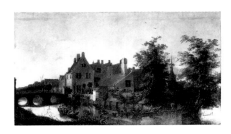

Asch, Pieter Jansz. van
Dutch, active Delft, 1603–1678
Previously listed as a Dutch
artist, c. 1650 (JFD 1972)
Houses beside a Canal
c. 1650
Oil on canvas
40 1/16 × 69 3/4" (101.8 × 177.2 cm)

John G. Johnson Collection
cat. 503

**Balen, Hendrik van,
the Elder**
Flemish, active Antwerp,
1575–1632
*Cephalus and Procris, Atalanta and
Hippomenes, Narcissus, and the
Mocking of Ceres*
c. 1600–25
Oil on panel
Top 3 panels [each]: 2 3/4 × 7 1/4"
(7 × 18.4 cm); bottom panel:
2 1/2 × 7 1/4" (6.3 × 18.4 cm)

John G. Johnson Collection
cat. 653

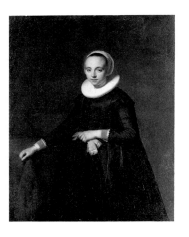

Backer, Jacob Adriaensz.
Dutch, active Amsterdam,
1608–1651
Portrait of a Lady
c. 1625–50
Center left: [illegible signature]
Oil on canvas
51 5/16 × 39 5/8" (130.3 × 100.6 cm)

John G. Johnson Collection
cat. 484

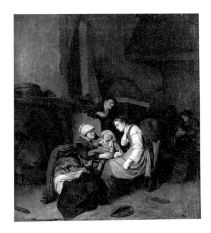

Bega, Cornelis Pietersz.
Dutch, active Haarlem,
active 1631/32–1664
Peasant Family
Mid-17th century
Oil on panel
16 1/4 × 13 15/16" (41.3 × 35.4 cm)

John G. Johnson Collection
cat. 527

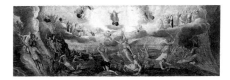

**Backer, Jacob de,
follower of**
Netherlandish, active Antwerp,
1530–1560
Previously listed as a Flemish
artist, late 16th century (JFD
1972)
The Last Judgment
Late 16th century
Oil on panel
11 3/16 × 31 1/8" (28.4 × 79.1 cm)

John G. Johnson Collection
cat. 407

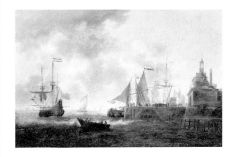

Bellevois, Jacob Adriaensz.
Dutch, active Rotterdam,
1621–1676
The Hoofdpoort, Rotterdam
Mid-17th century
Center right: Jbelevois
Oil on panel
28 3/4 × 42" (73 × 106.7 cm)

John G. Johnson Collection
cat. 588

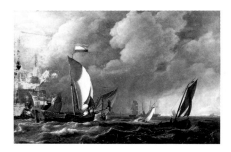

Backhuysen, Ludolf
Dutch, active Amsterdam,
1631–1708
Marine
Late 17th century
Oil on panel
25 5/8 × 37 7/8" (65.1 × 96.2 cm)

John G. Johnson Collection
cat. 592

Benson, Ambrosius
Netherlandish, active Bruges,
documented 1519–1550
Portrait of a Man Holding a Rose
1525
Upper left: ANOS-27;
center top: 1525
Oil on panel
20 9/16 × 18 1/2" (52.2 × 47 cm)

John G. Johnson Collection
cat. 360

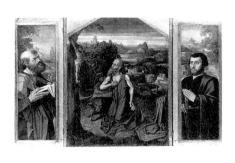

Benson, Ambrosius, attributed to
Previously listed as Ambrosius
Benson (JFD 1972)
*Penitent Saint Jerome, with Saint
Peter and a Donor as Saint Paul*
Triptych possibly assembled later;
center panel cut at top corners;
donor's hands once in prayer
c. 1525
Oil on panel
Center panel: 17 3/16 × 14 3/8" (43.7
× 36.5 cm); left panel: 18 1/4 ×
7 1/4" (46.3 × 18.4 cm); right panel:
18 1/4 × 7 1/8" (46.3 × 18.1 cm)

John G. Johnson Collection
cat. 359

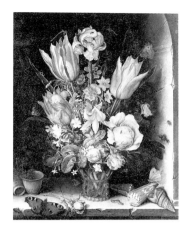

Berghe, Christoffel van den
Dutch, active Middelburg,
active c. 1617–c. 1642
Still Life with Flowers in a Vase
1617
Lower right: CV BERGHE 1617
Oil on copper
14 13/16 × 11 5/8" (37.6 × 29.5 cm)

John G. Johnson Collection
cat. 648

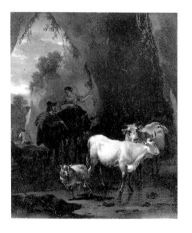

Berchem, Nicolaes Pietersz.
Dutch, active Haarlem,
Amsterdam, and Italy,
1620–1683
*A Shepherd and a Shepherdess with
Animals*
Mid-17th century
Lower left: Berchem
Oil on panel
12 3/8 × 9 3/4" (31.4 × 24.8 cm)

John G. Johnson Collection
cat. 610

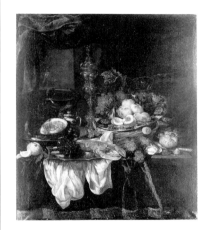

Beyeren, Abraham van
Dutch, active The Hague,
Leiden, Delft, and Alkmaar,
1620/21–1690
Banquet Still Life
c. 1654–67
Oil on canvas
50 5/16 × 42 13/16" (127.8 ×
108.7 cm)

The William L. Elkins Collection
E1924-3-23

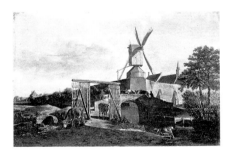

**Berckheyde, Gerrit
Adriaensz.**
Dutch, active Haarlem and
Amsterdam, 1638–1698
Mill on the Town Wall, Haarlem
Late 17th century
Lower left: Heyde
Oil on panel
16 1/4 × 24 3/4" (41.3 × 62.9 cm)

John G. Johnson Collection
cat. 598

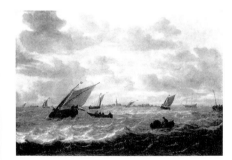

Beyeren, Abraham van
Marine with a Rough Sea
17th century
Center left: AB
Oil on canvas
32 1/2 × 44 1/2" (82.5 × 113 cm)

John G. Johnson Collection
cat. 637

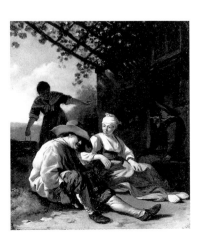

Berckheyde, Job
Dutch, active Haarlem and
Germany, 1630–1693
At the Inn
17th century
Lower right: JHBerckheyde
Oil on panel
12 15/16 × 10 15/16" (32.9 ×
27.8 cm)

John G. Johnson Collection
cat. 530

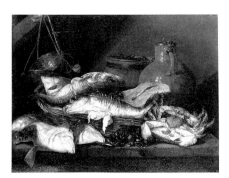

Beyeren, Abraham van
Still Life with Fish
17th century
Lower right: .AB.f.
Oil on canvas
28 1/8 × 36 3/8" (71.4 × 92.4 cm)

John G. Johnson Collection
cat. 639

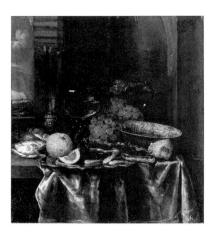

Beyeren, Abraham van, attributed to
Previously listed as Abraham van Beyeren (JFD 1972)
Still Life with Grapes and a Beaker
17th century
Center left: .AB.f.
Oil on panel
26 1/4 × 23 3/8" (66.7 × 59.4 cm)

John G. Johnson Collection
cat. 638

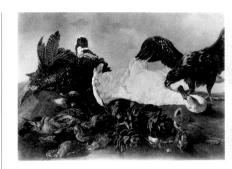

Boel, Pieter, attributed to
Previously listed as Frans Snyders (PMA 1965)
Dead Game with an Eagle
17th century
Oil on canvas
48 5/8 × 65 3/8" (123.5 × 166 cm)

Purchased with the W. P. Wilstach Fund
W1904-1-35

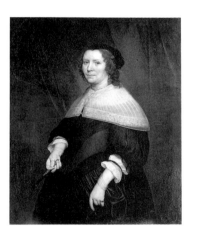

Bloemaert, Hendrick
Dutch, active Utrecht, 1601–1672
Portrait of an Elderly Lady
1663
Lower left: Henr. Bloemaert Ao 1663
Oil on canvas
43 × 34 1/2" (109.2 × 87.6 cm)

John G. Johnson Collection
cat. 494

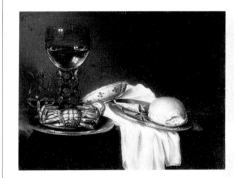

Boelema de Stomme, Maerten
Dutch, active Leeuwarden, first documented 1642, died after 1664
Still Life with a Roemer
Mid-17th century
Center right: M. B. / de Stomme
Oil on panel
16 3/8 × 20 7/8" (41.6 × 53 cm)

John G. Johnson Collection
cat. 649

Bloot, Pieter de
Dutch, active Rotterdam, c. 1601–1658
Cottage on the Waterside
17th century
Oil on panel
13 7/8 × 13 3/16" (35.2 × 33.5 cm)

John G. Johnson Collection
cat. 552

Bol, Ferdinand, copy after
Dutch, active Amsterdam, 1616–1680
Previously listed as Ferdinand Bol (PMA 1965)
Portrait of a Man
After the painting in the Bayerische Staatsgemälde-sammlungen, Alte Pinakothek, Munich (609)
After c. 1648
Oil on canvas
34 15/16 × 28 3/8" (88.7 × 72.1 cm)

Gift of Mr. and Mrs. William H. Donner
1948-95-2

Boel, Pieter
Flemish, active Antwerp and Paris, 1622–1674
Still Life with Fish and a Copper Kettle
Mid-17th century
Upper right: PBoel
Oil on panel
26 9/16 × 25 3/16" (67.5 × 64 cm)

John G. Johnson Collection
cat. 706

Borch, Gerard ter
Dutch, active Deventer after 1654, 1617–1681
Guardroom
1658
On cask under table: GTB 1658
Oil on canvas
38 1/2 × 32 1/2" (97.8 × 82.5 cm)

John G. Johnson Collection
cat. 504

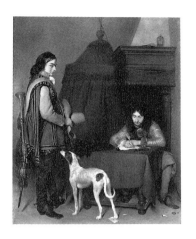

Borch, Gerard ter
Officer Writing a Letter, with a Trumpeter
c. 1658–59
Lower right: GTBorch
Oil on canvas
22 3/8 × 17 1/4" (56.8 × 43.8 cm)

The William L. Elkins Collection
E1924-3-21

Borssom, Anthonij van
Dutch, active Amsterdam,
1630/31–1677
Previously listed as Philips de Koninck (PMA 1965)
View of Schenkenschanz and the Eltenberg, near Emmerich
c. 1656
Oil on canvas
39 1/16 × 49 5/16" (99.2 × 125.2 cm)

Purchased with the W. P. Wilstach Fund
W1901-1-2

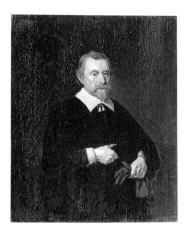

Borch, Gerard ter, copy after
Portrait of a Gentleman
After a lost painting
17th century
Lower left: [illegible signature]
Oil on panel
10 7/16 × 8" (26.5 × 20.3 cm)

John G. Johnson Collection
cat. 493

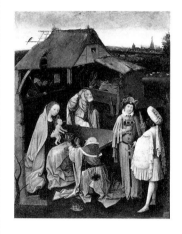

Bosch, Hieronymus
Netherlandish, active
's Hertogenbosch, c. 1450–1516
The Adoration of the Magi
Early 16th century
Oil on panel
30 1/2 × 22" (77.5 × 55.9 cm)

John G. Johnson Collection
inv. 1321

Borch, Gerard ter, copy after
Scene in an Inn
After a painting in a private collection
17th century
Oil on panel
9 3/16 × 7 1/2" (23.3 × 19 cm)

John G. Johnson Collection
cat. 1177

Bosch, Hieronymus, attributed to
Previously listed as Hieronymus Bosch (JFD 1972)
Two Shepherds
Left wing of a triptych, cut down on all sides; companion to the following painting
Early 16th century
Oil on panel
14 3/4 × 8 7/8" (37.5 × 22.5 cm)

John G. Johnson Collection
inv. 1275

Borch, Gerard ter, copy after
Smoker
After the painting in the Gemäldegalerie, Staatliche Museen zu Berlin-Preussischer Kulturbesitz (cat. no. 791 F)
17th century
Oil on canvas
15 9/16 × 12 3/4" (39.5 × 32.4 cm)

John G. Johnson Collection
inv. 377

Bosch, Hieronymus, attributed to
Previously listed as Hieronymus Bosch (JFD 1972)
Retinue of the Magi
Right wing of a triptych, cut down on all sides; companion to the preceding painting
Early 16th century
Oil on panel
14 1/4 × 8 3/8" (36.2 × 21.3 cm)

John G. Johnson Collection
inv. 1276

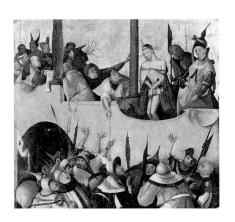

Bosch, Hieronymus, attributed to
Previously listed as Hieronymus Bosch (JFD 1972)
"Ecce Homo"
16th century
Oil and gold on panel
20 1/2 × 21 1/4" (52.1 × 54 cm)

John G. Johnson Collection
cat. 352

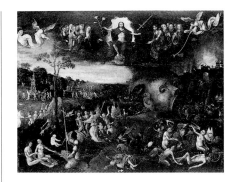

Bosch, Hieronymus, follower of
Previously listed as a remote follower of Hieronymus Bosch (JFD 1972)
The Last Judgment
Late 16th century
Oil on panel
29 7/8 × 37 3/4" (75.9 × 95.9 cm)

John G. Johnson Collection
cat. 386

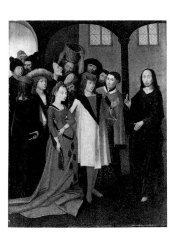

Bosch, Hieronymus, follower of
Previously listed as a unique copy after a lost original by Hieronymus Bosch (JFD 1972)
Christ and the Woman Taken in Adultery
16th century
Lower right: [illegible]
Oil on panel
29 7/8 × 22" (75.9 × 55.9 cm)

John G. Johnson Collection
inv. 353

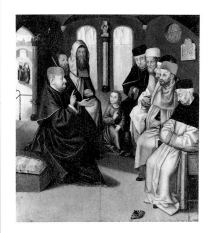

Bosch, Hieronymus, copy after
Christ among the Doctors
One of several copies after a lost painting
16th century
Oil and gold on panel
27 1/4 × 22 15/16" (69.2 × 58.3 cm)

John G. Johnson Collection
inv. 77

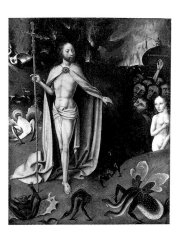

Bosch, Hieronymus, follower of
Christ in Limbo
A figure to the right of Christ has been painted out
16th century
Upper right: P. CHRISTOPSEN M F
Oil on panel
21 1/2 × 16 5/16" (54.6 × 41.4 cm)

John G. Johnson Collection
inv. 2055

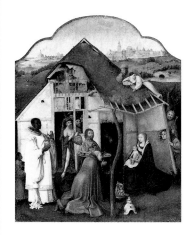

Bosch, Hieronymus, copy after
The Adoration of the Magi
After the center panel of a triptych in the Museo del Prado, Madrid (2048)
16th century
Oil on panel
37 × 29 5/16" (94 × 74.4 cm)

John G. Johnson Collection
cat. 354

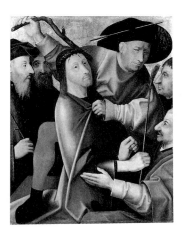

Bosch, Hieronymus, follower of
Previously listed as a copy after a lost original by Hieronymus Bosch (JFD 1972)
The Mocking of Christ
16th century
Oil and gold on panel
26 5/8 × 20 3/8" (67.6 × 51.7 cm)

John G. Johnson Collection
cat. 353

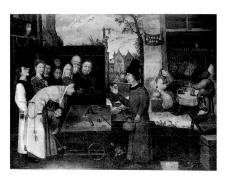

Bosch, Hieronymus, copy after
Previously listed as a variation on Hieronymous Bosch (PMA 1965)
The Conjurer (The Prestidigitator)
After a lost original of which the best and earliest copy is in the Musée Municipal, Saint-Germain-en-Laye, France (inv. no 872/1/87)
16th century
Oil on panel
41 1/2 × 54 5/8" (105.4 × 138.7 cm)

Purchased with the W. P. Wilstach Fund
W1914-1-2

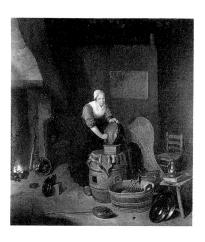

Bosch, Pieter van den
Dutch, active Leiden,
Amsterdam, and London,
born 1613, still active 1663
Maid Scouring a Kettle
Mid-17th century
Lower right (spurious): QvB.
Oil on panel
26 1/2 × 22 5/8" (67.3 × 57.5 cm)

John G. Johnson Collection
cat. 536

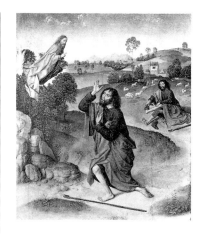

Bouts, Dierick, attributed to
Previously listed as Dierick Bouts
(JFD 1972)
*Moses and the Burning Bush, with
Moses Removing His Shoes*
c. 1465–70
Oil on panel
17 5/8 × 14" (44.8 × 35.6 cm)

John G. Johnson Collection
cat. 339

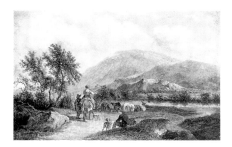

Both, Andries, imitator of
Dutch, active Utrecht and Rome,
1612–1641
Landscape with Cattle, Italy
17th century
Lower left: ABoth
Oil on panel
9 5/8 × 14 5/8" (24.4 × 37.1 cm)

John G. Johnson Collection
cat. 614

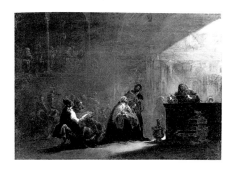

Brakenburg, Richard
Dutch, active Haarlem,
1650–1702
The Dice Players
Late 17th century
Lower right: R. Bra[k]enburgh
Oil on panel
14 13/16 × 11 11/16" (37.6 × 29.7 cm)

John G. Johnson Collection
cat. 528

Boursse, Esaias
Dutch, active Amsterdam,
1631–1672
Grace before Meat
Mid-17th century
Center left: EB
Oil on canvas
23 1/2 × 18 3/4" (59.7 × 47.6 cm)

John G. Johnson Collection
cat. 539

Bramer, Leonard
Dutch, active Delft, 1596–1674
*The Presentation of Christ in the
Temple*
17th century
Oil on panel
21 1/4 × 28 3/4" (54 × 73 cm)

John G. Johnson Collection
cat. 489

Bouts, Dierick, attributed to
Netherlandish, active Louvain,
first securely documented 1447,
died 1475
Previously listed as Dierick Bouts
(JFD 1972)
The Nativity
c. 1450–75
Oil on panel
10 1/4 × 8 5/8" (26 × 21.9 cm)

John G. Johnson Collection
cat. 340

**Brekelenkam, Quirijn
Gerritsz. van**
Dutch, active Leiden,
c. 1620–1668
A Wool Spinner and His Wife
c. 1653
Lower right: Q v B
Oil on panel
23 1/4 × 30 11/16" (59 × 77.9 cm)

John G. Johnson Collection
cat. 535

Brekelenkam, Quirijn Gerritsz. van
The Tailor
c. 1658
Lower left: QB
Oil on panel
22 3/8 × 32 3/8" (56.8 × 82.2 cm)

John G. Johnson Collection
cat. 534

Brouwer, Adriaen, attributed to
Previously listed as Adriaen Brouwer (JFD 1972)
Pancake Baker
c. 1625
Oil on panel
13 3/8 × 11 3/16" (34 × 28.4 cm)

John G. Johnson Collection
cat. 681

Brekelenkam, Quirijn Gerritsz. van
A Woman and a Girl in a Kitchen
Mid-17th century
Oil on panel
21 1/8 × 25 7/8" (53.7 × 65.7 cm)

John G. Johnson Collection
cat. 537

Brouwer, Adriaen, follower of
Interior of a School
17th century
Oil on panel
10 1/2" (26.7 cm) diameter

John G. Johnson Collection
inv. 1694

Brekelenkam, Quirijn Gerritsz. van, follower of
Previously listed as Quirijn Gerritsz. van Brekelenkam (JFD 1972)
Interior with an Old Man and His Wife
17th century
Oil on panel
15 1/2 × 22" (39.4 × 55.9 cm)

John G. Johnson Collection
cat. 538

Brouwer, Adriaen, follower of
Previously attributed to Adriaen Brouwer (JFD 1972)
Listening to the News
17th century
Lower left: AB
Oil on panel
18 3/8 × 17 7/16" (46.7 × 44.3 cm)

John G. Johnson Collection
cat. 1183

Brouwer, Adriaen
Dutch, active Haarlem, Amsterdam, and Antwerp, 1606–1638
Scene in a Tavern
17th century
Lower right: AB
Oil on panel
10 5/8 × 13 3/4" (27 × 34.9 cm)

John G. Johnson Collection
cat. 1184

Brouwer, Adriaen, follower of
Previously listed as Adriaen Brouwer (JFD 1972)
Woman Making Pancakes
17th century
Lower left: AB
Oil on panel
11 3/4 × 15 3/4" (29.8 × 40 cm)

John G. Johnson Collection
cat. 680

**Brouwer, Adriaen,
copy after?**
Previously listed as Adriaen
Brouwer (JFD 1972)
Road near a House
17th century
Lower right: AB
Oil on panel
9 7/8 × 7 1/2" (25.1 × 19 cm)

John G. Johnson Collection
cat. 685

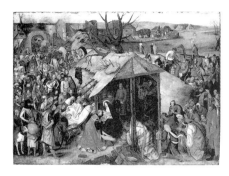

Brueghel, Pieter, the Younger
Flemish, active Antwerp,
1564–1637/38
The Adoration of the Magi
1595?
Lower left: P. BRUEGEL
Oil on canvas
48 1/2 × 63 3/8" (123.2 × 161 cm)

The Bloomfield Moore Collection
1883-73

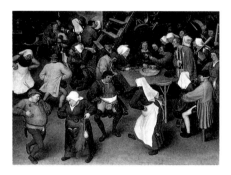

**Bruegel, Pieter, the Elder,
follower of**
Netherlandish, active Antwerp
and Brussels, first documented
1550, died 1569
Previously listed as a composition
of uncertain origin (JFD 1972)
Wedding Dance
Probably after a lost painting of
1567–69
c. 1575–1600
Oil on panel
31 5/8 × 41 7/8" (80.3 × 106.4 cm)

John G. Johnson Collection
cat. 420

Brueghel, Pieter, the Younger
*A Hurdy-Gurdy Player and a
Bagpiper*
c. 1600
Oil on panel
13 9/16" (34.4 cm) diameter

John G. Johnson Collection
cat. 1176

**Bruegel, Pieter, the Elder,
follower of**
Previously listed as a composition
of Pieter Bruegel the Elder,
painted possibly by Marten van
Cleve (JFD 1972)
The Unfaithful Shepherd
Probably after a lost painting of
1567–69
c. 1575–1600
On shepherd's staff: VV [ligated];
lower right: CSH [ligated]
Oil on panel
24 1/4 × 34 1/8" (61.6 × 86.7 cm)

John G. Johnson Collection
cat. 419

Brueghel, Pieter, the Younger
*Christ and the Woman Taken in
Adultery*
Based on the painting, dated
1565, by Pieter Bruegel the
Elder, in the Courtauld Institute
Galleries, London (The Princes
Gate Collection, 9)
c. 1600
Lower left: P BREVGHEL; center
bottom: DIE SONDER SONDE
IS / DIEW
Oil on panel
11 1/16 × 16" (28.1 × 40.6 cm)

John G. Johnson Collection
cat. 423

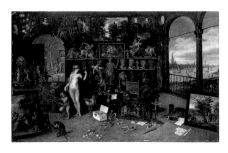

Brueghel, Jan, the Younger
Flemish, active Antwerp,
1601–1678
*Allegory of Sight (Venus and Cupid
in a Picture Gallery)*
c. 1660
Lower right: J Breugel
Oil on copper
22 7/8 × 35 5/16" (58.1 × 89.7 cm)

John G. Johnson Collection
cat. 656

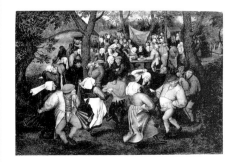

Brueghel, Pieter, the Younger
Wedding Dance in the Open Air
c. 1600
Oil on panel
14 7/8 × 21 1/8" (37.8 × 53.7 cm)

John G. Johnson Collection
cat. 421

Brueghel, Pieter, the Younger, attributed to
Previously listed as Pieter Brueghel the Younger (PMA 1965)
The Crucifixion
1617?
On cross: INRI
Oil on panel
25 5/8 × 47 3/4" (65.1 × 121.3 cm)

Purchased with the W. P. Wilstach Fund
W1903-1-6

Calraet, Abraham Pietersz. van
Dutch, active Dordrecht, 1642–1722
Bull in a Barn with Two Figures
Late 17th century
Oil on panel
13 7/8 × 17 1/2" (35.2 × 44.4 cm)

John G. Johnson Collection
cat. 625

Brueghel, Pieter, the Younger, imitator of
Previously listed as Pieter Brueghel the Younger (JFD 1972)
Fighting Peasants
One of many versions probably after a lost painting by Pieter Bruegel the Elder
c. 1600
Lower left (spurious): BREVGHEL
Oil on panel
14 × 22 1/4" (35.6 × 56.5 cm)

John G. Johnson Collection
cat. 422

Calraet, Abraham Pietersz. van
Cows in a Stable
Late 17th century
Lower left: A.C.
Oil on panel
17 9/16 × 23 3/8" (44.6 × 59.4 cm)

John G. Johnson Collection
inv. 424

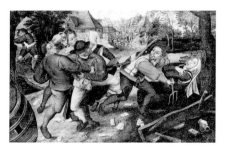

Brueghel, Pieter, the Younger, imitator of
Summer with Peasants at a Meal
Conflation of several summer scenes by Pieter Brueghel the Younger
19th century
Oil on panel
17 × 21 3/4" (43.2 × 55.2 cm)

John G. Johnson Collection
inv. 2519

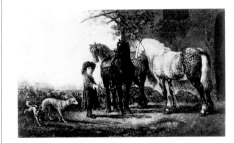

Calraet, Abraham Pietersz. van
Groom with Three Horses and Two Dogs
Late 17th century
Lower right: A C
Oil on panel
13 7/16 × 21" (34.1 × 53.3 cm)

The William L. Elkins Collection
E1924-3-3

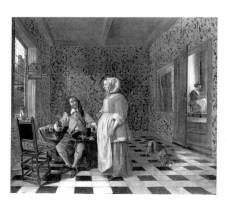

Burch, Hendrick van der
Dutch, active Delft and Leiden, born 1627, still active 1666
An Officer and a Standing Woman
c. 1665
Oil on canvas
22 3/4 × 25 1/4" (57.8 × 64.1 cm)

The William L. Elkins Collection
E1924-3-51

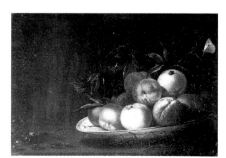

Calraet, Abraham Pietersz. van
Still Life with Peaches
Late 17th century
Lower left: A.C.
Oil on panel
17 3/8 × 25 1/2" (44.1 × 64.8 cm)

John G. Johnson Collection
cat. 628

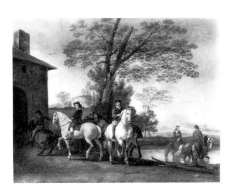

**Calraet, Abraham Pietersz.
van, attributed to**
Previously listed as Abraham
Pietersz. van Calraet (PMA 1965)
Horsemen Watering Their Horses
Late 17th century
Oil on panel
24 1/8 × 29 3/4" (61.3 × 75.6 cm)

The William L. Elkins Collection
E1924-3-74

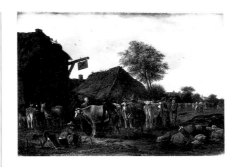

Camphuysen, Govert
Cattle Market
Mid-17th century
Lower right (spurious): A Cuyp
Oil on panel
22 3/8 × 32 1/4" (56.8 × 81.9 cm)

John G. Johnson Collection
cat. 1179

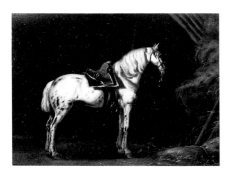

**Calraet, Abraham Pietersz.
van, copy after**
Previously listed as Abraham
Pietersz. van Calraet (PMA 1965)
White Horse in a Stable
After the painting in the
Collection of the Trustees of
Berkeley Castle, Gloucestershire
Late 17th century
Oil on panel
12 1/2 × 16 3/4" (31.7 × 42.5 cm)

The William L. Elkins Collection
E1924-3-91

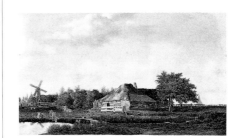

Camphuysen, Govert
Farm near a Village
Mid-17th century
Center bottom (spurious): Paulus
Potter; lower right (spurious):
P[?]er
Oil on panel
26 3/8 × 42 3/4" (67 × 108.6 cm)

John G. Johnson Collection
cat. 558

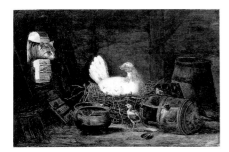

Camphuysen, Govert
Dutch, active Amsterdam and
Stockholm, 1623/24–1672
A Sitting Hen and a Cat
Mid-17th century
Lower left: G Camphuysen
Oil on panel
28 11/16 × 41 7/8" (72.9 × 106.4 cm)

John G. Johnson Collection
cat. 560

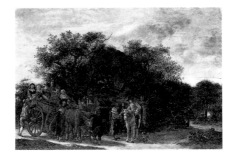

Camphuysen, Govert
The Halt at the Inn
Mid-17th century
Lower right: G Camphuysen
Oil on panel
26 3/16 × 36 1/4" (66.5 × 92.1 cm)

John G. Johnson Collection
cat. 557

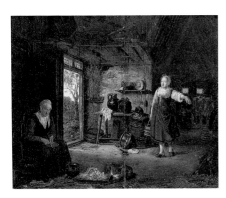

Camphuysen, Govert
A Woman and a Maid in a Barn
Mid-17th century
Oil on panel
13 7/8 × 16 1/4" (35.2 × 41.3 cm)

John G. Johnson Collection
cat. 559

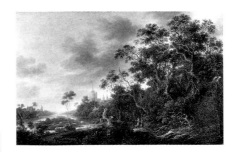

Camphuysen, Joachim
Dutch, active Amsterdam and
Stockholm, 1602–1659
Woods beside a Canal
17th century
Oil on panel
15 11/16 × 24 1/4" (39.8 × 61.6 cm)

John G. Johnson Collection
cat. 556

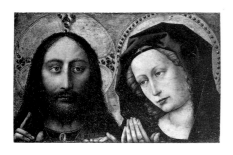

Campin, Robert, also called the Master of Flémalle
Netherlandish, active Tournai, first documented 1406, died 1444
Christ and the Virgin
Cut down at the top
c. 1430–35
Oil and gold on panel
11 1/4 × 17 15/16" (28.6 × 45.6 cm)

John G. Johnson Collection
cat. 332

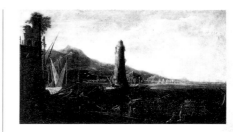

Casteels, Pieter, II, imitator of
Flemish, active Antwerp, active c. 1673/74
Harbor with a Lighthouse
Late 17th century
Oil on canvas
39 1/2 × 68 1/8" (100.3 × 173 cm)

Bequest of Arthur H. Lea
F1938-1-25

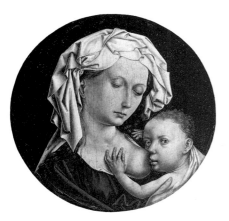

Campin, Robert, follower of
Previously listed as a copy after Robert Campin (JFD 1972)
The Virgin Suckling the Christ Child
Known in many versions; based on the painting in the Städelsches Kunstinstitut, Frankfurt (inv. no. 939), or a lost painting
Mid-15th century
Oil on panel
10 3/4" (27.3 cm) diameter

John G. Johnson Collection
cat. 331

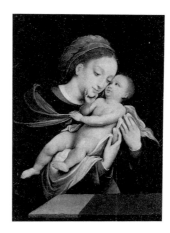

Cleve, Cornelis van
Netherlandish, active Antwerp, 1520–1567
Virgin and Child
Mid-16th century
Oil on panel
14 1/2 × 10 1/8" (36.8 × 25.7 cm)

John G. Johnson Collection
cat. 403

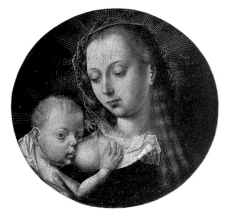

Campin, Robert, follower of
Previously listed as a copy after Robert Campin (JFD 1972)
The Virgin Suckling the Christ Child
See preceding painting
Mid-15th century
Oil on panel
10 9/16" (26.8 cm) diameter

John G. Johnson Collection
cat. 333

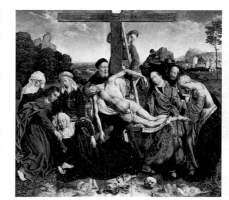

Cleve, Joos van
Netherlandish, active Antwerp and France, first documented 1511, died 1540/41
The Descent from the Cross
The composition of the figures is based on Rogier van der Weyden's *The Descent from the Cross*, in the Museo del Prado, Madrid (2825)
c. 1518–20
Oil on panel
45 1/4 × 49 3/4" (114.9 × 126.4 cm)

John G. Johnson Collection
cat. 373

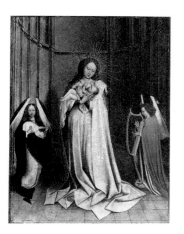

Campin, Robert, copy after
Virgin and Child, with Two Angels in an Apse
Known in many versions; probably after a lost painting
c. 1475–1500
Oil and gold on panel
19 × 13 7/8" (48.3 × 35.2 cm)

John G. Johnson Collection
inv. 458

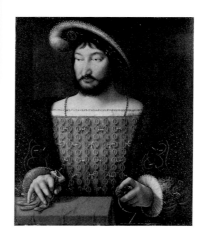

Cleve, Joos van
Portrait of Francis I, King of France
Known in several versions; this is probably the earliest
c. 1525
Oil on panel
28 3/8 × 23 5/16" (72.1 × 59.2 cm)

John G. Johnson Collection
cat. 769

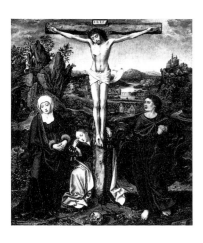

Cleve, Joos van, workshop of
The Crucifixion
Center panel of a triptych; a companion panel is in the Fitzwilliam Museum, Cambridge, England (1518a, b)
c. 1525
Center top: I N R I
Oil and gold on panel
12 ¾ × 11" (32.4 × 27.9 cm)

John G. Johnson Collection
cat. 374

Cleve, Marten van, follower of
Previously listed as Marten van Cleve (JFD 1972)
The Formal Visit
1624
Upper right: A1624
Oil on panel
29 × 41 ⅜" (73.7 × 105.1 cm)

John G. Johnson Collection
cat. 424

Cleve, Joos van, imitator of
Previously listed as Joos van Cleve (JFD 1972)
Portrait of a Young Man
16th century
Oil on panel
11 × 9 ½" (27.9 × 24.1 cm)

John G. Johnson Collection
cat. 375

Codde, Pieter
Dutch, active Amsterdam, 1599–1678
A Soldier, an Old Woman, and a Young Woman
Possibly cut down at the top and left
17th century
Oil on panel
10 ½ × 10 ⅞" (26.7 × 27.6 cm)

John G. Johnson Collection
cat. 443

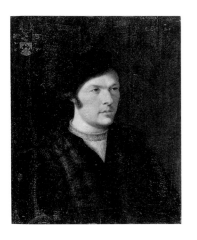

Cleve, Joos van, copy after
Portrait of a Gentleman [possibly Nicasius Hanneman]
After the painting in the Toledo Museum of Art, Ohio (26.59)
16th century
Upper right: AEt. 25
Oil on panel
26 ½ × 20 ¹³⁄₁₆" (67.3 × 52.9 cm)

John G. Johnson Collection
cat. 431

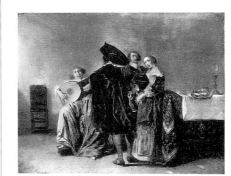

Codde, Pieter
The Lute Player
17th century
Oil on panel
14 ⅛ × 17 ¾" (35.9 × 45.1 cm)

John G. Johnson Collection
cat. 442

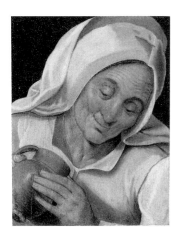

Cleve, Marten van
Netherlandish, active Antwerp, 1527–1581
Peasant Woman Holding a Mug
Probably a fragment
Mid-16th century
Oil on panel
13 × 9 ¾" (33 × 24.8 cm)

John G. Johnson Collection
cat. 425

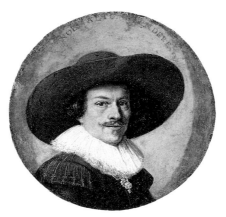

Codde, Pieter, attributed to
Previously listed as Pieter Codde (JFD 1972)
Portrait of a Man
17th century
Across top: NOL ALT ENDERE
Oil on canvas
5 ⅞" (14.9 cm) diameter

John G. Johnson Collection
cat. 455

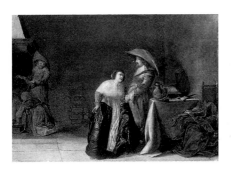

Codde, Pieter, follower of
Previously listed as Pieter Codde
(JFD 1972)
A Lady and a Cavalier
17th century
Oil on panel
15 5/8 × 20 11/16" (39.7 × 52.5 cm)

John G. Johnson Collection
cat. 444

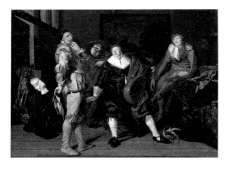

Codde, Pieter, copy after
Company of Actors
After the painting in the
Gemäldegalerie, Staatliche
Museen zu Berlin-Preussischer
Kulturbesitz (cat. no. 800 A)
17th century
Oil on panel
14 3/8 × 19 5/8" (36.5 × 49.8 cm)

John G. Johnson Collection
cat. 441

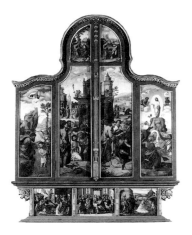

**Coecke van Aelst, Pieter,
follower of**
Netherlandish, active Antwerp,
1502–1550
Previously listed as the workshop
of Pieter Coecke van Aelst
(PMA 1965)
Altar of the Passion
Altarpiece with 19 painted and
6 carved panels; view with wings
closed; see following 20 entries
c. 1532–35
Wings: 88 1/2 × 42" (224.8 ×
106.7 cm); predella panels:
15 1/2 × 66" (39.4 × 167.6 cm)

Purchased from the George Grey
Barnard Collection with Museum
funds
1945-25-117

**Coecke van Aelst, Pieter,
follower of**
Previously listed as the workshop
of Pieter Coecke van Aelst
(PMA 1965)
The Temptation of Christ
Upper left outer panel from an
altarpiece; see previous and
following entries
c. 1532–35
Tempera on panel
20 1/2 × 10 5/8" (52 × 27 cm)

Purchased from the George Grey
Barnard Collection with Museum
funds
1945-25-117a

**Coecke van Aelst, Pieter,
follower of**
Previously listed as the workshop
of Pieter Coecke van Aelst
(PMA 1965)
Christ and the Samaritan Woman
Upper right outer panel from an
altarpiece; see previous and
following entries
c. 1532–35
Tempera on panel
20 1/2 × 10 3/4" (52 × 27.3 cm)

Purchased from the George Grey
Barnard Collection with Museum
funds
1945-25-117b

**Coecke van Aelst, Pieter,
follower of**
Previously listed as the workshop
of Pieter Coecke van Aelst
(PMA 1965)
The Baptism of Christ
Center far left outer panel from
an altarpiece; see previous and
following entries
c. 1532–35
Tempera on panel
48 5/8 × 16 3/8" (123.5 × 41.6 cm)

Purchased from the George Grey
Barnard Collection with Museum
funds
1945-25-117c

**Coecke van Aelst, Pieter,
follower of**
Previously listed as the workshop
of Pieter Coecke van Aelst
(PMA 1965)
The Raising of Lazarus
Center near left outer panel from
an altarpiece; see previous and
following entries
c. 1532–35
Tempera on panel
56 13/16 × 16 5/16" (144.3 × 41.5 cm)

Purchased from the George Grey
Barnard Collection with Museum
funds
1945-25-117d

**Coecke van Aelst, Pieter,
follower of**
Previously listed as the workshop
of Pieter Coecke van Aelst
(PMA 1965)
Christ Healing the Blind
Center near right outer panel
from an altarpiece; see previous
and following entries
c. 1532–35
Tempera on panel
56 13/16 × 16 3/8" (144.3 × 41.6 cm)

Purchased from the George Grey
Barnard Collection with Museum
funds
1945-25-117e

Coecke van Aelst, Pieter, follower of
Previously listed as the workshop of Pieter Coecke van Aelst (PMA 1965)
The Transfiguration
Center far right outer panel from an altarpiece; see previous and following entries
c. 1532–35
Tempera on panel
49 1/8 × 16 3/8" (124.8 × 41.6 cm)

Purchased from the George Grey Barnard Collection with Museum funds
1945-25-117 f

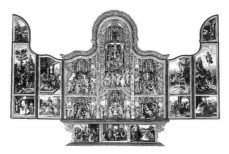

Coecke van Aelst, Pieter, follower of
Previously listed as the workshop of Pieter Coecke van Aelst (PMA 1965)
Altar of the Passion
Altarpiece with 19 painted and 6 carved panels; view with wings open; see previous and following entries
c. 1532–35
Wings: 88 1/2 × 42" (224.8 × 106.7 cm); predella panels: 15 1/2 × 66" (39.4 × 167.6 cm)

Purchased from the George Grey Barnard Collection with Museum funds
1945-25-117

Coecke van Aelst, Pieter, follower of
Previously listed as the workshop of Pieter Coecke van Aelst (PMA 1965)
The Meeting of Abraham and Melchizedek
Left predella panel from an altarpiece; see previous and following entries
c. 1532–35
Tempera on panel
15 3/16 × 20 1/16" (38.5 × 51 cm)

Purchased from the George Grey Barnard Collection with Museum funds
1945-25-117 g

Coecke van Aelst, Pieter, follower of
Previously listed as the workshop of Pieter Coecke van Aelst (PMA 1965)
The Agony in the Garden
Upper left inner panel from an altarpiece; see previous and following entries
c. 1532–35
Tempera on panel
20 11/16 × 10 7/16" (52.5 × 26.5 cm)

Purchased from the George Grey Barnard Collection with Museum funds
1945-25-117 j

Coecke van Aelst, Pieter, follower of
Previously listed as the workshop of Pieter Coecke van Aelst (PMA 1965)
The Last Supper
Center predella panel from an altarpiece; see previous and following entries
c. 1532–35
Tempera on panel
15 3/16 × 20 1/16" (38.5 × 51 cm)

Purchased from the George Grey Barnard Collection with Museum funds
1945-25-117 h

Coecke van Aelst, Pieter, follower of
Previously listed as the workshop of Pieter Coecke van Aelst (PMA 1965)
The Betrayal of Christ
Center far left inner panel from an altarpiece; see previous and following entries
c. 1532–35
Tempera on panel
41 11/16 × 17 1/8" (105.8 × 43.5 cm)

Purchased from the George Grey Barnard Collection with Museum funds
1945-25-117 k

Coecke van Aelst, Pieter, follower of
Previously listed as the workshop of Pieter Coecke van Aelst (PMA 1965)
The Gathering of Manna
Right predella panel from an altarpiece; see previous and following entries
c. 1532–35
Tempera on panel
15 3/16 × 20 1/2" (38.5 × 52 cm)

Purchased from the George Grey Barnard Collection with Museum funds
1945-25-117 i

Coecke van Aelst, Pieter, follower of
Previously listed as the workshop of Pieter Coecke van Aelst (PMA 1965)
Christ before Pilate
Center near left inner panel from an altarpiece; see previous and following entries
c. 1532–35
Tempera on panel
31 × 16 5/8" (78.7 × 42.3 cm)

Purchased from the George Grey Barnard Collection with Museum funds
1945-25-117 l

**Coecke van Aelst, Pieter,
follower of**
Previously listed as the workshop
of Pieter Coecke van Aelst
(PMA 1965)
The Entombment
Center near right inner panel
from an altarpiece; see previous
and following entries
c. 1532–35
Tempera on panel
30 11/16 × 16 5/8" (78 × 42.3 cm)

Purchased from the George Grey
Barnard Collection with Museum
funds
1945-25-117 m

**Coecke van Aelst, Pieter,
follower of**
Previously listed as the workshop
of Pieter Coecke van Aelst
(PMA 1965)
The Visitation
Lower near left inner panel from
an altarpiece; see previous and
following entries
c. 1532–35
Tempera on panel
17 1/2 × 16 7/8" (44.5 × 42.8 cm)

Purchased from the George Grey
Barnard Collection with Museum
funds
1945-25-117 q

**Coecke van Aelst, Pieter,
follower of**
Previously listed as the workshop
of Pieter Coecke van Aelst
(PMA 1965)
The Resurrection
Center far right inner panel from
an altarpiece; see previous and
following entries
c. 1532–35
Tempera on panel
41 3/4 × 16 7/8" (106 × 42.8 cm)

Purchased from the George Grey
Barnard Collection with Museum
funds
1945-25-117 n

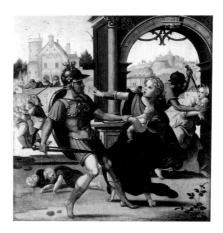

**Coecke van Aelst, Pieter,
follower of**
Previously listed as the workshop
of Pieter Coecke van Aelst
(PMA 1965)
The Massacre of the Innocents
Lower near right inner panel from
an altarpiece; see previous and
following entries
c. 1532–35
Tempera on panel
17 1/2 × 16 9/16" (44.5 × 42 cm)

Purchased from the George Grey
Barnard Collection with Museum
funds
1945-25-117 r

**Coecke van Aelst, Pieter,
follower of**
Previously listed as the workshop
of Pieter Coecke van Aelst
(PMA 1965)
"Noli Me Tangere"
Upper right inner panel from an
altarpiece; see previous and
following entries
c. 1532–35
Tempera on panel
20 1/2 × 10 13/16" (52 × 27.5 cm)

Purchased from the George Grey
Barnard Collection with Museum
funds
1945-25-117 o

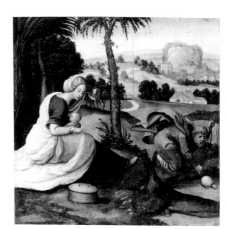

**Coecke van Aelst, Pieter,
follower of**
Previously listed as the workshop
of Pieter Coecke van Aelst
(PMA 1965)
Rest on the Flight into Egypt
Lower far right inner panel from
an altarpiece; see previous entries
c. 1532–35
Tempera on panel
17 1/2 × 16 3/4" (44.5 × 42.5 cm)

Purchased from the George Grey
Barnard Collection with Museum
funds
1945-25-117 s

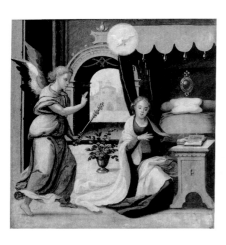

**Coecke van Aelst, Pieter,
follower of**
Previously listed as the workshop
of Pieter Coecke van Aelst
(PMA 1965)
The Annunciation
Lower far left inner panel from an
altarpiece; see previous and
following entries
c. 1532–35
Tempera on panel
17 1/2 × 16 7/8" (44.5 × 42.8 cm)

Purchased from the George Grey
Barnard Collection with Museum
funds
1945-25-117 p

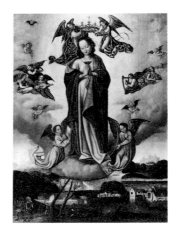

**Coffermans, Marcellus,
imitator of**
Netherlandish, active Antwerp,
first securely documented 1549,
last dated work 1570
Previously listed as Marcellus
Coffermans (JFD 1972)
The Assumption of the Virgin
16th century
Oil on panel
15 1/2 × 10 7/8" (39.4 × 27.6 cm)

John G. Johnson Collection
cat. 396

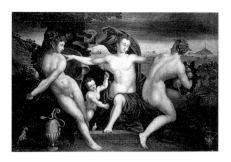

Coignet, Gillis, copy after
Flemish, 1538–1599
*Sine Cerere et Baccho friget Venus
(Without Ceres and Bacchus, Venus
Would Freeze)*
After an engraving by Raphaël
Sadeler (Flemish, 1560/61–1628/
32) of a lost painting by Coignet
Late 16th century
Center bottom: SINE CERERE ET
BACCHO / FRIGET VENVS / B.
DOSSI FERRARENSE PIN. 1553
Oil on canvas
24 7/8 × 36 1/4" (63.2 × 92.1 cm)

Purchased with the W. P.
Wilstach Fund
W1904-1-10

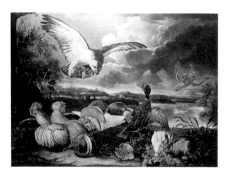

Coninck, David de
Flemish, active Antwerp and
Brussels, 1636–1699
Previously listed as Pauwel de
Vos (JFD 1972)
*Owl Attacking Chickens, Ducks,
and Hares*
Known in several versions
17th century
Lower left (spurious): A Cuyp
Oil on canvas
50 7/8 × 69" (129.2 × 175.3 cm)

John G. Johnson Collection
cat. 701

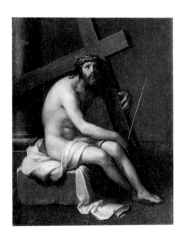

**Cornelis Cornelisz. van
Haarlem**
Dutch, active Haarlem,
1562–1638
The Man of Sorrows
1597
Lower left: CHaerlemesis Ao.
1597—
Oil on panel
16 3/4 × 12 3/8" (42.5 × 31.4 cm)

Gift of Dr. and Mrs. Richard W.
Levy
1968-182-1

Cossiau, Jan Joost van
Dutch, active Germany and
Paris?, 1660–1732/34
Ruins
Early 18th century
Oil on canvas
12 × 20 3/16" (30.5 × 51.3 cm)

Bequest of Robert Nebinger
1889-139

Coster, Hendrick
Dutch, active Arnhem,
active c. 1642–c. 1659
Portrait of a Lady
17th century
Oil on panel
19 1/2 × 14 9/16" (49.5 × 37 cm)

John G. Johnson Collection
cat. 460

Coveyn, Reinier
Flemish, active Antwerp
and Dordrecht, born 1636,
still active 1674
Interior with a Slaughtered Pig
17th century
Oil on panel
17 1/4 × 25 5/8" (43.8 × 65.1 cm)

John G. Johnson Collection
cat. 486

**Craesbeck, Joos van,
attributed to**
Flemish, active Antwerp and
Brussels, 1605/8–1662
Peasant Couple Drinking
17th century
Oil on panel
15 15/16 × 12 7/8" (40.5 × 32.7 cm)

John G. Johnson Collection
cat. 687

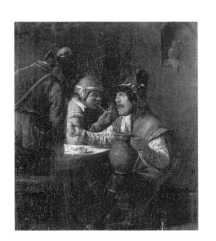

**Craesbeck, Joos van,
attributed to**
Previously listed as Joos van
Craesbeck (JFD 1972)
Smokers
17th century
Lower left: CB
Oil on panel
16 1/8 × 13 1/4" (41 × 33.6 cm)

John G. Johnson Collection
cat. 688

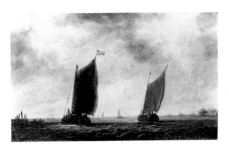

Cuyp, Aelbert
Dutch, active Dordrecht,
1620–1691
Fishing Boats on the Maas
c. 1641
Lower right: A Cuyp
Oil on panel
18 3/8 × 29" (46.7 × 73.7 cm)

John G. Johnson Collection
cat. 627

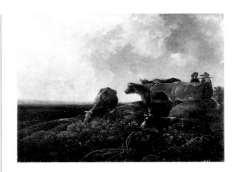

Cuyp, Aelbert, imitator of
Hilly Landscape with Cattle
17th century
Lower right (spurious): A. cuyp.
Oil on panel
17 5/8 × 24 3/16" (44.8 × 61.4 cm)

John G. Johnson Collection
cat. 624

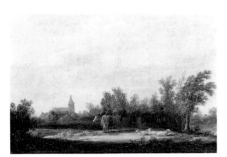

Cuyp, Aelbert
Landscape with Cows and Sheep
c. 1645
Lower left: A. cuyp.
Oil on panel
12 11/16 × 18 1/4" (32.2 × 46.3 cm)

John G. Johnson Collection
cat. 621

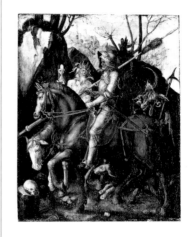

**Dalem, Cornelis van,
attributed to**
Netherlandish, active Antwerp,
first documented 1545, died
1573
Previously listed as Cornelis van
Dalem (JFD 1972)
A Knight, Death, and the Devil
After the engraving by Albrecht
Dürer (German, 1471–1528),
dated 1513 (Bartsch 98)
16th century
Oil on panel
10 5/8 × 8 3/16" (27 × 20.8 cm)

John G. Johnson Collection
cat. 405

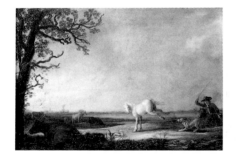

Cuyp, Aelbert
Kicking Horse
c. 1645–50
Lower right: AL [ligated] cuyp:
Oil on panel
25 7/8 × 36 3/16" (65.7 × 91.9 cm)

John G. Johnson Collection
cat. 622

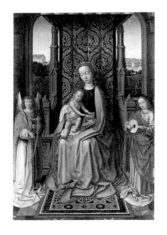

David, Gerard
Netherlandish, active Bruges,
first documented 1484, died
1523
*Enthroned Virgin and Child, with
Angels*
c. 1490–95
Oil on panel
39 1/16 × 25 11/16" (99.2 × 65.2 cm)

John G. Johnson Collection
cat. 329

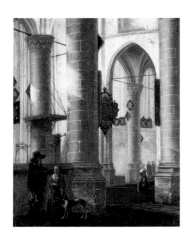

Cuyp, Aelbert, attributed to
Previously listed as Aelbert Cuyp
(JFD 1972)
*Interior of the Groote Kerk,
Dordrecht*
c. 1660
Lower left: A. cuyp fecit
Oil on panel
16 5/16 × 12 1/2" (41.4 × 31.7 cm)

John G. Johnson Collection
cat. 1181

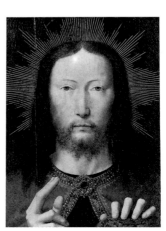

David, Gerard
Salvator Mundi
c. 1500
Oil on panel
18 1/8 × 13 1/4" (46 × 33.6 cm)

John G. Johnson Collection
cat. 330

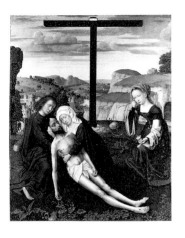

David, Gerard
Lamentation
c. 1515–20
On cross: INRI; center right, on ointment jar: [P?]AIS
Oil on panel
34 1/4 × 25 5/8" (87 × 65.1 cm)

John G. Johnson Collection
cat. 328

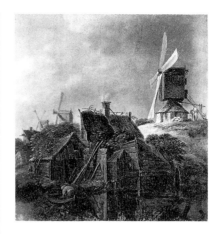

Decker, Cornelis
Windmills and Houses on the Waterside
17th century
Oil on panel
14 1/4 × 12 5/8" (36.2 × 32.1 cm)

John G. Johnson Collection
cat. 583

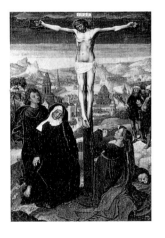

David, Gerard, follower of
Previously listed as a copy after Gerard David (JFD 1972)
Pietà
16th century
Oil on panel
7 13/16 × 7 3/16" (19.8 × 18.3 cm)

John G. Johnson Collection
inv. 54

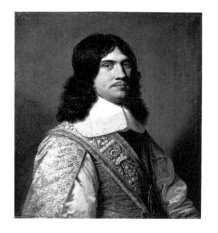

Delff, Jacob Willemsz., II
Dutch, active Delft, 1619–1661
Portrait of a Young Man
1655
Center left: AEtatis. 25. / JDelff. 1655.
Oil on canvas
27 9/16 × 24 3/16" (70 × 61.4 cm)

John G. Johnson Collection
cat. 496

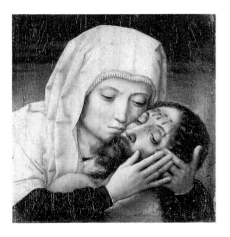

David, Gerard, follower of
Previously listed as a late copy after Gerard David (JFD 1972)
The Crucifixion
Another version is in the Bob Jones University Collection of Religious Art, Greenville, South Carolina
16th century
On cross: I N R I
Oil on panel
12 3/8 × 8 1/4" (31.4 × 20.9 cm)

John G. Johnson Collection
cat. 395

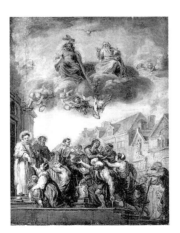

Diepenbeeck, Abraham van
Flemish, active Antwerp, 1596–1675
Saints Roch, Stephen, Lawrence, and Elizabeth Distributing Alms
c. 1635
Oil on panel
15 15/16 × 11 3/4" (40.5 × 29.8 cm)

John G. Johnson Collection
cat. 676

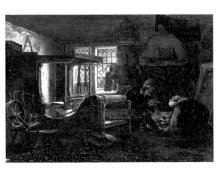

Decker, Cornelis
Dutch, active Haarlem, first documented 1623, died 1678
The Weaver
17th century
Oil on panel
12 5/16 × 16 1/4" (31.3 × 41.3 cm)

John G. Johnson Collection
cat. 549

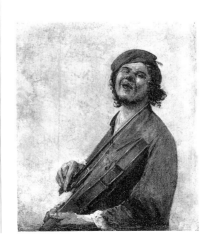

Diepraem, Abraham, copy after
Dutch, active Rotterdam, 1622?–1670?
Previously listed as Abraham Diepraem (JFD 1972)
Fiddler
17th century
Oil on panel
14 3/4 × 12 3/8" (37.5 × 31.4 cm)

John G. Johnson Collection
cat. 533

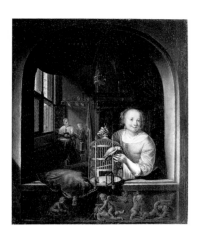

Dou, Gerard, follower of
Dutch, active Leiden,
1613–1675
Previously listed as a copy after
Gerard Dou (JFD 1972)
Girl with a Parrot
Possibly based on Dou's *Girl with
a Parrot*, formerly in the collection
of Graf Gagarin, St. Petersburg
17th century
Oil on panel
14 3/8 × 11 3/4" (36.5 × 29.8 cm)

John G. Johnson Collection
inv. 432

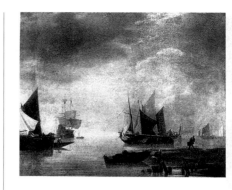

**Dubbels, Hendrick Jacobsz.,
attributed to**
Dutch, active Amsterdam,
1620/21–c. 1676
Previously listed as a copy after
Willem van de Velde the
Younger (JFD 1972)
Calm Sea
17th century
Oil on canvas
22 × 27 1/8" (55.9 × 68.9 cm)

John G. Johnson Collection
cat. 585

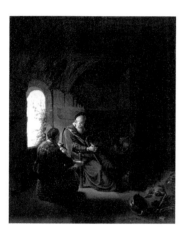

Dou, Gerard, copy after
Previously listed as a copy after
Rembrandt Harmensz. van Rijn
(JFD 1972)
Blind Tobit and His Wife
After the painting in the
National Gallery, London (4189)
17th century
Upper right (spurious): R
Oil on canvas
26 3/16 × 20 3/8" (66.5 × 51.7 cm)

John G. Johnson Collection
cat. 482

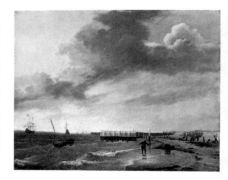

**Dubbels, Hendrick Jacobsz.,
copy after**
Coast Scene
After the painting in the Galleria
Palatina, Florence (457)
17th century
Lower right: DVBBELS
Oil on canvas
27 1/2 × 34 3/4" (69.8 × 88.3 cm)

John G. Johnson Collection
cat. 586

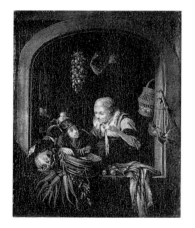

Dou, Gerard, copy after
Fishwife
After the painting formerly in the
collection of Henry Blank, Glen
Ridge, New Jersey
17th century
Oil on canvas
18 × 13 15/16" (45.7 × 35.4 cm)

John G. Johnson Collection
cat. 548

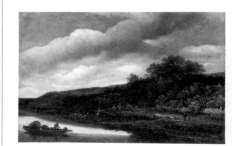

Dubois, Guillam
Dutch, active Haarlem,
c. 1610–1680
River Scene
1652
Lower left, on boat: G D Bois
1652
Oil on panel
15 1/2 × 23 3/4" (39.4 × 60.3 cm)

John G. Johnson Collection
cat. 562

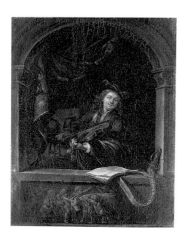

Dou, Gerard, copy after
Violinist
After the painting in the
Gemäldegalerie Alte Meister,
Staatliche Kunstsammlungen
Dresden (gal. no. 1707)
17th century
Oil on panel
13 × 9 7/8" (33 × 25.1 cm)

John G. Johnson Collection
cat. 545

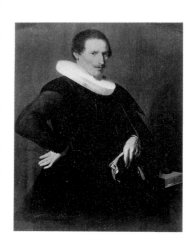

Dubordieu, Pieter
Dutch, active Leiden and
Amsterdam, born 1609/10,
still active 1678
Portrait of Pieter de la Court
Companion to the following
painting
1635
Upper left: AETATIS 42; upper
right: A N 1635; lower right: PD
[ligated] fecit
Oil on panel
45 1/2 × 33 1/8" (115.6 × 84.1 cm)

Purchased with the W. P.
Wilstach Fund
W1904-1-63

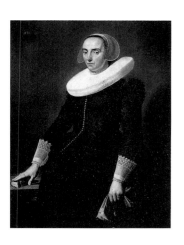

Dubordieu, Pieter
Portrait of Jeanne de Planque
Companion to the preceding
painting
1635
Upper left: AETATIS 43; lower
left: PD [ligated]; upper right: A
1635
Oil on panel
44 7/8 × 32 7/8" (114 × 83.5 cm)

Purchased with the George W.
Elkins Fund
E1982-1-1

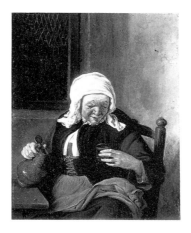

Dusart, Cornelis
Dutch, active Haarlem,
1660–1704
Old Woman Drinking
17th century
Lower left: Cordousart.
Oil on panel
13 × 10" (33 × 25.4 cm)

John G. Johnson Collection
cat. 529

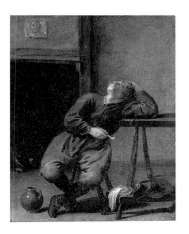

Duck, Jacob, attributed to
Dutch, active Utrecht, Haarlem,
and The Hague, c. 1600–1667
Previously listed as Adriaen
Brouwer (JFD 1972)
Smoker
17th century
Center bottom: AB
Oil on panel
12 5/8 × 9 9/16" (32.1 × 24.3 cm)

John G. Johnson Collection
cat. 683

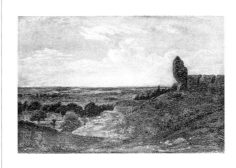

**Dutch, active Haarlem,
unknown artist**
Previously attributed to Hercules
Seghers (JFD 1972)
Landscape with Fences
c. 1600–25
Oil on panel
10 3/4 × 15 3/8" (27.3 × 39 cm)

John G. Johnson Collection
cat. 461

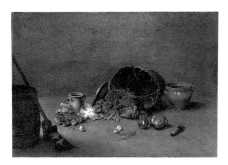

**Duifhuysen, Pieter Jacobsz.,
also called Colinckhovius**
Dutch, active Rotterdam,
1608–1677
Previously listed as Hendrik
Maertensz. Sorgh (JFD 1972)
Still Life
17th century
Oil on panel
11 1/16 × 14 7/8" (28.1 × 37.8 cm)

John G. Johnson Collection
cat. 783

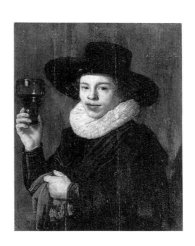

**Dutch, active Amsterdam,
unknown artist**
*Portrait of a Nineteen-Year-Old
Man*
1623
Upper right: 1623 /
AETATIS.SVAE. / 19.
Oil on panel
18 7/8 × 14 3/8" (47.9 × 36.5 cm)

John G. Johnson Collection
cat. 457

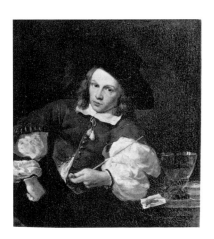

**Dujardin, Karel,
attributed to**
Dutch, active Amsterdam and
Italy, c. 1622–1678
*Portrait of a Young Man Seated
Smoking*
17th century
Oil on canvas
16 7/16 × 14 1/8" (41.7 × 35.9 cm)

John G. Johnson Collection
cat. 609

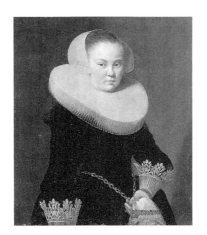

**Dutch, active Amsterdam,
unknown artist**
*Portrait of an Eighteen-Year-Old
Woman*
1631
Upper left: [AETA]TIS.SVAE.18. /
1631.
Oil on canvas
28 15/16 × 23 9/16" (73.5 × 59.8 cm)

John G. Johnson Collection
cat. 454

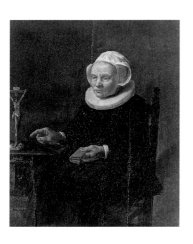

Dutch, active Haarlem, unknown artist
Portrait of a Seventy-Four-Year-Old Woman
1635
Upper left: AETATIS 74 1635; on crucifix: INRI
Oil on panel
12 3/4 × 10 3/8" (32.4 × 26.3 cm)

The William L. Elkins Collection
E1924-3-75

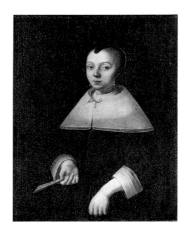

Dutch, unknown artist
Previously listed as Ludolf de Jongh (JFD 1972)
Portrait of a Lady
c. 1650–1700
Oil on canvas
34 1/2 × 26 7/16" (87.6 × 67.1 cm)

John G. Johnson Collection
inv. 2818

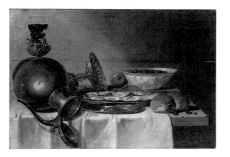

Dutch, unknown artist
Still Life with Metal Cups and Oysters
1636
Lower right: JS 1636
Oil on panel
22 1/16 × 31 7/8" (56 × 81 cm)

John G. Johnson Collection
cat. 651

Dutch, unknown artist
Still Life with a Heron
c. 1660
Lower right (spurious): B. F. / Fytt
Oil on canvas
41 1/2 × 29 7/8" (105.4 × 75.9 cm)

John G. Johnson Collection
cat. 641

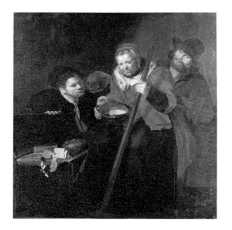

Dutch, unknown artist
Previously listed as an unknown artist, 17th century (JFD 1972)
The Miser
1646
Oil on canvas
56 1/2 × 52 5/8" (143.5 × 133.7 cm)

John G. Johnson Collection
cat. 436

Dutch, unknown artist
Previously listed as Aelbert Cuyp (JFD 1972)
A Cock and Hens
17th century
Oil on panel
35 9/16 × 45 1/2" (90.3 × 115.6 cm)

John G. Johnson Collection
cat. 623

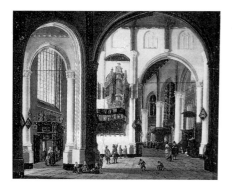

Dutch, active Rotterdam, unknown artist
Interior of the St. Laurenskerk, Rotterdam
c. 1650–60
Lower left: E. de Gruyter
Oil on panel
26 × 30 3/4" (66 × 78.1 cm)

John G. Johnson Collection
cat. 601

Dutch, unknown artist
Previously listed as Jacob Isaacksz. van Ruisdael (JFD 1972)
Cottage by the Waterside
17th century
Lower right (spurious): Ruysdael ft
Oil on canvas
11 3/16 × 13 5/8" (28.4 × 34.6 cm)

John G. Johnson Collection
cat. 568

Dutch, unknown artist
Girl Drawing
17th century
Oil on canvas
10 ⁵/₈ × 8 ⁷/₈" (27 × 22.5 cm)

John G. Johnson Collection
cat. 506

Dutch, unknown artist
Previously listed as Aelbert Cuyp
(JFD 1972)
Portrait of a Lady
A 4 ¹/₂" strip has been added to
each side
17th century
Oil on panel
27 ⁹/₁₆ × 20 ¹/₄" (70 × 51.4 cm)

John G. Johnson Collection
cat. 1182

Dutch, unknown artist
Landscape with a Windmill
17th century
Oil on canvas
10 ⁵/₈ × 14 ³/₄" (27 × 37.5 cm)

John G. Johnson Collection
cat. 579

Dutch, unknown artist
Still Life with Fish and a Cat
The signature "A. B. Beyeren"
came away in cleaning in 1970
17th century
Lower right: [illegible signature]
Oil on canvas
19 ¹/₄ × 24 ¹/₄" (48.9 × 61.6 cm)

John G. Johnson Collection
cat. 640

Dutch, unknown artist
Landscape with Dunes
17th century
Oil on canvas
31 ⁷/₈ × 40 ¹/₄" (81 × 102.2 cm)

John G. Johnson Collection
cat. 578

Dutch, unknown artist
Working Woman
17th century
Oil on canvas
28 ⁹/₁₆ × 24" (72.5 × 61 cm)

John G. Johnson Collection
cat. 540

Dutch, unknown artist
Portrait of a Field Marshal
17th century
Oil on canvas
80 ⁷/₈ × 45 ⁵/₈" (205.4 × 115.9 cm)

Purchased with the W. P.
Wilstach Fund
W1904-1-20

**Dutch or Flemish,
unknown artist**
Still Life with Flowers
Companion to the following
painting
18th century
Oil on canvas
38 ¹³/₁₆ × 29 ¹/₈" (98.6 × 74 cm)

The Bloomfield Moore Collection
1883-120

**Dutch or Flemish,
unknown artist**
Still Life with Flowers
Companion to the preceding
painting
18th century
Oil on canvas
39 × 29 1/4" (99.1 × 74.3 cm)

The Bloomfield Moore Collection
1883-121

**Dyck, Anthony van,
follower of**
Previously listed as an old copy
after Anthony van Dyck (JFD
1972)
The Crucifixion
17th century
Oil on canvas
15 1/4 × 10 1/2" (38.7 × 26.7 cm)

John G. Johnson Collection
cat. 673

Dutch, unknown artist
Village Church
18th century
Oil on panel
7 11/16 × 10" (19.5 × 25.4 cm)

John G. Johnson Collection
inv. 2811

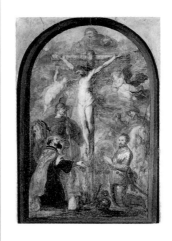

**Dyck, Anthony van,
follower of**
*The Crucifixion, with a Bishop, a
Saint, and a Donor in Armor*
17th century
Oil on panel
13 5/8 × 9 1/16" (34.6 × 23 cm)

Purchased with the W. P.
Wilstach Fund
W1902-1-8

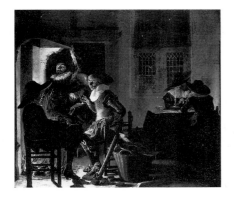

Duyster, Willem Cornelisz.
Dutch, active Amsterdam,
1598/99–1635
Soldiers beside a Fireplace
c. 1628–32
Oil on panel
16 1/2 × 18 1/2" (41.9 × 47 cm)

John G. Johnson Collection
cat. 445

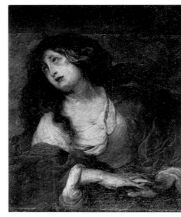

**Dyck, Anthony van,
follower of**
Saint Mary Magdalene Mourning
17th century
Oil on panel
29 1/8 × 23 3/8" (74 × 59.4 cm)

John G. Johnson Collection
cat. 670

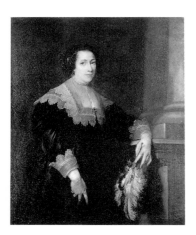

**Dyck, Anthony van,
attributed to**
Flemish, active Italy, Antwerp,
and England, 1599–1641
Previously listed as Anthony van
Dyck (JFD 1972)
Portrait of a Lady [possibly Lady
Philadelphia Wharton]
1636
Center right: AETATIS SVAE. /
22. ANNO 1636
Oil on canvas
47 3/4 × 38 1/4" (121.3 × 97.1 cm)

John G. Johnson Collection
cat. 674

**Dyck, Anthony van,
imitator of**
Previously listed as Anthony van
Dyck (JFD 1972)
Head of an Old Man
17th century
Oil on canvas
16 1/2 × 13 3/16" (41.9 × 33.5 cm)

John G. Johnson Collection
cat. 669

Dyck, Anthony van, imitator of
Previously listed as an old copy after Anthony van Dyck (JFD 1972)
Mater Dolorosa
17th century
Oil on canvas
18 3/8 × 16 3/8" (46.7 × 41.6 cm)

John G. Johnson Collection
cat. 672

Dyck, Anthony van, copy after
The Holy Family
After the painting in the Kunsthistorisches Museum, Vienna (inv. no. 1047)
17th century
Oil on canvas
20 1/8 × 15 7/8" (51.1 × 40.3 cm)

John G. Johnson Collection
inv. 2842

Eeckhout, Gerbrand van den
Dutch, active Amsterdam, 1621–1674
The Continence of Scipio
1659
Center bottom: G. V. Eeckhout fe. / A 1659
Oil on canvas
52 × 67" (132.1 × 170.2 cm)

Purchased with the George W. Elkins Fund
E1981-1-1

Eemont, Adriaen van, attributed to
Dutch, active Dordrecht, c. 1627–1662
Previously listed as Nicolaes Ficke (JFD 1972)
The Halt at the Cottage
17th century
Oil on canvas
25 9/16 × 28 3/8" (64.9 × 72.1 cm)

John G. Johnson Collection
cat. 526

Everdingen, Allart van
Dutch, active Alkmaar and Amsterdam, 1621–1675
Rough Sea
17th century
Lower right: AVE
Oil on canvas
24 3/4 × 30 15/16" (62.9 × 78.6 cm)

John G. Johnson Collection
cat. 587

Everdingen, Allart van, copy after
Rough Sea
After an engraving by Pierre-Charles Canot (French, 1710–1777) of a painting by Everdingen in the Landesmuseum für Kunst und Kulturgeschichte, Oldenburg, Germany
17th century
Lower right (spurious): JRuisdael
Oil on panel
13 3/16 × 23 1/8" (33.5 × 58.7 cm)

John G. Johnson Collection
cat. 470

Eyck, Jan van, attributed to
Netherlandish, active Bruges, first documented 1422, died 1441
Previously listed as Jan van Eyck (JFD 1972)
Saint Francis of Assisi Receiving the Stigmata
c. 1438–40
Oil on vellum on panel
5 × 5 3/4" (12.7 × 14.6 cm)

John G. Johnson Collection
cat. 314

Eyck, Jan van, follower of
Saint Christopher
c. 1440–50
Oil on panel
11 5/8 × 8 5/16" (29.5 × 21.1 cm)

John G. Johnson Collection
cat. 342

Eyck, Jan van, follower of
Portrait of a Man
Fragment [?] inlaid in a larger
panel
15th century
Oil on panel
Painting: 5 1/2 × 3 3/4"
(14 × 9.5 cm)

John G. Johnson Collection
cat. 315

Flemish, unknown artist
Winter
See previous three entries
c. 1575–1625
Oil on canvas
45 1/4 × 57 3/4" (114.9 × 146.7 cm)

Bequest of John W. Pepper
1935-10-95

Flemish, unknown artist
Spring
After an engraving by Adrian
Collaert (Flemish, c. 1560–
1618) after designs by Marten
de Vos (Flemish, 1532–1603);
companion to the following three
paintings
c. 1575–1625
Oil on canvas
45 1/4 × 57 7/8" (114.9 × 147 cm)

Bequest of John W. Pepper
1935-10-98

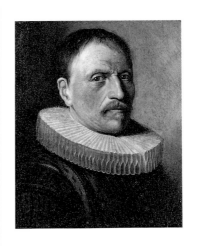

Flemish, unknown artist
Previously listed as an unknown
artist, c. 1600–10 (JFD 1972)
Portrait of a Gentleman
c. 1600–10
Oil on panel
18 1/8 × 14 1/8" (46 × 35.9 cm)

John G. Johnson Collection
cat. 458

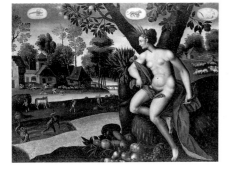

Flemish, unknown artist
Summer
See previous entry
c. 1575–1625
Oil on canvas
46 1/4 × 58" (117.5 × 147.3 cm)

Bequest of John W. Pepper
1935-10-96

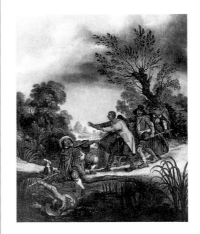

Flemish, unknown artist
Previously listed as an imitator of
Pieter Breugel the Elder,
mid-17th century (JFD 1972)
The Blind Leading the Blind
c. 1600–50
Oil on panel
16 9/16 × 12 11/16" (42.1 × 32.2 cm)

John G. Johnson Collection
cat. 472

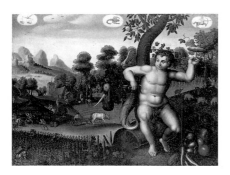

Flemish, unknown artist
Autumn
See previous two entries
c. 1575–1625
Oil on canvas
43 3/4 × 58 3/4" (111.1 × 149.2 cm)

Bequest of John W. Pepper
1935-10-97

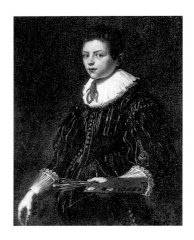

Flemish, unknown artist
Previously listed as Peter Paul
Rubens (JFD 1972)
*Portrait of a Young Man with a
Palette and Brushes*
c. 1615–20
Oil on canvas
30 3/16 × 23 13/16" (76.7 × 60.5 cm)

John G. Johnson Collection
cat. 810

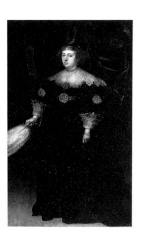

Flemish or Dutch, unknown artist
Previously listed as Flemish, unknown artist, 17th century (PMA 1965)
Portrait of a Lady
c. 1630–35
Oil on canvas
78 3/4 × 46 3/8" (200 × 117.8 cm)

Purchased with the W. P. Wilstach Fund
W1899-1-2

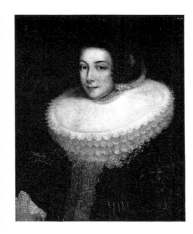

Flemish, unknown artist
Portrait of a Woman in a Ruff
17th century
Oil on canvas
31 9/16 × 24 1/2" (80.2 × 62.2 cm)

Bequest of Arthur H. Lea
F1938-1-8

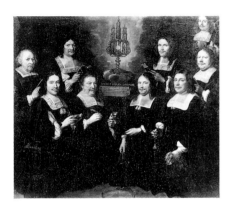

Flemish, unknown artist
Previously listed as Lodewyck van der Helst (PMA 1965)
Portrait of the Deacons of the Confraternity of the Holy Sacrament
1673
Center: LOF SŸ T HEŸLICH, SACRAMENT / Geen wiin, oft Ipocras, noch Terwe graen en Liet— / ons Goodt int Avontmael, maer 't Broot (Door 't Woort) herdreven, / Wordt Vleesch, de Wiin Wordt Bloet: daer en Bleef anders niet— / als Godt, wiens Vleesch, en Bloet ons daeghlijckx Wordt Ge geven; bottom center: DE-KENS / 1. Peeter Willemans 2. Carel Verhuyck / 3. Iõan de Haegh 4. Cornelis Peeters / 1673
Oil on canvas
71 1/4 × 81 1/4" (181 × 206.4 cm)

Gift of John G. Johnson for the W. P. Wilstach Collection
W1904-1-52

Flemish, unknown artist
Street Scene
18th century
Oil on canvas
11 15/16 × 10 1/16" (30.3 × 25.6 cm)

John G. Johnson Collection
cat. 541

Franco-Netherlandish, unknown artist
Portrait of a Man in Prayer
c. 1480?
Oil on panel
9 3/4 × 7 7/8" (24.8 × 20 cm)

John G. Johnson Collection
cat. 1174

Flemish, unknown artist
Peasant's Cottage
17th century
Lower right: AB
Oil on panel
9 1/2 × 13 3/4" (24.1 × 34.9 cm)

John G. Johnson Collection
cat. 684

Fris, Jan
Dutch, active Amsterdam, 1627–1672
Previously listed as Edwaert Kollier (JFD 1972)
Still Life with a Stoneware Jar and a Brazier
17th century
Lower left (spurious): Kollier
Oil on canvas
25 1/2 × 19 3/16" (64.8 × 48.7 cm)

John G. Johnson Collection
cat. 643

Fromantiou, Hendrik de
Dutch, active Maastricht, after
1670 active largely in Berlin,
1633–1694
Still Life with Birds
1679
Lower left: H d F 1679
Oil on canvas
21 1/4 × 16 7/8" (54 × 42.9 cm)

John G. Johnson Collection
cat. 645

Fyt, Jan, copy after
Watchdog Drinking Water
Known in several versions
17th century
Oil on canvas
38 3/4 × 51 3/16" (93.4 × 130 cm)

John G. Johnson Collection
cat. 702

Fyt, Jan
Flemish, active Antwerp,
1611–1661
*Flowers Enframing a Relief of the
Virgin*
1643
Center: Johannes Fyt / 1643
Oil on panel
32 5/16 × 22 3/4" (82.1 × 57.8 cm)

John G. Johnson Collection
cat. 704

**Geertgen tot Sint Jans,
follower of**
Netherlandish, active Haarlem,
active c. 1480–c. 1490
*Saint Martin of Tours and the
Beggar*
Early 16th century
Oil on panel
17 5/16 × 12 1/8" (44 × 30.8 cm)

John G. Johnson Collection
cat. 346

Fyt, Jan
*Still Life with Fruit, Dead
Partridges, and a Parrot*
1646
Center right: Joannes Fyt / 1646
Oil on canvas
29 7/8 × 43 3/4" (75.9 × 111.1 cm)

John G. Johnson Collection
cat. 705

Geffels, Frans
Flemish, active Mantua and
environs, first recorded 1635/36,
died c. 1699
Previously listed as a Flemish
artist, c. 1650 (JFD 1972)
Dinner Party on a Terrace
17th century
On chair (spurious): P. D. Hoog
Oil on canvas
33 1/2 × 40 3/8" (85.1 × 102.5 cm)

John G. Johnson Collection
cat. 502

Fyt, Jan
Previously attributed to Jan Fyt
(JFD 1972)
Still Life with Game and Fruit
17th century
Oil on canvas
36 7/8 × 49 7/8" (93.7 × 126.7 cm)

John G. Johnson Collection
cat. 703

**Goes, Hugo van der,
attributed to**
Netherlandish, active Ghent,
first documented 1467, died 1482
Previously listed as Hugo van der
Goes (JFD 1972)
Virgin and Child
c. 1470
Oil on panel
12 3/4 × 10" (32.4 × 25.4 cm)

John G. Johnson Collection
cat. 336

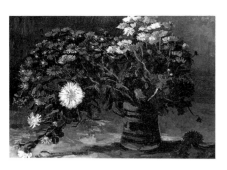

Gogh, Vincent Willem van
Dutch, 1853–1890
Still Life with a Bouquet of Daisies
1886
Oil on paper on panel
16 3/8 × 22 1/2" (41.6 × 57.1 cm)

Bequest of Charlotte Dorrance
Wright
1978-1-33

Gogh, Vincent Willem van
Rain
1889
Oil on canvas
28 7/8 × 36 3/8" (73.3 × 92.4 cm)

The Henry P. McIlhenny
Collection in memory of
Frances P. McIlhenny
1986-26-36

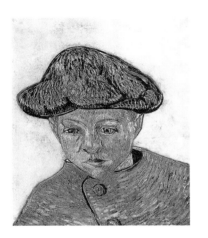

Gogh, Vincent Willem van
Portrait of Camille Roulin
1888 or 1889
Oil on canvas
17 × 13 3/4" (43.2 × 34.9 cm)

Gift of Mr. and Mrs. Rodolphe
Meyer de Schauensee
1973-129-1

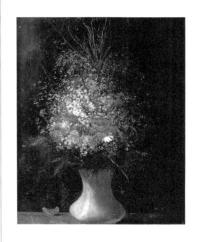

**Gogh, Vincent Willem van,
imitator of**
Previously listed as Vincent van
Gogh (JGJ 1941)
Still Life with a Vase of Flowers
c. 1900
Lower right (spurious): Vincent
Oil on canvas
30 3/4 × 25 3/16" (78.1 × 64.3 cm)

John G. Johnson Collection
inv. 2322

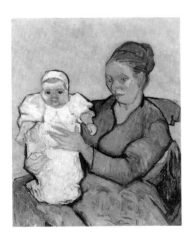

Gogh, Vincent Willem van
*Portrait of Madame Augustine Roulin
and Baby Marcelle*
1888 or 1889
Oil on canvas
36 3/8 × 28 15/16" (92.4 × 73.5 cm)

Bequest of Lisa Norris Elkins
1950-92-22

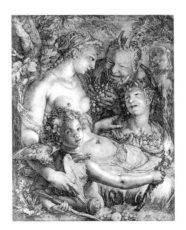

Goltzius, Hendrick
Dutch, active Haarlem,
1558–1617
*Sine Cerere et Libero friget Venus
(Without Ceres and Bacchus, Venus
Would Freeze)*
c. 1600–3
Lower right: HG[olt]z[ius]inv.[?]
Ink and oil on canvas
41 3/8 × 31 1/2" (105.1 × 80 cm)

Purchased with the Mr. and Mrs.
Walter H. Annenberg Fund for
Major Acquisitions, the Henry P.
McIlhenny Fund in memory of
Frances P. McIlhenny, bequest (by
exchange) of Mr. and Mrs. Herbert
C. Morris, and gift (by exchange)
of Frank and Alice Osborn
1990-100-1

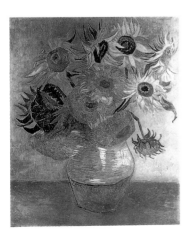

Gogh, Vincent Willem van
Sunflowers
1888 or 1889
On vase: Vincent
Oil on canvas
36 3/8 × 28" (92.4 × 71.1 cm)

The Mr. and Mrs. Carroll S.
Tyson, Jr., Collection
1963-116-19

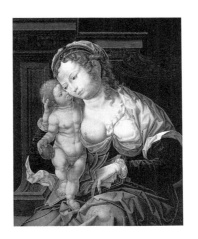

**Gossaert, Jan, also called
Jan Mabuse, follower of**
Netherlandish, active Antwerp,
Mechelen, Utrecht, and
Middelburg, c. 1478–1532
Previously listed as a copy after
Jan Gossaert (JFD 1972)
Virgin and Child
Based on the painting in the
Museo del Prado, Madrid (1930)
16th century
Oil on panel
22 1/8 × 16 5/8" (56.2 × 42.2 cm)

John G. Johnson Collection
cat. 390

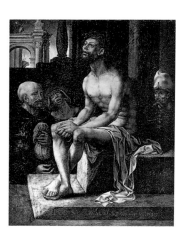

Gossaert, Jan, copy after
"Ecce Homo"
After a painting known through several copies
1527
Center bottom: IOANNES, MALBODIVS, INVENIT; lower right: 15,27
Oil on panel
9 3/4 × 7 3/8" (24.8 × 18.7 cm)

John G. Johnson Collection
cat. 391

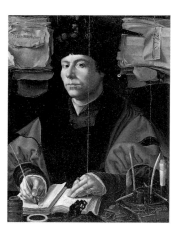

Gossaert, Jan, copy after
Portrait of a Merchant [possibly Jerome Sandelin]
After the painting in the National Gallery of Art, Washington, D.C. (1967.4.1)
16th century
Upper left: Alrehande Missiven; upper right: Alrehande Minuten; on pin in hat: IAS; on ring: IS
Oil on panel
25 1/4 × 19" (64.1 × 48.3 cm)

John G. Johnson Collection
inv. 2051

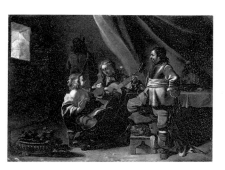

Goubau, Antoine
Flemish, active Antwerp and Rome, 1616–1698
Previously listed as Karel Dujardin? (JFD 1972)
Concert
c. 1645–50
On footstool: KDJ
Oil on copper
8 3/8 × 11 5/16" (21.3 × 28.7 cm)

John G. Johnson Collection
cat. 607

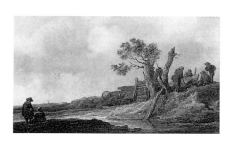

Goyen, Jan van
Dutch, active Leiden and The Hague, 1596–1656
Peasants near a Pool
1633
Lower left: VG 1633
Oil on panel
12 1/2 × 21 1/4" (31.7 × 54 cm)

John G. Johnson Collection
cat. 462

Goyen, Jan van
Peasants Resting before an Inn
Early 1640s
Oil on canvas
48 1/8 × 53 7/8" (122.2 × 136.8 cm)

The William L. Elkins Collection
E1924-3-30

Goyen, Jan van
Cathedral of Utrecht
1646
Center bottom: v G 1646
Oil on panel
14 3/8 × 12 3/8" (36.5 × 31.4 cm)

John G. Johnson Collection
cat. 463

Goyen, Jan van
Landscape with a Canal
1653
Center bottom: v G 1653
Oil on panel
9 1/2 × 12 1/2" (24.1 × 31.7 cm)

John G. Johnson Collection
cat. 464

Goyen, Jan van, imitator of
Previously listed as in the manner of Jan van Goyen (JFD 1972)
Boats on a Beach
17th century
Oil on panel
8 3/4 × 14 3/16" (22.2 × 36 cm)

John G. Johnson Collection
cat. 469

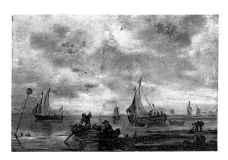

Goyen, Jan van, imitator of
Previously listed as Jan van
Goyen (JFD 1972)
Zuider Zee
Painted on the back of the plate
for the etching *Lot and His
Daughters*, by Gerard ter Borch
the Elder (Dutch, 1584–1662)
17th century
On reverse: GTBorch F Ano 1632
[in reverse]
Oil on copper
5 5/8 × 8" (14.3 × 20.3 cm)

John G. Johnson Collection
cat. 505

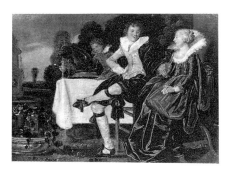

Hals, Dirck, attributed to
Previously listed as Dirck Hals
(JFD 1972)
*A Gentleman and a Lady Dining on
a Terrace*
c. 1625
Oil on panel
6 15/16 × 9 3/8" (17.6 × 23.8 cm)

John G. Johnson Collection
cat. 435

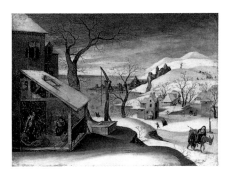

Grimmer, Abel
Flemish, active Antwerp,
active 1592–1619
*Winter Landscape with the Angel
Appearing to Saint Joseph, the
Massacre of the Innocents, and the
Flight into Egypt*
c. 1600–19
Lower right: ABEL GRIMER
FECIT
Oil on panel
10 1/8 × 13 1/16" (25.7 × 33.2 cm)

John G. Johnson Collection
cat. 654

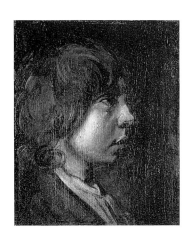

Hals, Frans, follower of
Dutch, active Haarlem,
c. 1582–1666
Previously listed as the school of
Frans Hals (JFD 1972)
Portrait of a Boy
17th century
Lower right (spurious): FH
Oil on panel
5 3/4 × 4 3/8" (14.6 × 11.1 cm)

John G. Johnson Collection
cat. 432

**Haagen, Joris van der,
attributed to**
Dutch, active The Hague and
Arnhem, born 1613–17,
died 1669
View of Arnhem
17th century
Oil on canvas
19 3/4 × 32 1/8" (50.2 × 81.6 cm)

John G. Johnson Collection
cat. 574

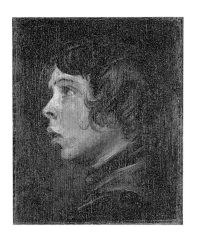

Hals, Frans, follower of
Previously listed as the school of
Frans Hals (JFD 1972)
Portrait of a Boy
17th century
Lower left (spurious): FH
Oil on panel
5 11/16 × 4 1/2" (14.4 × 11.4 cm)

John G. Johnson Collection
cat. 433

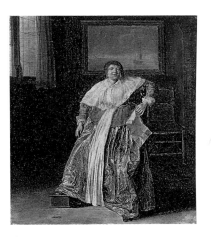

Hals, Dirck
Dutch, active Haarlem and
Leiden, 1591–1656
Seated Woman with a Letter
1633
Lower left: DHals / 1633
Oil on panel
13 5/16 × 11 1/4" (33.8 × 28.6 cm)

John G. Johnson Collection
cat. 434

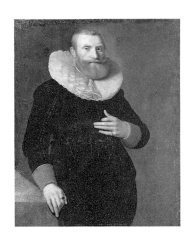

**Harings, Matthijs,
attributed to**
Dutch, active Leeuwarden and
Houbraken, documented
1609–1637
Previously listed as an Amsterdam
artist, c. 1610–15 (JFD 1972)
*Portrait of a Forty-One-Year-Old
Man*
1634
Upper left: AETAT.41 / Ao 1634
Oil on canvas
41 3/8 × 31 3/4" (105.1 × 81.6 cm)

John G. Johnson Collection
cat. 450

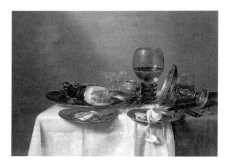

Heda, Willem Claesz.
Dutch, active Haarlem,
1594–1680/82
Previously listed as Pieter Claesz.
(JFD 1972)
Still Life with a Ham and a Roemer
c. 1631–34
Oil on panel
23 1/4 × 32 1/2" (59 × 82.5 cm)

John G. Johnson Collection
cat. 644

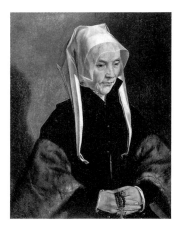

**Heemskerck, Maarten van,
attributed to**
Netherlandish, active Haarlem
and Rome, 1498–1574
Previously listed as the Master of
the 1540s (JFD 1972)
Portrait of Sophia van Amerongen
A version lacking the hands and
reversed is in the Rijksmuseum
Twenthe, Enschede (inv. no. 120)
c. 1550
Oil on panel
29 1/2 × 21 3/4" (74.9 × 55.2 cm)

John G. Johnson Collection
cat. 417

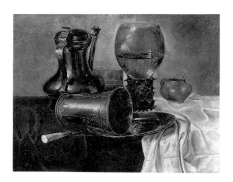

**Heda, Willem Claesz.,
imitator of**
Previously listed as Willem
Claesz. Heda (JFD 1972)
*Still Life with a Roemer, a Covered
Flagon, and a Beaker*
17th century
Oil on panel
16 5/8 × 19 3/4" (42.2 × 50.2 cm)

John G. Johnson Collection
cat. 642

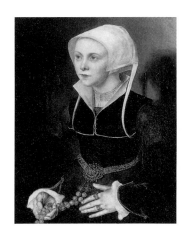

**Heemskerck, Maarten van,
follower of**
Previously listed as the school of
Maarten van Heemskerck (JFD
1972)
*Portrait of a Nineteen-Year-Old
Woman*
1548
Upper left: 1548; upper right: 19
Oil on panel
28 3/16 × 21 1/16" (71.6 × 53.5 cm)

John G. Johnson Collection
cat. 416

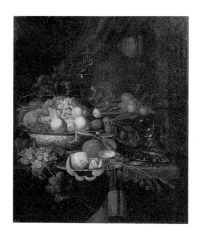

**Heem, Cornelis de,
attributed to**
Flemish, active Leiden and
Antwerp, 1631–1695
Previously listed as a follower of
Jan Davidsz. de Heem (JFD 1972)
*Still Life with Peaches, Grapes, and
Other Fruits*
17th century
Oil on canvas
39 × 31 1/8" (99.1 × 79.1 cm)

John G. Johnson Collection
cat. 631

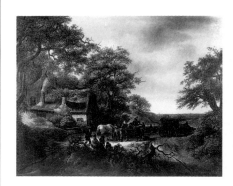

Hees, Gerrit van
Dutch, active Haarlem,
active by 1650, died 1670
Previously listed as Isaack van
Ostade (PMA 1965)
*Landscape with Travelers Resting by
an Inn*
1653
Lower right (spurious): I ostade .
f . / 1653
Oil on canvas
41 × 51 3/8" (104.1 × 130.5 cm)

The William L. Elkins Collection
E1924-3-35

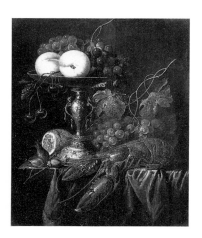

**Heem, Jan Davidsz. de,
follower of**
Flemish, active Utrecht, Leiden,
and Antwerp, 1606–1684
Still Life with Fruit and a Lobster
17th century
Lower left (spurious): Joh. Fyt
Oil on panel
17 3/4 × 15 3/8" (45.1 × 39 cm)

John G. Johnson Collection
inv. 421

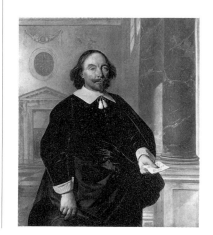

Helst, Bartholomeus van der
Dutch, active Amsterdam,
1613–1670
Portrait of Michiel Heusch
1653
Lower left: B. van der / Helst, f. /
1653; lower right, on letter: Al
sig. Michiel / Heusch /
Hamborgh in.
Oil on canvas
51 × 44" (129.5 × 111.8 cm)

John G. Johnson Collection
cat. 495

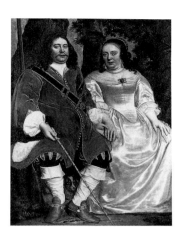

Helst, Lodewyck van der, attributed to
Dutch, active Amsterdam, 1642–c. 1684
Previously listed as Bartholomeus van der Helst (PMA 1965)
Portrait of a Gentleman and a Lady Seated Outdoors
c. 1670
Oil on canvas
62 ½ × 46 ½" (158.7 × 118.1 cm)

Purchased with the W. P. Wilstach Fund
W1904-1-60

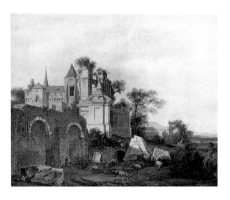

Heyden, Jan van der
Dutch, active Amsterdam, 1637–1712
Ideal Landscape with a Romanesque Church
17th century
Lower right, on stone: J V. Heyden; on pyramid of stones: [illegible signature]
Oil on panel
16 × 18 ³/₁₆" (40.6 × 46.2 cm)

John G. Johnson Collection
cat. 595

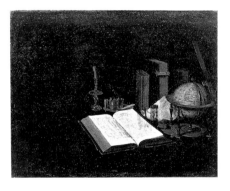

Heyden, Jan van der
Previously attributed to Jan van der Heyden (JFD 1972)
Still Life with Books and a Globe
17th century
Lower left: J.V. Heyde
Oil on panel
8 ¹⁵/₁₆ × 10 ⁵/₈" (22.7 × 27 cm)

John G. Johnson Collection
cat. 597

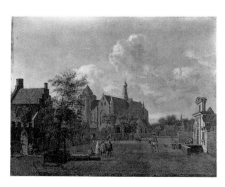

Heyden, Jan van der
View of Veere, Zeeland
17th century
Lower left: J.V.D Heyde
Oil on panel
16 ⁵/₈ × 21 ¹/₈" (42.2 × 53.7 cm)

John G. Johnson Collection
cat. 596

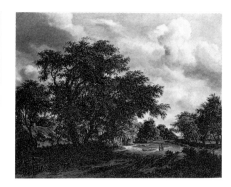

Hobbema, Meindert
Dutch, active Amsterdam, 1638–1709
Landscape with a Wooded Road
1662
Lower left: m. hobbema.f.166[2]
Oil on canvas
42 ¹/₈ × 51 ¹/₂" (107 × 130.8 cm)

The William L. Elkins Collection
E1924-3-7

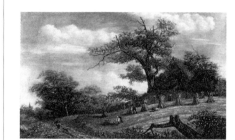

Hobbema, Meindert, imitator of
Sheaf Binders
17th century
Oil on panel
16 ¹⁵/₁₆ × 26 ³/₄" (43 × 67.9 cm)

John G. Johnson Collection
cat. 571

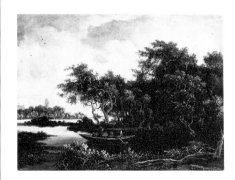

Hobbema, Meindert, copy after
Landscape with a River
After the painting formerly in the collection of the 2nd Earl of Northbrook
17th century
Oil on panel
11 ⁷/₈ × 15 ¹/₈" (30.2 × 38.4 cm)

John G. Johnson Collection
cat. 573

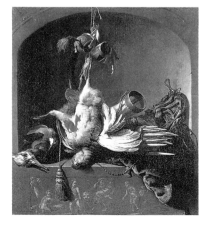

Hondecoeter, Melchior de
Dutch, active Utrecht, Amsterdam, and The Hague, 1636–1695
Still Life with Birds
17th century
Upper right: M d hondecoeter
Oil on canvas
28 ⁷/₈ × 25 ¹/₄" (73.3 × 64.1 cm)

John G. Johnson Collection
cat. 630

Hondecoeter, Melchior de, attributed to
Previously listed as Melchior de Hondecoeter (PMA 1965)
Still Life with Game Birds
c. 1665–75
Oil on canvas
31 7/8 × 27 1/2" (81 × 69.8 cm)
Purchased with the W. P. Wilstach Fund
W1902-1-18

Hondecoeter, Melchior de, workshop of
Previously listed as Melchior de Hondecoeter (PMA 1965)
Poultry Yard
1680s?
Oil on canvas
84 1/4 × 110 1/4" (214 × 280 cm)
Purchased with the W. P. Wilstach Fund
W1896-1-12

Hondecoeter, Melchior de, follower of
A Rooster and a Hen Fighting
17th century
Oil on canvas
42 × 51 1/2" (106.7 × 130.8 cm)
John G. Johnson Collection
cat. 629

Hooch, Pieter de
Dutch, active Delft and Amsterdam, 1629–1684
Previously listed as Hendrik van der Burgh (JFD 1972)
Soldier Smoking
c. 1650
On table edge: P. D Hooch
Oil on panel
13 15/16 × 10 5/8" (35.4 × 27 cm)
John G. Johnson Collection
cat. 499

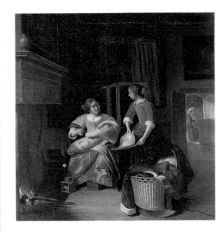

Hooch, Pieter de
Previously listed as a copy after Pieter de Hooch (JFD 1972)
A Lady and a Child with a Serving Maid
c. 1674–76
Oil on canvas
33 15/16 × 31 3/8" (86.2 × 79.7 cm)
John G. Johnson Collection
cat. 501

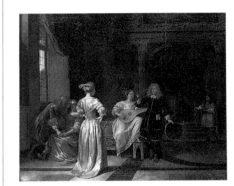

Hooch, Pieter de
Party
The inscription "P. de Hoogh / 1675" came away in cleaning in 1940
1675
Oil on canvas
32 3/16 × 38 15/16" (81.8 × 98.9 cm)
Purchased with the W. P. Wilstach Fund
W1912-1-7

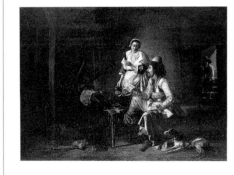

Hooch, Pieter de, follower of
Previously listed as Pieter de Hooch (JFD 1972)
Soldiers with a Serving Maid in a Barn
17th century
Oil on panel
21 9/16 × 27 3/16" (54.8 × 69.1 cm)
John G. Johnson Collection
cat. 498

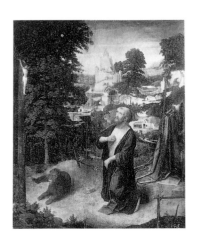

Isenbrant, Adriaen
Netherlandish, active Bruges, first documented 1510, died 1551
Penitent Saint Jerome
Upper corners have been added
c. 1525–50
Oil on panel
34 1/4 × 27" (87 × 68.6 cm)
John G. Johnson Collection
cat. 357

Isenbrant, Adriaen
Lamentation
Possibly a wing from a triptych
Mid-16th century
Oil on panel
12 1/4 × 4 7/8" (31.1 × 12.4 cm)

John G. Johnson Collection
cat. 358

Israëls, Jozef
Children at the Seashore
c. 1890
Lower right: Jozef Israels
Oil on canvas
21 3/8 × 32 9/16" (54.3 × 82.7 cm)

John G. Johnson Collection
cat. 1010

**Isenbrant, Adriaen,
workshop of**
The Crucifixion
Mid-16th century
On cross: [I] N R I
Oil on panel
19 9/16 × 14 15/16" (49.7 × 37.9 cm)

John G. Johnson Collection
cat. 356

Israëls, Jozef
Mother and Child
Before 1892
Lower left: Jozef Israels.
Oil on canvas
50 1/4 × 37 1/2" (127.6 × 95.2 cm)

John G. Johnson Collection
cat. 1009

Israëls, Jozef
Dutch, active The Hague,
Amsterdam, and Paris,
1824–1911
The Last Breath
1872
Lower right: Jozef Israels
Oil on canvas
44 × 69 1/2" (111.8 × 176.5 cm)

Gift of Ellen Harrison McMichael
in memory of C. Emory
McMichael
1942-60-2

Israëls, Jozef
The Fisherman's Family
Late 19th century
Lower left: Jozef Israels
Oil on panel
10 7/8 × 17 3/16" (27.6 × 43.7 cm)

The William L. Elkins Collection
E1924-3-79

Israëls, Jozef
Old Friends (Silent Conversation)
Before 1882
Lower left: Jozef Israels
Oil on canvas
52 1/8 × 69 1/16" (132.4 × 175.4 cm)

The William L. Elkins Collection
E1924-3-10

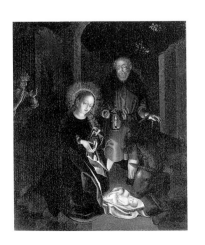

Joest, Jan, attributed to
Netherlandish, active Calcar and
Haarlem, first documented 1474,
died 1519
Previously listed as Jan Joest
(JGJ 1941)
The Nativity, at Night
Based on an engraving by Martin
Schongauer (German, 1445?–
1491) (Bartsch 4)
Early 16th century
Oil on panel
15 1/2 × 12 1/2" (39.4 × 31.7 cm)

John G. Johnson Collection
cat. 350

Jongkind, Johan Barthold
Dutch, active The Hague, Paris,
and Rotterdam, 1819–1891
Shipyard
1852
Lower right: Jongkind 52
Oil on canvas
16 7/8 × 23 5/8" (42.9 × 60 cm)

John G. Johnson Collection
cat. 1013

Jongkind, Johan Barthold
Port of Honfleur at Evening
1863
Lower right: Jongkind 1863
Oil on canvas
16 1/2 × 22 1/4" (41.9 × 56.5 cm)

The William L. Elkins Collection
E1924-3-76

Jongkind, Johan Barthold
The Seine near Rouen
1865
Lower right: Jongkind 1865
Oil on canvas
20 × 28 3/4" (50.8 × 73 cm)

Gift of Lucie Washington
Mitcheson in memory of Robert
Stockton Johnson Mitcheson for
the Robert Stockton Johnson
Mitcheson Collection
1938-22-8

Jongkind, Johan Barthold
Canal
1869
Lower left: Jongkind 1869
Oil on canvas
16 3/16 × 25 11/16" (41.1 × 65.2 cm)

John G. Johnson Collection
cat. 1012

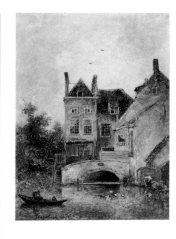

Jongkind, Johan Barthold
The Artist's House, Maassluis
1871
Lower left: Jongkind 1871
Oil on canvas
18 1/4 × 13 1/4" (46.3 × 33.6 cm)

The William L. Elkins Collection
E1924-3-84

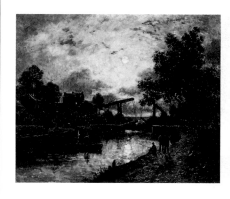

**Jongkind, Johan Barthold,
attributed to**
Previously listed as Johan
Barthold Jongkind (PMA 1965)
*Nocturnal Landscape with a
Drawbridge*
19th century
Lower right: Jongkind.
Oil on canvas
18 × 21 3/4" (45.7 × 55.2 cm)

Gift of Lucie Washington
Mitcheson in memory of Robert
Stockton Johnson Mitcheson for
the Robert Stockton Johnson
Mitcheson Collection
1938-22-7

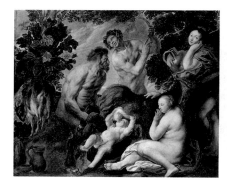

Jordaens, Jacob, copy after
Flemish, active Antwerp,
England, The Hague, and
Amsterdam, 1593–1678
*The Infant Jupiter Fed by the Goat
Amalthea*
After the lost original known
through the drawing in the
Hermitage, St. Petersburg
(inv. no. 4200), and a painted
studio replica in the museum in
Kishinev, Moldavia (inv. no. 340)
17th century
Oil on canvas
38 11/16 × 46 3/16" (98.3 ×
117.3 cm)

The Bloomfield Moore Collection
1889-79

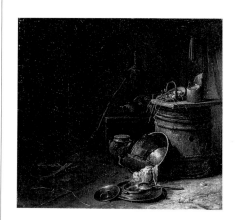

Kalf, Willem
Dutch, active Amsterdam,
1619–1693
Kitchen
c. 1642
Center right: WK
Oil on panel
9 3/4 × 9 13/16" (24.8 × 24.9 cm)

John G. Johnson Collection
cat. 636

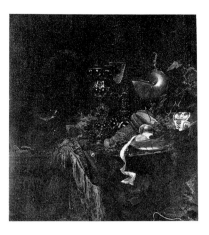

Kalf, Willem
Still Life
17th century
Oil on canvas
48 × 21 ¹/₂" (121.9 × 54.6 cm)

John G. Johnson Collection
cat. 634

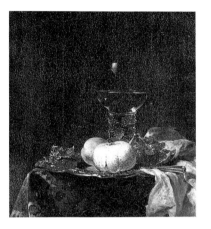

Kalf, Willem
Still Life with a Roemer
17th century
Lower left: W Kalf
Oil on canvas
19 ¹/₂ × 16 ¹¹/₁₆" (49.5 × 42.4 cm)

John G. Johnson Collection
cat. 635

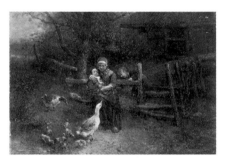

Kate, Johan Mari Henri ten
Dutch, active The Hague,
Amsterdam, England, and Paris,
1831–1910
Previously listed as Johannes
Marinus ten Kate (1859–1896)
(PMA 1965)
*A Mother and Two Children with
Geese*
c. 1870–75
Lower right: JM. ten Kate
Oil on canvas
14 ¹⁵/₁₆ × 21 ³/₁₆" (37.9 × 53.8 cm)

The Walter Lippincott Collection
1923-59-8

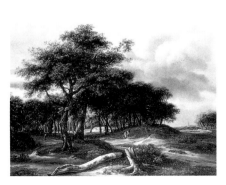

Kessel, Jan van, III
Dutch, active Amsterdam,
1641–1680
Previously listed as the school of
Jacob Isaacksz. van Ruisdael (JFD
1972)
Landscape with a Wood
c. 1665
Lower right (spurious):
M. Hobbema
Oil on canvas
41 ¹/₄ × 52 ⁷/₈" (104.8 × 134.3 cm)

John G. Johnson Collection
cat. 565

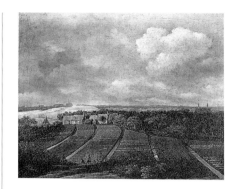

**Kessel, Jan van, III,
copy after**
Previously listed as a follower of
Jan van Kessel III (JFD 1972)
Dunes near Haarlem
After the painting formerly in the
National Art Collection, Warsaw
17th century
Oil on canvas
21 ³/₈ × 25 ⁹/₁₆" (54.3 × 64.9 cm)

John G. Johnson Collection
cat. 582

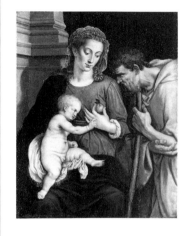

Key, Adriaen Thomasz.
Netherlandish, active Antwerp,
first documented 1558, still
active 1589?
The Holy Family
Late 16th century
Upper left: ATK
Oil on panel
33 ¹/₄ × 24 ¹/₂" (84.4 × 62.2 cm)

John G. Johnson Collection
cat. 430

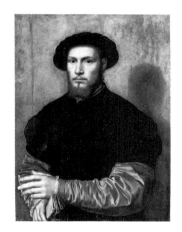

Key, Willem
Netherlandish, active Antwerp,
c. 1520–1568
Portrait of a Gentleman
Mid-16th century
Oil on panel
26 ³/₈ × 19" (67 × 48.3 cm)

John G. Johnson Collection
cat. 429

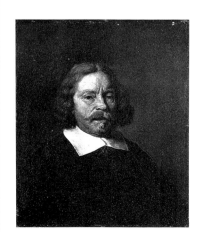

**Keyser, Thomas de,
attributed to**
Dutch, active Amsterdam,
1596/97–1667
Previously listed as Thomas de
Keyser (JFD 1972)
Portrait of a Gentleman [possibly
Jacob van Campen]
1659
Upper left: TDKeyser F. /
AETA. 59
Oil on copper
13 ¹/₄ × 10 ⁷/₈" (33.6 × 27.6 cm)

John G. Johnson Collection
cat. 456

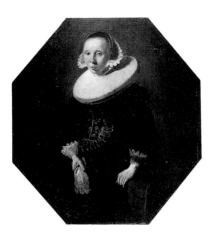

Keyser, Thomas de, follower of
Previously listed as Thomas de Keyser (PMA 1965)
Portrait of a Woman
c. 1635
Oil on panel
14 1/2 × 12 1/2" (36.8 × 31.7 cm)

The John D. McIlhenny Collection
1943-40-41

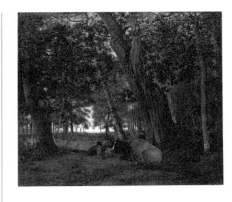

Koninck, Jacob
Dutch, active Rotterdam and Amsterdam, born 1614/15, died after 1690
Previously listed as Adriaen van de Velde (JFD 1972)
Cattle in a Wood
1656
Lower left: AvVelde / f. 1656
Oil on canvas
14 1/16 × 16" (35.7 × 40.6 cm)

John G. Johnson Collection
cat. 602

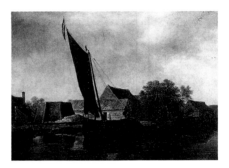

Knijff, Wouter
Dutch, active Haarlem, born c. 1607, still active 1693
Previously listed as Jacob Isaacksz. van Ruisdael (PMA 1965)
River with a Barge and a Limekiln
1640s
Lower left: [illegible signature?]
Oil on canvas
29 7/8 × 41 3/8" (75.9 × 105.1 cm)

Purchased with the W. P. Wilstach Fund
W1902-1-20

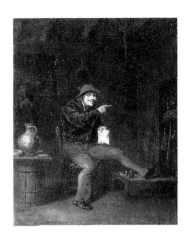

Koninck, Philips, attributed to
Dutch, active Amsterdam and Rotterdam, 1619–1688
Interior with Two Figures
17th century
Lower right: P. Koninck.
Oil on panel
13 1/8 × 9 1/4" (33.3 × 23.5 cm)

John G. Johnson Collection
inv. 742

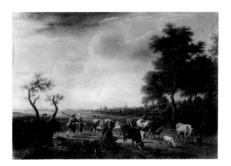

Kobell, Johannes Baptista, imitator of
Dutch, active Rotterdam and Gouda, 1756–1833
Previously listed as an imitator of Paulus Potter (JFD 1972)
Return from the Pasture
18th century
Oil on panel
20 3/4 × 28 1/8" (52.7 × 71.4 cm)

John G. Johnson Collection
cat. 712

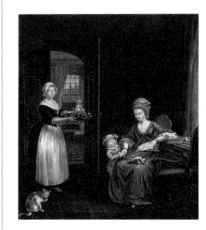

La Fargue, Maria
Dutch, active The Hague, 1743–1813
A Lady and a Servant
1777
Center left: Marie de / la Fargue / f 77
Oil on canvas
12 5/16 × 10 1/16" (31.3 × 25.6 cm)

John G. Johnson Collection
cat. 709

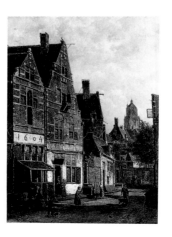

Koekkoek, Willem
Dutch, active Amsterdam, 1839–1895
Street
19th century
Center left, on building: 1604; lower right: W. Koekkoek
Oil on canvas
23 3/4 × 17 3/4" (60.3 × 45.1 cm)

The Walter Lippincott Collection
1923-59-12

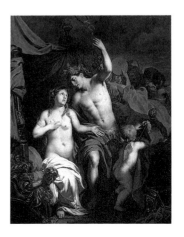

Lairesse, Gerard de
Dutch, active Liège, Amsterdam, and The Hague, 1641–1711
Bacchus and Ariadne
17th century
Lower left: G. Lairesse
Oil on canvas
26 1/4 × 20" (66.7 × 50.8 cm)

Gift of Mrs. Edgar P. Richardson
1986-83-1

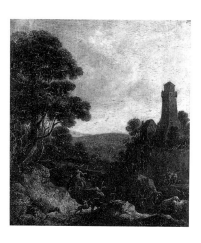

**Lapp, Jan Willemsz.,
follower of**
Dutch, active The Hague,
born c. 1600, died after 1663
Pastoral Landscape
17th century
Oil on panel
10 × 8 1/4" (25.4 × 20.9 cm)

Gift of Mrs. Hampton L. Carson
1929-136-148

**Leyden, Lucas van,
copy after**
Saint Luke
After the engraving (Bartsch 102)
16th century
Oil on copper
6 1/4 × 4 1/2" (15.9 × 11.4 cm)

John G. Johnson Collection
inv. 3

Lelienbergh, Cornelis
Dutch, active The Hague,
born c. 1626, died after 1676
Still Life of Dead Birds
1654
Lower left: C. Lelienbergh f. /
1654
Oil on canvas
19 1/2 × 16 1/4" (49.5 × 41.3 cm)

Purchased with the W. P.
Wilstach Fund
W1902-1-19

**Leyden, Lucas van,
copy after**
Saint Mark
After the engraving (Bartsch 100)
16th century
Oil on copper
6 1/4 × 4 3/8" (15.9 × 11.1 cm)

John G. Johnson Collection
inv. 4

**Leyden, Lucas van,
follower of**
Netherlandish, active Leiden,
c. 1494–1533
Previously listed as Lucas van
Leyden (JFD 1972)
*Salome Receiving the Head of Saint
John the Baptist*
Triptych
Early 16th century
Left wing: PRAEMIA / SALTATRIX
/ POSCIT / FVNEBRIA / VIRGO, /
IOANNIS / CAPVT / ABSCISVM /
QVOD LANCE / REPORTAT.; right
wing: INCESTAE / AD GRE- / MIVM
MA- / TRIS FERT / REGIA DONVM
/ PSALTRIA / RESPERSIS / MANI-
BVS / DE SANGV- / INE IVSTO.
Oil on panel
Center panel: 14 1/4 × 11 9/16"
(36.2 × 29.4 cm); left wing:
14 1/4 × 5 3/4" (36.2 × 14.6 cm);
right wing: 14 1/4 × 5 7/8"
(36.3 × 15 cm)

John G. Johnson Collection
cat. 413

Leyster, Judith
Dutch, active Haarlem and
Amsterdam, 1609–1660
The Last Drop (The Gay Cavalier)
Possibly a companion to
The Merry Trio, in the collection
of P. L. Galjart, Netherlands
c. 1639
Oil on canvas
35 1/16 × 28 15/16" (89.1 × 73.5 cm)

John G. Johnson Collection
cat. 440

Lievens, Jan, attributed to
Dutch, active Leiden and
Amsterdam, 1607–1674
Previously listed as Rembrandt
Harmensz. van Rijn (PMA 1965)
Portrait of a Man in a Turban
c. 1629
Oil on canvas
33 7/16 × 25 3/8" (84.9 × 64.4 cm)

Gift of the Reverend Theodore
Pitcairn
1961-195-1

Lievens, Jan, attributed to
Previously listed as Jan Lievens
(JFD 1972)
Old Woman Reading
17th century
Center left: J. L
Oil on panel
28 1/8 × 26 1/2" (71.4 × 67.3 cm)

John G. Johnson Collection
cat. 487

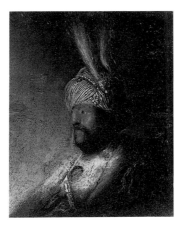

Lievens, Jan, copy after
Portrait of a Turk
After a painting known in versions
in the collection of D. Hudig,
Rotterdam, and the collection
of Victor Kock, London
17th century
Oil on panel
6 13/16 × 5 1/4" (17.3 × 13.3 cm)

John G. Johnson Collection
cat. 473

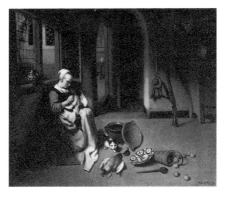

Maes, Nicolaes
Dutch, active Amsterdam and
Dordrecht, 1634–1693
Woman Plucking a Duck
c. 1655–56
Lower right: N. MAES
Oil on canvas
23 1/2 × 25 3/4" (59.7 × 65.4 cm)

Gift of Mrs. Gordon A. Hardwick
and Mrs. W. Newbold Ely in
memory of Mr. and Mrs.
Roland L. Taylor
1944-9-4

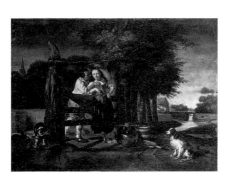

**Maes, Nicolaes,
attributed to**
Previously listed as Nicholaes
Maes (JFD 1972)
Lovers
17th century
On gate (spurious): N. MAES
Oil on panel
27 1/2 × 35 9/16" (69.8 × 90.3 cm)

John G. Johnson Collection
cat. 485

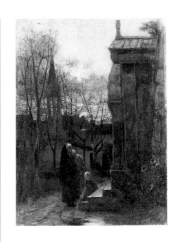

Maris, Jacob Hendricus
Dutch, active The Hague and
London, 1837–1899
Cemetery at Twilight
1867
Lower right: J. Maris 16[?] 1867
Oil on canvas
22 × 15 1/4" (55.9 × 38.7 cm)

John G. Johnson Collection
cat. 1032

Maris, Jacob Hendricus
Canal near Rijswijk
1872
Lower left: J Maris 1872
Oil on canvas
32 5/8 × 58" (82.9 × 147.3 cm)

John G. Johnson Collection
cat. 1030

Maris, Jacob Hendricus
*A Fishing Boat with a Horse on the
Beach, Sheveningen*
c. 1880–90
Lower right: J. Maris
Oil on canvas
50 × 37 5/8" (127 × 95.6 cm)

The William L. Elkins Collection
E1924-3-12

Maris, Jacob Hendricus
The Schreierstoren, Amsterdam
1882
Lower left: J. Maris
Oil on canvas
32 × 58 1/2" (81.3 × 148.6 cm)

The William L. Elkins Collection
E1924-3-11

Maris, Jacob Hendricus
Landscape with a Horseman
c. 1886–92
Oil on canvas
18 $^{11}/_{16}$ × 30 $^{5}/_{16}$" (47.5 × 77 cm)

John G. Johnson Collection
cat. 1029

Maris, Willem
Cows in a Marsh
c. 1897
Lower right: Willem Maris
Oil on canvas
25 $^{1}/_{2}$ × 29 $^{1}/_{2}$" (64.8 × 74.9 cm)

Gift of Mrs. Jay Besson Rudolphy
1978-118-1

Maris, Matthijs
Dutch, active The Hague and
London, 1839–1917
Head of a Girl
c. 1888–92
Oil on canvas
22 $^{1}/_{2}$ × 16 $^{1}/_{4}$" (57.1 × 41.3 cm)

John G. Johnson Collection
cat. 1033

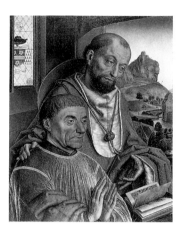

Marmion, Simon
Netherlandish, active Amiens,
Lille, Tournai, and Valenciennes,
first documented 1449, died 1489
*Saint Jerome and a Cardinal
Praying*
c. 1475–80
On window: placet / placet / PB
Oil on panel
25 $^{5}/_{8}$ × 19 $^{1}/_{4}$" (65.1 × 48.9 cm)

John G. Johnson Collection
inv. 1329

Maris, Willem
Dutch, active The Hague,
1844–1910
Previously listed as Jacob
Hendricus Maris (JGJ 1941)
Landscape with Cows
1884
Lower right: W Maris.
Oil on canvas on panel
5 $^{7}/_{8}$ × 8 $^{7}/_{8}$" (14.9 × 22.5 cm)

John G. Johnson Collection
cat. 1031

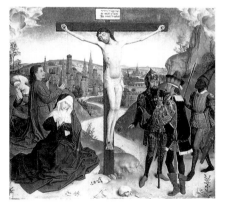

**Marmion, Simon,
attributed to**
Previously listed as Simon
Marmion (JFD 1972)
The Crucifixion
1470s
On cross: [Hebrew, Greek, and
Latin for "Jesus of Nazareth,
King of the Jews"]
Oil on panel
35 $^{3}/_{4}$ × 37 $^{1}/_{2}$" (90.8 × 95.2 cm)

John G. Johnson Collection
cat. 318

Maris, Willem
Cows in a Marsh
c. 1890–1900
Oil on canvas
31 $^{1}/_{4}$ × 57 $^{1}/_{2}$" (79.4 × 146 cm)

The George W. Elkins Collection
E1924-4-20

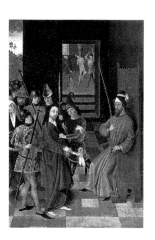

Marmion, Simon, imitator of
Previously listed as the school of
Simon Marmion (JFD 1972)
*Christ before Caiaphas, with the
Flagellation*
Early 16th century
Oil on panel
20 × 12 $^{15}/_{16}$" (50.8 × 32.9 cm)

John G. Johnson Collection
cat. 763

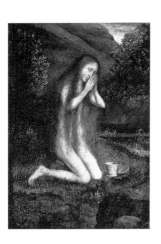

Massys, Quentin
Netherlandish, active Antwerp,
1466–1530
Saint Mary Magdalene
Companion to the following
painting
c. 1520–30
Oil on panel
12 1/4 × 8 3/8" (31.1 × 21.3 cm)

John G. Johnson Collection
cat. 367

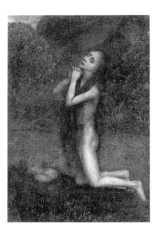

Massys, Quentin
Saint Mary of Egypt
Companion to the preceding
painting
c. 1520–30
Oil on panel
12 1/4 × 8 3/8" (31.1 × 21.3 cm)

John G. Johnson Collection
cat. 366

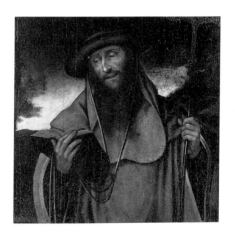

Massys, Quentin, follower of
Previously listed as Quentin
Massys (JFD 1972)
Saint Jerome
Early 16th century
Oil on panel
27 7/8 × 27" (70.8 × 68.6 cm)

John G. Johnson Collection
cat. 368

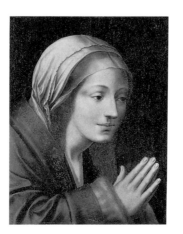

Massys, Quentin, imitator of
Previously listed as a Flemish
artist, c. 1600 (JFD 1972)
Virgin Praying
A strip has been added to each side
16th century
Oil on panel
18 9/16 × 13 3/8" (47.1 × 34 cm)

John G. Johnson Collection
inv. 1368

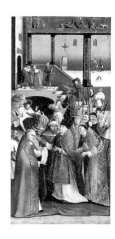

Master of Alkmaar (Cornelis Buys?), attributed to
Netherlandish, active Alkmaar
and Haarlem, active c. 1490–
c. 1520
Previously listed as Cornelis
Buys, the Master of Alkmaar
(JFD 1972)
The Death of Saint Alexis
Early 16th century
Oil on panel
29 × 14 1/8" (73.7 × 35.9 cm)

John G. Johnson Collection
cat. 351

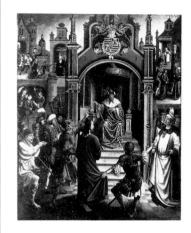

Master of the Beighem Altarpiece
Netherlandish, active Brussels,
active 1520–1540
*Christ before Pilate, with Christ Led
to Annas, the Mocking of Christ, the
Denial by Peter, and Christ before
Caiaphas*
c. 1520–40
Oil and gold on panel
67 7/8 × 50" (172.4 × 127 cm)

John G. Johnson Collection
cat. 362

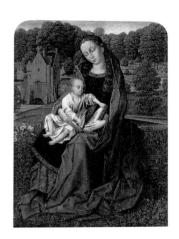

Master of the Embroidered Foliage
Netherlandish, active Brussels,
active c. 1490–c. 1520
Virgin and Child in a Landscape
The figures are based on Rogier
van der Weyden's *Virgin and
Child in a Niche*, in the Museo
del Prado, Madrid (2722)
c. 1500
Oil on panel
33 × 23 3/4" (83.8 × 60.3 cm)

John G. Johnson Collection
inv. 2518

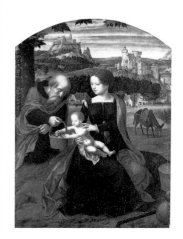

Master of the Female Half-Lengths
Netherlandish, active Antwerp,
active c. 1520–c. 1540
Rest on the Flight into Egypt
A 1 × 6" curved piece has been
added to the upper left corner
c. 1520–40
Oil on panel
33 1/8 × 24 7/16" (84.1 × 62.1 cm)

John G. Johnson Collection
cat. 389

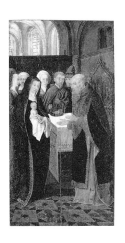

Master of Hoogstraeten
Netherlandish, active Antwerp,
active c. 1485–c. 1520
The Presentation of Christ in the Temple
Early 16th century
Center: MHPX
Oil on panel
26 × 13 ³/₈" (66 × 34 cm)

John G. Johnson Collection
cat. 370

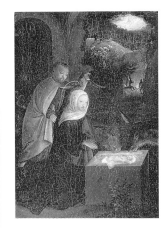

Master of Hoogstraeten
The Nativity
Panel from an altarpiece; see
previous two entries
Early 16th century
Oil on panel
6 ¹/₈ × 4 ⁵/₁₆" (15.6 × 10.9 cm)

John G. Johnson Collection
inv. 60c

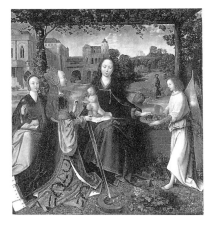

Master of Hoogstraeten
*Virgin and Child, with Saint
Catherine of Alexandria, a Female
Saint, and an Angel*
Early 16th century
Oil on panel
31 ¹⁵/₁₆ × 28 ³/₁₆" (81.1 × 71.6 cm)

John G. Johnson Collection
cat. 371

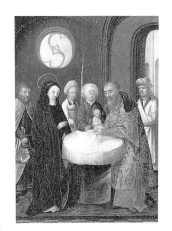

Master of Hoogstraeten
The Presentation of Christ in the Temple
Panel from an altarpiece; see
previous three entries
Early 16th century
Oil on panel
6 ¹/₈ × 4 ¹/₄" (15.6 × 10.8 cm)

John G. Johnson Collection
inv. 60d

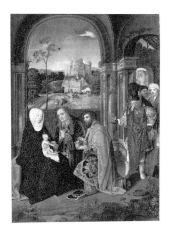

Master of Hoogstraeten
The Adoration of the Magi
Center panel from an altarpiece;
companion to the following four
panels
Early 16th century
Oil on panel
12 ¹/₂ × 7 ³/₈" (31.7 × 18.7 cm)

John G. Johnson Collection
inv. 60a

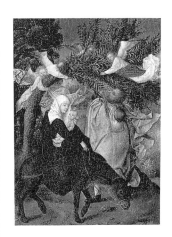

Master of Hoogstraeten
The Flight into Egypt
Panel from an altarpiece; see
previous four entries
Early 16th century
Oil on panel
6 ¹/₈ × 4 ⁵/₁₆" (15.6 × 10.9 cm)

John G. Johnson Collection
inv. 60e

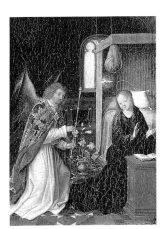

Master of Hoogstraeten
The Annunciation
Panel from an altarpiece; see
previous entry
Early 16th century
Oil on panel
6 ¹/₈ × 4 ³/₄" (15.6 × 12.1 cm)

John G. Johnson Collection
inv. 60b

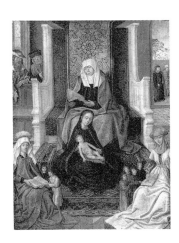

**Master of the Legend of
Saint Anna**
Netherlandish, active Ghent,
active c. 1475–c. 1500
Previously listed as in the manner
of the Master of the Legend of
Saint Ursula (JFD 1972)
The Holy Kinship
Late 15th century
Oil on panel
11 × 8" (27.9 × 20.3 cm)

John G. Johnson Collection
cat. 364

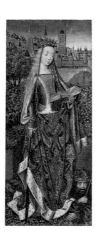

Master of the Legend of Saint Lucy
Netherlandish, active Bruges, active c. 1470–c. 1500
Saint Catherine of Alexandria, with the Defeated Emperor
Probably the left wing of a triptych
c. 1482
Oil on panel
26 1/4 × 10 5/8" (66.7 × 27 cm)

John G. Johnson Collection
cat. 326

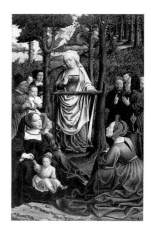

Master of the Magdalene Legend
Netherlandish, active Brussels, active c. 1480–c. 1520
Saint Mary Magdalene Preaching
Probably a right inner wing from an altarpiece; companion panels in the Statens Museum for Kunst, Copenhagen (Sp. 717); Museum of Fine Arts, Budapest (1338); Staatliches Museum, Schwerin, Germany (G. 196, G. 198); and (formerly) the Kaiser Friedrich Museum, Berlin (2128; destroyed)
c. 1500–20
Oil on panel
48 3/8 × 30 3/16" (122.9 × 76.7 cm)

John G. Johnson Collection
cat. 402

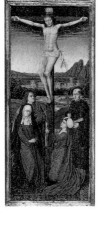

Master of the Legend of Saint Ursula
Netherlandish, active Bruges, active c. 1470–c. 1500
Portrait of a Man Praying
[possibly Ludovico Portinari]
Right panel from a votive diptych; the companion panel is in the Fogg Art Museum, Cambridge, Massachusetts (1943.07)
c. 1479
On reverse: [coat of arms of the Portinari family] / L P
Oil on panel
17 1/8 × 12 5/8" (43.5 × 32.1 cm)

John G. Johnson Collection
cat. 327

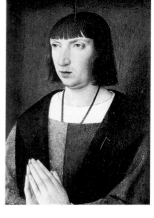

Master of the Magdalene Legend
Portrait of a Man Praying
Probably the right panel from a votive diptych
c. 1510–20
Oil on panel
14 5/8 × 10 7/8" (37.1 × 27.6 cm)

John G. Johnson Collection
cat. 410

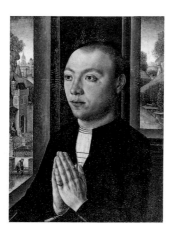

Master of the Legend of Saint Ursula, attributed to
The Crucifixion, with an Abbot Saint
Wing of a triptych; see following painting for reverse; a companion panel is in the Fitzwilliam Museum, Cambridge, England (1518a, b)
Late 15th century
On cross: INRI
Oil on panel
14 7/8 × 7" (37.8 × 17.8 cm)

John G. Johnson Collection
cat. 322a

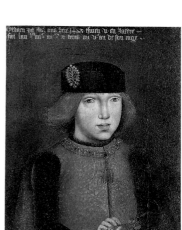

Master of the Magdalene Legend, attributed to
Previously listed as the Master of the Magdalene Legend (JFD 1972)
Portrait of Philip the Fair
Companion to the portrait of Margaret of Austria in the Musée National du Château de Versailles (MV 4026); 2" strip added at right 1483?
Across top: Gedaen Int Jaer ons here 1483 tsinen v en Jaerre / Fat Lan m. IIII c. IIII xx. z trois ou ve. an de son eage
Oil on panel
11 1/2 × 9 1/2" (29.2 × 24.1 cm)

John G. Johnson Collection
cat. 1175

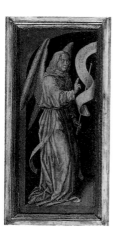

Master of the Legend of Saint Ursula, attributed to
Annunciate Angel
See previous entry
Late 15th century
On scroll: Ave gratia plena
Oil on panel
14 7/8 × 7" (37.8 × 17.8 cm)

John G. Johnson Collection
cat. 322b

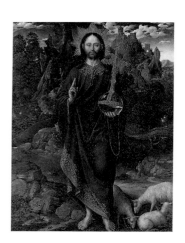

Master of the Mansi Magdalene
Netherlandish, active Antwerp, active c. 1510–c. 1530
Salvator Mundi in a Landscape
c. 1510–30
Oil and gold on panel
28 15/16 × 21 1/2" (73.5 × 54.6 cm)

John G. Johnson Collection
cat. 388

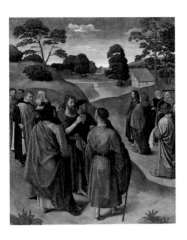

Master of the Saint John Altarpiece (Hugo Jacobsz.?)
Netherlandish, active Leiden and Gouda, first securely documented 1478, still active 1534
Saint John the Baptist Pointing out Christ as the Lamb of God
Companion panels are in the Museum Boymans–van Beuningen, Rotterdam
c. 1500–10
Oil on panel
48 × 37 5/8" (121.9 × 95.6 cm)

John G. Johnson Collection
cat. 347

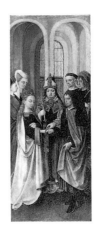

Master of the Virgin among Virgins, follower of
Netherlandish, active Delft, active c. 1480–c. 1500
Previously listed as the Master of the Virgin among Virgins (JFD 1972)
The Marriage of the Virgin
Late 15th century
Oil on panel transferred to canvas
44 3/8 × 17" (112.7 × 43.2 cm)

John G. Johnson Collection
cat. 349

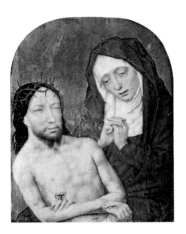

Master of Sir Thomas Louthe
Netherlandish, active Bruges or Ghent, active c. 1480
Previously listed as Simon Marmion (JFD 1972)
Pietà
Late 15th century
Tempera on vellum on panel
4 5/8 × 3 1/2" (11.7 × 8.9 cm)

John G. Johnson Collection
cat. 343

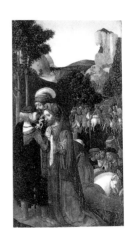

Master of the Virgin among Virgins, follower of
Previously listed as the Master of the Virgin among Virgins (JFD 1972)
Joseph of Arimathea and Nicodemus Asking Pilate for the Body of Christ [?]
Possibly the right wing from a triptych with the Crucifixion or the Descent from the Cross on its center panel
Late 15th century
Oil on panel
30 5/16 × 15 5/8" (77 × 39.7 cm)

John G. Johnson Collection
cat. 348

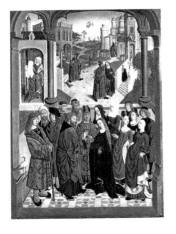

Master of the Tiburtine Sibyl
Netherlandish, active Louvain and Haarlem, active c. 1475–c. 1495
The Marriage of the Virgin, with the Expulsion of Saint Joachim from the Temple, the Angel Appearing to Saint Joachim, the Meeting at the Golden Gate, the Birth of the Virgin, and the Presentation of the Virgin
c. 1475–95
Oil on panel
57 × 40 1/2" (144.8 × 102.9 cm)

John G. Johnson Collection
cat. 344

Mauve, Anton
Dutch, active Haarlem, Amsterdam, The Hague, and Laren, 1838–1888
Milking Time
Late 1870s or 1880s
Lower right: A. Mauve f.
Oil on canvas
40 × 26" (101.6 × 66 cm)

The William L. Elkins Collection
E1924-3-13

Master of the Turin Adoration
Netherlandish, active southern Netherlands, active c. 1490–c. 1510
Christ Carrying the Cross, with the Entry of Christ into Jerusalem, Christ Driving the Moneychangers from the Temple, the Last Supper, Christ Crowned with Thorns, the Flagellation, "Ecce Homo," the Agony in the Garden, and the Crucifixion
c. 1500
Upper right, on banner: S P Q R
Oil on panel
37 × 66 1/2" (94 × 168.9 cm)

John G. Johnson Collection
cat. 338

Mauve, Anton
Cows in a Pasture
c. 1880
Lower left: A. Mauve
Oil on panel
8 5/8 × 11 5/16" (21.9 × 28.7 cm)

John G. Johnson Collection
cat. 1037

Mauve, Anton
Goose Girl
c. 1882
Lower right: AM
Oil on panel
18 5/16 × 13 11/16" (46.5 × 34.8 cm)

John G. Johnson Collection
cat. 1036

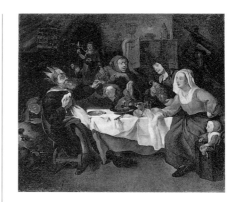

Metsu, Gabriel, copy after
Twelfth Night
After the painting in the
Bayerische Staatsgemälde-
sammlungen, Alte Pinakothek,
Munich (871)
17th century
Oil on canvas
28 × 31 9/16" (71.1 × 80.2 cm)

John G. Johnson Collection
cat. 508

Mauve, Anton
The Return of the Flock, Laren
c. 1886–87
Lower right: A. Mauve
Oil on canvas
39 7/16 × 63 1/2" (100.2 × 161.3 cm)

The George W. Elkins Collection
E1924-4-21

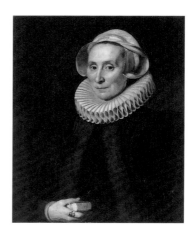

Metsu, Gabriel, copy after
Young Lady Sewing
After the painting in the State
Museum of A. S. Pushkin,
Moscow
17th century
Oil on canvas on panel
14 1/16 × 11 3/8" (35.7 × 28.9 cm)

John G. Johnson Collection
cat. 507

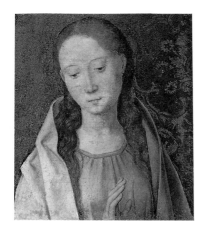

Memling, Hans
Netherlandish, active Bruges,
first documented 1465, died 1494
The Virgin
Fragment from a painting of the
Annunciation
Late 15th century
Oil on panel
11 1/2 × 9 3/4" (29.2 × 24.8 cm)

John G. Johnson Collection
cat. 324

Mierevelt, Michiel van
Dutch, active Delft, 1567–1641
*Portrait of a Fifty-Two-Year-Old
Woman*
1618?
Center right: AEtati[s] 52 / Ao
161[8?] / M. Mierevelt.
Oil on panel
28 1/8 × 22 1/2" (71.4 × 57.2 cm)

Gift of the family of J. J. Nevins
(1883–1968) in honor of
Marigene Harrington Butler
1992-41-1

Metsu, Gabriel
Dutch, active Leiden and
Amsterdam, 1629–1667
Previously listed as Frans van
Mieris the Elder (JFD 1972)
Young Woman at a Window
17th century
Center left: G. Metsu
Oil on panel
9 1/2 × 6 7/8" (24.1 × 17.5 cm)

John G. Johnson Collection
cat. 543

Mieris, Frans van
Dutch, active Leiden,
1635–1681
Portrait of a Husband and Wife
1675
Lower right: F van Mieris 1675
Oil on panel
10 × 8 1/16" (25.4 × 20.5 cm)

John G. Johnson Collection
inv. 310

Molenaer, Claes
Dutch, active Haarlem,
c. 1630–1676
Castle near a Canal
17th century
Lower left: K. Molenaer
Oil on panel
16 1/8 × 13 15/16" (41 × 35.4 cm)

John G. Johnson Collection
cat. 576

Momper, Frans de
Flemish, active Antwerp,
1603–1660
Mountainous Landscape with a River
c. 1640
Oil on panel
14 1/2 × 24 1/2" (36.8 × 62.2 cm)

The Henry P. McIlhenny
Collection in memory of
Frances P. McIlhenny
1986-26-276

Molenaer, Claes, imitator of
Previously listed as Claes
Molenaer (JFD 1972)
Windmill on the Dunes
17th century
Oil on panel
19 7/8 × 27 3/8" (50.5 × 69.5 cm)

John G. Johnson Collection
cat. 577

Momper, Frans de
Street in an Italian Village
17th century
Lower left (spurious): Av. / Neer
Oil on panel
15 1/16 × 24 11/16" (38.3 × 62.7 cm)

John G. Johnson Collection
cat. 655

Molenaer, Jan Miense
Dutch, active Haarlem and
Amsterdam, c. 1610–1668
Quarreling Children
c. 1630
Oil on canvas
18 1/2 × 25 3/8" (47 × 64.4 cm)

John G. Johnson Collection
cat. 438

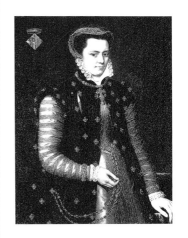

Mor van Dashorst, Anthonis
Netherlandish, active Utrecht,
Antwerp, Brussels, Lisbon, and
Madrid, first securely documented
1547, died 1576
Portrait of Margaret of Parma
16th century
Oil on panel transferred to canvas
38 1/2 × 28 1/4" (97.8 × 71.7 cm)

John G. Johnson Collection
cat. 428

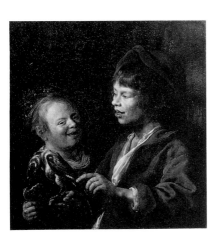

Molenaer, Jan Miense
Two Children Feeding a Bird
17th century
Oil on panel
22 13/16 × 20 3/16" (57.9 × 51.3 cm)

John G. Johnson Collection
cat. 439

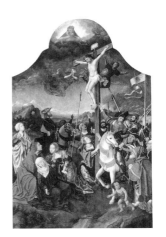

Mostaert, Jan
Netherlandish, active Haarlem
and Mechelen, 1472/73–1555/56
The Crucifixion
c. 1530
On cross: INRI
Oil on panel
45 1/8 × 29 3/8" (114.6 × 74.6 cm)

John G. Johnson Collection
cat. 411

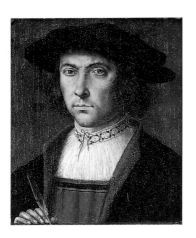

Mostaert, Jan, follower of
Previously listed as Jan Mostaert
(PMA 1965)
Portrait of a Man
c. 1520–30
Oil on panel
8 15/16 × 7 5/16" (22.7 × 18.6 cm)

The John D. McIlhenny
Collection
1943-40-42

Neer, Aert van der
Dutch, active Amsterdam,
1603/4–1677
Landscape with a River at Twilight
Late 1640s or early 1650s
Lower left: AVDN
Oil on panel
7 1/4 × 11 1/4" (18.4 × 28.6 cm)

The William L. Elkins Collection
E1924-3-52

**Moucheron, Isaac de,
imitator of**
Dutch, active Amsterdam,
1667–1744
Classical Landscape
Late 17th century
Oil on canvas
38 1/2 × 52" (97.8 × 132.1 cm)

Bequest of Arthur H. Lea
F1938-1-28

**Neer, Aert van der,
attributed to**
Previously listed as Aert van der
Neer (JFD 1972)
Moonlight on a Canal
Mid-17th century
Lower left: AVDN
Oil on canvas
25 9/16 × 33 1/2" (64.9 × 85.1 cm)

John G. Johnson Collection
cat. 553

**Natus, Johannes,
attributed to**
Dutch, active Middelburg,
active c. 1658–c. 1662
Previously listed as a Dutch
artist, mid-17th century (JFD
1972)
Village Surgeon
Mid-17th century
Lower right: He d
Oil on panel
23 5/8 × 18 7/8" (60 × 47.9 cm)

John G. Johnson Collection
cat. 511

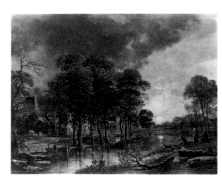

**Neer, Aert van der,
follower of**
Previously listed as Aert van der
Neer (PMA 1965)
*Landscape with a Brook and a
Village in Moonlight*
1650s
Oil on canvas
25 1/2 × 32 1/2" (64.8 × 82.5 cm)

Purchased with the W. P.
Wilstach Fund
W1895-1-7

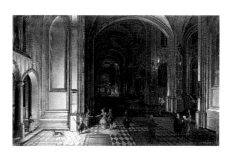

**Neeffs, Peter, the Elder,
attributed to**
Flemish, active Antwerp,
c. 1578–c. 1659
**and Frans Francken III,
attributed to**
Flemish, active Antwerp,
1607–1667
Previously listed as Peter Neeffs
the Younger (JFD 1972)
Interior of a Church with Torchlight
c. 1610–60
Oil on panel
10 3/16 × 15 5/8" (25.9 × 39.7 cm)

John G. Johnson Collection
cat. 708

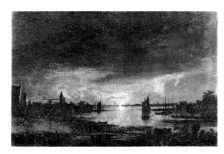

**Neer, Aert van der,
imitator of**
Harbor
17th century
Oil on canvas
20 1/8 × 30 1/16" (51.1 × 76.4 cm)

John G. Johnson Collection
inv. 2862

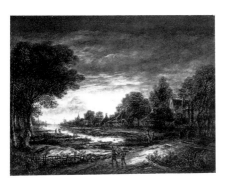

Neer, Aert van der, imitator of
Previously listed as a copy after
Aert van der Neer (JFD 1972)
Moonlight on a Canal
17th century
Lower right (spurious): AVDN
Oil on panel
12 $^{15}/_{16}$ × 16 $^1/_4$" (32.9 × 41.3 cm)

John G. Johnson Collection
cat. 555

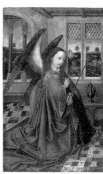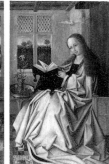

Netherlandish, active southern Netherlands, unknown artist
Previously listed as an unknown
artist, c. 1460 (JFD 1972)
The Annunciation
Diptych
c. 1450–70
Oil on panel
Each panel: 26 $^1/_4$ × 15 $^9/_{16}$"
(66.7 × 39.5 cm)

John G. Johnson Collection
cat. 320

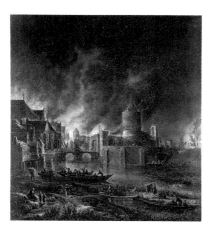

Neer, Aert van der, copy after
Fire at Night
17th century
Oil on canvas
25 $^1/_4$ × 22 $^3/_8$" (64.1 × 56.8 cm)

John G. Johnson Collection
cat. 554

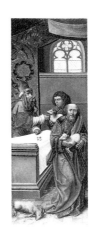

Netherlandish or German, unknown artist
Previously listed as a Brussels
artist, c. 1470 (JFD 1972)
The Expulsion of Saint Joachim from the Temple
Companion to the following
painting
c. 1475–1500
Oil on panel
30 $^7/_8$ × 11 $^1/_4$" (78.4 × 28.6 cm)

John G. Johnson Collection
inv. 339

Netherlandish?, unknown artist
Previously listed as a Bruges
artist, c. 1460 (JGJ 1941)
Saint Catherine of Alexandria Preaching to the Emperor
Probably from a series; a
companion panel is in the
Museum Boymans–van
Beuningen, Rotterdam (2468)
c. 1440–60
Oil on panel
14 $^7/_8$ × 9 $^1/_2$" (37.8 × 24.1 cm)

John G. Johnson Collection
cat. 319

Netherlandish or German, unknown artist
Previously listed as a Brussels
artist, c. 1470 (JFD 1972)
The Meeting at the Golden Gate
Companion to the preceding
painting
c. 1475–1500
Oil on panel
30 $^{13}/_{16}$ × 11" (78.3 × 27.9 cm)

John G. Johnson Collection
inv. 347

Netherlandish, active Utrecht?, unknown artist
Previously listed as an unknown
artist, c. 1450 (JFD 1972)
The Crucifixion
c. 1440–60
On cross: inri
Oil on panel
7 $^7/_8$ × 8 $^7/_8$" (20 × 22.5 cm)

John G. Johnson Collection
cat. 316

Netherlandish?, unknown artist
Previously listed as a Brussels
artist, c. 1500 (JGJ 1941)
The Annunciation
Diptych
c. 1480–1520
Oil on panel
Each panel: 24 $^7/_8$ × 14 $^1/_2$"
(63.2 × 36.8 cm)

John G. Johnson Collection
cat. 398 a, b

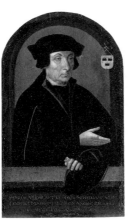

Netherlandish, active northern Netherlands, unknown artist
Previously listed as a Dutch artist, c. 1520 (JFD 1972)
Portrait of Peter Veenlant, Burgomaster of Schiedam
1489
Across bottom: PETRUS VEEN-LANT CONSUL SCHIEDAMENSIS. / TEMPORE MAXIMILIANI ROMA-NORU REGIS—ET / COMITIS HOLLANDIAE. ANO 1489.
Oil on panel
17 5/8 × 10 1/4" (44.8 × 26 cm)

John G. Johnson Collection
cat. 345

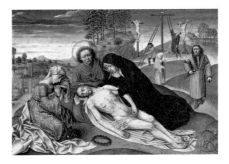

Netherlandish, active Brussels or Bruges, unknown artist
Previously listed as a Brussels artist, c. 1500 (JFD 1972)
Lamentation
c. 1490–1510
Oil on panel
11 3/8 × 15 5/16" (28.9 × 38.9 cm)

John G. Johnson Collection
cat. 337

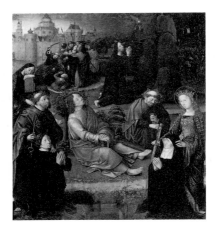

Netherlandish, active northern Netherlands, unknown artist
Previously listed as the Amsterdam Master of the Death of the Virgin (JFD 1972)
The Agony in the Garden, with the Betrayal of Christ, Saints Peter and Catherine of Alexandria, and Two Donors
c. 1490–1500
Oil and gold on panel
32 5/8 × 28 9/16" (82.9 × 72.5 cm)

John G. Johnson Collection
cat. 751

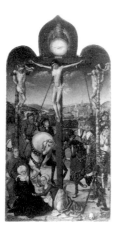

Netherlandish, active northern Netherlands?, unknown artist
Previously listed as a Bruges artist, c. 1480 (JFD 1972)
The Crucifixion
c. 1490–1510
On cross: INRI; lower right, on caparison of horse: DORO DORO; lower right, on edge of armor: HELGIEO [?] ALV M
Oil on panel
24 1/2 × 12 1/4" (62.2 × 31.1 cm)

John G. Johnson Collection
cat. 323

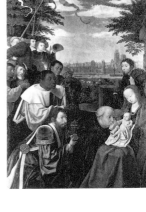

Netherlandish, active Antwerp, unknown artist
Previously listed as the Master of the Morrison Triptych (JFD 1972)
The Adoration of the Magi
By the same artist who painted a triptych in the National Gallery, London (1085)
c. 1500–10
Oil on panel
65 3/4 × 42 3/4" (167 × 108.6 cm)

John G. Johnson Collection
cat. 369

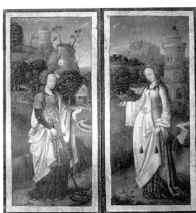

Netherlandish, active Antwerp?, unknown artist
Previously listed as an Antwerp Mannerist, c. 1510 (JFD 1972)
Saints Catherine of Alexandria and Barbara
Wings from a triptych
c. 1500–20
Oil and gold on panel
Left panel: 13 13/16 × 6 1/8" (35.1 × 15.6 cm); right panel: 13 7/8 × 6 1/8" (35.2 × 15.6 cm)

John G. Johnson Collection
cat. 381

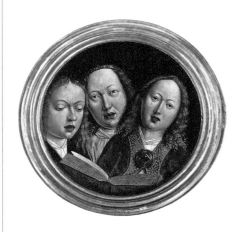

Netherlandish, unknown artist
Previously listed as a Bruges artist, c. 1500 (JFD 1972)
Three Singing Angels
Based on the panel from the Ghent Altarpiece, by Jan van Eyck, depicting singing angels, in the Cathedral of Saint Bavo, Ghent; see the following painting for reverse
c. 1500–25
Oil on panel
10 11/16" (27.1 cm) diameter

John G. Johnson Collection
cat. 317 a

Netherlandish, unknown artist
Previously listed as a Bruges artist, c. 1500 (JFD 1972)
Two Putti Holding a Shield
Reverse of the preceding painting
c. 1500–25
On frame: VT VIDEAM VIRTVTEM TVAM
Oil on panel
10 11/16" (27.1 cm) diameter

John G. Johnson Collection
cat. 317 b

Netherlandish, active northern Netherlands, unknown artist
Previously listed as a remote follower of Hieronymus Bosch (JFD 1972)
The Flagellation, with a Donor, and Christ Carrying the Cross
Possibly wings from a triptych
c. 1505–15
Oil and gold on panel
Right panel: 41 ¹³/₁₆ × 13 ¹/₄" (106.2 × 33.6 cm); left panel: 42 ¹/₁₆ × 13 ³/₁₆" (106.8 × 33.5 cm)

John G. Johnson Collection
cat. 408

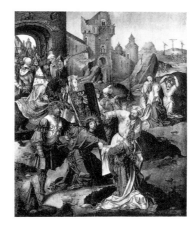

Netherlandish, active Antwerp, unknown artist
Previously listed as the Master of the Groote Adoration (JFD 1972)
Christ Carrying the Cross
c. 1515–25
Oil and gold on panel
40 × 32 ¹/₄" (101.6 × 81.9 cm)

John G. Johnson Collection
cat. 384

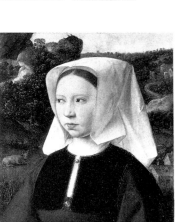

Netherlandish, active northern Netherlands?, unknown artist
Previously listed as a Netherlands artist, first half of the 16th century (JFD 1972)
Portrait of a Woman
Possibly a fragment of a panel from a diptych or a fragment of the right wing from a triptych
c. 1510–30
Oil on panel
10 ¹/₈ × 8 ³/₁₆" (25.7 × 20.8 cm)

John G. Johnson Collection
cat. 379

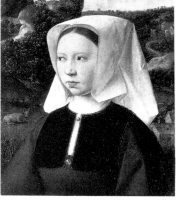

Netherlandish, active Antwerp, unknown artist
Previously listed as the Master of the Groote Adoration (JFD 1972)
The Adoration of the Magi
c. 1515–25
Oil on panel
27 ⁵/₈ × 21 ¹/₄" (70.2 × 54 cm)

John G. Johnson Collection
cat. 383

Netherlandish, active Antwerp?, unknown artist
Previously listed as an Antwerp Mannerist, c. 1520 (JFD 1972)
Saint Catherine of Alexandria, with the Defeated Emperor
Possibly the right wing from a triptych
c. 1510–30
Oil on panel
35 ⁹/₁₆ × 12" (90.3 × 30.5 cm)

John G. Johnson Collection
cat. 365

Netherlandish, active Antwerp, unknown artist
Previously listed as an Antwerp artist, perhaps to be identified with the Master of 1518 (JFD 1972)
The Adoration of the Magi
c. 1515–25
Oil on panel
30 × 21 ⁷/₈" (76.2 × 55.6 cm)

John G. Johnson Collection
cat. 385

Netherlandish, active Antwerp, unknown artist
Previously listed as an Antwerp Mannerist, c. 1520 (JFD 1972)
The Adoration of the Shepherds
c. 1510–30
Oil on panel
58 ³/₈ × 69 ⁷/₈" (148.3 × 177.5 cm)

John G. Johnson Collection
cat. 380

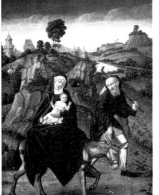

Netherlandish, unknown artist
Previously listed as a Flemish artist, mid-16th century (JGJ 1941)
The Flight into Egypt
c. 1520
Oil on panel
37 ¹/₂ × 24 ³/₄" (95.2 × 62.9 cm)

John G. Johnson Collection
inv. 2840

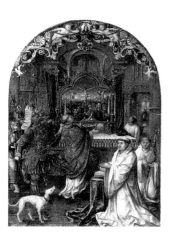

Netherlandish, active Antwerp, unknown artist
The Seizing of Saint Mark
c. 1520
Oil and gold on panel
14 5/8 × 11" (37.1 × 27.9 cm)

John G. Johnson Collection
cat. 384a

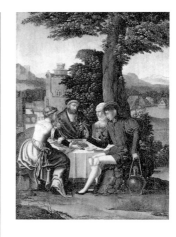

Netherlandish or German, unknown artist
Previously listed as a South German artist, c. 1560 (JGJ 1941)
Courtly Scene
c. 1525–30
Oil on panel
23 3/16 × 16 1/2" (58.9 × 41.9 cm)

John G. Johnson Collection
inv. 3023

Netherlandish, active Antwerp?, unknown artist
Previously listed as an Antwerp artist, c. 1510–20 (JFD 1972)
The Agony in the Garden
c. 1520–25
Oil on panel
11 11/16 × 7 3/4" (29.7 × 19.7 cm)

John G. Johnson Collection
cat. 382

Netherlandish, active Antwerp, unknown artist
Previously listed as an Antwerp artist, c. 1530 (JFD 1972)
Saint Jerome in His Study
Derived from the painting by Albrecht Dürer (German, 1471–1528) in the Museu Nacional de Arte Antiga, Lisbon
c. 1530–40
Center: OMNE HOQA.MORICS / NOSCE SVM
Oil on panel
29 5/8 × 23 9/16" (75.2 × 59.8 cm)

John G. Johnson Collection
cat. 387

Netherlandish, active Antwerp, unknown artist
Previously listed as an Antwerp Mannerist, c. 1530 (JFD 1972)
The Resurrection
Probably the right wing from a triptych
c. 1520–30
Oil on panel
12 7/16 × 2 3/8" (31.6 × 6 cm)

John G. Johnson Collection
cat. 412

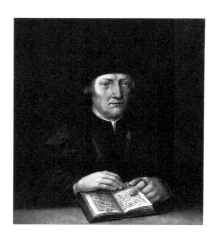

Netherlandish, active Antwerp?, unknown artist
Previously listed as an Antwerp artist, c. 1530 (JFD 1972)
Portrait of a Man with a Book of Hours
c. 1530–50
On book: [Latin text from the Gospels of Luke and John]
Oil on panel transferred to canvas
20 1/4 × 17 3/4" (51.4 × 45.1 cm)

John G. Johnson Collection
cat. 376

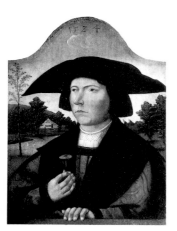

Netherlandish, active northern Netherlands, unknown artist
Previously listed as the Master of 1518 (JFD 1972)
Portrait of a Man Holding a Pink
1524
Center top: 1524
Oil on panel
22 7/8 × 17 1/4" (58.1 × 43.8 cm)

John G. Johnson Collection
inv. 2056

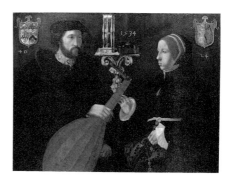

Netherlandish, active England?, unknown artist
Previously listed as an unknown artist, working 1534 (JFD 1972)
Portrait of a Husband and Wife
1534
Upper left: 40; center top: 1534; upper right: 24; on book: VERBVM DNI MANET IN ETERNVM
Oil on panel
33 3/4 × 43 3/4" (85.7 × 111.1 cm)

John G. Johnson Collection
cat. 392

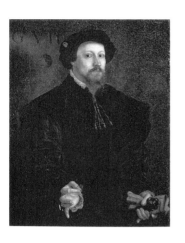

**Netherlandish,
unknown artist**
Previously listed as Johannes
Stephen von Calcar (JFD 1972)
*Portrait of a Gentleman Holding a
Ring*
c. 1545–55
Upper left: G.VIIF / N
Oil on panel
37 3/16 × 27 9/16" (94.5 × 70 cm)

John G. Johnson Collection
cat. 418

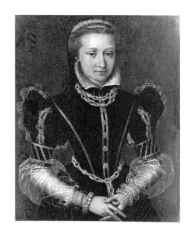

**Netherlandish,
unknown artist**
Previously attributed to François
Clouet (JGJ 1941)
Portrait of a Lady
1566
Upper right: 1566
Oil on panel
12 3/8 × 9 1/4" (31.4 × 23.5 cm)

John G. Johnson Collection
cat. 772

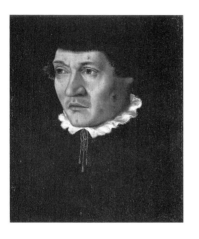

**Netherlandish,
unknown artist**
Previously listed as Nicolaes
Neufchatel (JGJ 1941)
Portrait of a Man
c. 1545–55
Oil on panel
19 1/2 × 7 1/4" (49.5 × 18.4 cm)

John G. Johnson Collection
cat. 397

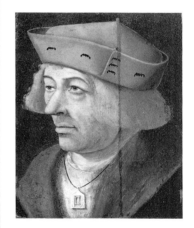

**Netherlandish?,
unknown artist**
Previously listed as a Flemish
artist, second half of the 16th
century (JFD 1972)
Portrait of a Man in a Red Hat
16th century
Oil on panel
13 1/8 × 10" (33.3 × 25.4 cm)

John G. Johnson Collection
cat. 426

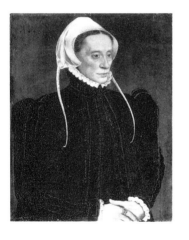

**Netherlandish, active
southern Netherlands,
unknown artist**
Previously attributed to Adriaen
Thomas Key (JFD 1972)
Portrait of a Lady
1558
Upper left: 1558
Oil on panel
27 × 20 1/4" (68.6 × 51.4 cm)

John G. Johnson Collection
cat. 427

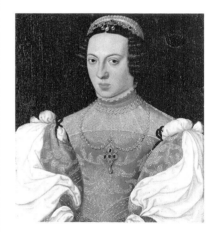

**Netherlandish,
unknown artist**
Previously listed as a Flemish
artist, c. 1530 (JFD 1972)
Portrait of a Lady
In a style of c. 1525–35
19th century
Oil on panel
12 1/4 × 10 3/4" (31.1 × 27.3 cm)

John G. Johnson Collection
inv. 387

**Netherlandish, active
Bruges, unknown artist**
Previously listed as a Bruges
artist, c. 1570 (JFD 1972)
*Portrait of a Man Kneeling before a
Crucifix in a Landscape*
The medallion worn by the man
indicates that he was a member of
a confraternity of the Holy Cross
c. 1565–75
On cross: INRI
Oil on panel
28 × 21 3/4" (71.1 × 55.2 cm)

John G. Johnson Collection
cat. 363

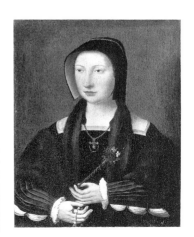

**Netherlandish,
unknown artist**
Previously listed as the school of
Joos van Cleve (JFD 1972)
*Portrait of a Lady with a Nosegay
and a Rosary*
In a style of c. 1520–30
19th century
Oil on panel
13 3/4 × 10 5/8" (34.9 × 27 cm)

John G. Johnson Collection
cat. 372

**Netherlandish,
unknown artist**
Virgin and Child
In a 15th-century style
19th century
Oil on panel
11 ½ × 8 ⅞" (29.2 × 22.5 cm)

John G. Johnson Collection
inv. 2847

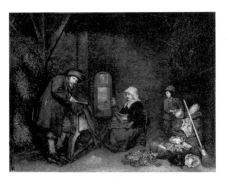

Netscher, Caspar
Dutch, active Arnhem, Deventer,
France, and The Hague,
c. 1639–1684
Chaffcutter with His Wife and Child
c. 1662–64
On base of cutter (date spurious):
C. Nets 164
Oil on canvas
26 ⅛ × 31" (66.4 × 78.7 cm)

John G. Johnson Collection
cat. 544

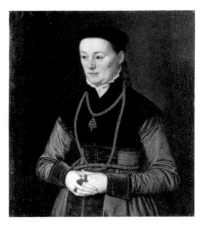

**Neufchatel, Nicolas,
attributed to**
Netherlandish, active
Nuremburg, born c. 1525,
still active c. 1565
*Portrait of a Thirty-Four-Year-Old
Woman*
1562
Upper right: Ao. 1562. /
AETATIS. 34.
Oil on canvas
29 ¾ × 26 ⅛" (75.6 × 66.4 cm)

John G. Johnson Collection
inv. 2095

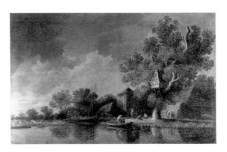

Neyn, Pieter de
Dutch, active Leiden,
1597–1639
Landscape with a Canal
Early 17th century
On boat (spurious): IVG 1644
Oil on panel
16 ½ × 25 ⅜" (41.9 × 64.4 cm)

John G. Johnson Collection
cat. 465

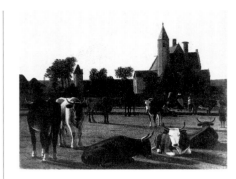

**Oever, Hendrick ten,
attributed to**
Dutch, active Zwolle,
1639–1716
Previously listed as Hendrick ten
Oever (JFD 1972)
Cattle near a Castle
17th century
Oil on canvas
21 ⁹⁄₁₆ × 27" (54.8 × 68.6 cm)

John G. Johnson Collection
cat. 561

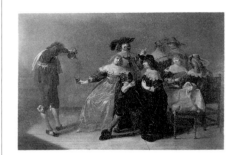

Olis, Jan
Dutch, active Rome, Dordrecht,
and Heusden, c. 1610–1676
Cavaliers and Ladies
1637
Center right: J Olis fe 1637
Oil on panel
15 ⁹⁄₁₆ × 23" (39.5 × 58.4 cm)

John G. Johnson Collection
cat. 446

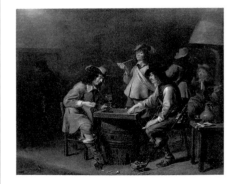

Olis, Jan
Soldiers Playing Draughts
1646
Lower right: .JOlis . fecit / .Ao .
1646.—
Oil on panel
22 ⅝ × 27" (57.5 × 68.6 cm)

John G. Johnson Collection
cat. 447

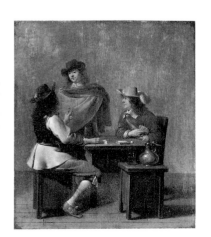

Olis, Jan
Card Players
Mid-17th century
Center: JO
Oil on panel
14 ⅛ × 11 ⅞" (35.9 × 30.2 cm)

John G. Johnson Collection
cat. 448

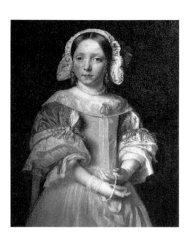

Oost, Jakob van, the Elder, attributed to
Flemish, active Italy and Bruges, 1601–1671
Previously listed as a Flemish artist, c. 1660 (JFD 1972)
Portrait of a Girl
Early 17th century
Oil on canvas
29 3/8 × 22 3/4" (74.6 × 57.8 cm)

John G. Johnson Collection
inv. 335

Ostade, Adriaen van
Dutch, active Haarlem, 1610–1685
Peasants Making Merry
1640
Lower right: A V OSTADE 1640
Oil on panel
8 7/8 × 9 1/16" (22.5 × 23 cm)

John G. Johnson Collection
cat. 521

Oostsanen, Jacob Cornelisz. van, workshop of
Netherlandish, active Amsterdam, first documented 1507, died 1533
The Crucifixion
Early 16th century
On cross: I N R I
Oil on panel
39 × 31 3/4" (99.1 × 80.6 cm)

John G. Johnson Collection
cat. 409

Ostade, Adriaen van
Peasants Drinking at a Window
c. 1640–70
Center bottom: AV. OSTADE
Oil on panel
11 1/4 × 9 1/8" (28.6 × 23.2 cm)

John G. Johnson Collection
cat. 522

Orley, Bernard van
Netherlandish, active Brussels, first documented 1515, died 1542
The Adoration of the Magi
c. 1520–40
Center right, on scabbard: MAGI AB ORIENTE
Oil on panel
13 5/16 × 18 1/8" (33.8 × 46 cm)

John G. Johnson Collection
cat. 400

Ostade, Adriaen van
Peasants Drinking and Making Music
Companion to *Peasants Fighting*, dated 1647, in an unknown location
1647?
Lower right: [illegible signature]
Oil on panel
10 5/8 × 14" (27 × 35.6 cm)

The William L. Elkins Collection
E1924-3-72

Orley, Bernard van, copy after
The Crucifixion
After the center panel of a triptych in the church of Onze Lieve Vrouw, Bruges
16th century
On cross: INRI
Oil on panel
44 3/16 × 32 13/16" (112.2 × 83.3 cm)

John G. Johnson Collection
cat. 401

Ostade, Adriaen van
Woman Leaning out a Half-Door
1660s?
Center bottom: Av Ostade
Oil on panel
10 5/8 × 8 5/8" (27 × 21.9 cm)

The William L. Elkins Collection
E1924-3-71

Ostade, Adriaen van, attributed to
Previously listed as Adriaen van Ostade (JFD 1972)
Portrait of an Elderly Lady
17th century
Center right: A Ostade
Oil on panel
6 × 5 3/8" (15.2 × 13.6 cm)

John G. Johnson Collection
inv. 1258

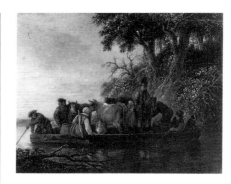

Ostade, Isaack van, attributed to
Previously listed as Isaack van Ostade (JFD 1972)
The Ferry
Mid-17th century
Oil on panel
9 7/8 × 12 1/4" (25.1 × 31.1 cm)

John G. Johnson Collection
cat. 525

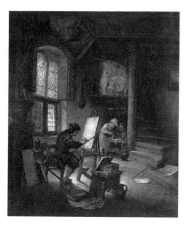

Ostade, Adriaen van, copy after
Interior with Figures
After the etching (Bartsch 39)
17th century
Oil on panel
3 3/8 × 2 7/8" (8.6 × 7.3 cm)

John G. Johnson Collection
inv. 194a

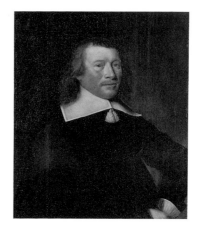

Palamedesz., Anthonie
Dutch, active Delft and Amsterdam, 1601–1673
Previously attributed to Anthonie Palamedesz. (PMA 1965)
Still Life with a Woman, a Boy, and a Dog
1640s?
Lower left: A. Palamedes
Oil on canvas
48 3/4 × 66" (123.8 × 167.6 cm)

The William L. Elkins Collection
E1924-3-53

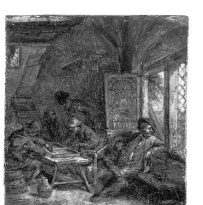

Ostade, Adriaen van, copy after
Painter in His Studio
After the etching (Bartsch 32)
17th century
Oil on panel
18 1/8 × 14 3/4" (46 × 37.5 cm)

John G. Johnson Collection
cat. 523

Palamedesz., Anthonie, attributed to
Previously listed as Anthonie Palamedesz. (JFD 1972)
Portrait of a Man
17th century
Oil on panel
29 1/4 × 23 3/4" (74.3 × 60.3 cm)

John G. Johnson Collection
inv. 1350

Ostade, Isaack van
Dutch, active Haarlem, 1621–1649
Peasants in a Barn
c. 1640–49
Center bottom: Isack van Ostade 16
Oil on panel
15 × 14 7/16" (38.1 × 36.7 cm)

John G. Johnson Collection
cat. 524

Patinir, Joachim
Netherlandish, active Antwerp, c. 1485–1524
The Assumption of the Virgin, with the Nativity, the Resurrection, the Adoration of the Magi, the Ascension of Christ, Saint Mark and an Angel, and Saint Luke and an Ox
c. 1510–20
Lower right, on coat of arms of Lucas Rem: ISTZ GVOT SO GEBS GO[T]
Oil on panel
24 1/2 × 23 1/8" (62.2 × 58.7 cm)

John G. Johnson Collection
cat. 378

Patinir, Joachim, workshop of
Previously listed as Joachim Patinir (PMA 1965)
Landscape with Saint John the Baptist Preaching
1516–17?
Lower right, on coat of arms:
POST TENEBRAS / SPERO LUC[EM]
Oil on panel
14 3/4 × 20" (37.5 × 50.8 cm)

Gift of Mrs. Gordon A. Hardwick and Mrs. W. Newbold Ely in memory of Mr. and Mrs. Roland L. Taylor
1944-9-2

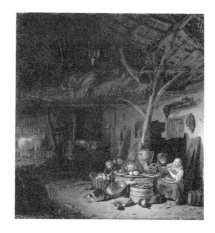

Poel, Egbert Lievensz. van der
Dutch, active Delft and Rotterdam, 1621–1664
The Barn
1648
Lower right: E V Poel 1648
Oil on panel
23 1/2 × 20" (59.7 × 50.8 cm)

John G. Johnson Collection
cat. 551

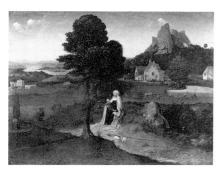

Patinir, Joachim, workshop of
Rest on the Flight into Egypt
Early 16th century
Oil on panel
18 1/4 × 23 15/16" (46.3 × 60.8 cm)

John G. Johnson Collection
cat. 377

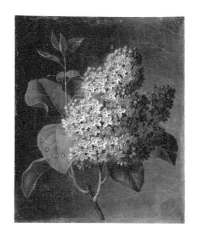

Pol, Christiaen van
Dutch, active Antwerp and France, 1752–1813
Lilac Blossoms
c. 1800
Lower left: VP
Oil on canvas
10 13/16 × 8 5/8" (27.5 × 21.9 cm)

John G. Johnson Collection
cat. 713

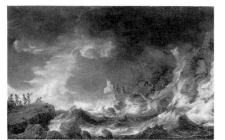

Peeters, Bonaventura
Flemish, active Antwerp, 1614–1652
Shipwreck on a Rocky Coast
c. 1640
Lower left: B P
Oil on panel
18 13/16 × 28 5/8" (47.8 × 72.7 cm)

Purchased with the Director's Discretionary Fund
1970-2-1

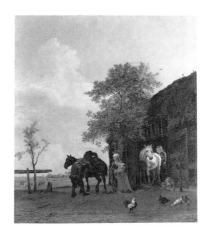

Potter, Paulus
Dutch, active The Hague, Delft, and Amsterdam, 1625–1654
Figures with Horses by a Stable
1647
Lower left: Paulus Potter. f. 1647
Oil on panel
17 3/4 × 14 3/4" (45.1 × 37.5 cm)

The William L. Elkins Collection
E1924-3-17

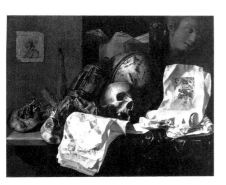

Peschier, N. L.
Netherlandish, active 1659–1661
Vanitas
1661
Lower left: N vs Le Peschier Fecit / 1661
Oil on canvas
31 1/2 × 40" (80 × 101.6 cm)

The Henry P. McIlhenny Collection in memory of Frances P. McIlhenny
1986-26-287

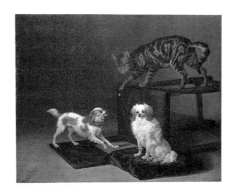

Potter, Paulus, follower of
Previously listed as an imitator of Paulus Potter (JFD 1972)
Cat Playing with Two Dogs
17th century
Lower right (spurious): Paulus Potter f. 1652
Oil on canvas
36 1/2 × 43" (92.7 × 109.2 cm)

John G. Johnson Collection
cat. 618

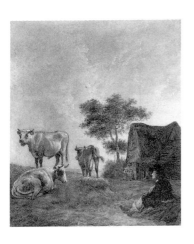

Potter, Paulus, imitator of
Landscape with Cows
17th century
Lower left (spurious): Paulus
Potter 16[]9
Oil on panel
19 5/8 × 15 1/2" (49.8 × 39.4 cm)

John G. Johnson Collection
inv. 2829

Potter, Paulus, copy after
Bellowing Bull
After a lost painting
17th century
Oil on canvas
36 1/4 × 45 1/2" (92.1 × 115.6 cm)

John G. Johnson Collection
cat. 619

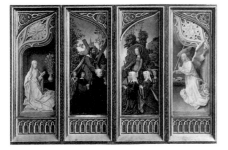

Provost, Jan
Netherlandish, active Antwerp
and Bruges, first documented
1493, died 1529
*The Annunciate Virgin, Saint
Andrew with a Donor and His Sons,
Saint Catherine of Alexandria with
a Donor and Her Daughters, and the
Annunciate Angel*
Wings from a triptych, made
into four panels
Early 16th century
Oil on panel
Far left panel: 23 3/8 × 8 3/8"
(59.4 × 21.3 cm); left panel:
23 3/8 × 8 1/4" (59.4 × 20.9 cm);
right panel: 23 1/8 × 8 5/8"
(58.7 × 21.9 cm); far right panel:
23 1/8 × 8 11/16" (58.7 × 22.1 cm)

John G. Johnson Collection
cat. 355

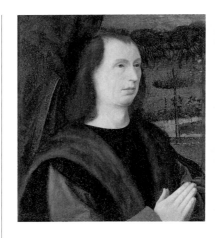

Provost, Jan, attributed to
Previously listed as Jan Provost
(JFD 1972)
Portrait of a Donor Praying
Fragment from left wing of a trip-
tych from San Colombeno, Genoa,
now in the Galleria di Palazzo
Bianco, on loan from the Ospedale
Civile di San Martino, Genoa; cor-
responding fragment from right
wing is in the Thyssen-Bornemisza
Collection, Madrid (255)
Early 16th century
Oil on panel
21 5/16 × 18 7/16" (54.1 × 46.8 cm)

John G. Johnson Collection
cat. 273

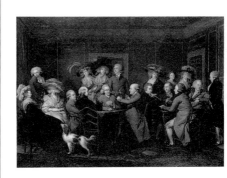

**Puyl, Louis François Gérard
van der**
Dutch, active France, England,
Utrecht, and Amsterdam,
1750–1824
*Portrait of Thomas Payne with His
Family and Friends*
1787
Lower right: L. F. G. van der Puyl
pt / 1787
Oil on canvas
35 × 47" (88.9 × 119.4 cm)

Gift of John Howard McFadden, Jr.
1951-125-17

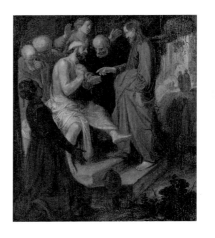

Pynas, Jan Symonsz.
Dutch, active Haarlem and
Amsterdam, 1583–1631
The Raising of Lazarus
Strips 4" wide have been added to
the top and right
1615?
Oil on panel
22 3/4 × 19 7/8" (57.8 × 50.5 cm)

John G. Johnson Collection
cat. 471

Quellinus, Erasmus, II
Flemish, active Antwerp,
1607–1678
*Saint Thomas Touching Christ's
Wounds*
1644
Lower right: Erasmus Quellinus
Delineat Anno 1644
Oil on panel
15 3/8 × 21 9/16" (39 × 54.8 cm)

John G. Johnson Collection
cat. 776

Ravesteyn, Jan Anthonisz. van
Dutch, active The Hague, 1572–1657
Portrait of a Lady and Her Child
c. 1625
Upper right: Ano [illegible date]
Oil on panel
38 3/8 × 30 11/16" (97.5 × 77.9 cm)

John G. Johnson Collection
cat. 451

Rembrandt Harmensz. van Rijn, follower of
Portrait of a Gentleman
17th century
Oil on canvas
29 3/4 × 25 3/4" (75.6 × 65.4 cm)

John G. Johnson Collection
cat. 492

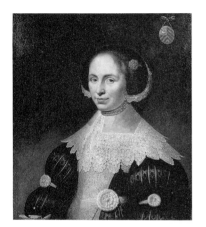

Ravesteyn, Jan Anthonisz. van
Portrait of Gertrude Teding van Berkhout
1634
Lower left: AEtatis. 23. / Ao. 1634.; on reverse [added later]:
Vrouwe Geertruijt Tedingh / van Berckhout weduwe wyler / D'Heer Hugo Brasser Bailla / van Hovingh Caspel dogter van / D'Heer Adriaan Tedingh van / Berckhout en vrouwe Marg / areta van Berestyn.
Oil on panel
26 7/8 × 22 1/16" (68.3 × 56 cm)

John G. Johnson Collection
cat. 452

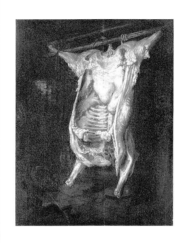

Rembrandt Harmensz. van Rijn, follower of
Previously listed as a copy after Rembrandt Harmensz. van Rijn (JFD 1972)
Slaughtered Ox
17th century
Center bottom (spurious): R. 1637
Oil on panel
19 5/8 × 14 1/2" (49.8 × 36.8 cm)

John G. Johnson Collection
cat. 475

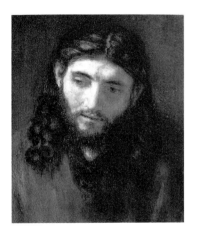

Rembrandt Harmensz. van Rijn, attributed to
Dutch, active Leiden and Amsterdam, 1606–1669
Previously listed as Rembrandt Harmensz. van Rijn (JFD 1972)
Head of Christ
Enlarged on all sides
17th century
Lower right (spurious): Rembran. / f. 1656
Oil on panel
9 3/4 × 7 7/8" (24.8 × 20 cm)

John G. Johnson Collection
cat. 480

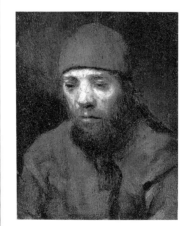

Rembrandt Harmensz. van Rijn, imitator of
Previously listed as Carel Fabritius (JFD 1972)
Head of an Old Man
17th century
Oil on panel
9 7/8 × 7 1/2" (25.1 × 19 cm)

John G. Johnson Collection
cat. 479

Rembrandt Harmensz. van Rijn, workshop of
Previously listed as Rembrandt Harmensz. van Rijn (JFD 1972)
The Finding of Moses
17th century
Oil on canvas
19 1/8 × 23 11/16" (48.6 × 60.2 cm)

John G. Johnson Collection
cat. 474

Rembrandt Harmensz. van Rijn, imitator of
The Crucifixion
17th century
Oil on panel
13 9/16 × 9 5/8" (34.4 × 24.4 cm)

John G. Johnson Collection
cat. 478

Rembrandt Harmensz. van Rijn, copy after
Head of a Man
17th century
Oil on panel
7 ¹³⁄₁₆ × 6 ³⁄₁₆" (19.8 × 15.7 cm)

John G. Johnson Collection
cat. 477

Rembrandt Harmensz. van Rijn, copy after
Saint Francis of Assisi Praying
After the Rembrandt School painting, dated 1637, in the Columbus Museum of Art, Ohio (61.2)
17th century
Oil on panel
24 ⁵⁄₁₆ × 19 ¹⁄₁₆" (61.7 × 48.4 cm)

John G. Johnson Collection
cat. 481

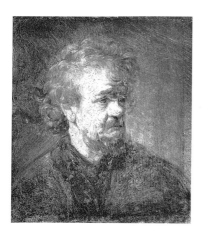

Rembrandt Harmensz. van Rijn, copy after
Head of an Old Man
After a painting known through many copies
17th century
Oil on panel
8 ¹⁄₄ × 6 ¹⁵⁄₁₆" (20.9 × 17.6 cm)

John G. Johnson Collection
cat. 476

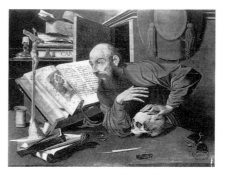

Reymerswaele, Marinus van, follower of
Netherlandish, active Antwerp, first securely documented 1509, died c. 1567
Saint Jerome in His Study
Mid-16th century
Upper left: CAR; center, on book: [Latin text of Matthew 25:31–34]
Oil on panel
39 ³⁄₈ × 50 ¹⁄₈" (100 × 127.3 cm)

John G. Johnson Collection
cat. 394

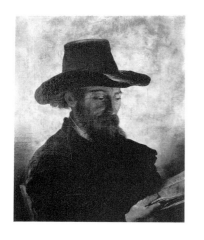

Rembrandt Harmensz. van Rijn, copy after
Man Reading
After a painting known through several copies, the best of which is in the Sterling and Francine Clark Art Institute, Williamstown, Massachusetts (no. 841)
17th century
Oil on canvas
29 ¹⁄₁₆ × 23 ¹⁄₄" (73.8 × 59 cm)

John G. Johnson Collection
cat. 483

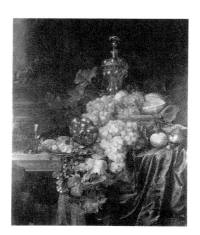

Ring, Pieter de
Dutch, active Leiden, c. 1615–1660
Still Life with Grapes
Mid-17th century
Center left: PDR
Oil on canvas
41 ¹⁄₂ × 33 ¹⁄₈" (105.4 × 84.1 cm)

John G. Johnson Collection
cat. 632

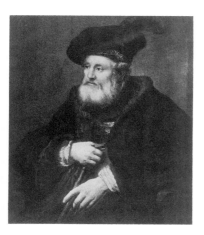

Rembrandt Harmensz. van Rijn, copy after
Old Man in Fanciful Costume Holding a Stick
After the painting, dated 1645, in the Museu Calouste Gulbenkian, Lisbon (inv. no. 1489)
17th century
Oil on canvas
38 ⁷⁄₈ × 32 ⁷⁄₈" (98.7 × 83.5 cm)

The William L. Elkins Collection
E1924-3-89

Roestraten, Pieter Gerritsz. van
Dutch, active Haarlem and England, 1627–1698
Still Life with an Ivory Cup
Late 17th century
Oil on canvas
37 ³⁄₁₆ × 32 ¹⁄₂" (94.5 × 82.5 cm)

John G. Johnson Collection
cat. 650

Rombouts, Theodor
Flemish, active Antwerp and
Italy, 1597?–1637
Lute Player
Known in many versions
c. 1620
Lower right: TR
Oil on canvas
43 3/4 × 39 1/4" (111.1 × 99.7 cm)

John G. Johnson Collection
cat. 679

Rubens, Peter Paul
*The Emblem of Christ Appearing to
Constantine*
1622
Oil on panel
18 3/16 × 22 1/16" (46.2 × 56 cm)

John G. Johnson Collection
cat. 659

**Romeyn, Willem,
attributed to**
Dutch, active Haarlem,
c. 1624–c. 1694
Previously attributed to Karel
Dujardin (JFD 1972)
*Italian Landscape with Two
Shepherds in a Ravine*
Late 17th century
Oil on canvas
18 × 21 11/16" (45.7 × 55.1 cm)

John G. Johnson Collection
cat. 608

Rubens, Peter Paul
*Franciscan Allegory in Honor of the
Immaculate Conception*
1631–32
Oil on panel
21 1/8 × 30 7/8" (53.7 × 78.4 cm)

John G. Johnson Collection
cat. 677

Rubens, Peter Paul
Flemish, active Italy, Antwerp,
and England, 1577–1640
and Frans Snyders
Flemish, active Antwerp,
1579–1657
Prometheus Bound
The eagle was painted by Snyders
Begun c. 1611–12, completed by
1618
Oil on canvas
95 1/2 × 82 1/2" (242.6 × 209.5 cm)

Purchased with the W. P.
Wilstach Fund
W 1950-3-1

Rubens, Peter Paul
*The Reconciliation of the Romans
and Sabines*
1634–36
Oil on panel
11 1/4 × 25 1/8" (28.6 × 63.8 cm)

John G. Johnson Collection
cat. 664

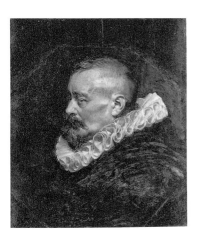

Rubens, Peter Paul
Portrait of a Gentleman [possibly
Burgomaster Nicholaes Rockox]
Originally octagonal
c. 1615
Oil on panel
15 1/2 × 12 5/16" (39.4 × 31.3 cm)

Gift of Mrs. Gordon A. Hardwick
and Mrs. W. Newbold Ely in
memory of Mr. and Mrs.
Roland L. Taylor
1944-9-9

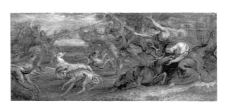

Rubens, Peter Paul
The Death of Silvia's Stag
c. 1638
Oil on panel
9 1/4 × 20 13/16" (23.5 × 52.9 cm)

John G. Johnson Collection
cat. 663

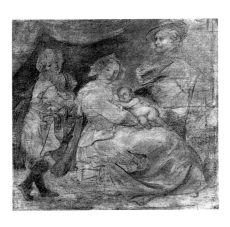

Rubens, Peter Paul, attributed to
Previously listed as an imitator of Peter Paul Rubens (JFD 1972)
Sketch for a Portrait of a Family
The figures are possibly the family of Rubens
1632–33
Oil on panel
14 × 15" (35.6 × 38.1 cm)

John G. Johnson Collection
cat. 662

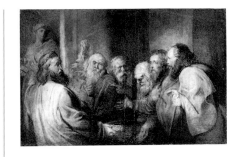

Rubens, Peter Paul, follower of
Previously listed as the school of Peter Paul Rubens (JFD 1972)
The Seven Sages of Greece Disputing over the Tripod
17th century
Oil on panel
13 5/8 × 19 7/8" (34.6 × 50.5 cm)

John G. Johnson Collection
cat. 658

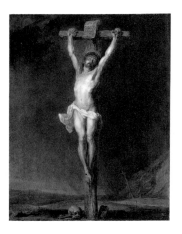

Rubens, Peter Paul, workshop of
The Crucifixion
17th century
On cross: [Hebrew, Greek, and Latin for "Jesus of Nazareth, King of the Jews"]
Oil on panel
48 1/4 × 36 3/4" (122.5 × 93.3 cm)

John G. Johnson Collection
cat. 657

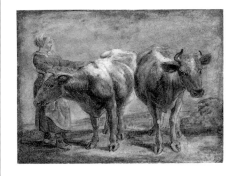

Rubens, Peter Paul, imitator of
Cows
17th century
Oil on paper on canvas
12 5/8 × 16 3/4" (32.1 × 42.5 cm)

John G. Johnson Collection
cat. 668

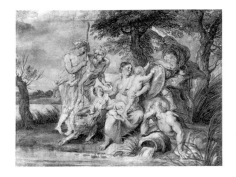

Rubens, Peter Paul, follower of
Previously listed as a copy after Peter Paul Rubens (JFD 1972)
Romulus and Remus
Based on a painting by a follower of Rubens, formerly in the Staatliche Schlösser und Gärten Potsdam-Sanssouci (7734)
17th century
Oil on panel
13 3/4 × 19 7/8" (34.9 × 50.5 cm)

John G. Johnson Collection
cat. 660

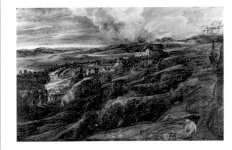

Rubens, Peter Paul, copy after
Previously listed as Lucas van Uden (JFD 1972)
Manzanares Valley
After a lost painting
c. 1629
Oil on panel
15 1/2 × 23 1/4" (39.4 × 59 cm)

John G. Johnson Collection
cat. 666

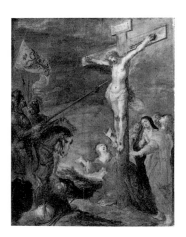

Rubens, Peter Paul, follower of
Previously listed as the school of Peter Paul Rubens (PMA 1965)
The Crucifixion
17th century
Oil on panel
14 × 10 7/16" (35.6 × 26.5 cm)

The John D. McIlhenny Collection
1943-40-43

Rubens, Peter Paul, copy after
Previously listed as Lucas van Uden (JFD 1972)
Landscape with Philemon and Baucis
After the painting in the Kunsthistorisches Museum, Vienna (inv. no. 806)
1630
Oil on panel
16 × 25 1/4" (40.6 × 64.1 cm)

John G. Johnson Collection
cat. 667

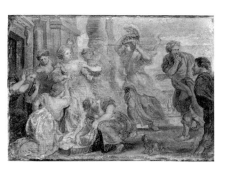

**Rubens, Peter Paul,
copy after**
Previously attributed to Peter
Paul Rubens (PMA 1965)
*Achilles Discovered among the
Daughters of Lycomedes*
After the painting in the Museum
Boymans–van Beuningen,
Rotterdam (2310)
17th century
Oil on panel
14 1/4 × 20 3/8" (36.2 × 51.7 cm)

Purchased with the W. P.
Wilstach Fund
W1902-1-10

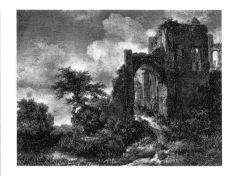

**Ruisdael, Jacob Isaacksz.
van**
*Entrance Gate of the Castle of
Brederode*
c. 1655
Lower right: JVR
Oil on panel
11 7/8 × 14 7/8" (30.2 × 37.8 cm)

John G. Johnson Collection
cat. 564

**Rubens, Peter Paul,
copy after**
The Fall of Icarus
After the painting in the Musées
Royaux des Beaux-Arts de
Belgique, Brussels (cat. no. 825)
17th century
Oil on panel
12 3/16 × 14 15/16" (31 × 37.9 cm)

John G. Johnson Collection
cat. 665

**Ruisdael, Jacob Isaacksz.
van**
Winter Landscape
c. 1665
Lower right: JvRuisdael
Oil on canvas
21 3/4 × 27" (55.2 × 68.6 cm)

John G. Johnson Collection
cat. 569

**Rubens, Peter Paul,
copy after**
*The Meeting of Abraham and
Melchizedek*
After the painting in the
National Gallery of Art,
Washington, D.C. (1506)
17th century
Oil on panel
25 3/8 × 32 3/8" (64.4 × 82.2 cm)

John G. Johnson Collection
cat. 661

**Ruisdael, Jacob Isaacksz.
van**
*Bleaching Fields to the
North-Northeast of Haarlem*
c. 1670–75
Lower right: [illegible signature]
Oil on canvas
17 1/4 × 21 1/8" (43.8 × 53.7 cm)

The William L. Elkins Collection
E1924-3-90

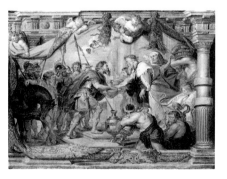

**Ruisdael, Jacob Isaacksz.
van**
Dutch, active Haarlem and
Amsterdam, 1628/29–1682
Dunes
c. 1651–55
Lower left: J v R
Oil on panel
13 3/16 × 19 3/8" (33.5 × 49.2 cm)

John G. Johnson Collection
cat. 563

**Ruisdael, Jacob Isaacksz.
van**
Boats on a Stormy Sea
After 1670
Lower right (spurious): JvR
Oil on canvas
30 3/16 × 41 3/16" (76.7 × 104.6 cm)

The William L. Elkins Collection
E1924-3-56

Ruisdael, Jacob Isaacksz. van
Landscape of a Forest with a Wooden Bridge
After 1670
Lower left: [illegible monogram]
Oil on canvas
41 1/8 × 50 3/8" (104.5 × 127.9 cm)

The William L. Elkins Collection
E1924-3-77

Ruisdael, Jacob Isaacksz. van, copy after
Canal
After the drawing in the collection of P. and N. de Boer, Amsterdam
17th century
Oil on panel
16 13/16 × 24" (42.7 × 61 cm)

John G. Johnson Collection
cat. 572

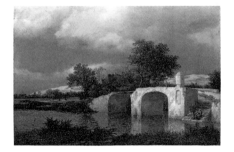

Ruisdael, Jacob Isaacksz. van
Landscape with a Waterfall
17th century
Lower left: JvRuisdael
Oil on canvas
40 3/4 × 56 1/2" (103.5 × 143.5 cm)

Purchased with the W. P. Wilstach Fund
W1895-1-8

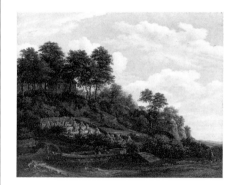

Ruisdael, Jacob Isaacksz. van, copy after
Sloping Field
After the painting sold at Sotheby's, New York, January 17, 1985 (lot 92)
17th century
Oil on canvas
26 7/16 × 31 3/4" (67.1 × 80.6 cm)

John G. Johnson Collection
cat. 566

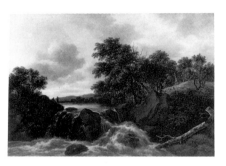

Ruisdael, Jacob Isaacksz. van
Stone Bridge
17th century
Lower right: JvR
Oil on canvas
14 1/4 × 20 1/2" (36.2 × 52.1 cm)

John G. Johnson Collection
cat. 570

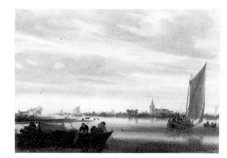

Ruysdael, Salomon van
Dutch, active Haarlem, 1600/03?–1670
Canal
c. 1650
Lower left: SvR 164
Oil on panel
17 3/16 × 23 3/4" (43.7 × 60.3 cm)

John G. Johnson Collection
cat. 466

Ruisdael, Jacob Isaacksz. van
Storm on the Dunes
17th century
Lower right: JRuisdael
Oil on canvas
27 3/8 × 32 1/4" (69.5 × 81.9 cm)

John G. Johnson Collection
cat. 567

Ruysdael, Salomon van
Evening on the Canal
c. 1660–70
Lower left: [illegible date]
Oil on panel
12 3/4 × 21 5/16" (32.4 × 54.1 cm)

John G. Johnson Collection
cat. 468

Ruysdael, Salomon van
Landscape with Cattle and an Inn
1661
Lower left: S. Ruysdael, 1661
Oil on panel
30 × 43 1/2" (76.2 × 110.5 cm)

The William L. Elkins Collection
E1924-3-55

Ryckaert, David, III
Peasant Smoking
Mid-17th century
Oil on panel transferred to canvas
10 5/16 × 8" (26.2 × 20.3 cm)

John G. Johnson Collection
cat. 698

Ruysdael, Salomon van
Beach at Scheveningen
1665
Lower right: SVRuysdael .1665.
Oil on canvas
34 1/8 × 43 5/8" (86.7 × 110.8 cm)

John G. Johnson Collection
cat. 467

Saenredam, Pieter Jansz.
Dutch, active Haarlem and
Utrecht, 1597–1665
Interior of Saint Bavo, Haarlem
The figures are attributed to
Pieter Jansz. Post (Dutch,
1608–1669)
1631
Lower left: PSaenredam 1631;
center bottom: 1631
Oil on panel
32 5/8 × 43 1/2" (82.9 × 110.5 cm)

John G. Johnson Collection
cat. 599

Ryckaert, David, III
Flemish, active Antwerp,
1612–1661
Drinker
Mid-17th century
Oil on panel
12 5/16 × 9 7/16" (31.3 × 24 cm)

John G. Johnson Collection
cat. 686

**Saftleven, Cornelis,
copy after**
Dutch, active Rotterdam,
Antwerp, and Utrecht,
c. 1607–1681
Portrait of Cornelis Saftleven
After a lost self-portrait
Mid-17th century
Oil on panel
16 3/4 × 13 5/16" (42.5 × 33.8 cm)

John G. Johnson Collection
cat. 546

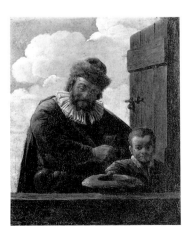

Ryckaert, David, III
Organ Player
Mid-17th century
Oil on copper
8 3/4 × 7" (22.2 × 17.8 cm)

John G. Johnson Collection
cat. 699

**Sauvage, Piat-Joseph,
attributed to**
Flemish, active Tournai,
1744–1818
Previously listed as Piat-Joseph
Sauvage (PMA 1965)
*Putti Leading a Goat by a Chain of
Flowers*
Late 18th century
Oil on canvas
23 × 57" (58.4 × 144.8 cm)

Gift of Mrs. Morris Hawkes
1942-90-2

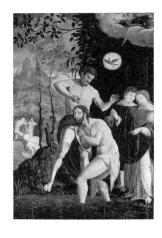

Sauvage, Piat-Joseph, attributed to
Previously listed as Piat-Joseph Sauvage (PMA 1965)
Putti Playing with Birds
Late 18th century
Oil on canvas
23 × 57" (58.4 × 144.8 cm)

Gift of Mrs. Morris Hawkes
1942-90-1

Scorel, Jan van, workshop of
Netherlandish, active Utrecht, 1495–1562
Previously listed as the school of Jan van Scorel (JFD 1972)
The Baptism of Christ
Mid-16th century
Oil on panel
49 5/8 × 32" (126 × 81.3 cm)

John G. Johnson Collection
cat. 414

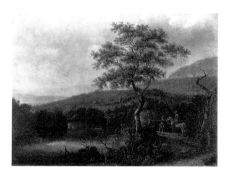

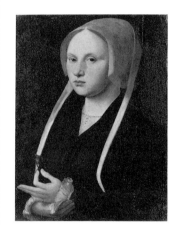

Schellinks, Willem
Dutch, active Amsterdam and London, 1627–1678
Italian Landscape
Mid-17th century
Lower left: JR; lower right: WS
Oil on panel
18 5/8 × 24 1/2" (47.3 × 62.2 cm)

John G. Johnson Collection
cat. 613

Scorel, Jan van, follower of
Previously attributed to Jan van Scorel (JFD 1972)
Portrait of a Lady
Mid-16th century
Oil on panel
19 × 13 9/16" (48.3 × 34.4 cm)

John G. Johnson Collection
cat. 415

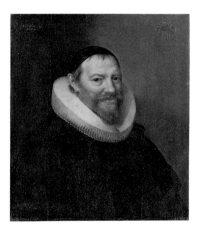

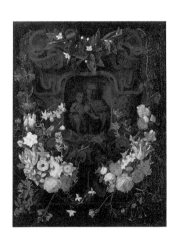

Schooten, Joris van
Dutch, active Leiden, 1587–1651
Portrait of a Clergyman [possibly Antonius Thysius]
1635
Upper left: Anno Salutis 1635 / Aetatis. 70—; upper right: Scientia et Conscientia / Anno Salutis 1635. / Aetatis 70.
Oil on panel
26 13/16 × 21 7/8" (68.1 × 55.6 cm)

John G. Johnson Collection
cat. 453

Seghers, Daniel, copy after
Flemish, active Antwerp, 1590–1661
Previously listed as Daniel Seghers (PMA 1965)
Garland of Flowers with a Cartouche of the Virgin and Child
After a painting in a private collection
Mid-17th century
Oil on canvas
40 × 29" (101.6 × 73.7 cm)

Purchased with the W. P. Wilstach Fund
W1904-1-54

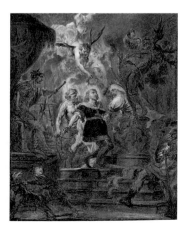

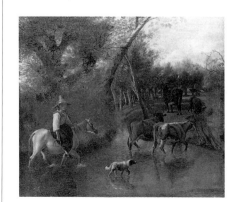

Schut, Cornelis
Flemish, active Antwerp, 1597–1655
The Martyrdom of Saint George
c. 1640–42
Oil on panel
25 × 19 5/16" (63.5 × 49 cm)

John G. Johnson Collection
cat. 675

Siberechts, Jan
Flemish, active Antwerp and London, 1627–c. 1703
Ford
1670
Lower right: J. Siberechts. / .1670.
Oil on canvas
29 1/4 × 32 1/2" (74.3 × 82.5 cm)

John G. Johnson Collection
cat. 707

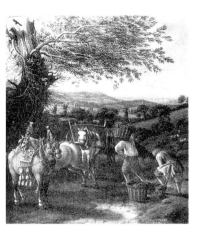

Siberechts, Jan
Horses and a Wagon
1694
Lower right: J. Siberechts. /
.1694.
Oil on canvas
14 1/8 × 12" (35.9 × 30.5 cm)

John G. Johnson Collection
cat. 1185

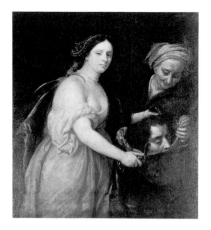

**Soutman, Pieter Claesz.,
attributed to**
Dutch, active Haarlem, Antwerp,
and Poland, c. 1580–1657
Previously attributed to Jacob
Jordaens (PMA 1965)
Judith with the Head of Holofernes
Early 17th century
Oil on canvas
46 5/8 × 39 3/8" (118.4 × 100 cm)

Gift of Mrs. George H. Frazier
1936-26-1

Snyders, Frans
Flemish, active Antwerp,
1579–1657
*Still Life with Terms and a Bust of
Ceres*
c. 1630
On bust: CERES; lower right: F.
Snyders fecit
Oil on canvas
67 3/8 × 95" (171.1 × 241.3 cm)

Purchased with the W. P.
Wilstach Fund
W1899-1-4

**Spierincks, Karel Philips,
attributed to**
Flemish, active Rome,
1609–1639
Previously listed as the circle of
Nicolas Poussin (PMA 1965)
Jupiter and Callisto
Early 17th century
Oil on canvas
53 × 70" (134.6 × 177.8 cm)

The Mr. and Mrs. Carroll S.
Tyson, Jr., Collection
1963-116-12

Snyders, Frans, attributed to
Previously listed as Frans Snyders
(JFD 1972)
Still Life with a Lobster
17th century
Oil on panel
27 3/8 × 41 13/16" (69.5 × 106.2 cm)

John G. Johnson Collection
cat. 700

**Spranger, Bartholomeus,
follower of**
Flemish, active Prague and Italy,
1546–1611
Previously listed as Italian,
unknown artist, 17th century
(PMA 1965)
*Saint John the Evangelist at the
Porta Latina*
Fragment
After 1573
Oil on panel
40 × 31" (101.6 × 78.7 cm)

Bequest of Arthur H. Lea
F1938-1-35

Sorgh, Hendrick Martensz.
Dutch, active Rotterdam,
born 1609–11, died 1670
Woman in a Kitchen
1648
Center: H Sorgh / 1648
Oil on panel
10 1/2 × 11 1/2" (26.7 × 29.2 cm)

John G. Johnson Collection
cat. 531

Steen, Jan
Dutch, active Leiden, Haarlem,
and The Hague, 1625/26–1679
The May Queen
c. 1648–51
Lower left: JSteen
Oil on panel
29 7/8 × 24 1/4" (75.9 × 61.6 cm)

John G. Johnson Collection
cat. 513

Steen, Jan
The Fortune Teller
c. 1648–52
Center bottom: JSteen
Oil on canvas
39 × 36" (99.1 × 91.4 cm)

Purchased with the W. P.
Wilstach Fund
W1902-1-21

Steen, Jan
Rhetoricians at a Window
c. 1661–66
Center, on paper: LOF LIET;
center bottom: IVGHT NEMT IN
Oil on canvas
29 7/8 × 23 1/16" (75.9 × 58.6 cm)

John G. Johnson Collection
cat. 512

Steen, Jan
Landscape with an Inn and Skittles
c. 1656–60
Lower right: JSteen
Oil on canvas
24 5/16 × 20 1/8" (61.7 × 51.1 cm)

John G. Johnson Collection
cat. 517

Steen, Jan
Prayer before the Meal
c. 1667–71
Lower left: JStin
Oil on canvas
24 3/4 × 30 3/4" (62.9 × 78.1 cm)

John G. Johnson Collection
cat. 514

Steen, Jan
Moses Striking the Rock
c. 1660–61
Lower left: JSteen
Oil on canvas
37 3/8 × 38 3/4" (94.9 × 98.4 cm)

John G. Johnson Collection
cat. 509

Steen, Jan
Tavern Scene with a Pregnant Hostess
c. 1670
Lower right: JSteen.
Oil on canvas
17 1/8 × 21 7/16" (43.5 × 54.4 cm)

John G. Johnson Collection
cat. 520

Steen, Jan
The Doctor's Visit
c. 1660–65
Lower right: JSteen
Oil on panel
18 1/8 × 14 1/2" (46 × 36.8 cm)

John G. Johnson Collection
cat. 510

Steen, Jan
Previously listed as a copy after
Jan Steen (JFD 1972)
As the Old Ones Sing, So the Young Ones Pipe
c. 1670–75
Lower right: JSteen.
Oil on canvas
37 5/8 × 42" (95.6 × 106.7 cm)

John G. Johnson Collection
cat. 519

Steen, Jan, attributed to
Previously listed as Jan Steen
(JFD 1972)
Merry Company
c. 1663–67
Lower left: JSteen.
Oil on canvas
20 7/8 × 17 1/4" (53 × 43.8 cm)

John G. Johnson Collection
cat. 515

Steen, Jan, follower of
Previously listed as Jan Steen
(JFD 1972)
Tavern Scene by Candlelight
17th century
Upper left (spurious): JSteen
Oil on panel
17 1/16 × 22 1/2" (43.3 × 57.1 cm)

John G. Johnson Collection
cat. 516

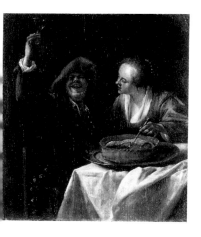

Steen, Jan, imitator of
Previously listed as a copy after
Jan Steen (JFD 1972)
Happy Lovers
17th century
Oil on panel
9 3/8 × 7 15/16" (23.8 × 20.2 cm)

John G. Johnson Collection
cat. 518

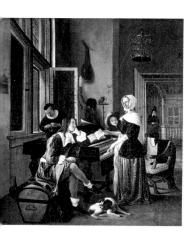

Steen, Jan, copy after
Previously listed as Jan Steen
(PMA 1965)
Lady at a Clavichord
After a lost painting
After 1661 or 1664
Lower left (spurious): J. Stein /
16[61 or 64]
Oil on canvas
25 1/4 × 21 3/4" (64.1 × 55.2 cm)

The William L. Elkins Collection
E1924-3-37

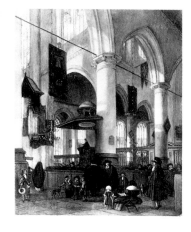

Streeck, Hendrik van
Dutch, active Amsterdam,
born 1659, still active 1719
Interior of the Oude Kerk, Delft
Late 17th century
Oil on panel
18 3/16 × 13 13/16" (46.2 × 35.1 cm)

John G. Johnson Collection
cat. 600

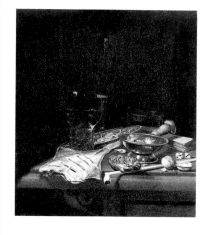

**Streeck, Juriaen van,
copy after?**
Dutch, active Amsterdam,
1632–1687
Previously listed as Juriaen van
Streeck (JFD 1972)
*Still Life with a Flounder and a
Goblet*
17th century
Lower left: J. v Streeck
Oil on canvas
25 7/8 × 21 7/8" (65.7 × 55.6 cm)

John G. Johnson Collection
cat. 652

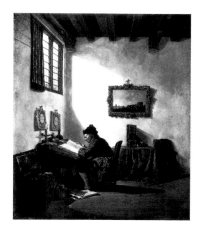

Strij, Abraham van
Dutch, active Dordrecht,
1753–1826
Scholar
c. 1800
Oil on panel
25 5/16 × 21 1/4" (64.3 × 54 cm)

John G. Johnson Collection
cat. 711

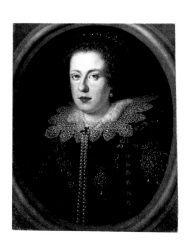

**Sustermans, Justus,
workshop of**
Flemish, active Florence,
1597–1681
Previously listed as Justus
Sustermans (JFD 1972)
*Portrait of Claudia, Daughter of
Ferdinand I, Grand Duke of
Tuscany*
Mid-17th century
Oil on canvas
22 3/4 × 17 1/4" (57.8 × 43.8 cm)

John G. Johnson Collection
cat. 678

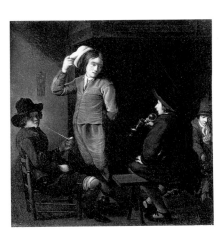

Sweerts, Michiel, copy after
Flemish, active Brussels and
Rome, 1624–1664
Four Youths around a Fire
After the painting in the
Bayerische Staatsgemälde-
sammlungen, Alte Pinakothek,
Munich (854)
17th century
Oil on canvas
20 5/8 × 20 1/4" (52.4 × 51.4 cm)

John G. Johnson Collection
cat. 550

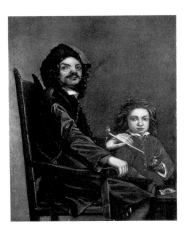

Sweerts, Michiel, copy after
Portrait of a Seated Man with a Boy
After the painting in the Schloss
Weissenstein der Grafen von
Schönborn, Pommersfelden,
Germany
17th century
Oil on panel
19 1/16 × 14 3/4" (48.4 × 37.5 cm)

John G. Johnson Collection
cat. 1178

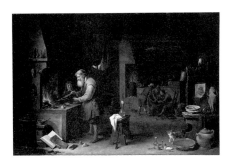

Teniers, David, II
Flemish, active Antwerp and
Brussels, 1610–1690
The Alchemist
1649
Center right: Ano 1649; lower
right: D. TENIERS. Fec.
Oil on panel transferred to canvas
23 1/2 × 33" (59.7 × 83.8 cm)

John G. Johnson Collection
cat. 689

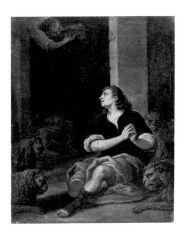

Teniers, David, II
Daniel in the Lion's Den
After a painting engraved in
Teniers, *Theatrum Pictorium*
(1660–73), and there attributed
to Palma il Giovane (Italian,
1544–1628)
Late 17th century
Oil on panel
9 1/8 × 6 7/8" (23.2 × 17.5 cm)

John G. Johnson Collection
cat. 697

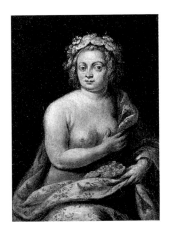

Teniers, David, II
Pomona
After a painting engraved in
Teniers, *Theatrum Pictorium*
(1660–73), and there attributed
to Palma il Giovane (Italian,
1544–1628)
Late 17th century
Oil on panel
6 3/4 × 4 3/4" (17.1 × 12.1 cm)

John G. Johnson Collection
cat. 694

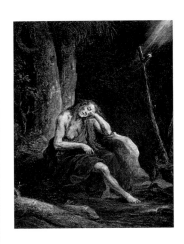

Teniers, David, II
Saint Mary of Egypt in the Desert
After a painting engraved in
Teniers, *Theatrum Pictorium*
(1660–73), and there attributed
to Palma il Giovane (Italian,
1544–1628)
Late 17th century
Oil on panel
8 7/8 × 6 3/4" (22.5 × 17.1 cm)

John G. Johnson Collection
cat. 693

Teniers, David, II
Toilet of Venus
After a painting engraved in
Teniers, *Theatrum Pictorium*
(1660–73), and there attributed
to Andrea Meldolla, also called
Schiavone (Italian, 1522–
c. 1582)
Late 17th century
Oil on panel
8 7/8 × 6 3/4" (22.5 × 17.1 cm)

John G. Johnson Collection
cat. 696

Teniers, David, II
Venus and Adonis
After a painting engraved in
Teniers, *Theatrum Pictorium*
(1660–73), and there attributed
to Antonio Correggio (Italian,
1494–1534)
Late 17th century
Oil on panel
8 7/8 × 6 3/4" (22.5 × 17.1 cm)

John G. Johnson Collection
cat. 695

**Teniers, David, II,
attributed to**
Previously listed as David
Teniers II (JFD 1972)
Departure of a Troop of Soldiers
Late 17th century
Center bottom: D Teniers, F.
Oil on canvas
23 1/8 × 33 1/2" (58.7 × 85.1 cm)

John G. Johnson Collection
cat. 690

Teniers, David, II, imitator of
Peasants Bowling before an Inn
Late 17th century
Oil on panel
6 × 8 1/8" (15.2 × 20.6 cm)

John G. Johnson Collection
inv. 162

**Teniers, David, II,
attributed to**
Previously listed as David
Teniers II (JFD 1972)
Sleeper
Late 17th century
Oil on panel transferred to canvas
10 13/16 × 15 1/16" (27.5 × 38.3 cm)

John G. Johnson Collection
cat. 691

Teniers, David, II, copy after
Previously listed as David
Teniers II (JFD 1972)
Operation on the Foot
After the painting in the
Staatliche Kunstsammlungen,
Schloss Wilhelmshöhe,
Gemäldegalerie Alte Meister,
Kassel, Germany
Late 17th century
Oil on panel
14 × 11 7/8" (35.6 × 30.2 cm)

John G. Johnson Collection
cat. 682

**Teniers, David, II,
attributed to**
Previously listed as David
Teniers II (JFD 1972)
Violin Player in a Tavern
Late 17th century
Center bottom, on footrest:
D. TENIERS. FEC
Oil on panel
11 5/8 × 14 1/2" (29.5 × 36.8 cm)

John G. Johnson Collection
cat. 692

Teniers, David, II, copy after
Two Peasants
After a lost painting
Late 17th century
Lower left: J. S.
Oil on panel
9 7/8 × 7 5/8" (25.1 × 19.4 cm)

John G. Johnson Collection
cat. 532

Teniers, David, II, follower of
Peasants in a Niche
Late 17th century
Lower right (spurious):
D TENIERS F
Oil on canvas
22 5/8 × 16 1/8" (57.5 × 41 cm)

Bequest of Arthur H. Lea
F1938-1-22

Teniers, David, II, copy after
Previously listed as David
Teniers II (PMA 1965)
Wedding Feast
After the painting, dated 1650,
in the Hermitage, St. Petersburg
(inv. no. 1719)
Late 17th century
Lower right (spurious):
D TENIERS F
Oil on panel
31 3/8 × 44 5/8" (79.7 × 113.3 cm)

The William L. Elkins Collection
E1924-3-38

Tol, Dominicus van
Dutch, active Leiden,
c. 1635–1676
Old Woman Reading
Mid-17th century
Oil on panel
13 3/16 × 10 7/8" (33.5 × 27.6 cm)

John G. Johnson Collection
cat. 547

Velde, Adriaen van de
A Shepherd and a Shepherdess with a Flock of Sheep
Mid-17th century
Lower left: AvVelde
Oil on panel transferred to canvas
16 13/16 × 22 7/16" (42.7 × 57 cm)

John G. Johnson Collection
cat. 606

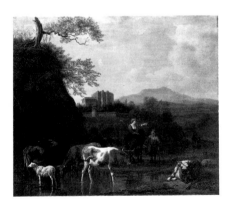

**Toorenvliet, Jacob,
attributed to**
Dutch, active Leiden,
1635/36–1719
Previously attributed to Nicolaes Hals (JFD 1972)
The Happy Lovers
Late 17th century
Oil on panel
22 7/16 × 19" (57 × 48.3 cm)

John G. Johnson Collection
cat. 437

**Velde, Adriaen van de,
attributed to**
Previously listed as Adriaen van de Velde (JFD 1972)
Cattle Grazing in a Wood
17th century
Oil on canvas
9 1/4 × 18 3/16" (23.5 × 46.2 cm)

John G. Johnson Collection
cat. 604

Velde, Adriaen van de
Dutch, active Amsterdam,
1632–1672
Landscape with Cattle
1659
Lower left: A. v. Velde f. 1659
Oil on canvas
21 15/16 × 23 15/16" (55.7 × 60.8 cm)

John G. Johnson Collection
cat. 605

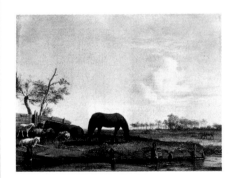

**Velde, Adriaen van de,
copy after?**
Horses and Sheep at Pasture
17th century
Lower left: A. v. Velde
Oil on canvas
11 7/8 × 15 1/8" (30.2 × 38.4 cm)

John G. Johnson Collection
cat. 1180

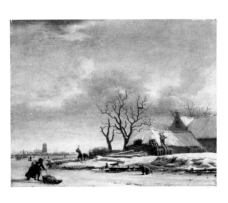

Velde, Adriaen van de
Winter Landscape
c. 1668
Lower right: AvVelde
Oil on panel
12 1/16 × 14 9/16" (30.6 × 37 cm)

John G. Johnson Collection
cat. 603

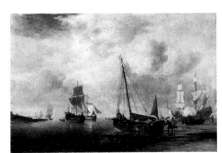

**Velde, Willem van de,
the Younger**
Dutch, active Amsterdam and London, 1633–1707
Calm (A Sloop Aground near the Shore in an Inlet)
c. 1665
Lower right: W.v.Velde.
Oil on canvas
16 3/8 × 24 1/4" (41.6 × 61.6 cm)

John G. Johnson Collection
cat. 590

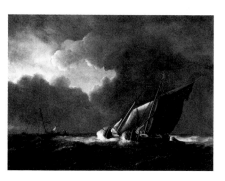

Velde, Willem van de, the Younger
Two Dutch Vessels Close-Hauled in a Strong Breeze
c. 1672
Oil on canvas
17 1/4 × 21 15/16" (43.8 × 55.7 cm)

John G. Johnson Collection
cat. 591

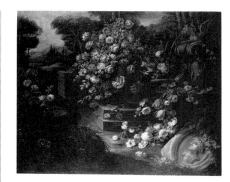

Verbrugghen, Gaspar Peeter, II, imitator of
Previously listed as Dutch, unknown artist, 17th century (PMA 1965)
Flowers in a Garden
c. 1700–20
Oil on canvas
58 3/8 × 76 1/2" (148.3 × 194.3 cm)

Gift of Mrs. Chester Dale
1950-121-3

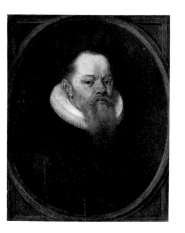

Venne, Adriaen Pietersz. van de
Dutch, active The Hague, Antwerp, and Middelburg, 1589–1662
Portrait of a Fifty-Nine-Year-Old Man
1624
Center left: Ao 1624 / AETATIS 59
Oil on panel
12 3/8 × 9 1/4" (31.4 × 23.5 cm)

John G. Johnson Collection
inv. 163

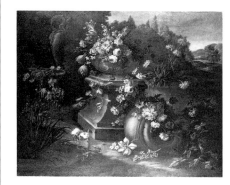

Verbrugghen, Gaspar Peeter, II, imitator of
Previously listed as Dutch, unknown artist, 17th century (PMA 1965)
Flowers in a Garden
c. 1700–20
Oil on canvas
58 3/8 × 76 1/2" (148.3 × 194.3 cm)

Gift of Mrs. Chester Dale
1950-121-4

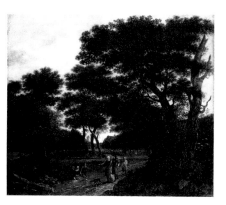

Verboom, Adriaen Hendriksz.
Dutch, active Amsterdam and Haarlem, c. 1628–c. 1670
Woods near a Village
Mid-17th century
Lower left (spurious): Av.Velde fec. 1638
Oil on canvas
20 3/8 × 22 1/2" (51.7 × 57.1 cm)

John G. Johnson Collection
cat. 575

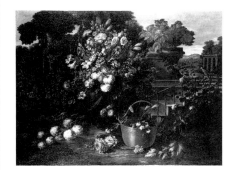

Verbrugghen, Gaspar Peeter, II, imitator of
Previously listed as Dutch, unknown artist, 17th century (PMA 1965)
Flowers on a Terrace
c. 1700–20
Oil on canvas
58 3/8 × 76 1/2" (148.3 × 194.3 cm)

Gift of Mrs. Chester Dale
1950-121-1

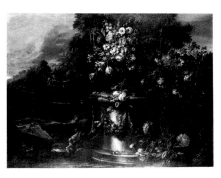

Verbrugghen, Gaspar Peeter, II, imitator of
Flemish, active Antwerp, 1664–1730
Previously listed as Dutch, unknown artist, 17th century (PMA 1965)
Flowers in a Garden
c. 1700–20
Oil on canvas
58 3/8 × 76 1/2" (148.3 × 194.3 cm)

Gift of Mrs. Chester Dale
1950-121-2

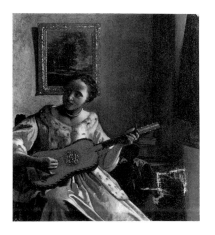

Vermeer, Johannes, copy after
Dutch, active Delft, 1632–1675
Lady with a Guitar
After the painting in the Iveagh Bequest, Kenwood, London (62)
Late 17th century
Oil on canvas
20 11/16 × 17 15/16" (52.5 × 45.6 cm)

John G. Johnson Collection
cat. 497

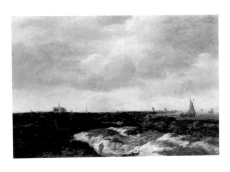

**Vermeer van Haarlem, Jan
(Jan van der Meer)**
Dutch, active Haarlem,
1628–1691
Dunes near Haarlem
1667 or 1677
Lower left: J V Meer 16[6 or 7?]7
Oil on panel
23 1/2 × 32 11/16" (59.7 × 83 cm)

The William L. Elkins Collection
E1924-3-95

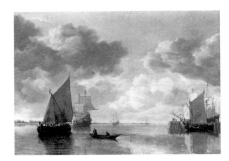

Vlieger, Simon Jacobsz. de
Dutch, active Delft and
Amsterdam, c. 1600–1653
Marine
c. 1600–50
Oil on panel
23 5/8 × 32 11/16" (60 × 83 cm)

John G. Johnson Collection
cat. 593

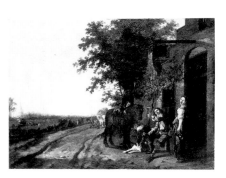

Vermeer van Utrecht, Johann
Dutch, active Utrecht,
c. 1640–1692
Previously listed as Ludolf de
Jongh (JFD 1972)
Halt at the Inn
Late 17th century
Oil on panel
18 7/8 × 25 1/8" (47.9 × 63.8 cm)

John G. Johnson Collection
cat. 626

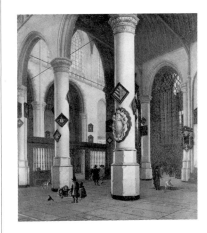

**Vliet, Hendrick Cornelisz.
van**
Dutch, active Delft,
1611/12–1675
Interior of the Oude Kerk, Delft
1659
Center bottom: H. van Vliet /
1659
Oil on canvas
31 3/4 × 26 5/8" (80.6 × 67.6 cm)

Purchased with the W. P.
Wilstach Fund
W1902-1-15

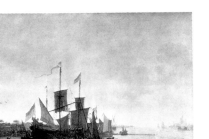

Verschuier, Lieve Pietersz.
Dutch, active Rotterdam,
c. 1630–1686
Marine
Mid-17th century
Oil on canvas
35 1/8 × 44 11/16" (89.2 ×
113.5 cm)

John G. Johnson Collection
cat. 594

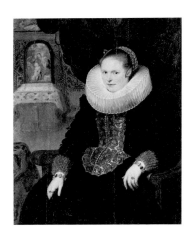

Vos, Cornelis de
Flemish, active Antwerp,
1584/85–1651
Portrait of a Thirty-Year-Old Woman
1622
Lower right: AET. 30 / A0 1622
Oil on panel
46 1/4 × 35 7/8" (117.5 × 91.1 cm)

John G. Johnson Collection
cat. 671

**Verschuier, Lieve Pietersz.,
attributed to**
Previously listed as Lieve
Pietersz. Verschuier (JFD 1972)
Calm Sea
17th century
Oil on canvas
20 9/16 × 20 15/16" (52.2 ×
53.2 cm)

John G. Johnson Collection
cat. 589

Vos, Cornelis de
*Portrait of Anthony Reyniers and
His Family*
1631
Lower left: C. DE VOS. F A0
1631
Oil on canvas
67 × 96 1/2" (170.2 × 245.1 cm)

Purchased with the W. P.
Wilstach Fund
W1902-1-22

Vos, Cornelis de, follower of
Head of a Woman in a Ruff
17th century
Oil on canvas
16 × 13 ½" (40.6 × 34.3 cm)

Gift of Peter D. Krumbhaar
1971-151-1

Vries, Roelof van
Dutch, active Haarlem and
Amsterdam, born 1630/31,
still active 1681
Landscape with a Canal
1652
Lower left: .RV . vries. 1652
Oil on panel
29 ⅞ × 43 ⅜" (75.9 × 110.2 cm)

John G. Johnson Collection
cat. 581

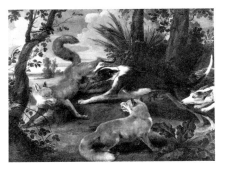

Vos, Paul de
Flemish, active Antwerp,
1596–1678
Previously listed as Frans Snyders
(PMA 1965)
Wolfhounds and Two Foxes
1630s
Oil on canvas
56 ½ × 76" (143.5 × 193 cm)

Gift of Nicholas Biddle
1957-130-1

Vries, Roelof van
Previously listed as Jacob
Isaacksz. van Ruisdael (PMA
1965)
Landscape with Men and Dogs
17th century
Lower left (spurious): JRuisd
Oil on panel
16 1/16 × 13 ¾" (40.8 × 34.9 cm)

The John D. McIlhenny
Collection
1943-40-38

Vosmaer, Daniel
Dutch, active Delft,
documented 1650
*View of Delft after the Explosion of
1654*
c. 1654
Oil on canvas
26 ⅝ × 21 ⅞" (67.6 × 55.6 cm)

John G. Johnson Collection
cat. 500

**Vries, Roelof van,
attributed to**
Landscape with Dunes
1664
Lower right: [illegible signature],
1664
Oil on panel
16 ⅝ × 23 ½" (42.2 × 59.7 cm)

John G. Johnson Collection
cat. 580

Vrel, Jacob
Dutch, active Delft,
active c. 1654–c. 1662
Street
Mid-17th century
Oil on panel
19 ¼ × 16 ½" (48.9 × 41.9 cm)

John G. Johnson Collection
cat. 542

Weenix, Jan
Dutch, active Amsterdam,
Utrecht, and Düsseldorf,
1642?–1719
Still Life with a Hare and Birds
Late 17th century
Oil on canvas
50 15/16 × 41 ⅞" (129.4 ×
106.4 cm)

John G. Johnson Collection
cat. 633

DUTCH, FLEMISH, AND NETHERLANDISH

Weenix, Jan
*Still Life with Dead Game, a
Monkey, and a Spaniel*
1700
Center bottom: J. Weenix f
1700—
Oil on canvas
21 1/2 × 19 3/4" (54.6 × 50.2 cm)

Purchased with the W. P.
Wilstach Fund
W1901-1-3

Weenix, Jan Baptist
Dutch, active Amsterdam, Rome,
and Utrecht, 1621–1660/61
Rest on the Flight into Egypt
c. 1647–50
Lower right: Gio Batta Weenix f.
Oil on canvas
21 3/4 × 20" (55.2 × 50.8 cm)

Purchased with the George W.
Elkins Fund
E1984-1-1

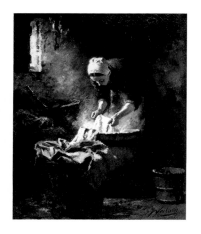

Weiland, Johannes
Dutch, active Rotterdam and
The Hague, 1856–1909
The Washerwoman
c. 1900
Lower right: Weiland
Oil on canvas
19 3/4 × 15 3/4" (50.2 × 40 cm)

The Walter Lippincott Collection
1923-59-9

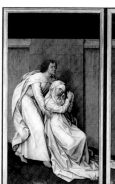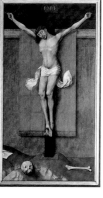

Weyden, Rogier van der
Netherlandish, active Tournai
and Brussels, 1399/1400–1464
*The Crucifixion, with the Virgin and
Saint John the Evangelist Mourning*
Companion paintings
c. 1450–55
On cross: I N R I
Oil and gold on panel
Left panel: 71 × 36 5/16"
(180.3 × 92.2 cm); right panel:
71 × 36 7/16" (180.3 × 92.5 cm)

John G. Johnson Collection
cat. 335, cat. 334

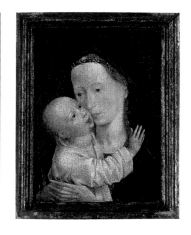

**Weyden, Rogier van der,
follower of**
Previously attributed to Hugo
van der Goes (JFD 1972)
Virgin and Child
c. 1460–1500
Oil on panel
11 13/16 × 8 1/4" (30 × 20.9 cm)

John G. Johnson Collection
cat. 341

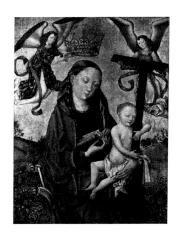

**Weyden, Rogier van der,
follower of**
Previously listed as derived from
a composition of Rogier van der
Weyden (JFD 1972)
Virgin and Child Holding the Cross
16th century
On cross: inri; on Virgin's
headband: A M ARI A GR ACIA
PLEA VE TECU
Oil and gold on panel transferred
to canvas
26 × 18 7/8" (66 × 47.9 cm)

John G. Johnson Collection
cat. 321

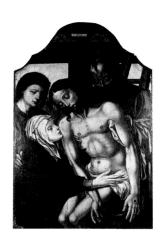

**Weyden, Rogier van der,
copy after**
The Descent from the Cross
After a lost painting
16th century?
On cross: I N R I
Oil on panel
42 1/2 × 27 1/2" (107.9 × 69.8 cm)

Purchased from the George Grey
Barnard Collection with Museum
funds
1945-25-124

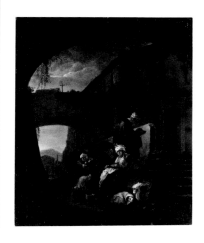

Wijck, Thomas
Dutch, active Haarlem and Italy,
c. 1616–1677
Almsgiving
Mid-17th century
Center left: TWijck
Oil on panel
16 7/16 × 13 9/16" (41.7 × 34.4 cm)

John G. Johnson Collection
cat. 611

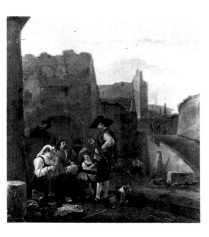

Wijck, Thomas
Italians in a Cloister Court
Mid-17th century
Lower left: TWijck
Oil on canvas
19 3/8 × 17 1/2" (49.2 × 44.4 cm)

John G. Johnson Collection
cat. 612

Wouwermans, Philips
Dutch, active Haarlem and
Hamburg, 1619–1668
The Blacksmith's Shop
Late 1640s
Lower left: PHILS.W
Oil on panel
17 3/8 × 16 1/2" (44.1 × 41.9 cm)

The William L. Elkins Collection
E1924-3-40

Wijnants, Jan
Dutch, active Rotterdam and
Amsterdam, born before 1630,
died 1684
Dunes
Mid-17th century
Lower left: J. Wijnants
Oil on canvas
19 1/4 × 16 1/2" (48.9 × 41.9 cm)

John G. Johnson Collection
cat. 584

Wouwermans, Philips
The Importunate Groom
Mid-17th century
Lower right: PHLS.W
Oil on panel
15 1/2 × 13 1/8" (39.4 × 33.3 cm)

John G. Johnson Collection
cat. 616

Wit, Jacob de
Dutch, active Amsterdam and
Antwerp, 1695–1754
Putti with Sheep
1749
Lower right: JdWit / 1749
Oil on canvas
48 1/4 × 39" (122.5 × 99.1 cm)

Gift of Mrs. Gordon A. Hardwick
and Mrs. W. Newbold Ely in
memory of Mr. and Mrs.
Roland L. Taylor
1944-9-5

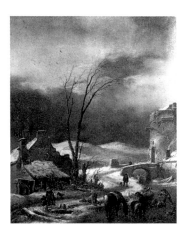

**Wouwermans, Philips,
attributed to**
*Winter Landscape with a Stone
Bridge*
17th century
Lower right: PHLSW
Oil on panel
16 1/4 × 12 1/4" (41.3 × 31.1 cm)

John G. Johnson Collection
cat. 615

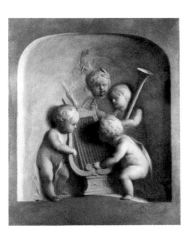

Wit, Jacob de
Putti with Musical Instruments
1750
Lower right: JdWit / 1750
Oil on canvas
48 7/16 × 39" (123 × 99.1 cm)

Gift of Mrs. Gordon A. Hardwick
and Mrs. W. Newbold Ely in
memory of Mr. and Mrs.
Roland L. Taylor
1944-9-6

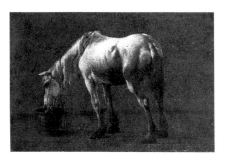

**Wouwermans, Philips,
follower of**
Previously listed as the school of
Philips Wouwermans (JFD 1972)
White Horse
17th century
Oil on panel
5 7/8 × 8 1/4" (14.9 × 20.9 cm)

John G. Johnson Collection
cat. 620

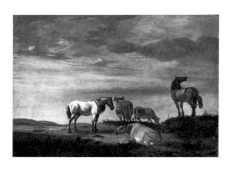

Wouwermans, Philips, and Paulus Potter, imitator of
Previously attributed to Philips Wouwermans (JGJ 1941)
Horses and Cattle
Mid-17th century
Lower right: E. D.
Oil on panel
15 $^{11}/_{16}$ × 21 $^9/_{16}$" (39.8 × 54.8 cm)

John G. Johnson Collection
cat. 617

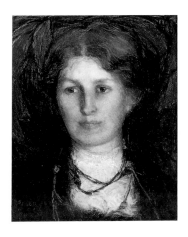

Aman-Jean, Edmond-François
French, 1860–1935/36
Portrait of Mrs. Bosworth
1904
Lower left: Aman Jean / 1904
Oil on canvas
16 $^7/_8$ × 13 $^3/_8$" (42.9 × 34 cm)

Gift of Francis Newton, F. Maurice Newton, and Richard Newton, Jr., in memory of their sister, Elizabeth Newton Bosworth
1962-142-1

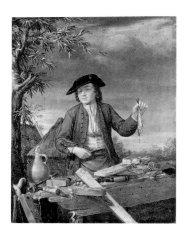

Zegelaar, Gerrit van
Dutch, active Amsterdam, 1719–1794
Carpenter Taking His Meal
Mid-18th century
Lower right: G. Zegelaar
Oil on panel
14 $^1/_8$ × 10 $^{13}/_{16}$" (35.9 × 27.5 cm)

John G. Johnson Collection
cat. 1186

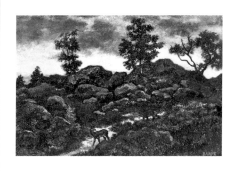

Barye, Antoine-Louis
French, 1796–1875
Rocky Landscape
c. 1850–75
Lower right: BARYE
Oil on canvas
9 × 12 $^1/_2$" (22.9 × 31.7 cm)

John G. Johnson Collection
cat. 890

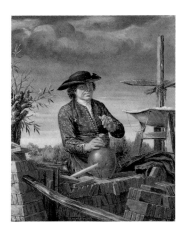

Zegelaar, Gerrit van
Stonemason Resting
Mid-18th century
Center bottom: G. Zegelaar
Oil on panel
14 $^1/_8$ × 10 $^3/_4$" (35.9 × 27.3 cm)

John G. Johnson Collection
cat. 1187

Bastien-Lepage, Jules
French, 1848–1884
Goose Girl
c. 1875
Lower left: J. BASTIEN-LEPAGE
Oil on canvas
16 $^5/_{16}$ × 23 $^1/_4$" (41.4 × 59 cm)

John G. Johnson Collection
cat. 893

Bastien-Lepage, Jules
Blackfriars Bridge and the Thames, London
1881
Lower left: J BASTIEN-LEPAGE / LONDRES Juillet 81
Oil on canvas
20 $^1/_8$ × 27 $^1/_8$" (51.1 × 68.9 cm)

John G. Johnson Collection
cat. 891

Bastien-Lepage, Jules
Evening at Damvillers
1882
Lower right: J BASTIEN-LEPAGE
/ Damvillers 1882
Oil on canvas
26 1/8 × 31 5/8" (66.4 × 80.3 cm)

John G. Johnson Collection
cat. 894

Bidauld, Jean-Joseph-Xavier
French, 1758–1846
Lake Albano
c. 1785–90
Lower left (spurious): COROT
Oil on canvas
11 1/2 × 17 3/8" (29.2 × 44.1 cm)

John G. Johnson Collection
cat. 937

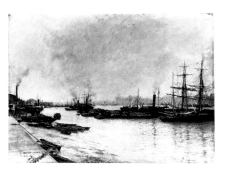

Bastien-Lepage, Jules
The Thames, London
1882
Lower left: J. BASTIEN-LEPAGE /
Londres 82.
Oil on canvas
22 5/16 × 30 3/8" (56.7 × 77.1 cm)

John G. Johnson Collection
cat. 892

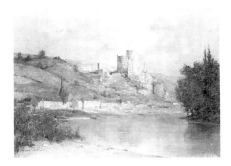

Billotte, René
French, 1846–1915
Château Gaillard des Andelys
By 1892
Lower left: René Billotte
Oil on canvas
21 1/4 × 28 15/16" (54 × 73.5 cm)

John G. Johnson Collection
cat. 896

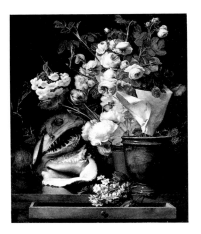

Berjon, Antoine
French, 1754–1843
*Still Life with Flowers, Shells, a
Shark's Head, and Petrifications*
1819
Lower right: Berjon / 1819
Oil on canvas
42 1/2 × 34 9/16" (107.9 × 87.8 cm)

Purchased with the Edith H. Bell
Fund
1981-62-1

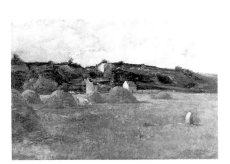

Billotte, René
Landscape
By 1892
Lower right: René Billotte
Oil on canvas
15 1/16 × 21 5/8" (38.3 × 54.9 cm)

John G. Johnson Collection
inv. 2692

Besnard, Albert
French, 1849–1934
Head of a Woman
1892
Lower left: ASBesnard / 1892
Oil on panel
24 1/16 × 19 5/8" (61.1 × 49.8 cm)

John G. Johnson Collection
cat. 895

**Boilly, Louis-Léopold,
attributed to**
French, 1761–1845
Previously listed as Louis-
Léopold Boilly (JGJ 1941)
Portrait of a Young Man
Early 19th century
Lower right (spurious): L. Boilly
Oil on canvas on panel
9 1/8 × 6 3/4" (23.2 × 17.1 cm)

John G. Johnson Collection
cat. 792

**Bonheur, Marie-Rosalie,
also called Rosa Bonheur**
French, 1822–1899
Forest with a Buck
1875
Lower left: Rosa Bonheur / 1875
Oil on canvas
15 × 18 ⁷/₁₆" (38.1 × 46.8 cm)

Gift of Robert Montgomery Scott
1981-116-1

Bonvin, François
French, 1817–1887
Woman Ironing
1858
Upper right: F. Bonvin. 1858.
Oil on canvas
21 ⁵/₈ × 14 ⁵/₈" (54.9 × 37.1 cm)

John G. Johnson Collection
cat. 901

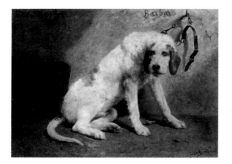

Bonheur, Marie-Rosalie
Two Horses
1893
Lower right: Rosa Bonheur 1893
Oil on canvas
38 ¹/₂ × 51 ¹/₄" (97.8 × 130.2 cm)

The William L. Elkins Collection
E1924-3-96

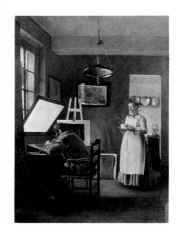

Bonvin, François
The Engraver
1872
Lower right: F. Bonvin. 1872.
Oil on panel
20 ³/₄ × 14 ⁵/₈" (52.7 × 37.1 cm)

John G. Johnson Collection
cat. 900

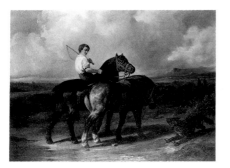

Bonheur, Marie-Rosalie
Barbaro after the Hunt
Late 19th century
Upper left: FL[rest illegible];
upper right: Barbaro; lower right:
Rosa Bonheur
Oil on canvas
38 × 51 ¹/₄" (96.5 × 130.2 cm)

Gift of John G. Johnson for the
W. P. Wilstach Collection
W1900-1-2

Boudin, Eugène-Louis
French, 1824–1898
Camaret, Le Toulinguet
c. 1871–73
Lower left: [E]i Boudin
Toulignon
Oil on panel
21 ¹/₄ × 35 ¹/₄" (54 × 89.5 cm)

John G. Johnson Collection
cat. 903

Bonheur, Marie-Rosalie
Landscape with Cattle
Late 19th century
Lower right: Rosa B
Oil on canvas
33 ³/₁₆ × 48 ¹/₄" (84.3 × 122.5 cm)

Gift of Hermann Krumbhaar and
Dr. Edward Krumbhaar
1921-69-1

Boudin, Eugène-Louis
View of Deauville
1873
Lower left: Trouville / E. Boudin
73.
Oil on canvas
12 ⁷/₁₆ × 22 ³/₄" (31.6 × 57.8 cm)

John G. Johnson Collection
cat. 902

Boudin, Eugène-Louis
Beach at Trouville
1880
Lower left: E. Boudin; lower
right: Trouville 80.
Oil on canvas
7 × 13 1/2" (17.8 × 34.3 cm)

Bequest of Lisa Norris Elkins
1950-92-2

Boudin, Eugène-Louis
Boats in Trouville Harbor
1894
Lower right: E. Boudin /
[illegible] 94.
Oil on panel
7 1/2 × 9 1/2" (19 × 24.1 cm)

The Louis E. Stern Collection
1963-181-3

Boudin, Eugène-Louis
Deauville, the Terrace
1882
Lower left: E. Boudin.; lower
right: Juillet 82
Oil on canvas
14 1/2 × 22 7/8" (36.8 × 58.1 cm)

The Albert M. Greenfield and
Elizabeth M. Greenfield
Collection
1974-178-20

Boudin, Eugène-Louis
*The "Bassin du Commerce" at
Le Havre*
1894
Lower right: Le Havre /
E. Boudin 94
Oil on canvas
16 1/8 × 12 11/16" (41 × 32.2 cm)

Bequest of Mrs. Edna M. Welsh
1982-1-1

Boudin, Eugène-Louis
Beach at Étretat
1890
Lower left: E. Boudin 90; lower
right: Etretat.
Oil on canvas
15 7/8 × 21 3/4" (40.3 × 55.2 cm)

The Samuel S. White 3rd and
Vera White Collection
1967-30-3

Boudin, Eugène-Louis
*The Bridge over the River Touques at
Deauville*
1894
Lower right: Deauville /
E. Boudin 94
Oil on canvas
14 1/4 × 23" (36.2 × 58.4 cm)

The Mr. and Mrs. Carroll S.
Tyson, Jr., Collection
1963-116-1

Boudin, Eugène-Louis
Le Cap, Antibes
1893
Lower left: Le Cap / E. Boudin.
93; lower right: 2 mai 93
Oil on canvas
21 5/8 × 35 3/8" (54.9 × 89.8 cm)

Bequest of Charlotte Dorrance
Wright
1978-1-2

Boudin, Eugène-Louis
*Deauville, Flag-Decked Ships in the
Inner Harbor*
1896
Lower left: Deauville / E. Boudin.
96
Oil on panel
12 3/4 × 16 3/16" (32.4 × 41.1 cm)

Bequest of Charlotte Dorrance
Wright
1978-1-3

Bouguereau, William-Adolphe
French, 1825–1905
The Thank Offering
1867
Upper right: w—
BOVGVEREAV—1867.
Oil on canvas
57 15/16 × 42 1/8" (147.2 × 107 cm)

Gift of John G. Johnson for the
W. P. Wilstach Collection
W1900-1-5

Brown, John Lewis
French, 1829–1890
Two Huntsmen in a Landscape
Late 19th century
Lower left: John Lewis Brown
Oil on panel
5 5/8 × 3 15/16" (14.3 × 10 cm)

Bequest of Charlotte Dorrance
Wright
1978-1-4

Brandon, Jacques-Émile-Édouard
French, 1831–1897
Scene in a Synagogue
1869–70
Lower left: Ed. Brandon /
1869–1870.
Oil on canvas
61 3/8 × 34 11/16" (155.9 × 88.1 cm)

John G. Johnson Collection
cat. 904

Cabanel, Alexandre, attributed to
French, 1823–1889
The Governess
c. 1865–70
Lower left: {spurious signature
"A. CABANEL" removed in
restoration in 1979}
Oil on canvas
45 1/4 × 39 3/8" (114.9 × 100 cm)

Purchased with the Edward and
Althea Budd Fund
1977-80-1

Brascassat, Jacques-Raymond
French, 1804–1867
Head of a Cow
Mid-19th century
Lower right: JR Brascassat
Oil on canvas
17 1/16 × 21 15/16" (43.3 × 55.7 cm)

John G. Johnson Collection
cat. 905

Cals, Adolphe-Félix
French, 1810–1880
The Farm at Saint Simon, Honfleur
1876
Lower right: Cals Honfleur /
1876
Oil on canvas
14 3/16 × 24 5/8" (36 × 62.5 cm)

John G. Johnson Collection
cat. 909

Breton, Jules-Adolphe-Aimé-Louis
French, 1827–1905
The Feast of Saint John
c. 1875
Lower left: Jules Breton
Oil on canvas
13 1/2 × 24 1/8" (34.3 × 61.3 cm)

John G. Johnson Collection
cat. 906

Carrière, Eugène
French, 1849–1906
Mother and Child Sleeping
c. 1889
Lower left: Eugène Carrière
Oil on canvas
19 3/4 × 24 1/8" (50.2 × 61.3 cm)

John G. Johnson Collection
cat. 910

Carrière, Eugène
Young Girl Counting
Late 19th century
Lower left: Eugène Carrière
Oil on canvas
24 1/4 × 19 13/16" (61.6 × 50.3 cm)

The William L. Elkins Collection
E1924-3-78

Cézanne, Paul
French, 1839–1906
*Quartier Four, Auvers-sur-Oise
(Landscape, Auvers)*
c. 1873
Oil on canvas
18 1/4 × 21 3/4" (46.3 × 55.2 cm)

The Samuel S. White 3rd and
Vera White Collection
1967-30-16

Cazin, Jean-Charles
French, 1841–1901
Pond
By 1883
Lower left: J. C. CAZIN
Oil on canvas
25 9/16 × 31 15/16" (64.9 × 81.1 cm)

John G. Johnson Collection
cat. 912

Cézanne, Paul
*Still Life with Apples and a Glass
of Wine*
1877–79
Oil on canvas
10 1/2 × 12 7/8" (26.7 × 32.7 cm)

The Louise and Walter Arensberg
Collection
1950-134-32

Cazin, Jean-Charles
Solitude
By 1889
Lower right: J. C. CAZIN
Oil on canvas
23 9/16 × 28 3/4" (59.8 × 73 cm)

John G. Johnson Collection
cat. 911

Cézanne, Paul
Still Life with a Dessert
1877 or 1879
Lower right: P. Cezanne.
Oil on canvas
23 1/4 × 28 11/16" (59 × 72.9 cm)

The Mr. and Mrs. Carroll S.
Tyson, Jr., Collection
1963-116-5

Cazin, Jean-Charles
Fisherman's Cottage
By 1893
Lower left: J. C. CAZIN
Oil on canvas
18 3/8 × 22 1/8" (46.7 × 56.2 cm)

The George W. Elkins Collection
E1924-4-3

Cézanne, Paul
Bay of l'Estaque
1879–83
Lower right: PC
Oil on canvas
23 3/4 × 29 1/4" (60.3 × 74.3 cm)

The Mr. and Mrs. Carroll S.
Tyson, Jr., Collection
1963-116-21

Cézanne, Paul
Still Life with Flowers in an Olive Jar
c. 1880
Oil on canvas
18 1/4 × 13 1/2" (46.3 × 34.3 cm)

The Mr. and Mrs. Carroll S. Tyson, Jr., Collection
1963-116-2

Cézanne, Paul
Portrait of Madame Cézanne
1890–92
Oil on canvas
24 3/8 × 20 1/8" (61.9 × 51.1 cm)

The Henry P. McIlhenny Collection in memory of Frances P. McIlhenny
1986-26-1

Cézanne, Paul
View of the Bay of Marseilles with the Village of Saint-Henri
c. 1883
Oil on canvas
25 15/16 × 32" (65.9 × 81.3 cm)

The Mr. and Mrs. Carroll S. Tyson, Jr., Collection
1963-116-3

Cézanne, Paul
Winter Landscape near Paris
1894
Oil on canvas
25 5/8 × 31 7/8" (65.1 × 81 cm)

Gift of Frank and Alice Osborn
1966-68-3

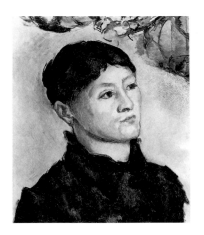

Cézanne, Paul
Portrait of Madame Cézanne
1885–87
Oil on canvas
18 1/8 × 15 1/16" (46 × 38.3 cm)

The Louis E. Stern Collection
1963-181-6

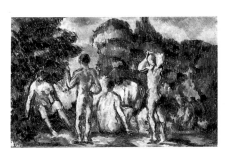

Cézanne, Paul
Group of Bathers
c. 1895
Oil on canvas
8 1/8 × 12 1/8" (20.6 × 30.8 cm)

The Louise and Walter Arensberg Collection
1950-134-34

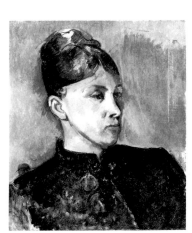

Cézanne, Paul
Portrait of Madame Cézanne
1886–87
Oil on canvas
18 7/16 × 15 5/16" (46.8 × 38.9 cm)

The Samuel S. White 3rd and Vera White Collection
1967-30-17

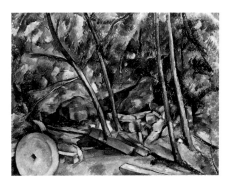

Cézanne, Paul
Millstone in the Park of the Château Noir
1898–1900
Oil on canvas
28 3/4 × 36 3/8" (73 × 92.4 cm)

The Mr. and Mrs. Carroll S. Tyson, Jr., Collection
1963-116-4

FRENCH

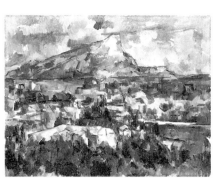

Cézanne, Paul
Mont Sainte-Victoire
1902–4
Oil on canvas
28 3/4 × 36 3/16" (73 × 91.9 cm)

The George W. Elkins Collection
E1936-1-1

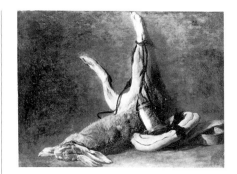

Chardin, Jean-Baptiste-Siméon
French, 1699–1779
Still Life with a Hare
c. 1730
Center right: chardin.
Oil on canvas
25 5/8 × 32" (65.1 × 81.3 cm)

Gift of Henry P. McIlhenny
1958-144-1

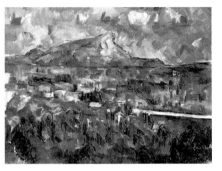

Cézanne, Paul
Mont Sainte-Victoire
1902–6
Oil on canvas
25 1/2 × 32" (64.8 × 81.3 cm)

Gift of Mrs. Louis C. Madeira
1977-288-1

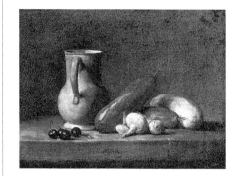

Chardin, Jean-Baptiste-Siméon, attributed to
Still Life with Cherries and Turnips
18th century
Center bottom: chardin
Oil on canvas
14 3/4 × 17 1/2" (37.5 × 44.4 cm)

John G. Johnson Collection
cat. 785

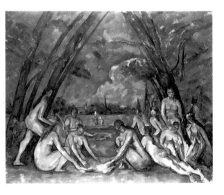

Cézanne, Paul
The Large Bathers
1906
Oil on canvas
82 7/8 × 98 3/4" (210.5 × 250.8 cm)

Purchased with the W. P. Wilstach Fund
W1937-1-1

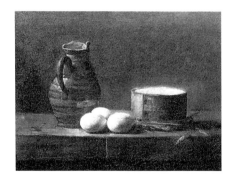

Chardin, Jean-Baptiste-Siméon, attributed to
Still Life with Eggs, Cheese, and a Pitcher
18th century
Lower left: chardin
Oil on canvas
14 7/8 × 17 15/16" (37.8 × 45.6 cm)

John G. Johnson Collection
cat. 786

Chambillan, J., attributed to
French, active c. 1870
Suit of Armor
c. 1870
Oil on canvas
29 × 16 1/2" (73.7 × 41.9 cm)

Bequest of Carl Otto Kretzschmar von Kienbusch
1977-167-1039

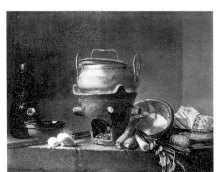

Chardin, Jean-Baptiste-Siméon, imitator of
Previously attributed to Jean-Baptiste-Siméon Chardin (JGJ 1941)
Still Life with a Kettle
19th century
Oil on canvas
27 3/16 × 33 1/4" (69.1 × 84.4 cm)

John G. Johnson Collection
cat. 788

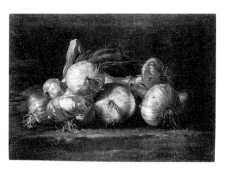

Chardin, Jean-Baptiste-Siméon, imitator of
Previously attributed to Jean-Baptiste-Siméon Chardin (JGJ 1941)
Still Life with Onions
19th century
Oil on canvas
19 1/8 × 25 3/8" (48.6 × 64.4 cm)

John G. Johnson Collection
cat. 789

Chintreuil, Antoine
Village Road and Two Figures
Mid-19th century
Lower right: Chintreuil
Oil on canvas
10 3/4 × 15 15/16" (27.3 × 40.5 cm)

John G. Johnson Collection
cat. 914

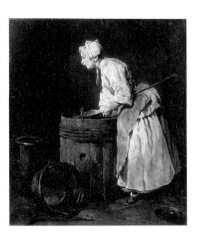

Chardin, Jean-Baptiste-Siméon, copy after
Scullery Maid
After the painting, dated 1738, in the Hunterian Art Gallery, University of Glasgow
19th century
Oil on canvas
18 1/4 × 15" (46.3 × 38.1 cm)

John G. Johnson Collection
cat. 782

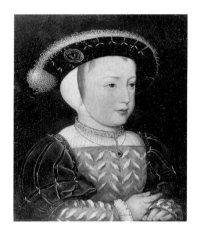

Clouet, Jean, copy after
French, c. 1475–1540/41
Previously listed as an old copy after François Clouet (JGJ 1941)
Portrait of the Dauphin Francis, Son of Francis I
After the painting in the Koninklijk Museum voor Schone Kunsten, Antwerp (cat. no. 33)
16th century
Oil on panel
12 3/8 × 9 1/8" (31.4 × 23.2 cm)

John G. Johnson Collection
inv. 309

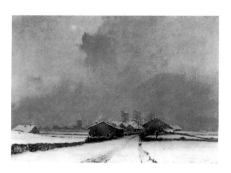

Chenu, Fleury (Augustin-Pierre-Bienvenu Chenu)
French, 1833–1875
Snowy Landscape
c. 1850–75
Lower right: Fleury Chenu
Oil on canvas on panel
24 1/4 × 32 1/2" (61.6 × 82.5 cm)

John G. Johnson Collection
cat. 913

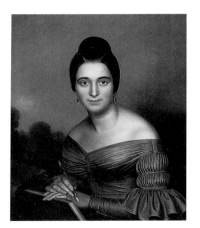

Collet, Édouard
French?, active c. 1839
Portrait of a Woman
1839
Lower right: Edouard Collet / 1839
Oil on canvas
25 9/16 × 21 5/16" (64.9 × 54.1 cm)

Gift of Mrs. Josiah Marvel
1962-74-1

Chintreuil, Antoine
French, 1816–1873
Village Road
c. 1850–73
Lower right: Chintreuil
Oil on canvas
18 7/8 × 14 1/2" (47.9 × 36.8 cm)

John G. Johnson Collection
cat. 915

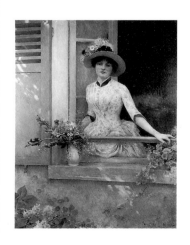

Collin, Louis-Joseph-Raphaël
French, 1850–1916
Morning
1884
Lower right: R COLLIN 1884
Oil on canvas
59 1/4 × 44 7/8" (150.5 × 114 cm)

John G. Johnson Collection
inv. 2956

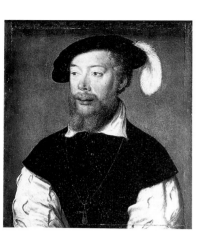

**Corneille de Lyon,
copy after?**
French, born The Hague, active
Lyon, active 1544–1574
Previously attributed to François
Clouet (JGJ 1941)
Portrait of a Man
16th century
Oil on panel
7 × 6 1/8" (17.8 × 15.6 cm)

John G. Johnson Collection
cat. 770

Corot, Jean-Baptiste-Camille
*Architectural Study (Door of the
Francis I Staircase, Cour Ovale,
Fontainebleau)*
1831–34
Oil on canvas
12 9/16 × 9 1/8" (31.9 × 23.2 cm)

Purchased with the W. P.
Wilstach Fund
W1897-1-4

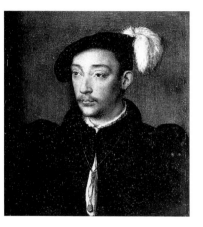

Corneille de Lyon, copy after
Previously listed as Corneille de
Lyon (JGJ 1941)
*Portrait of the Dauphin Francis, Son
of Francis I*
After a painting known in four
versions, none the original; other
versions are in the Isabella
Stewart Gardner Museum, Boston
(P21s23); the Musée Condé,
Chantilly (244); and the Musée
du Louvre, Paris (no. 1000)
16th century
Oil on panel
7 1/8 × 6" (18.1 × 15.2 cm)

John G. Johnson Collection
cat. 771

Corot, Jean-Baptiste-Camille
House and Factory of Monsieur Henry
1833
Lower right: C Corot / 1833
Oil on canvas
32 1/16 × 39 1/2" (81.4 × 100.3 cm)

Purchased with the W. P.
Wilstach Fund
W1950-1-1

Corot, Jean-Baptiste-Camille
French, 1796–1875
Aqueduct
c. 1826–28
Lower right: VENTE / COROT
Oil on canvas
9 1/2 × 17 1/4" (24.1 × 43.8 cm)

The Henry P. McIlhenny
Collection in memory of
Frances P. McIlhenny
1986-26-5

Corot, Jean-Baptiste-Camille
Edge of Lake Nemi
c. 1843
Lower right: COROT
Oil on canvas
23 5/8 × 36" (60 × 91.4 cm)

John G. Johnson Collection
cat. 940

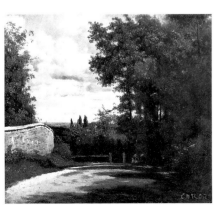

Corot, Jean-Baptiste-Camille
Ville d'Avray
c. 1828
Lower right: COROT
Oil on paper on canvas
10 7/8 × 11 9/16" (27.6 × 29.4 cm)

John G. Johnson Collection
cat. 931

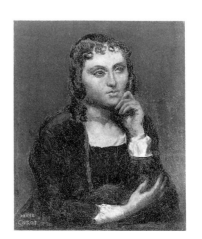

Corot, Jean-Baptiste-Camille
Pensive Young Brunette
1845–50
Lower left: VENTE / COROT
Oil on canvas
9 1/2 × 7 1/2" (24.1 × 19 cm)

The Louis E. Stern Collection
1963-181-18

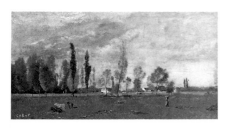

Corot, Jean-Baptiste-Camille
Fields of Saint-Ouen
1850–55
Lower left: COROT
Oil on canvas
8 1/16 × 14 3/4" (20.5 × 37.5 cm)

John G. Johnson Collection
cat. 918

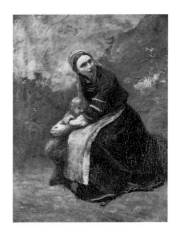

Corot, Jean-Baptiste-Camille
Mother Protecting Her Child
1855–58
Lower left: COROT
Oil on canvas
19 15/16 × 14 1/4" (50.6 × 36.2 cm)

The John D. McIlhenny
Collection
1943-40-52

Corot, Jean-Baptiste-Camille
Environs of Gruyères, Switzerland
c. 1850–65
Lower left: COROT
Oil on canvas
17 1/8 × 23 1/2" (43.5 × 59.7 cm)

John G. Johnson Collection
cat. 916

Corot, Jean-Baptiste-Camille
Château Thierry
1855–65
Lower right: COROT
Oil on canvas
8 7/8 × 13 1/8" (22.5 × 33.3 cm)

The William L. Elkins Collection
E1924-3-26

Corot, Jean-Baptiste-Camille
View in Holland
c. 1854
Lower right: COROT
Oil on canvas
15 7/16 × 20 5/16" (39.2 × 51.6 cm)

The George W. Elkins Collection
E1924-4-6

Corot, Jean-Baptiste-Camille
Under Trees, Marcoussy
c. 1855–65
Lower right: COROT
Oil on canvas
32 1/4 × 24 7/8" (81.9 × 63.2 cm)

John G. Johnson Collection
cat. 921

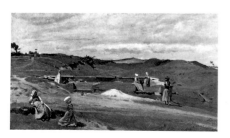

Corot, Jean-Baptiste-Camille
Wall, Côtes-du-Nord, Brittany
c. 1855
Lower right: COROT
Oil on canvas
12 3/4 × 21 3/4" (32.4 × 55.2 cm)

John G. Johnson Collection
cat. 922

Corot, Jean-Baptiste-Camille
Night Landscape with a Lioness
1857–73
Lower left: COROT
Oil on canvas
47 1/2 × 39" (120.6 × 99.1 cm)

John G. Johnson Collection
cat. 936

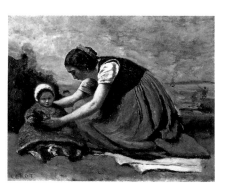

Corot, Jean-Baptiste-Camille
Mother and Child on a Beach
c. 1860
Lower left: COROT
Oil on canvas
14 15/16 × 18 3/16" (37.9 × 46.2 cm)

John G. Johnson Collection
cat. 930

Corot, Jean-Baptiste-Camille
Pollard Willows
1865–70
Lower left: COROT
Oil on canvas
16 3/16 × 23 11/16" (41.1 × 60.2 cm)

Gift of Elizabeth Donner
Norment
1980-100-1

Corot, Jean-Baptiste-Camille
*House in the Village of Saint-Martin,
near Boulogne-sur-Mer*
1860–65
Lower left: COROT
Oil on panel
16 1/8 × 12 7/8" (41 × 32.7 cm)

The George W. Elkins Collection
E1924-4-7

Corot, Jean-Baptiste-Camille
The Ferry
1865–72
Lower left: COROT
Oil on canvas
17 3/4 × 24" (45.1 × 61 cm)

The George W. Elkins Collection
E1924-4-5

Corot, Jean-Baptiste-Camille
Fisherman
1865–70
Lower left: COROT
Oil on canvas
19 3/8 × 29 3/4" (49.2 × 75.6 cm)

The William L. Elkins Collection
E1924-3-2

Corot, Jean-Baptiste-Camille
*Morning on the Estuary, Ville
d'Avray*
1870
Lower left: 1870; lower right:
COROT
Oil on canvas
22 × 31 7/8" (55.9 × 81 cm)

Bequest of Charlotte Dorrance
Wright
1978-1-7

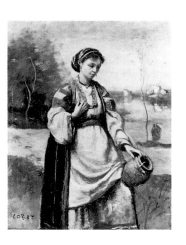

Corot, Jean-Baptiste-Camille
Gypsy Girl at a Fountain
1865–70
Lower left: COROT
Oil on canvas
22 7/8 × 16 7/8" (58.1 × 42.9 cm)

The George W. Elkins Collection
E1924-4-8

Corot, Jean-Baptiste-Camille
Goatherd of Terni
c. 1871
Lower right: COROT
Oil on canvas
32 3/8 × 24 5/8" (82.2 × 62.5 cm)

Bequest of Charlotte Dorrance
Wright
1978-1-8

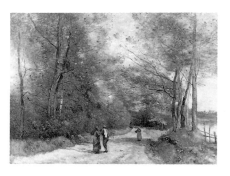

Corot, Jean-Baptiste-Camille
Wooded Path near Ville d'Avray
1872–74
Lower right: COROT
Oil on canvas
23 ⁷/₈ × 32 ¹/₄" (60.6 × 81.9 cm)

John G. Johnson Collection
cat. 928

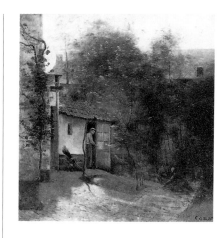

**Corot, Jean-Baptiste-Camille,
attributed to**
Previously listed as Jean-Baptiste-
Camille Corot (JGJ 1941)
Douai, the House of Alfred Robaut
1871
Lower right: COROT
Oil on canvas
21 ³/₄ × 19 ³/₄" (55.2 × 50.2 cm)

John G. Johnson Collection
cat. 929

**Corot, Jean-Baptiste-Camille,
attributed to**
Landscape
1825
Lower left: COROT 1825
Oil on canvas
16 ¹/₈ × 12 ⁷/₈" (41 × 32.7 cm)

John G. Johnson Collection
cat. 917

**Corot, Jean-Baptiste-Camille,
attributed to**
Previously listed as Jean-Baptiste-
Camille Corot (JGJ 1941)
Hilly Coast
19th century
Lower left: VENTE / COROT
Oil on canvas
10 × 14" (25.4 × 35.6 cm)

John G. Johnson Collection
cat. 926

**Corot, Jean-Baptiste-Camille,
attributed to**
Previously listed as Jean-Baptiste-
Camille Corot (JGJ 1941)
Lake Geneva
1839
Lower right: COROT
Oil on canvas
10 ¹/₄ × 13 ⁷/₈" (26 × 35.2 cm)

John G. Johnson Collection
cat. 925

**Corot, Jean-Baptiste-Camille,
imitator of**
Barbershop
19th century
Lower left (spurious): COROT; on
sign: COIFFEUR
Oil on canvas
16 ³/₈ × 13 ¹/₄" (41.6 × 33.6 cm)

John G. Johnson Collection
cat. 920

**Corot, Jean-Baptiste-Camille,
attributed to**
Previously listed as Jean-Baptiste-
Camille Corot (JGJ 1941)
*Landscape with a Stream and
Willows near Gisors*
c. 1860
Lower left: VENTE / COROT
Oil on canvas
21 ¹/₈ × 35 ⁷/₈" (53.7 × 91.1 cm)

John G. Johnson Collection
cat. 939

**Corot, Jean-Baptiste-Camille,
imitator of**
Cathedral of Nîmes
19th century
Lower left (spurious): COROT
Oil on canvas
14 × 10 ⁵/₈" (35.6 × 27 cm)

John G. Johnson Collection
cat. 927

Corot, Jean-Baptiste-Camille, imitator of
Courtyard
19th century
Lower right (spurious): COROT
Oil on canvas
17 $\frac{7}{16}$ × 13 $\frac{7}{8}$" (44.3 × 35.2 cm)

John G. Johnson Collection
cat. 941

Corot, Jean-Baptiste-Camille, imitator of
Previously listed as Jean-Baptiste-Camille Corot (JGJ 1941)
Landscape with a Village
19th century
Lower right (spurious): COROT
Oil on canvas
10 $\frac{5}{8}$ × 17 $\frac{3}{8}$" (27 × 44.1 cm)

John G. Johnson Collection
cat. 923

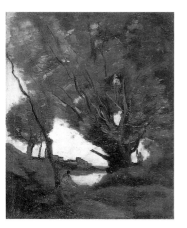

Corot, Jean-Baptiste-Camille, imitator of
Italian Landscape
19th century
Lower right (spurious): COROT
Oil on canvas
18 $\frac{5}{8}$ × 14 $\frac{3}{8}$" (47.3 × 36.5 cm)

John G. Johnson Collection
cat. 924

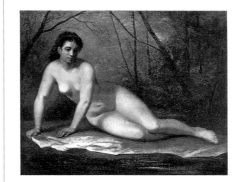

Corot, Jean-Baptiste-Camille, imitator of
Nude Woman
19th century
Lower left (spurious): COROT
Oil on canvas
21 $\frac{5}{8}$ × 26 $\frac{7}{8}$" (54.9 × 68.3 cm)

John G. Johnson Collection
cat. 933

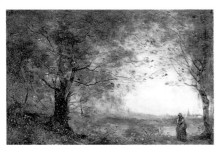

Corot, Jean-Baptiste-Camille, imitator of
Landscape with a Distant Village Spire
19th century
Lower left (spurious): COROT
Oil on canvas
10 × 14 $\frac{3}{8}$" (25.4 × 36.5 cm)

John G. Johnson Collection
cat. 932

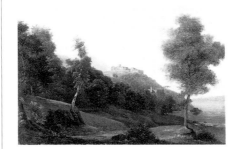

Corot, Jean-Baptiste-Camille, imitator of
Roman Landscape
19th century
Lower left (spurious): COROT
Oil on canvas
13 × 18 $\frac{5}{8}$" (33 × 47.3 cm)

John G. Johnson Collection
cat. 935

Corot, Jean-Baptiste-Camille, imitator of
Landscape with Two Figures
19th century
Lower right (spurious): COROT
Oil on canvas
8 $\frac{1}{8}$ × 13 $\frac{1}{4}$" (20.6 × 33.6 cm)

John G. Johnson Collection
cat. 934

Corot, Jean-Baptiste-Camille, imitator of
Village Lane and Gateway
19th century
Lower left (spurious): COROT
Oil on canvas
13 $\frac{1}{8}$ × 15 $\frac{1}{2}$" (33.3 × 39.4 cm)

John G. Johnson Collection
cat. 938

Courbet, Gustave
French, 1819–1877
Coast Scene
1854
Lower left: G. Courbet
Oil on canvas
37 ½ × 53 ¹¹⁄₁₆" (95.2 × 136.4 cm)

John G. Johnson Collection
cat. 947

Courbet, Gustave
Valley
c. 1865
Lower right: G. Courbet
Oil on canvas
25 ¾ × 32" (65.4 × 81.3 cm)

John G. Johnson Collection
cat. 942

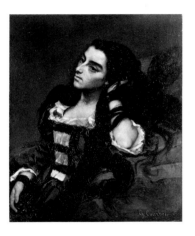

Courbet, Gustave
Spanish Woman
1855
Lower right: 55 / G. Courbet
Oil on canvas
31 ⅝ × 25 ½" (80.3 × 64.8 cm)

John G. Johnson Collection
inv. 2265

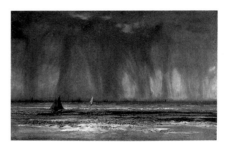

Courbet, Gustave
Marine
1866
Lower left: 66 / Gustave Courbet
Oil on canvas on gypsum board
17 × 25 ⅞" (43.2 × 65.7 cm)

John G. Johnson Collection
cat. 948

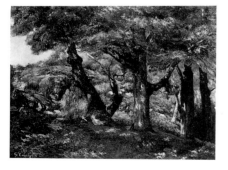

Courbet, Gustave
The Fringe of the Forest
c. 1856
Lower left: G. Courbet.
Oil on canvas
34 ¾ × 45 ⅜" (88.3 × 115.2 cm)

The Louis E. Stern Collection
1963-181-19

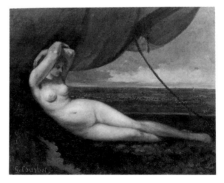

Courbet, Gustave
Nude Reclining by the Sea
1868
Lower left: 68 / G. Courbet.
Oil on canvas
18 ⁵⁄₁₆ × 21 ⅞" (46.5 × 55.6 cm)

The Louis E. Stern Collection
1963-181-20

Courbet, Gustave
La Charente, Port-Berteau
1862
Lower right: G. Courbet
Oil on canvas
16 ⅞ × 23 ¹⁵⁄₁₆" (42.9 × 60.8 cm)

John G. Johnson Collection
cat. 944

Courbet, Gustave
Waves
1869
Lower right: G. Courbet
Oil on canvas
29 ⅞ × 59 ⅝" (75.9 × 151.4 cm)

Gift of John G. Johnson for the
W. P. Wilstach Collection
W1905-1-1

Courbet, Gustave
Waves
c. 1870
Lower left: G. Courbet.
Oil on canvas
12 ³/₄ × 19" (32.4 × 48.3 cm)

The Louis E. Stern Collection
1963-181-21

**Courbet, Gustave,
attributed to**
Previously listed as Gustave
Courbet (PMA 1965)
Landscape at Ornans
c. 1868
Lower left: G. Courbet
Oil on canvas
18 ⁵/₈ × 22 ³/₁₆" (47.3 × 56.4 cm)

Purchased with the W. P.
Wilstach Fund
W1895-1-12

Courbet, Gustave
Head of a Woman and Flowers
1871
Lower right: .71 Ste. Pelagie /
G. Courbet.
Oil on canvas
21 ⁷/₈ × 18 ³/₈" (55.6 × 46.7 cm)

The Louis E. Stern Collection
1963-181-23

**Courbet, Gustave,
attributed to**
Previously listed as Gustave
Courbet (PMA 1965)
Landscape at Ornans
19th century
Lower right: G. Courbet
Oil on canvas
31 ⁷/₈ × 39 ¹/₂" (81 × 100.3 cm)

The John D. McIlhenny
Collection
1943-40-55

Courbet, Gustave
Still Life with Apples and a Pear
1871
Lower left: 71 G. Courbet.
Oil on canvas
9 ¹/₂ × 12 ⁵/₁₆" (24.1 × 31.3 cm)

The Louis E. Stern Collection
1963-181-22

Courbet, Gustave, studio of
Previously listed as Gustave
Courbet (JGJ 1941)
Rocky Coast
19th century
Lower right: G. Courbet
Oil on canvas
18 ⁵/₁₆ × 23 ¹¹/₁₆" (46.5 × 60.2 cm)

John G. Johnson Collection
cat. 943

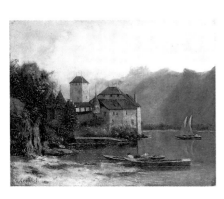

Courbet, Gustave
Château Chillon
c. 1874
Lower left: G. Courbet.
Oil on canvas on gypsum board
23 ⁹/₁₆ × 28 ¹¹/₁₆" (59.8 × 72.9 cm)

John G. Johnson Collection
cat. 945

**Courbet, Gustave,
imitator of**
Previously listed as Gustave
Courbet (PMA 1965)
Rill in the Mountains
19th century
Lower right (spurious):
G. Courbet. 73
Oil on canvas
21 ⁵/₁₆ × 25 ⁹/₁₆" (54.1 × 64.9 cm)

Gift of John G. Johnson for the
W. P. Wilstach Collection
W1907-1-21

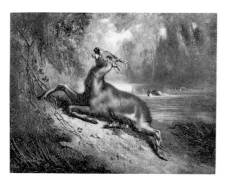

Courbet, Gustave, imitator of
Wounded Stag
19th century
Lower left (spurious): G. Courbet
Oil on canvas
19 5/8 × 24 9/16" (49.8 × 62.4 cm)

John G. Johnson Collection
cat. 946

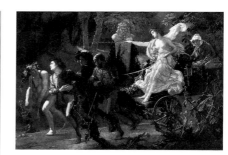

Couture, Thomas
The Thorny Path
1873
On herm: T. C. / 1873
Oil on canvas
51 1/2 × 75" (130.8 × 190.5 cm)

Purchased with the W. P. Wilstach Fund, the George W. Elkins Fund, and the Edith H. Bell Fund
EW1986-10-1

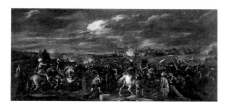

Courtois, Jacques, also called Il Borgognone, follower of
French, 1621–1675
Battle Scene
17th century
Oil on canvas
29 × 58 7/8" (73.7 × 149.5 cm)

The Bloomfield Moore Collection
1883-140

Couture, Thomas
Landscape near the Sea
1876
Lower left: T. C.
Oil on canvas
18 3/8 × 21 13/16" (46.7 × 55.4 cm)

John G. Johnson Collection
cat. 949

Courtois, Jacques, follower of
Battle Scene
17th century
Oil on canvas
28 15/16 × 59" (73.5 × 149.9 cm)

The Bloomfield Moore Collection
1883-141

Couture, Thomas
The Little Confectioner
c. 1878
Center right: T.C.
Oil on canvas
25 7/8 × 21 9/16" (65.7 × 54.8 cm)

The William L. Elkins Collection
E1924-3-67

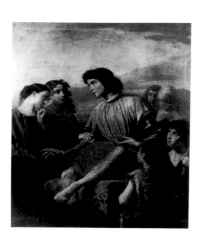

Couture, Thomas
French, 1815–1879
Troubadour
1843
Center bottom: Tas Couture
Oil on canvas
68 1/8 × 56 1/2" (173 × 143.5 cm)

John G. Johnson Collection
cat. 950

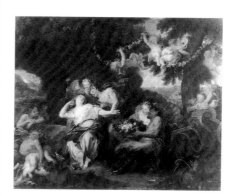

Coypel, Antoine
French, 1661–1722
Bacchus and Ariadne on the Isle of Naxos
c. 1693
Oil on canvas
28 3/4 × 33 2/3" (73 × 85.5 cm)

Bequest (by exchange) of Edna M. Welsh and gift of Mrs. R. Barclay Scull
1990-54-1

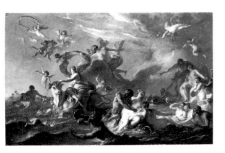

Coypel, Noël-Nicolas
French, 1690–1734
The Rape of Europa
1726–27
Lower right: Noel Coypel
172[7?]
Oil on canvas
50 1/4 × 76 3/8" (127.6 × 194 cm)

Gift of John Cadwalader
1978-160-1

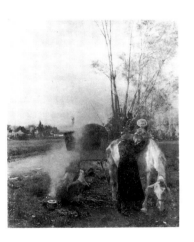

Dagnan-Bouveret, Pascal-Adolphe-Jean
French, 1852–1929
Gypsy Scene
1883
Lower left: P.A.J. Dagnan / 1883
Oil on canvas
17 3/8 × 14" (44.1 × 35.6 cm)

John G. Johnson Collection
cat. 952

Dagnan-Bouveret, Pascal-Adolphe-Jean
Bernoise
1887
Lower right: P.A.J. Dagnan.
PB 1887
Oil on canvas
21 7/8 × 16 1/2" (55.6 × 41.9 cm)

John G. Johnson Collection
cat. 953

Daubigny, Charles-François
French, 1817–1878
Mill
1857
Lower right: C. Daubigny 1857
Oil on canvas
34 1/8 × 59 1/4" (86.7 × 150.5 cm)

The William L. Elkins Collection
E1924-3-4

Daubigny, Charles-François
Moonlight
c. 1860–74
Lower left: Daubigny
Oil on canvas
25 1/2 × 38 3/4" (64.8 × 98.4 cm)

The William L. Elkins Collection
E1924-3-62

Daubigny, Charles-François
Oxen and a Cart
1862
Lower left: Daubigny 1862
Oil on canvas
16 15/16 × 28 7/8" (43 × 73.3 cm)

Bequest of Charlotte Dorrance
Wright
1978-1-9

Daubigny, Charles-François
River Scene, Conflans
1867
Lower left: Daubigny 1867
Oil on panel
17 15/16 × 31 5/8" (45.6 × 80.3 cm)

John G. Johnson Collection
cat. 958

Daubigny, Charles-François
Landscape near Villerville
1868
Lower left: Daubigny 68
Oil on canvas on gypsum board
18 3/4 × 31 5/8" (47.6 × 80.3 cm)

John G. Johnson Collection
cat. 956

Daubigny, Charles-François
Solitude
1869
Lower left: Daubigny 1869
Oil on canvas
19 5/8 × 36 9/16" (49.8 × 92.9 cm)

The George W. Elkins Collection
E1924-4-10

Daubigny, Charles-François
River and Bridge
Mid-19th century
Lower right: Daubigny
Oil on panel
10 3/8 × 17 7/16" (26.3 × 44.3 cm)

John G. Johnson Collection
cat. 957

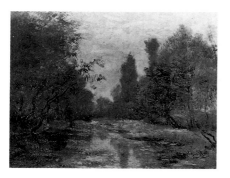

Daubigny, Charles-François
Brook
Mid-19th century
Lower left: Daubigny
Oil on canvas on gypsum board
10 3/4 × 13 3/4" (27.3 × 34.9 cm)

John G. Johnson Collection
cat. 959

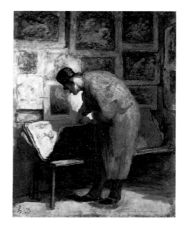

Daumier, Honoré
French, 1808–1879
The Print Collector
c. 1860
Lower left: h.D
Oil on panel
13 7/16 × 10 1/4" (34.1 × 26 cm)

Purchased with the W. P.
Wilstach Fund
W1954-1-1

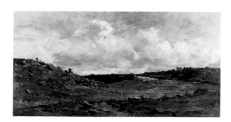

Daubigny, Charles-François
Hilly Landscape
Mid-19th century
Lower right: Daubigny
Oil on panel
9 3/4 × 18 3/4" (24.8 × 47.6 cm)

John G. Johnson Collection
cat. 955

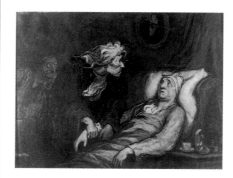

Daumier, Honoré
The Imaginary Illness
c. 1860–62
Lower right: h. Daumier
Oil on panel
10 1/2 × 13 7/8" (26.7 × 35.2 cm)

Purchased with the Lisa Norris
Elkins Fund and funds
contributed by R. Sturgis
Ingersoll, George D. Widener,
Lessing J. Rosenwald, Henry P.
McIlhenny, Dr. I. S. Ravdin,
Floyd T. Starr, Irving H. Vogel,
Mr. and Mrs. Rodolphe Meyer de
Schauensee, and Mrs. Herbert
Cameron Morris
1954-10-1

Daubigny, Charles-François
Landscape
Mid-19th century
Oil on canvas
34 9/16 × 75 11/16" (87.8 ×
192.2 cm)

John G. Johnson Collection
inv. 2976

Daumier, Honoré, imitator of
Man Bathing a Child
Based on the painting in the
Detroit Institute of Arts (70.166)
19th century
Lower right (spurious): h. Daumier
Oil on canvas
12 7/8 × 16 1/4" (32.7 × 41.3 cm)

John G. Johnson Collection
cat. 960

David, Jacques-Louis
French, 1748–1825
Portrait of Pope Pius VII and Cardinal Caprara
c. 1805
Upper left: PIE VII / A L'AGE DE 63 ANS.; upper right: LE CNAL. CAPRARA / SON LÉGAT EN FRANCE.
Oil on panel
54 3/8 × 37 3/4" (138.1 × 96 cm)

Gift of Henry P. McIlhenny
1971-265-1

Decamps, Gabriel-Alexandre
Marine with a Stormy Sunset
c. 1849
Lower left: DC
Oil on canvas
9 1/8 × 15 1/2" (23.2 × 39.4 cm)

John G. Johnson Collection
cat. 965

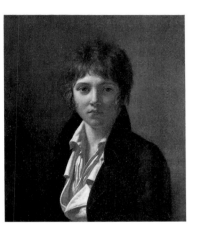

David, Jacques-Louis, follower of
Previously listed as Jacques-Louis David (PMA 1965)
Portrait of Édouard Duval d'Ogne
c. 1800–10
Oil on canvas
21 7/8 × 18 1/16" (55.6 × 45.9 cm)

The Mr. and Mrs. Carroll S. Tyson, Jr., Collection
1963-116-6

Decamps, Gabriel-Alexandre
Halt during a Hunt
Mid-19th century
Center bottom: DC.
Oil on canvas
6 3/4 × 8 5/8" (17.1 × 21.9 cm)

The William L. Elkins Collection
E1924-3-58

Decamps, Gabriel-Alexandre
French, 1803–1860
Bivouac before Waterloo
c. 1827
Lower left: DECAMPS.
Oil on canvas
12 5/8 × 17 3/4" (32.1 × 45.1 cm)

John G. Johnson Collection
cat. 967

Decamps, Gabriel-Alexandre
Oriental Landscape
Mid-19th century
Lower right: Decamps
Oil on canvas
16 1/4 × 23 3/8" (41.3 × 59.4 cm)

John G. Johnson Collection
cat. 968

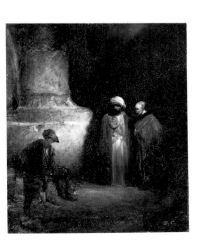

Decamps, Gabriel-Alexandre
Oriental Night Scene
c. 1836
Lower right: D.C.
Oil on canvas
23 13/16 × 20 3/16" (60.5 × 51.3 cm)

John G. Johnson Collection
cat. 966

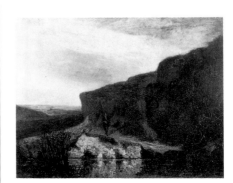

Decamps, Gabriel-Alexandre, attributed to
Syrian Landscape
19th century
Oil on canvas
19 7/8 × 25 5/8" (50.5 × 65.1 cm)

John G. Johnson Collection
cat. 964

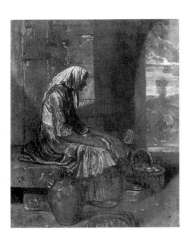

Decamps, Gabriel-Alexandre, attributed to
Vegetable Seller
19th century
Lower left: DC.
Oil on paper on canvas
26⁵/₁₆ × 20⁵/₁₆" (66.8 × 51.6 cm)

John G. Johnson Collection
cat. 961

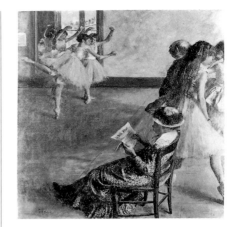

Degas, Hilaire-Germain-Edgar
The Ballet Class
c. 1880
Lower left: Degas
Oil on canvas
32³/₈ × 30¹/₄" (82.2 × 76.8 cm)

Purchased with the W. P.
Wilstach Fund
W1937-2-1

Decamps, Gabriel-Alexandre, attributed to
Previously listed as Gabriel-
Alexandre Decamps (JGJ 1941)
Woman and Boy
19th century
Lower left: DC
Oil on canvas
14¹/₈ × 11¹/₈" (35.9 × 28.3 cm)

John G. Johnson Collection
cat. 962

Degas, Hilaire-Germain-Edgar
After the Bath
c. 1895
Lower right: Degas
Oil on canvas
18¹/₄ × 25³/₄" (46.3 × 65.4 cm)

Gift of Mr. and Mrs. Orville H.
Bullitt
1963-117-1

Degas, Hilaire-Germain-Edgar
French, 1834–1917
Interior
1868 or 1869
Lower right: Degas
Oil on canvas
32 × 45" (81.3 × 114.3 cm)

The Henry P. McIlhenny
Collection in memory of
Frances P. McIlhenny
1986-26-10

Degas, Hilaire-Germain-Edgar
After the Bath (Woman Drying Herself)
c. 1896
Lower right: Degas
Oil on canvas
35¹/₄ × 46" (89.5 × 116.8 cm)

Purchased with funds from the
estate of George D. Widener
1980-6-1

Degas, Hilaire-Germain-Edgar
Cow
c. 1876
Lower left: Degas
Oil on cigar-box top
8 × 11⁵/₈" (20.3 × 29.5 cm)

John G. Johnson Collection
cat. 971

Delacroix, Ferdinand-Victor-Eugène
French, 1798–1863
Portrait of Eugène Berny d'Ouville
1828
Lower right: Eug. Delacroix /
1828
Oil on canvas
24 × 19⁵/₁₆" (61 × 49 cm)

The Henry P. McIlhenny
Collection in memory of
Frances P. McIlhenny
1986-26-18

Delacroix, Ferdinand-Victor-Eugène
Interior of a Dominican Convent in Madrid
1831
Center bottom: EUG. DELACROIX 1831
Oil on canvas
51 1/4 × 63 3/4" (130.2 × 161.9 cm)

Purchased with the W. P. Wilstach Fund
W1894-1-2

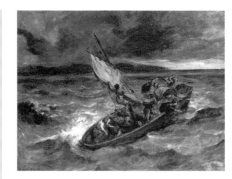

Delacroix, Ferdinand-Victor-Eugène
Christ on the Sea of Galilee
1853
Lower left: Eug Delacroix
Oil on composition board
18 3/4 × 22 7/8" (47.6 × 58.1 cm)

Gift of Mr. and Mrs. R. Sturgis Ingersoll
1950-6-1

Delacroix, Ferdinand-Victor-Eugène
Still Life with Dahlias
c. 1833
Oil on canvas
19 11/16 × 13" (50 × 33 cm)

John G. Johnson Collection
cat. 976

Delacroix, Ferdinand-Victor-Eugène
Horses at a Fountain
1862
Lower left: Eug. Delacroix 1862.
Oil on canvas
29 × 36 3/8" (73.7 × 92.4 cm)

Purchased with the W. P. Wilstach Fund
W1950-1-2

Delacroix, Ferdinand-Victor-Eugène
The Death of Sardanapalus
1844
Oil on canvas
29 × 32 7/16" (73.7 × 82.4 cm)

The Henry P. McIlhenny Collection in memory of Frances P. McIlhenny
1986-26-17

Delacroix, Ferdinand-Victor-Eugène, imitator of
Previously listed as Ferdinand-Victor-Eugène Delacroix (JGJ 1941)
Eagle
19th century
Lower right (spurious): Eug Delacroix
Oil on canvas
14 5/16 × 16 11/16" (36 × 42.4 cm)

John G. Johnson Collection
cat. 972

Delacroix, Ferdinand-Victor-Eugène
Still Life with Flowers and Fruit
1848
Oil on canvas
42 5/8 × 56 3/8" (108.3 × 143.2 cm)

John G. Johnson Collection
cat. 974

Delacroix, Ferdinand-Victor-Eugène, imitator of
Previously listed as Ferdinand-Victor-Eugène Delacroix (JGJ 1941)
Lion Devouring an Arab
19th century
Lower right (spurious): Eug. Delacroix
Oil on canvas
21 5/16 × 25 3/4" (54.1 × 65.4 cm)

John G. Johnson Collection
cat. 977

Delacroix, Ferdinand-Victor-Eugène, imitator of
Tigers Devouring a Horse
19th century
Lower right (spurious): E D.
Oil on canvas
19 1/16 × 23 5/8" (48.4 × 60 cm)

John G. Johnson Collection
inv. 2836

Diaz de la Peña, Narcisse-Virgile
Interior of a Forest
1862
Lower left: N. DIAZ, 62
Oil on canvas
32 × 39 1/2" (81.3 × 100.3 cm)

The Walter Lippincott Collection
1923-59-16

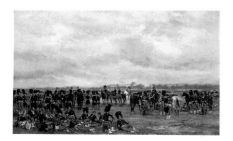

Detaille, Jean-Baptiste-Édouard
French, 1848–1912
Grenadiers at the Camp of Saint-Maur
1869
Lower right: EDOUARD DETAILLE. / 1869.
Oil on canvas
22 9/16 × 35 5/8" (57.3 × 90.5 cm)

The William L. Elkins Collection
E1924-3-82

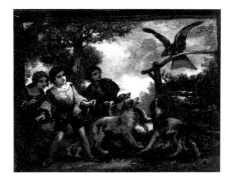

Diaz de la Peña, Narcisse-Virgile
Boys and an Eagle
1864
Lower right: N. Diaz. 64.
Oil on canvas
15 1/2 × 18 3/4" (39.4 × 47.6 cm)

The William L. Elkins Collection
E1924-3-63

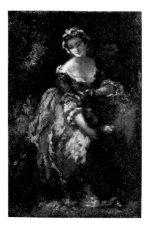

Diaz de la Peña, Narcisse-Virgile
French, 1808–1876
Girl in a Green Dress
c. 1850–55
Oil on panel
11 7/8 × 7 1/4" (30.2 × 18.4 cm)

Bequest of Arthur H. Lea
F1938-1-31

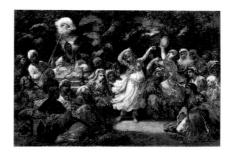

Diaz de la Peña, Narcisse-Virgile
Dance of the Almahs
1864
Lower right: N. Diaz 64.
Oil on canvas
17 1/2 × 25 11/16" (44.4 × 65.2 cm)

John G. Johnson Collection
cat. 978

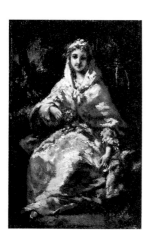

Diaz de la Peña, Narcisse-Virgile
Girl in a White-and-Pink Dress
c. 1850–55
Oil on canvas
11 7/8 × 7 1/4" (30.2 × 18.4 cm)

Bequest of Arthur H. Lea
F1938-1-20

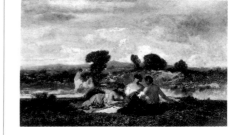

Diaz de la Peña, Narcisse-Virgile
Bathers
Mid-19th century
Lower left: N. Diaz.
Oil on panel
11 7/16 × 18 5/16" (29 × 46.5 cm)

The William L. Elkins Collection
E1924-3-66

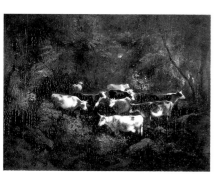

Diaz de la Peña, Narcisse-Virgile
Cows in the Forest
Mid-19th century
Lower left: N. Diaz
Oil on panel
10 9/16 × 13 13/16" (26.8 × 35.1 cm)

John G. Johnson Collection
cat. 981

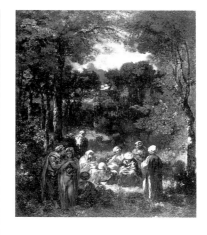

Diaz de la Peña, Narcisse-Virgile
Oriental Fantasy
Mid-19th century
Lower right: N. Diaz
Oil on canvas
18 3/16 × 15" (46.2 × 38.1 cm)

John G. Johnson Collection
inv. 2585

Diaz de la Peña, Narcisse-Virgile
Forest Path
Mid-19th century
Lower left: N. Diaz
Oil on panel
28 3/16 × 23 1/2" (71.6 × 59.7 cm)

John G. Johnson Collection
cat. 983

Diaz de la Peña, Narcisse-Virgile
Spring
Mid-19th century
Oil on canvas
86 7/8 × 58 1/8" (220.7 × 147.6 cm)

The William L. Elkins Collection
E1924-3-70

Diaz de la Peña, Narcisse-Virgile
Landscape
Mid-19th century
Lower right: D.
Oil on canvas
12 11/16 × 16 1/8" (32.2 × 41 cm)

John G. Johnson Collection
cat. 979

Diaz de la Peña, Narcisse-Virgile, follower of
Picture of a Portrait of a Boy and a Girl
c. 1860
Lower left: A. M.
Oil on cardboard
11 15/16 × 8 3/4" (30.3 × 22.2 cm)

The Samuel S. White 3rd and Vera White Collection
1967-30-61

Diaz de la Peña, Narcisse-Virgile
Landscape
Mid-19th century
Lower left: N. Diaz
Oil on panel
7 3/8 × 9 1/2" (18.7 × 24.1 cm)

John G. Johnson Collection
cat. 982

Dupré, Jules
French, 1811–1889
Landscape with a Windmill
c. 1870
Lower left: Jules Dupré; on card on reverse: Le tableau ci-contre representant / —le moulin de l'Isle-Adam.— / m'a ete personellement offert / par mon eminent cofrere et ami / Jules Dupré / Paris, ce 18 Juin 1870 / F. Flameng
Oil on panel
11 3/16 × 18 3/4" (28.4 × 47.6 cm)

John G. Johnson Collection
cat. 988

Dupré, Jules
Great Oak
By 1883
Lower right: Jules Dupré
Oil on canvas
67 1/2 × 56" (171.4 × 142.2 cm)

John G. Johnson Collection
cat. 984

Dupré, Jules
Marine
Mid-19th century
Lower left: Jules Dupré
Oil on canvas
29 1/8 × 36 9/16" (74 × 92.9 cm)

John G. Johnson Collection
cat. 986

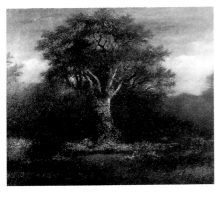

Dupré, Jules
Forest of Compiègne
Mid-19th century
Lower left: J. Dupré
Oil on panel
25 7/16 × 28 11/16" (64.6 × 72.9 cm)

John G. Johnson Collection
cat. 985

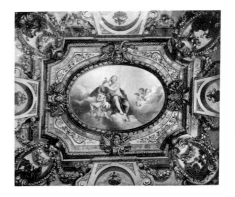

Dupuis, Pierre
French, 1610–1682
Perspectival Ceiling with Apollo Playing the Lyre
1678
Lower left border, central medallion: Pierre Dupuis 1678
Oil on canvas
204 × 234" (518.2 × 594.4 cm)

Purchased with funds contributed in memory of R. Nelson Buckley
1947-86-1

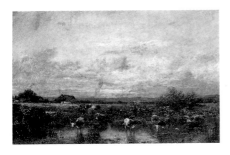

Dupré, Jules
Landscape
Mid-19th century
Lower right: Jules Dupré
Oil on canvas
20 7/8 × 31 3/4" (53 × 80.6 cm)

The William L. Elkins Collection
E1924-3-5

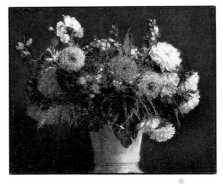

Fantin-Latour, Ignace-Henri-Jean-Théodore
French, 1836–1904
Still Life with Chrysanthemums
1862
Lower right: Fantin 62
Oil on canvas
18 1/8 × 21 7/8" (46 × 55.6 cm)

John G. Johnson Collection
cat. 990

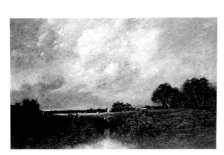

Dupré, Jules
Landscape
Mid-19th century
Lower right: Jules Dupré
Oil on canvas
23 5/8 × 35 3/8" (60 × 89.8 cm)

The George W. Elkins Collection
E1924-4-11

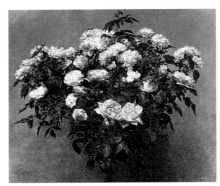

Fantin-Latour, Ignace-Henri-Jean-Théodore
Still Life with White Roses
1875
Lower left: Fantin / Juillet 1875
Oil on canvas
21 13/16 × 23 1/4" (55.4 × 59 cm)

Bequest of Charlotte Dorrance Wright
1978-1-17

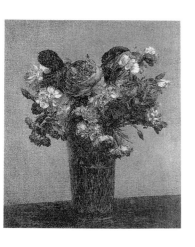

Fantin-Latour, Ignace-Henri-Jean-Théodore
Still Life with Roses and Asters in a Glass
1877
Lower left: Fantin 77
Oil on canvas
13 3/16 × 10 3/4" (33.5 × 27.3 cm)

Bequest of Charlotte Dorrance Wright
1978-1-13

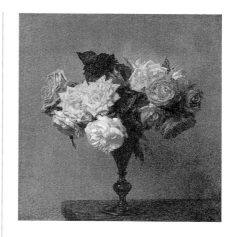

Fantin-Latour, Ignace-Henri-Jean-Théodore
Still Life with Roses in a Vase
1888
Lower left: Fantin
Oil on canvas
17 1/4 × 18" (43.8 × 45.7 cm)

Bequest of Charlotte Dorrance Wright
1978-1-16

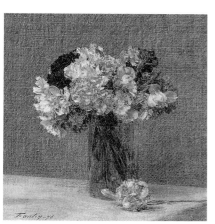

Fantin-Latour, Ignace-Henri-Jean-Théodore
Still Life with Carnations
1878
Lower left: Fantin—78
Oil on canvas
13 × 11 3/4" (33 × 29.8 cm)

Bequest of Charlotte Dorrance Wright
1978-1-14

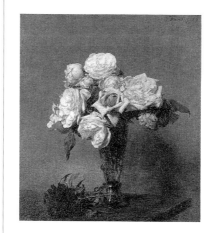

Fantin-Latour, Ignace-Henri-Jean-Théodore
Still Life with Roses in a Fluted Vase
1889
Upper right: Fantin 89
Oil on canvas
17 1/2 × 15" (44.4 × 38.1 cm)

Bequest of Charlotte Dorrance Wright
1978-1-10

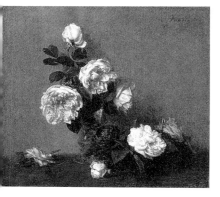

Fantin-Latour, Ignace-Henri-Jean-Théodore
Still Life with Roses of Dijon
1882
Upper right: Fantin / Bure oct. 1882
Oil on canvas
16 9/16 × 18 5/16" (42.1 × 46.5 cm)

Bequest of Charlotte Dorrance Wright
1978-1-11

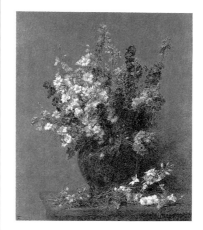

Fantin-Latour, Ignace-Henri-Jean-Théodore
Still Life with Imperial Delphiniums
1891
Lower left: Fantin—91
Oil on canvas
29 13/16 × 24 5/8" (75.7 × 62.5 cm)

Bequest of Charlotte Dorrance Wright
1978-1-15

Fantin-Latour, Ignace-Henri-Jean-Théodore
Still Life with White Pinks in a Glass Vase
c. 1885
Upper right: Fantin
Oil on canvas
13 5/8 × 12 3/4" (34.6 × 32.4 cm)

Bequest of Charlotte Dorrance Wright
1978-1-12

Forain, Jean-Louis
French, 1852–1931
The Hearing
c. 1900
Lower left: forain
Oil on canvas
29 3/8 × 23 7/8" (74.6 × 60.6 cm)

Gift of Mr. and Mrs. Arthur Wiesenberger
1962-206-1

Franco-Flemish, unknown artist
Previously listed as the school of Jean Bourdichon (JGJ 1941)
Virgin and Child, with Saints Anne and Elizabeth, and the Young Saint John the Baptist
Center panel of a triptych; companion to the following two panels
c. 1500
Oil on panel
36 3/8 × 30" (92.4 × 76.2 cm)

John G. Johnson Collection
cat. 762a

Franco-Flemish, unknown artist
Previously listed as the school of Jean Bourdichon (JGJ 1941)
The Presentation of Christ in the Temple and the Meeting at the Golden Gate
Wings of a triptych; companions to the preceding panel; see following two panels for reverse
c. 1500
Oil on panel
Each panel: 43 × 18 3/4"
(109.2 × 47.6 cm)

John G. Johnson Collection
cat. 762b, c

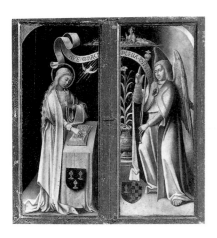

Franco-Flemish, unknown artist
Previously listed as the school of Jean Bourdichon (JGJ 1941)
The Annunciation
Reverse of the preceding two panels
c. 1500
On banner: AVE GRACI / PLENA DNS TECVM
Oil on panel
Each panel: 43 × 18 3/4"
(109.2 × 47.6 cm)

John G. Johnson Collection
cat. 762d, e

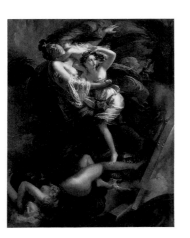

Franque, Joseph
French, active Naples,
1774–1833
Scene during the Eruption of Vesuvius
c. 1827
Oil on canvas
116 1/2 × 90" (295.9 × 228.6 cm)

Purchased with the George W. Elkins Fund
E1972-3-1

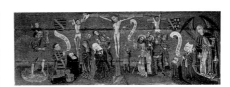

French, unknown artist
Previously listed as a South French artist, c. 1500 (JGJ 1941)
The Crucifixion, with Saint Christopher, the Archangel Michael, and Two Donors
From the parish church of Moyencourt
c. 1430
Left: [M]iserere mei deus.; center: [V]ere filius dei erat iste; right: [O] filij dei memento mei
Oil on panel
24 1/8 × 65 7/8" (61.3 × 167.3 cm)

John G. Johnson Collection
inv. 1729

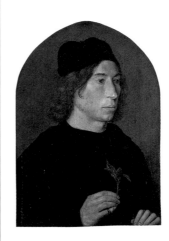

French, unknown artist
Previously listed as a French artist, c. 1490–95 (JGJ 1941)
Portrait of a Young Man Holding a Sprig of Coxcomb
c. 1490–1500
Oil on panel
17 3/4 × 13 1/8" (45.1 × 33.3 cm)

John G. Johnson Collection
cat. 764

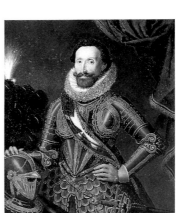

French, unknown artist
Portrait of a Man in Armor
c. 1575–1625
Oil on canvas
44 1/2 × 35" (113 × 88.9 cm)

Bequest of Carl Otto Kretzschmar von Kienbusch
1977-167-1085

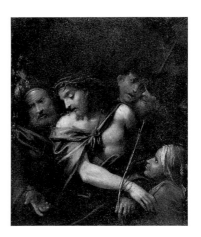

French, unknown artist
Previously listed as Jacques Stella (JGJ 1941)
The Mocking of Christ
17th century?
Oil on panel
8 3/8 × 6 13/16" (21.3 × 17.3 cm)

John G. Johnson Collection
cat. 774

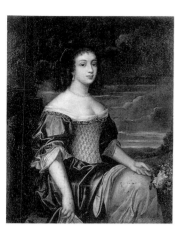

French, unknown artist
Portrait of the Duchess of Chevreuse
17th century
Oil on canvas
41 3/4 × 32 5/8" (106 × 82.9 cm)

Bequest of Arthur H. Lea
F1938-1-1

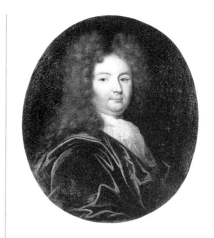

French, unknown artist
Portrait of a Man
18th century
Oil on canvas
28 3/4 × 23 1/4" (73 × 59 cm)

Bequest of Arthur H. Lea
F1938-1-12

French, unknown artist
Portrait of a Man in Armor
[possibly Louis XIII, King of
France]
17th century
Oil on canvas on fiberboard
39 1/2 × 33 1/2" (100.3 × 85.1 cm)

Bequest of Carl Otto
Kretzschmar von Kienbusch
1977-167-1084

French, unknown artist
Previously attributed to Jean-
Baptiste-Simeon Chardin
(JGJ 1941)
*Still Life of Kitchen Shelves with a
Ham*
18th century
Lower right (spurious): Chardin
1774
Oil on canvas
42 1/4 × 33 1/4" (107.3 × 84.4 cm)

John G. Johnson Collection
cat. 787

French?, unknown artist
Previously listed as a French
artist, c. 1740 (JGJ 1941)
Portrait of a Woman Drawing
c. 1750–1800
Oil on canvas
36 3/8 × 29 1/4" (92.4 × 74.3 cm)

John G. Johnson Collection
cat. 780

French, unknown artist
Landscape
c. 1800–25
Oil on canvas
19 3/4 × 23 3/8" (50.2 × 59.4 cm)

John G. Johnson Collection
inv. 2841

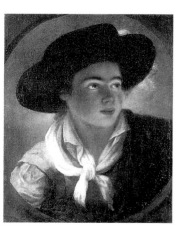

French, unknown artist
Portrait of a Boy
18th century?
Oil on canvas
19 3/4 × 15 1/2" (50.2 × 39.4 cm)

John G. Johnson Collection
inv. 2926

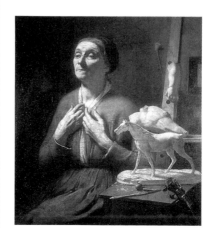

French, unknown artist
Previously listed as a French
artist, late 18th century (JGJ
1941)
*Old Woman Seated in an Artist's
Studio*
c. 1800–25
Oil on canvas
42 13/16 × 36 7/8" (108.7 ×
93.7 cm)

John G. Johnson Collection
cat. 779

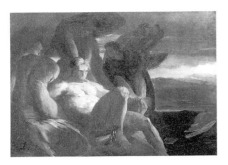

French, unknown artist
Prometheus Bound
c. 1800–25
Lower left (spurious): E. D.
Oil on paper on canvas
9 3/8 × 12 3/4" (23.8 × 32.4 cm)

John G. Johnson Collection
cat. 975

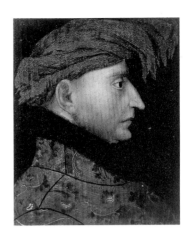

French, unknown artist
Previously listed as a French
artist, c. 1600 (JGJ 1941)
*Portrait of Louis II of Anjou, King
of Naples and Sicily*
In a 15th-century style; after an
ink and watercolor drawing in
the Bibliothèque Nationale, Paris
19th century
Upper left: A. Q. F.
Oil on panel
7 5/8 × 5 1/2" (19.4 × 14 cm)

John G. Johnson Collection
inv. 333

French, unknown artist
Rocky Landscape with a Castle
c. 1800–25
Oil on panel
9 1/4 × 12 1/2" (23.5 × 31.7 cm)

John G. Johnson Collection
cat. 919

French, unknown artist
Portrait of a Man
19th century
Oil on canvas
29 1/4 × 24 3/8" (74.3 × 61.9 cm)

John G. Johnson Collection
cat. 973

French, unknown artist
Previously attributed to Jean-
Louis-André-Théodore Géricault
(PMA 1965)
Arabian Horse
c. 1850
Oil on paper on canvas
26 × 20 1/2" (66 × 52.1 cm)

The William L. Elkins Collection
E1924-3-29

French, unknown artist
A Tigress and Three Cubs
19th century
Lower left (spurious): E. D.
Oil on canvas
14 1/8 × 16 1/2" (35.9 × 41.9 cm)

John G. Johnson Collection
inv. 2749

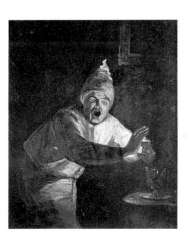

French, unknown artist
Previously listed as a French
artist, mid-18th century (JGJ
1941)
Man Carrying a Light
19th century
Oil on canvas
32 7/8 × 25 9/16" (83.5 × 64.9 cm)

John G. Johnson Collection
cat. 778

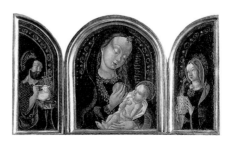

French, unknown artist
Previously listed as the school of
Nicolas Froment (JGJ 1941)
*Virgin and Child, with Saints John
the Baptist and Mary Magdalene*
Triptych
Late 15th century
Oil on panel
Center panel: 12 3/8 × 10 3/8"
(31.4 × 26.3 cm); wings [each]:
12 3/8 × 5 1/4" (31.4 × 13.3 cm)

John G. Johnson Collection
cat. 761

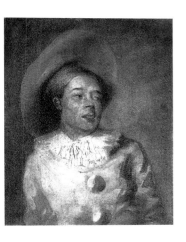

French, unknown artist
Portrait of an Actor Dressed as Harlequin
In an 18th-century style
Late 19th century
Oil on canvas
12 3/4 × 9 7/8" (32.4 × 25.1 cm)

John G. Johnson Collection
cat. 790

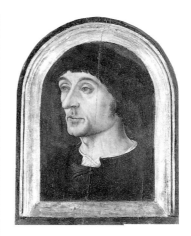

Froment, Nicolas, follower of
French, born c. 1425, died 1483–86
Previously listed as a Flemish artist, c. 1550 (JGJ 1941)
Portrait of a Man
Late 15th century
Oil on panel
11 13/16 × 8 3/4" (30 × 22.2 cm)

John G. Johnson Collection
cat. 404

French, unknown artist
Still Life
Late 19th century
Oil on canvas
10 7/8 × 9 7/8" (27.6 × 25.1 cm)

John G. Johnson Collection
cat. 784

Fromentin, Eugène (Eugène Fromentin-Dupeux)
French, 1820–1876
Arabian Shepherd (Shepherd: High Plateau of Kabylia)
Reduced-scale replica of a lost painting shown at the Paris Salon of 1861 (cat. no. 1186)
After 1861
Lower right: Eug. Fromentin
Oil on panel
18 × 11 15/16" (45.7 × 30.3 cm)

Bequest of Miss Willian Adger
1933-82-4

Frère, Pierre-Édouard
French, 1819–1886
Courtyard
1877
Lower left: Ed. Frère. 77.
Oil on canvas
12 15/16 × 16" (32.9 × 40.6 cm)

John G. Johnson Collection
cat. 993

Fromentin, Eugène
Canal in Venice
c. 1870
Lower right: —Eug. F.—
Oil on panel
11 1/16 × 14 3/8" (28.1 × 36.5 cm)

John G. Johnson Collection
cat. 995

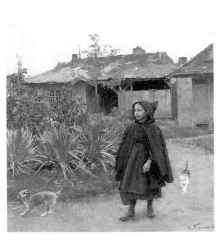

Friant, Émile
French, 1863–1932
The Garden Walk
1889
Lower right: E. Friant 89
Oil on panel
8 5/16 × 8 1/8" (21.1 × 20.6 cm)

John G. Johnson Collection
cat. 994

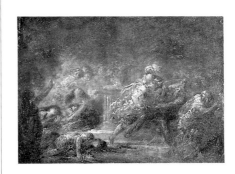

Gamelin, Jacques, attributed to
French, 1738–1803
Previously listed as Narcisse-Virgile Diaz de la Peña (JGJ 1941)
Sketch for "The Death of Priam"
For the painting in the Musée des Augustins, Toulouse
c. 1785–90
Oil on cardboard
5 1/2 × 7 1/4" (14 × 18.4 cm)

John G. Johnson Collection
cat. 980

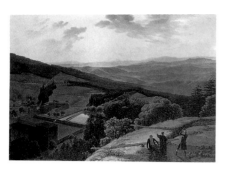

Gauffier, Louis
French, 1761–1801
The Monastery of Vallombrosa and the Arno Valley Seen from Paradisino
From a series of four paintings of the monastery; companion to the following painting
1797
Lower right: L. Gauffier
Oil on canvas
32 1/2 × 45" (82.5 × 114.3 cm)

Purchased with the W. P. Wilstach Fund
W1975-1-1

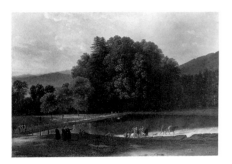

Gauffier, Louis
The Fish Pond at the Monastery of Vallombrosa with Horsemen and Monks
See previous entry
1797
Lower right: L. Gauffier. 1797.
Oil on canvas
32 1/2 × 45" (82.5 × 114.3 cm)

Purchased with the W. P. Wilstach Fund
W1975-1-2

Gauguin, Paul
French, 1848–1903
Still Life with Moss Roses in a Basket
1886
Lower right: a mon ami Schuffenecker / P. Gauguin
Oil on canvas
19 11/16 × 24 7/8" (50 × 63.2 cm)

Bequest of Charlotte Dorrance Wright
1978-1-18

Gauguin, Paul
Sacred Mountain (Parahi Te Marae)
1892
Lower right: PARAHI TE MARAE / P. Gauguin 92
Oil on canvas
26 × 35" (66 × 88.9 cm)

Gift of Mr. and Mrs. Rodolphe Meyer de Schauensee
1980-1-1

Gellée, Claude, also called Claude Lorrain
French, 1600–1682
Landscape with Cattle and Peasants
1629
Lower right: CLAUDIO IV ROMA / 1629
Oil on canvas
42 × 58 1/2" (106.7 × 148.6 cm)

The George W. Elkins Collection
E1950-2-1

Géricault, Jean-Louis-André-Théodore, attributed to
French, 1791–1824
Horses
19th century
Oil on canvas
12 3/4 × 16 1/16" (32.4 × 40.8 cm)

Purchased with the W. P. Wilstach Fund
W1912-1-2

Géricault, Jean-Louis-André-Théodore, copy after
Carbon Wagon
After the lithograph by Géricault
19th century
Center bottom (spurious): [illegible signature "Géricault"]
Oil on canvas
15 3/4 × 23 1/2" (40 × 59.7 cm)

John G. Johnson Collection
cat. 796

Géricault, Jean-Louis-André-Théodore, copy after
Previously listed as Jean-Louis-André-Théodore Géricault (JGJ 1941)
Figure from "The Raft of the Medusa"
After the painting in the Musée du Louvre, Paris (inv. 4884)
19th century
Lower right: [illegible]
Oil on canvas
32 1/8 × 25 3/4" (81.6 × 65.4 cm)

John G. Johnson Collection
cat. 795

**Girodet de Roucy Trioson,
Anne-Louis, attributed to**
French, 1767–1824
Portrait of a Man
c. 1810
Lower left: [monogram]
Oil on canvas
25 1/2 × 21" (64.8 × 53.3 cm)

The Henry P. McIlhenny
Collection in memory of
Frances P. McIlhenny
1986-26-35

Harpignies, Henri-Joseph
Landscape with a Donkey Cart
1874
Lower left: hy harpignies . 1874 .
Oil on canvas
11 × 20 1/2" (27.9 × 52.1 cm)

John G. Johnson Collection
cat. 996

**Greuze, Jean-Baptiste,
copy after**
French, 1725–1805
Previously attributed to Jean-
Baptiste Greuze (PMA 1965)
Innocence
After the painting in the Wallace
Collection, London (P. 384)
18th century
Oil on canvas
16 1/8 × 12 7/8" (41 × 32.7 cm)

Gift of Arthur Wiesenberger
1955-109-1

Harpignies, Henri-Joseph
Oak
1895
Lower left: h. harpignies. 95.
Oil on canvas
46 1/2 × 63 7/16" (118.1 × 161.1 cm)

The William L. Elkins Collection
E1924-3-88

Grison, François-Adolphe
French, 1845–1914
The Chiming Clock
c. 1900
Lower left: Grison
Oil on panel
10 11/16 × 8 5/8" (27.1 × 21.9 cm)

The William L. Elkins Collection
E1924-3-92

**Hebert, Antoine-Auguste-
Ernest**
French, 1817–1908
Neapolitan Women at a Well
By 1886
Oil on canvas
13 5/8 × 19 1/2" (34.6 × 49.5 cm)

John G. Johnson Collection
cat. 1003

Harpignies, Henri-Joseph
French, 1819–1916
Bank of a Stream
1857
Lower left: hy harpignies .1857.
Oil on canvas
26 3/16 × 39 1/2" (66.5 × 100.3 cm)

John G. Johnson Collection
cat. 997

Henner, Jean-Jacques
French, 1829–1905
Head of a Girl
Late 19th century
Center left: J J HENNER
Oil on canvas
18 3/16 × 15 1/4" (46.2 × 38.7 cm)

The Walter Lippincott Collection
1923-59-4

Henner, Jean-Jacques
Head of a Girl
c. 1900
Lower left: J J HENNER
Oil on canvas
24 1/16 × 18 1/8" (61.1 × 46 cm)

Bequest of Aaron E. Carpenter
1970-75-3

Ingres, Jean-Auguste-Dominique
The Martyrdom of Saint Symphorien
1865
Lower right: J. INGRES / 1865
Oil on canvas
14 7/16 × 12 7/16" (36.7 × 31.6 cm)

John G. Johnson Collection
cat. 793

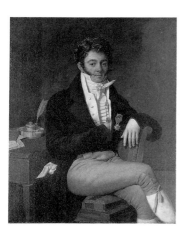

Hersent, Louis, attributed to
French, 1777–1860
Previously listed as Jean-Auguste-Dominique Ingres (JGJ 1941)
Portrait of Louis-Charles-Mercier Dupaty
c. 1810–20
Oil on canvas
45 3/8 × 34 7/8" (115.2 × 88.6 cm)

John G. Johnson Collection
cat. 794

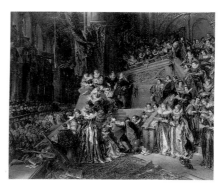

Isabey, Louis-Gabriel-Eugène
French, 1803–1886
The Marriage of Henry IV
1848
Lower left: E. Isabey / 1848
Oil on canvas
67 3/8 × 80 1/4" (171.1 × 203.8 cm)

The William L. Elkins Collection
E1924-3-86

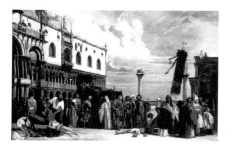

Hesse, Alexandre-Jean-Baptiste
French, 1806–1879
The Funerary Honors Rendered to Titian, Who Died in Venice during the Plague of 1576
Preparatory sketch for the painting in the Musée du Louvre, Paris (R.F. 1985-3), shown at the Salon of 1833
c. 1833
Oil on canvas
15 3/4 × 23 1/4" (40 × 59 cm)

The Henry P. McIlhenny Collection in memory of Frances P. McIlhenny
1986-26-277

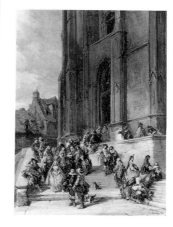

Isabey, Louis-Gabriel-Eugène
Leaving the Cathedral
1864
Lower right: E. Isabey. 64.
Oil on panel
23 11/16 × 16 5/8" (60.2 × 42.2 cm)

The William L. Elkins Collection
E1924-3-69

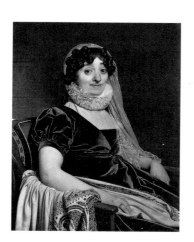

Ingres, Jean-Auguste-Dominique
French, 1780–1867
Portrait of the Countess of Tournon
1812
Lower right: Ingres Rome / 1812
Oil on canvas
36 3/8 × 28 13/16" (92.4 × 73.2 cm)

The Henry P. McIlhenny Collection in memory of Frances P. McIlhenny
1986-26-22

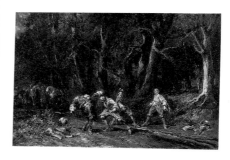

Isabey, Louis-Gabriel-Eugène
The Duel
1867
Lower left: E. Isabey. 67.
Oil on canvas
17 × 25 7/16" (43.2 × 64.6 cm)

John G. Johnson Collection
inv. 2753

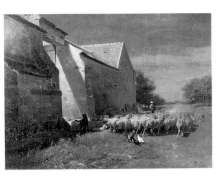

Jacque, Charles-Émile
French, 1813–1894
Sheep Leaving a Farmyard
1860
Upper left: ch. Jacque. / 1860.
Oil on panel
21 3/4 × 28 5/16" (55.2 × 71.9 cm)

John G. Johnson Collection
cat. 1011

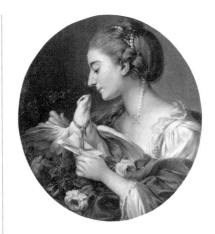

**Lagrenée, Louis, the Elder,
attributed to**
French, 1725–1805
*Young Woman Fastening a Letter to
the Neck of a Pigeon*
c. 1760
On letter: Monsieur / de Fontenet
/ {illegible} / Ponts
Oil on canvas
23 × 19 1/4" (58.4 × 48.9 cm)

Gift of John T. Dorrance
1965-85-1

Jacque, Charles-Émile
Percherons at Barbizon
c. 1880
Lower left: ch. Jacque.
Oil on canvas
32 1/4 × 25 3/16" (81.9 × 64 cm)

Bequest of Charlotte Dorrance
Wright
1978-1-19

Lambert, Louis-Eugène
French, 1825–1900
A Cat and Three Kittens
By 1892
Lower left: L Eug Lambert
Oil on canvas
12 3/4 × 16 1/8" (32.4 × 41 cm)

John G. Johnson Collection
cat. 1018

Jacque, Charles-Émile
Sheep in a Stable
Late 19th century
Lower left: ch. Jacque
Oil on canvas
26 3/4 × 20 3/4" (67.9 × 52.7 cm)

Gift of Walter Lippincott
1923-59-3

Laurens, Jean-Paul
French, 1838–1921
*The Parting of King Robert and
Bertha*
1883
Lower right: Jean Paul Laurens /
1883
Oil on canvas
32 1/8 × 39 1/2" (81.6 × 100.3 cm)

John G. Johnson Collection
inv. 2846

Lagarde, Pierre
French, 1853–1910
Village Street
c. 1891
Lower right: Pierre Lagarde
Oil on canvas
23 11/16 × 31 3/4" (60.2 × 80.6 cm)

John G. Johnson Collection
cat. 1017

Laurens, Jean-Paul
Torquemada, Grand Inquisitor
1886
Lower right: Jean-Paul Laurens
1886.
Oil on canvas
45 3/8 × 58 1/4" (115.2 × 147.9 cm)

The William L. Elkins Collection
E1924-3-57

Lemoyne, François
French, 1688–1737
*Putti Playing with the
Accoutrements of Hercules*
c. 1721–24
Oil on panel
5 ½ × 7 ¼" (14 × 18.5 cm)

Gift of the Friends of the
Philadelphia Museum of Art
1989-3-1

Lhermitte, Léon-Augustin
French, 1844–1925
*Apple Market, Landerneau,
Brittany*
c. 1878
Lower left: L. Lhermitte
Oil on canvas
33 ¾ × 47 ¼" (85.7 × 120 cm)

The George W. Elkins Collection
E1924-4-18

**Lepine, Stanislas-Victor-
Édouard**
French, 1835–1892
The Seine, Paris
c. 1865
Lower left: S. Lepine
Oil on canvas
17 ¾ × 29 ⅝" (45.1 × 75.2 cm)

The William L. Elkins Collection
E1924-3-80

Lhermitte, Léon-Augustin
Woman with a Jug
1882
Lower right: L. Lhermitte; on
jug: 882[?]
Oil on canvas
22 ⅛ × 16 ½" (56.2 × 41.9 cm)

The William L. Elkins Collection
E1924-3-68

**Lepine, Stanislas-Victor-
Édouard**
Saint-Ouen
Late 19th century
Lower right: S. Lepine
Oil on canvas on gypsum board
25 ⅞ × 38 ¼" (65.7 × 97.1 cm)

John G. Johnson Collection
cat. 1019

Lhermitte, Léon-Augustin
The Gleaners
c. 1890–95
Lower left: L. Lhermitte
Oil on canvas
29 ½ × 37 ¾" (74.9 × 95.9 cm)

The George W. Elkins Collection
E1924-4-19

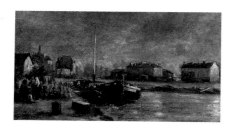

**Lepine, Stanislas-Victor-
Édouard**
The Seine
Late 19th century
Lower left: S. Lepine
Oil on panel
6 ¼ × 10 ¾" (15.9 × 27.3 cm)

Bequest of Charlotte Dorrance
Wright
1978-1-35

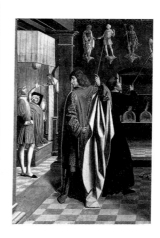

Lieferinxe, Josse
French, documented 1493–1505/8
Previously listed as a Rhone
Valley artist, c. 1500 (JGJ 1941)
Saint Sebastian Destroying the Idols
Panel from the altarpiece of the
Saint Sebastian chapel of Notre-
Dame-des-Accoules, Marseilles,
done in collaboration with
Bernardino Simondi (Italian,
died 1498); companion to the
following three panels and those
listed in the following entry
c. 1497
Oil on panel
32 ⅛ × 21 ½" (81.6 × 54.6 cm)

John G. Johnson Collection
cat. 765

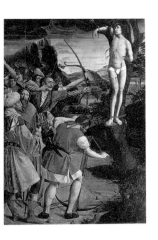

Lieferinxe, Josse
Previously listed as a Rhone
Valley artist, c. 1500 (JGJ 1941)
Saint Sebastian Pierced with Arrows
See previous entry; companion
panels are in the Walters Art
Gallery, Baltimore (37.1995); the
Hermitage, St. Petersburg (inv.
no. 6745); the Galleria Nazionale
d'Arte Antica, Rome (no. 1590);
and possibly the Musée Royal des
Beaux-Arts, Antwerp (5037)
c. 1497
Oil on panel
32 × 21 ⅝" (81.3 × 54.9 cm)

John G. Johnson Collection
cat. 766

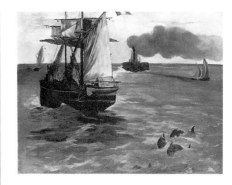

Manet, Édouard
Marine View
c. 1864
Lower right: Manet
Oil on canvas
32 ¹/₁₆ × 39 ½" (81.4 × 100.3 cm)

Bequest of Anne Thomson in
memory of her father, Frank
Thomson, and her mother, Mary
Elizabeth Clarke Thomson
1954-66-3

Lieferinxe, Josse
Previously listed as a Rhone
Valley artist, c. 1500 (JGJ 1941)
Saint Sebastian Cured by Irene
See previous two entries
c. 1497
Oil on panel
32 × 21 ⁹/₁₆" (81.3 × 54.8 cm)

John G. Johnson Collection
cat. 767

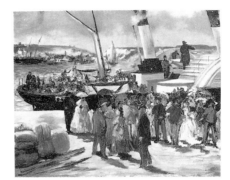

Manet, Édouard
The Folkestone Boat, Boulogne
1869
Lower left: Manet
Oil on canvas
23 ⅝ × 28 ¹⁵/₁₆" (60 × 73.5 cm)

The Mr. and Mrs. Carroll S.
Tyson, Jr., Collection
1963-116-10

Lieferinxe, Josse
Previously listed as a Rhone
Valley artist, c. 1500 (JGJ 1941)
The Martyrdom of Saint Sebastian
See previous three entries
c. 1497
Oil on panel
32 ½ × 21 ¾" (82.5 × 55.2 cm)

John G. Johnson Collection
cat. 768

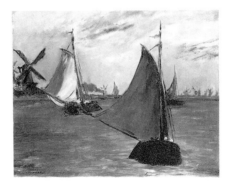

Manet, Édouard
Marine in Holland
1872
Lower left: Manet
Oil on canvas
19 ¾ × 23 ¾" (50.2 × 60.3 cm)

Purchased with the W. P.
Wilstach Fund
W1921-1-4

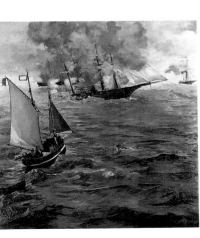

Manet, Édouard
French, 1832–1883
*The Battle of the "Kearsarge" and
the "Alabama"*
1864
Lower right: manet
Oil on canvas
54 ¼ × 50 ¾" (137.8 × 128.9 cm)

John G. Johnson Collection
cat. 1027

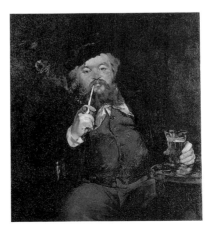

Manet, Édouard
Le Bon Bock
1873
Lower right: Manet 1873
Oil on canvas
37 ¼ × 32 ¹³/₁₆" (94.6 × 83.3 cm)

The Mr. and Mrs. Carroll S.
Tyson, Jr., Collection
1963-116-9

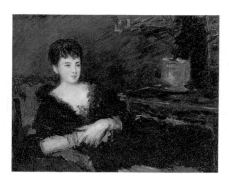

Manet, Édouard
Portrait of Isabelle Lemonnier
The face has been completely
repainted
c. 1877
Oil on canvas
13 × 16 1/8" (33 × 41 cm)

Bequest of Charlotte Dorrance
Wright
1978-1-21

Manet, Édouard
Knife Grinder, Rue Mosnier
1878
Oil on canvas
16 × 12 7/8" (40.6 × 32.7 cm)

Bequest of Charlotte Dorrance
Wright
1978-1-20

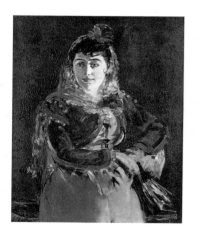

Manet, Édouard
Portrait of Émilie Ambre as Carmen
c. 1879
Oil on canvas
36 3/8 × 28 15/16" (92.4 × 73.5 cm)

Gift of Edgar Scott
1964-114-1

Marilhat, Prosper
French, 1811–1847
Oriental Caravansary
1835
Lower left: Marilhat, 1835
Oil on panel
10 13/16 × 16 15/16" (27.5 × 43 cm)

John G. Johnson Collection
cat. 1028

Martin, Henri-Jean-Guillaume
French, 1860–1943
Étude
1887
Upper left: Henri Martin / 87
Oil on canvas
25 3/4 × 21 1/4" (65.4 × 54 cm)

John G. Johnson Collection
cat. 1035

Master of the Processions
French, active mid-17th century
Previously listed as Louis and
Mathieu Le Nain (PMA 1965)
*Feast of the Wine (The Procession of
the Ram)*
Companion to *Feast of the Wine
(The Procession of the Fatted Ox)*,
in the Musée Picasso, Paris
Mid-17th century
Oil on canvas
44 × 65" (111.8 × 165.1 cm)

The George W. Elkins Collection
E1950-2-2

**Meissonier, Jean-Louis-
Ernest**
French, 1815–1891
The Seine at Poissy
1884
Lower right: EMeissonier Poissy
1884
Oil on panel
13 11/16 × 20 1/16" (34.8 × 51 cm)

John G. Johnson Collection
cat. 1039

Melin, Joseph-Urbain
French, 1814–1886
In Full Cry
1861
Lower left: J. Melin / 1861
Oil on canvas
53 × 83 3/4" (134.6 × 212.7 cm)

The William L. Elkins Collection
E1924-3-59

Mettling, Louis
French, 1847–1904
Street Sweeper at Lunch
By 1886
Lower left: Mettling.
Oil on panel
14 13/16 × 17 5/8" (37.6 × 44.8 cm)

John G. Johnson Collection
cat. 1040

Millet, Jean-François
Bark
c. 1871
Lower right: J.F. Millet
Oil and crayon on panel
29 × 37" (73.7 × 94 cm)

John G. Johnson Collection
cat. 1047

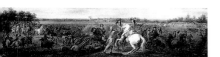

Meulen, Adam Frans van der, studio of
French, born Flanders, 1632–1690
Previously listed as Adam Frans van der Meulen (PMA 1965)
The Passage of the Rhine on June 12, 1672
c. 1672–90
Lower left: S. 5 E.; on reverse: Peint par van der Meulen. / Passage du Rhin en 1672, par l'Armee Francaise / sous les ordres de Louis XIV. / C. M.
Oil on canvas
20 1/8 × 76 9/16" (51.1 × 194.5 cm)

Gift of James H. Hyde
1948-27-1

Millet, Jean-François
Bird's-Nesters
1874
Lower right: J. F. Millet
Oil on canvas
29 × 36 1/2" (73.7 × 92.7 cm)

The William L. Elkins Collection
E1924-3-14

Michel, Georges
French, 1763–1843
Old Château
c. 1825–43
Lower right (spurious): Eug. Delacroix.
Oil on panel
20 1/4 × 27 7/8" (51.4 × 70.8 cm)

John G. Johnson Collection
cat. 1042

Millet, Jean-François, imitator of
Previously listed as Jean-François Millet (JGJ 1941)
Girl Rinsing Linen
19th century
Lower right (spurious): J. F. Millet.
Oil on canvas
21 3/8 × 15" (54.3 × 38.1 cm)

John G. Johnson Collection
cat. 1049

Millet, Jean-François
French, 1814–1875
Solitude
1853
Lower right: J. F. Millet
Oil on canvas
33 5/8 × 43 1/2" (85.4 × 110.5 cm)

Purchased with the W. P. Wilstach Fund
W1906-1-12

Millet, Jean-François, imitator of
Previously listed as Jean-François Millet (JGJ 1941)
Noonday Rest
19th century
Lower right (spurious): MILLET
Oil on canvas
10 5/16 × 14 5/8" (26.2 × 37.1 cm)

John G. Johnson Collection
cat. 1043

Millet, Jean-François, imitator of
Two Women at a Tub
19th century
Oil on canvas
14 × 10 3/4" (35.6 × 27.3 cm)

John G. Johnson Collection
cat. 1048

Monet, Claude
Port of Le Havre
1874
Lower left: Claude Monet
Oil on canvas
23 3/4 × 40 1/8" (60.3 × 101.9 cm)

Bequest of Mrs. Frank Graham
Thomson
1961-48-3

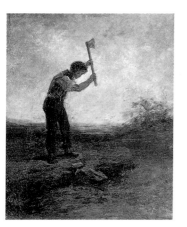

Millet, Jean-François, imitator of
Previously listed as Jean-François
Millet (JGJ 1941)
Woodsman
19th century
Lower left (spurious): J.F.M.
Oil on canvas
16 5/16 × 12 7/8" (41.4 × 32.7 cm)

John G. Johnson Collection
cat. 1044

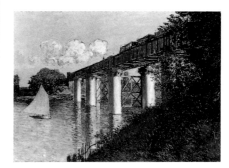

Monet, Claude
Railroad Bridge, Argenteuil
1874
Lower right: Claude Monet
Oil on canvas
21 3/8 × 28 7/8" (54.3 × 73.3 cm)

John G. Johnson Collection
cat. 1050

Monet, Claude
French, 1840–1926
Green Park, London
1870 or 1871
Lower left: Claude Monet
Oil on canvas
13 1/2 × 28 9/16" (34.3 × 72.5 cm)

Purchased with the W. P.
Wilstach Fund
W1921-1-7

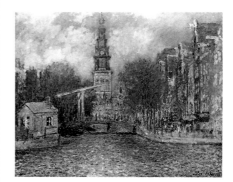

Monet, Claude
*The Zuiderkerk, Amsterdam
(Looking up the Groenburgwal)*
c. 1874
Lower right: Claude Monet
Oil on canvas
21 7/16 × 25 3/4" (54.4 × 65.4 cm)

Purchased with the W. P.
Wilstach Fund
W1921-1-6

Monet, Claude
The Sheltered Path
1873
Lower left: Claude Monet / 73
Oil on canvas
21 5/16 × 25 7/8" (54.1 × 65.7 cm)

Gift of Mr. and Mrs. Hughs
Norment in honor of William H.
Donner
1972-227-1

Monet, Claude
Marine View with a Sunset
c. 1875
Lower left: Claude Monet
Oil on canvas
19 1/2 × 25 5/8" (49.5 × 65.1 cm)

Purchased with the W. P.
Wilstach Fund
W1921-1-5

Monet, Claude
Customhouse, Varengeville
1882
Lower left: Claude Monet 82
Oil on canvas
23 3/4 × 32 1/16" (60.3 × 81.4 cm)

The William L. Elkins Collection
E1924-3-61

Monet, Claude
Flowers in a Vase
1888
Lower left: Cl Monet
Oil on canvas
31 1/2 × 17 3/4" (80 × 45.1 cm)

Bequest of Charlotte Dorrance
Wright
1978-1-23

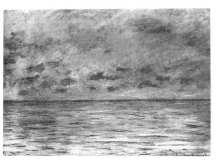

Monet, Claude
Marine near Étretat
1882
Lower right: Claude Monet
Oil on canvas
21 1/2 × 29 1/16" (54.6 × 73.8 cm)

Bequest of Mrs. Frank Graham
Thomson
1961-48-1

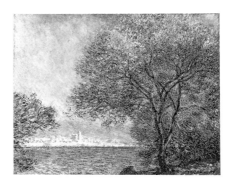

Monet, Claude
Morning at Antibes
1888
Lower right: Claude Monet 88
Oil on canvas
25 7/8 × 32 5/16" (65.7 × 82.1 cm)

Bequest of Charlotte Dorrance
Wright
1978-1-22

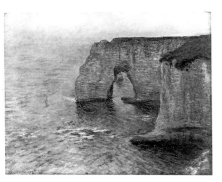

Monet, Claude
Manne-Porte, Étretat
1885
Lower left: Claude Monet 85
Oil on canvas
25 3/4 × 32" (65.4 × 81.3 cm)

John G. Johnson Collection
cat. 1051

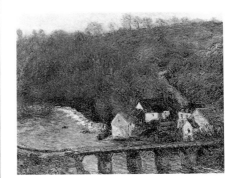

Monet, Claude
The Grande Creuse at Pont de Verry
1889
Lower left: Claude Monet 89
Oil on canvas
29 1/16 × 36 1/2" (73.8 × 92.7 cm)

The William L. Elkins Collection
E1924-3-32

Monet, Claude
Bend in the Epte River near Giverny
1888
Lower right: Claude Monet 88
Oil on canvas
29 × 36 9/16" (73.7 × 92.9 cm)

The William L. Elkins Collection
E1924-3-16

Monet, Claude
Poplars
1891
Lower right: Claude Monet 91
Oil on canvas
36 5/8 × 29 3/16" (93 × 74.1 cm)

The Chester Dale Collection
1951-109-1

Monet, Claude
Poplars on the Bank of the Epte River
1891
Lower right: Claude Monet 91
Oil on canvas
39 1/2 × 25 11/16" (100.3 × 65.2 cm)

Bequest of Anne Thomson in memory of her father, Frank Thomson, and her mother, Mary Elizabeth Clarke Thomson
1954-66-8

Monet, Claude
Nympheas, Japanese Bridge
1918–26
Oil on canvas
35 × 36 1/2" (88.9 × 92.7 cm)

The Albert M. Greenfield and Elizabeth M. Greenfield Collection
1974-178-38

Monet, Claude
Morning Haze
1894
Lower right: Claude Monet 94
Oil on canvas
25 7/8 × 39 1/2" (65.7 × 100.3 cm)

Bequest of Mrs. Frank Graham Thomson
1961-48-2

Monet, Claude, imitator of
Coast of Normandy
19th century
Lower left (spurious): Claude Monet–82
Oil on canvas
25 5/8 × 32 1/8" (65.1 × 81.6 cm)

Gift of Mr. and Mrs. Hughs Norment in honor of William H. Donner
1972-227-2

Monet, Claude
The Japanese Footbridge and the Water Lily Pool, Giverny
1899
Lower right: Claude Monet 99
Oil on canvas
35 1/8 × 36 3/4" (89.2 × 93.3 cm)

The Mr. and Mrs. Carroll S. Tyson, Jr., Collection
1963-116-11

Monticelli, Adolphe-Joseph-Thomas
French, 1824–1886
Boating Party
1886
Lower right: Monticelli
Oil on panel
18 1/8 × 30 15/16" (46 × 78.6 cm)

Purchased with the W. P. Wilstach Fund
W1897-1-5

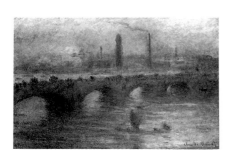

Monet, Claude
Waterloo Bridge, Morning Fog
1901
Lower right: Claude Monet
Oil on canvas
25 7/8 × 39 7/16" (65.7 × 100.2 cm)

Bequest of Anne Thomson in memory of her father, Frank Thomson, and her mother, Mary Elizabeth Clarke Thomson
1954-66-6

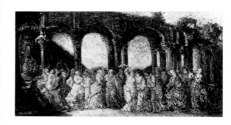

Monticelli, Adolphe-Joseph-Thomas
Masque
Late 19th century
Lower left: Monticelli
Oil on panel
15 1/4 × 29 5/16" (38.7 × 74.4 cm)

John G. Johnson Collection
cat. 1052

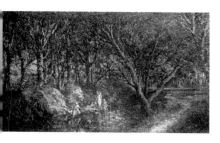

Monticelli, Adolphe-Joseph-Thomas
Nymphs Bathing
Late 19th century
Lower right: Monticelli
Oil on panel
23 ⅛ × 38 ⁷/₁₆" (58.7 × 97.6 cm)

John G. Johnson Collection
cat. 1053

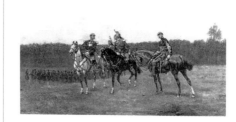

Neuville, Alphonse-Marie de
French, 1835–1885
Orders from Headquarters
c. 1880
Lower right: A. de Neuville
Oil on canvas
42 × 67 ½" (106.7 × 171.4 cm)

The William L. Elkins Collection
E1924-3-73

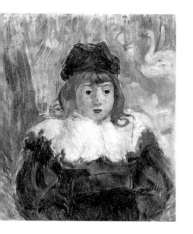

Morisot, Berthe-Marie-Pauline
French, 1841–1895
Portrait of a Child
1894
Upper left: Berthe Morisot
Oil on canvas
21 ¾ × 18 ¼" (55.2 × 46.3 cm)

Bequest of Lisa Norris Elkins
1950-92-10

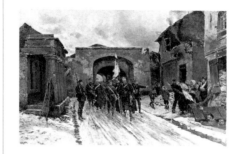

Neuville, Alphonse-Marie de
The Surrender
c. 1884
Lower left: A. Neuville
Oil on canvas
55 ¾ × 82 ¾" (141.6 × 210.2 cm)

The William L. Elkins Collection
E1924-3-34

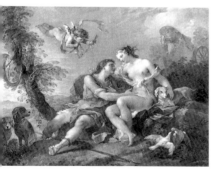

Natoire, Charles-Joseph
French, 1700–1777
Venus and Adonis
c. 1740
Oil on canvas
37 ⅜ × 46 ⁷/₈" (94.9 × 119.1 cm)

Gift of the Friends of the
Philadelphia Museum of Art
1989-3-2

Noël, Alexandre-Jean
French, 1752–1834
Quinta of Gerard de Visme, near Lisbon
Pendant to the following painting
c. 1785
Oil on canvas
33 ¹¹/₁₆ × 42 ¹/₁₆" (85.6 × 106.8 cm)

Gift of John Howard McFadden, Jr.
1946-36-5

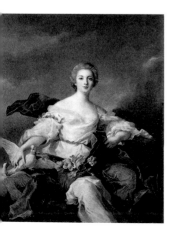

Nattier, Jean-Marc, studio of
French, 1685–1766
Portrait of the Marchioness of Baglion
Mid-18th century
Oil on canvas
59 × 46" (149.9 × 116.8 cm)

Gift of Mrs. Gordon A. Hardwick
and Mrs. W. Newbold Ely in
memory of Mr. and Mrs.
Roland L. Taylor
1944-9-3

Noël, Alexandre-Jean
Quinta of Gerard de Visme, near Lisbon
Pendant to the preceding painting
c. 1785
Oil on canvas
33 × 42" (83.8 × 106.7 cm)

Gift of John Howard McFadden, Jr.
1946-36-6

Picard, Louis
French, born 1861, still active
1900
Vendor of Statuettes
c. 1900
Lower right: LOUIS PICARD
Oil on canvas
21 5/8 × 13 7/8" (54.9 × 35.2 cm)

The Walter Lippincott Collection
1923-59-6

Pissarro, Camille
French, 1830–1903
Quai Napoléon, Rouen
1883
Lower right: C. Pissarro. 1883
Oil on canvas
21 3/8 × 25 3/8" (54.3 × 64.4 cm)

Bequest of Charlotte Dorrance
Wright
1978-1-25

Pillement, Jean
French, 1728–1808
Landscape
1793
Lower left: Jean Pillement / 1793
Oil on canvas
16 1/8 × 21 3/8" (41 × 54.3 cm)

Gift of Mrs. Morris Hawkes
1945-13-59

Pissarro, Camille
*The Field and the Great Walnut
Tree in Winter, Eragny*
1885
Lower right: C. Pissarro. 1885
Oil on canvas
23 5/8 × 28 7/8" (60 × 73.3 cm)

Purchased with the W. P.
Wilstach Fund
W1921-1-9

Pillement, Jean
Landscape
1794
Lower left: J. P. 1794 v
Oil on canvas
6 3/16 × 8 1/8" (15.7 × 20.6 cm)

Gift of Mrs. Morris Hawkes
1945-13-57

Pissarro, Camille
Summer Landscape, Eragny
1887 and 1902
Lower right: C. Pissarro. 87 1902
Oil on canvas
22 × 26" (55.9 × 66 cm)

Gift of Mrs. William I. Mirkil
1961-150-1

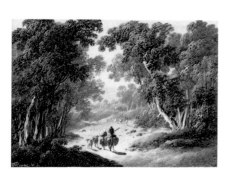

Pillement, Jean
Landscape
1794
Lower left: J. P. 1794 vs
Oil on canvas
6 3/16 × 8 1/16" (15.7 × 20.5 cm)

Gift of Mrs. Morris Hawkes
1945-13-58

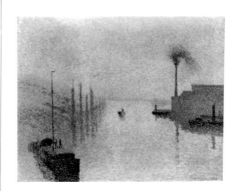

Pissarro, Camille
*L'Île Lacroix, Rouen
(The Effect of Fog)*
1888
Lower right: C. Pissarro 1888
Oil on canvas
18 3/8 × 22" (46.7 × 55.9 cm)

John G. Johnson Collection
cat. 1060

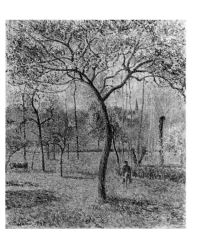

Pissarro, Camille
Landscape (Orchard)
1892
Lower left: C. Pissarro. 1892
Oil on canvas
25 ⁵/₈ × 21 ³/₈" (65.1 × 54.3 cm)

Purchased with the W. P.
Wilstach Fund
W1921-1-8

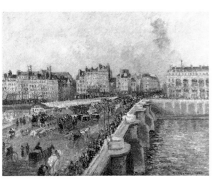

Pissarro, Camille
Afternoon Sunshine, Pont Neuf
1901
Lower right: C. Pissarro. 1901
Oil on canvas
28 ³/₄ × 36 ¹/₄" (73 × 92.1 cm)

Bequest of Charlotte Dorrance
Wright
1978-1-24

Pissarro, Camille
Fair on a Sunny Afternoon, Dieppe
1901
Lower right: C. Pissarro. 1901
Oil on canvas
28 ¹⁵/₁₆ × 36 ¹/₄" (73.5 × 92.1 cm)

Bequest of Lisa Norris Elkins
1950-92-12

Pissarro, Camille
*Vegetable Garden, Overcast
Morning, Eragny*
1901
Lower right: C. Pissarro. 1901
Oil on canvas
25 ¹/₂ × 32" (64.8 × 81.3 cm)

Bequest of Charlotte Dorrance
Wright
1978-1-26

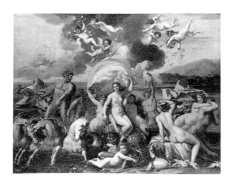

Poussin, Nicolas
French, 1594–1665
The Birth of Venus
1635 or 1636
Lower left: 1697
Oil on canvas
38 ¹/₄ × 42 ¹/₂" (97.1 × 107.9 cm)

The George W. Elkins Collection
E1932-1-1

Poussin, Nicolas
The Baptism of Christ
c. 1658
Oil on canvas
37 ⁷/₈ × 53 ³/₈" (96.2 × 135.6 cm)

John G. Johnson Collection
cat. 773

Puvis de Chavannes, Pierre
French, 1824–1898
Peace
Reduced version of the 1861
painting in the Musée de
Picardie, Amiens; companion to
the following painting and the
paintings *Work* and *Rest*, in the
National Gallery of Art,
Washington, D.C.
1867
Lower left: P. PUVIS DE
CHAVANNES; center bottom: LA
PAIX
Oil on canvas
42 ⁷/₈ × 58 ¹/₂" (108.9 × 148.6 cm)

John G. Johnson Collection
cat. 1062

Puvis de Chavannes, Pierre
War
Reduced version of the 1861
painting in the Musée de
Picardie, Amiens; companion to
the preceding painting and the
paintings *Work* and *Rest*, in the
National Gallery of Art,
Washington, D.C.
1867
Lower left: P. PUVIS DE
CHAVANNES; center bottom: LA
GUERRE
Oil on canvas
43 ¹/₈ × 58 ³/₄" (109.5 × 149.2 cm)

John G. Johnson Collection
cat. 1063

Puvis de Chavannes, Pierre
Legendary Saints of France
Reduced version of the frieze above
The Childhood of Saint Geneviève, in
the church of Saint Geneviève
[The Panthéon], Paris
c. 1879
Oil on canvas
Left canvas: 30 1/4 × 32 1/2"
(76.8 × 82.5 cm); center canvas:
30 1/4 × 35" (76.8 × 88.9 cm);
right canvas: 30 1/4 × 32"
(76.8 × 81.3 cm)

Gift of Dr. and Mrs. Richard W.
Levy
1969-167-1

Raffaëlli, Jean-François
Midday, Effect of Frost
1888
Lower right: J F RAFFAELLI
Oil on canvas
50 1/4 × 45 15/16" (127.6 ×
116.7 cm)

John G. Johnson Collection
cat. 1064

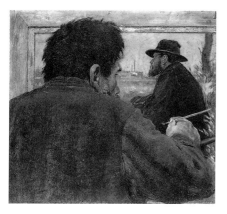

Raffaëlli, Jean-François
French, 1850–1924
Artist Painting
c. 1879
Lower right: J. F. RAFFAELLI
Oil on panel
20 1/2 × 20 7/8" (52.1 × 53 cm)

John G. Johnson Collection
cat. 1065

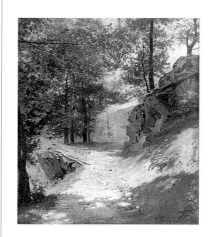

**Regnault, Henri-Georges-
Alexandre**
French, 1843–1871
The Pyrenees
c. 1868
Lower right: H. Regnault
Oil on canvas on gypsum board
26 1/2 × 21 13/16" (67.3 × 55.4 cm)

John G. Johnson Collection
cat. 1067

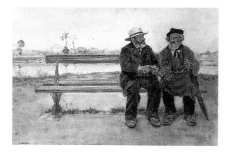

Raffaëlli, Jean-François
Comrades
1881–83
Lower right: J. F. RAFFAELLI
Oil on paper on panel
15 7/16 × 22" (39.2 × 55.9 cm)

John G. Johnson Collection
cat. 1066

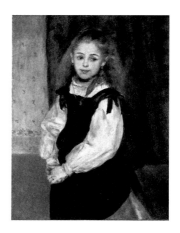

Renoir, Pierre-Auguste
French, 1841–1919
Portrait of Mademoiselle Legrand
1875
Lower right: Renoir. 75
Oil on canvas
32 × 23 1/2" (81.3 × 59.7 cm)

The Henry P. McIlhenny
Collection in memory of
Frances P. McIlhenny
1986-26-28

Raffaëlli, Jean-François
The Minstrels
1887
Lower left: JF RAFFAELLI
Oil on panel
15 7/8 × 22 15/16" (40.3 × 58.3 cm)

Gift of Mrs. Francis P. Garvan
1977-257-1

Renoir, Pierre-Auguste
The Grands Boulevards
1875
Lower right: Renoir. 75
Oil on canvas
20 1/2 × 25" (52.1 × 63.5 cm)

The Henry P. McIlhenny
Collection in memory of
Frances P. McIlhenny
1986-26-29

Renoir, Pierre-Auguste
Boy with a Toy Soldier (Portrait of Jean de La Pommeraye)
c. 1875
Center left: A. Renoir
Oil on canvas
13 15/16 × 10 5/8" (35.4 × 27 cm)

The Mr. and Mrs. Carroll S. Tyson, Jr., Collection
1963-116-14

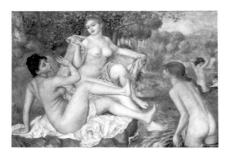

Renoir, Pierre-Auguste
The Great Bathers
1884–87
Lower left: Renoir. 87.
Oil on canvas
46 3/8 × 67 1/4" (117.8 × 170.8 cm)

The Mr. and Mrs. Carroll S. Tyson, Jr., Collection
1963-116-13

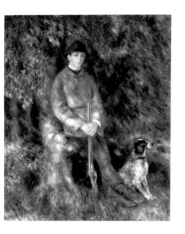

Renoir, Pierre-Auguste
Portrait of Alfred Bérard with His Dog
1881
Lower left: Renoir. 81.
Oil on canvas
25 11/16 × 20 1/8" (65.2 × 51.1 cm)

The Mr. and Mrs. Carroll S. Tyson, Jr., Collection
1963-116-17

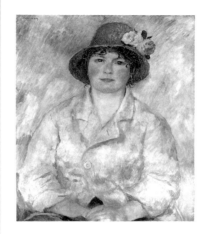

Renoir, Pierre-Auguste
Portrait of Madame Renoir
c. 1885
Upper left: Renoir
Oil on canvas
25 3/4 × 21 1/4" (65.4 × 54 cm)

Purchased with the W. P. Wilstach Fund
W1957-1-1

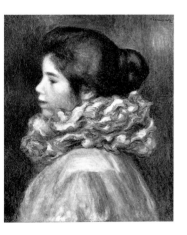

Renoir, Pierre-Auguste
Girl in a Red Ruff
1884
Upper right: Renoir.
Oil on canvas
16 1/4 × 13 1/8" (41.3 × 33.3 cm)

Bequest of Charlotte Dorrance Wright
1978-1-28

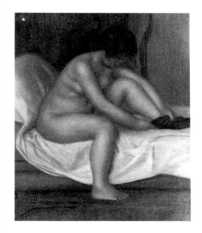

Renoir, Pierre-Auguste
Nude
1888
Lower right: Renoir.
Oil on canvas
22 × 18 1/4" (55.9 × 46.3 cm)

The Louis E. Stern Collection
1963-181-58

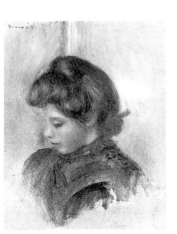

Renoir, Pierre-Auguste
Girl in a Red Scarf
c. 1884
Upper left: Renoir
Oil on canvas
10 1/4 × 8" (26 × 20.3 cm)

Bequest of Charlotte Dorrance Wright
1978-1-27

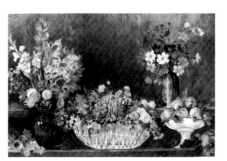

Renoir, Pierre-Auguste
Still Life with Flowers and Fruit
c. 1890
Lower right: Renoir
Oil on canvas
52 1/2 × 68 7/8" (133.3 × 174.9 cm)

The Mr. and Mrs. Carroll S. Tyson, Jr., Collection
1963-116-16

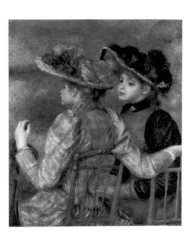

Renoir, Pierre-Auguste
Two Girls
c. 1892
Lower right: Renoir
Oil on canvas
32 1/4 × 25 13/16" (81.9 × 65.6 cm)

The Mr. and Mrs. Carroll S.
Tyson, Jr., Collection
1963-116-15

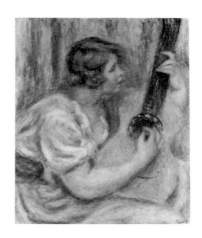

Renoir, Pierre-Auguste
Woman with a Guitar
c. 1918
Lower right: Renoir.
Oil on canvas
24 3/16 × 19 3/4" (61.4 × 50.2 cm)

Gift of Mr. and Mrs. J. Mahlon
Buck
1959-83-1

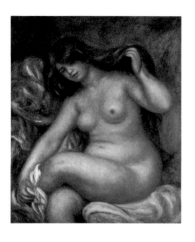

Renoir, Pierre-Auguste
Large Bather
1905
Lower right: Renoir. 05.
Oil on canvas
38 1/4 × 28 3/4" (97.1 × 73 cm)

Gift of Mr. and Mrs. Rodolphe
Meyer de Schauensee
1978-9-1

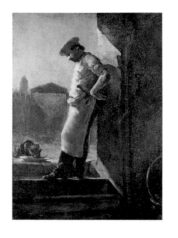

Ribot, Théodule
French, 1823–1891
Poultry Yard
1861
Lower left: T Ribot 1861
Oil on canvas
18 × 12 3/4" (45.7 × 32.4 cm)

John G. Johnson Collection
cat. 1069

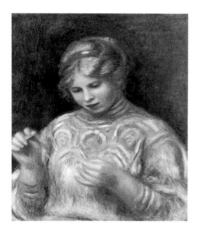

Renoir, Pierre-Auguste
Girl Tatting
1906–8
Upper right: Renoir.
Oil on canvas
22 1/4 × 18 3/8" (56.5 × 46.7 cm)

The Louis E. Stern Collection
1963-181-59

Ribot, Théodule
Chrysanthemums
Late 19th century
Lower left: T. Ribot.
Oil on canvas
15 × 18" (38.1 × 45.7 cm)

John G. Johnson Collection
cat. 1068

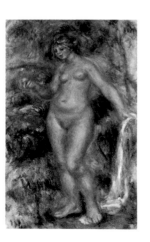

Renoir, Pierre-Auguste
Bather
c. 1917
Lower left: Renoir.
Oil on canvas
20 3/4 × 13" (52.7 × 33 cm)

The Louise and Walter Arensberg
Collection
1950-134-173

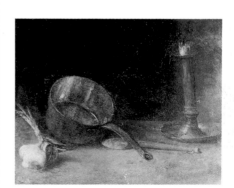

Ricard, Louis-Gustave
French, 1823–1873
Still Life
19th century
Lower right: GR
Oil on panel
14 11/16 × 18 1/16" (37.3 × 45.9 cm)

John G. Johnson Collection
cat. 1070

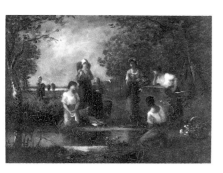

Richet, Léon
French, 1847–1907
The Spring
1882
Lower left: Leon Richet 1882
Oil on panel
9 1/4 × 13 3/4" (23.5 × 34.9 cm)

The Walter Lippincott Collection
1923-59-7

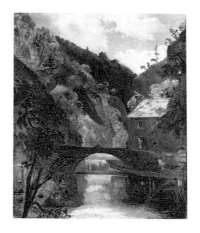

Rousseau, Pierre-Étienne-Théodore
French, 1812–1867
Water Mill, Thiers
c. 1830
Lower left: ThR
Oil on canvas
15 7/8 × 12 5/8" (40.3 × 32.1 cm)

Gift of John T. Dorrance
1965-85-2

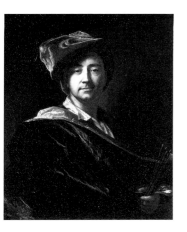

Rigaud, Hyacinthe, copy after
French, 1659–1743
Previously listed as Hyacinthe Rigaud (JGJ 1941)
Portrait of Hyacinthe Rigaud
Known in many versions; the finest is in the Musée Hyacinthe Rigaud, Perpignan (inv. D.53.1.1)
18th century
Oil on canvas
31 7/8 × 25 3/4" (81 × 65.4 cm)

John G. Johnson Collection
cat. 777

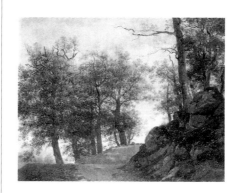

Rousseau, Pierre-Étienne-Théodore
Mountain Path
1831
Lower right: T. R. Oct re / 1831.
Oil on canvas
15 × 18 3/16" (38.1 × 46.2 cm)

John G. Johnson Collection
cat. 1075

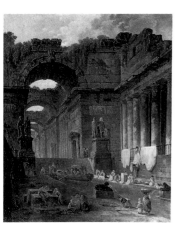

Robert, Hubert
French, 1733–1808
Ruins of a Roman Bath with Washerwomen
After 1766
Oil on canvas
54 × 41 1/2" (137.2 × 105.4 cm)

Gift of Dora Donner Ide in memory of John Jay Ide
1961-215-1

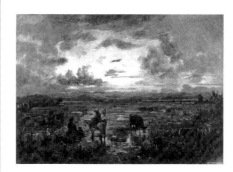

Rousseau, Pierre-Étienne-Théodore
Landscape with Cattle
c. 1860
Lower right: T. H. Rousseau
Oil on canvas
35 1/4 × 46" (89.5 × 116.8 cm)

The William L. Elkins Collection
E1924-3-36

Rousseau, Philippe
French, 1816–1887
Still Life
1857
Lower left: Ph. Rousseau. 57.
Oil on canvas
19 1/4 × 23 1/2" (48.9 × 59.7 cm)

John G. Johnson Collection
cat. 1077

Rousseau, Pierre-Étienne-Théodore
Landscape
Mid-19th century
Lower left: Th. Rousseau
Oil on panel
6 1/2 × 8 1/2" (16.5 × 21.6 cm)

John G. Johnson Collection
cat. 1074

Rousseau, Pierre-Étienne-Théodore
Sunset
Mid-19th century
Oil on panel
11 × 17 1/8" (27.9 × 43.5 cm)

John G. Johnson Collection
cat. 1072

Schlesinger, Henri-Guillaume
French, born Germany,
1814–1893
Alone at the Atelier
1868
Lower right: H. Schlesinger. 1868
Oil on canvas
36 1/2 × 29" (92.7 × 73.7 cm)

The W. P. Wilstach Collection,
bequest of Anna H. Wilstach
W1893-1-93

Rousseau, Pierre-Étienne-Théodore, attributed to
Previously listed as Pierre-Étienne-Théodore Rousseau
(JGJ 1941)
Evening Landscape
19th century
Lower right: Th. Rousseau
Oil on panel
6 11/16 × 9" (17 × 22.9 cm)

John G. Johnson Collection
cat. 1073

Simon, Lucien
French, 1861–1945
Christ Performing Miracles
1894
Lower left: LSimon 1894
Oil on canvas
48 1/4 × 55" (122.5 × 139.7 cm)

John G. Johnson Collection
cat. 1081

Rousseau, Pierre-Étienne-Théodore, attributed to
Outskirts of a Village
19th century
Lower left: Th. Rousseau
Oil on paper on canvas
9 3/8 × 15 3/8" (23.8 × 39 cm)

John G. Johnson Collection
cat. 1071

Sisley, Alfred
French, 1839–1899
Landscape (Spring at Bougival)
c. 1873
Lower left: Sisley.
Oil on canvas
16 × 22 1/2" (40.6 × 57.1 cm)

Bequest of Charlotte Dorrance
Wright
1978-1-31

Rousseau, Pierre-Étienne-Théodore, follower of
On the Seine
19th century
Lower left (spurious): Th. R
Oil on panel
15 15/16 × 30 3/4" (40.5 × 78.1 cm)

John G. Johnson Collection
cat. 1076

Sisley, Alfred
The Bridge at Saint-Mammes
1881
Lower right: Sisley.
Oil on canvas
21 1/2 × 28 13/16" (54.6 × 73.2 cm)

John G. Johnson Collection
cat. 1082

Sisley, Alfred
The Loing River at Saint-Mammes
1884
Lower left: Sisley.
Oil on canvas
15 × 21 3/4" (38.1 × 55.2 cm)

Bequest of Anne Thomson in
memory of her father, Frank
Thomson, and her mother, Mary
Elizabeth Clarke Thomson
1954-66-9

Stevens, Léopold
French, 1866–1935
Coastal Village
c. 1900
Lower left: .Léopold Stevens.
Oil on canvas
15 × 24" (38.1 × 61 cm)

John G. Johnson Collection
cat. 1084

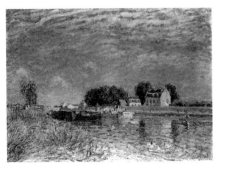

Sisley, Alfred
Banks of the Loing River
1885
Lower right: Sisley.85
Oil on canvas
21 11/16 × 28 7/8" (55.1 × 73.3 cm)

Bequest of Charlotte Dorrance
Wright
1978-1-30

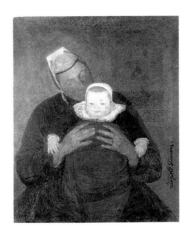

Stevens, Léopold
Mother and Baby
c. 1900
Lower right: Léopold Stevens.
Oil on canvas
25 5/8 × 19 3/4" (65.1 × 50.2 cm)

John G. Johnson Collection
cat. 1085

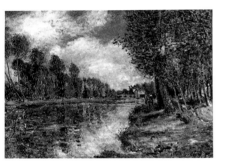

Sisley, Alfred
The Canal at Saint-Mammes
1885
Lower right: Sisley.85
Oil on canvas
21 3/4 × 29" (55.2 × 73.7 cm)

The Mr. and Mrs. Carroll S.
Tyson, Jr., Collection
1963-116-18

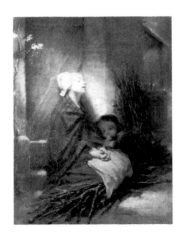

Tassaert, Octave
French, 1800–1874
Poor Children (The Forlorn)
1855
Lower right: Oct. Tassaert / 1855
Oil on canvas
12 7/8 × 9 3/4" (32.7 × 24.8 cm)

John G. Johnson Collection
cat. 1090

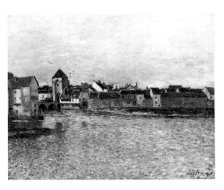

Sisley, Alfred
Bridge at Morny
1891
Lower right: Sisley 91
Oil on canvas
23 1/2 × 28 1/2" (59.7 × 72.4 cm)

Bequest of Charlotte Dorrance
Wright
1978-1-29

Taunay, Nicolas-Antoine
French, 1755–1830
Landscape with Horsemen
Companion to the following
painting
Late 18th century
Oil on canvas
21 3/4 × 17 1/2" (55.2 × 44.4 cm)

Gift of Mrs. Van Horn Ely
1971-169-1

Taunay, Nicolas-Antoine
Landscape with a Ruin and Peasants
Companion to the preceding
painting
Late 18th century
Oil on canvas
21 7/8 × 17 1/2" (55.6 × 44.4 cm)

Gift of Mrs. Van Horn Ely
1971-169-2

Troyon, Constant
French, 1810–1865
Forest Clearing
1846?
Lower left: C. TROYON
Oil on canvas
25 9/16 × 21 1/8" (64.9 × 53.7 cm)

John G. Johnson Collection
cat. 1095

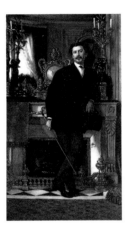

Tissot, James-Jacques-Joseph
French, 1836–1902
Portrait of Eugène Coppens de Fontenay
1867
Lower right: JJ. Tissot / AVRIL
1867
Oil on canvas
27 1/2 × 15 3/8" (69.8 × 39 cm)

Purchased with the W. P.
Wilstach Fund
W1972-2-1

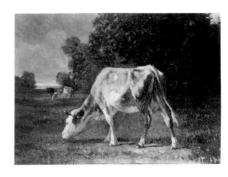

Troyon, Constant
Cows Grazing
1856
Lower left: C. TROYON. 1856
Oil on canvas
23 9/16 × 32 1/8" (59.8 × 81.6 cm)

John G. Johnson Collection
cat. 1094

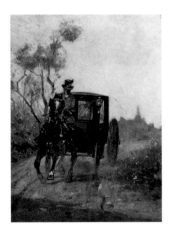

Toulouse-Lautrec, Henri de
French, 1864–1901
Carriage
c. 1881
Oil on panel
12 3/4 × 9 3/8" (32.4 × 23.8 cm)

Bequest of Charlotte Dorrance
Wright
1978-1-32

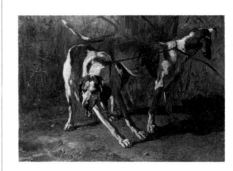

Troyon, Constant
Leashed Hounds
c. 1860
Lower left: C. TROYON.; lower
right: VENTE / TROYON
Oil on canvas
38 7/8 × 51 1/2" (98.7 × 130.8 cm)

John G. Johnson Collection
cat. 1102

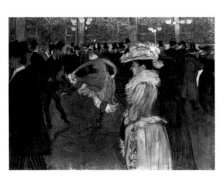

Toulouse-Lautrec, Henri de
At the Moulin Rouge: The Dance
1890
Upper right: HTLautrec 90
Oil on canvas
45 1/2 × 59" (115.6 × 149.9 cm)

The Henry P. McIlhenny
Collection in memory of
Frances P. McIlhenny
1986-26-32

Troyon, Constant
Le Tréport
1860–62
Lower left: C. TROYON
Oil on panel
10 3/4 × 15" (27.3 × 38.1 cm)

John G. Johnson Collection
cat. 1096

Troyon, Constant
Moerdijk, Holland
1861
Lower left: C. TROYON. 1861.
Oil on canvas
36 ⅝ × 51 ⁷/₁₆" (93 × 130.6 cm)

The William L. Elkins Collection
E1924-3-22

**Troyon, Constant,
attributed to**
Previously listed as Constant
Troyon (JGJ 1941)
Landscape
19th century
Oil on canvas
31 ½ × 46 ⅛" (80 × 117.2 cm)

John G. Johnson Collection
cat. 1099

Troyon, Constant
Going to Market
Mid-19th century
Lower left: C. TROYON
Oil on canvas
24 ¾ × 36 ⅜" (62.9 × 92.4 cm)

John G. Johnson Collection
cat. 1100

**Troyon, Constant,
attributed to**
Previously listed as Constant
Troyon (PMA 1965)
Landscape with Cattle and Sheep
19th century
Lower left: C. TROYON
Oil on canvas
38 ½ × 51" (97.8 × 129.5 cm)

The George W. Elkins Collection
E1924-4-29

**Troyon, Constant,
attributed to**
Cow
19th century
Lower left: C. TROYON
Oil on canvas
14 ½ × 11 ¼" (36.8 × 28.6 cm)

John G. Johnson Collection
cat. 1097

**Troyon, Constant,
attributed to**
Previously listed as Constant
Troyon (PMA 1965)
Landscape with a Cow and a Figure
19th century
Lower left: C. TROYON
Oil on panel
14 ¾ × 18 ⅛" (37.5 × 46 cm)

The George W. Elkins Collection
E1924-4-30

**Troyon, Constant,
attributed to**
Previously listed as Constant
Troyon (JGJ 1941)
The Garden Gate
19th century
Lower left: VENTE / TROYON
Oil on canvas
21 ½ × 25 ¾" (54.6 × 65.4 cm)

John G. Johnson Collection
cat. 1098

**Troyon, Constant,
attributed to**
Previously listed as Constant
Troyon (PMA 1965)
Return from the Market
19th century
Lower left: C. TROYON
Oil on canvas
28 ⅛ × 36 ¼" (71.4 × 92.1 cm)

The George W. Elkins Collection
E1924-4-31

Troyon, Constant, attributed to
Previously listed as Constant Troyon (JGJ 1941)
Stream
19th century
Lower right: C. TROYON.
Oil on canvas
32 × 25 ⅝" (81.3 × 65.1 cm)

John G. Johnson Collection
cat. 1093

Vernet, Claude-Joseph, imitator of
Coast Scene with a Storm
18th century
Oil on canvas
39 1/16 × 53" (99.2 × 134.6 cm)

The Bloomfield Moore Collection
1883-83

Troyon, Constant, imitator of
Previously listed as Constant Troyon (JGJ 1941)
Man with Sheep
19th century
Lower left: C T
Oil on canvas
10 ⅝ × 13 15/16" (27 × 35.4 cm)

John G. Johnson Collection
cat. 1101

Vernet, Claude-Joseph, imitator of
Marine
18th century
Oil on canvas
29 ⅜ × 38 ¾" (74.6 × 98.4 cm)

The Bloomfield Moore Collection
1883-112

Vernet, Claude-Joseph
French, 1714–1789
Villa at Caprarola
1746
Lower left: Joseph Vernet fecit Romae / 1746
Oil on canvas
52 3/16 × 121 13/16" (132.6 × 309.4 cm)

Purchased with the Edith H. Bell Fund
1977-79-1

Vernet, Claude-Joseph, imitator of
Marine
18th century
Oil on canvas
29 5/16 × 38 ⅛" (74.4 × 96.8 cm)

The Bloomfield Moore Collection
1883-113

Vernet, Claude-Joseph, imitator of
Coast Scene
18th century
Oil on canvas
28 ⅜ × 38 ¾" (72.1 × 98.4 cm)

The Bloomfield Moore Collection
1883-102

Vernet, Claude-Joseph, imitator of
Marine
18th century
Oil on canvas
29 ⅜ × 38 ⅝" (74.6 × 98.1 cm)

The Bloomfield Moore Collection
1883-114

Vernet, Claude-Joseph, imitator of
Shipwreck on a Coast
Late 18th century
Oil on canvas
38 ¹³/₁₆ × 53 ⁹/₁₆" (98.6 × 136 cm)

The Bloomfield Moore Collection
1883-85

Vollon, Antoine
Le Tréport
c. 1886
Lower right: A. Vollon
Oil on panel
20 ¹/₄ × 27 ⁵/₁₆" (51.4 × 69.1 cm)

John G. Johnson Collection
cat. 1105

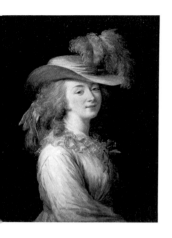

Vigée-Lebrun, Louise-Elisabeth
French, 1755–1842
Portrait of Madame Du Barry
1781
Oil on panel
27 ¹/₄ × 20 ¹/₄" (69.2 × 51.4 cm)

Gift of Mrs. Thomas T. Fleming
1984-137-1

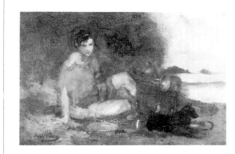

Vollon, Antoine
Musician
By 1887
Lower left: A. Vollon
Oil on canvas
9 ¹/₂ × 14 ¹/₈" (24.1 × 35.9 cm)

John G. Johnson Collection
cat. 1104

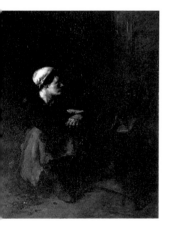

Vollon, Antoine
French, 1833–1900
Woman at a Spinning Wheel
1867
Lower right: A. Vollon
Oil on canvas
67 ¹/₈ × 51 ⁵/₈" (170.5 × 131.1 cm)

John G. Johnson Collection
cat. 1107

Vollon, Antoine
Dunkirk
By 1892
Lower right: A. Vollon
Oil on canvas
17 × 21 ¹/₄" (43.2 × 54 cm)

John G. Johnson Collection
cat. 1109

Vollon, Antoine
Monkey in a Studio
1869
Lower left: A. Vollon
Oil on panel
18 ¹/₈ × 14 ⁵/₈" (46 × 37.1 cm)

John G. Johnson Collection
cat. 1108

Vollon, Antoine
Still Life
By 1892
Lower left: A. Vollon
Oil on canvas
23 ¹/₄ × 30 ⁷/₈" (59 × 78.4 cm)

John G. Johnson Collection
cat. 1106

161

Vollon, Antoine
Still Life
Late 19th century
Lower left: A. Vollon
Oil on canvas
25 7/8 × 21 1/2" (65.7 × 54.6 cm)

The William L. Elkins Collection
E1924-3-64

Weisz, Adolphe
French, born Hungary,
1819–1878
Portrait of Bloomfield H. Moore
Companion to the following
painting
1877
Oil on canvas
28 3/4 × 20 5/8" (73 × 52.4 cm)

The Bloomfield Moore Collection
1882-210

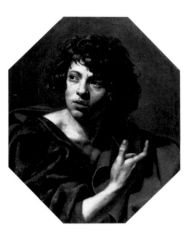

Vouet, Simon
French, 1590–1649
Saint John
c. 1622–25
Oil on canvas
29 × 23" (73.7 × 58.4 cm)

Purchased with the Henry P.
McIlhenny Fund in memory of
Frances P. McIlhenny, the
Edward and Althea Budd Fund,
the Edith H. Bell Fund, and
bequest (by exchange) of Lisa
Norris Elkins
1987-73-1

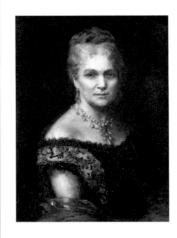

Weisz, Adolphe
Portrait of Mrs. Bloomfield Moore
Companion to the preceding
painting
1877
Lower left: A. Weisz
Oil on canvas
29 × 20 3/4" (73.7 × 52.7 cm)

The Bloomfield Moore Collection
1899-1099

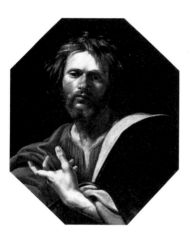

Vouet, Simon
Saint Luke
c. 1622–25
Oil on canvas
29 × 23" (73.7 × 58.4 cm)

Purchased with the Henry P.
McIlhenny Fund in memory of
Frances P. McIlhenny, the
Edward and Althea Budd Fund,
the Edith H. Bell Fund, and
bequest (by exchange) of Lisa
Norris Elkins
1987-73-2

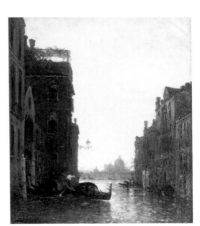

**Ziem, Félix-François-
Georges-Philibert**
French, 1821–1911
Canal in Venice
Before 1877
Lower left: Ziem.
Oil on canvas
25 9/16 × 21 1/4" (64.9 × 54 cm)

John G. Johnson Collection
cat. 1114

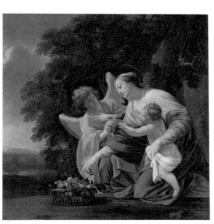

Vouet, Simon, studio of
Virgin and Child, with an Angel
1642
Oil on canvas
37 × 36" (94 × 91.4 cm)

Purchased with the Fiske
Kimball Fund and the Marie
Kimball Fund
1965-65-1

**Ziem, Félix-François-
Georges-Philibert**
The Divine Port, Constantinople
Late 19th century
Lower left: Ziem
Oil on canvas
27 × 40 3/8" (68.6 × 102.5 cm)

The William L. Elkins Collection
E1924-3-60

Ziem, Félix-François-Georges-Philibert
Venetian Scene
Late 19th century
Lower right: Ziem.
Oil on panel
16 11/16 × 25 1/8" (42.4 × 63.8 cm)

John G. Johnson Collection
cat. 1115

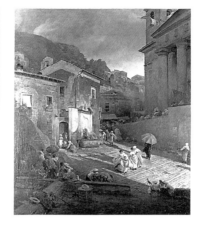

Achenbach, Oswald
German, active Italy, 1827–1905
Street Scene, Naples
c. 1876–80
Lower right: Osw. Achenbach
Oil on canvas
51 × 43" (129.5 × 109.2 cm)

The W. P. Wilstach Collection,
bequest of Anna H. Wilstach
W1893-1-3

Ziem, Félix-François-Georges-Philibert, attributed to
Previously listed as Félix-François-Georges-Philibert Ziem (JGJ 1941)
View of Paris from the Seine
19th century
Lower right: Ziem
Oil on panel
8 7/8 × 13 3/4" (22.5 × 34.9 cm)

John G. Johnson Collection
cat. 1116

Amberg, Wilhelm
German, 1822–1899
Young Woman Seated by a Stream (Contemplation)
Before 1886
Lower left: W. Amberg
Oil on canvas
32 1/8 × 24" (81.6 × 61 cm)

The W. P. Wilstach Collection,
bequest of Anna H. Wilstach
W1893-1-4

Beck, Leonhard, attributed to
German, active Augsburg,
c. 1475–1542
Saints Ulrich and Afra
Diptych; the monogram of Hans Burgkmair (German, 1473–1531) and the date "1523" came away in cleaning in 1940
1523?
Oil on panel
39 1/4 × 41 1/4" (99.7 × 104.8 cm)

Gift of John G. Johnson for the
W. P. Wilstach Collection
W1907-1-25

Beham, Barthel
German, active Nuremburg,
c. 1502–1540
Previously listed as a Swabian artist, c. 1525 (JGJ 1941)
Portrait of Margaret Urmiller and Her Daughter
Companion to the portrait of Hans Urmiller and his son, in the Städelsches Kunstinstitut, Frankfurt (inv. no. 919)
c. 1525
Oil on panel
25 3/4 × 18 5/8" (65.4 × 47.3 cm)

John G. Johnson Collection
cat. 728

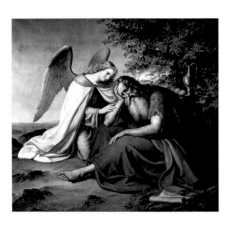

Berendt, Moritz
German, born 1803,
died after 1844
Elijah in the Desert
1834
Lower right: 1834 M. Berendt.;
on reverse: Berendt / 1834 /
Dusseldorfer / Schule
Oil on canvas
62 11/16 × 66 1/16" (159.2 ×
167.8 cm)

Gift of Abner Schreiber in
memory of Mary Schreiber
1978-8-1

Berninger, Edmund
German, born 1843,
still active 1886
View of Capri
c. 1877
Lower left: E. BERNINGER
Oil on canvas
21 3/4 × 32" (55.2 × 81.3 cm)

Gift of Jay Cooke
1955-2-3

**Bochmann, Alexander
Heinrich Gregor von**
German, 1850–1930
Landscape with Mowers
1886
Lower right: G. v Bochmann
Oil on canvas
10 1/2 × 17" (26.7 × 43.2 cm)

John G. Johnson Collection
cat. 897

**Bretschneider, Daniel, the
Younger**
German, active Dresden, died 1658
Portrait of Johann Georg I
c. 1647
Oil on panel
7 1/8 × 4 1/8" (18.1 × 10.5 cm)

Bequest of Carl Otto
Kretzschmar von Kienbusch
1977-167-1032

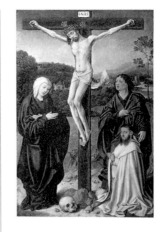

Bruyn, Bartel, the Elder
German, active Cologne,
c. 1493–1555
The Crucifixion, with a Donor
c. 1525–30
On cross: INRI
Oil on panel
17 × 11" (43.2 × 27.9 cm)

John G. Johnson Collection
cat. 750

**Bruyn, Bartel, the Elder,
copy after**
Previously listed as Bartel Bruyn
the Elder (JGJ 1941)
Portrait of a Man
After a lost painting dated 1536
16th century
Oil on panel
11 15/16 × 9 7/16" (30.3 × 24 cm)

John G. Johnson Collection
cat. 749

Bruyn, Bartel, the Younger
German, active Cologne,
born 1530, died 1607–10
Previously listed as Bartel Bruyn
the Elder (JGJ 1941)
*A Donor and His Son, with Saint
Peter*
Companion to the following
painting
16th century
Oil on panel
30 × 20 1/2" (76.2 × 52.1 cm)

John G. Johnson Collection
cat. 747

Bruyn, Bartel, the Younger
Previously listed as Bartel Bruyn
the Elder (JGJ 1941)
*Female Donor, with Saint Anne and
the Virgin and Child*
Companion to the preceding
painting
16th century
Oil on panel
30 × 20 7/16" (76.2 × 51.9 cm)

John G. Johnson Collection
cat. 748

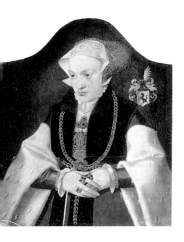

Bruyn, Bartel, the Younger
Portrait of a Lady
16th century
Oil on panel transferred to canvas
17 3/4 × 14" (45.1 × 35.6 cm)

John G. Johnson Collection
inv. 36

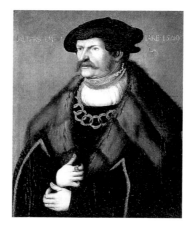

Doring, Hans
German, active Laubach and
Wetzlar, first documented 1511,
died 1558
Previously listed as Hans Mielich
(JGJ 1941)
Portrait of a Nobleman [possibly a
member of the Solms family]
The date in the inscription may
have been changed
1549
Across top: ALTERS IM I LARE
1549 / Az
Oil on panel
18 3/4 × 15 1/8" (47.6 × 38.4 cm)

John G. Johnson Collection
cat. 736

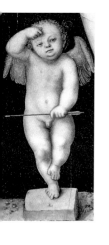

Cranach, Lucas, the Elder
German, active Wittenburg,
Vienna, and Weimar, 1472–1553
Cupid
Fragment
16th century
Center bottom: [artist's cipher]
Oil on panel
31 1/8 × 15" (79.1 × 38.1 cm)

John G. Johnson Collection
cat. 738

Encke, Fedor
German, born 1851,
still active 1913
Portrait of Edward Stieglitz
1879
Lower left: Fedor Encke. 1879. /
New York.
Oil on canvas
40 3/4 × 24 13/16" (103.5 × 63 cm)

Gift of Mrs. William Howard
Schubart
1968-45-1

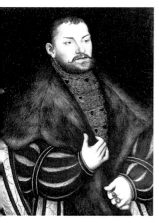

**Cranach, Lucas, the Elder,
attributed to**
Previously listed as Lucas
Cranach the Elder (JGJ 1941)
*Portrait of George the Devout,
Margrave of Brandenburg-Ansbach*
Companion to the portrait of
Margravine Hedwig in the Art
Institute of Chicago (38.310)
1529
Center left: 1529 / [artist's
cipher]
Oil on panel
23 3/8 × 16 3/8" (59.4 × 41.6 cm)

John G. Johnson Collection
cat. 739

Encke, Fedor
Portrait of Hedwig Stieglitz
1881–86
Lower right: Fedor Encke / Berlin
Oil on canvas
23 3/4 × 19 5/8" (60.3 × 49.8 cm)

Gift of Mrs. William Howard
Schubart
1968-45-2

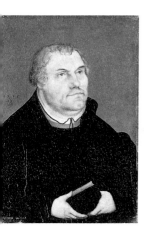

**Cranach, Lucas, the Elder,
workshop of**
Portrait of Martin Luther
Based on the painting by
Cranach, dated 1539, in the
collection of Émile Isambert,
Paris
1545
Upper left: 1545 / [artist's
cipher]
Oil on panel
14 1/16 × 9 1/8" (35.7 × 23.2 cm)

John G. Johnson Collection
cat. 740

Encke, Fedor
Portrait of Flora Stieglitz
1880s
Lower right: Fedor Encke.
Oil on canvas
23 1/4 × 19 1/4" (59 × 48.9 cm)

Gift of Sue Davidson Lowe
1968-69-53

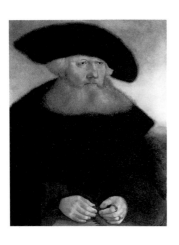

Faber von Creuznach, Conrad, attributed to
German, active Frankfurt, c. 1500–1552/53
Previously listed as Conrad Faber von Creuznach (JGJ 1941)
Portrait of a Man
c. 1500–50
Oil on panel
21 1/2 × 15" (54.6 × 38.1 cm)

John G. Johnson Collection
cat. 732

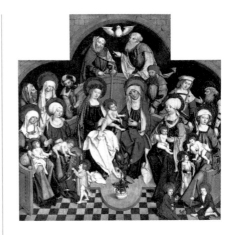

German, active Swabia, unknown artist
Previously listed as a Swabian artist, c. 1500 (JGJ 1941)
The Holy Kinship
c. 1500
Oil on panel
62 1/2 × 59 1/4" (158.7 × 150.5 cm)

John G. Johnson Collection
cat. 720

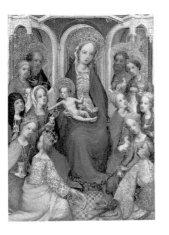

German, active Cologne, unknown artist
Previously listed as a Cologne artist, c. 1410 (JGJ 1941)
Enthroned Virgin and Child, with Saints Paul, Peter, Clare of Assisi, Mary Magdalene, Barbara, Catherine of Alexandria, John the Baptist, John the Evangelist, Agnes, Cecilia, Dorothy, and George
c. 1430 or after
On halos: S BARBARA /
S CATERINA / S AGNUSM /
S CECILIA / S DOROTHEA
Mixed media and tooled gold on panel
13 1/4 × 9 1/4" (33.6 × 23.5 cm)

John G. Johnson Collection
cat. 742

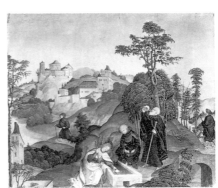

German, active Ulm or Augsburg, unknown artist,
Previously listed as an Austrian artist, c. 1500 (JGJ 1941)
The Separation of the Apostles
Fragment of an altarpiece; another panel is in the Rosgartenmuseum Konstanz, Germany
c. 1500
Oil on panel
21 1/8 × 24 1/2" (53.7 × 62.2 cm)

John G. Johnson Collection
cat. 726

German, active Swabia, unknown artist
Previously listed as a Swabian artist, c. 1490 (JGJ 1941)
The Entombment of Christ
c. 1490
Oil and tooled gold on panel
30 3/8 × 19" (77.1 × 48.3 cm)

John G. Johnson Collection
cat. 719

German, unknown artist
Previously listed as a follower of the Master of Alkmaar (JGJ 1941)
"Ecce Homo"
See following painting for reverse
c. 1500–25
Oil on panel
24 7/8 × 16 1/8" (63.2 × 41 cm)

John G. Johnson Collection
cat. 399a

German or Swiss, unknown artist
Saints Eustace, George, Christopher, and Acacius
Late 15th or early 16th century
Oil on panel
27 × 14 3/4" (68.6 × 37.5 cm)

Bequest of Carl Otto Kretzschmar von Kienbusch
1977-167-1040

German, unknown artist
Previously listed as a follower of the Master of Alkmaar (JGJ 1941)
Virgin and Child, with Saint Christopher
Reverse of preceding painting
c. 1500–25
Oil on panel
24 7/8 × 16 1/8" (63.2 × 41 cm)

John G. Johnson Collection
cat. 399b

German, active Bavaria, unknown artist
Previously listed as a Bavarian artist, c. 1520 (JGJ 1941)
The Martyrdom of the Ten Thousand
Companion panels; based on the woodcut, c. 1496, by Albrecht Dürer (German, 1471–1528) (Bartsch 117)
c. 1500–25
Oil on panel
Each panel: 49 1/4 × 17"
(125.1 × 43.2 cm)

John G. Johnson Collection
cat. 730

German, active southern Germany, unknown artist
Previously listed as a South German artist, c. 1545 (JGJ 1941)
Scenes from the Book of Esther
c. 1545
Oil on panel
19 1/16 × 26 1/2" (48.4 × 67.3 cm)

John G. Johnson Collection
cat. 734

German, active southern Germany, unknown artist
Previously listed as Martin Schaffner (JGJ 1941)
Portrait of a Lady
c. 1500–50
Upper right (spurious): LC Pinx. / 1505
Oil on panel
12 3/8 × 9 1/2" (31.4 × 24.1 cm)

John G. Johnson Collection
cat. 733

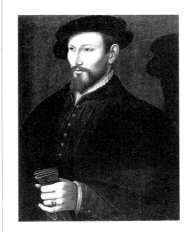

German, active lower Rhine, unknown artist
Previously attributed to Ludger Tom Ring the Younger (JGJ 1941)
Portrait of a Gentleman
c. 1550
Oil on panel
19 9/16 × 14 11/16" (49.7 × 37.3 cm)

John G. Johnson Collection
cat. 754

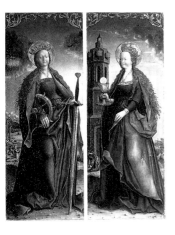

German, active Swabia, unknown artist
Previously listed as Hans Goldschmid (JGJ 1941)
Saints Catherine of Alexandria and Barbara
Companion panels
c. 1524
On sword: IZ; on tower: 1524 / HG / IZ—
Oil and gold on panel
Left panel: 58 5/8 × 21 7/8"
(148.9 × 55.6 cm); right panel:
58 7/16 × 21 7/8" (148.4 × 55.6 cm)

John G. Johnson Collection
cat. 729

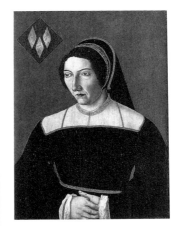

German, unknown artist
Previously attributed to Ludger Tom Ring the Younger (JGJ 1941)
Portrait of a Lady
c. 1550
Upper left: [coat of arms, possibly of Cambry family]
Oil on panel
18 1/8 × 12 5/8" (46 × 32.1 cm)

John G. Johnson Collection
cat. 755

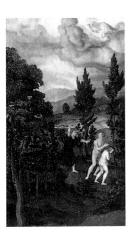

German, active southern Germany, unknown artist
Previously listed as a South German artist, c. 1530 (JGJ 1941)
The Expulsion from Eden
c. 1530–60
Oil on panel
33 3/8 × 18 1/4" (84.8 × 46.3 cm)

John G. Johnson Collection
cat. 731

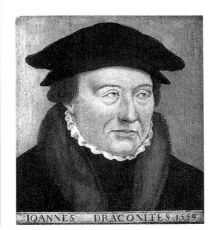

German, unknown artist
Previously listed as a Dutch artist, c. 1559 (JGJ 1941)
Portrait of Johannes Draconites
1559
Across bottom: IOANNES DRACONITES 1559
Oil on panel
9 7/16 × 8 1/4" (24 × 20.9 cm)

John G. Johnson Collection
inv. 1351

German, unknown artist
Previously listed as an old copy
after Martin Schongauer (JGJ
1941)
Christ Taken to Prison
Based on the print by Martin
Schongauer (German, c. 1445–
1491) (Bartsch 10)
Early 16th century
Center left (spurious): MS
Oil on panel
13 ³/₄ × 10 ⁵/₁₆" (34.9 × 26.2 cm)

John G. Johnson Collection
cat. 717

German, unknown artist
*Portrait of a Twenty-One-Year-Old
Woman*
1721
Upper right: AET. 21, 1721.
Oil on canvas
32 ¹/₈ × 25 ¹¹/₁₆" (81.6 × 65.2 cm)

Bequest of Mrs. John Harrison
1921-39-48

German, unknown artist
Previously listed as Christoph
Amberger (JGJ 1941)
Portrait of an Old Man
16th century
Oil on panel
14 ³/₈ × 11" (36.5 × 27.9 cm)

John G. Johnson Collection
inv. 220

German, unknown artist
*Portrait of a Seventy-One-Year-Old
Woman*
1745
Upper right: M.W.M. /
AETATIS.LXXI / MDCCXLV.
Oil on canvas
34 ¹/₄ × 26 ³/₄" (87 × 67.9 cm)

Bequest of Mrs. John Harrison
1921-39-49

German?, unknown artist
Previously listed as the school of
Rembrandt Harmensz. van Rijn
(JGJ 1941)
Portrait of a Gentleman
17th century
Oil on panel
32 × 34 ¹/₈" (81.3 × 86.7 cm)

John G. Johnson Collection
cat. 491

German, unknown artist
Portrait of a Young Man
c. 1775–1800
Oil on canvas
21 ¹/₄ × 16 ⁵/₁₆" (54 × 41.4 cm)

John G. Johnson Collection
cat. 791

German, unknown artist
Previously listed as a German
artist, mid-18th century (JGJ
1941)
The Deposition of Christ
After a woodcut by Albrecht
Dürer (German, 1471–1528)
(Bartsch 43)
17th century?
Oil on slate
9 × 7 ³/₈" (22.9 × 18.7 cm)

John G. Johnson Collection
cat. 406

**German?, active Rome,
unknown artist**
Previously listed as Raphael
Mengs (JGJ 1941)
The Holy Family
18th century
Oil on panel
11 ⁷/₈ × 8 ⁷/₈" (30.2 × 22.5 cm)

John G. Johnson Collection
inv. 2922

German, unknown artist
The Coronation of the Virgin
Early 19th century
Center bottom: KRÖNUNG
MARIA
Oil on glass
15 × 12" (38.1 × 30.5 cm)

Purchased with Museum funds
1913-455

German, unknown artist
Previously listed as Albrecht
Dürer (JGJ 1941)
Portrait of an Old Man
In a 16th-century style
19th century
Oil on vellum on canvas
15 5/16 × 11" (38.9 × 27.9 cm)

John G. Johnson Collection
cat. 737

German?, unknown artist
Fisherman
19th century
Oil on paper on fiberboard
9 1/2 × 7 5/16" (24.1 × 18.6 cm)

John G. Johnson Collection
inv. 2932

German, unknown artist
Sheep
19th century
Oil on canvas
18 3/4 × 27 1/8" (47.6 × 68.9 cm)

Bequest of Katherine E. Sheafer
1971-272-2

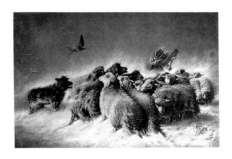

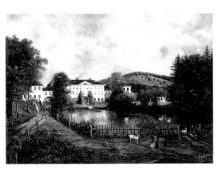

German, unknown artist
*The Kienbusch Estate, Unter
Marxgrun*
19th century
Lower right: Forli / Drsd[?]
Oil on canvas
28 × 37" (71.1 × 94 cm)

Bequest of Carl Otto
Kretzschmar von Kienbusch
1977-167-1087

German, unknown artist
The Vision of the Tiburtine Sibyl
In a 16th-century style;
companion to the following three
paintings
19th century
Oil on panel
7 3/16 × 5 9/16" (18.3 × 14.1 cm)

John G. Johnson Collection
inv. 457a

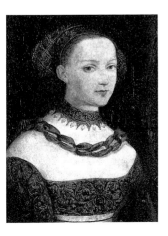

German, unknown artist
Previously listed as an old copy
after Lucas Cranach the Elder
(JGJ 1941)
Portrait of a Girl
In a 16th-century style
19th century
Oil on panel transferred to canvas
20 13/16 × 14 5/16" (52.9 × 36.3 cm)

John G. Johnson Collection
cat. 741

German, unknown artist
The Feast of Herod
See previous entry
19th century
Upper left: L; upper right: J
Oil on panel
7 1/4 × 5 7/8" (18.4 × 14.9 cm)

John G. Johnson Collection
inv. 457b

German, unknown artist
Pentecost
See previous two entries
19th century
Oil on panel
7 1/8 × 5 1/2" (18.1 × 14 cm)

John G. Johnson Collection
inv. 457c

**Holbein, Hans, the Younger,
copy after**
Portrait of Erasmus of Rotterdam
After the painting in the
Kunstmuseum Basel (inv. no. 324)
16th century
Oil on panel
8 1/8" (20.6 cm) diameter

John G. Johnson Collection
cat. 718

German, unknown artist
The Martyrdom of a Saint
See previous three entries
19th century
Center right: L. / J.
Oil on panel
7 1/8 × 5 1/2" (18.1 × 14 cm)

John G. Johnson Collection
inv. 457d

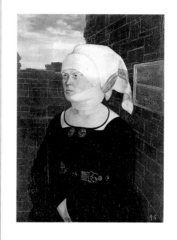

Huber, Wolf
German, active Passau,
c. 1485–1553
Portrait of Margaret Hundertpfundt
Companion to the portrait of
Antony Hundertpfundt, National
Gallery of Ireland, Dublin (15)
1526
Center right: MARGGRET / HVN-
DERPFV- / NDIN IST AB / GE-
MACHT IRS / ALTER 41 IAR / DA
MANZALT / 1526 IAR AM / 22 TAG
IENNARI / W H; lower right: 46
Oil on panel
27 × 18 5/8" (68.6 × 47.3 cm)

John G. Johnson Collection
inv. 1438

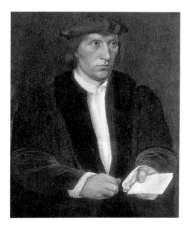

**Holbein, Hans, the Younger,
imitator of**
German, active Basel and
England, 1497–1543
Previously listed as Hans
Holbein the Younger (JGJ 1941)
Portrait of John Godsalve
Based on a drawing in the
collection of Her Majesty Queen
Elizabeth II (R. L. 12265)
16th century
Oil on panel
12 7/8 × 9 13/16" (32.7 × 24.9 cm)

John G. Johnson Collection
inv. 35

Kraus, August
German, 1852–1917
Interior (Tired Out)
c. 1900
Lower left: August Kraus.
Oil on canvas
20 3/4 × 16" (52.7 × 40.6 cm)

The Walter Lippincott Collection
1923-59-2

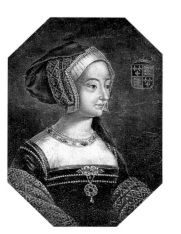

**Holbein, Hans, the Younger,
imitator of**
Portrait of a Woman
19th century
Oil on panel
6 3/8 × 4 1/2" (16.2 × 11.4 cm)

John G. Johnson Collection
inv. 1855

Kuehl, Gotthardt
German, 1850–1915
Wine Room
1891
Lower right: G Kuehl
Oil on canvas
34 5/8 × 25 3/4" (87.9 × 65.4 cm)

John G. Johnson Collection
cat. 1016

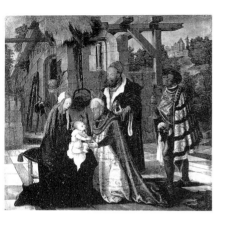

**Kulmbach, Hans Suess von,
attributed to**
German, active Nuremburg,
c. 1480–1522
The Adoration of the Magi
Early 16th century
Oil on panel
13 5/16 × 13 3/8" (33.8 × 34 cm)

John G. Johnson Collection
cat. 727

Löfftz, Ludwig
German, 1845–1910
Woman Sewing
1886
Lower right: L. Loefftz München
1886
Oil on canvas
33 3/8 × 28 1/4" (84.8 × 71.7 cm)

John G. Johnson Collection
cat. 1026

Lenbach, Franz von
German, 1836–1904
*Portrait of the Widow Marion
Knapp* [née Graham, later
Baroness Bateman]
c. 1903
Oil on construction board
28 3/16 × 26 7/8" (71.6 × 68.3 cm)
Gift of Mrs. Henry Clifford
1975-79-3

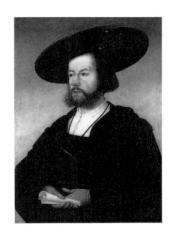

**Maler von Ulm, Hans,
attributed to**
German, active Schwaz, born
1470–80, still active c. 1530
Portrait of a Man
c. 1500–25
Oil on panel
23 × 16 1/16" (58.4 × 40.8 cm)

John G. Johnson Collection
inv. 2088

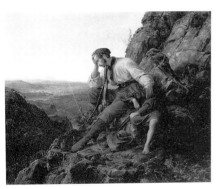

Lessing, Karl Friedrich
German, 1808–1880
The Robber and His Child
1832
Center bottom: C.F.L. 1832
Oil on canvas
16 5/8 × 19 1/8" (42.2 × 48.6 cm)

The W. P. Wilstach Collection,
bequest of Anna H. Wilstach
W1893-1-65

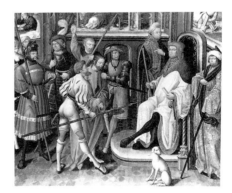

**Master of Cappenberg
(Jan Baegart)**
German, active Westphalia,
documented 1465–1515
Christ before Annas
Fragment of a panel from an
altarpiece; a related fragment was
formerly in the collection of
H. C. Kruger, Berlin
c. 1500
Oil on panel
49 × 56 1/8" (124.5 × 142.6 cm)

John G. Johnson Collection
cat. 753

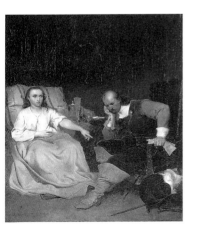

Leutze, Emanuel
German, active United States,
1816–1868
Oliver Cromwell and His Daughter
1843
Lower left: E. Leutze, Düss f. 1843.
Oil on canvas
29 1/8 × 24 1/2" (74 × 62.2 cm)

The W. P. Wilstach Collection,
bequest of Anna H. Wilstach
W1893-1-67

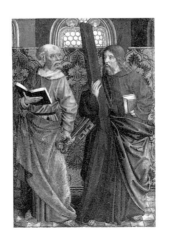

Master of the Holy Kinship
German, active Cologne,
c. 1450–c. 1515
Saints Peter and Andrew
Panel from an altarpiece; compan-
ion panels are in the Rheinisches
Landesmuseum, Bonn (141);
Museum of Fine Arts, Boston
(07.646); collection of Heinz and
Gerlinde Kisters, Kreuzlingen,
Switzerland; (formerly) the
Kulturhistorisches Museum,
Magdeburg (GK506, destroyed);
and (formerly) the von Schnitzler
collection, Cologne
c. 1500
Oil on panel
18 5/8 × 12 5/8" (47.3 × 32.1 cm)

John G. Johnson Collection
cat. 745

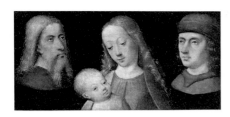

Master of Liesborn, workshop of
German, active Westphalia, active 1450–1475
Previously listed as the Master of Liesborn (JGJ 1941)
Virgin and Child, with Two Male Figures
c. 1450–75
Oil on panel
5 15/16 × 11 3/16" (15.1 × 28.4 cm)

John G. Johnson Collection
cat. 752

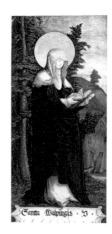

Master of Messkirch
Saint Walpurgis
See previous two entries
c. 1535–40
Across bottom: Santta Walpurgis V
Oil and gold on panel
24 3/8 × 11 1/4" (61.9 × 28.6 cm)

John G. Johnson Collection
cat. 723

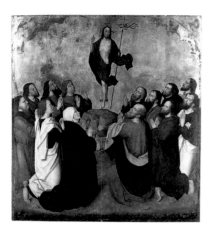

Master of the Lyversberg Passion, workshop of
German, active Cologne, active c. 1460–c. 1490
Previously listed as the Master of the Life of the Virgin (JGJ 1941)
The Ascension of Christ
Fragment of a panel from an altarpiece commissioned for the church of Saint Columba, Cologne; companion panels are in the Germanisches Nationalmuseum, Nuremberg (GM 19, GM 20), and Dom- und Diözesanmuseum, Speyer
c. 1473
Oil and gold on panel
35 7/8 × 31 5/8" (91.1 × 80.3 cm)

John G. Johnson Collection
cat. 743

Master of Messkirch
Saint Agatha
See previous three entries
c. 1535–40
Across bottom: Santta Agatha Virgo et M
Oil and gold on panel
25 7/8 × 9 3/4" (65.7 × 24.8 cm)

John G. Johnson Collection
cat. 724

Master of Messkirch
German, active 1520–1540
Saint Stephen
Panel from an altarpiece commissioned by Count Gattfried Werner von Zimmem for the church of Messkirch, Baden-Württemberg; companion to the following four panels
c. 1535–40
Across top: Santtus Steffanus martir
Oil and gold on panel
25 5/16 × 9 1/2" (64.3 × 24.1 cm)

John G. Johnson Collection
cat. 721

Master of Messkirch
Saint Ciriacus
See previous four entries
c. 1535–40
Across top: Santtus Ciriacus martir
Oil and gold on panel
25 1/4 × 9 1/2" (64.1 × 24.1 cm)

John G. Johnson Collection
cat. 725

Master of Messkirch
Saint Eulalia
See previous entry
c. 1535–40
Across bottom: Santta Eulalia V
Oil and gold on panel
24 5/16 × 10 7/8" (61.7 × 27.6 cm)

John G. Johnson Collection
cat. 722

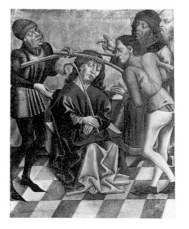

Master of the Munderkinger Altar
German, active Swabia, dated work 1473
Previously listed as a Swabian artist, c. 1460 (JGJ 1941)
Christ Crowned with Thorns
c. 1475
Oil and gold on panel
22 7/8 × 17" (58.1 × 43.2 cm)

John G. Johnson Collection
cat. 716

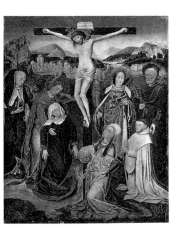

Master of the Munich Crucifixion Altarpiece
German, active Cologne?,
dated work 1517
Previously listed as Pierre des
Mares (JGJ 1941)
*The Crucifixion, with Saints Jerome,
Barbara, and Peter, and a Donor*
Early 16th century
Oil on panel transferred to canvas
24³/₄ × 19" (62.9 × 48.3 cm)

John G. Johnson Collection
cat. 746

Meyer, August Eduard Nicolaus, also called Claus Meyer
German, 1856–1919
Meditation
1885
Lower right: Claus Meyer / 85.
Oil on panel
10⁹/₁₆ × 8¹/₁₆" (26.8 × 20.5 cm)

John G. Johnson Collection
cat. 1041

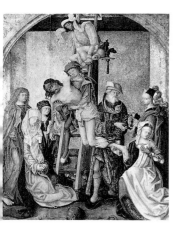

Master of the Saint Bartholomew Altar, follower of
German, active Cologne,
active c. 1470–c. 1510
Previously listed as a copy after
the Master of the Saint
Bartholomew Altar (JGJ 1941)
The Descent from the Cross
Based on the painting in the
Musée du Louvre, Paris (inv. 1445)
Early 16th century
Oil on panel
20³/₁₆ × 15⁹/₁₆" (51.3 × 39.5 cm)

John G. Johnson Collection
cat. 744

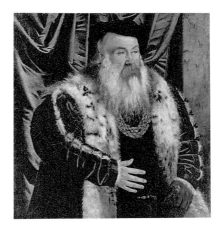

Mielich, Hans, attributed to
German, active Munich,
1516–1573
Previously listed as Hans Mielich
(JGJ 1941)
Portrait of a Nobleman
16th century
Oil on canvas
38¹/₈ × 34⁵/₈" (96.8 × 87.9 cm)

John G. Johnson Collection
cat. 735

Master of the Sterzingen Altar, workshop of
German, active Swabia,
active c. 1450–c. 1500
Previously listed as a Swabian
artist, c. 1440–50 (JGJ 1941)
The Birth of the Virgin
Panel from an altarpiece; see
following entry for companion
panels
c. 1450–1500
Oil on panel
40¹/₄ × 36⁷/₈" (102.2 × 93.7 cm)

John G. Johnson Collection
cat. 714

Oppenheimer, Josef
German, 1876–1967
Portrait of Selma Stieglitz Schubart
1901
Lower right: J. Oppenheimer /
NY. 1901.
Oil on canvas
40¹/₈ × 18" (101.9 × 45.7 cm)

Gift of Mrs. William Howard
Schubart
1968-45-4

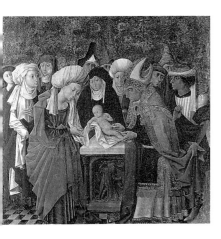

Master of the Sterzingen Altar, workshop of
Previously listed as an Upper
Rhenish artist, c. 1450 (JGJ 1941)
The Circumcision of Christ
Panel from an altarpiece;
companion to the preceding panel
and panels in the cloister of
Fischingen, Switzerland; the
Metropolitan Museum of Art,
New York (32.100.38, 32.100.39);
and the Diözesanmuseum
Rottenburg, Germany (B 5, B 6)
Mid-15th century
Oil and gold on panel
40³/₈ × 36¹/₄" (102.5 × 92.1 cm)

John G. Johnson Collection
cat. 715

Riefstahl, Wilhelm Ludwig Friedrich
German, 1827–1888
Return from the Christening
1865
Lower left: W. Riefstahl. 65
Oil on canvas
27⁵/₈ × 44³/₄" (70.2 × 113.7 cm)

The W. P. Wilstach Collection,
bequest of Anna H. Wilstach
W1893-1-90

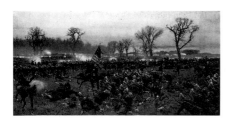

Röchling, Carl
German, 1855–1920
*The Battle of Fredericksburg,
December 13, 1862*
19th century
Lower right: C RÖCHLING
Oil on canvas
32 1/8 × 59" (81.6 × 149.9 cm)

Commissioners of Fairmount
Park
F1929-1-1

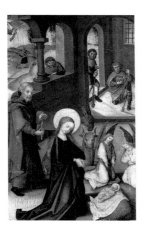

**Schongauer, Ludwig,
attributed to**
German, active Colmar, Ulm,
and Augsburg, c. 1440–1494
Previously listed as Bartholomaeus
Zeitblom (PMA 1965)
The Nativity
c. 1480–90
Oil on panel
18 1/4 × 11 1/4" (46.3 × 28.6 cm)

The John D. McIlhenny
Collection
1943-40-44

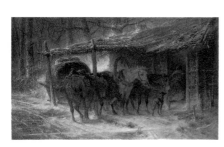

Schreyer, Adolf
German, 1828–1899
Post House, Walachia
1867
Lower right: Ad. Schreyer. / Paris
1867
Oil on canvas
38 1/4 × 62 1/2" (97.1 × 158.7 cm)

The William L. Elkins Collection
E1924-3-20

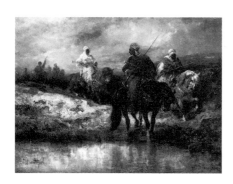

Schreyer, Adolf
Arab Horsemen
c. 1887–90
Lower right: Ad. Schreyer
Oil on canvas
25 1/4 × 34" (64.1 × 86.4 cm)

Bequest of Chester Waters Larner
1977-258-1

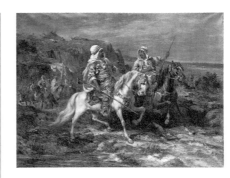

Schreyer, Adolf
Arab Horsemen
19th century
Lower left: Ad. Schreyer
Oil on canvas
35 1/4 × 45 7/8" (89.5 × 116.5 cm)

The Walter Lippincott Collection
1923-59-1

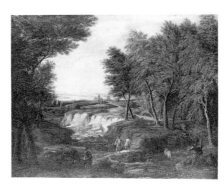

Weyermann, Jakob Christoph
German, 1698–1757
Previously listed as Jacob Campo
Weyerman (PMA 1965)
Ideal Landscape with Figures
c. 1730–35
Lower right: Weyerma{nn}
Oil on canvas
28 3/16 × 34 13/16" (71.6 × 88.4 cm)

Bequest of Robert Nebinger
1889-113

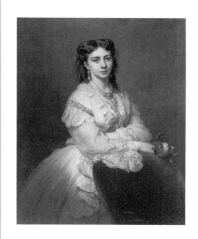

Winterhalter, Franz Xaver
German, 1805–1873
*Portrait of Countess Marie Branicka
de Bialacerkiew {née Princess
Sapicka}*
1865
Lower right: F. Winterhalter /
1865. Paris
Oil on canvas
45 11/16 × 35 5/16" (116 × 89.7 cm)

Purchased with the Edward G.
Budd, Jr., Memorial Fund
1973-252-1

**Zimmermann, Reinhard
Sebastian**
German, 1815–1893
Previously listed as August
Richard Zimmermann (PMA
1965)
Too Late for the Cars
1855
Lower left: R. S. Zimmermann
1855; on reverse: Vervielfaltigung
vorbehalten / R. S. Zimmermann
Oil on canvas
27 1/2 × 32 5/16" (69.8 × 82.1 cm)

The W. P. Wilstach Collection,
bequest of Anna H. Wilstach
W1893-1-135

Albertinelli, Mariotto, workshop of
Italian, active Florence, 1474–1515
Previously listed as Mariotto Albertinelli (JI 1966)
The Adoration of the Christ Child
Predella panel
After 1503
Oil and gold on panel
6 5/8 × 23 3/8" (16.8 × 59.4 cm)

John G. Johnson Collection
cat. 1168

Allegretto di Nuzio
Virgin and Child, and Christ as the Man of Sorrows
Diptych
c. 1366
Tempera and tooled gold on panel
15 3/8 × 20" (39 × 50.8 cm)
overall

John G. Johnson Collection
cat. 118

Allegretto di Nuzio, also called Allegretto Nuzi
Italian, active Fabriano and Florence, first recorded 1345, died 1373
Previously listed as close to Maso di Banco (JI 1966)
Virgin and Child, with Saints Mary Magdalene, James the Great, and Stephen, and a Bishop Saint
Panels from an altarpiece
c. 1345–46
Tempera and tooled gold on panel
Center panel: 28 3/8 × 16 1/2" (72.1 × 41.9 cm); side panels [each]: 23 5/8 × 11 3/4" (60 × 29.8 cm)

John G. Johnson Collection
cat. 5

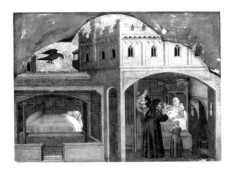

Altichiero, follower of
Italian, active Padua and Verona, documented 1369–1384
Previously listed as a Veronese artist, end of the 14th century (JI 1966)
Saint Eligius's Mother Told of Her Son's Future Fame
Panel from an altarpiece; companion panels are in the Ashmolean Museum, Oxford (A732); a private collection, England; and an unknown location
1390s
Tempera and gold on panel
20 3/4 × 27 1/2" (52.7 × 69.8 cm)

John G. Johnson Collection
inv. 3024

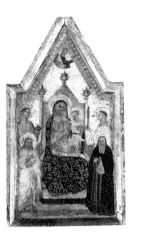

Allegretto di Nuzio
Enthroned Virgin and Child, with Saints Lucy, John the Baptist, and Anthony Abbot, and a Female Martyr
Panel from a diptych; the companion panel is in the Kérészteny Múzeum, Esztergom, Hungary (55.149)
c. 1350
Oil and tooled gold on panel
17 1/8 × 9 1/4" (43.5 × 23.5 cm)

John G. Johnson Collection
cat. 2

Amidano, Giulio Cesare
Italian, active Parma, 1566–1630
Previously attributed to Bartolomeo Schedoni (JI 1966)
Portrait of a Young Gentleman
Early 16th century
Across top (spurious): AVGVS MARTELLI AETATIS SVAE XVIII / ANGELVS BRONZINO FECIT ANNO
Oil on panel transferred to canvas
28 1/2 × 24 1/4" (72.4 × 61.6 cm)

John G. Johnson Collection
cat. 282

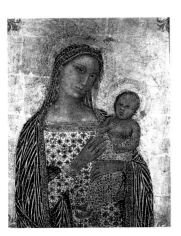

Allegretto di Nuzio
Virgin and Child
c. 1366
Tempera and tooled gold on panel
14 3/4 × 11 7/8" (37.5 × 30.2 cm)

John G. Johnson Collection
cat. 119

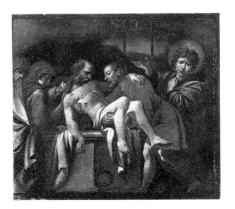

Amidano, Giulio Cesare, attributed to
The Entombment
Early 16th century
Oil on canvas on panel
8 × 9" (20.3 × 22.9 cm)

John G. Johnson Collection
inv. 198

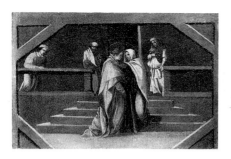

**Andrea del Sarto
(Andrea d'Agnolo di
Francesco), copy after**
Italian, active Florence,
1486–1530
The Visitation
After part of a fresco in the
Chiostro dello Scalzo, Florence
19th century
Oil on canvas
8 3/4 × 12 7/8" (22.2 × 32.7 cm)

John G. Johnson Collection
inv. 1410

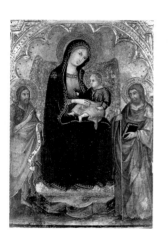

Andrea di Bartolo
Italian, active Siena, first
documented 1389, died 1428
Previously listed as Taddeo di
Bartolo (JI 1966)
*Enthroned Virgin and Child, with
Saints John the Baptist and James
the Great*
Center panel from a triptych; cut
down at the top
c. 1395–1400
On scroll: ECCE A[G]NVS DEI QUI
Tempera and tooled gold on panel
11 1/8 × 8" (28.3 × 20.3 cm)

John G. Johnson Collection
cat. 99

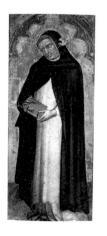

Andrea di Bartolo
Blessed Andrea Sansedoni
Pilaster panel from an altarpiece;
companion to the following panel
After 1413
Tempera and tooled gold on panel
15 × 6 1/2" (38.1 × 16.5 cm)

John G. Johnson Collection
cat. 96

Andrea di Bartolo
Saint Anthony Abbot
Pilaster panel from an altarpiece;
companion to the preceding panel
After 1413
Tempera and tooled gold on panel
16 × 6 5/8" (40.6 × 16.8 cm)

John G. Johnson Collection
cat. 97

**Fra Angelico (Guido di
Pietro), also called Fra
Giovanni da Fiesole**
Italian, active Florence and
Rome, first securely documented
by 1417, died 1455
Saint Francis of Assisi
Fragment from *The Crucifixion,
with Saints Nicholas of Bari and
Francis of Assisi*, in the
Confraternity of San Niccolò del
Ceppo, Florence
c. 1425–33
Tempera and tooled gold on panel
27 9/16 × 19 1/4" (70 × 48.9 cm)

John G. Johnson Collection
cat. 14

Fra Angelico
Previously listed as the studio of
Fra Angelico (JI 1966)
The Dormition of the Virgin
Predella panel; companion panels
are in the Kimbell Art Museum,
Fort Worth (AP 1986.03); the
Museo Nazionale di San Marco,
Florence (Uffizi 1499); and the M.
H. de Young Memorial Museum,
San Francisco (Kress 289)
c. 1427
Tempera and tooled gold on panel
10 1/4 × 20 13/16" (26 × 52.9 cm)

John G. Johnson Collection
cat. 15

Fra Angelico, follower of
*The Papacy Offered to Saint Gregory
the Great* [?]
Predella panel; possible
companion panels are in the
Koninklijk Museum voor Schone
Kunsten, Antwerp (117); the
Musée Condé, Chantilly (120);
the Musée Thomas Henry,
Cherbourg (8); and the Museum
of Fine Arts, Houston (44-550)
c. 1435
Tempera and gold on panel
11 × 7 3/4" (27.9 × 19.7 cm)

John G. Johnson Collection
cat. 1166

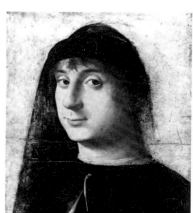

**Antonello da Messina
(Antonello di Giovanni di
Michele de Antonio)**
Italian, active Messina, Naples,
and Venice, first securely
documented 1456, died 1479
Portrait of a Young Gentleman
c. 1470–74
Oil on panel
12 5/8 × 10 11/16" (32.1 × 27.1 cm)

John G. Johnson Collection
cat. 159

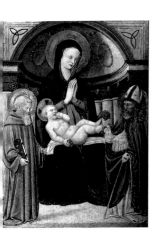

Apollonio di Giovanni di Tommaso, workshop of
Italian, active Florence, born 1415–17, died 1465
and Marco del Buono di Marco
Italian, 1403–1489
Previously listed as the Virgil Master (JI 1966)
Enthroned Virgin and Child, with Saint Benedict and a Bishop Saint
c. 1460
Tempera and tooled gold on panel
29 3/8 × 19 1/2" (74.6 × 49.5 cm)

John G. Johnson Collection
cat. 26

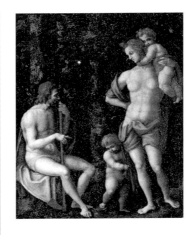

Bacchiacca (Francesco di Ubertino Verdi)
Italian, active Florence and Rome, 1494–1557
Adam and Eve with Cain and Abel
c. 1516–18
Oil on panel
14 × 11 1/16" (35.6 × 28.1 cm)

John G. Johnson Collection
cat. 80

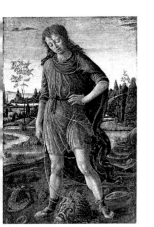

Argonaut Master
Italian, active Florence, active c. 1450–c. 1475
Previously listed as Jacopo del Sellaio (JI 1966)
David with the Head of Goliath
c. 1460
Tempera and gold on panel
23 × 15 1/4" (58.4 × 38.7 cm)

John G. Johnson Collection
cat. 51

Badile, Giovanni Antonio, attributed to
Italian, active Verona, 1518–1560
Previously listed as Giovanni Antonio Badile (JI 1966)
The Meeting of Solomon and the Queen of Sheba
Mid-16th century
Oil on canvas
28 1/16 × 43 1/16" (71.3 × 109.4 cm)

John G. Johnson Collection
inv. 729

Arrigo di Niccolò (Master of the Manassei Chapel)
Italian, active c. 1374–1446
Previously listed as Italian, unknown artist, 14th century (PMA 1965)
Saints Benedict, Sebastian, Stephen, and John the Evangelist
Panel from an altarpiece; companion to a panel formerly in a private collection in Milan
c. 1400–10
On Evangelist's book: FILIO / LI [MEI,] .N[ON]. / DILI / GAM[US] / VE[R]BO / NEQUE / LING / UA .S / ET . O / P[ER]E .[E]T / VERI / TATE; across bottom: MRE MMR G ME FECIM MEOT [?]
Tempera and tooled gold on panel
57 5/8 × 32" (146.4 × 81.3 cm)

The Louise and Walter Arensberg Collection
1950-134-528

Fra Bartolomeo (Bartolomeo di Paolo), also called Baccio della Porta
Italian, active Florence, Venice, and Rome, 1472–1517
Adam and Eve with Cain and Abel
By 1512
Oil on panel
12 1/2 × 9 7/8" (31.7 × 25.1 cm)

John G. Johnson Collection
cat. 78

Fra Bartolomeo, copy after
Portrait of Girolamo Savonarola
After the painting in the Museo Nazionale di San Marco, Florence
19th century
Oil on canvas
16 3/4 × 13 3/16" (42.5 × 33.5 cm)

John G. Johnson Collection
inv. 2059

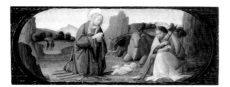

Bartolomeo di Giovanni
Italian, active Florence,
documented 1488–1511
The Adoration of the Christ Child
Predella panel; companion panels
are in the Gemäldegalerie Alte
Meister, Staatliche Kunst-
sammlungen Dresden; Ferens Art
Gallery, Hull, Yorkshire; and a
private collection, Fiesole
c. 1485
Oil on panel
7 9/16 × 19" (19.2 × 48.3 cm)

The John D. McIlhenny
Collection
1943-40-53

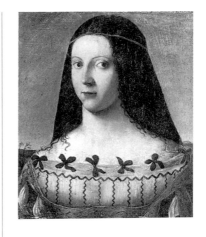

**Bartolomeo Veneto,
copy after**
Previously attributed to
Bernardino de' Conti (JI 1966)
*Portrait of a Woman Once Identified
as Beatrice d'Este*
After the painting in the Snite
Museum of Art, University of
Notre Dame, Indiana (51.4.13)
19th century
Oil on panel
16 1/4 × 13 3/16" (41.3 × 33.5 cm)

John G. Johnson Collection
cat. 270

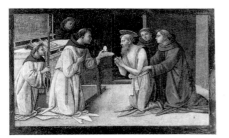

Bartolomeo di Giovanni
The Last Communion of Saint Jerome
Predella panel
c. 1490–1500
Oil on panel
7 7/8 × 12 11/16" (20 × 32.2 cm)

John G. Johnson Collection
cat. 70

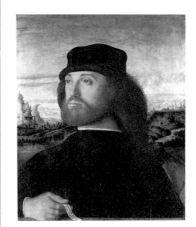

Basaiti, Marco
Italian, active Venice,
born c. 1470, still active 1530
Portrait of a Gentleman
c. 1500
Center bottom (spurious):
IOHANES BELLI / NVS/1488.
Oil on panel
21 1/2 × 16 7/8" (54.6 × 42.9 cm)

John G. Johnson Collection
cat. 179

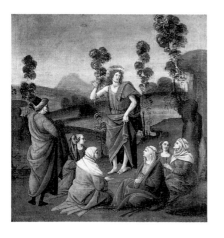

Bartolomeo di Giovanni
Saint John the Baptist Preaching
c. 1500–10
Oil and gold on canvas
24 1/4 × 21 3/16" (61.6 × 53.8 cm)

John G. Johnson Collection
cat. 71

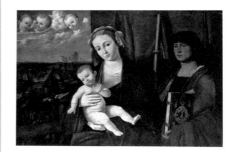

Basaiti, Marco
*Virgin and Child, with Saint James
the Great*
c. 1500–1
Center right: MARCVS.B[]I /
TI. / .F
Oil on panel transferred to canvas
28 1/4 × 40" (71.7 × 101.6 cm)

John G. Johnson Collection
cat. 180

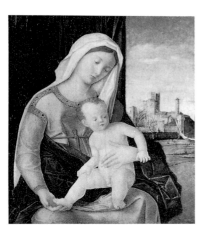

**Bartolomeo Veneto,
follower of**
Italian, active Veneto and
Lombardy, documented
1502–1530
Previously listed as the school of
Giovanni Bellini (JI 1966)
Virgin and Child before a Landscape
Based on a composition by
Giovanni Bellini, known through
several copies
Early 16th century
Oil on panel
27 5/8 × 24 1/8" (70.2 × 61.3 cm)

John G. Johnson Collection
cat. 183

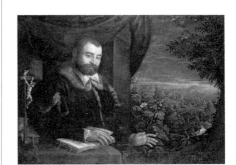

**Bassano, Leandro
(Leandro da Ponte)**
Italian, active Venice and
Bassano, 1557–1622
*Portrait of a Gentleman Seated
before a Landscape*
Early 17th century
Oil on canvas
39 7/8 × 53 3/8" (101.3 × 135.6 cm)

John G. Johnson Collection
cat. 212

Bassano, Leandro, follower of
The Birth of the Virgin
Late 16th century
Oil on canvas
61 × 67 ½" (154.9 × 171.4 cm)

Bequest of Arthur H. Lea
F1938-1-41

Battista di Maestro Gerio
Italian, active Pisa,
documented 1418–1433
Previously listed as the Master of
the Bambino Vispo (JI 1966)
Enthroned Virgin and Child
Center panel from an altarpiece;
companion to two panels in
private collections
c. 1426
Tempera and tooled gold on panel
46 ⅝ × 25 ½" (118.4 × 64.8 cm)

John G. Johnson Collection
cat. 12

Bastiani, Lazzaro di Jacopo, follower of
Italian, active Venice and
environs, first documented 1449,
died 1512
The Martyrdom of Saint George
Companion to the following
painting
c. 1495
Oil on panel
21 ⅜ × 14 ¾" (54.3 × 37.5 cm)

John G. Johnson Collection
cat. 174

Beccafumi, Domenico (Domenico di Pace), also called Mecarino, follower of
Italian, active Siena, 1486–1551
Virgin and Child
c. 1535–40
Oil on canvas
28 × 21" (71.1 × 53.3 cm)

Bequest of Arthur H. Lea
F1938-1-43

Bastiani, Lazzaro di Jacopo, follower of
The Burial of Saint George
Companion to the preceding
painting
c. 1495
Oil on panel
21 ⅜ × 17 ¾" (54.3 × 45.1 cm)

John G. Johnson Collection
cat. 175

Bellini, Gentile, follower of
Italian, active Venice and
Constantinople, first recorded
1460, died 1507
Previously listed as Lazzaro
Bastiani (JI 1966)
*The Nativity, with the Doge
Cristoforo Moro, and the
Annunciation to the Shepherds*
c. 1462–71
Oil on panel
37 ½ × 23 ⅝" (95.2 × 60 cm)

John G. Johnson Collection
cat. 163

Batoni, Pompeo Girolamo
Italian, 1708–1787
Esther before Ahasuerus
1738–40
Oil on canvas
29 ⅛ × 39 1/16" (74 × 99.2 cm)

Gift of the Women's Committee
of the Philadelphia Museum of
Art in honor of their 100th
anniversary
1982-89-1

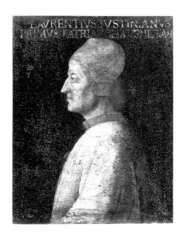

Bellini, Gentile, copy after
Portrait of Lorenzo Giustiniani
After the full-length portrait,
dated 1465, in the Gallerie
dell'Accademia, Venice
(inv. no. 593, cat. no. 570)
Late 15th century
Across top: LAVRENTIVS
IVSTINIANVS / PRIMVS
PATRIARCHA VENETIAE
Oil on canvas
25 ¾ × 19 ⅜" (65.4 × 49.2 cm)

John G. Johnson Collection
cat. 162

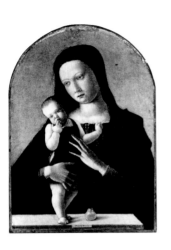

**Bellini, Giovanni,
also called Giambellino**
Italian, active Venice, first
documented 1459, died 1516
Virgin and Child
c. 1459–60
Center bottom: [I]OANNES
BELLINVS
Oil on panel
25 ³/₈ × 17 ³/₈" (64.4 × 44.1 cm)

John G. Johnson Collection
cat. 165

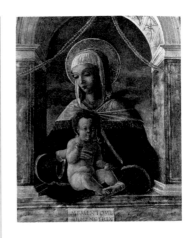

**Benaglio, Francesco,
attributed to**
Italian, active Verona, first
documented 1462, died c. 1492
Virgin and Child
c. 1460–70
Center bottom: MEMENTOMEI /
DEIGENETRIX
Oil on panel transferred to canvas
20 ¹/₈ × 16 ¹/₈" (51.1 × 41 cm)

John G. Johnson Collection
cat. 215

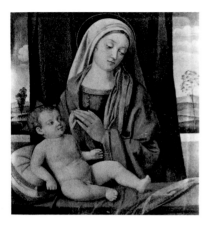

**Bellini, Giovanni,
Emilian follower of**
Previously listed as Gerolamo da
Santacroce (JI 1966)
Virgin and Child
Based on the composition by
Giovanni Bellini, in the Galleria
Doria Pamphili, Rome (521)
c. 1500
Oil on panel
20 × 17 ⁵/₈" (50.8 × 44.8 cm)

John G. Johnson Collection
cat. 185

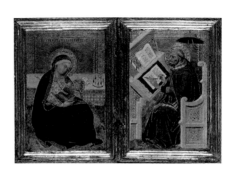

**Benedetto di Bindo,
attributed to**
Italian, active Siena and Perugia,
first securely documented 1410,
died 1417
Previously listed as a Sienese
artist, late 14th century (JI 1966)
*The Virgin of Humility, and Saint
Jerome Translating the Gospel of
John*
Diptych
c. 1400–5
Across lower frame: []OSTRA
DONNA DEL[]UM [rest
illegible]; left panel, on book:
[abbreviated Latin text of Psalm
69:2]; right panel, on book:
[abbreviated Latin text of John
1:1–7]
Tempera and tooled gold on panel
11 ⁷/₈ × 16 ⁵/₈" (30.2 × 42.2 cm)

John G. Johnson Collection
cat. 153

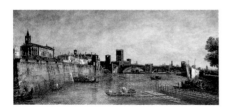

Bellotto, Bernardo
Italian, active Veneto,
1721–1780
*View of Verona with the
Castelvecchio and Ponte Scaligero*
c. 1745–46
Oil on canvas
29 × 60 ³/₄" (73.7 × 154.3 cm)

The William L. Elkins Collection
E1924-3-87

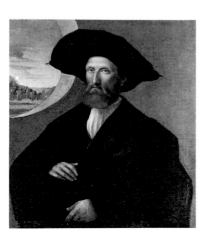

**Bembo, Gian Francesco,
attributed to**
Italian, active Cremona, first
documented 1515, died c. 1526
Previously listed as a Venetian
artist, c. 1520–30 (JI 1966)
Portrait of an Elderly Gentleman
c. 1520–25
Oil on canvas
31 ¹/₄ × 27 ³/₄" (79.4 × 70.5 cm)

John G. Johnson Collection
cat. 181

**Bergognone (Ambrogio di
Stefano da Fossano)**
Italian, active Lombardy,
documented 1481–1522
Saint Mary Magdalene
Panel from an altarpiece; other
panels are in the Accademia
Carrara, Bergamo; and a private
collection
c. 1515
Oil on panel
49 ¹/₈ × 17 ¹/₁₆" (124.8 × 43.3 cm)

John G. Johnson Collection
cat. 259

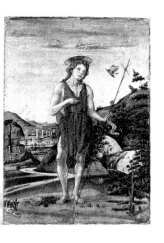

Biagio d'Antonio da Firenze
Italian, active Florence, Rome, and Faenza, documented 1476–1504
Previously listed as the school of Piero di Cosimo (JI 1966)
Saint John the Baptist in the Wilderness
Early 1480s
Center right, on banner: EGO VOS CHIAM []
Tempera on panel
11 1/8 × 7 3/4" (28.3 × 19.7 cm)

John G. Johnson Collection
cat. 77

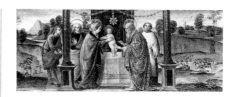

Binasco, Francesco (Francesco da Lonate)
Italian, active Milan, active c. 1486–1520
Previously listed as Vincenzo Civerchio (JI 1966)
The Circumcision of Christ
c. 1500
Oil on panel
9 1/4 × 21 3/16" (23.5 × 53.8 cm)

John G. Johnson Collection
cat. 263

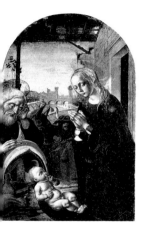

Biagio d'Antonio da Firenze
Previously listed as Giovanni Battista Utili da Faenza (JI 1966)
The Adoration of the Christ Child
Late 15th century
Tempera and gold on panel
38 3/8 × 22 3/8" (97.5 × 56.8 cm)

John G. Johnson Collection
cat. 62

Boldini, Giovanni
Italian, 1842–1931
Highway of Combes-la-Ville
1873
Lower left: Boldini / 73
Oil on canvas
27 1/4 × 39 15/16" (69.2 × 101.4 cm)

The George W. Elkins Collection
E1924-4-2

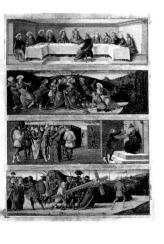

Biagio d'Antonio da Firenze
Previously listed as David Ghirlandaio (JI 1966)
The Last Supper, the Betrayal of Christ, Christ before Pilate, and Christ Carrying the Cross
Predella panels; now framed vertically
Late 15th century
Tempera and gold on panel
Each panel: 4 × 12 1/2" (10.2 × 31.7 cm)

John G. Johnson Collection
cat. 67

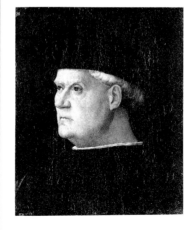

Bonsignori, Francesco
Italian, active Verona, c. 1460–1519
Portrait of an Elderly Gentleman
c. 1485–90
Oil on panel
16 1/16 × 12 5/8" (40.8 × 32.1 cm)

John G. Johnson Collection
cat. 171

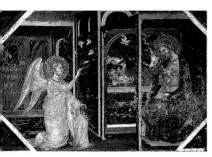

Bicci di Lorenzo, workshop of
Italian, active Florence, 1373–1452
Previously listed as the school of Agnolo Gaddi (JI 1966)
The Annunciation
Predella panel
c. 1415
Tempera and tooled gold on panel
9 5/8 × 13 7/8" (24.9 × 35.2 cm)

John G. Johnson Collection
cat. 7

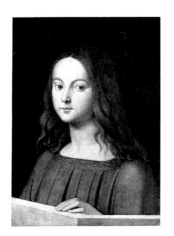

Bonsignori, Francesco
Christ as a Boy
c. 1510–14
Lower right: F B
Oil on panel
19 5/8 × 14" (49.8 × 35.6 cm)

John G. Johnson Collection
cat. 172

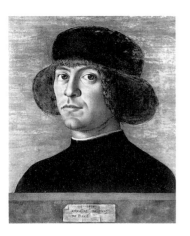

Bonsignori, Francesco, attributed to
Portrait of a Young Gentleman
c. 1485
Center bottom (spurious): 1477 /
antonellus messaneus / me Pinxit
Oil on panel
11 1/2 × 9 3/8" (29.2 × 23.8 cm)

John G. Johnson Collection
inv. 732

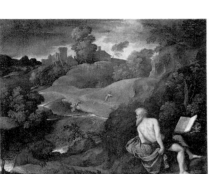

**Bordone, Paris
(Paris Pasqualino)**
Italian, active Venice,
1500–1571
Saint Jerome in the Wilderness
c. 1520–25
Oil on canvas
27 5/8 × 34 3/8" (70.2 × 87.3 cm)

John G. Johnson Collection
cat. 206

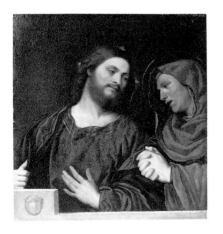

Bordone, Paris
Christ Taking Leave of His Mother
c. 1530
Oil on canvas transferred from
panel
32 3/4 × 28 3/4" (83.2 × 73 cm)

John G. Johnson Collection
cat. 207

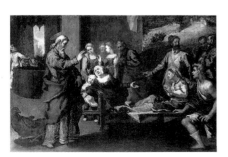

Boscoli, Andrea
Italian, active Florence,
c. 1560–1607
Previously listed as Pietro
Mariscalchi (JI 1966)
*Saint John the Evangelist Reviving
Drusiana*
1599
Oil on canvas
30 1/4 × 45 1/4" (76.8 × 114.9 cm)

John G. Johnson Collection
cat. 224

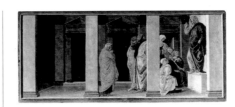

**Botticelli, Sandro (Alessandro
di Mariano Filipepi)**
Italian, active Florence and
Rome, 1445–1510
*Saint Mary Magdalene Listening to
Christ Preach*
Predella panel from an altarpiece
from the convent of Sant'Elisabet-
ta delle Convertite, Florence, the
main panel of which is in the
Courtauld Institute Galleries,
London (The Lee Collection, 61);
companion to the following three
panels
c. 1484–91
Tempera on panel
7 7/8 × 17 1/4" (20 × 43.8 cm)

John G. Johnson Collection
cat. 44

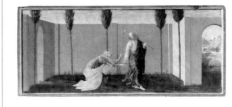

Botticelli, Sandro
The Feast in the House of Simon
See previous entry
c. 1484–91
Tempera on panel
7 13/16 × 17 3/16" (19.8 × 43.7 cm)

John G. Johnson Collection
cat. 45

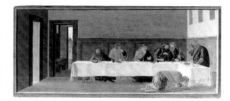

Botticelli, Sandro
"Noli Me Tangere"
See previous two entries
c. 1484–91
Tempera on panel
7 3/4 × 17 5/16" (19.7 × 44 cm)

John G. Johnson Collection
cat. 46

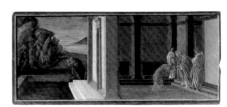

Botticelli, Sandro
*The Last Moments of Saint Mary
Magdalene*
See previous three entries
c. 1484–91
Tempera on panel
7 3/16 × 17 1/4" (18.3 × 43.8 cm)

John G. Johnson Collection
cat. 47

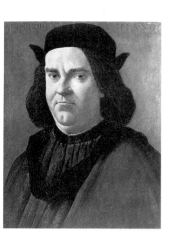

Botticelli, Sandro
Portrait of Lorenzo de' Lorenzi
c. 1492
Across top: L.LOREN TIANO
Oil on panel
20 × 14 ³/₈" (50.8 × 36.5 cm)

John G. Johnson Collection
cat. 48

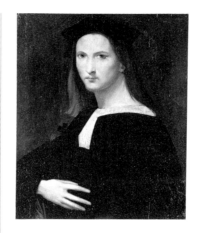

**Brescianino, Andrea,
attributed to**
Previously listed as Andrea
Brescianino (JI 1966)
Portrait of a Young Gentleman
c. 1510–15
Oil on panel
26 ¹/₄ × 21 ⁵/₁₆" (66.7 × 54.1 cm)

John G. Johnson Collection
cat. 113

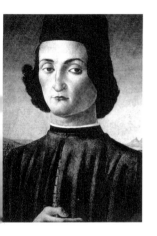

**Botticelli, Sandro,
follower of**
Previously listed as Sandro
Botticelli (JI 1966)
Portrait of a Young Man
Late 15th century
Tempera on panel
19 ¹/₁₆ × 12 ⁷/₈" (48.4 × 32.7 cm)

John G. Johnson Collection
cat. 50

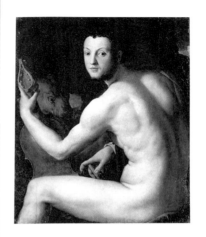

**Bronzino, Agnolo (Agnolo
di Cosimo di Mariano)**
Italian, active Florence,
1503–1572
*Portrait of Cosimo I de' Medici as
Orpheus*
c. 1538–40
Oil on panel
36 ⁷/₈ × 30 ¹/₁₆" (93.7 × 76.4 cm)

Gift of Mrs. John Wintersteen
1950-86-1

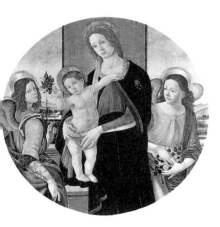

**Botticelli, Sandro,
follower of**
Virgin and Child, with Two Angels
c. 1500
Oil on panel
38" (96.5 cm) diameter

John G. Johnson Collection
cat. 49

**Brusasorci (Domenico
Riccio), also called Brusasorzi**
Italian, active Verona and
Mantua, c. 1516–1567
Previously listed as the area of
Paolo Veronese–Leandro Bassano
(JI 1966)
*Portrait of a Gentleman with a
Letter*
1551
On letter: MDLI
Oil on canvas
42 ³/₈ × 35 ¹/₄" (107.6 × 89.5 cm)

John G. Johnson Collection
cat. 229

**Brescianino, Andrea
(Andrea di Giovannantonio
di Tommaso Piccinelli)**
Italian, active Siena and Florence,
documented 1506–1525
*Virgin and Child, with the Young
Saint John the Baptist and Saints
Sebastian and Catherine of Siena*
1520s
Center bottom: [E]CCE AGNVS
DEI
Oil on panel
27 ¹/₈ × 20 ¹/₂" (68.9 × 52.1 cm)

John G. Johnson Collection
cat. 114

Brusasorci, attributed to
Shepherd with His Flock
c. 1540–50
Oil on canvas
17 ⁵/₈ × 15 ³/₈" (44.8 × 39 cm)

John G. Johnson Collection
cat. 227

Bulgarini, Bartolomeo
Italian, active Siena, first
documented 1337, died 1378
Left panel: *Annunciate Angel, Saint
Andrew, a Bishop Saint, Saint
Dominic, and Saint Francis of
Assisi*; right panel: *Annunciate
Virgin, Saint Bartholomew, a
Deacon Saint, Saint Lucy, and Saint
Agatha*
Wings from a triptych, framed
together; the center panel is in
the Isabella Stewart Gardner
Museum, Boston (P15n8)
c. 1355–60
On angel's scroll: AVE GRATIA
PLENA
Tempera and tooled gold on panel
25 1/8 × 16 7/8" (63.8 × 42.9 cm)
overall

John G. Johnson Collection
cat. 92

Campagnola, Domenico
Italian, active Venice and Padua,
c. 1500–1564
*Virgin and Child, with Saints
George and Catherine of Alexandria,
and a Putto*
c. 1520
Oil on canvas
34 1/2 × 40 1/16" (87.6 × 101.8 cm)

John G. Johnson Collection
cat. 202

Campi, Giulio, attributed to
Italian, active Cremona,
born 1500–2, died 1572
Previously listed as Giulio Campi
(PMA 1965)
Portrait of a Lady
Mid-16th century
Oil on panel
40 1/8 × 26 5/8" (101.9 × 67.6 cm)

Purchased with the W. P.
Wilstach Fund
W1896-1-6

**Canaletto (Giovanni Antonio
Canal)**
Italian, active Venice, Rome,
and England, 1697–1768
Rialto Bridge
c. 1730
Oil on canvas
14 9/16 × 25 11/16" (37 × 65.2 cm)

John G. Johnson Collection
inv. 1404

Canaletto
*The Bucintoro at the Molo on
Ascension Day*
c. 1745
Oil on canvas
45 1/4 × 64" (114.9 × 162.6 cm)

The William L. Elkins Collection
E1924-3-48

Canaletto, studio of
Bacino of San Marco
Unfinished
After 1726–28
Oil on canvas
13 1/8 × 19 3/8" (33.3 × 49.2 cm)

John G. Johnson Collection
cat. 1173

Canaletto, studio of
*The Bucintoro at the Molo on
Ascension Day*
Version of the painting in the
collection of the Duke of Bedford,
Woburn
After 1731
Oil on canvas
48 1/8 × 76 1/4" (122.2 × 193.7 cm)

John G. Johnson Collection
cat. 292

Canaletto, follower of
Grand Canal at Santa Maria della Carità
After 1726
Oil on canvas
20 5/16 × 30" (51.6 × 76.2 cm)

John G. Johnson Collection
cat. 295

Canaletto, follower of
Previously listed as an imitator of Canaletto (PMA 1965)
Rialto Bridge from the North
Close to Michele Marieschi; companion to the preceding painting
After 1741?
Oil on canvas
25 × 38 5/8" (63.5 × 98.1 cm)

The William L. Elkins Collection
E1924-3-24

Canaletto, follower of
Court of the Doge's Palace
1740s
Oil on canvas
29 1/2 × 44 7/8" (74.9 × 114 cm)

John G. Johnson Collection
cat. 293

Canaletto, copy after
Capriccio with a Palladian Design for the Rialto Bridge
After the painting in the collection of Her Majesty Queen Elizabeth II (408)
Soon after 1743–44
Lower right (spurious): ACanal F.
Oil on canvas
35 3/8 × 51 1/8" (89.8 × 129.9 cm)

Purchased with the W. P. Wilstach Fund
W1895-1-3

Canaletto, follower of
View from the Piazzetta
1740s?
Oil on canvas
20 1/4 × 30" (51.4 × 76.2 cm)

John G. Johnson Collection
cat. 294

Canaletto, copy after
Northumberland House
After the painting in the collection of the Duke of Northumberland, Alnwick Castle; possibly by an English copyist; pendant to the following painting
After 1752–53
Oil on canvas
22 1/2 × 35 1/4" (57.1 × 89.5 cm)

Gift of John Howard McFadden, Jr.
1946-36-2

Canaletto, follower of
Previously listed as the studio of Canaletto (PMA 1965)
Grand Canal from Campo di San Vio
Close to Michele Marieschi; companion to the following painting
After 1741?
Oil on canvas
25 × 38 1/2" (63.5 × 97.8 cm)

The William L. Elkins Collection
E1924-3-25

Canaletto, copy after
Old Somerset House from the River Thames
After a painting in a private collection in the United Kingdom; possibly by an English copyist; pendant to the preceding painting
After 1752–53
Oil on canvas
22 1/2 × 35 1/4" (57.1 × 89.5 cm)

Gift of John Howard McFadden, Jr.
1946-36-3

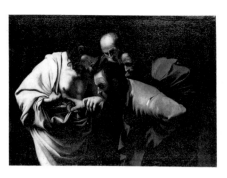

Caravaggio (Michelangelo Merisi), copy after
Italian, 1573–1610
The Incredulity of the Apostle Thomas
After a painting in the Staatliche Schlösser und Gärten Potsdam-Sanssouci
17th century
Oil on canvas
45 1/4 × 60 5/8" (114.9 × 154 cm)

Bequest of Arthur H. Lea
F1938-1-34

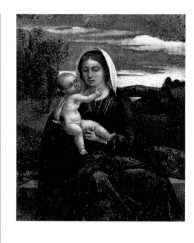

Cavazzola (Paolo Morando), attributed to
Italian, active Verona, 1486–1522
Virgin and Child in a Landscape
c. 1520–22
Oil on panel
15 5/16 × 12 1/8" (38.9 × 30.8 cm)

John G. Johnson Collection
cat. 220

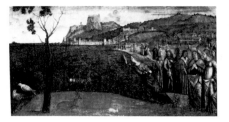

Carpaccio, Vittore
Italian, active Venice, first documented 1490, died 1523–26
The Metamorphosis of Alcyone
c. 1495–1500
Oil on panel
27 3/8 × 49 9/16" (69.5 × 125.9 cm)

John G. Johnson Collection
cat. 173

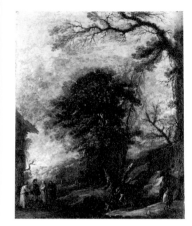

Cecco Bravo (Francesco Montelatici)
Italian, active Florence, 1601–1661
Landscape with Figures
c. 1635–40
Oil on canvas
31 3/8 × 24 1/2" (79.7 × 62.2 cm)

Bequest of Arthur H. Lea
F1938-1-32

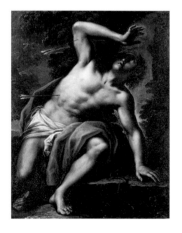

Carracci, Lodovico, follower of
Italian, active Bologna, 1555–1619
Saint Sebastian
Early 17th century
Oil on canvas
39 1/4 × 29 3/8" (99.7 × 74.6 cm)

Purchased with the W. P. Wilstach Fund
W1904-1-3

Cecco Bravo, attributed to
Andromeda [?]
Mid-17th century
Oil on canvas
45 3/16 × 59 5/8" (114.8 × 151.4 cm)

Bequest of Arthur H. Lea
F1938-1-23

Carracci, Lodovico, copy after
Previously listed as a North Italian artist, c. 1600 (JI 1966)
Saint John the Baptist Preaching
After the painting in the Pinacoteca Nazionale, Bologna (inv. 458)
Late 17th century?
Oil on canvas
20 3/4 × 16" (52.7 × 40.6 cm)

John G. Johnson Collection
cat. 240

Cenni di Francesco di Ser Cenni
Italian, active Florence, Volterra, and San Gimignano, documented 1369–1415
Previously listed as Giovanni del Biondo (JI 1966)
The Beheading of Saint John the Baptist and the Martyrdom of Saint Lawrence
Predella panel; companion to the following two panels
c. 1385–90
Tempera and tooled gold on panel
13 × 30 1/2" (33 × 77.5 cm)

John G. Johnson Collection
inv. 1290

Cenni di Francesco di Ser Cenni
Previously listed as Giovanni del Biondo (JI 1966)
The Adoration of the Magi
See previous entry
c. 1385–90
Tempera and tooled gold on panel
13 × 25 5/16" (33 × 64.3 cm)

John G. Johnson Collection
inv. 1291

Cima da Conegliano (Giovanni Battista Cima)
Italian, active Venice and Veneto, 1459/60–1517/18
Virgin and Child before a Landscape
c. 1485–86
Center bottom: IOANNES BAPTISTA / DE CONEGLIANO.P
Oil on panel
23 3/4 × 18 3/4" (60.3 × 47.6 cm)

John G. Johnson Collection
cat. 176

Cenni di Francesco di Ser Cenni
Previously listed as Giovanni del Biondo (JI 1966)
The Martyrdom of Saint Bartholomew and the Archangel Michael with the Bull on Mount Gargano
See previous two entries
c. 1385–90
Tempera and tooled gold on panel
13 × 30 5/16" (33 × 77 cm)

John G. Johnson Collection
inv. 1292

Cima da Conegliano
Head of Saint Stephen
Fragment
c. 1500–10
Oil on panel transferred to canvas
12 3/4 × 10 7/8" (32.4 × 27.6 cm)

John G. Johnson Collection
cat. 1171

Chiari, Giuseppe Bartolomeo, attributed to
Italian, 1654–1727
Previously listed as Alonso Cano (PMA 1965)
Carthusian Abbot
1720s
Oil on canvas
38 1/2 × 29 1/2" (97.8 × 74.9 cm)

Purchased with the W. P. Wilstach Fund
W1904-1-2

Cima da Conegliano
Bacchant
Fragment; companion to the following panel and a panel in a private collection in Paris
c. 1505–10
Oil on panel
9 11/16 × 7 5/8" (24.6 × 19.4 cm)

John G. Johnson Collection
cat. 178

Cigoli (Lodovico Cardi), copy after
Italian, active Florence, 1559–1613
The Holy Family
After the painting in the Galleria Palatina, Florence
17th century
Oil on canvas
24 7/8 × 18 7/16" (63.2 × 46.8 cm)

Bequest of Arthur H. Lea
F1938-1-19

Cima da Conegliano
Silenus and Satyrs
Fragment; companion to the preceding panel and a panel in a private collection in Paris
c. 1505–10
Oil on panel
12 1/4 × 16 1/8" (31.1 × 41 cm)

John G. Johnson Collection
cat. 177

Cima da Conegliano, copy after
Virgin and Child
After the painting in the National Gallery, London (no. 634)
16th century
Oil on panel
22 $^{1}/_{16}$ × 17 $^{1}/_{16}$" (56 × 43.3 cm)

John G. Johnson Collection
cat. 192

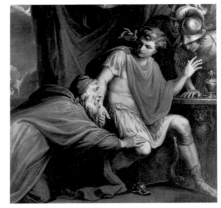

Cipriani, Giovanni Battista
Achilles Besought by Priam for the Body of His Son Hector
c. 1776
Oil on canvas
42 $^{1}/_{16}$ × 41 $^{3}/_{4}$" (106.8 × 106 cm)

Purchased with the John Howard McFadden, Jr., Fund
1972-250-4

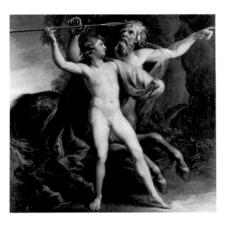

Cipriani, Giovanni Battista
Italian, active Florence and England, 1727–1785
The Education of Achilles
c. 1776
Oil on canvas
41 $^{1}/_{16}$ × 41" (104.3 × 104.1 cm)

Purchased with the John Howard McFadden, Jr., Fund
1972-250-1

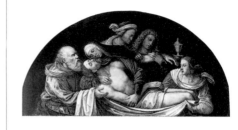

Coda, Benedetto, workshop of
Italian, active Rimini, first documented 1495–96, died before 1544
and Bartolomeo Coda
Italian, active Rimini, documented 1516–1565
Previously listed as School of the Marches, c. 1530 (JI 1966)
Lamentation
Lunette of an altarpiece
c. 1540–50
Oil on panel
33 $^{1}/_{8}$ × 63 $^{1}/_{8}$" (84.1 × 160.3 cm)

John G. Johnson Collection
cat. 201

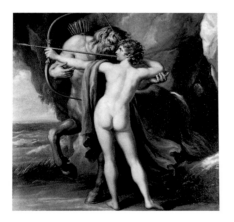

Cipriani, Giovanni Battista
Chiron Instructing Achilles in the Bow
c. 1776
Oil on canvas
42 $^{7}/_{16}$ × 42 $^{1}/_{8}$" (107.8 × 107 cm)

Purchased with the John Howard McFadden, Jr., Fund
1972-250-2

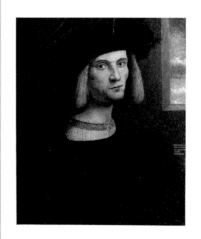

Conti, Bernardino de'
Italian, active Milan, documented 1494–1522
Portrait of a Gentleman
c. 1510
Center right: BERNARDINVS / DE' COMITIBVS / DE CASTRO / SEPII / FACIEBAT
Oil on panel
23 $^{1}/_{2}$ × 19 $^{1}/_{2}$" (59.7 × 49.5 cm)

John G. Johnson Collection
cat. 269

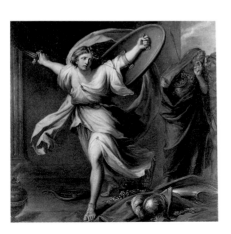

Cipriani, Giovanni Battista
Achilles Discovered by Ulysses among the Daughters of Lycomedes
c. 1776
Oil on canvas
42 $^{1}/_{2}$ × 42 $^{1}/_{4}$" (107.9 × 107.3 cm)

Purchased with the John Howard McFadden, Jr., Fund
1972-250-3

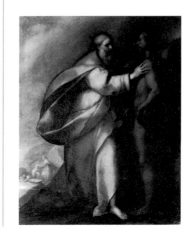

Cornara, Carlo, attributed to
Italian, active Milan and environs, 1605–1673
Previously listed as the school of Palma il Vecchio (JI 1966)
The Creation of Adam
Mid-17th century
Oil on canvas
56 $^{1}/_{2}$ × 42 $^{1}/_{2}$" (143.5 × 107.9 cm)

John G. Johnson Collection
cat. 189

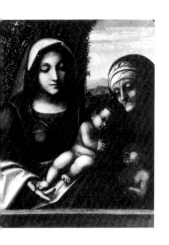

Correggio (Antonio di Pellegrino Allegri)
Italian, active Parma, 1489–1534
Virgin and Child, with Saint Elizabeth and the Young Saint John the Baptist
c. 1510–12
Oil on panel
23 ⁷⁄₈ × 17 ¹⁄₄" (60.6 × 43.8 cm)

John G. Johnson Collection
cat. 1173a

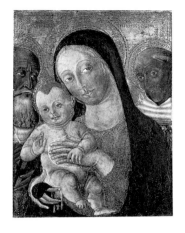

Cozzarelli, Guidoccio di Giovanni, follower of
Italian, active Siena, 1450–1517
Previously listed as Guidoccio di Giovanni Cozzarelli (JI 1966)
Virgin and Child, with Saints Jerome and Bernardino
Late 15th century
Tempera and tooled gold on panel
22 ³⁄₁₆ × 17 ¹⁄₈" (56.4 × 43.5 cm)

John G. Johnson Collection
cat. 112

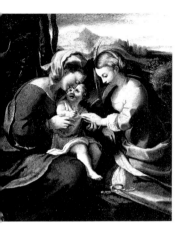

Correggio, copy after
The Mystic Marriage of Saint Catherine of Alexandria
After the painting in the Museo e Gallerie Nazionali di Capodimonte, Naples (106)
Late 17th century?
Oil on panel
11 ¹⁄₂ × 9 ¹⁄₂" (29.2 × 24.1 cm)

John G. Johnson Collection
cat. 254

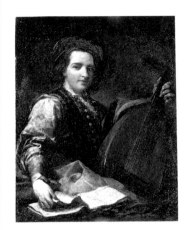

Crespi, Giuseppe Maria, attributed to
Italian, active Bologna, 1665–1747
Previously listed as Fra Vittorio Ghislandi (JI 1966)
Portrait of a Musician
c. 1740
Oil on canvas
41 ³⁄₈ × 30 ³⁄₄" (105.1 × 78.1 cm)

John G. Johnson Collection
cat. 291

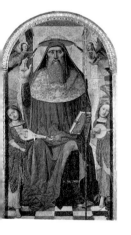

Corso, Nicolò (Nicolò di Lombarduccio da Pieve di Vico)
Italian, active Liguria, documented 1469–1503
Previously listed as Giovanni Massone (JI 1966)
Enthroned Saint Jerome, with Angels
Panel from the high altarpiece of San Gerolamo di Quarto, Genoa; two side panels are in the Museo e Galleria dell'Accademia Ligustica di Belle Arti, Genoa (inv. 68, 69)
c. 1495
Oil and gold on panel
57 × 29 ³⁄₄" (144.8 × 75.6 cm)

John G. Johnson Collection
cat. 262

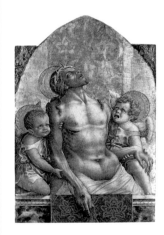

Crivelli, Carlo
Italian, active Venice and Marches, first documented 1457, died 1495–1500
Dead Christ Supported by Two Angels
Pinnacle from an altarpiece
c. 1472
Tempera and tooled gold on panel
28 × 18 ⁵⁄₈" (71.1 × 47.3 cm)

John G. Johnson Collection
cat. 158

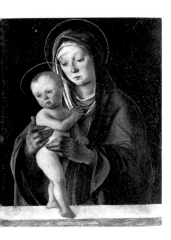

Costa, Lorenzo di Ottavio
Italian, active Bologna, Ferrara, and Mantua, c. 1460–1535
Virgin and Child
c. 1490
Oil on panel
18 ¹⁄₄ × 13 ¹⁄₂" (46.3 × 34.3 cm)

John G. Johnson Collection
cat. 244

Crivelli, Vittore
Italian, active Venice and Marches, active by c. 1481, died c. 1502
Enthroned Virgin and Child, with Angels and Saints Bonaventure, John the Baptist, Louis of Toulouse, and Francis of Assisi
Panels from an altarpiece; in a 19th-century frame
1481
On Baptist's scroll: ECCE ANGNVS DEI QVI / TOLLIS PECCATA MVNDI

Tempera on panel
Center panel: 55 3/4 × 30"
(141.6 × 76.2 cm); far left panel:
49 7/8 × 15 1/4" (126.7 × 38.7 cm);
near left panel: 50 × 15 1/8"
(127 × 38.4 cm); near right
panel: 49 7/8 × 15 1/4" (126.7 ×
38.7 cm); far right panel:
49 7/8 × 15 3/8" (126.7 × 39 cm)

Purchased with the W. P.
Wilstach Fund
W1896-1-11a–e

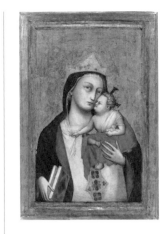

Dalmasio, attributed to
Italian, active Bologna, Pistoia,
and Florence, first documented
1342, died before 1377
Previously listed as an immediate
follower of Giotto (JI 1966)
Virgin and Child, with a Dog
c. 1330–35
Tempera and tooled gold on panel
18 5/16 × 12" (46.5 × 30.5 cm)

John G. Johnson Collection
cat. 3

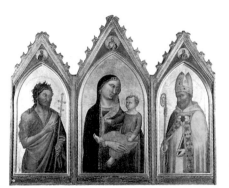

Daddi, Bernardo
Italian, active Florence, first
securely documented 1327,
died 1348?
Previously listed as a close
follower of Bernardo Daddi
(JI 1966)
*Virgin and Child, with Saints John
the Baptist and Giles, Two Prophets,
and Christ Blessing*
Panels from an altarpiece;
companion panels are in the Fogg
Art Museum, Cambridge, Mass.
(1936.56), and a private collection
1334
Left panel, bottom of frame: SCS
IOHES BTA; center panel, bottom
of frame: M CCC XXX IIII; right
panel, bottom of frame: SCS
EGIDIUS ABBAS
Tempera and tooled gold and
silver on panel
Left panel: 30 1/8 × 14 1/4"
(76.5 × 36.2 cm); center panel:
33 1/4 × 17 13/16" (84.4 × 45.2 cm);
right panel: 30 1/4 × 14 1/16"
(76.8 × 35.7 cm)

John G. Johnson Collection
inv. 334

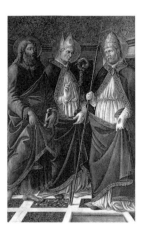

Dandini, Cesare
Italian, active Florence,
1596–1657
Previously attributed to Carlo
Dolci (PMA 1965)
*Salome with the Head of Saint John
the Baptist*
1630s
On banner: PARATE VIAM
DOMINI
Oil on canvas
45 1/4 × 36 1/4" (114.9 × 92.1 cm)

Purchased with the W. P.
Wilstach Fund
W1904-1-9

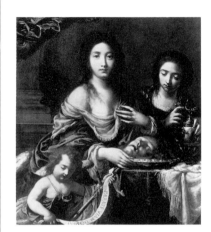

**Fra Diamante
(Diamante di Feo)**
Italian, active Florence, born
c. 1430, last documented 1498
Previously listed as Pesellino
(JI 1966)
*An Apostle Saint, a Bishop Saint,
and a Papal Saint*
Panel from an altarpiece
c. 1480
Tempera and tooled gold on
panel transferred to canvas
71 1/2 × 41" (181.6 × 104.1 cm)

John G. Johnson Collection
cat. 55

Daddi, Bernardo
Previously listed as Allegretto di
Nuzio (JI 1966)
Saint John the Evangelist
Panel from an altarpiece;
companion panels are in the
Fondazione Paolo VI, Gazzada
(Milan); the Thyssen-Bornemisza
Collection (1928.11); and Pieve
di San Giovanni Maggiore,
Panicaglia (on deposit Santo
Stefano al Ponte, Florence)
c. 1345–48
Tempera and tooled gold on panel
27 1/2 × 16 1/8" (69.8 × 41 cm)

John G. Johnson Collection
cat. 117

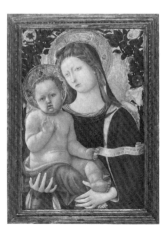

**Domenico di Bartolo (Dome-
nico di Bartolo Ghezzi)**
Italian, active Siena,
documented 1427–1444
Virgin and Child
1437
On banner: ME DVLCIS IN TE
NON DESINIT VSQUE PRECLARI
INGNEM VT NOMINIS PARCE MI-
TIS EGO; on frame: DOMENICUS
DE SENIIS ME PINXIT ANNO D[O-
MINI] MCCCCXXXVII; on Christ's
halo: MV[N]DI EG[O]; on Virgin's
halo: AVE REGI[N]A C[AELO]
Tempera and tooled gold on panel
24 3/8 × 17 1/4" (61.9 × 43.8 cm)

John G. Johnson Collection
cat. 102

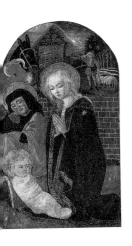

Domenico di Zanobi (Master of the Johnson Nativity)
Italian, active Florence, documented 1445–1481
Previously listed as the school of Cosimo Rosselli (JI 1966)
The Nativity
c. 1467
Tempera and tooled gold on panel
34 ¹⁄₂ × 19 ¹⁄₁₆" (87.6 × 48.4 cm)

John G. Johnson Collection
cat. 61

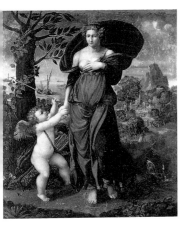

**Dossi, Battista
(Battista de' Luteri)**
Italian, active Ferrara,
c. 1474–1548
Venus and Cupid
c. 1540
Oil on canvas
62 × 50 ¹⁄₄" (157.5 × 127.6 cm)

Purchased with the George W. Elkins Fund
E1972-2-1

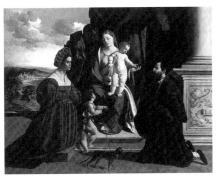

**Dossi, Dosso
(Giovanni de' Luteri)**
Italian, active Ferrara, first recorded 1512, died 1542
The Holy Family, with the Young Saint John the Baptist, a Cat, and Two Donors
c. 1512–13
Center right: LX
Oil on canvas
38 ¹⁄₁₆ × 45 ³⁄₄" (96.7 × 116.2 cm)

John G. Johnson Collection
cat. 197

Dossi, Dosso
Portrait of a Gentleman
c. 1520
Oil on canvas
35 ¹⁄₁₆ × 46 ¹⁄₂" (89.1 × 118.1 cm)

John G. Johnson Collection
cat. 251

Dossi, Dosso, copy after
Saul and David with the Head of Goliath
After a painting attributed to Dosso Dossi, in the Galleria Borghese, Rome (inv. no. 181)
16th century?
Oil on canvas
40 × 31 ¹⁄₂" (101.6 × 80 cm)

John G. Johnson Collection
cat. 252

Duccio di Buoninsegna and workshop
Italian, active Siena, first documented 1278, died 1318
Previously listed as Duccio di Buoninsegna (JI 1966)
Half-Length Angel
Pinnacle from Duccio's *Maestà*, from the Cathedral of Siena; cut and rounded at top; companion pinnacles in collection of J. H. van Heek, 's Heerenberg; Mount Holyoke College Art Museum (P.PI.45.1965); private collection
By 1311
Tempera and tooled gold on panel
9 ¹⁄₂ × 6 ¹¹⁄₁₆" (24.1 × 17 cm)

John G. Johnson Collection
cat. 88

Ferrari, Defendente
Italian, active Piedmont, dated works 1510–1535
Enthroned Virgin and Child, with Saints John the Evangelist, Catherine of Alexandria, and Anthony Abbot, and a Saint Reading a Book
Altarpiece
1520s
Oil and gold on panel transferred to canvas
53 ³⁄₄ × 45 ¹⁄₄" (136.5 × 114.9 cm)

John G. Johnson Collection
cat. 276

Folchetti, Stefano
Italian, active Marches, dated works 1492–1513
The Nativity and the Annunciation to the Shepherds, with Four Adorants
Predella panel; companion panel sold at Sotheby's, London, November 30, 1989 (lot 9)
c. 1500
Upper left, on scroll: ANONCIO. VOBIS.GAVDIVM; center top, on scroll: .GLORIA.IN ECELSIS.DEO. ED IN TE[R]RA.PAX.
Tempera and tooled gold on panel
12 ⁵⁄₈ × 19 ⁹⁄₁₆" (32.1 × 49.7 cm)

John G. Johnson Collection
cat. 134

Foppa, Vincenzo
Italian, active Milan,
born 1427–30, died 1515/16
Virgin and Child before a Landscape
c. 1490
Oil and gold on panel
17 1/4 × 13 5/16" (43.8 × 33.8 cm)

John G. Johnson Collection
cat. 257

**Francesco di Antonio
(Francesco di Antonio di
Bartolomeo)**
Italian, active Florence,
documented 1393–1433
Previously listed as Andrea di
Giusto (JI 1966)
*Christ Healing a Lunatic and Judas
Receiving Thirty Pieces of Silver*
Processional banner [?] based on a
design attributed to Masaccio
c. 1424–25
Tempera and gold on canvas
45 3/8 × 41 3/4" (115.2 × 106 cm)

John G. Johnson Collection
cat. 17

Foppa, Vincenzo
Previously listed as Giovanni
Ambrogio de Predis (JI 1966)
Portrait of an Elderly Gentleman
Bottom and right side are later
additions
c. 1495–1500
Oil on panel
13 1/8 × 10 3/4" (33.3 × 27.3 cm)

John G. Johnson Collection
cat. 264

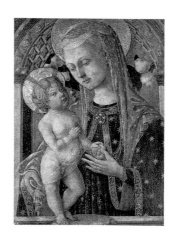

**Francesco di Gentile da
Fabriano**
Italian, active Umbria and
Marches, documented 1497
*Virgin and Child with a
Pomegranate*
Late 15th century
Oil and gold on panel
25 1/4 × 18 13/16" (64.1 × 47.8 cm)

John G. Johnson Collection
cat. 129

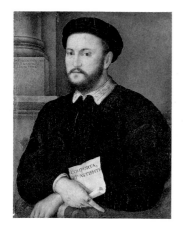

**Foschi, Pier Francesco di
Jacopo**
Italian, active Florence and Pisa,
1502–1567
Previously attributed to
Pontormo (JI 1966)
Portrait of Bartolomeo Gualterotti
1550
Upper left: BART DILOR
GVALTEROTTI / D'ETA DANNI
XLIIII / L'ANNO M D L; center
bottom, on paper: COMPORTA, /
ET ASTIENTI
Oil on panel
30 5/8 × 22 3/4" (77.8 × 57.8 cm)

John G. Johnson Collection
cat. 84

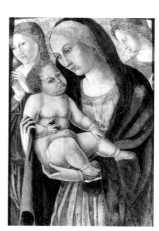

**Francesco di Giorgio
(Francesco di Giorgio
Martini), follower of**
Italian, active Siena, 1439–1502
Virgin and Child, with Two Angels
c. 1500
Oil and gold on panel
23 7/8 × 16 3/16" (60.6 × 41.1 cm)

Gift of Dr. Paul G. Ecker
1963-215-1

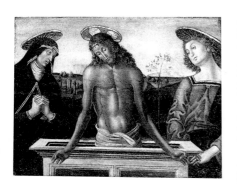

Francesco da Tolentino
Italian, active Tolentino and the
environs of Naples, dated works
1525–1531
Previously listed as Giovanni
Battista Bertucci da Faenza the
Elder (JI 1966)
*The Dead Christ, with the Virgin
and Saint John the Evangelist*
c. 1510
Oil on panel
17 × 21 3/8" (43.2 × 54.3 cm)

John G. Johnson Collection
inv. 716

Francesco di Vannuccio
Italian, active Siena,
first documented c. 1356,
last documented 1389
*The Crucifixion, with the Virgin,
Saint John the Evangelist, and Angels*
Panel from a diptych; companion
panel is in the Rijksmuseum
Meermanno-Westreenianum,
The Hague (no. 806)
c. 1387–88
On cross: I N R I; on frame: hoc.
hopus.nelmille.CCC.L.[] Iulii
Tempera and tooled gold on panel
16 7/8 × 12 1/8" (42.9 × 30.8 cm)

John G. Johnson Collection
cat. 94

Francia, Francesco (Francesco di Marco di Giacomo Raiboldini)
Italian, active Bologna and Ferrara, c. 1450–1517
Virgin and Child before a Landscape
c. 1517
Oil and gold on panel
23 × 17 3/16" (58.4 × 43.7 cm)

John G. Johnson Collection
inv. 1282

Gaddi, Agnolo di Taddeo
Italian, active Florence, first documented 1369, died 1396
Previously listed as a Florentine artist, c. 1400 (JI 1966)
Saint Sylvester and the Dragon
Predella panel; a companion panel was sold at Sotheby's, London, July 8, 1981 (lot 87)
c. 1380–85
Tempera and tooled gold on panel
11 1/2 × 15 1/8" (29.2 × 38.4 cm)

John G. Johnson Collection
cat. 9

Francia, Giacomo (Giacomo di Francesco Raiboldini)
Italian, active Bologna, first documented 1486, died 1557
Virgin and Child, with Saint Lawrence and a Papal Saint
Mid-16th century
Oil on canvas
39 5/16 × 28 5/16" (99.8 × 71.9 cm)

John G. Johnson Collection
cat. 250

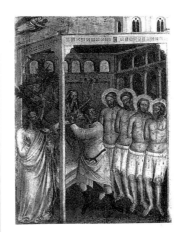

Gerini, Niccolò di Pietro
Italian, active Florence, first documented 1368, died 1415
Pietà
c. 1377
Tempera and tooled gold on panel
40 5/16 × 33 9/16" (102.4 × 85.2 cm)

John G. Johnson Collection
cat. 8

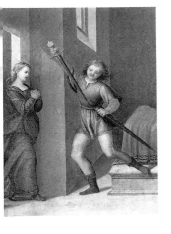

Franciabigio (Francesco di Cristofano di Francesco), attributed to
Italian, active Florence and environs, 1484–1524
Previously listed as Francesco Granacci (JI 1966)
Saint Julian the Hospitaler Meeting His Wife after Killing His Parents
Fragment of a predella panel
c. 1515
Oil on panel
10 5/16 × 7 5/16" (26.2 × 18.6 cm)

John G. Johnson Collection
inv. 2954

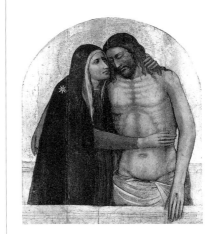

Gerini, Niccolò di Pietro
The Scourging of the Four Crowned Martyrs
Panel from an altarpiece; companion panels are in the Denver Art Museum (no. E-IT-18-XV-927); the Birmingham Museum of Art, Alabama (no. 1961.119); and a private collection
c. 1385–90
Tempera and tooled gold on panel
23 13/16 × 17" (60.5 × 43.2 cm)

John G. Johnson Collection
cat. 1163

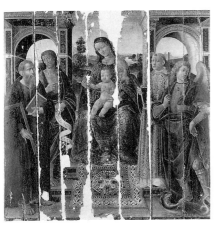

Frediani, Vincenzo di Antonio (Master of the Lucchese Immaculate Conception)
Italian, active Lucca, documented 1481–1505
Enthroned Virgin and Child, with Saint John the Baptist, the Apostle Thomas Didymus, a Deacon Saint, and the Archangel Michael
Panels from an altarpiece; the predella to this painting is in the Courtauld Institute Galleries, London (The Lee Collection, 65)
Mid-1480s
Oil and tempera on panel
66 1/8 × 63" (168 × 160 cm)

Bequest of Arthur H. Lea
F1938-1-39

Gherardo del Fora (Gherardo di Giovanni di Miniato)
Italian, active Florence, c. 1446–1497
Previously listed as Bastiano Mainardi (JI 1966)
Group of Men with Rosaries
Fragment from the same work as the following fragment
Late 15th century
Tempera on panel
11 1/8 × 15 9/16" (28.3 × 39.5 cm)

John G. Johnson Collection
cat. 1167b

Gherardo del Fora
Previously listed as Bastiano
Mainardi (JI 1966)
Group of Women with Rosaries
Fragment from the same work as
the preceding fragment
Late 15th century
Tempera on panel
11 1/8 × 15 9/16" (28.3 × 39.5 cm)

John G. Johnson Collection
cat. 1167a

**Ghirlandaio, Ridolfo del
(Ridolfo di Domenico
Bigordi)**
Italian, active Florence,
1483–1561
Portrait of Andrea Bandini
An alternative attribution to
Carlo Portelli (Italian, died
1574) has been proposed
Mid-16th century
Lower left, on paper: Dno Andrea
bandini / Infirenze
Oil on panel
35 × 28 1/4" (88.9 × 71.7 cm)

John G. Johnson Collection
cat. 73

**Ghirlandaio, Benedetto
(Benedetto Bigordi)**
Italian, active Florence,
1459–1497
The Nativity
c. 1490
Tempera and gold on panel
31 3/8 × 22 3/4" (79.7 × 57.8 cm)

John G. Johnson Collection
cat. 68

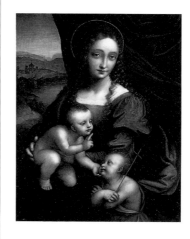

**Giampietrino
(Giovanni Pedrini?)**
Italian, active Milan and
environs, active c. 1510–c. 1540
*Virgin and Child, with the Young
Saint John the Baptist*
c. 1520
Oil on panel
25 3/4 × 18 7/8" (65.4 × 47.9 cm)

John G. Johnson Collection
cat. 271

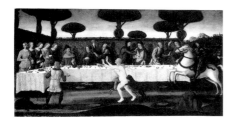

**Ghirlandaio, David
(David Bigordi)**
Italian, active Florence,
1452–1525
Previously listed as Jacopo del
Sellaio (JI 1966)
*Banquet Scene from the Tale of
Nastagio degli Onesti, in Boccaccio's
"Decameron"*
A companion panel is in the
Brooklyn Museum (25.95)
Late 1480s
Tempera on panel
27 5/8 × 53 1/2" (70.2 × 135.9 cm)

John G. Johnson Collection
cat. 64

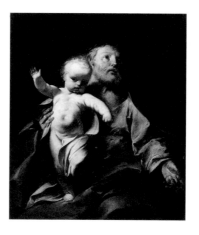

**Giaquinto, Corrado,
attributed to**
Italian, active Naples and Rome,
1703–1766
Previously listed as Corrado
Giaquinto (PMA 1965)
Saint Joseph and the Christ Child
1740s
Oil on canvas
46 1/4 × 37 7/16" (117.5 × 95.1 cm)

Purchased with the W. P.
Wilstach Fund
W1904-1-7

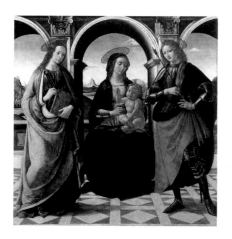

Ghirlandaio, David
Previously listed as Bastiano
Mainardi (JI 1966)
*Virgin and Child, with Saints
Apollonia and Sebastian*
Altarpiece
1490s
Tempera on panel
54 1/2 × 51 1/2" (138.4 × 130.8 cm)

John G. Johnson Collection
cat. 65

Giolfino, Niccolò
Italian, active Verona,
1476–1555
Triumph of Silenus
Companion to the following
painting
Early 16th century
Oil on panel
9 7/8 × 12 3/8" (25.1 × 31.4 cm)

John G. Johnson Collection
cat. 217

Giolfino, Niccolò
Silenus Sleeping
Companion to the preceding painting
Early 16th century
Oil on panel
9 ³/₄ × 12 ³/₈" (24.8 × 31.4 cm)

John G. Johnson Collection
cat. 218

Giordano, Luca, copy after
Virgin and Child
After the painting in the Quadreria dei Girolamini, Naples
Late 17th century
Oil on canvas
29 ¹/₂ × 23 ¹/₂" (74.9 × 59.7 cm)

John G. Johnson Collection
cat. 810a [formerly cat. 281]

Giolfino, Niccolò
Previously listed as Amico Aspertini (JI 1966)
The Death of the Blessed Filippo Benizzi
Predella panel; a companion panel is in the Slezské Museum, Opava, Czech Republic (D5 77)
1515
Oil on panel
12 ⁵/₁₆ × 19 ³/₁₆" (31.3 × 49.7 cm)

John G. Johnson Collection
cat. 247

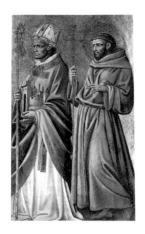

Giovanni dal Ponte (Giovanni di Marco)
Italian, active Florence, 1385–1437
Saints Geminianus and Francis of Assisi
Panel from an altarpiece; companion panels are in the M. H. de Young Memorial Museum, San Francisco, and the Niedersächisches Landesmuseum, Hannover (KM 87)
c. 1434–35
Tempera and tooled gold on panel
38 ¹/₄ × 21 ¹³/₁₆" (97.1 × 55.4 cm)

John G. Johnson Collection
inv. 1739

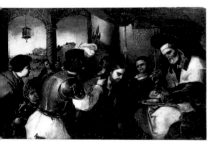

Giordano, Luca
Italian, active Italy and Spain, 1632–1705
Previously attributed to Luca Giordano (JI 1966)
Christ before Pilate
1650–55
Oil on panel
17 ⁷/₈ × 27 ¹/₄" (45.4 × 69.2 cm)

John G. Johnson Collection
cat. 249

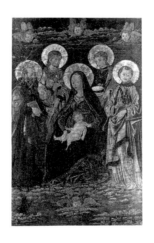

Giovanni di Francesco del Cervelliera
Italian, active Florence, first documented 1446, died 1459
Virgin and Child on Clouds, with Cherubim and Saints Anthony Abbot, Galganus, Ansanus, and Lawrence
c. 1454
Tempera and tooled gold on panel
22 ³/₄ × 14 ³/₄" (57.8 × 37.5 cm)

John G. Johnson Collection
cat. 59

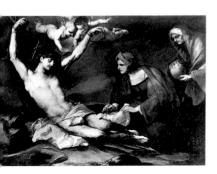

Giordano, Luca
Previously listed as Jusepe de Ribera (PMA 1965)
Saint Sebastian Cured by Irene
Painted over Giordano's *Christ among the Doctors*
c. 1665
Oil on canvas
72 ¹/₂ × 108 ³/₄" (184.1 × 276.2 cm)

Purchased with the W. P. Wilstach Fund
W1901-1-5

Giovanni di Paolo (Giovanni di Paolo di Grazia)
Italian, active Siena, first securely documented 1411, died 1482
Previously listed as Italian, unknown artist, 15th century (PMA 1965)
Saint Lawrence
Predella panel; see following entry for companion panels
c. 1430–35
Tempera and tooled gold on panel
9 ¹/₂ × 9 ¹/₂" (24.1 × 24.1 cm)

Purchased from the George Grey Barnard Collection with Museum funds
1945-25-121

Giovanni di Paolo
Previously listed as Italian,
unknown artist, 15th century
(PMA 1965)
Deacon Saint
Predella panel; companion to
preceding panel and to two
panels by Martino di Bartolomeo
in the York Art Gallery, England
(no. 779a, 779b)
c. 1430–35
Tempera and tooled gold on panel
9 1/2 × 9 1/2" (24.1 × 24.1 cm)

Purchased from the George Grey
Barnard Collection with Museum
funds
1945-25-122

Giovanni di Paolo
Christ on the Road to Calvary
Predella panel from an altarpiece;
other panels from the predella are
in the Staatliches Lindenau-
Museum, Altenburg, Germany
(78), and the Pinacoteca Vaticana
(no. 124, no. 129)
c. 1430–35
Tempera and tooled gold on panel
12 1/2 × 13 5/8" (31.7 × 33.3 cm)

John G. Johnson Collection
cat. 105

Giovanni di Paolo
*Saint Nicholas of Tolentino Saving a
Ship*
Panel from an altarpiece;
companion panels are in the
Gemäldegalerie der Akademie
der Bildenden Künste, Vienna
(inv. no. 1177), and
Sant'Agostino, Montepulciano
1457
Tempera and tooled gold on panel
20 1/2 × 16 5/8" (52.1 × 42.2 cm)

John G. Johnson Collection
inv. 723

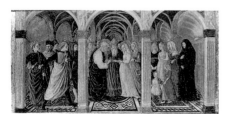

**Giovanni di Pietro, also
called Nanni di Pietro**
Italian, active Siena, first docu-
mented 1432, died before 1479
Previously listed as Pietro di
Giovanni d'Ambrogio (JI 1966)
The Marriage of the Virgin
Predella panel from an altarpiece
executed in collaboration with
Matteo di Giovanni, in San Pietro
Ovile, Siena; see following entry
for companion panels
c. 1455
Tempera and gold on panel
9 1/2 × 18 1/8" (24.1 × 46 cm)

John G. Johnson Collection
cat. 107

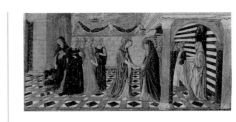

Giovanni di Pietro
Previously listed as Pietro di
Giovanni d'Ambrogio (JI 1966)
*The Return of the Virgin to Her
Parents' House*
Predella panel; companion to the
preceding panel and a predella
panel in the Musée du Louvre,
Paris (inv. 814); the main panels
are in San Pietro Ovile, Siena
c. 1455
Tempera and gold on panel
9 1/2 × 18 1/8" (24.1 × 46 cm)

John G. Johnson Collection
cat. 108

Fra Girolamo da Brescia
Italian, born Brescia, active
Florence, first documented 1490,
died 1529
Previously listed as Bartolomeo
Montagna (JI 1966)
Portrait of a Friar [possibly
Girolamo Savonarola]
c. 1490–1500
Oil on panel
17 15/16 × 13 1/8" (45.6 × 33.3 cm)

John G. Johnson Collection
cat. 169

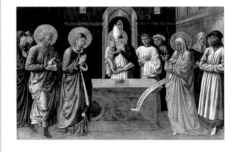

**Gozzoli, Benozzo
(Benozzo di Lese di Sandro)**
Italian, active Florence and
central Italy, born 1420–22,
died 1497
*The Presentation of Christ in the
Temple*
Predella panel from the altarpiece
from the Compagnia di Santa
Maria della Purificazione e di San
Zanobi, Florence, contracted
October 23, 1461; the main
panels from the altarpiece are in
the National Gallery, London
(283); companion predella panels
are in the collection of Her
Majesty Queen Elizabeth II
(132); the Pinacoteca di Brera,
Milan (475); the Gemäldegalerie,
Staatliche Museen zu Berlin-
Preussischer Kulturbesitz (60c);
and the National Gallery of Art,
Washington, D.C. (1086)
c. 1461–62
Tempera and tooled gold on panel
9 3/4 × 14 5/16" (24.8 × 36.3 cm)

John G. Johnson Collection
cat. 38

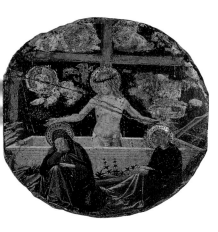

Gozzoli, Benozzo, attributed to
The Man of Sorrows, with the Mourning Virgin, Saint John the Evangelist, and Symbols of the Passion
Cut down to a circle
c. 1447
Tempera on panel
14 1/4 × 11 1/2" (36.2 × 29.2 cm)

John G. Johnson Collection
inv. 1305

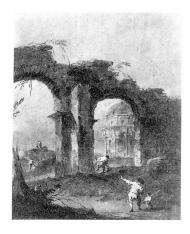

Guardi, Francesco
Capriccio
c. 1775–80
Oil on panel
7 3/8 × 5 13/16" (18.7 × 14.8 cm)

Gift of an anonymous donor
1974-159-1

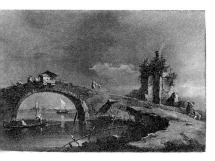

Guardi, Francesco
Italian, active Venice,
1712–1793
Regatta in "Volta di Canal"
c. 1760–70
Oil on canvas
47 5/16 × 66 1/2" (120.2 × 168.9 cm)

John G. Johnson Collection
cat. 307

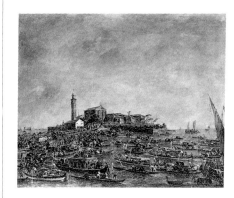

Guardi, Francesco
The Meeting of Pope Pius VI and Doge Paolo Renier at San Giorgio in Alga
1782
Oil on canvas
28 × 32" (71.1 × 81.3 cm)

The William L. Elkins Collection
E1924-3-49

Guardi, Francesco
Previously listed as Giacomo Guardi (JI 1966)
Capriccio with a Bridge
c. 1770–80
Oil on canvas
7 × 9 5/8" (17.8 × 24.4 cm)

John G. Johnson Collection
cat. 311

Guardi, Francesco, attributed to
Piazza San Marco
c. 1770–80
Oil on canvas
16 3/16 × 28" (41.1 × 71.1 cm)

John G. Johnson Collection
cat. 306

Guardi, Francesco
Grand Canal with San Simeone Piccolo and Santa Lucia
c. 1770–80
Oil on canvas
26 3/8 × 36 1/16" (67 × 91.6 cm)

John G. Johnson Collection
cat. 303

Guardi, Francesco, attributed to
Previously listed as Giacomo Guardi (JI 1966)
Capriccio with an Obelisk on a Lagoon
1780s
Oil on canvas
8 1/4 × 13 1/4" (20.9 × 33.6 cm)

John G. Johnson Collection
cat. 310

**Guardi, Francesco,
follower of**
*Doge's Palace and Libreria from the
Laguna*
c. 1785–90
Oil on canvas
15 1/8 × 20 3/8" (38.4 × 51.7 cm)

John G. Johnson Collection
cat. 301

**Guardi, Francesco,
follower of**
Previously listed as Francesco
Guardi (PMA 1965)
Venetian View
Late 18th century
Oil on panel
8 × 10 1/2" (20.3 × 26.7 cm)

The William L. Elkins Collection
E1924-3-50

**Guardi, Francesco,
follower of**
Previously listed as the school of
Francesco Guardi (PMA 1965)
Santa Maria della Carità
Late 18th century
Lower right (spurious): F. G.
Oil on canvas
13 × 17 5/8" (33 × 44.8 cm)

The William L. Elkins Collection
E1924-3-31

**Guardi, Francesco,
follower of**
Previously listed as Giacomo
Guardi (JI 1966)
*View between the Giudecca and
San Giorgio Maggiore*
Late 18th century?
Oil on canvas
13 × 17 9/16" (33 × 44.6 cm)

John G. Johnson Collection
cat. 308

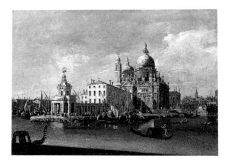

**Guardi, Francesco,
follower of**
Previously listed as Giacomo
Guardi (JI 1966)
*Santa Maria della Salute and the
Dogana*
Late 18th century?
Oil on canvas
13 × 17 9/16" (33 × 44.6 cm)

John G. Johnson Collection
cat. 309

**Guardi, Francesco,
imitator of**
Villa by the Sea
Late 18th century
Oil on canvas
14 1/2 × 22 1/8" (36.8 × 56.2 cm)

John G. Johnson Collection
cat. 300

**Guardi, Francesco,
follower of**
Previously listed as Giacomo
Guardi (JI 1966)
Seaport with a Castle
Late 18th century
Oil on canvas
7 × 9 5/8" (17.8 × 24.4 cm)

John G. Johnson Collection
inv. 446

**Guardi, Francesco,
imitator of**
*Capriccio with an Obelisk on a
Lagoon*
19th century
Oil on canvas
16 9/16 × 21 9/16" (42.1 × 54.8 cm)

John G. Johnson Collection
cat. 312

Guardi, Francesco, imitator of
Capriccio with Ruins
19th century
Oil on canvas
5 3/4 × 7 9/16" (14.6 × 19.2 cm)

John G. Johnson Collection
inv. 415

Guardi, Francesco, imitator of
Landscape with Cottages on Dunes
19th century
Oil on canvas
14 × 18 7/8" (35.6 × 47.9 cm)

John G. Johnson Collection
cat. 304

Guardi, Francesco, imitator of
San Giorgio Maggiore Seen through the Arches of the Doge's Palace
19th century
Oil on canvas
15 13/16 × 12 7/8" (40.2 × 32.7 cm)

John G. Johnson Collection
cat. 305

Guardi, Giacomo, follower of
Italian, active Venice,
1764–1835
The Island of San Michele with Venice in the Background
After 1782
Oil on canvas
7 1/2 × 9 9/16" (19 × 24.3 cm)

John G. Johnson Collection
cat. 302

Guardi, Giacomo, imitator of
Previously listed as Giacomo
Guardi (JI 1966)
Ruined Arch
19th century
Oil on canvas
5 13/16 × 7 13/16" (14.8 × 19.8 cm)

John G. Johnson Collection
cat. 313

Indoni, Filippo
Italian, active Rome,
active late 19th century
Roman Peasants
1878
Lower left: Indoni—Roma / 1878
Oil on canvas
66 1/4 × 44 5/8" (168.3 × 113.3 cm)

Gift of Mr. and Mrs. S. F. Houston
1914-26

Italian?, active Venice?, unknown artist
The Nativity and the Adoration of the Magi
Section of a reliquary
c. 1290–1300
Tempera, tooled gold, and glass on panel
14 1/4 × 11 3/8" (36.2 × 28.9 cm)

John G. Johnson Collection
cat. 116

Italian, active Padua?, unknown artist
Previously listed as an immediate
follower of Giotto (JI 1966)
The Crucifixion, the Nativity, and the Annunciation
c. 1320–30
Tempera and tooled gold on panel
24 7/8 × 11 7/8" (63.2 × 30.2 cm)

John G. Johnson Collection
cat. 1

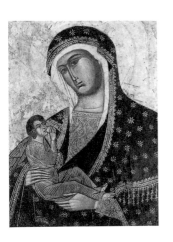

Italian?, active Adriatic coast, unknown artist
Virgin and Child
c. 1340–50
Oil on panel transferred to canvas
18 5/8 × 13 3/8" (47.3 × 34 cm)

The Louise and Walter Arensberg Collection
1950-134-195

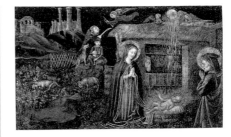

Italian, active Marches, unknown artist
Previously listed as an Umbrian follower of Fra Angelico (JI 1966)
The Nativity
Later repaintings
c. 1420
Tempera and tooled gold on panel
10 × 15 7/8" (25.4 × 40.3 cm)

John G. Johnson Collection
cat. 16

Italian, active central Italy?, unknown artist
The Three Marys at the Sepulcher and the Resurrection
c. 1375–1400
Detached fresco on canvas
40 1/4 × 87 1/8" (102.2 × 221.3 cm)

Purchased from the George Grey Barnard Collection with Museum funds
1945-25-118

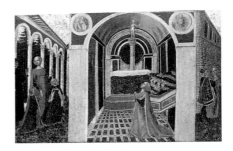

Italian, active Tuscany, unknown artist
Previously listed as Andrea di Giusto (JI 1966)
Scenes from the Book of Esther
A companion panel is in the Museum of Art, Science and Industry, Bridgeport, Connecticut (K269)
c. 1425–35
Tempera and gold on panel
17 × 26 5/8" (43.2 × 67.6 cm)

John G. Johnson Collection
cat. 20

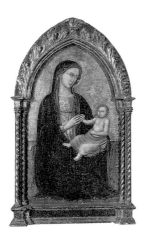

Italian, active Florence, unknown artist
Previously listed as an unknown Italian artist, c. 1400 (PMA 1965)
The Virgin of Humility
c. 1400
On frame, across bottom: AVE MARIA GRATIA PLENA DO. T.
Tempera and tooled gold on panel
33 5/8 × 20 1/8" (90.5 × 51.1 cm)

The Louise and Walter Arensberg Collection
1950-134-527

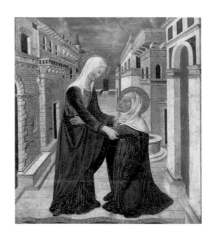

Italian, active central Italy, unknown artist
The Visitation
c. 1475
Across bottom: [ET] VNDE HOC MIVI [sic] VENIAT MATER DOMINI AD ME BEATA
Oil on panel
33 15/16 × 29" (86.2 × 73.7 cm)

Purchased with the W. P. Wilstach Fund
W1904-1-38

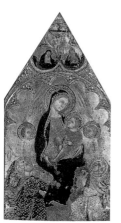

Italian, active Siena, unknown artist
Previously listed as Taddeo di Bartolo (JI 1966)
The Virgin of Humility, with Cherubim, Two Music-Making Angels, and the Crucifixion
Center panel from a triptych
c. 1400
Tempera and tooled gold on panel
13 3/4 × 7 1/4" (34.9 × 18.4 cm)

John G. Johnson Collection
cat. 100

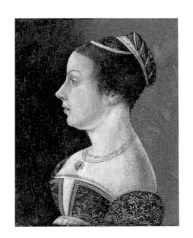

Italian, active Venice, unknown artist
Previously listed as a Lombard artist, mid-15th century (JI 1966)
Portrait of a Lady
See following painting for reverse
c. 1475–80
Oil on panel
11 1/16 × 8 11/16" (28.1 × 22.1 cm)

John G. Johnson Collection
cat. 164a

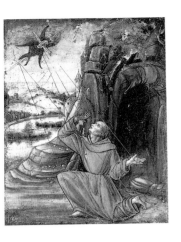

Italian, active Venice, unknown artist
Previously listed as a Lombard artist, mid-15th century (JI 1966)
Saint Francis of Assisi Receiving the Stigmata
Reverse of preceding painting
c. 1475–80
Oil on panel
11 1/16 × 8 11/16" (28.1 × 22.1 cm)

John G. Johnson Collection
cat. 164b

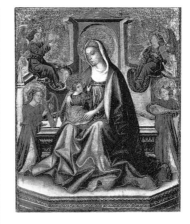

Italian, active Sicily, unknown artist
Enthroned Virgin and Child, with Four Angels
c. 1480–1500
Oil and tooled gold on panel
17 1/2 × 13 3/4" (44.4 × 34.9 cm)

John G. Johnson Collection
cat. 130

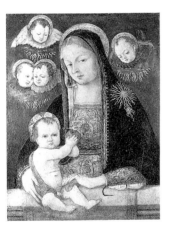

Italian, active Florence, unknown artist
Previously listed as David Ghirlandaio (JI 1966)
Virgin and Child
c. 1475–1500
Oil and gold on panel transferred to canvas
31 × 18 1/2" (78.7 × 47 cm)

John G. Johnson Collection
cat. 66

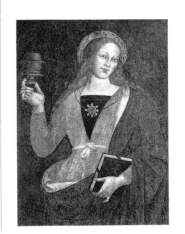

Italian, active Umbria, unknown artist
Previously attributed to Lo Spagna (JI 1966)
Saint Mary Magdalene
c. 1480–1500
Detached fresco on canvas
37 1/2 × 25 3/4" (95.2 × 65.4 cm)

John G. Johnson Collection
cat. 146

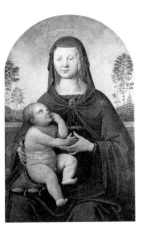

Italian, active Venice?, unknown artist
Previously listed as a Sicilian artist, early 16th century (JI 1966)
Virgin and Child with an Apple and Four Cherubim
c. 1475–1500
Oil and gold on panel
22 1/2 × 16" (57.1 × 40.6 cm)

John G. Johnson Collection
cat. 161

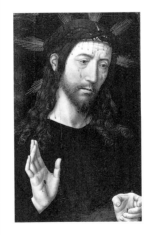

Italian, active Florence, unknown artist
Previously listed as a copy after Hans Memling (JFD 1972)
The Man of Sorrows
A Florentine copy after a Netherlandish painting in the Galleria di Palazzo Bianco, Genoa
c. 1495
Oil on panel
21 3/8 × 13 1/4" (54.3 × 33.6 cm)

John G. Johnson Collection
cat. 1176a

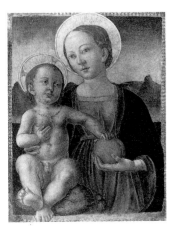

Italian, active Tuscany, unknown artist
Previously listed as Giovanni Battista Utili da Faenza (JI 1966)
Virgin and Child with an Apple before a Landscape
c. 1480
Tempera and gold on panel
16 3/4 × 12" (42.5 × 30.5 cm)

John G. Johnson Collection
cat. 63

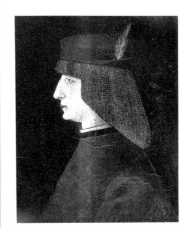

Italian, active Crema, unknown artist
Portrait of a Gentleman
Ceiling painting
c. 1500
Oil on panel
13 11/16 × 10 5/8" (34.8 × 27 cm)

John G. Johnson Collection
inv. 319

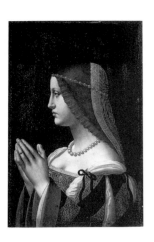

Italian, active Lombardy, unknown artist
Previously attributed to Bernardino de' Conti (JI 1966)
Portrait of a Lady
c. 1500
Oil on panel
21 3/4 × 13 3/4" (55.2 × 34.9 cm)

John G. Johnson Collection
cat. 265

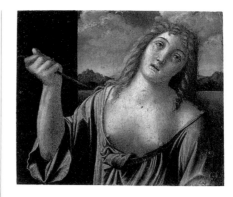

Italian, active Venice?, unknown artist
Previously listed as Bramantino (JI 1966)
The Suicide of Lucretia
c. 1500
Oil on panel
11 3/8 × 13 1/8" (28.9 × 33.3 cm)

John G. Johnson Collection
cat. 267

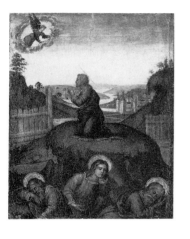

Italian, active Florence, unknown artist
The Agony in the Garden
c. 1500
Oil and gold on panel
11 3/8 × 8 1/2" (28.9 × 21.6 cm)

John G. Johnson Collection
inv. 1390

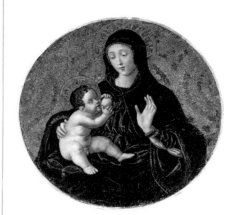

Italian, active Naples?, unknown artist
Previously listed as an Umbrian artist, c. 1500 (JI 1966)
Virgin and Child
c. 1500
On Virgin's halo: Ave Gratia Plena; on Christ's halo: XPOR IHS
Oil and tooled gold on panel
28" (71.1 cm) diameter

John G. Johnson Collection
cat. 133

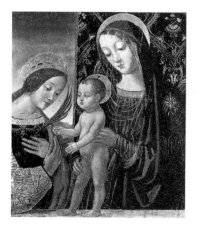

Italian, active Umbria?, unknown artist
The Mystic Marriage of Saint Catherine of Alexandria
c. 1500
Oil and gold on panel
14 3/4 × 12 1/16" (37.5 × 30.6 cm)

John G. Johnson Collection
cat. 132

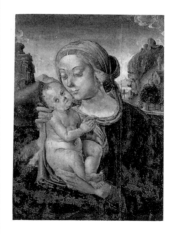

Italian, active Veneto-Romagna, unknown artist
Previously listed as a follower of Piero di Cosimo (JI 1966)
Virgin and Child
c. 1500
Oil on panel
17 7/8 × 12 7/8" (45.4 × 32.7 cm)

John G. Johnson Collection
cat. 131

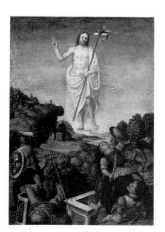

Italian, active Lombardy, unknown artist
Previously listed as the school of Bergognone (JI 1966)
The Resurrection
c. 1500
Oil on panel
13 7/16 × 9" (34.1 × 22.9 cm)

John G. Johnson Collection
cat. 258

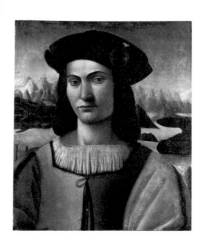

Italian, active Lombardy, unknown artist
Previously listed as Giovanni Antonio Boltraffio (JI 1966)
Portrait of a Young Gentleman before a Landscape
c. 1500–10
Oil on panel
22 1/8 × 17 5/8" (56.2 × 44.8 cm)

John G. Johnson Collection
cat. 268

Italian?, active Milan?, unknown artist
Previously listed as an imitation of Ambrosius Benson (JFD 1972)
Portrait of a Lady
c. 1500–25
Upper left: AB
Oil on panel
18 1/2 × 14 7/8" (47 × 37.8 cm)

John G. Johnson Collection
cat. 361

Italian, active Bergamo, unknown artist
Previously listed as Cariani (JI 1966)
Portrait of a Gentleman and a Lady
c. 1520–30
Oil on panel transferred to canvas
31 5/8 × 44" (80.3 × 111.8 cm)

John G. Johnson Collection
cat. 191

Italian, active Siena?, unknown artist
Previously listed as Domenico Beccafumi (JI 1966)
The Fate Clotho
c. 1510–30
Detached fresco
14" (35.6 cm) diameter

John G. Johnson Collection
cat. 115

Italian, active northern Italy, unknown artist
Previously listed as an Emilian artist, second half of the 16th century (JI 1966)
Portrait of a Young Gentlewoman
c. 1525–50
Oil on panel
25 1/16 × 19 1/2" (63.7 × 49.5 cm)

John G. Johnson Collection
cat. 205

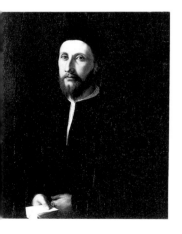

Italian, active Florence, unknown artist
Previously attributed to Palma il Vecchio (JI 1966)
Portrait of a Gentleman
1512
On letter: 1512; seal on ring
Oil on panel
33 7/16 × 28 1/8" (84.9 × 71.4 cm)

John G. Johnson Collection
cat. 186

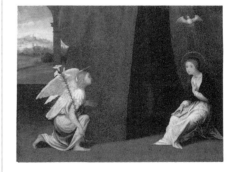

Italian, active Ferrara, unknown artist
The Annunciation
c. 1530
Oil on panel
14 1/2 × 18 7/8" (36.8 × 47.9 cm)

John G. Johnson Collection
cat. 245

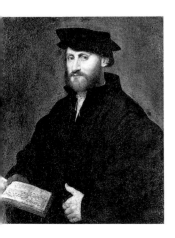

Italian, active Venice, unknown artist
Previously listed as the area of Lorenzo Lotto (JI 1966)
Portrait of a Gentleman with a Musical Score
c. 1520
On score: A. P. / Spes mea in deo est. [four times]
Oil on canvas
30 3/4 × 23 1/2" (78.1 × 59.7 cm)

John G. Johnson Collection
cat. 182

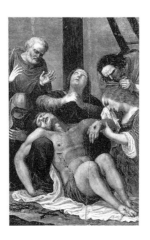

Italian, active Verona, unknown artist
Previously listed as Giovanni Francesco Caroto (JI 1966)
Lamentation
c. 1550
Oil on panel
19 3/4 × 11 11/16" (50.2 × 29.7 cm)

John G. Johnson Collection
cat. 223

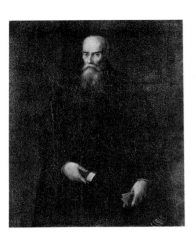

Italian, active Venice, unknown artist
Previously listed as Ridolfo del Ghirlandaio (JI 1966)
Portrait of an Elderly Gentleman
[possibly Oddo degli Oddi]
c. 1550
Oil on panel
49 ⅝ × 40 ⁵/₁₆" (126 × 102.4 cm)

John G. Johnson Collection
cat. 74

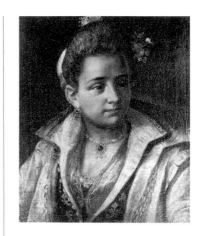

Italian?, unknown artist
Previously listed as Leandro Bassano da Ponte (JGJ 1941)
Portrait of a Lady
Copy of a portrait in the Statens Museum for Kunst, Copenhagen (no. 1027)
c. 1575–1600
Oil on canvas
21 ⅛ × 16 ⅝" (53.7 × 42.2 cm)

John G. Johnson Collection
inv. 2830

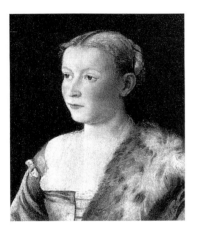

Italian, active Venice, unknown artist
Previously listed as after Paolo Veronese (JI 1966)
Portrait of a Lady
c. 1550
Oil on canvas
18 ¾ × 15 ⅝" (47.6 × 39.7 cm)

John G. Johnson Collection
cat. 226

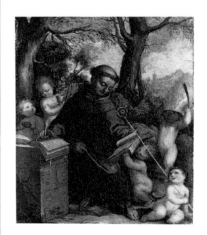

Italian, active Emilia-Romagna, unknown artist
Previously listed as a North Italian artist, c. 1590 (JI 1966)
Saint Bonaventure Writing in a Landscape
c. 1575–1600
Oil on canvas
9 × 7 ½" (22.9 × 19 cm)

John G. Johnson Collection
cat. 239

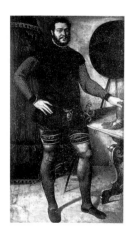

Italian, active Emilia?, unknown artist
Previously listed as Giovanni Battista Moroni (JI 1966)
Portrait of an Officer
1562
Center bottom: M D LXII
Oil on canvas
77 × 42 ¾" (195.6 × 108.6 cm)

John G. Johnson Collection
cat. 238

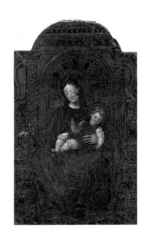

Italian, active Milan, unknown artist
Enthroned Virgin and Child
Early 16th century
Oil on tooled leather
23 ¾ × 14" (60.3 × 35.6 cm)

Purchased from the George Grey Barnard Collection with Museum funds
1945-25-264

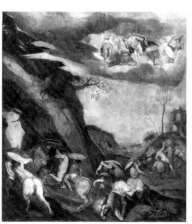

Italian?, active Rome?, unknown artist
The Conversion of Saint Paul
c. 1570
Oil on panel
32 ½ × 27 ½" (82.6 × 69.9 cm)

Gift of Mr. and Mrs. Edward B. Wilford III
1991-184-1

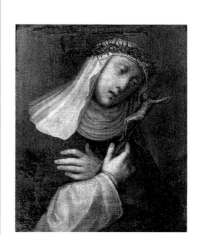

Italian, active Siena, unknown artist
Saint Catherine of Siena with a Crucifix and a Crown of Thorns
Mid-16th century
Oil on canvas
13 ⅝ × 11 ⁷/₁₆" (34.6 × 29 cm)

Bequest of Arthur H. Lea
F1938-1-21

Italian, unknown artist
Saint John the Evangelist
16th century
Oil on canvas
11 1/16 × 10 1/16" (28.1 × 25.6 cm)

Bequest of Arthur H. Lea
F1938-1-30

**Italian, active Bologna,
unknown artist**
Head of an Old Testament Heroine
c. 1600–25
Oil on canvas
23 × 26 1/2" (58.4 × 67.3 cm)

Bequest of Arthur H. Lea
F1938-1-9

**Italian, active Ferrara?,
unknown artist**
Previously listed as Giulio Campi
(JI 1966)
Saint Peter
Panel from an altarpiece
16th century
Oil and gold on panel
31 3/16 × 14 3/16" (79.2 × 36 cm)

John G. Johnson Collection
cat. 235

Italian, unknown artist
*Portrait of the Grand Duke
Ferdinando I de' Medici and
Probably His Son Cosimo II*
c. 1608
Oil on canvas
56 7/8 × 45 1/4" (144.5 × 114.9 cm)

The Bloomfield Moore Collection
1883-133

**Italian, active Bologna,
unknown artist**
Previously listed as an Italian
artist, early 17th century
(JI 1966)
Heads of Four Boys
c. 1600
Oil on canvas
14 3/4 × 11 7/16" (37.5 × 29 cm)

John G. Johnson Collection
cat. 279

**Italian, active Rome,
unknown artist**
Previously attributed to Claude
Gellée (JGJ 1941)
Coast Scene with Figures
c. 1625–50
Oil on canvas
18 1/8 × 23 5/8" (46 × 60 cm)

John G. Johnson Collection
cat. 775

**Italian, active Bologna,
unknown artist**
Previously listed as an Italian
artist, early 17th century
(JI 1966)
Heads of Three Boys and a Girl
c. 1600
Oil on panel
13 3/8 × 29 3/4" (34 × 75.6 cm)

John G. Johnson Collection
cat. 280

Italian, unknown artist
*Virgin and Child, with Saint
Elizabeth and the Young Saint John
the Baptist*
c. 1650–1700
On scroll: ECCE AGNVS DEI
Oil on canvas
69 1/8 × 52 1/2" (175.6 × 133.3 cm)

Bequest of Arthur H. Lea
F1938-1-33

Italian, unknown artist
Religious Procession to the Cathedral of Pisa
c. 1675–1700
Oil on canvas
13 × 29 ¼" (33 × 74.3 cm)

The Louise and Walter Arensberg Collection
1950-134-529

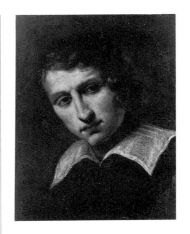

Italian, active Florence, unknown artist
Portrait of a Man with a White Collar
17th century
Oil on canvas
18 ⅝ × 14" (47.3 × 35.6 cm)

Bequest of Arthur H. Lea
F1938-1-15

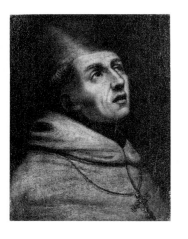

Italian, unknown artist
Head of a Bishop
17th century
Oil on canvas
21 ½ × 16 ¼" (54.6 × 41.3 cm)

Bequest of Arthur H. Lea
F1938-1-14

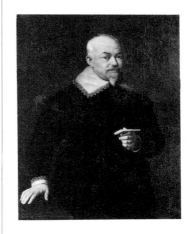

Italian, unknown artist
Previously listed as Hieronymus van Kessel (JFD 1972)
Portrait of an Elderly Gentleman
17th century
Oil on canvas
39 ⅝ × 29 ¹³⁄₁₆" (100.6 × 75.7 cm)

John G. Johnson Collection
cat. 459

Italian, active Florence, unknown artist
Head of a Woman
17th century
Oil on canvas
16 ⅝ × 12 ⅝" (42.2 × 32.1 cm)

Bequest of Arthur H. Lea
F1938-1-29

Italian, active Bologna, unknown artist
Saint Barbara
17th century
Oil on canvas
15 ⅜ × 12 ⅞" (39 × 32.7 cm)

Bequest of Arthur H. Lea
F1938-1-18

Italian, unknown artist
Penitent Saint Mary Magdalene
17th century
Oil on canvas
21 ⅜ × 16 ½" (54.3 × 41.9 cm)

Bequest of Arthur H. Lea
F1938-1-17

Italian, active Florence, unknown artist
Saint Mary Magdalene
17th century
Lower right (spurious):
GUERCINO
Oil on canvas
28 × 21 ¾" (71.1 × 55.2 cm)

Bequest of Arthur H. Lea
F1938-1-11

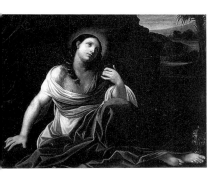

Italian, unknown artist
Saint Mary Magdalene in the Desert
17th century
Oil on canvas
43 ½ × 55 ¼" (110.5 × 140.3 cm)

Bequest of Arthur H. Lea
F1938-1-44

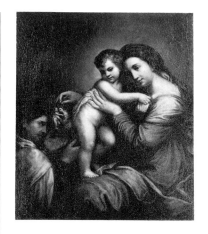

Italian, unknown artist
Virgin and Child, with Saint Vincent Ferrer
17th century?
Oil on canvas
37 × 30 ½" (94 × 77.5 cm)

Bequest of Arthur H. Lea
F1938-1-42

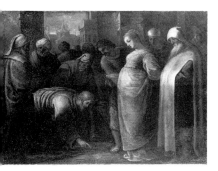

Italian, active Rome?, unknown artist
Previously attributed to Andrea Sacchi (JI 1966)
The Adulteress before Christ
17th century
Oil on canvas
15 ⅛ × 20 ⁵⁄₁₆" (38.4 × 51.6 cm)

John G. Johnson Collection
cat. 284

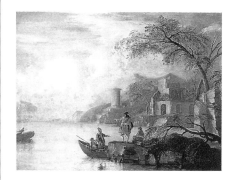

Italian, unknown artist
Landscape with a Lake
18th century
Oil on canvas
35 ⅛ × 42 ⅞" (89.2 × 108.9 cm)

Bequest of Arthur H. Lea
F1938-1-47

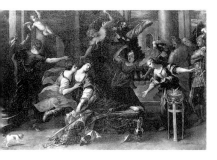

Italian, active Verona?, unknown artist
The Death of Dido
17th century
Oil on canvas
35 ⅛ × 45 ¾" (89.2 × 116.2 cm)

Bequest of Arthur H. Lea
F1938-1-36

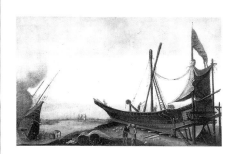

Italian, unknown artist
Previously listed as Francesco Fidanza (PMA 1965)
Marine with a Ship
Pendant to the following painting
18th century
Oil on canvas
25 × 38 ¼" (63.5 × 97.1 cm)

Bequest of Arthur H. Lea
F1938-1-7

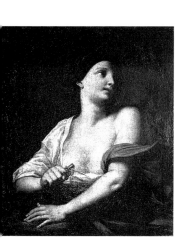

Italian, active Bologna, unknown artist
The Suicide of Lucretia
17th century
Oil on canvas
35 ½ × 29 ¾" (90.2 × 75.6 cm)

Bequest of Arthur H. Lea
F1938-1-6

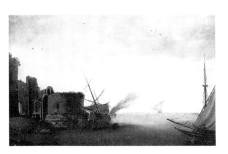

Italian, unknown artist
Previously listed as Francesco Fidanza (PMA 1965)
Marine with Ruins of a Castle
Pendant to the preceding painting
18th century
Oil on canvas
25 ¼ × 38 ⅜" (64.1 × 97.5 cm)

Bequest of Arthur H. Lea
F1938-1-38

Italian, active Venice?, unknown artist
Mourning Virgin
18th century
Oil on canvas
9 1/4 × 7 5/8" (23.5 × 19.4 cm)

John G. Johnson Collection
inv. 368

Italian, unknown artist
Portrait of a Man
In an 18th-century style
19th century?
Oil on canvas
18 3/8 × 14 3/8" (46.7 × 36.5 cm)

John G. Johnson Collection
inv. 2923

Italian, active Naples, unknown artist
The Assumption of the Virgin
18th century
Oil on canvas
24 1/8 × 29 1/8" (61.3 × 74 cm)

John G. Johnson Collection
cat. 285

Italian, unknown artist
Previously listed as an imitator of
Sandro Botticelli (JI 1966)
Portrait of a Young Gentleman
In a 15th-century Florentine style
19th century
Oil on panel
13 7/8 × 10 5/8" (35.2 × 27 cm)

John G. Johnson Collection
inv. 705

Italian?, unknown artist
Winter Landscape
18th century
Oil on canvas
62 1/2 × 45" (158.7 × 114.3 cm)

Bequest of Arthur H. Lea
F1938-1-24

Italian, unknown artist
Previously listed as Lorenzo di
Credi (JI 1966)
Portrait of a Young Gentleman
In a late 15th-century Florentine
style
19th century
Oil on panel
17 5/8 × 12 7/8" (44.8 × 32.7 cm)

John G. Johnson Collection
inv. 61

Italian, unknown artist
Previously listed as Italian,
unknown artist, 17th century
(PMA 1965)
Girl with Grapes
19th century
Oil on canvas
34 1/2 × 27 3/16" (87.6 × 69.1 cm)

Bequest of Arthur H. Lea
F1938-1-4

Italian, active Venice?, unknown artist
Previously listed as a Venetian
artist, 17th century (JI 1966)
Portrait of an Elderly Gentleman
19th century?
Oil on canvas
24 11/16 × 19 3/16" (62.7 × 48.7 cm)

John G. Johnson Collection
cat. 228

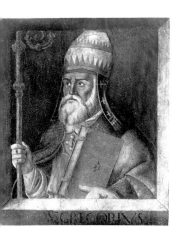

Italian, unknown artist
Saint Gregory the Great
In a 15th-century style
19th century
Across bottom: S. GREGORIVS
Oil on panel
31 ¼ × 25 ¾" (79.4 × 65.4 cm)

John G. Johnson Collection
inv. 448

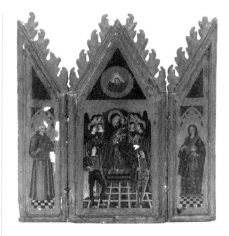

Italian, unknown artist
Enthroned Virgin and Child, with Angels, Candle Bearers, God, and Saints Bernard and Mary Magdalene
Triptych; in a 14th- and 15th-century Sienese style
c. 1900
Tempera and tooled gold on panel
Center panel: 23 ⅝ × 11 ¹/₁₆"
(60 × 28.1 cm); left wing:
23 ⅜ × 5 ⁹/₁₆" (59.4 × 14.1 cm);
right wing: 23 ⅜ × 5 ½"
(59.4 × 14 cm)

Gift of John Harrison, Jr.
1919-447

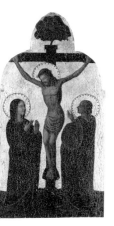

Italian, unknown artist
The Crucifixion
In a 15th-century style
19th century
Oil and tempera on panel
26 ⅝ × 13 ¾" (67.6 × 34.9 cm)

Bequest of Arthur H. Lea
F1938-1-51

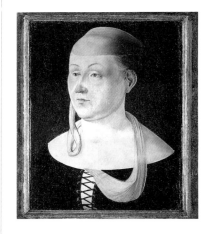

Jacometto Veneziano, attributed to
Italian, active Venice, active c. 1472, died c. 1497
Previously listed as Jacometto Veneziano (JI 1966)
Portrait of a Lady
Reverse painted with marbleized background and a flower
1470s
On reverse, partially in gold:
VLLLLF / DELITIIS ANIMVM /
EXPLE / POST MORTEM / NVLLA
VOLVP / TAS
Oil on panel
13 ⅜ × 10 ¹³/₁₆" (34 × 27.5 cm)

John G. Johnson Collection
cat. 243

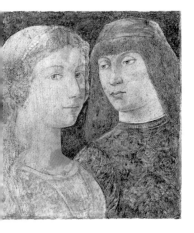

Italian, unknown artist
Two Figures
In a 15th-century Florentine style
19th century
Oil on panel
17 ⁷/₁₆ × 14 ⅞" (44.3 × 37.8 cm)

John G. Johnson Collection
inv. 2856

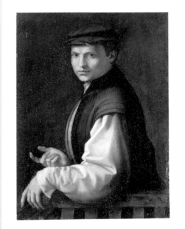

Jacopino del Conte
Italian, active Florence and Rome, 1510–1598
Portrait of a Gentleman
c. 1535
Oil on panel
26 × 18 ⅜" (66 × 46.7 cm)

John G. Johnson Collection
cat. 81

Italian, unknown artist
The Crucifixion
In a 14th-century Sienese style
Late 19th century
Tempera and tooled gold on panel
22 ¼ × 9 ¹¹/₁₆" (56.5 × 24.6 cm)

John G. Johnson Collection
cat. 93

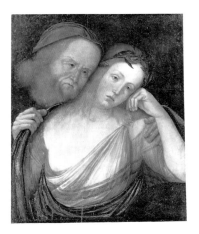

Jacopo de' Barbari
Italian, active Venice, Nuremberg, Mechelen, and Brussels, first documented 1497, died before 1515
An Old Man and a Young Woman (The Nymph Agapes and Her Old Husband)
1503
Center right: IA.D.BARBARI /
M.D.III / {caduceus}
Oil on panel
15 ⅞ × 12 ¾" (40.3 × 32.4 cm)

John G. Johnson Collection
cat. 167

Jacopo di Cione
Italian, active Florence,
first documented 1365,
died 1398–1400
Saint Peter Released from Prison
Predella panel from the high
altarpiece of San Pier Maggiore,
Florence, designed by Niccolaio
and made in collaboration with
Matteo di Pacino (Italian,
1359–1394); other panels from
the altarpiece are in the National
Gallery, London (569–578); the
Museum of Art, Rhode Island
School of Design, Providence; the
Pinacoteca Vaticana (no. 107,
no. 113, no. 21.04); (formerly)
the Thyssen-Bornemisza
Collection, Lugano, Switzerland;
and (formerly) the Sacerdoti
Collection, Milan
1370–71
Tempera and tooled gold on panel
15 5/16 × 20 5/8" (38.9 × 52.4 cm)

John G. Johnson Collection
cat. 4

Leonardi, A.
Italian, active 19th century
Portrait of a Girl
19th century
Lower right: A. Leonardi /
4 Fontane 17 / Roma
Oil on canvas
18 1/4 × 14 1/4" (46.3 × 36.2 cm)

Gift of Jay Cooke
1955-2-5

**Leonardo da Pistoia
(Leonardo di Francesco di
Lazzero Malatesta)**
Italian, active Pistoia and
environs and Volterra, born
c. 1483, still active 1518
*The Holy Family with Saint
Elizabeth and the Young Saint John
the Baptist*
Early 16th century
Oil on panel
30 15/16 × 28 13/16" (78.6 × 73.2 cm)

John G. Johnson Collection
cat. 79

Jacopo di Cione
*The Mystic Marriage of Saint
Catherine of Alexandria, with Saint
Louis of Toulouse and a Franciscan
Nun Donor*
c. 1375–80
Tempera and tooled gold on panel
31 15/16 × 24 1/2" (81.1 × 62.2 cm)

John G. Johnson Collection
cat. 6

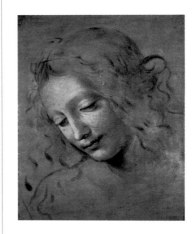

**Leonardo da Vinci,
copy after**
Italian, active Florence, Milan,
Mantua, Rome, and France,
1452–1519
Head of a Woman
After the painting in the Galleria
Nazionale, Parma (inv. no. 362)
18th century?
On reverse: Leonardo da Vinci /
[] / Parma; on sticker on reverse
Mar Dogoni cartone / Origle) di
Leonardo. a / Parma. 1797.
Oil on paper mounted on
cardboard backed with twill
9 3/4 × 7 3/8" (24.8 × 18.7 cm)

John G. Johnson Collection
cat. 266

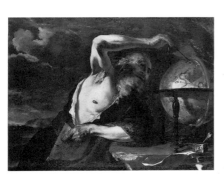

**Langetti, Giovanni Battista,
attributed to**
Italian, active Genoa and Rome,
1625–1676
Previously listed as Luca
Giordano (PMA 1965)
The Philosopher Anaxagoras
c. 1660
Oil on canvas
39 1/4 × 52 3/4" (99.7 × 134 cm)

Purchased with the W. P.
Wilstach Fund
W1904-1-25

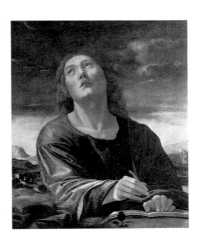

**Liberale da Verona (Liberale
di Jacopo dalla Biava)**
Italian, active Verona, Siena,
and environs, born 1445, died
1525–29
Saint John the Evangelist on Patmos
c. 1500
Oil on canvas
28 15/16 × 24 1/2" (73.5 × 62.2 cm)

John G. Johnson Collection
cat. 216

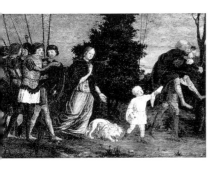

Libri, Girolamo dai, follower of
Italian, active Verona,
1474–1555
Aeneas Leaving Troy
Section of a cassone; companion
to the following painting
Mid-16th century
Oil on panel
8 × 11 ¼" (20.3 × 28.6 cm)

John G. Johnson Collection
cat. 221

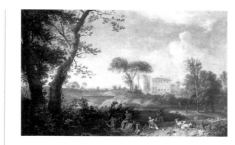

Locatelli, Andrea, studio of
Ideal Landscape
1730s
Oil on canvas
21 ½ × 33 ½" (54.6 × 85.1 cm)

The Bloomfield Moore Collection
1883-98

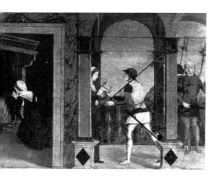

Libri, Girolamo dai, follower of
The Meeting of Dido and Aeneas
Section of a cassone; companion
to the preceding painting
Mid-16th century
Oil on panel
8 ¹³⁄₁₆ × 11 ½" (22.4 × 29.2 cm)

John G. Johnson Collection
cat. 222

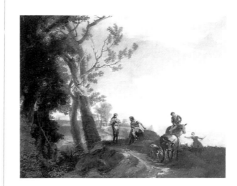

Locatelli, Andrea, studio of
Previously listed as Andrea
Locatelli (PMA 1965)
Pastoral Landscape
1730s
Oil on canvas
21 ¾ × 34" (55.2 × 86.4 cm)

The Bloomfield Moore Collection
1883-105

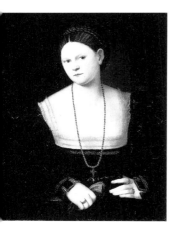

Licinio, Bernardino di Ser Antonio
Italian, active Venice,
documented 1511–1549
Portrait of a Young Lady
c. 1530
Oil on panel
27 ³⁄₈ × 22" (69.5 × 55.9 cm)

John G. Johnson Collection
cat. 203

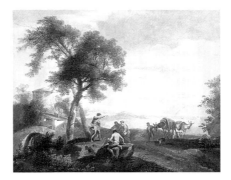

Locatelli, Andrea, studio of
Previously listed as Andrea
Locatelli (PMA 1965)
Pastoral Landscape
1730s
Oil on canvas
21 ½ × 33 ½" (54.6 × 85.1 cm)

The Bloomfield Moore Collection
1883-106

Locatelli, Andrea, studio of
Italian, active Rome, 1695–1741
Previously listed as Andrea
Locatelli (PMA 1965)
Ideal Landscape
1730s
Oil on canvas
23 ¾ × 29" (60.3 × 73.7 cm)

The Bloomfield Moore Collection
1883-97

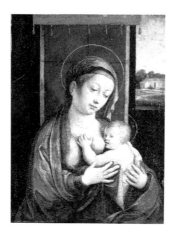

Longhi, Luca, workshop of
Italian, active Ravenna,
1507–1580
Previously listed as Luca Longhi
(JGJ 1941)
Virgin and Child
Mid-16th century
Oil on canvas on panel
17 ⅛ × 12 ⅛" (43.5 × 30.8 cm)

John G. Johnson Collection
cat. 256

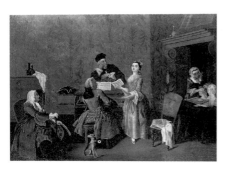

Longhi, Pietro, copy after
Italian, 1702–1785
Previously attributed to Pietro
Longhi (PMA 1965)
The Engagement of a Singer
After a picture in the Wyndham
Collection, Petworth House,
England
Late 18th or early 19th century
Oil on canvas
21 ³/₄ × 28 ⁵/₁₆" (55.2 × 71.9 cm)

Purchased with the W. P.
Wilstach Fund
W1916-1-4

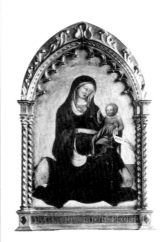

**Lorenzo di Giovanni di Nofri
(Master of San Miniato)**
Virgin and Child
c. 1465–70
Tempera and tooled gold on panel
28 ⁵/₁₆ × 19 ⁷/₈" (71.9 × 50.5 cm)

John G. Johnson Collection
cat. 37

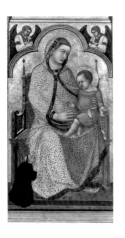

Lorenzetti, Pietro
Italian, active Siena, Assisi,
Arezzo, and Florence, first
securely documented 1320,
last documented 1344
*Enthroned Virgin and Child, with a
Monk or Friar Donor and Two
Angels*
Central panel and spandrels from
an altarpiece
1320s
Tempera and tooled gold on panel
Overall: 51 ³/₄ × 27 ¹/₂"
(131.5 × 69.9 cm); central panel:
49 ⁵/₈ × 29 ³/₄" (126 × 75.6 cm);
spandrels [each]: 9 ³/₄ × 10 ¹/₂"
(24.8 × 26.7 cm)

John G. Johnson Collection
[central panel]
Purchased with the George W.
Elkins Fund, the W. P. Wilstach
Fund, and the J. Stogdell Stokes
Fund [spandrels]
cat. 91 [central panel]
EW1985-21-1, 2 [spandrels]

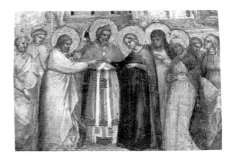

**Lorenzo Monaco (Piero di
Giovanni), workshop of**
Italian, active Florence, first
documented 1390, died 1424?
The Virgin of Humility
c. 1413
On scroll: EGO SUM LVX
MV[NDI]; on frame, across
bottom: AVE MARIA GRATIA
PLENA
Tempera and tooled gold on pane
32 ³/₄ × 19 ³/₄" (83.2 × 50.2 cm)

John G. Johnson Collection
cat. 10

Lorenzo Veneziano
Italian, active Veneto and
Bologna, dated works
1356–1372
Previously listed as an Umbro-
Florentine artist, c. 1425 (JI
1966)
The Marriage of the Virgin
Predella panel; cut down at top
1360s
Tempera and tooled gold on pane
7 ⁷/₈ × 10 ¹/₄" (20 × 26 cm)

John G. Johnson Collection
cat. 128

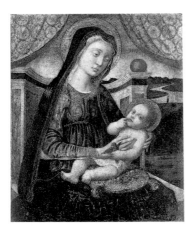

**Lorenzo di Giovanni di Nofri
(Master of San Miniato)**
Italian, active Florence, first
documented 1465, died 1512
Previously listed as the school of
Francesco Botticini (JI 1966)
Enthroned Virgin and Child
c. 1465–70
Tempera and tooled gold on panel
17 ¹/₁₆ × 14 ³/₈" (43.3 × 36.5 cm)

John G. Johnson Collection
cat. 57

**Lotto, Lorenzo (Lorenzo di
Tommaso Lotto)**
Italian, active Venice, northern
Italy, and Marches, first
documented 1503, died 1556
*Portrait of Gian Giacomo Stuer and
His Son Gian Antonio*
1544
Oil on canvas
35 ¹/₈ × 29 ³/₈" (89.2 × 74.6 cm)

John G. Johnson Collection
cat. 196

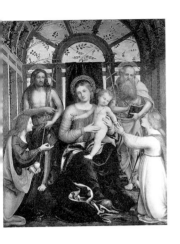

Lotto, Lorenzo, attributed to
Previously listed as Lorenzo Lotto
(JI 1966)
Virgin and Child. with Saints Mary Magdalene. John the Baptist. Jerome. and Catherine of Alexandria
Altarpiece
c. 1517
Oil and gold on panel
60 ⅜ × 45 ¾" (153.3 × 116.2 cm)

John G. Johnson Collection
cat. 195

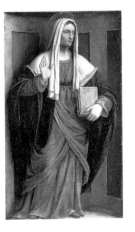

Lotto, Lorenzo, copy after
Previously listed as Lorenzo Lotto
(JI 1966)
Virgin and Child
Original is in the Hermitage,
St. Petersburg (inv. no. 76)
16th century
Oil on panel
13 ⅛ × 10 ¹⁵/₁₆" (33.3 × 27.8 cm)

John G. Johnson Collection
cat. 194

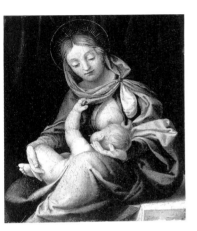

Luini, Bernardino
Italian, active Milan and
environs, first documented 1512,
died 1532
Saint Anne
Panel from an altarpiece
commissioned in 1523 for San
Sinisio della Torre, Mendrisio,
according to the bequest of
Cristoforo Torriani; companion
panels are in the Di Rovasenda
collection, Turin; the collection
of the Marquess of Normanby,
Whitby; and the Norton Simon
Museum of Art, Pasadena
c. 1523
Oil on panel
24 ⁹/₁₆ × 13 ⁷/₁₆" (62.4 × 34.1 cm)

John G. Johnson Collection
cat. 275

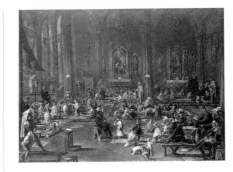

**Magnasco, Alessandro,
also called Lissandro and
Lissandrino**
Italian, active Genoa, Milan,
Venice, and Florence,
c. 1667–1749
Sermon to Jesuit Novices
Pendant to the following
painting
After 1711
Oil on canvas
22 ¹¹/₁₆ × 15 ¹³/₁₆" (57.6 × 40.2 cm)

Purchased with the Jay Cooke
Fund
1957-2-1

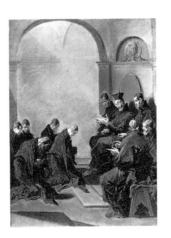

Magnasco, Alessandro
*Contrition and Confession of
Capuchin Friars*
Pendant to the preceding
painting
After 1711
On scroll: NII MEMORI IO[]
Oil on canvas
22 ⁹/₁₆ × 15 ¾" (57.3 × 40 cm)

Purchased with the Jay Cooke
Fund
1957-2-2

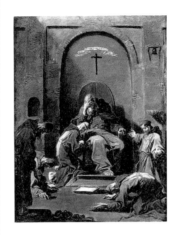

Magnasco, Alessandro
*The Catechism in the Cathedral of
Milan*
c. 1725–30
Oil on canvas
47 ⅛ × 59" (119.7 × 149.9 cm)

Purchased with the W. P.
Wilstach Fund
W1958-2-1

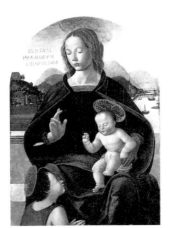

Mainardi, Sebastiano
Italian, active San Gimignano,
Pisa, and Florence, documented
1475, died 1513
*Virgin and Child with the Young
Saint John the Baptist*
c. 1500
Upper left: SVB CVM /
PRAESIDIVM / CONFVCIMVS
Oil and gold on panel
36 ½ × 24 ⅜" (92.7 × 61.9 cm)

John G. Johnson Collection
cat. 69

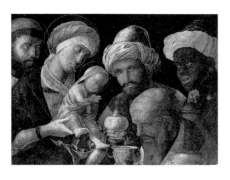

**Mantegna, Andrea,
copy after**
Italian, active Padua, Mantua,
and Verona, 1431–1506
The Adoration of the Magi
After the painting in the J. Paul
Getty Museum, Malibu
(85.PA.417)
19th century
Oil on canvas
20 1/4 × 29" (51.4 × 73.7 cm)

John G. Johnson Collection
cat. 213

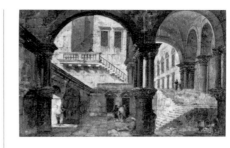

Marieschi, Michele
The Grand Canal at the Scalzi
Before 1740
Oil on canvas
21 7/8 × 33 3/8" (55.6 × 84.8 cm)

Purchased with the W. P.
Wilstach Fund
W1900-1-14

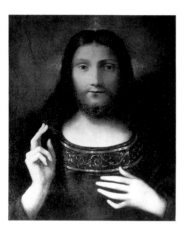

Marconi, Rocco
Italian, active Venice, first
documented 1504, died 1529
Christ Blessing
1520s
Oil on panel
20 11/16 × 16" (52.5 × 40.6 cm)

John G. Johnson Collection
cat. 190

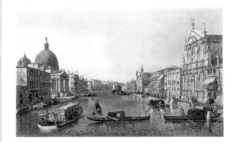

Marieschi, Michele
Courtyard of a Palace
The figures have been attributed
to Francesco Fontebasso (Italian,
1709–1769) as well as Giovanni
Battista Tiepolo (Italian,
1696–1770); pendant to a
painting in Washington
University, St. Louis (no. 2069)
c. 1740
Oil on canvas
14 1/4 × 22 1/4" (36.2 × 56.5 cm)

John G. Johnson Collection
cat. 299

Marieschi, Michele
Italian, active Venice,
1710–1744
Rialto Bridge
c. 1735–40
Oil on canvas
22 × 33 1/2" (55.9 × 85.1 cm)

John G. Johnson Collection
cat. 298

**Martino di Bartolomeo (Mar-
tino di Bartolomeo di Biagio)**
Italian, active Siena, first
documented 1389, died 1435
Previously listed as Italian,
unknown artist, 14th century
(PMA 1965)
Saint Barnabas Curing Cripples
Predella panel from an altarpiece
in the Pinacoteca Nazionale,
Siena (160); see following three
entries for companion panels
c. 1410
Tempera and tooled gold on panel
10 3/4 × 15 1/2" (27.3 × 39.4 cm)

Purchased from the George Grey
Barnard Collection with Museum
funds
1945-25-120a

Marieschi, Michele
The Bacino of San Marco
The figures have been attributed
to Francesco Guardi (Italian,
1712–1793) as well as Antonio
Guardi (Italian, c. 1698–1760)
c. 1735–40
Oil on canvas
23 11/16 × 44 1/2" (60.2 × 113 cm)

John G. Johnson Collection
cat. 297

Martino di Bartolomeo
Previously listed as Italian,
unknown artist, 14th century
(PMA 1965)
Saint Barnabas Preaching
See previous entry; a fifth
predella panel is in the El Paso
Museum of Art (K110)
c. 1410
Tempera and tooled gold on panel
10 3/8 × 15 5/8" (26.3 × 39.7 cm)

Purchased from the George Grey
Barnard Collection with Museum
funds
1945-25-120b

Martino di Bartolomeo
Previously listed as Italian,
unknown artist, 14th century
(PMA 1965)
*Saint Barnabas Laying Money at the
Feet of Saints Peter and John the
Evangelist*
See previous two entries
c. 1410
Tempera and tooled gold on panel
9 7/8 × 15 1/2" (25.1 × 39.4 cm)

Purchased from the George Grey
Barnard Collection with Museum
funds
1945-25-120c

Martino di Bartolomeo
Previously listed as Italian,
unknown artist, 14th century
(PMA 1965)
The Martyrdom of Saint Barnabas
See previous three entries
c. 1410
Tempera and tooled gold on panel
9 7/16 × 14 1/8" (24 × 35.9 cm)

Purchased from the George Grey
Barnard Collection with Museum
funds
1945-25-120d

**Masolino (Tommaso di
Cristoforo Fini), also called
Masolino da Panicale**
Italian, active Florence, Hungary,
Rome, Todi, and Castiglione
d'Olona, documented 1423–1435
**and Masaccio (Tommaso di
Ser Giovanni Cassai)**
Italian, active Florence,
1401–1428
Saints Paul and Peter
Panel from an altarpiece from
Santa Maria Maggiore, Rome;
probably begun by Masaccio and
finished after his death by
Masolino; see following entry for
companion panels
c. 1428
Tempera, oil, and tooled gold on
panel
45 × 21 3/8" (114.3 × 54.3 cm)

John G. Johnson Collection
inv. 408

Masolino and Masaccio
*Saints John the Evangelist and
Martin of Tours*
Companion to the previous panel
and panels in the National
Gallery, London (5962, 5963);
the Museo e Gallerie Nazionali di
Capodimonte, Naples (33,35);
and the Pinacoteca Vaticana
(no. 245, no. 260)
c. 1428
Tempera, oil, and tooled gold on
panel
45 × 21 3/8" (114.3 × 54.3 cm)

John G. Johnson Collection
inv. 409

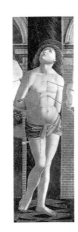

Master of the Baldraccani
Italian, active Romagnole,
1480–1510
Previously listed as Francesco
Zaganelli (JI 1966)
Saint Sebastian
Panel from an altarpiece
c. 1510
Oil on panel
57 × 14 3/4" (144.8 × 37.5 cm)

John G. Johnson Collection
cat. 148

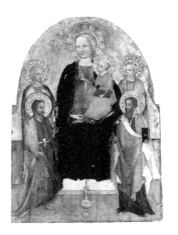

**Master of the Bracciolini
Chapel**
Italian, active Pistoia,
active c. 1414–c. 1426
Previously listed as Andrea di
Giusto (JI 1966)
*Virgin and Child, with Saints Lucy,
John the Baptist, Rose, and
Bartholomew*
c. 1426
Tempera and tooled gold on panel
22 3/4 × 16" (57.8 × 40.6 cm)

John G. Johnson Collection
cat. 21

**Master of the Castello
Nativity**
Italian, active Florence,
active c. 1450–c. 1475
*Saints Justus and Clement
Multiplying Grain*
Predella panel from an altarpiece
from Santi Giusto e Clemente, Fal-
tignano, now in the Museo Dioce-
sano, Prato; companion to the fol-
lowing panel and a panel in the
National Gallery, London (3648)
c. 1460
Tempera and gold on panel
8 1/2 × 18 3/8" (21.6 × 46.7 cm)

John G. Johnson Collection
cat. 24

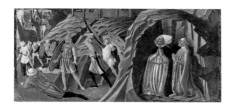

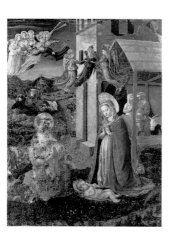

Master of the Castello Nativity
Saints Justus and Clement Praying for Deliverance from the Vandals, and the Departure of the Vandals
See previous entry
c. 1460
Tempera and gold on panel
8 1/2 × 18 1/2" (21.6 × 47 cm)

John G. Johnson Collection
cat. 25

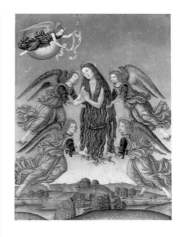

Master of the Johnson Ascension of Saint Mary Magdalene
Italian, active Florence, active c. 1500
Previously listed as Lorenzo di Credi (JI 1966)
The Ascension of Saint Mary Magdalene
Based on a painting by Lorenzo di Credi (Italian, 1549–1527), in the Kerészteny Múzeum, Esztergom, Hungary (55.191)
c. 1500
Tempera on panel
20 1/8 × 15 1/16" (51 × 38.2 cm)

John G. Johnson Collection
cat. 75

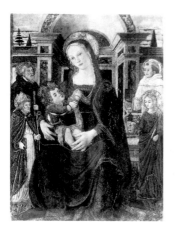

Master of the Castello Nativity
The Adoration of the Christ Child, with the Annunciation to the Shepherds
c. 1460–70
Tempera and tooled gold on panel
44 5/8 × 32 3/4" (113.3 × 83.2 cm)

John G. Johnson Collection
cat. 23

Master of the Johnson Tabernacle
Italian, active central Italy, c. 1420–c. 1465
Previously listed as a follower of Benozzo Gozzoli (JI 1966)
Center panel: *Virgin and Child, with Saints Dominic, John the Baptist, Thomas Aquinas, Peter Martyr, Francis, and Jerome, and an Angel and a Child* [Raphael and Tobias?]; left wing: *Annunciate Angel and Christ Carrying the Cross*; right wing: *Annunciate Virgin and the Crucifixion, with Saints Catherine of Siena and Mary Magdalene*
Triptych
c. 1461
On scroll of Saint John the Baptist: Ecce
Tempera on panel
Center panel: 19 11/16 × 11 1/8" (50 × 28.3 cm); left wing: 19 3/8 × 5 5/8" (49.2 × 14.3 cm); right wing: 19 9/16 × 5 3/8" (49.7 × 13.6 cm)

John G. Johnson Collection
inv. 2034a

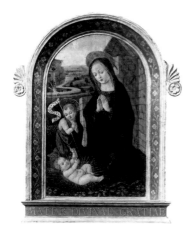

Master of the Fiesole Epiphany (Filippo di Giuliano Matteo?)
Italian, active Florence, active c. 1480–c. 1500
Previously listed as the school of Francesco Botticini (JI 1966)
Enthroned Virgin and Child, with a Bishop Saint, Saints Benedict, Bernard, and Mary Magdalene
Late 15th century
Tempera and tooled gold on panel
32 1/8 × 23 1/2" (81.6 × 59.7 cm)

John G. Johnson Collection
cat. 58

Master of the Fiesole Epiphany (Filippo di Giuliano Matteo?)
Previously listed as the school of Francesco Botticini (JI 1966)
The Virgin and the Young Saint John the Baptist Adoring the Christ Child
Late 15th century
On scroll: ECE AGNVS DEI; bottom, on frame [added later]: MATER DIVINAE GRATIAE
Tempera and gold on panel
27 3/4 × 16 3/4" (70.5 × 42.5 cm)

John G. Johnson Collection
cat. 56

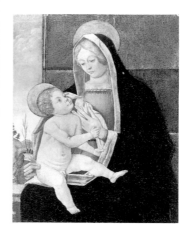

Master of the Johnson Virgin Lactans
Italian, active Veneto, active late 15th and early 16th centuries
Previously listed as Benedetto Montagna (JI 1966)
Virgin and Child before a Landscape
c. 1500
Oil on panel
16 15/16 × 13 3/16" (43 × 33.5 cm)

John G. Johnson Collection
cat. 170

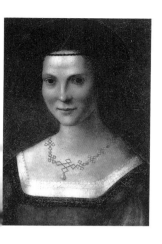

Master of the Leonardesque Female Portraits
Italian, active Milan,
active c. 1500–c. 1530
Previously listed as Francesco
Salviati (JI 1966)
Portrait of a Woman
Early 16th century
Oil on panel
16 3/4 × 11 3/4" (42.5 × 29.8 cm)

John G. Johnson Collection
cat. 85

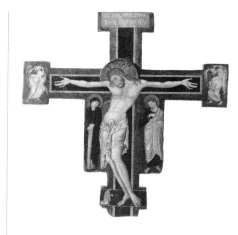

Master of Montelabate
Italian, active Perugia,
documented 1285
Previously listed as a follower of
the Master of San Francesco (PMA
1965)
Crucifix
c. 1285
Across top: IC .NAZARENVS. /
.REX. IVDEORV.
Tempera on panel
74 × 68 1/4" (188 × 173.3 cm)

Purchased with the W. P.
Wilstach Fund
W1952-1-1

Master of the Lives of the Emperors
Italian, active Lombardy,
dated works 1413–1459
The Adoration of the Magi
Cut from a manuscript
c. 1440
Text: ECCE / ADVE / NIT
DO{MINUS]; upper left: MONS
VICTORIALIS
Tempera and gold on vellum
9 1/4 × 15" (23.5 × 38.1 cm)

John G. Johnson Collection
cat. 122

Master of Montelabate
Previously listed as Salerno di
Coppo (JI 1966)
*Saint Francis of Assisi and a
Franciscan Devotee*
Valve of a diptych [?]; the other
panel is in a private collection in
Rome
c. 1285
Tempera on panel
6 15/16 × 10 1/16" (17.6 × 25.6 cm)

John G. Johnson Collection
inv. 325

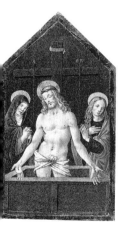

Master of Marradi
Italian, active Florence,
1480–1510
Previously listed as Bernardino di
Mariotto (JI 1966)
*The Man of Sorrows, with the Virgin
Mary and Saint John the Evangelist*
c. 1500
On cross: I N R I
Oil and gold on panel
14 5/8 × 7 13/16" (37.1 × 19.8 cm)

John G. Johnson Collection
cat. 144

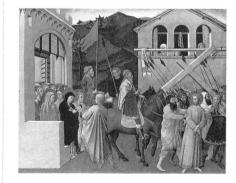

Master of the Osservanza
Italian, active Siena,
active c. 1430–c. 1460
Previously listed as Sano di
Pietro (JI 1966)
Christ on the Road to Calvary
Predella panel; companion panels
are in the Metropolitan Museum
of Art, New York (1975.1.41);
Fogg Art Museum, Cambridge,
Mass. (1922.172); Pinacoteca
Vaticana (no. 232); Museum of
Western and Oriental Art, Kiev;
Detroit Institute of Arts (60.61)
c. 1440–45
Tempera and tooled gold on panel
14 1/2 × 18 3/8" (36.8 × 46.7 cm)

John G. Johnson Collection
inv. 1295

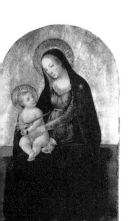

Master of Marradi
Virgin and Child
c. 1500
On Virgin's halo: AVE MARIA
Tempera and tooled gold on panel
37 3/4 × 21" (95.9 × 53.3 cm)

John G. Johnson Collection
cat. 139

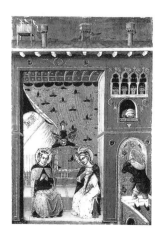

Master of the Pesaro Crucifix
Italian, active Venice,
active c. 1375–c. 1400
Previously listed as Jacobello del
Fiore (PMA 1965)
*The Crowning of Saint Cecilia of
Rome and Her Husband, Valerianus*
Panel from an altarpiece
c. 1375–80
Tempera and gold on panel
21 3/4 × 14 3/16" (55.2 × 36 cm)

The John D. McIlhenny
Collection
1943-40-51

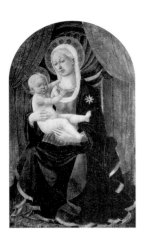

Master of the Pomegranate
Italian, active Florence,
active c. 1450–c. 1475
Previously listed as an old copy
after Pesellino (JI 1966)
Enthroned Virgin and Child
c. 1460
Tempera and tooled gold on panel
51 × 31 1/2" (129.5 × 80 cm)

John G. Johnson Collection
cat. 36

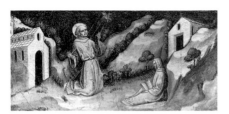

**Master of Staffolo
(Costantino di Francesuccio
di Cecco Ghissi?)**
Italian, active Marches,
documented 1417–1459
Previously listed as the school of
Fabriano (JI 1966)
*Saint Francis of Assisi Receiving the
Stigmata*
Predella panel of a processional
standard; the lower sides are
additions
c. 1420–30
Tempera on panel
6 7/8 × 12 1/2" (17.5 × 31.7 cm)

John G. Johnson Collection
cat. 121

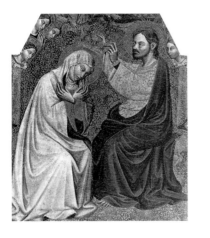

**Master of the Terni
Dormition**
Italian, active Umbria,
active c. 1370–c. 1400
The Coronation of the Virgin
Panel from an altarpiece, cut
down at the top; companion
panels are in the Pinacoteca
Capitolina, Rome (353), and the
Kisters Collection, Kreuzlingen,
Switzerland
c. 1390–1400
Tempera and tooled gold on panel
23 1/16 × 19 1/4" (58.6 × 48.9 cm)

John G. Johnson Collection
cat. 123

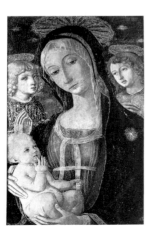

**Matteo di Giovanni (Matteo
di Giovanni di Bartolo)**
Italian, active Siena and environs
and Borgo San Sepolcro, first
documented 1452, died 1495
Virgin and Child, with Two Angels
c. 1470
Tempera and tooled gold on panel
23 7/8 × 15 15/16" (60.6 × 40.5 cm)

John G. Johnson Collection
cat. 110

**Matteo di Giovanni,
attributed to**
Previously listed as Guidoccio
Cozzarelli (JI 1966)
Camilla in Battle
Panel from a cassone; possibly a
companion to *The Legend of
Cloelia*, in the Metropolitan
Museum of Art, New York
(11.126.2)
1470s
Tempera and tooled gold on panel
15 5/8 × 41 5/8" (39.7 × 105.7 cm)

John G. Johnson Collection
cat. 111

Mazzanti, Lodovico
Italian, born Orvieto, active
Rome and Naples, c. 1679–1775
Previously listed as Italian,
unknown artist, 17th century
(PMA 1965)
The Death of Saint Francis Xavier
Possibly a sketch for the painting
in the Stadtmuseum Düsseldorf
c. 1740–45
Oil on canvas
17 7/16 × 14" (44.3 × 35.6 cm)

The Bloomfield Moore Collection
1883-89

Mazzolino, Lodovico
Italian, active Ferrara, first
documented 1504, died 1528–30
*Christ Washing the Feet of the
Disciples*
1527
Lower right: 1527 MESE
Oil on panel
19 7/16 × 21 1/16" (49.4 × 53.5 cm)

John G. Johnson Collection
cat. 248

Melone, Altobello
Italian, active Cremona,
documented 1516–1518
*Virgin and Child, with the Young
Saint John the Baptist*
c. 1510
Oil and gold on panel
29 3/4 × 19 1/4" (75.6 × 48.9 cm)

John G. Johnson Collection
cat. 151

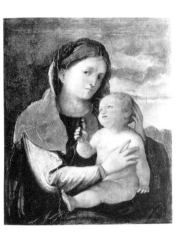

Melone, Altobello
Virgin and Child
c. 1525
Oil on panel
19 7/8 × 15 1/2" (50.5 × 39.4 cm)

John G. Johnson Collection
cat. 232

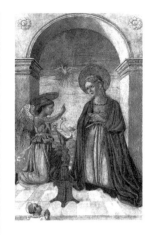

**Morone, Domenico,
workshop of**
Italian, active Verona,
born c. 1442, still active 1517
*The Annunciation, with a Haloed
Donor*
c. 1500
Oil on panel
36 1/4 × 21 1/8" (92.1 × 53.7 cm)

John G. Johnson Collection
cat. 219

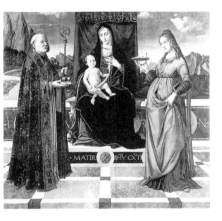

**Montagna, Bartolomeo
(Bartolomeo Cincani)**
Italian, active Veneto, first
documented 1459, died 1523
*Enthroned Virgin and Child, with
Saints Nicholas of Bari and Lucy*
Altarpiece from Santa Maria dei
Servi, Vicenza
c. 1480
Across center: T. V. T. N.; on
step: MATER IHV.CXTI
Oil on panel transferred to canvas
70 1/2 × 71" (179.1 × 180.3 cm)

John G. Johnson Collection
cat. 168

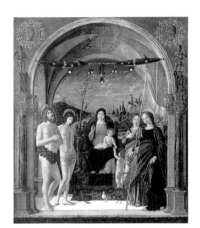

Morone, Francesco
Italian, active Verona,
1473–1529
Previously listed as Giovanni
Francesco Caroto (JI 1966)
*Virgin and Child, with Saints
Onuphrius, Sebastian, Justine, and
Ursula*
c. 1500
Center top: GLORIA / IN
EXCELSIS / DEO ET IN TE / RRA
PAX HOM / VOLVNTA / TIS;
center bottom (spurious):
ANDREA MANTEGNA PINGEBAT
Oil on canvas
22 3/8 × 18 3/8" (56.8 × 46.7 cm)

John G. Johnson Collection
cat. 214

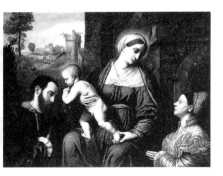

**Moretto da Brescia
(Alessandro Bonvicino)**
Italian, active Brescia,
c. 1498–1554
Virgin and Child, with Two Donors
c. 1528–30
Oil on canvas
48 1/2 × 62 1/2" (123.2 × 158.7 cm)

John G. Johnson Collection
cat. 236

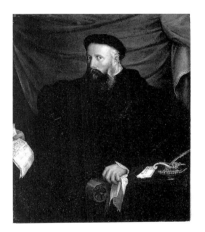

**Moroni, Giovan Battista di
Francesco, attributed to**
Italian, active Brescia,
born c. 1520–25, died 1578
Previously listed as Giovan
Battista di Francesco Moroni
(JI 1966)
Portrait of a Gentleman
1547
Center left, on letter: MDXLVII.
G.B.M.; lower right, on envelope:
Al Mageo Signor
Oil on canvas
44 3/4 × 36 3/4" (113.7 × 93.3 cm)

John G. Johnson Collection
cat. 237

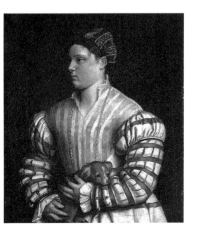

Moretto da Brescia
Portrait of Eleonora Averoldi
c. 1530
Oil on canvas
33 1/2 × 27 1/8" (85.1 × 68.9 cm)

John G. Johnson Collection
cat. 1172

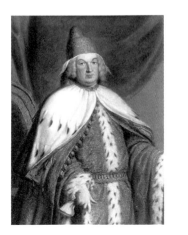

**Nazzari, Nazzario,
attributed to**
Italian, active Bergamo and
Venice, born 1724, still active
1793
Portrait of Doge Pietro Grimani
c. 1741–52
Oil on canvas
54 7/8 × 37 3/8" (139.4 × 94.9 cm)

John G. Johnson Collection
cat. 290

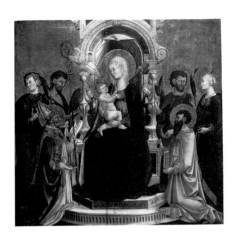

Neri di Bicci
Italian, active Florence,
1419–1492
*Enthroned Virgin and Child, with
Two Angels and Saints Nicholas of
Bari, Ansanus, John the Baptist,
Sebastian, Catherine of Alexandria,
and Bartholomew*
Altarpiece
1457
On cartellino: ECCE AGN[US]; on
base of throne: REGINA CELI
LETTARE ALLELVIA QVIA ME P
Tempera and tooled gold on panel
65 × 64 3/8" (165.1 × 163.5 cm)

The Bloomfield Moore Collection
1899-1108

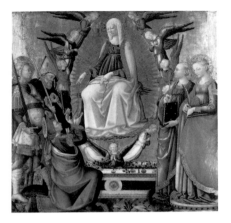

Neri di Bicci
*Saint Thomas Receiving the Virgin's
Girdle, with the Archangel Michael,
Saints Augustine, Margaret, and
Catherine of Alexandria, and Angels*
Panel from an altarpiece from San
Michele, Prato, finished in 1467;
the predella is in the Museu
Nacional d'Art de Catalunya,
Barcelona (64972)
1467
Tempera and tooled gold on panel
61 1/4 × 60 7/8" (155.6 × 154.6 cm)

John G. Johnson Collection
cat. 27

Neri di Bicci
*The Archangel Raphael Preventing
an Assassination*
Predella panel; companion panels
are in the Rijksdienst Beelende
Kunst, The Hague (NK1472,
NK2703), and a private
collection in Ferrara
1471?
Oil on panel
8 3/8 × 19 1/8" (21.3 × 48.6 cm)

John G. Johnson Collection
inv. 2073

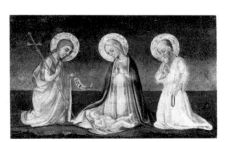

Neri di Bicci
*The Virgin and Saints John the
Baptist and Jerome Adoring the
Christ Child*
Predella panel; companion to the
following five panels
c. 1476
On scroll: ECCE AGN[US]
Tempera and gold on panel
7 × 11" (17.8 × 27.9 cm)

John G. Johnson Collection
cat. 28

Neri di Bicci
Two Young Martyr Saints
See previous entry
c. 1476
Tempera and gold on panel
7 × 11" (17.8 × 27.9 cm)

John G. Johnson Collection
cat. 29

Neri di Bicci
Two Papal Saints
See previous two entries
c. 1476
Tempera and gold on panel
7 × 11" (17.8 × 27.9 cm)

John G. Johnson Collection
cat. 30

Neri di Bicci
Saint Agnes and a Nun Saint
See previous three entries
c. 1476
Tempera and gold on panel
7 × 11" (17.8 × 27.9 cm)

John G. Johnson Collection
cat. 31

Neri di Bicci
Saints Dominic and Anthony Abbot
See previous four entries
c. 1476
Tempera and gold on panel
7 × 11" (17.8 × 27.9 cm)

John G. Johnson Collection
cat. 32

Neri di Bicci
Two Monastic Saints
See previous five entries
c. 1476
Tempera and gold on panel
7 × 11" (17.8 × 27.9 cm)

John G. Johnson Collection
cat. 33

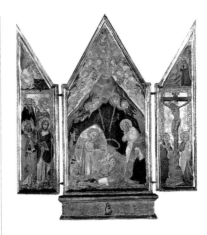

Niccolò di Tommaso
Italian, active Florence, Naples,
and Pistoia, documented
c. 1346–1376
Center panel: *Saint Bridget's
Vision of the Nativity*; left wing:
*The Annunciate Angel and Saints
Anthony Abbot, Catherine of
Alexandria, Nicholas of Bari, and
James the Great*; right wing: *The
Annunciate Virgin and the
Crucifixion*
Triptych
c. 1377
On Virgin's halo: AVE MARIA
GRATIA; from God the Father:
HIC EST FILIVS MEVS; center
left: GLORIA IN EXCELSIS DEO;
center right: ET IN TERRA PAX
HOMINIBVS; from the Virgin:
VIAT DEVS MEVS DOMINVS
MEVS FILIVS MEVS; on cross:
INRI
Tempera and tooled gold on panel
Center panel: 25 × 10 7/16"
(63.5 × 26.5 cm); left wing:
21 1/16 × 5" (53.5 × 12.7 cm);
right wing: 21 1/16 × 5 1/16"
(53.5 × 12.9 cm)

John G. Johnson Collection
cat. 120

**Neroccio (Neroccio di
Bartolomeo di Benedetto de'
Landi)**
Italian, active Siena and Lucca,
1447–1500
*Saints Christina of Bolsena [?],
Catherine of Alexandria, Jerome,
and Galganus*
c. 1470
Tempera and tooled gold on panel
11 3/4 × 10" (29.8 × 25.4 cm)

John G. Johnson Collection
cat. 1169

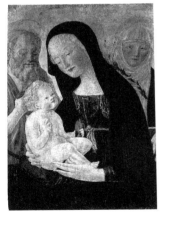

Neroccio
*Virgin and Child, with Saints
Jerome and Catherine of Siena*
1470s
Tempera on panel
21 15/16 × 15 1/8" (55.7 × 38.4 cm)

John G. Johnson Collection
cat. 109

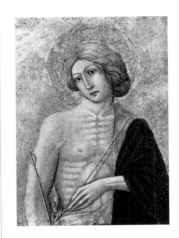

Nicola d'Ulisse da Siena
Italian, active Umbria, first
documented 1451, still active
1470
Previously attributed to Priamo
della Quercia (JI 1966)
Saint Sebastian
Panel from an altarpiece; cut
down on all sides; companion to
the following panel
Mid-15th century
Tempera and tooled gold on panel
16 3/4 × 11 3/4" (42.5 × 29.8 cm)

John G. Johnson Collection
cat. 103

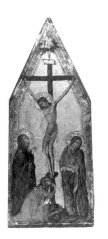

Niccolò di Segna
Italian, active Siena, first
documented 1331, last signed
work 1345
Previously listed as Ugolino di
Nerio (JI 1966)
The Crucifixion
c. 1330
Tempera and tooled gold on panel
13 5/8 × 5 5/16" (34.6 × 13.5 cm)

John G. Johnson Collection
cat. 90

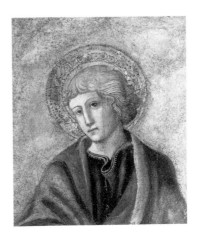

Nicola d'Ulisse da Siena
Previously attributed to Priamo
della Quercia (JI 1966)
Saint John the Evangelist [?]
Panel from an altarpiece; cut
down on all sides; companion to
the preceding panel
Mid-15th century
Tempera and tooled gold on panel
13 1/2 × 11" (34.3 × 27.9 cm)

John G. Johnson Collection
cat. 104

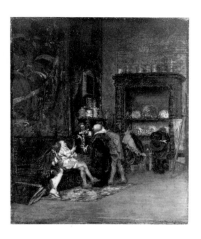

Nittis, Giuseppe De
Italian, 1846–1884
The Connoisseurs
1869
Lower left: De Nittis 69
Oil on panel
9 ³/₄ × 8" (24.8 × 20.3 cm)

John G. Johnson Collection
inv. 2700

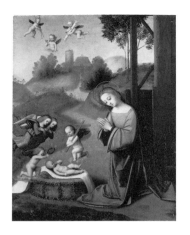

Ortolano (Giovanni Battista Benvenuti)
Italian, active Ferrara,
c. 1487–1527
The Adoration of the Christ Child
c. 1510
Oil on panel
19 ⁵/₈ × 14 ³/₄" (49.8 × 37.5 cm)

John G. Johnson Collection
cat. 246

Nittis, Giuseppe De
Return from the Races
1875
Lower right: D. Nittis '75
Oil on canvas
22 ⁷/₈ × 45 ¹/₈" (58.1 × 114.6 cm)

Gift of John G. Johnson for the
W. P. Wilstach Collection
W1906-1-10

Pacchiarotti, Giacomo
Italian, active Siena, 1474–1540
Previously listed as Pietro
Perugino (JI 1966)
Enthroned Virgin and Child
c. 1510
Tempera and gold on panel
43 ¹/₂ × 26 ¹/₂" (110.5 × 67.3 cm)

John G. Johnson Collection
cat. 141

Orsini, Antonio (Master of the Carminati Coronation)
Italian, active Ferrara,
first documented 1432,
died before 1491
Previously listed as a Sienese
artist, c. 1400 (JI 1966)
Saint John the Baptist
Companion to the following
painting
c. 1425
On scroll: Ecce / agnus / Dei/E /
cce qui / tollis x / peccha / to mun
/ di/mi / xazeme / nobis
Tempera and tooled gold on panel
12 ³/₈ × 5 ³/₁₆" (31.4 × 13.2 cm)

John G. Johnson Collection
cat. 98a

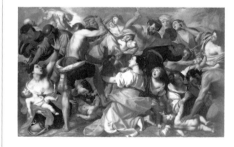

Pacecco de Rosa (Francesco de Rosa)
Italian, active Naples,
c. 1600–1654
The Massacre of the Innocents
c. 1640
Oil on canvas
78 × 120 ¹/₄" (198.1 × 305.4 cm)

Purchased with the John D.
McIlhenny Fund
1973-253-1

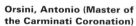

Orsini, Antonio (Master of the Carminati Coronation)
Previously listed as a Sienese
artist, c. 1400 (JI 1966)
Saint James the Great
Companion to the preceding
painting
c. 1425
Tempera and tooled gold on panel
12 ³/₈ × 5 ³/₁₆" (31.4 × 13.2 cm)

John G. Johnson Collection
cat. 98b

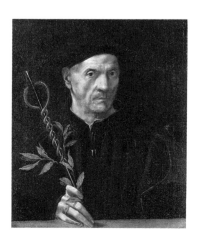

Pagani, Gaspare, attributed to
Italian, active Modena, first
documented 1521, died 1569
Previously listed as a North
Italian artist, 16th- or 17th-
century copy after original of
1500–10 (JI 1966)
Portrait of an Elderly Physician
c. 1540
Oil on canvas
26 ¹/₂ × 21 ³/₄" (67.3 × 55.2 cm)

John G. Johnson Collection
cat. 253

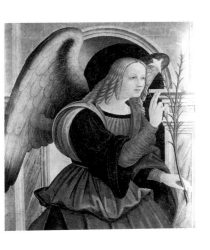

Pagani, Vincenzo
Italian, active Marches and
Perugia, c. 1490–1568
The Annunciate Angel
Companion to *The Virgin
Annunciate*, in a private collection
c. 1510
Oil on panel
29 5/8 × 26" (75.2 × 66 cm)

John G. Johnson Collection
cat. 198

Pagani, Vincenzo
The Flagellation
Predella panel
1530s
Oil on panel
9 11/16 × 33" (24.6 × 83.8 cm)

John G. Johnson Collection
cat. 199

Pagani, Vincenzo
*The Presentation of Christ in the
Temple*
Predella panel
1530s
Oil on panel
7 15/16 × 23 5/8" (20.2 × 60 cm)

John G. Johnson Collection
cat. 200

**Palma il Giovane (Jacopo
Negretti), attributed to**
Italian, active Venice,
1544–1628
Previously listed as Italian,
unknown artist, 16th century
(PMA 1965)
The Flagellation
Late 16th century
Oil on canvas
34 3/4 × 13 1/2" (88.3 × 34.3 cm)

The Louise and Walter Arensberg
Collection
1950-134-193

**Palma il Vecchio (Jacopo
d'Antonio Negretti)**
Italian, active Venice, first
documented 1510, died 1528
The Raising of Lazarus
c. 1514
Oil on panel
20 7/8 × 24 1/8" (53 × 61.3 cm)

John G. Johnson Collection
cat. 187

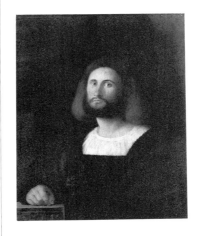

Palma il Vecchio
Portrait of a Gentleman
c. 1520–25
Oil on panel transferred to canvas
27 3/8 × 21 7/8" (69.5 × 55.6 cm)

John G. Johnson Collection
cat. 188

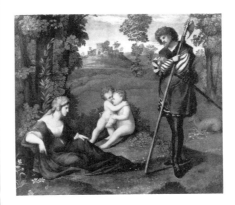

Palma il Vecchio, follower of
Previously listed as Palma il
Giovane (PMA 1965)
Allegory
c. 1515–20
Oil on canvas
55 7/8 × 62" (141.9 × 157.5 cm)

Purchased with the W. P.
Wilstach Fund
W1922-1-2

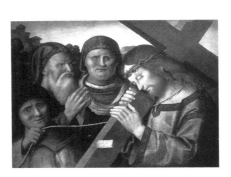

**Palmezzano, Marco (Marco
di Antonio Palmeggiano)**
Italian, active Forlì and Venice,
born c. 1459–63, died by 1539
Christ Carrying the Cross
c. 1530–39
Center bottom, on cartellino:
Marcus Palmezianus pictor /
forlienianus faciebat /
Mcccccxxx []
Oil on panel
22 3/8 × 32 3/16" (56.8 × 81.8 cm)

John G. Johnson Collection
inv. 212

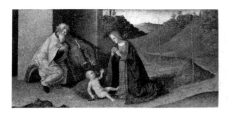

Palmezzano, Marco
The Nativity
Predella panel
Early 16th century
Oil on panel
9 3/4 × 19 1/2" (24.8 × 49.5 cm)

John G. Johnson Collection
cat. 147

Pannini, Giovanni Paolo, imitator of
Previously listed as the school of Giovanni Paolo Pannini (PMA 1965)
Landscape with Classical Ruins and Figures
18th century?
Oil on canvas
29 1/8 × 39 1/8" (74 × 99.4 cm)

The Bloomfield Moore Collection
1883-103

Pannini, Giovanni Paolo
Italian, born Piacenza, active Rome, 1692–1765
Landscape with Ruins
1730
Lower left: P. Pannini Rome 1730
Oil on canvas
39 × 53" (99.1 × 134.6 cm)

Gift of Dora Donner Ide in memory of John Jay Ide
1965-90-1

Pannini, Giovanni Paolo, imitator of
Previously attributed to Giovanni Paolo Pannini (PMA 1965)
The Roman Forum
18th century?
Oil on canvas
56 3/16 × 57 1/8" (142.7 × 145.1 cm)

Bequest of Mrs. Harry Markoe
1943-51-101

Pannini, Giovanni Paolo
Roman Monuments
1735?
Lower right: I. P. PANINI / Roma / 1735[?]; [monuments also inscribed]
Oil on canvas
38 3/4 × 53 1/4" (98.4 × 135.2 cm)

Purchased with Museum funds
1959-28-1

Pasini, Alberto
Italian, 1826–1899
Landscape with a River
1855
Lower right: A. Pasini. 55
Oil on panel
10 1/4 × 14" (26 × 35.6 cm)

John G. Johnson Collection
cat. 1055

Pannini, Giovanni Paolo, imitator of
Previously listed as Italian, unknown artist, 18th century (PMA 1965)
Architectural Composition
18th century?
Oil on canvas
28 1/4 × 35 3/8" (71.7 × 89.8 cm)

The Bloomfield Moore Collection
1883-115

Pasini, Alberto
Street in Constantinople
1867
Lower right: A Pasini, 1867
Oil on canvas
33 7/8 × 25 3/4" (86 × 65.4 cm)

John G. Johnson Collection
cat. 1056

Pasini, Alberto
Street in Damascus
1871
Lower right: A. Pasini. 1871.
Oil on canvas
9 5/16 × 15 13/16" (23.6 × 40.2 cm)

John G. Johnson Collection
cat. 1057

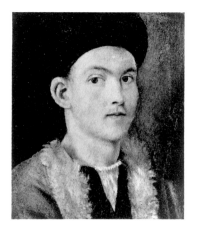

Piazza, Callisto, attributed to
Previously listed as Callisto
Piazza (JI 1966)
Portrait of a Young Man
Mid-16th century
Oil on panel
12 1/8 × 10 1/8" (30.8 × 25.7 cm)

John G. Johnson Collection
cat. 233

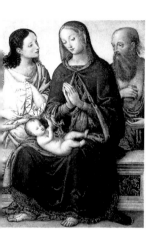

Pastura (Antonio del Massaro da Viterbo)
Italian, active central Italy,
documented 1478–1513,
died before 1516
Virgin and Child, with Saints John the Baptist and Jerome
Early 1480s?
On scroll: ECCE ANGNVS DEI
Oil on panel
31 × 21 1/16" (78.7 × 53.5 cm)

John G. Johnson Collection
cat. 143

Piermatteo Lauro de Manfredi da Amelia (Master of the Gardner Annunciation)
Italian, active central Italy,
documented 1467–1503
Saint Nicholas of Tolentino
Panel from an altarpiece;
companion panels are in the
Staatliche Museen zu Berlin-
Preussischer Kulturbesitz (129);
Staatliches Lindenau-Museum,
Altenburg, Germany (110, 111);
and a private collection
1481
On book, first page: ELC / ME /
ET / IN / SO; second page: ET
PRE / CECTA / PATRIS / MEI S /
RVARI; third page: ET MAN / EO
IN E / IVS DILE
Tempera and tooled gold on panel
47 1/2 × 16 1/2" (120.6 × 41.9 cm)

John G. Johnson Collection
cat. 140

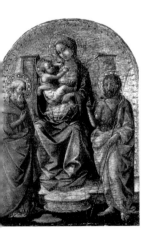

Pesellino (Francesco di Stefano)
Italian, active Florence,
c. 1422–1457
Enthroned Virgin and Child, with Saints Jerome and John the Baptist
c. 1448
Tempera and tooled gold on panel
11 3/4 × 7 7/8" (29.8 × 20 cm)

John G. Johnson Collection
cat. 35

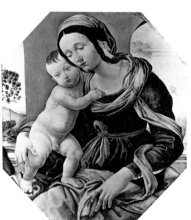

Piazza, Callisto (Calisto de la Piaza da Lodi)
Italian, active Lodi and Brescia,
first documented 1524, died 1561
Musical Group
1520s
Oil on panel
35 5/8 × 35 3/4" (90.5 × 90.8 cm)

John G. Johnson Collection
cat. 234

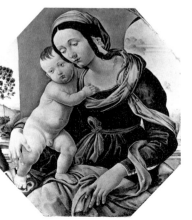

Piero di Cosimo (Piero di Lorenzo), follower of
Italian, active Florence,
1461/62–1521
Previously listed as Piero di
Cosimo (JI 1966)
Virgin and Child
Early 16th century?
Oil on panel
33 1/4 × 27 5/8" (84.4 × 70.2 cm)

John G. Johnson Collection
cat. 76

Pietro di Domenico da Montepulciano
Italian, active Marches,
dated works 1418–1422
Previously listed as a Sienese
artist, early 15th century (JI
1966)
Saint Paul
Predella panel
c. 1420
Tempera and tooled gold on panel
10 × 9 1/4" (25.4 × 23.5 cm)

John G. Johnson Collection
cat. 1170

**Piero di Miniato,
attributed to**
Italian, active Florence, first
documented 1386, died 1430–46
The Crucifixion
c. 1430
Tempera and tooled gold on panel
22 5/8 × 10 3/4" (57.5 × 27.3 cm)

The Louise and Walter Arensberg
Collection
1950-134-532

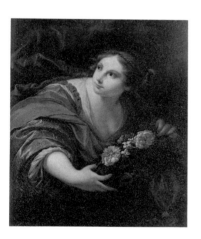

Pignoni, Simone
Italian, active Florence,
1611–1698
Previously listed as Italian,
unknown artist, 18th century
(PMA 1965)
Saint Rosalie [?]
Mid to late 17th century
Oil on canvas
34 × 28 1/2" (86.4 × 72.4 cm)

Bequest of Arthur H. Lea
F1938-1-2

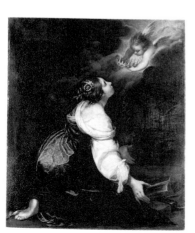

Pignoni, Simone, follower of
*Saint Catherine of Alexandria
Receiving the Crown of Heaven*
Late 17th century
Oil on canvas
80 1/2 × 63 3/4" (204.5 × 161.9 cm)

Bequest of Arthur H. Lea
F1938-1-40

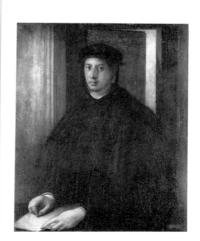

Pignoni, Simone, follower of
Previously listed as Italian,
unknown artist, 18th century
(PMA 1965)
Saint Dorothy of Cappadocia
Late 17th century
Oil on canvas
41 1/8 × 34" (104.5 × 86.4 cm)

Bequest of Arthur H. Lea
F1938-1-49

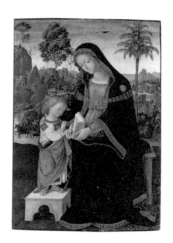

**Pinturicchio
(Bernardino di Betto)**
Italian, active central Italy,
1454–1513
Virgin Teaching Jesus to Read
c. 1500
Center, on book: Domine l[abia
mea] ape[ries]; on Virgin's halo:
AVE MARIA GRATIA PLENA
DOMINVS TECVM
Oil and gold on panel
24 1/8 × 16 1/2" (61.3 × 41.9 cm)

John G. Johnson Collection
inv. 1336

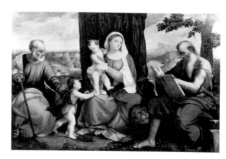

**Pitati, Bonifacio de', also
called Bonifacio Veronese**
Italian, c. 1487–1553
*The Holy Family, with the Young
Saint John the Baptist and Saint
Jerome*
c. 1530
Oil on canvas
55 1/4 × 80 3/4" (140.3 × 205.1 cm)

Purchased with the W. P.
Wilstach Fund
W1922-1-1

Pontormo (Jacopo Carucci)
Italian, active Florence,
1494–1557
Portrait of Alessandro de' Medici
1534–35
Oil on panel
39 3/4 × 32 1/16" (101 × 81.4 cm)

John G. Johnson Collection
cat. 83

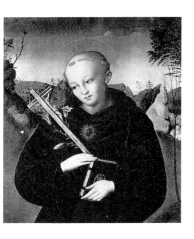

Pseudo Marco Meloni
Italian, active Mantua,
active c. 1510–1520
Previously listed as Gerolamo
Marchesi da Cotignola (JI 1966)
Saint Nicholas of Tolentino
c. 1510–20
Oil on panel
26 13/16 × 21 7/8" (68.1 × 55.6 cm)

John G. Johnson Collection
cat. 149

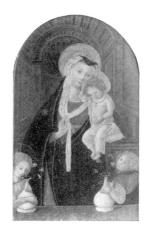

**Pseudo Pier Francesco
Fiorentino, follower of**
Previously listed as a composition
of Pier Francesco Fiorentino
(JI 1966)
Virgin and Child, with Two Angels
c. 1450–60
Across bottom: IVSTA PETENTI
GRATIOSA SINT
Tempera and tooled gold on panel
18 1/4 × 10 9/16" (46.3 × 26.8 cm)

John G. Johnson Collection
cat. 42

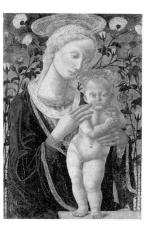

**Pseudo Pier Francesco
Fiorentino**
Italian, active Florence,
active c. 1445–1475
Previously listed as a composition
of Pier Francesco Fiorentino
(JI 1966)
Virgin and Child before a Rose Hedge
c. 1455–57
Tempera and tooled gold on panel
29 3/8 × 20 1/2" (74.6 × 52.1 cm)

John G. Johnson Collection
cat. 41

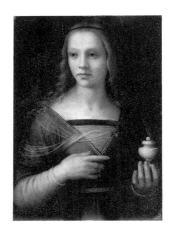

**Puligo, Domenico
(Domenico di Bartolomeo
degli Ubaldini), attributed to**
Italian, active Florence,
born 1492, still active 1527
Saint Mary Magdalene
An alternative attribution is to
Jacopino del Conte (Italian,
1510–1598)
Mid-1520s
Oil on panel
21 7/8 × 15 5/16" (55.6 × 38.9 cm)

John G. Johnson Collection
cat. 82

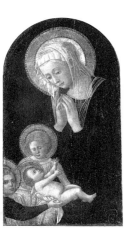

**Pseudo Pier Francesco
Fiorentino**
Previously listed as a composition
of Pier Francesco Fiorentino
(JI 1966)
Virgin and Child, with Two Angels
After 1458
Tempera and tooled gold on panel
19 3/16 × 11 1/8" (48.7 × 28.3 cm)

John G. Johnson Collection
cat. 40

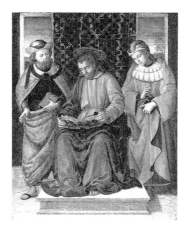

**Raphael (Raffaello Santi),
follower of**
Italian, active central Italy,
1483–1520
Previously listed as Pinturicchio
(JI 1966)
An Evangelist and Two Saints
Late 15th century
Oil and gold on panel
17 1/2 × 13 1/16" (44.4 × 33.2 cm)

John G. Johnson Collection
cat. 142

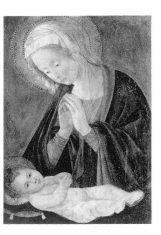

**Pseudo Pier Francesco
Fiorentino**
Previously listed as a composition
of Pier Francesco Fiorentino
(JI 1966)
Virgin and Child
After 1460
Tempera and tooled gold on panel
21 1/16 × 14 11/16" (53.5 × 37.3 cm)

John G. Johnson Collection
cat. 39

Raphael, copy after
The Christ Child
After the child in Raphael's
Madonna di Loreto, in the Musée
Condé, Chantilly
19th century?
Oil on panel
21 9/16 × 26" (54.8 × 66 cm)

John G. Johnson Collection
cat. 152

Reni, Guido, copy after
Italian, active Bologna and
Rome, 1575–1642
Lamentation
After the painting in the
Pinacoteca Nazionale, Bologna
(inv. 445)
19th century?
Oil on canvas
33 7/16 × 43 1/2" (84.9 × 110.5 cm)

John G. Johnson Collection
cat. 283

**Ricci, Sebastiano,
attributed to**
Italian, 1659–1734
Previously listed as Alessandro
Magnasco (JI 1966)
Christ Fed by Angels
c. 1690–1700
Oil on canvas
22 3/4 × 28 1/2" (57.8 × 72.4 cm)

John G. Johnson Collection
cat. 816

Reni, Guido, copy after
Rest on the Flight into Egypt
Copy by D. Titov (Russian,
active c. 1913) after the painting
in the Hermitage, St. Petersburg
(inv. no. 58)
1913
On reverse: [Russian for "Copy
from Guido Reni / painted by
D. Titov / from St. Petersburg"]
Oil on canvas
49 1/4 × 40 9/16" (125.1 × 103 cm)

Bequest of Arthur H. Lea
F1938-1-45

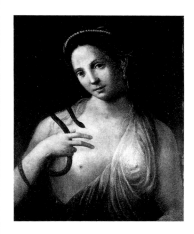

**Riccio (Bartolommeo
Neroni), attributed to**
Italian, active Siena,
born c. 1505–10, died 1571
Previously listed as Francesco
Salviati (JI 1966)
Cleopatra
Mid-16th century
Oil on panel
27 1/2 × 21 1/4" (69.8 × 54 cm)

John G. Johnson Collection
cat. 86

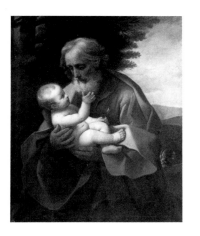

Reschi, Pandolfo
Italian, born Poland, active
Florence, 1643–1699
Encampment in a Storm
1690–92
Lower right: Pandolfo Reschi
Oil on canvas
57 1/2 × 80 1/2" (146 × 204.5 cm)

Bequest of Arthur H. Lea
F1938-1-46

Riccio, follower of
Previously listed as Sodoma
(JI 1966)
The Adoration of the Magi
Predella panel
c. 1525
Oil on panel
6 1/16 × 21 1/4" (15.4 × 54 cm)

John G. Johnson Collection
cat. 277

Ricci, Marco, follower of
Italian, active Venice, Veneto,
Rome, and England, 1676–1730
Previously listed as Philippe
Jacques de Loutherbourg
(PMA 1965)
*Landscape with Cattle and a
Horseman*
Possibly by an English artist
18th century
Oil on canvas
28 3/4 × 38 3/4" (73 × 98.4 cm)

The Bloomfield Moore Collection
1883-101

Rondinelli, Niccolò
Italian, active Ravenna, Venice,
and Forlì, documented
1495–1502
*The Miracle of the Oil Lamp and the
Flagellation of Saint Bartholomew*
Predella panel of an altarpiece
from San Domenico, Ravenna;
companion predella panels are in
the Musée du Petit Palais, Avi-
gnon (210, 211), and an
unknown location; the main sec-
tion is in the Pinacoteca di Brera,
Milan (453)
After 1496
Oil on panel
14 1/2 × 36" (36.8 × 91.4 cm)

John G. Johnson Collection
cat. 150

Rosa, Salvatore, follower of
Italian, 1615–1673
Previously listed as Salvatore
Rosa (PMA 1965)
Battle Scene
c. 1650
Oil on canvas
49 1/16 × 68" (124.6 × 172.7 cm)

Purchased with the W. P.
Wilstach Fund
W1904-1-26

Sano di Pietro, workshop of
Italian, active Siena, 1406–1481
Previously listed as Sano di Pietro
(JI 1966)
Virgin and Child, with Four Angels
Mid-15th century
On Virgin's halo: AVE GRATI{A}
PLENA DO[MINI]
Tempera and tooled gold on panel
18 1/4 × 14 5/16" (46.3 × 36.3 cm)

John G. Johnson Collection
cat. 106

**Rosselli, Bernardo di
Stefano**
Italian, active Florence,
1450–1526
Previously listed as the school of
Paolo Uccello (JI 1966)
Two Riders Watching a Bird
Late 15th century
Tempera on panel
16 3/8 × 14 1/8" (41.6 × 35.9 cm)

John G. Johnson Collection
cat. 1165

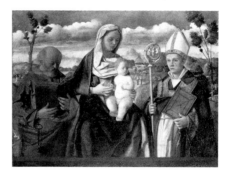

**Santacroce, Gerolamo da
(Gerolamo Galizzi)**
Italian, active Venice, first
recorded 1503, died 1556
*Virgin and Child, with Saints Peter
and Giles*
c. 1512
Oil on panel
28 3/4 × 36 3/8" (73 × 92.4 cm)

John G. Johnson Collection
cat. 184

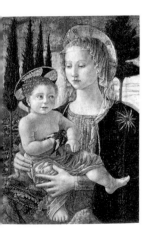

Rosselli, Cosimo
Italian, active Florence,
1439–1507
Virgin and Child
c. 1470
Tempera and tooled gold on panel
28 3/4 × 19" (73 × 48.3 cm)

John G. Johnson Collection
cat. 60

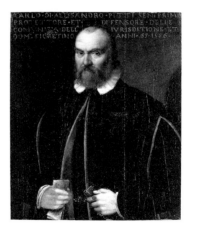

Santi di Tito, attributed to
Italian, active Florence and
Rome, 1536–1603
Previously listed as Santi di Tito
(JI 1966)
Portrait of Carlo Pitti
1586
Across top: CARLO DI ALESSAN-
DRO PITTI SEN[ATORE] PRIMO /
PROTETTORE ET DIFENSORE
DELLE / COMMVNITA DELLA IV-
RISDITIONE ET / DOM[INIONE]
FIORE[N]TINO ANNI 63 1586
Oil on panel
34 7/16 × 25 3/4" (87.5 × 65.4 cm)

John G. Johnson Collection
cat. 87

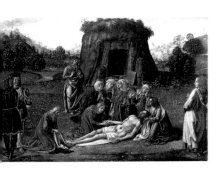

Rosselli, Cosimo
Lamentation
Predella panel
1480s?
Tempera and gold on panel
13 1/2 × 19 1/4" (34.3 × 48.9 cm)

John G. Johnson Collection
cat. 72

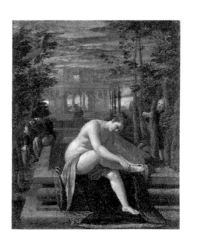

**Scarsellino
(Ippolito Scarsella)**
Italian, active Ferrara,
1551–1620
Susanna and the Elders
Early 17th century
Oil on copper
11 11/16 × 9 1/16" (29.7 × 23 cm)

John G. Johnson Collection
cat. 255

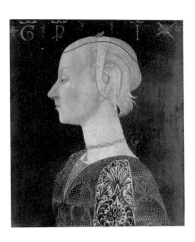

Scheggia (Giovanni di Ser Giovanni di Mone Cassai)
Italian, active Florence and environs, 1406–1486
Previously listed as the Master of the Fucecchio Altarpiece (JI 1966)
Portrait of a Lady
c. 1440–1450
Across top: G P I
Tempera on panel
17 3/8 × 14 5/16" (44.1 × 36.3 cm)

John G. Johnson Collection
cat. 34

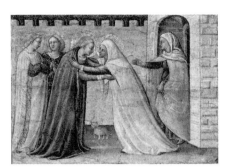

Schiavo, Paolo (Paolo di Stefano Badaloni)
Italian, active Florence and environs, 1397–1478
Previously listed as Arcangelo di Cola da Camerino (JI 1966)
The Visitation
Predella panel; companion to the following three panels; the main sections of the altarpiece are in the Gemäldegalerie, Staatliche Museen zu Berlin-Preussischer Kulturbesitz (cat. no. 1136, 1123)
Early 1430s
Tempera and tooled gold on panel
8 7/8 × 11 7/8" (22.5 × 30.2 cm)

John G. Johnson Collection
cat. 124

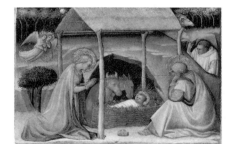

Schiavo, Paolo
Previously listed as Arcangelo di Cola da Camerino (JI 1966)
The Nativity
See previous entry
Early 1430s
Tempera and tooled gold on panel
8 7/8 × 12 3/4" (22.5 × 32.4 cm)

John G. Johnson Collection
cat. 125

Schiavo, Paolo
Previously listed as Arcangelo di Cola da Camerino (JI 1966)
The Adoration of the Magi
See previous two entries
Early 1430s
Tempera and tooled gold on panel
8 7/8 × 12 3/4" (22.5 × 32.4 cm)

John G. Johnson Collection
cat. 126

Schiavo, Paolo
Previously listed as Arcangelo di Cola da Camerino (JI 1966)
The Flight into Egypt
See previous three entries
Early 1430s
Tempera and tooled gold on panel
8 7/8 × 11 7/8" (22.5 × 30.2 cm)

John G. Johnson Collection
cat. 127

Sebastiano del Piombo (Sebastiano Luciani), copy after
Italian, active Venice and Rome, c. 1485–1547
Previously listed as a central Italian artist, late 16th century (JI 1966)
The Vision of Saint Anthony Abbot
Possibly by Girolamo Muziano (Italian, 1532–1592); after the painting in the Musée National du Château de Compiègne
Late 16th century
Oil on canvas
51 3/4 × 39" (131.4 × 99.1 cm)

John G. Johnson Collection
cat. 193

Sellaio, Jacopo del (Jacopo di Archangelo)
Italian, active Florence, 1441/42–1493
The Virgin Adoring the Christ Child, with Saint John the Baptist, the Three Magi, the Annunciation to the Shepherds, and the Penitent Saint Jerome
1480s
Tempera and gold on panel
41 3/4 × 25" (106 × 63.5 cm)

John G. Johnson Collection
cat. 52

Sellaio, Jacopo del
The Virgin of Humility before a Rose Hedge, with Saint John the Baptist and an Angel
1480s
On scroll: ECE ANIV DEH ECCE / LOT PEHATA
Tempera and gold on panel
29 × 20" (73.7 × 50.8 cm)

John G. Johnson Collection
cat. 53

230

Sellaio, Jacopo del
*The Reconciliation of the Romans
and Sabines*
Spalliera panel
Late 1480s
Tempera and gold on panel
23 3/4 × 67 1/4" (60.3 × 170.8 cm)

John G. Johnson Collection
cat. 54

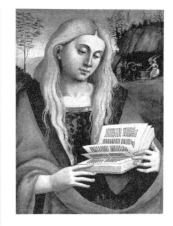

**Signorelli, Luca,
workshop of**
Previously listed as Luca
Signorelli (JI 1966)
Saint Mary Magdalene
Fragment
c. 1522–24
On collar: MADALE
Oil on panel transferred to canvas
28 3/8 × 19 7/8" (72.1 × 50.5 cm)

John G. Johnson Collection
cat. 135

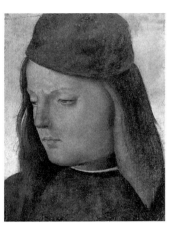

Signorelli, Luca
Italian, active central Italy, first
documented 1470, died 1523
Head of a Boy
Fragment from an altarpiece
c. 1492–93
Tempera on panel
10 9/16 × 8 1/16" (26.8 × 20.5 cm)

John G. Johnson Collection
cat. 138

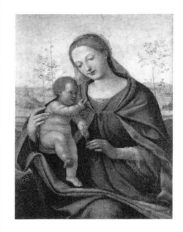

**Sodoma (Giovanni Antonio
Bazzi)**
Italian, active Siena and Rome,
1477–1549
Virgin and Child
c. 1508–10
Oil on panel
25 × 18 1/4" (63.5 × 46.3 cm)

John G. Johnson Collection
cat. 278

Signorelli, Luca
The Annunciation
Predella panel
c. 1496–1500
Oil on panel transferred to canvas
9 11/16 × 15 3/4" (24.6 × 40 cm)

John G. Johnson Collection
cat. 136

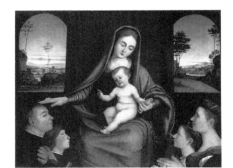

Solario, Andrea
Italian, active Venice, Milan,
Normandy, and Rome, first dated
work 1495, died 1524
*Enthroned Virgin and Child, with
Four Donors*
c. 1490–93
Oil on panel transferred to canvas
27 3/8 × 35 7/16" (69.5 × 90 cm)

John G. Johnson Collection
cat. 272

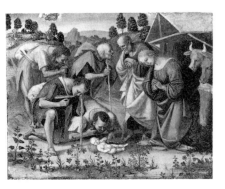

Signorelli, Luca
The Adoration of the Shepherds
Predella panel; a companion
panel is in the Yale University
Art Gallery (1871.69); they are
possibly from the predella of
Signorelli's *Virgin and Child and
Four Franciscan Saints*, in the
Museo Diocesano, Cortona, Italy
c. 1509–10
Tempera on panel
14 1/8 × 17 1/8" (35.9 × 43.5 cm)

John G. Johnson Collection
cat. 137

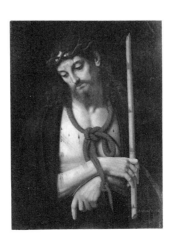

Solario, Andrea
*Christ Bound and Crowned with
Thorns*
c. 1509
Lower right: Andreas de Solario
Oil on panel
24 7/8 × 18" (63.2 × 45.7 cm)

John G. Johnson Collection
cat. 274

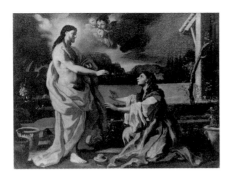

Solimena, Francesco, workshop of
Italian, 1657–1747
"Noli Me Tangere"
c. 1730
Oil on canvas
19 3/16 × 25 1/16" (48.7 × 63.7 cm)

Purchased with the W. P. Wilstach Fund
W1904-1-46

c. 1408
Tempera and tooled gold on panel
40 7/16 × 35 5/8" (102.7 × 90.5 cm)

John G. Johnson Collection
cat. 13

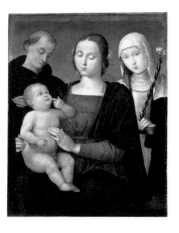

Lo Spagna (Giovanni di Pietro), workshop of
Italian, active Umbria and Marches, first documented 1470, died 1528
Virgin and Child, with a Monk Saint and Saint Catherine of Siena
A variant is in the National Gallery of Ireland, Dublin (no. 212)
Early 16th century
Oil on panel transferred to canvas
19 5/8 × 14 15/16" (49.8 × 37.9 cm)

John G. Johnson Collection
cat. 145

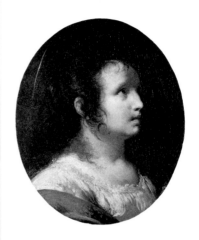

Strozzi, Bernardo
Italian, 1581–1644
Female Saint
c. 1625
Oil on canvas
22 × 17" (55.9 × 43.2 cm)

Bequest of Arthur H. Lea
F1938-1-16

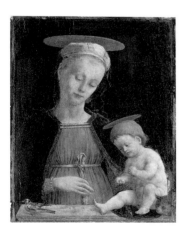

Spanzotti, Giovanni Martino
Italian, active Piedmont, documented 1480–1513
Previously listed as the studio of Cosimo Tura (JI 1966)
Virgin and Child, with a Bird and a Cat
c. 1475
Oil on panel
17 5/16 × 13 7/16" (44 × 34.1 cm)

John G. Johnson Collection
cat. 242

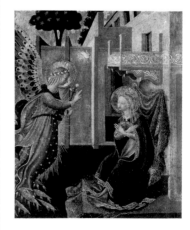

Strozzi, Zanobi (Zanobi di Benedetto di Caroccio degli Strozzi)
Italian, active Florence, 1412–1468
Previously listed as Domenico di Michelino (JI 1966)
The Annunciation
c. 1453
Tempera and gold on panel
14 9/16 × 11 7/8" (37 × 30.2 cm)

John G. Johnson Collection
cat. 22

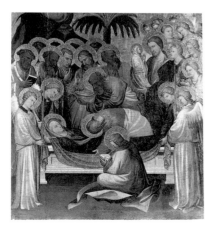

Starnina (Gherardo di Jacopo di Neri) (Master of the Bambino Vispo)
Italian, active Florence, Valencia, Toledo, and Empoli, documented 1387–1409, died before 1413
The Dormition of the Virgin
From an altarpiece from the Monastero dell'Angelo, Lucca; other panels from the altarpiece are in the Fogg Art Museum, Cambridge, Mass. (1920.1); the Museo Nazionale di Villa Guinigi, Lucca (287, 288); the Nelson-Atkins Museum of Art, Kansas City, Mo. (61-60); and a private collection in Turin

Taddeo di Bartolo
Italian, active Siena and environs, Perugia, Pisa, and Genoa, first documented 1383, died 1422
Previously listed as Barna (JI 1966)
Saint Anthony Abbot, Saint Andrew, the Virgin Mourning, the Man of Sorrows, Saint John the Evangelist Mourning, the Archangel Raphael, and Saint Lawrence
Predella from an altarpiece once in San Paolo, Collegarli (Pisa)
1389
Tempera, tooled gold, and colored glass on panel
9 1/16 × 82 5/8" (23 × 209.9 cm)

John G. Johnson Collection
cat. 95

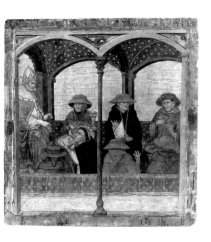

Taddeo di Bartolo
Saint Thomas Aquinas Submitting His Office for Corpus Domini to Pope Urban IV
Predella panel?; other panels from the altarpiece are in the Smith College Museum of Art, Northampton, Mass. (1958.38); the Marion Koogler McNay Art Museum, San Antonio, Texas (1955.11); and the Pinacoteca Nazionale di Siena (129)
c. 1403
Tempera and tooled gold on panel
16 × 14 ⅛" (40.6 × 35.9 cm)

John G. Johnson Collection
cat. 101

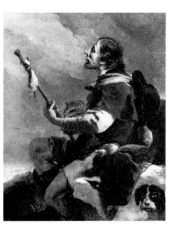

Tiepolo, Giovanni Battista
Italian, active Venice, Udine, Würzburg, and Madrid, 1696–1770
Saint Roch
1730–35
Oil on paper on canvas
17 ¾ × 13 ⅜" (45.1 × 34 cm)

John G. Johnson Collection
cat. 289

Tiepolo, Giovanni Battista
Sketch for "The Glory of Saint Dominic"
For the ceiling of the Church of the Gesuati, Venice
1738–39
Oil on canvas
15 ⅛ × 20 ⁹⁄₁₆" (38.4 × 52.2 cm)

John G. Johnson Collection
cat. 286

Tiepolo, Giovanni Battista
Sketch for "Venus and Vulcan"
For the ceiling of the Salón de Alabarderos, Palacio Real, Madrid
1765–66
Oil on paper on canvas
27 ³⁄₁₆ × 34 ⁵⁄₁₆" (69.1 × 87.1 cm)

John G. Johnson Collection
cat. 287

Tiepolo, Giovanni Battista, copy after
The Martyrdom of Saint Agatha
After the altarpiece in the Basilica di Sant'Antonio, Padua
c. 1750–1800
Oil on canvas
23 ½ × 13 ⅛" (59.7 × 33.3 cm)

The William L. Elkins Collection
E1924-3-94

Tiepolo, Giovanni Domenico
Italian, active Venice, Würzburg, and Madrid, 1727–1804
The Miracle of the Pool of Bethesda
c. 1759
Oil on canvas
28 × 45 ⅝" (71.1 × 115.9 cm)

Purchased with the W. P. Wilstach Fund
W1902-1-12

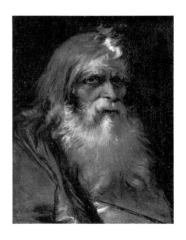

Tiepolo, Giovanni Domenico, studio of
Head of an Old Man
Variant of an autograph painting in the Museo Civico Malaspina, Pavia
c. 1773–75
Oil on canvas
18 ½ × 15" (47 × 38.1 cm)

John G. Johnson Collection
cat. 288

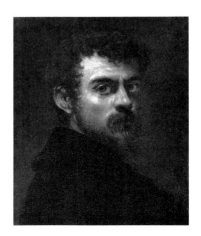

Tintoretto (Jacopo di Giovanni Battista Robusti)
Italian, active Venice, 1519–1594
Self-Portrait
c. 1546–48
Oil on canvas
17 ¾ × 15" (45.1 × 38.1 cm)

Gift of Marion R. Ascoli and the Marion R. and Max Ascoli Fund in honor of Lessing Rosenwald
1983-190-1

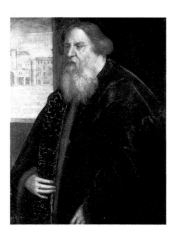

Tintoretto, follower of
Previously attributed to
Tintoretto (JI 1966)
Portrait of a Venetian Senator
Mid-16th century
Oil on canvas
41 3/4 × 29 3/4" (106 × 75.6 cm)

John G. Johnson Collection
cat. 209

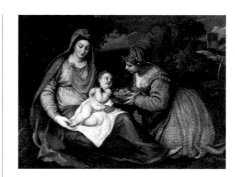

Titian, studio of
Previously listed as Titian
(PMA 1965)
*Virgin and Child, with Saint
Dorothy*
c. 1530–40
Oil on canvas
46 7/16 × 60 3/4" (117.9 × 154.3 cm)

The George W. Elkins Collection
E1957-1-1

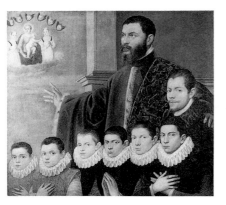

Tintoretto, follower of
Previously listed as the school of
Tintoretto (JI 1966)
*Portrait of a Venetian Senator with
Male Members of His Family, the
Virgin and Child with Cherubim,
and Two Female Figures in Glory*
Late 16th century
Oil on canvas
44 × 48 3/16" (111.8 × 122.4 cm)

John G. Johnson Collection
cat. 210

**Todeschini (Giacomo
Francesco Cipper)**
Italian, born Germany or
Switzerland?, active Bergamo,
dated works 1705–1736
Portrait of a Peasant Girl
1730s
Oil on canvas
15 5/8 × 13 7/16" (39.7 × 34.1 cm)

John G. Johnson Collection
cat. 781

Tintoretto, copy after
Previously listed as the school of
Tintoretto (JI 1966)
*The Parable of the Wise and Foolish
Virgins*
After the painting in the Museum
Boymans–van Beuningen,
Rotterdam (2567)
18th century?
Oil on canvas
34 1/4 × 41 3/4" (87 × 106 cm)

John G. Johnson Collection
cat. 211

**Tommaso del Mazza
(Master of Santa Verdiana)**
Italian, active Florence,
documented 1377–1375
*The Virgin of Humility, with Eight
Angels*
c. 1370–75
Tempera and tooled gold on panel
32 1/2 × 23 3/8" (82.5 × 59.4 cm)

Purchased from the George Grey
Barnard Collection with Museum
funds
1945-25-119

Titian (Tiziano Vecellio)
Italian, active Venice, first
securely documented 1508,
died 1576
*Portrait of Cardinal Filippo
Archinto*
1558
Oil on canvas
45 3/16 × 34 15/16" (114.8 ×
88.7 cm)

John G. Johnson Collection
cat. 204

**Toscani, Giovanni (Giovanni
di Francesco Toscani)**
Italian, active Florence,
born 1370–80, died 1430
Previously listed as the Master of
the Griggs Crucifixion (PMA
1965)
Virgin and Child
Cut; panel from the altarpiece
from San Bartolomeo, Prato;
companion panels are in the
Museo Diocesano, Prato
c. 1422–23
Tempera and tooled gold on panel
20 3/16 × 10 1/2" (51.3 × 26.7 cm)

The John D. McIlhenny
Collection
1943-40-45

Toscani, Giovanni
Previously listed as the Master of
the Griggs Crucifixion (JI 1966)
*The Baptism of Christ and the
Martyrdom of Saint James the Great*
Predella panel from the altarpiece
from the Ardinghelli Chapel in
Santa Trinita, Florence;
companion panels are in the
Galleria dell'Accademia, Florence
(no. 3333, no. 6089); the Walters
Art Gallery, Baltimore (37.632);
the Carandini Collection, Rome;
and a private collection in
Florence
1423–24
Tempera and tooled gold on panel
16 1/8 × 26 3/8" (41 × 67 cm)

John G. Johnson Collection
cat. 11

**Tosini, Michele (Michele di
Ridolfo del Ghirlandaio),
follower of**
Italian, active Florence,
1503–1577
*Virgin and Child, with Saint John
the Baptist*
Mid-16th century
Oil on panel
22 3/4 × 17 1/4" (57.8 × 43.8 cm)

Bequest of Arthur H. Lea
F1938-1-10

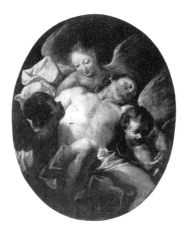

**Trevisani, Francesco,
follower of**
Italian, active Rome, 1656–1746
Previously listed as Raphael
Mengs (JGJ 1941)
Dead Christ Supported by Angels
Based on a painting by Trevisani
known in several versions, one of
which is in the Kunsthistorisches
Museum, Vienna (inv. no. 1564)
c. 1720
Oil on panel
11 7/8 × 8 3/4" (30.2 × 22.2 cm)

John G. Johnson Collection
inv. 2924

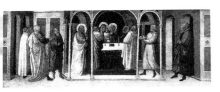

Toscani, Giovanni
Previously listed as Andrea di
Giusto (JI 1966)
*The Presentation of Christ in the
Temple*
Predella panel; companion to the
following panel and panels in the
National Gallery of Victoria,
Melbourne (1731/5)
c. 1427–30
Tempera and gold on panel
7 1/4 × 19 3/8" (18.4 × 49.2 cm)

John G. Johnson Collection
cat. 18

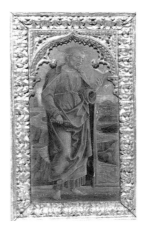

Tura, Cosimo (Cosmé Tura)
Italian, active Ferrara, first
documented 1430, died 1495
Saint Peter
Companion to the following
painting
c. 1474
Tempera on panel
9 3/8 × 5 5/8" (23.8 × 14.3 cm)

John G. Johnson Collection
cat. 241a

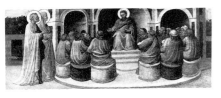

Toscani, Giovanni
Previously listed as Andrea di
Giusto (JI 1966)
Christ among the Doctors
See previous entry
c. 1427–30
Tempera and gold on panel
7 5/8 × 19 3/4" (19.4 × 50.2 cm)

John G. Johnson Collection
cat. 19

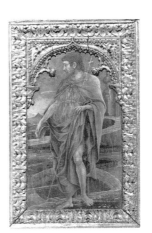

Tura, Cosimo
Saint John the Baptist
Companion to the preceding
painting
c. 1474
Tempera on panel
9 3/8 × 5 5/8" (23.8 × 14.3 cm)

John G. Johnson Collection
cat. 241b

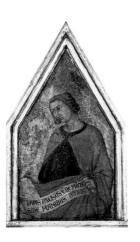

Ugolino di Nerio
Italian, active Siena,
documented 1317–27
Prophet Daniel
Pinnacle from the high altarpiece
from Santa Croce, Florence;
companion panels are in the
Gemäldegalerie, Staatliche
Museen zu Berlin-Preussischer
Kulturbesitz (cat. no. 1635
A–E); the National Gallery,
London (1188, 1189,
3376–3378, 3473, 4191); the
Los Angeles County Museum of
Art (49.17.40); and the
Metropolitan Museum of Art,
New York (1975.1.7)
c. 1325
On scroll: LAPIS ASCISUS E[ST]
DE MO[N]TE SINE MANIBUS
Tempera and tooled gold on panel
21 1/4 × 12 3/16" (54 × 31 cm)

John G. Johnson Collection
cat. 89

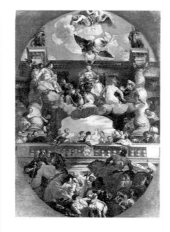

Veronese, Paolo, copy after
Previously listed as a Veronese
artist, c. 1600 (JI 1966)
Triumph of Venice
After the painting in the Sala del
Maggior Consiglio, Palazzo
Ducale, Venice
18th century
Oil on canvas
42 1/2 × 29" (107.9 × 73.7 cm)

John G. Johnson Collection
cat. 231

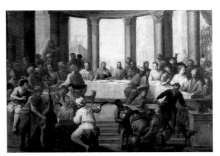

Veronese, Paolo, copy after
The Marriage at Cana
Based in part on the painting in
the Musée du Louvre, Paris (inv.
142)
19th century
Oil on canvas
38 × 52 1/2" (96.5 × 133.3 cm)

Bequest of Arthur H. Lea
F1938-1-26

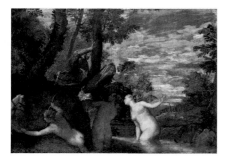

**Veronese, Paolo
(Paolo di Gabriele Caliari)**
Italian, active Verona, Venice,
and environs, 1528–1588
Diana and Actaeon
c. 1560
Oil on canvas
47 3/4 × 64 3/4" (121.3 × 164.5 cm)

John G. Johnson Collection
cat. 225

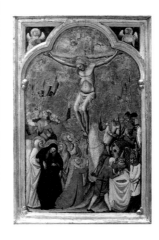

**Vitale da Bologna
(Vitale di Aimo degli Equi)**
Italian, active Bologna and
Udine, documented 1330–1359
Previously listed as a Bolognese
artist, c. 1375–1400 (JI 1966)
*The Crucifixion, with Symbols of
Saints Matthew and John the
Evangelist*
c. 1335
On crucifix: I N R I
Tempera and tooled gold on panel
24 7/16 × 15 3/4" (62.1 × 40 cm)

John G. Johnson Collection
cat. 1164

Veronese, Paolo
Portrait of Giuliano Contarini
1570s
Oil on canvas
49 5/8 × 44 5/8" (126 × 113.3 cm)

John G. Johnson Collection
cat. 208

Vivarini, Alvise
Italian, active Venice,
c. 1446–c. 1505
Portrait of an Elderly Gentleman
c. 1490
Oil on panel transferred to canvas
11 13/16 × 9 5/16" (30 × 23.6 cm)

John G. Johnson Collection
cat. 166

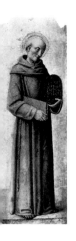

Vivarini, Antonio
Italian, active Venice,
born by 1441, died 1476–84
Saint Bernardino of Siena
Panel from an altarpiece
c. 1465–70
Oil and tooled gold on panel
44 × 14 ⅛" (111.8 × 35.9 cm)

John G. Johnson Collection
cat. 154

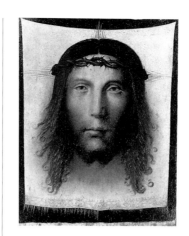

**Zaganelli, Bernardino di
Bosio**
Italian, active Romagna,
c. 1470–c. 1510
Previously listed as Antonello de
Saliba (JI 1966)
Saint Veronica's Veil
c. 1500
Oil on panel
10 ½ × 8" (26.7 × 20.3 cm)

John G. Johnson Collection
cat. 160

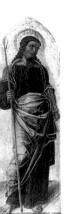

Vivarini, Bartolomeo
Italian, active Venice,
signed works 1450–1490
Saint James the Great
Panel from an altarpiece;
companion to the following panel
c. 1470–75
Tempera and tooled gold on panel
39 ⅞ × 11 ¹⁵/₁₆" (101.3 × 30.3 cm)

John G. Johnson Collection
cat. 155

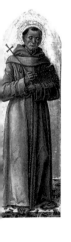

Vivarini, Bartolomeo
Saint Francis of Assisi
Panel from an altarpiece;
companion to the preceding panel
c. 1470–75
Tempera and tooled gold on panel
39 ¾ × 11 ½" (101 × 29.2 cm)

John G. Johnson Collection
cat. 156

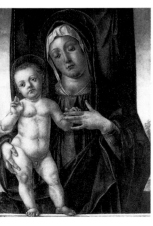

Vivarini, Bartolomeo
Previously listed as Jacopo da
Valenza (JI 1966)
Virgin and Child
c. 1480
Tempera on panel
26 ⅛ × 19 ⁷/₁₆" (66.4 × 49.4 cm)

John G. Johnson Collection
cat. 157

SPANISH

Alcañiz, Miguel, attributed to
Spanish, active Valencia and
Majorca, documented 1421–1434
Previously listed as Andreas
Marzal de Sax (JGJ 1941)
The Nativity
Panel from an altarpiece;
companion to the following panel
and a panel in the Museo
Provincial de Bellas Artes,
Zaragoza (8)
Early 1420s
Tempera and tooled gold on panel
33 1/2 × 11" (85.1 × 27.9 cm)

John G. Johnson Collection
cat. 756

Alcañiz, Miguel, attributed to
Previously listed as Andreas
Marzal de Sax (JGJ 1941)
The Dormition of the Virgin
See previous entry
Early 1420s
Tempera and tooled gold on panel
33 3/4 × 11 1/8" (85.7 × 28.3 cm)

John G. Johnson Collection
cat. 757

Cano, Alonso, follower of
Spanish, active Granada, Seville,
and Madrid, 1601–1667
Previously listed as Bartolomé
Esteban Murillo (PMA 1965)
Saint Anthony of Padua
Mid-17th century
Oil on canvas
46 5/8 × 39" (118.4 × 99.1 cm)

Purchased with the W. P.
Wilstach Fund
W1904-1-23

Castro, Bartolomé del
Spanish, active Palencia and
environs, died 1507
*Pope Honorius III Approving the
Rule of Saint Francis of Assisi*
Panel from an altarpiece
c. 1500
Tempera and tooled gold on panel
48 5/16 × 33 5/8" (122.7 × 85.4 cm)

John G. Johnson Collection
cat. 800

**Espalargues, Pere
(Pere Espalargucs)**
Spanish, active Lérida,
documented 1490
Saint Peter
Panel from an altarpiece;
companion to the following five
panels and panels in the
collection of the Hispanic Society
of America, New York (28320),
and an unknown location
c. 1490
On scroll: TIBI DABO CLAVES
REGNUM []UM
Oil and tooled gold on panel
51 1/4 × 22 1/8" (130.2 × 56.2 cm)

John G. Johnson Collection
inv. 170

Espalargues, Pere
Mourning Virgin
See previous entry
c. 1490
Oil and tooled gold on panel
16 3/8 × 10 5/16" (41.6 × 26.2 cm)

John G. Johnson Collection
inv. 171

Espalargues, Pere
Saint John the Evangelist Mourning
See previous two entries
c. 1490
Oil on panel
16 3/8 × 10 5/16" (41.6 × 26.2 cm)

John G. Johnson Collection
inv. 172

Espalargues, Pere
*Saints Mary Magdalene,
Ermengold, and Catherine of
Alexandria*
See previous three entries
c. 1490
On scroll: S M MAGDALENA
S ERMEGAUD S KATHERNIA
Oil and tooled gold on panel
26 3/4 × 22" (67.9 × 55.9 cm)

John G. Johnson Collection
inv. 173

Espalargues, Pere
Saints John the Baptist, Bridget, and the Archangel Michael
See previous four entries
c. 1490
On scroll: S JOHES S BRIGIDA
S MICHAEL
Oil and tooled gold on panel
26 13/16 × 22 1/2" (68.1 × 57.1 cm)

John G. Johnson Collection
inv. 174

Espalargues, Pere
Saint Paul
See previous five entries
c. 1490
On scroll: PREDICATOR VITA []T
ET DOCTOR GE[]CIU[?]
Oil and tooled gold on panel
51 1/4 × 22 1/8" (130.2 × 56.2 cm)

John G. Johnson Collection
inv. 175

Esteve y Marques, Agustín
Spanish, 1753–c. 1820
Previously attributed to Francisco
José de Goya y Lucientes (JGJ
1941)
*Portrait of Isidro González
Velásquez* [?]
Companion to the following
painting
c. 1803–5
Oil on canvas
36 3/4 × 28 1/8" (93.3 × 71.4 cm)

John G. Johnson Collection
cat. 818

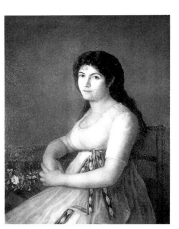

Esteve y Marques, Agustín
Previously attributed to Francisco
José de Goya y Lucientes (JGJ
1941)
*Portrait of the Wife of Isidro
González Velásquez* [?]
Companion to the preceding
painting
c. 1803–5
Oil on canvas
36 3/4 × 28 1/8" (93.3 × 71.4 cm)

John G. Johnson Collection
cat. 819

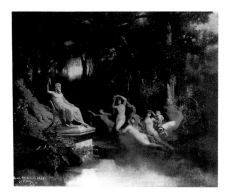

Fortuny y Carbó, Mariano
Spanish, 1838–1874
Statue of Dionysus
1858
Lower left: Roma 11 Septembre
1858. / M. Fortuny
Oil on canvas
28 1/2 × 32 1/2" (72.4 × 82.5 cm)

John G. Johnson Collection
cat. 991

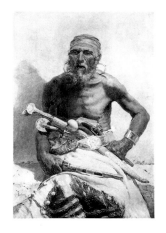

Fortuny y Carbó, Mariano
Arab Chief
1874
Lower left: Fortuny 74
Oil on canvas
48 3/8 × 31 1/8" (122.9 × 79.1 cm)

John G. Johnson Collection
cat. 992

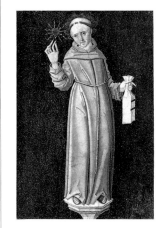

**Gallegos, Fernando,
follower of**
Spanish, active Castile,
documented 1466–1507
Saint Bernardino of Siena
c. 1500
Oil on panel
13 15/16 × 9" (35.4 × 22.9 cm)

John G. Johnson Collection
cat. 325

**Goya y Lucientes, Francisco
José de**
Spanish, 1746–1828
The Seesaw
Cartoon for a tapestry in the
Escorial
1791–92
Oil on canvas
32 7/16 × 64 1/4" (82.4 × 163.2 cm)

Gift of Miss Anna Warren
Ingersoll
1975-150-1

Goya y Lucientes, Francisco José de
Portrait of the Toreador José Romero
c. 1795
On label on reverse: El celebre torero José Romero, con el / rico vestido que le regaló la Duquesa / de Alva, à que se añade tener el Capote / Terezano, Pañuelo Rondeño al cuello, y / la faxa a lo Sevillano, para denotar / las proezas que en la lid de Toros / hizo en estas tres Ciudades. Este famoso / y diestro torero fue el que de una es— / tocada se dejó a sus pies el terrible toro / que mató al habil / Pepeillo.
Oil on canvas
36 5/16 × 29 7/8" (92.2 × 75.9 cm)

The Mr. and Mrs. Carroll S. Tyson, Jr., Collection
1963-116-8

Goya y Lucientes, Francisco José de, copy after
Previously attributed to Francisco José de Goya y Lucientes (JGJ 1941)
Mounted Cavalier with a Javelin
After the painting in the Museo del Prado, Madrid (744)
Late 19th century
Lower right (spurious): F. Goya
Oil on canvas
16 × 12 7/8" (40.6 × 32.7 cm)

John G. Johnson Collection
cat. 820

El Greco (Domenicos Theotocopulos)
Spanish, born Crete, active Italy and Toledo, 1541–1614
Lamentation
c. 1565–70
Oil on copper
11 3/8 × 7 7/8" (28.9 × 20 cm)

John G. Johnson Collection
cat. 807

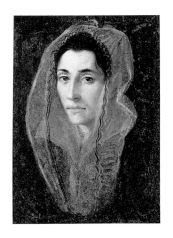

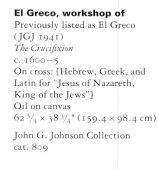

El Greco, workshop of
Previously listed as El Greco (JGJ 1941)
The Crucifixion
c. 1600–5
On cross: [Hebrew, Greek, and Latin for "Jesus of Nazareth, King of the Jews"]
Oil on canvas
62 3/4 × 38 3/4" (159.4 × 98.4 cm)

John G. Johnson Collection
cat. 809

El Greco, workshop of
The Crucifixion
c. 1605–10
On cross: [Hebrew, Greek, and Latin for "Jesus of Nazareth, King of the Jews"]
Oil on canvas
81 1/4 × 40 3/4" (206.4 × 103.5 cm)

Purchased with the W. P. Wilstach Fund
W1900-1-17

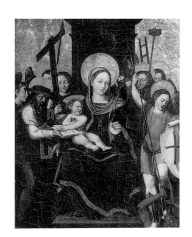

El Greco, attributed to
Previously listed as El Greco (JGJ 1941)
Portrait of a Lady
c. 1577–80
Oil on panel
15 5/8 × 12 5/8" (39.7 × 32.1 cm)

John G. Johnson Collection
cat. 808

Juan de Juanes (Juan Vincente Masip the Younger)
Spanish, active Valencia, c. 1510–1579
Enthroned Virgin and Child, with Saint Jerome, the Archangel Michael, and Angels Holding Instruments of the Passion
Mid-16th century
Oil and tooled gold on panel
48 3/4 × 35 1/4" (123.8 × 89.5 cm)

John G. Johnson Collection
cat. 806

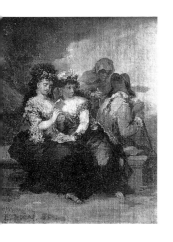

Lucas Velazquez, Eugenio
Spanish, 1817–1870
The Love Letter
1864
Lower left: Eg. Lucas, 1864.
Oil on canvas
12 ⁵/₈ × 9 ³/₈" (32.1 × 23.8 cm)

John G. Johnson Collection
cat. 821

Murillo, Bartolomé Esteban, copy after
Saint Thomas of Villanueva Distributing Alms
After the painting in the Museo de Bellas Artes, Seville (90)
18th century?
Lower left (spurious): Jan Roldan
Oil on panel
16 ¹/₈ × 11 ⁵/₈" (41 × 29.5 cm)

The Bloomfield Moore Collection
1899-1121

Martorell, Bernat
Spanish, active 1427–1452
Previously listed as a South French artist, c. 1450 (JGJ 1941)
Enthroned Virgin and Child, with the Cardinal Virtues and Two Figures Holding Scrolls
Center panel from an altarpiece once in the church of Santa María, Monzón (Barcelona)
1437
Tempera and tooled gold on panel
60 ³/₄ × 42 ¹/₄" (154.3 × 107.3 cm)

John G. Johnson Collection
cat. 759

Olot Master
Spanish, active Catalonia, active c. 1500
Previously listed as a Castilian artist, c. 1470 (JGJ 1941)
The Gathering of Manna and the Discovery of the Water of Elim
Panel from an altarpiece
c. 1500
Tempera and tooled gold on panel
21 ¹⁵/₁₆ × 17 ¹/₄" (55.7 × 43.8 cm)

John G. Johnson Collection
cat. 801

Murillo, Bartolomé Esteban
Spanish, active Seville, 1618–1682
Christ Bearing the Cross
c. 1665–75
Oil on canvas
60 ³/₄ × 83" (154.3 × 210.8 cm)

Purchased with the W. P. Wilstach Fund
W1900-1-7

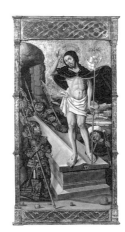

Oslo Master, attributed to
Spanish, active Aragon, active c. 1480
The Resurrection
Panel from an altarpiece
c. 1480
Oil, silver, and tooled gold on panel
67 ³/₄ × 35 ¹/₂" (172.1 × 90.2 cm)

Bequest of Carl Otto Kretzschmar von Kienbusch
1977-167-1041

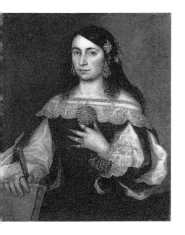

Murillo, Bartolomé Esteban, attributed to
Previously listed as Juan Bautista Martínez del Mazo (JGJ 1941)
Portrait of a Lady
c. 1655–65
Oil on canvas
31 ¹/₈ × 25" (79.1 × 63.5 cm)

John G. Johnson Collection
cat. 815

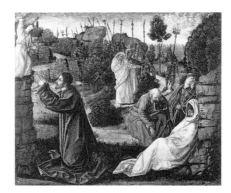

Osona, Rodrigo de, the Elder
Spanish, active Valencia, documented 1464–1484
Previously listed as an Aragonese artist, late 15th century (JGJ 1941)
The Agony in the Garden
Predella panel; companion to the following two panels
c. 1465
Oil and gold on panel
16 ³/₄ × 18 ³/₄" (42.5 × 47.6 cm)

John G. Johnson Collection
cat. 802

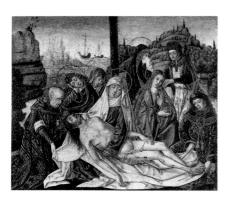

Osona, Rodrigo de, the Elder
Previously listed as an Aragonese
artist, late 15th century (JGJ
1941)
The Lamentation
Predella panel; see previous entry
c. 1465
Oil and gold on panel
16 3/8 × 18 5/8" (41.6 × 47.3 cm)

John G. Johnson Collection
cat. 803

Rexach, Juan
Spanish, active Valencia,
documented 1437–1484
The Death of Saint Giles
Predella panel
Late 1460s or early 1470s
Oil on panel
24 1/4 × 23 1/4" (61.6 × 59 cm)

John G. Johnson Collection
inv. 337

Osona, Rodrigo de, the Elder
Previously listed as an Aragonese
artist, late 15th century (JGJ
1941)
The Resurrection
Predella panel; see previous two
entries
c. 1465
Oil and gold on panel
16 3/8 × 19" (41.6 × 48.3 cm)

John G. Johnson Collection
cat. 804

Rexach, Juan
Christ Crowned with Thorns
Predella panel
c. 1476–80
Oil on panel
15 1/2 × 15 1/4" (39.4 × 38.7 cm)

John G. Johnson Collection
inv. 203

Palaquinos Master
Spanish, active León,
active c. 1510–c. 1520
*The Shooting of the Bull on Mount
Gargano*
Panel from an altarpiece;
companion to the following
painting
c. 1515
Tempera and tooled gold on panel
35 1/8 × 30 15/16" (89.2 × 78.6 cm)

John G. Johnson Collection
inv. 2100

Reyna, Antonio
Spanish, born 1861, death date
unknown
Canal in Venice
Early 20th century
Lower right: Reyna
Oil on panel
14 1/4 × 9 1/4" (36.2 × 23.5 cm)

The Walter Lippincott Collection
1923-59-10

Palaquinos Master
*The Episcopal Procession to Mount
Gargano*
Panel from an altarpiece;
companion to the preceding
painting
c. 1515
Tempera and tooled gold on panel
35 1/4 × 31" (89.5 × 78.7 cm)

John G. Johnson Collection
inv. 2101

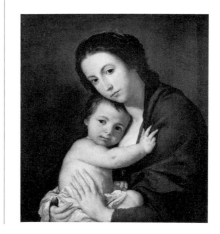

**Ribera, José Jusepe de,
also called Lo Spagnoletto**
Spanish, active Naples,
1591–1652
Virgin and Child
1646?
Lower left: Jusepe de Ribera /
español acade / mico Romano /
,F, 1646 [?]
Oil on canvas
27 3/8 × 23 7/16" (69.5 × 59.5 cm)

The William L. Elkins Collection
E1924-3-54

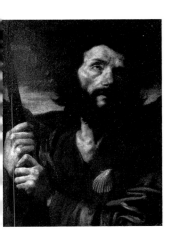

Ribera, José Jusepe de, attributed to
Previously listed as José Jusepe de Ribera (JGJ 1941)
Saint James the Great
Mid-17th century
Oil on canvas
25 1/2 × 19 3/8" (64.8 × 49.2 cm)

John G. Johnson Collection
cat. 811

Sanchez Perrier, Emilio
Spanish, 1855–1907
Landscape (Evening in Spain)
c. 1890
Lower left: E. Sanchez Perrier / Alcala
Oil on canvas
32 3/4 × 40" (83.2 × 101.6 cm)

Gift of Mrs. Joseph A. Henry in memory of William Robert White
F1923-4-1

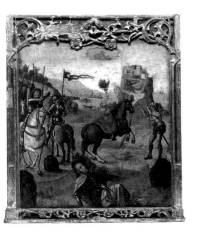

Rodríguez de Solís, Juan, attributed to
Spanish, active León and Zamora, active early 16th century
The Conversion of Saint Paul
Panel from an altarpiece
c. 1525
Oil on panel
32 × 25 3/4" (81.3 × 65.4 cm)

Bequest of Carl Otto Kretzschmar von Kienbusch
1977-167-1042

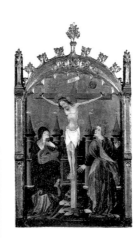

Spanish, active Catalonia, unknown artist
Previously listed as a South French artist, c. 1430–1450 (JGJ 1941)
The Crucifixion
Panel from an altarpiece
c. 1430–50
On cross: INRI
Oil and gold on panel
56 3/4 × 30 5/8" (144.1 × 77.8 cm)

John G. Johnson Collection
cat. 758

Rusiñol, Santiago
Spanish, 1861–1931
Interior of a Café
1892
Lower right: S. Rusiñol
Oil on canvas
39 1/2 × 32" (100.3 × 81.3 cm)

John G. Johnson Collection
cat. 1078

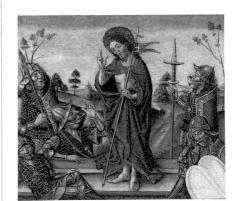

Spanish, unknown artist
The Resurrection
Predella panel
15th century
Oil on panel
13 × 13 7/8" (33 × 35.2 cm)

Bequest of Carl Otto Kretzschmar von Kienbusch
1977-167-1043

Salinas, Juan Pablo
Spanish, 1871–1946
Interior of a Spanish Church
c. 1900
Lower left: P. Salinas
Oil on canvas
16 1/4 × 27 5/8" (41.3 × 70.2 cm)

Gift of Mr. and Mrs. Leon H. Greenhouse
1973-130-1

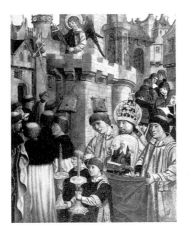

Spanish, active Aragon, unknown artist
Previously listed as a Castilian artist, second half of the 15th century (JGJ 1941)
The Miracle of Castel Sant'Angelo
Panel from an altarpiece
c. 1500
Tempera and tooled gold on panel
37 × 29 1/8" (94 × 74 cm)

John G. Johnson Collection
cat. 798

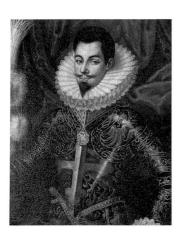

Spanish, unknown artist
Portrait of a Man in Armor
Late 16th century
Oil on canvas
32 × 24 1/2" (81.3 × 62.2 cm)

Bequest of Carl Otto
Kretzschmar von Kienbusch
1977-167-1083

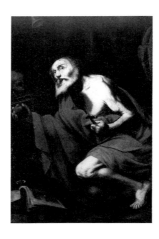

Spanish, unknown artist
Saint Jerome
17th century
Oil on canvas
61 3/8 × 42 1/4" (155.9 × 107.3 cm)

The Bloomfield Moore Collection
1899-1109

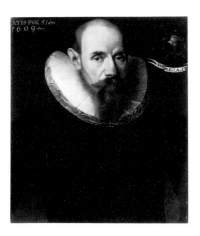

Spanish, unknown artist
Previously listed as Michiel van
Mierevelt (PMA 1965)
Portrait of Jaime la Cruz
1609
Upper left: [AET]ATIS SVAE. 51 /
1609; upper right: JAIME, LA,
CR[VZ]
Oil on panel
21 1/2 × 17 1/2" (54.6 × 44.4 cm)

Gift of Mrs. J. William White
1922-67-13

Spanish, unknown artist
Saints Anne and Christopher
17th century
Center: S. ANNA
Oil on leather
38 × 70 7/8" (96.5 × 180 cm)

Purchased from the George Grey
Barnard Collection with Museum
funds
1945-25-263

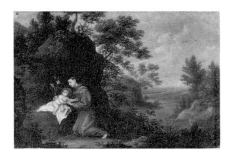

**Spanish, active Madrid,
unknown artist**
Previously listed as Ignacio de
Iriante (JGJ 1941)
*The Vision of Saint Anthony of
Padua*
c. 1650
Oil on canvas
10 5/16 × 15 1/8" (26.2 × 38.4 cm)

John G. Johnson Collection
cat. 817

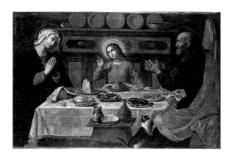

Spanish, unknown artist
The Supper at Emmaus
17th century
Oil on canvas
51 11/16 × 75 1/4" (131.3 ×
191.1 cm)

Purchased with the W. P.
Wilstach Fund
W1904-1-43

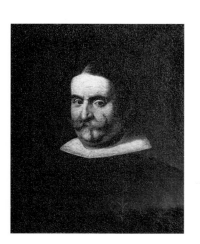

Spanish, unknown artist
Portrait of a Gentleman
17th century
Oil on canvas
22 7/8 × 17 3/4" (58.1 × 45.1 cm)

John G. Johnson Collection
cat. 813

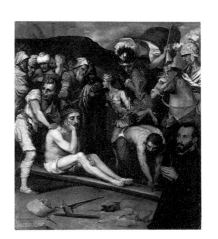

Vargas, Luis de
Spanish, active Seville and Rome,
1502–1568
Preparations for the Crucifixion
Mid-16th century
Lower right: LVISIVS DE /
VARGAS / FACIEBAT; on banner: P
Oil on panel transferred to canvas
34 5/8 × 30" (87.9 × 76.2 cm)

John G. Johnson Collection
cat. 805

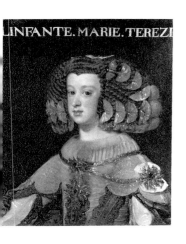

Velasquez, Diego Rodriguez de Silva y, studio of
Spanish, active Seville and Madrid, 1599–1660
Previously listed as an old copy after Diego Rodriguez de Silva y Velasquez (JGJ 1941)
Portrait of the Infanta Maria Teresa
1650s
Across top: LINFANTE.MARIE. TEREZ[E]
Oil on canvas
26 1/2 × 20 3/4" (67.3 × 52.7 cm)

John G. Johnson Collection
cat. 812

Villamediana Master
Previously listed as Luis Borrassá (JGJ 1941)
The Birth of the Virgin
Companion to a panel in a private collection in the United States
c. 1450
Tempera and tooled gold on panel
31 × 22 3/4" (78.7 × 57.8 cm)

John G. Johnson Collection
inv. 2493

Velasquez, Diego Rodriguez de Silva y, copy after
Cavaliers with a Dog
Based on a group of figures in the foreground of the painting *Philip IV Hunting Wild Boar ("La Tela Real")*, in the National Gallery, London (197)
19th century
Oil on canvas
19 3/4 × 14 3/4" (50.2 × 37.5 cm)

John G. Johnson Collection
cat. 814

Villegas y Cordero, José
Spanish, 1848–1922
Alhambra Interior
c. 1875
Lower right: Villegas; center, on curtain: [Arabic for "There is no God but God"]; center, on plaque: [Arabic for "Islam is enriched by God"]
Oil on canvas
29 1/16 × 17 15/16" (73.8 × 45.6 cm)

John G. Johnson Collection
cat. 1103

Villamediana Master
Spanish, active Palencia, active c. 1430–c. 1460
Previously listed as a Spanish international artist, c. 1450 (JGJ 1941)
Saints Sebastian and Catherine of Alexandria
Predella panel from the Saint Ursula altarpiece from San Pablo, Palencia; see following entry for companion panels
c. 1450
Tempera and tooled gold on panel
16 5/8 × 37 3/8" (42.2 × 94.9 cm)

John G. Johnson Collection
cat. 260

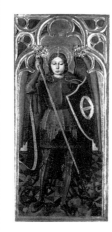

Ximénez, Juan
Spanish, active Aragon, first documented 1500, died 1505
Previously listed as a Spanish artist, mid-15th century (JGJ 1941)
The Archangel Michael
Panel from an altarpiece from the church of Tamarite de Litera, near Huesca, done in collaboration with Miguel Ximénez
1500–3
Oil and tooled gold on panel
50 1/2 × 22 11/16" (128.3 × 57.6 cm)

John G. Johnson Collection
inv. 183

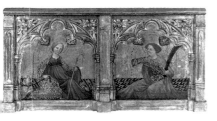

Villamediana Master
Previously listed as a Spanish international artist, c. 1450 (JGJ 1941)
Saints Margaret and Bartholomew
Predella panel; companion to the preceding panel and panels in the Lady Lever Art Gallery, Port Sunlight Village, England (LL3426–LL3429); the Zornmuseet, Mora, Sweden (Z1460); (formerly) the Gorostiza collection, Bilbao, Spain; and an unknown location
c. 1450
Tempera and tooled gold on panel
16 × 33" (40.6 × 83.8 cm)

John G. Johnson Collection
cat. 261

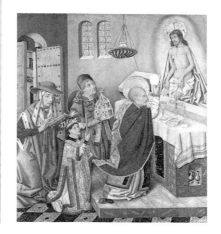

Ximénez, Miguel, workshop of
Spanish, active Aragon, first documented 1466, died 1505
and Martín Bernat
Spanish, documented 1469–1497
Previously listed as a Castilian artist, second half of the 15th century (JGJ 1941)
The Mass of Saint Gregory
c. 1500
Oil and tooled gold on panel transferred to canvas
42 5/8 × 38 5/8" (108.3 × 98.1 cm)

John G. Johnson Collection
cat. 799

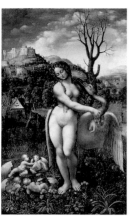

Yañez, Fernando (Fernando de Almedina), attributed to
Spanish, active Valencia and Italy, documented 1504/5–1536
Previously listed as a Flemish artist, c. 1540 (JFD 1972)
Leda and the Swan
Based on a composition by Leonardo da Vinci (Italian, 1452–1519) known through drawings
After 1508
Oil on panel
51 ⅝ × 30" (131.1 × 76.2 cm)

John G. Johnson Collection
cat. 393

Zamacois y Zabala, Eduardo
Spanish, 1842–1871
Toreador's Toilet
1866
Lower right: Ed ZAMACOIS. 1866.
Oil on panel
10 × 7 ¹³/₁₆" (25.4 × 19.8 cm)

John G. Johnson Collection
cat. 1113

Zamacois y Zabala, Eduardo
The Decorative Painter (Too Much Blood)
1868
Lower right: EZ ZAMACOIZ. 68.
Oil on canvas
22 ⅛ × 14 ⅞" (56.2 × 37.8 cm)

The W. P. Wilstach Collection, bequest of Anna H. Wilstach
W1893-1-132

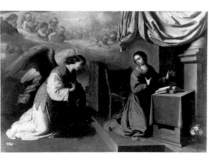

Zurbarán, Francisco de
Spanish, 1598–1664
The Annunciation
1650
Lower left: Franco de Zurbaran 1650
Oil on canvas
85 ⅝ × 124 ½" (217.5 × 316.2 cm)

Purchased with the W. P. Wilstach Fund
W1900-1-16

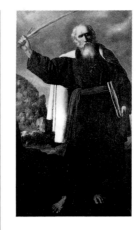

Zurbarán, Francisco de, workshop of
Saint Jerome
c. 1640–50
Oil on canvas
75 ¼ × 41 ³/₁₆" (191.1 × 104.6 cm)

Bequest of Sally W. Fisher
F1925-1-1

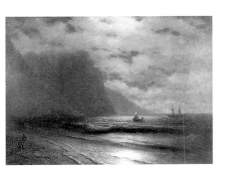

Aivasovsky, Ivan Konstantinovitsch
Armenian, 1817–1900
Rocky Seashore
1876
Lower left: Aivasovsky 1876
Oil on canvas
21 5/16 × 29 3/8" (54.1 × 74.6 cm)

John G. Johnson Collection
cat. 888

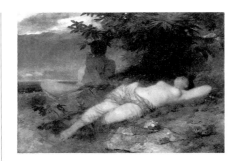

Böcklin, Arnold
Nymph and Satyr
1871
Lower right: AB
Oil on canvas
42 1/2 × 61" (107.9 × 154.9 cm)

John G. Johnson Collection
cat. 899

Beers, Jan van
Belgian, 1852–1927
Girl with a Parrot
1879
Lower left: JAN VAN BEERS / PARIS 1879
Oil on panel
20 3/8 × 12 7/8" (51.7 × 32.7 cm)

John G. Johnson Collection
inv. 2438

Calame, Alexandre
Swiss, 1810–1864
Oak Trees
1854
Lower left: A. Calame
Oil on canvas
14 1/2 × 12 7/8" (36.8 × 32.7 cm)

John G. Johnson Collection
cat. 908

Belgian, unknown artist
Man Reading
19th century
Oil on panel
14 1/4 × 16 5/8" (36.2 × 42.2 cm)

John G. Johnson Collection
inv. 2843

Carabain, Jacques-François
Belgian, born Netherlands, born 1834, still active 1891
Street Scene in Zug, Switzerland
1891
Lower right: J. Carabain; on reverse: I declare that this picture was painted to the order / of Mr. Craig and Evans / Brussels. 6 Mai 1891. / JS. Carabain
Oil on canvas
23 1/2 × 16 3/4" (59.7 × 42.5 cm)

The Walter Lippincott Collection
1923-59-5

Böcklin, Arnold
Swiss, 1827–1901
Sappho
1862
Upper right: A Böcklin
Oil on canvas
37 3/8 × 29" (94.9 × 73.7 cm)

John G. Johnson Collection
cat. 898

Charlemont, Eduard
Austrian, 1848–1906
The Moorish Chief
1878
Oil on panel
59 1/8 × 38 1/2" (150.2 × 97.8 cm)

John G. Johnson Collection
cat. 951

Edelfelt, Albert Gustaf Aristides
Finnish, 1854–1905
Two Boys on a Log (The Little Boat)
1884
Lower right: A. EDELFELT / 1884
Oil on canvas
35 5/16 × 41 15/16" (89.7 × 106.5 cm)

Purchased with the W. P. Wilstach Fund
W1906-1-9

European, unknown artist
Portrait of Sophia
Companion to the preceding painting
c. 1830–40
Center bottom: Sophia.
Oil on glass
12 9/16 × 10 9/16" (31.9 × 26.8 cm)

Bequest of Lisa Norris Elkins
1950-92-286

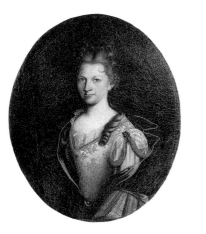

European, unknown artist
Portrait of a Lady
18th century
Oil on canvas
30 × 23 3/4" (76.2 × 60.3 cm)

Bequest of Arthur H. Lea
F1938-1-5

European, unknown artist
Display of Suits of Armor, Musée de l'Armée, Paris
19th century
Lower right: E. Traverllari
Oil on panel
18 × 14 1/4" (45.7 × 36.2 cm)

Bequest of Carl Otto Kretzschmar von Kienbusch
1977-167-1086

European, unknown artist
Wedding
c. 1775–1825
Oil on canvas
33 3/16 × 45 3/8" (84.3 × 115.2 cm)

Bequest of Arthur H. Lea
F1938-1-37

Greek, unknown artist
Previously listed as Byzantine, unknown artist, 15th century (PMA 1965)
The Entombment of Saint Catherine of Alexandria
Late 15th century
Center top: [Greek for "The Entombment of Saint Catherine"]
Tempera and gold on panel
10 5/8 × 13 1/2" (27 × 34.3 cm)

The Louise and Walter Arensberg Collection
1950-134-194

European, unknown artist
Portrait of Harison
Companion to the following painting
c. 1830–40
Center bottom: Harison.
Oil on glass
12 9/16 × 10 9/16" (31.9 × 26.8 cm)

Bequest of Lisa Norris Elkins
1950-92-285

Greek, active Crete, unknown artist
Previously listed as Italian, unknown artist, 15th century (PMA 1965)
The Nativity and the Arrival of the Magi
Late 15th century
Tempera on panel
13 13/16 × 18 1/8" (35.1 × 46 cm)

The Louise and Walter Arensberg Collection
1950-134-192

Jansen, Heinrich
Danish, 1625–1667
Previously listed as Jacob de
Wett (JFD 1972)
*The Presentation of Christ in the
Temple*
17th century
Oil on panel
22 15/16 × 16 15/16" (58.3 × 43 cm)

John G. Johnson Collection
cat. 490

Johansen, Viggo
Danish, 1851–1935
My Friends
1887
Lower left: V Johansen. 1887.
Oil on canvas
42 7/8 × 54 7/8" (108.9 ×
139.4 cm)

John G. Johnson Collection
cat. 1014

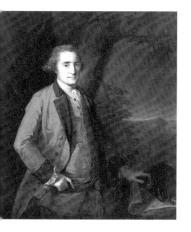

Kauffman, Angelica
Swiss, 1741–1807
*Portrait of Lieutenant General
James Cuninghame*
c. 1775
Oil on canvas
72 × 48" (183 × 121.9 cm)

Gift of Mrs. Charles Hamilton
1990-31-1

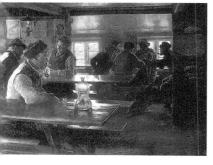

Krøyer, Peter Severin
Danish, 1851–1909
Interior of a Tavern
1886
Lower left: S Kroyer. SKAGEN
1886.
Oil on canvas
33 3/4 × 45" (85.7 × 114.3 cm)

John G. Johnson Collection
cat. 1015

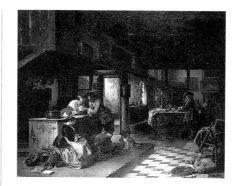

Leys, Hendrik Jan August
Belgian, 1815–1869
Interior of an Inn
1849
Lower left: H. Leys 1849
Oil on panel
28 7/8 × 35 1/2" (73.3 × 90.2 cm)

John G. Johnson Collection
cat. 1020

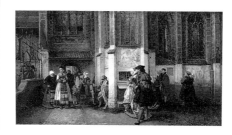

Leys, Hendrik Jan August
Faust and Marguerite
1856
Lower left: H. Leys f. 1856
Oil on panel
39 1/4 × 69 3/4" (99.7 × 177.2 cm)

The William L. Elkins Collection
E1924-3-83

**Master of Schloss
Lichtenstein**
Austrian, active 1440–1445
The Meeting at the Golden Gate
Panel from an altarpiece;
companion panels are in the State
Museum of A. S. Pushkin,
Moscow (421); the Bayerische
Staatsgemäldesammlungen, Alte
Pinakothek, Munich (13201);
the State Museum of Art, Tallinn,
Estonia (M1149); Osterreichische
Galerie im Belvedere, Vienna
(inv. 4778, inv. 4904–4906,
inv. 4908); the National Museum,
Warsaw (SR86 MNW); and
(formerly) the Rothschild
collection, Vienna
c. 1440–45
Lower right (spurious):
[Schäufelein monogram]; center
top: [Hebrew letter "sin"]
Oil and gold on panel
32 7/16 × 19 13/16" (82.4 × 50.3 cm)

John G. Johnson Collection
inv. 456

Max, Gabriel Cornelius von
Bohemian, 1840–1915
Girl with Music
c. 1900
On music: Nachtspiell; lower
right: Gab. Max
Oil on canvas
14 × 11 1/4" (35.6 × 28.6 cm)

John G. Johnson Collection
cat. 1038

**Pettenkofen, August Xaver
Carl von**
Austrian, 1822–1889
Market in Hungary
Before 1888
Lower right: a. p.
Oil on panel
5 1/2 × 4 1/8" (14 × 10.5 cm)

John G. Johnson Collection
cat. 1059

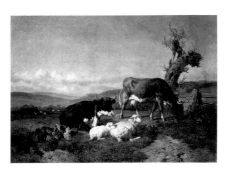

**Robbe, Louis-Marie-
Dominique**
Belgian, 1806–1887
Pastoral Landscape
After 1878
Lower left: Robbe
Oil on canvas
31 3/16 × 42 3/4" (79.2 × 108.6 cm)

Gift of Hermann Krumbhaar and
Dr. Edward Krumbhaar
1921-69-2

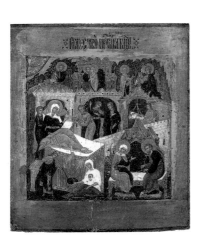

Russian, unknown artist
Episodes from the Life of Saint Anne
17th century
Across top: [Russian for "The
Nativity of the Mother of God"]
Tempera on panel
12 5/8 × 10 3/4" (32.1 × 27.3 cm)

Gift of Christian Brinton
1941-79-153

Russian, unknown artist
Christ and the Woman of Samaria
c. 1750–60
Oil on canvas on panel
21 3/16 × 15 3/8" (53.8 × 39 cm)

The Bloomfield Moore Collection
1883-132

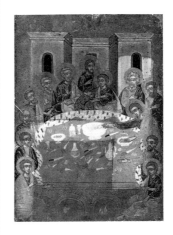

Russian, unknown artist
The Last Supper
c. 1750–60
Oil on canvas on panel
21 7/8 × 15 1/16" (55.6 × 38.3 cm)

The Bloomfield Moore Collection
1883-131

Sittow, Michel, follower of
Estonian, 1468–1525/26
Previously listed as Flemish,
unknown artist, early 16th
century (PMA 1965)
The Nativity, at Night
Early 16th century
Oil on panel
48 7/8 × 27 5/8" (124.1 × 70.2 cm)

Purchased with the W. P.
Wilstach Fund
W1902-1-13

The Spanish Forger
European, active c. 1875–1925
Woman with a Hawk
c. 1875–1925
On scroll: aetatas suae XVIII
Oil and gold on panel
12 1/4 × 8 7/8" (31.1 × 22.5 cm)

John G. Johnson Collection
cat. 760

Stevens, Alfred-Émile-Léopold
Belgian, 1823–1906
Departing for the Promenade
(Will You Go Out with Me, Fido?)
1859
Lower right: Alfred Stevens. 59
Oil on panel
24 ¼ × 19 ¼" (61.6 × 48.9 cm)

The W. P. Wilstach Collection,
bequest of Anna H. Wilstach
W1893-1-106

Swedish?, unknown artist
Portrait of a Queen [?]
c. 1600
Oil on canvas
73 ¼ × 42 ¼" (186 × 107.3 cm)

The Bloomfield Moore Collection
1883-136

Stevens, Alfred-Émile-Léopold
Reverie
c. 1875
Lower left: AStevens
Oil on canvas
30 ⅝ × 11 ¼" (77.8 × 28.6 cm)

John G. Johnson Collection
cat. 1083

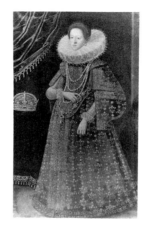

Swedish?, unknown artist
Portrait of a Queen [?]
c. 1600
Oil on canvas
73 ¼ × 42 ¼" (186 × 107.3 cm)

The Bloomfield Moore Collection
1883-137

Stevens, Alfred-Émile-Léopold, follower of
Lake
19th century
Lower left (spurious): ats
Oil on panel
8 × 6" (20.3 × 15.2 cm)

John G. Johnson Collection
inv. 2822

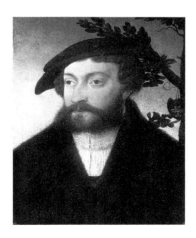

Swiss, active Basel, unknown artist
Portrait of a Man
c. 1525
Oil on panel
10 ½ × 8 5⁄16" (26.7 × 21.1 cm)

John G. Johnson Collection
inv. 1850

Stevens, Alfred-Émile-Léopold, follower of
Rocks and Waves
19th century
Lower right (spurious): ATS
Oil on panel
8 × 6" (20.3 × 15.2 cm)

John G. Johnson Collection
inv. 2848

Thaulow, Frits
Norwegian, 1847–1906
Water Mill
1892
Lower right: Frits Thaulow 92.
Oil on canvas
32 × 47 ⅝" (81.3 × 121 cm)

John G. Johnson Collection
cat. 1091

Thaulow, Frits
Snow Scene
1893
Lower right: Frits Thaulow 93.
Oil on canvas
21 3/8 × 29" (54.3 × 73.7 cm)

John G. Johnson Collection
cat. 1092

Wertmüller, Adolph-Ulrich
Swedish, active United States,
1751–1811
Portrait of George Washington
c. 1794
Oil on canvas
25 3/8 × 21 1/8" (64.4 × 53.7 cm)

Gift of Mr. and Mrs. John
Wagner
1986-100-1

Thaulow, Frits
*The Arques River at Ancourt,
Evening*
1895
Lower right: Frits Thaulow. 95.
Oil on canvas
34 1/4 × 25 1/2" (87 × 64.8 cm)

The William L. Elkins Collection
E1924-3-93

Wutky, Michael
Austrian, 1739–1823
*The Sala a Croce Greca of the
Vatican under Construction*
c. 1776
Oil on canvas
39 1/2 × 54 1/4" (100.3 × 137.8 cm)

The Bloomfield Moore Collection
1883-82

Wauters, Émile-Charles
Belgian, 1846–1933
*Mary of Burgundy Granting the
Great Privilege*
By 1878
Lower left: Emile Wauters; top
center, on curtain: [illegible]
Oil on canvas
50 5/8 × 39 3/4" (128.6 × 101 cm)

John G. Johnson Collection
cat. 1110

Wauters, Émile-Charles
Head of a Man
1878
Upper right: E. Wauters
Oil on canvas
12 1/4 × 9 1/8" (31.1 × 23.2 cm)

John G. Johnson Collection
inv. 2943

American Painting before 1900

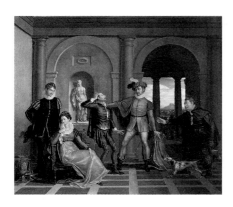

Allston, Washington
American, 1779–1843
Scene from "The Taming of the Shrew"
1809
Lower left: W. Allston.—
Oil on canvas
27 3/4 × 30 7/8" (70.5 × 78.4 cm)

Purchased with the Edith H. Bell Fund and the J. Stogdell Stokes Fund
1987-8-1

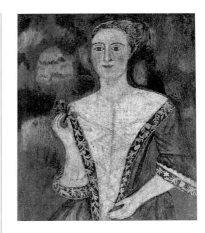

American, unknown artist
Previously listed as American, unknown artist, 18th century (PMA 1965)
Portrait of a Woman
c. 1750
Oil on panel
24 1/4 × 20 1/4" (61.6 × 51.4 cm)

The Louise and Walter Arensberg Collection
1950-134-198

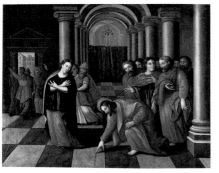

American, unknown artist
Christ and the Scribes
c. 1725–30
Oil on canvas
41 1/2 × 50 1/2" (105.4 × 128.3 cm)

Bequest of Edgar William and Bernice Chrysler Garbisch
1980-64-12

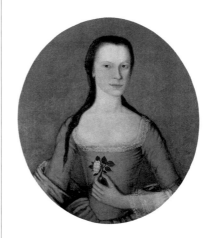

American, unknown artist
Portrait of a Woman
c. 1750
Oil on canvas
28 3/4 × 24 1/4" (73 × 61.6 cm)

The Louise and Walter Arensberg Collection
1950-134-196

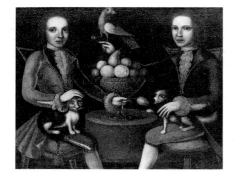

American, unknown artist
Portrait of Two Boys with Pets
c. 1730
Oil on canvas
31 3/4 × 38 7/8" (80.6 × 98.7 cm)

The Collection of Edgar William and Bernice Chrysler Garbisch
1967-268-2

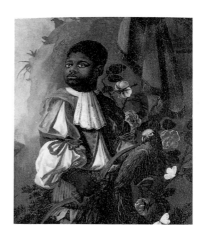

American, unknown artist
Previously listed as American, unknown artist, 19th century (PMA 1965)
Young Black Boy with a Parrot
c. 1760
Oil on canvas
27 3/4 × 22 3/4" (70.5 × 57.8 cm)

Bequest of Lisa Norris Elkins
1950-92-23

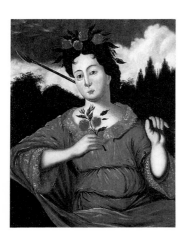

American, unknown artist
Ceres
c. 1750
Oil on panel
24 3/4 × 18 7/8" (62.9 × 47.9 cm)

Bequest of Edgar William and Bernice Chrysler Garbisch
1981-1-1

American, unknown artist
The Annunciation
c. 1775–1800
Oil on panel
23 × 32 7/8" (58.4 × 83.5 cm)

The Collection of Edgar William and Bernice Chrysler Garbisch
1966-219-1

American, unknown artist
Portrait of Thomas Cullum
Companion to the following
painting
c. 1780
On reverse: Mr. Thomas Cullum /
born February 21st 1751
Oil on panel
9 ³/₄ × 8 ¹/₈" (24.8 × 20.6 cm)

Bequest of Emily G. Porter
1974-41-4

American, unknown artist
Portrait of a Man
c. 1800
Oil on canvas
30 ¹/₈ × 24 ⁷/₈" (76.5 × 63.2 cm)

The Louise and Walter Arensberg
Collection
1950-134-538

American, unknown artist
Portrait of Mrs. Mary Cullum
Companion to the preceding
painting
c. 1780
On reverse: Mrs. Mary Cullum
Oil on panel
10 × 8" (25.4 × 20.3 cm)

Bequest of Emily G. Porter
1974-41-5

American, unknown artist
Portrait of Paul Beck
c. 1800
Oil on canvas
22 × 16 ¹⁵/₁₆" (55.9 × 43 cm)

Gift of Miss Virginia D. Flanagan
1972-201-1

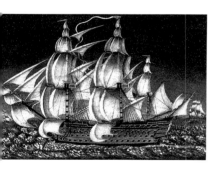

American, unknown artist
First-Rate Ship of the Line
c. 1790
Oil on panel
18 ¹/₄ × 25 ¹/₄" (46.3 × 64.1 cm)

Bequest of Edgar William and
Bernice Chrysler Garbisch
1981-1-3

American, unknown artist
Previously listed as American,
unknown artist, 19th century
(PMA 1965)
Portrait of John Paul Schott
Companion to the following
painting
c. 1805–20
Oil on canvas
29 ¹³/₁₆ × 24 ⁵/₈" (75.7 × 62.5 cm)

Gift of Marie Josephine Rozet
and Rebecca Mandeville Rozet
Hunt
1935-13-24

American, unknown artist
*Jewett House, Portsmouth,
New Hampshire*
Overmantel from the Jewett
house
c. 1795
Oil on panel
22 ¹¹/₁₆ × 52 ⁵/₈" (57.6 × 133.7 cm)

Bequest of Edgar William and
Bernice Chrysler Garbisch
1981-1-4

American, unknown artist
Previously listed as American,
unknown artist, 19th century
(PMA 1965)
Portrait of Naomi Sill Schott
Companion to the preceding
painting
c. 1805–20
Oil on canvas
30 ¹/₈ × 24 ¹³/₁₆" (76.5 × 63 cm)

Gift of Marie Josephine Rozet
and Rebecca Mandeville Rozet
Hunt
1935-13-25

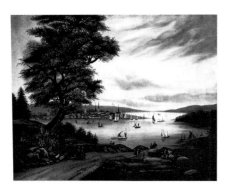

American, unknown artist
View of Baltimore
c. 1810
Oil on canvas
26 × 31 1/8" (66 × 79 cm)

Bequest of Edgar William and
Bernice Chrysler Garbisch
1980-64-13

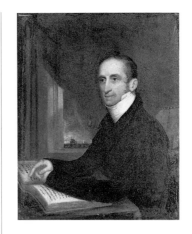

American, unknown artist
Portrait of James Lloyd
c. 1815–25
Oil on panel
9 1/2 × 7 5/16" (24.1 × 18.6 cm)

Gift of Mrs. C. P. Beauchamp
Jefferys
1966-53-2

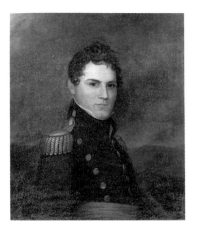

American, unknown artist
Previously listed as American,
unknown artist, 18th–19th
century (PMA 1965)
Portrait of Robert Hector Macpherson
c. 1810–17
Oil on canvas
29 × 24" (73.7 × 61 cm)

Bequest of Mellicent Story
Garland
1963-75-3

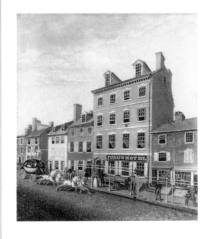

American, unknown artist
Judd's Hotel, Philadelphia
c. 1820
On signboards: TRENTON
COACH OFFICE; JUDD'S HOTEL;
J. WALNUT HAIR DRESSER
Oil on canvas
30 1/8 × 24 1/2" (76.5 × 62.2 cm)

The Collection of Edgar William
and Bernice Chrysler Garbisch
1968-222-4

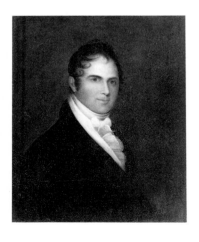

American, unknown artist
Previously listed as American,
unknown artist, 18th–19th
century (PMA 1965)
*Portrait of John Montgomery
Macpherson*
c. 1810–20
Oil on canvas
28 7/8 × 23 13/16" (73.3 × 60.5 cm)

Bequest of Mellicent Story
Garland
1963-75-4

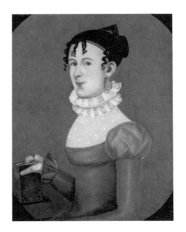

American, unknown artist
Portrait of Adeline Harwood
c. 1820
Oil on canvas
27 1/4 × 21 1/4" (69.2 × 54 cm)

Bequest of Edgar William and
Bernice Chrysler Garbisch
1980-64-4

American, unknown artist
Still Life with Flowers
c. 1810–35
Oil on velvet on panel
16 1/2 × 16 3/4" (41.9 × 42.5 cm)

Gift of Mr. and Mrs. Leon C.
Sunstein, Jr.
1969-166-2

American, unknown artist
*Portrait of the Oneida Chieftain
Shikellamy*
c. 1820
Oil on canvas
45 1/8 × 31 7/8" (114.6 × 81 cm)

The Collection of Edgar William
and Bernice Chrysler Garbisch
1966-219-3

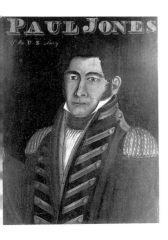

American, unknown artist
Portrait of Paul Jones
c. 1820–40
Across top: PAUL JONES / of the
U. S. Navy
Oil on panel
29 1/2 × 21 5/8" (74.9 × 54.9 cm)

Gift of Frank and Alice Osborn
1966-68-56

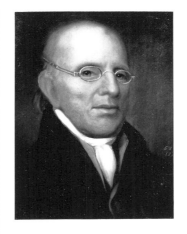

American, unknown artist
Previously listed as American,
unknown artist, 19th century
(PMA 1965)
Portrait of I. W. Morris
1828
Lower right: 58 / 1828
Oil on panel
10 1/16 × 7 11/16" (25.6 × 19.5 cm)

Gift of Miss Lydia Thompson
Morris
1930-73-4

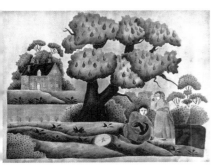

American, unknown artist
Landscape with Figures
c. 1825
Oil on velvet
16 3/4 × 21 3/4" (42.5 × 55.2 cm)

The Louise and Walter Arensberg
Collection
1950-134-535

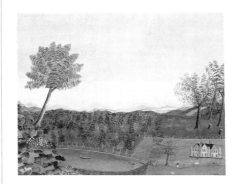

American, unknown artist
Connecticut Landscape
c. 1830
Oil on ticking
21 1/2 × 26 1/2" (54.6 × 67.3 cm)

Gift of Mrs. Edith Gregor Halpert
1957-4-1

American, unknown artist
Still Life with Fruit
c. 1825–50
Oil on velvet
19 7/8 × 25 13/16" (50.5 × 65.6 cm)

Gift of Frank and Alice Osborn
1966-68-60

American, unknown artist
*Portrait of a Woman Wearing a
Miniature*
c. 1830
Oil on canvas
28 1/16 × 23 9/16" (71.3 × 59.8 cm)

Bequest of Edgar William and
Bernice Chrysler Garbisch
1980-64-5

American, unknown artist
*Portrait of a Girl of the Lathrop
Family*
1828
On paper on reverse: Given to
Capt. Lathrop / In the year 1828 /
A.D.S. / Dec. 3rd 1875
Oil on panel
15 × 11 1/2" (38.1 × 29.2 cm)

The Collection of Edgar William
and Bernice Chrysler Garbisch
1972-262-2

American, unknown artist
*The Adoration of the Shepherds and
the Magi*
c. 1830
Center top, on banner: GLORY TO
GOD ON HIGH.
Oil on copper
30 1/16 × 38 1/8" (76.4 × 96.8 cm)

The Collection of Edgar William
and Bernice Chrysler Garbisch
1965-209-3

American, unknown artist
A Woman and a Girl at the Tombstone of Israel Jones
Fragment from the same work as the following two paintings
c. 1831
On tombstone: mot[] / ISRAEL JONES / died Jan 6 / 1828
Aged 62
Oil on panel
14 × 11 1/16" (35.6 × 28.1 cm)

Bequest of Edgar William and Bernice Chrysler Garbisch
1980-64-10

American, unknown artist
Portrait of David Witmer, Sr.
Companion to the following painting
c. 1835
On reverse: Born December 15th 1752 Old Style / Died August 15 1835 New Style / Aged 82 years 7 mos 19 days.
Oil on canvas on panel
41 5/8 × 35 3/4" (105.7 × 90.8 cm)

The Collection of Edgar William and Bernice Chrysler Garbisch
1970-254-1

American, unknown artist
A Boy at a Memorial to Sanford and Wealthy Palmer
See previous entry
c. 1831
On memorial: SACRED TO THE MEMORY / OF / SANFORD PALMER / Who died Octr 14th 1828 / in the 66th year of his age. / AND / WEALTHY his wife / who died June 30th 1831 / in the 63rd year of her age.
Oil on panel
9 7/8 × 9 7/8" (25.1 × 25.1 cm)

Bequest of Edgar William and Bernice Chrysler Garbisch
1980-64-15

American, unknown artist
Portrait of Mrs. David Witmer, Sr.
Companion to the preceding painting
c. 1835
Oil on canvas on panel
41 5/8 × 35 3/4" (105.7 × 90.8 cm)

The Collection of Edgar William and Bernice Chrysler Garbisch
1970-254-2

American, unknown artist
A Man and a Girl at a Memorial
See previous two entries
c. 1831
Oil on panel
14 × 10 1/16" (35.6 × 25.6 cm)

Bequest of Edgar William and Bernice Chrysler Garbisch
1980-64-16

American, unknown artist
Portrait of Sarah Yaw Jones
c. 1835
Oil on canvas
39 1/2 × 29 1/2" (100.3 × 74.9 cm)

Bequest of Edgar William and Bernice Chrysler Garbisch
1981-1-11

American, unknown artist
Portrait of Agnes Frazee and Her Child
1834
Oil on canvas
30 × 26" (76.2 × 66 cm)

The Collection of Edgar William and Bernice Chrysler Garbisch
1972-262-1

American, unknown artist
Treaty with the Five Nations
1838?
Lower left: TREATY / with the FIVE / NATIONS; on reverse: 1838
Oil on panel
8 5/8 × 10" (21.9 × 25.4 cm)

Gift of Titus C. Geesey
1969-284-13

American, unknown artist
In Full Stride
c. 1840
Oil on canvas
23 3/4 × 33 1/4" (60.3 × 84.4 cm)

The Collection of Edgar William
and Bernice Chrysler Garbisch
1965-209-4

American, unknown artist
*Portrait of a Woman in Gray and
White*
c. 1840
Oil on canvas
30 1/8 × 25 1/16" (76.5 × 63.7 cm)

Bequest of Edgar William and
Bernice Chrysler Garbisch
1980-64-6

American, unknown artist
*Portrait of a Baby, Doylestown,
Pennsylvania*
c. 1840
Oil on canvas
33 × 28 1/4" (83.8 × 71.7 cm)

Gift of Mrs. Edith Gregor Halpert
1957-4-2

American, unknown artist
Portrait of a Young Girl
c. 1840
Oil on canvas
30 1/8 × 25 1/16" (76.5 × 63.7 cm)

Bequest of Edgar William and
Bernice Chrysler Garbisch
1980-64-7

American, unknown artist
Previously listed as American,
unknown artist, 19th century
(PMA 1965)
Portrait of a Child Holding a Dog
c. 1840
Oil on canvas
36 1/8 × 29" (91.8 × 73.7 cm)

The Louise and Walter Arensberg
Collection
1950-134-533

American, unknown artist
Previously listed as American,
unknown artist, 19th century
(PMA 1965)
*Portrait of a Young Girl Holding
an Apple*
c. 1840
Oil on canvas
34 1/2 × 25" (87.6 × 63.5 cm)

Bequest of Lisa Norris Elkins
1950-92-231

American, unknown artist
Previously listed as Jacob
Eicholtz (PMA 1965)
Portrait of a Woman
c. 1840
On reverse (spurious):
J. Eicholtz [?] / 36
Oil on canvas
30 × 25" (76.2 × 63.5 cm)

Gift of John F. Braun
1949-73-1

American, unknown artist
Portrait of Cornelia Mandeville
c. 1840
Oil on canvas
30 × 24 7/8" (76.2 × 63.2 cm)

Gift of Marie Josephine Rozet
and Rebecca Mandeville Rozet
Hunt
1935-13-26

American, unknown artist
Still Life with Fruit, Flowers, and a Jewel Case
c. 1840
Oil on canvas
23 1/16 × 20 1/2" (58.6 × 52.1 cm)

Bequest of Edgar William and Bernice Chrysler Garbisch
1981-1-8

American, unknown artist
"He That Tilleth His Land Shall Be Satisfied"
c. 1850
Oil on panel
22 7/16 × 29 3/4" (57 × 75.6 cm)

The Collection of Edgar William and Bernice Chrysler Garbisch
1965-209-5

American, unknown artist
The Battle of Lake Erie
c. 1840
On ships: DETROIT; LAWRENCE; NIAGARA; on banner: DON'T GIVE UP / THE SHIP
Oil on panel
22 3/4 × 35 3/8" (57.8 × 89.8 cm)

The Collection of Edgar William and Bernice Chrysler Garbisch
1973-258-4

American, unknown artist
Previously listed as American, unknown artist, 19th century (PMA 1965)
Romantic Landscape
c. 1850
Oil on canvas
25 × 30 1/4" (63.5 × 76.8 cm)

Bequest of Lisa Norris Elkins
1950-92-232

American, unknown artist
View of Reading, Pennsylvania
c. 1840
Oil on canvas
22 × 30" (55.9 × 76.2 cm)

Bequest of Edgar William and Bernice Chrysler Garbisch
1981-1-5

American, unknown artist
Previously attributed to James Peale (PMA 1965)
Still Life
c. 1850
Oil on canvas
29 1/8 × 37" (74 × 94 cm)

Purchased with Museum funds
1954-31-1

American, unknown artist
Previously listed as American, unknown artist, 19th century (PMA 1965)
A Woman and Children under a Canopy with Flags
c. 1850
Oil on paper
16 3/4 × 20" (42.5 × 50.8 cm)

Gift of Mrs. Frederick Thurston Mason
1914-365

American, unknown artist
View of a Village
c. 1850
Oil on canvas
35 5/8 × 45 1/8" (90.5 × 114.6 cm)

The Collection of Edgar William and Bernice Chrysler Garbisch
1966-219-4

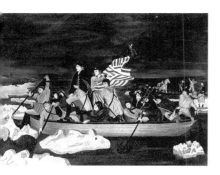

American, unknown artist
Washington Crossing the Delaware
Based on the painting by Emanuel
Leutze (German, 1816–1868),
dated 1851, in the Metropolitan
Museum of Art, New York (97.34)
After 1851
Oil on canvas
29 3/4 × 39 13/16" (75.6 × 101.1 cm)

The Collection of Edgar William
and Bernice Chrysler Garbisch
1973-258-5

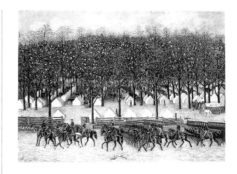

American, unknown artist
Fourth Pennsylvania Cavalry
1861
Center bottom: Oct 1861; center
right: 4th.PA.CAVALRY
Oil on canvas
36 × 47 7/8" (91.4 × 121.6 cm)

The Collection of Edgar William
and Bernice Chrysler Garbisch
1968-222-3

American, unknown artist
*Portrait of Caroline Margaret
Seagraves Mensch and Her Son,
John Roseberry Mensch*
c. 1855
Oil on canvas
32 3/4 × 26 1/4" (83.2 × 66.7 cm)

Gift of the Reverend Dr. Franklin
Joiner
1958-92-1

American, unknown artist
Portrait of Sophia Ramsay
c. 1870
Oil on canvas
35 × 28" (88.9 × 71.1 cm)

Gift of Peter D. Krumbhaar
1969-289-1

American, unknown artist
Full-Rigged Clipper Ships
c. 1860
Oil on canvas
26 × 32" (66 × 81.3 cm)

Bequest of Edgar William and
Bernice Chrysler Garbisch
1981-1-2

American, unknown artist
Portrait of Two Boys
c. 1870
Oil on canvas
27 × 42" (68.6 × 106.7 cm)

Gift of Mrs. Edith Gregor Halpert
1957-4-3

American, unknown artist
Portrait of the Robinson Family
c. 1860
Oil on canvas
29 1/2 × 49 1/2" (74.9 × 125.7 cm)

The Collection of Edgar William
and Bernice Chrysler Garbisch
1972-262-9

American, unknown artist
Two Doves at a Fountain
Fireboard
c. 1870
Oil on panel
34 1/4 × 48 1/2" (87 × 123.2 cm)

Bequest of Edgar William and
Bernice Chrysler Garbisch
1980-64-14

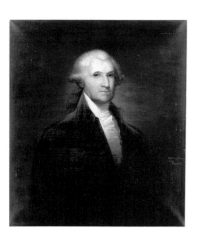

American, unknown artist
Portrait of George Washington
c. 1876
Center right: E. D. Marchant. /
after / Stuart.
Oil on canvas
36 1/4 × 29 3/8" (92.1 × 74.6 cm)

Gift of the Haas Community
Funds
1968-118-53

American, unknown artist
Previously listed as George Inness
(JGJ 1941)
Woodland Scene
Mid-19th century
Oil on panel
10 3/8 × 16 3/8" (26.3 × 41.6 cm)

John G. Johnson Collection
cat. 1008

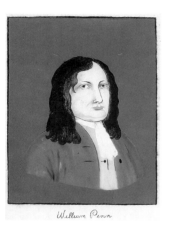

American, unknown artist
Previously listed as American,
unknown artist, 19th century
(PMA 1965)
Portrait of William Penn
c. 1876
Center bottom: William Penn
Oil on glass
14 1/2 × 10 1/4" (36.8 × 26 cm)

Gift of J. Stogdell Stokes
1927-62-1

American, unknown artist
Still Life with Flowers
19th century
Oil and tinfoil on glass
14 × 18" (35.6 × 45.7 cm)

The Louise and Walter Arensberg
Collection
1950-134-534

American, unknown artist
Conversation in a Punt
c. 1880
Oil on canvas
8 1/8 × 12" (20.6 × 30.5 cm)

Gift of Frank and Alice Osborn
1966-68-62

American, unknown artist
*Portrait of Mrs. Peter A. B.
Widener* [née Hannah Josephine
Dunton]
c. 1900–10
Oil on canvas
29 1/8 × 23 1/8" (74 × 58.7 cm)

Gift of Peter A. B. Widener III
1971-271-1

American, unknown artist
Home of John Greenleaf Whittier
c. 1892
Oil on panel
9 1/4 × 12 1/4" (23.5 × 31.1 cm)

Gift of Frank and Alice Osborn
1966-68-61

American, unknown artist
Portrait of a Young Girl
In an early 19th-century style
20th century
Oil on canvas
35 5/8 × 28 7/8" (90.5 × 73.3 cm)

The Collection of Edgar William
and Bernice Chrysler Garbisch
1973-258-6

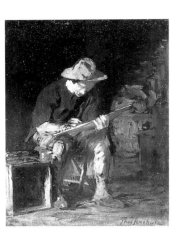

Anshutz, Thomas Pollock
American, 1851–1912
Man Drawing
c. 1890
Lower right: Thos Anshutz
Oil on canvas
26 1/8 × 20" (66.4 × 50.8 cm)

Bequest of Annie Lovering Perot
1936-1-1

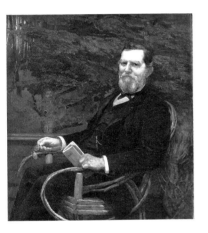

Beaux, Cecilia
American, 1855–1942
Portrait of George Burnham
1887
Lower right: Cecilia Beaux 87—
Oil on canvas
47 3/4 × 41 3/8" (121.3 × 105.1 cm)

Gift of Mrs. George Burnham III
1986-17-1

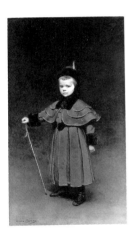

Beaux, Cecilia
Portrait of Cecil Kent Drinker
1891
Lower left: Cecilia Beaux
Oil on canvas
64 × 34 1/2" (162.6 × 87.6 cm)

Purchased with the Joseph E.
Temple Fund
1966-110-1

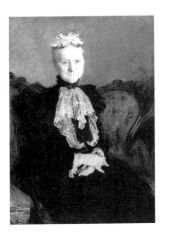

Beaux, Cecilia
Portrait of Mrs. Alexander Biddle
[née Julia Williams Rush]
1897
Lower left: Cecilia Beaux
Oil on canvas
40 1/4 × 30 3/16" (102.2 × 76.7 cm)

Gift of Horace Brock
1978-35-1

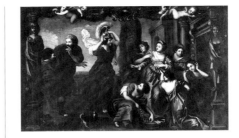

Benbridge, Henry
American, 1743–1812
Achilles among the Daughters of Lycomedes
c. 1758–64
Oil on canvas
26 1/4 × 42 1/4" (66.7 × 107.3 cm)

Purchased with the J. Stogdell
Stokes Fund, the Edith H. Bell
Fund, and the Katharine Levin
Farrell Fund
1990-88-1

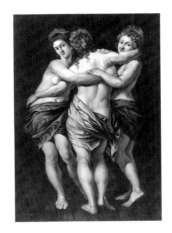

Benbridge, Henry
The Three Graces
c. 1762–68
Oil on canvas
48 1/2 × 33" (123.2 × 83.8 cm)

Purchased with the J. Stogdell
Stokes Fund, the Edith H. Bell
Fund, and the Katharine Levin
Farrell Fund
1990-88-2

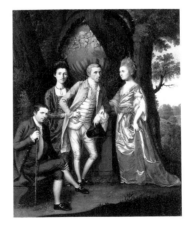

Benbridge, Henry
Portrait of the Enoch Edwards Family
c. 1783
Oil on canvas
30 × 23 11/16" (76.2 × 60.2 cm)

Gift of Miss Fannie Ringgold
Carter
1949-53-1

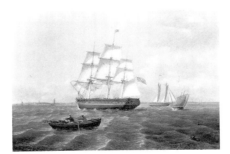

Birch, Thomas
American, born England,
1779–1851
Clipper Ships, New York Harbor
c. 1830
Lower right: [illegible signature]
Oil on canvas
20 3/4 × 30 1/8" (52.7 × 76.5 cm)

Gift of Caleb W. Hornor and
Peter T. Hornor
1968-44-1

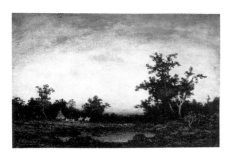

Blakelock, Ralph A.
American, 1847–1919
Indian Encampment
c. 1890
Lower left: R. A. Blakelock
Oil on canvas
16 × 24" (40.6 × 61 cm)

The Alex Simpson, Jr., Collection
1928-63-2

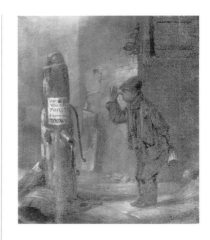

Blythe, David Gilmour
American, 1815–1865
Boy at a Pump
c. 1858–59
Lower right: Blythe; on pump:
Ho! all ye / who are / THIRSTY /
Come and / DRINK
Oil on canvas
14 1/8 × 12" (35.9 × 30.5 cm)

The W. P. Wilstach Collection,
bequest of Anna H. Wilstach
W1893-1-11

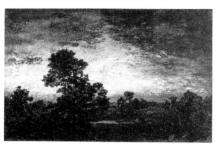

Blakelock, Ralph A.
The Glow, Evening
c. 1890–98
Lower left: R. A. Blakelock
Oil on panel
15 3/4 × 24 1/8" (40 × 61.3 cm)

Gift of William P. Wood in
memory of Mia Wood
1978-103-1

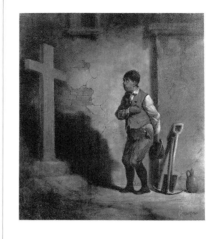

Blythe, David Gilmour
Conscience Stricken
c. 1860
Lower right: Blythe
Oil on canvas
14 1/8 × 12" (35.9 × 30.5 cm)

The W. P. Wilstach Collection,
bequest of Anna H. Wilstach
W1893-1-12

Blashfield, Edwin Howland
American, 1848–1936
The Widow
1873
Lower left: Edwin H. Blashfield /
1873
Oil on canvas
24 1/8 × 18 1/8" (61.3 × 46 cm)

The Alex Simpson, Jr., Collection
1944-13-1

Blythe, David Gilmour
Flour Inspector
c. 1860
Lower left: Blythe; center, on sign:
FINE / []MILY FLOWER, / CASH /
[F]OR WHEAT / RYE [B]ARLY &;
bottom, on casks: SUPERFINE /
PIGEONCREEK / MILLS;
LISBON & LEE; SUPERFINE /
EXTRA; CONOSTO[GA] / MILLS
Oil on canvas
17 1/8 × 13 15/16" (43.5 × 35.4 cm)

The W. P. Wilstach Collection,
bequest of Anna H. Wilstach
W1893-1-13

Blauvelt, Charles F.
American, 1824–1900
The Lost Child
c. 1866
Lower right: C. F. Blauvelt
Oil on canvas
10 1/8 × 8" (25.7 × 20.3 cm)

The W. P. Wilstach Collection,
bequest of Anna H. Wilstach
W1893-1-10

Bordley, Judge John Beale
American, 1727–1804
Temple of Apollo
After an engraving by William
Woollet (English, 1735–1785)
of the painting *Landscape with the
Father of Psyche Sacrificing at the
Milesian Temple of Apollo*, by
Claude Gellée (French,
1600–1682), in the collection of
Lord Fairhaven
1776
Oil on canvas
16 3/4 × 23 5/8" (42.5 × 60 cm)

Gift of Mr. and Mrs. William F.
Machold
1975-125-1

Bresse, W. L.
American, active c. 1860
Locomotive Briar Cliff
c. 1860
Lower left: WL BRESSE; center:
BRIAR CLIFF
Oil on canvas
24 1/8 × 35 3/4" (61.3 × 90.8 cm)

Gift of Frank and Alice Osborn
1966-68-55

Britton, William
American, active c. 1820
*Market Square. Germantown.
Pennsylvania*
c. 1820
Oil on canvas
12 1/4 × 19 7/8" (31.1 × 50.5 cm)

The Collection of Edgar William
and Bernice Chrysler Garbisch
1965-209-2

Brush, George de Forest
American, 1855–1941
The Revenge (The Escape)
1882
Lower right: Geo. de Forest
Brush. / 1882
Oil on canvas
15 1/2 × 19 1/2" (39.4 × 49.5 cm)

The Alex Simpson, Jr., Collection
1944-13-2

Brush, George de Forest
Portrait of Miss Polly Cabot
1896
Lower left: Geo. de Forest Brush /
1896
Oil on canvas
61 3/8 × 36 5/8" (155.9 × 93 cm)

Centennial gift of the Friends of
the Philadelphia Museum of Art
1976-156-1

Cassatt, Mary Stevenson
American, 1844–1926
On the Balcony
1873
Lower left: M.S.C. / a Seville /
1873
Oil on canvas
39 3/4 × 21 1/2" (101 × 54.6 cm)

Gift of John G. Johnson for the
W. P. Wilstach Collection
W1906-1-7

Cassatt, Mary Stevenson
Mary Ellison Embroidering
1877
Oil on canvas
29 1/4 × 23 1/2" (74.3 × 59.7 cm)

Gift of the children of Jean
Thompson Thayer
1986-108-1

Cassatt, Mary Stevenson
*Woman with a Pearl Necklace in a
Loge*
1879
Lower left: Mary Cassatt
Oil on canvas
32 × 23 1/2" (81.3 × 59.7 cm)

Bequest of Charlotte Dorrance
Wright
1978-1-5

Cassatt, Mary Stevenson
In the Loge
c. 1879
Pastel and metallic paint on
canvas
25 5/8 × 32" (65.1 × 81.3 cm)

Gift of Mrs. Sargent McKean
1950-52-1

Cassatt, Mary Stevenson
A Woman and a Girl Driving
1881
Lower right: Mary Cassatt
Oil on canvas
35 5/16 × 51 3/8" (89.7 × 130.5 cm)

Purchased with the W. P.
Wilstach Fund
W1921-1-1

Cassatt, Mary Stevenson
*Portrait of Alexander J. Cassatt and
His Son, Robert Kelso Cassatt*
1884
Lower left: Mary Cassatt 1884
Oil on canvas
39 1/2 × 32" (100.3 × 81.3 cm)

Purchased with the W. P.
Wilstach Fund and funds
contributed by Mrs. William
Coxe Wright
W1959-1-1

Cassatt, Mary Stevenson
Maternal Caress
c. 1896
Lower right: Mary Cassatt
Oil on canvas
15 × 21 1/4" (38.1 × 54 cm)

Bequest of Aaron E. Carpenter
1970-75-2

Cassatt, Mary Stevenson
Family Group Reading
c. 1901
Lower left: Mary Cassatt
Oil on canvas
22 1/4 × 44 1/4" (56.5 × 112.4 cm)

Gift of Mr. and Mrs. J. Watson
Webb
1942-102-1

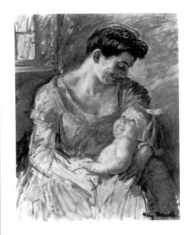

Cassatt, Mary Stevenson
Mother and Child
1908
Lower right: Mary Cassatt
Oil on canvas
32 × 23 7/8" (81.3 × 60.6 cm)

The Alex Simpson, Jr., Collection
1928-63-3

**Cassatt, Mary Stevenson,
attributed to**
Poppies in a Field
c. 1874–80
Lower right (spurious): Mary
Cassatt
Oil on panel
10 9/16 × 13 7/8" (26.8 × 35.2 cm)

Bequest of Charlotte Dorrance
Wright
1978-1-6

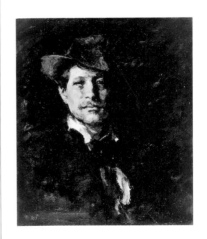

Chase, William Merritt
American, 1849–1916
The Unknown Dane
c. 1876
Lower right: Chase
Oil on canvas
24 × 20 1/8" (61 × 51.1 cm)

Bequest of Annie Lovering Perot
1936-1-2

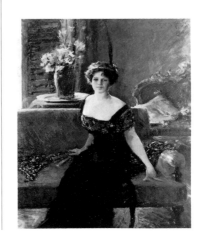

Chase, William Merritt
Portrait of Anna Trequar Lang
1911
Upper right: Wm M. Chase. /
1911.
Oil on canvas
59 1/2 × 47 3/4" (151.1 × 121.3 cm)

The Alex Simpson, Jr., Collection
1928-63-4

Chase, William Merritt
Portrait of a Lady
c. 1915
Lower left: Wm. M. Chase
Oil on canvas
70 × 60" (177.8 × 152.4 cm)

Gift of Eldridge R. Johnson
1922-87-1

**Cogswell, Charles Nathaniel,
attributed to**
American, 1797–1843
Previously listed as Charles
Nathaniel Cogswell (PMA 1965)
*Portrait of Red Jacket, Chief of the
Six Nations*
c. 1830–40
Lower right: Cog
Oil on canvas
33 ³/₄ × 25 ⁷/₈" (85.7 × 65.7 cm)

Gift of Peter T. Hornor
1956-40-2

Conarroe, George W.
American, born 1803,
died 1882–84
Portrait of Catharine Benezet Porter
Companion to following painting
After 1843
On label on reverse: Catharine
Benezet / daughter of Sarah Rod-
man / and John Stephen Benezet /
married to William G. / Porter—
1843—Painted by / Geo. W.
Conarroe. Grand- / mother of
Emily G, Susan H. and Catharine
B. Porter
Oil on canvas
27 ³/₈ × 22" (69.5 × 55.9 cm)

Bequest of Emily G. Porter
1974-41-2

Conarroe, George W.
Portrait of William Gibbs Porter
Companion to preceding painting
After 1843
Oil on canvas
27 ¹/₈ × 22 ¹/₈" (68.9 × 56.2 cm)

Bequest of Emily G. Porter
1974-41-3

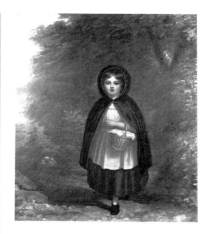

Conarroe, George W.
Little Red Riding Hood
Mid-19th century
Oil on canvas
30 ¹/₈ × 25 ³/₈" (76.5 × 64.4 cm)

The W. P. Wilstach Collection,
bequest of Anna H. Wilstach
W1893-1-27

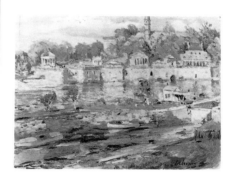

Cooper, Colin Campbell
American, 1856–1937
*Sketch for "Old Waterworks,
Fairmount"*
For the following painting
c. 1913
Lower right: C. C. Cooper;
on reverse: Old Waterworks at
Fairmount, Philada
Oil on cardboard
10 ¹/₂ × 13 ¹⁵/₁₆" (26.7 × 35.4 cm)

Gift of the artist
1936-50-2

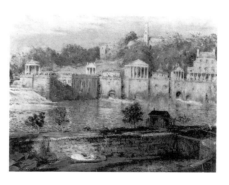

Cooper, Colin Campbell
Old Waterworks, Fairmount
1913
Lower left: Colin Campbell
Cooper 1913
Oil on canvas
38 × 48" (96.5 × 121.9 cm)

Gift of the artist
1936-50-1

Craig, Thomas Bigelow
American, 1849–1924
White Mountain Landscape
1880
Lower left: Thom. B. Craig, 1880
Oil on canvas
30 ¹/₈ × 50 ³/₈" (76.5 × 127.9 cm)

Gift of Edgar C. Felton
1932-48-1

Craig, Thomas Bigelow
Cedar Grove
1890
Lower left: Thos. B. Craig, 1890;
on reverse: Painted by Thos.
Craig, 1890 for John T. Morris of
Philadelphia Pa.
Oil on canvas
18 1/2 × 26 1/2" (47 × 67.3 cm)

Bequest of Lydia Thompson
Morris
1932-45-117

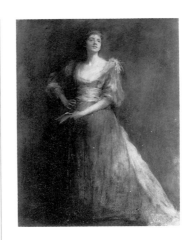

Dewing, Thomas Wilmer
American, 1851–1938
Commedia
c. 1892–94
Lower left: T W Dewing
Oil on panel
20 1/16 × 15 1/2" (51 × 39.4 cm)

The Alex Simpson, Jr., Collection
1943-74-2

Culverhouse, Johan Mengels
American, born Netherlands,
1820–c. 1891
Night Scene
1850s
Oil on canvas
25 3/4 × 19 1/8" (65.4 × 48.6 cm)

Gift of Thatcher Longstreth
1975-70-1

Dodson, Sarah Paxton Ball
American, born England,
1847–1906
The Wyck, Malvern (A Windy Day)
1892
Oil on canvas
14 × 18" (35.6 × 45.7 cm)

Gift of R. Ball Dodson in
memory of Sarah Ball Dodson
1926-9-1

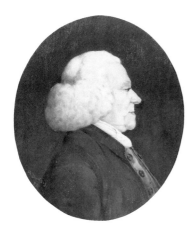

Dantzig, Meyer
American, active c. 1897–c. 1904
Portrait of Captain Samuel Morris
After the engraving by Charles-
Balthazar-Julien Fevret de Saint-
Mémin (French, 1770–1852)
1897
Lower left: M. Dantzig / 97.; on
reverse: Captain Samuel Morris,
Born 4 mo. 1734—Died 7 mo. 7,
1812.
Oil on canvas
27 × 21 15/16" (68.6 × 55.7 cm)

Bequest of Lydia Thompson
Morris
1932-45-83

Dodson, Sarah Paxton Ball
Under the Weeping Ash Tree
1900
Oil on canvas
24 × 18" (61 × 45.7 cm)

Gift of R. Ball Dodson in
memory of Sarah Ball Dodson
1926-9-2

Dantzig, Meyer
Portrait of James Thompson Morris
1897
Lower right: M. DANTZIG; on
reverse: James t Morris / Born
9 mo. 18 1842 / Died 9 mo. 23
1874
Oil on canvas
27 × 22" (68.6 × 55.9 cm)

Bequest of Lydia Thompson
Morris
1932-45-120

Drexel, Francis Martin
American, born Austria,
1792–1863
*Portrait of Edwin Jackson Haas and
His Brother*
c. 1820–25
Oil on canvas
50 1/8 × 39 11/16" (127.3 ×
100.8 cm)

Bequest of Beatrice Pastorius
Turner
1949-16-1

Durand, John
American, active 1766–1782
*Portrait of Sarah Whitehead
Hubbard*
1768
Oil on canvas
33 × 27 1/8" (83.8 × 68.9 cm)

The Collection of Edgar William
and Bernice Chrysler Garbisch
1965-209-1

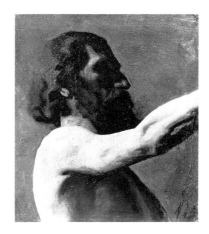

Eakins, Thomas
Study of a Nude Man
c. 1869
On reverse: T.E.
Oil on canvas
21 1/2 × 18 1/4" (54.6 × 46.4 cm)

Gift of Mrs. Thomas Eakins and
Miss Mary Adeline Williams
1929-184-9

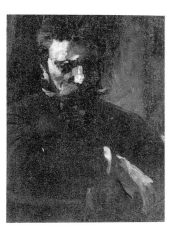

Duveneck, Frank
American, 1848–1919
Portrait of William Merritt Chase
c. 1876
Oil on canvas
20 1/8 × 15 1/16" (51.1 × 38.3 cm)

Bequest of T. Edward Hanley
1970-76-9

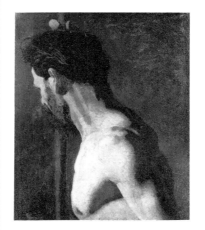

Eakins, Thomas
*Study of a Nude Man (The Strong
Man)*
c. 1869
On reverse: T.E.
Oil on canvas
21 1/2 × 17 5/8" (54.6 × 44.8 cm)

Gift of Mrs. Thomas Eakins and
Miss Mary Adeline Williams
1929-184-18

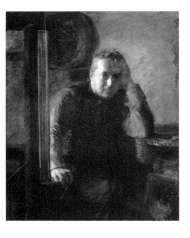

Eakins, Susan MacDowell
American, 1851–1938
Portrait of Thomas Eakins
c. 1920–25
Oil on canvas
50 × 40" (127 × 101.6 cm)

Gift of Charles Bregler
1939-11-1

Eakins, Thomas
*Sketch of Max Schmitt in a Single
Scull*
c. 1870–71
Oil on canvas
10 × 14 1/4" (25.4 × 36.2 cm)

Gift of Mrs. Thomas Eakins and
Miss Mary Adeline Williams
1930-32-5

Eakins, Thomas
American, 1844–1916
Study of a Young Woman
c. 1868
Oil on canvas
17 9/16 × 14 5/16" (44.6 × 36.4 cm)

Gift of Mrs. Thomas Eakins and
Miss Mary Adeline Williams
1929-184-8

Eakins, Thomas
*Portrait of Margaret Eakins in a
Skating Costume*
1871
Lower right: T.E. 1871;
on reverse: Eakins
Oil on canvas
24 1/8 × 20 1/8" (61.3 × 51.1 cm)

Gift of Mrs. Thomas Eakins and
Miss Mary Adeline Williams
1929-184-14

Eakins, Thomas
The Pair-Oared Shell
1872
Center right: EAKINS / 1872.;
on reverse: Eakins
Oil on canvas
24 × 36" (61 × 91.4 cm)

Gift of Mrs. Thomas Eakins and
Miss Mary Adeline Williams
1929-184-35

Eakins, Thomas
Sketch for "The Gross Clinic"
For the painting in the collection
of Jefferson Medical College,
Thomas Jefferson University,
Philadelphia
1875
Signed, lower right: E; lower
right: T.E. 75.; on reverse: T.E.
Oil on canvas
26 × 22" (66 × 55.9 cm)

Gift of Mrs. Thomas Eakins and
Miss Mary Adeline Williams
1929-184-31

Eakins, Thomas
Sailboats Racing
1874
Center right: EAKINS / 74.;
on reverse: T.E.
Oil on canvas
24 × 36" (61 × 91.4 cm)

Gift of Mrs. Thomas Eakins and
Miss Mary Adeline Williams
1929-184-28

Eakins, Thomas
Sailing
c. 1875
Lower right: To his friend /
William M. Chase. / Eakins
Oil on canvas
31 7/8 × 46 1/4" (81 × 117.5 cm)

The Alex Simpson, Jr., Collection
1928-63-6

Eakins, Thomas
Ships and Sailboats on the Delaware
1874
Lower right: EAKINS 74;
on reverse: T.E.
Oil on canvas
10 1/8 × 17 1/8" (25.7 × 43.5 cm)

Gift of Mrs. Thomas Eakins and
Miss Mary Adeline Williams
1929-184-25

Eakins, Thomas
Portrait of Bertrand Gardel
(Study for "The Chess Players")
For the painting in the
Metropolitan Museum of Art,
New York (81.14)
c. 1875
Lower right: T.E.
Oil on paper on cardboard
12 1/8 × 9 3/4" (30.8 × 24.8 cm)

Gift of Mrs. Thomas Eakins and
Miss Mary Adeline Williams
1930-32-6

Eakins, Thomas
Landscape with a Dog
c. 1874
Oil on canvas
17 7/8 × 32" (45.4 × 81.3 cm)

Gift of Seymour Adelman
1947-96-3

Eakins, Thomas
Portrait of J. Harry Lewis
1876
Lower right: EAKINS 76.;
on reverse: Eakins
Oil on canvas
23 5/8 × 19 3/4" (60 × 50.2 cm)

Gift of Mrs. Thomas Eakins and
Miss Mary Adeline Williams
1929-184-3

Eakins, Thomas
*Interior of a Woodcarver's Shop
(Sketch for "William Rush Carving
His Allegorical Figure of the
Schuylkill River")*
For the following painting
1876–77
Oil on canvas on cardboard
8 ⁵/₈ × 13" (21.9 × 33 cm)

Gift of Charles Bregler
1946-19-1

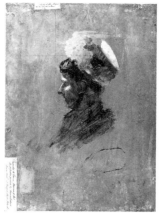

Eakins, Thomas
*Portrait of Mrs. Fairman Rogers
(Study for "The Fairman Rogers
Four-in-Hand")*
Reverse of the preceding painting
1879
Upper left, on label: Study of
Mrs. Rogers / for the Coach &
Four / T.E.; lower left, on label:
Presented to Penna. Museum of
Art / Small picture painted by
Thomas Eakins / "Four-in-Hand"
at Newport, Rhode Island
Oil on panel
14 ¹/₂ × 10 ¹/₄" (36.8 × 26 cm)

Gift of Mrs. Thomas Eakins and
Miss Mary Adeline Williams
1930-32-18b

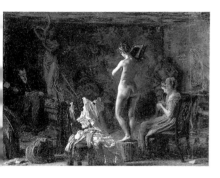

Eakins, Thomas
*William Rush Carving His
Allegorical Figure of the Schuylkill
River*
1876–77
Lower right: EAKINS. 77.; on
reverse: T.E.
Oil on canvas on Masonite
20 ¹/₈ × 26 ¹/₈" (51.1 × 66.4 cm)

Gift of Mrs. Thomas Eakins and
Miss Mary Adeline Williams
1929-184-27

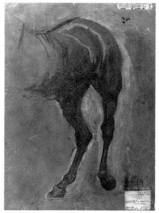

Eakins, Thomas
*Study of Hindquarters of Left
Leader Horse for "The Fairman
Rogers Four-in-Hand"*
See following painting for reverse
1879
Lower right, on label: Sketch
other side / "Boat-man" /
Presented to Museum / by Mrs.
Eakins / T. Eakins / Below, Study
of horses for / "Coach & Four"
Oil on panel
14 ¹/₂ × 10 ¹/₄" (36.8 × 26 cm)

Gift of Mrs. Thomas Eakins and
Miss Mary Adeline Williams
1930-32-11a

Eakins, Thomas
*Sketch of Lafayette Park,
Washington, D.C. (In Washington)*
1877
Lower right: T.E.
Oil on panel
10 ¹/₂ × 14 ¹/₂" (26.7 × 36.8 cm)

Gift of Mrs. Thomas Eakins and
Miss Mary Adeline Williams
1930-32-17

Eakins, Thomas
Study of a Groom
Reverse of the preceding painting
c. 1879
Oil on panel
14 ¹/₂ × 10 ¹/₄" (36.8 × 26 cm)

Gift of Mrs. Thomas Eakins and
Miss Mary Adeline Williams
1930-32-11b

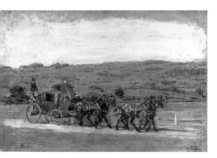

Eakins, Thomas
*Sketch for "The Fairman Rogers
Four-in-Hand"*
See following painting for reverse
1879
Lower right: T.E.
Oil on panel
10 ¹/₄ × 14 ¹/₂" (26 × 36.8 cm)

Gift of Mrs. Thomas Eakins and
Miss Mary Adeline Williams
1930-32-18a

Eakins, Thomas
*Fairmount Park (Sketch for "The
Fairman Rogers Four-in-Hand")*
Color samples for the following
painting are on reverse
1879 or 1880
Lower right: Fair Mount Park /
T.E. / Eakins; on reverse: 'Study
in Fairmount Park'/ T.E.; on
reverse, on label: Study of
Fairmount Park / for picture of
Fairman Rogers / Four-in-Hand /
Painted by Thomas Eakins / 1879;

on reverse, on label: Presented to
Penna. Museum of Art / by Mrs.
Thos. Eakins / Study in
Fairmount Park for picture /
"Coach and Four" painted for
Fairman Rogers / by Thomas
Eakins
Oil on panel
14 9/16 × 10 1/4" (37 × 26 cm)

Gift of Mrs. Thomas Eakins and
Miss Mary Adeline Williams
1930-32-10

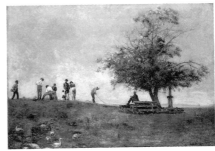

Eakins, Thomas
Mending the Net
1881
Center right: EAKINS 81.
Oil on canvas
32 1/8 × 45 1/8" (81.6 × 114.6 cm)

Gift of Mrs. Thomas Eakins and
Miss Mary Adeline Williams
1929-184-34

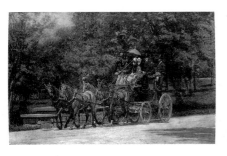

Eakins, Thomas
*The Fairman Rogers Four-in-Hand
(A May Morning in the Park)*
1879–80
Lower left: EAKINS. / 79
Oil on canvas
23 3/4 × 36" (60.3 × 91.4 cm)

Gift of William Alexander Dick
1930-105-1

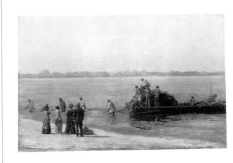

Eakins, Thomas
*Shad Fishing at Gloucester on the
Delaware River*
1881
On reverse: T.E.
Oil on canvas
12 1/8 × 18 1/8" (30.8 × 46 cm)

Gift of Mrs. Thomas Eakins and
Miss Mary Adeline Williams
1929-184-33

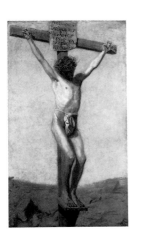

Eakins, Thomas
The Crucifixion
1880
Center top: [Greek and Latin for
"Jesus of Nazareth, King of the
Jews"]; on reverse, covered by
relining: CHRISTI EFFIGIEM
EAKINS PHIL[ADEL]PHIENSIS
PINXIT MDCCCLXXX
Oil on canvas
96 × 54" (243.8 × 137.2 cm)

Gift of Mrs. Thomas Eakins and
Miss Mary Adeline Williams
1929-184-24

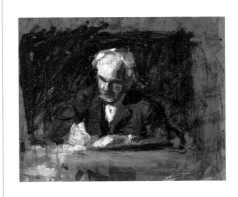

Eakins, Thomas
*Portrait of Benjamin Eakins
(Sketch for "The Writing Master")*
For the painting in the
Metropolitan Museum of Art,
New York (17.173); see
following painting for reverse
1882
Oil on panel
8 1/4 × 10 1/8" (20.9 × 25.7 cm)

Gift of Mrs. Thomas Eakins and
Miss Mary Adeline Williams
1930-32-4a

Eakins, Thomas
Landscape Sketch
c. 1880–90
Oil on canvas on cardboard
6 1/4 × 7" (15.9 × 17.8 cm)

Gift of an anonymous donor
1985-25-1

Eakins, Thomas
*Sketch of a Man and Study of
Drapery*
Reverse of the preceding painting
c. 1882
Upper right, on label: Presented
to Penna. Museum of Art. /
Sketch for 'The Writing Master'
Thomas Eakins / Board 8 high 1c
wide
Oil on panel
10 1/8 × 8 1/4" (25.7 × 20.9 cm)

Gift of Mrs. Thomas Eakins and
Miss Mary Adeline Williams
1930-32-4b

Eakins, Thomas
Sketch of a Landscape
See following painting for reverse
c. 1882
Oil on cardboard
13 × 8 3/4" (33 × 22.2 cm);
composition: 4 1/2 × 7"
(11.4 × 17.8 cm)

Gift of Seymour Adelman
1947-96-1a

Eakins, Thomas
Sketch of a Landscape
Reverse of the preceding painting
c. 1882
Oil on cardboard
13 × 8 3/4" (33 × 22.2 cm);
composition: 4 3/4 × 6 1/2"
(12.1 × 16.5 cm)

Gift of Seymour Adelman
1947-96-1b

Eakins, Thomas
The Meadows, Gloucester
c. 1882
On reverse: T. EAKINS
Oil on canvas
31 15/16 × 45 1/8" (81.1 × 114.6 cm)

Gift of Mrs. Thomas Eakins and
Miss Mary Adeline Williams
1929-184-32

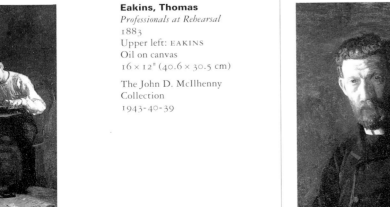

Eakins, Thomas
Professionals at Rehearsal
1883
Upper left: EAKINS
Oil on canvas
16 × 12" (40.6 × 30.5 cm)

The John D. McIlhenny
Collection
1943-40-39

Eakins, Thomas
Portrait of Blanche Hurlbut
1885 or 1886
Lower right: Thomas Eakins
Oil on canvas
24 × 20" (61 × 50.8 cm)

Gift of Mrs. Thomas Eakins and
Miss Mary Adeline Williams
1929-184-5

Eakins, Thomas
*Sketch for "Portrait of Professor
George F. Barker"*
For the painting in the Mitchell
Museum, Mount Vernon, Illinois
(1973.6.1a, b); see the following
painting for reverse
1886
Oil on cardboard
12 3/8 × 10 1/8" (31.4 × 25.7 cm);
composition: 12 1/4 × 7"
(31.1 × 17.8 cm)

Gift of Mrs. Thomas Eakins and
Miss Mary Adeline Williams
1930-32-7a

Eakins, Thomas
Seated Figures
Reverse of the preceding painting
c. 1886
Upper left, on label: Sketch for
portrait of / Prof. Barker /
Thomas Eakins; top center, on
label: Presented to Penna.
Museum of Art, / Sketch—Prof.
G. F. Barker / Eakins / 12 1/8 high.
10 1/8 wide
Oil on cardboard
12 3/8 × 10 1/8" (31.4 × 25.7 cm)

Gift of Mrs. Thomas Eakins and
Miss Mary Adeline Williams
1930-32-7b

Eakins, Thomas
Portrait of Arthur Burdett Frost
c. 1886
On reverse: T.E.
Oil on canvas
27 1/16 × 21 15/16" (68.7 × 55.7 cm)

Gift of Mrs. Thomas Eakins and
Miss Mary Adeline Williams
1929-184-1

Eakins, Thomas
Cowboy (Sketch for "Cowboys in the Bad Lands")
For a painting in a private collection
1887
Oil on canvas on Masonite
10 × 14 1/4" (25.4 × 36.2 cm)

Gift of Mrs. Thomas Eakins and Miss Mary Adeline Williams
1930-32-3

Eakins, Thomas
Saddle (Sketch for "Cowboys in the Bad Lands")
For a painting in a private collection
1887
Oil on canvas on cardboard
8 5/8 × 9 3/8" (21.9 × 23.8 cm)

Gift of Mr. and Mrs. Chaim Gross
1979-147-1

Eakins, Thomas
Landscape (Sketch for "Cowboys in the Bad Lands")
For a painting in a private collection
1887
Oil on canvas on cardboard
10 1/2 × 14 1/2" (26.7 × 36.8 cm)

Gift of Mrs. Thomas Eakins and Miss Mary Adeline Williams
1930-32-13

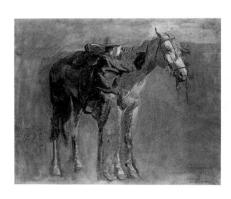

Eakins, Thomas
Cowboy (Study for "Cowboys in the Bad Lands")
For a painting in a private collection
1887–88
Lower right: Study for picture / 'Cow Boys in Bad Lands' / Eakins
Oil on canvas
20 1/16 × 24 1/16" (51 × 61.1 cm)

Gift of Mrs. Thomas Eakins and Miss Mary Adeline Williams
1930-32-12

Eakins, Thomas
Landscape (Sketch for "Cowboys in the Bad Lands")
For a painting in a private collection; originally held the following painting on reverse
1887
Oil on canvas on Masonite
10 7/16 × 14 1/2" (26.5 × 36.8 cm)

Gift of Seymour Adelman
1947-96-2a

Eakins, Thomas
Sketch for "Portrait of Letitia Wilson Jordan" [later Mrs. Leonard Woolsey Bacon]
For the painting, dated 1888, in the Brooklyn Museum, New York (27.50)
c. 1888
Lower left: T.E.
Oil on cardboard on Masonite
13 3/4 × 10 3/4" (34.9 × 27.3 cm)

Gift of Mrs. Thomas Eakins and Miss Mary Adeline Williams
1930-32-8

Eakins, Thomas
Landscape (Sketch for "Cowboys in the Bad Lands")
For a painting in a private collection; originally reverse of the preceding painting
1887
Oil on canvas on Masonite
10 1/4 × 14 1/2" (26 × 36.8 cm)

Gift of Seymour Adelman
1947-96-2b

Eakins, Thomas
Portrait of Douglass Morgan Hall
c. 1889
Oil on canvas
24 × 20" (61 × 50.8 cm)

Gift of Mrs. William E. Studdiford
1975-90-1

Eakins, Thomas
The Bohemian (Portrait of Franklin Louis Schenck)
c. 1890
Lower right: EAKINS; on reverse: T.E.
Oil on canvas
23 7/8 × 19 3/4" (60.6 × 50.2 cm)

Gift of Mrs. Thomas Eakins and Miss Mary Adeline Williams
1929-184-15

Eakins, Thomas
The Black Fan (Portrait of Mrs. Talcott Williams)
c. 1891
Oil on canvas
80 1/16 × 40 1/16" (203.4 × 101.8 cm)

Gift of Mrs. Thomas Eakins and Miss Mary Adeline Williams
1929-184-30

Eakins, Thomas
The Red Shawl
c. 1890
On reverse: Eakins
Oil on canvas
24 × 20" (61 × 50.8 cm)

Gift of Mrs. Thomas Eakins and Miss Mary Adeline Williams
1929-184-11

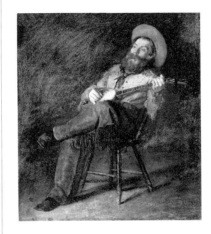

Eakins, Thomas
Cowboy Singing
c. 1892
Lower right: Eakins
Oil on canvas
24 × 20" (61 × 50.8 cm)

Gift of Mrs. Thomas Eakins and Miss Mary Adeline Williams
1929-184-22

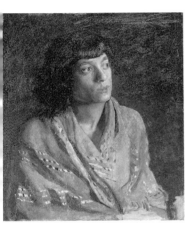

Eakins, Thomas
Sketch for "The Concert Singer"
For the following painting
c. 1890
Oil on canvas on cardboard
13 3/4 × 10 3/8" (34.9 × 26.4 cm);
composition: 13 × 8 1/2"
(33 × 21.6 cm)

Gift of Mrs. Thomas Eakins and Miss Mary Adeline Williams
1929-184-20

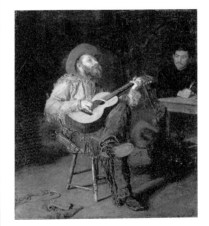

Eakins, Thomas
Home Ranch
1892
Center right: EAKINS 92; on reverse: T.E.
Oil on canvas
24 × 20" (61 × 50.8 cm)

Gift of Mrs. Thomas Eakins and Miss Mary Adeline Williams
1929-184-12

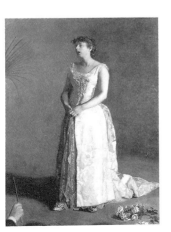

Eakins, Thomas
The Concert Singer
1890–92
Upper right: EAKINS. / 92.
Oil on canvas
75 1/8 × 54 1/4" (190.8 × 137.8 cm)

Gift of Mrs. Thomas Eakins and Miss Mary Adeline Williams
1929-184-19

Eakins, Thomas
Portrait of Joshua Ballinger Lippincott
1892
Lower left: T.E. / 92.
Oil on canvas
30 1/8 × 25" (76.5 × 63.5 cm)

Gift of Mrs. Bertha Coles in memory of Mrs. Stricker Coles
1967-37-1

Eakins, Thomas
Sketch for "Portrait of Dr. Jacob Mendez da Costa"
For the painting in the collection of the Pennsylvania Hospital, Philadelphia
c. 1893
Lower right: Sketch / T.E.
Oil on canvas on cardboard
14 1/2 × 10 1/2" (36.8 × 26.7 cm);
composition: 8 3/4 × 7 1/2"
(22.2 × 19.1 cm)

Gift of Mrs. Thomas Eakins and Miss Mary Adeline Williams
1930-32-16

Eakins, Thomas
Portrait of Mrs. James Mapes Dodge
[née Josephine Kern]
1896
Lower right: EAKINS 96 / to his friend / James M. Dodge
Oil on canvas
24 1/8 × 20 1/8" (61.3 × 51.1 cm)

Gift of Mrs. James Mapes Dodge
1951-79-1

Eakins, Thomas
Portrait of Benjamin Eakins
c. 1894
Oil on canvas
24 1/8 × 20" (61.3 × 50.8 cm)

Gift of Mrs. Thomas Eakins and Miss Mary Adeline Williams
1929-184-36

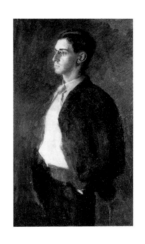

Eakins, Thomas
The Young Man (Portrait of Kern Dodge)
c. 1898–1902
Oil on canvas
45 3/16 × 26 1/8" (114.8 × 66.4 cm)

Gift of Mrs. Thomas Eakins and Miss Mary Adeline Williams
1929-184-21

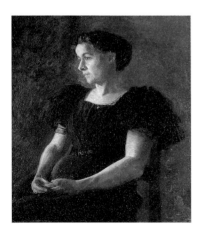

Eakins, Thomas
Portrait of Mrs. Frank Hamilton Cushing
1895
Lower right: T.E.
Oil on canvas
26 3/16 × 22" (66.5 × 55.9 cm)

Gift of Mrs. Thomas Eakins and Miss Mary Adeline Williams
1929-184-4

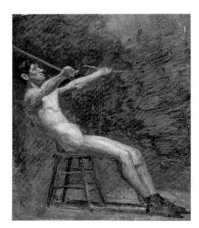

Eakins, Thomas
Portrait of Billy Smith (Study for "Between Rounds")
For the following painting
c. 1898
On reverse: T.E.
Oil on canvas
20 × 16" (50.8 × 40.6 cm)

Gift of Mrs. Thomas Eakins and Miss Mary Adeline Williams
1929-184-17

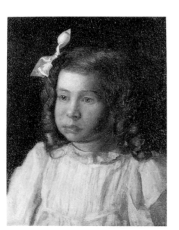

Eakins, Thomas
Portrait of a Little Girl
c. 1895–1900
Lower right: EAKINS
Oil on canvas
16 1/8 × 12 1/8" (41 × 30.8 cm)

The Louis E. Stern Collection
1963-181-25

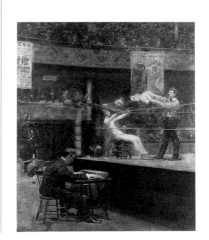

Eakins, Thomas
Between Rounds
1899
Lower right: EAKINS. 99.
Oil on canvas
50 1/8 × 39 7/8" (127.3 × 101.3 cm)

Gift of Mrs. Thomas Eakins and Miss Mary Adeline Williams
1929-184-16

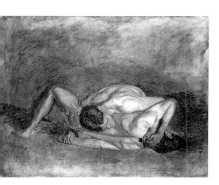

Eakins, Thomas
Wrestlers
A later, finished version is in the
Columbus Museum of Art, Ohio
(70.38)
1899
Oil on canvas
40 × 50 1/16" (101.6 × 127.2 cm)

Bequest of Fiske and Marie
Kimball
1955-86-14

Eakins, Thomas
*Sketch for "Portrait of Leslie W.
Miller"*
For the following painting; *Sketch
of Harry* originally on reverse
1901
Oil on cardboard on panel
13 3/8 × 9 5/8" (34 × 24.4 cm);
composition: 13 1/4 × 8"
(33.7 × 20.3 cm)

Gift of Percy Chase Miller
1945-33-1

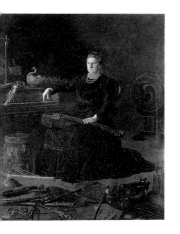

Eakins, Thomas
*Portrait of Mrs. William D.
Frishmuth (Antiquated Music)*
1900
Lower right: EAKINS. 1900.
Oil on canvas
97 × 72" (246.4 × 182.9 cm)

Gift of Mrs. Thomas Eakins and
Miss Mary Adeline Williams
1929-184-7

Eakins, Thomas
Portrait of Leslie W. Miller
1901
Lower right: Eakins / 1901.
Oil on burlap
88 × 44" (223.5 × 111.8 cm)

Gift of Martha Page Laughlin
Seeler in memory of Edgar
Viguers Seeler
1932-13-1

Eakins, Thomas
Portrait of Dr. Edward J. Nolan
c. 1900
Lower right: EAKINS; on reverse:
T.E.
Oil on canvas
24 × 20" (61 × 50.8 cm)

Gift of Mrs. Thomas Eakins and
Miss Mary Adeline Williams
1929-184-2

Eakins, Thomas
Sketch of Harry
Originally on reverse of *Sketch
for "Portrait of Leslie W. Miller"*
c. 1901
Oil on cardboard on hardboard
9 5/8 × 13 3/8" (24.4 × 34 cm)

Gift of Percy Chase Miller
1945-33-2

Eakins, Thomas
*Portrait of Mary Adeline Williams
(Addie)*
c. 1900
On reverse: T.E.
Oil on canvas
24 1/8 × 18 1/8" (61.3 × 46 cm)

Gift of Mrs. Thomas Eakins and
Miss Mary Adeline Williams
1929-184-10

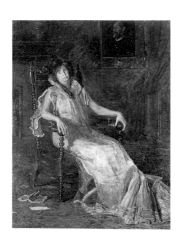

Eakins, Thomas
Actress (Portrait of Suzanne Santje)
[née Suzanne Keyser]
1903
Lower left: Eakins / 1903; lower
left, on letter: Miss Suzanne
Santje / Roanoke / Va.
Oil on canvas
79 3/4 × 59 7/8" (202.6 × 152.1 cm)

Gift of Mrs. Thomas Eakins and
Miss Mary Adeline Williams
1929-184-23

Eakins, Thomas
Sketch for "Portrait of Mother Patricia Waldron"
For a lost painting
1903
Lower right: Sketch / T.E.
Oil on canvas on Masonite
14 3/8 × 10 1/2" (36.5 × 26.7 cm);
composition: 9 1/2 × 7 1/2"
(24.1 × 19.1 cm)

Gift of Mrs. Thomas Eakins and
Miss Mary Adeline Williams
1930-32-14

RELIEF / EXPEDITION 1873 /
CHIEF ENGINEER JEANNETTE /
EXPEDITION 1879–82 /
CHIEF ENGINEER GREELEY
RELIEF / EXPEDITION 1883 /
DEGREES / LLD (PA) DE
(STEVENS) MA / (GEORGETOWN)
ME (COLUMBIA)
Oil on canvas
48 × 30 1/8" (121.9 × 76.5 cm)

Gift of Mrs. Thomas Eakins and
Miss Mary Adeline Williams
1929-184-6

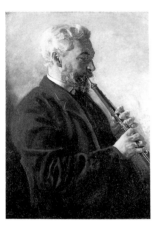

Eakins, Thomas
The Oboe Player (Portrait of Dr. Benjamin Sharp)
1903
Lower left: EAKINS 1903
Oil on canvas
36 1/8 × 24 1/8" (91.8 × 61.3 cm)

Gift of Mrs. Benjamin Sharp
1946-77-1

Eakins, Thomas
Sketch for "Music" (The Violinist)
For the painting in the Albright-Knox Art Gallery, Buffalo
(inv. no. 55.4)
c. 1904
Oil on canvas on cardboard
13 × 14 7/8" (33 × 37.8 cm)
composition: 11 1/2 × 13 1/2"
(29.2 × 34.3 cm)

Gift of Mrs. Thomas Eakins and
Miss Mary Adeline Williams
1930-32-9

Eakins, Thomas
Portrait of Edward Taylor Snow
1904
On reverse: TO MY FRIEND /
E. TAYLOR SNOW / THOMAS
EAKINS / 1904
Oil on canvas
24 1/16 × 20 1/8" (61.1 × 51.1 cm)

Bequest of Mrs. Laura Elliot
Harmstad
1953-120-1

Eakins, Thomas
Sketch for "Portrait of Monsignor James P. Turner"
For the painting in the Nelson-Atkins Museum of Art, Kansas
City, Missouri (F38-41); see the
following painting for reverse
c. 1906
Lower right: Sketch / T.E.
Oil on cardboard
14 1/2 × 10 1/2" (36.8 × 26.7 cm);
composition: 12 1/2 × 6 1/2"
(31.8 × 16.5 cm)

Gift of Mrs. Thomas Eakins and
Miss Mary Adeline Williams
1930-32-15a

Eakins, Thomas
Portrait of Rear Admiral George Wallace Melville
1904
Lower right: EAKINS / 1904.;
on reverse: REAR ADMIRAL /
GEORGE WALLACE MELVILLE
U S N / BORN NEW YORK CITY
JANUARY 10 1841 / ENTERED
U S NAVY JULY 29, 1861. / 1881
CHIEF ENGINEER / 1887
ENGINEER IN CHIEF / 1898
REAR ADMIRAL / 1904 RETIRED.
/ MEMBER OF THE HALL

Eakins, Thomas
Sketch for "William Rush and His Model"
For the painting in the Honolulu
Academy of Arts (548.1); reverse
of the preceding painting
c. 1908
Upper left, on label: Presented to
Penna. Museum of Art. / by Mrs.
Eakins / Sketch of Rev. James P.
Turner / for Life size portrait / by
Thos. Eakins 1906; lower left, on
label: Sketch in studio / 7-5
Oil on cardboard
14 1/2 × 10 1/2" (36.8 × 26.7 cm)

Gift of Mrs. Thomas Eakins and
Miss Mary Adeline Williams
1930-32-15b

Eakins, Thomas
The Old-Fashioned Dress (Portrait of Helen Parker)
c. 1908
Lower right: T.E.; on reverse:
T. Eakins
Oil on canvas
60 1/8 × 40 3/16" (152.7 × 102.1 cm)

Gift of Mrs. Thomas Eakins and
Miss Mary Adeline Williams
1929-184-29

Eichholtz, Jacob
Portrait of Josiah Stewart
c. 1825
Oil on canvas
29 3/4 × 25" (75.6 × 63.5 cm)

Bequest of Emily Stewart Smith
1951-2-1

**Eakins, Thomas,
attributed to**
Views of Harry
c. 1890–1900
Oil on canvasboard
21 × 14" (53.3 × 35.6 cm)

Gift of Mr. and Mrs. Ulrich W.
Hiesinger in honor of Bea Garvan
1981-66-1

Eichholtz, Jacob
Cape Henlopen
After the painting by Thomas
Birch (American, 1779–1851),
in the Museum of Fine Arts,
Boston (62.261)
1832
Oil on canvas
20 1/8 × 29 7/8" (51.1 × 75.9 cm)

Gift of Mrs. William M. Wills
1930-50-2

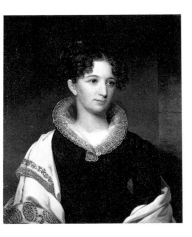

Earl, Ralph
American, 1751–1801
*Portrait of Sara Bradley and Her
Son*
c. 1788
Oil on canvas
44 × 35 3/4" (111.8 × 90.8 cm)

The Collection of Edgar William
and Bernice Chrysler Garbisch
1972-262-7

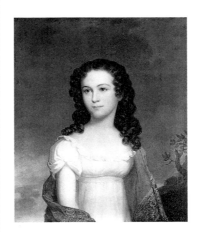

Eichholtz, Jacob
Portrait of Miss Julia Nicklin
1837
Lower right: J.E / 1837
Oil on canvas
30 1/8 × 25 5/16" (76.5 × 64.3 cm)

Gift of Peter T. Hornor
1956-40-1

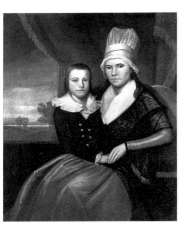

Eichholtz, Jacob
American, 1776–1842
*Portrait of Eliza Teackle
Montgomery*
1822
Oil on canvas
30 1/8 × 25" (76.5 × 63.5 cm)

Purchased for the Cadwalader
Collection with funds
contributed by the Mabel Pew
Myrin Trust and the gift of an
anonymous donor
1983-90-11

Eichholtz, Jacob
Dorothea
1841
Lower right: J. E. / 1841
Oil on canvas
20 1/16 × 13 3/4" (51 × 34.9 cm)

Gift of Mrs. William M. Wills
1930-50-3

Feke, Robert
American, born c. 1705,
still active 1750
Portrait of Dr. Phineas Bond
1750
Oil on canvas
40 × 32 ½" (101.6 × 82.5 cm)

Gift of Phyllis Cochran Denby in
memory of her uncle, George
Bond Cochran
1963-191-1

França, Manuel Joachim de
American, born Portugal,
1808–1865
*Portrait of Matthew Hinzinga
Messchert*
1839
On monument: SACRED / To the
Memory of / ELIZABETH A.
MESSCHERT / Born Sept 14 1809
/ Died May 20 1839; on book:
To / M. H. Messchert / a
Remembrance / from his /
Mother; on reverse: M. J. de
Franca / Pinxit Aug' 9 1839 /
Matthew Hinzinga Messchert /
Aged 8 years and 5 months /
Born March 1831
Oil on canvas
50 ⅛ × 40 ¼" (127.3 × 102.2 cm)

Gift of Dr. and Mrs. Harold Lefft
1965-214-1

Francis, John F.
American, c. 1808–1886
Still Life with Apples
1858
Lower left: J. F. Francis. pt. 1858.
Oil on canvas
22 ⅞ × 30 ⅛" (58.1 × 76.5 cm)

Gift of the Haas family in
memory of Joseph S. Haas
1979-32-1

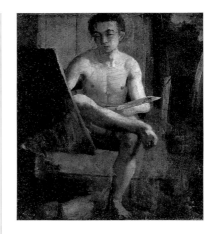

Fussell, Charles Lewis
American, 1840–1909
*A Young Art Student (Portrait of
Thomas Eakins)*
c. 1860–65
Oil on paper on canvas
15 × 13" (38.1 × 33 cm)

Gift of Seymour Adelman
1946-73-1

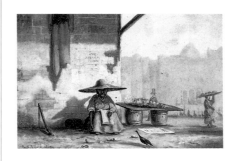

Gifford, Robert Swain
American, 1840–1905
Our American Cousin
1860
Lower left: R. S. Gifford 1860;
center: OUR AMERICAN COUSIN
Oil on millboard
6 ¹³⁄₁₆ × 10" (17.3 × 25.4 cm)

The W. P. Wilstach Collection,
bequest of Anna H. Wilstach
W1893-1-46

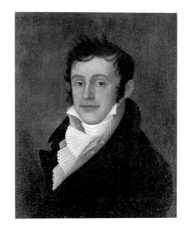

Greenwood, Ethan Allen
American, 1779–1856
*Portrait of a Man Wearing a
Brown-and-White Striped Vest*
Companion to the following
painting
1810
Lower left: E. A. Greenwood /
Pinxit 1810
Oil on canvas
24 ⅛ × 18" (61.3 × 45.7 cm)

The Collection of Edgar William
and Bernice Chrysler Garbisch
1972-262-3

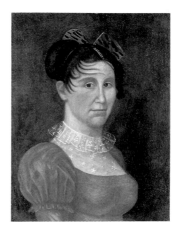

Greenwood, Ethan Allen
*Portrait of a Woman Wearing a Red
Dress and Combs*
Companion to the preceding
painting
1810
Lower right: E. A. Greenwood /
Pinxit 1810
Oil on canvas
24 ⅛ × 18" (61.3 × 45.7 cm)

The Collection of Edgar William
and Bernice Chrysler Garbisch
1972-262-4

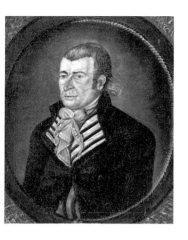

**Gullager, Christian,
attributed to**
American, born Denmark,
1759–1826
Portrait of Ebenezer Bancroft
c. 1785–90
Oil on canvas
29 × 23 9/16" (73.7 × 59.8 cm)

Centennial gift of Mrs. Francis P.
Garvan
1976-164-4

Harnett, William Michael
Still Life with a Writing Table
1877
Lower left: WMHARNETT / 1877
Oil on canvas
8 1/16 × 12 13/16" (20.5 × 32.5 cm)

The Alex Simpson, Jr., Collection
1943-74-4

Guy, Seymour Joseph
American, born England,
1824–1910
Making a Train
1867
Lower left: SJGuy. 1867
Oil on canvas
18 1/8 × 24 1/8" (46 × 61.3 cm)

The George W. Elkins Collection
E1924-4-14

Harnett, William Michael
*Still Life with a Ten-Cent Bill
(Shinplaster)*
1879
Upper left: WMHARNETT;
upper right: 1879
Oil on cardboard
5 9/16 × 7 5/8" (14.1 × 19.4 cm)

The Alex Simpson, Jr., Collection
1943-74-6

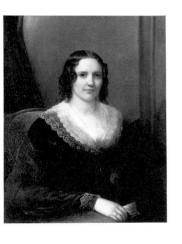

Harding, Chester
American, 1792–1866
Portrait of Fanny Hayes
1840s
Oil on canvas
36 1/4 × 28 1/8" (92.1 × 71.4 cm)

Bequest of T. Edward Hanley
1970-76-3

Harnett, William Michael
Still Life
1882
Lower left: WMHARNETT /
MUNCHEN / 1882
Oil on canvas
7 1/4 × 11 7/8" (18.4 × 30.2 cm)

The Albert M. Greenfield and
Elizabeth M. Greenfield
Collection
1974-178-32

Harnett, William Michael
American, 1848–1892
Still Life—Five-Dollar Bill
1877
Upper left: WMHarnett / 1877
Oil on canvas
8 × 12 1/8" (20.3 × 30.8 cm)

The Alex Simpson, Jr., Collection
1943-74-5

**Harnett, William Michael,
copy after**
Previously listed as William
Michael Harnett (PMA 1965)
Still Life
After the painting, dated 1882,
in the Munson-Williams-Proctor
Institute Museum of Art, Utica,
New York (57.67)
After 1882
Lower right (spurious):
WMHARNETT
Oil on canvas
12 × 16" (30.5 × 40.6 cm)

The Gertrude Schemm Binder
Collection
1951-84-1

Harrison, Alexander
American, 1853–1930
Coast Scene
1882
Lower right: A. Harrison
Oil on canvas
24 1/8 × 36 1/4" (61.3 × 92.1 cm)

John G. Johnson Collection
cat. 998

Harrison, Alexander
Three Schooners at Anchor
c. 1890–1913
Lower left: Alex–Harrison
Oil on canvas on panel
25 3/8 × 32 1/8" (64.4 × 81.6 cm)

John G. Johnson Collection
cat. 1000

Harrison, Alexander
Harbor of Concarneau
c. 1882–92
Lower right: Alex Harrison
Oil on panel
10 1/4 × 13 3/4" (26 × 34.9 cm)

John G. Johnson Collection
cat. 1001

Harrison, Lowell Birge
American, 1854–1929
Misty Morn
c. 1900–15
Lower left: Birge Harrison
Oil on canvas
17 × 23 1/4" (43.2 × 59 cm)

The Alex Simpson, Jr., Collection
1943-74-3

Harrison, Alexander
Moonlight Marine
c. 1882–92
Lower left: Alex Harrison
Oil on canvas
23 1/2 × 32" (59.7 × 81.3 cm)

John G. Johnson Collection
cat. 999

Harrison, Lowell Birge
Girl in a Wood
1920
On reverse: M. Chabod / Md. de
Couleurs / & Toiels a Tableaux /
Re Jacob, 20
Oil on canvas
19 5/8 × 30 3/4" (49.8 × 78.1 cm)

John G. Johnson Collection
cat. 1002

Harrison, Alexander
*Caricature of John G. Johnson as a
Sick Dog*
c. 1883–1908
Lower left: To Mrs. Johnson;
lower right: With kind regards /
Alex Harrison; on bottle: COUGH
Oil on canvas
15 7/8 × 24 1/8" (40.3 × 61.3 cm)

John G. Johnson Collection
inv. 2827

Hassam, Childe
American, 1859–1935
Boat off East Hampton
1909
On reverse: Childe Hassam /
1909
Oil on panel
5 5/8 × 9 1/4" (14.3 × 23.5 cm)

The Louis E. Stern Collection
1963-181-32

Hathaway, Rufus
American, 1770–1822
Portrait of the Reverend Nehemiah Thomas
1794
On reverse: Nehemiah Thomas age 28, June 10th 1794—/ Ordained Nov. 12th, 1792 this likeness / was taken by Dr. Rufus Hathaway of Duxbury / June 10th, 1794.
Oil on canvas on panel
29 1/4 × 24 1/4" (74.3 × 61.6 cm)

The Collection of Edgar William and Bernice Chrysler Garbisch
1972-262-10

Hesselius, Gustavus
American, born Sweden,
1682–1755
Portrait of a Woman
1751
On book: O Lord I give / thee praise / for health / strength / length of / days my Age / Being Seventy- / two years and / five days April / the 25 : 1751
Oil on canvas
32 7/8 × 24 11/16" (83.5 × 62.7 cm)

Gift of Mr. and Mrs. William F. Machold
1978-100-1

Heade, Martin Johnson
American, 1819–1904
Still Life with Flowers
c. 1865–70
Oil on canvas
18 1/4 × 14 5/16" (46.3 × 36.3 cm)

Bequest of Lisa Norris Elkins
1950-92-5

Hicks, Edward
American, 1780–1849
The Peaceable Kingdom
1826
On border: The wolf did with the lambkin dwell in peace / His grim carnivorous nature there did cease / The leopard with the harmless kid laid down / And not one savage beast was seen to frown / The lion with the fatling on did move / A little child was leading them in love; / When the great PENN his famous treaty made / With indian chiefs beneath the Elm-tree's shade.; on reverse: Edw. Hicks painter / New-town Bucks County / Penna. 8 moth. 26th / 1826
Oil on canvas
32 7/8 × 41 3/4" (83.5 × 106 cm)

Bequest of Charles C. Willis
1956-59-1

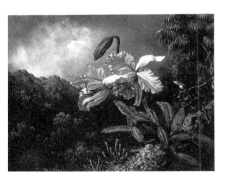

Heade, Martin Johnson
Orchids in a Jungle
1870s
Lower left: M J. Heade
Oil on canvas
16 3/16 × 20 1/4" (41.1 × 51.4 cm)

Bequest of Charlotte Dorrance Wright
1978-1-48

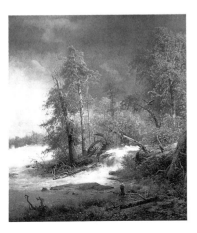

Herzog, Hermann
American, born Germany,
1832–1932
Goat Island, Niagara Falls
1878
Lower left: H. Herzog, 1878
Oil on canvas
56 × 47 3/4" (142.2 × 121.3 cm)

Bequest of Arthur H. Lea
F1938-1-117

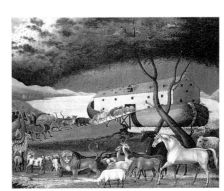

Hicks, Edward
Noah's Ark
1846
Oil on canvas
26 5/16 × 30 3/8" (66.8 × 77.1 cm)

Bequest of Lisa Norris Elkins
1950-92-7

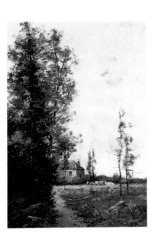

Hilliard, William Henry
American, 1836–1905
Pasturage near Rapendrecht,
Holland
c. 1880–1900
Lower right: W.H. Hilliard
Oil on canvas
24 1/8 × 16 1/8" (61.3 × 41 cm)

The Walter Lippincott Collection
1923-59-15

Homer, Winslow
A Huntsman and Dogs
1891
Lower right: Winslow Homer
1891
Oil on canvas
28 1/8 × 48" (71.4 × 121.9 cm)

The William L. Elkins Collection
E1924-3-8

Homer, Winslow
American, 1836–1910
Farm at Gloucester
1874
Lower right: WINSLOW HOMER.
N. A / 1874
Oil on canvas
20 3/8 × 30 1/8" (51.7 × 76.5 cm)

Purchased with the John Howard
McFadden, Jr., Fund
1956-118-1

Hovenden, Thomas
American, born Ireland,
1840–1895
Breaking Home Ties
1890
Lower right: T HOVENDEN 1890
/ COPYRIGHTED 1891
Oil on canvas
52 1/8 × 72 1/4" (132.4 × 183.5 cm)

Gift of Ellen Harrison McMichael
in memory of C. Emory
McMichael
1942-60-1

Homer, Winslow
The Life Line
1884
Lower right: WINSLOW HOMER /
1884
Oil on canvas
28 5/8 × 44 3/4" (72.7 × 113.7 cm)

The George W. Elkins Collection
E1924-4-15

Inman, Henry
American, 1801–1846
Portrait of Moses Seixas
1837
Oil on canvas
30 1/8 × 25 3/16" (76.5 × 64 cm)

Gift of an anonymous donor
1941-78-1

Homer, Winslow
Winter Coast
1890
Lower left: Winslow Homer /
1890
Oil on canvas
36 1/8 × 31 11/16" (91.8 × 80.5 cm)

John G. Johnson Collection
cat. 1004

Inness, George
American, 1825–1894
Twilight on the Campagna
Early 1850s
Oil on canvas
37 7/8 × 53 5/8" (96.2 × 136.2 cm)

The Alex Simpson, Jr., Collection
1945-5-1

Inness, George
Landscape with Yellow Bushes
1865
Lower left: G. Inness 1865
Oil on canvas on panel
12 1/16 × 18 1/8" (30.6 × 46 cm)

John G. Johnson Collection
cat. 1005

Inness, George
Valley of Cadore, Italy
1873
Lower right: G. Inness Rome
1873
Oil on canvas
16 3/16 × 24 5/16" (41.1 × 61.7 cm)

John G. Johnson Collection
cat. 1007

Inness, George
Landscape near Medfield,
Massachusetts
1868
Lower right: G. Inness 1868
Oil on panel
12 1/4 × 17 1/4" (31.1 × 43.8 cm)

The John D. McIlhenny
Collection
1943-40-48

Inness, George
Roman Campagna (Passing Shower)
1875
Lower right: G. Inness 1875
Oil on canvas
20 1/8 × 31 1/2" (51.1 × 80 cm)

Gift of Lucie Washington
Mitcheson in memory of Robert
Stockton Johnson Mitcheson for
the Robert Stockton Johnson
Mitcheson Collection
1938-22-9

Inness, George
Evening Landscape
c. 1868
Lower right: G. Inness
Oil on canvas
14 3/4 × 23 1/2" (37.5 × 59.7 cm)

Bequest of R. Nelson Buckley
1943-85-1

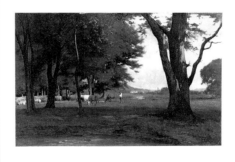

Inness, George
Summer Landscape
1876
Lower right: G. Inness 1876
Oil on canvas
30 1/4 × 45 1/4" (76.8 × 114.9 cm)

The William L. Elkins Collection
E1924-3-9

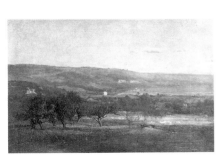

Inness, George
Landscape
c. 1871
Lower right: G. Inness
Oil on canvas
14 1/2 × 21 1/2" (36.8 × 54.6 cm)

Gift of Miss Anna Catherine
Stinson in memory of Mary
Arthur Burnham
1930-7-1

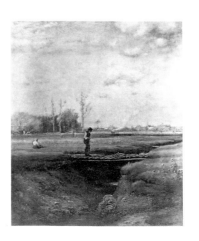

Inness, George
Short Cut, Watchung Station,
New Jersey
1883
Lower right: G. Inness 1883
Oil on canvas
37 5/8 × 29 1/8" (95.6 × 74 cm)

Purchased with the W. P.
Wilstach Fund
W1895-1-5

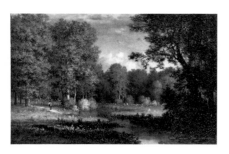

Inness, George
Landscape with a Stream
1885
Lower left: Inness
Oil on canvas
12 1/16 × 18 3/16" (30.6 × 46.2 cm)

John G. Johnson Collection
cat. 1006

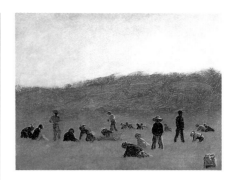

Johnson, Eastman
Cranberry Pickers
c. 1879
Oil on cardboard
13 15/16 × 17 1/2" (35.4 × 44.4 cm)

Gift of Mr. and Mrs. Arthur U. Crosby
1974-229-1

Jarvis, John Wesley
American, 1780–1840
Self-Portrait
c. 1810
Oil on canvas
23 7/8 × 19 5/8" (60.6 × 49.8 cm)

Bequest of T. Edward Hanley
1970-76-6

Johnson, Eastman
Portrait of Mrs. Allen Shelden
c. 1885
Lower left: E. J.
Oil on canvas
36 1/4 × 30 1/8" (92.1 × 76.5 cm)

The Alex Simpson, Jr., Collection
1928-63-7

Jarvis, John Wesley
Portrait of William Norris
1813
On label on reverse: Willm Norris / Son of Joseph / Born in Lancaster County / Virginia in the year of our / Lord 1774 the 21 March / this likeness is taken by Jarvis in the year of our / Lord 1813 being 39 years old
Oil on panel
34 × 26 1/8" (86.4 × 66.4 cm)

Bequest of G. Heide Norris
1944-1-1

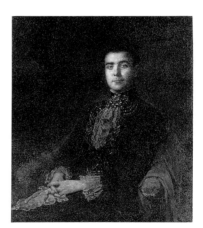

Johnson, Eastman
Portrait of Mrs. Ellen Inslee Eichholtz
c. 1885
Lower left: E. Johnson
Oil on canvas
36 × 30" (91.4 × 76.2 cm)

Gift of Paul Denckla
1958-94-1

Johnson, Eastman
American, 1824–1906
Barn Swallows
1878
Lower right: Eastman Johnson / 1878; on reverse: Barn Swallows—Mary K. Johnson from E.J.
Oil on canvas
27 3/16 × 22 3/16" (69.1 × 56.4 cm)

Gift of Mrs. John Wintersteen in memory of John Wintersteen
1953-111-1

Jones, H. Bolton
American, 1848–1927
Landscape with a Stream through Fields
1889
Lower right: H. BOLTON JONES 1889
Oil on canvas
16 × 24 1/8" (40.6 × 61.3 cm)

Bequest of Lydia Thompson Morris
1932-45-116

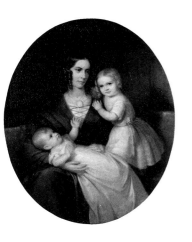

Lambdin, James Reid
American, 1807–1889
Portrait of Mrs. Miles and Her Children
1840s
Oil on canvas
50 × 37 3/4" (127 × 95.9 cm)

Gift of W. Parsons Todd and
Miss Mary J. Todd
1938-25-1

Martin, Homer D.
American, 1836–1897
Beach Road, Normandy
c. 1885
Lower right: Homer Martin
Oil on canvas
35 3/16 × 44 1/16" (89.4 × 111.9 cm)

Bequest of T. Edward Hanley
1970-76-7

Landis, John
American, born 1805,
still active 1851
Christ in the Upper Room
1836
On reverse: Jno. Landis, /
Pinxit / 1836
Oil on canvas
13 7/8 × 18 7/8" (35.2 × 47.9 cm)

The Titus C. Geesey Collection
1953-125-20

Martin, Homer D.
Sand Dunes
1887
Lower right: Homer Martin / 1887
Oil on canvas
14 × 22 1/16" (35.6 × 56 cm)

The Alex Simpson, Jr., Collection
1944-13-5

Linford, Charles
American, 1846–1897
Landscape
1888
Lower left: C. LINFORD. 1888
Oil on canvas
22 1/8 × 30 3/16" (56.2 × 76.7 cm)

Bequest of Lydia Thompson
Morris
1932-45-121

Mason, William Sanford
American, 1824–1864
Sledding
1854
Lower left: W. Sanford Mason /
1854
Oil on canvas
25 × 30 5/16" (63.5 × 77 cm)

Centennial gift of Mr. and Mrs.
Stuart P. Feld
1976-168-1

Lovejoy, E. W.
American, active c. 1840
Road Master
c. 1840
Center bottom: ROAD MASTER;
lower right: E. W. LOVEJOY. P.R.
Oil on cardboard
10 5/8 × 23 3/8" (27 × 59.4 cm)

The Collection of Edgar William
and Bernice Chrysler Garbisch
1972-262-8

Mason, William Sanford
Two Children Sailing a Boat
1857
Lower right: Wm Sanford Mason
/ 1857
Oil on canvas
30 1/8 × 25" (76.5 × 63.5 cm)

Bequest of Katherine E. Sheafer
1971-272-3

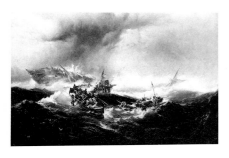

Moran, Edward
American, born England,
1829–1901
Shipwreck
1858
Lower left: E. Moran
Oil on canvas
40 1/8 × 60 1/8" (101.9 × 152.7 cm)

Gift of E. H. Butler
1894-276

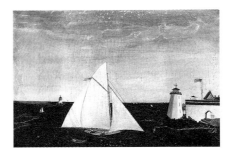

Moses, Thomas
American, born England,
1856–1934
Portsmouth Harbor
Late 19th or early 20th century
Oil on canvas
18 1/16 × 20 1/8" (45.9 × 51.1 cm)

Gift of Frank and Alice Osborn
1966-68-30

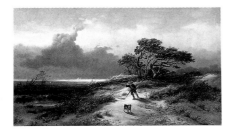

Moran, Edward
Windy Day, Coney Island
1871
Lower left: Edward Moran 1871
Oil on canvas
18 1/2 × 30 1/2" (47 × 77.5 cm)

Gift of Harry S. Dion
1979-105-1

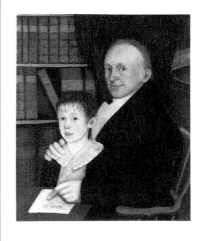

Moulthrop, Reuben
American, 1763–1814
Portrait of John Broadbent and His Son
Companion to the following painting
c. 1795
Lower left, on paper: Sheffield
Oil on canvas
31 5/16 × 25 5/16" (79.5 × 64.3 cm)

The Collection of Edgar William and Bernice Chrysler Garbisch
1972-262-5

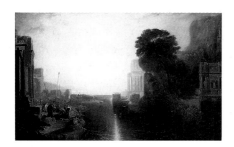

Moran, Thomas
American, 1837–1926
The Building of Carthage
After Joseph Mallord William Turner's *Dido Building Carthage; or the Rise of the Carthaginian Empire*, dated 1815, in the National Gallery, London (498)
1862
Lower left: T. MORAN After J.M.W. TURNER 1862
Oil on canvas
40 1/4 × 60 1/4" (102.2 × 153 cm)

Gift of Bradford S. Magill in memory of Matthew Baird
1977-174-1

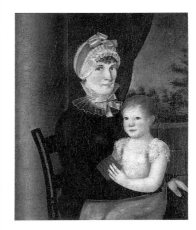

Moulthrop, Reuben
Portrait of Mrs. John Broadbent and Her Child
Companion to the preceding painting
c. 1795
Oil on canvas
31 5/16 × 25 5/16" (79.5 × 64.3 cm)

The Collection of Edgar William and Bernice Chrysler Garbisch
1972-262-6

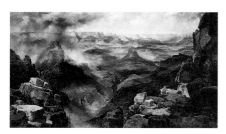

Moran, Thomas
Grand Canyon of the Colorado River
1892 and 1908
Lower right: TMORAN.
1892–1908 Copyright
Oil on canvas
53 × 94" (134.6 × 238.8 cm)

Gift of Graeme Lorimer
1975-182-1

Murphy, John Francis
American, 1853–1921
Landscape
1901
Lower left: J FRANCIS MURPHY.
1901—
Oil on canvas
14 × 19" (35.6 × 48.3 cm)

Gift of Lucie Washington Mitcheson in memory of Robert Stockton Johnson Mitcheson for the Robert Stockton Johnson Mitcheson Collection
1938-22-1

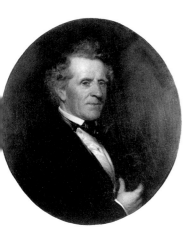

Neagle, John
American, 1796–1865
Portrait of Samuel Vaughan
Companion to the following
painting
c. 1820–30
Oil on canvas
30 1/4 × 25" (76.8 × 63.5 cm)

Gift of Mrs. Samuel M. Baker
1925-83-2

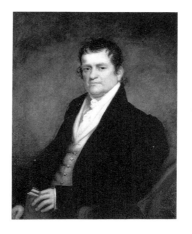

Otis, Bass
Portrait of Newberry Smith
1820s
Oil on canvas
36 1/2 × 28 1/16" (92.7 × 71.3 cm)

Gift of Mrs. Mary Stockton
Taylor
1944-77-1

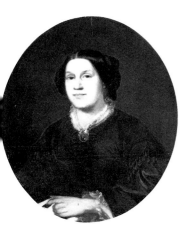

Neagle, John
Portrait of Susan Hoffman Vaughan
Companion to the preceding
painting
c. 1820–30
Oil on canvas
29 3/4 × 24 3/4" (75.6 × 62.9 cm)

Gift of Mrs. Samuel M. Baker
1925-83-1

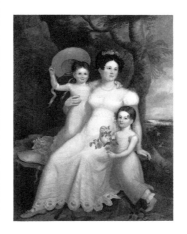

Otis, Bass
*Portrait of a Philadelphian and Her
Two Children*
1823
Center left: B. OTIS pinxt. AD 1823
Oil on canvas
66 3/8 × 50 1/4" (168.6 × 127.6 cm)

Purchased with the Edgar V.
Seeler Fund
1965-48-1

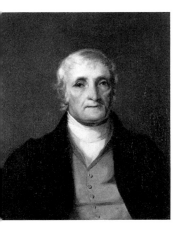

Ord, Joseph Biays
American, 1805–1865
Portrait of John McMullin
1834
Oil on canvas
16 1/4 × 13 1/2" (41.3 × 34.3 cm)

Purchased with Museum funds
1950-13-1

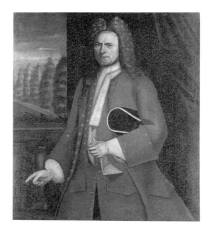

Partridge, Nehemiah
American, 1683–c. 1737
Portrait of Johannes ten Broeck
Companion to the following
painting
1720
Center left: Etas. Sue. 37. 1720
Oil on ticking
46 3/8 × 39 9/16" (117.8 × 100.5 cm)

Gift of the Runk family
1972-124-1

Otis, Bass
American, 1784–1861
Portrait of Samuel Breck
c. 1816
On reverse: Portrait of Samuel
Breck / of Sweetbriar, taken by
Otis, / when Mr. Breck was about
forty / five. It is a good likeness.
Oil on panel
9 1/16 × 6 7/8" (23 × 17.5 cm)

Gift of Mrs. C. P. Beauchamp
Jefferys
1966-53-1

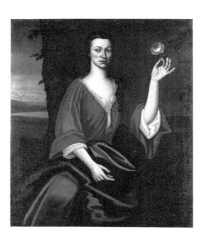

Partridge, Nehemiah
*Portrait of Catryna van Rensselaer
ten Broeck*
Companion to the preceding
painting
1720
Lower right: Etats. Suae. / 29.
years / 1720:
Oil on ticking
46 1/4 × 39 7/16" (117.5 × 100.2 cm)

Gift of the Runk family
1972-124-2

Paxton, William McGregor
American, 1869–1941
Portrait of General Wendell Phillips Bowman
1930s
Lower right: PAXTON
Oil on canvas
101 × 66 1/2" (256.5 × 168.9 cm)

Gift of Elizabeth Malcolm Bowman in memory of Wendell Phillips Bowman
1936-17-1

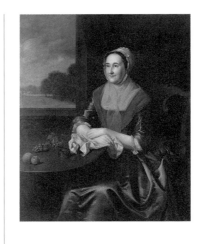

Peale, Charles Willson
Portrait of Hannah Lambert Cadwalader
c. 1772
Oil on canvas
50 × 40" (127 × 101.6 cm)

Purchased for the Cadwalader Collection with funds contributed by the Mabel Pew Myrin Trust and the gift of an anonymous donor
1983-90-2

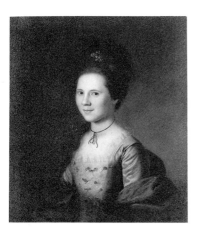

Peale, Charles Willson
American, 1741–1827
Portrait of Mary Benezet
1772
Lower left: Chas. Wn. Peale / pinxt: 1772
Oil on canvas
30 1/8 × 25 3/16" (76.5 × 64 cm)

Gift of Mrs. Thomas Evans
1962-126-1

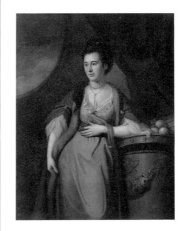

Peale, Charles Willson
Portrait of Colonel Lambert Cadwalader
c. 1772
Oil on canvas
50 × 40" (127 × 101.6 cm)

Purchased for the Cadwalader Collection with funds contributed by the Mabel Pew Myrin Trust and the gift of an anonymous donor
1983-90-4

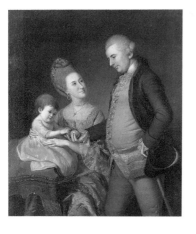

Peale, Charles Willson
Portrait of John and Elizabeth Lloyd Cadwalader and Their Daughter Anne
1772
Oil on canvas
51 1/2 × 41 1/4" (130.8 × 104.8 cm)

Purchased for the Cadwalader Collection with funds contributed by the Mabel Pew Myrin Trust and the gift of an anonymous donor
1983-90-3

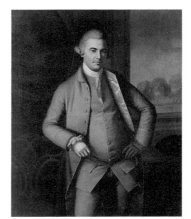

Peale, Charles Willson
Portrait of Martha Cadwalader Dagworthy
c. 1772
Center right: C Peale pinxit 1771
Oil on canvas
50 × 40" (127 × 101.6 cm)

Purchased for the Cadwalader Collection with funds contributed by the Mabel Pew Myrin Trust and the gift of an anonymous donor
1980-135-1

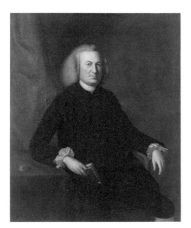

Peale, Charles Willson
Portrait of Dr. Thomas Cadwalader
c. 1772
Oil on canvas
50 × 40" (127 × 101.6 cm)

Purchased for the Cadwalader Collection with funds contributed by the Mabel Pew Myrin Trust and the gift of an anonymous donor
1983-90-1

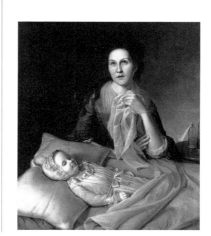

Peale, Charles Willson
Rachel Weeping
Enlarged in 1776; repainted in 1818
1772, 1776, and 1818
Oil on canvas
36 13/16 × 32 1/16" (93.5 × 81.4 cm)

Gift of the Barra Foundation, Inc
1977-34-1

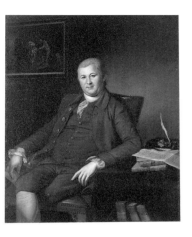

Peale, Charles Willson
Portrait of John B. Bayard
Companion to the following
painting
1780
On reverse: John Bayard / Chas.
Peale pinxit / 1780
Oil on canvas
50 1/4 × 40 1/2" (127.6 × 102.9 cm)

Gift of Mrs. T. Charlton Henry
1964-105-2

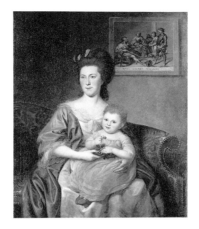

Peale, Charles Willson
*Portrait of Mrs. Thomas McKean
and Her Daughter, Sophia Dorothea*
Companion to the preceding
painting
1787
Lower right: C. W Peale pinxit
1787; on print: DATE OBOLUM
BELISARIO
Oil on canvas
50 5/8 × 41 1/16" (128.6 × 104.3 cm)

Bequest of Phebe Warren
McKean Downs
1968-74-2

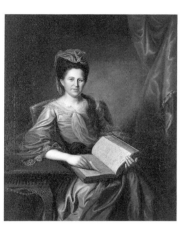

Peale, Charles Willson
Portrait of Mrs. John B. Bayard
Companion to the preceding
painting
1780
On book: PROVERBS / CHAP.
XXXI; on reverse: Chas. Peale
pinxit, 1780
Oil on canvas
50 1/4 × 40 1/2" (127.6 × 102.9 cm)

Gift of Mrs. T. Charlton Henry
1964-105-3

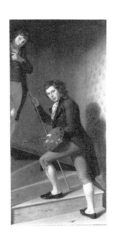

Peale, Charles Willson
*Staircase Group (Portrait of
Raphaelle Peale and Titian
Ramsey Peale)*
1795
Center bottom, on card: [illegible
signature]
Oil on canvas
89 1/2 × 39 3/8" (227.3 × 100 cm)

The George W. Elkins Collection
E1945-1-1

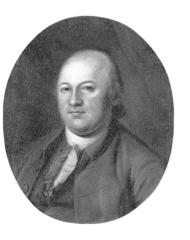

Peale, Charles Willson
Portrait of Thomas Wharton
c. 1781–1805
Oil on canvas
23 5/16 × 19 1/2" (59.2 × 49.5 cm)

Gift of the children of Marianna
Lippincott O'Neill in her memory
1967-216-1

Peale, Charles Willson
Portrait of Mrs. Leonard Nutz
c. 1815–20
Oil on canvas
26 1/8 × 22 1/8" (66.4 × 56.2 cm)

Gift of the Frescoln family
1969-266-1

Peale, Charles Willson
*Portrait of Governor Thomas
McKean and His Son, Thomas
McKean, Jr.*
Companion to the following
painting
1787
Center right: C. W Peale, 1787
Oil on canvas
50 5/8 × 41 1/8" (128.6 × 104.5 cm)

Bequest of Phebe Warren
McKean Downs
1968-74-1

Peale, Charles Willson
Previously listed as Rembrandt
Peale (PMA 1965)
Portrait of Polly S. Royal
1821
Oil on canvas
29 1/2 × 24 3/8" (74.9 × 61.9 cm)

Gift of Eliza Royal Finckel
1956-66-5

Peale, Charles Willson, attributed to
Portrait of Colonel Samuel Miles
c. 1790–1800
Oil on canvas
28 1/2 × 23 3/4" (72.4 × 60.3 cm)

Gift of Mrs. Catherine M. G.
Dinges
1930-54-1

Peale, James
Wissahickon Creek
1830
On reverse: S. Olivia S. Morris /
Pa. / and / Painted by Jn. Peale
Sen. in the year of his / Age 81 /
Philada. 1830.
Oil on canvas
20 1/8 × 27" (51.1 × 68.6 cm)

Gift of T. Edward Hanley
1964-210-2

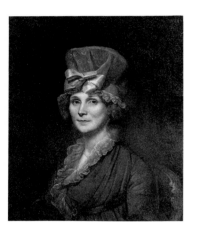

Peale, Charles Willson, attributed to
Portrait of Mary Ann MacNeal Macpherson
1799
On reverse, covered by relining:
[] Peale / pted 1799
Oil on canvas
29 × 24 1/2" (73.7 × 62.2 cm)

Bequest of Mellicent Story
Garland
1963-75-2

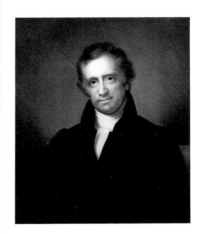

Peale, Rembrandt
American, 1778–1860
Portrait of Bartholomew Wistar
c. 1820
Oil on canvas
30 1/8 × 24 7/8" (76.5 × 63.2 cm)

Gift of Mrs. J. Morris Wistar
1976-223-3

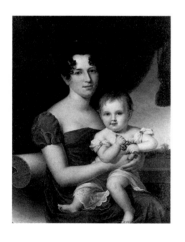

Peale, James
American, 1749–1831
Portrait of Mrs. Nathaniel Waples and Her Daughter, Sarah Ann
1817
Lower right: Jas. Peale / 1817
Oil on canvas
36 × 28" (91.4 × 71.1 cm)

Gift of Mrs. C. Emory McMichael
1950-51-1

Peale, Rembrandt
Portrait of a Boy in a Red Jacket
1845
Lower left: R. Peale. / 1845.
Oil on canvas
24 × 18 5/16" (61 × 46.5 cm)

Purchased with the W. P.
Wilstach Fund
W1918-3-1

Peale, James
Wissahickon Creek
1830
On reverse: S. Olivia S. Morris /
Pa. / and / Painted by Jn. Peale
Sen. in the year of his / Age 81 /
Philada. 1830.
Oil on canvas
20 1/8 × 27" (51.1 × 68.6 cm)

Gift of T. Edward Hanley
1964-210-1

Peale, Rembrandt
Bust of Washington
After a bust by Jean-Antoine
Houdon (French, 1741–1828)
1857
Lower right: Painted by
Rembrandt Peale from Houdon
Oil on canvas
36 1/8 × 29 1/8" (91.8 × 74 cm)

The W. P. Wilstach Collection,
bequest of Anna H. Wilstach
W1893-1-84

Perot, Annie Lovering
American, 1854–1931
Little Lane, East Gloucester
c. 1900–25
Lower left: A. L. Perot
Oil on canvas
29 3/4 × 25" (75.6 × 63.5 cm)

Bequest of Annie Lovering Perot
1936-1-3

Peto, John Frederick
American, 1854–1907
Still Life with a Hat, an Umbrella, and a Bag
1905
Lower right: John F. Peto / 1905;
on reverse: J.F.Peto / 1905 /
ISLAND HEIGHTS / N.J.
Oil on canvas
20 1/8 × 12 1/16" (51.1 × 30.6 cm)

The Albert M. Greenfield and
Elizabeth M. Greenfield
Collection
1974-178-40

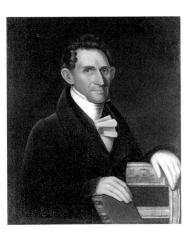

Phillips, Ammi
American, 1788–1865
Portrait of Mr. Warburton of Rockboro, Virginia
Companion to the following
painting
c. 1825
On book: WARBURTON'S /
LETTERS
Oil on canvas
28 7/8 × 23 13/16" (73.3 × 60.5 cm)

The Collection of Edgar William
and Bernice Chrysler Garbisch
1973-258-1

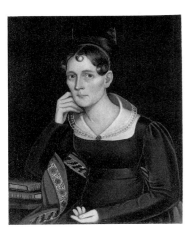

Phillips, Ammi
Portrait of Mrs. Warburton of Rockboro, Virginia
Companion to the preceding
painting
c. 1825
On books: NEWTON'S / WORKS;
MILTON'S WORKS
Oil on canvas
29 13/16 × 23 7/8" (75.8 × 60.6 cm)

The Collection of Edgar William
and Bernice Chrysler Garbisch
1973-258-2

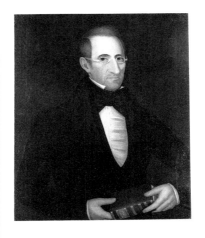

Phillips, Ammi
Portrait of a Man
Companion to the following
painting
c. 1830
On book: HOLY- / BIBLE.
Oil on canvas
33 1/2 × 28" (85.1 × 71.1 cm)

Gift of Mr. and Mrs. John B.
Schorsch
1973-263-1

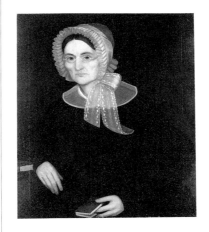

Phillips, Ammi
Portrait of a Woman
Companion to the preceding
painting
c. 1830
Oil on canvas
33 5/8 × 23 1/8" (85.4 × 58.7 cm)

Gift of Mr. and Mrs. John B.
Schorsch
1973-263-2

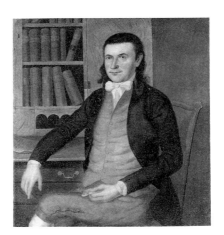

Polk, Charles Peale
American, 1767–1822
Portrait of John Hart
Companion to following painting
c. 1795
On books: COOK'S / [V]OYAGE;
HERVEY / MEDITATIONS;
MCEWEN / ON THE / TYPES;
PAINE'S / WORKS; BLAIR'S /
LECTURES; WORLD; BELKNAP'S
/ AMERICAN / BIOGRAPHY;
ROBERTSON / INDIA; NATUREAL
/ HISTORY; POPES WORKS;
on paper: Invoice / of / Books
Oil on canvas
37 1/2 × 33 5/8" (95.2 × 85.4 cm)

The Collection of Edgar William
and Bernice Chrysler Garbisch
1968-222-1

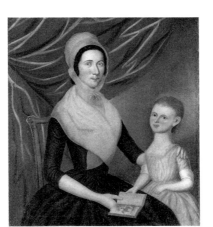

Polk, Charles Peale
Portrait of Mrs. John Hart and Her Daughter
Companion to preceding painting
c. 1795
Oil on canvas
37 1/8 × 33 1/8" (94.3 × 84.1 cm)

The Collection of Edgar William
and Bernice Chrysler Garbisch
1968-222-2

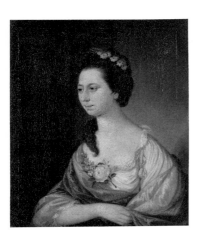

Pratt, Matthew
American, 1734–1805
Portrait of Mrs. Samuel Powel
[née Elizabeth Willing]
1768–70
Oil on canvas
29 ⁷/₈ × 25" (75.9 × 63.5 cm)

Purchased with the George W.
Elkins Fund
E1973-1-1

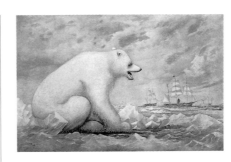

Raleigh, Charles Sidney
American, born England,
1830–1925
Chilly Observation
1889
Lower left: C. S. Raleigh / 1889
Oil on canvas
29 ¹³/₁₆ × 43 ⁷/₈" (75.7 × 111.4 cm)

The Collection of Edgar William
and Bernice Chrysler Garbisch
1965-209-6

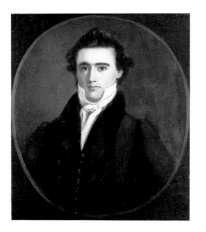

Prior, William Matthew
American, 1806–1873
Portrait of a Man
1829
On reverse: Wm. M. Prior / 1829
Oil on canvas
26 ³/₈ × 22 ¹/₁₆" (67 × 56 cm)

Bequest of Edgar William and
Bernice Chrysler Garbisch
1980-64-8

Richards, William Trost
American, 1833–1905
Landscape
1864
Lower left: Wm. T. Richards.
1864
Oil on canvas
16 × 22 ³/₈" (40.6 × 56.8 cm)

Centennial gift of Dr. and Mrs.
Bernard J. Ronis and family
1976-222-1

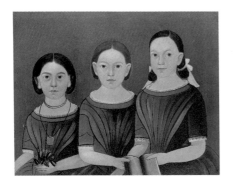

Prior, William Matthew
Portrait of Three Girls
c. 1850
Oil on canvas
21 ¹³/₁₆ × 26 ³/₄" (55.4 × 67.9 cm)

The Collection of Edgar William
and Bernice Chrysler Garbisch
1973-258-3

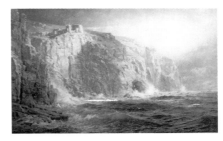

Richards, William Trost
Marine
1886
Lower left: Wm. T. Richards
1886
Oil on canvas
28 ¹/₄ × 44" (71.7 × 111.8 cm)

Bequest of Arthur H. Lea
F1938-1-48

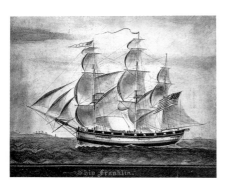

Ralb, G. E.
American, active 19th century
The Ship "Franklin"
c. 1830
Center bottom: Ship Franklin;
lower right: G. E. RALB.
Oil on panel
15 ³/₄ × 20 ¹/₈" (40 × 51.1 cm)

Bequest of Edgar William and
Bernice Chrysler Garbisch
1980-64-11

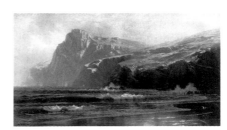

Richards, William Trost
*Marine with a View of the English
Coast*
1891
Oil on canvas
44 × 65" (111.7 × 165.1 cm)

Gift of the estate of Katharine C.
Wharton
1986-76-4

Richards, William Trost
Fast Castle
1892
Lower left: W. T. Richards, 92.
Oil on canvas
48 × 36 3/8" (121.9 × 92.4 cm)

Bequest of Arthur H. Lea
F1938-1-27

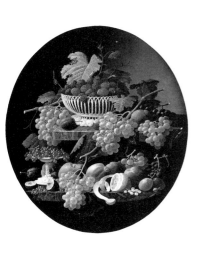

Roesen, Severin
Still Life with Fruit and a Wine Glass
c. 1850–70
Lower right: Roesen
Oil on canvas
11 3/4 × 16" (29.8 × 40.6 cm)

Purchased with the Joseph E. Temple Fund
1969-259-1

Roath, H. A.
American, active c. 1825
US Revenue Cutter
c. 1825
Center bottom: U S / REVENUE
CUTTER; on capstan: U S /
MORRIS; lower right: H A ROATH
Oil on canvas
15 1/2 × 21" (39.4 × 53.3 cm)

The Collection of Edgar William and Bernice Chrysler Garbisch
1967-268-3

Sargent, John Singer
American, active London,
Florence, and Paris, 1856–1925
Portrait of Frances Sherborne Ridley Watts
1877
Upper right: John S. Sargent
Oil on canvas
41 11/16 × 32" (105.9 × 81.3 cm)

Gift of Mr. and Mrs. Wharton Sinkler
1962-193-1

Robinson, Théodore
American, 1852–1896
Giverny
c. 1888
Lower left: Th. Robinson
Oil on canvas
18 1/8 × 21 7/8" (46 × 55.6 cm)

Gift of Lucie Washington Mitcheson in memory of Robert Stockton Johnson Mitcheson for the Robert Stockton Johnson Mitcheson Collection
1938-22-10

Sargent, John Singer
In the Luxembourg Gardens
1879
Lower right: John S. Sargent, Paris / 1879
Oil on canvas
25 7/8 × 36 3/8" (65.7 × 92.4 cm)

John G. Johnson Collection
cat. 1080

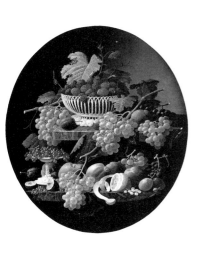

Roesen, Severin
American, born Germany,
1848–1871
Still Life with Fruit
c. 1850–70
Lower right: Roesen
Oil on canvas
30 1/4 × 25" (76.8 × 63.5 cm)

This painting by Severin Roesen, known as the pauper painter of Williamsport, Pennsylvania, was given by Theodore Wiedemann in memory of his wife, Letha M. Wiedemann, a native of that city
1980-63-1

Sargent, John Singer
Portrait of Mrs. J. William White
1903
Across top: To my friend Mrs. White John S. Sargent, 1903
Oil on canvas
30 1/16 × 25 1/16" (76.4 × 63.7 cm)

Commissioners of Fairmount Park
F1925-5-1

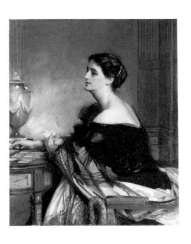

Sargent, John Singer
Portrait of Lady Eden
1906
Upper left: John S. Sargent;
upper right: 1906
Oil on canvas
43 9/16 × 34 1/16" (110.6 × 86.5 cm)

Purchased with the W. P.
Wilstach Fund
W1920-2-1

Sartain, William
*The Royal Mill on the Eresma River,
Segovia, Spain*
c. 1880–1900
Lower right: W. Sartain.
Oil on canvas
30 × 45 1/8" (76.2 × 114.6 cm)

Purchased with the Edward and
Althea Budd Fund
1977-114-1

Sargent, John Singer
The Rialto, Venice
c. 1911
Lower left: John S. Sargent
Oil on canvas
22 × 36 1/4" (55.9 × 92.1 cm)

The George W. Elkins Collection
E1924-4-28

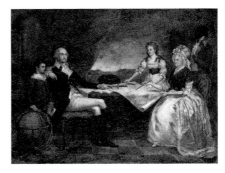

Savage, Edward, copy after
American, 1761–1817
*Portrait of George Washington and
His Family*
After the engraving, dated 1798,
by Edward Savage and David
Edwin (American, 1776–1841),
of the painting by Savage, in the
Henry Francis du Pont
Winterthur Museum,
Winterthur, Delaware (61.708)
c. 1850
Oil on canvas
28 × 36" (71.1 × 91.4 cm)

Bequest of F. King Wainwright
1952-65-1

Sartain, William
American, 1843–1924
Green Meadow
c. 1880–1900
Lower right: W. SARTAIN.
Oil on canvas
22 1/8 × 32" (56.2 × 81.3 cm)

Gift of Miss Harriet Sartain
1947-81-1

Schussele, Christian
American, 1824?–1879
Hubert and Arthur
1858
Lower right: C. Schuessele /
Philada. / 1858
Oil on canvas
62 5/8 × 46" (159.1 × 116.8 cm)

Gift of R. A. Ellison
1979-146-1

Sartain, William
Rosa
c. 1880–1900
Lower right: W. SARTAIN
Oil on canvas
20 1/8 × 16 1/16" (51.1 × 40.8 cm)

Gift of Lucie Washington
Mitcheson in memory of Robert
Stockton Johnson Mitcheson for
the Robert Stockton Johnson
Mitcheson Collection
1938-22-6

Smith, T. Henry
American, active c. 1861–1896
With Love (Con Amore)
1866
Lower left: T. HENRY SMITH /
1866
Oil on canvas
20 1/8 × 24" (51.1 × 61 cm)

The W. P. Wilstach Collection,
bequest of Anna H. Wilstach
W1893-1-100

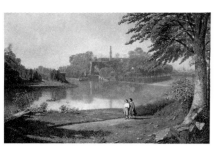

Smith, T. Henry
Fairmount Waterworks
1871
Lower left: T. Henry Smith. /
1871; on reverse: Fairmount /
Painted by / T. Henry Smith /
1871
Oil on canvas
30 $^{13}/_{16}$ × 47 $^1/_{16}$" (78.3 ×
119.5 cm)

Purchased with the Bloomfield
Moore Fund
1966-4-1

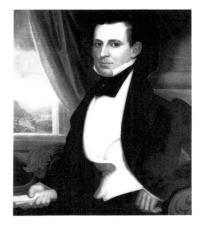

Street, Robert
Portrait of Joseph Mount
Companion to the preceding
painting
1835
Center right: R. STREET / 1835
Oil on canvas on panel
30 × 25 $^1/_{16}$" (76.2 × 63.7 cm)

Gift of Miss Eleanor Bispham
1975-40-1

Stieglitz, Edward
American, born Germany,
1833–1909
Portrait of a Young Woman
After a painting by Fedor Encke
(German, born 1851, still active
1913), in an unknown location
1885
Upper right: Copie F. Encke, /
Mittenwald Sept / 85 / ES; on
reverse: Copy of picture by Fedor
Encke, Mittenwald, September
'85 by Edward Stieglitz
Oil on panel
7 $^1/_{16}$ × 5 $^3/_8$" (17.9 × 13.6 cm)

Gift of Katherine Kuh
1972-100-1

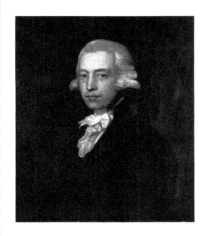

Stuart, Gilbert Charles
American, 1755–1828
Portrait of Phineas Bond
c. 1780
Oil on canvas
29 $^9/_{16}$ × 25 $^1/_8$" (75.1 × 63.8 cm)

Purchased for the Cadwalader
Collection with funds
contributed by the Mabel Pew
Myrin Trust and the gift of an
anonymous donor
1983-90-5

Street, Robert
American, 1796–1865
Portrait of William H. Klapp
1820
Lower left: R. Street 1820
Oil on canvas
72 × 48" (182.9 × 121.9 cm)

Purchased with the J. Stogdell
Stokes Fund
1992-60-1

Stuart, Gilbert Charles
Portrait of Dean Christopher Bertson
Companion to the following
painting
c. 1788–92
Oil on canvas
30 × 25" (76.2 × 63.5 cm)

Gift of Muriel and Philip Berman
1992-15-1

Street, Robert
Portrait of Susan Baker Mount
Companion to the following
painting
1834
Upper left: R. STREET / 1834
Oil on canvas on panel
30 $^1/_8$ × 25 $^1/_{16}$" (76.5 × 63.7 cm)

Gift of Miss Eleanor Bispham
1975-40-2

Stuart, Gilbert Charles
Portrait of Mrs. Christopher Bertson
Companion to the preceding
painting
c. 1788–92
Oil on canvas
30 × 25" (76.2 × 63.5 cm)

Gift of Muriel and Philip Berman
1992-15-2

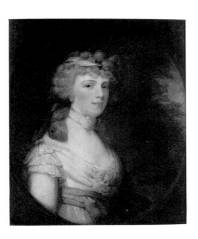

Stuart, Gilbert Charles
Portrait of Ann Penn Allen
Replica of the painting in the
Metropolitan Museum of Art,
New York (43.86.3)
c. 1795
Oil on canvas
30 × 25 1/8" (76.2 × 63.8 cm)

Gift of Mr. and Mrs. Wharton
Sinkler
1959-79-1

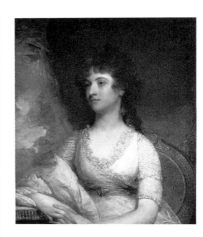

Stuart, Gilbert Charles
*Portrait of Frances Cadwalader
Montagu, Lady Erskine*
Companion to the preceding
painting
1802
Oil on canvas
29 5/16 × 24 1/8" (74.4 × 61.3 cm)

Purchased for the Cadwalader
Collection with funds
contributed by the Mabel Pew
Myrin Trust and the gift of an
anonymous donor
1983-90-7

Stuart, Gilbert Charles
Portrait of George Washington
(The Mount Vernon Washington)
After the painting, dated 1796,
jointly owned by the Museum of
Fine Arts, Boston, and the
National Portrait Gallery,
Washington, D.C.
1796
Oil on canvas
28 1/8 × 24 3/16" (71.4 × 61.4 cm)

Gift of Mr. and Mrs. Wharton
Sinkler
1957-67-1

**Stuart, Gilbert Charles,
attributed to**
Previously listed as Gilbert
Charles Stuart (PMA 1965)
Portrait of John Browne Davy
c. 1815
Oil on canvas
29 1/8 × 21 1/16" (74 × 53.5 cm)

Purchased with the Katharine
Levin Farrell Fund
1960-109-1

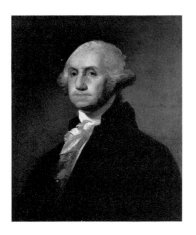

Stuart, Gilbert Charles
Portrait of George Washington
After the painting, dated 1796,
jointly owned by the Museum of
Fine Arts, Boston, and the
National Portrait Gallery,
Washington, D.C.
After 1796
Oil on canvas
30 × 24 1/8" (76.2 × 61.3 cm)

Gift of Mrs. T. Charlton Henry
1964-105-1

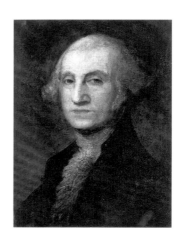

**Stuart, Gilbert Charles,
copy after**
Portrait of George Washington
After a painting known in many
versions
Mid-19th century
Oil on canvas
22 × 16 1/8" (55.9 × 41 cm)

Gift of Mrs. Robert F. Beard
1961-21-1

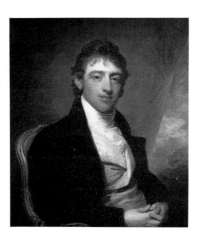

Stuart, Gilbert Charles
*Portrait of David Montagu,
2nd Baron Erskine*
Companion to the following
painting
1802
Oil on canvas
29 1/8 × 24 1/8" (74 × 61.3 cm)

Purchased for the Cadwalader
Collection with funds
contributed by the Mabel Pew
Myrin Trust and the gift of an
anonymous donor
1983-90-6

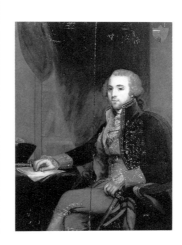

**Stuart, Gilbert Charles,
copy after**
*Portrait of Don Josef de Jaudenes y
Nebot*
After the painting, dated 1794,
in the Metropolitan Museum of
Art, New York (07.75);
companion to the following
painting
19th century
Oil on panel
25 13/16 × 19 1/8" (65.6 × 48.6 cm)

Gift of Mr. and Mrs. Rowland
Evans
1956-61-1

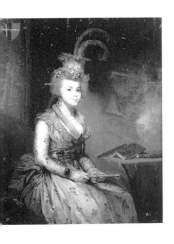

Stuart, Gilbert Charles, copy after
Portrait of Doña Matilda Stoughton de Jaudenes y Nebot
After the painting, dated 1794, in the Metropolitan Museum of Art, New York (07.76); companion to the preceding painting
19th century
Oil on panel
25 3/4 × 19 1/2" (65.4 × 49.5 cm)

Gift of Mr. and Mrs. Rowland Evans
1956-61-2

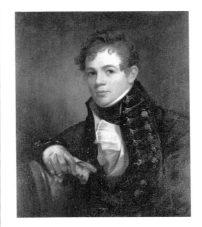

Sully, Thomas
Portrait of Dr. William P. C. Barton
1809
Oil on canvas
29 × 24" (73.7 × 61 cm)

Gift of Dr. William Barton Brewster for the W. P. Wilstach Collection
W1919-2-1

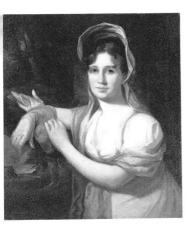

Sully, Thomas
American, born England, 1783–1872
Portrait of Sarah Sully, Wife of the Artist
1806, retouched 1856
On reverse: Painted in 1806 / Retouched 1856 / TS / Sarah wife of / Thos Sully
Oil on canvas
30 × 25 1/8" (76.2 × 63.8 cm)

Gift of Mr. and Mrs. Wharton Sinkler
1962-193-2

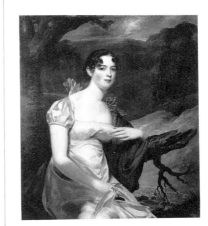

Sully, Thomas
Portrait of Mrs. Mary Siddons Whelen
1812
Oil on canvas
44 1/2 × 37 1/4" (113 × 94.6 cm)

Gift of Mrs. Thomas J. Dolan
1943-53-1

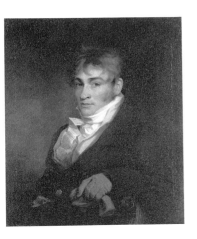

Sully, Thomas
Portrait of Redwood Fisher
1808, retouched 1847
Oil on canvas
29 1/4 × 24 1/8" (74.3 × 61.3 cm)

Gift of the estate of Lydia Fisher Warner
1949-54-1

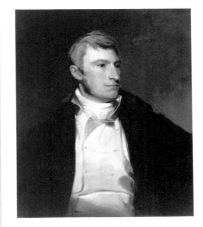

Sully, Thomas
Portrait of Charles Willing Hare
1814
Oil on canvas
29 × 24" (73.7 × 61 cm)

Bequest of Elizabeth C. Hare
1938-8-1

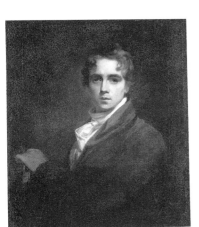

Sully, Thomas
Self-Portrait
1808, retouched 1856
Lower left: TS. 1808 / AE 25; on reverse: [pa]inted 1808 / retouched & / repai[n]ted / 1856 / Thos. Sully
Oil on canvas
30 1/8 × 25 3/16" (76.5 × 64 cm)

Gift of Mr. and Mrs. Wharton Sinkler
1961-171-1

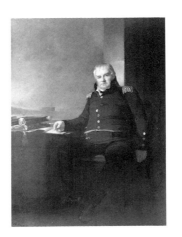

Sully, Thomas
Portrait of Colonel Jonathan Williams
1815
Lower left: TS 1815
Oil on canvas on plywood
81 × 58" (205.7 × 147.3 cm)

Gift of Alexander Biddle
1964-111-1

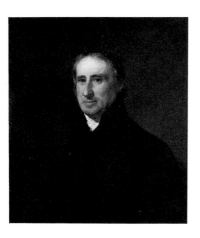

Sully, Thomas
Portrait of John Teackle
1815
Oil on canvas
30 5/16 × 25 5/16" (77 × 64.3 cm)

Purchased for the Cadwalader
Collection with funds
contributed by the Mabel Pew
Myrin Trust and the gift of an
anonymous donor
1983-90-8

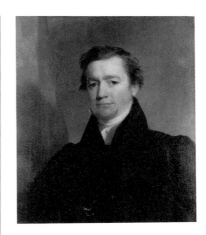

Sully, Thomas
Portrait of William Norris
Companion to the following
painting
1830
Lower left: TS. 1830.
Oil on canvas
30 1/8 × 25 3/16" (76.5 × 64 cm)

Bequest of G. Heide Norris
1960-78-1

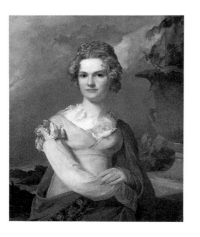

Sully, Thomas
Portrait of Maria Donath Koecker
1820
Center right: TS. 1820
Oil on canvas
35 1/2 × 27 1/2" (90.2 × 69.8 cm)

Bequest of Leonora L. Koecker
1942-37-2

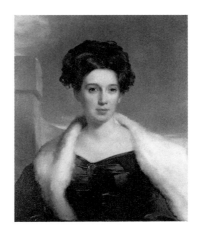

Sully, Thomas
Portrait of Mary Anne Heide Norris
Companion to the preceding
painting
1830
Lower left: TS 1830.
Oil on canvas
30 5/16 × 25 1/4" (77 × 64.1 cm)

Bequest of G. Heide Norris
1960-78-2

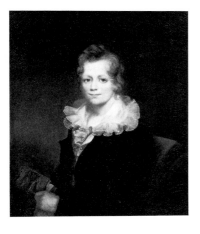

Sully, Thomas
Previously attributed to Thomas
Sully (PMA 1965)
Portrait of William Pitt Bedlock
c. 1825–30
Oil on canvas
30 3/16 × 25 3/16" (76.7 × 64 cm)

Gift of Maria Godey Bedlock
Thomas
1943-90-1

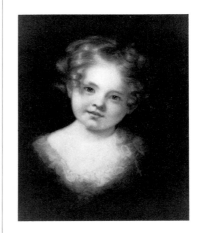

Sully, Thomas
Previously attributed to Thomas
Sully (PMA 1965)
Head of a Girl
c. 1830–50
Oil on cardboard
21 1/4 × 17 1/16" (54 × 43.3 cm)

Bequest of Bertha H. Giles
1935-9-1

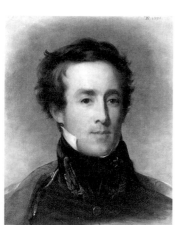

Sully, Thomas
Portrait of Captain Hartman Bache
1826
Upper right: TS. 1826.
Oil on canvas
19 1/16 × 15 1/8" (48.4 × 38.4 cm)

Bequest of Henrietta D. Pepper
1958-28-1

Sully, Thomas
Portrait of Mrs. Robert Ewing
1831
Lower left: T.S. 1831
Oil on canvas
30 1/8 × 25 1/4" (76.5 × 64.1 cm)

Gift of Mrs. Harvey Nelson
Carpenter
1936-10-1

Sully, Thomas
Portrait of General Thomas Cadwalader
1833
Lower left: TS. 1833
Oil on canvas
30 5/16 × 25" (77 × 63.5 cm)

Purchased for the Cadwalader Collection with funds contributed by the Mabel Pew Myrin Trust and the gift of an anonymous donor
1983-90-10

Sully, Thomas
Previously attributed to Thomas Sully (PMA 1965)
Portrait of Amos Pennebaker, Jr.
See previous two entries
c. 1835–40
Oil on canvas
30 × 24 1/2" (76.2 × 62.2 cm)

Bequest of Susan B. Pennebaker in memory of Sophie E. Pennebaker
1942-31-3

Sully, Thomas
Portrait of Sarah Franklin Bache, Daughter of Benjamin Franklin
After the painting by John Hoppner (English, 1758–1810), in the Metropolitan Museum of Art, New York (01.20)
1834
On reverse: TS 1834 / Portrait / Copied from Hoppner
Oil on canvas
30 × 25" (76.2 × 63.5 cm)

Bequest of Caroline D. Bache
1958-27-1

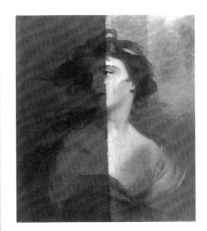

Sully, Thomas
Portrait of Lady Hamilton as Ariadne
Possibly after a painting by Sir Joshua Reynolds (English, 1723–1792)
1837
Oil on canvas
24 × 20" (61 × 50.8 cm)

Bequest of Mrs. Mary Frances Nunns
1959-59-1

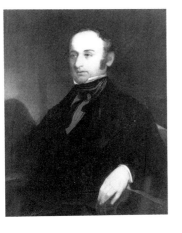

Sully, Thomas
Previously attributed to Thomas Sully (PMA 1965)
Portrait of Amos Pennebaker
Pendant to the following two paintings
c. 1835–40
Oil on canvas
36 1/8 × 29" (91.8 × 73.7 cm)

Bequest of Susan B. Pennebaker in memory of Sophie E. Pennebaker
1942-31-1

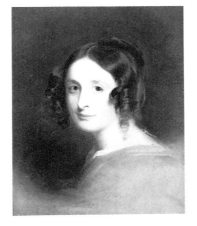

Sully, Thomas
Portrait of Maria Markoe Wharton
1837
Center bottom: TS. 1837
Oil on cardboard
21 1/8 × 17 1/8" (53.7 × 43.5 cm)

Bequest of Mrs. Maria McKean Allen
1951-44-1

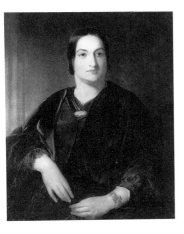

Sully, Thomas
Previously attributed to Thomas Sully (PMA 1965)
Portrait of Susan Campbell Pennebaker
See previous entry
c. 1835–40
Oil on canvas
36 × 28 3/4" (91.4 × 73 cm)

Bequest of Susan B. Pennebaker in memory of Sophie E. Pennebaker
1942-31-2

Sully, Thomas
Portrait of Charles Nicoll Bancker
1850
Oil on canvas
30 1/16 × 25 1/4" (76.4 × 64.1 cm)

Purchased for the Cadwalader Collection with funds contributed by the Mabel Pew Myrin Trust and the gift of an anonymous donor
1983-90-9

Sully, Thomas
Portrait of Mrs. Evan Poultney
1857
On reverse: TS 1857
Oil on canvas
24 × 20" (61 × 50.8 cm)

Gift of Brig. Gen. Bryan Conrad
1964-31-1

Tanner, Henry Ossawa
American, active France,
1859–1937
The Annunciation
1898
Lower left: H. O. TANNER / 1898
Oil on canvas
57 × 71 1/4" (144.8 × 181 cm)

Purchased with the W. P.
Wilstach Fund
W1899-1-1

Sully, Thomas
Gypsy Woman and Child
After a painting possibly by
Bartolomeo Morelli (Italian,
died 1703)
1859
On reverse: TS 1859 / copied
from Morelli
Oil on canvas
30 1/16 × 25 3/16" (76.4 × 64 cm)

The W. P. Wilstach Collection,
bequest of Anna H. Wilstach
W1893-1-107

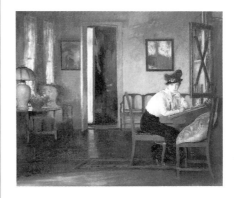

Tarbell, Edmund Charles
American, 1862–1938
Girl Writing
1917
Lower right: Tarbell 17
Oil on canvas
32 7/16 × 36 1/2" (82.4 × 92.7 cm)

The Alex Simpson, Jr., Collection
1944-13-6

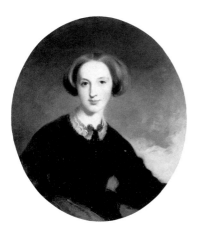

Sully, Thomas
Portrait of Virginia Earp
1859
On reverse: Virginia Earp / April
12, 1859 / Lillie Estelle Earp's /
private property / Sep. 23rd,
1892 / TS 1859 April
Oil on canvas
30 1/8 × 25" (76.5 × 63.5 cm)

Bequest of Anne Tucker Earp
1953-11-18

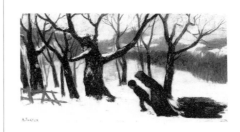

Thayer, Abbott Handerson
American, 1849–1921
Winter 1890
1890
Lower left: A. THAYER
Oil on canvas
10 1/4 × 18 1/8" (26 × 46 cm)

Centennial gift of Mrs. Francis P.
Garvan
1976-164-1

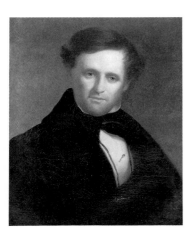

Sully, Thomas, follower of
Previously listed as in the manner
of Thomas Sully (PMA 1965)
Portrait of Isaac Paschal Morris
c. 1835–40
Oil on canvas
24 × 20 1/4" (61 × 51.4 cm)

Gift of Miss Lydia Thompson
Morris
1928-7-121

Thayer, Abbott Handerson
*My Daughter Mary (Portrait of
Mary Thayer)*
c. 1894
Lower right: Abbott H. Thayer
Oil on canvas
24 1/8 × 20 1/8" (61.3 × 51.1 cm)

The Alex Simpson, Jr., Collection
1928-63-9

Theus, Jeremiah
American, born Switzerland,
c. 1719–1774
Portrait of Ellinor Cordes
c. 1746
Oil on canvas
29 7/8 × 24 3/8" (75.9 × 61.9 cm)

The Collection of Edgar William
and Bernice Chrysler Garbisch
1967-268-1

Twachtman, John Henry
American, 1853–1902
Japanese Winter Landscape
1879
Lower left: J. H. Twachtman /
New York / 79
Oil on canvas
12 3/4 × 20 1/8" (32.4 × 51.1 cm)

The Alex Simpson, Jr., Collection
1946-5-3

Trotter, Mary K.
American, active France and
United States, active 1888–1901
Lamplight
1888
Lower right: M K Trotter 1888
Oil on canvas
20 1/8 × 24 3/8" (51.1 × 61.9 cm)

John G. Johnson Collection
inv. 2773

Vincent, Mary
American, active c. 1800–c. 1830
Still Life with a Basket of Fruit
Center bottom: MARY . VINCENT.
Oil on velvet
15 13/16 × 18" (40.2 × 45.7 cm)

Gift of Frank and Alice Osborn
1966-68-54

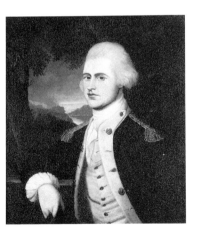

Trumbull, John, attributed to
American, 1756–1843
Portrait of Major John Macpherson
c. 1775–85
Oil on canvas on panel
30 × 25" (76.2 × 63.5 cm)

Gift of Caleb W. Hornor
1956-39-1

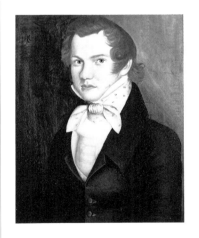

Wale, T., attributed to
American, active c. 1810–c. 1820
*Portrait of Edwin Sturdevant of
Hartland, Vermont*
Companion to the following
painting
c. 1810
Oil on panel
25 7/8 × 20 3/8" (65.7 × 51.7 cm)

Bequest of Edgar William and
Bernice Chrysler Garbisch
1981-1-6

Tryon, Dwight W.
American, 1849–1925
Autumn Evening
1919–20
Lower right: D. W. TRYON;
on reverse: Autumn Evening /
D W Tryon / 1919–20
Oil on panel
13 7/8 × 20" (35.2 × 50.8 cm)

The Alex Simpson, Jr., Collection
1945-5-2

Wale, T., attributed to
*Portrait of Cullen Sturdevant of
Hartland, Vermont*
Companion to the preceding
painting
c. 1810
Oil on panel
25 15/16 × 21 9/16" (65.9 × 54.8 cm)

Bequest of Edgar William and
Bernice Chrysler Garbisch
1981-1-7

Waugh, Samuel Bell
American, 1814–1885
Portrait of Isaac Paschal Morris
1873
Lower right: 1873. / S. B.
Waugh.
Oil on canvas
36 1/8 × 29" (91.8 × 73.7 cm)

Bequest of Lydia Thompson
Morris
1932-45-119

**Waugh, Samuel Bell,
follower of**
Previously listed as Samuel Bell
Waugh (PMA 1965)
Portrait of Rebecca Thompson Morris
After 1873
Oil on canvas
39 × 29 1/8" (99.1 × 74 cm)

Bequest of Lydia Thompson
Morris
1932-45-118

Wayne, Hattie
American, active c. 1864
Portrait of Abraham Lincoln
1864
Oil on canvas
30 1/8 × 25 1/16" (76.5 × 63.7 cm)

Gift of Mrs. Richard Waln Meirs
1933-11-2

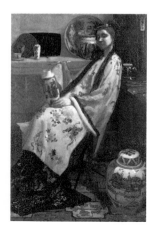

**Whistler, James Abbott
McNeill**
American, active England,
1834–1903
The Lady of the Lang Lijsen
1864
Upper right: Whistler 1864
Oil on canvas
36 3/4 × 24 1/8" (93.3 × 61.3 cm)

John G. Johnson Collection
cat. 1112

**Whistler, James Abbott
McNeill**
Nocturne
c. 1875–80
Oil on canvas
12 1/4 × 20 3/8" (31.1 × 51.7 cm)

John G. Johnson Collection
cat. 1111

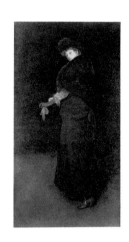

**Whistler, James Abbott
McNeill**
*Arrangement in Black (The Lady in
the Yellow Buskin)*
c. 1883
Oil on canvas
86 × 43 1/2" (218.4 × 110.5 cm)

Purchased with the W. P.
Wilstach Fund
W1895-1-11

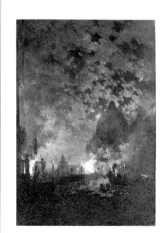

**Whistler, James Abbott
McNeill, imitator of**
Previously listed as James Abbott
McNeill Whistler (PMA 1965)
Grand Canal, Venice (Moonlight)
After 1890
Lower right (spurious): Whistler,
1890.
Oil on canvas
33 1/8 × 21 3/8" (84.1 × 54.3 cm)

The George W. Elkins Collection
E1924-4-32

Wiess, J.
American, active c. 1797
Home of George Washington
1797
Oil on canvas
15 13/16 × 20 11/16" (40.2 × 52.5 cm)

The Collection of Edgar William
and Bernice Chrysler Garbisch
1966-219-2

Wilkie, John
American, active c. 1830–c. 1840
Portrait of a Man
1836
On reverse: John Wilkie Pinxit /
Hamilton 20 Dec-1836
Oil on canvas
29 7/8 × 25" (75.9 × 63.5 cm)

The Louise and Walter Arensberg
Collection
1950-134-523

**Wollaston, John,
attributed to**
American, born England,
active c. 1736–c. 1767
Previously listed as John
Wollaston (PMA 1965)
*Portrait of Mrs. Perry and Her
Daughter Anna*
c. 1758
Oil on canvas
49 15/16 × 37 1/4" (126.8 × 94.6 cm)

Gift of the Robert L. McNeil, Jr.,
Trusts
1961-226-1

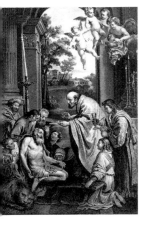

Winner, William E.
American, c. 1815–1883
Domestic Felicity
c. 1845–50
Oil on canvas
20 × 26 5/8" (50.8 × 67.6 cm)

The W. P. Wilstach Collection,
bequest of Anna H. Wilstach
W1893-1-125

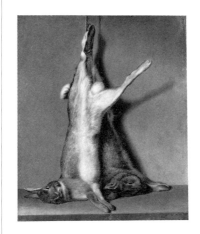

Woodside, John Archibald, Sr.
American, 1781–1852
Still Life with Rabbits
1827
Lower right: J. A. Woodside
1827
Oil on canvas
23 7/16 × 17 7/16" (59.5 × 44.3 cm)

Bequest of Robert Nebinger
1889-110

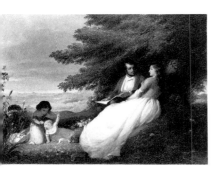

Winner, William E.
The Last Communion of Saint Jerome
Copy after the painting by
Domenichino (Italian,
1581–1641), in the Vatican
c. 1850
Lower left: wm e WINNER
Oil on canvas
29 × 19 1/8" (73.7 × 48.6 cm)

Gift of Mr. and Mrs. Samuel
James
1975-86-1

Wyant, Alexander Helwig
American, 1836–1892
The Gathering Storm
c. 1875–90
Lower right: A. H. Wyant
Oil on canvas
15 3/8 × 25" (39 × 63.5 cm)

The Alex Simpson, Jr., Collection
1928-63-11

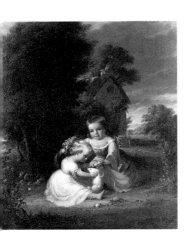

Winner, William E.
Landscape with Figures
c. 1855–65
On reverse: Winner Pinxit
Oil on canvas
30 1/4 × 25 1/4" (76.8 × 64.1 cm)

The W. P. Wilstach Collection,
bequest of Anna H. Wilstach
W1893-1-126

Wyant, Alexander Helwig
Pastureland, Kaaterskill
1880s
Lower left: A. H. Wyant
Oil on canvas
14 × 19 1/4" (35.6 × 48.9 cm)

Gift of Lucie Washington
Mitcheson in memory of Robert
Stockton Johnson Mitcheson for
the Robert Stockton Johnson
Mitcheson Collection
1938-22-4

Wyckoff, Sylvester
American, active 19th century
Self-Portrait
See following painting for reverse
c. 1825
Oil on panel
29 1/4 × 19 1/4" (74.3 × 48.9 cm)

The Louise and Walter Arensberg
Collection
1950-134-526a

Arellano
Mexican, active c. 1774
Previously listed as Juan de
Arellano (PMA 1965)
Portrait of an Ecclesiastic
1774
Upper right: IHS; lower right:
IHS / ADMA / IOREM / DEI / GLO
/ RIAM / Arellano. f. 1774
Oil on copper
13 5/8 × 10 1/2" (34.6 × 26.7 cm)

The Robert H. Lamborn
Collection
1903-904

Wyckoff, Sylvester
Portrait of a Man
Reverse of the preceding painting
c. 1825
Oil on panel
29 1/4 × 19 1/4" (74.3 × 48.9 cm)

The Louise and Walter Arensberg
Collection
1950-134-526b

Becerra, Fray Diego
Mexican, active c. 1640–c. 1699
Rest on the Flight into Egypt
c. 1640–50
Center bottom: S. P. De Becerra
Oil on canvas
18 5/8 × 24 1/4" (47.3 × 61.6 cm)

The Robert H. Lamborn
Collection
1903-935

Cabrera, Miguel
Mexican, 1695–1768
Martyr
c. 1740
Oil on canvas
8 3/8 × 6 1/8" (20.3 × 15.6 cm)

The Robert H. Lamborn
Collection
1903-879

Cabrera, Miguel
Crowned Virgin and Child
1762
Center bottom: Mich Cabrera,
pinxit 1762; on book held by
Christ child: Volvio / christo / el
Ros- / tro por / no ver / vo sacri- /
legio.
Oil on copper
16 9/16 × 12 1/2" (42.1 × 31.7 cm)

The Robert H. Lamborn
Collection
1903-897

**Cabrera, Miguel,
attributed to**
Previously listed as Mexican,
unknown artist, 18th century
(PMA 1965)
The Last Supper
After 1719
Oil on canvas
77 1/8 × 44" (195.9 × 111.8 cm)

The Robert H. Lamborn
Collection
1903-915

Caro, Manuel
Mexican, active c. 1781–c. 1820
The Virgin
c. 1781
Lower right: Manl. Caro. F.
Oil on canvas
16 1/2 × 12 1/2" (41.9 × 31.7 cm)

The Robert H. Lamborn
Collection
1903-872

**Cabrera, Miguel,
attributed to**
Virgin of Guadalupe
c. 1740
Oil on copper
15 1/2 × 11 5/8" (39.4 × 29.5 cm)

The Louise and Walter Arensberg
Collection
1950-134-817

Correa, Juan, the Younger
Mexican, active c. 1731–1760
The Virgin
c. 1735
Lower right: Juan Correa / F.
Oil on canvas
8 3/8 × 6 1/8" (21.3 × 15.6 cm)

The Robert H. Lamborn
Collection
1903-877

Cabrera, Miguel, follower of
Previously listed as Mexican,
unknown artist, 19th century
(PMA 1965)
Capuchin Nun Carrying Food
Companion to the following
painting
c. 1775–1800
Oil on canvas
70 × 42" (177.8 × 106.7 cm)

The Robert H. Lamborn
Collection
1903-938

Correa, Juan, the Younger
The Archangel Michael
1739
Upper right, on banner: QUIS UT
DE US; lower right: Juan Correa,
1739
Oil on canvas
71 1/2 × 36 5/16" (181.6 × 92.2 cm)

The Robert H. Lamborn
Collection
1903-919

Cabrera, Miguel, follower of
Previously listed as Mexican,
unknown artist, 19th century
(PMA 1965)
*Capuchin Nun Reading to an Indian
Visitor through the Gates of a
Convent*
Companion to the preceding
painting
c. 1775–1800
Oil on canvas
70 3/8 × 41 3/4" (178.7 × 106 cm)

The Robert H. Lamborn
Collection
1903-933

Correa, Juan, the Younger
The Archangel Gabriel
1739
Lower right: Juan Correa f. 1739.
Oil on canvas
71 3/4 × 36 3/8" (182.2 × 92.4 cm)

The Robert H. Lamborn
Collection
1903-923

Echave Orio, Baltasar de
Mexican, born c. 1548, last dated
work 1612
Saint Augustine
c. 1600
Oil on canvas
19 11/16 × 15" (50 × 38.1 cm)

The Robert H. Lamborn
Collection
1903-934

Herrera, Fray Miguel de
*Saint Limbania the Virgin and
Sympathetic Wild Animals*
1725
Lower left: A. Migl. de Herrera, /
Aug. Anno fait. 1725 ad; lower
right: SCTA. Limbania Virg.
Oil on canvas
43 × 66 1/8" (109.2 × 168 cm)

The Robert H. Lamborn
Collection
1903-906

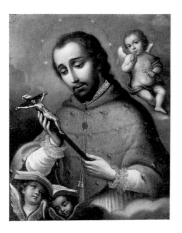

Enriquez, Nicolas
Mexican, active c. 1730–c. 1768
Saint John Nepomuck
1738
Lower right: N. Enriquz. Fct.;
on book: Pro Sigillo / Confes- /
sion.; on crucifix: INRI
Oil on copper
11 1/4 × 8 1/4" (28.6 × 20.9 cm)

The Robert H. Lamborn
Collection
1903-889

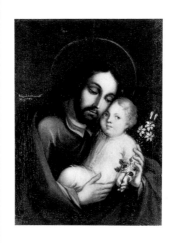

Herrera, Fray Miguel de
Christ and a Child
1778
Center left: Miguel de Herrera.
Ft. / Megco. 1778.
Oil on canvas
16 3/8 × 11 1/2" (41.6 × 29.2 cm)

The Robert H. Lamborn
Collection
1903-894

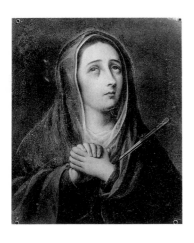

Enriquez, Nicolas
The Suicide of Lucretia
c. 1750
Center right: Nicolas / Enriq /
Fecit
Oil on copper
10 7/8 × 8 3/8" (27.6 × 21.3 cm)

The Robert H. Lamborn
Collection
1903-891

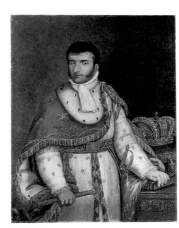

**Huerta, Josephus Arias,
attributed to**
Mexican, active 19th century
*Portrait of Agustín de Iturbide,
Emperor of Mexico*
Companion to the following
painting
1822
On book: CONSTI / TUCION /
AMERI / [CA]NA; on robe: A / I.;
on belt buckle: AP.
Oil on canvas
44 1/16 × 33 1/2" (111.9 × 85.1 cm)

Gift of an anonymous donor
1922-89-2

Herrera, Fray Miguel de
Mexican, active c. 1725–c. 1780
*Saint Anthony in Prayer before the
Christ Child*
1725
Lower right: Fr. Miguel de
Herrera, Augustino, fect. / 1725
ad.
Oil on canvas
43 1/4 × 66 3/8" (109.8 × 168.6 cm)

The Robert H. Lamborn
Collection
1903-943

**Huerta, Josephus Arias,
attributed to**
*Portrait of Anna Maria Iturbide,
Empress of Mexico*
Companion to the preceding
painting
1822
Oil on canvas
44 1/8 × 33 1/2" (112.1 × 85.1 cm)

Gift of an anonymous donor
1922-89-1

Juarez, Juan Rodriguez
Mexican, c. 1675–1728
Virgin and Child
c. 1700
Center left: Ju Rodriguez /
Xuarez f.a
Oil on copper
11 × 8 ½" (27.9 × 21.6 cm)

The Robert H. Lamborn
Collection
1903-878

Juarez, Juan Rodriguez
Saint Rose of Lima
c. 1710
Lower right: Juan Juarez; on
reverse: Santa Rosalia de Lima,
Convent of St. Catherine of Siena,
Juan Juarez, Mexico
Oil on copper
13 ½ × 12 ¾" (34.3 × 32.4 cm)

The Robert H. Lamborn
Collection
1903-901

Jurado, Juan José
Mexican, active c. 1727
The Archangel Raphael
1727
Lower left: Juan Joseph. Jurado.
fa. / Año 1727
Oil on canvas
64 ⅛ × 42 1/16" (162.9 × 106.8 cm)

The Robert H. Lamborn
Collection
1903-914

López, Andreas
Mexican, active 1777–1805
The Adoration of the Magi
c. 1800
Center bottom: Andreas Lopez
fecit.
Oil on canvas
36 ¾ × 43 ¼" (93.3 × 109.8 cm)

The Robert H. Lamborn
Collection
1903-932

Martínez, Francisco
Mexican, active by c. 1718,
died 1758
The Nativity
c. 1750
On scroll: GLORIA IN
EXCELS[IS] [DEO] ET IN TERRA
PAX HOMINIBUS BONAE
VOLUNTATIS [N]OBIS HODIE
Oil on canvas
23 1/16 × 51 9/16" (58.6 × 131 cm)

The Robert H. Lamborn
Collection
1903-939

Mexican?, unknown artist
Previously listed as Spanish,
unknown artist, 17th century
(PMA 1965)
Portrait of a Gentleman
1679
Center right: Natg Ao 1643 d /
18 Aprilus / Pietg est Ao 1679
Oil on canvas
35 3/16 × 29" (89.4 × 73.7 cm)

The Bloomfield Moore Collection
1899-1120

Mexican, unknown artist
Previously listed as Mexican,
unknown artist, 18th century
(PMA 1965)
*Portrait of the Reverend Mother
Maria Antonia de Rivera*
Retable
c. 1775
Lower left: Fue electa Priora en- /
Relecta e la misma fha. y / el dia
Miercoles 12. de 94. Fallecio / del
Marzo 1806.; lower right: 24 de
Marzo de 1791 / mes de año de
94 Falleció / de Marzo 1806.;
bottom center: La Ra. Madre
Maria Antonia de Rivera,
Religiosa de la Sagda. Compa. /
de Maria SSma. comunmente
llamada de la Enseñanza. Resibió
el habi- / to de edad de
diezynueve Años, el dia 9. de
Noviembre de 1755. y Professo /
el dia 12. de Diziembe. de 57. en
el Sagdo. Convto. de N. S. del
Pilar de la Ciud. de Mexco. / En
Manos del ylustrisimo. Sr. Dr.
Dn. Manuel Ant. Rojo del Rio. y
Bieyra dignimo. Arsovpo. de la
Ciud. de Mania.
Oil on canvas
49 × 31 ⅝" (124.5 × 80.3 cm)

The Robert H. Lamborn
Collection
1903-920

Mexican, unknown artist
Previously listed as Mexican,
unknown artist, 17th century
(PMA 1965)
Portrait of a Lady
18th century
Oil on copper
6 1/8 × 4 5/8" (15.6 × 11.7 cm)

The Robert H. Lamborn
Collection
1903-874

Mexican, unknown artist
The Archangel Raphael
18th century
Oil on copper
5 3/4 × 4 1/8" (14.6 × 10.5 cm)

The Robert H. Lamborn
Collection
1903-875

Mexican, unknown artist
Previously listed as Mexican,
unknown artist, 17th century
(PMA 1965)
Virgin and Child, with Saints
Escudo
18th century
Oil on vellum
5 15/16" (15.1 cm) diameter

The Robert H. Lamborn
Collection
1903-900

Mexican, unknown artist
The Divine Shepherd
18th century
Oil on canvas
9 1/4 × 7 1/2" (23.5 × 19 cm)

The Robert H. Lamborn
Collection
1903-876

Mexican, unknown artist
Saint Augustine as a Youth
18th century
Across bottom: RETRATO DE S.S.
AUGUSTIN QVANDO ERA JOVEN.
CONFORME AL ORIGINAL. Q' /
entre las cosas raras del Principe
Aresio, se conserva en grande
estimacion en Milan: donde hay /
una continua tradicion, que Sn.
Ambrosio Hizo añadir en las
Letanias publicas De la Logica
de- / Augustino libranos Señor;
pero de quanta ventaja haya sido
para la Iglesia esta Logica /
despues de catolico Augustino lo
publican tantos hereges
convencidos, confundidos,
conver- / tidos a si en su tiempo
soma despues; por lo que el
intimo Sn Augustino lo Uoma
Filorofo Aibri- / [] y otro lo
aclaman Principe de toi Filorofos.
Manuel Villa en Año de 1784.
Oil on paper
6 3/8 × 4 3/4" (16.2 × 12.1 cm)

The Robert H. Lamborn
Collection
1903-873

Mexican, unknown artist
Saint Anthony Abbot
18th century
Oil on copper
6 7/8 × 5 5/16" (17.5 × 13.5 cm)

The Robert H. Lamborn
Collection
1903-880

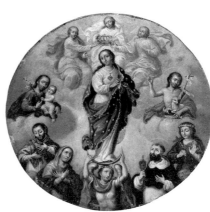

Mexican, unknown artist
The Assumption of the Virgin
18th century
Lower right: Faxfan de / los Go / F
Oil on copper
6 1/2" (16.5 cm) diameter

The Robert H. Lamborn
Collection
1903-882

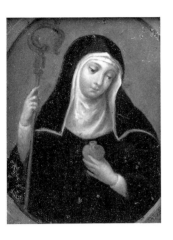

Mexican, unknown artist
Saint Gertrude
18th century
Lower right: Br. Alva
Oil on copper
4 × 3" (10.2 × 7.6 cm)

The Robert H. Lamborn
Collection
1903-883

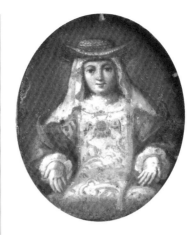

Mexican, unknown artist
The Divine Shepherd
Reverse of the preceding painting
18th century
Oil on copper
2 3/16 × 1 11/16" (5.6 × 4.3 cm)

The Robert H. Lamborn
Collection
1903-886b

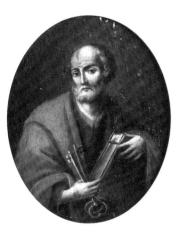

Mexican, unknown artist
Saint Peter
18th century
Oil on panel
5 × 3 5/8" (12.7 × 9.2 cm)

The Robert H. Lamborn
Collection
1903-884

Mexican, unknown artist
Apostle
18th century
Oil on panel
4 15/16 × 3 11/16" (12.5 × 9.4 cm)

The Robert H. Lamborn
Collection
1903-887

Mexican, unknown artist
The Lamb of God
18th century
Lower left: A.F.M.
Oil on copper
2 3/16 × 1 13/16" (5.6 × 4.6 cm)

The Robert H. Lamborn
Collection
1903-885

Mexican, unknown artist
Saint John of God
See following painting for reverse
18th century
Upper left, on cloth covering
staff: JHS
Oil on copper
7 1/2 × 6 1/2" (19 × 16.5 cm)

The Robert H. Lamborn
Collection
1903-888a

Mexican, unknown artist
Saint Peter Nolasco
See following painting for reverse
18th century
Oil on copper
2 3/16 × 1 11/16" (5.6 × 4.3 cm)

The Robert H. Lamborn
Collection
1903-886a

Mexican, unknown artist
Saint Christopher
Reverse of the preceding painting
18th century
Oil on copper
7 1/2 × 6 1/2" (19 × 16.5 cm)

The Robert H. Lamborn
Collection
1903-888b

Mexican, unknown artist
Saint Theresa in Ecstasy
Based on the sculpture, dated
1644–52, by Gian Lorenzo
Bernini (Italian, 1598–1680), in
Santa Maria della Vittoria, Rome
18th century
Oil on copper
9 1/2 × 6 7/8" (24.1 × 17.5 cm)

The Robert H. Lamborn
Collection
1903-892

Mexican, unknown artist
Angel with Flowers
18th century
Oil on canvas
65 1/4 × 39 1/4" (165.7 × 99.7 cm)

The Robert H. Lamborn
Collection
1903-908

Mexican, unknown artist
Christ Crucified on the Sacred Heart
18th century
Oil on canvas
18 3/8 × 13 1/2" (46.7 × 34.3 cm)

The Robert H. Lamborn
Collection
1903-902

Mexican, unknown artist
Guardian Angel
18th century
Oil on canvas
32 15/16 × 40 5/8" (83.7 × 103.2 cm)

The Robert H. Lamborn
Collection
1903-909

Mexican, unknown artist
Saint Francis Xavier
18th century
Oil on copper
12 1/2 × 10 1/8" (31.7 × 25.7 cm)

The Robert H. Lamborn
Collection
1903-903

Mexican, unknown artist
Portrait of a Nun (Sister Inés Jopha)
18th century
Center bottom, in medallion: Sor
Ines Jopha del / Corason de Jesus /
Relixiosa Profesa / En el Conto.
Nuedo / de Sta Theresa / de
Mexico; lower right: Profleso el
dia 25 de Junio / del año de 1756
Oil on canvas
36 13/16 × 30 1/8" (93.5 × 76.5 cm)

The Robert H. Lamborn
Collection
1903-911

Mexican, unknown artist
*The Holy Trinity, with the Virgin
and Saints*
18th century
Center top: IDEA / DIVINA / IN
CRISTALO ENTIS MEI INTACTAM
TE LABE PREPARO
Oil on copper
12 5/8 × 10 1/8" (32.1 × 25.7 cm)

The Robert H. Lamborn
Collection
1903-905

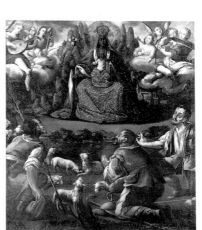

Mexican, unknown artist
Black Virgin and Child
18th century
Oil on canvas
60 1/4 × 53 3/16" (153 × 135.1 cm)

The Robert H. Lamborn
Collection
1903-912

Mexican, unknown artist
Saint John the Evangelist
18th century
Oil on burlap
32 3/4 × 26 1/16" (83.2 × 66.2 cm)

The Robert H. Lamborn
Collection
1903-913

Mexican, unknown artist
Saint Joseph with the Christ Child
18th century
Center bottom: IOSEPH VIR
MARIAE, / dequa natus est
JESUS.
Oil on canvas
33 1/8 × 24 7/8" (84.1 × 63.2 cm)

The Robert H. Lamborn
Collection
1903-916

Mexican, unknown artist
*Portrait of Sister Juana Inés de la
Cruz*
After a self-portrait
18th century
Across bottom: FIEL / Copia de
otra que de si hizo, y de su mano
pintò la R. M. Juana Ynés de la
Cruz Fenix de la / America,
Glorioso desempeño de su Sexo,
Honrra de la Nacion de este
Nuevo Mundo, y argu- / mento
de las admiraciones, y elogios de
el Antiguo. Naciò el dia 12. de
Nove. de el año de 1651. á las /
onse de la noche. Reciuiò el
Sagrado Habito de el Maximo Dr.
Sr. Sn. Geronimo en su Convento
de / esta Ciudad de Mexico. de
edad / 40. y 4. años, cinco mezes,
cinco dias. y cinco horas.
Requiescat in pace. Amen.; on
book: Obras de la Unica Poetisa /
Soror Juana Ynés / de la Cruz.
Oil on canvas
41 1/2 × 32 1/2" (105.4 × 82.5 cm)

The Robert H. Lamborn
Collection
1903-918

Mexican, unknown artist
Figures on a Street
Decorative panel; companion to
the following three paintings
18th century
Center top: NADA ES CON
PARABLE VERDADERO AMIGO
Oil on canvas
15 3/4 × 22 1/2" (40 × 57.1 cm)

The Robert H. Lamborn
Collection
1903-922

Mexican, unknown artist
Old Man Led by Children
See previous entry
18th century
Center top: NO HA DE ENFADAR
EL VICIO DEL AMIGO.
Oil on canvas
15 3/4 × 21 7/8" (40 × 55.6 cm)

The Robert H. Lamborn
Collection
1903-924

Mexican, unknown artist
Old Man at a Fountain
See previous two entries
18th century
Center top: NADA DESSEA
QUIEN TIENE LO QUE BASTA
Oil on canvas
15 3/4 × 21 7/8" (40 × 55.6 cm)

The Robert H. Lamborn
Collection
1903-925

Mexican, unknown artist
Allegorical Figures in a Landscape
See previous three entries
18th century
Center top: EL VIRTUOSO
TRADAXO FIDE SU REPOSO.
Oil on canvas
15 1/2 × 22 1/2" (39.4 × 57.1 cm)

The Robert H. Lamborn
Collection
1903-926

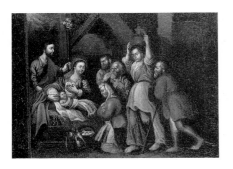

Mexican, unknown artist
The Adoration of the Shepherds
18th century
Oil on canvas
11 5/8 × 16 1/16" (29.5 × 40.8 cm)

The Robert H. Lamborn
Collection
1903-927

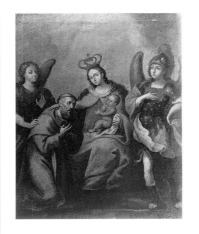

Mexican, unknown artist
Virgin and Child Guarded by Angels
18th century
Oil on canvas
23 1/4 × 18 1/2" (59 × 47 cm)

The Robert H. Lamborn
Collection
1903-940

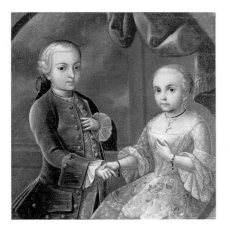

Mexican, unknown artist
Portrait of Two Children of the Aristocracy
18th century
Oil on canvas
31 5/8 × 29 7/8" (80.3 × 75.9 cm)

The Robert H. Lamborn
Collection
1903-929

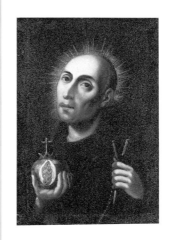

Mexican, unknown artist
Saint John of God with a Pomegranate Surmounted by a Cross
18th century
Oil on canvas
24 3/16 × 16 7/16" (61.4 × 41.7 cm)

The Robert H. Lamborn
Collection
1903-942

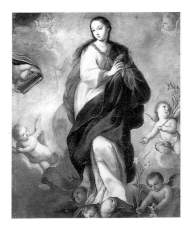

Mexican, unknown artist
The Assumption of the Virgin
18th century
Oil on canvas
51 × 40 3/4" (129.5 × 103.5 cm)

The Robert H. Lamborn
Collection
1903-930

Mexican, unknown artist
Angel in Clouds
18th century
Oil on canvas
65 3/8 × 39 5/8" (166 × 100.6 cm)

The Robert H. Lamborn
Collection
1903-944

Mexican, unknown artist
The Expulsion from Eden
18th century
Oil on canvas
19 3/16 × 26 1/2" (48.7 × 67.3 cm)

The Robert H. Lamborn
Collection
1903-936

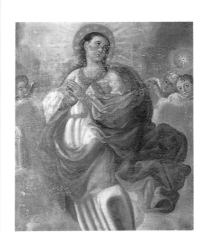

Mexican, unknown artist
The Virgin with Cherubim
18th century
Oil on burlap
40 × 33 9/16" (101.6 × 85.2 cm)

The Robert H. Lamborn
Collection
1903-946

Mexican, unknown artist
The Assumption of the Virgin
Escudo
18th century
Oil on vellum
7 1/2" (19 cm) diameter

Gift of Mrs. John Harrison
1915-196

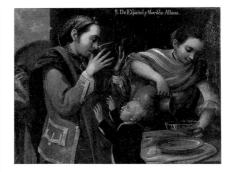

Mexican, unknown artist
Racial Examples
From an untraced series;
companion to the preceding
painting
c. 1840
Upper right: 8. De Español, y
Morisca. Albino.
Oil on canvas
31 × 39 3/4" (78.7 × 101 cm)

Gift of the nieces and nephews of
Wright S. Ludington in his honor
1980-139-2

Mexican, unknown artist
Fall from a Balcony
Retable
After c. 1803
Across bottom: El Dia Martes 22.
de Febrero del año de 1803.
tercero de Carnestolendas entre
ocho y nueve / de la mañana,
estando la Criada Barbara Rico
con el Niño de edad de dos años y
medio en los bra- / zos
improvasimente, y sin haber
causa se desquició, y undió un
pedazo del Corredor de la Casa
Estanco; / y haviendo caido
abrazados Criada, y niño do la
altitud de seis y media varas, que
hày desde / donde si undiò à el
empedrado del suelo, al dar el
golpe, quedaron apartados, pero
sin daño, ni / lesion alguna, à
causa de haver invocado la Criada
à el Alma de Maria Santisima, por
/ cuya intercecion se deja vèr el
presente Portento.
Oil on canvas
33 3/4 × 24 1/2" (85.7 × 62.2 cm)

The Louise and Walter Arensberg
Collection
1950-134-492

Mexican, unknown artist
Accident in a Well
Retable
After 1864
Across bottom: En el año de 1864
sucedio este fatal acontecimiento
á pablo hernandez y en tan grande
tribu- / lacion Doña Gerbaca
Licea aclamo al Sr de los trabajos,
al ver caer á su hijo en el pozo:
y alcanzó por su micericordia
el detenerse con un pie y no
precipitarse hastá el fondo
y á- / ber perecido y para para
perpetuar tan gra[n]de maravilla
pu-blican este retablo.
Oil on tin
7 × 10" (17.8 × 25.4 cm)

The Louise and Walter Arensberg
Collection
1950-134-824

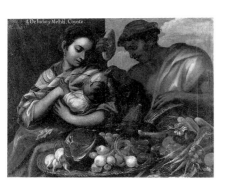

Mexican, unknown artist
Racial Examples
From an untraced series;
companion to the following
painting
c. 1840
Upper left: 4. De Indio, y
Mestisa. Coyote.
Oil on canvas
31 × 39 3/4" (78.7 × 101 cm)

Gift of the nieces and nephews of
Wright S. Ludington in his honor
1980-139-1

Mexican, unknown artist
Recovery from an Illness
Retable
After 1865
On crucifix: INRI; across bottom:
En el año de 1865 en el mes de
Junio, enpeso a estar grabemente
enfermo Juan Ebangelista
Gonsales, de / una inflamasion
de vientre y mal de Orina, que
lo cual se bido a la muerte,
tanto que duro en cama / dies
meses catorse dias, y mirandose
en esta aflision tan grande, dicho
enfermo y su Sra. Madre / Maria
Bustamante, lo encomendo con

todos las beras de su corazon, al Sor. del Ospital de la villa / de Salamanca, y a Nra. Sra. de la SALUD; que le diera el alibio si le conbenia.—por lo que lo consiguio / milagrosamente, y por este beneficio tan singular le dedican este cuadrito a dichas Ymagenes. / y tanbien para demostrar que es mui grande su / misericordia.

Oil on panel

5 7/8 × 9 1/4" (14.9 × 23.5 cm)

The Louise and Walter Arensberg Collection
1950-134-823

Mexican, unknown artist

The Execution of Maximilian
After 1867
Oil on canvas
14 7/8 × 20 1/4" (37.8 × 51.4 cm)

The Louise and Walter Arensberg Collection
1950-134-827

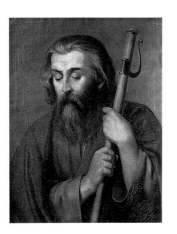

Mexican, unknown artist

Head of a Pilgrim
19th century
Oil on canvas
30 3/8 × 22" (77.1 × 55.9 cm)

The Robert H. Lamborn Collection
1903-907

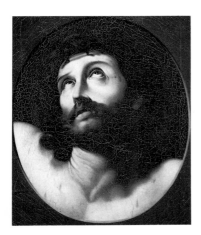

Mexican, unknown artist

Christ as the Man of Sorrows
19th century
After a painting by Guido Reni (Italian, 1575–1642) known in many versions
Oil on canvas
21 × 15 3/16" (53.3 × 38.6 cm)

The Robert H. Lamborn Collection
1903-941

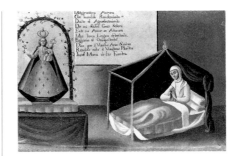

Mexican, unknown artist

Joseph Maria de las Fuentes
Retable
19th century
Center top: Milagrosisima Aurora / Con humilde Rendimiento / Doite el Agradecimiento / De mi Salud Gran Señora / Enti mi Amor se Atesora / Mas tosca Lengua detentente. / ¿Balgame el Omnipotente? / Dios que a Vuestrs Aras Santas / Rendido esta a Vuestras Plantas / Josef Maria de las Fuentes.
Oil on canvas
11 7/8 × 16 7/8" (30.2 × 42.9 cm)

The Louise and Walter Arensberg Collection
1950-134-815

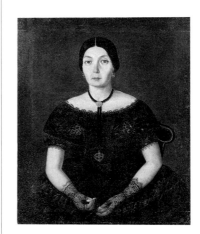

Mexican, unknown artist

Portrait of the Countess of Canal
19th century
Oil on canvas
25 3/16 × 20" (64 × 50.8 cm)

Gift of Mrs. René d'Harnoncourt
1969-273-1

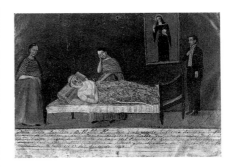

Middle American, unknown artist

Recovery from an Illness
Retable
1849
Across bottom: Doña Josefa Aguilera y Billalobos Hayandose grabemente Enferma de Una Enfla / macion de Bientre y allandose en los ultimos Casie Instantes de Bida, Inboco a / la Milagrosa Imagen de Sta. Rita de Casia del Recinto de Guadalupe y Milagrosamente / Consignio la Salud Despues de 3 Meses de padeser: y en Memoria de tan grande beneficio / Dedica Este Retablo en 13. de Agosto de 1849.
Oil on tin
10 1/8 × 14" (25.7 × 35.6 cm)

The Louise and Walter Arensberg Collection
1950-134-814

Middle American, unknown artist
Figure Praying
19th century
Oil on panel
13 × 8 5/8" (33 × 21.9 cm)

The Louise and Walter Arensberg Collection
1950-134-826

Peruvian, unknown artist
Previously listed as Peruvian, unknown artist, 17th century (PMA 1965)
The Virgin Glorified with Virtues, with Saints Francis of Assisi and Anthony Abbot
c. 1775–1825
Oil on canvas
51 3/8 × 34 1/2" (130.5 × 87.6 cm)

Gift of Mr. and Mrs. Leopold Tschirky
1956-112-3

Pérez, Diego
Mexican, active c. 1720
The Revelation to Saint Joseph
1720
Center bottom: Diego Pérez fta. 1720.
Oil on canvas
42 7/8 × 57" (108.9 × 144.8 cm)

The Robert H. Lamborn Collection
1903-910

Vallejo, Francisco Antonio
Mexican, active c. 1770–c. 1800
Angels Bearing Ecclesiastical Insignia
Fragment from the same original as the following painting
c. 1780
Center: Cherubini. Throni. Poteltates.; lower left: Angeli.; lower right: Archangeli.
Oil on canvas
33 7/8 × 27 3/8" (86 × 69.5 cm)

The Robert H. Lamborn Collection
1903-928

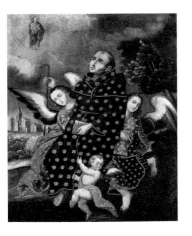

Peruvian, unknown artist
Previously listed as Peruvian, unknown artist, 17th century (PMA 1965)
Saint Francis of Assisi
c. 1775–1825
Oil on canvas
50 3/16 × 39 3/4" (127.5 × 101 cm)

Gift of Mr. and Mrs. Leopold Tschirky
1956-112-2

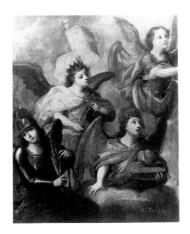

Vallejo, Francisco Antonio
Angels Bearing Ecclesiastical Insignia
Fragment from the same original as the preceding painting
c. 1780
Center top: Principatus.; center right: Seraphini.; lower right: Dominationes. / Francus Anto. à Vallejo ft.
Oil on canvas
33 7/8 × 27 3/8" (86 × 69.5 cm)

The Robert H. Lamborn Collection
1903-931

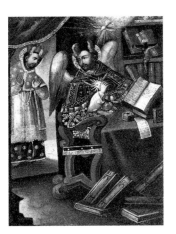

Peruvian, unknown artist
Previously listed as Peruvian, unknown artist, 17th century (PMA 1965)
Saint Thomas Aquinas in His Study
c. 1775–1825
Oil on canvas
32 3/4 × 24 1/16" (83.2 × 61.1 cm)

Gift of Mr. and Mrs. Leopold Tschirky
1956-112-1

Velasco, José Maria
Mexican, 1840–1912
Valley of Oaxaca
1888
Lower right: José M. Velasco. / Mexico 1888.
Oil on canvas
41 7/8 × 63 1/4" (106.4 × 160.6 cm)

Gift of the Mauch Chunk National Bank
1949-56-1

Twentieth-Century Painting

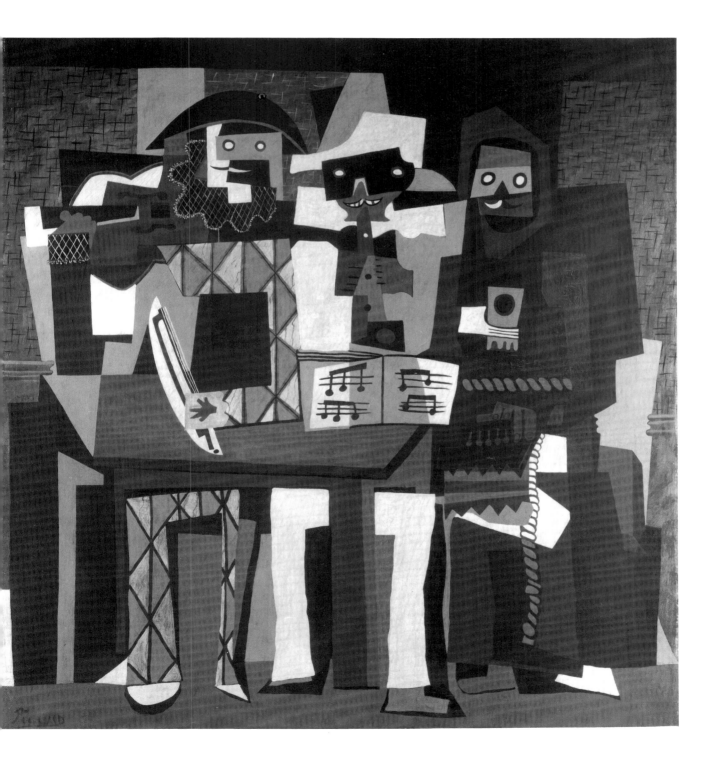

Abidine (Abidine Dino)
Turkish, born 1911
Parade
c. 1957
Lower left: Abidine
Oil on canvas
76 5/8 × 51 1/16" (194.6 × 129.7 cm)

Gift of Frederick Chait
1980-150-1

Andrade, Edna
American, born 1917
Hot Blocks
1966–67
Lower left: EA
Acrylic on canvas
60 × 60" (152.4 × 152.4 cm)

Purchased with the Philadelphia
Foundation Fund
1967-65-1

Afro (Afro Basaldella)
Italian, born 1912
Abstraction of Two Figures
1954
Lower right: Afro. 54
Oil on canvas
32 5/8 × 18 1/2" (82.9 × 47 cm)

Gift of Mr. and Mrs. James P.
Magill
1957-127-1

Andrade, Edna
Night Sea
1977
Lower left: EA
Acrylic on canvas
72 × 71 15/16" (182.9 × 182.7 cm)

Gift of the Philadelphia Arts
Exchange
1978-13-1

Albers, Josef
American, born Germany,
1888–1976
Homage to the Square (It Seems)
1963
Lower right: A 63
Oil on panel
39 7/8 × 40" (101.3 × 101.6 cm)

Gift of the Friends of the
Philadelphia Museum of Art
1968-183-1

André, Françoise
American, born France,
born 1926
Untitled
1975
Lower left: Fr. Andre. 75.
Oil on canvas
68 3/4 × 85 3/4" (174.6 × 217.8 cm)

Purchased with funds contributed
by the friends of Charles
Stegeman and Françoise André
1975-165-2

Alexander, John White
American, 1856–1915
The Gossip
1912
Lower left: John W. Alexander
1912
Oil on canvas
63 5/16 × 54" (160.8 × 137.2 cm)

The Alex Simpson, Jr., Collection
1928-63-1

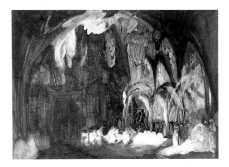

Anisfeld, Boris
Russian, active United States,
1879–1973
Sketch for "Egyptian Nights"
Sketch for a backdrop for the
ballet *Egyptian Nights*, by Michel
Fokine, based on a story by
Aleksander Pushkin and music by
Nikolai Rimski-Korsakov
1913
Lower left: Boris Anisfeld / 1913
Tempera on composition board
27 × 36" (68.6 × 91.4 cm)

Gift of Christian Brinton
1941-79-144

Anisfeld, Boris
Portrait of Christian Brinton
1920
Oil on canvas
41 × 25 ³/₄" (104.1 × 65.4 cm)

Gift of Mrs. Otis Chatfield-
Taylor
1985-112-4

Anuszkiewicz, Richard
American, born 1930
Knowledge and Disappearance
1961
Oil on canvas
50 ¹/₈ × 49 ¹/₁₆" (127.3 × 124.6 cm)

Purchased with the Adele Haas
Turner and Beatrice Pastorius
Turner Memorial Fund
1968-77-1

**Ara (Benjamin Dusanovich
Kosich)**
Mexican, active c. 1935
Mother and Child Standing
1935
Lower right: Ara; on reverse:
Benjamin Dusanovich Kosich
ARA / 1935 Boom Boom Barabas
Oil on gypsum board
20 ³/₁₆ × 11 ⁷/₈" (51.3 × 30.2 cm)

The Louise and Walter Arensberg
Collection
1950-134-505

Ara
Mother and Child Stooping
c. 1940
Lower right: BDK ara; on reverse:
Benjamin Dusanovich Kosich
ARA
Oil on gypsum board
10 ³/₄ × 13 ⁷/₁₆" (27.3 × 34.1 cm)

The Louise and Walter Arensberg
Collection
1950-134-504

Ara
Self-Portrait
c. 1940
On reverse: Self Portrait by
B.D.K. Ara the Abbacuch Cook
Book painted in the time of
harvest
Oil on canvas
10 × 8 ¹/₈" (25.4 × 20.6 cm)

The Louise and Walter Arensberg
Collection
1950-134-506

**Archipenko, Alexander
Porfirevich**
American, born Ukraine,
1887–1964
In the Boudoir (Before the Mirror)
1915
Lower right: A. Archipenko.
Oil, graphite, photograph, and
metal on panel
18 × 12" (45.7 × 30.5 cm)

Gift of Christian Brinton
1941-79-119

**Archipenko, Alexander
Porfirevich**
The Bather
1915
Lower left: A. Archipenko / Nice
1915
Oil, graphite, paper, and metal
on panel
20 × 11 ¹/₂" (50.8 × 29.2 cm)

The Louise and Walter Arensberg
Collection
1950-134-1

Archipenko, Gela Forster
American, born Russia,
1887–1957
Autumn
1928
Lower right: Gela Forster; on
reverse: gela forster to / Christian
Brinton / with love / gela /
N.Y.C. / feb. 7th 1928
Oil on canvas
18 ¹/₁₆ × 24" (45.9 × 61 cm)

Gift of Christian Brinton
1941-79-77

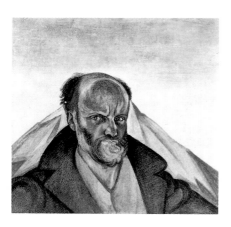

Dr. Atl (Gerardo Murillo)
Mexican, 1877–1964
Self-Portrait with Popocatépetl
1928
Lower left: Dr. Atl; lower right:
1928
Atl color [oil, wax, dry resin, and gasoline] on canvas
26 3/4 × 26 3/4" (67.9 × 67.9 cm)

Gift of Dr. MacKinley Helm
1949-30-1

Avery, Milton
Still Life (Blue Bowl with Nuts)
1945
Center bottom: Milton Avery /
1945
Oil on canvas
25 1/8 × 30" (63.8 × 76.2 cm)

Gift of Mrs. Herbert Cameron
Morris
1946-13-1

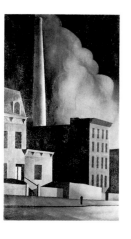

Ault, George C.
American, 1891–1948
Factory Chimney, Brooklyn
1924
Lower left: G. C. Ault '24.
Oil on canvas
30 × 16" (76.2 × 40.6 cm)

Gift of Dr. Samuel W. Fernberger
1950-5-1

Avery, Milton
Interlude
1960
Lower right: Milton Avery 1960;
on reverse: "Interlude" / by /
Milton Avery / 68" × 58" / 1960
Oil on canvas
68 × 58" (172.7 × 147.3 cm)

Centennial gift of the Woodward
Foundation
1975-81-1

Avery, Milton
American, 1893–1965
Brook Bathers
1938
Lower left: Milton Avery;
on reverse: "Brook Bathers" /
Milton Avery / 1938 / 30 × 40
Oil on canvas
30 1/8 × 39 7/8" (76.5 × 101.3 cm)

Gift of Dr. and Mrs. Paul Todd
Makler
1971-170-1

**Balthus (Balthazar
Klossowski de Rola)**
French, born 1908
Girl on a Bed
c. 1950
Lower right: Balthus
Oil on canvas
18 × 21 3/4" (45.7 × 55.2 cm)

The Albert M. Greenfield and
Elizabeth M. Greenfield
Collection
1974-178-17

Avery, Milton
Black Jumper
1944
Center right: Milton Avery /
1944
Oil on canvas
54 3/16 × 33 3/4" (137.6 × 85.7 cm)

Bequest of Mrs. Maurice J. Speiser
in memory of Raymond A. Speiser
1968-177-1

Balthus
Young Girl Asleep (Frédérique)
1955
Lower right: Balthus.55.
Oil on canvas
45 7/8 × 34 7/8" (116.5 × 88.6 cm)

The Albert M. Greenfield and
Elizabeth M. Greenfield
Collection
1974-178-18

Bannard, Walter Darby
American, born 1934
Amazon No. 3
1968
Acrylic on canvas
65 $^{15}/_{16}$ × 99 $^{1}/_{8}$" (164.5 × 251.8 cm)

Gift of Mr. and Mrs. J. Welles Henderson
1973-259-2

Bateman, Ronald C.
American, born Wales, born 1947
Still Life with Melons
1975
Oil on canvas
56 $^{1}/_{2}$ × 66 $^{1}/_{8}$" (143.5 × 168 cm)

Gift of the Cheltenham Art Centre
1976-35-1

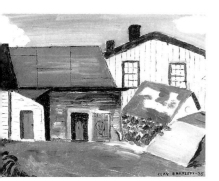

Barnett, William
American, 1911–1992
Widow in White
1956
Lower left: William Barnett—56
Oil on canvas
37 $^{1}/_{4}$ × 75 $^{5}/_{8}$" (94.6 × 192.1 cm)

Purchased with the Adele Haas Turner and Beatrice Pastorius Turner Memorial Fund
1959-12-1

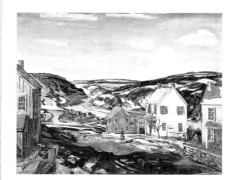

Baum, Walter Emerson
American, 1884–1956
Hill Houses
1942
Lower left: W.E.BAUM
Oil on canvas
32 $^{1}/_{4}$ × 40 $^{1}/_{8}$" (81.9 × 101.9 cm)

Gift of Luther A. Harr
1943-43-1

Bartlett, Frederic Clay
American, 1873–1953
Open Door
1935
Lower right: CLAY BARTLETT—35
Oil on canvas board
8 $^{15}/_{16}$ × 10 $^{7}/_{8}$" (22.7 × 27.6 cm)

Gift of Frank and Alice Osborn
1966-68-20

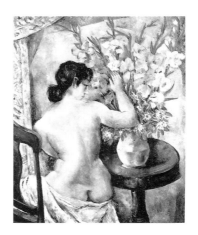

Baylinson, Abraham S.
American, born Russia, 1882–1950
Girl with Gladioli
1942
Lower right: A.S.Baylinson / 1942
Oil on canvas
41 $^{15}/_{16}$ × 34" (106.5 × 86.4 cm)

Gift of the Shilling Foundation
1946-46-1

Bartlett, Jennifer
American, born 1941
2 Priory Walk
1977
Baked enamel, silk-screened ink, and enamel on sixty-four steel plaques
Each plaque: 12 × 12" (30.5 × 30.5 cm); overall: 103 × 103" (261.6 × 261.6 cm)

Purchased with the Adele Haas Turner and Beatrice Pastorius Turner Memorial Fund
1979-14-1

Baziotes, William
American, 1912–1963
Night
1953
Lower right: Baziotes
Oil on canvas
19 $^{3}/_{4}$ × 24 $^{3}/_{16}$" (50.2 × 61.4 cm)

Gift of Anne d'Harnoncourt Rishel
1982-103-1

Beckmann, Max
German, active United States,
1884–1950
Portrait of John S. Newberry
1947
Lower right: John Newberry /
Beckmann / St. Louis / 47
Oil on canvas
29 × 21 15/16" (73.7 × 55.7 cm)

Gift of the Barry and Marilyn
Peril Foundation and gifts (by
exchange) of Fiske and Marie
Kimball and Mr. and Mrs. Joseph
Slifka
1972-267-1

Belmont, Ira Jean
American, born Lithuania,
1885–1964
*An Expression from "Moment
Musicale," by Franz Schubert*
c. 1920
Lower right: I. J. Belmont
Oil on canvas
36 × 30 1/4" (91.4 × 76.8 cm)

Gift of Mrs. I. J. Belmont
1977-203-1

Bérard, Marius-Honoré
French, born 1896
English Suite
1934
Lower right: HM Berard 34
Oil on canvas
28 3/4 × 21 5/16" (73 × 54.1 cm)

Gift of the artist
1949-33-1

Bérard, Marius-Honoré
Negro Spirituals
1944
Lower right: HM Berard 44
Oil on canvas
31 3/4 × 25 3/8" (80.6 × 64.4 cm)

Gift of the artist
1949-33-2

Berman, Eugène
American, born Russia,
1899–1972
Bridges of Paris
1932
Lower right: E. B. / 1932; on
reverse: E. Berman / Paris Sept.
1932 / Perspective de Ponts
Oil on canvas
36 3/16 × 25 1/2" (91.9 × 64.8 cm)

Gift of Briggs W. Buchanan
1945-85-1

Berman, Eugène
*View in Perspective of a Perfect
Sunset*
1941
Lower right: E. B. / 1941; on
reverse: E. Berman / Hollywood:
May–October 1941. View in
Perspective of a Perfect Sunset /
(Avanzi della Citta Perfetta.)
Oil on canvas
36 1/16 × 50" (91.6 × 127 cm)

Gift of Mr. and Mrs. Henry
Clifford
1951-28-1

Bernard, Émile
French, 1868–1941
Portrait of a Woman
1919
Lower right: Emile Bernard
Oil on canvas
43 1/4 × 33 1/2" (109.8 × 85.1 cm)

Gift of Samuel Pesin and Morris
Lerner
1973-76-1

Bershad, Helen
American, born 1934
Middle Field
1984
Acrylic and pastel on canvas
49 × 85" (124.5 × 215.9 cm)

Gift of Mr. and Mrs. Edwin P.
Rome
1984-69-1

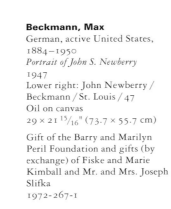

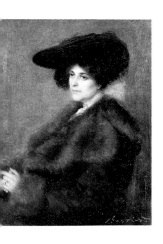

Bertieri, Pilade
American, born Italy,
born 1874, death date unknown
Portrait of Selma Stieglitz Schubart
c. 1900
Lower right: Bertieri
Oil on canvas
36 1/8 × 26 1/8" (91.8 × 66.4 cm)

Gift of Mrs. William Howard
Schubart
1968-45-3

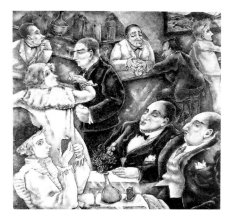

Biddle, George
Whoopee at Sloppy Joe's
1933
Lower left: Biddle 1933
Oil on canvas
40 1/2 × 40 3/8" (102.9 × 102.5 cm)

Gift of the artist
1972-121-1

Biddle, George
American, 1885–1973
Mango Market, Haiti
1927
Lower right: Biddle, 1927.
Oil on canvas
20 1/4 × 30 1/4" (51.4 × 76.8 cm)

Gift of Bernard Davis
1942-64-1

Biddle, George
Portrait of Hélène Sardeau
1934
Lower right: Biddle 1934; on
reverse: Biddle / 309 / HELENE
SARDEAU
Oil on canvas
30 1/16 × 25 1/8" (76.4 × 63.8 cm)

Gift of the artist
1972-121-3

Biddle, George
Cow and Calf
1929
Lower left: Biddle / 1929; on
reverse: Biddle 199 Cow and Calf
Oil on canvas
21 1/2 × 25 1/2" (54.6 × 64.8 cm)

Bequest of Anne Hinchman
1952-82-12

Biddle, George
Portrait of William Gropper
1938
Lower left: Biddle 1938; on
reverse: Biddle / 373 / "Bill
Gropper"
Oil on canvas
40 1/16 × 30 1/8" (101.8 × 76.5 cm)

Gift of Mr. and Mrs. R. Sturgis
Ingersoll
1942-1-1

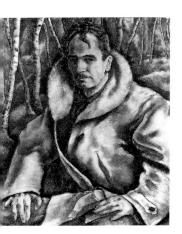

Biddle, George
Self-Portrait
1933
Lower left: Biddle 1933; on
reverse: Biddle 298 Self Portrait
Oil on canvas
31 1/8 × 25 1/4" (79.1 × 64.1 cm)

Bequest of Margaretta S.
Hinchman
1955-96-1

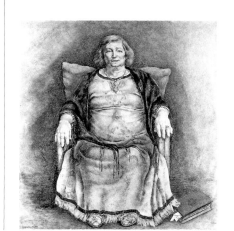

Biddle, George
Portrait of Frieda Lawrence
1941
Lower left: Biddle 1941; on
reverse: Biddle / Frieda Lawrence
/ No. 471
Oil on canvas
44 1/16 × 40 1/8" (111.9 × 101.9 cm)

Gift of the artist
1972-121-2

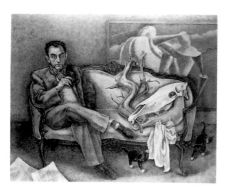

Biddle, George
Portrait of Man Ray
1941
Lower right: Biddle 41
Oil on canvas
50 × 60 1/16" (127 × 152.6 cm)

Gift of the artist
1972-121-4

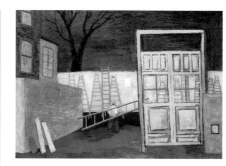

Blackburn, Morris Atkinson
The Blue Door
1950
Center bottom: Morris Blackburn
Oil on canvas
24 × 32" (61 × 81.3 cm)

Purchased with the Bloomfield
Moore Fund
1951-31-1

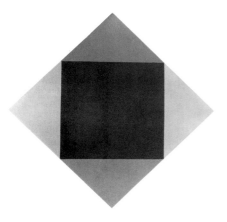

Bill, Max
Swiss, born 1908
Diffusion of Light Green
1959–69
On reverse: Bill / 1959–69 / max
bill haut oben top zerstrah lung
von hellgrun 1959–69
Oil on canvas
15 7/8 × 15 13/16" (40.3 × 40.2 cm)
diagonal

Gift of Dr. and Mrs. Paul Todd
Makler
1971-170-2

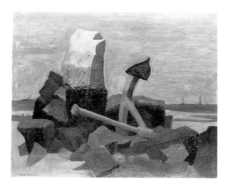

Blackburn, Morris Atkinson
Rock and Anchor
c. 1961
Lower left: Morris Blackburn
Oil on canvas
30 × 36 1/8" (76.2 × 91.8 cm)

Gift of Dr. Faith S. Fetterman
1961-64-1

Bishop, Isabel
American, 1902–1988
Sketch for "Eve in the Underground"
c. 1955
Oil, tempera, and gesso on
Masonite
21 7/8 × 17 3/8" (55.6 × 44.1 cm)

Gift of Mrs. Henry W. Breyer
1977-204-1

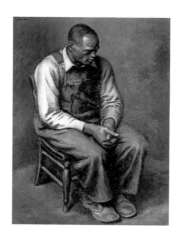

Bloch, Julius T.
American, born Germany,
1888–1966
The Stevedore
1936
Upper left: Julius Bloch
Oil on canvas
29 3/4 × 22 1/8" (75.6 × 56.2 cm)

Gift of the Committee on
Painting and Sculpture
1947-32-1

Blackburn, Morris Atkinson
American, 1902–1979
Factory by the Delaware
c. 1923
On reverse: Morris Blackburn /
1923 approx.
Oil on cardboard
9 1/8 × 12" (23.2 × 30.5 cm)

Gift of the artist
1975-164-1

Bloch, Julius T.
Sisters
1954–55
Upper left: Bloch; on reverse:
November 1954–January 1955
"SISTERS" 1954–55 Julius Bloch
10 So. 18- St Philadelphia
Oil on canvas
40 × 60 1/4" (101.6 × 153 cm)

Gift of Mrs. Lina B. Schwab, Miss
Flora B. Bloch, and Miss Clara B.
Bloch, the sisters of Julius T.
Bloch
1955-33-1

Blume, Peter
American, born Belorussia,
born 1906
The Sheds (Frankie and Johnny)
c. 1928
Lower left: PETER / BLUME
Oil on canvas
20 3/16 × 24 1/8" (51.3 × 61.3 cm)

Gift of Mr. and Mrs. R. Sturgis
Ingersoll
1941-103-1

Bolotowsky, Ilya
American, born Russia,
1907–1981
Abstraction in Light Blue
1940
Lower right: Ilya Bolotowsky 40
Oil on panel
8 × 10" (20.3 × 25.4 cm)

A. E. Gallatin Collection
1946-70-7

Bonevardi, Marcelo
Argentine, active United States,
born 1929
Landscape with Figures
1965
On reverse: Bonevardi 65
"Landscape with Figures" no. 190
Oil and painted wood on canvas
39 1/4 × 55 1/4" (99.7 × 140.3 cm)

Gift of Mrs. John Wintersteen
1969-245-1

Bonnard, Pierre
French, 1867–1947
Nude with a Maid Attending
c. 1895
Lower left: PB
Oil and graphite on canvas
15 × 27 1/2" (38.1 × 69.8 cm)

Gift of Mrs. Samuel Brady
1976-242-1

Bonnard, Pierre
Portrait of Madame Franc-Nohain
c. 1905
Upper right: Bonnard
Oil on canvas
25 × 16 5/16" (63.5 × 41.4 cm)

Gift of Maurice Newton
1966-220-1

Bonnard, Pierre
Woman in a White Hat
c. 1908
Upper right: Bonnard
Oil on paper on panel
27 15/16 × 21 13/16" (71 × 55.4 cm)

Bequest of Charlotte Dorrance
Wright
1978-1-1

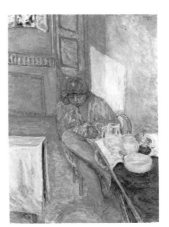

Bonnard, Pierre
After the Shower
1914
Upper right: Bonnard / 1914
Oil on canvas
37 3/8 × 26 3/16" (94.9 × 66.5 cm)

The Louis E. Stern Collection
1963-181-1

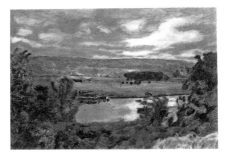

Bonnard, Pierre
*Landscape with a River in Stormy
Weather, Vernon*
1914
Lower right: Bonnard / 14
Oil on canvas
15 3/4 × 22 3/8" (40 × 56.8 cm)

Gift of Frank and Alice Osborn
1966-68-2

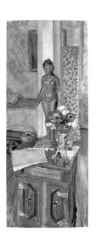

Bonnard, Pierre
Homage to Maillol
1917
Upper right: Bonnard
Oil on canvas
48 × 18 1/2" (121.9 × 47 cm)

The Louis E. Stern Collection
1963-181-2

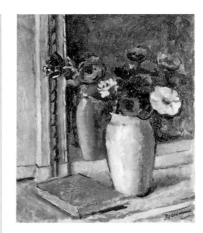

Borie, Adolphe
Still Life with a Vase of Flowers
c. 1910
Lower right: BORIE
Oil on composition board
21 1/4 × 17 3/8" (54 × 44.1 cm)

Bequest of Marguerite Lahalle
Cret
1965-117-10

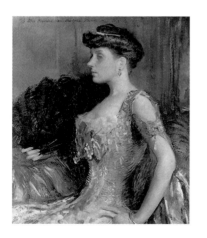

Bonnard, Pierre
Still Life with a Bowl of Fruit
1933
Lower left: Bonnard
Oil on canvas
22 13/16 × 20 7/8" (57.9 × 53 cm)

Bequest of Lisa Norris Elkins
1950-92-1

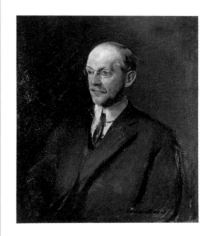

Borie, Adolphe
Portrait of John D. McIlhenny
1918
Lower right: Adolphe Borie
Oil on canvas
30 × 24 7/8" (76.2 × 63.2 cm)

The John D. McIlhenny
Collection
1943-40-54

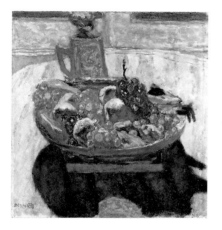

Borie, Adolphe
American, active France,
1877–1934
*Portrait of Mrs. Betty Campbell
Madeira*
1907
Upper left: To Mrs. Madeira from
Adolphe Borie—April 1907.
Oil on canvas
36 1/8 × 29 1/4" (91.8 × 74.3 cm)

Gift of Mrs. Brannan Reath II
1931-64-1

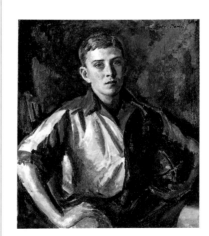

Borie, Adolphe
Portrait of Jack
1924
Upper right: Adolphe Borie.
Oil on canvas
30 3/16 × 25" (76.7 × 63.5 cm)

Gift of Samuel R. Rosenbaum
1941-22-1

Borie, Adolphe
Woman Reading
1907
Upper left: Adolphe Borie.
Oil on canvas
26 3/16 × 25 3/16" (66.5 × 64 cm)

Purchased with funds contributed
by a group of ninety-two painters
and sculptors
1935-6-1

Borofsky, Jonathan
American, born 1942
2,841,777 Sing
1978–83
Acrylic on canvas, three Polaroid
prints, painted aluminum, and a
stereo cassette with a tape loop
127 × 96" (322.6 × 243.8 cm)

Purchased with the Edward and
Althea Budd Fund, the Adele
Haas Turner and Beatrice
Pastorius Turner Memorial Fund,
and funds contributed by Marion
Boulton Stroud, Mr. and Mrs.
Harvey Gushner, Ella B. Schaap,
Mrs. H. Gates Lloyd, Eileen and
Peter Rosenau, Frances and

Bayard Storey, Dr. and Mrs.
William Wolgin, Mrs. Donald A.
Petrie, Mark Rosenthal, Harold P.
Starr, and two anonymous donors
1984-79-1

Bouche, Louis
Still Life
1921
Upper right: LOUIS BOUCHE /
PARIS 1921
Oil on canvas
20 × 16 1/8" (50.8 × 41 cm)

Gift of Frank and Alice Osborn
1966-68-22

Bosos
Unknown nationality,
active 20th century
The Japanese Fishermen
1954
Center bottom: les pécheurs
japonais Bosos 54
Oil on paperboard
12 7/8 × 15 15/16" (32.7 × 40.5 cm)

The Albert M. Greenfield and
Elizabeth M. Greenfield
Collection
1974-178-19

Branchard, Emile Pierre
American, 1881–1938
Midsummer Night's Dream
c. 1920
Lower right: EMILE /
BRANCHARD
Oil on panel
16 5/8 × 13 1/2" (42.2 × 34.3 cm)

Gift of an anonymous donor
1964-61-1

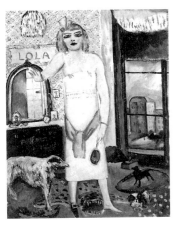

Bouche, Louis
American, 1896–1969
Lola
c. 1918
Oil on canvas
26 × 20" (66 × 50.8 cm)

The Louise and Walter Arensberg
Collection
1950-134-507

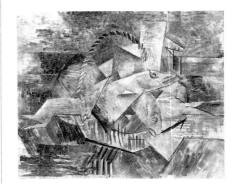

Braque, Georges
French, 1882–1963
Basket of Fish
c. 1910
Oil on canvas
19 13/16 × 24" (50.3 × 61 cm)

The Samuel S. White 3rd and
Vera White Collection
1967-30-7

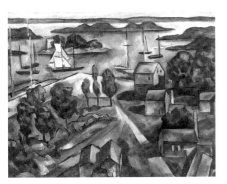

Bouche, Louis
Landscape
1919
Lower left: L BOUCHE 1919
Oil on canvas
19 7/8 × 24 1/8" (50.5 × 61.3 cm)

Gift of George Biddle
1945-16-36

Braque, Georges
Harmonica and Flageolet
1910–11
On reverse: G. Braque
Oil on canvas
13 1/8 × 16 1/4" (33.3 × 41.2 cm)

A. E. Gallatin Collection
1952-61-4

Braque, Georges
Violin and Newspaper
1912–13
Upper right: FÊTE; lower right:
JOURN[AL]; on reverse: G. Braque
Graphite, charcoal, and oil on
canvas
36 × 23 ½" (91.5 × 59.7 cm)

The Louise and Walter Arensberg
Collection
1950-134-26

Braque, Georges
Still Life
See following painting for reverse
1918
Center: G. Braque 18
Oil, gouache, paper, and charcoal
on canvas
52 ⁵⁄₁₆ × 29 ¾" (132.9 × 75.6 cm)

The Louise and Walter Arensberg
Collection
1950-134-29a

Braque, Georges
Still Life (Newspaper and Lemon)
1913
Center: LE PETIT PE[];
on reverse: G. Braque
Oil, graphite, and charcoal on
canvas
13 ¹¹⁄₁₆ × 10 ½" (34.8 × 26.7 cm)

A. E. Gallatin Collection
1952-61-5

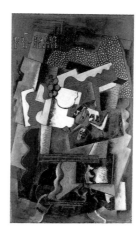

Braque, Georges
The Table
Reverse of the preceding painting
1918
Upper left: FÉ-BAR
Oil on canvas
52 ⁵⁄₁₆ × 29 ¾" (132.9 × 75.6 cm)

The Louise and Walter Arensberg
Collection
1950-134-29b

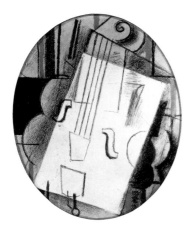

Braque, Georges
Still Life (Violin)
1913
On reverse: G. Braque
Graphite, charcoal, and oil on
canvas
13 ⁷⁄₈ × 10 ⁷⁄₈" (35.2 × 27.6 cm)

The Louise and Walter Arensberg
Collection
1950-134-25

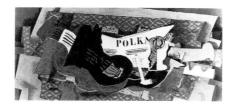

Braque, Georges
Violin and Pipe
1920–21
Center: POLKA; on reverse:
G. BRAQUE
Oil and sand on canvas
17 × 36 ³⁄₈" (43.2 × 92.4 cm)

The Louise and Walter Arensberg
Collection
1950-134-30

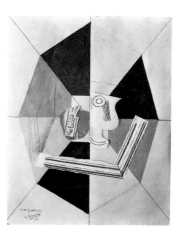

Braque, Georges
The Cup
1917–18
Lower left: A M.Gallatin /
G Braque / 1918
Oil and graphite on cardboard
25 × 18 ⁷⁄₈" (63.5 × 47.9 cm)

A. E. Gallatin Collection
1952-61-6

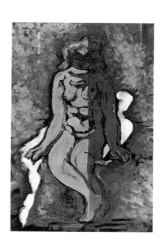

Braque, Georges
Seated Bather
1925
Lower right: G. Braque / 25
Oil on canvas
15 ⁷⁄₈ × 10 ⁵⁄₈" (40.3 × 27 cm)

Gift of Miss Anna Warren
Ingersoll
1950-27-1

Braque, Georges
Still Life with Fruit
c. 1926
On reverse: G Braque
Oil on canvas
7 3/4 × 25 1/2" (19.7 × 64.8 cm)

Gift of Miss Anna Warren
Ingersoll
1964-108-1

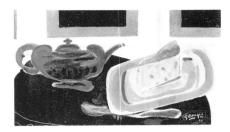

Braque, Georges
A Teapot and a Plate of Cheese
1942
Lower right: G Braque / 42
Oil on canvas
13 5/16 × 21 13/16" (33.8 × 55.4 cm)

The Louis E. Stern Collection
1963-181-4

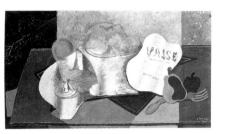

Braque, Georges
Still Life (Compote and Fruit)
1926–28
Center right: VALSE; lower right:
G Braque
Oil on canvas
17 3/16 × 28 7/8" (43.7 × 73.3 cm)

A. E. Gallatin Collection
1952-61-8

Breckenridge, Hugh Henry
American, 1870–1937
Autumn
c. 1931
Lower right: Hugh H.
Breckenridge
Oil on canvas
43 1/16 × 37 1/16" (109.4 × 94.1 cm)

Gift of Mrs. Hugh H.
Breckenridge
1936-35-1

Braque, Georges
Still Life with a Fruit Dish
1936
Lower left: G Braque / 36;
center right: LE PETI[T]
Oil on canvas
23 3/4 × 32" (60.3 × 81.3 cm)

The Samuel S. White 3rd and
Vera White Collection
1967-30-9

Brodhead, Quita
American, born 1901
Girl with a Mask
1935
Oil on canvas
36 × 30" (91.4 × 76.2 cm)

Gift of Bill Scott in memory of
Jane Piper
1991-141-1

Braque, Georges
Stormy Beach
1938
Lower left: G Braque / 38
Oil on panel
8 1/16 × 15" (20.5 × 38.1 cm)

The Samuel S. White 3rd and
Vera White Collection
1967-30-10

Brook, Alexander
American, 1898–1980
Sleeping Woman
1929
Upper right: A. Brook
Oil on canvas
36 3/8 × 29 3/4" (92.4 × 75.6 cm)

The Louis E. Stern Collection
1963-181-5

Brown, Joan
American, 1938–1990
Woman in Room
1975
On reverse: Joan Brown / Woman in Room / 5/16/75
Acrylic on canvas
72 × 62" (182.9 × 157.5 cm)

Gift of Ernie and Lynn Mieger
1988-33-7

Burliuk, David Davidovich
American, born Ukraine, 1882–1967
A Close Shave
1910
Lower right: BURLIUK / 1910.
Oil on canvas
13 ¹/₁₆ × 12 ¹/₈" (33.2 × 30.8 cm)

Gift of Christian Brinton
1941-79-47

Bruce, Patrick Henry
American, active France, 1880–1937
Still Life
c. 1921
On reverse: [The inscription "116 × 89 50F grande barre bleu verticale #13 fond sombre" was removed during relining in the 1960s]
Oil on canvas
34 ³/₄ × 45 ¹/₄" (88.3 × 114.9 cm)

Centennial gift of the Woodward Foundation
1975-81-2

Burliuk, David Davidovich
Icon after the Revolution
c. 1920
Oil on cardboard
20 × 16" (50.8 × 40.6 cm)

Gift of Christian Brinton
1941-79-95

Bubenik, Gernot
German, born 1942
Realization III
1966
On reverse: Bubenik 66
Acrylic on panel
35 ¹/₂ × 47 ¹/₄" (90.2 × 120 cm)

Gift of Dr. and Mrs. William Wolgin
1967-41-1

Burliuk, David Davidovich
Pacific Island Totem Pole
1923
Lower right: Burliuk. / 1923.
Oil on canvas
24 ¹/₄ × 18 ¹/₄" (61.6 × 46.3 cm)

Gift of Christian Brinton
1941-79-76

Burko, Diane
American, born 1945
Nevada Ulta
1975
On reverse: Diane Burko / 12/75 / "Nevada Ulta"
Acrylic on canvas
60 × 72" (152.4 × 182.9 cm)

Gift of Rachel Seymour
1977-260-1

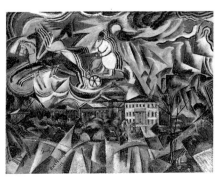

Burliuk, David Davidovich
Elijah the Prophet
1924
Lower left: Burliuk / 1924.
Oil on burlap
30 × 37 ⁷/₈" (76.2 × 96.2 cm)

Gift of Christian Brinton
1941-79-112

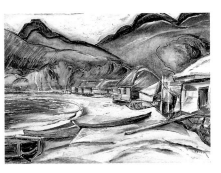

Burliuk, David Davidovich
Island Village, Bonin Archipelago
1924
Lower right: Burliuk / 1924
Oil on canvas
13 × 17" (33 × 43.2 cm)

Gift of Christian Brinton
1941-79-48

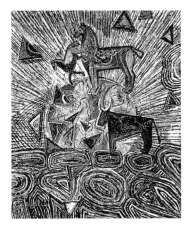

Burliuk, David Davidovich
Dawn, Russia
c. 1925
Lower left: Burliuk
Oil on canvas
30 1/8 × 24" (76.5 × 61 cm)

Gift of Christian Brinton
1941-79-69

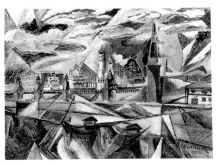

Burliuk, David Davidovich
Moscow in Revolution
1924
Lower right: Burliuk / 1924.
Oil on canvas
13 × 17" (33 × 43.2 cm)

Gift of Christian Brinton
1941-79-89

Burliuk, David Davidovich
End of the Day
c. 1925
Oil on burlap
13 × 18" (33 × 45.7 cm)

Gift of Christian Brinton
1941-79-38

Burliuk, David Davidovich
Portrait of Christian Brinton and Nine Artists
1924
Lower right: D. Burliuk / 1924
Oil on canvas
25 × 28" (63.5 × 71.1 cm)

Gift of Christian Brinton
1941-79-106

Burliuk, David Davidovich
Bashkir Family. Kargalinskaya Steppe
1927
Lower left: Burliuk / 1927 / NY.
Oil on canvas
16 1/16 × 20" (40.8 × 50.8 cm)

Gift of Christian Brinton
1941-79-94

Burliuk, David Davidovich
Russian Village Boy and Girl
1925
Lower left: Burliuk / 1925.
Oil on canvas
14 × 10" (35.6 × 25.4 cm)

Gift of Christian Brinton
1941-79-82

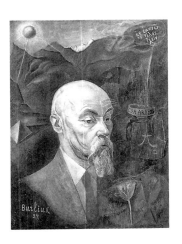

Burliuk, David Davidovich
Portrait of Professor Nicholas K. Roerich, First President of the World of Art Group
1929
Lower left: Burliuk / 29; upper right: [Greek for "to have fulfillment in itself"]; center right: COR ARDENS
Oil on canvas
24 1/8 × 18" (61.3 × 45.7 cm)

Gift of Christian Brinton
1941-79-3

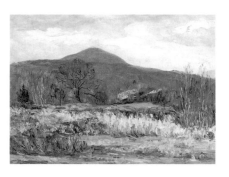

Butler, Mary
American, 1865–1946
The Catskills, December
1919
Lower right: MARY BUTLER
Oil on canvas
24 × 32 ⅛" (61 × 81.6 cm)

Gift of the Fellowship of the
Pennsylvania Academy of the
Fine Arts
1945-38-1

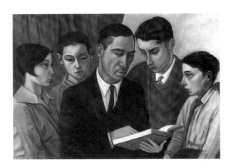

Canadé, Vincent
American, born Italy,
1879–1961
Family Group Reading
c. 1930
Lower left: To my Friend G. Biddle
/ VINCENT CANADÉ
Oil on canvas
17 ⅞ × 25 ¼" (45.4 × 64.1 cm)

Gift of George Biddle
1945-16-37

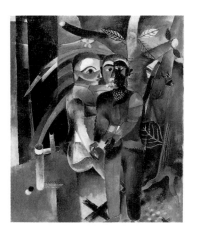

Campendonk, Heinrich
German, 1889–1957
Love in the Forest
c. 1920
Oil on canvas
29 × 23 ⅛" (73.7 × 58.7 cm)

Gift of Christian Brinton
1941-79-70

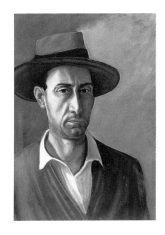

Canadé, Vincent
Self-Portrait
c. 1930
Oil on canvas
19 ⅛ × 13 ¼" (48.6 × 33.6 cm)

Gift of an anonymous donor
1948-53-1

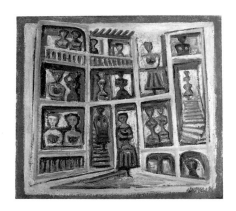

Campigli, Massimo
Italian, 1895–1971
Theater
1956
Lower right: CAMPIGLI 56
Oil on canvas
19 ⅝ × 21 ⅝" (49.8 × 54.9 cm)

Gift of Mr. and Mrs. William P.
Wood
1981-58-1

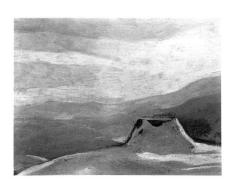

Canadé, Vincent
Winter Landscape
c. 1930
Oil on panel
8 × 10" (20.3 × 25.4 cm)

Gift of Carl Zigrosser
1972-237-5

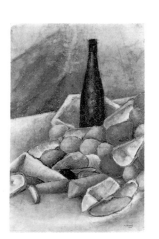

Canadé, Eugene George
American, born 1914
Still Life with Fruit and a Bottle
c. 1940
Lower right: E. CANADÉ / 604
Oil on canvas
25 ⅝ × 15 ⅞" (65.1 × 40.3 cm)

Gift of Carl Zigrosser
1972-237-6

Canadé, Vincent
Dark Landscape with Two Houses
c. 1935
Lower right: V. CANADÉ
Oil on composition board
13 ¼ × 19 ⅜" (33.6 × 49.2 cm)

Gift of Carl Zigrosser
1972-237-1

Canadé, Vincent
River Landscape with Trees
c. 1935
Oil on canvas board
13 1/2 × 10 1/8" (34.3 × 25.7 cm)

Gift of Carl Zigrosser
1972-237-4

Capraro, Vincent
American, born 1924
Hawks and Doves (Abstraction)
c. 1955
Oil on canvas
54 3/4 × 71 1/2" (139.1 × 181.6 cm)

The Albert M. Greenfield and
Elizabeth M. Greenfield
Collection
1974-178-21

Canadé, Vincent
*River Landscape with Trees and
Houses*
c. 1935
Lower left: V. CANADÉ
Oil on canvas on panel
13 5/8 × 10 1/8" (34.6 × 25.7 cm)

Gift of Carl Zigrosser
1972-237-2

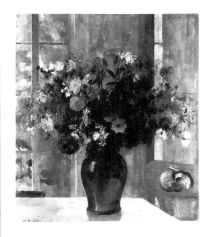

Carles, Arthur Beecher
American, 1882–1952
Bouquet in a Blue Vase
1914
Lower left: CARLES
Oil on canvas
48 × 40" (121.9 × 101.6 cm)

Gift of Mr. and Mrs. David
Bortin
1956-37-1

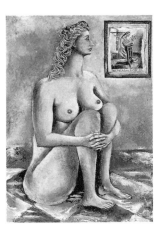

Cantú, Federico
Mexican, born 1908
Sacred and Profane Love
1937
On picture on wall: federico
Cantú. / "Amour Sacré et Amour
Profane." ad.37.
Oil on canvas
18 × 13" (45.7 × 33 cm)

Gift of Mr. and Mrs. Joseph J.
Gersten
1951-120-1

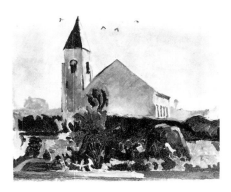

Carles, Arthur Beecher
French Village Church
c. 1914
Lower left: CARLES
Oil on canvas
23 5/8 × 28 5/8" (60 × 72.7 cm)

The Samuel S. White 3rd and
Vera White Collection
1967-30-11

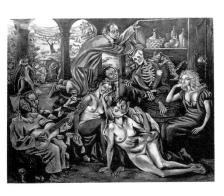

Cantú, Federico
Triumph of Death
1938
Lower left: Federico Cantú /
A.d. MCMXXXVIII
Oil on canvas
58 1/4 × 72 5/8" (147.9 × 184.5 cm)

Gift of Dr. and Mrs. MacKinley
Helm
1943-44-1

Carles, Arthur Beecher
Study for "The Marseillaise"
See following painting for reverse
1918
Lower left: To Dorziat / with
appreciation / Carles
Oil on cardboard
13 15/16 × 12 1/16" (35.4 × 30.6 cm)

Gift of John T. Dorrance
1969-140-1a

Carles, Arthur Beecher
Autumn Landscape with Blue Mountains
Reverse of the preceding painting
c. 1918
Oil on cardboard
12 1/16 × 13 15/16" (30.6 × 35.4 cm)

Gift of John T. Dorrance
1969-140-1b

Carles, Arthur Beecher
Portrait of Vera White
1922
Lower right: CARLES
Oil on canvas
39 1/2 × 32" (100.3 × 81.3 cm)

The Samuel S. White 3rd and
Vera White Collection
1967-30-13

Carles, Arthur Beecher
The Marseillaise
c. 1918
Center bottom: CARLES
Oil on canvas
77 1/4 × 63 1/8" (196.2 × 160.3 cm)

Purchased with subscription
funds
1930-67-1

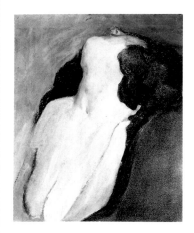

Carles, Arthur Beecher
Redheaded Woman
1922
Lower right: CARLES
Oil on canvas
16 1/8 × 13" (41 × 33 cm)

The Samuel S. White 3rd and
Vera White Collection
1967-30-15

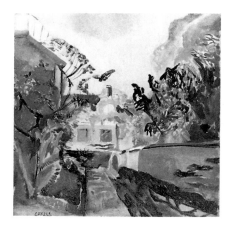

Carles, Arthur Beecher
Steichen's Garden
c. 1921
Lower left: CARLES
Oil on canvas
24 7/8 × 24 1/8" (63.2 × 61.3 cm)

The Samuel S. White 3rd and
Vera White Collection
1967-30-12

Carles, Arthur Beecher
Abstract of Flowers
c. 1922
Lower right: CARLES
Oil on canvas
21 1/4 × 25 1/2" (54 × 64.8 cm)

The Samuel S. White 3rd and
Vera White Collection
1967-30-14

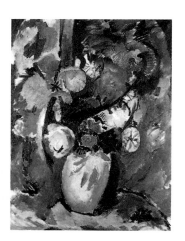

Carles, Arthur Beecher
Composition of Flowers
1922
Oil on canvas
49 3/8 × 36 3/8" (125.4 × 92.4 cm)

Gift of Mrs. Earle Horter
1950-40-1

Carles, Arthur Beecher
Nude
c. 1923
Oil on canvas
16 3/8 × 13" (41.6 × 33 cm)

Gift of Benjamin D. Bernstein
1964-106-1

Carles, Arthur Beecher
Figure on a Couch
1924–25
Upper left: CARLES
Oil on canvas
45 1/8 × 60" (114.6 × 152.4 cm)

Gift of Mr. and Mrs. David
Bortin
1956-37-2

Carles, Arthur Beecher
Blue Abstraction
c. 1929
Lower right: CARLES
Oil on canvas
40 1/4 × 33 3/16" (102.2 × 84.3 cm)

Gift of Mr. and Mrs. Robert
McLean
1977-202-1

Carles, Arthur Beecher
Still Life
c. 1926
Oil on canvas
47 1/16 × 40" (119.5 × 101.6 cm)

Gift of Mr. and Mrs. Charles C. G.
Chaplin in memory of Mia Wood
1978-149-1

Carles, Arthur Beecher
Flowers
c. 1930
Oil on canvas
28 7/8 × 23 3/4" (73.3 × 60.3 cm)

The Albert M. Greenfield and
Elizabeth M. Greenfield
Collection
1974-178-22

Carles, Arthur Beecher
Through the Arch (Procession)
1927
On reverse: Arthur B. Carles /
Through the Arch—Carles
Oil on canvas
52 1/4 × 40 1/4" (132.7 × 102.2 cm)

Gift of Mr. and Mrs. C. Earle
Miller
1970-15-1

Carles, Arthur Beecher
Abstraction (Composition No. 5)
c. 1935
Lower left: CARLES
Oil on canvas
38 3/8 × 51 1/2" (97.5 × 130.8 cm)

Gift of Mr. and Mrs. R. Sturgis
Ingersoll
1941-103-4

Carles, Arthur Beecher
Turkey
1927
Lower right: CARLES
Oil on canvas
56 1/2 × 44 1/2" (143.5 × 113 cm)

Gift of Mr. and Mrs. R. Sturgis
Ingersoll
1941-103-5

Carlson, Cynthia J.
American, born 1942
Moonlight
1976
On reverse: Cynthia Carlson 1976 /
ACRYLIC and OIL ON CANVAS /
"MOONLIGHT" 48" × 60"
Acrylic and oil on canvas
60 1/8 × 48 1/16" (152.7 × 122.1 cm)

Gift of Dr. and Mrs. Lorenzo
Margini
1980-131-1

337

Carter, Clarence Holbrook
American, born 1904
Poor Man's Pullman
1930
Lower right: Clarence H. Carter
30.
Oil on canvas
35 15/16 × 44 5/16" (91.3 × 112.5 cm)

Purchased with the Edith H. Bell
Fund
1979-163-1

Castellon, Federico
American, born Spain,
1914–1971
Two Heads, One with a Red Veil
1946
Lower right: TO LAURA / AND
CARL / FEDERO 46
Oil on canvas
12 1/16 × 10 1/8" (30.6 × 25.7 cm)

Gift of Carl Zigrosser
1974-179-1

Casorati, Felice
Italian, 1883–1963
The Studio
c. 1956
Lower right: .F.CASORATI.
Oil on canvas
55 1/4 × 51" (140.3 × 129.5 cm)

Gift of Mrs. Arthur Barnwell
1957-25-1

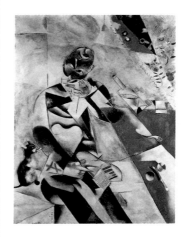

Chagall, Marc
French, born Belorussia,
1887–1985
Half Past Three (The Poet)
1911
Lower left: Chagall / Paris 1911
Oil on canvas
77 1/8 × 57" (195.9 × 144.8 cm)

The Louise and Walter Arensberg
Collection
1950-134-36

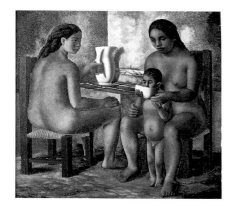

Castellanos, Julio
Mexican, 1905–1947
Three Nudes (The Aunts)
1930
Oil on canvas
51 15/16 × 55 1/2" (131.9 × 141 cm)

Gift of the Committee on
Painting and Sculpture
1943-45-1

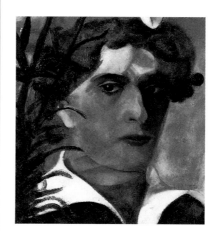

Chagall, Marc
Self-Portrait
1914
Lower right: Chagall / 1914
Oil on cardboard
11 1/2 × 10 1/8" (29.2 × 25.7 cm)

The Louis E. Stern Collection
1963-181-9

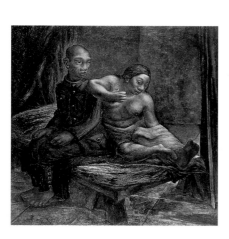

Castellanos, Julio
*A Soldier and a Woman (The
Dialogue)*
c. 1936
Oil and wax on canvas
47 3/8 × 47 3/8" (120.3 × 120.3 cm)

Gift of Mr. and Mrs. Henry
Clifford
1947-29-1

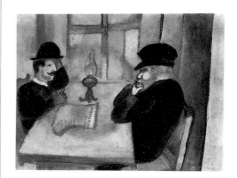

Chagall, Marc
The Smolensk Newspaper
1914
Center: [Russian for "Smolensk
News / War"]; center right:
[Yiddish for "Smolensk News /
War"]; lower right: Chagall /
Chagall 1914
Oil on cardboard
14 15/16 × 19 3/4" (37.9 × 50.2 cm)

The Louis E. Stern Collection
1963-181-13

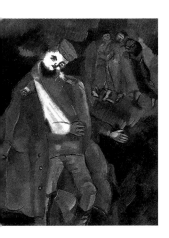

Chagall, Marc
Wounded Soldier
1914
Oil, watercolor, and gouache on cardboard
19 1/4 × 14 7/8" (48.9 × 37.8 cm)

Gift of Mary Katharine Woodworth in memory of Allegra Woodworth
1986-124-1

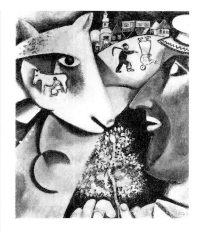

Chagall, Marc
I and the Village
A larger version, dated 1911, is in the Museum of Modern Art, New York
c. 1924
Lower right: Marc / Chagall.
Oil on canvas
21 15/16 × 18 1/4" (55.7 × 46.3 cm)

Gift of Mr. and Mrs. Rodolphe Meyer de Schauensee
1944-36-1

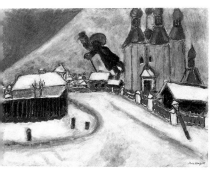

Chagall, Marc
Over Vitebsk
c. 1914
Lower right: Marc Chagall
Oil, gouache, graphite, and ink on paper
12 3/8 × 15 3/4" (31.4 × 40 cm)

The Louis E. Stern Collection
1963-181-10

Chagall, Marc
The Watering Trough
c. 1925
Lower right: Marc Chagall.
Oil on canvas
39 1/4 × 34 11/16" (99.7 × 88.1 cm)

The Louis E. Stern Collection
1963-181-14

Chagall, Marc
Purim
1916–18
Lower right: Marc / Chagall.
Oil on canvas
19 7/8 × 28 5/16" (50.5 × 71.9 cm)

The Louis E. Stern Collection
1963-181-11

Chagall, Marc
The Crucifixion
1940
Lower left: Chagall / Marc
Oil on canvas
13 3/8 × 11 9/16" (34 × 29.4 cm)

The Samuel S. White 3rd and Vera White Collection
1959-133-1

Chagall, Marc
Oh God
1919
Upper right: [Russian for "Oh God"]; lower left: Marc / 1919; lower right: Chagall
Oil, tempera, crayon, and distemper on paper mounted on cardboard on panel
22 3/4 × 18 5/16" (57.8 × 46.5 cm)

The Louis E. Stern Collection
1963-181-12

Chagall, Marc
A Wheatfield on a Summer's Afternoon
Backdrop for Scene III of the ballet *Aleko*, by Léonide Massine, based on a poem by Aleksander Pushkin and music by Peter Ilyich Tchaikovsky
1942
Tempera on fabric
360 × 600" (914.4 × 1524 cm)

Gift of Leslie and Stanley Westreich
1986-173-1

Chagall, Marc
In the Night
1943
Lower right: Marc Chagall / 43
Oil on canvas
18 1/2 × 20 5/8" (47 × 52.4 cm)

The Louis E. Stern Collection
1963-181-16

Chernoff, Vadim Anatolievich
Ukrainian, 1887–1954
Sketch for Act I of "Judith"
Sketch for a backdrop for the play
Judith, by Friedrich Hebbel
c. 1920
Lower left: V. CHERNOFF; on
reverse: TO MY DEAR FRIEND /
DR. CHRISTIAN BRINTON /
FROM / VADIM CHERNOFF /
DECEMBER 25 / 1929 / "Judith"
/ ACT I / FRIEDERICK GEBEL /
PRODUCED / REVAL / APRIL 1920
Tempera on canvas
24 × 29" (61 × 73.7 cm)

Gift of Christian Brinton
1941-79-80

Chanler, Robert Winthrop
American, 1872–1930
The Rokeby Hunt
1924
Lower right: Robert W. Chanler
1924
Gesso on panel
14 1/2 × 18" (36.8 × 45.7 cm)

Gift of Christian Brinton
1941-79-74

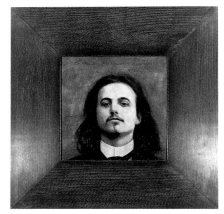

Chimes, Thomas
American, born 1921
Portrait of Alfred Jarry
1974
Across top: Doctor Alfred Jarry
as he appeared in the year 1896. /
Pa Pa Ebé; center left: Thomas
Chimes / 1974
Oil on panel
12 × 11 11/16" (30.5 × 29.7 cm)

Purchased with the Adele Haas
Turner and Beatrice Pastorius
Turner Memorial Fund
1975-82-1

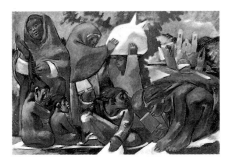

Charlot, Jean
Mexican, born France,
1898–1979
Bathers
1943
Lower right: Jean Charlot / 43
Oil on canvas
50 × 69 3/4" (127 × 177.2 cm)

Gift of an anonymous donor
1956-26-1

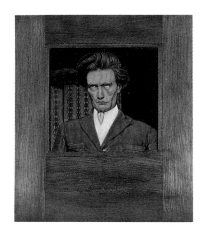

Chimes, Thomas
Portrait of Antonin Artaud
1974
Upper left: Chimes 1974; center
bottom, on frame: Antonin
Artaud / 1920
Oil on panel
9 1/8 × 9 1/8" (23.2 × 23.2 cm)

Gift of the artist
1975-78-1

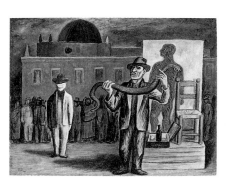

Chavez-Morado, José
Mexican, born 1909
The Charlatan
1942
Lower left: CHAVEZ / MORADO /
42
Oil on canvas
22 × 28 3/8" (55.9 × 72.1 cm)

Gift of Dr. MacKinley Helm
1947-30-1

Chimes, Thomas
Portrait of Apollinaire
1974
Lower left: Chimes 74 / Près du
passé luisant / demain est
incolore; lower right: Guillaume
Apollinaire / Paris
Oil on panel
12 × 9 3/8" (30.5 × 23.8 cm)

Purchased with the Adele Haas
Turner and Beatrice Pastorius
Turner Memorial Fund
1975-82-2

Chimes, Thomas
Portrait of Oscar Wilde
1975
Lower right: Chimes / 75
Oil on panel
11 × 9 1/4" (27.9 × 23.5 cm)

Gift of the artist
1976-154-1

Chirico, Giorgio de
The Poet and His Muse
1921
Upper right: G. de Chirico / 21
Oil and tempera on canvas
35 7/8 × 29" (91.1 × 73.7 cm)

The Louise and Walter Arensberg
Collection
1950-134-39

Chimes, Thomas
Faustroll (L'Infini)
1988
Center: Faustroll
Oil on linen
48 × 68" (121.9 × 172.7 cm)

Purchased with the Julius Bloch
Memorial Fund
1988-42-1

**Cickowsky, Nikolai
Stepanovich**
American, born Belorussia,
born 1894, death date unknown
Russia
1925
Lower right: 1925 / N. Cickowsky
Oil on canvas
40 1/8 × 37" (101.9 × 94 cm)

Gift of Christian Brinton
1941-79-116

Chirico, Giorgio de
Italian, born Greece,
1888–1978
The Soothsayer's Recompense
1913
Lower left: Giorgio de Chirico /
M.CM.XIII.
Oil on canvas
53 3/8 × 70 7/8" (135.6 × 180 cm)

The Louise and Walter Arensberg
Collection
1950-134-38

**Cickowsky, Nikolai
Stepanovich**
Russian Dancer
c. 1926
Lower right: N. Cickowsky
Oil on canvas
35 1/8 × 30 1/8" (89.2 × 76.5 cm)

Gift of Christian Brinton
1941-79-149

Chirico, Giorgio de
The Fatal Temple
c. 1913?
Center left: G. de Chirico; center:
Joie / Souffrance; center bottom:
éternité d'un moment / chose /
étrange / non-sens; lower right:
énigme / vie
Oil on canvas
13 1/8 × 16 1/8" (33.3 × 41 cm)

A. E. Gallatin Collection
1947-88-14

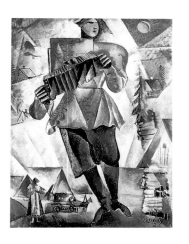

**Cickowsky, Nikolai
Stepanovich**
Russian Legend
c. 1926
Lower right: Cickowsky
Oil on canvas
33 × 26" (83.8 × 66 cm)

Gift of Christian Brinton
1941-79-108

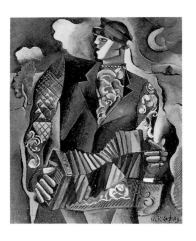

Cickowsky, Nikolai Stepanovich
Young Man from Penza
By 1931
Lower right: NCickowsky.
Oil on canvas
33 × 26" (83.8 × 66 cm)

Gift of Christian Brinton
1941-79-107

Coiner, Charles Toucey
American, born 1897
The Blue Door
c. 1959
Lower right: C. C.
Oil on canvas
22 ¹/₂ × 29 ⁵/₈" (57.1 × 75.2 cm)

Purchased with the Adele Haas Turner and Beatrice Pastorius Turner Memorial Fund
1959-12-2

Claisse, Geneviève
French, born 1935
H.
1969
On reverse: Claisse 1969
Oil on canvas
31 ¹/₂ × 31 ¹/₂" (80 × 80 cm)

Gift of Dr. and Mrs. Paul Todd Makler
1979-186-3

Coleman, Glenn O.
American, 1887–1932
Street Scene, Chinatown, New York City
c. 1910–15
Lower right: Glenn Coleman
Oil on panel
23 ¹/₂ × 29 ⁷/₈" (59.7 × 75.9 cm)

Gift of Mrs. John Wintersteen
1942-66-1

Clemente, Francesco
Italian, born 1952
Hunger
1980
Gouache on Pondicherry paper, joined by cotton strips
93 ¹/₂ × 96 ¹/₂" (237.5 × 245.1 cm)

Gift of Marion Boulton Stroud
1991-142-1

Cook, Howard Norton
American, 1901–1980
Sangre de Cristo Mountains
1958
Lower right: HOWARD COOK
Oil on panel
5 ⁷/₈ × 18 ¹/₈" (14.9 × 46 cm)

Gift of Carl Zigrosser
1972-237-8

Clemente, Francesco
Sun
1980
Gouache on twelve sheets of paper, joined by cotton strips
95 × 91" (241.3 × 231.1 cm)

Purchased with the Edward and Althea Budd Fund, the Katharine Levin Farrell Fund, and funds contributed by Mrs. H. Gates Lloyd
1984-118-1

Copley, William Nelson
American, born 1919
Tendresse
See following painting for reverse
1969
Lower left: CpLy / 69
Liquitex on canvas
26 × 32 ³/₁₆" (66 × 81.8 cm)

Gift of an anonymous donor
1970-204-1a

Copley, William Nelson
Nude Woman
Reverse of the preceding painting
c. 1969
Liquitex on canvas
26 × 32 3/16" (66 × 81.8 cm)

Gift of an anonymous donor
1970-204-1b

Crimmins, Jerry
American, born 1940
The Ambassador and Her Assistant
1973
Lower right: G. CRIMMINS. 73
Oil on Masonite
16 1/4 × 13 1/4" (33.6 × 41.3 cm)

Gift of the Cheltenham Art
Centre
1979-30-1

Corinth, Lovis
German, 1858–1925
Portrait of Sophie Cassirer
1906
Upper left: LOVIS CORINTH. /
October 1906
Oil on canvas
37 11/16 × 29 5/8" (95.7 × 75.2 cm)

Purchased with the George W.
Elkins Fund
E1975-1-1

Criss, Francis H.
American, 1901–1973
*Words and Music of Two
Hemispheres*
c. 1940
Lower right: Francis Criss
Oil on Masonite
14 1/8 × 18 9/16" (35.9 × 47.1 cm)

Gift of Dr. Herman Lorber
1944-95-1

Covert, John R.
American, 1882–1960
Hydro Cell
1918
Lower right: HYDRO CELL; on
reverse: Hydro Cell / John R.
Covert / NYC—1918
Oil on cardboard
24 1/4 × 26 1/2" (61.6 × 67.3 cm)

The Louise and Walter Arensberg
Collection
1950-134-509

Crowell, Lucius
American, 1911–1988
Profile of a Young Man
1949
Lower left: L CROWELL
Oil on canvas
10 × 14" (25.4 × 35.6 cm)

Bequest of Lisa Norris Elkins
1950-92-4

Cox, Jan
American, born Netherlands,
born 1919
Good Night Black Olive
1959
On reverse: 18 JANUARY 59
Oil and mother-of-pearl on panel
23 13/16 × 11" (60.5 × 27.9 cm)

Gift of Dr. and Mrs. Joseph N.
Epstein
1963-192-1

Crowell, Lucius
From Tunnel Hill
c. 1955
Lower right: L CROWELL
Oil on canvas
16 × 28 1/4" (40.6 × 71.7 cm)

Purchased with the Adele Haas
Turner and Beatrice Pastorius
Turner Memorial Fund
1959-12-3

Cucchi, Enzo
Italian, born 1950
Entry into Port of a Ship with a Red Rose Aboard
1985–86
Fresco
110 × 157" (279.4 × 398.8 cm)

Gift of Mr. and Mrs. David N. Pincus
1991-140-1

Danziger, Fred
American, born 1946
Playroom Portrait
1972
Lower right: DANZIGER 72
Oil on canvas
70 × 56⁹/₁₆" (177.8 × 143.7 cm)

Gift of Fidelity Bank
1973-131-1

Curtiss, Deborah
American, born 1937
Too
1972
Lower right: Curtiss
Acrylic on unprimed canvas
50 × 48¹/₈" (127 × 122.2 cm)

Centennial gift of the friends of Deborah Curtiss
1976-98-1

Dash, Robert
American, born 1934
Autumn Bridge
1971
Lower right: Robert Dash
Acrylic on canvas
30 × 40" (76.2 × 101.6 cm)

Gift of Barbara Kulicke
1973-71-1

Dalí, Salvador
Spanish, 1904–1989
Agnostic Symbol
1932
Lower right: gala salvador Dali
1932
Oil on canvas
21¹/₄ × 25¹¹/₁₆" (54 × 65.2 cm)

The Louise and Walter Arensberg Collection
1950-134-40

Davie, Alan
Scottish, born 1920
Egg Rocker
c. 1952
On reverse: ALAN DAVIE
Oil on canvas
47⁷/₈ × 60" (121.6 × 152.4 cm)

Gift of Mr. and Mrs. David N. Pincus
1971-263-1

Dalí, Salvador
Soft Construction with Boiled Beans (Premonition of Civil War)
1936
Oil on canvas
39⁵/₁₆ × 39³/₈" (99.8 × 100 cm)

The Louise and Walter Arensberg Collection
1950-134-41

Davies, Arthur Bowen
American, 1862–1928
Apuan, Many-Folded Mountains
1907
Lower left: A. B. Davies 07
Oil on canvas
26 × 40" (66 × 101.6 cm)

Gift of Mr. and Mrs. Philip S. Collins
1929-79-2

Davies, Arthur Bowen
Autumn—Enchanted Salutation
1907
Lower left: A. B. Davies
Oil on canvas
18 1/8 × 30 1/4" (46 × 76.8 cm)

Gift of Mr. and Mrs. Meyer P.
Potamkin (reserving life interest)
1964-116-3

Davis, Gene
Study for "Franklin's Footpath"
See previous two entries
1971
Liquitex on canvas
99 3/16 × 120 1/8" (251.9 ×
305.1 cm)

Gift of the artist and Dr. and
Mrs. William Wolgin
1972-54-1

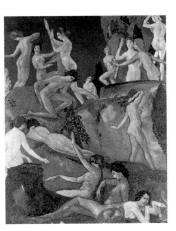

Davies, Arthur Bowen
Daphnes of the Ravine
1922
Lower left: A / B / Davies
Oil on canvas
32 1/8 × 24 1/8" (81.6 × 61.3 cm)

Gift of Mr. and Mrs. Philip S.
Collins
1929-79-1

Davis, Ron
American, born 1937
One-Ninth Green
1966
Plastic, fiberglass, wood, and
polyester
70 × 130" (177.8 × 330.2 cm)

Centennial gift of the Woodward
Foundation
1975-83-3

Davis, Gene
American, 1920–1985
Study for "Franklin's Footpath"
For the painting executed on the
Benjamin Franklin Parkway,
Philadelphia, in 1971 and
removed in 1976
1971
Liquitex on canvas
29 3/4 × 24 1/8" (75.6 × 61.3 cm)

Gift of the artist and Dr. and
Mrs. William Wolgin
1972-30-1

Davis, Stuart
American, 1892–1964
Something on the Eight Ball
1953–54
Lower right: Stuart Davis.; on
reverse: Something on the 8 Ball,
1953–4
Oil on canvas
56 × 45" (142.2 × 114.3 cm)

Purchased with the Adele Haas
Turner and Beatrice Pastorius
Turner Memorial Fund
1954-30-1

Davis, Gene
Study for "Franklin's Footpath"
See previous entry
1971
Liquitex on canvas
29 × 22 1/2" (73.7 × 57.1 cm)

Gift of the artist and Dr. and
Mrs. William Wolgin
1972-30-2

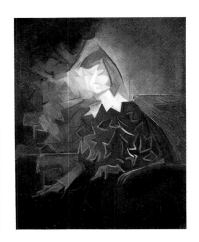

Dawson, Manierre
American, 1887–1969
Eugenia
1911
Lower right: M Dawson 11
Oil on canvas
36 × 28 1/8" (91.4 × 71.4 cm)

Purchased with the Edith H. Bell
Fund
1975-169-1

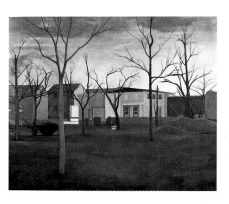

Day, Larry
American, born 1921
Suburban Landscape
1976
Lower right: Day
Oil on canvas
60 1/2 × 71 1/2" (153.7 × 181.6 cm)

Purchased with funds contributed
by Dr. and Mrs. Stephen D.
Silberstein
1977-201-1

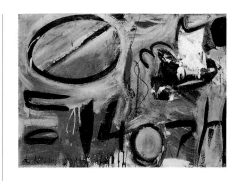

de Kooning, Willem
Open Road
1950
Lower left: de Kooning; on
reverse: OPEN ROAD 1950
Oil and enamel on cardboard on
Masonite
29 7/8 × 39 15/16" (75.9 × 101.4 cm)

The Albert M. Greenfield and
Elizabeth M. Greenfield
Collection
1974-178-25

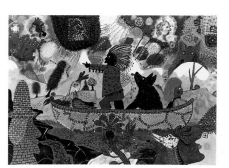

De Forest, Roy
American, born 1930
Canoe of Fate
1974
On reverse: POLYMER / ROY DE
FOREST 1974 / "CANOE OF
FATE" / VARNISH B-72
Acrylic on canvas
66 3/4 × 90 1/4" (169.5 × 229.2 cm)

Purchased with the Adele Haas
Turner and Beatrice Pastorius
Turner Memorial Fund
1975-83-1

Delaney, Beauford
American, 1901–1979
Portrait of Marian and Betty
1970
Lower right: B. Delaney / 1970
Oil on canvas
25 × 31" (63.5 × 78.7 cm)

Gift of Gene Locks
1991-139-1

de Kooning, Willem
American, born Netherlands,
born 1904
Seated Woman
c. 1940
Oil and charcoal on Masonite
54 1/16 × 36" (137.3 × 91.4 cm)

The Albert M. Greenfield and
Elizabeth M. Greenfield
Collection
1974-178-23

Delaunay, Robert
French, 1885–1941
Saint Séverin
See following painting for reverse
1909
Lower left: r. delaunay 1909
Oil on canvas
38 × 27 3/4" (96.5 × 70.5 cm)

The Louise and Walter Arensberg
Collection
1950-134-42a

de Kooning, Willem
Noon
c. 1947
Upper left: de Kooning
Oil and enamel on Masonite
48 × 13 15/16" (121.9 × 35.4 cm)

The Albert M. Greenfield and
Elizabeth M. Greenfield
Collection
1974-178-24

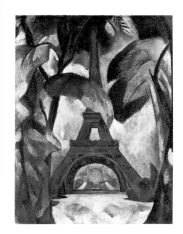

Delaunay, Robert
Eiffel Tower
Reverse of the preceding painting
c. 1909
Oil on canvas
38 × 27 3/4" (96.5 × 70.5 cm)

The Louise and Walter Arensberg
Collection
1950-134-42b

Delaunay, Robert
Three-Part Windows
1912
Lower left: r delaunay 1912
Oil on canvas
13 7/8 × 36 1/8" (35.2 × 91.8 cm)

A. E. Gallatin Collection
1952-61-13

Demuth, Charles
Trees
1908
On reverse: Demuth
Oil on canvas
12 1/8 × 10 1/8" (30.8 × 25.7 cm)

Gift of Mr. and Mrs. Herman
Finklestein
1962-205-2

Delaunay, Robert
Eiffel Tower
See following painting for reverse
c. 1925
Lower left: r. delaunay
Oil on burlap
51 1/2 × 12 1/2" (130.8 × 31.7 cm)

The Louise and Walter Arensberg
Collection
1950-134-43a

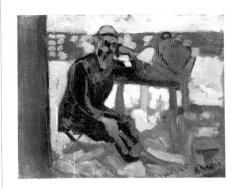

Derain, André
French, 1880–1954
Portrait of Henri Matisse
c. 1905
Lower right: A. Derain
Oil on canvas
13 × 16 1/8" (33 × 41 cm)

A. E. Gallatin Collection
1952-61-22

Delaunay, Robert
Untitled
Reverse of the preceding painting
c. 1925
Oil on burlap
51 1/2 × 12 1/2" (130.8 × 31.7 cm)

The Louise and Walter Arensberg
Collection
1950-134-43b

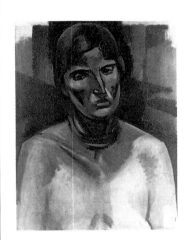

Derain, André
Woman
c. 1914
Oil on canvas
24 1/8 × 18 1/2" (61.3 × 47 cm)

The Louise and Walter Arensberg
Collection
1950-134-47

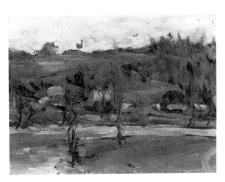

Demuth, Charles
American, 1883–1935
River Scene
1908
Oil on cardboard
8 × 9 7/8" (20.3 × 25.1 cm)

Gift of Mr. and Mrs. Herman
Finklestein
1962-205-1

Dessner, Murray
American, born 1934
Oranges for Red Rodney
1969
Acrylic on canvas
88 1/8 × 76 5/8" (223.8 × 194.6 cm)

Gift of the Cheltenham Art
Centre
1969-88-1

Dessner, Murray
Xanadu
1972
Acrylic on canvas
108 7/16 × 100 7/8" (275.4 × 256.2 cm)

Purchased with the Philadelphia Foundation Fund
1973-134-1

Dickinson, Preston
American, 1891–1930
Old Street, Quebec
c. 1928
Lower right: P. DICKINSON
Oil on canvas
34 1/16 × 23 7/8" (86.5 × 60.6 cm)

Gift of Mr. and Mrs. R. Sturgis Ingersoll
1941-103-2

Dickinson, Edwin Walter
American, 1891–1979
Self-Portrait
1940
Upper left: EW Dickinson; upper right: 1940
Oil on canvas
20 × 15 1/8" (50.8 × 38.4 cm)

Bequest of T. Edward Hanley
1970-76-2

Diebenkorn, Richard
American, 1922–1993
Ocean Park No. 79
1975
Lower right: R D 75; on reverse: R. DIEBENKORN / Ocean Park #79 1975
Oil on canvas
93 × 81" (236.2 × 205.7 cm)

Purchased with a grant from the National Endowment for the Arts and with funds contributed by private donors
1977-28-1

Dickinson, Edwin Walter
Simba and Three in One (Mayo's Beach from Indian Neck)
1951
Upper left: E W Dickinson; center left: SIMBA; lower left: Wellfleet; center bottom: 1951 / SIMBA
Oil on panel
12 1/16 × 15 13/16" (30.6 × 40.2 cm)

The Albert M. Greenfield and Elizabeth M. Greenfield Collection
1974-178-27

Dine, Jim
American, born 1935
Balcony
1979
On reverse: BALCONY / Jim Dine 1979
Oil on canvas
102 1/2 × 81" (260.3 × 205.7 cm)

Gift of the Friends of the Philadelphia Museum of Art
1981-56-1

Dickinson, Edwin Walter
Still Life, Lascaux
1953
Upper left: E W Dickinson / 1953 / Grotte de Lascaux; lower right: 1953 EW Dickinson
Oil on canvas
37 × 30 1/8" (94 × 76.5 cm)

The Albert M. Greenfield and Elizabeth M. Greenfield Collection
1974-178-26

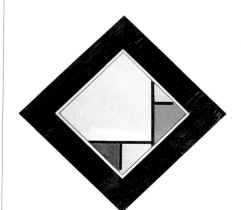

Doesburg, Theo van (Christian Emil Marie Kupper)
Dutch, 1883–1931
Composition
1929
On reverse: Theo van / Doesburg '29
Oil on canvas
11 13/16 × 11 7/8" (30 × 30.2 cm) diagonal

A. E. Gallatin Collection
1952-61-124

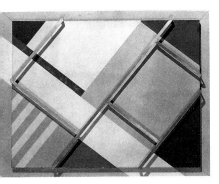

Domela, César
Dutch, active France, born 1900
Construction
c. 1929
Oil and metal on panel
18 1/4 × 22 1/4" (46.3 × 56.5 cm)

A. E. Gallatin Collection
1952-61-23

Dove, Arthur Garfield
Silver Tanks and Moon
1930
Lower right: Dove
Oil and silver paint on canvas
28 3/16 × 18 1/16" (71.6 × 45.9 cm)

The Alfred Stieglitz Collection
1949-18-3

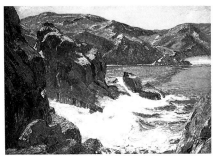

Dougherty, Paul
American, 1877–1947
Cove
1912
Lower left: Paul Dougherty
Oil on canvas
36 3/4 × 48 1/4" (93.3 × 122.5 cm)

The Alex Simpson, Jr., Collection
1928-63-5

Dowell, John E., Jr.
American, born 1941
Trane Scape
1972
On reverse: "Trane / Scape" /
John Dowell / '72
Acrylic on canvas
83 3/4 × 63 13/16" (212.7 × 162.1 cm)

Gift of Dr. Luther W. Brady, Jr.
1984-109-1

Dove, Arthur Garfield
American, 1880–1946
No. 1
c. 1915–20
Oil on canvas
21 5/16 × 18" (54.1 × 45.7 cm)

The Alfred Stieglitz Collection
1949-18-1

Dowell, John E., Jr.
To Weave through Time
1979
On reverse: Dowell / 1979 / TO
WEAVE / THROUGH / TIME /
John E. Dowell "R" / 1979
Oil on canvas
84 1/8 × 20 1/8" (213.7 × 51.1 cm)

Gift of Dr. Luther W. Brady, Jr.
1980-57-1

Dove, Arthur Garfield
Chinese Music
1923
Oil on panel
21 11/16 × 18 1/8" (55.1 × 46 cm)

The Alfred Stieglitz Collection
1949-18-2

Downing, Tom
American, born 1928
Fan on the Pharaoh
1966
Oil on canvas
76 5/8 × 106 1/4" (194.6 ×
269.9 cm)

Gift of Vincent Melzac
1967-39-1

Drew-Bear, Jessie
American, born England,
1880–1962
Still Life: Cocktails
c. 1960
Center bottom: DREW-BEAR; on
bottles: GILBEYS / GIN; NOILLY-
PRAT / EXTRA-DRY /
VERMOUTH; SEAGRAMS / 7
Oil on canvas
24 3/16 × 35 7/8" (61.4 × 91.1 cm)

Gift of Mrs. William Thomas
Tonner
1960-57-1

Duchamp, Marcel
Portrait of Marcel Lefrançois
1904
On reverse: 1904 / J'ATTESTE
QUE CETTE TOILE EST BIEN
DE / MON FRÈRE MARCEL
DUCHAMP / Jacques Villon / 29
Dec. 1949; Portrait de Marcel /
Lefrançois / Marcel Duchamp /
1904 / Signé en 1950
Oil on canvas
25 5/8 × 23 15/16" (65.1 × 60.8 cm)

The Louise and Walter Arensberg
Collection
1950-134-80

du Bois, Guy Pène
American, 1884–1958
Cabaret
1915
Lower right: Guy Pène du Bois.
Oil on panel
20 × 14 3/4" (50.8 × 37.5 cm)

The Chester Dale Collection
1946-50-3

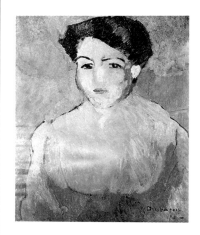

Duchamp, Marcel
Brunette in a Green Blouse (Portrait of Nana)
1910
Lower right: Duchamp / 10
Oil on canvas
24 1/4 × 19 15/16" (61.6 × 50.6 cm)

The Louise and Walter Arensberg
Collection
1950-134-48

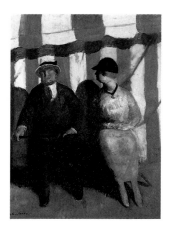

du Bois, Guy Pène
Sporting Life
1915
Lower left: Guy Pène du Bois.
1915.
Oil on panel
20 × 15" (50.8 × 38.1 cm)

The Chester Dale Collection
1946-50-2

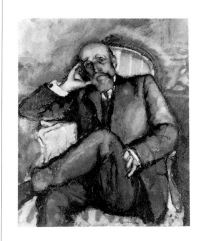

Duchamp, Marcel
Portrait of the Artist's Father
1910
Center bottom: Marcel Duchamp
10
Oil on canvas
36 3/8 × 28 7/8" (92.4 × 73.3 cm)

The Louise and Walter Arensberg
Collection
1950-134-49

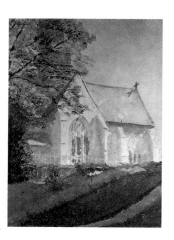

Duchamp, Marcel
American, born France,
1887–1968
Church at Blainville
1902
Lower right: M Duchamp / 02
Oil on canvas
24 1/8 × 16 7/8" (61.3 × 42.9 cm)

The Louise and Walter Arensberg
Collection
1950-134-81

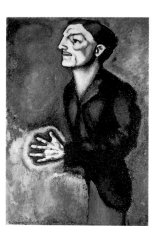

Duchamp, Marcel
Portrait of Dr. Dumouchel
1910
Lower left: Duchamp / 10; on
reverse: à propos de ta "figure" /
mon cher Dumouchel / Bien
cordialement / Duchamp.
Oil on canvas
39 1/2 × 25 7/8" (100.3 × 65.7 cm)

The Louise and Walter Arensberg
Collection
1950-134-508

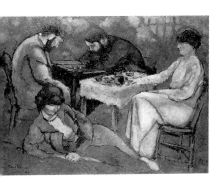

Duchamp, Marcel
The Chess Game
1910
Lower left: Duchamp / 10—
Oil on canvas
44 7/8 × 57 11/16" (114 × 146.5 cm)

The Louise and Walter Arensberg
Collection
1950-134-82

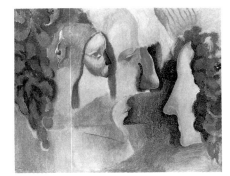

Duchamp, Marcel
*Yvonne and Magdeleine Torn in
Tatters*
1911
Lower left: Dchp / Sept. 11;
on reverse: Marcel Duchamp /
Yvonne et Magdeleine /
déchiquetées 1911
Oil on canvas
23 3/4 × 28 7/8" (60.3 × 73.3 cm)

The Louise and Walter Arensberg
Collection
1950-134-53

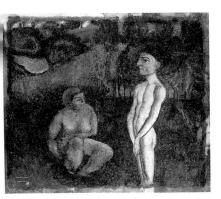

Duchamp, Marcel
Paradise (Adam and Eve)
Painted on reverse of *The King
and Queen Surrounded by Swift
Nudes*
1910–11
Lower left [added later by the
artist]: MARCEL DUCHAMP /
(PAINTED 1910).
Oil on canvas
45 1/8 × 50 3/4" (114.6 × 128.9 cm)

The Louise and Walter Arensberg
Collection
1950-134-63b

Duchamp, Marcel
Sonata
1911
Lower left: MARCEL DUCHAMP /
11; on reverse: Sonate / MARCEL
DUCHAMP / 11
Oil on canvas
57 1/8 × 44 5/8" (145.1 × 113.3 cm)

The Louise and Walter Arensberg
Collection
1950-134-52

Duchamp, Marcel
The Bush
1910–11
Lower right: MARCEL
DUCHAMP / 11
Oil on canvas
50 1/8 × 36 3/16" (127.3 × 91.9 cm)

The Louise and Walter Arensberg
Collection
1950-134-51

Duchamp, Marcel
Portrait (Dulcinea)
1911
Lower left: MARCEL DUCHAMP /
11; on reverse: Duchamp Marcel /
Portrait
Oil on canvas
57 5/8 × 44 7/8" (146.4 × 114 cm)

The Louise and Walter Arensberg
Collection
1950-134-54

Duchamp, Marcel
Baptism
1911
Lower right: MARCEL
DUCHAMP / 11; on reverse,
covered by relining: Au cher
Tribout Carabin / j'offre ce
"Baptême": M.D.
Oil on canvas
36 × 25 5/8" (91.5 × 72.7 cm)

The Louise and Walter Arensberg
Collection
1950-134-50

Duchamp, Marcel
Portrait of Chess Players
1911
Lower left: MARCEL DUCHAMP /
11; on reverse: Marcel Duchamp /
Portrait de joueurs d'échecs
Oil on canvas
39 5/8 × 39 9/16" (100.6 × 100.5 cm)

The Louise and Walter Arensberg
Collection
1950-134-56

Duchamp, Marcel
Nude Descending a Staircase (No. 1)
1911
Lower left: MARCEL DUCHAMP /
11 / NU DESCENDANT UN
ESCALIER
Oil on cardboard on panel
37 3/4 × 23 3/4" (95.9 × 60.3 cm)

The Louise and Walter Arensberg
Collection
1950-134-58

Duchamp, Marcel
Chocolate Grinder (No. 1)
1913
Upper right, on leather strip:
BROYEUSE DE CHOCOLAT—
1913; on reverse: Broyeuse de
Chocolat 1913 / appartenant à
Marcel Duchamp
Oil on canvas
24 3/8 × 25 3/8" (61.9 × 64.4 cm)

The Louise and Walter Arensberg
Collection
1950-134-69

Duchamp, Marcel
Nude Descending a Staircase (No. 2)
1912
Center bottom: MARCEL
DUCHAMP 12; lower left: NU
DESCENDANT UN ESCALIER; on
reverse: Marcel Duchamp 12
Oil on canvas
57 7/8 × 35 1/8" (147 × 89.2 cm)

The Louise and Walter Arensberg
Collection
1950-134-59

Duchamp, Marcel
*Glider Containing a Water Mill in
Neighboring Metals*
1913–15
On reverse: GLISSIERE /
contenant / un MOULIN à Eau /
(en métaux voisins) / appartenant
à / Marcel Duchamp / —1913–
14–15—
Oil and lead wire on glass
59 3/8 × 32 15/16" (150.8 × 83.7 cm)

The Louise and Walter Arensberg
Collection
1950-134-68

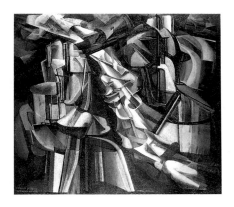

Duchamp, Marcel
*The King and Queen Surrounded by
Swift Nudes*
Painted on reverse of *Paradise
(Adam and Eve)*
1912
Lower left: LE ROI ET LA REINE
/ ENTOURES DE NUS VITES;
center bottom: MARCEL
DUCHAMP 12
Oil on canvas
45 1/8 × 50 3/4" (114.6 × 128.9 cm)

The Louise and Walter Arensberg
Collection
1950-134-63a

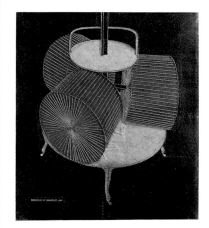

Duchamp, Marcel
Chocolate Grinder (No. 2)
1914
Lower left, on leather strip:
BROYEUSE DE CHOCOLAT—1914
Oil, graphite, and thread on
canvas
25 3/4 × 21 3/8" (65.4 × 54.3 cm)

The Louise and Walter Arensberg
Collection
1950-134-70

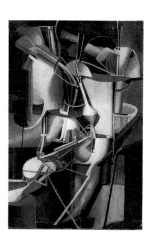

Duchamp, Marcel
Bride
1912
Lower left: MARIÉE MARCEL
DUCHAMP / august 12
Oil on canvas
35 1/4 × 21 7/8" (89.5 × 55.6 cm)

The Louise and Walter Arensberg
Collection
1950-134-65

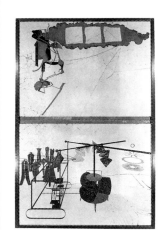

Duchamp, Marcel
*The Bride Stripped Bare by Her
Bachelors, Even (The Large Glass)*
1915–23
On reverse: LA MARIEE MISE A
NU PAR / SES CELIBATAIRES,
MEME / MARCEL DUCHAMP /
1915–1923 / —inachevé /
—cassé 1931 / —réparé 1936
Oil, varnish, lead foil, lead wire,
and dust on two glass panels
109 1/4 × 69 1/4" (277.5 × 175.9 cm)

Bequest of Katherine S. Dreier
1952-98-1

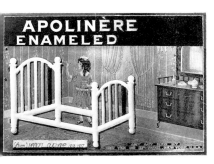

Duchamp, Marcel
Apolinère Enameled
1916–17
Across top: APOLINÈRE /
ENAMELED; lower left: [from]
MARCEL DUCHAMP 1916 1917;
lower right: ANY ACT RED BY /
HER TEN OR EPERGNE, NEW
YORK, U.S.A.
Graphite on cardboard and
painted tin (Readymade)
9 5/8 × 13 3/8" (24.4 × 34 cm)

The Louise and Walter Arensberg
Collection
1950-134-73

**Dunoyer de Segonzac,
André**
French, 1884–1974
On the Table
c. 1926
Upper left: A D de Segonzac
Oil on canvas
13 1/4 × 31 1/2" (33.6 × 80 cm)

Bequest of Lisa Norris Elkins
1950-92-16

**Duchamp-Villon, Raymond
(Pierre-Maurice-Raymond
Duchamp)**
French, 1876–1918
Untitled (Three Figures Dancing)
1913
Center bottom: Rduchamp
Oil on canvas
23 5/8 × 32" (60 × 81.3 cm)

Purchased with the Edward and
Althea Budd Fund
1984-22-1

Dupree, James
American, born 1950
Theme 5, Part 1
1976–77
On reverse: James Dupree 76/77
Acrylic on canvas
72 5/8 × 36 3/4" (184.5 × 93.3 cm)

Gift of the Friends of the Junior
League of Philadelphia
1979-97-1

Dudreville, Leonardo
Italian, 1885–1975
Daily Domestic Arguments
1913
Lower right: L. DUDREVILLE
1913
Oil on canvas
90 3/4 × 98 7/8" (230.5 × 251.1 cm)

Gift of Mr. and Mrs. N. Richard
Miller
1969-265-1

Edlich, Stephen
American, born 1944
*Untitled (German Academic
Exchange Service)*
1977
On reverse: Edlich. "Deutscher
Akademicher Austauschdienst"
84 × 60", 1977. Mixed media:
acrylic polymer, / paper and jute
on primed canvas. LES MARTINS
PAR GORDES
Charcoal, acrylic polymer, paper,
and jute on canvas
84 1/4 × 60 3/16 (214 × 152.9 cm)

Gift of Mr. and Mrs. David N.
Pincus
1980-147-1

Dufy, Raoul
French, 1877–1953
*Window on the Promenade des
Anglais, Nice*
1938
Lower left: Raoul Dufy / Nice
1938
Oil on canvas
18 1/8 × 15 1/16" (46 × 38.3 cm)

The Samuel S. White 3rd and
Vera White Collection
1967-30-36

Egnal, Stuart
American, 1940–1966
Roof Tops
1962
On reverse: Stuart Egnal 1962
#29
Oil on canvas
18 × 16 1/8" (45.7 × 41 cm)

Gift of Mr. and Mrs. Michael H.
Egnal in memory of their son,
Stuart Egnal
1967-193-2

Egnal, Stuart
Still Life
1966
Oil on canvas
38 1/16 × 28 3/16" (96.7 × 71.6 cm)

Gift of Mr. and Mrs. Michael H. Egnal in memory of their son, Stuart Egnal
1967-193-1

Eilshemius, Louis Michel
Landscape
1917
Lower left: Eilshemius—1917—
Oil on Masonite
11 5/8 × 22 3/8" (29.5 × 56.8 cm)

The Louise and Walter Arensberg Collection
1950-134-510

Eilshemius, Louis Michel
American, 1864–1941
Early American Story
1908
Lower left: Elshemus. / 1908; on reverse: He called it / "Early American Story" / This painting I bought from Eilshemius / in 1935 J Zirinsky
Oil on canvas
27 13/16 × 38 3/4" (70.6 × 98.4 cm)

Gift of James N. Rosenberg in memory of Felix M. Warburg
1944-96-1

Eilshemius, Louis Michel
Bather in an Architectural Landscape
1919
Lower left: Eilshemius—; lower right: 1919—
Oil on cardboard
12 1/4 × 22" (31.1 × 55.9 cm)

Gift of Frank and Alice Osborn
1966-68-14

Eilshemius, Louis Michel
Vaudeville
1909
Lower right: 1909 Elshemus
Oil on Masonite
19 1/8 × 25 11/16" (48.6 × 65.2 cm)

Gift of Mr. and Mrs. Henry Clifford
1973-256-4

Eilshemius, Louis Michel
Bather in a Wooded Landscape
1919
Lower left: 1919—; lower right: Eilshemius—
Oil on cardboard
14 1/8 × 22 1/4" (35.9 × 56.5 cm)

Gift of Frank and Alice Osborn
1966-68-13

Eilshemius, Louis Michel
Jealousy
c. 1915
Lower left: Eilshemius.
Oil on cardboard
21 7/8 × 30" (55.6 × 76.2 cm)

Gift of Mr. and Mrs. Henry Clifford
1973-256-5

Eisenstat, Ben
American, born 1915
Late Afternoon
c. 1965
Lower right: Eisenstat
Oil and casein on cardboard
15 × 19 7/8" (38.1 × 50.5 cm)

Gift of Mr. and Mrs. Paul M. Ingersoll
1967-158-1

Emerson, Edith
American, 1888–1981
Portrait of Violet Oakley
1919
Lower right: Edith Emerson /
1919
Oil on canvas
30 1/16 × 20" (76.4 × 50.8 cm)

Bequest of Edith Emerson
1984-66-1

Emerson, Edith
Traveling Altarpiece
Triptych
1942
Left wing, upper left: MOSES; left
wing, bottom: HEAR O ISRAEL
THE LORD OUR GOD IS ONE
LORD; center panel, top: THIS IS
MY BELOVED SON IN WHOM I
AM WELL PLEASED HEAR YE
HIM; center panel, bottom: ARISE
/ BE NOT AFRAID; right wing,
upper right: ELIAS; right wing,
bottom: THE WORD OF THE
LORD IN THY MOUTH IS TRUTH;
left wing, on reverse: the
Citizen's Committee / for the
Army & Navy
Oil on panel
Center panel: 47 7/8 × 47 15/16"
(121.6 × 121.8 cm); wings [each]:
47 7/8 × 23 7/8" (121.6 × 60.6 cm)

Gift of Joseph Flom and Martin
Horwitz
1975-180-2

Emerson, Edith
Traveling Altarpiece
Triptych
1945
Across top: AS CAPTAIN OF THE
HOST OF THE LORD AM I NOW
COME; right wing, upper right:
JOSHUA 5:14; right wing, lower
right: Edith Emerson 1945; left
wing, on reverse: PRESENTED TO
THE / U.S.S. YORKTOWN; right
wing, on reverse: THE /
CITIZEN'S COMMITTEE / FOR
THE / ARMY AND NAVY /
INCORPORATED / NEW YORK
Oil on metal

Center panel: 36 × 36"
(91.4 × 91.4 cm); wings [each]:
36 × 17 15/16" (91.4 × 45.6 cm)

Gift of Joseph Flom and Martin
Horwitz
1976-245-1

Ensor, James
Belgian, 1860–1949
Self-Portrait with Masks
1937
Center bottom: ENSOR
Oil on canvas
12 1/4 × 9 5/8" (31.1 × 24.4 cm)

The Louis E. Stern Collection
1963-181-26

Erlebacher, Martha Mayer
American, born 1937
Self-Portrait
1975
Lower left: M.M.E.; lower right:
1975
Oil on Masonite
23 7/8 × 23 7/8" (60.6 × 60.6 cm)

Purchased with funds contributed
by Henry Strater
1981-93-1

Ernst, Max
American, born Germany,
1891–1976
The Forest
1923
Lower right: max ernst
Oil on canvas
28 3/4 × 19 13/16" (73 × 50.3 cm)

The Louise and Walter Arensberg
Collection
1950-134-85

Ernst, Max
Seashell
1928
Lower right: max ernst
Oil on canvas
25 1/2 × 21 1/4" (64.8 × 54 cm)

The Louise and Walter Arensberg
Collection
1950-134-86

Etting, Emlen
American, 1905–1993
Portrait of Andrew Dasburg
1939
Lower right: Etting
Oil on canvas
21 5/8 × 18 1/8" (54.9 × 46 cm)

Centennial gift of Mrs. Herbert
Cameron Morris
1977-27-1

Ernst, Max
Garden Plane Trap
1934–35
Lower right: Max Ernst 34–35
Oil on canvas
23 7/8 × 28 7/8" (60.6 × 73.3 cm)

The Louise and Walter Arensberg
Collection
1950-134-87

Etting, Emlen
Reverie
1939
Lower right: Etting
Oil on canvas
23 × 19" (58.4 × 48.3 cm)

The Henry P. McIlhenny
Collection in memory of
Frances P. McIlhenny
1986-26-402

Esherick, Wharton
American, 1887–1970
Moonlight
1921
Lower right: Wharton Esherick
1921
Oil on canvas
24 1/16 × 8 1/8" (61.1 × 20.6 cm)

Purchased with the Director's
Discretionary Fund
1968-226-1

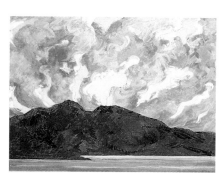

Etting, Emlen
*View from Glenveagh (Mount
Dooish)*
1958
Lower right: Etting
Oil on canvas
22 × 28" (55.9 × 71.1 cm)

Centennial gift of Mrs. Herbert
Cameron Morris
1977-27-2

Estock, Stephen
American, born 1942
Babylon
1978
On reverse: S. Estock Babylon
1978
Acrylic on canvas
84 × 65" (213.4 × 165.1 cm)

Gift of the Cheltenham Art
Centre
1978-58-1

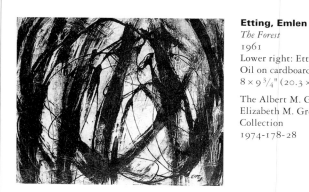

Etting, Emlen
The Forest
1961
Lower right: Etting
Oil on cardboard on plywood
8 × 9 3/4" (20.3 × 24.8 cm)

The Albert M. Greenfield and
Elizabeth M. Greenfield
Collection
1974-178-28

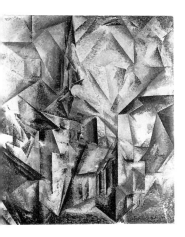

Feininger, Lyonel
American, active Germany,
1871–1956
Umpferstedt II
1914
Upper left: Feininger; on reverse:
Kiste L. F. VIII Umpferstedt II
1914
Oil on canvas
39 5/8 × 31 5/8" (100.6 × 80.3 cm)

The Louise and Walter Arensberg
Collection
1950-134-88

Feininger, Lyonel
Bridge V
1919
Lower right: Feininger / 1919;
on reverse: Brucke V 1919
Oil on canvas
31 5/8 × 39 1/2" (80.3 × 100.3 cm)

Purchased with the Bloomfield
Moore Fund
1951-31-2

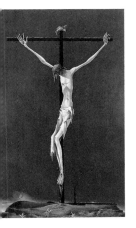

Ferguson, William H.
American, born 1905
Agnus Dei
1934
Lower right: W. H. FERGUSON
Oil on panel
53 9/16 × 31" (136 × 78.7 cm)

Gift of Henry Clifford
1943-42-1

Ferguson, William H.
Pietà
1934
Lower left: Wm H Ferguson
Oil on panel
11 × 27 15/16" (27.9 × 71 cm)

Gift of Henry Clifford
1943-42-2

Ferrandier, Gisele
French, born 1909
Flowers in a Vase
c. 1945
Lower left: G. Ferrandier
Oil on panel
24 × 18 1/8" (61 × 46 cm)

The Albert M. Greenfield and
Elizabeth M. Greenfield
Collection
1974-178-29

Ferris, John
American, born 1952
Vase with Black Figures
1984
Lower left: 1984; lower right:
JOHN FERRIS
Oil on linen
54 1/16 × 30 1/8" (137.3 × 76.5 cm)

Purchased with the Julius Bloch
Memorial Fund and with funds
contributed in memory of
Maurice J. Hammond
1984-119-1

Ferszt, Ed
American, born 1947
Inset No. 1
1974
On reverse: ED FERSZT / INSET
#1 1974
Acrylic on canvas
54 × 54" (137.2 × 137.2 cm)

Gift of the Cheltenham Art
Centre
1975-54-1

Finkelstein, Louis
American, born 1923
Variations on a Provençal Theme
c. 1959
Lower right: Louis
Oil on canvas
70 × 49 3/8" (177.8 × 125.4 cm)

Purchased with the Adele Haas
Turner and Beatrice Pastorius
Turner Memorial Fund
1959-12-4

Foppiani, Gustavo
Italian, born 1925
Ancient City No. 4
1954
Oil on panel
5 ⁵/₈ × 15 ⁵/₈" (14.3 × 39.7 cm)

Gift of Mr. and Mrs. N. Richard
Miller
1978-151-1

Francés, Esteban
Mexican, 1914–1976
Cock on Block
1944
Lower right: Esteban Francés /
1944
Oil on canvas
21 ³/₄ × 17 ⁷/₈" (55.2 × 45.4 cm)

Gift of Mr. and Mrs. Henry
Clifford
1973-256-8

Foppiani, Gustavo
Cafeteria
1954
Lower right: FOPPIANI
Oil on panel
5 ⁹/₁₆ × 15 ¹/₄" (14.1 × 38.7 cm)

Gift of Mr. and Mrs. N. Richard
Miller
1978-151-2

Frankenthaler, Helen
American, born 1928
White Sage
1962
Lower right: Frankenthaler '62;
on reverse: "WHITE SAGE"—
top—frankenthaler '62
Oil on canvas
54 × 70 ⁷/₈" (137.2 × 180 cm)

Centennial gift of the Woodward
Foundation
1975-81-4

Formicola, John
American, born 1941
Meditative Series
1973
On reverse: Formicola / —73—
Oil on canvas
72 × 60" (182.9 × 152.4 cm)

Gift of Benjamin D. Bernstein
1973-70-1

**Frelinghuysen, Suzy (Estelle
Condit Frelinghuysen)**
American, 1912–1988
Composition (Toreador Drinking)
See following painting for reverse
1940
Oil and paper on composition
board
39 ¹/₂ × 31 ³/₈" (100.3 × 79.7 cm)

A. E. Gallatin Collection
1952-61-26a

Foss, Olivier
French, 1920–1957?
Street Scene
c. 1955
Upper right: O FOSS
Oil on canvas
19 ¹/₂ × 23 ³/₄" (49.5 × 60.3 cm)

The Albert M. Greenfield and
Elizabeth M. Greenfield
Collection
1974-178-30

Frelinghuysen, Suzy
Composition
Reverse of the preceding painting
1940
Lower right: S. F. 1940
Oil and sand on composition
board
39 ¹/₂ × 31 ³/₈" (100.3 × 79.7 cm)

A. E. Gallatin Collection
1952-61-26b

Frelinghuysen, Suzy
Dubonnet
1942
Lower right: S.F.
Oil, gouache, ink, and paper on panel
15 × 9 ½" (38.1 × 24.1 cm)

The Samuel S. White 3rd and Vera White Collection
1960-23-3

Gallatin, Albert Eugene
Untitled No. 106
1949
On reverse: A. E. Gallatin / March 1949.
Oil on canvas
20 × 24" (50.8 × 61 cm)

Gift of Mrs. Virginia M. Zabriskie
1980-149-1

Frieseke, Frederick Carl
American, active France, 1874–1939
The Rose Peignoir
c. 1915
Lower left: F. C. Frieseke.
Oil on canvas
32 ¼ × 32" (81.9 × 81.3 cm)

The Alex Simpson, Jr., Collection
1943-74-1

Galván, Jesús Guerrero
American, 1910–1973
Nude Figure
1939
Lower left: GUERRERO Galván / 1939
Oil on canvas
31 ⅝ × 23 ¾" (80.3 × 60.3 cm)

Gift of Daniel Goldberg
1945-37-1

Gallatin, Albert Eugene
American, 1881–1952
Composition
1942
On reverse: A. E. Gallatin / January / 1942
Oil on canvas
59 ⅞ × 25" (152.1 × 63.5 cm)

A. E. Gallatin Collection
1952-61-29

Garber, Daniel
American, 1880–1958
Quarry, Evening
1913
Lower right: DANIEL GARBER
Oil on canvas
50 × 60" (127 × 152.4 cm)

Purchased with the W. P. Wilstach Fund
W1921-1-3

Gallatin, Albert Eugene
Painting
1944
On reverse: A. E. Gallatin Jan'y 1944
Oil on canvas
37 × 50" (94 × 127 cm)

A. E. Gallatin Collection
1952-61-28

Garber, Daniel
Quarry, Lumberton
1918
Lower left: DANIEL GARBER
Oil on canvas
29 ½ × 24" (74.9 × 61 cm)

Gift of Mr. and Mrs. J. Stogdell Stokes
1940-18-1

Garber, Daniel
The Orchard Window
1918
Center bottom: DANIEL GARBER
Oil on canvas
56 7/16 × 52 1/4" (143.3 × 132.7 cm)

Centennial gift of the family of
Daniel Garber
1976-216-1

Gatch, Lee
American, 1909–1968
Crow Country
1953
Lower right: GATCH
Oil on canvas on panel
5 5/16 × 32" (13.5 × 81.3 cm)

The Louis E. Stern Collection
1963-181-29

Garber, Daniel
Morning Light, Interior
1923
Lower right: Daniel Garber
Oil on canvas
30 1/16 × 25 1/8" (76.4 × 63.8 cm)

The Sallie Crozer Hilprecht
Collection, gift of her
granddaughter, Elsie
Robinson Paumgarten
1945-57-191

Gatch, Lee
Lambertville Pietà
1958
Lower right: GATCH
Oil on canvas
34 1/4 × 50 3/16" (87 × 127.5 cm)

Gift of Mr. and Mrs. William P.
Wood
1980-148-1

Garber, Daniel
Landscape
c. 1925
Lower left: Daniel Garber
Oil on canvas
28 1/4 × 30 1/4" (71.7 × 76.8 cm)

Gift of Mrs. Mary B. Mucci
1973-201-1

Gaughan, Tom
American, born 1923
Structure
1973
On reverse: Gaughan '73
Acrylic on canvas
72 × 50 1/8" (182.9 × 127.3 cm)

Gift of the friends of Tom
Gaughan
1975-53-1

Garber, Daniel
The Glen—Winter
1926
Lower left: Daniel Garber; on
reverse: "The Glen—Winter" by
Daniel Garber
Oil on canvas
20 1/4 × 18 1/4" (51.4 × 46.3 cm)

The Sallie Crozer Hilprecht
Collection, gift of her
granddaughter, Elsie
Robinson Paumgarten
1945-57-196

Gest, Margaret
American, 1900–1965
Torch Bouquet
c. 1955
Oil on canvas
36 1/8 × 25 3/4" (91.8 × 65.4 cm)

Gift of Miss Miriam H. Thrall
1966-221-1

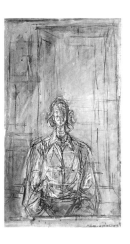

Giacometti, Alberto
Swiss, 1901–1966
Annette in a Red Blouse
1954
Lower right: Alberto Giacometti
Oil on canvas
22 1/2 × 12 1/2" (57.1 × 31.7 cm)

The Albert M. Greenfield and
Elizabeth M. Greenfield
Collection
1974-178-31

Glarner, Fritz
Relational Painting No. 75
1955
Center bottom: GLARNER. 1955
Oil on canvas
56 × 42" (142.2 × 106.7 cm)

Centennial gift of Mrs. Henry
Clifford
1975-79-1

Glackens, William
American, 1870–1938
Skating Rink, New York City
c. 1906
Oil on canvas
26 × 33" (66 × 83.8 cm)

Gift of Mr. and Mrs. Meyer P.
Potamkin (reserving life interest)
1964-116-7

Gleizes, Albert
French, 1881–1953
*Man on a Balcony (Portrait of Dr.
Morinaud)*
1912
Lower left: Albert Gleizes / 12
Oil on canvas
77 × 45 1/4" (195.6 × 114.9 cm)

The Louise and Walter Arensberg
Collection
1950-134-91

Glarner, Fritz
American, born Switzerland,
1899–1972
Tondo No. 6
1948
Lower right: F. GLARNER 48
Oil on Masonite
51 1/2" (130.8 cm) diameter

Gift of Mr. and Mrs. Henry
Clifford
1973-256-1

Gleizes, Albert
Woman at the Piano
1914
Lower right: Albert Gleizes / 14
Oil on canvas
57 5/8 × 44 3/4" (146.4 × 113.7 cm)

The Louise and Walter Arensberg
Collection
1950-134-93

Glarner, Fritz
Tondo No. 8
1948
Lower right: F. GLARNER 48
Oil on composition board
17 1/2 × 17 3/8" (44.4 × 44.1 cm)

A. E. Gallatin Collection
1949-22-1

Goldberg, Michael
American, born 1924
Le Grotte Vecchie VII
1981
On reverse: GOLDBERG '81 / LE
GROTTE VECCHIE VII
Bronze powders, clear alkyd,
pastel, and Liquitex mat medium
on canvas
83 7/8 × 75" (213 × 190.5 cm)

Gift of the artist and gift (by
exchange) of Ronald Stark
1982-3-1

Goldthwaite, Anne Wilson
American, 1869–1944
Magnolia and Passion Flowers
c. 1938
Lower left: ANNE GOLDTHWAITE
Oil on canvas
24 × 20" (61 × 50.8 cm)

Gift of the estate of Anne
Goldthwaite
1945-83-2

Gorchov, Ron
American, born 1930
Stele
1959
Upper left: Gorchov 1959
Oil on panel
13 5/8 × 8 5/8" (34.6 × 21.9 cm)

Gift of the Kulicke family in
memory of Lt. Frederick W.
Kulicke III
1969-86-5

Goodman, Sidney
American, born 1936
Swimming Pool
1961
Lower left: GOODMAN 61
Oil on canvas
50 × 74" (127 × 188 cm)

Centennial gift of Mr. and Mrs.
David N. Pincus
1976-246-1

Gordey, Ida
French, born 1916
Portrait of Marc Chagall
1944
Lower left: For L. Stern / my
papa. / Ida Gordey / 1944
Oil and charcoal on canvas board
24 3/16 × 18 1/8" (61.4 × 46 cm)

The Louis E. Stern Collection
1963-181-30

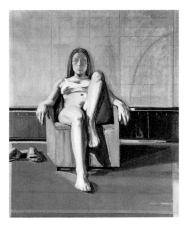

Goodman, Sidney
Seated Woman
1965
On reverse: GOODMAN 65
"SEATED WOMAN"
Oil on canvas
43 5/8 × 34 5/8" (110.8 × 87.9 cm)

Gift of the American Academy
and Institute of Arts and Letters,
and the Hassam and Speicher
Purchase Funds
1980-56-1

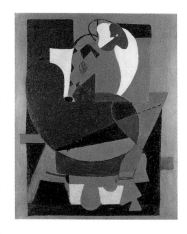

Gorky, Arshile
American, born Armenia,
1904–1948
Abstraction with a Palette
c. 1930
Oil on canvas
48 × 35 15/16" (121.9 × 91.3 cm)

Gift of Bernard Davis
1942-64-3

Goodman, Sidney
Figures in a Landscape
1972–73
Lower left: GOODMAN—/72–73
Oil on canvas
55 × 96" (139.7 × 243.8 cm)

Purchased with the Philadelphia
Foundation Fund (by exchange)
and the Adele Haas Turner and
Beatrice Pastorius Turner
Memorial Fund
1974-112-1

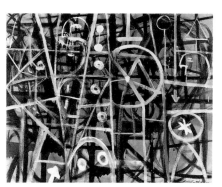

Gottlieb, Adolph
American, 1903–1974
The Cadmium Sound
1954
Lower right: Adolph Gottlieb 54
Oil on canvas
60 1/16 × 72 1/4" (152.6 × 183.5 cm)

Purchased with the Edward and
Althea Budd Fund
1980-60-1

**Graham, John D.
(Ivan Dabrowsky)**
American, born Ukraine,
1891–1961
Study for "Ikon of the Modern Age"
1930
Upper left: GRAHAM / 30; on
reverse: To Dr Brinton / with
my / regards / Graham.
Oil on canvas
24 1/8 × 15" (61.3 × 38.1 cm)

Gift of Christian Brinton
1941-79-66

Graves, Morris Cole
American, born 1910
Fox with a Phoenix Wing
1952
Lower right: Graves '52
Oil on canvas on Masonite
32 × 48" (81.3 × 121.9 cm)

Purchased with the Adele Haas
Turner and Beatrice Pastorius
Turner Memorial Fund
1956-11-1

Graziani, Sante
American, born 1920
A Play in Three Acts Titled Motion
1965
Acrylic on canvas
48 × 48" (121.9 × 121.9 cm)

Gift of an anonymous donor
1968-224-1

Grigoriev, Boris Dmitryevich
Russian, 1886–1939
*Portrait of the Peasant Poet Nikolai
Alexeyevich Kluyev*
1918
Lower left: Boris Grigoriev
Oil, gouache, and ink on
composition board
24 × 20" (61 × 50.8 cm)

Gift of Christian Brinton
1941-79-120

Grigoriev, Boris Dmitryevich
Woman of the Fields
1920
Lower left: Boris Grigorieff 1920
Oil on cardboard
20 × 24" (50.8 × 61 cm)

Gift of Christian Brinton
1941-79-29

Grigoriev, Boris Dmitryevich
Peasant Family before an Isba
c. 1920
Upper right: Boris Grigoriev
Tempera on cardboard
37 × 25" (94 × 63.5 cm)

Gift of Christian Brinton
1941-79-99

Grigoriev, Boris Dmitryevich
End of the Harvest
1921
Lower right: Boris Grigorieff / 21.
Tempera and oil on canvas
28 3/4 × 36 1/4" (73 × 92.1 cm)

Gift of Christian Brinton
1941-79-150

Grigoriev, Boris Dmitryevich
End of the Harvest (Faces of Russia)
1923
Lower right: Boris Grigorieff 23
Tempera and oil on canvas on
cardboard
28 5/8 × 36" (72.7 × 91.9 cm)

Gift of Christian Brinton
1941-79-68

Grigoriev, Boris Dmitryevich
White Nights, Petrograd
c. 1923
On reverse: Boris Grigoryev
Oil on composition board
33 3/8 × 29 3/8" (84.8 × 74.6 cm)

Gift of Christian Brinton
1941-79-147

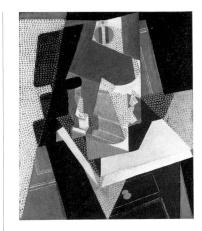

Gris, Juan
Lamp
1916
On reverse: Juan Gris / 3-16 / 4e
Oil on canvas
31 7/8 × 25 1/2" (81 × 64.8 cm)

The Louise and Walter Arensberg
Collection
1950-134-96

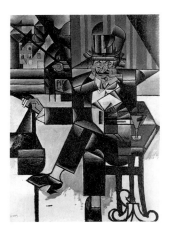

**Gris, Juan (José Victoriano
González Pérez)**
Spanish, 1887–1927
Man in a Café
1912
Lower left: Juan Gris
Oil on canvas
50 1/4 × 34 3/4" (127.6 × 88.3 cm)

The Louise and Walter Arensberg
Collection
1950-134-94

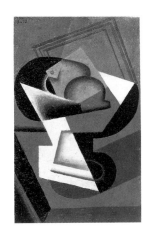

Gris, Juan
Dish of Fruit
1916
Upper left: Juan Gris / 11-16
Oil on panel
16 × 9 1/2" (40.6 × 24.1 cm)

A. E. Gallatin Collection
1952-61-36

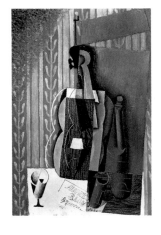

Gris, Juan
Violin
Pencil sketch on reverse
1913
On reverse: Juan Gris 7-13
Oil on canvas
36 1/4 × 23 5/8" (92.1 × 60 cm)

A. E. Gallatin Collection
1952-61-34

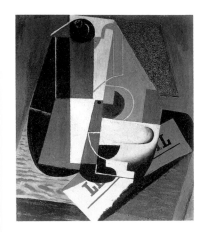

Gris, Juan
Coffeepot
1916
Upper left: juan gris / 12-1916
Oil on panel
18 1/2 × 15 3/8" (47 × 39 cm)

A. E. Gallatin Collection
1952-61-35

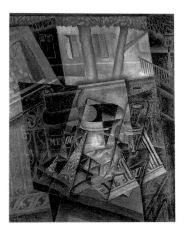

Gris, Juan
*Still Life before an Open Window,
Place Ravignan*
1915
Lower left: Juan Gris / 6-1915;
center: MEDOC / LE JOURNAL
Oil on canvas
45 5/8 × 35" (115.9 × 88.9 cm)

The Louise and Walter Arensberg
Collection
1950-134-95

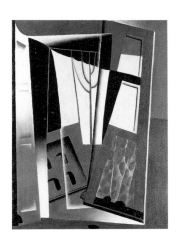

Gris, Juan
Open Window
1917
Lower right: Juan Gris / 3-1917
Oil, mixed media, and wax on
panel
39 9/16 × 28 13/16" (100.5 ×
73.2 cm)

The Louise and Walter Arensberg
Collection
1950-134-97

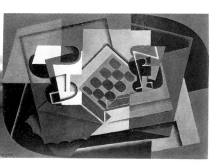

Gris, Juan
Chessboard, Glass, and Dish
1917
Lower left: Juan Gris / 6-17
Oil on panel
28 ⅞ × 40 ⅝" (73.3 × 103.2 cm)

The Louise and Walter Arensberg
Collection
1950-134-98

Gris, Juan
A Bottle and Fruit
1923
Lower left: Juan Gris 23
Oil on canvas
13 × 9 ½" (33 × 24.1 cm)

A. E. Gallatin Collection
1952-61-40

Gris, Juan
Still Life with a Glass
See following painting for reverse
1917
Lower left: Juan Gris / Paris
9-1917
Oil on panel
13 × 7 ½" (33 × 19 cm)

A. E. Gallatin Collection
1952-61-38a

Gris, Juan
Knife
1926
Lower right: Juan Gris 26
Oil on canvas
10 ¾ × 13 ¾" (27.3 × 34.9 cm)

A. E. Gallatin Collection
1952-61-41

Gris, Juan
Untitled
Reverse of the preceding painting
1917
Oil on panel
13 × 7 ½" (33 × 19 cm)

A. E. Gallatin Collection
1952-61-38b

Gromaire, Marcel
French, 1892–1971
Still Life
1920
Lower right: 20 / Gromaire
Oil on canvas
21 ½ × 18 ⅛" (54.6 × 46 cm)

Bequest of Fiske and Marie
Kimball
1955-86-18

Gris, Juan
*A Dish of Grapes and a Pipe on a
Table*
1918
Upper left: Juan Gris / 5-18
Oil on panel
14 ⅛ × 10 ⅞" (35.9 × 27.6 cm)

A. E. Gallatin Collection
1952-61-39

Grow, Allan
American, born 1940
Junkyard
1983
Lower left: Allan Grow
Acrylic on canvas
44 ⅞ × 33 ⅞" (114 × 86 cm)

Purchased with the Julius Bloch
Memorial Fund
1984-80-1

Guillaume, Albert
French, 1873–1942
Portrait of Auguste Rodin
c. 1915
Lower left: APGuillaume
Oil on canvas
31 1/8 × 28 1/4" (79.1 × 71.7 cm)

Gift of Jules E. Mastbaum
F1929-7-205

Gwathmey, Robert
American, 1903–1988
Singing and Mending
1948
Upper left: gwathmey
Oil on canvas
25 3/16 × 30 1/8" (64 × 76.5 cm)

Gift of Edna Beron
1984-159-1

Gwathmey, Robert
Sunup
c. 1955
Lower right: gwathmey
Oil on canvas
16 × 11" (40.6 × 27.9 cm)

The Louis E. Stern Collection
1963-181-31

Haeseler, Conrad F.
American, active c. 1917
Portrait of John G. Johnson
1917
Upper left: CONRAD / F.
HAESELER / 1917
Oil on panel
34 × 24" (86.4 × 61 cm)

Gift of Miss Julia W. Frick and
Sidney W. Frick
1971-36-1

Hamilton, John McLure
American, 1853–1936
Portrait of Joseph Pennell
c. 1910
Oil on canvas
30 × 42" (76.2 × 106.7 cm)

Gift of Gustavus Wynne Cook
1937-18-1

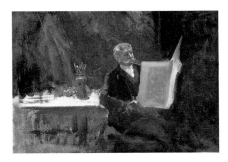

Hamilton, John McLure
Portrait of Charles E. Dana
c. 1915
Oil on canvas
18 × 24 1/4" (45.7 × 61.6 cm)

Gift of the Philadelphia
Watercolor Club
1941-99-19

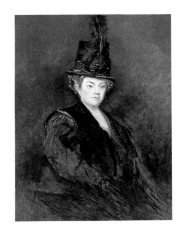

Hamilton, John McLure
Portrait of Mrs. Hamilton
c. 1915
Oil on canvas
40 × 30 1/16" (101.6 × 76.4 cm)

Gift of George Earle Raiguel
1938-14-1

Hankins, Abraham P.
American, born Belorussia,
1900–1963
Tribute to El Greco
c. 1940
Lower left: APH
Oil on cardboard
12 1/4 × 9 1/16" (31.1 × 23 cm)

Gift of Mrs. James Clark
1964-117-3

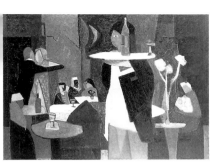

Hankins, Abraham P.
Nightclub
1942
Lower left: Hankins
Oil on panel
29 ¹⁵/₁₆ × 40 ³/₄" (76 × 103.5 cm)

Gift of Mrs. James Clark
1964-117-1

Hankins, Abraham P.
Private Aquarium
1959
Lower left: A Hankins
Oil on canvas
42 ¹/₁₆ × 42" (106.8 × 106.7 cm)

Gift of the students and friends
of Abraham P. Hankins
1964-32-1

Hankins, Abraham P.
Conshohocken
c. 1942
Lower right: A P Hankins; on
reverse: 1942 / Victory Show /
Metropolitan Museum / 1943.
Oil on panel
24 × 30" (61 × 76.2 cm)

Gift of Mrs. James Clark
1964-117-5

Hankins, Abraham P.
Aux Enfants
c. 1960
Center bottom: A.P.H.
Oil on canvas
22 ¹/₈ × 21 ³/₁₆" (56.2 × 53.8 cm)

Gift of the estate of Estelle
Hankins
1968-40-3

Hankins, Abraham P.
Anniversary
1949
Lower right: Hankins
Oil on canvas
27 ⁷/₈ × 36 ¹/₈" (70.8 × 91.8 cm)

Gift of Mrs. James Clark
1964-117-4

Hankins, Abraham P.
Squicker Cove. Monhegan. Maine
c. 1960
Oil on canvas
33 × 24 ¹/₈" (83.8 × 61.3 cm)

Gift of the estate of Estelle
Hankins
1968-40-1

Hankins, Abraham P.
Dancers
c. 1949
Center bottom: A. P. Hankins
Oil on cardboard
34 ⁵/₈ × 27" (87.9 × 68.6 cm)

Gift of Mrs. James Clark
1964-117-2

Hankins, Abraham P.
Flowers by the Window
c. 1960–63
Center top: APH; on reverse:
[date?]
Oil on canvas
29 × 29" (73.7 × 73.7 cm)

Gift of the estate of Estelle
Hankins
1968-40-2

Harding, George
American, 1882–1959
December
c. 1950–55
Lower left: GEORGE HARDING
Oil on canvas
50 1/2 × 40" (128.3 × 101.6 cm)

Gift of Mrs. John S. Kistler and
George M. Harding, Jr., in
memory of their father, George
Harding
1967-99-1

Hartley, Marsden
Painting No. 4 (A Black Horse)
1915
Oil on canvas
39 1/4 × 31 5/8" (99.7 × 80.3 cm)

The Alfred Stieglitz Collection
1949-18-8

Hartigan, Grace
American, born 1922
Essex and Hester
1958
Lower right: Hartigan '58
Oil on canvas
71 5/8 × 40 1/4" (181.9 × 102.2 cm)

Gift of Dr. and Mrs. Richard
Kaplan
1967-271-1

Hartley, Marsden
Movement No. 1 (Provincetown)
1916
Oil on panel
20 × 15 13/16" (50.8 × 40.2 cm)

The Alfred Stieglitz Collection
1949-18-9

Hartley, Marsden
American, 1877–1943
Maine Landscape No. 27
1909
Oil on cardboard
12 × 12" (30.5 × 30.5 cm)

The Alfred Stieglitz Collection
1949-18-6

Hartley, Marsden
Sextant
c. 1917
Lower right: Marsden Hartley.
Oil on panel
20 × 16" (50.8 × 40.6 cm)

Gift of Dr. Herman Lorber
1944-95-2

Hartley, Marsden
Winter Chaos (Blizzard)
1909–11?
Oil on canvas
33 15/16 × 34" (86.2 × 86.4 cm)

The Alfred Stieglitz Collection
1949-18-7

Hartley, Marsden
*Blessing the Melon (The Indians
Bring the Harvest to Christian Mary
for Her Blessing)*
c. 1918
On reverse: Blessing the Melon /
by Marsden Hartley / Blessing
the Melon / The indians bring
the harvest / To Christian Mary
for her / blessing
Oil on panel
32 3/8 × 23 7/8" (82.2 × 60.6 cm)

The Alfred Stieglitz Collection
1949-18-13

Hartley, Marsden
New Mexico Landscape
1919
Oil on canvas
17 7/8 × 26" (45.4 × 66 cm)

The Alfred Stieglitz Collection
1949-18-4

Hartley, Marsden
New Hampshire Mountains
c. 1928
Oil on Masonite
30 1/8 × 36 1/8" (76.5 × 91.8 cm)

Bequest of T. Edward Hanley
1970-76-4

Hartley, Marsden
New Mexico Landscape
1919
On reverse: Marsden Hartley
1919
Oil on canvas
30 × 36" (76.2 × 91.4 cm)

The Alfred Stieglitz Collection
1949-18-10

Hartley, Marsden
Landscape No. 35 (Beaver Lake, Lost River Region)
c. 1930
Oil on canvas
25 1/2 × 31 3/4" (64.8 × 80.6 cm)

The Alfred Stieglitz Collection
1949-18-5

Hartley, Marsden
Landscape No. 1 (Trees, France)
1919
Oil on panel
14 5/8 × 18 1/8" (37.1 × 46 cm)

The Alfred Stieglitz Collection
1949-18-11

Hartley, Marsden
Hurricane Island, Vinalhaven, Maine
1942
Center right: MH/42
Oil on Masonite
30 × 39 15/16" (76.2 × 101.4 cm)

Gift of Mrs. Herbert Cameron Morris
1943-5-1

Hartley, Marsden
Still Life with Fish
1921
Oil on canvas
23 × 39 1/8" (58.4 × 99.4 cm)

The Alfred Stieglitz Collection
1949-18-12

Hartung, Hans
French, born Germany,
born 1904
Composition
1936
Lower left: Hartung 36
Oil on canvas
33 3/16 × 22 1/8" (84.3 × 56.2 cm)

A. E. Gallatin Collection
1952-61-46

Hatten, Thomas
American, born 1946
Tomhattenxochital
Diptych; companion to the
following three paintings
1973
Oil and Rhoplex on linen
Left panel: 22 × 18 1/8"
(55.9 × 46 cm); right panel:
22 1/8 × 18 1/8" (56.2 × 46 cm)

Purchased with the Julius Bloch
Memorial Fund
1981-95-1

Hausch, Aleksandr F.
Russian, born 1873, death date
unknown
Russian Carpets and Toys
c. 1926
Lower right: A. Tayen[?]
Oil on canvas
42 3/16 × 35 1/2" (107.2 × 90.2 cm)

Gift of Christian Brinton
1941-79-102

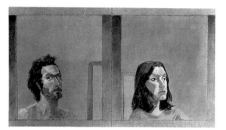

Hatten, Thomas
X.T.H.
Diptych; see previous entry
1974
Oil and Rhoplex on linen
Each panel: 22 1/8 × 18"
(56.2 × 46 cm)

Purchased with the Julius Bloch
Memorial Fund
1981-95-2

Havard, James
American, born 1937
Wapello III
1970
Acrylic and lacquer on plexiglass
57 1/2 × 57 1/2" (146 × 146 cm)

Purchased with the Philadelphia
Foundation Fund
1971-9-1

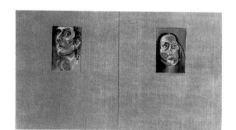

Hatten, Thomas
T.H.X.
Diptych; see previous two entries
1975
Oil and Rhoplex on linen
Left panel: 22 1/8 × 18"
(56.2 × 45.7 cm); right panel:
22 1/4 × 18" (56.5 × 45.7 cm)

Purchased with the Julius Bloch
Memorial Fund
1981-95-3

Havard, James
Drink the Juice of the Stone
1973
Acrylic on canvas
96 × 72" (243.8 × 182.9 cm)

Purchased with the Philadelphia
Foundation Fund
1973-133-1

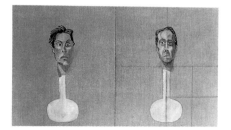

Hatten, Thomas
T.H.X.
Diptych; see previous three
entries
1975
Oil and Rhoplex on linen
Each panel: 22 × 18"
(55.9 × 45.7 cm)

Purchased with the Julius Bloch
Memorial Fund
1981-95-4

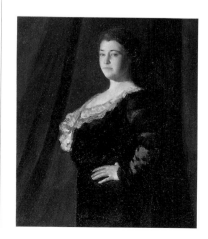

Hawthorne, Charles Webster
American, 1872–1930
Portrait of Georgiana Goddard King
c. 1905
Oil on canvas
36 1/4 × 30 1/8" (92.1 × 76.5 cm)

Gift of Miss Georgiana Goddard
King
1934-10-1

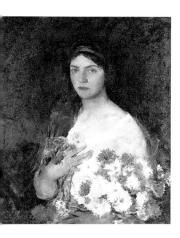

Hawthorne, Charles Webster
Girl with Asters
c. 1920
Lower left: C. W. Hawthorne
Oil on panel
30 1/8 × 25" (76.5 × 63.5 cm)

Gift of Dr. and Mrs. George
Woodward
1939-7-16

Hélion, Jean
Red Tensions
1933
On reverse: Jean / Hélion /
painted in / Virginia / 1933 /
(Tensions / Rouges)
Oil on canvas
23 3/4 × 28 5/8" (60.3 × 72.7 cm)

The Louise and Walter Arensberg
Collection
1950-134-99

Heliker, John Edward
American, born 1909
Monréale
1950
Lower left: HELIKER.
Oil on Masonite
28 × 22" (71.1 × 55.9 cm)

Purchased with the Bloomfield
Moore Fund
1951-31-3

Hélion, Jean
Composition
1934
On reverse: Hélion / Paris 34
Oil on canvas
14 × 10 3/4" (35.6 × 27.3 cm)

A. E. Gallatin Collection
1945-91-3

Hélion, Jean
French, 1904–1987
Composition
1932
On reverse: Jean / Hélion
Oil on canvas
25 7/16 × 19 13/16" (64.6 × 50.3 cm)

A. E. Gallatin Collection
1945-91-1

Hendricks, Barkley
American, born 1945
Miss T
1969
Lower right: B. Hendricks 69
Oil on canvas
66 1/8 × 48 1/8" (168 × 122.2 cm)

Purchased with the Philadelphia
Foundation Fund
1970-134-1

Hélion, Jean
Composition
1933
On reverse: Hélion / 33
Oil on canvas
25 7/8 × 32" (65.7 × 81.3 cm)

A. E. Gallatin Collection
1945-91-2

Henri, Robert
American, 1865–1929
Boulevard in Wet Weather, Paris
1899
Lower left: Robert Henri Paris
'99
Oil on canvas
25 × 32" (63.5 × 81.3 cm)

Gift of Mr. and Mrs. Meyer P.
Potamkin (reserving life interest)
1964-116-6

Herbin, Auguste
French, 1882–1960
Composition
1940
Lower right: Herbin 1940
Oil on canvas
45 ⁵/₈ × 35" (115.9 × 88.9 cm)

Gift of Lady George Weidenfeld
1972-125-1

Hofmann, Hans
American, born Germany,
1880–1966
Lumen Naturale
1962
Lower right: Hans Hofmann '62
Oil on canvas
84 × 77 ¹¹/₁₆" (213.4 × 197.3 cm)

Purchased with the John Howard
McFadden, Jr., Fund
1963-180-1

Hill, Derek
English, born 1916
Bernard Berenson in the Snow at Bagazzano
1951
Oil on panel
11 × 13" (27.9 × 33 cm)

The Henry P. McIlhenny
Collection in memory of
Frances P. McIlhenny
1986-26-403

Horter, Earl
American, 1881–1940
Still Life with a Pitcher
c. 1930
Center: BIER RE; lower right:
E Horter
Oil on canvas
10 ¹/₂ × 13 ⁷/₈" (26.7 × 35.2 cm)

Gift of the Honorable Joseph E.
Gold
1974-231-2

Hill, Derek
Portrait of Henry P. McIlhenny
c. 1962
Oil on canvas
27 ¹/₄ × 47 ¹/₂" (69.2 × 120.6 cm)

The Henry P. McIlhenny
Collection in memory of
Frances P. McIlhenny
1986-26-404

Horter, Earl
Wissahickon Creek
1938
Lower right: E. Horter 38
Oil on canvas
26 × 40 ¹/₂" (66 × 102.9 cm)

Gift of R. Sturgis Ingersoll and
Carroll S. Tyson, Jr.
1939-53-1

Hinchman, Margaretta S.
American, died 1955
The String of Beads (Portrait of Conti La Boiteaux Drake)
1903
Oil on panel
38 ¹/₈ × 23 ³/₈" (96.8 × 59.4 cm)

Gift of Mrs. Thomas E. Drake
1947-31-1

Hullond, Paul
American, active c. 1939
Landscape
1939
Lower right: Paul Hullond 39
Oil on cardboard
13 ³/₄ × 10 ⁷/₈" (34.9 × 27.6 cm)

Gift of Frank and Alice Osborn
1966-68-26a

Hullond, Paul
Landscape
1939
Lower right: Paul Hullond 1939
Oil on cardboard
13 ⅝ × 10 ⅞" (34.6 × 27.6 cm)

Gift of Frank and Alice Osborn
1966-68-26b

Hullond, Paul
Landscape
c. 1940
Oil on cardboard
13 ¾ × 10 ⅞" (34.9 × 27.6 cm)

Gift of Frank and Alice Osborn
1966-68-26f

Hullond, Paul
Landscape
1939
Lower right: Paul Hullond 39
Oil on cardboard
13 ¾ × 11" (34.9 × 27.9 cm)

Gift of Frank and Alice Osborn
1966-68-26d

Hullond, Paul
Landscape
c. 1940
Oil on cardboard
10 ⅝ × 13 ¾" (27 × 34.9 cm)

Gift of Frank and Alice Osborn
1966-68-26g

Hullond, Paul
Landscape
1940
Lower right: Paul Hullond /
1940
Oil on cardboard
10 ⅞ × 14" (27.6 × 35.6 cm)

Gift of Frank and Alice Osborn
1966-68-26c

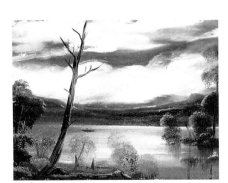

Hullond, Paul
Landscape
c. 1940
Lower right: Paul Hullond
Oil on cardboard
10 ⅝ × 13 ½" (27 × 34.3 cm)

Gift of Frank and Alice Osborn
1966-68-26h

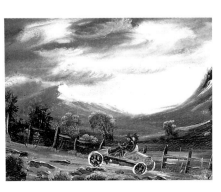

Hullond, Paul
Landscape
c. 1940
Oil on cardboard
10 ⅝ × 14" (27 × 35.6 cm)

Gift of Frank and Alice Osborn
1966-68-26e

Hultberg, John
American, born 1922
Against the Sky
1962
On reverse: J. Hultberg / 1962 /
AGAINST THE SKY
Oil on Masonite
25 ⅜ × 31 ½" (64.4 × 80 cm)

Gift of Mr. and Mrs. Barry R.
Peril
1967-269-4

Humphrey, Ralph
American, born 1932
Slice of Life
1980
On reverse: SLICE OF LIFE /
RALPH 1980 / HUMPHREY
48 DIAM.
Acrylic, modeling paste, and
casein on panel
48 1/4" (122.5 cm) diameter

Purchased with the Adele Haas
Turner and Beatrice Pastorius
Turner Memorial Fund
1981-40-1

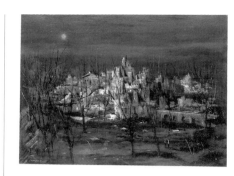

Jackson, Martin
American, 1919–1986
Moon Poem
1948
Lower left: MARTIN JACKSON 48
Oil on Masonite
29 × 38" (73.7 × 96.5 cm)

Gift of the Honorable Joseph E.
Gold
1973-200-1

Hyder, Frank
American, born 1951
Sea Watcher
1986
Acrylic and pastel on carved
wood
96 × 48" (243.8 × 121.9 cm)

Purchased with the Julius Bloch
Memorial Fund
1986-73-1

Jacovleff, Alexander
Russian, active France,
1887–1938
Chinese Masks
c. 1925
Tempera on canvas
31 1/8 × 33 3/4" (79.1 × 85.7 cm)

Gift of Christian Brinton
1941-79-100

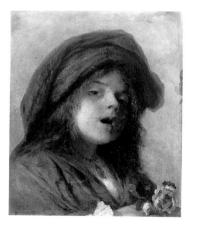

Innocenti, Camillo
Italian, 1871–1961
Head of a Child
c. 1900
Lower left: Innocenti
Oil on canvas
16 × 13" (40.6 × 33 cm)

John G. Johnson Collection
inv. 2944

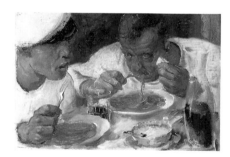

Jacovleff, Alexander
Spaghetti
1936
Lower right: A Jacovliff Capri /
1936
Oil on burlap on cardboard
21 1/2 × 31 5/8" (54.6 × 80.3 cm)

Gift of Martin Birnbaum in
memory of Mr. and Mrs. John D.
McIlhenny
1944-94-1

Irwin, Robert
American, born 1928
Untitled
From the series "Venice"
c. 1963–65
Oil on canvas
82 1/2 × 84 1/2" (209.5 × 214.6 cm)

Centennial gift of the Woodward
Foundation
1975-81-5

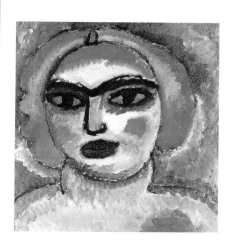

Jawlensky, Alexey von
Russian, active Germany,
1864–1941
Portrait
See following painting for reverse
1912
Upper left: A.Jawlensky; upper
right: Jawlensky 12
Oil on cardboard
21 1/8 × 19 1/2" (53.7 × 49.5 cm)

The Louise and Walter Arensberg
Collection
1950-134-512a

Jawlensky, Alexey von
Seated Woman
Reverse of the preceding painting
1912
Upper left: N. 6; upper right:
A. Jawlensky / 1912
Oil on cardboard
21 1/8 × 19 1/2" (53.7 × 49.5 cm)

The Louise and Walter Arensberg
Collection
1950-134-512b

Jawlensky, Alexey von
Looking Within: Rosy Light
1926
Lower left: A.j.; lower right: V.
26; on reverse: A. v. jawlensky /
Inneres Schauen / "Rosiges Licht /
Annunciator"
Oil on cardboard
21 1/4 × 18 3/4" (54 × 47.6 cm)

The Louise and Walter Arensberg
Collection
1950-134-511

Jawlensky, Alexey von
Earth
See following painting for reverse
1913
Lower left: Jawlensky. / 1913
Oil on cardboard
26 7/8 × 19 7/8" (68.3 × 50.5 cm)

The Louise and Walter Arensberg
Collection
1950-134-100a

Jean, Felix
French, active 20th century
Bowl of Fruit
c. 1955
Lower right: Felix Jean
Oil on panel
29 7/8 × 24" (75.9 × 61 cm)

The Albert M. Greenfield and
Elizabeth M. Greenfield
Collection
1974-178-33

Jawlensky, Alexey von
Head of a Woman
Reverse of the preceding painting
c. 1913
Oil and graphite on cardboard
26 7/8 × 19 7/8" (68.3 × 50.5 cm)

The Louise and Walter Arensberg
Collection
1950-134-100b

Jenkins, Paul
American, born 1923
Phenomena: Break Rope
1961
Lower right: Paul Jenkins
Oil on canvas
20 × 36 1/16" (50.8 × 91.6 cm)

Gift of Mr. and Mrs. Barry R.
Peril
1967-269-2

Jawlensky, Alexey von
Looking Within: Night
1923
Lower left: A.j.; upper right:
Nacht / A jawlensky. / 1923.;
lower right: 1923; on reverse:
Inneres Schauen / Nacht
Oil on cardboard
16 5/8 × 12 3/4" (42.2 × 32.4 cm)

The Louise and Walter Arensberg
Collection
1950-134-101

Jenkins, Paul
*Phenomena: Guide Polestar,
New York*
1964
Lower left: Paul Jenkins; on
reverse: Paul Jenkins
"Phenomena Guide Pole Star"
New York, 1964 / Phenomena
Guide Pole Star Paul Jenkins—
New York, 1964
Oil on canvas
60 × 39 7/8" (152.4 × 101.3 cm)

Gift of Mr. and Mrs. Barry R.
Peril
1969-282-6

Jenkins, Paul
Phenomena: Shadow Fall
1964
Lower right: Paul Jenkins
Oil on canvas
20 1/8 × 16 1/16" (51.1 × 40.8 cm)

Gift of Mr. and Mrs. Barry R.
Peril
1967-269-3

John, Augustus
English, 1878–1961
*Head of a Woman (The White
Kerchief)*
1913
Oil on panel
16 × 12 3/4" (40.6 × 32.4 cm)

Gift of Mr. and Mrs. Charles C. G.
Chaplin
1978-173-2

Jenkins, Paul
Phenomena: West Specter
1964
Lower right: Jenkins
Oil on canvas
20 × 36" (50.8 × 91.4 cm)

Gift of Mr. and Mrs. Barry R.
Peril
1967-269-1

Johns, Jasper
American, born 1930
Sculpmetal Numbers
1963
On reverse: J Johns / 1963
Sculpmetal on canvas
57 7/8 × 43 7/8" (147 × 111.4 cm)

Centennial gift of the Woodward
Foundation
1975-81-6

Jenney, Neil
American, born 1945
Meltdown Morning
1975
Across bottom: MELTDOWN
MORNING
Oil on panel
25 3/4 × 112 1/2" (65.4 × 285.7 cm)

Gift (by exchange) of Samuel S.
White 3rd and Vera White, with
additional funds contributed by
the Daniel W. Dietrich
Foundation in honor of Mrs. H.
Gates Lloyd
1985-23-1

Kádár, Béla
Hungarian, 1877–1956
Angel of Peace
c. 1925
Lower right: KÁDÁR / BÉLA
Oil on canvas
28 1/8 × 38 3/8" (71.4 × 97.5 cm)

Gift of Christian Brinton
1941-79-103

Jess (Jess Collins)
American, born 1923
*Ex. 6, No Traveller's Borne
(Translation No. 13)*
1965
Across bottom: EX. 6—NO—
Traveller's Borne; on reverse: 172
Jess '65
Oil on canvas on panel
36 1/4 × 29 1/4" (92.1 × 74.3 cm)

Purchased with the Edith H. Bell
Fund
1979-74-1

Kádár, Béla
*Portrait of an Art Critic (Portrait of
Christian Brinton)*
c. 1925
Upper right: Dr. CHRISTIAN /
BRINTON / BY / KÁDÁR / BÉLA
Oil on canvas
29 1/8 × 22 1/8" (74 × 56.2 cm)

Gift of Christian Brinton
1941-79-105

Kádár, Béla
Sunset-Moonrise
c. 1925
Lower left: KÁDÁR / BÉLA
Oil on canvas
20 1/16 × 29 11/16" (51 × 75.4 cm)

Gift of Christian Brinton
1941-79-138

Kandinsky, Wassily
Russian, active Germany,
1866–1944
Improvisation No. 29 (The Swan)
1912
Lower left: KANDINSKY / 1912.
Oil on canvas
41 3/4 × 38 3/16" (106 × 97 cm)

The Louise and Walter Arensberg
Collection
1950-134-102

Kádár, Béla
The Impromptu Visitor
1928
Lower left: KÁDÁR / BÉLA
Oil on canvas
31 3/4 × 36 3/4" (80.6 × 93.3 cm)

Gift of Christian Brinton
1941-79-101

Kandinsky, Wassily
*Little Painting with Yellow
(Improvisation)*
1914
Lower right: KANDINSKY / 1914.
Oil on canvas
31 × 39 5/8" (78.7 × 100.6 cm)

The Louise and Walter Arensberg
Collection
1950-134-103

Kahn, Wolf
American, born Germany,
born 1927
Landscape
1960
Lower right: W. Kahn
Oil on canvas
9 1/8 × 14 1/8" (23.2 × 35.9 cm)

Gift of Barbara Kulicke
1973-71-2

Kandinsky, Wassily
Circles in a Circle
1923
Lower left: WK 23; on reverse:
N 26i / 1923 / Kreise im Kreis
Oil on canvas
38 7/8 × 37 5/8" (98.7 × 95.6 cm)

The Louise and Walter Arensberg
Collection
1950-134-104

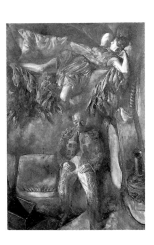

Kamihira, Ben
American, born 1925
Faded Suit of Lights
1966
Lower right: KAMIHIRA
Oil on canvas
64 1/2 × 42 3/16" (163.8 × 107.2 cm)

Purchased with funds contributed
by Dr. Luther W. Brady, Jr., and
anonymous donors
1978-14-1

Kantor, Morris
American, born Belorussia,
1896–1974
Vase of Flowers
1928
Lower left: M. Kantor 1928
Oil on canvas
24 1/2 × 28" (62.2 × 71.1 cm)

Bequest of Anne Hinchman
1952-82-13

Kantor, Morris
Apple Trees with a Girl in a Chair
1929
Lower right: M. Kantor / 1929
Oil on canvas
36 1/8 × 29 1/8" (91.8 × 74 cm)

Bequest of Anne Hinchman
1952-82-15

Katz, Alex
American, born 1927
West Interior
1979
Oil on canvas
96 × 72" (243.8 × 182.9 cm)

Gift of the Friends of the
Philadelphia Museum of Art
1979-145-1

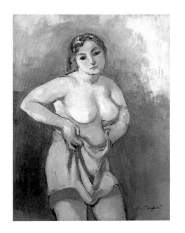

Kantor, Morris
Vase of Flowers
c. 1930
Lower right: M. Kantor
Oil on canvas
27 1/2 × 21 1/2" (69.8 × 54.6 cm)

Bequest of Anne Hinchman
1952-82-14

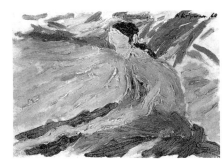

Katzman, Herbert
American, born 1923
Duny
1960
Upper right: H. Katzman, 60
Oil on canvas
8 1/16 × 11 1/8" (20.5 × 28.3 cm)

Gift of the Kulicke family in
memory of Lt. Frederick W.
Kulicke III
1969-86-1

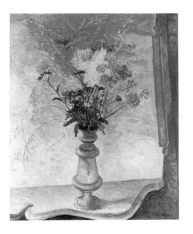

Karfiol, Bernard
American, born Hungary,
1886–1952
The Yellow Slip
c. 1938
Lower right: B. Karfiol; on
reverse: BERNARD KARFIOL /
THE YELLOW SLIP / THE
DOWNTOWN GALLERY /
32 E. 51st St., NY
Oil on canvas board
16 × 12" (40.6 × 30.5 cm)

Gift of Bryant W. Langston
1961-77-1

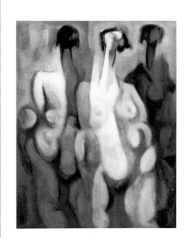

Keene, Paul
American, born 1920
Three Graces
c. 1960
Oil on canvas
30 × 24" (76.2 × 61 cm)

Gift of Benjamin D. Bernstein
1964-106-2

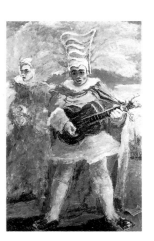

Karp, Leon
American, 1903–1951
New-Year Shooters
1940
Lower right: Leon Karp
Oil on canvas
48 1/8 × 30" (122.2 × 76.2 cm)

Gift of H. A. Batten, George W.
Cecil, C. T. Coiner, Paul Darrow,
Mrs. Elizabeth Kidd, Gerald M.
Lauck, Leonard Lionni, Walter
Reinsel, Harry Rosin, Granville E.
Toogood, and Edward Zern
1942-65-1

Keene, Paul
Untitled
From the "Sky Windows" series
1984
Lower right: Keene 84
Oil on canvas
9 3/8 × 9" (23.8 × 22.9 cm)

Purchased with the Julius Bloch
Memorial Fund
1990-119-5

Keene, Paul
Untitled
From the "Sky Windows" series
1984
Lower right: Keene 84
Oil on canvas
12 × 8" (30.5 × 20.3 cm)

Purchased with the Julius Bloch
Memorial Fund
1990-119-7

Keene, Paul
Untitled
From the "Sky Windows" series
1985
Lower right: Keene 85
Oil on canvas
8 ³/₈ × 12" (21.3 × 30.5 cm)

Purchased with the Julius Bloch
Memorial Fund
1990-119-6

Keene, Paul
Untitled
From the "Sky Windows" series
1985
Lower right: Keene 85
Oil on canvas
10 × 13" (25.4 × 33 cm)

Purchased with the Julius Bloch
Memorial Fund
1990-119-1

Keene, Paul
Untitled
From the "Sky Windows" series
c. 1985
Oil on canvas
9 × 12" (22.9 × 30.5 cm)

Purchased with the Julius Bloch
Memorial Fund
1990-119-3

Keene, Paul
Untitled
From the "Sky Windows" series
1985
Lower right: Keene 85
Oil on canvas
14 × 10" (35.6 × 25.4 cm)

Purchased with the Julius Bloch
Memorial Fund
1990-119-2

Kelly, Ellsworth
American, born 1923
Diagonal with Curve III
1978
Oil on canvas
135 × 99" (342.9 × 251.5 cm)

Gift of the Friends of the
Philadelphia Museum of Art
1979-99-1

Keene, Paul
Untitled
From the "Sky Windows" series
1985
Lower right: 85
Oil on canvas
10 × 11" (25.4 × 28 cm)

Purchased with the Julius Bloch
Memorial Fund
1990-119-4

Kelly, Leon
American, born France,
1901–1982
Abstraction
1922
Lower right: Leon Kelly; on
reverse: Leon Kelly / 1922
Oil on canvas
23 × 29" (58.4 × 73.7 cm)

Gift of Bernard Davis
1942-64-2

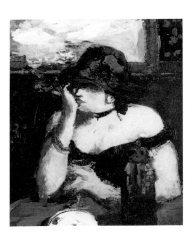

Kelly, Leon
Au Café
c. 1930
Lower right: Leon Kelly
Oil on canvas
25 5/8 × 21 5/16" (65.1 × 54.1 cm)

Gift of Bernard Davis
1942-14-1

Keyser, Robert
American, born 1927
Ur Landscape
1974
Lower right: Robert Keyser / '74
Oil on canvas
44 1/8 × 66" (112.1 × 167.6 cm)

Gift of the Women's Committee
of the Philadelphia Museum of
Art in memory of Mrs. Morris
Wenger, with additional funds
contributed by Gene Locks and
Frederick R. McBrien
1975-120-1

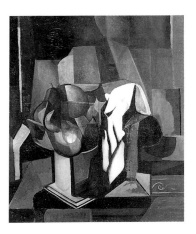

Kelly, Leon
Abstraction
1937
Upper left: Leon Kelly; on
reverse: Leon Kelly / Vernis
Vibert / April 1937
Oil on canvas
21 3/4 × 18 1/8" (55.2 × 46 cm)

Bequest of Margaretta S.
Hinchman
1955-96-7

Kiefer, Anselm
German, born 1945
Nigredo
1984
Upper left: Nigredo
Oil, acrylic, emulsion, shellac,
and straw on photograph on
canvas, with woodcut
130 × 218 1/2" (330.2 × 555 cm)

Gift of the Friends of the
Philadelphia Museum of Art in
celebration of their 20th
anniversary
1985-5-1

Kendall, William Sergeant
American, 1869–1938
Penumbra
1917
Lower left: Sergeant Kendall /
1917
Oil on canvas
48 1/2 × 36 3/8" (123.2 × 92.4 cm)

The Walter Lippincott Collection
1923-59-14

Kisling, Moïse
French, born Poland,
1891–1953
Landscape (Woman with a Jug)
c. 1920
Lower right: Kisling
Oil on canvas
31 13/16 × 23 5/8" (80.8 × 60 cm)

Gift of George Biddle
1945-16-38

Kessler, Michael
American, born 1954
Swamp Grove
1984
Oil on panel
32 × 28" (81.3 × 71.1 cm)

Purchased with the Julius Bloch
Memorial Fund
1986-136-1

Kisling, Moïse
Central Park, New York City
1941
Lower left: Kisling; lower right:
New York 1941
Oil on canvas
26 3/8 × 22 3/8" (67 × 56.8 cm)

Gift of Mr. and Mrs. Fredric R.
Mann
1955-24-1

Klee, Paul
Swiss, 1879–1940
City of Towers
1916
Lower left: Klee / 1916 40; on
reverse: 1916.40. Stadt der
Türme / Klee
Oil on canvas on panel
12 7/8 × 14 1/8" (32.7 × 35.9 cm)

The Louise and Walter Arensberg
Collection
1950-134-109

Klee, Paul
Prestidigitator (Conjuring Trick)
1927
Upper left: Klee 1927 Omega. 7;
on reverse: 1927 Omega 7 /
Zauber Kunst Stuck Klee
Oil on canvas on Masonite
19 9/16 × 16 7/16" (49.7 × 41.7 cm)

The Louise and Walter Arensberg
Collection
1950-134-118

Klee, Paul
Fish Magic
1925
Lower left: Klee / 1925 R. 5; on
reverse: 1925 R.5 Fischzauber
Klee
Oil and watercolor on canvas on
panel
30 3/8 × 38 3/4" (77.1 × 98.4 cm)

The Louise and Walter Arensberg
Collection
1950-134-112

Klee, Paul
But the Red Roof
1935
Upper left: Klee
Glue tempera on jute-and-flax
fabric
23 3/4 × 35 11/16" (60.3 × 90.6 cm)

The Louise and Walter Arensberg
Collection
1950-134-121

Klee, Paul
Animal Terror
1926
Upper right: Klee 1926 U. 4.;
on reverse: 1926 U. 4 Der Tie
Schreck Klee
Tempera on canvas
13 7/8 × 19 1/16" (35.2 × 48.4 cm)

The Louise and Walter Arensberg
Collection
1950-134-113

Kline, Franz
American, 1910–1962
Torches Mauve
1960
On reverse: Franz Kline 60, R 14,
NY, Made in Belgium / Torches
Mauve / Kline
Oil on canvas
120 1/8 × 81 1/8" (305.1 × 206.1 cm)

Gift of the artist
1961-223-1

Klee, Paul
Village Carnival
1926
Center top: Klee 1926 D 5; on
reverse: D 5 Dorf-Carnaval Klee
Oil on canvas on panel
25 11/16 × 17 5/16" (65.2 × 44 cm)

The Louise and Walter Arensberg
Collection
1950-134-115

Knaths, Karl
American, 1891–1971
Still Life
1927
Lower right: KNATHS
Oil on canvas
30 1/8 × 20" (76.5 × 50.8 cm)

A. E. Gallatin Collection
1952-61-51

Knight, Dame Laura
English, 1877–1970
The Knap Stroppers
c. 1925
Lower left: Laura Knight
Oil on canvas
27 1/4 × 30 1/4" (69.2 × 76.8 cm)

Bequest of Charlotte Dorrance
Wright
1978-1-37

Kroll, Leon
American, 1884–1974
Head of a Girl in a Red Dress
c. 1930
Lower right: Leon Kroll
Oil on Masonite
18 × 15" (45.7 × 38.1 cm)

The Louis E. Stern Collection
1963-181-38

Konolyi, Mary Barnwell
American, active c. 1954
The Spy
1954
Lower right: KONOLYI / 54
Oil on canvas
36 7/8 × 36 5/8" (93.7 × 93 cm)

Gift of an anonymous donor
1962-49-1

Kuhn, Walt
American, 1880–1949
Athlete in Whiteface
1934
Lower left: Walt Kuhn / 1934
Oil on canvas
40 1/8 × 30 1/8" (101.9 × 76.5 cm)

Purchased with the W. P.
Wilstach Fund
W1962-1-1

Krasner, Lee
American, 1908–1984
Composition
1949
On reverse: Lee KRASNER—
'49 / 1949
Oil on canvas
38 1/16 × 27 13/16" (96.7 × 70.6 cm)

Gift of the Aaron E. Norman
Fund, Inc.
1959-31-1

Kulicke, Robert
American, born 1924
Pear
1966
Lower left: OCT 29-66; lower
right: Kulicke
Oil on panel
9 1/2 × 7 1/8" (24.1 × 18.1 cm)

Gift of the Kulicke family in
memory of Lt. Frederick W.
Kulicke III
1969-86-2

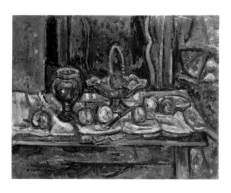

Kremegne, Pinchus
Russian, born 1890, death date
unknown
Still Life with a Fruit Dish
1958
Lower left: Kremegne
Oil on canvas
25 5/8 × 31 7/8" (65.1 × 81 cm)

Gift of Dr. and Mrs. Paul Todd
Makler
1970-92-1

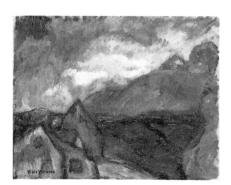

Kuniyoshi, Yasuo
American, born Japan,
1893–1953
Landscape
c. 1919
Lower left: KUIYOSHI
Oil on panel
8 1/4 × 10 3/8" (20.9 × 26.3 cm)

Gift of Frank and Alice Osborn
1966-68-16

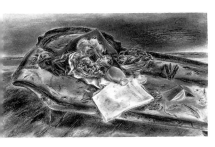

Kuniyoshi, Yasuo
Odd Objects on a Couch
1930
Lower left: Yasuo Kuniyoshi /
1930
Oil on canvas
40 × 65 ⅜" (101.6 × 166 cm)

Gift of Mrs. Frank C. Osborn
1957-65-1

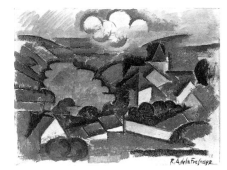

La Fresnaye, Roger de
Landscape
1912
Lower right: 12 / R. A. de la
Fresnaye
Oil on canvas
18 ¾ × 23 ¾" (47.6 × 60.3 cm)

The Louise and Walter Arensberg
Collection
1950-134-90

Kupka, Frank (Frantisek Kupka)
Czech, active France,
1871–1957
Disks of Newton (Study for "Fugue in Two Colors")
1912
Lower left: Kupka; on reverse:
Frank Kupka "Disque de
Newton" Etude pour: "La fugue à
2 couleurs"—1912—
Oil on canvas
39 ½ × 29" (100.3 × 73.7 cm)

The Louise and Walter Arensberg
Collection
1950-134-122

Lagrange, Jacques
French, born 1917
Still Life with a Goose
c. 1950
Lower right: Lagrange
Oil on canvas
19 ¾ × 24" (50.2 × 61 cm)

Gift of John Wanamaker
1951-69-1

Kurtz, Elaine
American, born 1928
Incandescent Cool
1982
Acrylic on canvas
84 × 48" (213.4 × 121.9 cm)

Gift of the artist and gift (by
exchange) of James Lee
1982-32-1

Lam, Jennett
American, born 1911
Chair Plus, Night
1964
Lower right: Jennett Lam 1964
Oil on canvas
61 × 39" (154.9 × 99.1 cm)

Gift of Haig Tashjian
1966-227-1

La Fresnaye, Roger de
French, 1885–1925
Nude
1911
Lower right: mai 1911 / LA
FRESNAYE
Oil on cardboard
50 ¹¹⁄₁₆ × 22 ¼" (128.7 × 56.5 cm)

The Louise and Walter Arensberg
Collection
1950-134-89

Lansner, Fay
American, born 1921
Metamorphosis
1954
Lower left: Fay Lansner July / 54;
on reverse: Fay Lansner / 1954
Oil on canvas
89 ¾ × 69" (228 × 175.3 cm)

The Albert M. Greenfield and
Elizabeth M. Greenfield
Collection
1974-178-34

László, Philip A. de
English, born Hungary,
1869–1937
Portrait of John H. McFadden
1916
Lower left: Laszlo / LONDON /
1916.XI.I
Oil on canvas
35 3/4 × 27 1/2" (90.8 × 69.8 cm)

Gift of Mr. and Mrs. John
Howard McFadden, Jr.
1956-13-1

Laurencin, Marie
French, 1885–1956
Young Girl Models
c. 1913
Lower right: Marie / Laurencin;
center: LES PETITES / FILLES
MODÈLES
Oil on panel
21 × 16 1/2" (53.3 × 41.9 cm)

A. E. Gallatin Collection
1944-12-1

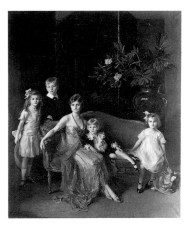

László, Philip A. de
*Portrait of Mrs. Francis P. Garvan
and Her Four Children*
1921
Lower left: de Laszlo / Roslyn
House 1921. august.
Oil on canvas
110 × 88" (279.4 × 223.5 cm)

Gift of Mrs. Francis P. Garvan
1965-208-1

Laurencin, Marie
Leda and the Swan
1923
Lower right: Marie Laurencin
1923
Oil on canvas
26 1/2 × 32" (67.3 × 81.3 cm)

Gift of Mr. and Mrs. Charles C. G.
Chaplin
1978-173-1

Lathrop, William Langson
American, 1859–1938
Landscape
1915
Lower right: WL LATHROP / '15
Oil on canvas
25 × 30 3/16" (63.5 × 76.7 cm)

Gift of Lucie Washington
Mitcheson in memory of Robert
Stockton Johnson Mitcheson for
the Robert Stockton Johnson
Mitcheson Collection
1938-22-5

Laurencin, Marie
Nymph and Hind
1925
Lower right: Marie Laurencin
1925
Oil on canvas
28 5/8 × 21 3/8" (72.7 × 54.3 cm)

Gift of Mr. and Mrs. Herbert
Cameron Morris
1951-104-1

Lathrop, William Langson
Spring Landscape
c. 1915
Lower right: WL LATHROP
Oil on canvas
32 3/16 × 40 1/16" (81.8 × 101.8 cm)

The Alex Simpson, Jr., Collection
1944-13-3

Lawson, Adelaide
American, born 1889,
still active 1940
Ogunquit
c. 1925
Lower right: A. LAWSON
Oil on canvas
24 3/16 × 30" (61.4 × 76.2 cm)

Gift of Frank and Alice Osborn
1966-68-29

Lawson, Adelaide
Winter
1926
On reverse: Painted by / Adelaide
Lawson / (Mrs. Wood Taylor)
Glenwood Landing / Long Island
N.Y. / 1926
Oil on cardboard
10 1/8 × 16 1/16" (25.7 × 40.8 cm)

Gift of Frank and Alice Osborn
1966-68-28

Lawson, Ernest
Woman at a Marketplace
Reverse of the preceding painting
c. 1913
Oil on canvas
18 × 22" (45.7 × 55.9 cm)

The Alex Simpson, Jr., Collection
1944-13-4b

Lawson, Ernest
American, 1873–1939
Chatham Square
c. 1910
Lower right: E. LAWSON
Oil on canvas
20 1/16 × 26 1/16" (51 × 66.2 cm)

Bequest of T. Edward Hanley
1970-76-8

Lawson, Ernest
Winter Landscape
c. 1925
Lower left: E. Lawson
Oil on canvas on Masonite
25 × 29 15/16" (63.5 × 76 cm)

Gift of Lucie Washington
Mitcheson in memory of Robert
Stockton Johnson Mitcheson for
the Robert Stockton Johnson
Mitcheson Collection
1938-22-3

Lawson, Ernest
Landscape near the Harlem River
c. 1913
Oil on cardboard
25 1/2 × 21 1/2" (64.8 × 54.6 cm)

Gift of Mr. and Mrs. Meyer P.
Potamkin (reserving life interest)
1964-116-4

Lazo, Agustin
Mexican, born 1900
View of the City of Morelia
1938
Lower left: Vista de la / Ciudad
de Mo / relia par Agustin / Lazo.
1938
Oil on canvas
27 1/2 × 25 3/4" (69.8 × 65.4 cm)

Gift of Dr. and Mrs. MacKinley
Helm
1952-57-3

Lawson, Ernest
River
See following painting for reverse
c. 1913
Lower left: E. LAWSON
Oil on canvas
18 × 22" (45.7 × 55.9 cm)

The Alex Simpson, Jr., Collection
1944-13-4a

Lebduska, Lawrence H.
American, 1894–1966
Temple of Venus
1932
Lower right: L. H. Lebduska 32
Oil on canvas
21 × 30" (53.3 × 76.2 cm)

The Louise and Walter Arensberg
Collection
1950-134-513

Lebduska, Lawrence H.
White-Belted Cattle
1937
Upper right: Lebduska / 37
Oil on canvas
24 1/16 × 30 3/16" (61.1 × 76.7 cm)

The Louise and Walter Arensberg
Collection
1950-134-514

Léger, Fernand
Typographer (Final State)
1919
Lower right: F. LEGER; on
reverse: LE TYPOGRAPHE ETAT
DEFinitif / F LEGER / 19
Oil on canvas
51 5/16 × 38 3/8" (130.3 × 97.5 cm)

The Louise and Walter Arensberg
Collection
1950-134-125

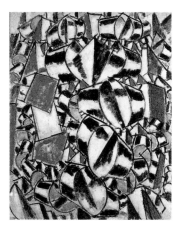

Léger, Fernand
French, 1881–1955
Contrast of Forms
1913
On reverse: F LEGER / (1913)
Oil on burlap
51 1/4 × 38 7/16" (130.2 × 97.6 cm)

The Louise and Walter Arensberg
Collection
1950-134-123

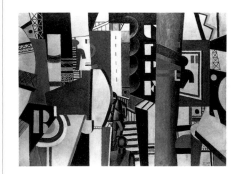

Léger, Fernand
The City
1919
Lower right: F. LÉGER /
PARIS—19; on reverse: LA VILLE /
1919–20 / F. LEGER
Oil on canvas
91 × 117 1/2" (231.1 × 298.4 cm)

A. E. Gallatin Collection
1952-61-58

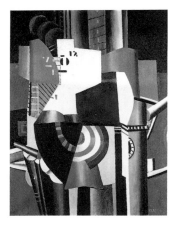

Léger, Fernand
The City (Fragment, Third State)
1919
Lower right: F. LEGER; on
reverse: LA VILLE (fraGMENT). /
3e ETAT / F. LEGER / 19.
Oil on canvas
51 1/8 × 38 1/4" (129.9 × 97.1 cm)

The Louise and Walter Arensberg
Collection
1950-134-124

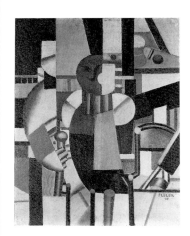

Léger, Fernand
Man with a Cane (First State)
1920
Lower right: F. LEGER / 20; on
reverse: L'Homme à la Canne /
1e ETAT / F. LEGER / 20
Oil on burlap
25 5/8 × 19 9/16" (65.1 × 49.7 cm)

The Louise and Walter Arensberg
Collection
1950-134-126

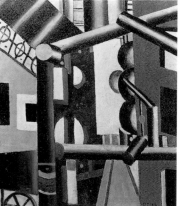

Léger, Fernand
The Scaffolding (First State)
1919
Lower right: F. LEGER / 19;
on reverse: L'Echafaudage I état
F. Léger —19
Oil on canvas
25 9/16 × 21 3/16" (64.9 × 53.8 cm)

A. E. Gallatin Collection
1952-61-57

Léger, Fernand
Mechanical Element
1920
Lower right: F. LÉGER. 20; on
reverse: Elément / Mécanique /
1920 / F. LEGER
Oil on canvas
25 5/8 × 19 3/4" (65.1 × 50.2 cm)

Gift of Miss Anna Warren
Ingersoll
1958-12-1

Léger, Fernand
Composition
1923–27
Lower right: F. LÉGER. 27; on
reverse: Composition / F. LEGER /
23–27
Oil on canvas
50 1/2 × 38 1/4" (128.3 × 97.1 cm)

A. E. Gallatin Collection
1952-61-63

Le Sidaner, Henri-Eugène-Augustin
French, 1862–1939
House of Roses
By 1917
Lower left: Le SIDANER
Oil on canvas
32 1/8 × 39 1/2" (81.6 × 100.3 cm)

Purchased with the W. P.
Wilstach Fund
W1917-1-10

Léger, Fernand
Animated Landscape
1924
Lower right: F. LEGER. 24.; on
reverse: Paysage Animé—24
F. Leger
Oil on canvas
19 1/2 × 25 5/8" (49.5 × 65.1 cm)

Gift of Bernard Davis
1950-63-1

LeWitt, Sol
American, born 1928
On a Blue Ceiling. Eight Geometric Figures: Circle. Trapezoid. Parallelogram. Rectangle. Square. Triangle. Right Triangle. X (Wall Drawing No. 548)
Executed on a gallery ceiling in
the museum
1981
Chalk and latex paint on plaster
186 × 655" (472.4 × 1663.7 cm)

Purchased with a grant from the
National Endowment for the Arts
and with funds contributed by
Mrs. H. Gates Lloyd, Mr. and
Mrs. N. Richard Miller, Mrs.
Donald A. Petrie, Eileen and
Peter Rosenau, Mrs. Adolf
Schaap, Frances and Bayard
Storey, Marion Boulton Stroud,
and two anonymous donors (by
exchange), with additional funds
from Dr. and Mrs. William
Wolgin, the Daniel W. Dietrich
Foundation, and the Friends of
the Philadelphia Museum of Art
1982-121-1

Léger, Fernand
Green Foliage
1930
Lower right: F. LÉGER. 30;
on reverse: L. Feuille Verte /
F. LEGER. 30
Oil on canvas
25 5/8 × 19 3/4" (65.1 × 50.2 cm)

A. E. Gallatin Collection
1952-61-64

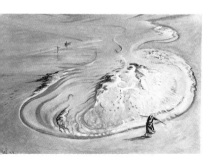

Leonid (Leonid Berman)
French, born Russia,
1896–1976
Fishermen at Belle-Île-sur-Mer
1949
Lower left: Leonid. 49.
Oil on canvas
25 × 36" (63.5 × 91.4 cm)

Gift of Mme Florence de
Montferrier
1961-180-1

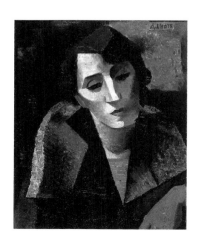

Lhôte, André
French, 1885–1962
Head of a Woman
c. 1921
Upper right: A. LHOTE
Oil on canvas
24 × 18 1/8" (61 × 46 cm)

Gift of Benjamin D. Bernstein
1978-172-3

Liberman, Alexander
American, born Ukraine,
born 1912
Great Mysteries IV
1962
Acrylic on canvas
112 × 50" (284.5 × 127 cm)

Centennial gift of the Woodward
Foundation
1975-81-8

Louis, Morris
American, 1912–1962
Beth
1960
Acrylic resin on canvas
105 × 106 1/4" (266.7 × 269.9 cm)

Purchased with the Adele Haas
Turner and Beatrice Pastorius
Turner Memorial Fund
1966-172-1

Lichtenstein, Roy
American, born 1923
Still Life with Goldfish
1974
Oil and Magna on canvas
80 × 60" (203.2 × 152.4 cm)

Purchased with the Edith H. Bell
Fund
1974-110-1

Louis, Morris
Delta
1960
Acrylic resin on canvas
105 × 141 1/2" (266.7 × 359.4 cm)

Centennial gift of the Woodward
Foundation
1975-81-9

Lissitzky, El (Eleazar Lissitzky)
Russian, 1890–1941
Proun 2 (Construction)
"Proun" is a Russian acronym for
"Project for the Establishment of
a New Art"
1920
On reverse: [Russian for "El
Lissitzky"], 1920 Proun 2c 1920
Oil, paper, and metal on panel
23 7/16 × 15 11/16" (59.5 × 39.8 cm)

A. E. Gallatin Collection
1952-61-72

Lueders, Jimmy C.
American, born 1927
Ascension
Diptych
1965
Lower left: Lueders
Acrylic on canvas
85 7/8 × 125 1/4" (218.1 × 318.1 cm)

Purchased with the Philadelphia
Foundation Fund
1965-158-1

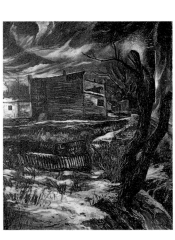

Loper, Edward
American, born 1916
Backyards
c. 1935
Lower right: Edw. L. Loper
Oil on canvas
30 1/8 × 23 7/8" (76.5 × 60.6 cm)

Gift of Sam A. Lewisohn
1944-85-1

Luks, George B.
American, 1867–1933
Old Beggar Woman
1907
Lower right: George Luks; on
reverse: Beggar Woman by
George Luks 1907
Oil on canvas
24 1/8 × 18 1/8" (61.3 × 46 cm)

Gift of Mr. and Mrs. Meyer P.
Potamkin (reserving life interest
1964-116-2

Lund, Henrik
Norwegian, 1879–1935
Portrait of Christian Brinton
1912
Lower right: Henrik Lund 1912
Oil on composition board
21 5/8 × 18" (54.9 × 45.7 cm)

Gift of Christian Brinton
1941-79-336

Lurçat, Jean
French, 1892–1966
Composition No. 2
1925
Lower right: Lurçat / 25
Oil on canvas
15 × 24 1/4" (38.1 × 61.6 cm)

Bequest of Fiske and Marie
Kimball
1955-86-19

Lutz, Dan
American, 1906–1978
String Quartet
c. 1940
Lower right: DAN LUTZ
Oil on canvas
18 × 36" (45.7 × 91.4 cm)

Gift of Mrs. Herbert Cameron
Morris
1946-40-1

McCarter, Henry
American, 1866–1942
Trees in Bloom
c. 1930
Oil on cardboard
20 1/2 × 12 5/8" (52.1 × 32.1 cm)

Bequest of Henry McCarter
1944-44-2

McCarter, Henry
Farm Scene
c. 1940
Lower left: H.M.C
Oil on canvas
29 13/16 × 35 15/16" (75.7 × 91.3 cm)

Gift of Miss Anna Warren
Ingersoll and R. Sturgis Ingersoll
1942-45-1

McCarter, Henry
Bells No. 6
c. 1941
Oil on canvas
48 5/16 × 41 15/16" (122.7 ×
106.5 cm)

Bequest of Henry McCarter
1944-44-3

Magritte, René
Belgian, 1898–1967
The Six Elements
1929
Upper left: Magritte
Oil on canvas
28 3/4 × 39 5/16" (73 × 99.8 cm)

The Louise and Walter Arensberg
Collection
1950-134-127

Mahaffey, Noel
American, born 1944
Catfish
1969
Lower right: N Mahaffey '69
Oil on canvas
72 1/4 × 72 1/4" (183.5 × 183.5 cm)

Gift of the Cheltenham Art
Centre
1970-91-1

Malherbe, William
American, born France,
died 1951
Rouen Cathedral
1929
Lower left: WILLIAM MALHERBE.
1929.
Oil on canvas
25 ³/₄ × 21 ³/₈" (65.4 × 54.3 cm)

Gift of Mrs. A. W. Erickson
1945-69-1

**Marcoussis, Louis (Louis
Casimir Ladislas Markus)**
Polish, active France,
1883–1941
Still Life
1920
Lower right: LM 1920
Oil on glass
13 ¹/₈ × 18 ¹/₈" (33.3 × 46 cm)

Gift of Richard Davis
1945-40-2

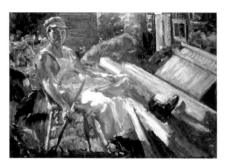

Malherbe, William
*The Farmer, Lynne, New Hampshire
(Portrait of Bill Stevens)*
1940
Lower right: WILLIAM
MALHERBE. 1940
Oil on canvas
18 × 24" (45.7 × 61 cm)

Gift of Mrs. A. W. Erickson
1945-69-2

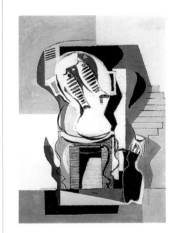

Marcoussis, Louis
Still Life with Fish
1928
Lower left: Marcoussis 28
Oil on canvas
36 ¹/₄ × 25 ¹/₂" (92.1 × 64.8 cm)

Bequest of Fiske and Marie
Kimball
1955-86-17

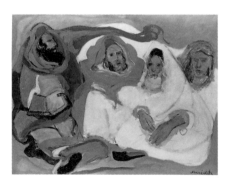

Mané-Katz
French, born Ukraine,
1894–1962
Men at Prayer
c. 1950
Lower right: Mané-Katz
Oil on canvas
31 ⁷/₈ × 39 ¹/₄" (81 × 99.7 cm)

Bequest of Rosaline B. Feinstein
1972-239-1

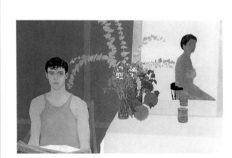

Marcus, Marcia
American, born 1928
Double Portrait with Still Life
1960
Oil and newspaper on canvas
42 × 59 ⁷/₈" (106.7 × 152.1 cm)

Centennial gift of the Woodward
Foundation
1975-81-10

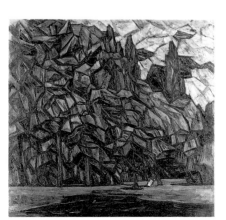

**Manievich, Abraham
Anshelovich**
American, born Belorussia,
1881–1942
Park Fantasy, Autumn, Kiev
c. 1918
Oil on canvas
36 × 35 ¹³/₁₆" (91.4 × 91 cm)

Gift of Christian Brinton
1941-79-98

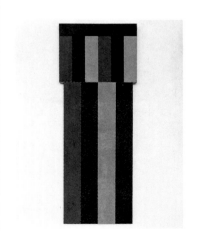

Marden, Brice
American, born 1938
Coda
1983–84
Oil and wax on canvas
120 × 39 × 9"
(304.8 × 99.1 × 22.9 cm)

Purchased with funds contributed
by the Daniel W. Dietrich
Foundation in honor of Mrs. H.
Gates Lloyd, and gifts (by
exchange) of Samuel S. White
3rd and Vera White and Mr. and
Mrs. Charles C. G. Chaplin
1985-22-1

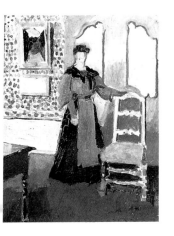

Marinot, Maurice
French, 1882–1960
Helen by a Chair
1904
On reverse: MARINOT / 1904 /
HELENE / A LA CHAISE
Oil on panel
13 × 9¼" (33 × 23.5 cm)

Gift of Mlle Florence Marinot
1967-98-1

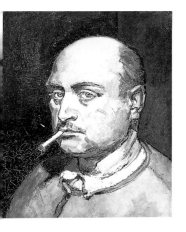

Marinot, Maurice
Self-Portrait
1927
On reverse: 626 / MARINOT /
1927 / AUTO PORTRAIT
Oil on canvas
16¼ × 13⅛" (41.3 × 33.3 cm)

Gift of Mlle Florence Marinot
1967-98-2

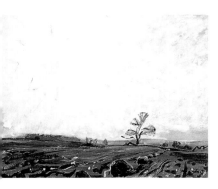

Marinot, Maurice
Landscape
1953
Lower right: Marinot
Oil on cardboard
13 × 16³⁄₁₆" (33 × 41.1 cm)

Gift of Mlle Florence Marinot
1967-98-3

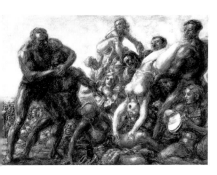

Marsh, Reginald
American, 1898–1954
Coney Island Beach
1932
Lower right: Marsh / 1932
Tempera on Masonite
36⅛ × 48⅛" (91.8 × 122.2 cm)

Gift of the estate of Felicia Meyer
Marsh
1979-98-1

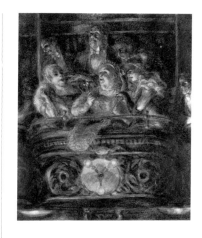

Marsh, Reginald
They Pay to Be Seen
1934
Lower right: REGINALD MARSH
1934
Oil on canvas
23¾ × 19¹⁵⁄₁₆" (60.3 × 50.6 cm)

Bequest of Margaretta S.
Hinchman
1955-96-8

Martin, Agnes
American, born Canada,
born 1912
The Rose
1965
On reverse: "The Rose" / Acryllic
72" × 72" / a. martin '65
Acrylic on canvas
72 × 72" (182.9 × 182.9 cm)

Centennial gift of the Woodward
Foundation
1975-81-11

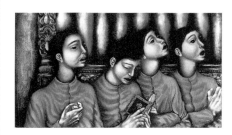

Martínez de Hoyos, Ricardo
Mexican, born 1918
Choir Boys
1942
Lower right: Ricardo Martínez /
de Hoyos 7-42
Oil on canvas
20½ × 34⅝" (52.1 × 87.9 cm)

Gift of Mr. and Mrs. Henry
Clifford
1947-29-2

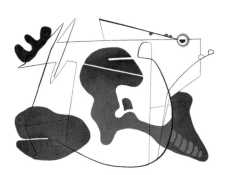

Mason, Alice Trumbull
American, 1904–1971
Brown Shapes White
1941
On reverse: Alice Trumbull
Mason / 40 Monroe St., / New
York City, / Oil Painting 1941
Oil on panel
23¹⁵⁄₁₆ × 31¾" (60.8 × 80.6 cm)

A. E. Gallatin Collection
1952-61-76

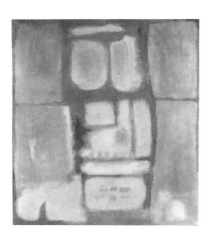

Massey, John L.
American, born 1925
Boy and Balloon
c. 1958
Oil on canvas
50 × 43" (127 × 109.2 cm)

Purchased with the Adele Haas
Turner and Beatrice Pastorius
Turner Memorial Fund
1959-12-5

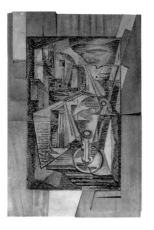

Masson, André
French, 1896–1987
Italian Postcard
The frame was made by Pierre
Legrain (French, 1889–1929)
1925
On reverse: André Masson
Oil on canvas
16 1/4 × 9 7/16" (41.3 × 24 cm)

A. E. Gallatin Collection
1952-61-77

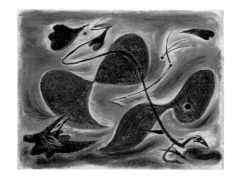

Masson, André
Cockfight
1930
On reverse: André Masson
Oil on canvas
8 9/16 × 10 5/8" (21.7 × 27 cm)

A. E. Gallatin Collection
1952-61-78

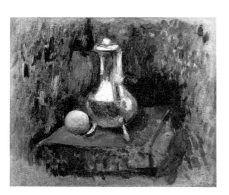

Matisse, Henri
French, 1869–1954
Still Life
c. 1901
Lower right: Henri-Matisse
Oil on canvas
18 1/4 × 22" (46.3 × 55.9 cm)

The Albert M. Greenfield and
Elizabeth M. Greenfield
Collection
1974-178-35

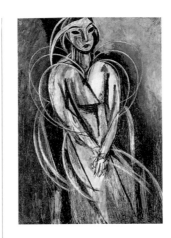

Matisse, Henri
Mademoiselle Yvonne Landsberg
1914
Lower left: Henri-Matisse 1914
Oil on canvas
58 × 38 3/8" (147.3 × 97.5 cm)

The Louise and Walter Arensberg
Collection
1950-134-130

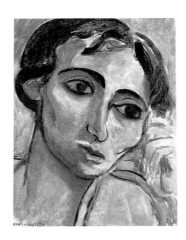

Matisse, Henri
Head of a Woman
1917
Lower left: Henri.Matisse
Oil on panel
13 3/4 × 10 5/8" (34.9 × 27 cm)

The Samuel S. White 3rd and
Vera White Collection
1967-30-52

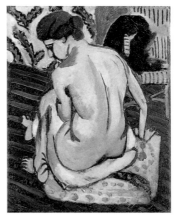

Matisse, Henri
Seated Nude, Back Turned
1917
Lower left: Henri.Matisse
Oil on canvas
24 1/2 × 18 9/16" (62.2 × 47.1 cm)

The Samuel S. White 3rd and
Vera White Collection
1967-30-53

Matisse, Henri
*Interior at Nice (Room at the
Beau Rivage)*
1917–18
Lower right: Henri-Matisse
Oil on canvas
29 × 23 3/4" (73.7 × 60.3 cm)

A. E. Gallatin Collection
1952-61-79

Matisse, Henri
Interior at Nice (Woman Seated in an Armchair)
1919 or 1920
Lower right: Henri.Matisse
Oil on canvas
18 × 25 3/4" (45.7 × 65.4 cm)

Gift of Mr. and Mrs. R. Sturgis Ingersoll
1944-88-1

Matisse, Henri
Still Life (Histoire Juive)
1924
Lower left: Henri-Matisse; on books: HISTOIR[E] / JUIVE; L'AMO / ROMA; PHILO / SOPH / IE
Oil on canvas
32 1/8 × 39 1/2" (81.6 × 100.3 cm)

The Samuel S. White 3rd and Vera White Collection
1967-30-56

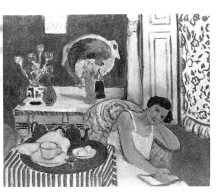

Matisse, Henri
Breakfast
1921
Lower right: Henri Matisse
Oil on canvas
25 1/4 × 29 1/16" (64.1 × 73.8 cm)

The Samuel S. White 3rd and Vera White Collection
1967-30-55

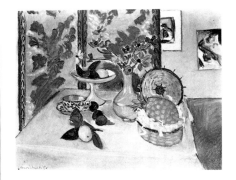

Matisse, Henri
Still Life on a Table
1925
Lower left: Henri-Matisse
Oil on canvas
31 3/4 × 39 1/4" (80.6 × 99.7 cm)

Gift of Henry P. McIlhenny
1964-77-1

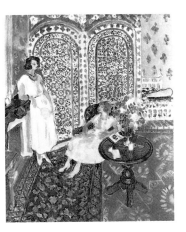

Matisse, Henri
The Moorish Screen
1921
Lower right: Henri Matisse; on reverse: Les Jeunes filles au paravent, Nice, 1922, Henri Matisse
Oil on canvas
36 3/16 × 29 1/4" (91.9 × 74.3 cm)

Bequest of Lisa Norris Elkins
1950-92-9

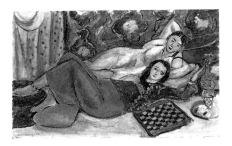

Matisse, Henri
Two Models Resting
1928
Lower left: Henri-Matisse 28
Oil on canvas
18 1/2 × 28 7/8" (47 × 73.3 cm)

Gift of Mrs. Frank Abercrombie Elliott
1964-107-1

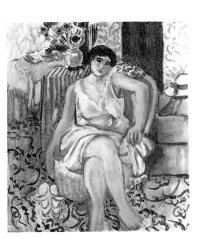

Matisse, Henri
Woman Seated in an Armchair
1923
Lower left: Henri.Matisse
Oil on canvas
18 1/4 × 15 1/2" (46.3 × 39.4 cm)

The Louis E. Stern Collection
1963-181-45

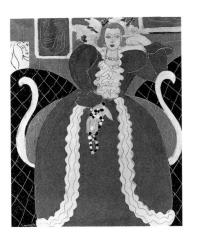

Matisse, Henri
Woman in Blue
1937
Lower left: Henri Matisse / 37
Oil on canvas
36 1/2 × 29" (92.7 × 73.7 cm)

Gift of Mrs. John Wintersteen
1956-23-1

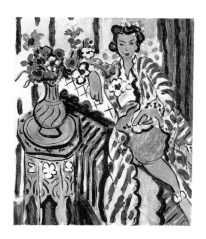

Matisse, Henri
Yellow Odalisque
1937
Lower right: 37 / Henri Matisse
Oil on canvas
21 ³/₄ × 18 ¹/₈" (55.2 × 46 cm)

The Samuel S. White 3rd and
Vera White Collection
1967-30-57

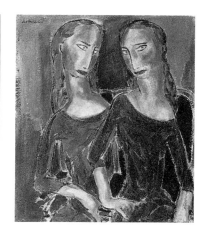

Maurer, Alfred Henry
Two Figures
c. 1925
Upper left: A. H. Maurer
Oil on composition board
21 ⁵/₈ × 18" (54.9 × 45.7 cm)

Gift of Carl Zigrosser
1942-15-1

Matta, Roberto
Chilean, born 1911
The Bachelors Twenty Years After
1943
Oil on canvas
38 × 40" (96.52 × 101.6 cm)

Purchased with the Edith H. Bell
Fund, the Edward and Althea
Budd Fund, gifts (by exchange)
of Mr. and Mrs. William P. Wood
and Bernard Davis, and bequest
(by exchange) of Miss Anna
Warren Ingersoll
1989-51-1

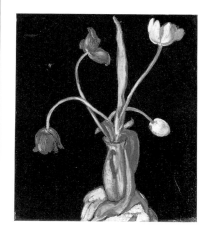

Maurer, Alfred Henry
Vase of Flowers
c. 1925
Center bottom: A.H. Maurer
Oil on canvas on panel
22 × 18 ¹/₈" (55.9 × 46 cm)

Gift of Carl Zigrosser
1972-237-7

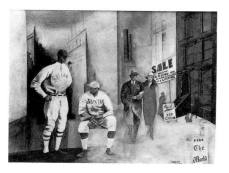

Mauny, Jacques
French, 1893–1962
New York
1925
Lower right: MAUNY / NEW
YORK; on figures: CHICAG[O];
BOSTON; on signs: SALE / NOW /
GOING ON / BIGGEST BARGAINS
/ OF A LIFETIME; Reid's / IT'S
THE BEST / ICE / CREAM; READ
/ The World
Oil on canvas
17 × 21 ³/₈" (43.2 × 54.3 cm)

A. E. Gallatin Collection
1945-14-1

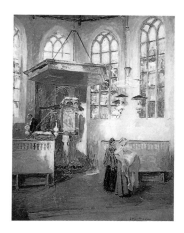

Melchers, Julius Gari
American, 1860–1932
Baptism (Church Interior)
c. 1900
Lower right: Gari Melchers
Oil on canvas
43 ¹/₂ × 33 ³/₁₆" (110.5 × 84.3 cm)

The Alex Simpson, Jr., Collection
1946-5-1

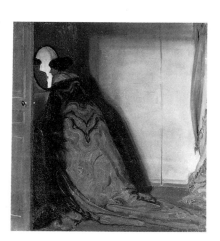

Maurer, Alfred Henry
American, 1868–1932
The Peacock (Portrait of a Woman)
c. 1903
Lower left: Alfred H. / Maurer
Oil on canvas
36 ¹/₁₆ × 32 ³/₈" (91.6 × 82.2 cm)

Purchased with the W. P.
Wilstach Fund
W1903-1-7

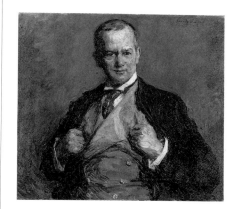

Melchers, Julius Gari
*Portrait of a Friend (Portrait of
Christian Brinton)*
1910
Upper right: Gari Melchers.
Oil on canvas
27 ¹/₈ × 29 ¹⁵/₁₆" (68.9 × 76 cm)

Gift of Christian Brinton
1941-79-81

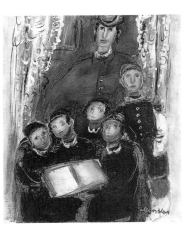

Menkès, Sigmund
American, born Poland,
born 1896
Family Group
c. 1935
Lower right: Menkes
Oil on canvas
25 ⁵/₈ × 21 ¹/₄" (65.1 × 54 cm)

Gift of Bernard Davis
1950-43-2

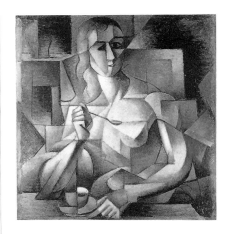

Metzinger, Jean
Tea Time (Woman with a Teaspoon)
1911
Lower right: 1911 / J. Metzinger
Oil on cardboard
29 ⁷/₈ × 27 ⁵/₈" (75.9 × 70.2 cm)

The Louise and Walter Arensberg
Collection
1950-134-139

Merida, Carlos
Guatemalan, 1891–1984
Deer Dance
1935
Center bottom: CARLOS /
MERIDA / 1935
Oil on canvas
24 ³/₁₆ × 20 ³/₁₆" (61.4 × 51.3 cm)

The Louise and Walter Arensberg
Collection
1950-134-134

Metzinger, Jean
The Bathers
1913
Lower right: J. Metzinger; on
reverse: Metzinger "Les
Baigneuses" / Meudon, 1913
Oil on canvas
58 ³/₈ × 41 ⁷/₈" (148.3 × 106.4 cm)

The Louise and Walter Arensberg
Collection
1950-134-140

Metcalf, Willard Leroy
American, 1858–1925
Blossoming Willows
c. 1920
Lower left: W. L. METCALF
Oil on canvas
26 ¹/₄ × 29 ¹/₈" (66.7 × 74 cm)

The Alex Simpson, Jr., Collection
1946-5-2

Metzinger, Jean
Landscape with Roofs
c. 1914
Lower right: JMetzinger
Oil on panel
16 ¹/₈ × 12 ⁷/₈" (41 × 32.7 cm)

The Louise and Walter Arensberg
Collection
1950-134-138

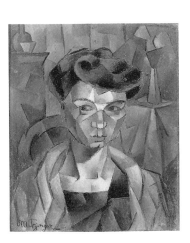

Metzinger, Jean
French, 1883–1956
Portrait of Madame Metzinger
1911
Lower left: JMetzinger
Oil on canvas board on panel
10 ³/₄ × 8 ¹/₂" (27.3 × 21.6 cm)

A. E. Gallatin Collection
1952-61-81

Mexican, unknown artist
Recovery from an Illness
Retable
1927
Center left: Doy gracias al Sr. de
la Penitencia / por haverme
consedido me salud / Ignacio
Ramirez, / Flaquepaque 1927
Oil on tin
7 × 9 ⁷/₈" (17.8 × 25.1 cm)

The Louise and Walter Arensberg
Collection
1950-134-493

Mexican, unknown artist
The Blessing of the Animals
c. 1930
Upper right: LA BENDICION /
DE LOS ANIMALES / EN EL
EXCOMVENTO / DE TAXCO,
EDO. GRO. / EL 17 DE ENERO
DE / 1930.
Oil on panel
9 7/8 × 13 3/8" (25.1 × 34 cm)

Gift of Carl Zigrosser
1972-237-11

**Middle American, unknown
artist**
Delivery from Prison
Retable
After 1902
Across bottom: En Septiembre de
1902 dia 9 sue conducido a la
Carcel por un gran crimen. /
Felipe Servin, y su esposa Justa
Busa y la Sra Madre lo
encomendaron a la / Milagrosa
Imagen de la Madre Sma de
Loreto que lo salvara de tan
grande pelig[ro] / y quedo en
entera libertad y por tan grande
maravailla le dedica este retablo.
Oil on tin
7 × 10" (17.8 × 25.4 cm)

The Louise and Walter Arensberg
Collection
1950-134-813

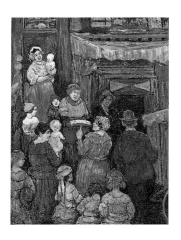

Meyers, Jerome
American, 1867–1940
*The Tambourine (East Side New
York)*
c. 1905
Lower left: JEROME MEYERS
Oil on canvas
15 15/16 × 12" (40.5 × 30.5 cm)

Centennial gift of Mrs. Francis P.
Garvan
1976-164-2

Meza, Guillermo
Mexican, born 1917
Saints Monica and Augustine
c. 1940
Lower right: G. MEZA
Oil on paper on Masonite
18 × 15 1/8" (45.7 × 38.4 cm)

Gift of Dr. and Mrs. MacKinley
Helm
1951-33-1

Mingorance, Juan
Spanish, active Mexico,
active 20th century
Coppers
c. 1960
Lower right: Mingorance
Oil on canvas
27 3/8 × 35 3/8" (69.5 × 89.8 cm)

Gift of Victor Sanchez-Mesas
1963-214-1

Meza, Guillermo
The White Shirt
1946
Lower right: G. Meza. a. / 1946
Oil on canvas
30 1/8 × 43 5/8" (76.5 × 110.8 cm)

Gift of Mrs. Herbert Cameron
Morris
1948-11-1

Miró, Joan
Spanish, 1893–1983
Horse, Pipe, and Red Flower
1920
Lower right: Miró / 1920
Oil on canvas
32 1/2 × 29 1/2" (82.5 × 74.9 cm)

Gift of Mr. and Mrs. C. Earle
Miller
1986-97-1

Miró, Joan
The Hermitage
1924
Lower left: Miró. / 1924.; on
reverse: Joan Miró / L'Ermitage /
1924
Oil?, crayon, and graphite on
canvas
45 × 57 9/16" (114.3 × 146.2 cm)

The Louise and Walter Arensberg
Collection
1950-134-141

Miró, Joan
Painting
1926
Lower right: Miró. / 1926.; on
reverse: Joan Miró. / 1926.
Oil and aqueous medium on
canvas
8 5/8 × 10 5/8" (21.9 × 27 cm)

A. E. Gallatin Collection
1952-61-83

Miró, Joan
Man and Woman
1925
Lower right: Miró. / 1925.;
on reverse: Joan Miró / 1925
Oil? on canvas
39 3/8 × 31 13/16" (100 × 80.8 cm)

The Louise and Walter Arensberg
Collection
1950-134-142

Miró, Joan
Painting (Fratellini)
1927
On reverse: Joan Miró / 1927
Oil and aqueous medium on
canvas
51 1/4 × 38 1/4" (130.2 × 97.1 cm)

A. E. Gallatin Collection
1952-16-1

Miró, Joan
Dog Barking at the Moon
1926
Lower left: Miró. / 1926.; on
reverse: Joan Miró / Chien
aboyant la lune / 1926
Oil on canvas
28 3/4 × 36 1/4" (73 × 92.1 cm)

A. E. Gallatin Collection
1952-61-82

Miró, Joan
Head
1927
Lower right: Miró. / 1927.; on
reverse: Joan Miró / 1927
Oil? and graphite on canvas
57 1/2 × 44 5/8" (146 × 113.3 cm)

The Albert M. Greenfield and
Elizabeth M. Greenfield
Collection
1974-178-37

Miró, Joan
Nude
1926
Center bottom: Miró. / 1926.; on
reverse: Joan Miró / Nu / 1926
Oil on canvas
36 3/8 × 29" (92.4 × 73.7 cm)

The Louise and Walter Arensberg
Collection
1950-134-143

Miró, Joan
Untitled Painting
1927
Lower left: Miró. / 1927.; on
reverse: Joan Miró / 1927
Oil? on canvas
44 11/16 × 57 1/2" (113.5 × 146 cm)

The Albert M. Greenfield and
Elizabeth M. Greenfield
Collection
1974-178-36

Miró, Joan
Man, Woman, and Child
1931
Center bottom: Miró. / 2-31.; on
reverse: Homme, femme et enfant
Oil and/or aqueous medium on
canvas
35 3/16 × 45 3/4" (89.4 × 116.2 cm)

The Louise and Walter Arensberg
Collection
1950-134-144

Mitchell, Joan
American, 1926–1992
Untitled
c. 1960
Oil on canvas
70 3/4 × 63" (179.7 × 160 cm)

Gift of Mr. and Mrs. Joseph
Slifka
1971-264-1

Miró, Joan
Painting
1933
On reverse: Miró 8-3-33
Oil and aqueous medium on
canvas
51 3/8 × 64 1/4" (130.5 × 163.2 cm)

A. E. Gallatin Collection
1952-61-85

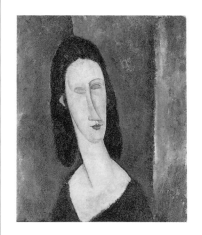

Modigliani, Amedeo
Italian, 1884–1920
*Blue Eyes (Portrait of Madame
Jeanne Hebuterne)*
1917
Upper right: Modigliani
Oil on canvas
21 1/2 × 16 7/8" (54.6 × 42.9 cm)

The Samuel S. White 3rd and
Vera White Collection
1967-30-59

Miró, Joan
Person in the Presence of Nature
1935
Oil and aqueous medium on
panel
29 5/16 × 41 3/16" (74.9 × 104.6 cm)

The Louise and Walter Arensberg
Collection
1950-134-149

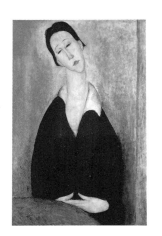

Modigliani, Amedeo
Portrait of a Polish Woman
1919
Upper right: Modigliani
Oil on canvas
39 1/2 × 25 1/2" (100.3 × 64.8 cm)

The Louis E. Stern Collection
1963-181-48

Miró, Joan
Woman in Front of the Sun
1944
On reverse: Miró. / 1944
Oil and aqueous medium on
burlap
13 1/8 × 9 5/8" (33.3 × 24.4 cm)

The Louis E. Stern Collection
1963-181-47

Mondrian, Piet
Dutch, 1872–1944
Composition in Black and Gray
1919
Center bottom: PM / 19
Oil on canvas
23 5/8 × 23 11/16" (60 × 60.2 cm)
diagonal

The Louise and Walter Arensberg
Collection
1950-134-151

Mondrian, Piet
Composition with Blue
1926
Lower left: PM 26
Oil on canvas
24 1/16 × 24 1/16" (61.1 × 61.1 cm)
diagonal

A. E. Gallatin Collection
1952-61-87

Mondrian, Piet
Opposition of Lines, Red and Yellow
1937
Lower left: 37; lower right: PM;
on reverse: PIET MONDRIAN '37.
/ Opposition de lignes, / de rouge
et jaune.
Oil on canvas
17 1/8 × 13 1/4" (43.5 × 33.6 cm)

A. E. Gallatin Collection
1952-61-90

Mondrian, Piet
Composition with Blue and Yellow
1932
Lower right: P M 32; on reverse:
PIET MONDRIAN
Oil on canvas
16 3/8 × 13 1/8" (41.6 × 33.3 cm)

A. E. Gallatin Collection
1952-61-88

Montenegro, Roberto
Mexican, 1881–1968
The Double
1938
Lower left: MONTENEGRO.
Oil on panel
26 × 20" (66 × 50.8 cm)

The Louise and Walter Arensberg
Collection
1950-134-153

Mondrian, Piet
Composition
1936
Lower right: PM 36; on reverse:
P MONDRIAN
Oil on canvas
28 3/4 × 26 1/16" (73 × 66.2 cm)

The Louise and Walter Arensberg
Collection
1950-134-152

**Morris, George Lovett
Kingsland**
American, 1905–1975
Composition
1936
On reverse: George L. K. / Morris
/ 1936
Oil on canvas
8 7/8 × 8 1/8" (22.5 × 20.6 cm)

A. E. Gallatin Collection
1946-70-14

Mondrian, Piet
Composition with White and Red
1936
Center bottom: P M 36; on
reverse: P. MONDRIAN—PARIS /
Composition—blanc et rouge
Oil on canvas
19 7/8 × 20 1/4" (50.5 × 51.4 cm)

A. E. Gallatin Collection
1952-61-89

**Morris, George Lovett
Kingsland**
Composition
1940
Lower right: Morris / 1940
Oil on canvas
30 3/16 × 23 1/8" (76.7 × 58.7 cm)

A. E. Gallatin Collection
1946-70-15

Moses, Ed
American, born 1926
Ill. Hegemann 63
1972
Pigment and resin on canvas
61 × 74" (154.9 × 188 cm)

Purchased with the Adele Haas
Turner and Beatrice Pastorius
Turner Memorial Fund
1975-38-1

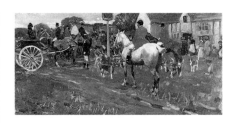

Munnings, Sir Alfred
The Meet
1902
Lower left: A. J. MUNNINGS /
1902
Oil on canvas
10 3/8 × 20" (26.3 × 50.8 cm)

Bequest of Charlotte Dorrance
Wright
1978-1-42

Munnings, Sir Alfred
English, 1878–1959
Going Out
1902
Lower left: A. J. MUNNINGS /
1902
Oil on canvas
10 3/8 × 20 1/8" (26.3 × 51.1 cm)

Bequest of Charlotte Dorrance
Wright
1978-1-41

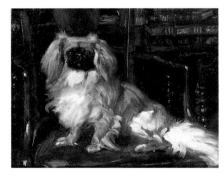

Munnings, Sir Alfred
Pekingese
1909
Center right: A. J. MUNNINGS /
1909.
Oil on panel
12 7/8 × 16" (32.7 × 40.6 cm)

Bequest of Charlotte Dorrance
Wright
1978-1-39

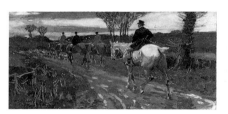

Munnings, Sir Alfred
Homeward Bound
1902
Lower left: A. J. MUNNINGS /
1902
Oil on canvas
10 1/2 × 20 1/4" (26.7 × 51.4 cm)

Bequest of Charlotte Dorrance
Wright
1978-1-43

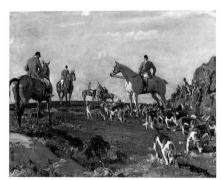

Munnings, Sir Alfred
Hunting on Zennor Hill
c. 1910
Lower left: A. J. MUNNINGS
Oil on canvas
30 5/8 × 35 1/2" (77.8 × 90.2 cm)

Bequest of Charlotte Dorrance
Wright
1978-1-47

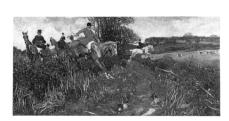

Munnings, Sir Alfred
Racing for the Kill
1902
Lower right: A. J. MUNNINGS /
1902
Oil on canvas
10 1/2 × 20 1/4" (26.7 × 51.4 cm)

Bequest of Charlotte Dorrance
Wright
1978-1-44

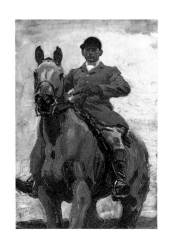

Munnings, Sir Alfred
Portrait of Ned Osborne on Grey Tick
c. 1910
Lower right: A. J. MUNNINGS
Oil on canvas
30 × 20" (76.2 × 50.8 cm)

Bequest of Charlotte Dorrance
Wright
1978-1-46

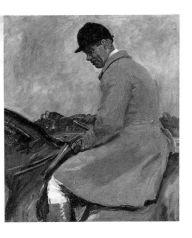

Munnings, Sir Alfred
Portrait of Nobby Grey
c. 1910
Lower right: A. J. MUNNINGS
Oil on canvas
24 3/16 × 20 1/8" (61.4 × 51.1 cm)

Bequest of Charlotte Dorrance
Wright
1978-1-40

Neff, Edith
American, born 1943
The Magi
1978
On reverse: Neff
Oil on canvas
71 × 67 1/2" (180.3 × 171.4 cm)

Purchased with the Julius Bloch
Memorial Fund
1983-1-1

Munnings, Sir Alfred
Welsh Ponies
1911
Lower right: A. J. MUNNINGS /
1911
Oil on canvas
47 × 67" (119.4 × 170.2 cm)

Bequest of Charlotte Dorrance
Wright
1978-1-38

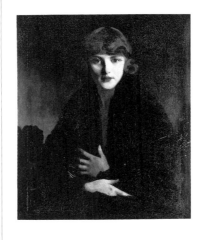

**Neilson, Raymond Perry
Rodgers**
American, 1881–1964
Portrait of a Woman
c. 1925
Lower left: Raymond Neilson
Oil on canvas
30 × 24" (76.2 × 61 cm)

Gift of Rodman A. Heeren
1970-255-20

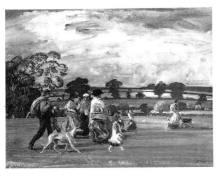

Munnings, Sir Alfred
Hop Pickers, Hampshire
c. 1913
Lower right: A. J. MUNNINGS
Oil on canvas
28 1/8 × 36" (71.4 × 91.4 cm)

Bequest of Charlotte Dorrance
Wright
1978-1-45

**Neilson, Raymond Perry
Rodgers**
Portrait of Miss Margaret Wall
c. 1925
Lower right: Raymond P. R
Neilson
Oil on canvas
36 × 30 1/8" (91.4 × 76.5 cm)

Gift of Rodman A. Heeren
1972-252-21

Murray, Elizabeth
American, born 1940
Just in Time
1981
Oil on canvas
106 × 97" (269.2 × 246.4 cm)

Purchased with the Edward and
Althea Budd Fund, the Adele
Haas Turner and Beatrice
Pastorius Turner Memorial Fund,
and funds contributed by Marion
Boulton Stroud and Lorine E.
Vogt
1981-94-1a, b

Newman, Carl
American, 1858–1932
Landscape
c. 1915
Oil on canvas
25 1/8 × 30 1/8" (63.8 × 76.5 cm)

Gift of Dr. and Mrs. Milton Luria
in memory of Mr. and Mrs.
Samuel Herman
1976-37-1

Newton, Alice M.
American, active c. 1930–c. 1940
Clasped Hands
1930
Lower right: ALICE M. NEWTON
Oil on canvas
12 × 16" (30.5 × 40.6 cm)

Gift of Frank and Alice Osborn
1966-68-32

Nutt, Jim (James Tureman)
American, born 1938
The Cards Were in His Favor
1970–71
Across top: I'm afraid he's taken
something; bottom: time will
tell; on reverse: "The [cards] /
were in his / favour, un. . . ." /
hand-delt and reshuffled By / Jim
Nutt
Acrylic on panel
42 1/2 × 27" (107.9 × 68.6 cm)

Gift of Marion Boulton Stroud
1980-59-1

Newton, Alice M.
White Vase
c. 1930
Lower right: ALICE M. NEWTON
Oil on canvas
20 × 16 1/8" (50.8 × 41 cm)

Gift of Frank and Alice Osborn
1966-68-31

Oakley, Violet
American, 1874–1961
*Sketch for the Right Mural of "The
Heavenly Host"*
For the mural in All Angels
Church, New York
c. 1900
Across top: and saying Holy Holy
Holy Lord God of hosts heaven
and earth / are full of thy glory
Glory be to thee O Lord Most
High Amen
Oil and charcoal on paper on
canvas
45 1/4 × 55 1/2" (114.9 × 141 cm)

Purchased with the Lola Downin
Peck Fund
1981-59-1

Nicholson, Ben
English, 1894–1982
Painting
1936
On reverse: Ben Nicholson 1936
Oil on canvas on panel
15 × 20" (38.1 × 50.8 cm)

A. E. Gallatin Collection
1945-91-4

Oakley, Violet
*Sketch for "The Child and
Tradition"*
For the lunette in the Charlton
Yarnall house, Philadelphia
1910–11
Oil on canvas
36 × 54" (91.4 × 137.2 cm)

Gift of the Violet Oakley
Memorial Foundation
1984-67-3

Noland, Kenneth
American, born 1924
Continue
1967
On reverse: Continue 1967 /
Kenneth Noland
Acrylic on canvas
32 5/8 × 203 1/16" (82.9 × 515.8 cm)

Centennial gift of the Woodward
Foundation
1975-81-12

Oakley, Violet
Sketch for "Wisdom"
For the stained-glass dome in the
Charlton Yarnall house,
Philadelphia
1910–11
Center: WISDOM HATH BUILDED
HER HOUSE; outer circle:
WHOSO FINDETH ME FINDETH
LIFE FOR BY ME THY DAYS
SHALL BE MULTIPLIED
Oil on canvas
101" (256.5 cm) diameter

Gift of the Violet Oakley
Memorial Foundation
1984-67-2

Oakley, Violet
Sketch for "Youth and the Arts"
For the lunette in the Charlton
Yarnall house, Philadelphia
1910–11
Oil on canvas
36 × 54 ³/₁₆" (91.4 × 137.6 cm)

Gift of the Violet Oakley
Memorial Foundation
1984-67-4

O'Keeffe, Georgia
American, 1887–1986
Orange and Red Streak
1919
Oil on canvas
27 × 23" (68.6 × 58.4 cm)

Bequest of Georgia O'Keeffe for
the Alfred Stieglitz Collection
1987-70-3

Oakley, Violet
Sketch for "The Life of Moses"
For the painting in the Samuel S.
Fleisher Art Memorial,
Philadelphia (F29-1)
1927–29
Bottom center: AND THE CHILD
GREW AND HE BECAME HER
SON / AND SHE CALLED HIS
NAME MOSES & SHE SAID /
BECAVSE I DREW HIM OVT OF
THE WATER
Oil on canvas
67 ⁵/₈ × 33 ⁷/₈" (171.7 × 86 cm)

Gift of the Violet Oakley
Memorial Foundation
1984-67-1

O'Keeffe, Georgia
From the Lake No. 3
1924
Oil on canvas
36 × 30" (91.4 × 76.2 cm)

Bequest of Georgia O'Keeffe for
the Alfred Stieglitz Collection
1987-70-2

Oakley, Violet
Traveling Altarpiece
Triptych
1944
Oil on metal
Center panel: 36 × 36 ¼"
(91.4 × 92.1 cm); wings [each]:
36 × 18" (91.4 × 45.7 cm)

Gift of Joseph Flom and Martin
Horwitz
1975-180-1

O'Keeffe, Georgia
Birch and Pine Tree No. 1
1925
Oil on canvas
35 × 22" (88.9 × 55.9 cm)

Bequest of Georgia O'Keeffe for
the Alfred Stieglitz Collection
1987-70-1

Okada, Kenzo
American, born Japan,
1902–1982
Blue Abstraction
c. 1952
Lower right: Kenzo Okada
Oil on canvas
57 ¹/₈ × 69 ⁷/₈" (145.1 × 177.5 cm)

The Albert M. Greenfield and
Elizabeth M. Greenfield
Collection
1974-178-39

O'Keeffe, Georgia
Peach and Glass
1927
Oil on canvas
9 ¹/₈ × 6 ¹/₁₆" (23.2 × 15.4 cm)

Gift of Dr. Herman Lorber
1944-95-4

O'Keeffe, Georgia
Two Calla Lilies on Pink
1928
Oil on canvas
40 × 30" (101.6 × 76.2 cm)

Bequest of Georgia O'Keeffe for
the Alfred Stieglitz Collection
1987-70-4

Oliveira, Nathan
American, born 1928
Standing Figure
1960
Center bottom: Oliveira 60
Oil on canvas
77 1/2 × 71 7/8" (196.8 × 182.6 cm)

Gift of Mr. and Mrs. David N.
Pincus
1968-223-1

O'Keeffe, Georgia
After a Walk Back of Mabel's
1929
Oil on canvas
40 × 30" (101.6 × 76.2 cm)

Gift of Dr. and Mrs. Paul Todd
Makler
1967-38-1

**Omwake, Leon William, Jr.
(EO Omwake)**
American, born 1946
Recodilam Mullic
1972
On reverse: Omwake '72
Recodilam Mullic
Acrylic on canvas
72 1/8 × 61 7/8" (183.2 × 157.2 cm)

Gift of the Cheltenham Art
Centre in memory of Tobeleah
Wechsler
1972-131-1

O'Keeffe, Georgia
Three Small Rocks Big
1937
Oil on canvas
20 × 12" (50.8 × 30.5 cm)

Gift of George Howe
1949-57-1

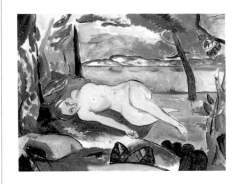

Osborn, Frank
American, 1887–1948
Reclining Nude
1930
Lower right: Frank Osborn
Oil on canvas
16 × 20 9/16" (40.6 × 52.2 cm)

Gift of Frank and Alice Osborn
1966-68-40

O'Keeffe, Georgia
Red Hills and Bones
1941
Oil on canvas
29 3/4 × 40" (75.6 × 101.6 cm)

The Alfred Stieglitz Collection
1949-18-109

Osborn, Frank
Flowers
1933
Lower right: FRANK OSBORN /
1933.
Oil on canvas
23 7/8 × 20 1/8" (60.6 × 51.1 cm)

Gift of Frank and Alice Osborn
1966-68-33

Osborn, Frank
The Poor Man's Picasso
See following painting for reverse
c. 1935
Lower right: BY F. OSBORN /
THE POOR MAN'S PICASSO.
Oil on canvas
16 × 20" (40.6 × 50.8 cm)

Gift of Frank and Alice Osborn
1966-68-41a

Osborn, Frank
Equinox
1937
Lower right: FRANK OSBORN—
37
Oil on canvas
12 × 16" (30.5 × 40.6 cm)

Gift of Frank and Alice Osborn
1966-68-36

Osborn, Frank
Woman Painting a Portrait
Reverse of the preceding painting
c. 1935
Oil on canvas
16 × 20" (40.6 × 50.8 cm)

Gift of Frank and Alice Osborn
1966-68-41b

Osborn, Frank
Still Life No. 2
1937
Lower left: Frank Osborn / 1937
Oil on canvas
16 × 20" (40.6 × 50.8 cm)

Gift of Frank and Alice Osborn
1966-68-39

Osborn, Frank
Tulips in a Pot
c. 1935
Lower right: FRANK OSBORN
Oil on canvas
16 × 12" (40.6 × 30.5 cm)

Gift of Frank and Alice Osborn
1966-68-38

Osborn, Frank
Landscape
c. 1937
Oil on canvas
12 1/16 × 20" (30.6 × 50.8 cm)

Gift of Frank and Alice Osborn
1966-68-42

Osborn, Frank
Abandoned Marble
1936
Lower right: FRANK OSBORN—
36
Oil on canvas
16 × 20" (40.6 × 50.8 cm)

Gift of Frank and Alice Osborn
1966-68-34

Osborn, Frank
Abandoned Marble
1940
Lower right: FRANK OSBORN
1940
Oil on canvas
26 × 32 1/8" (66 × 81.6 cm)

Gift of Frank and Alice Osborn
1966-68-37

Osborn, Frank
Landscape with a Road
c. 1940
Oil on canvas
16 × 20" (40.6 × 50.8 cm)

Gift of Frank and Alice Osborn
1966-68-59

Osborn, Frank
Untitled (Four Horses in a Pasture)
c. 1948
Oil on canvas
16 ⅛ × 20" (41 × 50.8 cm)

Gift of Frank and Alice Osborn
1966-68-58

Osborn, Frank
Marble Remainders
1942
Lower right: FRANK OSBORN
1942
Oil on canvas
26 ⅛ × 34" (66.4 × 86.4 cm)

Gift of Frank and Alice Osborn
1966-68-12

Osborne, Elizabeth
American, born 1936
January Still Life
1967
Lower right: OSBORNE
Oil on canvas
50 × 57 ⁵⁄₁₆" (127 × 145.6 cm)

Gift of the Women's Committee
of the Philadelphia Museum of
Art
1968-39-1

Osborn, Frank
Five Horses
1948
Lower right: FRANK OSBORN
1948
Oil on canvas
16 × 20" (40.6 × 50.8 cm)

Gift of Frank and Alice Osborn
1966-68-43

Ossorio, Alfonso
American, born Philippines,
1916–1990
Time Present
c. 1950
Oil on cardboard collage
36 × 32 ¼" (91.4 × 81.9 cm)

Gift of Mrs. Dorothy Norman
1959-30-1

Osborn, Frank
Untitled (Four Horses in a Pasture)
c. 1948
Oil on canvas
26 × 33 ⅞" (66 × 86 cm)

Gift of Frank and Alice Osborn
1966-68-57

Ossorio, Alfonso
Rescue
1961–62
Mixed media on panel
47 ¹⁵⁄₁₆ × 96 ⅛" (121.8 ×
244.2 cm)

Gift of the artist
1969-294-4

Oudot, Roland
French, born 1897
Portrait of a Young Woman
1929
Upper left: Roland Oudot 1929
Oil on canvas
28 5/8 × 23 5/8" (72.7 × 60 cm)

The Chester Dale Collection
1946-50-4

Palmov, Viktor Nikandrovich
Russian, 1887–1929
Impression of Red Cavalry Driving Petlura from Kiev
1923
Lower right: [Russian for "Palmov"]; on reverse: 1923
Oil on panel
8 7/8 × 11 3/8" (22.5 × 28.9 cm)

Gift of Christian Brinton
1941-79-4

Ozenfant, Amédée
French, 1886–1966
Still Life with a Glass and a Pipe
1919
Lower left: Ozenfant 1919
Oil on canvas
13 3/4 × 10 5/8" (34.9 × 27 cm)

A. E. Gallatin Collection
1952-61-91

Palmov, Viktor Nikandrovich
Village Carpenters
c. 1923
Tempera and oil on panel
40 5/8 × 48 5/8" (103.2 × 123.5 cm)

Gift of Christian Brinton
1941-79-115

Ozenfant, Amédée
Nacres No. 2
1923–26
Lower right: ozenfant
Oil on canvas
51 5/16 × 38" (130.3 × 96.5 cm)

Purchased with the Edith H. Bell
Fund and the Edward and Althea
Budd Fund
1975-170-1

Paone, Peter
American, born 1936
Italian Landscape
1958
Lower left: Paone '58; on reverse:
Italian Landscape Paone
Oil on canvas
40 1/4 × 51" (102.2 × 129.5 cm)

Purchased with the Adele Haas
Turner and Beatrice Pastorius
Turner Memorial Fund
1959-12-6

Palmore, Tommy Dale
American, born 1944
Reclining Nude
1976
On reverse: Palmore 76 /
"Reclining Nude"
Acrylic on canvas
66 × 84" (167.6 × 213.4 cm)

Purchased with the Adele Haas
Turner and Beatrice Pastorius
Turner Memorial Fund and with
funds contributed by Marion
Boulton Stroud
1976-99-1

Parker, Raymond
American, born 1922
Untitled
1960
Lower right: Parker; on reverse:
R. Parker / 1960
Oil on canvas
71 × 47 15/16" (180.3 × 121.8 cm)

Gift of Mr. and Mrs. Joseph
Slifka
1971-264-2

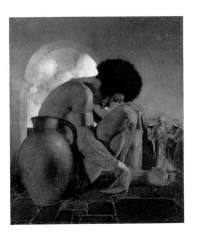

Parrish, Maxfield
American, 1870–1966
Sinbad Plots against the Giant
1907
Oil on cardboard
20 1/8 × 16 1/8" (51.1 × 41 cm)

Centennial gift of Mrs. Francis P.
Garvan
1976-164-3

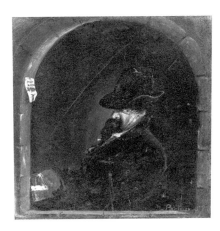

Paxton, W.
American, active c. 1925–c. 1957
Portrait (Bum Bock)
1957
Lower right: Paxton 57
Oil on cardboard
9 × 8 5/8" (22.9 × 21.9 cm)

Gift of Mrs. Louis C. Madeira
and Charles R. Tyson
1965-205-23

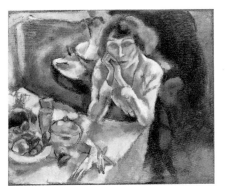

Pascin, Jules
American, born Bulgaria,
1885–1930
Portrait of Madame Pascin [née
Hermine David}
1915–16
Upper left: Pascin
Oil on canvas
21 × 24" (53.3 × 61 cm)

The Samuel S. White 3rd and
Vera White Collection
1967-30-66

Pearlstein, Philip
American, born 1924
*Two Female Models with a Drawing
Table*
1973
Oil on canvas
72 × 60" (182.9 × 152.4 cm)

Purchased with a grant from the
National Endowment for the Arts
and with funds contributed by
private donors
1974-111-1

Pascin, Jules
Woman on a Couch
c. 1925
Lower left: Pascin; on reverse:
PASCIN—Bergere endormie.
Oil on canvas
28 7/8 × 38 1/4" (73.3 × 97.1 cm)

The Samuel S. White 3rd and
Vera White Collection
1967-30-67

Pease, David
American, born 1932
Don't Drink the Water
1968
Acrylic on canvas
67 15/16 × 75" (172.6 × 190.5 cm)

Purchased with the Philadelphia
Foundation Fund
1969-7-1

Pascin, Jules
*Nude in a Blue Turban (Girl in a
Blue Bonnet)*
c. 1928
Lower right: Pascin
Oil and crayon on canvas
36 5/8 × 26" (93 × 66 cm)

The Louis E. Stern Collection
1963-181-51

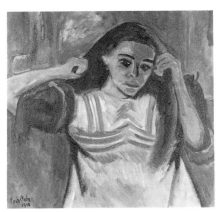

Pechstein, Max
German, 1881–1955
Girl Combing Her Hair
1910
Lower left: Pechstein / 1910;
on reverse: Pechstein / Berlin /
Mädchen
Oil on canvas
28 9/16 × 28 13/16" (72.5 × 73.2 cm)

Purchased with the J. Stogdell
Stokes Fund
1980-61-1

Petersen, Roland Conrad
American, born Denmark,
born 1926
Summer Landscape
1964
Lower left: Roland Petersen
Acrylic on canvas
47 1/4 × 62 1/8" (120 × 157.8 cm)

Purchased with the Adele Haas
Turner and Beatrice Pastorius
Turner Memorial Fund
1968-76-1

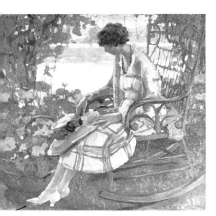

Peterson, Jane
American, 1876–1965
Summertime
c. 1921
Lower right: JANE PETERSON
Oil on canvas
32 1/4 × 32 3/16" (81.9 × 81.8 cm)

Gift of Martin Horwitz
1976-244-1

Picabia, Francis
French, 1879–1953
*Sunlight on the Banks of the Loing
River, Moret*
1905
Lower left: Picabia 1905; on
reverse: Picabia. effet de Soleil
sur les bords du Loing Moret
1908
Oil on canvas
28 13/16 × 36 3/8" (73.2 × 92.4 cm)

The Gertrude Schemm Binder
Collection
1951-84-2

Picabia, Francis
Dances at the Spring
1912
Upper right: DANSES A LA
SOURCE; lower right: Picabia
1912
Oil on canvas
47 7/16 × 47 1/2" (120.5 × 120.6 cm)

The Louise and Walter Arensberg
Collection
1950-134-155

Picabia, Francis
Catch as Catch Can
1913
Upper left: CATCH AS CATCH
CAN; center bottom: EDTAONISL
1913; on reverse: Picabia / 1913
Oil on canvas
39 5/8 × 32 1/8" (100.6 × 81.6 cm)

The Louise and Walter Arensberg
Collection
1950-134-156

Picabia, Francis
Physical Culture
1913
On reverse: Picabia / 1913
Oil on canvas
35 1/4 × 45 7/8" (89.5 × 116.5 cm)

The Louise and Walter Arensberg
Collection
1950-134-157

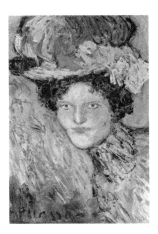

Picasso, Pablo Ruiz
Spanish, 1881–1973
Head of a Woman
1901
Lower left: Picasso
Oil on millboard
18 1/2 × 12" (47 × 30.5 cm)

Bequest of Lisa Norris Elkins
1950-92-11

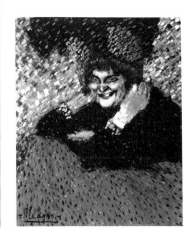

Picasso, Pablo Ruiz
Old Woman (Woman with Gloves)
1901
Lower left: Picasso
Oil on panel
26 3/8 × 20 1/2" (67 × 52.1 cm)

The Louise and Walter Arensberg
Collection
1950-134-158

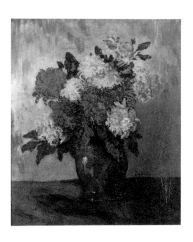

Picasso, Pablo Ruiz
Chrysanthemums
1901
Lower right: Picasso
Oil on canvas
31 15/16 × 25 5/8" (81.1 × 65.1 cm)

Gift of Mrs. John Wintersteen
1964-46-1

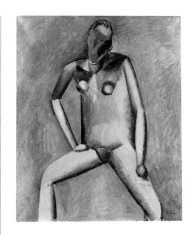

Picasso, Pablo Ruiz
Seated Female Nude
1908–9
Lower right: Picasso
Oil on canvas
45 7/8 × 35 3/16" (116.5 × 89.4 cm)

The Louise and Walter Arensberg
Collection
1950-134-164

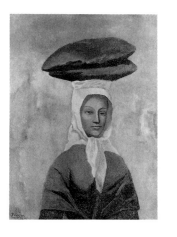

Picasso, Pablo Ruiz
Woman with Loaves
1906
Lower left [added later by the
artist]: Picasso / 1905
Oil on canvas
39 3/16 × 27 1/2" (99.5 × 69.8 cm)

Gift of Charles E. Ingersoll
1931-7-1

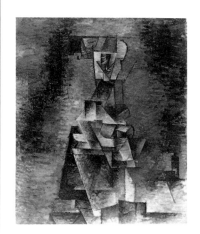

Picasso, Pablo Ruiz
Female Nude
1910
On reverse: Picasso
Oil on canvas
39 7/8 × 30 9/16" (101.3 × 77.6 cm)

The Louise and Walter Arensberg
Collection
1950-134-166

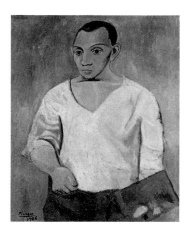

Picasso, Pablo Ruiz
Self-Portrait
1906
Lower left: Picasso / 1906
Oil on canvas
36 3/16 × 28 7/8" (91.9 × 73.3 cm)

A. E. Gallatin Collection
1950-1-1

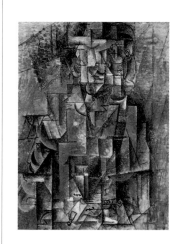

Picasso, Pablo Ruiz
Man with a Violin
1911–12
On reverse [date spurious]:
Picasso / 1910
Oil on canvas
39 3/8 × 28 13/16" (100 × 73.2 cm)

The Louise and Walter Arensberg
Collection
1950-134-168

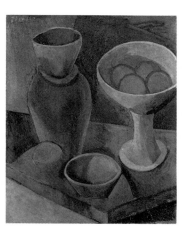

Picasso, Pablo Ruiz
Still Life with Bowls and a Jug
1908
Upper left: Picasso
Oil on canvas
32 1/4 × 25 7/8" (81.9 × 65.7 cm)

A. E. Gallatin Collection
1952-61-93

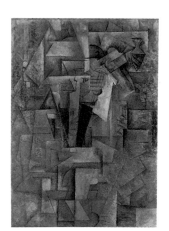

Picasso, Pablo Ruiz
Man with a Guitar
1912
On reverse: Homme Avec une /
guitare / SORGUES 1912 /
Sorgues / Picasso
Oil on canvas
51 13/16 × 35 1/16" (131.6 × 89.1 cm)

The Louise and Walter Arensberg
Collection
1950-134-169

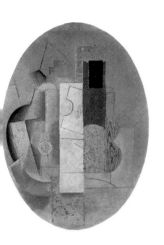

Picasso, Pablo Ruiz
Still Life with a Violin and a Guitar
1913
On reverse: Picasso / 1913
Graphite, plaster, oil, and other
material on canvas
36 1/16 × 25 3/8" (91.6 × 64.4 cm)

The Louise and Walter Arensberg
Collection
1950-134-170

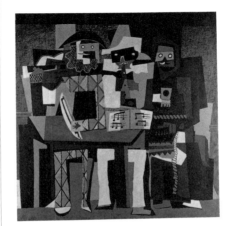

Picasso, Pablo Ruiz
*Still Life with a Vase, a Pipe, and a
Package of Tobacco*
1919
Lower right: Picasso / 19
Oil on canvas
25 5/8 × 21 1/4" (65.1 × 54 cm)

The Samuel S. White 3rd and
Vera White Collection
1967-30-71

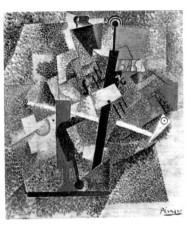

Picasso, Pablo Ruiz
*Still Life with a Pipe, a Violin, and
a Bottle of Bass*
1914
Center: BASS; lower right: Picasso
Oil on canvas
21 13/16 × 18 1/8" (55.4 × 46 cm)

A. E. Gallatin Collection
1952-61-94

Picasso, Pablo Ruiz
Three Musicians
1921
Center left: Fontainebleau /
1921; lower left: Picasso
Oil on canvas
80 1/2 × 74 1/8" (204.5 × 188.3 cm)

A. E. Gallatin Collection
1952-61-96

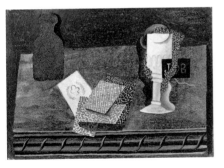

Picasso, Pablo Ruiz
*Still Life with a Bottle, Playing
Cards, and a Wineglass on a Table*
1914
Center: J B; upper right: Picasso /
Avignon / 1914
Oil on panel
12 1/2 × 16 7/8" (31.7 × 42.9 cm)

A. E. Gallatin Collection
1952-61-95

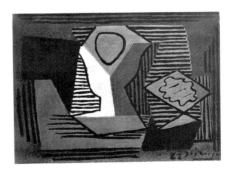

Picasso, Pablo Ruiz
*Still Life with a Glass and a
Package of Tobacco (Composition)*
1922
Lower right: 22 Picasso
Oil on canvas
6 3/8 × 8 5/8" (16.2 × 21.9 cm)

A. E. Gallatin Collection
1952-61-97

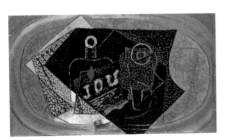

Picasso, Pablo Ruiz
*Still Life with a Bottle, a
Newspaper, and a Glass*
c. 1914
Center: JOU
Oil, graphite, tempera, and cork
on cardboard
11 3/8 × 18 5/8" (28.9 × 47.3 cm)

The Samuel S. White 3rd and
Vera White Collection
1967-30-70

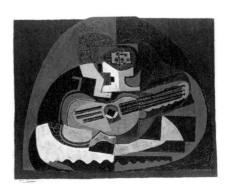

Picasso, Pablo Ruiz
*Still Life with a Guitar and a
Compote (The Mandolin)*
1923
Lower left: Picasso 23
Oil on canvas
31 3/4 × 39 7/16" (80.6 × 100.2 cm)

A. E. Gallatin Collection
1952-61-98

Picasso, Pablo Ruiz
*Bather, Design for a Monument
(Dinard)*
1928
Lower left: Picasso / 28
Oil on canvas
9 1/2 × 6 3/8" (24.1 × 16.2 cm)

A. E. Gallatin Collection
1952-61-99

Picasso, Pablo Ruiz
Woman and Children
1961
Upper left: Picasso
Oil on canvas
57 1/2 × 44 3/4" (146 × 113.7 cm)

Gift of Mrs. John Wintersteen
1964-109-1

Picasso, Pablo Ruiz
Bullfight
1934
Lower left: Boisgeloup 9
September XXXIV; lower right:
Picasso
Oil and sand on canvas
13 × 16 1/8" (33 × 41 cm)

Gift of Henry P. McIlhenny
1957-125-1

Pignon, Édouard
French, 1905–1993
Olive Trees
1959
Lower right: 59 / Pignon
Oil on canvas
25 5/8 × 32 1/16" (65.1 × 81.4 cm)

Gift of Dr. and Mrs. Paul Todd
Makler
1969-174-1

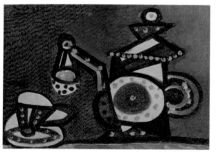

Picasso, Pablo Ruiz
Still Life with a Teapot and a Cup
1953
Upper left: Picasso; on reverse:
1er Juillet 53
Oil on canvas
9 1/2 × 12 15/16" (24.1 × 32.9 cm)

The Louis E. Stern Collection
1963-181-53

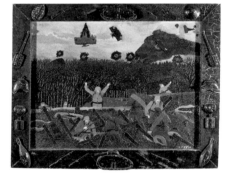

Pippin, Horace
American, 1888–1946
The End of the War: Starting Home
1930–33
Lower right: H. PIPPIN; on
reverse: S-SEP 15TH 1930 /
BY—HORACE PIPPIN / 327
W. GAY. ST / WEST CHESTER
P.A. / F-DEC 21TH. 1933
Oil on canvas
26 × 30 1/16" (66 × 76.4 cm)

Gift of Robert Carlen
1941-2-1

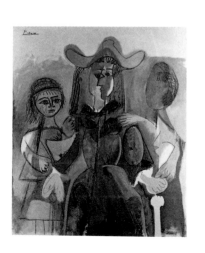

Picasso, Pablo Ruiz
Woman and Children
1961
Upper left: Picasso; on reverse:
20.4.61
Oil on canvas
63 3/4 × 51 3/16" (161.9 × 130 cm)

Gift of Mrs. Herbert Cameron
Morris
1964-89-1

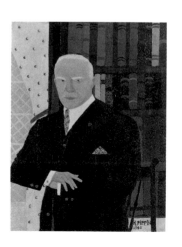

Pippin, Horace
*A Chester County Art Critic
(Portrait of Christian Brinton)*
1940
Lower right: H. PIPPIN / 1940
Oil on canvas
21 1/2 × 15 7/8" (54.6 × 40.3 cm)

Gift of Christian Brinton
1941-79-139

Pippin, Horace
Mr. Prejudice
1943
Lower right: H. PIPPIN, 1943.
Oil on canvas
18 1/8 × 14 1/8" (46 × 35.9 cm)

Gift of Dr. and Mrs. Matthew T. Moore
1984-108-1

Pittman, Hobson L.
Still Life with Anemones in a Pitcher
c. 1960
Upper left: Hobson Pittman
Oil on cardboard
30 × 30 1/8" (76.2 × 76.5 cm)

Bequest of Hobson L. Pittman
1972-238-15

Pittman, Hobson L.
American, 1899–1972
Full Moon
1947–50
Lower right: Hobson Pittman
Oil on cardboard
30 × 40" (76.2 × 101.6 cm)

Purchased with the Bloomfield Moore Fund
1951-31-4

Pittman, Hobson L.
Conversation
1967–69
Upper left: Hobson Pittman
Oil on canvas
48 × 71 5/8" (121.9 × 181.9 cm)

Bequest of Hobson L. Pittman
1972-238-3

Pittman, Hobson L.
Still Life with Letters and a Container
c. 1955
Oil on cardboard
30 × 42" (76.2 × 106.7 cm)

Bequest of Hobson L. Pittman
1972-238-18

Pittman, Hobson L.
Clouds and Petals
Two three-panel screens
c. 1968
Right screen, upper right:
Hobson Pittman
Oil on Masonite
Each panel: 67 3/4 × 17 3/4"
(172.1 × 45.1 cm)

Gift of an anonymous donor
1969-87-1a, b

Pittman, Hobson L.
Still Life with Cards, a White Pitcher, a Cup, and an Orange
1960
Upper right: Hobson Pittman
Oil on Masonite
12 1/8 × 36 13/16" (30.8 × 93.5 cm)

Bequest of Hobson L. Pittman
1972-238-13

Pittman, Hobson L.
Carnations No. 3
1969
Lower left: Hobson Pittman
Oil on Masonite
30 × 42" (76.2 × 106.7 cm)

Bequest of Hobson L. Pittman
1972-238-189

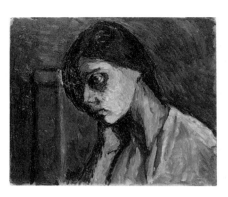

Pogany, Margit
Hungarian, 1879/80–1964
Self-Portrait
1913
Lower right: Pogany
Oil on cardboard
14 7/8 × 18 1/16" (37.8 × 45.9 cm)

Purchased with the Thomas
Skelton Harrison Fund
1966-173-1

Pollock, Jackson
No. 22
1950
Center bottom: J. Pollock. 50
Enamel on Masonite
22 3/16 × 22 3/16" (56.4 × 56.4 cm)

The Albert M. Greenfield and
Elizabeth M. Greenfield
Collection
1974-178-41

Polke, Sigmar
German, born 1941
Ginkgo
1989
Gold, graphite, natural pigments,
and synthetic resin on woven
polyester
102 × 160" (259.1 × 406.4 cm)

Gift of the Friends of the
Philadelphia Museum of Art
1990-39-1

Poons, Larry
American, born 1937
Brown Sound
1968
Acrylic on canvas
96 1/16 × 125 1/4" (244 × 318.1 cm)

Centennial gift of the Woodward
Foundation
1975-81-13

Pollock, Bruce
American, born 1951
Cart
1987
On reverse: Pollock / 1987 /
'Cart'
Acrylic on panel
6 1/2 × 46 1/2" (16.5 × 118.1 cm)

Purchased with the Julius Bloch
Memorial Fund
1988-41-1

Poons, Larry
At Last
1970
On reverse: L. Poons / '72 /
"Hornwell"
Oil on canvas
87 5/8 × 54 5/8" (222.6 × 138.7 cm)

Gift of Mr. and Mrs. J. Welles
Henderson
1983-161-1

Pollock, Jackson
American, 1912–1956
Male and Female
c. 1942
Oil on canvas
73 1/4 × 48 15/16" (186 × 124.3 cm)

Gift of Mr. and Mrs. H. Gates
Lloyd
1974-232-1

Porter, Katherine
American, born 1941
Truth Rescued from Romance
1980
On reverse: Truth Rescued From
Romance
Oil on canvas
86 3/8 × 88 5/8" (219.4 × 225.1 cm)

Purchased with the Edward and
Althea Budd Fund
1981-44-1

Portinari, Candido
Brazilian, 1903–1962
Discovery of Brazil
1941
Lower left: PORTINARI / 1941
Oil on canvas
28³/₄ × 23¹/₂" (73 × 59.7 cm)

Gift of Dr. Robert C. Smith
1970-253-1

Prendergast, Maurice B.
The Harbor
1914
Lower left: Prendergast
Oil on canvas
24⁵/₁₆ × 30¹/₄" (61.7 × 76.8 cm)

Gift of Mr. and Mrs. Philip
Newman
1983-64-1

Pousette-Dart, Richard
American, 1916–1992
White Gothic No. 3
1957
Oil on canvas
97³/₁₆ × 64⁷/₈" (246.9 × 164.8 cm)

The Albert M. Greenfield and
Elizabeth M. Greenfield
Collection
1974-178-42

Prendergast, Maurice B.
Sunday Promenade
1922
Lower left: Prendergast
Oil on canvas
24 × 32" (61 × 81.3 cm)

Gift of Mr. and Mrs. Meyer P.
Potamkin (reserving life interest)
1964-116-1

Prendergast, Maurice B.
American, 1859–1924
Seated Nude
c. 1905
Oil on canvas
24 × 19" (61 × 48.3 cm)

Gift of Mrs. Eugénie Prendergast
1964-104-1

"I eat politics and I sleep politics, but I never drink politi..."

Prince, Richard
American, born 1949
Untitled
1991
Across bottom: "I eat politics and
I sleep politics, but I never drink
politics."
Acrylic, silk screen, and graphite
on canvas
99¹/₂ × 116" (252.7 × 294.6 cm)

Purchased with a grant from the
National Endowment for the Arts,
with matching funds from various
donors, and funds from the Adele
Haas Turner and Beatrice Pastorius
Turner Memorial Fund
1991-51-1

Prendergast, Maurice B.
Night Study of Flowers
1912
Lower right: Prendergast; on
reverse: "NIGHT STUDY OF
FLOWERS" / MAURICE B.
PRENDERGAST. / 1912
Oil on panel
10¹/₂ × 13⁷/₈" (26.7 × 35.2 cm)

Gift of Mrs. Charles Prendergast
in memory of Henry Clifford
1975-119-1

Rattner, Abraham
American, 1895–1978
Gargoyle in Flames No. 2
1961
Center bottom: RATTNER '61
Oil on canvas
51¹/₄ × 38¹/₄" (130.2 × 97.1 cm)

Gift of Mr. and Mrs. Barry R.
Peril
1971-266-1

Rauschenberg, Robert
American, born 1925
K 24976 S
1952
On reverse: RAUSCHENBERG
1952 1 of 4 3' by 3' [three times]
/ 61 FULTON STREET—N.Y.C. /
RAUSCHENBERG PAINTING—
1952.
Oil, cloth, metal, paper, and
wood on four canvases
72 × 72" (182.9 × 182.9 cm)
overall

Gift of Mr. and Mrs. N. Richard
Miller
1967-217-1

Ray, Man
A.D. 1914
1914
Lower right: ADMCMXIV /
man ray
Oil on canvas
36 7/8 × 69 3/4" (93.7 × 177.2 cm)

A. E. Gallatin Collection
1944-90-1

Rauschenberg, Robert
Estate
1963
Lower left, on space capsule:
UNITED / [S]TATES; center, on
signs: NASSAU ST; PINE ST.;
ONE WAY; ONE; PUBLIC /
SHELTER; STOP; on reverse:
Robert Rauschenberg, 1963
Oil and silk-screened inks on
canvas
96 × 69 13/16" (243.8 × 177.3 cm)

Gift of the Friends of the
Philadelphia Museum of Art
1967-88-1

Ray, Man
Still Life
1915
Lower right: Man Ray / 1915
Oil on cardboard
18 1/2 × 12 1/4" (47 × 31.1 cm)

A. E. Gallatin Collection
1946-70-17

Rauschenberg, Robert
Flush
1964
Oil and silk-screened inks on
canvas
95 3/16 × 71 5/16" (241.8 × 181.1 cm)

Centennial gift of the Woodward
Foundation
1975-81-14

Ray, Man
Ecila for Alice
1962–64
Acrylic on cardboard
9 3/4 × 7" (24.8 × 17.8 cm)

Gift of John Rewald
1985-62-1

Ray, Man
American, active France,
1890–1976
Still Life with a Teapot
c. 1910
Lower left: man / ray
Oil on canvas board
8 1/4 × 10 5/16" (20.9 × 26.2 cm)

Gift of Frank and Alice Osborn
1966-68-15

Ray, Rudolf
American, 1891–1984
Nanda Devi (Almora, Himalayas)
1959
On reverse: Nanda DEVI / Rudol
Ray / Almora Himalyas / 1959
Burned charcoal and ground
white rock on panel
15 1/4 × 41" (38.7 × 104.1 cm)

Gift of an anonymous donor
1978-123-2

Ray, Rudolf
Sarita
1968–69
On reverse: Rudolf Ray /
Tepoztlan / 1968/9
Oil on canvas on panel
39 $^{1}/_{16}$ × 61 $^{1}/_{16}$" (99.2 × 155.1 cm)

Gift of an anonymous donor
1983-213-1

Redfield, Edward Willis
Overlooking the Delaware
c. 1919
Lower left: E. W. REDFIELD
Oil on canvas
38 × 50 $^{1}/_{4}$" (96.5 × 127.6 cm)

Gift of Mr. and Mrs. J. Stogdell
Stokes
1931-40-1

**Reckless, Stanley L.
(Stanley L. Zbytneiwski)**
American, born 1892, death date
unknown
*Portrait of Brigadier General
Casimir Pulaski*
c. 1915–25
Lower right: STAN
ZBYTNEIWSKI / RECKLESS
Oil on canvas
24 × 21 $^{3}/_{16}$" (61 × 53.8 cm)

Commissioners of Fairmount
Park
F1926-3-1

Reinhardt, Ad
American, 1913–1967
Abstraction
c. 1940
Lower right: REINHARDT
Oil on panel
24 $^{7}/_{8}$ × 30 $^{3}/_{4}$" (63.2 × 78.1 cm)

A. E. Gallatin Collection
1946-70-2

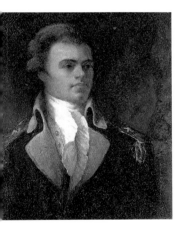

Reckless, Stanley L.
*Portrait of Colonel Thaddeus
Kosciusko*
1926
Lower right: STAN Zbytneiwski /
Reckless; on reverse: STANLEY L.
/ RECKLESS / 1926.
Oil on canvas
24 $^{1}/_{8}$ × 20 $^{1}/_{16}$" (61.3 × 51 cm)

Commissioners of Fairmount
Park
F1926-3-2

Reinhardt, Ad
Abstraction No. 12
1950
Lower right: REINHARDT '50;
on reverse: AD REINHARDT
Oil on canvas
40 $^{1}/_{16}$ × 59 $^{7}/_{8}$" (101.8 × 152.1 cm)

Gift of Mr. and Mrs. Gerrish H.
Milliken
1978-177-1

Redfield, Edward Willis
American, 1869–1965
The Day before Christmas
1919
Lower right: E. W. REDFIELD
DEC. 24, 19.
Oil on canvas
50 × 55 $^{13}/_{16}$" (127 × 141.8 cm)

Gift of the Art Club of
Philadelphia
1928-37-1

Reinhardt, Ad
Black Cross
1967
Oil on panel
11 $^{3}/_{8}$ × 10 $^{1}/_{8}$" (28.9 × 25.7 cm)

Gift of the Kulicke family in
memory of Lt. Frederick W.
Kulicke III
1969-86-4

Remenick, Seymour
American, born 1923
Still Life, Artist's Studio
1951
Lower right: REMENICK
Oil on canvas
18 1/8 × 24" (46 × 61 cm)

Gift of Benjamin D. Bernstein
1964-106-5

Remenick, Seymour
Fairmount Waterworks
c. 1962
Lower left: REMENICK
Oil on panel
14 × 18" (35.6 × 45.7 cm)

Gift of Benjamin D. Bernstein
1964-106-4

Remenick, Seymour
Rooftops, Philadelphia
1954
Lower right: REMENICK
Oil on canvas
28 × 32" (71.1 × 81.3 cm)

Gift of Benjamin D. Bernstein
1964-106-3

Ricciardi, Cesare A.
American, born Italy,
born 1892, still active 1925
Portrait of Joshua Cope
c. 1930
Lower right: C. A. Ricciardi
Oil on canvas
30 × 24" (76.2 × 61 cm)

Gift of Mrs. Cesare Ricciardi
1974-233-1

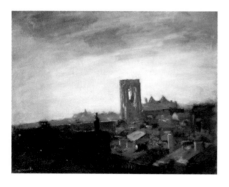

Remenick, Seymour
Church Tower
c. 1954
Lower left: REMENICK
Oil on canvas
21 × 25 7/8" (53.3 × 65.7 cm)

The Albert M. Greenfield and
Elizabeth M. Greenfield
Collection
1974-178-44

Richenberg, Robert
American, born 1917
Untitled
1962
On reverse: Robert Richenberg
1962
Oil and newspaper on panel
72 × 40 1/8" (182.9 × 101.9 cm)

Gift of Mr. and Mrs. David N.
Pincus
1965-218-1

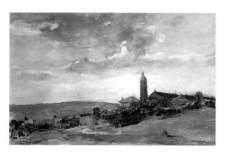

Remenick, Seymour
Holy Family Church, Manayunk
c. 1957
Lower right: REMENICK
Oil on panel
10 × 15 7/16" (25.4 × 39.2 cm)

The Albert M. Greenfield and
Elizabeth M. Greenfield
Collection
1974-178-43

Riopelle, Jean-Paul
Canadian, 1923–1990
Abstraction (Orange)
1952
Lower right: Riopelle; on reverse:
Riopelle, J. P. 5-52
Oil on canvas
37 3/4 × 76 5/8" (95.9 × 194.6 cm)

Gift of Mr. and Mrs. R. Sturgis
Ingersoll
1964-30-1

Riopelle, Jean-Paul
Abstraction (Green)
1952
On reverse: Riopelle, 1952
Oil on canvas
59 × 78 ³/₄" (150 × 200 cm)

Gift of Mr. and Mrs. R. Sturgis
Ingersoll
1966-190-1

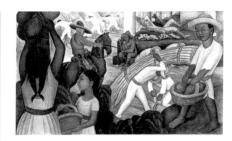

Rivera, José Diego Maria
Sugar Cane
1931
Fresco
57 ¹/₈ × 94 ¹/₈" (145.1 × 239.1 cm)

Gift of Mr. and Mrs. Herbert
Cameron Morris
1943-46-2

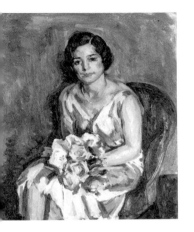

Ritman, Louis
American, born Ukraine,
1889–1963
Portrait of Irene Hudson (Mrs. Louis E. Stern)
c. 1930
Lower right: RITMAN
Oil on panel
18 ¹/₄ × 15 ³/₈" (46.3 × 39 cm)

The Louis E. Stern Collection
1963-181-60

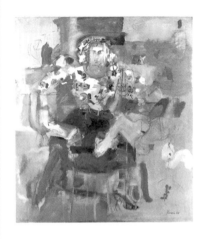

Rivers, Larry
American, born 1923
Blue (The Byzantine Empress)
1958
Lower right: Rivers '58
Oil on canvas
70 × 69" (177.8 × 175.3 cm)

The Albert M. Greenfield and
Elizabeth M. Greenfield
Collection
1974-178-45

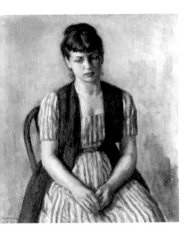

Ritman, Louis
Woman in a Striped Dress
c. 1930
Lower left: L RITMAN
Oil on canvas
35 ⁷/₈ × 30" (91.1 × 76.2 cm)

Gift of Louis E. Stern
1945-15-1

Rockburne, Dorothea
American, born Canada,
born 1934
Robe Series, the Descent
1976
Gesso, varnish, glue, and oil on
linen
52 × 29" (132.1 × 73.7 cm)

Purchased with the Adele Haas
Turner and Beatrice Pastorius
Turner Memorial Fund
1978-68-1

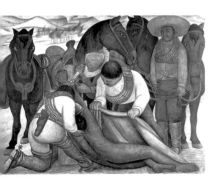

Rivera, José Diego Maria
Mexican, 1886–1957
Liberation of the Peon
1931
Fresco
73 × 94 ¹/₄" (185.4 × 239.4 cm)

Gift of Mr. and Mrs. Herbert
Cameron Morris
1943-46-1

**Roerich, Nicholas
Konstantinovich**
Russian, 1874–1947
Village of the Berendey
c. 1919
Lower left: [artist's monogram in
Russian]
Oil on linen
24 ¹/₂ × 36 ¹⁵/₁₆" (62.2 × 93.8 cm)

Gift of Christian Brinton
1941-79-71

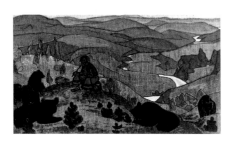

Roerich, Nicholas Konstantinovich
Our Forefathers
c. 1920
Lower left: [artist's monogram in Russian]
Tempera on burlap
18 7/8 × 31 1/8" (47.9 × 79.1 cm)

Gift of Christian Brinton
1941-79-67

Rohrer, Warren
Settlement Magenta
1980
On reverse: "Settlement Magenta" 1980 W. Rohrer
Oil on canvas
72 1/16 × 72 1/8" (183 × 183.2 cm)

Purchased with funds contributed by Henry Strater and Marion Boulton Stroud
1982-46-1

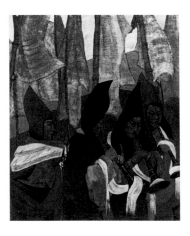

Roerich, Svyatoslav Nikolaievich
Russian, born 1904
Tibetan Red-Sect Lamas at a Ceremony
c. 1925
Lower left: [artist's monogram in Russian]; on reverse: TO DR. CHRISTIAN BRINTON. / TIBETAN RED SECT MUSICIANS AT CEREMONY / BY SVYATOSLAV NIKOLAIEVICH / ROERICH
Oil on composition board
37 × 24 3/8" (94 × 61.9 cm)

Gift of Christian Brinton
1941-79-148

Rollins, Tim
American, born 1955
and K.O.S. (Kids of Survival)
Amerika VII
1986–87
Metallic paint, opaque watercolor, and black crayon on paper with printed text mounted on linen
64 × 169" (162.6 × 429.3 cm)

Purchased with funds contributed by Mr. and Mrs. Harvey Gushner, Mr. and Mrs. Leonard Korman, Mr. and Mrs. David N. Pincus, and Marion Boulton Stroud
1987-31-1

Roger, Suzanne
French, born 1899/1900
Wedding amid Ruins
1952
Lower left: Suzanne Roger
Oil on canvas
28 1/2 × 23 3/8" (72.4 × 59.4 cm)

The Albert M. Greenfield and Elizabeth M. Greenfield Collection
1974-178-46

Rosen, Charles
American, 1878–1950
The Delaware in Winter
c. 1918
Lower left: CHARLES ROSEN
Oil on canvas
31 7/8 × 40" (81 × 101.6 cm)

The Alex Simpson, Jr., Collection
1928-63-8

Rohrer, Warren
American, born 1927
November
1973
On reverse: 'November' W. Rohrer 1973
Oil on canvas
66 × 66 1/4" (167.6 × 168.3 cm)

Gift of Rachel Seymour and Gene Locks
1974-77-1

Rosenquist, James
American, born 1933
Zone
1961
Oil on two canvas sections
Each section: 95 × 47 11/16" (241.3 × 121.1 cm)

Purchased with the Edith H. Bell Fund
1982-9-1

Roth, David
American, born 1942
Full Color Painting
1970
Acrylic on string
84 × 74" (213.4 × 188 cm)

Gift of Mr. and Mrs. N. Richard
Miller
1985-86-1

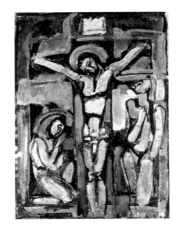

Rouault, Georges
The Crucifixion
c. 1918
Lower right: G Rouault
Oil and gouache on paper
41 ¼ × 29 ⅝" (104.8 × 75.2 cm)

Gift of Henry P. McIlhenny
1964-77-2

Rothko, Mark
American, born Latvia,
1903–1970
Gyrations on Four Planes
1944
Lower right: MARK ROTHKO
Oil on canvas
24 × 48" (61 × 121.9 cm)

Gift of the Mark Rothko
Foundation, Inc.
1985-19-3

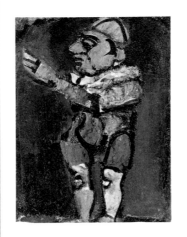

Rouault, Georges
Polichinelle
c. 1930
Oil on paper on canvas
28 ¾ × 20 ⁹⁄₁₆" (73 × 52.2 cm)

The Louise and Walter Arensberg
Collection
1950-134-174

Rothko, Mark
Untitled
1955
Oil on canvas
68 ¹⁄₁₆ × 45 ¼" (172.9 × 114.9 cm)

Gift of the Mark Rothko
Foundation, Inc.
1985-19-2

Rouault, Georges
Scene from the Life of Christ
1935–38
Oil on panel
16 ⅜ × 11 ⅝" (41.6 × 29.5 cm)

The Louis E. Stern Collection
1963-181-62

Rouault, Georges
French, 1871–1958
At the Circus (The Mad Clown)
1907
Oil on cardboard
29 ⁹⁄₁₆ × 22 ½" (75.1 × 57.1 cm)

The Louis E. Stern Collection
1963-181-61

Rouault, Georges
Pierrot with a Rose
c. 1936
Oil on canvas
36 ½ × 24 ⁵⁄₁₆" (92.7 × 61.7 cm)

The Samuel S. White 3rd and
Vera White Collection
1967-30-76

Rouault, Georges
Christ
c. 1938
Lower right: G. Rouault
Oil on canvas
19 3/8 × 15 7/8" (49.2 × 40.3 cm)

The Samuel S. White 3rd and
Vera White Collection
1967-30-79

Rousseau, Henri-Julien-Félix
Farm
c. 1899
Lower left: H. Rousseau
Oil on canvas
13 × 10 3/8" (33 × 26.3 cm)

The Samuel S. White 3rd and
Vera White Collection
1967-30-80

Rousseau, Henri-Julien-Félix
French, 1844–1910
Carnival Evening
1886
Lower right: H. Rousseau
Oil on canvas
46 3/16 × 35 1/4" (117.3 × 89.5 cm)

The Louis E. Stern Collection
1963-181-64

Rousseau, Henri-Julien-Félix
Still Life with Flowers
c. 1905
Lower left: H Rousseau.
Oil on paper on canvas
13 × 9 1/2" (33 × 24.1 cm)

The Louis E. Stern Collection
1963-181-65

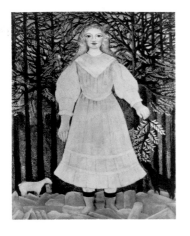

Rousseau, Henri-Julien-Félix
Young Girl in Pink
1893–95
Oil on canvas
24 × 18" (61 × 45.7 cm)

Gift of Mr. and Mrs. R. Sturgis
Ingersoll
1938-38-1

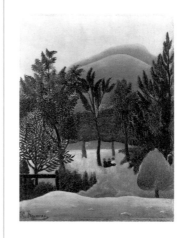

Rousseau, Henri-Julien-Félix
Landscape
1905–10
Lower left: H. Rousseau
Oil on canvas
18 1/4 × 12 3/4" (46.3 × 32.4 cm)

The Louise and Walter Arensberg
Collection
1950-134-177

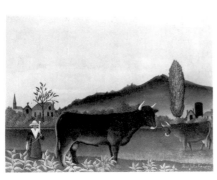

Rousseau, Henri-Julien-Félix
Landscape with Cattle
1895–1900
Lower right: Henri Julien
Rousseau
Oil on canvas
20 1/16 × 26" (51 × 66 cm)

The Louise and Walter Arensberg
Collection
1950-134-175

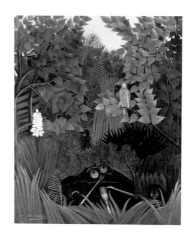

Rousseau, Henri-Julien-Félix
The Merry Jesters
1906
Lower left: Henri Julien Rousseau
Oil on canvas
57 3/8 × 44 5/8" (145.7 × 113.3 cm)

The Louise and Walter Arensberg
Collection
1950-134-176

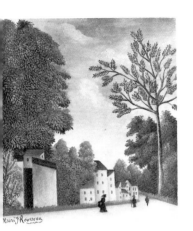

Rousseau, Henri-Julien-Félix
Village Street
1909–10
Lower left: Henri J. Rousseau
Oil on canvas
17 1/8 × 14 1/8" (43.5 × 35.9 cm)

The Louise and Walter Arensberg
Collection
1950-134-178

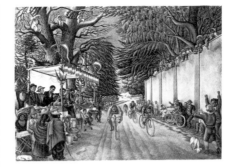

Ruiz, Antonio
Mexican, 1897–1964
Bicycle Race
1938
Lower right: A. Ruiz 1938
Oil on canvas
13 1/8 × 17" (33.3 × 43.2 cm)

Purchased with the Nebinger
Fund
1949-24-1

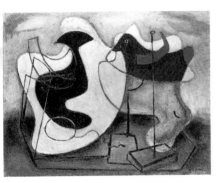

Roux, Gaston-Louis
French, born 1904
Composition
1927
Lower right: G. L. ROUX.
Oil on canvas
14 15/16 × 18 1/16" (37.9 × 45.9 cm)

A. E. Gallatin Collection
1946-70-5

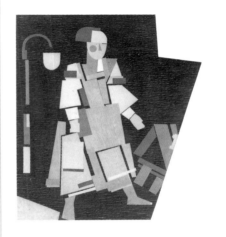

Russian, unknown artist
Milkmaid and Model Barn
Painted by students at the
Leningrad Institute
c. 1925–35
Tempera on paper on panel
27 3/8 × 22 1/4" (69.5 × 56.5 cm)

Gift of Christian Brinton
1941-79-2

Roy, Pierre
French, 1880–1950
Metric System
c. 1933
Across top, on portraits:
DELAMERE; MECHAIN;
lower right: P. Roy
Oil on canvas
57 5/8 × 39" (146.4 × 99.1 cm)

The Louise and Walter Arensberg
Collection
1950-134-179

Russian, unknown artist
Muzhik and Tractor
Painted by students at the
Leningrad Institute
c. 1925–35
Tempera on paper on panel
27 1/2 × 22 1/2" (69.8 × 57.1 cm)

Gift of Christian Brinton
1941-79-1

Rubin, Reuven
Israeli, born Rumania,
1893–1974
The Road to Bethlehem
1939
Lower left: RIKI / Rubin; on
reverse: RUBIN—The Road to
Bethlehem 1939
Oil on canvas
21 3/8 × 28 3/4" (54.3 × 73 cm)

The Louis E. Stern Collection
1963-181-66

Salemme, Attilio
American, 1911–1955
The Oracle
1950
Lower right: Attilio Salemme /
'50
Oil on canvas
48 × 72" (121.9 × 182.9 cm)

Gift of Mrs. H. Gates Lloyd
1956-5-1

Sander, Ludwig
American, 1906–1975
Adirondacks I
1971
On reverse: Sander / 1971 /
L. S 312
Oil on canvas
40 1/8 × 44 1/8" (101.9 × 112.1 cm)

Gift of the Childe Hassam Fund
of the American Academy and
Institute of Arts and Letters
1974-10-1

**Schamberg, Morton
Livingston**
*Painting IV (Mechanical
Abstraction)*
See following painting for reverse
1916
Lower right: Schamberg / 1916
Oil on panel
13 3/4 × 10 3/4" (34.9 × 27.3 cm)

The Louise and Walter Arensberg
Collection
1950-134-180a

Saÿen, Henry Lyman
American, 1875–1918
Fir Trees
1915–16
On reverse: H. Lyman Sayen.
S. 312
Oil on canvas
25 × 30" (63.5 × 76.2 cm)

Gift of the National Collection of
Fine Arts
1972-123-1

**Schamberg, Morton
Livingston**
Landscape
Reverse of the preceding painting
c. 1916
Oil on canvas
13 3/4 × 10 3/4" (34.9 × 27.3 cm)

The Louise and Walter Arensberg
Collection
1950-134-180b

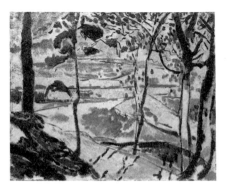

**Schamberg, Morton
Livingston**
American, 1881–1918
Boulevard in Paris
1908
On reverse: Paris 1908 /
Schamberg
Oil on cardboard
6 × 8" (15.2 × 20.3 cm)

Bequest of Jean L. Whitehill
1986-9-1

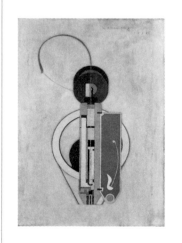

**Schamberg, Morton
Livingston**
*Painting VIII (Mechanical
Abstraction)*
1916
Upper right: Schamberg / 1916
Oil on canvas
30 1/8 × 20 1/4" (76.5 × 51.4 cm)

The Louise and Walter Arensberg
Collection
1950-134-181

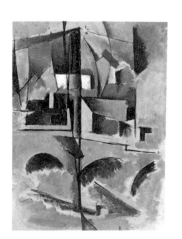

**Schamberg, Morton
Livingston**
Landscape Bridge
1915
Oil on panel
13 3/4 × 10" (34.9 × 25.4 cm)

Gift of Dr. and Mrs. Ira Leo
Schamberg
1969-228-1

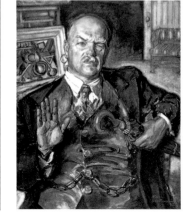

**Schattenstein, Nikol
Ovseyvich**
American, born Lithuania,
1879–1954
*Portrait of David Davidovich
Burliuk, Father of Russian Cubo-
Futurism*
c. 1930
Lower right: Nikol. /
Schattenstein / N.Y.
Oil on canvas
37 × 27 3/4" (94 × 70.5 cm)

Gift of Christian Brinton
1941-79-111

Schattenstein, Nikol Ovseyvich
Adoration of Moscow (Portrait of Christian Brinton)
1932
Across top: [Russian for "The Little Pope"]; lower right: Nikol. / Schattenstein / N.Y. / 1932.
Oil on canvas
49 15/16 × 40 1/8" (126.8 × 101.9 cm)

Gift of Christian Brinton
1941-79-335

Schwartz, Manfred
American, born Poland, 1909–1970
The Finding of Moses
c. 1955
Lower right: Manfred Schwartz
Oil on canvas
26 × 36 1/8" (66 × 91.8 cm)

Gift of the M. L. Annenberg Foundation
1955-51-1

Schock, Maya
American, born Japan, 1928–1975
Fantasia No. 5
1973
Lower left: [artist's signature in Japanese]
Oil on canvas
29 15/16 × 29 7/8" (76 × 75.9 cm)

Gift of Benjamin D. Bernstein
1975-163-1

Schwedler, William
American, 1942–1982
Bad Reception
1976
On reverse: WM. SCHWEDLER / 1976 / "BAD / RECEPTION"
Oil, acrylic, and charcoal on canvas
60 × 70 1/8" (152.4 × 178.1 cm)

Gift of Frederic Mueller
1978-29-1

Schofield, Walter Elmer
American, active England, 1869–1944
Winter in Picardy
1907
Lower right: Schofield— / '07
Oil on canvas
38 1/2 × 48" (97.8 × 121.9 cm)

Gift of Dr. and Mrs. George Woodward
1939-7-18

Sefarbi, Harry
American, born 1917
Group at a Table
c. 1960
Lower left: Sefarbi
Oil on Masonite
14 × 16" (35.6 × 40.6 cm)

Gift of Young America Preserves, Inc.
1976-152-2

Schumacher, Emil
German, born 1912
Nambit
1959
Lower right: 59 / E. Schumacher
Oil on canvas
31 9/16 × 23 5/8" (80.2 × 60 cm)

Gift of Mr. and Mrs. Arthur A. Goldberg
1971-218-1

Sefarbi, Harry
Triptych
c. 1960
Oil on Masonite
Center panel: 16 × 11 15/16" (40.6 × 30.3 cm); left wing: 16 × 6" (40.6 × 15.2 cm); right wing: 16 × 5 7/8" (40.6 × 14.9 cm)

Gift of Young America Preserves, Inc.
1976-152-1

Sekoto, G.
American?, active 20th century
Four Children
c. 1955
Lower right: G. SEKOTO
Oil on canvas
24 × 19 5/8" (61 × 49.8 cm)

The Albert M. Greenfield and
Elizabeth M. Greenfield
Collection
1974-178-48

Sekoto, G.
Young Girl
c. 1955
Lower right: G. SEKOTO
Oil on canvas
24 × 15" (61 × 38.1 cm)

The Albert M. Greenfield and
Elizabeth M. Greenfield
Collection
1974-178-47

Seligmann, Kurt
Swiss, active United States,
1900–1961
Flight to the Sabbath
1956
Lower left: Seligmann 1956
Oil on canvas
30 1/8 × 27" (76.5 × 68.6 cm)

Gift of George Dix
1980-58-1

Serisawa, Sueo
American, born Japan,
born 1910
Pierrot
c. 1947
Lower right: Serisawa
Oil on canvas
12 × 9" (30.5 × 22.9 cm)

Bequest of Lisa Norris Elkins
1950-92-17

Shahn, Ben
American, born Lithuania,
1898–1969
Miners' Wives
c. 1948
Center bottom: Ben Shahn
Tempera on panel
48 × 36" (121.9 × 91.4 cm)

Gift of Wright S. Ludington
1951-3-1

Shahn, Ben
Epoch
c. 1950
Center left, on card: NO; center
right, on card: YES; lower right:
Ben Shahn; on reverse: from Shahn
Roosevelt N.J. / to B. Shahn / c/o
Rose / 2425 6th St. / Boulder /
Colorado
Tempera on panel
52 × 31 1/4" (132.1 × 79.4 cm)

Purchased with the Bloomfield
Moore Fund
1951-31-5

Sharp, John
American, born 1926
The Jethro Coffin House, Nantucket
1950
Lower right: J. Sharp. '50; on
reverse: "THE JETHRO COFFIN
HOUSE—NANTUCKET" / JOHN
SHARP
Oil on canvas
19 15/16 × 29 15/16" (50.6 × 76 cm)

Gift of the American Academy of
Arts and Letters
1951-105-1

Shaw, Charles Green
American, 1892–1974
Plastic Polygon
1938
On reverse: CHARLES G. SHAW /
APRIL—1938 / PLASTIC
POLYGON
Oil and wood on panel
42 3/4 × 26 13/16" (108.6 × 68.1 cm)

A. E. Gallatin Collection
1946-70-18

Shaw, Charles Green
Composition
1942
On reverse: C. G. SHAW / 1942
Oil on canvas
18 1/16 × 22 1/16" (45.9 × 56 cm)

A. E. Gallatin Collection
1946-70-20

Sheeler, Charles
Cactus
1931
Lower right: Sheeler. 1931.
Oil on canvas
45 1/8 × 30 1/16" (114.6 × 76.4 cm)

The Louise and Walter Arensberg
Collection
1950-134-186

Shaw, Charles Green
Ascent
c. 1964
Lower right: Shaw
Oil on canvas
61 1/16 × 58" (155.1 × 147.3 cm)

Gift of Bertha Schaefer
1968-43-1

Shields, Alan
American, born 1944
N. D. T. N. A. R. I. A. A. S. H.
1971
Acrylic on canvas
94 × 83" (238.8 × 210.8 cm)

Gift of the Friends of the
Philadelphia Museum of Art
1972-53-1

Sheeler, Charles
American, 1883–1965
Pertaining to Yachts and Yachting
1922
On reverse: Pertaining to Yachts
and Yachting / Charles Sheeler /
1922
Oil on canvas
20 × 24 1/16" (50.8 × 61.1 cm)

Bequest of Margaretta S.
Hinchman
1955-96-9

Simpson, David
American, born 1928
*After the Storm, Stars and Stripes,
No. 2*
c. 1959
Oil on canvas
65 3/8 × 49 3/4" (166 × 126.4 cm)

Gift of N. Richard Miller in
memory of his parents, Samuel
and Tobie Miller
1966-180-1

Sheeler, Charles
Pennsylvania Landscape
1925
Lower right: Sheeler 1925
Oil on canvas
10 × 12 1/16" (25.4 × 30.6 cm)

The Louis E. Stern Collection
1963-181-68

Siqueiros, David Alfaro
Mexican, 1896–1974
The Giants
1939
Lower left: SIQUIROS / 7-1939
Duco on Masonite
46 3/4 × 33" (118.7 × 83.8 cm)

Gift of Dr. and Mrs. MacKinley
Helm
1944-87-1

Siqueiros, David Alfaro
War
1939
Lower left: SIQUEIROS; lower
right: SIQUEIROS / 39
Duco on two panels
Each panel: 48 × 31 ⁵/₈"
(121.9 × 80.3 cm)

Gift of Ines Amor
1945-84-1

Sloan, John
Arachne
c. 1940
Lower left: John Sloan
Tempera glazed with oil on
Masonite
27 ¹⁵/₁₆ × 26" (71 × 66 cm)

Gift of Mr. and Mrs. R. Sturgis
Ingersoll
1941-103-3

Sloan, John
American, 1871–1951
*Sixth Avenue and Thirtieth Street,
New York City*
1907
Lower left: John Sloan 1907
Oil on canvas
24 ¹/₄ × 32" (61.6 × 81.3 cm)

Gift of Mr. and Mrs. Meyer P.
Potamkin (reserving life interest)
1964-116-5

Sloan, Louis Baynard
American, born 1932
Manayunk
1959
Lower right: SLOAN / 1959
Oil on canvas
42 × 60" (106.7 × 152.4 cm)

Gift of Mr. and Mrs. Theodor
Siegl
1969-50-1

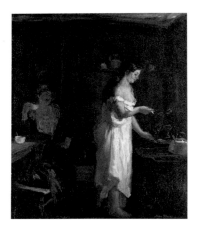

Sloan, John
Three A.M.
1909
Lower right: John Sloan; on
reverse: THREE A.M. / John Sloan
/ Painted in New York / 1909
Oil on canvas
32 ¹/₈ × 26 ¹/₄" (81.6 × 66.7 cm)

Gift of Mrs. Cyrus McCormick
1946-10-1

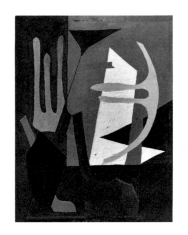

Slobodkina, Esphyr
American, born Russia,
born 1908
Composition
1940
Lower right: E. S.
Oil on Masonite
12 ¹/₄ × 9 ¹/₄" (31.1 × 23.5 cm)

A. E. Gallatin Collection
1946-70-19

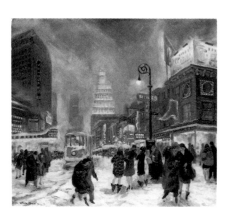

Sloan, John
The White Way
c. 1926
Lower left: John Sloan
Oil on canvas
30 ¹/₈ × 32 ¹/₄" (76.5 × 81.9 cm)

Gift of Mrs. Cyrus McCormick
1946-10-2

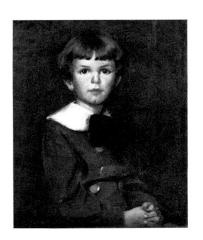

Smith, Jessie Wilcox
American, 1863–1935
*Child in a Blue Suit (Portrait of
Henry P. McIlhenny)*
1916
Oil on canvas
22 × 18" (55.9 × 45.7 cm)

The Henry P. McIlhenny
Collection in memory of
Frances P. McIlhenny
1986-26-405

Smith, Richard
English, born 1931
Capsule
1960–61
On reverse: R. Smith / 1961 /
Capsule
Oil on canvas
84 1/8 × 90 1/4" (213.7 × 229.2 cm)

Centennial gift of the Woodward
Foundation
1975-81-15

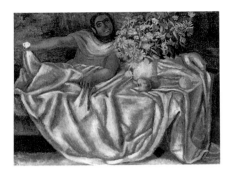

Soriano, Juan
Girl with a Bouquet
1946
Upper left: J. Soriano / 46.
Oil on canvas
18 1/2 × 23 3/4" (47 × 60.3 cm)

Gift of Mr. and Mrs. Herbert
Cameron Morris
1957-94-1

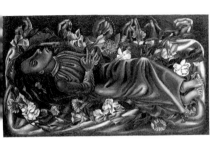

Soriano, Juan
Mexican, born 1920
The Dead Girl
1938
Lower right: J. Soriano / 38.
Oil on panel
18 1/2 × 31 1/2" (47 × 80 cm)

Gift of Mr. and Mrs. Henry
Clifford
1947-29-3

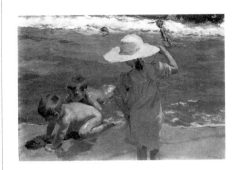

Sorolla y Bastida, Joaquin
Spanish, 1863–1923
The Young Amphibians
1903
Lower right: J. Sorolla y Bastida /
1903 / Valencia
Oil on canvas
37 7/8 × 51 3/8" (96.2 × 130.5 cm)

Purchased with the W. P.
Wilstach Fund
W1904-1-55

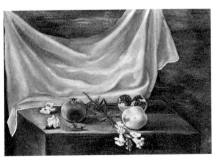

Soriano, Juan
Still Life
1942
Upper right: J. Soriano. / 42
Oil on canvas
19 5/8 × 27 5/8" (49.8 × 70.2 cm)

Gift of Mr. and Mrs. Joseph J.
Gersten
1951-120-4

Soulages, Pierre
French, born 1919
Painting November 9, 1966
1966
Lower right: Soulages
Oil on canvas
51 × 38" (129.5 × 96.5 cm)

Gift of Benjamin D. Bernstein
1978-172-4

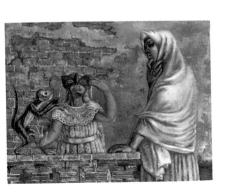

Soriano, Juan
Girl with a Mask
1945
Upper left: J. Soriano. / 45.
Oil on canvas
31 5/8 × 39 1/2" (80.3 × 100.3 cm)

Gift of Mrs. Herbert Cameron
Morris
1947-24-1

Soutine, Chaim
French, born Lithuania,
1894–1943
Landscape, Céret
1921
Oil on canvas
26 1/4 × 35 3/4" (66.7 × 90.8 cm)

Gift of Mr. and Mrs. R. Sturgis
Ingersoll
1953-136-1

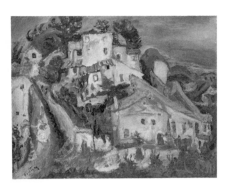

Soutine, Chaim
Landscape, Chemin des Caucourts,
Cagnes-sur-Mer
c. 1924
Lower left: Soutine
Oil on canvas
21 1/8 × 25 1/2" (53.7 × 64.8 cm)

The Louis E. Stern Collection
1963-181-71

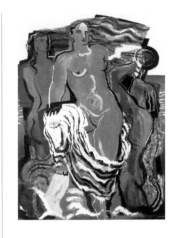

Souverbie, Jean
French, born 1891, death date
unknown
Composition
c. 1926
Lower right: Souverbie
Oil on canvas
36 1/8 × 25 5/8" (91.8 × 65.1 cm)

Bequest of Fiske and Marie
Kimball
1955-86-16

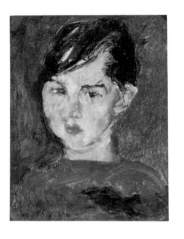

Soutine, Chaim
Girl in Green
c. 1925–28
On reverse: Chaim Soutine
Oil on canvas
14 5/16 × 11 1/16" (36.3 × 28.1 cm)

The Louis E. Stern Collection
1963-181-72

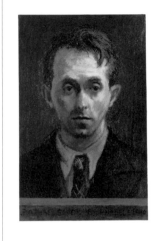

Soyer, Raphael
American, 1899–1987
Self-Portrait
1940
Across bottom: .RAPHAEL.SOYER.
BY.HIMSELF.1940
Oil on canvas
15 15/16 × 9 7/8" (40.5 × 25.1 cm)

The Louis E. Stern Collection
1963-181-69

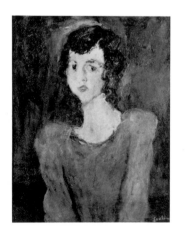

Soutine, Chaim
Woman in Red
c. 1927–30
Lower right: Soutine
Oil on canvas
25 9/16 × 19 3/4" (64.9 × 50.2 cm)

The Louis E. Stern Collection
1963-181-73

Spandorfer, Merle
American, born 1934
Echo G
1976
On reverse: Merle / Spandorfer /
"Echo G"
Acrylic and mixed media on
canvas
77 1/8 × 62 7/8" (195.9 × 159.7 cm)

Gift of the Cheltenham Art
Centre
1977-81-1

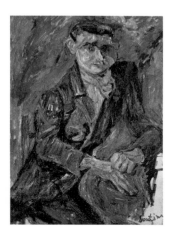

Soutine, Chaim
Portrait of Moïse Kisling
c. 1930
Lower right: Soutine
Oil on cardboard on Masonite
39 × 27 1/4" (99.1 × 69.2 cm)

Gift of Arthur Wiesenberger
1943-101-1

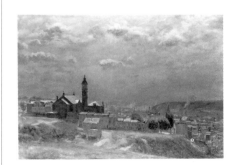

Speight, Francis
American, 1896–1989
Industrial Area
c. 1952
Lower right: Francis Speight
Oil on canvas
36 3/16 × 50 1/4" (91.9 × 127.6 cm)

Gift of Walter Stuempfig
1961-78-1

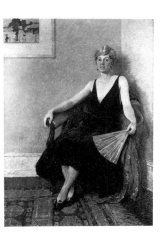

Spencer, Robert
American, 1879–1931
Portrait of Brenda Biddle
1926
Lower left: Robert Spencer /
1926; on reverse: Portrait of
Mrs. Moncure Biddle by Robert
Spencer
Oil on canvas
60 1/8 × 42 9/16" (152.7 × 108.1 cm)

Gift of Owen Biddle and
Peyton R. Biddle
1978-12-1

Stegeman, Charles
Canadian, born Netherlands,
born 1924
Untitled
1975
Lower left: C. Stegeman 75
Oil on canvas
70 × 82" (177.8 × 208.3 cm)

Purchased with funds contributed
by the friends of Charles
Stegeman and Françoise André
1975-165-1

Sprinchorn, Carl
Swedish, 1887–1971
*Nijinsky and Pavlova in
"Les Sylphides"*
c. 1920
Upper left: C. Sprinchorn
Oil on canvas
31 1/8 × 39 1/8" (79.1 × 99.4 cm)

Gift of Christian Brinton
1941-79-151

Stella, Frank
American, born 1936
Sanbornville IV
1966
Acrylic on canvas
104 1/2 × 144" (265.4 × 365.8 cm)

Gift of the Friends of the
Philadelphia Museum of Art
1968-183-2

Springer, Charles
American, born 1950
The Majestic
1985
Lower right: chaspringer 1985;
on reverse: CHARLES SPRINGER /
"THE MAJESTIC" 1985 ACRYLIC
/ CANVAS / 56 × 66 inches
Acrylic on canvas
66 1/16 × 56 3/8" (167.8 × 143.2 cm)

Purchased with the Julius Bloch
Memorial Fund and funds
contributed by the Cheltenham
Art Centre
1986-72-1

Stella, Frank
Hockenheim
1982
Oil stick, urethane enamel,
fluorescent alkyd, and Magna on
etched magnesium
124 × 128 × 19"
(315 × 325.1 × 48.3 cm)

Purchased with funds contributed
by Muriel and Philip Berman and
gift (by exchange) of the
Woodward Foundation
1982-48-1

Stanczak, Julian
American, born Poland,
born 1928
Obedient Square
1970
On reverse: JULIAN STANCZAK /
"OBEDIENT SQUARE"
Acrylic on canvas
73 × 73" (185.4 × 185.4 cm)

Gift of Mr. and Mrs. Paul M.
Ingersoll
1980-129-1

Stella, Joseph
American, born Italy,
1880–1946
Chinatown
c. 1917
Oil on glass
20 × 8 11/16" (50.8 × 22.1 cm)

The Louise and Walter Arensberg
Collection
1950-134-519

Sterne, Maurice
American, born Latvia,
1878–1957
Bali Priestess
c. 1913
Lower right: Maurice Sterne
Oil on canvas
24 1/8 × 20 3/8" (61.3 × 51.7 cm)

The Louis E. Stern Collection
1963-181-70

Strater, Henry
American, born 1896
Autumn at Henderson's
1927
Lower right: Strater '27.
Oil on canvas
30 × 39 15/16" (76.2 × 101.4 cm)

Gift of David Strater
1965-170-1

Sterne, Maurice
Eggs
1930
Lower left: Maurice Sterne / 1930
Oil on panel
14 5/8 × 18 5/8" (37.1 × 47.3 cm)

Bequest of Margaretta S.
Hinchman
1955-96-11

Stuempfig, Walter, Jr.
American, 1914–1970
Back of a Man (Self-Portrait)
1945
Bottom center: STUEMPFIG
Oil on canvas
24 × 18" (61 × 45.7 cm)

The Henry P. McIlhenny
Collection in memory of
Frances P. McIlhenny
1986-26-401

Stettheimer, Florine
American, 1871–1948
Spring Sale at Bendel's
1921
On reverse: BENDEL—SPRING
SALE BY Florine Stettheimer
1921
Oil on canvas
50 × 40" (127 × 101.6 cm)

Gift of Miss Ettie Stettheimer
1951-27-1

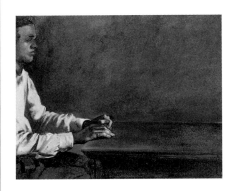

Stuempfig, Walter, Jr.
Meditation
1946
Oil on canvas
30 1/8 × 36" (76.5 × 91.4 cm)

Bequest of Lisa Norris Elkins
1950-92-18

Stevens, Frances Simpson
American, 1894–1976
*Dynamic Velocity of Interborough
Rapid Transit Power Station*
c. 1915
Oil and charcoal on canvas
48 3/8 × 35 7/8" (122.9 × 91.1 cm)

The Louise and Walter Arensberg
Collection
1950-134-520

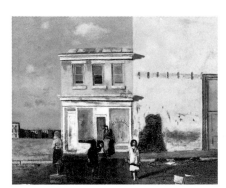

Stuempfig, Walter, Jr.
The Reprimand
1946
Lower left: STUEMPFIG; center,
on window: NELSON'S
Oil on canvas
24 3/4 × 30" (62.9 × 76.2 cm)

Gift of the Committee on
Painting and Sculpture
1947-33-1

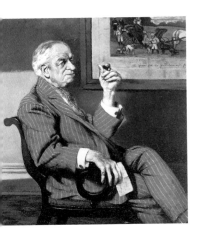

Stuempfig, Walter, Jr.
Portrait of John C. Norris
1949
Center bottom, on envelope: John
C. Norris / from his friend /
Stuempfig / 1949
Oil on canvas
39 7/8 × 36 1/8" (101.3 × 91.8 cm)

Bequest of Lisa Norris Elkins
1950-92-20

Stuempfig, Walter, Jr.
*Still Life with a Sugar Bowl and a
Green Fruit*
1949
Oil on canvas
8 × 10" (20.3 × 25.4 cm)

Bequest of Lisa Norris Elkins
1950-92-19

Stuempfig, Walter, Jr.
*Still Life with Persimmons and
Grapes*
1949
Oil on canvas
19 1/4 × 33 1/2" (48.9 × 85.1 cm)

Bequest of Lisa Norris Elkins
1950-92-32

Stuempfig, Walter, Jr.
View of Naples
1954
Lower left: STUEMPFIG / 1954
Oil on canvas
20 1/8 × 28" (51.1 × 71.1 cm)

Bequest of Mrs. Edna M. Welsh
1982-1-9

Sugai, Kumi
Japanese, active France,
born 1919
Maison du Diable
1961
Lower right: SUGAI 61
Oil on canvas
63 5/8 × 44 3/4" (161.6 × 113.7 cm)

Gift of Keith Wellin
1971-219-1

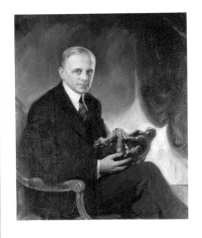

Susan, Robert
American, born Netherlands,
1888–1957
Portrait of Jules E. Mastbaum
1923
Upper left: Robert Susan / 1923
Oil on canvas
30 × 25 1/8" (76.2 × 63.8 cm)

Gift of Mrs. Charles Solomon,
Mrs. Jefferson Dickson, and Mrs.
Patrick Dinehart, the daughters of
Mr. and Mrs. Jules E. Mastbaum
1953-119-1

Taeuber-Arp, Sophie
Swiss, 1889–1943
Point on Point
1931–34
On reverse: SH Taeuber-Arp /
1931/4
Oil on canvas
25 1/2 × 21 1/4" (64.8 × 54 cm)

A. E. Gallatin Collection
1952-61-120

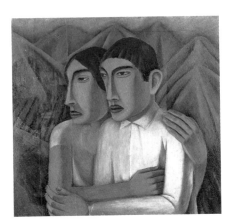

Tamayo, Rufino
Mexican, 1899–1991
Man and Woman
1926
Lower right: Tamayo / "1926"
Oil on canvas
27 1/2 × 27 5/8" (69.8 × 70.2 cm)

Gift of Mr. and Mrs. James P.
Magill
1957-127-6

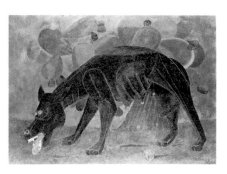

Tamayo, Rufino
The Mad Dog
1943
Lower right: Tamayo / 0.43
Oil on canvas
32 × 43" (81.3 × 109.2 cm)

Gift of Mrs. Herbert Cameron
Morris
1945-2-1

Tanguy, Yves
Explosions of Fire
1950
Lower right: YVES TANGUY 50
Oil on canvas
28 × 23" (71.1 × 58.4 cm)

Bequest of Kay Sage Tanguy
1964-181-1

Tanguy, Kay Sage
American, 1898–1963
Unicorns Came Down to the Sea
1948
Lower left: Kay Sage '48
Oil on canvas
36 1/4 × 28 1/4" (92.1 × 71.7 cm)

Bequest of Hobson L. Pittman
1964-151-1

Tanguy, Yves
American, born France,
1900–1955
The Storm (Black Landscape)
1926
Lower right: YVES TANGUY 26
Oil on canvas
32 1/8 × 25 3/4" (81.6 × 65.4 cm)

The Louise and Walter Arensberg
Collection
1950-134-187

Taylor, Charles
American, born 1910
Shoring
c. 1958
Lower left: Charles Taylor
Oil on canvas
23 15/16 × 35 7/8" (60.8 × 91.1 cm)

Purchased with the Adele Haas
Turner and Beatrice Pastorius
Turner Memorial Fund
1959-12-7

Tchelitchew, Pavel
Russian, active United States,
1898–1957
Leopard Boy
1935
Lower right: P. Tchelitchew / 35
Oil on canvas
21 5/8 × 18" (54.9 × 45.7 cm)

Gift of Mr. and Mrs. Henry
Clifford
1973-256-3

Tanguy, Yves
The Parallels
1929
Lower right: YVES TANGUY 29
Oil on canvas
36 5/16 × 28 3/4" (92.2 × 73 cm)

The Louise and Walter Arensberg
Collection
1950-134-188

Thiebaud, Wayne
American, born 1920
Cake
1963
Upper left: Thiebaud 1963
Oil on canvas on panel
5 × 8 5/8" (12.7 × 21.9 cm)

Gift of the Kulicke family in
memory of Lt. Frederick W.
Kulicke III
1969-86-3

Torres-Garcia, Joaquin
Uruguayan, 1874–1949
Composition
1929
Upper left: J. Torres-GARCIA;
upper right: 29
Oil on burlap
32 × 39 7/16" (81.3 × 100.2 cm)

A. E. Gallatin Collection
1952-61-121

Turner, Helen Maria
American, 1858–1958
Arrangement in Dark and Light
1912
Upper left: Helen M. Turner
1912
Oil on canvas
24 × 18" (61 × 45.7 cm)

Gift of Dr. and Mrs. George
Woodward
1939-7-17

Torres-Garcia, Joaquin
Head
1930
Upper left: JTG; upper right: 30;
on reverse: J. Torres GARCIA / 30
Oil on canvas
13 3/4 × 10 5/8" (34.9 × 27 cm)

A. E. Gallatin Collection
1952-61-122

Twombly, Cy
American, born 1928
*Fifty Days at Iliam: Shield of
Achilles*
First of ten parts; see following
nine paintings
1978
Upper left: ACHILLES' SHIELD
Oil, oil crayon, and graphite on
canvas
75 1/2 × 67" (191.8 × 170.2 cm)

Gift (by exchange) of Samuel S.
White 3rd and Vera White
1989-90-1

Torres-Garcia, Joaquin
Street
1930
Upper left: JTG; upper right: 30;
on reverse: J. Torres-Garcia 30
Oil on cardboard
13 × 11 13/16" (33 × 30 cm)

A. E. Gallatin Collection
1937-31-1

Twombly, Cy
*Fifty Days at Iliam: Heroes of the
Achaeans*
Second of ten parts
1978
Top: THETIS / HERA / ATHENA /
POSEDON / HERMES /
HEPHAESTUS; center: ACHAEANS;
bottom: CALCHAS / AG[AMEMNO]N
/ ACHILLES / PATROCLUS /
MENELLAUS / DIOMEDES /
TELAMONIAN AJAX
Oil, oil crayon, and graphite on
canvas
75 1/2 × 59" (191.8 × 149.9 cm)

Gift (by exchange) of Samuel S.
White 3rd and Vera White
1989-90-2

Tucker, Allen
American, 1866–1939
Landscape
c. 1935
Oil on canvas
24 1/16 × 20 1/8" (61.1 × 51.1 cm)

Gift of Mrs. F. Taylor Gauze
1939-3-1

Twombly, Cy
*Fifty Days at Iliam: Vengeance of
Achilles*
Third of ten parts
1978
Center: VENGEANCE of
ACHILLES
Oil, oil crayon, and graphite on
canvas
118 × 94 1/4" (299.7 × 239.4 cm)

Gift (by exchange) of Samuel S.
White 3rd and Vera White
1989-90-3

Twombly, Cy
Fifty Days at Iliam: Achaeans in Battle
Fourth of ten parts
1978
Top center: AXAIOI [Greek for "Achaeans"]; left: THETIS / ATHENA; center: VENUS / DIOMEDES / ACHILLES / AGAMEMNON / AJAX / ACHILLES / PATROCLUS / MENELAUS / HERA; bottom: ARTIST [] []
Oil, oil crayon, and graphite on canvas
118 × 149 1/2" (299.7 × 379.7 cm)

Gift (by exchange) of Samuel S. White 3rd and Vera White
1989-90-4

Twombly, Cy
Fifty Days at Iliam: Ilians in Battle
Eighth of ten parts
1978
Top center: APOLLO / APHRODITE / ARES; ARTEMIS / XANTHUS / LETO; left: PARIS / ANTIPHUS / TROILUS / POLITES / PRIAM; center: ARTEMIS; APOLLO; ARES; Aphrodite / VENUS; right: HECTOR / HEKTOR
Oil, oil crayon, and graphite on canvas
118 × 149 1/2" (299.7 × 379.7 cm)

Gift (by exchange) of Samuel S. White 3rd and Vera White
1989-90-8

Twombly, Cy
Fifty Days at Iliam: The Fire that Consumes All before It
Fifth of ten parts
1978
Center: Like a fire that consumes all before it
Oil, oil crayon, and graphite on canvas
118 1/8 × 75 5/8" (300 × 192 cm)

Gift (by exchange) of Samuel S. White 3rd and Vera White
1989-90-5

Twombly, Cy
Fifty Days at Iliam: Shades of Eternal Night
Ninth of ten parts
1978
Center: SHADES OF ETERNAL NIGHT
Oil, oil crayon, and graphite on canvas
118 × 94 1/4" (299.7 × 239.4 cm)

Gift (by exchange) of Samuel S. White 3rd and Vera White
1989-90-9

Twombly, Cy
Fifty Days at Iliam: Shades of Achilles, Patroclus, and Hector
Sixth of ten parts
1978
Left to right, above shades: ACHILLES; PATROCLUS; HECTOR
Oil, oil crayon, and graphite on canvas
118 × 193 1/2" (299.7 × 491.5 cm)

Gift (by exchange) of Samuel S. White 3rd and Vera White
1989-90-6

Twombly, Cy
Fifty Days at Iliam: Heroes of the Ilians
Tenth of ten parts
1978
Top: Apollo / Aphrodite / Ares / Artemis / Xanthus / Leto; center: ILIANS; bottom: HECTOR / PARIS / AENEAS / HELELNUS / ANTENOR / DOLON / RHESUS
Oil, oil crayon, and graphite on canvas
63 3/4 × 59" (161.9 × 149.9 cm)

Gift (by exchange) of Samuel S. White 3rd and Vera White
1989-90-10

Twombly, Cy
Fifty Days at Iliam: House of Priam
Seventh of ten parts
1978
Top to bottom: HOUSE of PRIAM / ARISBE – AESACUS / HYRTACUS / HECUBA / (50 19 SONS by Hecuba / 12 Daughter / HECTOR / PARIS / CASSANDRA / HELENUS / DIEPHONOS / POLITES / POLYDOROS / ANTIPHUS / TROILUS / Creusa / LAODICE / POLYXENA
Oil, oil crayon, and graphite on canvas
118 × 149 1/2" (299.7 × 379.7 cm)

Gift (by exchange) of Samuel S. White 3rd and Vera White
1989-90-7

Tworkov, Jack
American, born Poland, 1900–1982
Untitled
1973
On reverse: Tworkov / 73
Oil on canvas
96 1/4 × 68" (244.5 × 172.7 cm)

Gift of Mr. and Mrs. N. Richard Miller
1979-160-1

Tyson, Carroll Sargent, Jr.
American, 1877–1956
Before Moonrise
1912
Lower right: Carroll S. Tyson Jr.
1912.
Oil on canvas
25 × 30 3/16" (63.5 × 76.7 cm)

The Alex Simpson, Jr., Collection
1946-5-4

Utrillo, Maurice
The Ancestral Property of Gabrielle d'Estrees (Le Lapin Agile)
1913
Center: AGILE; lower right:
Maurice. Utrillo. V. 1913.
Oil on panel
23 5/16 × 31 3/16" (59.2 × 79.2 cm)

Bequest of Charlotte Dorrance
Wright
1978-1-36

Tyson, Carroll Sargent, Jr.
Inland Maine
1931
Lower right: Carroll Tyson 1931
Oil on canvas
29 15/16 × 36 1/8" (76 × 91.8 cm)

Gift of an anonymous donor
1932-49-1

Utrillo, Maurice
Berlioz's House
1914
Lower right: Maurice Utrillo. /
AOÛT 1914.
Oil on canvas
28 3/4 × 39 3/8" (73 × 100 cm)

The Samuel S. White 3rd and
Vera White Collection
1967-30-84

Utrillo, Maurice
French, 1883–1955
Place du Pont, Sarcelles
1911
Center left: CAFE RESTAURANT /
VINS, CAFE, LIQUEURS; center
right: HOTEL / RESTAURANT;
lower right: Maurice Utrillo, V.
Oil on paper on panel
21 1/2 × 29 3/8" (54.6 × 74.6 cm)

The Louis E. Stern Collection
1963-181-74

Utrillo, Maurice
Place du Tertre, Montmartre
c. 1925
Center left: HÔTEL DU TERTRE /
VINS CAFÉ RESTAURANT; lower
right: Maurice. Utrillo. V.
Oil on canvas
21 1/4 × 25 9/16" (54 × 64.9 cm)

Gift of Mr. and Mrs. Cummins
Catherwood
1983-160-1

Utrillo, Maurice
Place du Tertre, Montmartre
c. 1912
Center left: HÔTEL DU TERTRE;
lower right: Maurice Utrillo. V.
Oil on cardboard on panel
19 1/2 × 28 1/2" (49.5 × 72.4 cm)

The Samuel S. White 3rd and
Vera White Collection
1967-30-83

Valledor, Leo
American, born 1936
The Calm
1966
On reverse: L.V. '66
Acrylic on canvas
15 1/16 × 84 7/16" (38.3 × 214.5 cm)

Purchased with the Adele Haas
Turner and Beatrice Pastorius
Turner Memorial Fund
1967-261-1

Valverde, Joaquin
Spanish, born 1896
The Hunters
1931
Lower right: J. VALVERDE /
ALBERCA 930
Oil on canvas
59 × 62 15/16" (149.9 × 159.9 cm)

Gift of Mr. and Mrs. Henry
Clifford
1973-256-9

Vasilieff, Nicholas
Young Russia (Child with a Rooster)
1926
Lower right: N. Vassileff 26; on
reverse: N. Vassileff / 111 W.
122 st
Oil on canvas
40 11/16 × 35 1/8" (103.3 × 89.2 cm)

Gift of Christian Brinton
1941-79-113

Van Loan, Dorothy
American, active c. 1927–c. 1962
Hercules Cluster
c. 1944
Lower right: van Loan
Oil on canvas
22 1/8 × 31 7/8" (56.2 × 81 cm)

Gift of John J. Raskob
1945-39-1

Vasilieff, Nicholas
Return from Work
1926?
Lower left: Vassileff / 26 [?]
Oil on canvas
21 1/8 × 23 7/8" (53.7 × 60.6 cm)

Gift of Christian Brinton
1941-79-79

Varian, Dorothy
American, born 1895
Ogunquit
c. 1930
Lower right: D. Varian
Oil on canvas
15 × 18" (38.1 × 45.7 cm)

Gift of Frank and Alice Osborn
1966-68-53

Vasilieff, Nicholas
Rest at Midday
c. 1926
Lower left: N. Vassileff
Oil on canvas
42 7/8 × 35" (108.9 × 88.9 cm)

Gift of Christian Brinton
1941-79-117

Vasilieff, Nicholas
American, born Russia,
1892–1970
Modern Icon
c. 1925
Lower left: N. Vassileff
Oil on canvas
40 × 29 7/8" (101.6 × 75.9 cm)

Gift of Christian Brinton
1941-79-110

Vasilieff, Nicholas
Tea for Two
c. 1926
Lower left: Vassileff
Oil on canvas
33 13/16 × 28" (85.9 × 71.1 cm)

Gift of Christian Brinton
1941-79-109

Vedova, Emilio
Italian, born 1919
Plurimi
1964
Oil on plywood
54 × 56 × 24"
(137.2 × 142.2 × 61 cm)

Gift of Mr. and Mrs. N. Richard
Miller
1972-204-1

Vlaminck, Maurice de
French, 1876–1958
The Seine at Châtou
c. 1908
Lower right: Vlaminck
Oil on panel
14 1/2 × 18 1/4" (36.8 × 46.3 cm)

A. E. Gallatin Collection
1944-12-3

**Villon, Jacques
(Gaston Duchamp)**
French, 1875–1963
*Sketch for "Puteaux (Smoke and
Trees in Bloom No. 2)"*
1912
Lower right: Jacques Villon
Oil on canvas
18 1/4 × 21 3/4" (46.3 × 55.2 cm)

The Louise and Walter Arensberg
Collection
1950-134-189

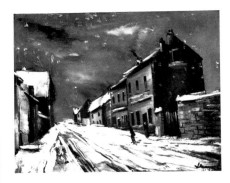

Vlaminck, Maurice de
Winter Scene
c. 1925
Lower right: Vlaminck
Oil on canvas
28 3/4 × 36" (73 × 91.4 cm)

Gift of Mr. and Mrs. Charles C. G.
Chaplin
1978-149-3

Villon, Jacques
Young Girl
1912
Center right: Jacques Villon
Oil on canvas
57 9/16 × 45" (146.2 × 114.3 cm)

The Louise and Walter Arensberg
Collection
1950-134-190

**Vordemberge-Gildewart,
Friedel**
Dutch, born Germany,
1899–1963
Composition No. 169 (Diptychon)
1934–48
Right panel, across top:
VORDEMBERGE-GILDEWART /
COMPOSITION No 169 /
1934–1948; on reverse:
VORDEMBERGE-GILDEWART
Composition No. 169 /
1934–1948 DIPTYCHON
Oil on canvas
31 3/4 × 39 7/16" (80.6 × 100.2 cm)
overall

Gift of Mr. and Mrs. Henry
Clifford
1973-256-7

Villon, Jacques
Abstraction
1932
Lower left: JACQUES VILLON /
32; on reverse: "Abstraction"
Jacques Villon
Oil on canvas
21 7/8 × 26 3/16" (55.6 × 66.5 cm)

The Louise and Walter Arensberg
Collection
1950-134-191

Vuillard, Édouard
French, 1868–1940
Self-Portrait with Sister
c. 1892
Lower right: E. Vuillard
Oil on paper on cardboard
9 × 6 1/2" (22.9 × 16.5 cm)

The Louis E. Stern Collection
1963-181-76

Vuillard, Édouard
Flowers with Leda
1898–1900
Lower left: E. Vuillard
Oil on cardboard
19 ⁹/₁₆ × 17 ³/₁₆" (49.7 × 43.7 cm)

The Louis E. Stern Collection
1963-181-77

Wallace, John
American, born c. 1862, death
date unknown
Untitled
Wall panel
1939
Oil on panel
36 × 19 ³/₄" (91.4 × 50.2 cm)

A. E. Gallatin Collection
1952-61-126

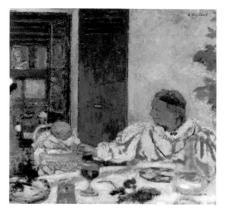

Vuillard, Édouard
The Meal
c. 1899
Upper right: E. Vuillard
Oil on cardboard
18 ¹/₂ × 18 ³/₄" (47 × 47.6 cm)

Gift of Henry P. McIlhenny
1964-77-3

Warhol, Andy
American, 1928–1987
Electric Chair (Red)
1964
On reverse: Andy Warhol
Silk-screened synthetic polymer
on canvas
22 × 28" (55.9 × 71.1 cm)

Gift of Mr. and Mrs. David N.
Pincus
1979-161-1

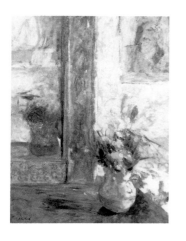

Vuillard, Édouard
Flowers in the Salon
c. 1905
Lower left: E. Vuillard
Oil on cardboard on canvas
24 ⁷/₁₆ × 18 ⁵/₈" (62.1 × 47.3 cm)

Bequest of Charlotte Dorrance
Wright
1978-1-34

Warhol, Andy
Electric Chair (Gray)
1964
On reverse: Andy Warhol
Silk-screened synthetic polymer
on canvas
22 ¹/₈ × 28 ¹/₈" (56.2 × 71.4 cm)

Gift of Mr. and Mrs. David N.
Pincus
1979-161-2

Wagner, Frederick
American, 1864–1940
Logan Circle, Winter
c. 1920
Lower left: F. WAGNER
Oil on canvas
40 ¹/₈ × 50 ³/₁₆" (101.9 × 127.5 cm)

Purchased with subscription
funds
1939-12-1

Warhol, Andy
*Jackie (Four Jackies) (Portraits of
Mrs. Jacqueline Kennedy)*
1964
On reverse: WARHOL 64 / ANDY
WARHOL '4
Silk-screened acrylic on four
canvas panels
Each panel: 20 × 16" (50.8 ×
40.6 cm)

Gift of Mrs. H. Gates Lloyd
1966-57-1-4

Wasserman, Burton
American, born 1929
1966–67B
1966–67
On reverse: BURTON
WASSERMAN / 1966/1967-PB
Oil on composition board
30 1/8 × 60" (76.5 × 152.4 cm)

Gift of Mr. and Mrs. Josef Jaffe
1971-220-1

Watkins, Franklin Chenault
The Fire-Eater
1933–34
On reverse: WATKINS
Oil on canvas
64 3/16 × 37 1/2" (163 × 95.2 cm)

Purchased with subscription
funds
1935-46-1

Watkins, Franklin Chenault
American, 1894–1972
Suicide in Costume
1931–34
Lower left: Watkins
Oil on canvas
36 7/8 × 45 1/16" (93.7 × 114.5 cm)

Purchased with subscription
funds
1942-17-1

Watkins, Franklin Chenault
Portrait of Henry P. McIlhenny
1941
Oil on canvas
47 × 33" (119.4 × 83.8 cm)

The Henry P. McIlhenny
Collection in memory of
Frances P. McIlhenny
1986-26-38

Watkins, Franklin Chenault
Portrait of Mrs. McCarthy
c. 1932
Oil on canvas
37 1/16 × 22" (94.1 × 55.9 cm)

Gift of Dr. and Mrs. Daniel J.
McCarthy
1942-87-1

Watkins, Franklin Chenault
Portrait of J. Stogdell Stokes
1943
Lower left: Watkins/43
Oil on canvas
35 × 27 1/4" (88.9 × 69.2 cm)

Gift of the Board of Trustees
1943-72-1

Watkins, Franklin Chenault
Art and Science
c. 1933
Lower left: FW
Tempera and gesso on panel
11 5/16 × 47" (28.7 × 119.4 cm)

Gift of Dr. and Mrs. Matthew T.
Moore
1964-45-1

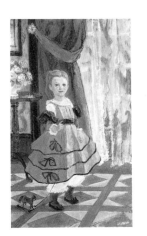

Watkins, Franklin Chenault
Portrait of Sophie Pennebaker
1943
Lower right: Watkins; on reverse:
derived from a photo taken about
1855. F.C Watkins 1943
Oil on canvas
48 × 27 3/4" (121.9 × 70.5 cm)

Bequest of Susan B. Pennebaker
in memory of Sophie E.
Pennebaker
1944-5-1

Watkins, Franklin Chenault
Adam and Eve
Two-panel screen
c. 1947
Silver leaf, tempera, and charcoal
on plywood
Each panel: 79 3/4 × 27 1/2"
(202.6 × 69.8 cm)

Bequest of R. Sturgis Ingersoll
1973-254-1

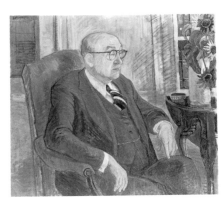

Watkins, Franklin Chenault
Portrait of Albert M. Greenfield
1959
Upper left: Watkins
Oil on canvas
36 × 40" (91.4 × 101.6 cm)

The Albert M. Greenfield and
Elizabeth M. Greenfield
Collection
1974-178-50

Watkins, Franklin Chenault
Sketch for "The Resurrection"
For the following painting
c. 1947
Oil on canvas
40 × 60" (101.6 × 152.4 cm)

Bequest of Miss Anna Warren
Ingersoll
1985-85-2

Watkins, Franklin Chenault
Sketch for "Annual Meeting of the Budd Company"
For the following painting
c. 1960
Oil, graphite, and newspaper on
panel
16 × 19 1/2" (40.6 × 49.5 cm)

Bequest of Mrs. Edward G.
Budd, Jr.
1973-202-38

Watkins, Franklin Chenault
The Resurrection
1948–49
On reverse: Watkins 1948–49
Oil and tempera on canvas
108 × 172" (274.3 × 436.9 cm)

Gift of Henry P. McIlhenny
1955-113-1

Watkins, Franklin Chenault
Annual Meeting of the Budd Company
1960
Upper right: for Ed / from /
Watty
Oil on canvas
24 × 32" (61 × 81.3 cm)

Bequest of Mrs. Edward G.
Budd, Jr.
1973-202-50

Watkins, Franklin Chenault
Death
1948–49
On reverse: Watkins 1948–49
Oil and tempera on canvas
108 × 172" (274.3 × 436.9 cm)

Gift of Henry P. McIlhenny
1956-107-1

Watkins, Franklin Chenault
Portrait of Elizabeth Greenfield
1967–68
Upper right: Watkins / 67–68
Oil on canvas
38 1/8 × 28 1/4" (96.8 × 71.7 cm)

Gift of an anonymous donor
1970-52-1

Watkins, Franklin Chenault
Portrait of Henri Marceau
1970
Lower left: F.C.Watkins / 1970
Oil on canvas
39 1/16 × 29" (99.2 × 73.7 cm)

Purchased with funds contributed
in memory of Henri Marceau
1970-169-1

White, Vera M.
American, 1888–1966
Still Life: Cyclamen
c. 1925
Oil on canvas
8 × 10 1/2" (20.3 × 26.7 cm)

Gift of Salander-O'Reilly
Galleries, Inc.
1988-114-1

Weinstone, Howard
American, born 1928
Natural Bridge. Pacific Coast
1971
On reverse: Howard Weinstone
1971 / NATURAL BRIDGES—
PACIFIC COAST #3
Acrylic on canvas
52 1/4 × 72 1/4" (132.7 × 183.5 cm)

Gift of Mr. and Mrs. Walter S.
Marine
1971-222-1

White, Vera M.
Orchid
1928
On reverse: Vera M. White /
1928
Oil on canvas
12 1/16 × 10" (30.6 × 25.4 cm)

The Samuel S. White 3rd and
Vera White Collection
1967-30-90

Wesselmann, Tom
American, born 1931
Bedroom Painting No. 7
1967–69
On reverse: OIL PAINT /
Wesselman 69
Oil on canvas
78 × 87 1/4" (198.1 × 221.6 cm)

Purchased with the Adele Haas
Turner and Beatrice Pastorius
Turner Memorial Fund
1972-156-1

Wiggins, Guy Carleton
American, 1883–1962
Snowstorm. Fifth Avenue
c. 1935
Lower right: Guy C. Wiggins;
on reverse: "Snow Storm Fifth
Avenue" Guy C. Wiggins
Oil on canvas
40 × 30" (101.6 × 76.2 cm)

The Alex Simpson, Jr., Collection
1946-5-5

Weston, Harold
American, 1894–1972
The Elm Tree
1922
Lower right: W. 22
Oil on canvas
24 × 18" (61 × 45.7 cm)

Gift of Mrs. S. Emlen Stokes
1979-13-1

Wiley, William T.
American, born 1937
Known Ooze
1981
Acrylic and charcoal on canvas
88 × 161" (223.5 × 408.9 cm)

Purchased with the Adele Haas
Turner and Beatrice Pastorius
Turner Memorial Fund and the
Edward and Althea Budd Fund
1982-120-1

Williams, Edith Clifford
American, 1880–1971
Two Rhythms
1916
On reverse: Two Rhythms—
1916 / Clifford Williams
Oil on canvas
29 × 28 15/16" (73.7 × 73.5 cm)

The Louise and Walter Arensberg
Collection
1950-134-524

Wood, Edith Longstreth
*Still Life with Calla Lilies and
Fruit*
c. 1940
Lower right: EDITH / WOOD
Oil on canvas
30 × 25" (76.2 × 63.5 cm)

Gift of Walter Longstreth
1968-41-1

Williams, Neil
American, born 1934
The Return
1968
Acrylic on canvas
71 5/16 × 24" (181.1 × 61 cm)

Purchased with the Adele Haas
Turner and Beatrice Pastorius
Turner Memorial Fund
1968-119-1

Wyeth, Andrew Newell
American, born 1917
Groundhog Day
1959
Center right: Andrew Wyeth
Tempera on Masonite
31 3/8 × 32 1/8" (79.7 × 81.6 cm)

Gift of Henry F. du Pont and
Mrs. John Wintersteen
1959-102-1

Wood, Beatrice
American, born 1896
Nuit Blanche
1917
Lower right: Beatrice Wood
Oil on canvas board
10 × 14" (25.4 × 35.6 cm)

Gift of the artist
1978-98-1

Yerxa, Thomas
American, born 1923
City Children
1959
Lower left: YERXA 59
Oil on canvas
48 3/16 × 15 15/16" (122.4 × 40.5 cm)

Purchased with the Adele Haas
Turner and Beatrice Pastorius
Turner Memorial Fund
1959-12-8

Wood, Edith Longstreth
American, 1885–1967
Still Life with Anemones
c. 1940
Lower right: E. L. WOOD
Oil on canvas
30 1/4 × 25 1/8" (76.8 × 63.8 cm)

Gift of Miss Miriam H. Thrall
1968-42-1

Zakanitch, Robert
American, born 1935
Hexagon Series VI
1968
Acrylic on canvas
87 3/4 × 76 3/16" (222.9 × 193.5 cm)

Gift of an anonymous donor
1973-73-2

444

Zalce, Alfredo
Mexican, born 1908
Yucatán. Sleeping on the Deck of a Small Boat
1945
Lower right: ALFREDO / ZALCE
1945
Oil on canvas
22 1/2 × 33 1/2" (57.1 × 85.1 cm)

Gift of Mr. and Mrs. James P. Magill
1957-127-7

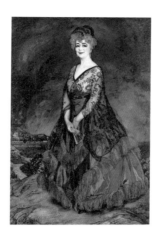

Zuloaga y Zabaleta, Ignacio
Spanish, 1870–1945
Portrait of Mrs. William Fahnestock
1923
Lower left: I. Zuloaga
Oil on canvas
82 1/4 × 54 1/16" (208.9 × 137.3 cm)

Gift of Julia G. Fahnestock in memory of her husband, William Fahnestock
1940-17-27

Zalce, Alfredo
Barrancas de Cuernavacas
1953
Lower left: ALFREDO / ZALCE.53.
Oil on Masonite
23 × 47 5/8" (58.4 × 121 cm)

Gift of Mrs. Beryl Price
1982-104-1

Zorach, Marguerite Thompson
American, 1887–1968
Girl and Cat
c. 1917
Oil on canvas
24 1/16 × 20 1/16" (61.1 × 51 cm)

Gift of George Biddle
1945-16-39

Zucker, Joe
American, born 1941
Porthole No. 3
1981
Acrylic, cotton, and Rhoplex on canvas
72" (182.9 cm) diameter

Gift of Trisha Brown
1988-80-1

Miniatures

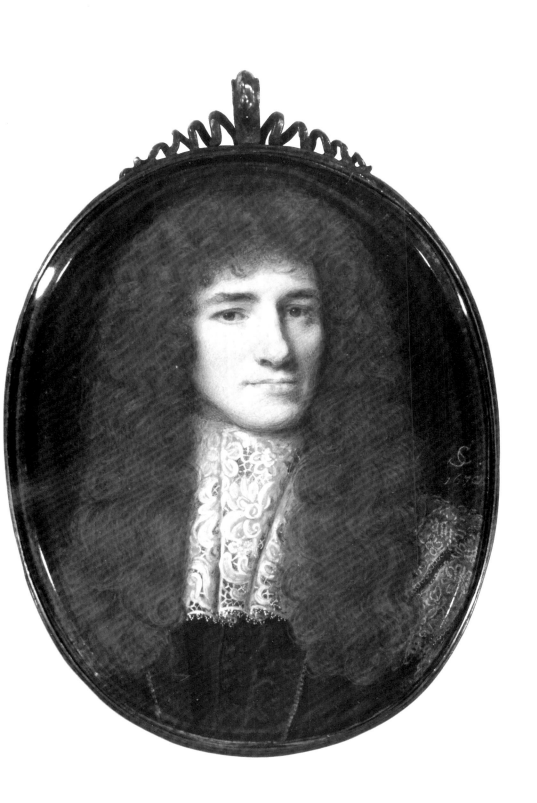

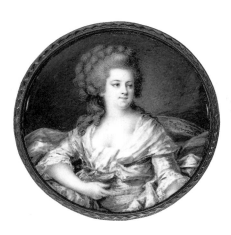

Augustin, Jean-Baptiste-Jacques
French, 1759–1832
Portrait of a Woman
c. 1800
Watercolor and gouache on cardboard
2 13/16 × 2 7/8" (7.1 × 7.3 cm)

Gift of Mrs. Daniel J. McCarthy
1953-142-2

Beetham, Isabella Robinson, attributed to
Silhouette of a Woman
c. 1800
Watercolor reverse-painted on glass
4 1/2 × 4" (11.4 × 10.2 cm)

Gift of Sarah McLean Williams in memory of Mrs. William L. McLean
1942-101-32

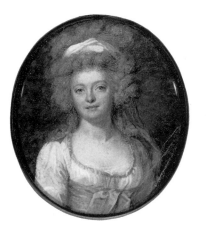

Augustin, Jean-Baptiste-Jacques
Portrait of a Woman
c. 1800
Watercolor and gouache on cardboard
2 3/8 × 2" (6 × 5.1 cm)

Gift of Mrs. Daniel J. McCarthy
1953-142-3

Bertoldi, Antonio
Italian, active late 18th century
Portrait of a Gentleman
1779
Center left: Ante. Bertoldi / F. 1779
Watercolor on ivory
2 1/8 × 1 5/8" (5.4 × 4.1 cm)

The Bloomfield Moore Collection
1899-966

Barry, John
English, active 1784–1827
Portrait of a Man
Early 19th century
On reverse of frame: Ozias Humphrey / b. 1742 d. 1810
Watercolor on ivory
2 11/16 × 2 3/16" (6.8 × 5.6 cm)

Gift of Mrs. Daniel J. McCarthy
1954-21-11

Bigot, Andrée
French, active 18th century
Portrait of a Woman
18th century
Center left: Andrée Bigot.
Watercolor on ivory
3 5/8 × 2 15/16" (9.2 × 7.5 cm)

Gift of Sarah McLean Williams in memory of Mrs. William L. McLean
1942-101-22

Beetham, Isabella Robinson, attributed to
English, 1744–c. 1819
Silhouette of a Man
c. 1800
Watercolor reverse-painted on glass
4 1/8 × 3 3/4" (10.5 × 9.5 cm)

Gift of Sarah McLean Williams in memory of Mrs. William L. McLean
1942-101-34

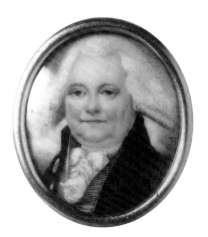

Bogle, John, attributed to
Scottish, active England, active c. 1746–c. 1803
Portrait of a Man
c. 1800
Center right: JB
Watercolor on ivory
1 9/16 × 1 1/4" (4 × 3.2 cm)

The Bloomfield Moore Collection
1899-968

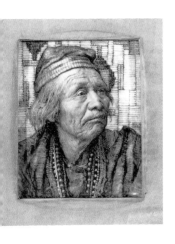

Brunton, Violet
English, 1878–1951
Portrait of an Old Chief
20th century
Watercolor on ivory
3 ⅝ × 2 ¾" (9.2 × 7 cm)

Gift of Mrs. Daniel J. McCarthy
1953-142-8

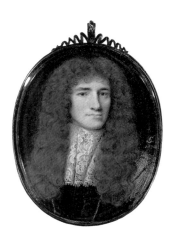

Cooper, Samuel
Portrait of Anthony Ashley Cooper,
2nd Earl of Shaftesbury
1670
Center right: SC. / 1670
Watercolor on vellum
3 3/16 × 2 ½" (8.1 × 6.3 cm)

Gift of Mrs. Daniel J. McCarthy
1953-142-10

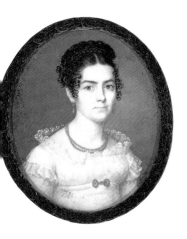

Buncombe, John
English, active c. 1790–c. 1800
Silhouette of an Officer
c. 1790
Watercolor on cardboard
3 ⅞ × 3" (9.8 × 7.6 cm)

Gift of Sarah McLean Williams
in memory of Mrs. William L.
McLean
1942-101-26

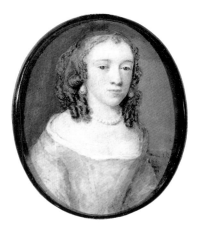

Cooper, Samuel, attributed to
Portrait of Mary, Daughter of
Oliver Cromwell
17th century
Center right: SC
Watercolor and gouache on
vellum
2 ⅝ × 2 ⅛" (6.7 × 5.4 cm)

Gift of Mrs. Daniel J. McCarthy
1953-142-12

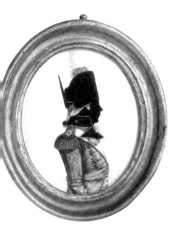

Collas, Louis-Antoine
French, born 1775, death date
unknown
Portrait of Antoinette Melizet
c. 1820–30
Watercolor on ivory
2 9/16 × 2 1/16" (6.5 × 5.2 cm)

Bequest of Leonora L. Koecker
1942-37-5

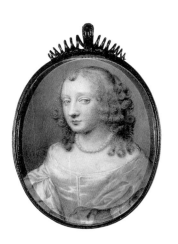

Cooper, Samuel, copy after
Portrait of the Countess of
Shaftesbury
After 1672
On reverse of frame: Countess of
Shaftesbury, / Samuel Cooper. /
ob. 1672
Watercolor on vellum
2 15/16 × 2 ⅜" (7.5 × 6 cm)

Gift of Mrs. Daniel J. McCarthy
1953-142-11

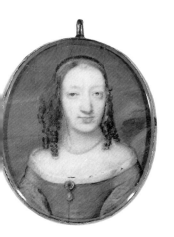

Cooper, Samuel
English, 1609–1672
Portrait of a Woman
c. 1650–60
Watercolor and gouache on
vellum
1 ¼ × 1" (3.2 × 2.5 cm)

Gift of Mrs. Daniel J. McCarthy
1953-142-13

Cosway, Richard
English, 1742–1821
Portrait of the Princess Lubomirska
1789
On card on reverse: Rdus.
Cosway / R.A. / Primarius Pictor /
Serenissimi Walliae / Principis /
Pinxit / 1789
Watercolor on ivory
2 ⅞ × 2 ⅜" (7.3 × 6 cm)

Gift of Mrs. Daniel J. McCarthy
1953-142-14

449

Cosway, Richard
Portrait of a Man in a Black Coat
c. 1790
Watercolor on ivory
2 1/16 × 1 5/8" (5.2 × 4.1 cm)

Gift of Mrs. Daniel J. McCarthy
1953-142-18

Cosway, Richard
Portrait of Mrs. Jackson
1794
On paper on reverse: Mrs.
Jackson / 1794
Watercolor on ivory
2 1/2 × 2 3/16" (6.3 × 5.6 cm)

Gift of Mrs. Daniel J. McCarthy
1953-142-19

Cosway, Richard
Portrait of a Man in a Blue Coat
c. 1790
Watercolor on ivory
2 1/16 × 1 5/8" (5.2 × 4.1 cm)

Gift of Mrs. Daniel J. McCarthy
1953-142-17

Crosse, Richard, attributed to
English, 1742–1810
Portrait of a Man
c. 1800
Watercolor on ivory
1 7/16 × 1 1/4" (3.6 × 3.2 cm)

The Bloomfield Moore Collection
1899-969

Cosway, Richard
Portrait of a Man in a White Coat
c. 1790
Watercolor on ivory
2 1/16 × 1 5/8" (5.2 × 4.1 cm)

Gift of Mrs. Daniel J. McCarthy
1953-142-16

**Daniel of Bath, Joseph,
attributed to**
English, c. 1760–1803
**or Abraham Daniel of Bath,
attributed to**
English, died 1806
Portrait of Joseph Galloway
c. 1790–1803
Watercolor on ivory
2 3/8 × 1 15/16" (6 × 4.9 cm)

Purchased with the John D.
McIlhenny Fund
1966-20-3

Cosway, Richard
*Portrait of the Honorable Andrew
James Cochrane*
1793
On card on reverse: Rdus.
Cosway / R.A. / Primarius Pictor /
Serenissimi Walliae / Principis /
Pinxit / 1793
Watercolor on ivory
2 15/16 × 2 5/16" (7.5 × 5.9 cm)

Gift of Mrs. Daniel J. McCarthy
1953-142-15

**Daniel of Bath, Joseph,
attributed to
or Abraham Daniel of Bath,
attributed to**
Portrait of Mrs. Roberts [née
Galloway]
c. 1790–1803
Watercolor on ivory
1 13/16 × 1 3/8" (4.6 × 3.5 cm)

Purchased with the John D.
McIlhenny Fund
1966-20-6

Debillemont-Chardon, Gabrielle
French, 1860?–1957
Portrait of a Girl
1929
Upper right: G. Debillemont-Chardon
Watercolor on ivory
2 ³/₄ × 2 ¹/₈" (7 × 5.4 cm)

Gift of the Pennsylvania Society of Miniature Painters in memory of Emily Drayton Taylor
1954-42-25

Dutch, unknown artist
Portrait of a Man
Companion to the following miniature
1626
Upper right: 1626 / AET. 62
Oil on copper
2 ⁹/₁₆ × 1 ¹⁵/₁₆" (6.5 × 4.9 cm)

Bequest of A. Manderson Troth
1927-52-37

Debillemont-Chardon, Gabrielle
Portrait of an Old, One-Armed, Italian Veteran
1929
On reverse: June 1929
Watercolor on ivory
3 ⁷/₁₆ × 2 ⁵/₈" (8.7 × 6.7 cm)

Gift of the Pennsylvania Society of Miniature Painters in memory of Emily Drayton Taylor
1954-42-24

Dutch, unknown artist
Portrait of a Woman
Companion to the preceding miniature
1626
Upper left: 1626 / AE [illegible]
Oil on copper
2 ⁹/₁₆ × 1 ¹⁵/₁₆" (6.5 × 4.9 cm)

Bequest of A. Manderson Troth
1927-52-38

Debillemont-Chardon, Gabrielle
La Mère Melv
20th century
Lower right: G. Debillemont-Chardon
Watercolor on ivory substitute
3 ¹/₂ × 4 ¹/₂" (8.9 × 11.4 cm)

Gift of Mrs. Daniel J. McCarthy
1953-142-20

Dutch, unknown artist
Previously attributed to Nicolaes Maes (JFD 1972)
Portrait of a Man
c. 1675–1700
Oil on copper
2 ¹/₄ × 1 ⁷/₈" (5.7 × 4.8 cm)

John G. Johnson Collection
cat. 488

Duplessis, Joseph-Siffred, attributed to
French, 1725–1802
Portrait of Benjamin Franklin
18th century
Watercolor on ivory
1 ⁵/₈ × 1 ³/₈" (4.1 × 3.5 cm)

Gift of Mrs. Edward S. Harkness
1932-8-1

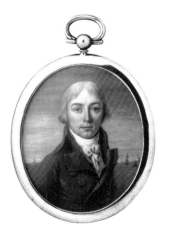

Dutch or English, unknown artist
Portrait of Samuel Hunter Eakin
18th century
Watercolor on ivory
2 ¹/₂ × 2 ¹/₈" (6.4 × 5.4 cm)

Bequest of Constance A. Jones
1988-27-114

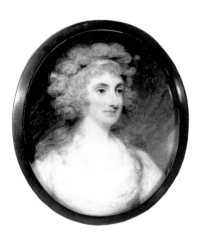

Edridge, Henry
English, 1769–1821
Portrait of Mrs. Berridge
c. 1790
Watercolor on ivory
2 ¹/₂ × 2" (6.3 × 5.1 cm)

Gift of Mrs. Daniel J. McCarthy
1954-21-7

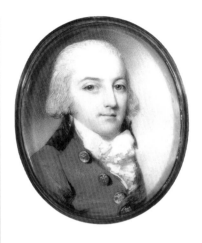

Engleheart, George
Portrait of a Man
c. 1800
Watercolor on ivory
2 ¹/₁₆ × 1 ⁵/₈" (5.2 × 4.1 cm)

Gift of Mrs. Daniel J. McCarthy
1953-142-25

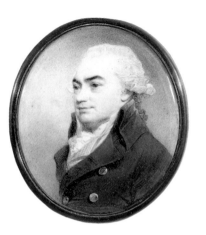

Engleheart, George
English, 1752–1829
Portrait of a Man
c. 1795
Lower right: E
Watercolor on ivory
2 ⁷/₁₆ × 2 ¹/₁₆" (6.2 × 5.2 cm)

Gift of Mrs. Daniel J. McCarthy
1953-142-23

Engleheart, George
Portrait of Captain Roger Curtis, R.N.
1811
On paper on reverse: George Engleheart / Hartford Street Mayfair / Pinxit / 1811
Watercolor on ivory
3 ³/₄ × 2 ⁷/₈" (9.5 × 7.3 cm)

Gift of Mrs. Daniel J. McCarthy
1953-142-21

Engleheart, George
Portrait of a Man
c. 1795
Watercolor on ivory
2 ³/₈ × 1 ¹⁵/₁₆" (6 × 4.9 cm)

Gift of Mrs. Daniel J. McCarthy
1953-142-24

English, unknown artist
Previously listed as an English artist, c. 1650 (JGJ 1941)
Portrait of a Man
c. 1600
Oil on copper
3 ¹³/₁₆ × 2 ¹⁵/₁₆" (9.7 × 7.5 cm)

John G. Johnson Collection
cat. 449

Engleheart, George
Portrait of Lord Northhampton
c. 1795
Watercolor on ivory
1 ¹⁵/₁₆ × 1 ⁵/₈" (4.9 × 4.1 cm)

Gift of Mrs. Daniel J. McCarthy
1953-142-22

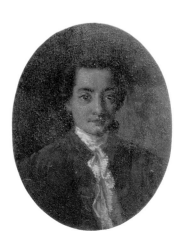

English, unknown artist
Portrait of a Man
c. 1740
Oil on copper
3 ⁹/₁₆ × 2 ⁵/₈" (9 × 6.7 cm)

The Bloomfield Moore Collection
1899-957

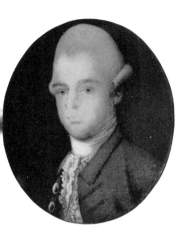

English, unknown artist
Portrait of a Man
c. 1750
Lower right: JD
Watercolor on ivory
1 9/16 × 1 1/4" (4 × 3.2 cm)

The Bloomfield Moore Collection
1899-965

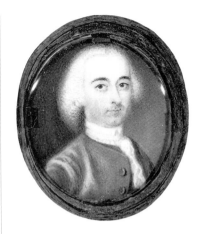

English, unknown artist
Portrait of a Man of the Galloway Family
c. 1775
Watercolor on ivory
1 9/16 × 1 1/4" (4 × 3.2 cm)

Purchased with the John D. McIlhenny Fund
1966-20-4

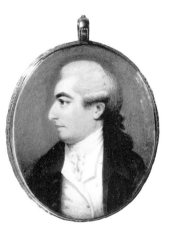

English?, unknown artist
Portrait of a Man
c. 1750–75
Watercolor and gouache on cardboard
1 13/16 × 1 7/16" (4.6 × 3.6 cm)

The Bloomfield Moore Collection
1899-1029

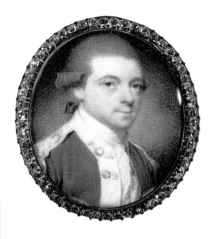

English, unknown artist
Portrait of Joseph Galloway
c. 1775
Watercolor on ivory
1 7/16 × 1 3/16" (3.6 × 3 cm)

Purchased with the John D. McIlhenny Fund
1966-20-2

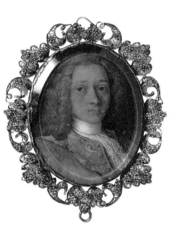

English, unknown artist
Portrait of a Man
c. 1770
Watercolor on ivory
1 3/4 × 1 3/8" (4.4 × 3.5 cm)

Gift of W. Parsons Todd and Miss Mary J. Todd
1938-29-6

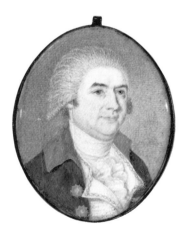

English, unknown artist
Portrait of a Man
c. 1780–1800
Watercolor on ivory
2 × 1 9/16" (5.1 × 4 cm)

The Bloomfield Moore Collection
1899-964

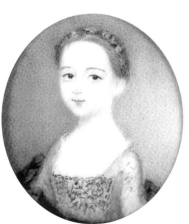

English, unknown artist
Portrait of Miss Roberts
c. 1770
Watercolor on ivory
1 1/2 × 1 1/4" (3.8 × 3.2 cm)

Purchased with the John D. McIlhenny Fund
1966-20-5

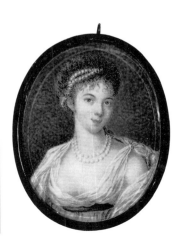

English, unknown artist
Portrait of a Woman
c. 1780–1800
Watercolor on cardboard
3 × 2 1/4" (7.6 × 5.7 cm)

The Bloomfield Moore Collection
1882-1175

453

English, unknown artist
Portrait of a Right Eye
c. 1790–1800
Watercolor on ivory
1 1/8 × 11/16" (2.9 × 1.7 cm)

Gift of Joseph Carson, Hope
Carson Randolph, John B.
Carson, and Anna Hampton
Carson in memory of their
mother, Mrs. Hampton L. Carson
1935-17-6

English, unknown artist
Portrait of Mr. Keppel's Left Eye
c. 1790–1800
Watercolor on ivory
1/2 × 3/4" (1.3 × 1.9 cm)

Gift of Joseph Carson, Hope
Carson Randolph, John B.
Carson, and Anna Hampton
Carson in memory of their
mother, Mrs. Hampton L. Carson
1935-17-18

English, unknown artist
Portrait of a Woman's Left Eye
c. 1790–1800
Watercolor on ivory
5/8 × 3/4" (1.6 × 1.9 cm)

Gift of Joseph Carson, Hope
Carson Randolph, John B.
Carson, and Anna Hampton
Carson in memory of their
mother, Mrs. Hampton L. Carson
1935-17-20

English, unknown artist
Portrait of Part of Mr. Keppel's Face
c. 1790–1800
Watercolor on ivory
5/8 × 13/16" (1.6 × 2.1 cm)

Gift of Joseph Carson, Hope
Carson Randolph, John B.
Carson, and Anna Hampton
Carson in memory of their
mother, Mrs. Hampton L. Carson
1935-17-19

English, unknown artist
Portrait of a Woman's Left Eye
c. 1790–1800
Watercolor on ivory
9/16 × 3/4" (1.4 × 1.9 cm)

Gift of Joseph Carson, Hope
Carson Randolph, John B.
Carson, and Anna Hampton
Carson in memory of their
mother, Mrs. Hampton L. Carson
1935-17-21

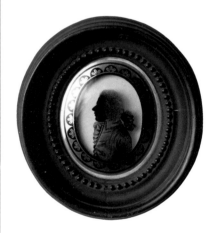

English, unknown artist
Silhouette of a Man
18th century
Watercolor reverse-painted on
glass
4 3/8 × 3 1/2" (11.1 × 8.9 cm)

Gift of Sarah McLean Williams
in memory of Mrs. William L.
McLean
1942-101-33

English, unknown artist
Portrait of a Woman's Right Eye
c. 1790–1800
Watercolor on ivory
9/16 × 11/16" (1.4 × 1.7 cm)

Gift of Joseph Carson, Hope
Carson Randolph, John B.
Carson, and Anna Hampton
Carson in memory of their
mother, Mrs. Hampton L. Carson
1935-17-22

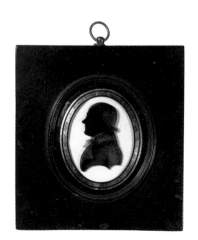

English, unknown artist
Silhouette of a Man
18th century
Watercolor reverse-painted on
glass
2 7/8 × 2 1/4" (7.3 × 5.7 cm)

Gift of Sarah McLean Williams
in memory of Mrs. William L.
McLean
1942-101-35

English, unknown artist
Mourner by a Monument
c. 1800
On plinth: GONE TO BLISS /
Mary Howard; on reverse: MB
Watercolor on ivory
1 7/8 × 1 1/2" (4.8 × 3.8 cm)

Gift of Miss Sara A. Swain in
memory of Mrs. Sara S. Swain
1909-142

English, unknown artist
Portrait of a Left Eye
c. 1800
Watercolor on ivory
3/8 × 5/8" (0.9 × 1.6 cm)

Gift of Mrs. Charles Francis
Griffith in memory of Dr. L.
Webster Fox
1936-6-1

English, unknown artist
Mourner by a Monument
c. 1800
On plinth: Gone to BLISS / MH;
on reverse: RB
Watercolor on ivory
1 7/8 × 1 1/2" (4.8 × 3.8 cm)

Gift of Miss Sara A. Swain in
memory of Mrs. Sara S. Swain
1909-143

English, unknown artist
Portrait of a Left Eye
c. 1800
Watercolor on ivory
1/2 × 15/16" (1.3 × 2.4 cm)

Gift of Mrs. Charles Francis
Griffith in memory of Dr. L.
Webster Fox
1936-6-5

English, unknown artist
Mourner by a Monument
c. 1800
On urn: WME; on plinth: NOT
LOST / BUT GONE / BEFORE
Watercolor on ivory
1 7/8 × 1 1/2" (4.8 × 3.8 cm)

The Ozeas, Ramborger, Keehmle
Collection
1921-34-119

English, unknown artist
Portrait of a Left Eye
c. 1800
Watercolor on ivory
1/4 × 1/2" (0.6 × 1.3 cm)

Gift of Mrs. Charles Francis
Griffith in memory of Dr. L.
Webster Fox
1936-6-8

English, unknown artist
Portrait of a Left Eye
c. 1800
Watercolor on ivory
1/4 × 1/2" (0.6 × 1.3 cm)

Gift of Joseph Carson, Hope
Carson Randolph, John B.
Carson, and Anna Hampton
Carson in memory of their
mother, Mrs. Hampton L. Carson
1935-17-14

English, unknown artist
Portrait of a Left Eye
c. 1800
Watercolor on ivory
5/16 × 1/2" (0.8 × 1.3 cm)

Gift of Mrs. Charles Francis
Griffith in memory of Dr. L.
Webster Fox
1936-6-14

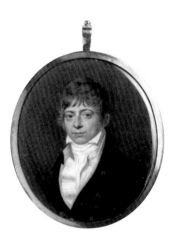

English, unknown artist
Portrait of a Man
c. 1800
Watercolor on ivory
2 ¹³/₁₆ × 2 ³/₈" (7.1 × 6 cm)

Gift of Mrs. Daniel J. McCarthy
1954-63-11

English, unknown artist
Portrait of a Right Eye
c. 1800
Watercolor on ivory
³/₄" (1.9 cm) diameter

Gift of Joseph Carson, Hope
Carson Randolph, John B.
Carson, and Anna Hampton
Carson in memory of their
mother, Mrs. Hampton L. Carson
1935-17-13

English, unknown artist
Portrait of a Man's Right Eye
c. 1800
Watercolor on ivory
⁵/₈ × ³/₄" (1.6 × 1.9 cm)

Gift of Joseph Carson, Hope
Carson Randolph, John B.
Carson, and Anna Hampton
Carson in memory of their
mother, Mrs. Hampton L. Carson
1935-17-9

English, unknown artist
Portrait of a Right Eye
c. 1800
Watercolor on ivory
1 × ⁵/₈" (2.5 × 1.6 cm)

Gift of Joseph Carson, Hope
Carson Randolph, John B.
Carson, and Anna Hampton
Carson in memory of their
mother, Mrs. Hampton L. Carson
1935-17-16

English, unknown artist
Portrait of a Man's Right Eye
c. 1800
Watercolor on ivory
¹/₂ × ¹¹/₁₆" (1.3 × 1.7 cm)

Gift of Joseph Carson, Hope
Carson Randolph, John B.
Carson, and Anna Hampton
Carson in memory of their
mother, Mrs. Hampton L. Carson
1935-17-17

English, unknown artist
Portrait of a Right Eye
c. 1800
Watercolor on ivory
⁵/₁₆ × ¹/₂" (0.8 × 1.3 cm)

Gift of Mrs. Charles Francis
Griffith in memory of Dr. L.
Webster Fox
1936-6-2

English, unknown artist
Portrait of a Man's Right Eye
c. 1800
Watercolor on ivory
⁵/₁₆ × ⁵/₈" (0.8 × 1.6 cm)

Gift of Mrs. Charles Francis
Griffith in memory of Dr. L.
Webster Fox
1936-6-4

English, unknown artist
Portrait of a Right Eye
c. 1800
Watercolor on ivory
¹/₂ × ⁷/₈" (1.3 × 2.2 cm)

Gift of Mrs. Charles Francis
Griffith in memory of Dr. L.
Webster Fox
1936-6-3

English, unknown artist
Portrait of a Right Eye
c. 1800
Watercolor on ivory
³⁄₈ × ⁵⁄₈" (0.9 × 1.6 cm)

Gift of Mrs. Charles Francis
Griffith in memory of Dr. L.
Webster Fox
1936-6-12

English, unknown artist
Portrait of a Woman's Left Eye
c. 1800
Watercolor on ivory
⁷⁄₁₆ × ⁵⁄₈" (1.1 × 1.6 cm)

Gift of Joseph Carson, Hope
Carson Randolph, John B.
Carson, and Anna Hampton
Carson in memory of their
mother, Mrs. Hampton L. Carson
1935-17-2

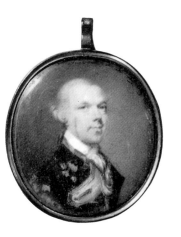

English, unknown artist
Portrait of a Soldier
c. 1800
Watercolor on ivory
1 ¼ × 1 ¹⁄₁₆" (3.2 × 2.7 cm)

Gift of W. Parsons Todd and
Miss Mary J. Todd
1938-29-7

English, unknown artist
Portrait of a Woman's Left Eye
c. 1800
Watercolor on ivory
⁵⁄₈ × ⁵⁄₈" (1.6 × 1.6 cm)

Gift of Joseph Carson, Hope
Carson Randolph, John B.
Carson, and Anna Hampton
Carson in memory of their
mother, Mrs. Hampton L. Carson
1935-17-3

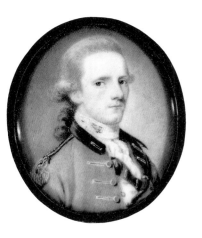

English, unknown artist
Portrait of a Soldier
c. 1800
Watercolor on ivory
1 ⁷⁄₁₆ × 1 ³⁄₁₆" (3.6 × 3 cm)

Gift of Mrs. Daniel J. McCarthy
1955-1-17

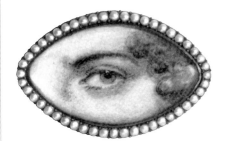

English, unknown artist
Portrait of a Woman's Left Eye
c. 1800
Watercolor on ivory
³⁄₄ × 1 ¼" (1.9 × 3.2 cm)

Gift of Joseph Carson, Hope
Carson Randolph, John B.
Carson, and Anna Hampton
Carson in memory of their
mother, Mrs. Hampton L. Carson
1935-17-5

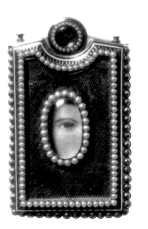

English, unknown artist
Portrait of a Woman's Left Eye
c. 1800
Watercolor on ivory
¹⁵⁄₁₆ × ⁹⁄₁₆" (2.4 × 1.4 cm)

Gift of Joseph Carson, Hope
Carson Randolph, John B.
Carson, and Anna Hampton
Carson in memory of their
mother, Mrs. Hampton L. Carson
1935-17-1

English, unknown artist
Portrait of a Woman's Left Eye
c. 1800
Watercolor on ivory
³⁄₈ × ⁹⁄₁₆" (0.9 × 1.4 cm)

Gift of Joseph Carson, Hope
Carson Randolph, John B.
Carson, and Anna Hampton
Carson in memory of their
mother, Mrs. Hampton L. Carson
1935-17-8

English, unknown artist
Portrait of a Woman's Left Eye
c. 1800
Watercolor on ivory
$^3/_8 \times {}^9/_{16}$" (0.9 × 1.4 cm)

Gift of Mrs. Charles Francis
Griffith in memory of Dr. L.
Webster Fox
1936-6-10

English, unknown artist
Portrait of Part of a Woman's Face
c. 1800
Watercolor on ivory
$^3/_8 \times {}^3/_8$" (0.9 × 0.9 cm)

Gift of Joseph Carson, Hope
Carson Randolph, John B.
Carson, and Anna Hampton
Carson in memory of their
mother, Mrs. Hampton L. Carson
1935-17-15

English, unknown artist
Portrait of a Woman's Left Eye
c. 1800
Watercolor on ivory
$^{13}/_{16} \times 1 {}^5/_{16}$" (2.1 × 3.3 cm)

Gift of Mrs. Charles Francis
Griffith in memory of Dr. L.
Webster Fox
1936-6-13

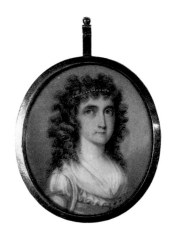

English, unknown artist
Portrait of Catherine Warner Hosach
c. 1800
Watercolor on ivory
$2 {}^1/_8 \times 1 {}^3/_4$" (5.4 × 4.4 cm)

Gift of Mrs. H. Gates Lloyd
1973-154-1

English, unknown artist
Portrait of a Woman's Right Eye
c. 1800
Watercolor on cardboard
$1 {}^5/_8 \times 1 {}^3/_{16}$" (4.1 × 3 cm)

Gift of Joseph Carson, Hope
Carson Randolph, John B.
Carson, and Anna Hampton
Carson in memory of their
mother, Mrs. Hampton L. Carson
1935-17-4

English, unknown artist
Portrait of a Left Eye
c. 1800–10
Watercolor on ivory
$^1/_4 \times {}^9/_{16}$" (0.6 × 1.4 cm)

Gift of Mrs. Charles Francis
Griffith in memory of Dr. L.
Webster Fox
1936-6-6

English, unknown artist
Portrait of a Woman's Right Eye
c. 1800
Watercolor on ivory
$^9/_{16} \times {}^{15}/_{16}$" (1.4 × 2.4 cm)

Gift of Joseph Carson, Hope
Carson Randolph, John B.
Carson, and Anna Hampton
Carson in memory of their
mother, Mrs. Hampton L. Carson
1935-17-12

English, unknown artist
Portrait of a Left Eye
c. 1800–10
Watercolor on ivory
$^3/_8 \times {}^5/_8$" (0.9 × 1.6 cm)

Gift of Mrs. Charles Francis
Griffith in memory of Dr. L.
Webster Fox
1936-6-11

English, unknown artist
Portrait of a Man's Right Eye
c. 1800–10
Watercolor on ivory
⁵⁄₈" (1.6 cm) diameter

Gift of Mrs. Charles Francis
Griffith in memory of Dr. L.
Webster Fox
1936-6-15

English, unknown artist
Portrait of a Woman's Left Eye
c. 1800–10
Watercolor on ivory
⁹⁄₁₆ × ⁷⁄₈" (1.4 × 2.2 cm)

Gift of Joseph Carson, Hope
Carson Randolph, John B.
Carson, and Anna Hampton
Carson in memory of their
mother, Mrs. Hampton L. Carson
1935-17-23

English, unknown artist
Portrait of a Right Eye
c. 1800–10
On reverse of frame: Ann Saner /
died 5 Oct. / 1797. / Aged 66. /
Adam Saner / died 30 Nov / 1805
/ Aged 7
Watercolor on ivory
³⁄₈ × ⁹⁄₁₆" (0.9 × 1.4 cm)

Gift of Joseph Carson, Hope
Carson Randolph, John B.
Carson, and Anna Hampton
Carson in memory of their
mother, Mrs. Hampton L. Carson
1935-17-10

English, unknown artist
Portrait of E. Vestell's Left Eye
c. 1800–10
On reverse: Eliza Hunt /
E. Vestell
Watercolor on ivory
⁵⁄₁₆ × ¹⁄₂" (0.8 × 1.3 cm)

Gift of Mrs. Charles Francis
Griffith in memory of Dr. L.
Webster Fox
1936-6-9

English, unknown artist
Portrait of a Right Eye
c. 1800–10
Watercolor on ivory
¹⁄₄ × ¹⁄₂" (0.6 × 1.3 cm)

Gift of Mrs. Charles Francis
Griffith in memory of Dr. L.
Webster Fox
1936-6-7

English, unknown artist
Portrait of Sarah Best's Right Eye
c. 1800–10
On reverse of frame: Sarah Best /
Obt July 6; / 1833 / Aet 79
Watercolor on ivory
⁷⁄₁₆ × ³⁄₄" (1.1 × 1.9 cm)

Gift of Joseph Carson, Hope
Carson Randolph, John B.
Carson, and Anna Hampton
Carson in memory of their
mother, Mrs. Hampton L. Carson
1935-17-11

English, unknown artist
Portrait of a Woman's Left Eye
c. 1800–10
Watercolor on ivory
⁹⁄₁₆" (1.4 cm) diameter

Gift of Joseph Carson, Hope
Carson Randolph, John B.
Carson, and Anna Hampton
Carson in memory of their
mother, Mrs. Hampton L. Carson
1935-17-7

English, unknown artist
Silhouette of Thomas Campbell
c. 1800–25
Watercolor reverse-painted on
glass
3 × 2¹⁄₂" (7.6 × 6.3 cm)

Gift of Sarah McLean Williams
in memory of Mrs. William L.
McLean
1942-101-36

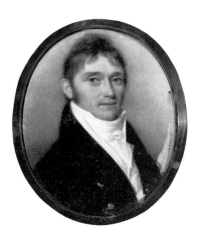

English, unknown artist
*Portrait of Alexander Reed of
Reading, Pennsylvania*
c. 1830
Watercolor on ivory
3 × 2 ⅜" (7.6 × 6 cm)

Gift of Mrs. Edward A. White
1945-64-1

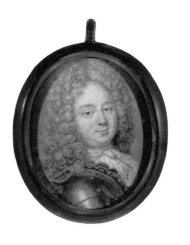

European, unknown artist
*Portrait of John Churchill, Duke of
Marlborough*
c. 1700
Watercolor on cardboard
1 ¼ × 1 ⅛" (3.2 × 2.9 cm)

Bequest of A. Manderson Troth
1927-52-209

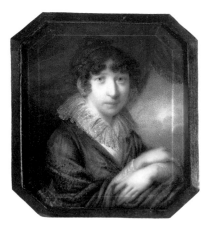

English, unknown artist
Portrait of a Woman
c. 1830
Watercolor on ivory
2 ⅝ × 2 ¼" (6.7 × 5.7 cm)

Gift of Mrs. Daniel J. McCarthy
1955-1-26

European, unknown artist
Balloon Ascension, Annonay, France
18th century
Lower right: Rotte
Watercolor on ivory
1 ⅞" (4.8 cm) diameter

Gift of the Pennsylvania Society
of Miniature Painters in memory
of Emily Drayton Taylor, bequest
of Berta Carew
1959-91-9

English, unknown artist
Portrait of Isaac Tapping
c. 1830
Watercolor on cardboard
3 5⁄16 × 2 ⅝" (8.4 × 6.7 cm)

Gift of Mrs. Hampton L. Carson
1929-126-14

European, unknown artist
Portrait of a Man
18th century
Watercolor on ivory
9⁄16 × ½" (1.4 × 1.3 cm)

The Bloomfield Moore Collection
1882-1168

English, unknown artist
Portrait of Two Girls
c. 1840
Lower right: C [illegible]
Watercolor on ivory
2 15⁄16 × 2 ¼" (7.5 × 5.7 cm)

Gift of the Pennsylvania Society
of Miniature Painters in memory
of Emily Drayton Taylor, bequest
of Berta Carew
1959-91-1

European, unknown artist
Portrait of a Woman
Late 18th century
Watercolor on ivory
2 × 1 ½" (5.1 × 3.8 cm)

Gift of Sarah McLean Williams
in memory of Mrs. William L.
McLean
1942-101-25

European, unknown artist
Portrait of a Man
c. 1800
Watercolor on ivory
2 5/8 × 1 7/8" (6 × 4.8 cm)

Gift of the Pennsylvania Society
of Miniature Painters in memory
of Emily Drayton Taylor, bequest
of Berta Carew
1959-91-2

European, unknown artist
Ships at Sea
19th century
Oil on panel
1 15/16" (4.9 cm) diameter

Gift of the Pennsylvania Society
of Miniature Painters in memory
of Emily Drayton Taylor, bequest
of Berta Carew
1959-91-13

European, unknown artist
Portrait of a Woman
c. 1800
Watercolor on ivory
2 3/8 × 1 15/16" (6 × 4.9 cm)

Gift of Sarah McLean Williams
in memory of Mrs. William L.
McLean
1942-101-29

Field, John
English, 1771–1841
*Silhouette of Dr. Maltby, Bishop of
Chichester and Durham*
c. 1810
Lower left: Field, 11 Strand
Watercolor on plaster
2 × 1 5/8" (5.1 × 4.1 cm)

Gift of Sarah McLean Williams
in memory of Mrs. William L.
McLean
1942-101-38

European, unknown artist
Portrait of a Man
c. 1800–10
Watercolor on ivory
2 3/8" (6 cm) diameter

Gift of the Pennsylvania Society
of Miniature Painters in memory
of Emily Drayton Taylor, bequest
of Berta Carew
1959-91-6

French, unknown artist
Portrait of a Woman
c. 1790
Watercolor on ivory
2 5/16" (5.9 cm) diameter

The Bloomfield Moore Collection
1882-1171

European, unknown artist
Landscape with Ships
19th century
Watercolor on ivory
1 7/8" (4.8 cm) diameter

Gift of the Pennsylvania Society
of Miniature Painters in memory
of Emily Drayton Taylor, bequest
of Berta Carew
1959-91-14

French, unknown artist
Putti with Attributes of Hunters
Cover of a patch box
c. 1790
Watercolor on ivory
1 × 2 7/8" (2.5 × 7.3 cm)

The Bloomfield Moore Collection
1899-1011

French, unknown artist
Portrait of a Woman
c. 1790–1800
Watercolor on ivory
2 1/4" (5.7 cm) diameter

The Bloomfield Moore Collection
1899-1030

French?, unknown artist
Portrait of a Man
c. 1800
Watercolor on ivory
1 1/16 × 7/8" (2.7 × 2.2 cm)

Gift of the Pennsylvania Society
of Miniature Painters in memory
of Emily Drayton Taylor, bequest
of Berta Carew
1959-91-4

French, unknown artist
Portrait of a Man
1791
On reverse: 1791
Oil on ivory
2 1/16 × 1 5/8" (5.2 × 4.1 cm)

Bequest of A. Manderson Troth
1927-52-212

French, unknown artist
Portrait of a Woman
c. 1800
Watercolor on ivory
2 1/4 × 1 7/16" (5.7 × 3.6 cm)

The Bloomfield Moore Collection
1899-976

French, unknown artist
Portrait of a Man
c. 1800
Oil on linen
2 3/8" (6 cm) diameter

The Bloomfield Moore Collection
1899-967

French, unknown artist
Portrait of a Woman
Companion to the following
miniature
c. 1800
Watercolor on ivory
2 11/16" (6.8 cm) diameter

Gift of Sarah McLean Williams
in memory of Mrs. William L.
McLean
1942-101-27a

French, unknown artist
Portrait of a Man
c. 1800
Lower right: K. Feriet
Watercolor on ivory
2 5/8" (6.7 cm) diameter

Gift of Sarah McLean Williams
in memory of Mrs. William L.
McLean
1942-101-30

French, unknown artist
Portrait of a Man
Companion to the preceding
miniature
c. 1800
Watercolor on ivory
2 5/8" (6.7 cm) diameter

Gift of Sarah McLean Williams
in memory of Mrs. William L.
McLean
1942-101-27b

French, unknown artist
Portrait of a Man
c. 1800–10
Watercolor on ivory
2 ¹¹/₁₆ × 2 ¹/₁₆" (6.8 × 5.2 cm)

The Bloomfield Moore Collection
1882-1176

French, unknown artist
Portrait of a Woman
Companion to the following
miniature
c. 1840
Watercolor on ivory
2 ⁵/₈" (6.7 cm) diameter

Gift of Mrs. Daniel J. McCarthy
1955-1-27a

French, unknown artist
Portrait of Napoleon Bonaparte
c. 1804
Center right (spurious): Isabey
Watercolor on ivory
2 ¹/₈" (5.4 cm) diameter

Bequest of A. Manderson Troth
1927-52-206

French?, unknown artist
Portrait of a Man
Companion to the preceding
miniature
c. 1840
Watercolor on ivory
2 ⁵/₈" (6.7 cm) diameter

Gift of Mrs. Daniel J. McCarthy
1955-1-27b

French?, unknown artist
*Portrait of Matilda de Burlo-
Ramborger*
c. 1820–40
Watercolor on ivory
2 ¹¹/₁₆ × 2 ⁵/₈" (6.8 × 6.7 cm)

The Ozeas, Ramborger, Keehmle
Collection
1921-34-96

French?, unknown artist
Portrait of a Woman
Companion to the following
miniature
c. 1850
Watercolor on ivory
3 ¹/₂" (8.9 cm) diameter

Gift of Sarah McLean Williams
in memory of Mrs. William L.
McLean
1942-101-28a

French, unknown artist
Portrait of Henry D. Mandeville
1822
Oil on mother-of-pearl
3 ³/₁₆ × 2 ³/₈" (8.1 × 6 cm)

Gift of Marie Josephine Rozet
and Rebecca Mandeville Rozet
Hunt
1935-13-47

French?, unknown artist
Portrait of a Man
Companion to the preceding
miniature
c. 1850
Watercolor on ivory
3 ¹/₂" (8.9 cm) diameter

Gift of Sarah McLean Williams
in memory of Mrs. William L.
McLean
1942-101-28b

French, unknown artist
Portrait of Madame Guimard
Possibly based on *L'Étude*, by
Jean-Honoré Fragonard (French,
1732–1806), in the Musée du
Louvre, Paris (cat. no. 297)
19th century
Watercolor on ivory
1" (2.5 cm) diameter

Gift of Mrs. Daniel J. McCarthy
1954-21-2

German, unknown artist
Portrait of a Man
18th century
Watercolor on cardboard
1 3/8 × 1 1/8" (3.5 × 2.9 cm)

The Bloomfield Moore Collection
1882-1170

French, unknown artist
Portrait of a Woman
Late 19th century
Watercolor on ivory
2 5/8" (6.7 cm) diameter

The Bloomfield Moore Collection
1882-1177

German, unknown artist
Portrait of Wilhelm Christian Stoll
c. 1800–10
Graphite and wash on cardboard
1 7/8 × 1 3/8" (4.8 × 3.5 cm)

Gift of Mrs. Charles V. Hemsley
and Miss Helen A. Kimmig
1961-179-1

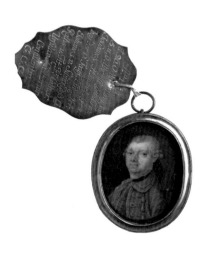

German, unknown artist
Portrait of Johannes Hommel
1626
Upper left: 1626 / AJS; on metal
tag: Ao. 1760. / d. 26. Octbr.
Morg. zw. / 5.u.6. Uhr ist
gebohren / Johannes Hommel,
Gev. / bey der H. Tauff, Tit. Hr. /
Johan[n]es v. Schütz, dess G. /
Raths, u. Tit. Fr. Cathar. / Ursula
v. Schelhornin / Consulentin. /
G.G.G
Oil on ivory
1 5/8 × 1 1/4" (4.1 × 3.2 cm)

Bequest of A. Manderson Troth
1927-52-42

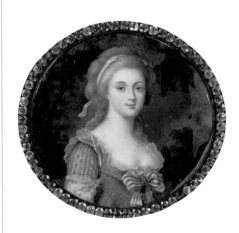

Giraud, D.
French, active late 18th and
early 19th centuries
Portrait of a Woman
1785
Lower right: Giraud / 1785
Watercolor on ivory
2 7/16" (6.2 cm) diameter

Bequest of A. Manderson Troth
1927-52-218

German, unknown artist
Portrait of a Man
18th century
Watercolor and gouache on
cardboard
1 3/8 × 1 3/16" (3.5 × 3 cm)

The Bloomfield Moore Collection
1882-1169

Henri, Pierre
English, born France, active
United States c. 1790–1812
Portrait of Louis Marie Clapier
c. 1800
Watercolor on ivory
2 3/4 × 2 1/8" (7 × 5.4 cm)

Bequest of Miss Fanny Norris in
memory of Louis Marie Clapier
1940-46-1

Hervé, Henry
English, active 1801–1817
Portrait of a Boy
c. 1817
Watercolor on cardboard
3 × 2 3/8" (7.6 × 6 cm)

Gift of Mrs. Hampton L. Carson
1929-126-15

Hoskins, John
English, c. 1595–1664/65
Portrait of a Man
1657
Center left: 1657 / JH
Watercolor on cardboard
2 15/16 × 2 5/16" (7.5 × 5.9 cm)

Gift of Mrs. Daniel J. McCarthy
1954-21-9

Hoin, Claude-Jean-Baptiste
French, 1750–1817
Portrait of a Man
1790s
Lower right: Hoin
Watercolor on ivory
2 3/8 × 1 15/16" (6 × 4.9 cm)

Gift of the Pennsylvania Society
of Miniature Painters in memory
of Emily Drayton Taylor, bequest
of Berta Carew
1959-91-7

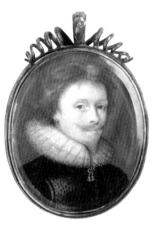

Hoskins, John, attributed to
Portrait of a Man
c. 1625
Watercolor on cardboard
1 5/8 × 1 5/16" (4.1 × 3.3 cm)

Gift of Mrs. Daniel J. McCarthy
1954-21-8

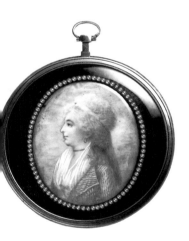

Hoin, Claude-Jean-Baptiste
Portrait of a Woman
1790s
Lower right: Hoin
Watercolor on ivory
2 7/16 × 2" (6.2 × 5.1 cm)

Gift of the Pennsylvania Society
of Miniature Painters in memory
of Emily Drayton Taylor, bequest
of Berta Carew
1959-91-8

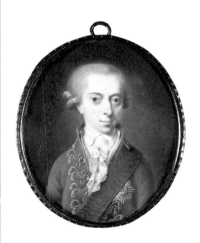

Høyer, Cornelius
Danish, 1741–1804
*Portrait of Christian VII, King of
Denmark and Norway*
c. 1784
Watercolor on ivory
2 13/16 × 2 3/8" (7.1 × 6 cm)

Gift of Mrs. Daniel J. McCarthy
1954-21-10

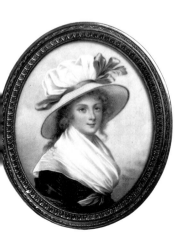

Hoppner, John, attributed to
English, 1758–1810
Portrait of the Princess of Wales
1787
Lower right: Hoppner / 1787
Watercolor on ivory
3 3/4 × 3 1/8" (9.5 × 7.9 cm)

Gift of Sarah McLean Williams
in memory of Mrs. William L.
McLean
1942-101-24

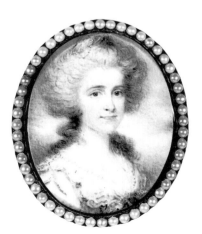

Humphrey, Ozias
English, 1742–1810
Portrait of a Woman
c. 1800
Center bottom: [illegible
monogram]
Watercolor on ivory
2 1/16 × 1 5/8" (5.2 × 4.1 cm)

Gift of Mrs. Daniel J. McCarthy
1954-21-12

Humphrey, Ozias
Portrait of Mr. Joyot
c. 1800
Watercolor on ivory
1 7/8 × 1 3/4" (4.8 × 4.4 cm)

Gift of Mrs. Daniel J. McCarthy
1954-63-5

Italian, unknown artist
Still Life with Flowers in a Vase
18th century
Oil on panel
8 × 6 1/4" (20.3 × 15.9 cm)

Gift of the Pennsylvania Society
of Miniature Painters in memory
of Emily Drayton Taylor, bequest
of Berta Carew
1959-91-52

**Italian, active northern
Italy?, unknown artist**
Annunciate Virgin
See following miniature for
reverse
16th century
Watercolor reverse-painted on
glass
1 1/16 × 7/8" (2.7 × 2.2 cm)

Purchased with Museum funds
1949-40-1a

Italian, unknown artist
Still Life with Flowers in a Vase
18th century
Oil on panel
7 3/4 × 6 1/8" (19.7 × 15.6 cm)

Gift of the Pennsylvania Society
of Miniature Painters in memory
of Emily Drayton Taylor, bequest
of Berta Carew
1959-91-53

**Italian, active northern
Italy?, unknown artist**
*Saint John the Evangelist with a
Chalice*
Reverse of the preceding
miniature
16th century
Upper left: S.G.
Watercolor reverse-painted on
glass
1 1/16 × 7/8" (2.7 × 2.2 cm)

Purchased with Museum funds
1949-40-1b

Italian, unknown artist
*Portrait of Mrs. Jane Cunningham
Drake*
c. 1850
Watercolor on ivory
3 3/4 × 3" (9.5 × 7.6 cm)

Gift of Miss Millicent J. Drake
1935-14-2

Italian, unknown artist
Portrait of the Duchess of Leinster
18th century
Watercolor on ivory
3 7/16 × 2 3/4" (8.7 × 7 cm)

Gift of the Pennsylvania Society
of Miniature Painters in memory
of Emily Drayton Taylor, bequest
of Berta Carew
1959-91-3

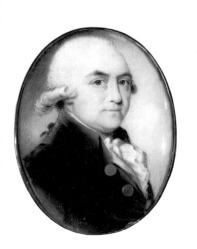

Jean, Philip
English, 1755–1802
Portrait of John Tyers
1787
Watercolor on ivory
1 9/16 × 1 1/4" (4 × 3.2 cm)

Gift of Mrs. Daniel J. McCarthy
1954-21-14

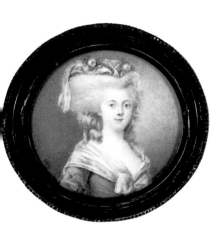

Joffray
French, 18th century
Portrait of a Woman
18th century
Lower left: Joffray
Watercolor on ivory
2 ¼" (5.7 cm) diameter

Bequest of A. Manderson Troth
1927-52-192

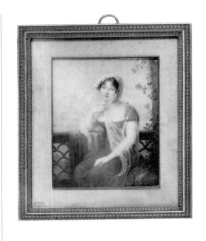

Leguay, Étienne-Charles, attributed to
French, 1762–1846
Portrait of Caroline Bonaparte Murat, Queen of Naples
c. 1812
Center left: E. Le Guay
Watercolor on ivory
4 ⁷⁄₁₆ × 3 ¹¹⁄₁₆" (11.3 × 9.4 cm)

Bequest of Elizabeth Ellen Keating
F1920-1-2

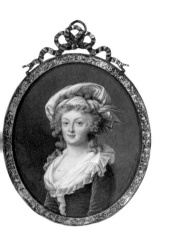

Kauffmann, Angelica
Swiss, 1741–1807
Portrait of Marie Caroline, Queen of Naples
1780
Lower right: Angca Kaufmann 1780.
Watercolor on ivory
3 ⅝ × 2 ¹⁵⁄₁₆" (9.2 × 7.5 cm)

Gift of Sarah McLean Williams in memory of Mrs. William L. McLean
1942-101-23

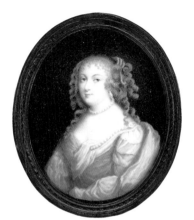

Lemoine, Jacques-Antoine-Marie
French, 1751–1824
Portrait of Henrietta Maria, Queen of England
After an earlier portrait
1769
Lower left: Lemoine
Watercolor on ivory
3 ¼ × 2 ½" (8.2 × 6.3 cm)

Gift of Mr. and Mrs. John Harrison
1952-46-1

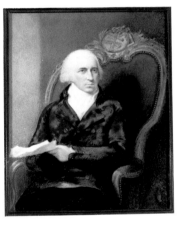

Lane, John
English, 1788–1868
Portrait of Benjamin West, President of the Royal Academy
After 1792
Watercolor on ivory
6 ³⁄₁₆ × 4 ⅞" (15.7 × 12.4 cm)

Gift of Mrs. Daniel J. McCarthy
1954-21-16

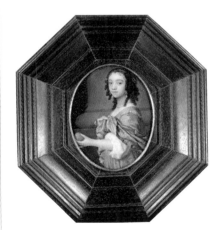

Luttichuys, Isaac
Dutch, born England, 1616–1673
Portrait of a Young Woman Holding an Orange
c. 1646–50
Oil on copper
4 ½ × 3 ¼" (11.4 × 8.2 cm)

Purchased with the Director's Discretionary Fund
1968-97-1

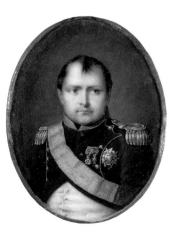

Larue, André-Léon, also called Mansion, attributed to
French, 1785–c. 1834
Portrait of Napoleon Bonaparte
c. 1810
Center left: Mansion.
Watercolor on ivory
4 ¹⁄₁₆ × 3" (10.3 × 7.6 cm)

Gift of Mrs. Jacob Riegel and Mrs. Daniel Whitney
1952-3-1

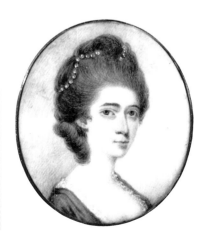

McMoreland, Patrick John, attributed to
Scottish, born 1741, still active 1809
Portrait of Mrs. Joseph Galloway [née Grace Growden]
c. 1770
Watercolor on ivory
1 ½ × 1 ¼" (3.8 × 3.2 cm)

Purchased with the John D. McIlhenny Fund
1966-20-7

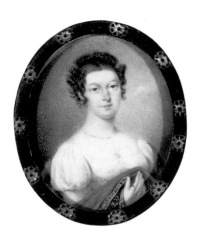

Mason
French?, active c. 1849
Portrait of a Woman
1849
Lower right: Mason 1849
Watercolor on ivory
1 3/4 × 1 3/8" (4.4 × 3.5 cm)

Gift of the Pennsylvania Society
of Miniature Painters in memory
of Emily Drayton Taylor, bequest
of Berta Carew
1959-91-5

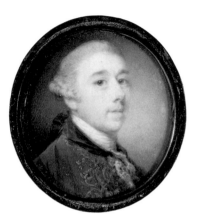

Meyer, Jeremiah
English, born Germany,
1735–1789
Portrait of a Man
c. 1775
Watercolor on ivory
1 3/8 × 1 1/8" (3.5 × 2.9 cm)

Gift of Mrs. Daniel J. McCarthy
1954-63-4

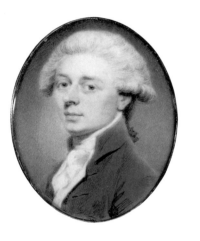

Meyer, Jeremiah
Portrait of Mr. Pilkington
c. 1775–80
Watercolor on ivory
1 11/16 × 1 5/16" (4.3 × 3.3 cm)

Gift of Mrs. Daniel J. McCarthy
1953-142-4

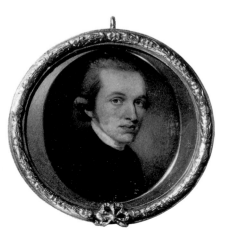

Miles, Edward
English, 1752–1828
Portrait of a Man
1773
Lower right: EM / 1773
Watercolor on ivory
1 5/8 × 1 3/8" (4.1 × 3.5 cm)

Gift of W. Parsons Todd and
Miss Mary J. Todd
1938-29-17

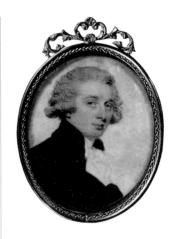

Miles, Edward
Portrait of a Man
c. 1790
Watercolor on ivory
2 × 1 9/16" (5.1 × 4 cm)

Gift of W. Parsons Todd and
Miss Mary J. Todd
1938-29-11

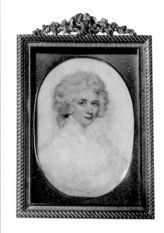

Miles, Edward
Portrait of a Woman
c. 1790
Watercolor on ivory
3 × 2" (7.6 × 5.1 cm)

Gift of W. Parsons Todd and
Miss Mary J. Todd
1938-29-12

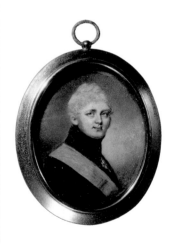

Miles, Edward
*Portrait of Alexander I, Czar of
Russia*
Companion to the following
miniature
c. 1797–1807
Watercolor on ivory
2 3/4 × 2" (7 × 5.1 cm)

Gift of W. Parsons Todd and
Miss Mary J. Todd
1938-29-2

Miles, Edward
*Portrait of Louise Marie, Empress of
Russia*
Companion to the preceding
miniature
c. 1797–1807
Watercolor on ivory
2 11/16 × 2 1/8" (6.8 × 5.4 cm)

Gift of W. Parsons Todd and
Miss Mary J. Todd
1938-29-1

Miles, Edward
Portrait of a Lady of the Imperial Court
c. 1797–1807
Watercolor on ivory
2 ³/₄ × 2 ³/₁₆" (7 × 5.6 cm)

Gift of W. Parsons Todd and
Miss Mary J. Todd
1938-29-9

Miles, Edward
Portrait of a Man
c. 1800
Watercolor on ivory
2 ¹³/₁₆ × 2 ⁵/₁₆" (7.1 × 5.9 cm)

Gift of W. Parsons Todd and
Miss Mary J. Todd
1938-29-14

Miles, Edward
Portrait of a Russian Princess
c. 1797–1807
Watercolor on ivory
1 ¹⁵/₁₆ × 1 ¹/₂" (4.9 × 3.8 cm)

Gift of W. Parsons Todd and
Miss Mary J. Todd
1938-29-13

Miles, Edward
Portrait of a Man
c. 1800
Watercolor on ivory
2 ¹³/₁₆ × 2 ⁵/₁₆" (7.1 × 5.9 cm)

Gift of W. Parsons Todd and
Miss Mary J. Todd
1938-29-15

Miles, Edward
Portrait of a Man
c. 1800
Watercolor on ivory
2 ³/₄ × 2 ¹/₄" (7 × 5.7 cm)

Gift of W. Parsons Todd and
Miss Mary J. Todd
1938-29-5

Miles, Edward
Portrait of a Woman
c. 1800
Watercolor on ivory
2 ⁷/₈ × 2 ⁵/₁₆" (7.3 × 5.9 cm)

Gift of W. Parsons Todd and
Miss Mary J. Todd
1938-29-3

Miles, Edward
Portrait of a Man
c. 1800
Watercolor on ivory
2 ³/₄ × 2 ¹/₁₆" (7 × 5.2 cm)

Gift of W. Parsons Todd and
Miss Mary J. Todd
1938-29-10

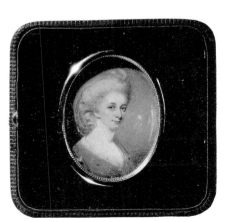

Miles, Edward
Portrait of a Woman
c. 1800
Watercolor on ivory
1 ³/₄ × 1 ¹/₂" (4.4 × 3.8 cm)

Gift of W. Parsons Todd and
Miss Mary J. Todd
1938-29-4

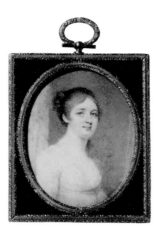

Miles, Edward
Portrait of a Woman
c. 1800
Watercolor on ivory
3 1/16 × 2 5/16" (7.8 × 5.9 cm)

Gift of W. Parsons Todd and
Miss Mary J. Todd
1938-29-8

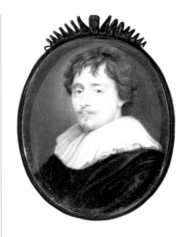

Oliver, Isaac, copy after
Self-Portrait
17th century
Watercolor and gouache on
cardboard
2 1/2 × 2" (6.3 × 5.1 cm)

Gift of Mrs. Daniel J. McCarthy
1954-21-22

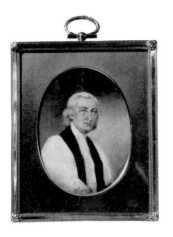

Miles, Edward
Portrait of Bishop William White
c. 1810
Watercolor on ivory
3 1/16 × 2 1/8" (7.8 × 5.4 cm)

Gift of W. Parsons Todd and
Miss Mary J. Todd
1938-29-16

Parant, Louis-Bertin
French, 1768–1851
Portrait of Napoleon Bonaparte
c. 1810
Lower right: LbParant
Watercolor on ivory
2 × 1 5/8" (5.1 × 4.1 cm)

The Bloomfield Moore Collection
1899-1007

Monogrammist P. D.
English, active c. 1665
Portrait of Edward Hyde,
1st Earl of Clarendon
1665
Center left: An: / 55.; center
right: 1665. / P.D. / Ft.
Watercolor on vellum
1 7/8 × 1 9/16" (4.8 × 4 cm)

Gift of Mrs. Daniel J. McCarthy
1954-21-1

Petitot, Jean
French, 1607–1691
Portrait of Catherine-Henriette
d'Angennes, Countess d'Olonne, as
Diana
c. 1680
Oil on copper
1 1/2 × 1 1/4" (3.8 × 3.2 cm)

Gift of Mrs. Lessing J. Rosenwald
1961-37-1

Oliver, Isaac, attributed to
English, born France,
born 1551–56, died 1617
Portrait of Robert Devereux,
2nd Earl of Essex
c. 1590
Watercolor and gouache on
vellum
2 × 1 5/8" (5.1 × 4.1 cm)

Gift of Mrs. Daniel J. McCarthy
1954-21-23

Pilo, Carl Gustav,
attributed to
Swedish, 1712–1792
Portrait of Sophie Magdalene,
Queen of Denmark and Norway
c. 1740
Watercolor on ivory
4 1/8 × 3 1/16" (10.5 × 7.8 cm)

Gift of Mrs. Daniel J. McCarthy
1955-1-1

Plimer, Andrew
English, 1763–1837
Portrait of a Woman
Companion to the following
miniature
c. 1800
Watercolor on ivory
2 ⅜ × 2" (6 × 5.1 cm)

Gift of Sarah McLean Williams
in memory of Mrs. William L.
McLean
1942-101-31a

Plimer, Andrew
Portrait of a Man
Companion to the preceding
miniature
c. 1800
Center left: A Plimer
Watercolor on ivory
2 ⁷⁄₁₆ × 2 ¹⁄₁₆" (6.2 × 5.2 cm)

Gift of Sarah McLean Williams
in memory of Mrs. William L.
McLean
1942-101-31b

Plimer, Andrew
Portrait of a Woman
c. 1800
Watercolor on ivory
3 ³⁄₁₆ × 2 ⁹⁄₁₆" (8.1 × 6.5 cm)

Gift of Mrs. Daniel J. McCarthy
1955-1-4

Plimer, Andrew
*Portrait of Selina Plimer, Daughter
of the Artist*
c. 1800
Watercolor on ivory
3 ¹⁄₁₆ × 2 ⁷⁄₁₆" (7.8 × 6.2 cm)

Gift of Mrs. Daniel J. McCarthy
1955-1-3

Plimer, Andrew
*Portrait of the Honorable Anne
Rushout*
c. 1800
Watercolor on ivory
3 ¹⁄₁₆ × 2 ⅜" (7.8 × 6 cm)

Gift of Mrs. Daniel J. McCarthy
1955-1-2

Readhead, H.
English, active 18th century
Silhouette of a Woman
18th century
On paper on reverse: Mr H
Readhead / Profilest / No 54
Upper Norton Street / Fitzroy
Ignace / London, V / time of
sitting 5 Minutes
Watercolor reverse-painted on
glass
3 × 2 ½" (7.6 × 6.3 cm)

Gift of Sarah McLean Williams
in memory of Mrs. William L.
McLean
1942-101-37

Richter, Christian
Swedish, active England,
1678–1732
Portrait of Peter Paul Rubens
After a self-portrait in the
collection of Her Majesty Queen
Elizabeth II, Windsor Castle (157)
c. 1702
Watercolor on cardboard
3 ⅛ × 2 ⁹⁄₁₆" (7.9 × 6.5 cm)

Gift of Mrs. Daniel J. McCarthy
1955-1-6

Robinson, John
English, active United States,
active 1817–1829
Portrait of Dr. John Henderson
1825
Lower right: JR / 1825
Watercolor on ivory
2 ⁹⁄₁₆ × 2" (6.5 × 5.1 cm)

Gift of Dr. William A. Jaquette, Jr.
1962-219-1

Rota, Giuseppe, copy after
Italian, 1777–1821?
Portrait of Michael Leman
Companion to the following
miniature
c. 1825
Watercolor on ivory
2 3/4 × 2" (7 × 5.1 cm)

Gift of Mrs. George A. Saportas
1955-66-1

Rymsdyck, Andreas van
Dutch, active England, died 1786
Portrait of Miss Bedingfield
c. 1767–86
Watercolor on paper
4 3/8 × 3 7/16" (11.1 × 8.7 cm)

Gift of Mrs. Daniel J. McCarthy
1954-21-4

Rota, Giuseppe, copy after
Portrait of Zipporah Leman
Companion to the preceding
miniature
c. 1825
Watercolor on ivory
2 3/4 × 2" (7 × 5.1 cm)

Gift of Mrs. George A. Saportas
1955-66-2

Saint, Daniel
French, 1778–1847
Portrait of a Woman
c. 1810
Center right: Saint.
Watercolor on ivory
2 3/4 × 2 3/16" (7 × 5.6 cm)

Gift of Mrs. Daniel J. McCarthy
1955-1-9

**Rowlandson, Thomas,
attributed to**
English, 1756–1827
Portrait of the Duchess of Cambridge
1785
Lower right: Rowlandson. 1785
Watercolor on ivory
3 3/4 × 3 1/8" (9.5 × 7.9 cm)

Gift of Sarah McLean Williams
in memory of Mrs. William L.
McLean
1942-101-21

**Saunders, George
Lethbridge**
English, 1807–1863
Portrait of Benjamin Chew Wilcock
Companion to the following
miniature
c. 1840
Watercolor on ivory
5 1/4 × 4" (13.3 × 10.2 cm)

Bequest of Dorothy Fisher Reath
1988-72-18

Russell, John, attributed to
English, 1745–1806
*Portrait of George Augustus
Frederick, Prince of Wales*
c. 1788
Watercolor on ivory
5 3/8 × 4 1/2" (13.6 × 11.4 cm)

Gift of Mrs. Daniel J. McCarthy
1955-1-8

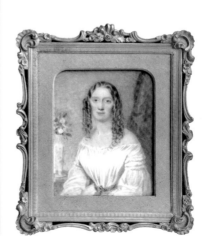

**Saunders, George
Lethbridge**
Portrait of Sally Waln Wilcock
Companion to the preceding
miniature
c. 1840
Watercolor on ivory
4 5/16 × 3 5/16" (11 × 8.4 cm)

Bequest of Dorothy Fisher Reath
1988-72-19

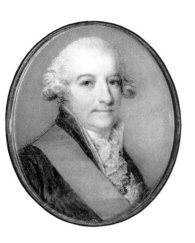

Shelley, Samuel
English, c. 1750–1808
Portrait of the Marquess of Waterford
c. 1800
Watercolor on ivory
2 1/16 × 1 11/16" (5.2 × 4.3 cm)

Gift of Mrs. Daniel J. McCarthy
1955-1-5

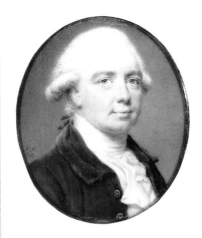

Smart, John
Portrait of a Man
1781
Lower left: JS / 1781
Watercolor on ivory
1 7/16 × 1 1/8" (3.6 × 2.9 cm)

Gift of Mrs. Daniel J. McCarthy
1955-1-16

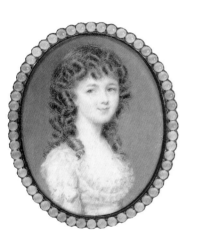

Smart, John
English, 1742/43–1811
*Portrait of Colonel Valentine Morris,
Governor of Saint Vincent*
1765
Lower right: J. S. / 1765.
Watercolor on ivory
1 1/4 × 1 1/16" (3.2 × 2.7 cm)

Gift of Mrs. Daniel J. McCarthy
1955-1-15

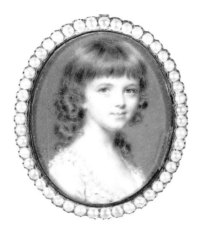

Smart, John
Portrait of Elizabeth Townsend
1784
Lower left: JS / 1784
Watercolor on ivory
1 7/16 × 1 1/8" (3.6 × 2.9 cm)

Gift of Mrs. Daniel J. McCarthy
1955-1-13

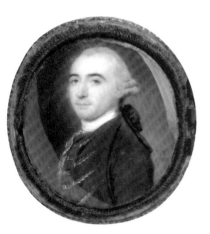

Smart, John
Portrait of Elizabeth Townsend
1770
Watercolor on ivory
2 3/8 × 1 13/16" (6 × 4.6 cm)

Gift of Mrs. Daniel J. McCarthy
1955-1-12

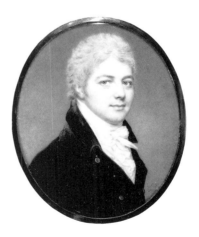

Smart, John
*Portrait of Lieutenant Colonel John
Wingfield*
Companion to the following
miniature
1803
Lower right: JS / 1803
Watercolor on ivory
3 1/16 × 2 1/2" (7.8 × 6.3 cm)

Gift of Mrs. Daniel J. McCarthy
1955-1-10

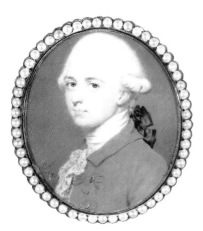

Smart, John
Portrait of a Man
1779
Lower left: JS. / 1779
Watercolor on ivory
1 5/8 × 1 1/4" (4.1 × 3.2 cm)

Gift of Mrs. Daniel J. McCarthy
1955-1-14

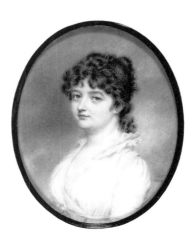

Smart, John
*Portrait of the Honorable Mrs. John
Wingfield*
Companion to the preceding
miniature
1803
Lower right: JS / 1803
Watercolor on ivory
3 1/16 × 2 3/8" (7.8 × 6 cm)

Gift of Mrs. Daniel J. McCarthy
1955-1-11

Spanish, unknown artist
Virgin and Child, with a Nun and a Monk
See following miniature for reverse
c. 1600
Upper left: .S.G.
Watercolor on ivory
2 × 2" (5.1 × 5.1 cm)

Purchased from the George Grey Barnard Collection with Museum funds
1945-25-261a

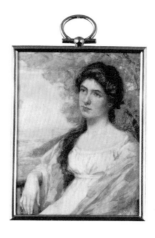

Ahrens, Ellen Wetherald
American, 1859–1953
Day Dreams
1902
Lower right: EWA 1902
Watercolor on ivory
4 9/16 × 3 7/16" (11.6 × 8.7 cm)

Gift of the Pennsylvania Society of Miniature Painters in memory of Emily Drayton Taylor
1954-42-1

Spanish, unknown artist
Saint Barbara Crowned by an Angel
Reverse of the preceding miniature
c. 1600
Watercolor on ivory
2 × 2" (5.1 × 5.1 cm)

Purchased from the George Grey Barnard Collection with Museum funds
1945-25-261b

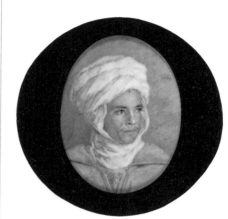

Ahrens, Ellen Wetherald
Portrait of an Arab Guide
1911
Upper right: EWA 1911
Watercolor on ivory
2 5/8 × 2" (6.7 × 5.1 cm)

Gift of Mrs. Daniel J. McCarthy
1953-142-1

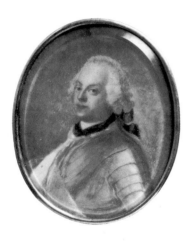

Swedish, unknown artist
Portrait of Adolphus Frederick, King of Sweden
c. 1751–71
Watercolor on cardboard
3 × 2 1/4" (7.6 × 5.7 cm)

The Bloomfield Moore Collection
1882-1174

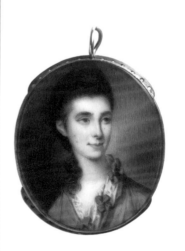

American, unknown artist
Portrait of Frances Strettel
c. 1765–75
Watercolor on ivory
1 1/4 × 1 1/8" (3.2 × 2.9 cm)

Gift of an anonymous donor in memory of Elizabeth Wheatley Bendiner
1991-76-2

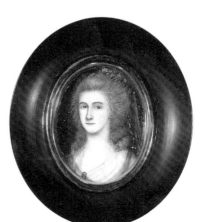

American, unknown artist
Portrait of Lydia Williamson of Virginia
c. 1775–1800
Watercolor on ivory
2 1/2 × 2 3/16" (6.3 × 5.6 cm)

Gift of the Pennsylvania Society of Miniature Painters in memory of Emily Drayton Taylor
1954-42-103

American, unknown artist
Portrait of a Man
c. 1780–1800
Watercolor on ivory
3 ³/₈ × 2 ³/₄" (8.6 × 7 cm)

Bequest of Mrs. Edna M. Welsh
1982-1-2

American, unknown artist
*Portrait of Elizabeth Ozeas
Ramborger*
c. 1800
Watercolor on ivory
2 ³/₄ × 2 ³/₁₆" (7 × 5.6 cm)

The Ozeas, Ramborger, Keehmle
Collection
1921-34-101

American, unknown artist
Silhouette of Captain Abel Coffin
c. 1780–1800
Center bottom: A. COFFIN.
Watercolor reverse-painted on
glass
5 × 4" (12.7 × 10.2 cm)

Gift of Miss Evelyn L. Whitaker
in memory of her mother
1930-46-16

American, unknown artist
Portrait of Erasmus J. Pierce
c. 1810
Watercolor on ivory
2 ³/₄ × 2 ¹/₄" (7 × 5.7 cm)

Gift of William Drown Phelps
1938-2-1

American, unknown artist
*Portrait of Captain John Terris of
Philadelphia*
1797
Center right: John S[?] Pt 1797.
Watercolor on ivory
2 ³/₄ × 2 ⁵/₁₆" (7 × 5.9 cm)

Gift of the Pennsylvania Society
of Miniature Painters in memory
of Emily Drayton Taylor
1954-42-104

American, unknown artist
*Portrait of Julia Macpherson
Nicklin*
Companion to the following
miniature
c. 1810–20
Watercolor on ivory
2 ³/₄ × 2 ³/₁₆" (7 × 5.6 cm)

Gift of Caleb W. Hornor and
Peter T. Hornor
1967-79-5

American, unknown artist
Portrait of Benjamin Franklin
c. 1800
Watercolor and gouache on ivory
2 ¹/₂" (6.3 cm) diameter

Gift of Mrs. Daniel J. McCarthy
1955-1-25

American, unknown artist
Portrait of Philip Nicklin
Companion to the preceding
miniature
c. 1810–20
Watercolor on ivory
2 ³/₄ × 2 ¹/₄" (7 × 5.7 cm)

Gift of Caleb W. Hornor and
Peter T. Hornor
1967-79-6

American, unknown artist
Portrait of Mrs. T. T. Heartte
Companion to the following
miniature
c. 1811
Watercolor on ivory
3 3/8 × 2 1/4" (8.6 × 5.7 cm)

The Ozeas, Ramborger, Keehmle
Collection
1921-34-99

American, unknown artist
Portrait of a Woman
Companion to the preceding
miniature
c. 1820–30
Watercolor and gouache on ivory
2 3/4 × 2 1/8" (7 × 5.4 cm)

Gift of Mrs. Daniel J. McCarthy
1955-1-28b

American, unknown artist
Portrait of T. T. Heartte
Companion to the preceding
miniature
c. 1811
Watercolor on ivory
3 3/8 × 2 1/4" (8.6 × 5.7 cm)

The Ozeas, Ramborger, Keehmle
Collection
1921-34-100

American, unknown artist
Portrait of Dr. Philip Syng Physick
c. 1820–40
Watercolor on ivory
15/16 × 3/4" (2.4 × 1.9 cm)

Gift of Mrs. Daniel J. McCarthy
1954-63-6

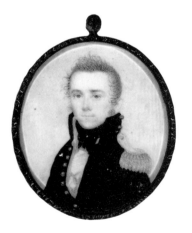

American, unknown artist
*Portrait of Lieutenant Horace L.
Broughton*
c. 1812
Watercolor on ivory
2 1/2 × 2 1/8" (6.3 × 5.4 cm)

Gift of Miss D. M. Broughton
1899-1151

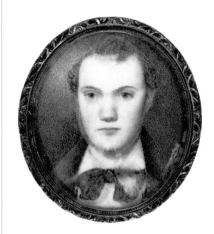

American, unknown artist
Portrait of a Cape Cod Sea Captain
c. 1830
Watercolor on ivory
1 5/8 × 1 5/16" (4.1 × 3.3 cm)

Gift of the Pennsylvania Society
of Miniature Painters in memory
of Emily Drayton Taylor, bequest
of Berta Carew
1959-91-11

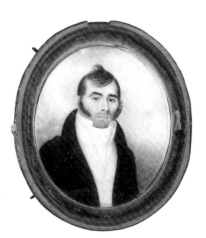

American, unknown artist
Portrait of a Man
Companion to the following
miniature
c. 1820–30
Watercolor and gouache on ivory
2 11/16 × 2 3/16" (6.8 × 5.6 cm)

Gift of Mrs. Daniel J. McCarthy
1955-1-28a

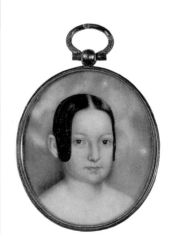

American, unknown artist
Portrait of a Girl
c. 1830
Watercolor on ivory
1 13/16 × 1 5/8" (4.6 × 4.1 cm)

Gift of the Pennsylvania Society
of Miniature Painters in memory
of Emily Drayton Taylor
1954-42-105

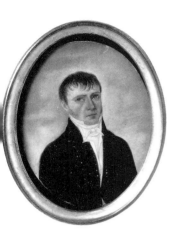

American, unknown artist
Portrait of a Man
c. 1830
Watercolor on cardboard
2 ¹³/₁₆ × 2 ¼" (7.1 × 5.7 cm)

The Ozeas, Ramborger, Keehmle
Collection
1921-34-223

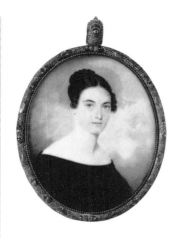

American, unknown artist
Portrait of Mrs. W. C. Keehmle
c. 1830
Watercolor on ivory
2 ⁹/₁₆ × 2 ⅛" (6.5 × 5.4 cm)

The Ozeas, Ramborger, Keehmle
Collection
1921-34-97

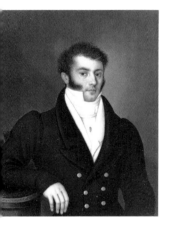

American, unknown artist
Portrait of a Man
c. 1830
Watercolor on ivory
3 ⁹/₁₆ × 2 ¾" (9 × 7 cm)

Gift of Miss Pauline Townsend
Pease
1979-108-7

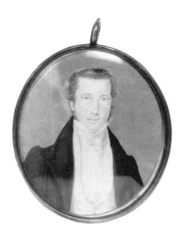

American, unknown artist
Portrait of Ozeas Heartte
c. 1830
Watercolor on cardboard
2 ⅝ × 2 ³/₁₆" (6.7 × 5.6 cm)

The Ozeas, Ramborger, Keehmle
Collection
1921-34-104

American, unknown artist
Portrait of Dr. Ellis Harland
c. 1830
Watercolor on ivory
2 ⅝ × 2 ¼" (6.7 × 5.7 cm)

Gift of Mrs. John Morton
McIlvain
1929-48-2

American, unknown artist
Portrait of Samuel Thompson
c. 1830
Watercolor on ivory
3 ⅛ × 2 ⅝" (7.9 × 6.7 cm)

Bequest of Lydia Thompson
Morris
1932-45-18

American, unknown artist
Portrait of John Paul Schott III
c. 1830
Watercolor on ivory
2 ³/₁₆ × 1 ⅞" (5.6 × 4.8 cm)

Gift of Marie Josephine Rozet
and Rebecca Mandeville Rozet
Hunt
1935-13-34

American, unknown artist
Portrait of William C. Poultney
c. 1830
Watercolor on ivory
3 × 2 ⅜" (7.6 × 6 cm)

Bequest of Lydia Thompson
Morris
1932-45-19

American, unknown artist
Portrait of Henry Ash
1839
On reverse: May 9th (1839)
Watercolor on ivory
2 ¹/₂ × 2" (6.3 × 5.1 cm)

Gift of Mrs. Frances C. Ely
1944-58-1

American, unknown artist
Portrait of Josephine Mandeville Rozet
c. 1860
Lower left: York
Watercolor on ivory
2 ¹/₂ × 2" (6.3 × 5.1 cm)

Gift of Marie Josephine Rozet
and Rebecca Mandeville Rozet
Hunt
1935-13-33

American, unknown artist
Portrait of Samuel R. Marshall
c. 1839
Watercolor on ivory
2 ³/₈ × 2" (6 × 5.1 cm)

Bequest of Harold S. Truitt
1927-5-12

American, unknown artist
Portrait of George H. Rozet
c. 1880
Watercolor on ivory
2 ¹/₂ × 2" (6.3 × 5.1 cm)

Gift of Marie Josephine Rozet
and Rebecca Mandeville Rozet
Hunt
1935-13-46

American, unknown artist
Portrait of a Man
c. 1840
Watercolor on ivory
2 ³/₄ × 2 ¹/₈" (7 × 5.4 cm)

Gift of Miss Pauline Townsend
Pease
1979-108-8

Archambault, Anna Margaretta
American, 1856–1956
Portrait of Miss Lillian R. Reed
1915
Lower right: Archambault / 1915
Watercolor on ivory
4 ¹⁵/₁₆ × 3 ¹⁵/₁₆" (12.5 × 10 cm)

Gift of the Pennsylvania Society
of Miniature Painters in memory
of Emily Drayton Taylor
1954-42-2

American, unknown artist
Portrait of a Woman
c. 1850
Watercolor on ivory
3 ¹/₈ × 2 ¹/₂" (7.9 × 6.3 cm)

Bequest of Leonora L. Koecker
1942-37-3

Archambault, Anna Margaretta
Portrait of Mrs. Clyde Beaumont Cunningham
1919
Center right: Archambault. 1919.
Watercolor on ivory
3 ⁵/₁₆ × 2 ¹/₂" (8.4 × 6.3 cm)

Gift of the Pennsylvania Society
of Miniature Painters in memory
of Emily Drayton Taylor
1954-42-3

Archambault, Anna Margaretta
Portrait of Mrs. J. Madison Taylor
[née Emily Drayton]
1924
Center left: Archambault 1924
Watercolor on ivory
4 3/16 × 3 3/16" (10.6 × 8.1 cm)

Gift of an anonymous donor
1955-53-1

Baum, Walter Emerson
Pennsylvania Hills
Early to mid-20th century
Lower right: WEBAUM
Gouache on beaverboard
2 7/8 × 5" (7.3 × 12.7 cm)

Gift of Mrs. Daniel J. McCarthy
1954-63-1

Baer, William Jacob
American, 1860–1941
Portrait of Mrs. H. A. Ashforth
1924
Lower left: W J. Baer / 1924
Watercolor on ivory
4 × 3 1/8" (10.2 × 7.9 cm)

Gift of the Pennsylvania Society
of Miniature Painters in memory
of Emily Drayton Taylor
1954-42-4

Baxter, Martha Wheeler
American, 1869–1955
Portrait of a Woman in White
1915
Center left: M. W. Baxter—1915
Watercolor on ivory
4 3/16 × 3 1/16" (10.6 × 7.8 cm)

Gift of the Pennsylvania Society
of Miniature Painters in memory
of Emily Drayton Taylor
1954-42-7

Barrett, Lisbeth S.
American, born 1904
Self-Portrait
1930s
Lower left: LSB
Watercolor on ivory
2 1/2 × 1 15/16" (6.3 × 4.9 cm)

Gift of the Pennsylvania Society
of Miniature Painters in memory
of Emily Drayton Taylor
1954-42-5

Baxter, Martha Wheeler
Portrait of a Woman
1926
Center right: M. W. Baxter—/
1926
Watercolor on ivory
2 3/8 × 1 13/16" (6 × 4.6 cm)

Gift of the Pennsylvania Society
of Miniature Painters in memory
of Emily Drayton Taylor
1954-42-9

Baum, Walter Emerson
American, 1884–1956
Delaware River
Early to mid-20th century
Lower left: BAUM
Watercolor on ivory
3 5/16 × 4 1/16" (8.4 × 10.3 cm)

Gift of the Pennsylvania Society
of Miniature Painters in memory
of Emily Drayton Taylor
1954-42-6

Baxter, Martha Wheeler
Portrait of a Woman with a Fan
1926
Lower right: M. W. Baxter—/
1926
Watercolor on ivory
4 3/16 × 3 3/16" (10.6 × 8.1 cm)

Gift of the Pennsylvania Society
of Miniature Painters in memory
of Emily Drayton Taylor
1954-42-8

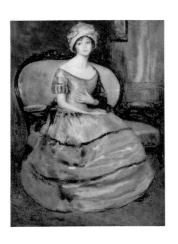

Becker, Eulabee Dix
American, 1878–1961
A Visitor One Hundred Years Ago
1922
Lower right: E. Dix 1922
Watercolor on ivory
8 1/8 × 6 3/16" (20.6 × 15.7 cm)

Gift of Mrs. Daniel J. McCarthy
1954-63-2

Bill, Sally Cross
American, 1874–1950
Portrait of Mrs. Edwin Blashfield
c. 1910–20
Watercolor on ivory
2 15/16 × 2 1/4" (7.5 × 5.7 cm)

Gift of the Pennsylvania Society
of Miniature Painters in memory
of Emily Drayton Taylor
1954-42-12

Beckington, Alice
American, 1868–1942
Study in Blues and Greens (Self-Portrait)
c. 1900
Watercolor on ivory
4 × 2 1/2" (10.2 × 6.3 cm)

Gift of the Pennsylvania Society
of Miniature Painters in memory
of Emily Drayton Taylor
1954-42-10

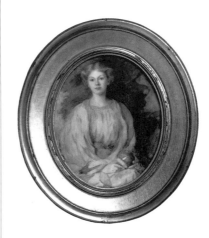

Bill, Sally Cross
Portrait of Miss Dora Wetherbee
1931
Lower right: SALLY CROSS 31
Watercolor on ivory
5 3/16 × 4 1/8" (13.2 × 10.4 cm)

Gift of the Pennsylvania Society
of Miniature Painters in memory
of Emily Drayton Taylor
1954-42-13

**Benbridge, Henry,
attributed to**
American, 1743–1812
Portrait of Cadwalader Morris
c. 1765–75
Watercolor on ivory
1 5/8 × 1 1/4" (4.1 × 3.2 cm)

Gift of an anonymous donor in
memory of Elizabeth Wheatley
Bendiner
1991-76-4

Birch, Thomas
American, born England,
1779–1851
Portrait of Dr. George S. Schott III
c. 1800–10
Watercolor on cardboard
6 × 4 1/4" (15.2 × 10.8 cm)

Gift of Marie Josephine Rozet
and Rebecca Mandeville Rozet
Hunt
1935-13-22

Benton, Margaret Peake
American, active by 1944,
died 1975
The Swiss Costume
c. 1945–60
Lower right: M. Peake Benton
Watercolor on ivory substitute
3 15/16 × 3" (10 × 7.6 cm)

Gift of the Pennsylvania Society
of Miniature Painters in memory
of Emily Drayton Taylor
1954-42-11

Birch, Thomas
Portrait of Charles Schott
c. 1808
Watercolor on cardboard
7 1/4 × 5 3/4" (18.4 × 14.6 cm)

Gift of Marie Josephine Rozet
and Rebecca Mandeville Rozet
Hunt
1935-13-21

Bliss, Alma Hirsig
American, born Switzerland,
born 1875, still active 1956
Blue and Ivory
1937
Lower right: ALMA H. BLISS /
1937
Watercolor on ivory
2 ¹¹/₁₆ × 3 ⁵/₁₆" (6.8 × 8.4 cm)

Gift of the Pennsylvania Society
of Miniature Painters in memory
of Emily Drayton Taylor
1954-42-14

**Boericke, Johanna
Magdalene**
Rocky Shore
Early 20th century
Lower left: J. M. Boericke
Watercolor on ivory
2 ¹/₁₆ × 5" (5.2 × 12.7 cm)

Gift of the Pennsylvania Society
of Miniature Painters in memory
of Emily Drayton Taylor
1954-42-17

Boardman, Rosina Cox
American, 1878–1970
Chinquilla Weaving
1927
Upper left: 1927
Watercolor on ivory
4 ⁵/₈ × 3 ¹/₂" (11.7 × 8.9 cm)

Gift of the Pennsylvania Society
of Miniature Painters in memory
of Emily Drayton Taylor
1954-42-15

Bonsall, Mary Waterman
American, born 1868,
still active 1915
Portrait of Amos Bonsall
1903
Lower right: Mary W. Bonsall /
Dec., 1903
Watercolor on ivory substitute
3 × 2 ⁵/₈" (7.6 × 6.7 cm)

Gift of the Pennsylvania Society
of Miniature Painters in memory
of Emily Drayton Taylor
1954-42-18

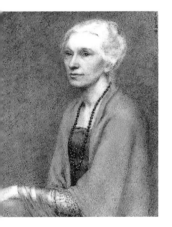

Boardman, Rosina Cox
Portrait of Miss Lydia Longacre
1929
Upper left: ROSINA COX
BOARDMAN; upper right: 1929
Watercolor on ivory
3 ⁵/₈ × 2 ⁷/₈" (9.2 × 7.3 cm)

Bequest of Rosina Cox Boardman
1971-199-4

Borda, Katharine K.
American, born 1886,
still active 1946
Portrait of Harry L. Johnson
1947
Lower left: KB / 1947
Watercolor on ivory substitute
3 ¹/₈" (7.9 cm) diameter

Gift of the Pennsylvania Society
of Miniature Painters in memory
of Emily Drayton Taylor
1954-42-19

**Boericke, Johanna
Magdalene**
American, born 1868,
still active 1915
Alaska Coast
Early 20th century
Lower left: J. M. Boericke
Watercolor on ivory
2 × 4 ⁷/₈" (5.1 × 12.4 cm)

Gift of the Pennsylvania Society
of Miniature Painters in memory
of Emily Drayton Taylor
1954-42-16

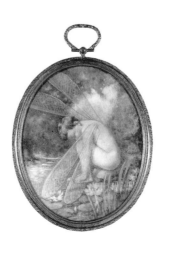

**Boyle, Sarah Yocum
McFadden**
American, active 1909–1940
Little Sleepy Dragonfly
1920s
Lower right: TMcF
Watercolor on ivory
4 ¹/₂ × 3 ⁹/₁₆" (11.4 × 9 cm)

Gift of the Pennsylvania Society
of Miniature Painters in memory
of Emily Drayton Taylor
1954-42-20

Bridport, Hugh
American, born England,
1794–c. 1869
Portrait of a Man
c. 1810
Lower right: Bridport
Watercolor on ivory
2 ¹¹/₁₆ × 2 ¹/₄" (6.8 × 5.7 cm)

Gift of Mrs. Daniel J. McCarthy
1953-142-6

Bush, Ella Shepard
American, 1863–c. 1950
Portrait of Herman Livezey
c. 1930–50
Lower right: E. S. BUSH
Watercolor on ivory
5 ¹/₂ × 3 ¹³/₁₆" (14 × 9.7 cm)

Gift of the Pennsylvania Society
of Miniature Painters in memory
of Emily Drayton Taylor
1954-42-21

Bridport, Hugh
Portrait of Mrs. Jacob Broom
c. 1830
Lower right: Bridport
Watercolor on ivory
3 × 2 ¹/₂" (7.6 × 6.3 cm)

Gift of Mrs. Daniel J. McCarthy
1953-142-7

Carew, Berta
American, 1878–1956
The Rose
1904
Lower right: Berta Carew '04
Watercolor on ivory
3 ⁷/₈ × 2 ¹/₂" (9.8 × 6.3 cm)

Gift of the Pennsylvania Society
of Miniature Painters in memory
of Emily Drayton Taylor, bequest
of Berta Carew
1959-91-31

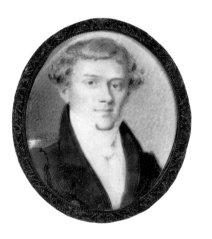

Bridport, Hugh
Portrait of W. C. Keehmle
c. 1830
On reverse: H Bridport
Watercolor on ivory
2 ³/₈ × 1 ¹⁵/₁₆" (6 × 4.9 cm)

The Ozeas, Ramborger, Keehmle
Collection
1921-34-98

Carew, Berta
Self-Portrait
c. 1905
Watercolor on ivory
5 ⁷/₈ × 3 ¹³/₁₆" (14.9 × 9.7 cm)

Gift of the Pennsylvania Society
of Miniature Painters in memory
of Emily Drayton Taylor, bequest
of Berta Carew
1959-91-16

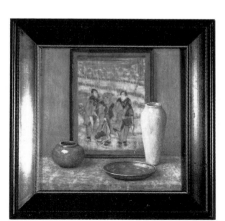

Brugger, Dorothy
American, active 1938–1947
The Japanese Print
c. 1940
Upper left: DOROTHY BRUGGER
Watercolor on ivory
3 ³/₄ × 3 ³/₄" (9.5 × 9.5 cm)

Gift of the Pennsylvania Society
of Miniature Painters in memory
of Emily Drayton Taylor, bequest
of Berta Carew
1959-91-47

Carew, Berta
Portrait of Mr. Emerson
c. 1905–10
Lower right: Berta Carew
Watercolor on ivory
3 × 2 ³/₈" (7.6 × 6 cm)

Gift of the Pennsylvania Society
of Miniature Painters in memory
of Emily Drayton Taylor, bequest
of Berta Carew
1959-91-35

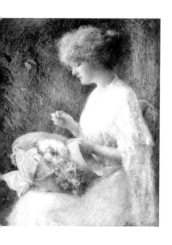

Carew, Berta
Portrait of Silvia Jewel Clay
c. 1910
Lower right: Berta Carew
Watercolor on ivory
6 × 4 1/2" (15.2 × 11.4 cm)

Gift of the Pennsylvania Society
of Miniature Painters in memory
of Emily Drayton Taylor, bequest
of Berta Carew
1959-91-20

Carew, Berta
*My Mother (Portrait of Laura
Adelaide Colman)*
1918
Lower right: Berta Carew / Oct.
1918
Watercolor on ivory
2 7/8 × 2 1/4" (7.3 × 5.7 cm)

Gift of the Pennsylvania Society
of Miniature Painters in memory
of Emily Drayton Taylor, bequest
of Berta Carew
1959-91-21

Carew, Berta
*My Mother (Portrait of Laura
Adelaide Colman)*
c. 1910–20
Lower right: Berta Carew
Watercolor on ivory
5 15/16 × 4 7/16" (15.1 × 11.3 cm)

Gift of the Pennsylvania Society
of Miniature Painters in memory
of Emily Drayton Taylor, bequest
of Berta Carew
1959-91-22

Carew, Berta
Portrait of Mrs. David Rutter [née
Mary Elizabeth McMurtrie}
c. 1920
Upper right: Berta Carew
Watercolor on ivory
5 1/4 × 3 1/4" (13.3 × 8.2 cm)

Gift of the Pennsylvania Society
of Miniature Painters in memory
of Emily Drayton Taylor
1954-42-22

Carew, Berta
*Portrait of a Girl in a Pink-and-
Green Scarf*
1917
On reverse: Berta Carew / 1917
Watercolor on ivory
2 1/4 × 1 7/8" (5.7 × 4.8 cm)

Gift of the Pennsylvania Society
of Miniature Painters in memory
of Emily Drayton Taylor, bequest
of Berta Carew
1959-91-34

Carew, Berta
Studio Properties
c. 1920–50
Lower right: Berta Carew
Watercolor on ivory
5 9/16 × 3 13/16" (14.1 × 9.7 cm)

Gift of the Pennsylvania Society
of Miniature Painters in memory
of Emily Drayton Taylor, bequest
of Berta Carew
1959-91-32

Carew, Berta
Self-Portrait (The Crystal Box)
1917
Lower right: Berta Carew / 1917
Watercolor on ivory
4 × 3" (10.2 × 7.6 cm)

Gift of the Pennsylvania Society
of Miniature Painters in memory
of Emily Drayton Taylor, bequest
of Berta Carew
1959-91-15

Carew, Berta
Portrait of a French Peasant
1921
Lower right: Berta Carew / 21
Watercolor on ivory
4 1/2 × 3 3/8" (11.4 × 8.6 cm)

Gift of the Pennsylvania Society
of Miniature Painters in memory
of Emily Drayton Taylor, bequest
of Berta Carew
1959-91-36

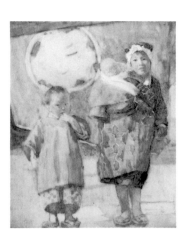

Carew, Berta
Children of Japan
1928
Watercolor on ivory
3 1/8 × 2 9/16" (7.9 × 6.5 cm)

Gift of the Pennsylvania Society
of Miniature Painters in memory
of Emily Drayton Taylor, bequest
of Berta Carew
1959-91-39

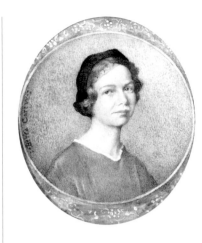

Carew, Berta
Portrait of Mary Catherine Kerwin
c. 1930
Center left: Berta Carew
Watercolor on ivory
4 1/8 × 3 3/8" (10.5 × 8.6 cm)

Gift of the Pennsylvania Society
of Miniature Painters in memory
of Emily Drayton Taylor, bequest
of Berta Carew
1959-91-27

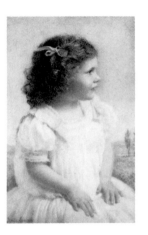

Carew, Berta
Little Mary (Portrait of Mary)
1920s
Lower left: Berta Carew
Watercolor on ivory
4 7/8 × 2 3/4" (12.4 × 7 cm)

Gift of the Pennsylvania Society
of Miniature Painters in memory
of Emily Drayton Taylor, bequest
of Berta Carew
1959-91-28

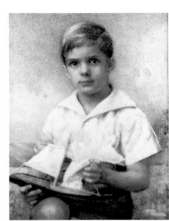

Carew, Berta
Portrait of a Young Sailor
1937
Lower right: Berta Carew / 1937
Watercolor on ivory
3 5/8 × 2 13/16" (9.2 × 7.1 cm)

Gift of the Pennsylvania Society
of Miniature Painters in memory
of Emily Drayton Taylor, bequest
of Berta Carew
1959-91-29

Carew, Berta
Portrait of Virginia
1920s
Watercolor on ivory
1 3/4" (4.4 cm) diameter

Gift of the Pennsylvania Society
of Miniature Painters in memory
of Emily Drayton Taylor, bequest
of Berta Carew
1959-91-33

Carew, Berta
Portrait of Josiah Bardwell
Early 20th century
Lower right: Berta Carew
Watercolor on ivory
3 3/8 × 2 5/8" (8.6 × 6.7 cm)

Gift of the Pennsylvania Society
of Miniature Painters in memory
of Emily Drayton Taylor, bequest
of Berta Carew
1959-91-30

Carew, Berta
Portrait of Mary Catherine Kerwin
c. 1930
Watercolor on ivory
2 1/4" (5.7 cm) diameter

Gift of the Pennsylvania Society
of Miniature Painters in memory
of Emily Drayton Taylor, bequest
of Berta Carew
1959-91-26

Carew, Berta
*Portrait of the Late Archbishop
Corrigan*
Early 20th century
Upper left: Berta Carew
Watercolor on ivory
5 3/4 × 4 1/4" (14.6 × 10.8 cm)

Gift of the Pennsylvania Society
of Miniature Painters in memory
of Emily Drayton Taylor, bequest
of Berta Carew
1959-91-23

Carew, Berta
The Sisters
Early 20th century
Watercolor on ivory
4 1/16 × 3 3/8" (10.3 × 8.6 cm)

Gift of the Pennsylvania Society
of Miniature Painters in memory
of Emily Drayton Taylor, bequest
of Berta Carew
1959-91-19

Carew, Berta
Portrait of an Alsacienne
Early 20th century
Lower right: Berta Carew
Watercolor on ivory
3 7/8 × 2 1/2" (9.8 × 6.3 cm)

Gift of the Pennsylvania Society
of Miniature Painters in memory
of Emily Drayton Taylor, bequest
of Berta Carew
1959-91-17

Carew, Berta
Arab Musicians, Tunis
Early 20th century
Upper left: Berta Carew
Watercolor on ivory
2 1/8 × 2 9/16" (5.4 × 6.5 cm)

Gift of the Pennsylvania Society
of Miniature Painters in memory
of Emily Drayton Taylor, bequest
of Berta Carew
1959-91-45

Carew, Berta
Venetian Memories
Early 20th century
Watercolor on ivory
2 11/16 × 1 3/4" (6.8 × 4.4 cm)

Gift of the Pennsylvania Society
of Miniature Painters in memory
of Emily Drayton Taylor, bequest
of Berta Carew
1959-91-41

Carew, Berta
Portrait of the Arab Bou Saada
Early 20th century
Lower left: B. C.
Watercolor on ivory
2 1/2 × 1 9/16" (6.3 × 4 cm)

Gift of the Pennsylvania Society
of Miniature Painters in memory
of Emily Drayton Taylor, bequest
of Berta Carew
1959-91-38

Carew, Berta
Aigle, Switzerland
Early to mid-20th century
Watercolor on ivory
2 5/8 × 3 1/4" (6.7 × 8.2 cm)

Gift of the Pennsylvania Society
of Miniature Painters in memory
of Emily Drayton Taylor, bequest
of Berta Carew
1959-91-42

Carew, Berta
Shopping in Tunis
Early 20th century
Lower left: Berta Carew
Watercolor on ivory
2 5/8 × 2 1/8" (6.7 × 5.4 cm)

Gift of the Pennsylvania Society
of Miniature Painters in memory
of Emily Drayton Taylor, bequest
of Berta Carew
1959-91-44

Carew, Berta
French Alps
Early to mid-20th century
Lower left: Berta Carew
Watercolor on ivory
2 5/8 × 3 1/4" (6.7 × 8.2 cm)

Gift of the Pennsylvania Society
of Miniature Painters in memory
of Emily Drayton Taylor, bequest
of Berta Carew
1959-91-43

Carew, Braley Colman
American, active 20th century
*Portrait of a Woman in White
(Portrait of Cora Braley Venturini)*
Early 20th century
Lower right: BRALEY Colman.
CAREW.
Watercolor on ivory
3 $^1/_{16}$ × 2 $^5/_{16}$" (7.8 × 5.9 cm)

Gift of the Pennsylvania Society
of Miniature Painters in memory
of Emily Drayton Taylor, bequest
of Berta Carew
1959-91-46

Collier, Grace
American, active c. 1940
White Petunias
Mid-20th century
Lower left: Grace Collier
Watercolor on ivory
5 $^5/_8$ × 4 $^1/_8$" (14.3 × 10.5 cm)

Gift of the Pennsylvania Society
of Miniature Painters in memory
of Emily Drayton Taylor
1954-42-27

**Cariss, Marguerite
Feldpauche**
American, 1883–1959
*Self-Portrait (Mrs. John Mundell
Hutchinson)*
c. 1905
Watercolor on ivory
2 $^7/_{16}$ × 1 $^{15}/_{16}$" (6.2 × 4.9 cm)

Gift of the Pennsylvania Society
of Miniature Painters in memory
of Emily Drayton Taylor
1954-42-23

Coolidge, Bertha
American, 1880–1934
Portrait of a Girl
1923
Lower left: B. Coolidge 1923
Watercolor on ivory
3 $^1/_{16}$ × 2 $^7/_{16}$" (7.8 × 6.2 cm)

Gift of the Pennsylvania Society
of Miniature Painters in memory
of Emily Drayton Taylor
1954-42-28

Chase, Violet Thompson
American, active 1926–1929
Portrait of Elizabeth MacNeill
1929
Lower right: VIOLET T SMITH
1929
Watercolor on ivory
3 $^{11}/_{16}$ × 2 $^7/_8$" (9.4 × 7.3 cm)

Gift of the Pennsylvania Society
of Miniature Painters in memory
of Emily Drayton Taylor
1954-42-26

Coolidge, Bertha
Portrait of Poppy
1926
Center bottom: Coolidge 1926
Watercolor on ivory
4 $^3/_4$ × 3 $^3/_4$" (12.1 × 9.5 cm)

Gift of the Pennsylvania Society
of Miniature Painters in memory
of Emily Drayton Taylor
1954-42-29

Clark, Alvan, Jr.
American?, 1804–1887
Portrait of Mrs. Goddard
1840s
Watercolor on ivory
2 $^{13}/_{16}$ × 2 $^3/_8$" (7.1 × 6 cm)

Gift of Mrs. Daniel J. McCarthy
1953-142-9

Cowan, Sarah Eakin
American, 1875–1958
Portrait of Emily
1920s
Watercolor on ivory
2 $^{15}/_{16}$ × 2 $^7/_{16}$" (7.5 × 6.2 cm)

Gift of the Pennsylvania Society
of Miniature Painters in memory
of Emily Drayton Taylor
1954-42-30

Cushman, George Hewitt
American, 1814–1876
Portrait of Susan Wetherill Cushman
1840s
On reverse of frame: Susan
Wetherill Cushman / Painted by /
Her Husband / George Hewitt
Cushman
Watercolor on ivory
2 7/16 × 2" (6.2 × 5.1 cm)

Gift of Miss Alice Cushman
1940-10-2

**Dalrymple, Lucille
Stevenson**
American, 1882–1955
*The Red Cross Nurse (Portrait of
Dorothy Diane Dalrymple)*
c. 1917–19
Upper left: L. S. Dalrymple
Watercolor on ivory
3 11/16 × 3 1/16" (9.4 × 7.8 cm)

Gift of the Pennsylvania Society
of Miniature Painters in memory
of Emily Drayton Taylor
1954-42-32

Cushman, George Hewitt
Portrait of Susan Wetherill Cushman
1850s
Watercolor on vellum
7 3/4 × 6 1/8" (19.7 × 15.6 cm)

Gift of Miss Alice Cushman
1940-10-1

Day, Martha B. Willson
American, born 1885,
still active 1978
Portrait of a Girl
c. 1910
Watercolor on ivory
1 3/4 × 1 5/16" (4.4 × 3.3 cm)

Gift of the Pennsylvania Society
of Miniature Painters in memory
of Emily Drayton Taylor
1954-42-33

Cushman, George Hewitt
Portrait of Alice Cushman
c. 1860
Watercolor on ivory
1 3/16 × 7/8" (3 × 2.2 cm)

Bequest of Janet B. Fine
1973-250-1

Dickinson, Anson
American, 1779–1852
Portrait of Captain T. T. Heartte
Companion to the following
miniature
Early 1820s
Watercolor on ivory
3 1/4 × 2 5/8" (8.2 × 6.7 cm)

The Ozeas, Ramborger, Keehmle
Collection
1919-163

Daggett, Grace E.
American, born 1867,
still active 1947
Portrait of Frank Tiernan
Early 20th century
Lower right: GED
Watercolor on ivory
3 1/16 × 2 3/8" (7.8 × 6 cm)

Gift of the Pennsylvania Society
of Miniature Painters in memory
of Emily Drayton Taylor
1954-42-31

Dickinson, Anson
Portrait of Mary E. Heartte
Companion to the preceding
miniature
Early 1820s
Watercolor on ivory
3 1/4 × 2 7/16" (8.2 × 6.2 cm)

The Ozeas, Ramborger, Keehmle
Collection
1919-164

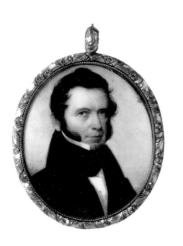

Dickinson, Anson
Portrait of John J. Ramborger
c. 1830
Watercolor on ivory
2 5/8 × 2 3/16" (6.7 × 5.6 cm)

The Ozeas, Ramborger, Keehmle
Collection
1921-34-102

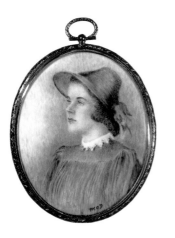

Dunn, Marjorie Cline
American, born 1894
Portrait of Barbara
c. 1940–60
Lower right: M C D
Watercolor on ivory
4 3/16 × 3 3/16" (10.6 × 8.1 cm)

Gift of the Pennsylvania Society
of Miniature Painters in memory
of Emily Drayton Taylor
1954-42-34

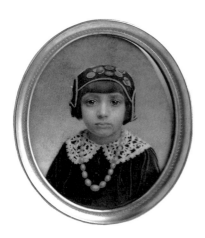

Durante, M.
American, active 20th century
Portrait of an Italian Girl
1924
Center right: Durante. M. 1924
Watercolor on ivory
3 3/8 × 2 5/8" (8.6 × 6.7 cm)

Gift of the Pennsylvania Society
of Miniature Painters in memory
of Emily Drayton Taylor, bequest
of Berta Carew
1959-91-18

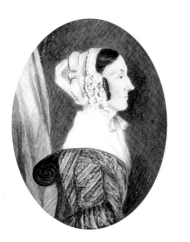

Ellsworth, James Sanford
American, 1802–1873/74
Portrait of Mrs. S. B. Webb
1840s
On paper on reverse: Sanford
Ellsworth / Guilford Conn. / Mrs.
S. B. Webb / of Wethersfield /
Conn.
Watercolor on paper
3 3/8 × 2 5/16" (8.6 × 5.9 cm)

The Samuel S. White 3rd and
Vera White Collection
1967-30-38

Ely, Frances Campbell
American, 1868–1952
Mornings at Seven
Early 20th century
Watercolor on ivory
3 × 2 1/4" (7.6 × 5.7 cm)

Gift of the Pennsylvania Society
of Miniature Painters in memory
of Emily Drayton Taylor
1954-42-35

Fenderson, Annie M.
American, died 1934
Portrait of Mrs. M. J. Moffett
1924
Center left: AMF / 1924
Watercolor on ivory
2 15/16 × 2 1/4" (7.5 × 5.7 cm)

Gift of the Pennsylvania Society
of Miniature Painters in memory
of Emily Drayton Taylor
1954-42-37

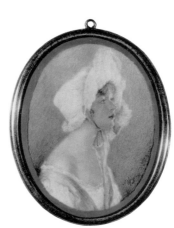

Fenderson, Annie M.
In Fancy Dress
1920s
Lower right: AMF
Watercolor on ivory
2 15/16 × 2 3/16" (7.5 × 5.6 cm)

Gift of the Pennsylvania Society
of Miniature Painters in memory
of Emily Drayton Taylor
1954-42-36

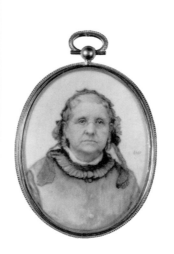

Fenderson, Annie M.
*Portrait of Mrs. Fenderson
(Grandmother Fenderson)*
Early 20th century
Center right: AMF
Watercolor on ivory
3 1/4 × 2 7/16" (8.2 × 6.2 cm)

Gift of the Pennsylvania Society
of Miniature Painters in memory
of Emily Drayton Taylor
1954-42-38

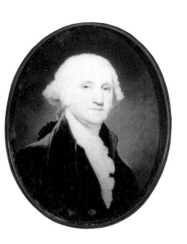

Field, Robert
American, born England,
active by 1794, died 1819
Portrait of George Washington
After a painting by Gilbert
Stuart (American, 1755–1828)
known in many versions
After 1796
Watercolor on ivory
3 ¹¹/₁₆ × 2 ¹³/₁₆" (9.4 × 7.1 cm)

Gift of Mrs. Daniel J. McCarthy
1953-142-26

Fisher, Howell Tracy
*Young Camels Drinking at the Base
of the Kutubia Mosque. Marrakech*
1929
Lower right: HTFisher 1929
Watercolor on ivory
2 ³/₁₆ × 3 ³/₈" (5.6 × 8.6 cm)

Gift of the Pennsylvania Society
of Miniature Painters in memory
of Emily Drayton Taylor
1954-42-39

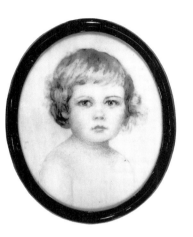

Fisher, Howell Tracy
American, active by 1929,
died 1938
Portrait of Claire
1920s
Watercolor on ivory
2 ¹/₂ × 1 ¹⁵/₁₆" (6.3 × 4.9 cm)

Gift of the Pennsylvania Society
of Miniature Painters in memory
of Emily Drayton Taylor
1954-42-42

Fraser, Charles
American, 1782–1860
Portrait of Judge Daniel O'Hara
Mid-19th century
Watercolor on ivory
4 ¹/₂ × 3 ⁷/₈" (11.4 × 9.8 cm)

Gift of Mrs. Daniel J. McCarthy
1954-21-3

Fisher, Howell Tracy
Street in Tétouan. Spanish Morocco
1929
Lower left: HTFisher
Watercolor on ivory
3 ⁷/₈ × 2 ⁵/₁₆" (9.8 × 5.9 cm)

Gift of the Pennsylvania Society
of Miniature Painters in memory
of Emily Drayton Taylor
1954-42-41

Gilpin, Blanche R.
American, active 20th century
Portrait of Miss Santa Maria
1930s
Watercolor on ivory
2 ³/₄ × 2 ¹/₄" (7 × 5.7 cm)

Gift of the Pennsylvania Society
of Miniature Painters in memory
of Emily Drayton Taylor
1954-42-43

Fisher, Howell Tracy
Sultan's Gate. Marrakech
1929
Lower left: HTFisher 1929
Watercolor on ivory
2 ¹/₈ × 3 ⁵/₁₆" (5.4 × 8.4 cm)

Gift of the Pennsylvania Society
of Miniature Painters in memory
of Emily Drayton Taylor
1954-42-40

**Graham, Elizabeth
Sutherland**
American, died 1938
*Of the Old School (Portrait of
John S. Graham)*
c. 1915–35
Upper left: E. S. Graham
Watercolor on ivory
4 ¹/₈ × 3 ¹/₈" (10.5 × 7.9 cm)

Gift of the Pennsylvania Society
of Miniature Painters in memory
of Emily Drayton Taylor
1954-42-44

Harris, Alexandrina Robertson
American, born Scotland, born 1886, still active 1962
Meditation
1920s
Lower left: Alexandrina. R. Harris.
Watercolor on ivory
3 15/16 × 3 3/16" (10 × 8.1 cm)

Gift of the Pennsylvania Society of Miniature Painters in memory of Emily Drayton Taylor
1954-42-46

Harris, Alexandrina Robertson
Portrait of a Woman
Early to mid-20th century
Lower left: A R. Harris
Watercolor on ivory
3 1/2 × 2 11/16" (8.9 × 6.8 cm)

Gift of the Pennsylvania Society of Miniature Painters in memory of Emily Drayton Taylor
1954-42-45

Harrison, Catherine Norris
American, active c. 1903–c. 1914
Portrait of Sophy B. Norris
1903
Center left: C. N. Harrison 1903
Watercolor on ivory
3 1/8 × 2 7/16" (7.9 × 6.2 cm)

Gift of the Pennsylvania Society of Miniature Painters in memory of Emily Drayton Taylor
1954-42-48

Harrison, Catherine Norris
Portrait of Agnes Irwin
Early 20th century
Center right: CNH
Watercolor on ivory
2 1/2 × 1 13/16" (6.3 × 4.6 cm)

Gift of the Pennsylvania Society of Miniature Painters in memory of Emily Drayton Taylor
1954-42-47

Hawley, Margaret Foote
American, 1880–1963
Portrait of Madame C.
1925
Lower left: MFH / '25
Watercolor on ivory
1 11/16 × 1 13/16" (4.3 × 4.6 cm)

Gift of Mrs. Daniel J. McCarthy
1954-21-5

Hays, Gertrude V.
American, active 20th century
Portrait of Mr. Osborne
Early to mid-20th century
Lower left: GerTRUDe HAYS
Watercolor on ivory
3 1/4 × 2 7/16" (8.2 × 6.2 cm)

Gift of the Pennsylvania Society of Miniature Painters in memory of Emily Drayton Taylor
1954-42-49

Hewitt, William K.
American, 1817–1893
Portrait of Major Daniel M. Fox
c. 1840
Watercolor on ivory
2 11/16 × 2 1/8" (6.8 × 5.4 cm)

Gift of the Pennsylvania Society of Miniature Painters in memory of Emily Drayton Taylor
1954-42-107

Hildebrandt, Cornelia Trumbull Ellis
American, 1878–1962
Portrait of Sallie Moon
c. 1945
Center right: Cornelia E Hildebrandt
Watercolor on ivory
3 11/16 × 2 7/8" (9.4 × 7.3 cm)

Gift of the Pennsylvania Society of Miniature Painters in memory of Emily Drayton Taylor
1954-42-50

Hills, Laura Coombs
American, 1859–1952
Blue and Crimson
1920s
Center bottom: Laura Hills
Watercolor on ivory
5 3/4 × 4 3/8" (14.6 × 11.1 cm)

Gift of the Pennsylvania Society
of Miniature Painters in memory
of Emily Drayton Taylor
1954-42-51

Huey, Florence Greene
American, 1872–1961
Portrait of Marion Pettit
c. 1905–25
Lower right: F. G. Huey
Watercolor on ivory
3 × 2 3/8" (7.6 × 6 cm)

Gift of the Pennsylvania Society
of Miniature Painters in memory
of Emily Drayton Taylor
1954-42-52

Hills, Laura Coombs
The Green Hat
1920s
Center bottom: Laura Hills
Watercolor on ivory
5 5/8 × 4 1/8" (14.3 × 10.5 cm)

Gift of Mrs. Daniel J. McCarthy
1954-21-6

Inman, Henry
American, 1801–1846
Portrait of a Woman
c. 1830
Watercolor on ivory
2 11/16 × 2 3/16" (6.8 × 5.6 cm)

Gift of Mrs. Daniel J. McCarthy
1954-21-13

Hitchner, Mary
American, born 1884,
still active 1924
Portrait of Mrs. Howell Tracy Fisher
1924
Watercolor on ivory
2 15/16 × 2 3/8" (7.5 × 6 cm)

Gift of the Pennsylvania Society
of Miniature Painters in memory
of Emily Drayton Taylor
1954-42-110

Irvin, Virginia Hendrickson
American, born 1904
Baby Oliver (Portrait of Oliver)
Early to mid-20th century
Watercolor on ivory
1" (2.5 cm) diameter

Gift of the Pennsylvania Society
of Miniature Painters in memory
of Emily Drayton Taylor
1954-42-53

Holme, Lucy D.
American, 1848–1928
Portrait of a Woman in Elizabethan Dress
Late 19th or early 20th century
Watercolor on ivory
3/4" (1.9 cm) diameter

Gift of Miss Elizabeth D. Hoffman
1976-199-1

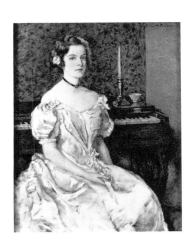

Jackson, Annie Hurlburt
American, 1877–1959
Rosewood and Old Satin
1930s
Upper right: Annie H. Jackson
Watercolor on ivory
5 7/16 × 4 3/8" (13.8 × 11.1 cm)

Gift of the Pennsylvania Society
of Miniature Painters in memory
of Emily Drayton Taylor
1954-42-54

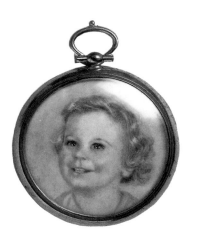

Jackson, Nathalie L'Hommedieu
American, born 1883,
still active 1940
Portrait of Daniel N. Phillips
c. 1930–50
Watercolor on ivory
2" (5.1 cm) diameter

Gift of the Pennsylvania Society
of Miniature Painters in memory
of Emily Drayton Taylor
1954-42-55

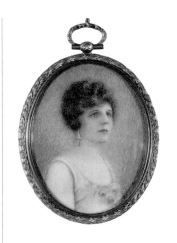

Kellett, Edith
Canadian, born England,
born 1877, still active 1928
Portrait of Madame R.
Mid-1920s
Lower right: Edith Kellett
Watercolor on ivory
2 13/16 × 2 1/8" (7.1 × 5.4 cm)

Gift of the Pennsylvania Society
of Miniature Painters in memory
of Emily Drayton Taylor
1954-42-58

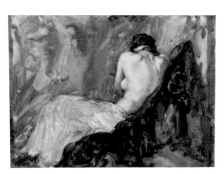

Johnson, Harry L.
American, active c. 1940
La Vie
1930s
Lower right: HLJ
Watercolor on ivory substitute
3 5/8 × 4 1/2" (9.2 × 11.4 cm)

Gift of the Pennsylvania Society
of Miniature Painters in memory
of Emily Drayton Taylor
1954-42-56

King, Angelica
American, active 1941–1951
Portrait of Dr. Morland King
1951
Center left: Angelica King—'51
Oil on paper
5 × 4" (12.7 × 10.2 cm)

Gift of the Pennsylvania Society
of Miniature Painters in memory
of Emily Drayton Taylor
1954-42-59

Johnson, Harry L.
Portrait of Miss Julia Waters
Early 20th century
Center right: HLJ
Watercolor on ivory
3 5/8 × 2 3/4" (9.2 × 7 cm)

Gift of the Pennsylvania Society
of Miniature Painters in memory
of Emily Drayton Taylor
1954-42-57

Knowles, Elizabeth A. McGillivray
American, born Canada,
1866–1928
The Explanation
Early 20th century
Lower left: Elizabeth A. McG.
Knowles
Watercolor on ivory
3 7/16 × 2 1/2" (8.7 × 6.3 cm)

Gift of the Pennsylvania Society
of Miniature Painters in memory
of Emily Drayton Taylor
1954-42-60

Johnson, Jeanne Payne
American, 1887–1958
Portrait of Sister Madelaine
Mid-20th century
Watercolor on ivory
3 1/8 × 2 1/2" (7.9 × 6.3 cm)

Gift of Mrs. Daniel J. McCarthy
1954-21-15

Little, Gertrude L.
American, active 1924–1962
Signe
1934
Lower left: Gertrude L. Little '34
Watercolor on ivory
4 7/8 × 3 3/4" (12.4 × 9.5 cm)

Gift of the Pennsylvania Society
of Miniature Painters in memory
of Emily Drayton Taylor
1954-42-61

Longacre, Lydia Eastwick
American, 1870–1951
Portrait of Judy
1943
Lower left: LEL / 1943
Watercolor on ivory
3 1/8 × 2 9/16" (7.9 × 6.5 cm)

Gift of the Pennsylvania Society
of Miniature Painters in memory
of Emily Drayton Taylor
1954-42-62

McKerwin
American, active c. 1935
Virgin del Rayo
1935
Lower right: MCKERWIN 1935
Watercolor on ivory
2 1/2 × 1 15/16" (6.3 × 4.9 cm)

Gift of the Pennsylvania Society
of Miniature Painters in memory
of Emily Drayton Taylor, bequest
of Berta Carew
1959-91-40

Lugano, Ines Somenzini
American, born Italy,
active 1930–1959
The Little Bridesmaid
1954
Lower left: I. Lugano 1954
Watercolor and graphite on ivory
substitute
5 11/16 × 4 3/16" (14.4 × 10.6 cm)

Gift of the Pennsylvania Society
of Miniature Painters in memory
of Emily Drayton Taylor
1954-42-63

McMillan, Mary
American, 1895–1958
Profile
1934
Lower left: MARY MCMILLAN 1934
Watercolor on ivory
3 × 2 7/16" (7.6 × 6.2 cm)

Gift of the Pennsylvania Society
of Miniature Painters in memory
of Emily Drayton Taylor
1954-42-65

Lynch, Anna
American, active by 1915,
died 1940
Portrait of Charlotte Vanderlip
1920s
Lower right: Anna Lynch
Watercolor on ivory
3 13/16 × 3" (9.7 × 7.6 cm)

Gift of the Pennsylvania Society
of Miniature Painters in memory
of Emily Drayton Taylor
1954-42-64

Malbone, Edward Greene
American, 1777–1807
Portrait of Colonel John Nixon
1790
Lower left: Malbone—90
Watercolor on ivory
3 × 2 1/2" (7.6 × 6.3 cm)

Bequest of Elizabeth Ellen
Keating
F1920-1-1

McCarthy, Elizabeth White
American, 1891–1952
Portrait of Dr. Judson Deland
Mid-20th century
Watercolor on ivory
3 1/4 × 2 1/2" (8.2 × 6.3 cm)

Gift of Mrs. Daniel J. McCarthy
1954-63-7

Malbone, Edward Greene
*Portrait of General Anne-Louis de
Tousard*
c. 1790
Watercolor on ivory
3 5/8 × 2 3/4" (9.2 × 7 cm)

Gift of Mrs. Daniel J. McCarthy
1954-21-18

Malbone, Edward Greene
Portrait of J. Higbie
Companion to the following
miniature
c. 1795–1800
Lower right: E. G. Malbone
Watercolor on ivory
3 × 2 1/2" (7.6 × 6.3 cm)

Gift of Mrs. Daniel J. McCarthy
1954-21-19

Malbone, Edward Greene
Portrait of Mrs. J. Higbie
Companion to the preceding
miniature
c. 1795–1800
Watercolor on ivory
3 1/8 × 2 3/8" (7.9 × 6 cm)

Gift of Mrs. Daniel J. McCarthy
1954-21-20

Malbone, Edward Greene
Portrait of Caroline Fenno
c. 1800
Watercolor on ivory
3 3/16 × 2 3/8" (8.1 × 6 cm)

Gift of Mrs. Daniel J. McCarthy
1954-21-17

Marchant, Edward Dalton
American, 1806–1887
*Portrait of Chancellor Kent of
New York*
Mid-19th century
Watercolor on cardboard
1 13/16" (4.6 cm) diameter

Gift of Mrs. Daniel J. McCarthy
1954-21-21

Melcher, Betsy Flagg
American, born 1900,
still active 1946
Portrait of Pamela Melcher
1939
Lower left: 1939 Betsy.Flagg.
Melcher.; center left: PAMELA /
MELCHER; center right: ANNO
1939 / ETATIS SUAE / 12
Watercolor on ivory
3 5/8 × 3 1/4" (9.2 × 8.2 cm)

Gift of the Pennsylvania Society
of Miniature Painters in memory
of Emily Drayton Taylor
1954-42-66

Murray, Grace Harper
American, 1872–1944
*Portrait of Justice Oliver Wendell
Holmes*
1920s
Lower right: GHM
Watercolor on ivory
5 1/2 × 4 1/8" (14 × 10.5 cm)

Gift of the Pennsylvania Society
of Miniature Painters in memory
of Emily Drayton Taylor
1954-42-67

Murray, Grace Harper
Still Life
c. 1920–40
Center right: GHM
Watercolor on ivory
2 7/8 × 3 1/2" (7.3 × 8.9 cm)

Gift of the Pennsylvania Society
of Miniature Painters in memory
of Emily Drayton Taylor
1954-42-68

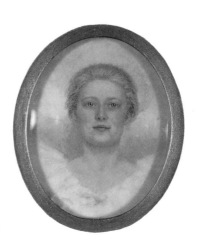

Otis, Amy
American, active 1926–1940
*A College Girl (Portrait of Dorothy
Gifford)*
c. 1920–40
Lower left: Amy Otis
Watercolor on ivory
3 3/8 × 2 9/16" (8.6 × 6.5 cm)

Gift of the Pennsylvania Society
of Miniature Painters in memory
of Emily Drayton Taylor
1954-42-69

Page, Polly
American, active c. 1937
Portrait of Caspar Wistar Hacker
c. 1920–40
Lower right: Polly Page
Watercolor on ivory
3 ⁵/₈ × 2 ¹³/₁₆" (9.2 × 7.1 cm)

Gift of the Pennsylvania Society
of Miniature Painters in memory
of Emily Drayton Taylor
1954-42-109

Pattee, Elsie Dodge
Portrait of Eleanor
1930s
Center right: E. D. PATTEE
Watercolor on ivory
5 ¹/₄ × 3 ³/₄" (13.3 × 9.5 cm)

Bequest of Rosina Cox Boardman
1971-199-1

Parke, Jessie Burns
American, 1889–1964
Portrait of Martha Peabody Parke
Mid-20th century
Lower right: J. B. PARKE
Watercolor on ivory
1 ¹³/₁₆ × 1 ¹/₂" (4.6 × 3.8 cm)

Gift of the Pennsylvania Society
of Miniature Painters in memory
of Emily Drayton Taylor
1954-42-70

**Patterson, Rebecca Burd
Peale**
American, 1881–1952
The Japanese Coat
1920s
Watercolor on ivory
3 ¹/₈ × 4 ⁵/₁₆" (7.9 × 10.9 cm)

Gift of the Pennsylvania Society
of Miniature Painters in memory
of Emily Drayton Taylor
1954-42-73

Pattee, Elsie Dodge
American, born 1876,
still active 1940
Little Betsy (Portrait of Betsy)
c. 1920–40
Center right: E. D. PATTEE
Watercolor on ivory substitute
1 ¹³/₁₆ × 1 ¹/₂" (4.6 × 3.8 cm)

Gift of the Pennsylvania Society
of Miniature Painters in memory
of Emily Drayton Taylor
1954-42-72

Peale, Anna Claypoole
American, 1791–1878
Portrait of a Man
1812
Lower right: Anna C. / Peale /
1812
Watercolor on ivory
2 ⁵/₈ × 2 ¹/₈" (6.7 × 5.4 cm)

Gift of George W. Norris
1937-14-1

Pattee, Elsie Dodge
Portrait of Lillian
c. 1920–50
Center left: EDP
Watercolor on ivory substitute
2 ¹/₄" (5.7 cm) diameter

Gift of the Pennsylvania Society
of Miniature Painters in memory
of Emily Drayton Taylor
1954-42-71

Peale, Anna Claypoole
Portrait of Ellen Matlack Price
1822
Lower left: Anna C. / Peale / 1822
Oil on ivory
2 ⁷/₈ × 2 ⁵/₁₆" (7.3 × 5.9 cm)

Bequest of Constance A. Jones
1988-27-50

Peale, Charles Willson
American, 1741–1827
Portrait of Benjamin Randolph
c. 1775–80
Watercolor on ivory
1 1/4 × 1" (3.2 × 2.5 cm)

Gift of Mr. and Mrs. Timothy
Johnes Westbrook
1990-21-1

Peale, Charles Willson
Portrait of Captain John MacPherson
c. 1787–92
Watercolor on ivory
2 1/8 × 1 11/16" (5.4 × 4.3 cm)

Bequest of Mellicent Story
Garland
1963-75-1

**Peale, Charles Willson,
attributed to**
Portrait of Hannah Cadwalader Morris
c. 1765–75
Watercolor on ivory
1 1/2 × 1 1/4" (3.8 × 3.2 cm)

Gift of an anonymous donor in
memory of Elizabeth Wheatley
Bendiner
1991-76-3

Peale, James
American, 1749–1831
Portrait of a Man
c. 1790
Watercolor on ivory
1 7/8 × 1 3/8" (4.8 × 3.5 cm)

The Ozeas, Ramborger, Keehmle
Collection
1919-162

Peale, James
Portrait of Mollie Callahan
1799
Lower left: JP / 1799
Watercolor on ivory
2 5/8 × 2 1/8" (6.7 × 5.4 cm)

Gift of Mrs. Daniel J. McCarthy
1954-21-25

Peale, James
Portrait of Maria Bassett
1801
Lower right: P / 1801
Oil on ivory
2 3/4 × 2 1/8" (7 × 5.4 cm)

Bequest of Jane Barbour Charles
1980-101-1

Peale, James
Portrait of a Woman
1805
Lower right: JP / 1805
Watercolor on ivory
2 15/16 × 2 7/16" (7.5 × 6.2 cm)

Gift of Jeanette Stern Whitebook
in memory of Louise Stern Shanis
1984-102-1

Peale, James
Portrait of a Man
1812
Lower right: JP / 1812
Watercolor on ivory
2 5/8 × 2" (6.7 × 5.1 cm)

Gift of Mrs. Frederick W. W.
Graham in memory of Mrs.
George H. Earle, Jr.
1944-47-1

Peale, James
Portrait of Sarah Maria McClintock
1813
Lower left: J P. / 1813
Watercolor on ivory
3 ³/₁₆ × 2 ½" (8.1 × 6.3 cm)

Bequest of Anne Maria Meeteer
1938-4-1

Pinter, Dora
American, active c. 1950
Halloween
Mid-20th century
Watercolor on ivory
1 ⁵/₈ × 2" (4.1 × 5.1 cm)

Gift of the Pennsylvania Society
of Miniature Painters in memory
of Emily Drayton Taylor
1954-42-75

Peale, Raphaelle
American, 1774–1825
Portrait of Catherine Mellish
c. 1810–20
Watercolor on ivory
2 ³/₄ × 2 ¼" (7 × 5.7 cm)

Gift of Mrs. Daniel J. McCarthy
1954-21-26

Pollock, L.
American, active 20th century
*Portrait of a Woman with a White
Cap*
Early 20th century
Lower right: L. Pollock
Watercolor on ivory
3 ⁷/₁₆ × 2 ¹¹/₁₆" (8.7 × 6.8 cm)

Gift of the Pennsylvania Society
of Miniature Painters in memory
of Emily Drayton Taylor, bequest
of Berta Carew
1959-91-24

Peale, Raphaelle
Portrait of a Woman
c. 1810–20
Lower right: R Peale
Watercolor on ivory
2 ⁵/₈ × 2 ¼" (6.7 × 5.7 cm)

Gift of Mrs. Daniel J. McCarthy
1954-21-27

Purdie, Evelyn
American, born Turkey,
1858–1943
Portrait of a Brittany Woman
Early 20th century
Watercolor on ivory
3 ⁷/₈ × 2 ⁷/₈" (9.8 × 7.3 cm)

Gift of the Pennsylvania Society
of Miniature Painters in memory
of Emily Drayton Taylor
1954-42-76

Phillips, Josephine Neall
American, 1887–1953
Model
c. 1930–50
Watercolor on ivory
3 ¼ × 2 ½" (8.2 × 6.3 cm)

Gift of the Pennsylvania Society
of Miniature Painters in memory
of Emily Drayton Taylor
1954-42-74

Purdie, Evelyn
Still Life with Flowers and Fruit
Mid-20th century
Watercolor on ivory
5 ⅛ × 3 ³/₁₆" (13 × 8.1 cm)

Gift of the Pennsylvania Society
of Miniature Painters in memory
of Emily Drayton Taylor
1954-42-77

Reece, Dora
American, active 1936–1962
Still Life with Flowers and a Samovar
Mid-20th century
Lower left: Dora Reece
Watercolor on ivory
3 13/16 × 4 15/16" (9.7 × 12.5 cm)

Gift of the Pennsylvania Society
of Miniature Painters in memory
of Emily Drayton Taylor
1954-42-78

Robertson, Archibald
American, born Scotland,
1765–1835
Portrait of a Man
c. 1790
Watercolor on ivory
1 5/8 × 1 1/8" (4.1 × 2.9 cm)

Gift of Mrs. Daniel J. McCarthy
1955-1-7

Reid, Aurelia Wheeler
American, 1876–1969
Portrait of Elizabeth Meldrum Reid
c. 1930
Upper right: A. W. REID.
Watercolor on ivory
3 13/16 × 2 15/16" (9.7 × 7.5 cm)

Gift of the Pennsylvania Society
of Miniature Painters in memory
of Emily Drayton Taylor
1954-42-79

Saint-Gaudens, Carlota
American, 1884–1927
Portrait of Theodore Roosevelt
Early 20th century
On border: .THEODORE.
ROOSEVELT. /.26th. PRESIDENT.
OF.THE.UNITED.STATES.
Watercolor on ivory
2 5/8" (6.7 cm) diameter

Gift of the Pennsylvania Society
of Miniature Painters in memory
of Emily Drayton Taylor
1954-42-82

Rhome, Lily Blanche Peterson
American, 1874–1943
Portrait of Sui Fun (Katherine) Cheung
1939
Center bottom: —Rhome—/
L. B. P. Rhome / 1939
Watercolor on ivory substitute
2 7/8 × 2 1/8" (7.3 × 5.4 cm)

Gift of the Pennsylvania Society
of Miniature Painters in memory
of Emily Drayton Taylor
1954-42-80

Sawyer, Edith
American, active 1926–1933
Portrait of a Woman in White
c. 1920
Watercolor on ivory
4 5/16 × 3 1/4" (10.9 × 8.2 cm)

Gift of the Pennsylvania Society
of Miniature Painters in memory
of Emily Drayton Taylor
1954-42-83

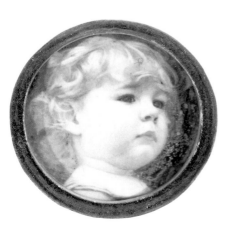

Richards, Glenora
American, born 1909
Portrait of Henry Tracy Richards
Mid-20th century
Watercolor on ivory substitute
1 5/8" (4.1 cm) diameter

Gift of the Pennsylvania Society
of Miniature Painters in memory
of Emily Drayton Taylor
1954-42-81

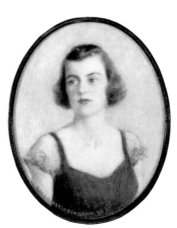

Simpson, Edna Huestis
American, 1882–1964
Portrait of Mrs. Francis H. Brinkley
1940
Lower left: Edna Huestis
Simpson '40
Watercolor on ivory
4 × 3" (10.2 × 7.6 cm)

Gift of the Pennsylvania Society
of Miniature Painters in memory
of Emily Drayton Taylor
1954-42-84

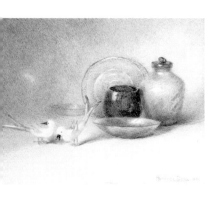

Sims, Florence
American, born 1891,
still active 1962
Still Life with Blue Glass
1951
Lower right: Florence Sims—1951
Watercolor on ivory
2 1/2 × 3 1/4" (6.3 × 8.2 cm)

Gift of the Pennsylvania Society
of Miniature Painters in memory
of Emily Drayton Taylor
1954-42-85

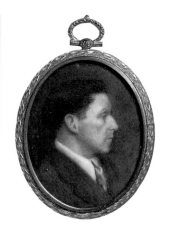

Starr, Lorraine Webster
American, born 1887,
still active 1962
An Actor (Portrait of Arthur Rowe)
Mid-20th century
Center left: L. W. Starr
Watercolor on ivory
2 3/4 × 2 1/16" (7 × 5.2 cm)

Gift of the Pennsylvania Society
of Miniature Painters in memory
of Emily Drayton Taylor
1954-42-88

Springer, Eva
American, born 1882,
died 1962–64
Portrait of Count Volney de Saint-Aignau
1913
Lower right: EVA SPRINGER. /
Paris 1913
Watercolor on ivory
5 7/16 × 4" (13.8 × 10.2 cm)

Gift of the Pennsylvania Society
of Miniature Painters in memory
of Emily Drayton Taylor
1954-42-86

Stedman, Margaret Weir
American, born 1882,
still active 1937
Portrait of Miss Santa Maria
c. 1950
Watercolor on ivory
2 3/4 × 2 1/4" (7 × 5.7 cm)

Gift of the Pennsylvania Society
of Miniature Painters in memory
of Emily Drayton Taylor
1954-42-89

Stanton, Lucy May
American, 1875–1931
Portrait of Miss Jule Moss
c. 1920
Upper right: Lucy M. Stanton
Watercolor on ivory
5 15/16 × 4 1/2" (15.1 × 11.4 cm)

Gift of Mrs. Daniel J. McCarthy
1955-1-18

Stout, Virginia Hollinger
American, born 1903
Portrait of a Polo Player
1950
Watercolor on ivory
2 3/8 × 1 13/16" (6 × 4.6 cm)

Gift of the Pennsylvania Society
of Miniature Painters in memory
of Emily Drayton Taylor
1954-42-90

Stanton, Lucy May
Self-Portrait in the Garden
1928
Upper right: Lucy M. Stanton
1928
Watercolor on ivory
5 11/16 × 4 7/16" (14.4 × 11.3 cm)

Gift of the Pennsylvania Society
of Miniature Painters in memory
of Emily Drayton Taylor
1954-42-87

Strean, Maria Judson
American, 1865–1949
Portrait of a Red-Haired Girl
c. 1915–20
Lower left: M. J. Strean
Watercolor on ivory
3 13/16 × 2 7/8" (9.7 × 7.3 cm)

Bequest of Rosina Cox Boardman
1971-199-2

Strean, Maria Judson
Portrait of Dorothy
1920
Lower right: M. J. Strean
Watercolor on ivory
3 ³/₄ × 2 ⁷/₈" (9.5 × 7.3 cm)

Gift of the Pennsylvania Society
of Miniature Painters in memory
of Emily Drayton Taylor
1954-42-91

Stuart, Gilbert, copy after
Portrait of Benjamin West
After the painting, dated c. 1785,
in the National Gallery, London
(no. 895)
c. 1900–25
Upper left (spurious): G. S. / 1792
Watercolor on ivory
4 ⁵/₈ × 3 ¹/₂" (11.7 × 8.9 cm)

Gift of Miss Lena Cadwalader
Evans
1936-22-9

Strean, Maria Judson
The Red Hat
1940s
Lower right: M. J. Strean
Watercolor on ivory
3 ³/₄ × 2 ⁵/₈" (9.5 × 6.7 cm)

Gift of the Pennsylvania Society
of Miniature Painters in memory
of Emily Drayton Taylor
1954-42-92

Stuart, Gilbert, copy after
Portrait of George Washington
A composite of several portraits
by Stuart
c. 1900–25
Lower left (spurious): G. S / 1793
Watercolor on ivory
5 ¹/₈ × 4 ¹/₄" (13 × 10.8 cm)

Gift of Miss Lena Cadwalader
Evans
1936-22-10

Strean, Maria Judson
Sea
Early to mid-20th century
Lower left: M. J. Strean
Watercolor on ivory
2 ¹¹/₁₆ × 3 ³/₁₆" (6.8 × 8.1 cm)

Gift of Mrs. Daniel J. McCarthy
1955-1-19

Stuart, Gilbert, copy after
Portrait of Martha Washington
Possibly after *Portrait of Martha
Washington*, in the Museum of
Fine Arts, Boston (1980.2)
c. 1900–25
Center right (spurious): G. S.
Watercolor on ivory
4 ³/₈ × 3 ¹/₂" (11.1 × 8.9 cm)

Gift of Miss Lena Cadwalader
Evans
1936-22-12

Stuart, Gilbert, attributed to
American, 1755–1828
Portrait of Paul Revere
Early 19th century
Watercolor on ivory
1 ³/₄ × 1 ⁹/₁₆" (4.4 × 4 cm)

Gift of Mrs. Daniel J. McCarthy
1955-1-20

Tannahill, Mary H.
American, born 1868,
still active 1940
Portrait of Elizabeth
Early 20th century
Lower right: Mary H. Tannahill
Watercolor on ivory
3 ⁷/₈ × 3" (9.8 × 7.6 cm)

Gift of the Pennsylvania Society
of Miniature Painters in memory
of Emily Drayton Taylor
1954-42-93

Taylor, Emily Drayton
American, 1860–1952
Portrait of Mrs. Richard Berridge
[née Eulalie Lesley]
1906
Center left: E. D. Taylor / 1906
Watercolor on ivory
4 ³/₈ × 3 ⁹/₁₆" (11.1 × 9 cm)

Gift of the Pennsylvania Society
of Miniature Painters in memory
of Emily Drayton Taylor
1954-42-94

**Tolman, Nelly Summerill
McKenzie**
American, 1877–1961
Portrait of Elizabeth C. Wickersham
c. 1915–25
Center right: Nelly McK. Tolman.
Watercolor on ivory
3 ¹/₂ × 2 ¹¹/₁₆" (8.9 × 6.8 cm)

Gift of the Pennsylvania Society
of Miniature Painters in memory
of Emily Drayton Taylor
1954-42-96

Taylor, Emily Drayton
Portrait of Mrs. John Innes Kane
1911
Lower right: E. D. Taylor / 1911
Watercolor on ivory
3 ¹/₈ × 2 ⁵/₈" (7.9 × 6.7 cm)

Gift of Edith M. Patterson in
memory of her mother, Emily
Drayton Taylor
1956-36-1

Trott, Benjamin
American, c. 1770–1843
Portrait of Colonel William King
c. 1800
Watercolor on ivory
2 ⁵/₈ × 2 ³/₁₆" (6.7 × 5.6 cm)

Gift of Mrs. Daniel J. McCarthy
1954-63-8

Taylor, Emily Drayton
*Portrait of a Woman Leaning on a
Cushion*
Early 20th century
Lower right: E. D. Taylor
Watercolor on ivory
5 × 3 ¹⁵/₁₆" (12.7 × 10 cm)

Gift of Edith M. Patterson in
memory of her mother, Emily
Drayton Taylor
1956-36-2

Trott, Benjamin
Portrait of Mary Catherine Sprogell
c. 1800
Watercolor on ivory
3 × 2 ³/₈" (7.6 × 6 cm)

Gift of John J. Jaquette
1962-218-1

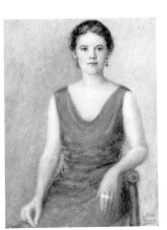

Thomas, Lillian M.
American, active c. 1946
Portrait of a Woman in Red
1930s
Lower right: Lillian / Thomas
Watercolor on ivory
3 ⁷/₈ × 2 ¹³/₁₆" (9.8 × 7.1 cm)

Gift of the Pennsylvania Society
of Miniature Painters in memory
of Emily Drayton Taylor
1954-42-95

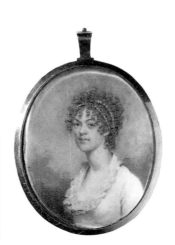

Trott, Benjamin
Portrait of Mary Catherine Sprogell
1805
Watercolor on ivory
3 ¹/₁₆ × 2 ⁷/₁₆" (7.8 × 6.2 cm)

Gift of Mrs. William A. Jaquette
1962-217-1

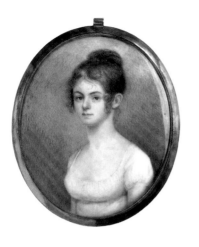

Trott, Benjamin
Portrait of Mrs. Walter Livingston
c. 1820
Watercolor on ivory
3 × 2 1/4" (7.6 × 5.7 cm)

Gift of Mrs. Daniel J. McCarthy
1955-1-21

Trueworthy, Jessie
American, born 1891,
still active 1962
Still Life
Early 20th century
Lower left: J. Trueworthy
Watercolor on ivory
3 1/4 × 4 1/4" (8.2 × 10.8 cm)

Gift of the Pennsylvania Society
of Miniature Painters in memory
of Emily Drayton Taylor, bequest
of Berta Carew
1959-91-37

Trumbull, John
American, 1756–1843
Portrait of Robert Morris
Companion to the following
miniature
1790
Oil on panel
4 × 3 1/4" (10.2 × 8.2 cm)

Gift of Mrs. Philip Livingston
Poe
1981-99-1

Trumbull, John
Portrait of Mary White Morris
Companion to the preceding
miniature
1790
Oil on panel
4 × 3 1/4" (10.2 × 8.2 cm)

Gift of Mrs. Philip Livingston
Poe
1981-99-2

Turner, Helen Maria
American, 1858–1958
Portrait of Lettie Turner
c. 1903–5
Center left: Helen M. Turner
Watercolor on ivory
4 1/4 × 3 1/4" (10.8 × 8.2 cm)

Bequest of Rosina Cox Boardman
1971-199-3

Turner, Matilda Hutchinson
American, born 1869,
still active 1959
Portrait of Mildred Louise Otto
Early 20th century
Center left: Matilda H Turner;
lower right: M H Turner
Watercolor on ivory
3 5/16 × 2 5/8" (8.4 × 6.7 cm)

Gift of the Pennsylvania Society
of Miniature Painters in memory
of Emily Drayton Taylor
1954-42-106

Tuttle, Adrianna
American, 1870–1941
Portrait of James A. Coe III
1922
Center right: A. Tuttle 1922
Watercolor on ivory
3 3/4 × 2 7/8" (9.5 × 7.3 cm)

Gift of the Pennsylvania Society
of Miniature Painters in memory
of Emily Drayton Taylor
1954-42-97

Tuttle, Adrianna
*Portrait of the Reverend
Alexander N. Keedwell*
1929
Lower left: A Tuttle / 1929
Watercolor on ivory
4 1/8 × 3 1/4" (10.5 × 8.2 cm)

Gift of Mrs. Albert Keedwell
1972-43-1

Washington, Elizabeth Fisher
American, 1872–1953
The Blue Locket
c. 1920–25
Lower right: E. F. WASHINGTON
Watercolor on ivory
3 ³/₄ × 3" (9.5 × 7.6 cm)

Gift of the Pennsylvania Society
of Miniature Painters in memory
of Emily Drayton Taylor
1954-42-98

Wilde, Ida M.
American, active 1926–1940
Portrait of Leslie Hall
1930s
Lower right: Ida M. Wilde.
Watercolor on ivory
3 ³/₄ × 3" (9.5 × 7.6 cm)

Gift of Mrs. Sylvia Wilde
Cornwell
1954-42-108

Welch, Mabel R.
American, active by 1915,
died 1959
Portrait of Mrs. Hahn
c. 1915
Lower left: M. R. Welch.
Watercolor on ivory
4 × 3" (10.2 × 7.6 cm)

Gift of the Pennsylvania Society
of Miniature Painters in memory
of Emily Drayton Taylor
1954-42-99

Williams, Alyn
American, born Wales,
1865–1955
Portrait of Calvin Coolidge
1925
Lower left: Alyn Williams R M S /
1925; center bottom: Calvin
Coolidge
Watercolor on ivory
4 ¹/₈ × 3 ¹/₈" (10.5 × 7.9 cm)

Gift of Mrs. Daniel J. McCarthy
1955-1-23

Welch, Mabel R.
Portrait of William J. Baer
1923
Lower left: M. R. Welch / 1923
Watercolor on ivory
3 ⁷/₁₆ × 4 ³/₈" (8.7 × 11.1 cm)

Gift of Mrs. Daniel J. McCarthy
1955-1-22

Williams, Alyn
Portrait of Kaiser Wilhelm II
Early 20th century
Watercolor on ivory
1 ³/₄ × ⁹/₁₆" (4.4 × 1.4 cm)

Gift of Mrs. Daniel J. McCarthy
1954-63-9

Whittemore, William John
American, 1860–1955
Portrait of Marion
c. 1925
Lower right: WHITTEMORE
Watercolor on ivory
3 ⁷/₈" (9.8 cm) diameter

Gift of the Pennsylvania Society
of Miniature Painters in memory
of Emily Drayton Taylor
1954-42-100

Wright, Catherine Morris
American, 1899–1988
Portrait of Jim Emlen
1945
Center right: C. M. Wright / 1945
Watercolor on ivory
3 × 2 ¹/₂" (7.6 × 6.3 cm)

Gift of the Pennsylvania Society
of Miniature Painters in memory
of Emily Drayton Taylor
1954-42-101

Zimmerman, Elinor Carr
American, born 1878,
still active 1947
The Old-Fashioned Bonnet
1942
Center right: E. C. ZIMMERMAN
1942
Watercolor on ivory
$3\,^7/_8 \times 2\,^7/_8$" (9.8×7.3 cm)

Gift of the Pennsylvania Society
of Miniature Painters in memory
of Emily Drayton Taylor
1954-42-102

Indexes

The Aaron E. Norman Fund, Inc.
 Gift 1959-31-1
Adelman, Seymour
 Gift 1946-73-1–3
Adger, Miss Willian
 Bequest 1933-82-4
A group of ninety-two painters and sculptors
 Funds contributed 1935-6-1
Allen, Mrs. Maria McKean
 Bequest 1951-44-1
The American Academy and Institute of Arts
and Letters
 Gift 1980-56-1
The American Academy of Arts and Letters
 Gift 1951-105-1
Amor, Ines
 Gift 1945-84-1
André, Françoise (friends of)
 Funds contributed 1975-165-1–2
Annenberg, Mr. and Mrs. Walter H.
 Fund for Major Acquisitions 1990-100-1
Anonymous donor
 Funds contributed 1984-79-1
 Gift 1922-89-1–2, 1932-49-1, 1941-78-1, 1948-
 53-1, 1955-53-1, 1956-26-1, 1962-49-1, 1964-
 61-1, 1968-224-1, 1969-87-1a–b, 1970-52-1,
 1970-204-1a–b, 1973-73-2, 1974-159-1, 1978-
 123-2, 1982-121-1, 1983-213-1, 1985-25-1,
 1991-76-2–4
Arensberg, Louise and Walter
 Collection 1950-134-1, 25–26, 29–30, 32, 34,
 36, 38–43, 47–54, 56, 58–59, 63, 65, 68–70, 73,
 80–82, 85–91, 93–99, 100–104, 109, 112–113,
 115, 118, 121–27, 130, 134, 138–44, 149, 151–
 53, 155–58, 164, 166, 168–70, 173–81, 186–96,
 198, 492–93, 504–14, 519–20, 523–24, 526–
 29, 532–35, 538, 813–15, 817, 823–24, 826–27
The Art Club of Philadelphia
 Gift 1928-37-1
Ascoli, Marion R.
 Gift 1983-190-1
Ascoli, Marion R. and Max
 Fund 1983-190-1
Bache, Caroline D.
 Bequest 1958-27-1
Baker, Mrs. Samuel M.
 Gift 1925-83-1–2
Barnard, George Grey
 Collection (purchased from) 1945-25-117–22,
 124, 261, 263–64
Barnwell, Mrs. Arthur
 Gift 1957-25-1
The Barra Foundation, Inc.
 Gift 1977-34-1
The Barry and Marilyn Peril Foundation
 Gift 1972-267-1
Batten, H. A.
 Gift 1942-65-1
Beard, Mrs. Robert F.
 Gift 1961-21-1
Bell, Edith H.
 Fund 1974-110-1, 1975-169-1, 1975-170-1,
 1977-79-1, 1979-163-1, 1979-74-1, 1981-62-1,
 1982-9-1, EW1986-10-1, 1987-8-1, 1987-73-1–2,
 1989-51-1, 1990-88-1–2
Belmont, Mrs. I. J.
 Gift 1977-203-1
Bendiner, Elizabeth Wheatley
 Gift of an anonymous donor in memory of 1991-
 76-2–4
Bérard, Marius-Honoré
 Gift of the artist 1949-33-1–2

Berman, Muriel and Philip
 Funds contributed 1982-48-1
 Gift 1989-70-5–6, 1992-15-1–2
Bernstein, Benjamin D.
 Gift 1964-106-1–5, 1973-70-1, 1975-163-1,
 1978-172-3–4
Beron, Edna
 Gift 1984-159-1
Biddle, Alexander
 Gift 1964-111-1
Biddle, George
 Gift 1945-16-36–39
 Gift of the artist 1972-121-1–4
Biddle, Nicholas
 Gift 1957-130-1
Biddle, Owen, and Peyton R. Biddle
 Gift 1978-12-1
Binder, Gertrude Schemm
 Collection 1951-84-1–2
Birnbaum, Martin
 Gift 1944-94-1
Bispham, Miss Eleanor
 Gift 1975-40-1–2
Blackburn, Morris Atkinson
 Gift of the artist 1975-164-1
Bloch, Miss Clara B.
 Gift 1955-33-1
Bloch, Miss Flora B.
 Gift 1955-33-1
Bloch, Julius
 Memorial Fund 1981-95-1–4, 1983-1-1, 1984-80-
 1, 1984-119-1, 1986-72-1, 1986-73-1, 1986-136-
 1, 1988-41-1, 1988-42-1, 1990-119-1–7
Boardman, Rosina Cox
 Bequest 1971-199-1–4
The Board of Trustees
 Gift 1943-72-1
Bortin, Mr. and Mrs. David
 Gift 1956-37-1–2
Bowman, Elizabeth Malcolm
 Gift 1936-17-1
Brady, Dr. Luther W., Jr.
 Funds contributed 1978-14-1
 Gift 1980-57-1, 1984-109-1
Brady, Mrs. Samuel
 Gift 1976-242-1
Braun, John F.
 Gift 1949-73-1
Breckenridge, Mrs. Hugh H.
 Gift 1936-35-1
Bregler, Charles
 Gift 1939-11-1, 1946-19-1
Brewster, Dr. William Barton
 Gift W1919-2-1
Breyer, Mrs. Henry W.
 Gift 1974-98-1–2, 1977-204-1
Breyer, Mr. and Mrs. Henry W., Jr.
 Gift 1968-73-1
Brinton, Christian
 Gift 1941-79-1–4, 29, 47–48, 66–71, 74, 76–
 77, 79–82, 89, 94–95, 98–103, 105–13, 115–
 17, 119–20, 138–39, 144, 147–51, 153, 335–36
Brock, Horace
 Gift 1978-35-1
Broughton, Miss D. M.
 Gift 1899-1151
Brown, Trisha
 Gift 1988-80-1
Browning, Mrs. Edward
 Gift 1947-99-1
Buchanan, Briggs W.
 Gift 1945-85-1

Buck, Mr. and Mrs. J. Mahlon
 Gift 1959-83-1
Buckley, R. Nelson
 Bequest 1943-85-1
 Funds contributed in memory of 1947-86-1
Budd, Edward and Althea
 Fund 1975-170-1, 1977-80-1, 1977-114-1, 1980-
 60-1, 1981-44-1, 1981-94-1a–b, 1982-120-1,
 1984-22-1, 1984-79-1, 1984-118-1, 1987-73-1–2,
 1989-51-1
Budd, Edward G., Jr.
 Memorial Fund 1973-252-1
Budd, Mrs. Edward G., Jr.
 Bequest 1973-202-38, 50
Bullitt, Mr. and Mrs. Orville H.
 Gift 1963-117-1
Burnham, Mrs. George, III
 Gift 1986-17-1
Butler, E. H.
 Gift 1894-276
Cadwalader, John
 Gift 1978-160-1
Cadwalader Collection
 Gift of an anonymous donor 1980-135-1,
 1983-90-1–11
Carew, Berta
 Bequest 1959-91-1–9, 11, 13–24, 26–47, 52–53
Carlen, Robert
 Gift 1941-2-1
Carpenter, Aaron E.
 Bequest 1970-75-2–3
Carpenter, Mrs. Harvey Nelson
 Gift 1936-10-1
Carson, Mrs. Hampton L.
 Gift 1929-126-14–15, 1929-136-148
Carson, Joseph, Hope Carson Randolph, John B.
 Carson, and Anna Hampton Carson
 Gift 1935-17-1–23
Carter, Miss Fannie Ringgold
 Gift 1949-53-1
Catherwood, Mr. and Mrs. Cummins
 Gift 1983-160-1
Cecil, George W.
 Gift 1942-65-1
Chait, Frederick
 Gift 1980-150-1
Chaplin, Mr. and Mrs. Charles C. G.
 Gift 1978-149-1, 3, 1978-173-1–2, 1985-22-1
Charles, Jane Barbour
 Bequest 1980-101-1
Chatfield-Taylor, Mrs. Otis
 Gift 1985-112-4
The Cheltenham Art Centre
 Funds contributed 1986-72-1
 Gift 1969-88-1, 1970-91-1, 1972-131-1,
 1975-54-1, 1976-35-1, 1977-81-1, 1978-58-1,
 1979-30-1
The Childe Hassam Fund of the American Academy
and Institute of Arts and Letters
 Gift 1974-10-1
Chimes, Thomas
 Gift of the artist 1975-78-1, 1976-154-1
Clark, Mrs. James
 Gift 1964-117-1–5
Clifford, Henry
 Gift 1943-42-1–2
 Memorial Fund 1976-34-1
Clifford, Mr. and Mrs. Henry
 Gift 1947-29-1–3, 1951-28-1, 1973-256-1, 3–5,
 7–9
Clifford, Mrs. Henry
 Gift 1975-79-1, 3

Coiner, C. T.
Gift 1942-65-1

Coles, Mrs. Bertha
Gift 1967-37-1

Collins, Mr. and Mrs. Philip S.
Gift 1929-79-1–2

Commissioners of Fairmount Park
F1925-5-1, F1926-3-1–2, F1929-1-1

The Committee on Painting and Sculpture
Gift 1943-45-1, 1947-32-1, 1947-33-1

Conrad, Brig. Gen. Bryan
Gift 1964-31-1

Cook, Gustavus Wynne
Gift 1937-18-1

Cooke, Jay
Fund 1957-2-1–2
Gift 1955-2-3–5

Cooper, Colin Campbell
Gift of the artist 1936-50-1–2

Cornwell, Mrs. Sylvia Wilde
Gift 1954-42-108

Cret, Marguerite Lahalle
Bequest 1965-117-10

Crosby, Mr. and Mrs. Arthur U.
Gift 1974-229-1

Curtiss, Deborah (friends of)
Gift 1976-98-1

Cushman, Miss Alice
Gift 1940-10-1–2

Dale, Chester
Collection 1946-50-2–4, 1951-109-1

Dale, Mrs. Chester
Gift 1950-121-1–4

The Daniel W. Dietrich Foundation
Funds contributed 1982-121-1, 1985-22-1, 1985-23-1

Darrow, Paul
Gift 1942-65-1

Davis, Bernard
Gift 1942-14-1, 1942-64-1–3, 1950-43-2, 1950-63-1, 1989-51-1

Davis, Gene
Gift of the artist 1972-30-1–2, 1972-54-1

Davis, Richard
Gift 1945-40-2

Denby, Phyllis Cochran
Gift 1963-191-1

Denckla, Paul
Gift 1958-94-1

de Schauensee, Mr. and Mrs. Rodolphe Meyer
Funds contributed 1954-10-1
Gift 1944-36-1, 1973-129-1, 1978-9-1, 1980-1-1

Dewey, Alexandra
Gift 1978-40-1

d'Harnoncourt, Mrs. René
Gift 1969-273-1

Dick, William Alexander
Gift 1930-105-1

Dickson, Mrs. Jefferson
Gift 1953-119-1

Dinehart, Mrs. Patrick
Gift 1953-119-1

Dinges, Mrs. Catherine M. G.
Gift 1930-54-1

Dion, Harry S.
Gift 1979-105-1

Director's Discretionary Fund
1968-226-1, 1968-97-1, 1970-2-1

Dix, George
Gift 1980-58-1

Dodge, Mrs. James Mapes
Gift 1951-79-1

Dodson, R. Ball
Gift 1926-9-1–2

Dolan, Mrs. Thomas J.
Gift 1943-53-1

Donner, Mr. and Mrs. William H.
Gift 1948-95-1–2

Dorrance, John T.
Gift 1965-85-1–2, 1969-140-1a–b

Downs, Mrs. Phebe Warren McKean
Bequest 1968-74-1–2

Drake, Miss Millicent J.
Gift 1935-14-2

Drake, Mrs. Thomas E.
Gift 1947-31-1

Dreier, Katherine S.
Bequest 1952-98-1

Dunlap, Mrs. William M.
Gift 1974-160-1

duPont, Henry F.
Gift 1959-102-1

Eakins, Mrs. Thomas
Gift 1929-184-1–12, 14–25, 27–36, 1930-32-3–18b

Earp, Anne Tucker
Bequest 1953-11-18

Ecker, Dr. Paul G.
Gift 1963-215-1

Eddleman, Joseph K.
Gift 1974-160-1

Egnal, Mr. and Mrs. Michael H.
Gift 1967-193-1–2

Elkins, George W.
Collection E1924-4-1–21, 23–32, E1932-1-1, E1936-1-1, E1945-1-1, E1950-2-1–2, E1957-1-1
Fund E1972-1-1, E1972-2-1, E1972-3-1, E1973-1-1, E1975-1-1, E1981-1-1, E1982-1-1, E1984-1-1, EW1985-21-1, 2, EW1986-10-1

Elkins, Lisa Norris
Bequest 1950-92-1–2, 4–12, 16–23, 231–32, 285–86, 1987-73-1–2
Fund 1954-10-1

Elkins, William L.
Collection E1924-3-1–14, 16–98

Elliott, Mrs. Frank Abercrombie
Gift 1964-107-1

Ellison, R. A.
Gift 1979-146-1

Ely, Mrs. Frances C.
Gift 1944-58-1

Ely, Mrs. Van Horn
Gift 1971-169-1–2

Ely, Mrs. W. Newbold
Gift 1944-9-1–6, 9

Emerson, Edith
Bequest 1984-66-1

Epstein, Dr. and Mrs. Joseph N.
Gift 1963-192-1

Erickson, Mrs. A. W.
Gift 1945-69-1–2

Evans, Miss Lena Cadwalader
Gift 1935-28-1, 1928-7-121, 1936-22-9–10, 12

Evans, Mr. and Mrs. Rowland
Gift 1956-61-1–2

Evans, Mrs. Thomas
Gift 1962-126-1

Fahnestock, Julia G.
Gift 1940-17-27

Farrell, Katharine Levin
Fund 1960-109-1, 1970-3-1–2, 1984-118-1, 1990-88-1–2

Feinstein, Rosaline B.
Bequest 1972-239-1

Feld, Mr. and Mrs. Stuart P.
Gift 1976-168-1

The Fellowship of the Pennsylvania Academy of the Fine Arts
Gift 1945-38-1

Felton, Edgar C.
Gift 1932-48-1

Fennessey, Helen S.
Bequest 1974-161-1–2

Fernberger, Dr. Samuel W.
Gift 1950-5-1

Fetterman, Dr. Faith S.
Gift 1961-64-1

Fidelity Bank
Gift 1973-131-1

Finckel, Eliza Royal
Gift 1956-66-5

Fine, Janet B.
Bequest 1973-250-1

Finklestein, Mr. and Mrs. Herman
Gift 1962-205-1–2

Fisher, Sally W.
Bequest F1925-1-1

Flanagan, Miss Virginia D.
Gift 1972-201-1

Fleming, Mrs. Thomas T.
Gift 1984-137-1

Flock, Sol M.
Gift 1966-121-1

Flom, Joseph
Gift 1975-180-1–2, 1976-245-1

Frazier, Mrs. George H.
Gift 1936-26-1

Frescoln family
Gift 1969-266-1

Frick, Miss Julia W., and Sidney W. Frick
Gift 1971-36-1

The Friends of the Junior League of Philadelphia
Gift 1979-97-1

The Friends of the Philadelphia Museum of Art
Funds contributed 1982-121-1
Gift 1967-88-1, 1968-183-1–2, 1972-53-1, 1976-156-1, 1979-145-1, 1979-99-1, 1981-56-1, 1985-5-1, 1989-3-1–2, 1990-39-1

Gallatin, A. E.
Collection 1937-31-1, 1944-12-1,3, 1944-90-1, 1945-14-1, 1945-91-1–4, 1946-70-2, 5, 7, 14–20, 1947-88-14, 1949-22-1, 1950-1-1, 1952-16-1, 1952-61-4–6, 8, 13, 22–23, 26, 28–29, 34–36, 38–41, 46, 51, 57–58, 63–64, 72, 76–79, 81–83, 85, 87–91, 93–99, 120–22, 124, 126

Garber, Daniel (family of)
Gift 1976-216-1

Garbisch, Edgar William and Bernice Chrysler
Bequest 1980-64-4–8, 10–16, 1981-1-1–8
Collection 1965-209-1–6, 1966-219-1–4, 1967-268-1–3, 1968-222-1–4, 1969-276-1, 1970-254-1–2, 1972-262-1–10, 1973-258-1–6

Garland, Mellicent Story
Bequest 1963-75-1–4

Garvan, Mrs. Francis P.
Gift 1965-208-1, 1976-164-1–4, 1977-257-1

Gaskill, Mrs. Joseph H.
Gift 1970-89-1

Gaughan, Tom (friends of)
Gift 1975-53-1

Gauze, Mrs. F. Taylor
Gift 1939-3-1

Geesey, Titus C.
Collection 1953-125-20
Gift 1969-284-13

Kulicke family
Gift 1969-86-1–5

Kurtz, Elaine
Gift of the artist 1982-32-1

Lamborn, Robert H.
Collection 1903-872–80, 882–89, 891–92, 894, 897, 900–916, 918–20, 922–36, 938–44, 946

Langston, Bryant W.
Gift 1961-77-1

Larner, Chester Waters
Bequest 1977-258-1

Lauck, Gerald M.
Gift 1942-65-1

Lea, Arthur H.
Bequest F1938-1-1–49, 51, 117

Lee, James
Gift 1982-32-1

Lefft, Dr. and Mrs. Harold
Gift 1965-214-1

Lefton, Mrs. Al Paul
Gift 1972-264-1

Lerner, Morris
Gift 1973-76-1

Levy, Dr. and Mrs. Richard W.
Gift 1968-182-1, 1969-167-1

Lewisohn, Sam A.
Gift 1944-85-1

Lionni, Leonard
Gift 1942-65-1

Lippincott, Walter
Collection 1923-59-1–2, 4–17
Gift 1923-59-3

Lloyd, Mr. and Mrs. H. Gates
Gift 1974-232-1

Lloyd, Mrs. H. Gates
Funds contributed 1982-121-1, 1984-79-1, 1984-118-1
Gift 1956-5-1, 1966-57-1–4, 1973-154-1

Locks, Gene
Funds contributed 1975-120-1
Gift 1974-77-1, 1991-139-1

Longstreth, Thatcher
Gift 1975-70-1

Longstreth, Walter
Gift 1968-41-1

Lorber, Dr. Herman
Gift 1944-95-1–2, 4

Lorimer, Graeme
Gift 1975-182-1

Lowe, Sue Davidson
Gift 1968-69-53

Ludington, Wright S.
Gift 1951-3-1

Ludington, Wright S. (nieces and nephews of)
Gift 1980-139-1–2

Luria, Dr. and Mrs. Milton
Gift 1976-37-1

The M. L. Annenberg Foundation
Gift 1955-51-1

The Mabel Pew Myrin Trust
Funds contributed 1980-135-1, 1983-90-1–11

McBrien, Frederick R.
Funds contributed 1975-120-1

McCarter, Henry
Bequest 1944-44-2–3, 1964-151-1, 1972-238-3, 13, 15, 18, 189

McCarthy, Dr. and Mrs. Daniel
Gift 1942-87-1

McCarthy, Mrs. Daniel J.
Gift 1953-142-1–4, 6–26, 1954-21-1–23, 25–27, 1954-63-1–2, 4–9, 11, 1955-1-1–23, 1955-1-25–28b

McCormick, Mrs. Cyrus
Gift 1946-10-1–2

McFadden, John Howard
Collection M1928-1-1–43

McFadden, John Howard, Jr.
Fund 1956-118-1, 1963-180-1, 1971-164-1, 1972-250-1–4
Gift 1946-36-1–3, 5–6, 1951-125-17–18

McFadden, Mr. and Mrs. John Howard, Jr.
Gift 1952-97-1, 1956-13-1

Machold, Mr. and Mrs. William F.
Gift 1975-125-1, 1978-100-1

McIlhenny, Henry P.
Collection 1986-26-1, 4–5, 10, 17–18, 22, 24, 28–29, 32, 35–36, 38, 271–74, 276–285, 287, 401–5
Fund 1987-73-1–2, 1990-100-1
Funds contributed 1954-10-1
Gift 1955-113-1, 1956-107-1, 1957-125-1, 1958-144-1, 1964-77-1–3, 1971-265-1

McIlhenny, John D.
Collection 1943-40-38–45, 48–49, 51–55
Fund 1938-11-1, 1966-20-2–7, 1973-253-1, W1984-57-1

McIlvain, Mrs. John Morton
Gift 1929-48-2

McKean, Mrs. Sargent
Gift 1950-52-1

McLean, Mr. and Mrs. Robert
Gift 1977-202-1

McMichael, Mrs. C. Emory
Gift 1950-51-1

McMichael, Ellen Harrison
Gift 1942-60-1–2

Madeira, Mrs. Louis C.
Gift 1965-205-23, 1977-288-1

Magill, Bradford S.
Gift 1977-174-1

Magill, Mr. and Mrs. James P.
Gift 1957-127-1, 6–7

Makler, Dr. and Mrs. Paul Todd
Gift 1967-38-1, 1969-174-1, 1970-92-1, 1971-170-1–2, 1979-186-3

Mann, Mr. and Mrs. Fredric R.
Gift 1955-24-1

Marceau, Henri
Funds contributed in memory of 1970-169-1

Margini, Dr. and Mrs. Lorenzo
Gift 1980-131-1

Marine, Mr. and Mrs. Walter S.
Gift 1971-222-1

Marinot, Mlle Florence
Gift 1967-98-1–3

Markoe, Mrs. Harry
Bequest 1943-51-101

The Mark Rothko Foundation, Inc.
Gift 1985-19-2–3

Marsh, Felicia Meyer
Gift of the estate 1979-98-1

Marvel, Mrs. Josiah
Gift 1962-74-1

Mason, Mrs. Frederick Thurston
Gift 1914-365

Mastbaum, Jules E.
Gift F1929-7-205

Mauch Chunk National Bank
Gift 1949-56-1

Meeteer, Anne Maria
Bequest 1938-4-1

Meirs, Mrs. Richard Waln
Gift 1933-11-2

Melzac, Vincent
Gift 1967-39-1

Mieger, Ernie and Lynn
Gift 1988-33-7

Miller, Mr. and Mrs. C. Earle
Gift 1970-15-1, 1986-97-1

Miller, N. Richard
Gift 1966-180-1

Miller, Mr. and Mrs. N. Richard
Funds contributed 1982-121-1
Gift 1967-217-1, 1969-265-1, 1972-204-1, 1978-151-1–2, 1979-160-1, 1985-86-1

Miller, Percy Chase
Gift 1945-33-1–2

Milliken, Mr. and Mrs. Gerrish H.
Gift 1978-177-1

Mirkil, Mrs. William I.
Gift 1961-150-1

Mitcheson, Lucie Washington
Gift 1938-22-1, 3–10

Mitcheson, Robert Stockton Johnson
Collection 1938-22-1, 3–10

Montferrier, Mme Florence de
Gift 1961-180-1

Moore, Bloomfield
Collection 1882-210, 1168–71, 1174–77, 1883-73, 82–83, 85, 89, 97–98, 101–3, 105–6, 112–15, 120–21, 131–33, 136–37, 140–41, 1889-79, 1899-957, 964–69, 976, 1007, 1011, 1029–30, 1099, 1106, 1108–9, 1120–21
Fund 1951-31-1–5, 1966-4-1

Moore, Dr. and Mrs. Matthew T.
Gift 1964-45-1, 1984-108-1

Morris, Mr. and Mrs. Herbert Cameron
Bequest 1990-100-1
Gift 1943-46-1–2, 1951-104-1, 1957-94-1

Morris, Mrs. Herbert Cameron
Funds contributed 1954-10-1
Gift 1943-5-1, 1945-2-1, 1946-13-1, 1946-40-1, 1947-24-1, 1948-11-1, 1964-89-1, 1977-27-1–2

Morris, Lydia Thompson
Bequest 1932-45-18–19, 83, 116–21
Gift 1930-73-4

Mucci, Mrs. Mary B.
Gift 1973-201-1

Muckle, Mrs. Craig W.
Gift 1991-182-1

Mueller, Frederic
Gift 1978-29-1

Museum funds
1913-455, 1949-40-1a–b, 1950-13-1, 1954-31-1, 1959-28-1

The National Collection of Fine Arts
Gift 1972-123-1

National Endowment for the Arts
Grant 1974-111-1, 1977-28-1, 1982-121-1, 1991-51-1

Nebinger, Robert
Bequest 1889-110, 113, 139

The Nebinger Fund
1949-24-1

Neville, Sheila
Gift 1978-40-1

Nevins, J. J. (family of)
Gift 1992-41-1

Newman, Mr. and Mrs. Philip
Gift 1983-64-1

Newton, Francis, F. Maurice Newton, and Richard Newton, Jr.
Gift 1962-142-1

Newton, Maurice
Gift 1966-220-1

Norman, Mrs. Dorothy
Gift 1959-30-1

Stettheimer, Miss Ettie
 Gift 1951-27-1
Stieglitz, Alfred
 Collection 1949-18-1–13, 109
Stinson, Miss Anna Catherine
 Gift 1930-7-1
Stokes, J. Stogdell
 Fund 1980-61-1, EW1985-21-1, 2, 1987-8-1,
 1990-88-1–2, 1992-60-1
 Gift 1927-62-1
Stokes, Mr. and Mrs. J. Stogdell
 Gift 1931-40-1, 1940-18-1
Stokes, Mrs. S. Emlen
 Gift 1973-264-1, 1979-13-1
Storey, Frances and Bayard
 Funds contributed 1982-121-1, 1984-79-1
Strater, David
 Gift 1965-170-1
Strater, Henry
 Funds contributed 1981-93-1, 1982-46-1
Stroud, Marion Boulton
 Funds contributed 1976-99-1, 1981-94-1a–b,
 1982-46-1, 1982-121-1, 1984-79-1, 1987-31-1
 Gift 1980-59-1, 1991-142-1
Studdiford, Mrs. William E.
 Gift 1975-90-1
Stuempfig, Walter
 Gift 1961-78-1
Subscription funds
 1930-67-1, 1935-46-1, 1939-12-1, 1942-17-1
Sunstein, Mr. and Mrs. Leon C., Jr.
 Gift 1969-166-2
Swain, Miss Sara A.
 Gift 1909-142–43
Tanguy, Kay Sage
 Bequest 1964-181-1
Tashjian, Haig
 Gift 1966-227-1
Taylor, Mrs. Mary Stockton
 Gift 1944-77-1
Temple, Joseph E.
 Fund 1966-110-1, 1969-259-1
Thayer, Jean Thompson (children of)
 Gift 1986-108-1
Thomas, Maria Godey Bedlock
 Gift 1943-90-1
Thomson, Anne
 Bequest 1954-66-3, 6, 8–9
Thomson, Mrs. Frank Graham
 Bequest 1961-48-1–3
Thrall, Miss Miriam H.
 Gift 1966-221-1, 1968-42-1
Todd, W. Parsons, and Miss Mary J. Todd
 Gift 1938-25-1, 1938-29-1–17
Tonner, Mrs. William Thomas
 Gift 1960-57-1, 1964-110-1
Toogood, Granville E.
 Gift 1942-65-1
Troth, A. Manderson
 Bequest 1927-52-37–38, 42, 192, 206, 209,
 212, 218
Truitt, Harold S.
 Bequest 1927-5-12
Tschirky, Mr. and Mrs. Leopold
 Gift 1956-112-1–3
Turner, Adele Haas, and Beatrice Pastorius Turner
 Memorial Fund 1954-30-1, 1956-11-1, 1959-12-
 1–8, 1966-172-1, 1967-261-1, 1968-76-1, 1968-
 77-1, 1968-119-1, 1972-156-1, 1974-112-1,
 1975-38-1, 1975-82-1–2, 1975-83-1, 1976-99-
 1, 1978-68-1, 1979-14-1, 1981-40-1, 1981-
 94-1a–b, 1982-120-1, 1984-79-1, 1991-51-1

Turner, Beatrice Pastorius
 Bequest 1949-16-1
Tyson, Carroll S., Jr.
 Gift 1939-53-1
Tyson, Mr. and Mrs. Carroll S., Jr.
 Collection 1963-116-1–6, 8–19, 21
Tyson, Charles R.
 Gift 1965-205-23
The Violet Oakley Memorial Foundation
 Gift 1984-67-1–4
Vogel, Irving H.
 Funds contributed 1954-10-1
Vogt, Lorine E.
 Funds contributed 1981-94-1a–b
Wagner, Mr. and Mrs. John
 Gift 1986-100-1
Wainwright, F. King
 Bequest 1952-65-1
Wanamaker, John
 Gift 1951-69-1
Warner, Lydia Fisher
 Gift of the estate 1949-54-1
Webb, Mr. and Mrs. J. Watson
 Gift 1942-102-1
Weidenfeld, Lady George
 Gift 1972-125-1
Wellin, Keith
 Gift 1971-219-1
Welsh, Edna M.
 Bequest 1982-1-1–2, 9, 1990-54-1
 Gift W1984-57-1
Westbrook, Mr. and Mrs. Timothy Johnes
 Gift 1990-21-1
Westreich, Leslie and Stanley
 Gift 1986-173-1
Wharton, Katharine C.
 Gift of the estate 1986-76-4
Whitaker, Miss Evelyn L.
 Gift 1930-46-16
White, Mrs. Edward A.
 Gift 1945-64-1
White, Mrs. J. William
 Gift 1922-67-13
White, Samuel S., 3rd, and Vera White
 Collection 1959-133-1, 1960-23-3,
 1967-30-3, 7, 9–17, 36, 38, 52–53, 55–57,
 59, 61, 66–67, 70–71, 76, 79–80,
 83–84, 90
 Gift W1984-57-1, 1985-22-1, 1985-23-1, 1989-
 90-1–10
Whitebrook, Jeanette Stern
 Gift 1984-102-1
Whitehill, Jean L.
 Bequest 1986-9-1
Whitney, Mrs. Daniel
 Gift 1952-3-1
Widener, George D.
 Bequest 1972-50-1–3
 Funds contributed 1954-10-1
 Funds from the estate 1980-6-1
Widener, Peter A. B., III
 Gift 1971-271-1
Wiedemann, Theodore
 Gift 1980-63-1
Wiesenberger, Arthur
 Gift 1943-101-1, 1955-109-1
Wiesenberger, Mr. and Mrs. Arthur
 Gift 1962-206-1
Wiford, Mr. and Mrs. Edward B., III
 Gift 1991-184-1
Williams, John S.
 Gift 1947-100-1–3

Williams, Mrs. John S.
 Gift 1946-88-1
Williams, Miss Mary Adeline
 Gift 1929-184-1–12, 14–25, 27–36,
 1930-32-3–18b
Williams, Sarah McLean
 Gift 1942-101-21–38
Willis, Charles C.
 Bequest 1956-59-1
Wills, Mrs. William M.
 Gift 1930-50-2–3
Wilstach, W. P.
 Collection (bequest of Anna H. Wilstach) W1893-
 1-3–4, 10–13, 27, 46, 65, 67, 84, 90, 93, 100,
 106–7, 125–26, 132, 135
 Fund W1894-1-2–5, 7–9, 11–12, W1896-1-5–6,
 11–12, W1897-1-4–5, W1899-1-1–2, 4, W1900-
 1-7, 14, 16–17, W1901-1-2–3, 5, W1902-1-8, 10,
 12–13, 15, 18–22, W1903-1-6–7, W1904-1-2–3,
 7, 9–10, 20, 23, 25–26, 35, 38, 43, 46, 54–55, 60,
 63, W1906-1-4–5, 9, 12, W1912-1-2, 7, W1914-
 1-2, W1916-1-4, W1917-1-10, W1918-3-1,
 W1920-2-1, W1921-1-1, 3–9, W1922-1-1–2,
 W1937-1-1, W1937-2-1, W1950-1-1–2, W1950-
 3-1, W1952-1-1, W1954-1-1, W1957-1-1, 1958-
 2-1, W1959-1-1, W1962-1-1, W1972-2-1,
 W1975-1-1–2, W1984-57-1, EW1985-21-1, 2,
 EW1986-10-1
Wintersteen, Mrs. John
 Gift 1942-66-1, 1950-86-1, 1953-111-1, 1956-
 23-1, 1959-102-1, 1964-46-1, 1964-109-1,
 1969-245-1
Wistar, Mrs. J. Morris
 Gift 1976-223-3
Wolgin, Dr. and Mrs. William
 Gift 1967-41-1, 1972-30-1–2, 1972-54-1
 Funds contributed 1982-121-1, 1984-79-1
The Women's Committee of the Philadelphia
Museum of Art
 Gift 1968-39-1, 1975-120-1, 1982-89-1
Wood, Beatrice
 Gift of the artist 1978-98-1
Wood, William P.
 Gift 1978-103-1
Wood, Mr. and Mrs. William P.
 Gift 1980-148-1, 1981-58-1, 1989-51-1
The Woodward Foundation
 Gift 1975-81-1–2, 4–6, 8–15, 1975-83-3,
 1982-48-1
Woodward, Dr. and Mrs. George
 Gift 1939-7-16–18
Woodworth, Mary Katharine
 Gift 1986-124-1
Wright, Charlotte Dorrance
 Bequest 1978-1-1–48
Wright, Mrs. William Coxe
 Funds contributed W1959-1-1
Young America Preserves, Inc.
 Gift 1976-152-1–2
Zabriskie, Mrs. Virginia M.
 Gift 1980-149-1
Zern, Edward
 Gift 1942-65-1
Zigrosser, Carl
 Gift 1942-15-1, 1972-237-1–2, 4–8, 11,
 1974-179-1

1882-210	Weisz, Adolphe 162	
1882-1168	European, unknown artist 460	
1882-1169	German, unknown artist 464	
1882-1170	German, unknown artist 464	
1882-1171	French, unknown artist 461	
1882-1174	Swedish, unknown artist 474	
1882-1175	English, unknown artist 453	
1882-1176	French, unknown artist 463	
1882-1177	French, unknown artist 464	
1883-73	Brueghel, Pieter, the Younger 39	
1883-82	Wutky, Michael 252	
1883-83	Vernet, Claude-Joseph, imitator of 160	
1883-85	Vernet, Claude-Joseph, imitator of 161	
1883-89	Mazzanti, Lodovico 218	
1883-97	Locatelli, Andrea, studio of 211	
1883-98	Locatelli, Andrea, studio of 211	
1883-101	Ricci, Marco, follower of 228	
1883-102	Vernet, Claude-Joseph, imitator of 160	
1883-103	Pannini, Giovanni Paolo, imitator of 224	
1883-105	Locatelli, Andrea, studio of 211	
1883-106	Locatelli, Andrea, studio of 211	
1883-112	Vernet, Claude-Joseph, imitator of 160	
1883-113	Vernet, Claude-Joseph, imitator of 160	
1883-114	Vernet, Claude-Joseph, imitator of 160	
1883-115	Pannini, Giovanni Paolo, imitator of 224	
1883-120	Dutch or Flemish, unknown artist 53	
1883-121	Dutch or Flemish, unknown artist 54	
1883-131	Russian, unknown artist 250	
1883-132	Russian, unknown artist 250	
1883-133	Italian, unknown artist 205	
1883-136	Swedish?, unknown artist 251	
1883-137	Swedish?, unknown artist 251	
1883-140	Courtois, Jacques, follower of 124	
1883-141	Courtois, Jacques, follower of 124	
1889-79	Jordaens, Jacob, copy after 66	
1889-110	Woodside, John Archibald, Sr. 305	
1889-113	Weyermann, Jakob Christoph 174	
1889-139	Cossiau, Jan Joost van 47	
W1893-1-3	Achenbach, Oswald 163	
W1893-1-4	Amberg, Wilhelm 163	
W1893-1-10	Blauvelt, Charles F. 264	
W1893-1-11	Blythe, David Gilmour 264	
W1893-1-12	Blythe, David Gilmour 264	
W1893-1-13	Blythe, David Gilmour 264	
W1893-1-27	Conarroe, George W. 267	
W1893-1-46	Gifford, Robert Swain 280	
W1893-1-65	Lessing, Karl Friedrich 171	
W1893-1-67	Leutze, Emanuel 171	
W1893-1-84	Peale, Rembrandt 292	
W1893-1-90	Riefstahl, Wilhelm Ludwig Friedrich 173	
W1893-1-93	Schlesinger, Henri-Guillaume 156	
W1893-1-100	Smith, T. Henry 296	
W1893-1-106	Stevens, Alfred-Émile-Léopold 251	
W1893-1-107	Sully, Thomas 302	
W1893-1-125	Winner, William E. 305	
W1893-1-126	Winner, William E. 305	
W1893-1-132	Zamacois y Zabala, Eduardo 246	
W1893-1-135	Zimmermann, Reinhard Sebastian 174	
W1894-1-2	Delacroix, Ferdinand-Victor-Eugène 129	
1894-276	Moran, Edward 288	
W1895-1-3	Canaletto, copy after 185	
W1895-1-4	Gainsborough, Thomas 13	
W1895-1-5	Inness, George 285	
W1895-1-7	Neer, Aert van der, follower of 78	
W1895-1-8	Ruisdael, Jacob Isaacksz. van 94	
W1895-1-9	Raeburn, Sir Henry 22	
W1895-1-11	Whistler, James Abbott McNeill 304	

W1895-1-12	Courbet, Gustave, attributed to 123	
W1896-1-5	Constable, John 5	
W1896-1-6	Campi, Giulio, attributed to 184	
W1896-1-11a–e	Crivelli, Vittore 189	
W1896-1-12	Hondecoeter, Melchior de, workshop of 64	
W1897-1-4	Corot, Jean-Baptiste-Camille 117	
W1897-1-5	Monticelli, Adolphe-Joseph-Thomas 148	
W1899-1-1	Tanner, Henry Ossawa 302	
W1899-1-2	Flemish or Dutch, unknown artist 57	
W1899-1-4	Snyders, Frans 97	
1899-957	English, unknown artist 452	
1899-964	English, unknown artist 453	
1899-965	English, unknown artist 453	
1899-966	Bertoldi, Antonio 448	
1899-967	French, unknown artist 462	
1899-968	Bogle, John, attributed to 448	
1899-969	Crosse, Richard, attributed to 450	
1899-976	French, unknown artist 462	
1899-1007	Parant, Louis-Bertin 470	
1899-1011	French, unknown artist 461	
1899-1029	English?, unknown artist 453	
1899-1030	French, unknown artist 462	
1899-1099	Weisz, Adolphe 162	
1899-1106	West, Benjamin 29	
1899-1108	Neri di Bicci 220	
1899-1109	Spanish, unknown artist 244	
1899-1120	Mexican?, unknown artist 309	
1899-1121	Murillo, Bartolomé Esteban, copy after 241	
1899-1151	American, unknown artist 476	
W1900-1-2	Bonheur, Marie-Rosalie 110	
W1900-1-5	Bouguereau, William-Adolphe 112	
W1900-1-7	Murillo, Bartolomé Esteban 241	
W1900-1-14	Marieschi, Michele 214	
W1900-1-16	Zurbarán, Francisco de 246	
W1900-1-17	El Greco, workshop of 240	
W1901-1-2	Borssom, Anthonij van 35	
W1901-1-3	Weenix, Jan 106	
W1901-1-5	Giordano, Luca 195	
W1902-1-8	Dyck, Anthony van, follower of 54	
W1902-1-10	Rubens, Peter Paul, copy after 93	
W1902-1-12	Tiepolo, Giovanni Domenico 233	
W1902-1-13	Sittow, Michel, follower of 250	
W1902-1-15	Vliet, Hendrick Cornelisz. van 104	
W1902-1-18	Hondecoeter, Melchior de, attributed to 64	
W1902-1-19	Lelienbergh, Cornelis 69	
W1902-1-20	Knijff, Wouter 68	
W1902-1-21	Steen, Jan 98	
W1902-1-22	Vos, Cornelis de 104	
W1903-1-5	Barker, Thomas 2	
W1903-1-6	Brueghel, Pieter, the Younger, attributed to 40	
W1903-1-7	Maurer, Alfred Henry 394	
1903-872	Caro, Manuel 307	
1903-873	Mexican, unknown artist 310	
1903-874	Mexican, unknown artist 310	
1903-875	Mexican, unknown artist 310	
1903-876	Mexican, unknown artist 310	
1903-877	Correa, Juan, the Younger 307	
1903-878	Juarez, Juan Rodriguez 309	
1903-879	Cabrera, Miguel 306	
1903-880	Mexican, unknown artist 310	
1903-882	Mexican, unknown artist 310	
1903-883	Mexican, unknown artist 311	
1903-884	Mexican, unknown artist 311	
1903-885	Mexican, unknown artist 311	
1903-886a	Mexican, unknown artist 311	
1903-886b	Mexican, unknown artist 311	
1903-887	Mexican, unknown artist 311	

1903-888a	Mexican, unknown artist 311	
1903-888b	Mexican, unknown artist 311	
1903-889	Enriquez, Nicolas 308	
1903-891	Enriquez, Nicolas 308	
1903-892	Mexican, unknown artist 312	
1903-894	Herrera, Fray Miguel de 308	
1903-897	Cabrera, Miguel 306	
1903-900	Mexican, unknown artist 310	
1903-901	Juarez, Juan Rodriguez 309	
1903-902	Mexican, unknown artist 312	
1903-903	Mexican, unknown artist 312	
1903-904	Arellano 306	
1903-905	Mexican, unknown artist 312	
1903-906	Herrera, Fray Miguel de 308	
1903-907	Mexican, unknown artist 316	
1903-908	Mexican, unknown artist 312	
1903-909	Mexican, unknown artist 312	
1903-910	Pérez, Diego 317	
1903-911	Mexican, unknown artist 312	
1903-912	Mexican, unknown artist 312	
1903-913	Mexican, unknown artist 313	
1903-914	Jurado, Juan José 309	
1903-915	Cabrera, Miguel, attributed to 307	
1903-916	Mexican, unknown artist 313	
1903-918	Mexican, unknown artist 313	
1903-919	Correa, Juan, the Younger 307	
1903-920	Mexican, unknown artist 309	
1903-922	Mexican, unknown artist 309	
1903-923	Correa, Juan, the Younger 307	
1903-924	Mexican, unknown artist 313	
1903-925	Mexican, unknown artist 313	
1903-926	Mexican, unknown artist 313	
1903-927	Mexican, unknown artist 314	
1903-928	Vallejo, Francisco Antonio 317	
1903-929	Mexican, unknown artist 314	
1903-930	Mexican, unknown artist 314	
1903-931	Vallejo, Francisco Antonio 317	
1903-932	López, Andreas 309	
1903-933	Cabrera, Miguel, follower of 307	
1903-934	Echave Orio, Baltasar de 308	
1903-935	Becerra, Fray Diego 306	
1903-936	Mexican, unknown artist 314	
1903-938	Cabrera, Miguel, follower of 307	
1903-939	Martínez, Francisco 309	
1903-940	Mexican, unknown artist 314	
1903-941	Mexican, unknown artist 316	
1903-942	Mexican, unknown artist 314	
1903-943	Herrera, Fray Miguel de 308	
1903-944	Mexican, unknown artist 314	
1903-946	Mexican, unknown artist 314	
W1904-1-2	Chiari, Giuseppe Bartolomeo, attributed to 187	
W1904-1-3	Carracci, Lodovico, follower of 186	
W1904-1-7	Giaquinto, Corrado, attributed to 194	
W1904-1-9	Dandini, Cesare 190	
W1904-1-10	Coignet, Gillis, copy after 47	
W1904-1-20	Dutch, unknown artist 53	
W1904-1-23	Cano, Alonso, follower of 238	
W1904-1-25	Langetti, Giovanni Battista, attributed to 210	
W1904-1-26	Rosa, Salvatore, follower of 229	
W1904-1-35	Boel, Pieter, attributed to 34	
W1904-1-38	Italian, active central Italy, unknown artist 200	
W1904-1-43	Spanish, unknown artist 244	
W1904-1-46	Solimena, Francesco, workshop of 232	
W1904-1-52	Flemish, unknown artist 57	
W1904-1-54	Seghers, Daniel, copy after 96	
W1904-1-55	Sorolla y Bastida, Joaquin 429	
W1904-1-60	Helst, Lodewyck van der, attributed to 63	
W1904-1-63	Dubordieu, Pieter 50	

E1924-4-32	Whistler, James Abbott McNeill, imitator of 304	1928-63-6	Eakins, Thomas 270	1930-50-3	Eichholtz, Jacob 279
F1925-1-1	Zurbarán, Francisco de, workshop of 246	1928-63-7	Johnson, Eastman 286	1930-54-1	Peale, Charles Willson, attributed to 292
		1928-63-8	Rosen, Charles 420		
F1925-5-1	Sargent, John Singer 295	1928-63-9	Thayer, Abbott Handerson 302	1930-67-1	Carles, Arthur Beecher 336
1925-83-1	Neagle, John 289	1928-63-11	Wyant, Alexander Helwig 305	1930-73-4	American, unknown artist 257
1925-83-2	Neagle, John 289	1928-112-1	West, Benjamin, copy after 30	1930-105-1	Eakins, Thomas 272
F1926-3-1	Reckless, Stanley L. 417	F1929-1-1	Röchling, Carl 174	1931-7-1	Picasso, Pablo Ruiz 410
F1926-3-2	Reckless, Stanley L. 417	F1929-7-205	Guillaume, Albert 366	1931-40-1	Redfield, Edward Willis 417
1926-9-1	Dodson, Sarah Paxton Ball 268	1929-48-2	American, unknown artist 477	1931-64-1	Borie, Adolphe 328
1926-9-2	Dodson, Sarah Paxton Ball 268	1929-79-1	Davies, Arthur Bowen 345	E1932-1-1	Poussin, Nicolas 151
1927-5-12	American, unknown artist 478	1929-79-2	Davies, Arthur Bowen 344	1932-8-1	Duplessis, Joseph-Siffred, attributed to 451
1927-52-37	Dutch, unknown artist 451	1929-126-14	English, unknown artist 460		
1927-52-38	Dutch, unknown artist 451	1929-126-15	Hervé, Henry 465	1932-13-1	Eakins, Thomas 277
1927-52-42	German, unknown artist 464	1929-136-148	Lapp, Jan Willemsz., follower of 69	1932-45-18	American, unknown artist 477
1927-52-192	Joffray 467	1929-184-1	Eakins, Thomas 273	1932-45-19	American, unknown artist 477
1927-52-206	French, unknown artist 463	1929-184-2	Eakins, Thomas 277	1932-45-83	Dantzig, Meyer 268
1927-52-209	European, unknown artist 460	1929-184-3	Eakins, Thomas 270	1932-45-116	Jones, H. Bolton 286
1927-52-212	French, unknown artist 462	1929-184-4	Eakins, Thomas 276	1932-45-117	Craig, Thomas Bigelow 268
1927-52-218	Giraud, D. 464	1929-184-5	Eakins, Thomas 273	1932-45-118	Waugh, Samuel Bell, follower of 304
1927-62-1	American, unknown artist 262	1929-184-6	Eakins, Thomas 278	1932-45-119	Waugh, Samuel Bell 304
M1928-1-1	Bonington, Richard Parkes, follower of 3	1929-184-7	Eakins, Thomas 277	1932-45-120	Dantzig, Meyer 268
		1929-184-8	Eakins, Thomas 269	1932-45-121	Linford, Charles 287
M1928-1-2	Constable, John 5	1929-184-9	Eakins, Thomas 269	1932-48-1	Craig, Thomas Bigelow 267
M1928-1-3	Constable, John, studio of 6	1929-184-10	Eakins, Thomas 277	1932-49-1	Tyson, Carroll Sargent, Jr. 437
M1928-1-4	Constable, John, imitator of 6	1929-184-11	Eakins, Thomas 275	1933-11-2	Wayne, Hattie 304
M1928-1-5	Cox, David 8	1929-184-12	Eakins, Thomas 275	1933-82-4	Fromentin, Eugène 137
M1928-1-6	Crome, John 8	1929-184-14	Eakins, Thomas 269	1934-10-1	Hawthorne, Charles Webster 370
M1928-1-7	Crome, John, copy after 9	1929-184-15	Eakins, Thomas 275	1935-6-1	Borie, Adolphe 328
M1928-1-8	Gainsborough, Thomas 14	1929-184-16	Eakins, Thomas 276	1935-9-1	Sully, Thomas 300
M1928-1-9	Gainsborough, Thomas 14	1929-184-17	Eakins, Thomas 276	1935-10-95	Flemish, unknown artist 56
M1928-1-10	Harlow, George Henry 15	1929-184-18	Eakins, Thomas 269	1935-10-96	Flemish, unknown artist 56
M1928-1-11	Harlow, George Henry 15	1929-184-19	Eakins, Thomas 275	1935-10-97	Flemish, unknown artist 56
M1928-1-12	Harlow, George Henry 15	1929-184-20	Eakins, Thomas 275	1935-10-98	Flemish, unknown artist 56
M1928-1-13	Hogarth, William 15	1929-184-21	Eakins, Thomas 276	1935-13-21	Birch, Thomas 480
M1928-1-14	Hogarth, William 16	1929-184-22	Eakins, Thomas 275	1935-13-22	Birch, Thomas 480
M1928-1-15	Hoppner, John, imitator of 16	1929-184-23	Eakins, Thomas 277	1935-13-24	American, unknown artist 255
M1928-1-16	Lawrence, Sir Thomas 18	1929-184-24	Eakins, Thomas 272	1935-13-25	American, unknown artist 255
M1928-1-17	Linnell, John 19	1929-184-25	Eakins, Thomas 270	1935-13-26	American, unknown artist 259
M1928-1-18	Morland, George 20	1929-184-27	Eakins, Thomas 271	1935-13-33	American, unknown artist 478
M1928-1-19	Morland, George 19	1929-184-28	Eakins, Thomas 270	1935-13-34	American, unknown artist 477
M1928-1-20	Morland, George 20	1929-184-29	Eakins, Thomas 279	1935-13-46	American, unknown artist 478
M1928-1-21	Raeburn, Sir Henry 21	1929-184-30	Eakins, Thomas 275	1935-13-47	French, unknown artist 463
M1928-1-22	Raeburn, Sir Henry 22	1929-184-31	Eakins, Thomas 270	1935-14-2	Italian, unknown artist 466
M1928-1-23	Raeburn, Sir Henry 22	1929-184-32	Eakins, Thomas 273	1935-17-1	English, unknown artist 457
M1928-1-24	Raeburn, Sir Henry 22	1929-184-33	Eakins, Thomas 272	1935-17-2	English, unknown artist 457
M1928-1-25	Raeburn, Sir Henry 21	1929-184-34	Eakins, Thomas 272	1935-17-3	English, unknown artist 457
M1928-1-26	Raeburn, Sir Henry 22	1929-184-35	Eakins, Thomas 270	1935-17-4	English, unknown artist 458
M1928-1-27	Raeburn, Sir Henry 22	1929-184-36	Eakins, Thomas 276	1935-17-5	English, unknown artist 457
M1928-1-28	Raeburn, Sir Henry, follower of 23	1930-7-1	Inness, George 285	1935-17-6	English, unknown artist 454
M1928-1-29	Reynolds, Sir Joshua 23	1930-32-3	Eakins, Thomas 274	1935-17-7	English, unknown artist 459
M1928-1-30	Reynolds, Sir Joshua, follower of 23	1930-32-4a	Eakins, Thomas 272	1935-17-8	English, unknown artist 457
M1928-1-31	Romney, George 26	1930-32-4b	Eakins, Thomas 272	1935-17-9	English, unknown artist 456
M1928-1-32	Romney, George 25	1930-32-5	Eakins, Thomas 269	1935-17-10	English, unknown artist 459
M1928-1-33	Romney, George 25	1930-32-6	Eakins, Thomas 270	1935-17-11	English, unknown artist 459
M1928-1-34	Romney, George 25	1930-32-7a	Eakins, Thomas 273	1935-17-12	English, unknown artist 458
M1928-1-35	Romney, George 25	1930-32-7b	Eakins, Thomas 273	1935-17-13	English, unknown artist 456
M1928-1-36	Romney, George 24	1930-32-8	Eakins, Thomas 274	1935-17-14	English, unknown artist 455
M1928-1-37	Romney, George 25	1930-32-9	Eakins, Thomas 278	1935-17-15	English, unknown artist 458
M1928-1-38	Romney, George 24	1930-32-10	Eakins, Thomas 271	1935-17-16	English, unknown artist 456
M1928-1-39	Stark, James 26	1930-32-11a	Eakins, Thomas 271	1935-17-17	English, unknown artist 456
M1928-1-40	Stubbs, George 27	1930-32-11b	Eakins, Thomas 271	1935-17-18	English, unknown artist 454
M1928-1-41	Turner, Joseph Mallord William 28	1930-32-12	Eakins, Thomas 274	1935-17-19	English, unknown artist 454
M1928-1-42	Gordon, Sir John Watson 15	1930-32-13	Eakins, Thomas 274	1935-17-20	English, unknown artist 454
M1928-1-43	Wilson, Richard 30	1930-32-14	Eakins, Thomas 278	1935-17-21	English, unknown artist 454
1928-7-121	Sully, Thomas, follower of 302	1930-32-15a	Eakins, Thomas 278	1935-17-22	English, unknown artist 454
1928-37-1	Redfield, Edward Willis 417	1930-32-15b	Eakins, Thomas 278	1935-17-23	English, unknown artist 459
1928-63-1	Alexander, John White 320	1930-32-16	Eakins, Thomas 276	1935-28-1	West, Benjamin, copy after 30
1928-63-2	Blakelock, Ralph A. 264	1930-32-17	Eakins, Thomas 271	1935-46-1	Watkins, Franklin Chenault 441
1928-63-3	Cassatt, Mary Stevenson 266	1930-32-18a	Eakins, Thomas 271	1936-1-1	Anshutz, Thomas Pollock 263
1928-63-4	Chase, William Merritt 266	1930-32-18b	Eakins, Thomas 271	E1936-1-1	Cézanne, Paul 115
1928-63-5	Dougherty, Paul 349	1930-46-16	American, unknown artist 475	1936-1-2	Chase, William Merritt 266
		1930-50-2	Eichholtz, Jacob 279	1936-1-3	Perot, Annie Lovering 293

1936-6-1	English, unknown artist 455	
1936-6-2	English, unknown artist 456	
1936-6-3	English, unknown artist 456	
1936-6-4	English, unknown artist 456	
1936-6-5	English, unknown artist 455	
1936-6-6	English, unknown artist 458	
1936-6-7	English, unknown artist 459	
1936-6-8	English, unknown artist 455	
1936-6-9	English, unknown artist 459	
1936-6-10	English, unknown artist 458	
1936-6-11	English, unknown artist 458	
1936-6-12	English, unknown artist 457	
1936-6-13	English, unknown artist 458	
1936-6-14	English, unknown artist 455	
1936-6-15	English, unknown artist 459	
1936-10-1	Sully, Thomas 300	
1936-17-1	Paxton, William McGregor 290	
1936-22-9	Stuart, Gilbert, copy after 500	
1936-22-10	Stuart, Gilbert, copy after 500	
1936-22-12	Stuart, Gilbert, copy after 500	
1936-26-1	Soutman, Pieter Claesz., attributed to 97	
1936-35-1	Breckenridge, Hugh Henry 331	
1936-50-1	Cooper, Colin Campbell 267	
1936-50-2	Cooper, Colin Campbell 267	
W1937-1-1	Cézanne, Paul 115	
W1937-2-1	Degas, Hilaire-Germain-Edgar 128	
1937-14-1	Peale, Anna Claypoole 495	
1937-18-1	Hamilton, John McLure 366	
1937-31-1	Torres-Garcia, Joaquin 435	
F1938-1-1	French, unknown artist 135	
F1938-1-2	Pignoni, Simone 226	
F1938-1-3	Lely, Sir Peter 18	
F1938-1-4	Italian, unknown artist 208	
F1938-1-5	European, unknown artist 248	
F1938-1-6	Italian, active Bologna, unknown artist 207	
F1938-1-7	Italian, unknown artist 207	
F1938-1-8	Flemish, unknown artist 57	
F1938-1-9	Italian, active Bologna, unknown artist 205	
F1938-1-10	Tosini, Michele, follower of 235	
F1938-1-11	Italian, active Florence, unknown artist 206	
F1938-1-12	French, unknown artist 135	
F1938-1-13	Wilson, Richard, follower of 31	
F1938-1-14	Italian, unknown artist 206	
F1938-1-15	Italian, active Florence, unknown artist 206	
F1938-1-16	Strozzi, Bernardo 232	
F1938-1-17	Italian, unknown artist 206	
F1938-1-18	Italian, active Bologna, unknown artist 206	
F1938-1-19	Cigoli, copy after 187	
F1938-1-20	Diaz de la Peña, Narcisse-Virgile 130	
F1938-1-21	Italian, active Siena, unknown artist 204	
F1938-1-22	Teniers, David, II, follower of 101	
F1938-1-23	Cecco Bravo, attributed to 186	
F1938-1-24	Italian?, unknown artist 208	
F1938-1-25	Casteels, Pieter, II, imitator of 42	
F1938-1-26	Veronese, Paolo, copy after 236	
F1938-1-27	Richards, William Trost 295	
F1938-1-28	Moucheron, Isaac de, imitator of 78	
F1938-1-29	Italian, active Florence, unknown artist 206	
F1938-1-30	Italian, unknown artist 205	
F1938-1-31	Diaz de la Peña, Narcisse-Virgile 130	
F1938-1-32	Cecco Bravo 186	
F1938-1-33	Italian, unknown artist 205	
F1938-1-34	Caravaggio, copy after 186	
F1938-1-35	Spranger, Bartholomeus, follower of 97	

F1938-1-36	Italian, active Verona?, unknown artist 207	
F1938-1-37	European, unknown artist 248	
F1938-1-38	Italian, unknown artist 207	
F1938-1-39	Frediani, Vincenzo di Antonio 193	
F1938-1-40	Pignoni, Simone, follower of 226	
F1938-1-41	Bassano, Leandro, follower of 179	
F1938-1-42	Italian, unknown artist 207	
F1938-1-43	Beccafumi, Domenico, follower of 179	
F1938-1-44	Italian, unknown artist 207	
F1938-1-45	Reni, Guido, copy after 228	
F1938-1-46	Reschi, Pandolfo 228	
F1938-1-47	Italian, unknown artist 207	
F1938-1-48	Richards, William Trost 294	
F1938-1-49	Pignoni, Simone, follower of 226	
F1938-1-51	Italian, unknown artist 209	
F1938-1-117	Herzog, Hermann 283	
1938-2-1	American, unknown artist 475	
1938-4-1	Peale, James 497	
1938-8-1	Sully, Thomas 299	
1938-11-1	West, Benjamin, copy after 30	
1938-14-1	Hamilton, John McLure 366	
1938-22-1	Murphy, John Francis 288	
1938-22-3	Lawson, Ernest 385	
1938-22-4	Wyant, Alexander Helwig 305	
1938-22-5	Lathrop, William Langson 384	
1938-22-6	Sartain, William 296	
1938-22-7	Jongkind, Johan Barthold, attributed to 66	
1938-22-8	Jongkind, Johan Barthold 66	
1938-22-9	Inness, George 285	
1938-22-10	Robinson, Théodore 295	
1938-25-1	Lambdin, James Reid 287	
1938-29-1	Miles, Edward 468	
1938-29-2	Miles, Edward 468	
1938-29-3	Miles, Edward 469	
1938-29-4	Miles, Edward 469	
1938-29-5	Miles, Edward 469	
1938-29-6	English, unknown artist 453	
1938-29-7	English, unknown artist 457	
1938-29-8	Miles, Edward 470	
1938-29-9	Miles, Edward 469	
1938-29-10	Miles, Edward 469	
1938-29-11	Miles, Edward 468	
1938-29-12	Miles, Edward 468	
1938-29-13	Miles, Edward 469	
1938-29-14	Miles, Edward 469	
1938-29-15	Miles, Edward 469	
1938-29-16	Miles, Edward 470	
1938-29-17	Miles, Edward 468	
1938-38-1	Rousseau, Henri-Julien-Félix 422	
1939-3-1	Tucker, Allen 435	
1939-7-16	Hawthorne, Charles Webster 371	
1939-7-17	Turner, Helen Maria 435	
1939-7-18	Schofield, Walter Elmer 425	
1939-11-1	Eakins, Susan MacDowell 269	
1939-12-1	Wagner, Frederick 440	
1939-53-1	Horter, Earl 372	
1940-10-1	Cushman, George Hewitt 487	
1940-10-2	Cushman, George Hewitt 487	
1940-17-27	Zuloaga y Zabaleta, Ignacio 445	
1940-18-1	Garber, Daniel 359	
1940-46-1	Henri, Pierre 464	
1941-2-1	Pippin, Horace 412	
1941-22-1	Borie, Adolphe 328	
1941-78-1	Inman, Henry 284	
1941-79-1	Russian, unknown artist 423	
1941-79-2	Russian, unknown artist 423	
1941-79-3	Burliuk, David Davidovich 333	
1941-79-4	Palmov, Viktor Nikandrovich 407	
1941-79-29	Grigoriev, Boris Dmitryevich 363	
1941-79-38	Burliuk, David Davidovich 333	

1941-79-47	Burliuk, David Davidovich 332	
1941-79-48	Burliuk, David Davidovich 333	
1941-79-66	Graham, John D. 363	
1941-79-67	Roerich, Nicholas Konstantinovich 420	
1941-79-68	Grigoriev, Boris Dmitryevich 363	
1941-79-69	Burliuk, David Davidovich 333	
1941-79-70	Campendonk, Heinrich 334	
1941-79-71	Roerich, Nicholas Konstantinovich 419	
1941-79-74	Chanler, Robert Winthrop 340	
1941-79-76	Burliuk, David Davidovich 332	
1941-79-77	Archipenko, Gela Forster 321	
1941-79-79	Vasilieff, Nicholas 438	
1941-79-80	Chernoff, Vadim Anatolievich 340	
1941-79-81	Melchers, Julius Gari 394	
1941-79-82	Burliuk, David Davidovich 333	
1941-79-89	Burliuk, David Davidovich 333	
1941-79-94	Burliuk, David Davidovich 333	
1941-79-95	Burliuk, David Davidovich 332	
1941-79-98	Manievich, Abraham Anshelovich 390	
1941-79-99	Grigoriev, Boris Dmitryevich 363	
1941-79-100	Jacovleff, Alexander 374	
1941-79-101	Kádár, Béla 377	
1941-79-102	Hausch, Aleksandr F. 370	
1941-79-103	Kádár, Béla 376	
1941-79-105	Kádár, Béla 376	
1941-79-106	Burliuk, David Davidovich 333	
1941-79-107	Cickowsky, Nikolai Stepanovich 342	
1941-79-108	Cickowsky, Nikolai Stepanovich 341	
1941-79-109	Vasilieff, Nicholas 438	
1941-79-110	Vasilieff, Nicholas 438	
1941-79-111	Schattenstein, Nikol Ovseyvich 424	
1941-79-112	Burliuk, David Davidovich 332	
1941-79-113	Vasilieff, Nicholas 438	
1941-79-115	Palmov, Viktor Nikandrovich 407	
1941-79-116	Cickowsky, Nikolai Stepanovich 341	
1941-79-117	Vasilieff, Nicholas 438	
1941-79-119	Archipenko, Alexander Porfirevich 321	
1941-79-120	Grigoriev, Boris Dmitryevich 363	
1941-79-138	Kádár, Béla 377	
1941-79-139	Pippin, Horace 412	
1941-79-144	Anisfeld, Boris 320	
1941-79-147	Grigoriev, Boris Dmitryevich 364	
1941-79-148	Roerich, Svyatoslav Nikolaievich 420	
1941-79-149	Cickowsky, Nikolai Stepanovich 341	
1941-79-150	Grigoriev, Boris Dmitryevich 363	
1941-79-151	Sprinchorn, Carl 431	
1941-79-153	Russian, unknown artist 250	
1941-79-335	Schattenstein, Nikol Ovseyvich 425	
1941-79-336	Lund, Henrik 389	
1941-99-19	Hamilton, John McLure 366	
1941-103-1	Blume, Peter 327	
1941-103-2	Dickinson, Preston 348	
1941-103-3	Sloan, John 428	
1941-103-4	Carles, Arthur Beecher 337	
1941-103-5	Carles, Arthur Beecher 337	
1942-1-1	Biddle, George 325	
1942-14-1	Kelly, Leon 380	
1942-15-1	Maurer, Alfred Henry 394	
1942-17-1	Watkins, Franklin Chenault 441	
1942-31-1	Sully, Thomas 301	
1942-31-2	Sully, Thomas 301	
1942-31-3	Sully, Thomas 301	
1942-37-2	Sully, Thomas 300	
1942-37-3	American, unknown artist 478	
1942-37-5	Collas, Louis-Antoine 449	
1942-45-1	McCarter, Henry 389	
1942-60-1	Hovenden, Thomas 284	
1942-60-2	Israëls, Jozef 65	

1942-64-1	Biddle, George 325	1944-5-1	Watkins, Franklin Chenault 441	1945-25-120d	Martino di Bartolomeo 215
1942-64-2	Kelly, Leon 379	1944-9-1	Morland, George 19	1945-25-121	Giovanni di Paolo 195
1942-64-3	Gorky, Arshile 362	1944-9-2	Patinir, Joachim, workshop of 87	1945-25-122	Giovanni di Paolo 196
1942-65-1	Karp, Leon 378	1944-9-3	Nattier, Jean-Marc, studio of 149	1945-25-124	Weyden, Rogier van der, copy after 106
1942-66-1	Coleman, Glenn O. 342	1944-9-4	Maes, Nicolaes 70	1945-25-261a	Spanish, unknown artist 474
1942-87-1	Watkins, Franklin Chenault 441	1944-9-5	Wit, Jacob de 107	1945-25-261b	Spanish, unknown artist 474
1942-90-1	Sauvage, Piat-Joseph, attributed to 96	1944-9-6	Wit, Jacob de 107	1945-25-263	Spanish, unknown artist 244
1942-90-2	Sauvage, Piat-Joseph, attributed to 95	1944-9-9	Rubens, Peter Paul 91	1945-25-264	Italian, active Milan, unknown artist 204
1942-101-21	Rowlandson, Thomas, attributed to 472	1944-12-1	Laurencin, Marie 384	1945-33-1	Eakins, Thomas 277
1942-101-22	Bigot, Andrée 448	1944-12-3	Vlaminck, Maurice de 439	1945-33-2	Eakins, Thomas 277
1942-101-23	Kauffmann, Angelica 467	1944-13-1	Blashfield, Edwin Howland 264	1945-37-1	Galván, Jesús Guerrero 359
1942-101-24	Hoppner, John, attributed to 465	1944-13-2	Brush, George de Forest 265	1945-38-1	Butler, Mary 334
1942-101-25	European, unknown artist 460	1944-13-3	Lathrop, William Langson 384	1945-39-1	Van Loan, Dorothy 438
1942-101-26	Buncombe, John 449	1944-13-4a	Lawson, Ernest 385	1945-40-2	Marcoussis, Louis 390
1942-101-27a	French, unknown artist 462	1944-13-4b	Lawson, Ernest 385	1945-57-191	Garber, Daniel 360
1942-101-27b	French, unknown artist 462	1944-13-5	Martin, Homer D. 287	1945-57-196	Garber, Daniel 360
1942-101-28a	French?, unknown artist 463	1944-13-6	Tarbell, Edmund Charles 302	1945-64-1	English, unknown artist 460
1942-101-28b	French?, unknown artist 463	1944-36-1	Chagall, Marc 339	1945-69-1	Malherbe, William 390
1942-101-29	European, unknown artist 461	1944-44-2	McCarter, Henry 389	1945-69-2	Malherbe, William 390
1942-101-30	French, unknown artist 462	1944-44-3	McCarter, Henry 389	1945-83-2	Goldthwaite, Anne Wilson 362
1942-101-31a	Plimer, Andrew 471	1944-47-1	Peale, James 496	1945-84-1	Siqueiros, David Alfaro 428
1942-101-31b	Plimer, Andrew 471	1944-58-1	American, unknown artist 478	1945-85-1	Berman, Eugène 324
1942-101-32	Beetham, Isabella Robinson, attributed to 448	1944-77-1	Otis, Bass 289	1945-91-1	Hélion, Jean 371
1942-101-33	English, unknown artist 454	1944-85-1	Loper, Edward 388	1945-91-2	Hélion, Jean 371
1942-101-34	Beetham, Isabella Robinson, attributed to 448	1944-87-1	Siqueiros, David Alfaro 427	1945-91-3	Hélion, Jean 371
1942-101-35	English, unknown artist 454	1944-88-1	Matisse, Henri 393	1945-91-4	Nicholson, Ben 402
1942-101-36	English, unknown artist 459	1944-90-1	Ray, Man 416	1946-5-1	Melchers, Julius Gari 394
1942-101-37	Readhead, H. 471	1944-94-1	Jacovleff, Alexander 374	1946-5-2	Metcalf, Willard Leroy 395
1942-101-38	Field, John 461	1944-95-1	Criss, Francis H. 343	1946-5-3	Twachtman, John Henry 303
1942-102-1	Cassatt, Mary Stevenson 266	1944-95-2	Hartley, Marsden 368	1946-5-4	Tyson, Carroll Sargent, Jr. 437
1943-5-1	Hartley, Marsden 369	1944-95-4	O'Keeffe, Georgia 403	1946-5-5	Wiggins, Guy Carleton 443
1943-40-38	Vries, Roelof van 105	1944-96-1	Eilshemius, Louis Michel 354	1946-10-1	Sloan, John 428
1943-40-39	Eakins, Thomas 273	E1945-1-1	Peale, Charles Willson 291	1946-10-2	Sloan, John 428
1943-40-40	Reynolds, Sir Joshua 23	1945-2-1	Tamayo, Rufino 434	1946-13-1	Avery, Milton 322
1943-40-41	Keyser, Thomas de, follower of 68	1945-5-1	Inness, George 284	1946-19-1	Eakins, Thomas 271
1943-40-42	Mostaert, Jan, follower of 78	1945-5-2	Tryon, Dwight W. 303	1946-36-1	Dance, Nathaniel 9
1943-40-43	Rubens, Peter Paul, follower of 92	1945-13-57	Pillement, Jean 150	1946-36-2	Canaletto, copy after 185
1943-40-44	Schongauer, Ludwig, attributed to 174	1945-13-58	Pillement, Jean 150	1946-36-3	Canaletto, copy after 185
1943-40-45	Toscani, Giovanni 234	1945-13-59	Pillement, Jean 150	1946-36-5	Noël, Alexandre-Jean 149
1943-40-48	Inness, George 285	1945-14-1	Mauny, Jacques 394	1946-36-6	Noël, Alexandre-Jean 149
1943-40-49	Hogarth, William, copy after 16	1945-15-1	Ritman, Louis 419	1946-40-1	Lutz, Dan 389
1943-40-51	Master of the Pesaro Crucifix 217	1945-16-36	Bouche, Louis 329	1946-46-1	Baylinson, Abraham S. 323
1943-40-52	Corot, Jean-Baptiste-Camille 118	1945-16-37	Canadé, Vincent 334	1946-50-2	du Bois, Guy Pène 350
1943-40-53	Bartolomeo di Giovanni 178	1945-16-38	Kisling, Moïse 380	1946-50-3	du Bois, Guy Pène 350
1943-40-54	Borie, Adolphe 328	1945-16-39	Zorach, Marguerite Thompson 445	1946-50-4	Oudot, Roland 407
1943-40-55	Courbet, Gustave, attributed to 123	1945-25-117	Coecke van Aelst, Pieter, follower of 44, 45	1946-70-2	Reinhardt, Ad 417
1943-42-1	Ferguson, William H. 357			1946-70-5	Roux, Gaston-Louis 423
1943-42-2	Ferguson, William H. 357	1945-25-117a	Coecke van Aelst, Pieter, follower of 44	1946-70-7	Bolotowsky, Ilya 327
1943-43-1	Baum, Walter Emerson 323	1945-25-117b	Coecke van Aelst, Pieter, follower of 44	1946-70-14	Morris, George Lovett Kingsland 399
1943-44-1	Cantú, Federico 335	1945-25-117c	Coecke van Aelst, Pieter, follower of 44	1946-70-15	Morris, George Lovett Kingsland 399
1943-45-1	Castellanos, Julio 338	1945-25-117d	Coecke van Aelst, Pieter, follower of 44	1946-70-17	Ray, Man 416
1943-46-1	Rivera, José Diego Maria 419	1945-25-117e	Coecke van Aelst, Pieter, follower of 44	1946-70-18	Shaw, Charles Green 426
1943-46-2	Rivera, José Diego Maria 419	1945-25-117f	Coecke van Aelst, Pieter, follower of 45	1946-70-19	Slobodkina, Esphyr 428
1943-50-1	English, unknown artist 12	1945-25-117g	Coecke van Aelst, Pieter, follower of 45	1946-70-20	Shaw, Charles Green 427
1943-51-101	Pannini, Giovanni Paolo, imitator of 224	1945-25-117h	Coecke van Aelst, Pieter, follower of 45	1946-73-1	Fussell, Charles Lewis 280
1943-53-1	Sully, Thomas 299	1945-25-117i	Coecke van Aelst, Pieter, follower of 45	1946-77-1	Eakins, Thomas 278
1943-72-1	Watkins, Franklin Chenault 441	1945-25-117j	Coecke van Aelst, Pieter, follower of 45	1946-88-1	Beechey, Sir William 2
1943-74-1	Frieseke, Frederick Carl 359	1945-25-117k	Coecke van Aelst, Pieter, follower of 45	1947-24-1	Soriano, Juan 429
1943-74-2	Dewing, Thomas Wilmer 268	1945-25-117l	Coecke van Aelst, Pieter, follower of 45	1947-29-1	Castellanos, Julio 338
1943-74-3	Harrison, Lowell Birge 282	1945-25-117m	Coecke van Aelst, Pieter, follower of 46	1947-29-2	Martínez de Hoyos, Ricardo 391
1943-74-4	Harnett, William Michael 281	1945-25-117n	Coecke van Aelst, Pieter, follower of 46	1947-29-3	Soriano, Juan 429
1943-74-5	Harnett, William Michael 281	1945-25-117o	Coecke van Aelst, Pieter, follower of 46	1947-30-1	Chavez-Morado, José 340
1943-74-6	Harnett, William Michael 281	1945-25-117p	Coecke van Aelst, Pieter, follower of 46	1947-31-1	Hinchman, Margaretta S. 372
1943-85-1	Inness, George 285	1945-25-117q	Coecke van Aelst, Pieter, follower of 46	1947-32-1	Bloch, Julius T. 326
1943-90-1	Sully, Thomas 300	1945-25-117r	Coecke van Aelst, Pieter, follower of 46	1947-33-1	Stuempfig, Walter, Jr. 432
1943-101-1	Soutine, Chaim 430	1945-25-117s	Coecke van Aelst, Pieter, follower of 46	1947-64-1	Bigg, William Redmore 3
1944-1-1	Jarvis, John Wesley 286	1945-25-118	Italian, active central Italy?, unknown artist 200	1947-81-1	Sartain, William 296
				1947-86-1	Dupuis, Pierre 132
		1945-25-119	Tommaso del Mazza 234	1947-88-14	Chirico, Giorgio de 341
		1945-25-120a	Martino di Bartolomeo 214	1947-96-1a	Eakins, Thomas 273
		1945-25-120b	Martino di Bartolomeo 214	1947-96-1b	Eakins, Thomas 273
		1945-25-120c	Martino di Bartolomeo 215	1947-96-2a	Eakins, Thomas 274

1947-96-2b	Eakins, Thomas 274	
1947-96-3	Eakins, Thomas 270	
1947-99-1	Morland, George 19	
1947-100-1	Opie, John 21	
1947-100-2	Opie, John 21	
1947-100-3	Russell, William 26	
1948-11-1	Meza, Guillermo 396	
1948-27-1	Meulen, Adam Frans van der, studio of 145	
1948-53-1	Canadé, Vincent 334	
1948-95-1	Reynolds, Sir Joshua 23	
1948-95-2	Bol, Ferdinand, copy after 34	
1949-16-1	Drexel, Francis Martin 268	
1949-18-1	Dove, Arthur Garfield 349	
1949-18-2	Dove, Arthur Garfield 349	
1949-18-3	Dove, Arthur Garfield 349	
1949-18-4	Hartley, Marsden 369	
1949-18-5	Hartley, Marsden 369	
1949-18-6	Hartley, Marsden 368	
1949-18-7	Hartley, Marsden 368	
1949-18-8	Hartley, Marsden 368	
1949-18-9	Hartley, Marsden 368	
1949-18-10	Hartley, Marsden 369	
1949-18-11	Hartley, Marsden 369	
1949-18-12	Hartley, Marsden 369	
1949-18-13	Hartley, Marsden 368	
1949-18-109	O'Keeffe, Georgia 404	
1949-22-1	Glarner, Fritz 361	
1949-24-1	Ruiz, Antonio 423	
1949-30-1	Dr. Atl 322	
1949-33-1	Bérard, Marius-Honoré 324	
1949-33-2	Bérard, Marius-Honoré 324	
1949-40-1a	Italian, active northern Italy?, unknown artist 466	
1949-40-1b	Italian, active northern Italy?, unknown artist 466	
1949-53-1	Benbridge, Henry 263	
1949-54-1	Sully, Thomas 299	
1949-56-1	Velasco, José Maria 317	
1949-57-1	O'Keeffe, Georgia 404	
1949-73-1	American, unknown artist 259	
1950-1-1	Picasso, Pablo Ruiz 410	
W1950-1-1	Corot, Jean-Baptiste-Camille 117	
W1950-1-2	Delacroix, Ferdinand-Victor-Eugène 129	
E1950-2-1	Gellée, Claude 138	
E1950-2-2	Master of the Processions 144	
W1950-3-1	Rubens, Peter Paul, and Frans Snyders 91	
1950-5-1	Ault, George C. 322	
1950-6-1	Delacroix, Ferdinand-Victor-Eugène 129	
1950-13-1	Ord, Joseph Biays 289	
1950-27-1	Braque, Georges 330	
1950-40-1	Carles, Arthur Beecher 336	
1950-43-2	Menkès, Sigmund 395	
1950-51-1	Peale, James 292	
1950-52-1	Cassatt, Mary Stevenson 265	
1950-63-1	Léger, Fernand 387	
1950-86-1	Bronzino, Agnolo 183	
1950-92-1	Bonnard, Pierre 328	
1950-92-2	Boudin, Eugène-Louis 111	
1950-92-4	Crowell, Lucius 343	
1950-92-5	Heade, Martin Johnson 283	
1950-92-7	Hicks, Edward 283	
1950-92-8	Lawrence, Sir Thomas, copy after 18	
1950-92-9	Matisse, Henri 393	
1950-92-10	Morisot, Berthe-Marie-Pauline 149	
1950-92-11	Picasso, Pablo Ruiz 409	
1950-92-12	Pissarro, Camille 151	
1950-92-16	Dunoyer de Segonzac, André 353	
1950-92-17	Serisawa, Sueo 426	
1950-92-18	Stuempfig, Walter, Jr. 432	
1950-92-19	Stuempfig, Walter, Jr. 433	
1950-92-20	Stuempfig, Walter, Jr. 433	
1950-92-22	Gogh, Vincent Willem van 59	
1950-92-23	American, unknown artist 254	
1950-92-32	Stuempfig, Walter, Jr. 433	
1950-92-231	American, unknown artist 259	
1950-92-232	American, unknown artist 260	
1950-92-285	European, unknown artist 248	
1950-92-286	European, unknown artist 248	
1950-121-1	Verbrugghen, Gaspar Peeter, II, imitator of 103	
1950-121-2	Verbrugghen, Gaspar Peeter, II, imitator of 103	
1950-121-3	Verbrugghen, Gaspar Peeter, II, imitator of 103	
1950-121-4	Verbrugghen, Gaspar Peeter, II, imitator of 103	
1950-134-1	Archipenko, Alexander Porfirevich 321	
1950-134-25	Braque, Georges 330	
1950-134-26	Braque, Georges 330	
1950-134-29a	Braque, Georges 330	
1950-134-29b	Braque, Georges 330	
1950-134-30	Braque, Georges 330	
1950-134-32	Cézanne, Paul 113	
1950-134-34	Cézanne, Paul 114	
1950-134-36	Chagall, Marc 338	
1950-134-38	Chirico, Giorgio de 341	
1950-134-39	Chirico, Giorgio de 341	
1950-134-40	Dalí, Salvador 344	
1950-134-41	Dalí, Salvador 344	
1950-134-42a	Delaunay, Robert 346	
1950-134-42b	Delaunay, Robert 346	
1950-134-43a	Delaunay, Robert 347	
1950-134-43b	Delaunay, Robert 347	
1950-134-47	Derain, André 347	
1950-134-48	Duchamp, Marcel 350	
1950-134-49	Duchamp, Marcel 350	
1950-134-50	Duchamp, Marcel 351	
1950-134-51	Duchamp, Marcel 351	
1950-134-52	Duchamp, Marcel 351	
1950-134-53	Duchamp, Marcel 351	
1950-134-54	Duchamp, Marcel 351	
1950-134-56	Duchamp, Marcel 351	
1950-134-58	Duchamp, Marcel 352	
1950-134-59	Duchamp, Marcel 352	
1950-134-63a	Duchamp, Marcel 352	
1950-134-63b	Duchamp, Marcel 351	
1950-134-65	Duchamp, Marcel 352	
1950-134-68	Duchamp, Marcel 352	
1950-134-69	Duchamp, Marcel 352	
1950-134-70	Duchamp, Marcel 352	
1950-134-73	Duchamp, Marcel 353	
1950-134-80	Duchamp, Marcel 350	
1950-134-81	Duchamp, Marcel 350	
1950-134-82	Duchamp, Marcel 351	
1950-134-85	Ernst, Max 355	
1950-134-86	Ernst, Max 356	
1950-134-87	Ernst, Max 356	
1950-134-88	Feininger, Lyonel 357	
1950-134-89	La Fresnaye, Roger de 383	
1950-134-90	La Fresnaye, Roger de 383	
1950-134-91	Gleizes, Albert 361	
1950-134-93	Gleizes, Albert 361	
1950-134-94	Gris, Juan 364	
1950-134-95	Gris, Juan 364	
1950-134-96	Gris, Juan 364	
1950-134-97	Gris, Juan 364	
1950-134-98	Gris, Juan 365	
1950-134-99	Hélion, Jean 371	
1950-134-100a	Jawlensky, Alexey von 375	

1950-134-100b	Jawlensky, Alexey von 375	
1950-134-101	Jawlensky, Alexey von 375	
1950-134-102	Kandinsky, Wassily 377	
1950-134-103	Kandinsky, Wassily 377	
1950-134-104	Kandinsky, Wassily 377	
1950-134-109	Klee, Paul 381	
1950-134-112	Klee, Paul 381	
1950-134-113	Klee, Paul 381	
1950-134-115	Klee, Paul 381	
1950-134-118	Klee, Paul 381	
1950-134-121	Klee, Paul 381	
1950-134-122	Kupka, Frank 383	
1950-134-123	Léger, Fernand 386	
1950-134-124	Léger, Fernand 386	
1950-134-125	Léger, Fernand 386	
1950-134-126	Léger, Fernand 386	
1950-134-127	Magritte, René 389	
1950-134-130	Matisse, Henri 392	
1950-134-134	Merida, Carlos 395	
1950-134-138	Metzinger, Jean 395	
1950-134-139	Metzinger, Jean 395	
1950-134-140	Metzinger, Jean 395	
1950-134-141	Miró, Joan 397	
1950-134-142	Miró, Joan 397	
1950-134-143	Miró, Joan 397	
1950-134-144	Miró, Joan 398	
1950-134-149	Miró, Joan 398	
1950-134-151	Mondrian, Piet 398	
1950-134-152	Mondrian, Piet 399	
1950-134-153	Montenegro, Roberto 399	
1950-134-155	Picabia, Francis 409	
1950-134-156	Picabia, Francis 409	
1950-134-157	Picabia, Francis 409	
1950-134-158	Picasso, Pablo Ruiz 409	
1950-134-164	Picasso, Pablo Ruiz 410	
1950-134-166	Picasso, Pablo Ruiz 410	
1950-134-168	Picasso, Pablo Ruiz 410	
1950-134-169	Picasso, Pablo Ruiz 410	
1950-134-170	Picasso, Pablo Ruiz 411	
1950-134-173	Renoir, Pierre-Auguste 154	
1950-134-174	Rouault, Georges 421	
1950-134-175	Rousseau, Henri-Julien-Félix 422	
1950-134-176	Rousseau, Henri-Julien-Félix 422	
1950-134-177	Rousseau, Henri-Julien-Félix 422	
1950-134-178	Rousseau, Henri-Julien-Félix 423	
1950-134-179	Roy, Pierre 423	
1950-134-180a	Schamberg, Morton Livingston 424	
1950-134-180b	Schamberg, Morton Livingston 424	
1950-134-181	Schamberg, Morton Livingston 424	
1950-134-186	Sheeler, Charles 427	
1950-134-187	Tanguy, Yves 434	
1950-134-188	Tanguy, Yves 434	
1950-134-189	Villon, Jacques 439	
1950-134-190	Villon, Jacques 439	
1950-134-191	Villon, Jacques 439	
1950-134-192	Greek, active Crete, unknown artist 248	
1950-134-193	Palma il Giovane, attributed to 223	
1950-134-194	Greek, unknown artist 248	
1950-134-195	Italian?, active Adriatic coast, unknown artist 200	
1950-134-196	American, unknown artist 254	
1950-134-198	American, unknown artist 254	
1950-134-492	Mexican, unknown artist 315	
1950-134-493	Mexican, unknown artist 395	
1950-134-504	Ara 321	
1950-134-505	Ara 321	
1950-134-506	Ara 321	
1950-134-507	Bouche, Louis 329	
1950-134-508	Duchamp, Marcel 350	
1950-134-509	Covert, John R. 343	
1950-134-510	Eilshemius, Louis Michel 354	
1950-134-511	Jawlensky, Alexey von 375	

Accession No.	Entry
1954-42-42	Fisher, Howell Tracy 489
1954-42-43	Gilpin, Blanche R. 489
1954-42-44	Graham, Elizabeth Sutherland 489
1954-42-45	Harris, Alexandrina Robertson 490
1954-42-46	Harris, Alexandrina Robertson 490
1954-42-47	Harrison, Catherine Norris 490
1954-42-48	Harrison, Catherine Norris 490
1954-42-49	Hays, Gertrude V. 490
1954-42-50	Hildebrandt, Cornelia Trumbull Ellis 490
1954-42-51	Hills, Laura Coombs 491
1954-42-52	Huey, Florence Greene 491
1954-42-53	Irvin, Virginia Hendrickson 491
1954-42-54	Jackson, Annie Hurlburt 491
1954-42-55	Jackson, Nathalie L'Hommedieu 492
1954-42-56	Johnson, Harry L. 492
1954-42-57	Johnson, Harry L. 492
1954-42-58	Kellett, Edith 492
1954-42-59	King, Angelica 492
1954-42-60	Knowles, Elizabeth A. McGillivray 492
1954-42-61	Little, Gertrude L. 492
1954-42-62	Longacre, Lydia Eastwick 493
1954-42-63	Lugano, Ines Somenzini 493
1954-42-64	Lynch, Anna 493
1954-42-65	McMillan, Mary 493
1954-42-66	Melcher, Betsy Flagg 494
1954-42-67	Murray, Grace Harper 494
1954-42-68	Murray, Grace Harper 494
1954-42-69	Otis, Amy 494
1954-42-70	Parke, Jessie Burns 495
1954-42-71	Pattee, Elsie Dodge 495
1954-42-72	Pattee, Elsie Dodge 495
1954-42-73	Patterson, Rebecca Burd Peale 495
1954-42-74	Phillips, Josephine Neall 497
1954-42-75	Pinter, Dora 497
1954-42-76	Purdie, Evelyn 497
1954-42-77	Purdie, Evelyn 497
1954-42-78	Reece, Dora 498
1954-42-79	Reid, Aurelia Wheeler 498
1954-42-80	Rhome, Lily Blanche Peterson 498
1954-42-81	Richards, Glenora 498
1954-42-82	Saint-Gaudens, Carlota 498
1954-42-83	Sawyer, Edith 498
1954-42-84	Simpson, Edna Huestis 498
1954-42-85	Sims, Florence 499
1954-42-86	Springer, Eva 499
1954-42-87	Stanton, Lucy May 499
1954-42-88	Starr, Lorraine Webster 499
1954-42-89	Stedman, Margaret Weir 499
1954-42-90	Stout, Virginia Hollinger 499
1954-42-91	Strean, Maria Judson 500
1954-42-92	Strean, Maria Judson 500
1954-42-93	Tannahill, Mary H. 500
1954-42-94	Taylor, Emily Drayton 501
1954-42-95	Thomas, Lillian M. 501
1954-42-96	Tolman, Nelly Summerill McKenzie 501
1954-42-97	Tuttle, Adrianna 502
1954-42-98	Washington, Elizabeth Fisher 503
1954-42-99	Welch, Mabel R. 503
1954-42-100	Whittemore, William John 503
1954-42-101	Wright, Catherine Morris 503
1954-42-102	Zimmerman, Elinor Carr 504
1954-42-103	American, unknown artist 474
1954-42-104	American, unknown artist 475
1954-42-105	American, unknown artist 476
1954-42-106	Turner, Matilda Hutchinson 502
1954-42-107	Hewitt, William K. 490
1954-42-108	Wilde, Ida M. 503
1954-42-109	Page, Polly 495
1954-42-110	Hitchner, Mary 491
1954-63-1	Baum, Walter Emerson 479
1954-63-2	Becker, Eulabee Dix 480
1954-63-4	Meyer, Jeremiah 468
1954-63-5	Humphrey, Ozias 466
1954-63-6	American, unknown artist 476
1954-63-7	McCarthy, Elizabeth White 493
1954-63-8	Trott, Benjamin 501
1954-63-9	Williams, Alyn 503
1954-63-11	English, unknown artist 456
1954-66-3	Manet, Édouard 143
1954-66-6	Monet, Claude 148
1954-66-8	Monet, Claude 148
1954-66-9	Sisley, Alfred 157
1955-1-1	Pilo, Carl Gustav, attributed to 470
1955-1-2	Plimer, Andrew 471
1955-1-3	Plimer, Andrew 471
1955-1-4	Plimer, Andrew 471
1955-1-5	Shelley, Samuel 473
1955-1-6	Richter, Christian 471
1955-1-7	Robertson, Archibald 498
1955-1-8	Russell, John, attributed to 472
1955-1-9	Saint, Daniel 472
1955-1-10	Smart, John 473
1955-1-11	Smart, John 473
1955-1-12	Smart, John 473
1955-1-13	Smart, John 473
1955-1-14	Smart, John 473
1955-1-15	Smart, John 473
1955-1-16	Smart, John 473
1955-1-17	English, unknown artist 457
1955-1-18	Stanton, Lucy May 499
1955-1-19	Strean, Maria Judson 500
1955-1-20	Stuart, Gilbert, attributed to 500
1955-1-21	Trott, Benjamin 502
1955-1-22	Welch, Mabel R. 503
1955-1-23	Williams, Alyn 503
1955-1-25	American, unknown artist 475
1955-1-26	English, unknown artist 460
1955-1-27a	French, unknown artist 463
1955-1-27b	French?, unknown artist 463
1955-1-28a	American, unknown artist 476
1955-1-28b	American, unknown artist 476
1955-2-3	Berninger, Edmund 164
1955-2-4	Marlow, William 19
1955-2-5	Leonardi, A. 210
1955-24-1	Kisling, Moïse 380
1955-33-1	Bloch, Julius T. 326
1955-51-1	Schwartz, Manfred 425
1955-53-1	Archambault, Anna Margaretta 479
1955-66-1	Rota, Giuseppe, copy after 472
1955-66-2	Rota, Giuseppe, copy after 472
1955-86-14	Eakins, Thomas 277
1955-86-16	Souverbie, Jean 430
1955-86-17	Marcoussis, Louis 390
1955-86-18	Gromaire, Marcel 365
1955-86-19	Lurçat, Jean 389
1955-96-1	Biddle, George 325
1955-96-7	Kelly, Leon 380
1955-96-8	Marsh, Reginald 391
1955-96-9	Sheeler, Charles 427
1955-96-11	Sterne, Maurice 432
1955-109-1	Greuze, Jean-Baptiste, copy after 139
1955-113-1	Watkins, Franklin Chenault 442
1956-5-1	Salemme, Attilio 423
1956-11-1	Graves, Morris Cole 363
1956-13-1	László, Philip A. de 384
1956-23-1	Matisse, Henri 393
1956-26-1	Charlot, Jean 340
1956-36-1	Taylor, Emily Drayton 501
1956-36-2	Taylor, Emily Drayton 501
1956-37-1	Carles, Arthur Beecher 335
1956-37-2	Carles, Arthur Beecher 337
1956-39-1	Trumbull, John, attributed to 303
1956-39-2	West, Benjamin 29
1956-40-1	Eichholtz, Jacob 279
1956-40-2	Cogswell, Charles Nathaniel, attributed to 267
1956-59-1	Hicks, Edward 283
1956-61-1	Stuart, Gilbert Charles, copy after 298
1956-61-2	Stuart, Gilbert Charles, copy after 299
1956-66-5	Peale, Charles Willson 291
1956-88-1	Chamberlin, Mason 3
1956-107-1	Watkins, Franklin Chenault 442
1956-112-1	Peruvian, unknown artist 317
1956-112-2	Peruvian, unknown artist 317
1956-112-3	Peruvian, unknown artist 317
1956-118-1	Homer, Winslow 284
E1957-1-1	Titian, studio of 234
W1957-1-1	Renoir, Pierre-Auguste 153
1957-2-1	Magnasco, Alessandro 213
1957-2-2	Magnasco, Alessandro 213
1957-4-1	American, unknown artist 257
1957-4-2	American, unknown artist 259
1957-4-3	American, unknown artist 261
1957-25-1	Casorati, Felice 338
1957-65-1	Kuniyoshi, Yasuo 383
1957-67-1	Stuart, Gilbert Charles 298
1957-94-1	Soriano, Juan 429
1957-125-1	Picasso, Pablo Ruiz 412
1957-127-1	Afro 320
1957-127-6	Tamayo, Rufino 433
1957-127-7	Zalce, Alfredo 445
1957-130-1	Vos, Paul de 105
W1958-2-1	Magnasco, Alessandro 213
1958-12-1	Léger, Fernand 386
1958-27-1	Sully, Thomas 301
1958-28-1	Sully, Thomas 300
1958-92-1	American, unknown artist 261
1958-94-1	Johnson, Eastman 286
1958-132-1	West, Benjamin 29
1958-144-1	Chardin, Jean-Baptiste-Siméon 115
W1959-1-1	Cassatt, Mary Stevenson 266
1959-12-1	Barnett, William 323
1959-12-2	Coiner, Charles Toucey 342
1959-12-3	Crowell, Lucius 343
1959-12-4	Finkelstein, Louis 357
1959-12-5	Massey, John L. 392
1959-12-6	Paone, Peter 407
1959-12-7	Taylor, Charles 434
1959-12-8	Yerxa, Thomas 444
1959-28-1	Pannini, Giovanni Paolo 224
1959-30-1	Ossorio, Alfonso 406
1959-31-1	Krasner, Lee 382
1959-59-1	Sully, Thomas 301
1959-79-1	Stuart, Gilbert Charles 298
1959-83-1	Renoir, Pierre-Auguste 154
1959-91-1	English, unknown artist 460
1959-91-2	European, unknown artist 461
1959-91-3	Italian, unknown artist 466
1959-91-4	French?, unknown artist 462
1959-91-5	Mason 468
1959-91-6	European, unknown artist 461
1959-91-7	Hoin, Claude-Jean-Baptiste 465
1959-91-8	Hoin, Claude-Jean-Baptiste 465
1959-91-9	European, unknown artist 460
1959-91-11	American, unknown artist 476
1959-91-13	European, unknown artist 461
1959-91-14	European, unknown artist 461
1959-91-15	Carew, Berta 483
1959-91-16	Carew, Berta 482
1959-91-17	Carew, Berta 485
1959-91-18	Durante, M. 488
1959-91-19	Carew, Berta 485
1959-91-20	Carew, Berta 483

ACCESSION NUMBERS

1959-91-21	Carew, Berta 483
1959-91-22	Carew, Berta 483
1959-91-23	Carew, Berta 484
1959-91-24	Pollock, L. 497
1959-91-26	Carew, Berta 484
1959-91-27	Carew, Berta 484
1959-91-28	Carew, Berta 484
1959-91-29	Carew, Berta 484
1959-91-30	Carew, Berta 484
1959-91-31	Carew, Berta 482
1959-91-32	Carew, Berta 483
1959-91-33	Carew, Berta 484
1959-91-34	Carew, Berta 483
1959-91-35	Carew, Berta 482
1959-91-36	Carew, Berta 483
1959-91-37	Trueworthy, Jessie 502
1959-91-38	Carew, Berta 485
1959-91-39	Carew, Berta 484
1959-91-40	McKerwin 493
1959-91-41	Carew, Berta 485
1959-91-42	Carew, Berta 485
1959-91-43	Carew, Berta 485
1959-91-44	Carew, Berta 485
1959-91-45	Carew, Berta 485
1959-91-46	Carew, Braley Colman 486
1959-91-47	Brugger, Dorothy 482
1959-91-52	Italian, unknown artist 466
1959-91-53	Italian, unknown artist 466
1959-102-1	Wyeth, Andrew Newell 444
1959-133-1	Chagall, Marc 339
1960-23-3	Frelinghuysen, Suzy 359
1960-57-1	Drew-Bear, Jessie 350
1960-78-1	Sully, Thomas 300
1960-78-2	Sully, Thomas 300
1960-109-1	Stuart, Gilbert Charles, attributed to 298
1961-21-1	Stuart, Gilbert Charles, copy after 298
1961-37-1	Petitot, Jean 470
1961-48-1	Monet, Claude 147
1961-48-2	Monet, Claude 148
1961-48-3	Monet, Claude 146
1961-64-1	Blackburn, Morris Atkinson 326
1961-77-1	Karfiol, Bernard 378
1961-78-1	Speight, Francis 430
1961-150-1	Pissarro, Camille 150
1961-171-1	Sully, Thomas 299
1961-179-1	German, unknown artist 464
1961-180-1	Leonid 387
1961-195-1	Lievens, Jan, attributed to 69
1961-215-1	Robert, Hubert 155
1961-223-1	Kline, Franz 381
1961-226-1	Wollaston, John, attributed to 305
W1962-1-1	Kuhn, Walt 382
1962-49-1	Konolyi, Mary Barnwell 382
1962-74-1	Collet, Édouard 116
1962-126-1	Peale, Charles Willson 290
1962-142-1	Aman-Jean, Edmond-François 108
1962-193-1	Sargent, John Singer 295
1962-193-2	Sully, Thomas 299
1962-205-1	Demuth, Charles 347
1962-205-2	Demuth, Charles 347
1962-206-1	Forain, Jean-Louis 133
1962-217-1	Trott, Benjamin 501
1962-218-1	Trott, Benjamin 501
1962-219-1	Robinson, John 471
1963-75-1	Peale, Charles Willson 496
1963-75-2	Peale, Charles Willson, attributed to 292
1963-75-3	American, unknown artist 256
1963-75-4	American, unknown artist 256
1963-116-1	Boudin, Eugène-Louis 111
1963-116-2	Cézanne, Paul 114

1963-116-3	Cézanne, Paul 114
1963-116-4	Cézanne, Paul 114
1963-116-5	Cézanne, Paul 113
1963-116-6	David, Jacques-Louis, follower of 127
1963-116-8	Goya y Lucientes, Francisco José de 240
1963-116-9	Manet, Édouard 143
1963-116-10	Manet, Édouard 143
1963-116-11	Monet, Claude 148
1963-116-12	Spierincks, Karel Philips, attributed to 97
1963-116-13	Renoir, Pierre-Auguste 153
1963-116-14	Renoir, Pierre-Auguste 153
1963-116-15	Renoir, Pierre-Auguste 154
1963-116-16	Renoir, Pierre-Auguste 153
1963-116-17	Renoir, Pierre-Auguste 153
1963-116-18	Sisley, Alfred 157
1963-116-19	Gogh, Vincent Willem van 59
1963-116-21	Cézanne, Paul 113
1963-117-1	Degas, Hilaire-Germain-Edgar 128
1963-171-1	Raeburn, Sir Henry 22
1963-180-1	Hofmann, Hans 372
1963-181-1	Bonnard, Pierre 327
1963-181-2	Bonnard, Pierre 328
1963-181-3	Boudin, Eugène-Louis 111
1963-181-4	Braque, Georges 331
1963-181-5	Brook, Alexander 331
1963-181-6	Cézanne, Paul 114
1963-181-9	Chagall, Marc 338
1963-181-10	Chagall, Marc 339
1963-181-11	Chagall, Marc 339
1963-181-12	Chagall, Marc 339
1963-181-13	Chagall, Marc 338
1963-181-14	Chagall, Marc 339
1963-181-16	Chagall, Marc 340
1963-181-18	Corot, Jean-Baptiste-Camille 117
1963-181-19	Courbet, Gustave 122
1963-181-20	Courbet, Gustave 122
1963-181-21	Courbet, Gustave 123
1963-181-22	Courbet, Gustave 123
1963-181-23	Courbet, Gustave 123
1963-181-25	Eakins, Thomas 276
1963-181-26	Ensor, James 355
1963-181-29	Gatch, Lee 360
1963-181-30	Gordey, Ida 362
1963-181-31	Gwathmey, Robert 366
1963-181-32	Hassam, Childe 282
1963-181-38	Kroll, Leon 382
1963-181-45	Matisse, Henri 393
1963-181-47	Miró, Joan 398
1963-181-48	Modigliani, Amedeo 398
1963-181-51	Pascin, Jules 408
1963-181-53	Picasso, Pablo Ruiz 412
1963-181-58	Renoir, Pierre-Auguste 153
1963-181-59	Renoir, Pierre-Auguste 154
1963-181-60	Ritman, Louis 419
1963-181-61	Rouault, Georges 421
1963-181-62	Rouault, Georges 421
1963-181-64	Rousseau, Henri-Julien-Félix 422
1963-181-65	Rousseau, Henri-Julien-Félix 422
1963-181-66	Rubin, Reuven 423
1963-181-68	Sheeler, Charles 427
1963-181-69	Soyer, Raphael 430
1963-181-70	Sterne, Maurice 432
1963-181-71	Soutine, Chaim 430
1963-181-72	Soutine, Chaim 430
1963-181-73	Soutine, Chaim 430
1963-181-74	Utrillo, Maurice 437
1963-181-76	Vuillard, Édouard 439
1963-181-77	Vuillard, Édouard 440
1963-191-1	Feke, Robert 280
1963-192-1	Cox, Jan 343
1963-214-1	Mingorance, Juan 396

1963-215-1	Francesco di Giorgio, follower of 192
1964-30-1	Riopelle, Jean-Paul 418
1964-31-1	Sully, Thomas 302
1964-32-1	Hankins, Abraham P. 367
1964-45-1	Watkins, Franklin Chenault 441
1964-46-1	Picasso, Pablo Ruiz 410
1964-61-1	Branchard, Emile Pierre 329
1964-77-1	Matisse, Henri 393
1964-77-2	Rouault, Georges 421
1964-77-3	Vuillard, Édouard 440
1964-89-1	Picasso, Pablo Ruiz 412
1964-103-1	Gainsborough, Thomas 13
1964-104-1	Prendergast, Maurice B. 415
1964-105-1	Stuart, Gilbert Charles 298
1964-105-2	Peale, Charles Willson 291
1964-105-3	Peale, Charles Willson 291
1964-106-1	Carles, Arthur Beecher 336
1964-106-2	Keene, Paul 378
1964-106-3	Remenick, Seymour 418
1964-106-4	Remenick, Seymour 418
1964-106-5	Remenick, Seymour 418
1964-107-1	Matisse, Henri 393
1964-108-1	Braque, Georges 331
1964-109-1	Picasso, Pablo Ruiz 412
1964-110-1	Blake, William 3
1964-111-1	Sully, Thomas 299
1964-114-1	Manet, Édouard 144
1964-116-1	Prendergast, Maurice B. 415
1964-116-2	Luks, George B. 388
1964-116-3	Davies, Arthur Bowen 345
1964-116-4	Lawson, Ernest 385
1964-116-5	Sloan, John 428
1964-116-6	Henri, Robert 371
1964-116-7	Glackens, William 361
1964-117-1	Hankins, Abraham P. 367
1964-117-2	Hankins, Abraham P. 367
1964-117-3	Hankins, Abraham P. 366
1964-117-4	Hankins, Abraham P. 367
1964-117-5	Hankins, Abraham P. 367
1964-151-1	Tanguy, Kay Sage 434
1964-181-1	Tanguy, Yves 434
1964-210-1	Peale, James 292
1964-210-2	Peale, James 292
1965-48-1	Otis, Bass 289
1965-49-1	West, Benjamin 29
1965-65-1	Vouet, Simon, studio of 162
1965-85-1	Lagrenée, Louis, the Elder, attributed to 141
1965-85-2	Rousseau, Pierre-Étienne-Théodore 155
1965-90-1	Pannini, Giovanni Paolo 224
1965-117-10	Borie, Adolphe 328
1965-158-1	Lueders, Jimmy C. 388
1965-170-1	Strater, Henry 432
1965-205-23	Paxton, W. 408
1965-208-1	László, Philip A. de 384
1965-209-1	Durand, John 269
1965-209-2	Britton, William 265
1965-209-3	American, unknown artist 257
1965-209-4	American, unknown artist 259
1965-209-5	American, unknown artist 260
1965-209-6	Raleigh, Charles Sidney 294
1965-214-1	França, Manuel Joachim de 280
1965-218-1	Richenberg, Robert 418
1966-4-1	Smith, T. Henry 297
1966-20-2	English, unknown artist 453
1966-20-3	Daniel of Bath, Joseph, or Abraham Daniel of Bath, attributed to 450
1966-20-4	English, unknown artist 453
1966-20-5	English, unknown artist 453
1966-20-6	Daniel of Bath, Joseph, or Abraham Daniel of Bath, attributed to 450

537

1966-20-7	McMoreland, Patrick John, attributed to 467	
1966-53-1	Otis, Bass 289	
1966-53-2	American, unknown artist 256	
1966-57-1–4	Warhol, Andy 440	
1966-68-2	Bonnard, Pierre 327	
1966-68-3	Cézanne, Paul 114	
1966-68-12	Osborn, Frank 406	
1966-68-13	Eilshemius, Louis Michel 354	
1966-68-14	Eilshemius, Louis Michel 354	
1966-68-15	Ray, Man 416	
1966-68-16	Kuniyoshi, Yasuo 382	
1966-68-20	Bartlett, Frederic Clay 323	
1966-68-22	Bouche, Louis 329	
1966-68-26a	Hullond, Paul 372	
1966-68-26b	Hullond, Paul 373	
1966-68-26c	Hullond, Paul 373	
1966-68-26d	Hullond, Paul 373	
1966-68-26e	Hullond, Paul 373	
1966-68-26f	Hullond, Paul 373	
1966-68-26g	Hullond, Paul 373	
1966-68-26h	Hullond, Paul 373	
1966-68-28	Lawson, Adelaide 385	
1966-68-29	Lawson, Adelaide 384	
1966-68-30	Moses, Thomas 288	
1966-68-31	Newton, Alice M. 402	
1966-68-32	Newton, Alice M. 402	
1966-68-33	Osborn, Frank 404	
1966-68-34	Osborn, Frank 405	
1966-68-36	Osborn, Frank 405	
1966-68-37	Osborn, Frank 405	
1966-68-38	Osborn, Frank 405	
1966-68-39	Osborn, Frank 405	
1966-68-40	Osborn, Frank 404	
1966-68-41a	Osborn, Frank 405	
1966-68-41b	Osborn, Frank 405	
1966-68-42	Osborn, Frank 405	
1966-68-43	Osborn, Frank 406	
1966-68-53	Varian, Dorothy 438	
1966-68-54	Vincent, Mary 303	
1966-68-55	Bresse, W. L. 265	
1966-68-56	American, unknown artist 257	
1966-68-57	Osborn, Frank 406	
1966-68-58	Osborn, Frank 406	
1966-68-59	Osborn, Frank 406	
1966-68-60	American, unknown artist 257	
1966-68-61	American, unknown artist 262	
1966-68-62	American, unknown artist 262	
1966-110-1	Beaux, Cecilia 263	
1966-121-1	Wilson, Benjamin, attributed to 30	
1966-172-1	Louis, Morris 388	
1966-173-1	Pogany, Margit 414	
1966-180-1	Simpson, David 427	
1966-190-1	Riopelle, Jean-Paul 419	
1966-219-1	American, unknown artist 254	
1966-219-2	Wiess, J. 304	
1966-219-3	American, unknown artist 256	
1966-219-4	American, unknown artist 260	
1966-220-1	Bonnard, Pierre 327	
1966-221-1	Gest, Margaret 360	
1966-227-1	Lam, Jennett 383	
1967-30-3	Boudin, Eugène-Louis 111	
1967-30-7	Braque, Georges 329	
1967-30-9	Braque, Georges 331	
1967-30-10	Braque, Georges 331	
1967-30-11	Carles, Arthur Beecher 335	
1967-30-12	Carles, Arthur Beecher 336	
1967-30-13	Carles, Arthur Beecher 336	
1967-30-14	Carles, Arthur Beecher 336	
1967-30-15	Carles, Arthur Beecher 336	
1967-30-16	Cézanne, Paul 113	
1967-30-17	Cézanne, Paul 114	

1967-30-36	Dufy, Raoul 353	
1967-30-38	Ellsworth, James Sanford 488	
1967-30-52	Matisse, Henri 392	
1967-30-53	Matisse, Henri 392	
1967-30-55	Matisse, Henri 393	
1967-30-56	Matisse, Henri 393	
1967-30-57	Matisse, Henri 394	
1967-30-59	Modigliani, Amedeo 398	
1967-30-61	Diaz de la Peña, Narcisse-Virgile, follower of 131	
1967-30-66	Pascin, Jules 408	
1967-30-67	Pascin, Jules 408	
1967-30-70	Picasso, Pablo Ruiz 411	
1967-30-71	Picasso, Pablo Ruiz 411	
1967-30-76	Rouault, Georges 421	
1967-30-79	Rouault, Georges 422	
1967-30-80	Rousseau, Henri-Julien-Félix 422	
1967-30-83	Utrillo, Maurice 437	
1967-30-84	Utrillo, Maurice 437	
1967-30-90	White, Vera M. 443	
1967-37-1	Eakins, Thomas 275	
1967-38-1	O'Keeffe, Georgia 404	
1967-39-1	Downing, Tom 349	
1967-41-1	Bubenik, Gernot 332	
1967-65-1	Andrade, Edna 320	
1967-79-5	American, unknown artist 475	
1967-79-6	American, unknown artist 475	
1967-88-1	Rauschenberg, Robert 416	
1967-98-1	Marinot, Maurice 391	
1967-98-2	Marinot, Maurice 391	
1967-98-3	Marinot, Maurice 391	
1967-99-1	Harding, George 368	
1967-158-1	Eisenstat, Ben 354	
1967-193-1	Egnal, Stuart 354	
1967-193-2	Egnal, Stuart 353	
1967-195-1	West, Benjamin 29	
1967-216-1	Peale, Charles Willson 291	
1967-217-1	Rauschenberg, Robert 416	
1967-261-1	Valledor, Leo 437	
1967-268-1	Theus, Jeremiah 303	
1967-268-2	American, unknown artist 254	
1967-268-3	Roath, H. A. 295	
1967-269-1	Jenkins, Paul 376	
1967-269-2	Jenkins, Paul 375	
1967-269-3	Jenkins, Paul 376	
1967-269-4	Hultberg, John 373	
1967-271-1	Hartigan, Grace 368	
1968-39-1	Osborne, Elizabeth 406	
1968-40-1	Hankins, Abraham P. 367	
1968-40-2	Hankins, Abraham P. 367	
1968-40-3	Hankins, Abraham P. 367	
1968-41-1	Wood, Edith Longstreth 444	
1968-42-1	Wood, Edith Longstreth 444	
1968-43-1	Shaw, Charles Green 427	
1968-44-1	Birch, Thomas 263	
1968-45-1	Encke, Fedor 165	
1968-45-2	Encke, Fedor 165	
1968-45-3	Bertieri, Pilade 325	
1968-45-4	Oppenheimer, Josef 173	
1968-69-53	Encke, Fedor 165	
1968-73-1	Wright, Joseph 31	
1968-74-1	Peale, Charles Willson 291	
1968-74-2	Peale, Charles Willson 291	
1968-76-1	Petersen, Roland Conrad 409	
1968-77-1	Anuszkiewicz, Richard 321	
1968-97-1	Luttichuys, Isaac 467	
1968-118-53	American, unknown artist 262	
1968-119-1	Williams, Neil 444	
1968-177-1	Avery, Milton 322	
1968-181-1	Dowling, Robert 9	
1968-182-1	Cornelis Cornelisz. van Haarlem 47	
1968-183-1	Albers, Josef 320	

1968-183-2	Stella, Frank 431	
1968-222-1	Polk, Charles Peale 293	
1968-222-2	Polk, Charles Peale 293	
1968-222-3	American, unknown artist 261	
1968-222-4	American, unknown artist 256	
1968-223-1	Oliveira, Nathan 404	
1968-224-1	Graziani, Sante 363	
1968-226-1	Esherick, Wharton 356	
1969-7-1	Pease, David 408	
1969-50-1	Sloan, Louis Baynard 428	
1969-86-1	Katzman, Herbert 378	
1969-86-2	Kulicke, Robert 382	
1969-86-3	Thiebaud, Wayne 434	
1969-86-4	Reinhardt, Ad 417	
1969-86-5	Gorchov, Ron 362	
1969-87-1a, b	Pittman, Hobson L. 413	
1969-88-1	Dessner, Murray 347	
1969-140-1a	Carles, Arthur Beecher 335	
1969-140-1b	Carles, Arthur Beecher 336	
1969-166-2	American, unknown artist 256	
1969-167-1	Puvis de Chavannes, Pierre 152	
1969-174-1	Pignon, Édouard 412	
1969-228-1	Schamberg, Morton Livingston 424	
1969-245-1	Bonevardi, Marcelo 327	
1969-259-1	Roesen, Severin 295	
1969-265-1	Dudreville, Leonardo 353	
1969-266-1	Peale, Charles Willson 291	
1969-273-1	Mexican, unknown artist 316	
1969-276-1	Cooper, J., attributed to 8	
1969-282-6	Jenkins, Paul 375	
1969-284-13	American, unknown artist 258	
1969-289-1	American, unknown artist 261	
1969-294-4	Ossorio, Alfonso 406	
1970-2-1	Peeters, Bonaventura 87	
1970-3-1	Egley, William Maw 9	
1970-3-2	Egley, William Maw 9	
1970-15-1	Carles, Arthur Beecher 337	
1970-52-1	Watkins, Franklin Chenault 442	
1970-75-2	Cassatt, Mary Stevenson 266	
1970-75-3	Henner, Jean-Jacques 140	
1970-76-1	English, unknown artist 12	
1970-76-2	Dickinson, Edwin Walter 348	
1970-76-3	Harding, Chester 281	
1970-76-4	Hartley, Marsden 369	
1970-76-6	Jarvis, John Wesley 286	
1970-76-7	Martin, Homer D. 287	
1970-76-8	Lawson, Ernest 385	
1970-76-9	Duveneck, Frank 269	
1970-89-1	Chinnery, George, attributed to 4	
1970-91-1	Mahaffey, Noel 389	
1970-92-1	Kremegne, Pinchus 382	
1970-134-1	Hendricks, Barkley 371	
1970-169-1	Watkins, Franklin Chenault 443	
1970-204-1a	Copley, William Nelson 342	
1970-204-1b	Copley, William Nelson 343	
1970-253-1	Portinari, Candido 415	
1970-254-1	American, unknown artist 258	
1970-254-2	American, unknown artist 258	
1970-255-20	Neilson, Raymond Perry Rodgers 401	
1971-9-1	Havard, James 370	
1971-36-1	Haeseler, Conrad F. 366	
1971-151-1	Vos, Cornelis de, follower of 105	
1971-164-1	Scott, William Bell 26	
1971-169-1	Taunay, Nicolas-Antoine 157	
1971-169-2	Taunay, Nicolas-Antoine 158	
1971-170-1	Avery, Milton 322	
1971-170-2	Bill, Max 326	
1971-199-1	Pattee, Elsie Dodge 495	
1971-199-2	Strean, Maria Judson 499	
1971-199-3	Turner, Helen Maria 502	
1971-199-4	Boardman, Rosina Cox 481	
1971-218-1	Schumacher, Emil 425	

cat. 588 Bellevois, Jacob Adriaensz. 32
cat. 589 Verschuier, Lieve Pietersz., attributed to 104
cat. 590 Velde, Willem van de, the Younger 102
cat. 591 Velde, Willem van de, the Younger 103
cat. 592 Backhuysen, Ludolf 32
cat. 593 Vlieger, Simon Jacobsz. de 104
cat. 594 Verschuier, Lieve Pietersz. 104
cat. 595 Heyden, Jan van der 63
cat. 596 Heyden, Jan van der 63
cat. 597 Heyden, Jan van der 63
cat. 598 Berckheyde, Gerrit Adriaensz. 33
cat. 599 Saenredam, Pieter Jansz. 95
cat. 600 Streeck, Hendrik van 99
cat. 601 Dutch, active Rotterdam, unknown artist 52
cat. 602 Koninck, Jacob 68
cat. 603 Velde, Adriaen van de 102
cat. 604 Velde, Adriaen van de, attributed to 102
cat. 605 Velde, Adriaen van de 102
cat. 606 Velde, Adriaen van de 102
cat. 607 Goubau, Antoine 60
cat. 608 Romeyn, Willem, attributed to 91
cat. 609 Dujardin, Karel, attributed to 51
cat. 610 Berchem, Nicolaes Pietersz. 33
cat. 611 Wijck, Thomas 106
cat. 612 Wijck, Thomas 107
cat. 613 Schellinks, Willem 96
cat. 614 Both, Andries, imitator of 37
cat. 615 Wouwermans, Philips, attributed to 107
cat. 616 Wouwermans, Philips 107
cat. 617 Wouwermans, Philips, and Paulus Potter, imitator of 108
cat. 618 Potter, Paulus, follower of 87
cat. 619 Potter, Paulus, copy after 88
cat. 620 Wouwermans, Philips, follower of 107
cat. 621 Cuyp, Aelbert 48
cat. 622 Cuyp, Aelbert 48
cat. 623 Dutch, unknown artist 52
cat. 624 Cuyp, Aelbert, imitator of 48
cat. 625 Calraet, Abraham Pietersz. van 40
cat. 626 Vermeer van Utrecht, Johann 104
cat. 627 Cuyp, Aelbert 48
cat. 628 Calraet, Abraham Pietersz. van 40
cat. 629 Hondecoeter, Melchior de, follower of 64
cat. 630 Hondecoeter, Melchior de 63
cat. 631 Heem, Cornelis de, attributed to 62
cat. 632 Ring, Pieter de 90
cat. 633 Weenix, Jan 105
cat. 634 Kalf, Willem 67
cat. 635 Kalf, Willem 67
cat. 636 Kalf, Willem 66
cat. 637 Beyeren, Abraham van 33
cat. 638 Beyeren, Abraham van, attributed to 34
cat. 639 Beyeren, Abraham van 33
cat. 640 Dutch, unknown artist 53
cat. 641 Dutch, unknown artist 52
cat. 642 Heda, Willem Claesz., imitator of 62
cat. 643 Fris, Jan 57
cat. 644 Heda, Willem Claesz. 62
cat. 645 Fromantiou, Hendrik de 58
cat. 646 Adriaenssen, Alexander 31
cat. 647 Adriaenssen, Alexander, attributed to 31
cat. 648 Berghe, Christoffel van den 33
cat. 649 Boelema de Stomme, Maerten 34

cat. 650 Roestraten, Pieter Gerritsz. van 90
cat. 651 Dutch, unknown artist 52
cat. 652 Streeck, Juriaen van, copy after? 99
cat. 653 Balen, Hendrik van, the Elder 32
cat. 654 Grimmer, Abel 61
cat. 655 Momper, Frans de 77
cat. 656 Brueghel, Jan, the Younger 39
cat. 657 Rubens, Peter Paul, workshop of 92
cat. 658 Rubens, Peter Paul, follower of 92
cat. 659 Rubens, Peter Paul 91
cat. 660 Rubens, Peter Paul, follower of 92
cat. 661 Rubens, Peter Paul, copy after 93
cat. 662 Rubens, Peter Paul, attributed to 92
cat. 663 Rubens, Peter Paul 91
cat. 664 Rubens, Peter Paul 91
cat. 665 Rubens, Peter Paul, copy after 93
cat. 666 Rubens, Peter Paul, copy after 92
cat. 667 Rubens, Peter Paul, copy after 92
cat. 668 Rubens, Peter Paul, imitator of 92
cat. 669 Dyck, Anthony van, imitator of 54
cat. 670 Dyck, Anthony van, follower of 54
cat. 671 Vos, Cornelis de 104
cat. 672 Dyck, Anthony van, imitator of 55
cat. 673 Dyck, Anthony van, follower of 54
cat. 674 Dyck, Anthony van, attributed to 54
cat. 675 Schut, Cornelis 96
cat. 676 Diepenbeeck, Abraham van 49
cat. 677 Rubens, Peter Paul 91
cat. 678 Sustermans, Justus, workshop of 99
cat. 679 Rombouts, Theodor 91
cat. 680 Brouwer, Adriaen, follower of 38
cat. 681 Brouwer, Adriaen, attributed to 38
cat. 682 Teniers, David, II, copy after 101
cat. 683 Duck, Jacob, attributed to 51
cat. 684 Flemish, unknown artist 57
cat. 685 Brouwer, Adriaen, copy after? 39
cat. 686 Ryckaert, David, III 95
cat. 687 Craesbeck, Joos van, attributed to 47
cat. 688 Craesbeck, Joos van, attributed to 47
cat. 689 Teniers, David, II 100
cat. 690 Teniers, David, II, attributed to 101
cat. 691 Teniers, David, II, attributed to 101
cat. 692 Teniers, David, II, attributed to 101
cat. 693 Teniers, David, II 100
cat. 694 Teniers, David, II 100
cat. 695 Teniers, David, II 100
cat. 696 Teniers, David, II 100
cat. 697 Teniers, David, II 100
cat. 698 Ryckaert, David, III 95
cat. 699 Ryckaert, David, III 95
cat. 700 Snyders, Frans, attributed to 97
cat. 701 Coninck, David de 47
cat. 702 Fyt, Jan, copy after 58
cat. 703 Fyt, Jan 58
cat. 704 Fyt, Jan 58
cat. 705 Fyt, Jan 58
cat. 706 Boel, Pieter 34
cat. 707 Siberechts, Jan 96
cat. 708 Neeffs, Peter, the Elder, and Frans Francken III, attributed to 78
cat. 709 La Fargue, Maria 68
cat. 711 Strij, Abraham van 99
cat. 712 Kobell, Johannes Baptista, imitator of 68
cat. 713 Pol, Christiaen van 87
cat. 714 Master of the Sterzingen Altar, workshop of 173
cat. 715 Master of the Sterzingen Altar, workshop of 173
cat. 716 Master of the Munderkinger Altar 172
cat. 717 German, unknown artist 168

cat. 718 Holbein, Hans, the Younger, copy after 170
cat. 719 German, active Swabia, unknown artist 166
cat. 720 German, active Swabia, unknown artist 166
cat. 721 Master of Messkirch 172
cat. 722 Master of Messkirch 172
cat. 723 Master of Messkirch 172
cat. 724 Master of Messkirch 172
cat. 725 Master of Messkirch 172
cat. 726 German, active Ulm or Augsburg, unknown artist 166
cat. 727 Kulmbach, Hans Suess von, attributed to 171
cat. 728 Beham, Barthel 163
cat. 729 German, active Swabia, unknown artist 167
cat. 730 German, active Bavaria, unknown artist 167
cat. 731 German, active southern Germany, unknown artist 167
cat. 732 Faber von Creuznach, Conrad, attributed to 166
cat. 733 German, active southern Germany, unknown artist 167
cat. 734 German, active southern Germany, unknown artist 167
cat. 735 Mielich, Hans, attributed to 173
cat. 736 Doring, Hans 165
cat. 737 German, unknown artist 169
cat. 738 Cranach, Lucas, the Elder 165
cat. 739 Cranach, Lucas, the Elder, attributed to 165
cat. 740 Cranach, Lucas, the Elder, workshop of 165
cat. 741 German, unknown artist 169
cat. 742 German, active Cologne, unknown artist 166
cat. 743 Master of the Lyversberg Passion, workshop of 172
cat. 744 Master of the Saint Bartholomew Altar, follower of 173
cat. 745 Master of the Holy Kinship 171
cat. 746 Master of the Munich Crucifixion Altarpiece 173
cat. 747 Bruyn, Bartel, the Younger 164
cat. 748 Bruyn, Bartel, the Younger 164
cat. 749 Bruyn, Bartel, the Elder, copy after 164
cat. 750 Bruyn, Bartel, the Elder 164
cat. 751 Netherlandish, active northern Netherlands, unknown artist 80
cat. 752 Master of Liesborn, workshop of 172
cat. 753 Master of Cappenberg 171
cat. 754 German, active lower Rhine, unknown artist 167
cat. 755 German, unknown artist 167
cat. 756 Alcañiz, Miguel, attributed to 238
cat. 757 Alcañiz, Miguel, attributed to 238
cat. 758 Spanish, active Catalonia, unknown artist 243
cat. 759 Martorell, Bernat 241
cat. 760 The Spanish Forger 250
cat. 761 French, unknown artist 136
cat. 762 a Franco-Flemish, unknown artist 134
cat. 762 b, c Franco-Flemish, unknown artist 134
cat. 762 d, e Franco-Flemish, unknown artist 134
cat. 763 Marmion, Simon, imitator of 71
cat. 764 French, unknown artist 134
cat. 765 Lieferinxe, Josse 142
cat. 766 Lieferinxe, Josse 143
cat. 767 Lieferinxe, Josse 143

cat. 768	Lieferinxe, Josse 143	cat. 824	English, unknown artist 10	cat. 891	Bastien-Lepage, Jules 108
cat. 769	Cleve, Joos van 42	cat. 825	English, unknown artist 11	cat. 892	Bastien-Lepage, Jules 109
cat. 770	Corneille de Lyon, copy after? 117	cat. 826	English, unknown artist 10	cat. 893	Bastien-Lepage, Jules 108
cat. 771	Corneille de Lyon, copy after 117	cat. 827	Reynolds, Sir Joshua, copy after 24	cat. 894	Bastien-Lepage, Jules 109
cat. 772	Netherlandish, unknown artist 83	cat. 828	English, unknown artist 10	cat. 895	Besnard, Albert 109
cat. 773	Poussin, Nicolas 151	cat. 829	English, unknown artist 10	cat. 896	Billotte, René 109
cat. 774	French, unknown artist 134	cat. 830	English, unknown artist 11	cat. 897	Bochmann, Alexander Heinrich Gregor von 164
cat. 775	Italian, active Rome, unknown artist 205	cat. 831	Reynolds, Sir Joshua, attributed to 23	cat. 898	Böcklin, Arnold 247
cat. 776	Quellinus, Erasmus, II 88	cat. 832	English, unknown artist 11	cat. 899	Böcklin, Arnold 247
cat. 777	Rigaud, Hyacinthe, copy after 155	cat. 833	Gainsborough, Thomas, attributed to 14	cat. 900	Bonvin, François 110
cat. 778	French, unknown artist 136	cat. 834	Gainsborough, Thomas, copy after 15	cat. 901	Bonvin, François 110
cat. 779	French, unknown artist 135	cat. 835	Gainsborough, Thomas, imitator of 15	cat. 902	Boudin, Eugène-Louis 110
cat. 780	French?, unknown artist 135	cat. 836	English, unknown artist 11	cat. 903	Boudin, Eugène-Louis 110
cat. 781	Todeschini 234	cat. 837	Romney, George, copy after 26	cat. 904	Brandon, Jacques-Émile-Édouard 112
cat. 782	Chardin, Jean-Baptiste-Siméon, copy after 116	cat. 838	English, unknown artist 10	cat. 905	Brascassat, Jacques-Raymond 112
cat. 783	Duifhuysen, Pieter Jacobsz. 51	cat. 839	English, unknown artist 13	cat. 906	Breton, Jules-Adolphe-Aimé-Louis 112
cat. 784	French, unknown artist 137	cat. 840	English, unknown artist 10		
cat. 785	Chardin, Jean-Baptiste-Siméon, attributed to 115	cat. 841	English, unknown artist 13	cat. 907	Brown, Frederick 3
		cat. 842	English, unknown artist 10	cat. 908	Calame, Alexandre 247
cat. 786	Chardin, Jean-Baptiste-Siméon, attributed to 115	cat. 843	English, unknown artist 11	cat. 909	Cals, Adolphe-Félix 112
cat. 787	French, unknown artist 135	cat. 844	Morland, George 20	cat. 910	Carrière, Eugène 112
cat. 788	Chardin, Jean-Baptiste-Siméon, imitator of 115	cat. 845	Morland, George, attributed to 20	cat. 911	Cazin, Jean-Charles 113
		cat. 846	Morland, George 19	cat. 912	Cazin, Jean-Charles 113
cat. 789	Chardin, Jean-Baptiste-Siméon, imitator of 116	cat. 847	Reynolds, Samuel William, attributed to 24	cat. 913	Chenu, Fleury 116
cat. 790	French, unknown artist 137	cat. 848	Turner, Joseph Mallord William 28	cat. 914	Chintreuil, Antoine 116
cat. 791	German, unknown artist 168	cat. 849	English, unknown artist 13	cat. 915	Chintreuil, Antoine 116
cat. 792	Boilly, Louis-Léopold, attributed to 109	cat. 850	English?, unknown artist 12	cat. 916	Corot, Jean-Baptiste-Camille 118
cat. 793	Ingres, Jean-Auguste-Dominique 140	cat. 851	Constable, John, follower of? 6	cat. 917	Corot, Jean-Baptiste-Camille, attributed to 120
cat. 794	Hersent, Louis, attributed to 140	cat. 852	Constable, Lionel Bicknell 7	cat. 918	Corot, Jean-Baptiste-Camille 118
cat. 795	Géricault, Jean-Louis-André-Théodore, copy after 138	cat. 853	Constable, John, attributed to 6	cat. 919	French, unknown artist 136
		cat. 854	Constable, Lionel Bicknell 7	cat. 920	Corot, Jean-Baptiste-Camille, imitator of 120
cat. 796	Géricault, Jean-Louis-André-Théodore, copy after 138	cat. 855	Constable, John, imitator of 6	cat. 921	Corot, Jean-Baptiste-Camille 118
		cat. 856	Constable, John 4	cat. 922	Corot, Jean-Baptiste-Camille 118
cat. 798	Spanish, active Aragon, unknown artist 243	cat. 857	Constable, John 4	cat. 923	Corot, Jean-Baptiste-Camille, imitator of 121
cat. 799	Ximénez, Miguel, and Martín Bernat, workshop of 245	cat. 858	Constable, John 5	cat. 924	Corot, Jean-Baptiste-Camille, imitator of 121
		cat. 859	Constable, John 4		
cat. 800	Castro, Bartolomé del 238	cat. 860	Constable, John, imitator of 7	cat. 925	Corot, Jean-Baptiste-Camille, attributed to 120
cat. 801	Olot Master 241	cat. 861	Constable, John, imitator of 7		
cat. 802	Osona, Rodrigo de, the Elder 241	cat. 862	Constable, John, copy after 7	cat. 926	Corot, Jean-Baptiste-Camille, attributed to 120
cat. 803	Osona, Rodrigo de, the Elder 242	cat. 863	Constable, John 5		
cat. 804	Osona, Rodrigo de, the Elder 242	cat. 864	Constable, John 5	cat. 927	Corot, Jean-Baptiste-Camille, imitator of 120
cat. 805	Vargas, Luis de 244	cat. 865	Constable, John, attributed to 6	cat. 928	Corot, Jean-Baptiste-Camille 120
cat. 806	Juan de Juanes 240	cat. 866	Constable, John, copy after 7	cat. 929	Corot, Jean-Baptiste-Camille, attributed to 120
cat. 807	El Greco 240	cat. 867	Constable, Lionel Bicknell, attributed to 7	cat. 930	Corot, Jean-Baptiste-Camille 119
cat. 808	El Greco, attributed to 240	cat. 868	Constable, John 5	cat. 931	Corot, Jean-Baptiste-Camille 117
cat. 809	El Greco, workshop of 240	cat. 869	Constable, John, attributed to 6	cat. 932	Corot, Jean-Baptiste-Camille, imitator of 121
cat. 810	Flemish, unknown artist 56	cat. 871	Constable, John 5		
cat. 810a	Giordano, Luca, copy after 195	cat. 872	Constable, John 4	cat. 933	Corot, Jean-Baptiste-Camille, imitator of 121
cat. 811	Ribera, José Jusepe de, attributed to 243	cat. 873	Constable, John 4	cat. 934	Corot, Jean-Baptiste-Camille, imitator of 121
		cat. 874	Watts, William 28		
cat. 812	Velasquez, Diego Rodriguez de Silva y, studio of 245	cat. 875	Watts, William, attributed to 29	cat. 935	Corot, Jean-Baptiste-Camille, imitator of 121
		cat. 876	Crome, John, copy after 9		
cat. 813	Spanish, unknown artist 244	cat. 877	English, unknown artist 13	cat. 936	Corot, Jean-Baptiste-Camille 118
cat. 814	Velasquez, Diego Rodriguez de Silva y, copy after 245	cat. 878	Cotman, John Sell, imitator of 8	cat. 937	Bidauld, Jean-Joseph-Xavier 109
		cat. 879	Vincent, George 28	cat. 938	Corot, Jean-Baptiste-Camille, imitator of 121
cat. 815	Murillo, Bartolomé Esteban, attributed to 241	cat. 880	Nasmyth, Peter 20		
		cat. 881	Pyne, James Baker, attributed to 21	cat. 939	Corot, Jean-Baptiste-Camille, attributed to 120
cat. 816	Ricci, Sebastiano, attributed to 228	cat. 882	Bonington, Richard Parkes, imitator of 3	cat. 940	Corot, Jean-Baptiste-Camille 117
cat. 817	Spanish, active Madrid, unknown artist 244	cat. 883	Bonington, Richard Parkes, follower of 3	cat. 941	Corot, Jean-Baptiste-Camille, imitator of 121
cat. 818	Esteve y Marques, Agustín 239	cat. 884	Etty, William 13		
cat. 819	Esteve y Marques, Agustín 239	cat. 885	Dawson, Henry, attributed to 9	cat. 942	Courbet, Gustave 122
cat. 820	Goya y Lucientes, Francisco José de, copy after 240	cat. 886	Holland, James 16	cat. 943	Courbet, Gustave, studio of 123
		cat. 887	Holland, James, attributed to 16	cat. 944	Courbet, Gustave 122
cat. 821	Lucas Velazquez, Eugenio 241	cat. 888	Aivasovsky, Ivan Konstantinovitsch 247	cat. 945	Courbet, Gustave 123
cat. 822	Aken, Joseph van, attributed to 31	cat. 889	Bartlett, William H. 2		
cat. 823	Hogarth, William, imitator of 16	cat. 890	Barye, Antoine-Louis 108		

Left: *Ulmus procera*
Left below: *Ulmus glabra* Camperdownii
Above: *Ulmus americana* autumn colours
Below: *Umbellularia californica*

long, smooth, deep glossy green; *U.* × *h.* Commelin, similar to *U.* × *h.* Vegeta but more narrowly domed and smaller-leaved, resistant to some strains of Dutch elm disease; *U.* × *h.* Dampieri (*U. carpinifolia* Dampieri), narrowly conical habit. *U. montana*, see *U. glabra*. *U. nitens*, see *U. carpinifolia*. *U. parvifolia*, Chinese elm; China, Korea, Japan; to 18m tall, often less in gardens; bark cracked and flaking, red-brown to dark grey, densely domed habit; leaves 3–4cm or more long, elliptic to oblanceolate, semi-evergreen, at least in mild winters; flowers in autumn; apparently resistant to Dutch elm disease; a graceful species deserving to be more widely planted. *U. procera* (*U. campestris*), English elm; England, possibly S.E.France; to 36m tall; bark deeply cracked into small squares, dark brown to blackish; of conical habit when young, then developing a billowing, domed head; leaves mainly ovate to orbicular, 4–10cm long, dark green; largely sterile, spreading by root suckers. *U.p.* Louis van Houtte (*U.p.* Van Houttei), leaves yellow; *U.p.* Wheatleyi, see *U. carpinifolia sarniensis*. *U.* × *sarniensis*, see *U. carpinifolia s. U. scabra*, see *U. glabra. U. stricta*, see *U. carpinifolia cornubiensis. U.* × *vegeta*, see *U.* × *hollandica* Vegeta. *U. wheatleyi*, see *U. carpinifolia sarniensis*.

Umbellularia

(having flowers in umbels). LAURACEAE. A gen evergreen tree from California and Oreg *californica*, California laurel, bay or olive tall in the wild, often less in garden alternate, 6–12cm long, oblong-lanceola narrow but rounded tip, somewhat strongly aromatic; flowers small, pe

to Siberia to 30m tall or more; bark smooth and grey on youngish trees, then browner and ridged; branches spreading, forming an irregularly domed head; leaves 10–18cm long, obovate, sometimes with 1 or 2 pointed lobes. *U.g.* Camperdownii, branches and branchlets pendulous, forming a rounded, weeping head; *U.g.* Exoniensis (*U.g.* Fastigiata), Exeter elm, to 17m tall, narrowly columnar when young, broadening with age; *U.g.* Lutescens (*U. americana* Aurea),

leaves creamy-yellow when young, ageing yellow-green; *U.g.* Pendula, weeping wych elm, rarely to 9m tall, flat-topped with long, pendulous branches. *U.* × *hollandica* (*U. carpinifolia* × *U. glabra*), Dutch elm; to 35m or more tall; main branches strongly ascending, laterals spreading to form a shallowly domed head; leaves 12–15cm long, elliptic to obovate, often puckered. *U.* × *h.* Vegeta (*U.* × *vegeta*), Huntingdon or Chichester elm, narrower domed habit than type, leaves 10–13cm

lowish, in umbels from upper leaf-axils; fruit to 2·5cm long, obovoid, plum-like, dark purple drupes. Grow in fertile, moisture-retentive but not wet soil in sheltered, sunny sites. Plant spring. Propagate from ripe seed in cold frame, by layering spring.

Umbrella pine – see *Sciadopitys verticillata*.

Umbrella plant – see *Peltiphyllum peltatum*.

Unicorn plant – see *Proboscidea louisianica*.

Ursinia

(for Johannes Heinrich Ursinus, 1608–67, German botanist and author). COMPOSITAE. A genus of 40–80 species, depending on botanical authority, of annuals, perennials, sub-shrubs and shrubs from S.Africa. They are mainly of slender growth with

Above: *Ursinia speciosa*

...ves pinnately cut into linear or thread-like ...nts and terminal, daisy-like flower-heads in ...r. Grow in well-drained soil in sunny, ... sites or as pot plants in a sunny, well-... greenhouse. Plant or sow when fear of ...sed in late spring. Propagate annuals ... from seed at 18°C, perennials also by ...ings spring, late summer.

...*U. anethoides*, shrub to 60cm tall; ...dissected into filiform, semi-... ...ften hairy; flower-heads to ...with purple base; usually ...ed sown under glass. *U.* ...m tall; leaves to 6·5cm ...out 6cm wide, rays ...*speciosa*, annual ...pinnate; flower-...w to orange,

Grow in ponds or aquaria. Species that dwell partly in the mud should be anchored to the bottom of pots or trays of loam or potting mix. Floating species should be dropped into the water. Plant spring or summer. Propagate by division at planting time.
Species cultivated: *U. intermedia*, N.Hemisphere, but local; stems 10–25cm long, some with green leaves with few or no bladders, others colourless, buried in the mud and bearing bladders; leaves 4–12mm long, palmately lobed, bristly; bladders 3mm long; flowers 8–12mm long, bright yellow with red-brown lines, in short racemes above the water, late summer; best in acid water. *U. minor*, lesser bladderwort; N.Hemisphere; stems 7–25cm long, similar to *U. intermedia* but smaller; leaf segments branched, smooth; flowers 6–8mm long, pale yellow, summer. *U. vulgaris*, greater or common bladderwort; N.Hemisphere; stems 15–45cm long, free-floating, all bearing green leaves with many bladders; leaves 2–2·5cm long, pinnate, segments with bristly teeth; bladders 3mm long; flowers 1·2–1·8cm long, bright yellow.

Above: *Utricularia vulgaris*

Uvularia

(anatomical term *uvula* for the lobe hanging at the top of the throat in man, a not very apt allusion to the pendant flowers). Bellwort, merrybells (USA). LILIACEAE. A genus of 4–5 species of herbaceous perennials from E. N.America. They are rhizomatous, eventually forming colonies of erect to arching stems with alternate, sessile or perfoliate leaves, and pendant, 6-tepalled, bell-like flowers. Grow in moisture-retentive but not wet, humus-rich soil in partial shade. Plant autumn to early spring. Propagate by division at planting time or, from seed.
Species cultivated: *U. grandiflora*, stems 35–60cm tall, usually branched; leaves 6–13cm long, perfoliate, oblong to narrowly ovate, downy beneath; flowers to 5cm long, lemon-yellow, early summer. *U. perfoliata*, similar to *U. grandiflora*, with which it is often confused, but less robust; leaves glabrous beneath; flowers to 4cm long, pale yellow.

Below: *Uvularia grandiflora*

Vaccinium

(probably Latin *vaccinus*, of cows). Blueberry, bilberry. ERICACEAE. A genus of 150–400 species, depending on botanical authority, of evergreen and deciduous shrubs, rarely small trees, from temperate regions of the world including tropical mountains. They have alternate, obovate or ovate to linear leaves, nodding, bell- to urn-shaped, 4–5 lobed flowers, and edible, globular, fleshy, berry-fruit. Culture as for × *Gaulnettya*; propagation also from seed when ripe, or spring.
Species cultivated: *V. angustifolium*, lowbush blueberry; rhizomatous, deciduous, twiggy shrub to 30cm tall; leaves 7–20mm long, narrowly lanceolate; flowers 5–6mm long, urn-shaped, white or tinged pink, in short racemes, late spring; berries to 8mm wide, blue with waxy white patina. *V. corymbosum*, highbush or swamp blueberry; E. N.America; deciduous shrub to 2m or more tall; leaves 4–8cm long, elliptic to ovate, turning scarlet and bronze in

Above: *Vaccinium vitis-idaea*

autumn; flowers 6–12mm long, narrowly urn-shaped, white or pale pink, early summer; berries to 1cm or more wide, blue-black with waxy patina; several cultivars have been raised for their fruit quality and are grown commercially, particularly in USA; the following are usually available in Europe and USA (ideally, 2 different cultivars should be grown together for cross-pollination; a moist, acid, peaty soil is essential): *V.c.* Early Blue (*V.c.* Earliblue), early; *V.c.* Grover, mid-season; *V.c.* Jersey and *V.c.* Pemberton, late. *V. delavayi*, W.China; evergreen shrub to 1·5m or more, but slow-growing; compact habit; leaves to 1·2cm long, ovate to obovate, notched at tip; flowers 4mm long, broadly urn-shaped, white, tinted pink, early summer; berries 4mm wide, red to purplish. *V. floribundum* (*V. mortinia*), mountains of Ecuador; evergreen shrub to 1m or more tall; spreading widely when established; leaves 1–1·5cm long, ovate to rounded, dark green above, red-purple when young; flowers 4–6mm long, narrowly urn-shaped, pink, in

Below: *Vaccinium nummularia*

racemes, summer; fruit 5mm wide, glaucous-red to purple. *V. glaucoalbum*, Himalaya; suckering, evergreen shrub 1–1·8m tall; leaves 4–6·5cm long, elliptic to oblong-obovate, leathery, vivid glaucous beneath; flowers to 6mm long, almost cylindrical, white, flushed pink, in racemes with glaucous bracts, early summer; berries 5–8mm wide, glaucous-black; not fully hardy in severe winters. *V. macrocarpum*, see *Oxycoccus m. V. mortinia*, see *V. floribundum. V. moupinense*, W.China; evergreen shrub to 60cm tall; neat, compact habit; leaves 1–1·5cm long, elliptic to obovate; flowers 4–5mm long, urn-shaped, red to mahogany, early summer; fruit 6mm wide, purple-black. *V. myrtillus*, bilberry, blueberry, whortleberry; Europe, N.Asia; in general appearance much like *V. angustifolium* but leaves 1–3cm long, ovate, and berries black with a waxy white patina. *V. nummularia*, Himalaya; evergreen shrub to 45cm tall; compact habit; stems arching, brown-bristly; leaves 1·2–2·5cm long, orbicular-ovate, dark glossy green; flowers 5mm long, cylindrical, pink to rose-red, in racemes, early summer; berries 6mm long,

divided; flowers about 1cm long, pink, sometimes white, in head-like clusters, spring, summer. *V. montana*, mountain valerian; Pyrenees, Alps, Apennines; rhizomatous, 12–50cm tall; leaves to 4cm long, elliptic-ovate to orbicular; flowers 3–5mm long, pink or white, in clustered cymes, spring, summer; represented in British gardens by a dwarf, broad-leaved form, 7–10cm tall. *V. officinalis*, common or cat's valerian; Europe, temperate Asia; clump-forming, 1–1·5m tall; leaves to 20cm long, pinnate, leaflets lanceolate, sometimes irregularly toothed; flowers 5mm long, pale pink, lavender or white, fragrant, in panicles, summer. *V. phu*, Caucasus; clump-forming, to 90cm tall; leaves oblong-elliptic, 7–15cm long; flowers tiny, white, in panicles, late summer; represented in gardens mainly by *V.p.* Aurea with bright yellow young foliage. *V. saxatilis*, rock valerian; N.Apennines, C. and E.Alps; rhizomatous, mat-forming, 7–30cm tall; leaves to 3cm or more long, elliptic to oblanceolate; flowers 1–2mm long, white, in small, long-stalked clusters, summer; seldom cultivated,

translucent leaves and tiny, 3-petalled, dioecious flowers. The female flowers are solitary on very slender stems just above the water, the males in short, ovoid spikes that break off and float to the surface where they open and discharge pollen. After fertilization the female stems coil up, drawing the developing fruit to the bottom. Grow in sheltered ponds or aquaria, planted in a natural mud bottom or in pots or pans of loam or potting mix. Plant spring. Propagate by division spring or early summer. In cold areas plants are best over-wintered in tanks in a frost-free greenhouse.

Species cultivated: *V. gigantea*, S.E.Asia to Australia; leaves to 1m long if grown in rich compost or mud, to 2cm wide, deep green with longitudinal black and brown lines. *V.g. minor*, smaller than type, leaves very pale green; *V.g.* Rubrifolia (*V. rubra* of gardens), leaves bronzy-crimson, lined purple. *V. spiralis*, S.E.Europe, W.Asia; leaves to 60cm or more long by 5–12mm wide, bright green. *V.s.* Torta, leaves twisted in corkscrew fashion.

Above: *Vaccinium corymbosum* autumn colour

ovoid, black; 1 of the most attractive species but not fully hardy and in cold areas best in an alpine house. *V. ovatum*, California huckleberry; W. N.America; evergreen shrub to 3m tall, of compact habit; leaves 2–4cm long, ovate to oblong-lanceolate, toothed, lustrous above; flowers 6mm long, bell-shaped, white to pink, summer; berries 6–8mm wide, red, ripening black; the pleasing foliage is used by florists in USA. *V. oxycoccus*, see *Oxycoccus palustris. V. vitis-idaea*, cowberry; Asia, Europe; creeping evergreen rhizomatous shrub 10–30cm tall; leaves 1–3cm long, obovate, dark lustrous green above, paler beneath; flowers 4mm long, bell-shaped, white, tinged pink, in short racemes, summer; berries 8–10mm wide, red. *V.v.-i. minus*, mountain cranberry, N.America, dwarf, mat-forming, leaves 1–2cm long, flowers pink to red.

Valerian – see *Valeriana*.

Valeriana

(medieval Latin name, perhaps from *valere*, to be healthy – alluding to the medicinal properties of some species). Valerian. VALERIANACEAE. A genus of about 200 species of perennials, sub-shrubs and shrubs of wide distribution in both hemispheres. They have opposite pairs of simple or pinnate leaves and small, tubular, 5-lobed flowers in terminal, often paniculate cymes. Fruits are tiny, ovoid nuts with a feathery pappus. Needs fertile, well-drained soil, sun, partial shade. Plant autumn to spring. Propagate spring by division, basal cuttings, seed.

Species cultivated: *V. arizonica*, Colorado and Utah to Mexico; rhizomatous, mat-forming with flowering stems to 10cm tall (up to 30cm in the wild); leaves 2–6cm long, ovate to rounded, sometimes pinnately

Top: *Valeriana montana*
Above: *Valeriana phu* Aurea

but confused with *V. montana* and other small, pink-flowered species. *V. supina*, dwarf valerian; E. and E.C.Alps; rhizomatous, mat-forming, 2–12cm tall; leaves to 2cm long, spathulate or orbicular; flowers 3–4mm long, deep pink, in dense, head-like clusters, throughout summer.

Vallisneria

(for Antonio Vallisnieri, 1661–1730, professor of botany at Padua, Italy). Eel or tape grass. HYDROCHARITACEAE. A genus of 8–10 species of aquatic perennials of wide distribution in both hemispheres. They are tufted, often spreading by runners, with slender, strap-shaped, semi-

Above: *Vallisneria spiralis*

Vancouveria

(for Captain George Vancouver, R.N., 1758–98, British explorer, particularly of the N.W. coast of N.America, 1791–5, see also *Menziesii*). BERBERIDACEAE. A genus of 3 species of evergreen and deciduous perennials from N.W.America, basically resembling *Epimedium*. 1 species is generally available: *V. hexandra*, deciduous, rhizomatous, 20–40cm tall, forming colonies; leaves long-stalked, 10–30cm long, biternate, or partially triternate, leaflets ovate-cordate, 3-lobed; flowers in open panicles, nodding, sepals and petals reflexed, the latter white, 5–8mm long, early summer. Culture as for *Epimedium*.

Below: *Vancouveria hexandra*

× Venidio-arctotis

(hybrids between species of *Venidium* and *Arctotis*). COMPOSITAE. A group of cultivars derived from crossing *Arctotis breviscapa* and *A. grandis* with *Venidium fastuosum*, blending the parental characters in various ways. They are erect, well-branched plants to 50cm tall with oblong-lanceolate, lobed leaves, white-felted beneath, and a profusion of 6·5–7·5cm wide, daisy-like flowers in summer and autumn. The following cultivars are sometimes available: × *V.-a.* Aurora, chestnut-bronze; × *V.-a.* Bacchus, wine-purple; × *V.-a.* China Rose, rose-pink; × *V.-a.* Sunshine, buff-yellow with crimson zone; × *V.-a.* Tangerine, orange-yellow; × *V.-a.* Terra-cotta, rich brownish-red. The plants are sterile and half-hardy and must be over-wintered in a frost-free greenhouse. Grow in fertile, well-drained soil in sun. Plant early summer or when fear

orange, yellow, ivory, cream and white. Grow in moderately fertile soil in sun. Sow seed under glass in spring at 16–18°C; prick off seedlings when first true leaf shows, either at 5cm apart each way in boxes, or singly into 7·5–9cm pots of a good commercial potting mixture. Harden off and plant out during early summer or when any possibility of frost has passed.

Venus's looking glass – see *Legousia speculum-veneris.*

Veratrum

(Latin vernacular, from *vere*, truly, and *ater* or *atratum*, black or darkened, from the poisonous black roots). False hellebore or helleborine.

of frost has passed. Propagate by cuttings late summer or spring, bottom heat 16–18°C.

Venidium

(Latin *vena*, a vein – alluding to the ribbed fruit, or seed). COMPOSITAE. A genus of 20–30 species of half-hardy perennials and annuals from S.Africa, 1 of which is usually available: *V. fastuosum*, monarch of the veldt; annual; 60–90cm tall; branched from the base; leaves 10–15cm long, irregularly pinnately lobed, grey-hairy; flowers solitary, 10–15cm wide, rays golden-yellow to bright orange with purple-brown basal blotch, summer to autumn, only opening in sunshine. A so-called hybrid strain, *V.f.* Art Shades, is available with flowers in shades of

LILIACEAE. A genus of 25 species of mainly robust herbaceous perennials from the northern temperate zone. They are shortly rhizomatous, clump-forming, with alternate or whorled, boldly ribbed and pleated, ovate to lanceolate leaves, and generally large, dense panicles of small, 6-tepalled flowers in summer. Grow in moisture-retentive, humus-rich soil in sun or partial shade. Plant autumn to spring. Propagate from seed in spring, which takes several years to flower, or by careful division in late winter.
Species cultivated: *V. album*, white false hellebore; Europe, temperate Asia; to 2m tall; basal leaves to 30cm long, oblong to elliptic, stem leaves many, smaller, in whorls of 3, hairy beneath; flowers 1·5cm wide, palest green, almost white within, in panicles 30–60cm long. *V. nigrum*, black false hellebore; C. and S.E.Europe, N.Asia; 1·2–2m tall; basal leaves to 30cm long, broadly elliptic, stem leaves few, smaller and narrower, smooth beneath; flowers 1cm wide,

Far left above : × *Venidio-arctotis* China Rose
Far left below: *Venidium fastuosum*
Above and top : *Veratrum album* in flower and spring foliage

maroon. *V. viride*, Indian poke, American white hellebore; E. N.America; 1·2–2m tall; basal leaves 20–30cm long, elliptic to ovate, stem leaves many, smaller; flowers 2–2·5cm wide, yellow-green, in panicles 30–60cm long.

Verbascum

(Latin vernacular name for mullein). Mullein. SCROPHULARIACEAE. A genus of 250–360 species, depending on botanical authority, of biennials, perennials and sub-shrubs from Europe and Asia, mainly Mediterranean, several species naturalized world-wide. The biennials and perennials are

rosette-forming, the latter developing into clumps, with ovate to lanceolate, usually hairy leaves and long, simple or branched flowering spikes or racemes. The sub-shrubs are twiggy, with smaller alternate leaves and short racemes. Flowers rotate with 5 broad lobes and woolly stamen filaments mainly in summer. Grow in any well-drained soil in sun. Plant perennials and sub-shrubs autumn or spring. Propagate all species from seed in spring, perennials by division and sub-shrubs, cuttings of roots in late winter or basal non-flowering shoots in late summer. Biennials may be sown *in situ* or grown on in nursery rows and planted in permanent sites in autumn.

Species cultivated: *V. arcturus* (*Celsia a.*), Crete; sub-shrub 30–70cm tall; lower leaves 8–15cm long, lyrate, terminal lobe ovate-oblong, upper leaves smaller; flowers 2·5–3cm wide, yellow, anthers violet woolly; not reliably **hardy** and needs sheltered site

and cloche protection in all but the mildest areas; makes an effective plant for the cool greenhouse. *V. bombyciferum* (*V. broussa* of gardens), Turkey; biennial to 2m tall; basal leaves to 40cm long, ovate to obovate, silky white-felted; flowers to 4cm wide, bright yellow. *V. broussa* of gardens, see *V. bombyciferum*. *V. chaixii* (also see *V. vernale*), S.C. and E.Europe including N.E.Spain; perennial 50–90cm tall; basal leaves 10–30cm long, ovate-oblong, crenate, sometimes slightly lobed at the base, grey hairy; flowers 1·5–2·2cm or more wide, yellow, anthers purple woolly. *V.c.* Album, flowers white. *V. densiflorum* (*V. thapsiforme*), Europe; biennial, to 1·5m tall; basal leaves to 30cm long, sometimes more, oblong-elliptic, stem leaves smaller, long decurrent, yellow to white woolly; flowers 2·5–5cm wide, yellow. *V. dumulosum*, S.W.Turkey; sub-shrub 15–30cm tall; leaves elliptic to oblong, woolly; flowers to 2·5cm wide, lemon-yellow,

long, ovate, usually dark green above; flowers 2·5–3·5cm wide, shades of purple, rarely yellow; many cultivars are recorded, some of hybrid origin, the following available: *V.p.* Bridal Bouquet, white; *V.p.* Cotswold Beauty, biscuit, anthers lilac woolly; *V.p.* Cotswold Queen, terracotta; *V.p.* Gainsborough, primrose-yellow, to 1·35m tall; *V.p.* Hartleyi, biscuit-yellow, suffused plum-purple. *V. thapsiforme*, see *V. densiflorum*. *V. thapsus*, common mullein, flannel plant; Europe, Asia; biennial 1·2–2m tall; basal leaves 20–50cm long, elliptic to oblong-obovate, grey or white woolly; flowers 2–3·5cm wide, yellow. *V. vernale* of gardens, botanically a synonym of *V. chaixii* and other species but distinct as a garden plant; perennial to 2m tall; stem freely branching; leaves to 30cm or more long; flowers vivid yellow.

Verbena

(old Latin name for vervain – *V. officinalis* – a herb credited with medicinal and magical properties). VERBENACEAE. A genus of about 250 species of annuals, perennials, sub-shrubs and shrubs mainly from N. and S.America, a few in Europe, Asia. They are prostrate to erect, with opposite pairs or whorls of 3, linear to ovate, usually toothed or lobed leaves, and terminal spikes, corymbs or panicles of small, tubular, 5-lobed, somewhat 2-lipped flowers. Grow in fertile, well-drained soil in sun, half-hardy sorts planted out as soon as fear of frost has passed and either over-wintered under glass or discarded and grown annually from seed. Plant hardy species in spring. Propagate from seed in spring under glass, half-hardy sorts at 18–20°C; hardy species also by division in spring; all species by cuttings late spring or late summer.

Species cultivated: *V. aubletia*, see *V. canadensis. V.*

Above: *Verbascum phoeniceum* Gainsborough
Left: *Verbascum bombyciferum*
Top right: *Verbascum* × Letitia
Above right: *Verbascum vernale*

anthers purple woolly; not fully hardy and needs sheltered, sunny site; makes an excellent alpine house plant. *V.* × Letitia (*V. dumulosum* × *V. spinosum*), sub-shrub to 25cm tall and wide, intermediate between parents; leaves oblong-lanceolate, to 5cm long, silvery-white woolly; flowers 2·5cm wide, bright yellow, freely produced; hardier than *V. dumulosum* but needs a sheltered site. *V. olympicum* of gardens, reputedly from Greece; biennial or perennial 1·5–2·5m tall; basal leaves to 30cm or more long, lanceolate, white woolly; flowers 2·5–3cm wide, bright rich yellow. *V. phoeniceum*, purple mullein; E.C. and S.E.Europe, Asia; perennial 90–120cm tall; basal leaves to 18cm

Top: *Verbena tenera* Mahonettii
Above: *Verbena rigida*
Top right: *Verbena peruviana*
Above right: *Verbena × hybrida* Sparkle

bonariensis, Brazil, Paraguay, Argentina; perennial, hardy or almost so, 1–1·5m tall; stems 4-angled; leaves 4–10cm long, oblong-lanceolate, rugose, dark green; flowers 3mm wide, lavender-blue in several short dense spikes forming head-like clusters, summer to autumn. *V. canadensis* (*V. aubletia*), rose verbena; E. N.America west to Colorado and Mexico; hardy perennial to 45cm tall; stems decumbent or ascending; leaves 3–9cm long, ovate-oblong, pinnately lobed or cleft; flowers about 1·5cm wide, red-purple to lilac, pink or white; several cultivars are available. *V. chamaedrifolia* and *V. chamaedryoides*, see *V. peruviana*. *V. corymbosa*, Chile; hardy perennial much like *V. rigida*, but to 90cm tall and with leaves having 2 small, often toothed, basal lobes. *V. × hortensis*, see next entry. *V. × hybrida*, garden or florists' verbena; exact origin unknown but probably *V. peruviana* is the primary parent crossed with the more tender and seldom grown *V. incisa*, *V. phlogiflora* and *V. platensis*; tender perennial usually grown as a half-hardy annual; stems procumbent to ascending, 20–30cm tall; leaves 5–10cm long, oblong-lanceolate to ovate, usually with lobe-like teeth; flowers 1–2cm wide, in dense, head-like spikes, scarlet, purple, lavender, creamy-yellow and white, fragrant, summer to autumn; several mixed strains and single-colour cultivars are available, eg *V. × h.* Amethyst, mid blue; *V. × h.* Blaze, bright scarlet; *V. × h.* Delight, coral-pink; *V. × h.* Sparkle, scarlet with white eye; *V. × h.* White Ball, pure white. *V. peruviana* (*V. chamaedrifolia* and *V. chamaedryoides* of gardens), S.Brazil to Argentina; half-hardy perennial usually grown as an annual; stems prostrate, tips ascending to 10cm tall; leaves to 5cm long, oblong-lanceolate to ovate; flowers 1cm wide in head-like spikes, bright scarlet, summer to autumn; can be over-wintered outside in mild

areas or under a cloche. *V. pulchella*, see *V. tenera*. *V. rigida* (*V. venosa*), S.Brazil to Argentina; almost hardy, erect tuberous-rooted perennial 30–60cm tall; leaves 5–7·5cm long, oblong, rigid and harsh-textured; flowers 5mm wide in dense spikes, purple to magenta, usually borne in groups of 3, summer. *V. tenera* (*V. pulchella*), S.Brazil; mat-forming, almost hardy perennial to 15cm tall; leaves to 2·5cm long, usually trilobed, each lobe pinnatisect; flowers 1·5cm wide, rose-violet, in short, dense spikes, summer; usually represented in gardens as *V.t.* Mahonettii (*V. alpina* of gardens), having white-margined petals. *V. venosa*, see *V. rigida*.

Veronica

(for St Veronica). Speedwell. SCROPHULARIACEAE. A genus of about 300 species of annuals, perennials and sub-shrubs mainly from the northern temperate zone. For the shrubby species formerly included, see *Hebe* and *Parahebe*. They have opposite pairs of linear to ovate, sometimes lobed leaves, and axillary or terminal racemes or spikes of irregular flowers – the latter have tubular bases and basically 5 lobes often of varying sizes but frequently appearing as 4 owing to the fusion of the 2 upper ones. Grow the species described here in fertile, well-drained soil in sun, but see also species descriptions for special requirements. The genus also contains aquatic species, eg *V. beccabunga*, that require wet soil or shallow water over mud to thrive. Plant autumn to spring. Propagate by division at planting time or from seed in spring, the sub-shrubs and evergreen perennials also by cuttings in summer.

Species cultivated: *V. austriaca* (*V. latifolia*), Europe; clump-forming perennial 25–50cm tall; stems erect to ascending; leaves 2–5cm long, narrowly lanceolate to rounded in outline, pinnatisect or bipinnatisect; flowers 1–1·3cm wide, blue, in racemes from upper leaf-axils, early summer; a variable plant with several sub-species, usually represented in cultivation by: *V.a. teucrium* (*V.*

teucrium), 30–100cm tall; leaves to 7cm long, deeply toothed or cleft or merely crenate; flowers rich blue. *V.a.t.* Crater Lake Blue, 30cm tall, deep blue; *V. a.t.* Pavane, 60cm tall, pink; *V.a.t.* Shirley Blue, 20cm tall, brilliant blue; *V.a.t.* Trehane, 20cm tall, golden-green foliage, deep blue flowers. *V. balfouriana* of gardens, a confusing name, having been used for a hybrid *Hebe* and a more robust form or hybrid of *V. fruticans*. *V. beccabunga*, brooklime; Europe to Japan, N.Africa; aquatic evergreen perennial 20–30cm or more tall; stem creeping and rooting, decumbent; leaves 3–6cm long, elliptic-oblong; flowers 7–8mm wide, blue, in axillary racemes, early summer to autumn; does not need standing water but soil must be wet. *V. bombycina*, Lebanon; tufted, mat-forming perennial a few centimetres tall; leaves 3–4mm long, ovate to spathulate, silky white woolly; flowers about 5mm wide, pale blue or reddish, summer; needs a sheltered scree or an alpine house. *V. cinerea*, Turkey; mat-forming, evergreen perennial 10–15cm tall; leaves lanceolate to linear, margins inrolled, grey-white downy; flowers 5–7mm wide, pale blue, in spikes, summer. *V. exaltata*, see *V. longifolia exaltata*. *V. filiformis*, Turkey, Caucasus; densely mat-forming perennial spreading widely; leaves about 5mm long, rounded, crenate; flowers solitary from the crowded upper leaf-axils, 1–1·3cm wide, mauve-blue with darker stripes, spring to summer; although undeniably attractive, this species soon becomes an invasive weed of lawns and borders and its planting is not recommended. *V. fruticans* (*V. saxatilis*), rock speedwell; Greenland, Iceland, arctic Europe and mountains farther south; sub-shrubby, evergreen perennial to 15cm tall, usually much-branched; leaves 8–20mm long, obovate to narrowly oblong, entire or slightly crenate; flowers 1·1–1·5cm wide, deep blue with reddish centres, in short racemes, late summer. *V. fruticulosa*, higher mountains of W. and S.C.Europe; much like *V. fruticans* but a little smaller and with pink flowers 9–12mm wide. *V. gentianoides*, Crimea, Caucasus; rhizomatous perennial 30–40cm tall; leaves in tufts or rosettes, 3–8cm long, lanceolate to broadly obovate, dark green; flowers 1cm wide, palest blue with darker veins, in terminal racemes, early summer. *V.g. variegata*, leaves spashed white. *V. incana*, see *V. spicata incana*. *V. latifolia*, see *V austriaca*. *V. longifolia*, N.E. and C.Europe, Asia; herbaceous

Below: *Veronica longifolia* Foerster's Blue

(*V. incana*), 30cm tall, leaves silvery-white hairy, flowers deep blue; *V.s.* Red Fox, flowers crimson; *V.s.* Snow White, flowers pure white. *V. teucrium*, see *V. austriaca teucrium*. *V. virginica* (*Veronicastrum v.*), Culver's root, blackroot (USA); E.USA; herbaceous perennial 1·2–2m tall; stem erect, clump-forming; leaves in whorls of about 5, each to 15cm long, lanceolate, slender-pointed; flowers 3–4mm wide, palest blue or lilac-pink, late summer to autumn. *V.v.* Alba, like type, but with white flowers.

Veronicastrum – see *Veronica virginica*.
Vervain – see *Verbena*.

Viburnum

(old Latin name for *Viburnum lantana*, the wayfaring tree). CAPRIFOLIACEAE. A genus of about 200

species of evergreen and deciduous shrubs and occasionally small trees, mainly from N.Hemisphere but also S.America and Java. They have opposite pairs of lanceolate to orbicular leaves, and terminal, often flattish, umbel-like cymes or panicles of small, tubular, 5-lobed, mainly white flowers followed by often showy, berry-like, 1-

Above: *Viburnum lantana*
Below: *Viburnum davidii*

perennial 60–120cm tall; leaves 3–12cm long, lanceolate to narrowly so, doubly toothed, slender-pointed; flowers 6–8mm wide, lilac or blue, in long, terminal racemes, summer. *V.l. exaltata*, Siberia, 1·2m tall, leaves more deeply toothed, flowers clear pale blue, the most distinctive and graceful form of *V. longifolia*; *V.l.* Foerster's Blue, 60cm tall, flowers deep blue. *V. nummularia*, Pyrenees; mat-forming, woody-based perennial 5–10cm tall; leaves 4–5mm long, broadly elliptic to rounded; flowers 6mm wide,

Top left: *Veronica austriaca teucrium* Trehane
Above left: *Veronica cinerea*
Below left: *Veronica austriaca teucrium* Shirley Blue
Top: *Veronica virginica* Rosea
Above: *Veronica pectinata* Rosea

blue or pink, in short, head-like spikes, summer. *V. pectinata*, Turkey; mat-forming, to 5cm tall; leaves 1–2·5cm long, obovate to elliptic, deeply toothed, white hairy; flowers to 1cm wide, deep blue, in racemes. *V.p.* Rosea, flowers bright pink. *V. perfoliata*, digger speedwell; S.E.Australia; evergreen, almost sub-shrubby, rhizomatous perennial to 60cm or more tall; leaves 3–6·5cm long, sessile, each pair united at their bases; flowers about 1cm wide, blue-violet, in nodding-tipped racemes from upper leaf-axils, summer to autumn; classified by some authorities in *Parahebe* but not generally accepted. *V. prostrata* (*V. rupestris* of gardens), Europe; mat-forming perennial to 10cm tall; leaves 8–25mm long, narrowly oblong to ovate, downy; flowers 6–8mm wide, pale blue, in lateral racemes near stem tips, early summer. *V.p. scheereri*, W. and W.C.Europe, leaves narrowly oblong to lanceolate, sparsely shortly downy, flowers 8–14mm wide, deep bright blue – the commonest variety in cultivation. *V. rupestris* of gardens, see *V. prostrata*. *V. saturejoides*, Balkan Peninsula; mat-forming perennial 5–8cm tall; leaves 6–10mm long, oblanceolate to rounded, entire, somewhat fleshy, ciliate; flowers 7mm wide, bright blue, late spring to early summer. *V. saxatilis*, see *V. fruticans*. *V. selleri*, Japan; a diminutive, dark blue flowered *V. spicata* to 15cm tall. *V. spicata*, spiked speedwell; Europe, Asia; herbaceous perennial 30–60cm tall; stems erect; leaves 2–8cm long, lanceolate to ovate, crenate, more or less hairy; flowers 5–8mm wide, blue, in terminal spikes, late summer; a variable species in stature, hairiness, spike-length and colour. *V.s.* Barcarolle, 45cm tall, flowers rich pink; *V.s.* Blue Fox, 40cm tall, bright lavender-blue; *V.s. incana*

421

seeded drupes. Grow the hardy species described here in fertile, well-drained but not dry soil in sun or partial shade. Plant autumn to spring. Propagate from seed when ripe – in some species it takes 18 months to germinate – by layering in late winter or cuttings late summer, ideally with bottom heat of approximately 18°C.

Species cultivated: *V. americanum*, see *V. trilobum*. *V. betulifolium*, China; 3–4m tall, erect habit; leaves deciduous, 5–8cm long, ovate to rhombic, coarsely toothed; flowers 5mm wide, in flattened cymes, summer; fruit to 6mm long, almost translucent bright red, sometimes in abundance and then among the finest of berrying shrubs; ideally, several different individuals (not the same clone) should be planted together for cross-pollination. *V. × bodnantense* (*V. farreri × V. grandiflorum*), several hybrid cultivars blending the characters of the parents, generally like *V. farreri* but with larger flowers. *V. × b.* Dawn, leaves similar to *V. grandiflorum*, flowers white, tinted pink, very freely borne, autumn to spring; *V. × b.* Deben, flowers pink in bud, opening white. *V. buddleifolium*, China; 2–3m tall; leaves almost evergreen, 10–20cm long, lanceolate to obovate, pale green, downy above, grey-felted beneath; flowers 8mm wide, in clusters 7·5cm wide, summer; fruit ovoid, 8mm long, red, turning black. *V. × burkwoodii* (*V. carlesii × V. utile*), to 2m high, taller if trained on a wall; leaves evergreen or semi-evergreen, 4–10cm long, ovate, dark glossy green above, downy beneath; flowers 7–10mm wide, pink in bud, very fragrant, in flattish clusters to 9cm wide, late winter to spring; a good wall shrub; several similar clones are available, eg *V. × b.* Chenaultii, *V. × b.* Park Farm Hybrid. *V. × carlcephalum* (*V. carlesii × V. macrocephalum*), similar to the first

Left: *Viburnum plicatum*
Below left: *Viburnum opulus* Compactus
Below: *Viburnum carlesii* Aurora

parent, but more robust and with pink-tinted flowers in clusters to 13cm wide. *V. carlesii*, Korea; to 1·5m or more tall, rounded habit; leaves deciduous, 5–9cm long, ovate to elliptic, downy matt green above, greyish beneath, often colouring in autumn; flowers to 1cm wide, waxy white, pink in bud, strongly fragrant, in cymes to 7cm wide, spring. *V. cinnamomifolium*, China; to 3m or more tall; leaves evergreen, to 13cm long, elliptic-oblong, boldly veined, dark glossy green; flowers 5mm wide, in flattish clusters 10–15cm wide, summer; fruit ovoid, 5mm long, glossy blue-black; needs a sheltered site and thrives in partial shade. *V. davidii*, W.China; 1–1·5m tall, compact and wide-spreading, otherwise like *V. cinnamomifolium* but with bright blue fruit; some plants tend to be largely male or female and several clones should be planted together if a good crop of fruit is required. *V. farreri* (*V. fragrans*), N.China; shrub to 3m; leaves deciduous, 4–8cm long, elliptic to obovate, toothed, conspicuously veined, bronze-flushed when young; flowers to 1cm or more long, white or pink-flushed, fragrant, in small, panicled cymes, late autumn to spring. *V.f.* Candidissimum, flowers pure white; *V.f.* Nanum (*V.f.* Compactum), dwarf, dense habit, but not flowering very freely. *V. furcatum*, Japan, Korea; 3–4m tall; leaves deciduous, 9–15cm long, broadly ovate-cordate, crimson in autumn; fertile flowers 4–5mm wide in flat clusters to 10cm wide surrounded by several large, sterile flowers like those of a lacecap hydrangea, early summer; fruit 8mm long, red, finally black; needs shade and moist, acid soil to thrive. *V. grandiflorum* (*V. nervosum*), Himalaya; similar to *V. farreri*, but of more erect habit; leaves and flowers a little larger, the latter carmine in bud and often in nodding clusters, mainly late winter to spring. *V. henryi*, C.China;

Below: *Viburnum tinus*
Right: *Viburnum plicatum tomentosum* Pink Beauty

2–3m tall, of erect but open habit; leaves evergreen, 5–13cm long, narrowly elliptic to obovate, somewhat toothed and lustrous; flowers to 6mm wide in pyramidal panicles to 10cm long and wide, summer; fruit to 8mm long, bright red then black. *V. hupehense*, C.China; to 2m tall; leaves deciduous, 5–7·5cm long, broadly ov te, slender-pointed, coarsely toothed; flowers a out 5mm wide, in clusters to 5cm wide, early summer; fruit ovoid, 8–15mm long, orange-yellow to red. *V. × juddii* (*V. bitchiuense* × *V. carlesii*), much like latter parent but more vigorous and usually freer-flowering. *V. lantana*, wayfaring tree; Europe to Turkey and Caucasus, Algeria; 2–4m tall; leaves deciduous, 5–10cm long, elliptic, ovate to obovate, rugose above, densely downy beneath; flowers 6mm wide in dense cymes 6–10cm wide, early summer; fruit elliptic, flattened, 8mm long, red, finally black. *V. nervosum*, see *V. grandiflorum*. *V. opulus*, guelder rose; Europe, W. and N.Asia, Algeria; 2–4m tall; leaves 5–8cm long, 3–5 lobed, irregularly toothed, rather maple-like, usually turning red in autumn, leaf-stalks with disc-like glands; fertile flowers 6mm wide, in cymes 5–10cm wide, surrounded by several, much larger, sterile flowers, summer; fruit rounded, 8mm long, bright translucent red. *V.o.* Aureum, compact habit, leaves bright yellow, best in partial shade; *V.o.* Compactum, small, 1–1·5m tall, compact habit; *V.o.* Fructuluteo, fruit chrome-yellow, tinted pink; *V.o.* Notcutts, larger flowers and fruit than type; *V.o.* Roseum (*V. o.* Sterile), snowball tree, all flowers sterile, in mop-like heads becoming pink-tinged with age; *V.o.* Sterile, see *V.o.* Roseum; *V.o.* Xanthocarpum, fruit golden-yellow, translucent on maturity. *V. plicatum* (*V. tomentosum* Plicatum, *V.t. sterile*), Japanese snowball tree; China, Japan; to 3m or more tall, wide-spreading, horizontal branches creating a tiered effect; leaves deciduous, 5–10cm long, elliptic to ovate, more or less downy, usually colouring in autumn; flowers all sterile in globular heads, 5–7·5cm wide, early summer; long cultivated in China and Japan and described before the wild species was known to Western botanists. *V.p. tomentosum* (*V. tomentosum*), the original wild species, with flattened cymes of 5–6mm wide fertile flowers, surrounded by a few larger sterile ones; fruit small, red, then black. *V.p.t.* Lanarth, strong-growing with a less obviously tiered habit of growth; *V.p.t.* Mariesii, strongly tiered habit, very free-flowering; *V.p.t.* Pink Beauty, sterile flowers, mature pink; *V.p.t.* Rowallane, similar to *V.p.t.* Lanarth, but less vigorous and sterile flowers larger, more freely fruiting than other forms of *V.p. tomentosum*. *V. × rhytidophylloides* (*V. lantana* × *V. rhytidophyllum*), much like latter parent but more vigorous and often to 5m or more high and wide; leaves evergreen, broader and less rugose. *V. rhytidophyllum*, C. and W.China; 4–5m or more high and wide; leaves evergreen, 10–20cm long, oblong-elliptic, rugose and deep, lustrous green above, grey-felted beneath; flowers about 6mm wide, yellowish-white, in cymes to 15cm or more wide, early summer; fruit ovoid, 8mm long, red, then black. *V. tinus*, laurustinus; S.E.Europe; 3–5m tall, sometimes tree-like; leaves 4–9cm long, ovate-oblong, dark, somewhat glossy green; flowers 5–6mm wide, pink in bud, in flattened cymes 5–10cm wide, late autumn to spring, depending on mildness of winter; fruit ovoid, 6mm long, deep blue but usually rather hidden by the foliage. *V.t.* Eve Price, very dense habit, leaves smaller than type, flowers carmine in bud; *V.t. hirtulum* (*V.t. hirtum*), leaves larger, bristly hairy, less hardy than type; *V.t. lucidum*, larger glossier leaves than type, cymes wider, flowering in spring; *V.t.* Variegatum, leaves marked creamy-yellow. *V.*

Top right: *Viburnum opulus* Xanthocarpum
Above right: *Viburnum rhytidophyllum* unripe fruit
Right: *Viburnum × rhytidophylloides*
Above far right: *Vinca major*
Far right: *Vinca minor* Atropurpurea

tomentosum, see under *V. plicatum*. *V. trilobum* (*V. americanum*), cranberry bush, highbush cranberry, squawbush (USA); N. N.America; virtually identical to *V. opulus* but leaf-stalks with small glands. *V. utile*, C.China; 2m or more tall, open, graceful habit; leaves evergreen, 3–7·5cm long, narrowly ovate to oblong, glossy deep green above, white downy beneath; flowers 5–8mm wide, fragrant, in dense rounded clusters 7cm wide, early summer.

Vinca

(Latin *vincio*, to bind up – alluding to the use of the wiry stems in wreath-making). Periwinkle. APOCYNACEAE. A genus of 5 species of evergreen perennials or sub-shrubs from Europe, W.Asia, N.Africa. They have opposite pairs of lanceolate to elliptic or ovate, leathery, glossy leaves, tubular flowers with 5, somewhat asymmetrical lobes, solitary from the leaf-axils, and fruit of a pair of cylindrical capsules joined at the base. Grow in any well-drained soil in sun or shade. Plant autumn to spring. Propagate by division or separating rooted stems at planting, cuttings in cold frame late summer.

Vine – see *Vitis*.

Vine, Russian – see *Polygonum baldschuanicum*.

Viola

(Latin name for various fragrant flowers, including violets – used for this genus by Linnaeus). Pansy, violet. VIOLACEAE. A genus of 500 species of annuals, perennials and sub-shrubs of cosmopolitan distribution, but mainly the northern temperate zone and Andes. They are mostly clump-forming, sometimes stoloniferous, with cordate, linear to orbicular leaves, although some species are semi-climbers and many of the almost uncultivatable Andean species mimic houseleeks. The horizontally-borne or nodding flowers have 5 petals, the upper 2 often longer and erect, the lower 1 usually broader and with a nectary spur. Many species also produce tiny cleistogamic flowers that never open and produce seed by self-fertilization. From a gardener's point of view, the group of species and hybrids with flat-faced flowers and prominent, leafy, lobed stipules

Species cultivated: *V. acutifolia*, see next species. *V. difformis* (*V. acutifolia*), W.Mediterranean; much like *V. major* but completely hairless, with pale lilac-blue flowers having rhomboid lobes, autumn to early winter only; evergreen only in mild areas. *V. major*, greater periwinkle; C. and S.Europe, N.Africa; evergreen perennial, to 30cm or more tall; stems slender, ascending then arching over and trailing and rooting, soon forming mat-like colonies to 2m wide or so; leaves to 5cm long, ovate, sometimes heart-shaped, ciliate; flowers to 4cm wide, bright purple-blue, early spring to summer, sometimes later. *V.m.* Elegantissima, see *V.m.* Variegata; *V.m.* hirsuta, see next entry; *V.m. pubescens* (*V.m. hirsuta*), leaves narrower than type, downy, flowers with narrower, pointed, rich purple lobes; *V.m.* Variegata, leaves blotched and margined creamy-white. *V. minor*, lesser periwinkle, running myrtle; Europe, W.Asia; evergreen perennial; stems wiry, prostrate, mat-forming; leaves 2·5–4cm long, elliptic to ovate; flowers about 2·5cm wide, purple-blue, spring to summer, then off and on to autumn. *V.m.* Alba, flowers white; *V.m.* Atropurpurea, deep plum-purple; *V.m.* Azurea Flore Pleno, double blue; *V.m.* Bowles Variety (*V.m.* Bowlesii), flowers larger than type, blue; *V.m.* Multiplex, double, plum-purple; *V.m.* Variegata, leaves marked creamy-white, flowers as type.

are known as pansies. They are distinguished in the descriptions below by a (p) after the species' names. When ripe, the ovoid seed capsules split into 3 sections or valves. Each valve then folds upwards squeezing the smooth seeds, like an orange pip between thumb and forefinger, shooting them away to considerable distances. Grow in at least moderately humus-rich soil, well-drained but not dry, in partial shade or sun, the latter ideally for the pansies. Plant autumn to spring. Propagate from seed or by division in spring, or by basal cuttings late summer in a cold frame. For winter- and spring-flowering pansies, sow seed late summer in nursery rows or boxes and plant out the young plants into permanent sites in late autumn. For summer blooming, sow seed under glass in early spring at 13–16°C, setting out the young plants in flowering quarters late spring.

Species cultivated (all perennials): *V. aetolica* (*V. saxatilis a.*) (p), Balkan Peninsula; similar and allied to *V. tricolor*, but more prostrate and to 10cm tall;

Top left: *Vinca minor* Aureo-variegata Alba
Above left: *Vinca difformis*
Above: *Viola hederacea*
Top right: *Viola gracilis*
Above right: *Viola labradorica* Purpurea
Right: *Viola tricolor*

leaves about 2cm long, ovate to lanceolate, ciliate, greyish-green; flowers 1·5–2cm wide, bright yellow. *V. cornuta* (p), Pyrenees; rhizomatous and small clump-forming, to 15cm or more tall; stems ascending to decumbent; leaves 2–5cm long, ovate, crenate, hairy beneath; flowers 2–3cm or more wide, with slender spur 1–1·5cm long, fragrant, violet-purple to lilac, summer. *V.c.* Alba, flowers white; *V.c. minor*, plant smaller and neater than type, see also *V.* × *williamsii*. *V. cucculata*, E. N.America; deciduous, from thick fleshy rhizomes, 7–10cm tall; leaves 5–9cm wide, broadly ovate-cordate to kidney-shaped, crenate; flowers about 2cm wide, violet-purple, spring to summer. *V.c. albiflora*, white, confused with *V. sororia* in some gardens. *V. elatior*, Europe, W.Asia; deciduous, tufted or forming small clumps, 30–50cm tall; stems erect; leaves 4–7·5cm long, lanceolate to narrowly ovate, shortly hairy; flowers 2–2·5cm wide, pale blue, early summer. *V. gracilis* (p), Balkan Peninsula; mat-forming, 10–15cm tall; stems decumbent; leaves 2–3cm long, broadly ovate to oblong; flowers 2–3cm wide, yellow or violet; often represented in gardens by more robust forms or hybrids. *V.g.* Major, flowers deep purple; *V.g.* Moonlight, pale yellow. *V. hederacea*, ivy-leaf violet; S.E.Australia; stoloniferous, mat-forming, about 10cm tall; leaves 2·5–4cm wide, kidney-shaped, wavy, pale green; flowers well above leaves, to 2cm wide, petals violet-purple with white tips, mainly spring to summer, but

off and on all year; not winter-hardy in the colder areas but easily over-wintered with a cloche or in a frost-free greenhouse; makes a good pot plant for a cool room. *V.* × *hortensis*, see *V.* × *wittrockiana*, *V. labradorica*, N. N.America to Greenland; mat-forming to 10cm tall; leaves 1·5–3cm long, broadly ovate to orbicular, cordate; flowers 1–1·5cm wide, light purple-blue, spring. *V.l.* Purpurea, leaves suffused deep purple. *V. lyallii*, New Zealand; tufted, to 10cm or more tall; leaves 1–3cm long, broadly ovate to rounded, cordate; flowers 1–2cm wide, white, streaked lilac and yellow, summer. *V. odorata*, sweet violet; Europe, N.Africa, Asia; stoloniferous, mat-forming, to 10cm or more tall; leaves 4–7cm long, orbicular to kidney-shaped, cordate; flowers 1·5–2cm wide, violet-purple, fragrant, early spring to summer; a variable species and many cultivars have been recorded in shades of violet, purple and lilac, some much larger and double. *V.o.* Alba, flowers white; *V.o.* Coeur d'Alsace, carmine-pink; *V.o.* Czar, large deep violet-purple flowers; *V.o.* Sulphurea, apricot-yellow within, purple-tinted without. *V. papilionacea*, see *V. sororia p. V. pedata*, bird's foot or pansy violet; E.USA; tufted or small clump-forming, to 15 cm tall; leaves 5–10cm long, palmately cleft into 3–5 lobes, each lobe again divided; flowers to 3cm wide with broad, flat lobes, entirely lilac-purple or with upper lobes much darker, stamens orange, spring to summer; best in free draining soil in a sunny site.

V. riviniana, common dog violet; Europe including Iceland, N.Africa, Madeira; tufted, producing colonies from sucker shoots, to 15cm tall, usually less; leaves 2–8cm long, ovate-orbicular, cordate; flowers 1·5–2cm wide, blue-violet, spring to summer; confused with *V. odorata*, but flowers scentless and plant lacking stolons. *V. rupestris*, N. Hemisphere; 2–4cm tall; leaves 5–10mm long; flowers 1–1·5cm wide, pale blue-purple, early summer; pink, white and reddish-purple flowered forms are known; much like a diminutive *V. riviniana*. *V. saxatilis aetolica*, see *V. aetolica. V. septentrionalis*, N.E. N.America; similar to *V. sororia* but smaller, the leaves generally narrower and more prominently toothed; flowers deep violet-purple to lilac or white, all petals downy. *V. sororia* (*V. papilionacea*), E. N.America; deciduous, from thick fleshy rhizomes, to 10cm tall; leaves broadly ovate, wider than long, toothed, softly hairy beneath; flowers to 3cm wide, rich violet with white eye, sometimes light blue or reddish, late spring to summer. *V.s.* Albiflora, white with blue-purple

wittrockiana (*V.* × *hortensis*), garden pansy; a varied group of cultivars and strains of the familiar pansy, derived from crossing *V. lutea*, *V. tricolor* and *V. altaica*; short-lived perennials much like *V. tricolor*, but more robust and having larger flowers 4–12cm across in a wide range of colours usually with a black mask-like blotch in the centre; among the many cultivars and strains offered by seedsmen the following are recommended – Hiemalis or winter-flowering: *V.* × *w.* Celestial Queen, light blue; *V.* × *w.* Claret, wine-red; *V.* × *w.* Helios, golden-yellow; *V.* × *w.* Ice King, white with dark eye; *V.* × *w.* Mars, deep blue; *V.* × *w.* Winter Sun, yellow with dark eye. Spring to early summer flowering: *V.* × *w.* Azure Blue, bright blue; *V.* × *w.* Majestic Giants, mixed colours, including red, yellow, blue, white; *V.* × *w.* Sunny Boy, golden-yellow, black blotch. Summer-flowering: *V.* × *w.* Clear Crystals, mixed self-colours; *V.* × *w.* Engelman's Giant, mixed; *V.* × *w.* Roggli Swiss Giants, as a mixture or named single colour shades, eg *V.* × *w.* Berna, deep violet; *V.* × *w.* Brunig, mahogany-red; *V.* × *w.* Jungfrau, creamy-white; *V.* × *w.* Monch, yellow; see also *V.* × *williamsii*. *V. yakusimana*, see *V. verecunda y.*

Violet – see *Viola*.

Virginia creeper – see *Parthenocissus*.

Virginian stock – see *Malcolmia maritima*.

Virgin's bower – see *Clematis viticella*.

Viscaria alpina, V. vulgaris – see *Lychnis*.

Viscaria elegans – see *Silene coeli-rosa*.

Vitaliana – see *Douglasia*.

Vitex

(Latin name for the chaste tree). VERBENACEAE. A genus of 250 species of shrubs and trees mainly from tropical to warm temperate regions. 1 species is usually available: *V. agnus-castus*, chaste or hemp tree; S.Europe; aromatic shrub or small tree 3–6m tall, of spreading habit; leaves in opposite pairs, digitate, leaflets 5–7, lanceolate to elliptic, 5–12cm long, grey downy beneath; flowers to 8mm long, tubular, 5-lobed and somewhat 2-lipped, pale violet, fragrant, in terminal racemes to 18cm long, late summer to autumn. *V. a.-c.* Alba, flowers white; *V.a.-c.* Latifolia, more vigorous, with broader leaflets. Grow in moderately fertile, well-drained soil in sun, preferably against a south wall. Plant autumn or spring. Propagate by cuttings late summer, bottom heat 18–21°C.

Vitis

(Latin name for grape vine). VITIDACEAE (VITACEAE). A genus of 60–70 woody climbers from N.Hemisphere. They have branched, modified stem tendrils that may twine or produce sucker-like tips, alternate, generally palmate leaves, small, insignificant flowers with petals that fall as a cap on opening, and edible berry-fruit. Grow in humus-rich, moisture-retentive but well-drained soil in sun or partial shade. Plant autumn to spring. Propagate from seed when ripe in a cold frame, or by eye cuttings in late winter or hardwood cuttings *in situ* in autumn.
Species cultivated: *V. aconitifolia*, see *Ampelopsis a. V.* × Brant (*V. vinifera* Brant), (*V. labrusca* × *V. riparia* × *V. vinifera*), similar to *V. vinifera* but

Top right: *Vitis vinifera* Purpurea
Centre right: *Vitis* × Brant autumn colour
Right: *Vitis coignetiae* autumn colour

Top: *Viola cornuta* Alba
Above: *Viola* × *wittrockiana* Jungfrau

veining and suffusion in the centre, confused with *V. cucculata albiflora* in gardens; *V.s. papilionacea* (*V. papilionacea*), leaves hairless. *V. tricolor* (p), heartsease, wild pansy; Europe, Asia; annual or short-lived tufted perennial; to 15cm or more tall; stems ascending to decumbent; leaves to 5cm long, ovate to lanceolate, crenate but sometimes cordate; flowers 1–2.5cm or more wide, blue-violet or yellow, often bi-coloured, spring to autumn; most cultivars listed under this name belong to *V.* × *wittrockiana*. *V.t.* Bowles Black, flowers black-purple. *V. verecunda yakusimana* (*V. yakusimana*), Yakushima, Japan; tufted, 2–3cm tall; leaves to 6mm long, reniform, cordate, shallowly toothed; flowers 7–8mm wide, white, lower lobes purple-veined, early summer; the tiniest violet. *V.* × *williamsii* (p), group name covering the several sorts of tufted pansies or so-called garden or bedding violas, derived from crossing *V.* × *wittrockiana* and *V. cornuta*; habit of latter parent and sound perennials but with round, pansy-like flowers usually in self colours; normally propagated by division or summer cuttings; cultivars available include: *V.* × *w.* Admiration, deep blue-purple; *V.* × *w.* Irish Molly, copper-yellow; *V.* × *w.* Maggie Mott, silvery-mauve; *V.* × *w.* Norah Leigh, lavender-blue; *V.* × *w.* Primrose Dame, light yellow; *V.* × *w.* White Swan, pure white. *V.* ×

robust, the deeply 3–5 lobed leaves turning shades of dark red to purple with yellow veins in autumn; fruit like that of a small black common grape, having a sweet, somewhat aromatic flavour. *V. brevipedunculata*, see *Ampelopsis b. V. capensis*, see *Rhoicissus c. V. coignetiae,* crimson glory vine; Japan, Korea, Sakhalin; to 20m or more high; leaves to 30cm long, orbicular-cordate, sometimes shallowly lobed, grey to rusty-downy beneath, turning to shades of crimson and scarlet in autumn; berries about 1cm long, black with a glaucous bloom, barely edible. *V. elegans*, see *Ampelopsis brevipedunculata* Elegans. *V. henryana*, see *Parthenocissus h. V. heterophylla*, see *Ampelopsis brevipedunculata. V. inconstans*, see *Parthenocissus tricuspidata. V. quinquefolia*, see *Parthenocissus q. V.vinifera*, grape vine; in addition to the fruiting cultivars of this species there are several with ornamental foliage: *V.v.* Apiifolia (*V.v.* Laciniosa), parsley vine, leaves deeply dissected; *V.v.* Brant, see *V.* × Brant; *V.v.* Purpurea, Teinturier grape, leaves claret-red when young, ageing red-purple.

Wahlenbergia

(for George Wahlenberg, 1780–1851, Swedish botanist and professor at Uppsala). CAMPANULACEAE. A genus of about 150 species of annuals, perennials and sub-shrubs of wide distribution but mainly temperate S. Hemisphere. They have the same basic characters as *Campanula*, differing only in the way the seed capsules open by pores at the top within the persistent sepals (in *Campanula* they open at the base or sides beneath the sepals). Culture as for *Campanula*.
Species cultivated: *W. albomarginata*, New Zealand bluebell; S.Island, New Zealand; rhizomatous, tufted perennial forming mat-like colonies to 10cm tall or more; leaves 1–3cm or more long, elliptic to lanceolate or spathulate; flowers usually solitary, nodding, 1·5–2·5cm wide, pale blue to white; a variable species and growing longer in rich soil. *W. congesta* (*W. saxicola c.*), New Zealand; rhizomatous perennial forming low, dense mats to 10cm or more wide by 5cm high; leaves 8–25mm long, rounded to oblong or elliptic-spathulate, glossy; flowers solitary, to 1·2cm wide, pale blue or white, summer. *W. graminifolius*, see *Edraianthus g. W. pumilio*, see *Edraianthus p. W. saxicola congesta*, see *W. congesta. W. serpyllifolius*, see *Edraianthus s.*

Wake-robin – see *Trillium*.

Waldsteinia

(for Count Franz Adam Waldstein-Wartenburg, 1759–1823, Austrian botanist and author). ROSACEAE. A genus of 5–6 species of mat-forming perennials, akin to *Potentilla* and *Fragaria*, and from the northern temperate zone, 1 of of which is generally available: *W. ternata*, C.Europe to Siberia and Japan; evergreen; forming mats to 1m or so wide by 10cm tall; leaves trifoliate, leaflets 1–3cm long, ovate, irregularly toothed; flowers in stalked clusters of 2–7, 5-petalled, to 2cm wide, yellow, spring to early summer; a good ground cover plant for sun or shade. Grow in any well-drained but not dry soil. Plant autumn to spring. Propagate by division at planting time.

Wallflower – see *Cheiranthus cheiri*.

Wall-rue – see *Asplenium ruta-muraria*.

Walnut – see *Juglans*.

Wand flower – see *Dierama*.

Water avens – see *Geum rivale*.

Water crowfoot – see *Ranunculus aquatilis*.

Water fern – see *Azolla*.

Water hawthorn – see *Aponogeton*.

Water milfoil – see *Myriophyllum*.

Water plantain – see *Alisma*.

Water soldier – see *Stratiotes*.

Water-lily – see *Nuphar* and *Nymphaea*.

Watsonia

(for Sir William Watson, 1715–87, British physician and scientist). Bugle lily. IRIDACEAE. A genus of 60–70 species of cormous perennials mainly from S.Africa. They are clump-forming, each corm producing a fan of sword-shaped leaves and a slender spike, sometimes branched, of 6-lobed flowers, each with a slender curved tube. Grow in moderately fertile, well-drained soil in sun. The species described here are half-hardy and outside need warm areas and with some protection in winter where frost is slight. In cold areas they are best in a frost-free greenhouse in either a border, or large pots of a good commercial potting mixture. Plant or pot in spring, or the deciduous species in late summer. Propagate by division of clumps at potting or planting time, or from seed under glass in spring, growing on in pots for the first year until good-sized corms have formed.
Species cultivated: *W. ardernei*, 1–1·5m tall; leaves deciduous, 60cm long; spikes branched, flowers about 4cm long, white, early summer. *W. beatricis*, 1–1·2m tall; leaves evergreen, 60–75cm long; flowers 5cm long, orange-red, late summer to autumn. *W. marginata*, 1–1·5m tall; leaves deciduous, to 75cm long; flowers 3–4·5cm long, rose-pink, fragrant, early summer. *W. versfeldii*, to 1·5m tall; leaves deciduous, to 90cm long; flowers to 5cm or more long, rose, early summer.

Wayfaring tree – see *Viburnum lantana*.

Top: *Waldsteinia ternata*
Below left: *Watsonia ardernii*
Below: *Watsonia beatricis*

Weigela

(for Christian Ehrenfried Weigel, 1748–1831, German professor of botany). CAPRIFOLIACEAE. A genus of 10–12 species of deciduous shrubs from E.Asia. They have opposite pairs of elliptic to ovate leaves and small, lateral clusters of funnel-shaped, 5-lobed flowers in early summer. Grow in any moderately fertile soil that does not dry out, preferably in sun, although partial shade is tolerated. Plant autumn to spring. More shapely and floriferous specimens can be had by annually removing the flowered stems once the last blossom has faded, cutting back to a healthy shoot below the lowest truss of faded or fallen flowers. Propagation by semi-hardwood cuttings in late summer, by hardwood cuttings outside in autumn, or from seed in spring, the latter not coming true to type from cultivars.

Species cultivated: *W. florida* (*W. rosea*, *Diervilla f.*, *Diervilla r.*), N.China, Korea; 2–3m tall if not regularly pruned; leaves 5–10cm long, ovate-oblong to obovate, acuminate; flowers 3cm long, rose-pink without, paler within; several cultivars are available, some of them probably of hybrid origin with the allied, hairy-leaved *W. floribunda*: *W.* Abel Carrière, flowers large, rose-carmine; *W.* Avalanche, white; *W.* Bristol Ruby, erect habit, flowers ruby-red; *W.*

Conquête, flowers to 5cm long, deep rose-pink; *W.* Eva Rathke, bright crimson, long-flowering; *W.* Fleur de Mai, flowers salmon-rose within, marbled rose-purple without; *W.* Foliis Purpureis, leaves purple-flushed, flowers pink; *W.* Looymansii Aurea, leaves yellow, flowers pink; *W.* Newport Red, like *W.* Eva Rathke, but more erect habit and larger, brighter red flowers; *W.* Variegata, compact habit, leaves margined creamy-white, flowers pink. *W. middendorffiana*, N.China, Japan; to 1·5m tall; leaves 5–8cm long; ovate; flowers about 3cm long, almost bell-shaped, sulphur-yellow with dark orange markings on lower lobes; thrives best in a sheltered, partially shaded position. *W. rosea*, see *W. florida*.

Wellingtonia – see *Sequoiadendron*.

Whitebeam – see *Sorbus aria*.

Whortleberry – see *Vaccinium myrtillus*.

Willow – see *Salix*.

Willow herb – see *Epilobium*.

Wineberry – see *Rubus*.

Winter cherry – see *Physalis alkekengi*.

Winter heliotrope – see *Petasites fragrans*.

Wintergreen – see *Gaultheria procumbens*.

Winter's bark – see *Drimys winteri*.

Wintersweet – see *Chimonanthus*.

Wisteria

(*Wistaria*). (for Caspar Wistar, 1761–1818, professor of anatomy at the University of Pennsylvania, USA). LEGUMINOSAE. A genus of 9–10 species of woody climbers from E.Asia and E.USA. They have alternate pinnate leaves, and pendant racemes of often fragrant pea-flowers, sometimes followed by quite large, bean-shaped pods that explode when ripe. Grow in humus-rich, well-drained but moisture-retentive soil in sun, providing support for the vigorous twining stems. Plant autumn or spring. Propagate from seed under glass and by layering in spring, or by cuttings late summer – bottom heat about 18°C. Plants may be allowed to grow

Below left: *Weigela* Variegata
Bottom left: *Weigela* Newport Red
Below: *Weigela florida*

naturally if there is adequate space; however, they are amenable to pruning – ideally all young twining stems should be cut back to 2–3 basal leaves during late summer, with the same treatment being afforded to any stems that grow subsequently in winter.

Species cultivated: *W. brachybotrys*, see next species. *W. floribunda* (*W. brachybotrys*), Japan; stems to 10m or more long; leaflets 13–19, ovate, 3–8cm long, racemes 13–25cm long; flowers to 2cm long, violet to purple-blue, summer. *W.f.* Alba (*W. multijuga* Alba), flowers white, tinted lilac; *W.f.* Macrobotrys (*W. multijuga*), racemes 30–90cm long, sometimes more, flowers lilac, tinted blue-purple. *W. multijuga*, see *W. floribunda* Macrobotrys and *W.floribunda* Alba. *W. sinensis*, China; stems 18–20m long; leaflets 9–13, elliptic to oblong, 4–7·5cm long; racemes 20–30cm long, flowers about 2·5cm long, mauve to deep lilac, opening just before or with young leaves, late spring to early summer. *W.s.* Alba, flowers white; *W. s.* Black Dragon, double, deep purple; *W.s.* Plena, double, rosetted, lilac.

Witch hazel – see *Hamamelis*.

Wolf's bane – see *Aconitum vulparia*.

Wood anemone – see *Anemone nemorosa*.

Wood lily – see *Trillium*.

Wood sorrel – see *Oxalis acetosella*.

Woodbine – see *Lonicera periclymenum*.

Woodwardia

(for Thomas Jenkinson Woodward, 1745–1820, British botanist). Chain fern. BLECHNACEAE (POLYPODIACEAE). A genus of about 12 species of ferns, mainly from the N.Hemisphere, 1 of which is usually available: *W. virginica*, N.America; rootstock a far-creeping robust rhizome; fronds solitary along the rhizome or in small clusters, to 1m or more tall with blades to 60cm long, pinnate, the pinnae narrowly oblong, deeply and regularly lobed; sori in 2 chain-like rows along the middle of each lobe. Grow in humus-rich, moisture-retentive or wet soil in partial shade; thrives well in the bog garden and even in shallow water at the edge of a pond. Plant autumn or spring. Propagate by division in spring.

Below: *Wisteria floribunda* Alba
Right: *Woodwardia radicans*
Below right: *Wisteria sinensis*
Bottom right: *Wisteria floribunda* Macrobotrys

Xeranthemum

(Greek *xeros*, dry, and *anthos*, a flower – alluding to the petal-like involucral bracts that surround the flower-heads). COMPOSITAE. A genus of 6 species of annuals from the Mediterranean to S.W.Asia, 1 of which is usually available: *X. annuum*, immortelle; S.E. and E. C.Europe; erect annual, branching from the base, to 60cm tall; leaves 2–6cm long, linear to oblong, densely white downy beneath, more sparsely above; flower-heads solitary, 3–5cm wide, the petal-like bracts spreading, bright pink, lilac, purple and white, florets all tubular, purple or white, summer; a useful everlasting, keeping its colour well if cut and dried when in full bloom. *X.a.* Ligulosum (*X. imperiale*, *X. superbissimum*), flower-heads double to semi-double. Grow in fertile, well-drained soil in sun. Sow seed *in situ* in spring.

Yarrow – see *Achillea millefolium.*

Yellow archangel – see *Lamiastrum galeobdolon.*

Yew – see *Taxus.*

Youth and age – see *Zinnia elegans.*

Yucca

(from the Carib Indian name for manihot or cassava, a member of the spurge family EUPHORBIACEAE, unfortunately chosen for this genus by Linnaeus). Adam's needle, Spanish bayonet. AGAVACEAE (LILIACEAE). A genus of about 40 species of evergreen trees and shrubs from S.USA, Mexico and W.Indies. They may be stemless, or almost so, or have erect, robust stems, sometimes sparingly branched, bearing terminal rosettes of linear, pointed leaves and large panicles of 6-tepalled, bell-shaped, white to cream flowers. In the wild the flowers are uniquely pollinated by the small *Pronuba* moth that gathers a ball of pollen from 1 flower, flies to another, lays eggs in the ovary, and then presses the pollen onto the stigma. The moth larvae feed on some of the developing seed, but there are plenty left to mature. Grow the hardy species mentioned here in well-drained soil in sunny, preferably sheltered sites. Plant autumn or spring. Propagate from seed when available, under glass, or by separating suckers in spring.
Species cultivated: *Y. filamentosa*, S.E.USA; almost stemless, forming clumps, 2–5m tall in bloom; leaves 35–75cm long, oblong-lanceolate to oblanceolate, slightly glaucous, with numerous margined curly threads; flowers white, 5cm long, late summer; confused with *Y. flaccida* and the narrower-leaved

Top far left: *Xeranthemum annuum*
Top: *Yucca glauca*
Left: *Yucca recurvifolia*
Above: *Yucca filamentosa* Variegata

Y. smalliana. Y. flaccida, S.E. USA; much like *Y. filamentosa*, but with less rigid, more-tapered leaves having straight, marginal threads. *Y. glauca*, S.Dakota to N.Mexico, USA; clump-forming, to

1m tall in bloom; leaves to 60cm or more long by 1–1·5cm wide, linear, margins white with a few threads; flowers to 6·5cm long, greenish-cream, often tinged red-brown, summer. *Y. gloriosa*, Spanish dagger, palm lily (USA); to 2m or more tall; leaves to 75cm long, rigid, dark green; panicles 1–2m tall, flowers 6–10cm long, white, often tinged red, late summer to autumn. *Y. recurvifolia*, S.E.USA; similar habit to *Y. gloriosa*, but leaves softer, recurved; panicles looser and more branched. *Y.r.* Variegata, leaves with central yellow stripe.

Zantedeschia

(*Richardia*). (for Francesco Zantedeschi, born 1797, Italian botanist). Calla lily (USA), arum lily. ARACEAE. A genus of about 6 species of rhizomatous perennials from tropical to S.Africa. They have short, thick, fleshy, tuber-like rhizomes, tufts of long-stalked, sagittate to lanceolate leaves, and small, petalless flowers in spadices surrounded by broad, often coloured and showy spathes in

aethiopica is best kept just moist at all times, but the other species should be dried off once the leaves start to yellow after flowering. Propagation by offsets separated at potting time, or from seed in spring at 16–18°C.

Species cultivated: *Z. aethiopica* (*Z. africana* and *Richardia a.*), common calla or arum lily; S.Africa, naturalized in many frost-free areas of the world; to 1m tall; leafy blades sagittate, 25–45cm long, lustrous deep green; spathes 13–25cm long, white to creamy, surrounding bright yellow spadix; as a pot plant, best stood outside in summer; may be grown outside in sheltered moist sites, mounded over with peat, sand, pulverized bark, in late autumn; also thrives in water to 30cm deep, and in such situations survives moderate frost. *Z.a.* Crowborough, more compact-growing than type and reputedly hardier. *Z. albomaculata* (*Richardia a.* and *Z. melanoleuca*), S.Africa to Zambia; to 60cm tall; leaf-blades 20–45cm long, narrowly triangular, translucent white-spotted; spathes to 10cm or more long, whitish to pale yellow, red-purple at base within, rarely pink. *Z. elliottiana* (*Richardia e.*), golden or

varying from bright pink to violet-red. Hybrids between this and other species are sometimes offered.

Zanthoxylum

(*Xanthoxylum*). (Greek *xanthos*, yellow, and *xylon*, wood – referring to the colour of the heart wood of some species). Prickly ash. RUTACEAE. A genus of about 200 species of deciduous and evergreen trees with pinnate leaves, from N. and S.America, Africa, Asia and Australia, 1 of which is usually available: *Z. americana*, northern prickly ash, toothache tree; E. N.America; deciduous large shrub or small tree 3–7m tall; stems spiny; leaves alternate, pinnate, leaflets 5–11, oblong to ovate, 4–6·5cm long, aromatic; flowers very small with 4–5 yellow-green petals in axillary, umbel-like clusters, spring; fruit berry-like, jet-black; the dried bark has medicinal uses. Grow in ordinary, well-drained soil in sun or partial shade. Plant autumn to spring. Propagate by suckers removed at planting time, from seed when ripe, and by root cuttings in late winter in a cold frame.

Zauschneria

(for Johann Baptist Zauschner, 1737–99, Bohemian professor of natural history). California fuchsia. ONAGRACEAE. A genus of 4 species of somewhat woody-based rhizomatous perennials from W.USA to Mexico. They have opposite pairs of linear to ovate leaves and terminal racemes of tubular, somewhat fuchsia-like flowers having 4 sepal-lobes and 4 petal-lobes. Grow in well-drained soil in sunny, sheltered sites. Plant autumn or spring. Propagate by cuttings of basal non-flowering sideshoots in late summer, or by division in spring. In cold areas cover with a cloche late autumn or propagate by cuttings which should be over-wintered in a frost-free place.

Left: *Zantedeschia aethiopica*
Below: *Zauschneria cana*

summer. Greenhouse, but see also under *Z. aethiopica*; minimum temperature about 10°C, although *Z. aethiopica* will survive at 5–7°C, and *Z. elliottiana* is best at 12–15°C. Grow in pots of a standard compost such as J.I. No 2 or 3. Pot early spring and give 1 good watering, applying no more until shoots are several centimetres high. Water regularly thereafter and apply liquid feed at 7–10 day intervals once the young spathes show. *Z.*

yellow calla or arum lily; S.Africa; 60–90cm tall; leaf-blades 15–30cm long, ovate-cordate, translucent whitish-spotted; spathes to 15cm long, bright yellow within, green-tinted without. *Z.melanoleuca*, see *Z. albomaculata*. *Z. rehmannii* (*Richardia r.*), pink or red calla or arum lily; S.Africa; 40–60cm tall; leaf-blades 15–30cm long, lanceolate, slender-pointed; spathes 7–13cm long, rosy-purple with white to pink margins but variable, some clones

ZEA

Variegata, leaves white-striped; *Z.m.* Japonica Variegata and *Z.m.* Japonica Quadricolor, leaves striped yellow and white, often flushed pink. There are also mutant forms with grains red, purple and almost black, sometimes all in 1 cob.

Species cultivated: *Z. californica* (*Z. mexicana*), California, Mexico; sub-shrubby at base, 30cm or more tall; stems branched; leaves crowded, linear, 1–4cm long, 2–6mm wide, grey-downy; flowers 2·5–4cm long, summer to autumn. *Z.c. canescens*, see next entry; *Z.c. latifolia* (*Z.c. canescens*), herbaceous, leaves broader than type, 7–17mm wide. *Z. cana* (*Z. microphylla*), California; sub-shrubby at base; similar to *Z. californica* but leaves narrowly linear to 2mm wide; whole plant more downy grey-hairy. *Z. canescens*, see *Z. californica latifolia*. *Z. mexicana*, see *Z. californica*. *Z. microphylla*, see *Z. cana*.

Zea

(Greek name for a food grass, probably a primitive type of wheat called spelt). GRAMINEAE. A genus of 3 species of annual and perennial grasses from tropical America, 1 of which is widely grown: *Z. mays*, sweet corn, maize, Indian corn, mealies. Of ancient origin. Not found wild; arose in Mexico and possibly Peru. Many cultivars are grown for 'corn on the cob' but several cultivars are grown primarily for ornamental purposes: *Z.m.* Gracillima, dwarf, leaves very narrow; *Z.m.* Gracillima

Zelkova

(from the Caucasian vernacular name *zelkoua* or *tselkwa*). ULMACEAE. A genus of 5–7 species of deciduous trees from Crete to Japan. They are elm-like in general appearance but have small, rounded fruit technically classified as drupes. Culture as for *Ulmus*. May be propagated by grafting on to elm.
Species cultivated: *Z. carpinifolia* (*Z. crenata*), Caucasian elm; to 35m tall, rarely above 25m in Britain; of unique habit, a great sheaf of branches radiating from the top of a short, smooth trunk; leaves 5–9cm long, elliptic, prominently crenate; fruit about 5mm wide. *Z. crenatae*, see *Z. carpinifolia*. *Z. serrata*, saw-leaf zelkova or keaki; Japan; to 30m or more in the wild but rarely above 20m in Britain; widely domed habit with spreading branches; leaves 5–12cm long, ovate, coarsely sharp-toothed, colouring well in autumn; fruit 3mm wide.

Zenobia

(named after Zenobia, Queen of Palmyra, Syria, about AD266). ERICACEAE. A genus of 1 species of semi-evergreen shrub from S.E. USA: *Z. pulverulenta* (*Z. speciosa*), to 2m tall, of loose habit; leaves alternate, 3–7cm long, oblong to elliptic, entire or slightly toothed, bright glaucous particularly while young; flowers about 1cm long, bell-shaped, 5-lobed, waxy-white, fragrant, in lateral, pendulous umbels, summer. *Z.p. nitida* (*Z.p. nuda*), leaves non-glaucous. Grow in moisture-retentive, peaty, acid soil, preferably in partial shade. Plant autumn to spring. Propagate from seed or by layering in spring, by cuttings late summer, and suckers when available at planting time.

Top far left: *Zauschneria californica latifolia*
Left: *Zea mays* Gracillima Variegata
Top left: *Zea mays* Japonica Quadricolor
Above: *Zea mays* coloured grain cultivar

Zephyranthes

(Greek *zephyros*, the west wind, and *anthos*, a flower – alluding to plants' W.Hemisphere origin). Zephyr or rain lily. AMARYLLIDACEAE. A genus of

about 40 species of bulbous perennials from the warmer parts of N. and S.America, W.Indies. They have tufts of all-basal, linear to filiform, evergreen or deciduous leaves and solitary, 6-tepalled, tubular-based flowers. Grow hardy or half-hardy

Left: *Zelkova carpinifolia*
Below left: *Zenobia pulverulenta*
Above: *Zephyranthes candida*
Below: *Zephyranthes grandiflora*

species in well-drained, moderately fertile soil in sunny, sheltered sites, protecting the half-hardies in cold areas. Frost-free greenhouse or home for the tender species, in pots of J.I. potting compost No 1 or 2. Pot, repot or plant, spring. Potted specimens seem to flower more freely if they are left in the same container for several years (until congested, in fact). During the growing season liquid feed should be applied at 10-day intervals. Watering should be done with care, allowing the compost almost to dry out between applications. Little or no water is required in winter. Plants outdoors in wet areas benefit from a cloche in winter to keep off excess water. Propagation by separating offsets or dividing clumps at planting or potting time, or from seed in spring under glass.

Species cultivated: *Z. candida*, Argentina, Uruguay; hardy, evergreen except in severe winters; leaves rush-like, 20–30cm long; scapes 10–20cm tall, flowers crocus-like, 3·5–5cm long, white, autumn. *Z. carinata*, see *Z. grandiflora*. *Z. citrina*, S.America; tender; leaves to 30cm long, narrowly linear, channelled; scapes 15–25cm tall, flowers 3·5–4·5cm

Above: *Zigadenus elegans*
Above: right: *Zinnia elegans* Pink Ruffles
Right: *Zinnia elegans* Envy
Above far right: *Zinnia haageana* Persian Carpet
Far right: *Zinnia elegans* Scarlet Ruffles

long, bright yellow, summer to autumn. *Z. grandiflora* (*Z. carinata*, *Z. rosea* of gardens, not the much smaller-flowered true species), S.Mexico, Guatemala; half-hardy; leaves 25–40cm long by up to 8mm wide; scapes to 20cm or more tall, flowers 7–10cm long, opening widely, late summer to autumn; best under glass in cold areas. *Z. robusta*, see *Z. tubispatha*. *Z. rosea* of gardens, see *Z. grandiflora*. *Z. tubispatha* (*Z. robusta*, *Habranthus r.*), Argentina, Uruguay; half-hardy; leaves to 30cm or so long, linear, greyish; scapes 15–25cm tall, flowers 6–9cm long and wide, bright pink, late summer after leaves have died down; classified by some botanists under *Habranthus*.

Zigadenus

(*Zygadenus*). (Greek *zygon*, a yoke, and *aden*, a gland – referring to the paired glands at the base of the tepals of the first described species). LILIACEAE. A genus of 15 species of bulbous or rhizomatous perennials mainly from N.America (with 1 in E.Asia), 1 of which is generally available: *Z. elegans* (*Z. glaucus*), white camass, alkali grass; C.USA to N.Mexico and Alaska; bulbous, clump-forming, to 60cm or more tall; leaves 15–30cm long, linear, glaucous; flowers 6-tepalled, 1·5–2cm wide, each tepal greenish without, whitish within, bearing a conspicuous bilobed gland, in racemes or panicles, summer. Grow in moisture-retentive but not wet, neutral to acid, preferably peaty soil. Plant autumn to spring. Propagate by division or seed, spring.

Zinnia

(for Johann Gottfried Zinn, 1727–1759, German professor of botany at Gottingen). COMPOSITAE. A genus of 17–20 species of annuals, perennials and shrubs from S.W.USA and Mexico to Chile. They are mainly erect, with opposite pairs of linear to ovate leaves and solitary flower-heads with tubular to bell-shaped involucres and 1 to several rows of ray florets. Grow the annuals described here in at least moderately humus-rich soil in full sun and, ideally, sheltered from strong winds. Sow seed in spring at 21°C, if possible dressed with orthocide captan to minimize damping off. For best results space-sow in boxes at 4–5cm apart, or sow singly into 5cm pots. If seedlings are to be pricked off, do

this within 4–5 days of germination to avoid root breakage. Seedlings in small pots are best potted on into 7–9cm containers of a good commercial potting mixture, when well-rooted. Harden off and plant out in early summer or when fear of frost has passed.

Species cultivated: *Z. angustifolia*, see comments under *Z. haageana*. *Z. elegans*, youth and age; Mexico; to 60cm or more tall; leaves 7–13cm long, sessile, lanceolate to ovate-oblong; flower-heads to 10cm or more wide, basically red but also in shades of purple-pink, orange, buff and white, summer to autumn. Many cultivars and mixed strains are available, varying greatly in stature, flower size and doubleness, the ray florets often elongated, or broader, or quilled. California Giant type: *Z.e.* Dahlia-flowered, very large heads; *Z.e.* State Fair, vigorous, good in poor summers; *Z.e.* Super Giants, florets quilled. Ruffles group, very fully double, freely branching and vigorous in single colours, eg *Z.e.* Cherry Ruffles, *Z.e.* White Ruffles, *Z.e.* Yellow Ruffles, or mixed; *Z.e.* Envy, chartreuse-green; *Z.e.* Peter Pan, to 30cm tall, very weather-resistant, good colour range. *Z. haageana* (*Z. angustifolia* of gardens, not the true species, with linear leaves and flower-heads to 4cm; *Z. mexicana*), Mexico; to 45cm or more tall; leaves 4–7·5cm long, lanceolate; flower-heads to 5cm wide, rays orange, or red and yellow or orange bi-coloured, summer to autumn; several cultivars are available with double flower-heads in a wide colour range, eg *Z.h.* Old Mexico, 30cm tall, flowers larger than type; *Z.h.* Persian

Carpet, 30–37cm tall, many miniature flowers including bright bicolors.

Zizania

(Greek name for an unspecified wild grain, used by Linnaeus for this genus). Wild rice, water oats, Canada rice. GRAMINEAE. A genus of 3 species of annual and perennial aquatic grasses from N.E. N.America, E.Asia. They are of tufted or rhizomatous habit with broad but typically grass-like, linear leaves and terminal panicles of 1-flowered spikelets followed by large, cylindrical grains with a high nutritive value and greatly liked by water fowl. Grow in containers of rich loamy compost submerged in water 30–60cm deep, or plant directly into a natural mud bottom. Plant spring. Propagate perennials by division at planting time, the annuals from seed sown in spring, ideally in pots of compost stood in trays of water under glass, planting out when each plant has 3–4 leaves.

Species cultivated: *Z. aquatica*, annual wild or Indian rice; E. N.America; to 3m tall; leaves 2–4cm wide; panicles to 30cm or more long, female spikelets and subsequent grain to 2cm long, late summer to autumn. *Z. latifolia*, Manchurian wild rice; E.Asia; rhizomatous perennial 1·5–2·5m tall; leaves glaucous-green, 50–150cm long by 2–3cm wide; panicles 40–60cm long, female spikelets 1·8–2·5cm long, summer, when produced; grown mainly for its long, arching, densely-borne leaves.

Glossary

ACUMINATE	tapering to a slender point
ACUTE	sharply pointed but not tapering
AMPLEXICAUL	stem clasping, as a leaf base might
AXIL	junction between leaves, leaf stems, bracts, lateral flower buds, and the stem from which they arise
BI-	2, thus bipinnate is 2-pinnate
BRACT	a modified leaf below flowers, or clusters of flowers, and sometimes as showy as petals may be, as in many spurges, *Euphorbia*
CALYX	the outer whorl of modified leaves that protect the flower organs, sometimes persisting and showy, as in anemones, sometimes being shed when the flower opens, as in poppies
CLADODE	a flattened leaf like stem, as in butcher's broom, *Ruscus*
CORDATE	heart shaped with 2 rounded lobes at the base on either side of a stalk
CORYMB	a flat topped inflorescence made by the lower flower stalks being longer than those higher, as in candytuft, *Iberis*
CULTIVAR	short for cultivated variety and referring to a distinct variant of a species or hybrid maintained in cultivation
CYME	an inflorescence formed by repeated branching of each successive flowering stem, as in campion, *Silene* and in forget-me-not, *Myosotis*
DIGITATE	fingered leaves composed of more than 3 leaflets radiating from the same point at the top of a stalk, as in horse chestnut, *Aesculus*
DIOECIOUS	having male and female flowers on separate plants, as in holly, *Ilex*
DRUPE	a fleshy fruit with, usually, 1 hard, stony walled, seed, as in plums and cherries; small drupes, druplets, or drupels, form fruits such as of the raspberries and blackberries, *Rubus*
FILIFORM	thread like
GLANDULAR	with glands – small secretory organs often terminating in hairs or like minute pores
GLOBOSE	spherical, ball like
GLUME	a small bract with an axillary flower, as in grasses
HASTATE	triangular as a spear head
IMPARIPINNATE	see PINNATE
INFLORESCENCE	the flower bearing part of a plant formed of one or more flowers and arranged in various ways, such as a corymb or cyme for instance
INVOLUCRE	a ring of bracts surrounding a flower cluster, as the daisy, *Bellis*
LABELLUM	a specially modified tepal or petal, usually of an orchid flower, also called a lip
LANCEOLATE	lance or spear head shaped, 3–6 times as long as wide, broadest below the middle, with curving, tapered sides
LINEAR	leaves, petals and other organs with parallel sides for much of their length and at least 12 times as long as wide
MONOECIOUS	having separate male and female flowers on the same plant, as in hazel, *Corylus*
OB-	usually a prefix meaning inverted, as in oblanceolate or obovate with the broadest parts above the middle instead of below
ORBICULAR	disc shaped
OVATE	egg shaped in outline, from twice as long to as long as broad, widest below the middle and rounded to point tipped
OVOID	a solid, egg-shaped object
PALMATE	hand shaped, often fingered or lobed, as in maples, *Acer*
PANICLE	branched flower cluster of corymbs or racemes
PAPPUS	the modified calyx of members of the daisy family, the Compositae
PARIPINNATE	see PINNATE
PEDATE	shaped or lobed as a (bird's) foot
PETALOID	petal like
PHYLLOCLADE	a cladode

PINNATE	compound leaves with opposite pairs of separate leaflets, as in ash, *Fraxinus*. Pinnate leaves ending with an odd terminal leaflet are imparipinnate; those ending with a pair of leaflets paripinnate
PINNATIFID	leaves pinnately cut, the lobes extending less than halfway to the midrib; leaves with lobes extending more than halfway are pinnatipartite and those with lobes extending to the midrib pinnatisect
PINNATIPARTITE	see PINNATIFID
PINNATISECT	see PINNATIFID
PINNULE	leaflet of a bipinnate leaf, particularly applied to ferns
PSEUDOBULB	the bulb like swollen stems of orchids which store food and water
RACEME	inflorescence with a central stem bearing alternate or spirally arranged flowers each on a separate stalk
SAGITTATE	shaped like an arrowhead
SEPAL	one of the outer of the perianth segments, sometimes petal like as in the tulip, but usually green and often leaf like
SESSILE	without stalk
SORI	groups of sporangia, the spore containing bodies of ferns, often oval or circular, found on the under surface of the leaves
SPADIX	a flower spike the central stem of which is fleshy with the flowers embedded in it, as in cuckoo pint, *Arum*
SPATHE	the protective bract, or hood, ensheathing flowers. In cuckoo pint, *Arum*, and other similar flowers, it is large, showy and may be coloured while in other plants such as the daffodil, *Narcissus*, it forms a papery membrane
SPATHULATE	spoon or spatula shaped
STAMINODE	a stamen
STELLATE	star shaped
STIPULE	outgrowths, usually paired, at the base of the leaf stalks in some plants and taking various forms such as scale like and protecting the young leaves, then falling, in oak, *Quercus*, or spine like in false acacia, *Robinia*, and in many plants leaf like
STROBILI	cone, also the bud and catkin like inflorescence of conifers
TEPAL	tepals are the combined sepals and petals of a flower when they are similar as in the tulip
TERNATE	in threes, biternate therefore with 3 further divided into 3
TRI-	3, thus trifoliate – leaves in groups of 3 or leaves cut into 3 leaflets
UMBEL	an inflorescence the stalks of which arise from one point, usually the terminal one
WHORL	a ring of leaves, bracts, flowers or other parts, radiating out from the same level on a stem similarly to the spokes of a wheel
ZYGOMORPHIC	applied to irregular flowers (e.g. pansies, peas and snapdragons) which can be cut into mirror halves in one plane only

Bibliography

The Concise Encyclopedia concentrates on describing the best of the hardy plants and the bedding plants commercially available, and also covers their basic cultivation. For further reading therefore, the *Reader's Digest Illustrated Guide to Gardening* (Reader's Digest, London) is recommended for its fuller approach to the practical aspects of cultivation, for the various groups of garden plants including those grown for indoor decoration and those grown for culinary purposes. It is mainly illustrated with black and white drawings and diagrams though a most useful section on pests and diseases is illustrated in colour.

Also to be recommended for those who wish to extend their knowledge of the huge range of plants available in cultivation is the one volume *Hortus Third* (by the staff of the L. H. Bailey Hortorium, Cornell University; Macmillan, New York) which is unparalleled. It is a large, not inexpensive but good value, dictionary of plants which in covering the plants in cultivation in the United States incidentally covers most of those available in Europe, including Britain. The few illustrations are black and white diagrams showing family characteristics.

A fuller version of the same sort of information but with the addition of more cultural details is *The New York Botanical Garden Encyclopedia of Gardening* (Garland Publishing, New York and London), which is written in an easily accessible style.

Further identification pictures of plants are to be found in the book published as the *Color Dictionary of Garden Plants* (McGraw Hill) in the United States and as the *Dictionary of Garden Plants in Colour* (Michael Joseph) in Britain. Though now old in origin it has been reprinted regularly and has over 2000 colour photographs.

The Royal Horticultural Society's *Dictionary of Gardening* (Oxford University Press) in four volumes with a supplement, although published some years ago, is still an indispensable reference work for the serious gardener.

For specialist subjects, books dealing with a single group or genus of plants, there is a flood of new writing constantly appearing. There is also a large number of possible subjects and the best plan is to get advice from the appropriate specialist society or association dealing with your particular interest. Your local gardening group or national horticultural society should be able to supply you with the right information and will almost certainly be delighted to do so.

Acknowledgments

Photographs were supplied by A-Z Botanical Collection, B. Alfieri, Heather Angel, K. A. & G. Beckett, Pat Brindley, R. J. Corbin, John K. B. Cowley, Valerie Finnis, Brian Furner, S. Hamilton, Iris Hardwick Library, Anthony Huxley, G. E. Hyde, Archivio IGDA, Tania Midgely, Ray Proctor, G. Rodway, Kenneth Scowen, Donald Smith, Harry Smith Horticultural Photographic Collection, Peter Stiles, Michael Warren.